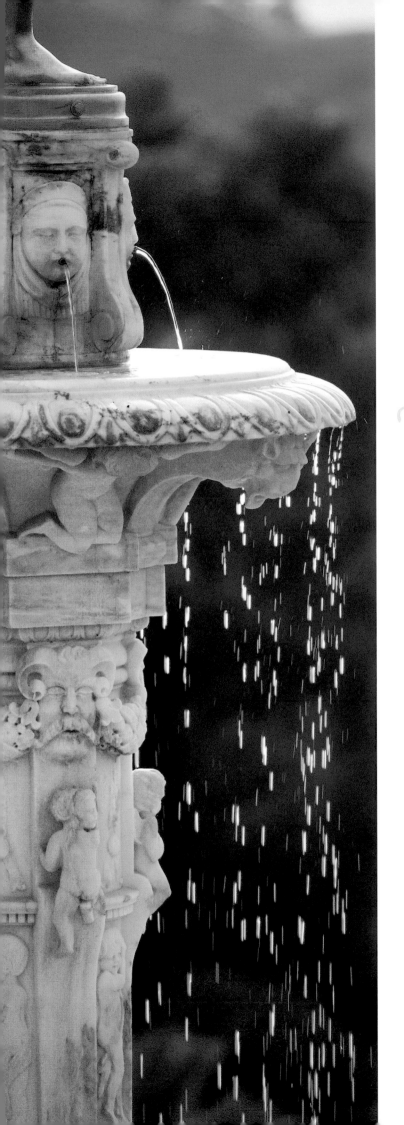

HEARST'S
SAN SIMEON

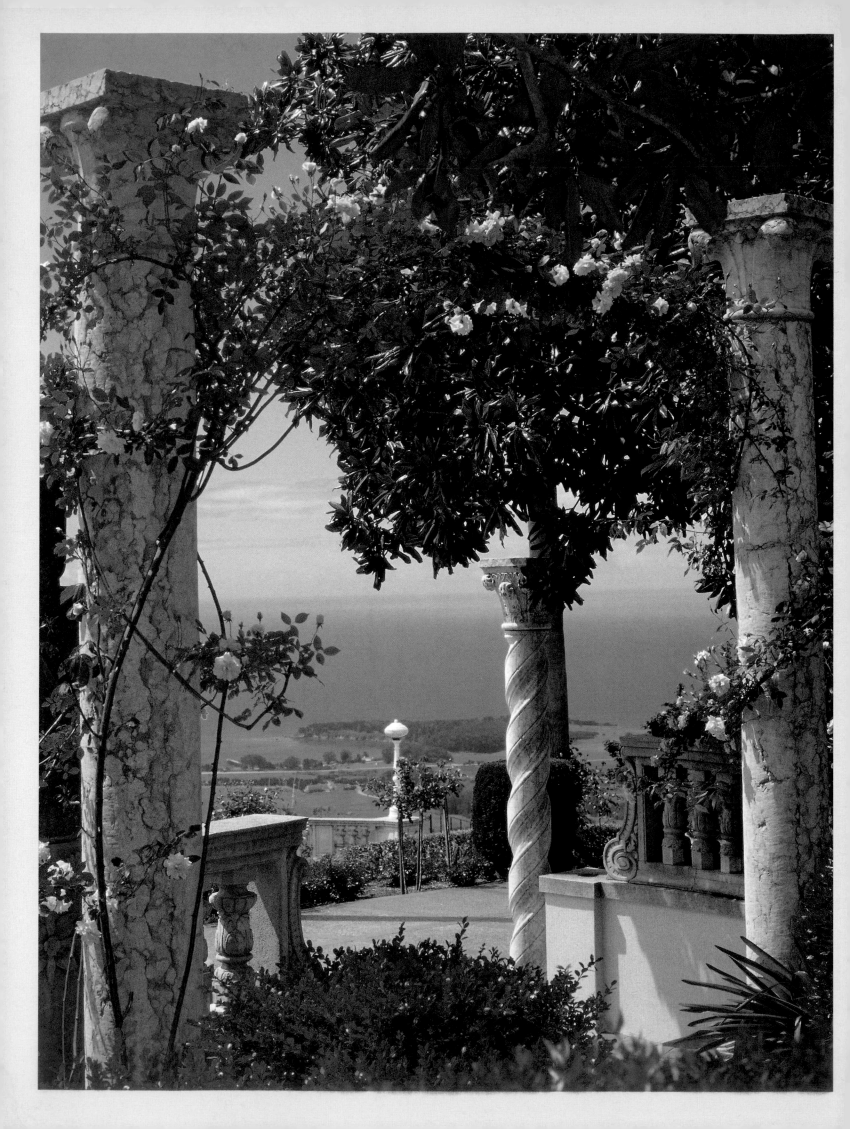

VICTORIA KASTNER

PHOTOGRAPHS BY VICTORIA GARAGLIANO

HEARST'S SAN SIMEON

THE GARDENS AND THE LAND

ABRAMS, NEW YORK

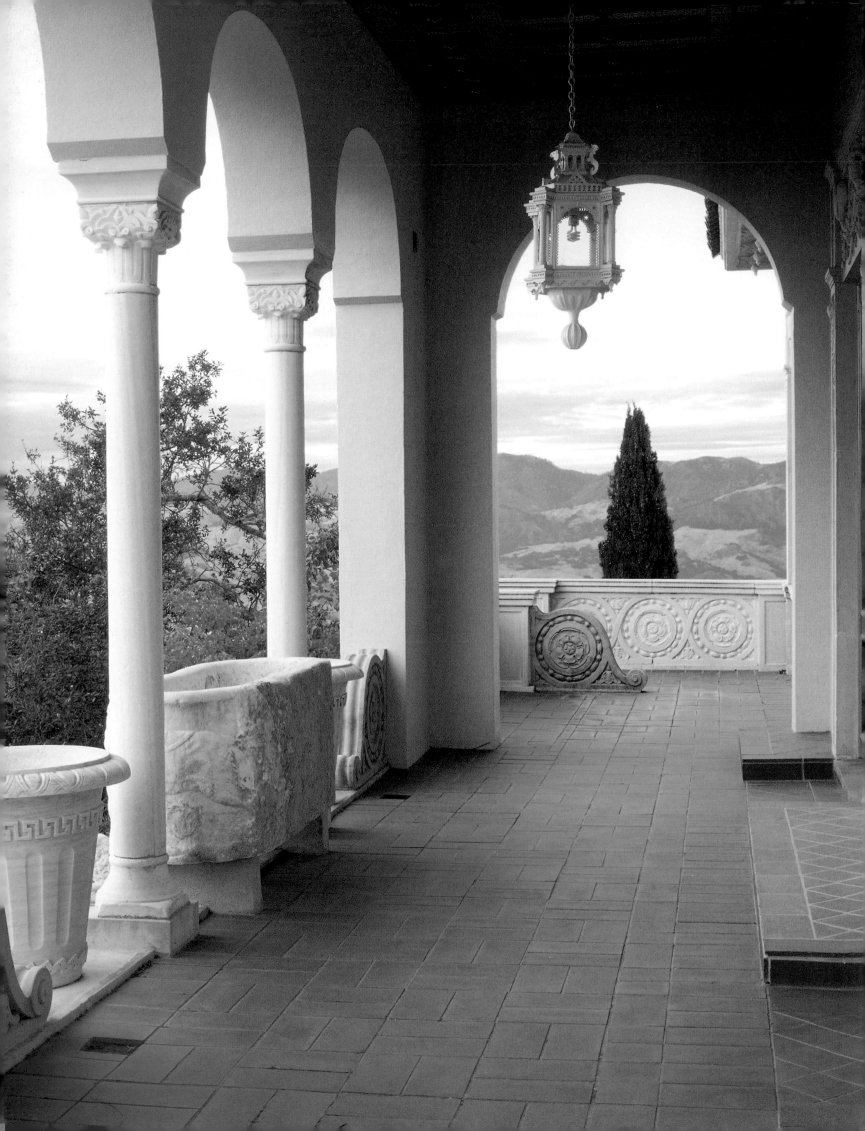

Contents

In memory of PAUL GOTTLIEB,

publisher, bon vivant, and friend

page 1
Detail of a fountain carved in 1922, reproducing the Fountain of the Labyrinth, designed by Il Tribolo and Pierino da Vinci in the 1540s for the Villa Castello outside Florence.

page 2
Blossoms on the climbing Cécile Brunner rose complement the Verona limestone of these sixteenth-century Italian columns. The rose arch frames the distant view of San Simeon Bay.

page 4
The loggia of House C at dusk. In the early years, the hilltop architecture and landscape design were inspired by Renaissance examples in southern Spain.

right
Clouds gather over the tree-lined entrance to the Hearst ranch. A 2005 conservation easement ended a forty-year-long battle for its commercial development and ensured that its eighty thousand acres will remain a working cattle ranch operated by the Hearst family, as it has been since 1865.

6

Preface Nicholas Franco

As Superintendent for the California State Parks District that includes Hearst Castle, I am proud to contribute to our mission to provide for the health, inspiration, and education of the park visitors. In this book, Victoria Kastner inspires us to view this site as what we in the park profession call a Cultural Landscape. Hearst Castle is not simply an artifact that is a touchstone to the past. It is not only a building where you learn about the craft of the workers and designers but also a place that was affected by the forces of nature, appreciated and loved by W. R. Hearst, and enhanced by the design of Julia Morgan.

Although I am fortunate to see Hearst Castle nearly every day, the photographs by Victoria Garagliano are breathtaking in capturing the nuance and grandeur of the gardens and landscape. You will be captivated by every image.

You can read much about William Randolph Hearst and the impact he had on American culture and history. You can read even more about Hearst Castle, the wonderful architecture of Julia Morgan, and the amazing art and antiquities that Hearst acquired over his lifetime. How-
ever, as spectacular as the buildings and collections are, nothing has been written heretofore about the entire landscape—the setting and its sense of place—that gives context and meaning to the collective whole of Hearst Castle and the man who built his dream.

Victoria Kastner and Victoria Garagliano revealed the partnership between Hearst and Morgan in their previous book, *Hearst Castle: The Biography of a Country House*. In this new book, they have captured the essence of the landscape and gardens, which were so significant to the overall design that went into creating this world-class site.

In the pages that follow, you will feel the sense of place and experience the same range of emotions that Hearst experienced when enjoying the views, smelling the flowers, or taking shade under the oaks. We can all thank the Hearst family, who generously donated Hearst Castle to California State Parks fifty years ago and who, in 2005, completed a conservation easement that protects the historic views and adds thirteen miles of coastline to the adjacent Hearst San Simeon State Park. As you read this book, allow yourself to find your own inspiration in this special place. I hope that you will visit soon.

This terrace, located west of House C, was rebuilt twice to create an Italian-inspired promenade. It is ornamented with a bronze copy of the ancient Roman statue *Discobolus* and provides a matchless view of San Simeon Bay.

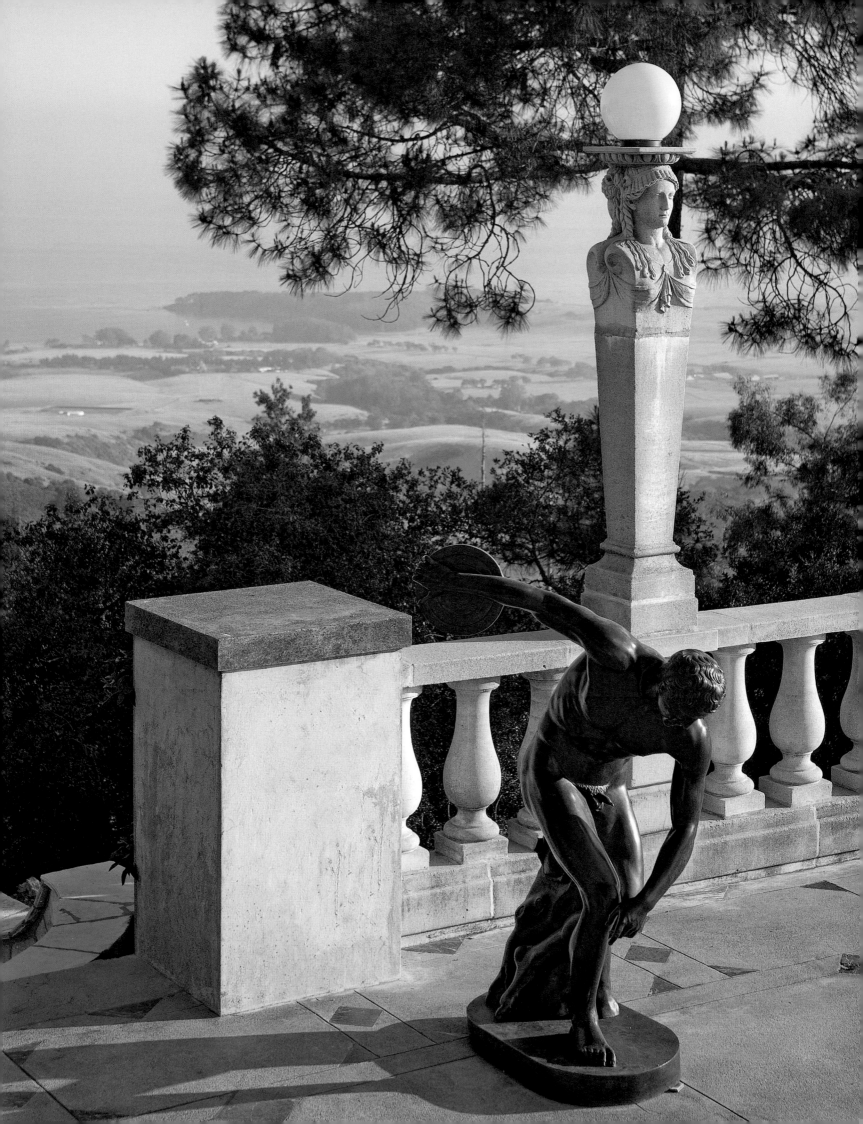

Introduction

William Randolph Hearst's ranch at San Simeon.

The phrase conjures up several images: a glittering court for Hollywood's royalty, presided over by Hearst and his companion, the actress Marion Davies, in the years between the world wars; a creative collaboration between Hearst and his indefatigable architect, Julia Morgan, who over the course of nearly three decades placed his wide-ranging Mediterranean art collection into its storybook setting; or a forbidding and somber Xanadu, indelibly sketched by Orson Welles in 1941 for the opening scenes of *Citizen Kane*. This 165-room country house, built between 1919 and 1947, was emblematic of the aspirations of the twentieth century—the American century. It was the home of a media mogul, presided over by a movie star, built by a woman architect, and immortalized by a film.

But the aspect of the estate most important to both Hearst and Morgan has never been fully examined: the land itself, which at its height totaled more than 250,000 acres. San Simeon's hilltop gardens are a Mediterranean fantasy. A thousand roses and miles of boxwood hedges frame dozens of citrus and palm trees, planted among the native centuries-old oaks. These grounds are not separated from the main building—which resembles an old Spanish cathedral—or from its three surrounding cottages—each of which evokes an Italian or Spanish villa. Instead the gardens surround the buildings and provide the atmosphere of a Mediterranean hill town. At their edge, two swimming pools built in an ancient Roman style sit like ruins from the classical age. Further out on the hillsides, as around the villas of ancient Rome, were orchards, a long pergola, and a menagerie. All these features defer to the sweeping views of the extensive ranchlands and the Pacific Ocean beyond.

One family's devotion to this site throughout the twentieth century has preserved it from the commercial development that transformed much of California's coastline and former coastal ranches into businesses, houses, ports,

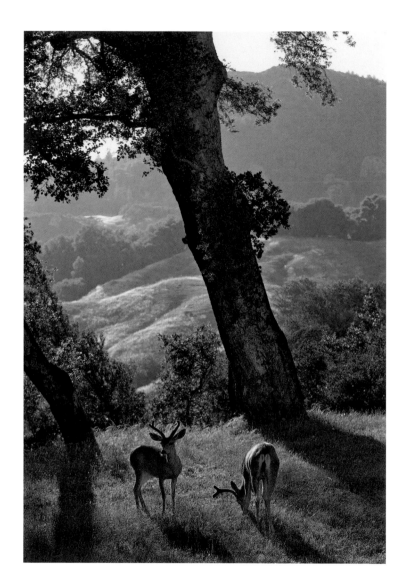

Mule deer (*Odocoileus hemionus*) graze underneath the oak trees at the ranch. Hearst wrote to his mother, Phoebe, in 1917 about this landscape: "I love this ranch. It is wonderful. I love the sea and I love the mountains and the hollows in the hills and the shady places in the creeks and even the hot brushy hillsides—full of quail—and the canyons full of deer."

opposite
Hearst called his estate at San Simeon La Cuesta Encantada, the Enchanted Hill, but the public observing it from below called it Hearst Castle. This romantic assembly of four major buildings, two swimming pools, and acres of lush gardens represented Hearst's fantasy of a Mediterranean hill town.

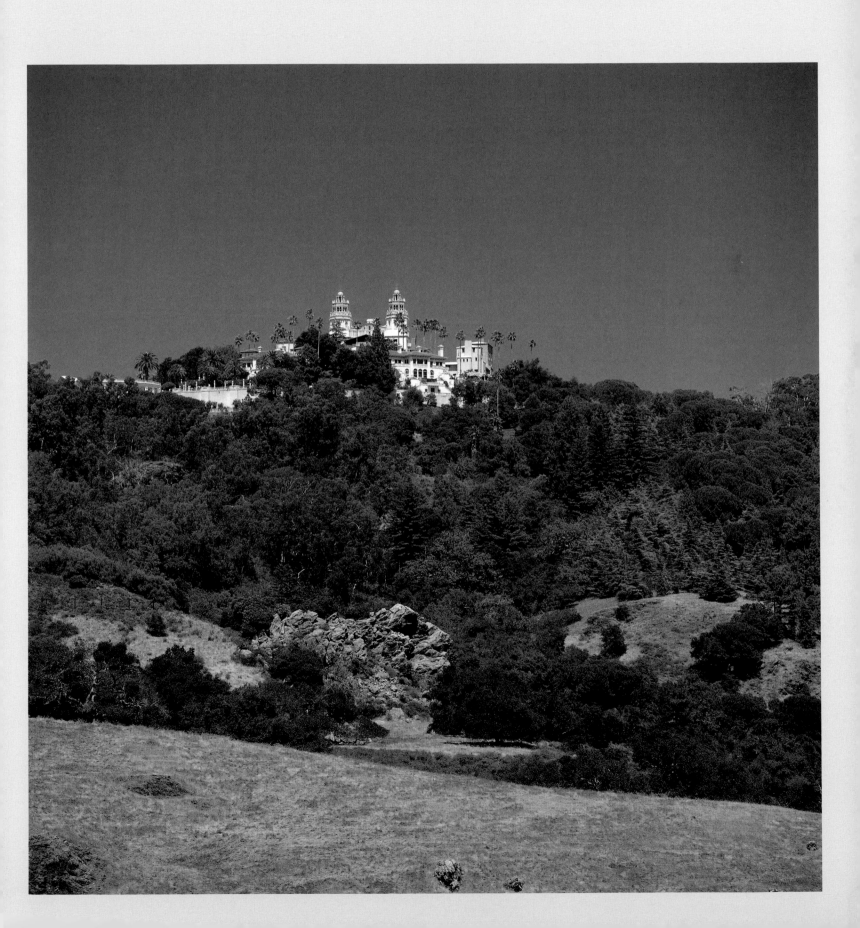

and parking lots. In 1957, six years after William Randolph Hearst's death, the Hearst Corporation and Hearst family donated the hilltop estate—including 120 acres of gardens, the buildings, and their contents—to the California State Parks Department. William Randolph Hearst wished it to be in public ownership, and over the past fifty years it has been seen by nearly 40 million visitors. In 2005, the ranch-lands surrounding the hilltop were preserved by means of a land conservation deal reached among the Hearst Corporation, the American Land Conservancy, and California State Parks. After decades of discussion about possible develop-ment, this agreement ensures that the region will never be marred by golf courses and mega-resorts. It will remain as William Randolph Hearst and Julia Morgan last saw it. La Cuesta Encantada (The Enchanted Hill, their formal name for the hilltop estate often called "Hearst Castle") and its verdant gardens will forever sit within the Santa Lucia coastal mountain range, presiding over rolling hillsides dotted with oak trees and grazing cattle, which extend clear down to the rocky, uncrowded shore. This fitting outcome would have delighted its two creators.

Hearst's love for San Simeon was his most enduring attachment. He was two years old in 1865 when his father, George Hearst—one of America's wealthiest gold, silver, and copper miners—bought the property. Young Willie's happy times there remained lifelong memories. For Mor-gan, building San Simeon's structures and designing its landscaping conferred a kind of ownership. She exhibited the most sensual aspects of her skill when creating its gar-dens and swimming pools and her greatest ingenuity when making its roads, water and power systems, and ranch and zoo structures. Together at San Simeon, Hearst and Mor-gan built something that eluded each of them apart. None of Hearst's other residences or Morgan's other seven hun-dred commissions comes close to San Simeon's dramatic interplay of structure and setting. Here an earlier Califor-nia lives on.

The rugged cliffs of the Big Sur coastline subside into gentle marine terraces sloping to the sea at the northern property line of the Hearst ranch (known, in reference to one of its Spanish land grants, as the Piedra Blanca Land and Cattle Company). Several thousand head of cattle graze the pastures abutting the Pacific Ocean; birds swarm the skies. Henry Miller described Big Sur as "a region where extremes meet, a region where one is always conscious of weather, of space, of grandeur, and of eloquent silence. . . . Often when the clouds pile up in the north and the sea is churned with white caps, I say to myself, 'This is the Cali-fornia that men dreamed of years ago . . . this is the face of the earth as the Creator intended it to look.'"[1]

One such dreamer was William Randolph Hearst, who wrote in 1917 to his mother, Phoebe Apperson Hearst, about San Simeon: "I love this ranch. It is wonderful. I love the sea and I love the mountains and the hollows in the hills and the shady places in the creeks and the fine old oaks and even the hot brushy hillsides—full of quail—and the canyons, full of deer. It is a wonderful place. I would rather spend a month here than any place in the world. And as a sanitarium!! Mother it has Nauheim, Carlsbad, Vichy, Wiesbaden, French Lick, Saratoga and every other so-called health resort beaten a nautical mile."[2] Hearst wrote this while camping with his wife, Millicent, and their five young sons, aged two to thirteen, in the hilly landscape above San Simeon Bay. He was fifty-four at the time, one of the country's most influential newspapermen and contro-versial figures. A frequent candidate for public office and the editor of twenty-eight daily American newspapers, he had been on the losing side of many political battles. After repeatedly belittling President Woodrow Wilson's admin-istration from 1913 to 1917, he became its reluctant cham-pion in the war against Germany. During the first decades of the century, Hearst launched frequent and unsuccessful bids for the White House. But his enduring contribution was more cultural than political. Hearst's media empire treated news as entertainment, foreshadowing our own era with its creation of a celebrity culture based on achieve-

ment (however dubious) rather than birthright. In spite of being the publisher of the most influential society magazine in America, *Town & Country*, Hearst was scornful of the wealthy and their aristocratic trappings. He saw himself as an outsider. This 1917 camping trip to California was a chance to regain his health and stamina in his favorite setting.

For all of William Randolph Hearst's life, the family had made a summer tradition of climbing a hill sixteen hundred feet above the sea to camp in platform tents on a sunlit mountaintop, the swirling mists of coastal fog often lingering just below them. Hearst knew this landscape—its encompassing views, its swimming holes and rocky outcroppings, its chaparral carpet that covered the steepest canyons, its steelhead trout–filled creeks flowing down to the sea.

San Simeon in 1917 was a large ranch with few improvements. The small village down on San Simeon Bay (given the name of a Roman pillar-sitting saint, San Simeon Stylites, by Spanish explorers in the eighteenth century) was a shipping port with a pier and warehouse built by George Hearst in 1878. Nearby was an eighteen-room Italianate Victorian house, which the elder Hearst had built that same year to oversee his horse-racing track and poultry and cattle ranch. By 1917 many of the area's landholders from the time of California's statehood in 1850 had been gradually bought out, first by George and then by his widow, Phoebe, after George's death in 1891, as the family continued to consolidate its ranch acreage. Just two years after that 1917 camping trip, Phoebe Hearst died of the influenza epidemic that felled millions across the world in the waning days of World War I. At the age of fifty-six, her sole heir inherited a 10-million-dollar fortune and became the owner of the vast San Simeon ranch.

Hearst immediately hired Morgan and commenced building. In fact, Morgan's office travel records indicate that she made journeys to San Simeon in the spring of 1919, ten days before Phoebe's death.[3] He first planned a modest bungalow that could be constructed in time for the

family's arrival that summer. "I get tired of going up there and camping in tents," he told Morgan. "I'm getting a little old for that. I'd like to get something that would be more comfortable." Walter Steilberg, an employee in Morgan's firm who overheard their earliest conversation about the project, recalled how quickly the plans expanded: "I don't think it was a month before we were going on the grand scale."[4] The hilltop complex included the 115-room main building—known as Casa Grande—and three cottages, each named for its view—Casa del Monte, facing north to the mountains; Casa del Sol, facing west to the sunset; and Casa del Mar, facing south to the sea. They also built many other ranch features: an estate village (expanding the existing structures in the town of San Simeon on the bay), a distant lodge twenty-three miles north, a reservoir of more than one million gallons, an airstrip, a pergola just over a mile in length, orchards and vegetable gardens, backcountry roads and bridges, and the largest private zoo in America—composed not only of grazing animals like zebras and antelope but also polar bears, big cats, elephants, and gorillas. Additionally they expanded many of the existing ranch features, including the horse ranch, cattle ranch, poultry ranch, warehouses, and pier.

Amid these numerous architectural creations, the gardens remained Hearst's highest priority. He chose the individual plants and determined their locations, trusting that the plantings would give unity and a sense of permanence to the hilltop. In an early letter in the fall of 1919, he wrote to Morgan: "I think that when we get the cottages built, we can lay out a plan of walks and flower beds or landscape features of some kind that will bring all of the structures together into a harmonious whole."[5]

Hearst had a lifelong appreciation for the rugged western landscape of California. "I long to get out in the woods and breathe the fresh mountain air, and listen to the moaning of the pines," he had written to Phoebe in his second year at Harvard. "It makes me almost crazy with homesickness when I think of it, and I hate their weak,

pretty New England scenery with its gently rolling hills, its pea green foliage, its vistas, tame enough to begin with but totally disfigured by houses and barns which could not be told apart save for the respective inhabitants. I hate it as I do a weak, pretty face without force or character. I long to see our own woods, the jagged rocks and towering mountains, the majestic pines, the grand impressive scenery of the 'far west.' I shall never live anywhere but in California. I like to be away for a while only to appreciate it the more when I return."[6]

Hearst believed in the curative power of wild nature, though he occasionally feigned a lack of interest in it. When later in life he was reproached by a female reader that none of his fourteen magazines included a title about nature (besides *Town & Country* and *Connoisseur*, he owned shelter magazines like *House Beautiful* and *Good Housekeeping*), he replied, "My dear lady, alligators love alligators, plants love plants, but people love people. When alligators and plants buy magazines, we'll do a magazine on nature."[7] Throughout his life, Hearst was involved (often alongside his mother) in some of California's major landscape and preservation movements, including the campus design for the University of California at Berkeley, the restoration of California's historic missions, and the staging of the influential 1915 San Francisco world's fair, known as the Panama-Pacific International Exposition. Hearst commissioned projects from many leading Arts and Crafts architects and artists of the San Francisco Bay Area tradition, including Albert C. Schweinfurth, Bruce Porter, and Bernard Maybeck. But creating San Simeon with Julia Morgan was his most important building project.

The estate is an example of what landscape architect Norman Newton has termed the "Country Place Era," which began with the 1893 World's Columbian Exposition in Chicago and extended to World War I. During this interval the wealthy embraced period revival styles in their landscape designs.[8] George Washington Vanderbilt's Biltmore Estate, designed in 1896 in Asheville, North Carolina, by Richard Morris Hunt, denotes its grand beginnings. La Cuesta Encantada serves as the pendant piece for the era, its design and construction extending until the years just after World War II. Hearst's initial conception for its garden evoked Moorish Spain, in keeping with his choice of building style. As the buildings increased greatly in size, Hearst and Morgan began scaling up the garden features, turning more to Italian Renaissance villas for their design inspiration. Morgan did not have formal landscape training, but she showed an affinity for landscape dating back to her student days at the Ecole des Beaux-Arts.

Much has been written recently about Morgan's impressive career. Her work at San Simeon remains one of the greatest architectural achievements by a woman. She was the first woman to graduate from the University of California with an engineering degree and practice architecture professionally, and the first woman in the world to obtain her *diplôme* from the Ecole des Beaux-Arts in Paris, the finest school for architects. Her projects included hotels, churches, schools, hospitals, and an impressive number of private residences, in addition to many commissions for the Hearst family. America's first woman architect of prominence, Morgan nevertheless remained largely unknown for thirty years after her death in 1957. This obscurity can partly be traced to her own reticence.

Walter Steilberg wrote, "Julia Morgan believed that architecture is an art of form, not an art of words. She was not given to talking, writing, or gesturing about her profession."[9] Determination, dedication, and impatience with any self-aggrandizing were essential aspects of her personality.

A myth endures that Morgan burned all her papers. She did inquire if her clients wanted to retain their drawings, destroying many to save space when she closed down her architectural practice in 1947. But Morgan left a large archive of work, the biggest portion of which concerns San Simeon—more than ten thousand drawings and one thousand letters exchanged with Hearst over its twenty-eight-year building period, augmented by thousands of additional letters generated by their staffs. New material is still being discovered, including recently archived diaries and letters of Morgan's that are quoted here for the first time.

Another erroneous assumption is that Morgan lost money working for Hearst. As Walter Steilberg pointed out, residential work is never as profitable as commercial work because there are so many details to attend to.[10] Morgan did often pay herself last, and late. And Hearst nearly always exceeded his budget, leaving her the exasperating task of managing his many creditors until their eventual payment. Her office records demonstrate, however, that her final profit on San Simeon from 1919 to 1937 exceeded one hundred thousand dollars.[11]

Misconceptions about the nature of Morgan and Hearst's collaboration are also common. Many initially assumed they had a romance. When this flight of fancy was refuted by copious evidence, another misguided surmise sprang up: Morgan must be a lesbian. Her work has been co-opted by some scholars to exemplify "queer architecture," implying it has a capacity for sensuality ascribed only to homosexuals.[12] Such wrongheaded assumptions show ignorance about social mores in the early twentieth century. When Morgan returned to America after eight years at the Ecole des Beaux-Arts, she was already thirty and her "marriageable" days were over. There is no evidence that

she lived with or traveled with a long-term female companion. The truth is simpler: Women in the early twentieth century chose either marriage or career. And architecture was Morgan's great passion.

Morgan has still not been recognized for her talents as a landscape designer. Without formal training, she created all the elements in San Simeon's gardens and extensive family farm. In this Mediterranean climate, she produced a version of what California might have looked like if it had remained under Spanish rule. There is a stage-set quality—a Hollywood effect—to the site's historical references, fitting for her movie-producer client, who made more than 120 films through his Cosmopolitan production company. His thirty-year relationship with the actress Marion Davies ensured that the ranch was filled with Hollywood folk, guests who may have lacked formal education but were attuned to setting and visual effect. Hearst was also fond of Washington Irving's *The Alhambra* and of the fairy-tale paintings of Maxfield Parrish, whose sun-drenched imaginary landscapes may have influenced San Simeon's design.

In their many missives, Morgan often served as Hearst's reporter. While he toiled at the office in New York, she detailed for him San Simeon's wonders: the size of its avocados, the sparkling light after a rain, the fierce-

ness and beauty of the lion cubs newly arrived for the zoo. Surely such subjects also filled their conversations at their frequent Sunday meetings when Hearst was in residence. In a travel diary from a freighter trip she took through the Mediterranean in 1938, Morgan revisited these familiar scenes, noting effects at San Simeon that she felt were superior to those in the actual Mediterranean.[13]

In the scale of its 250,000-acre setting and the drama of its hilltop complex, San Simeon is unlike any other American country house. It conjures up instead some of the grandest historic ensembles of Europe and Asia: the rocky monasteries of Mount Athos that overlook the Aegean Sea in Greece, or the Topkapi Palace, stretching across a high hillside down to the Bosphorus Strait in Turkey. Unlike these sites, La Cuesta Encantada was occupied for only thirty years, and it was the residence of a private citizen.

Perhaps in the totality of its scheme San Simeon best echoes another complex—one that lacked a coastal setting and a towering view, but matched its blending of architecture, landscape, and society. It resembles a modern-day Versailles, depicting the aspirations of the twentieth century as skillfully as Versailles expressed those of the seventeenth and eighteenth centuries—substituting the power of the press for the rule of monarchy. San Simeon, like Versailles, was a private court, located far from the city. It had an etiquette and hierarchy all its own. Hearst built on family land his father had purchased, just as Louis XIV did, and assembled an army of craftsmen to work on site in a specialized architectural style. Like Louis XIV, and later Louis XV, Hearst was involved in every aspect of his project and similarly assembled gardens, water effects, and a large menagerie, in addition to palatial residences. Hearst and Morgan even built their version of the Petit Trianon—the Milpitas Hacienda, a remote lodge more than twenty miles to the north, beside Mission San Antonio de Padua. Riding there on horseback, Hearst and his guests re-created the halcyon California days of the Mexican dons just as surely as Marie-Antoinette and her court searched for pastoral simplicity at the Petit Trianon. But while the suburbs of Paris have largely subsumed the original 20,000 acres of Versailles, San Simeon is still surrounded by its original 450 square miles of scenery. Its buildings are still furnished, its gardens abundant, its views unaltered. As a California State Park already visited by 40 million people, it is an homage to the first half of the twentieth century, and to William Randolph Hearst and Julia Morgan's love for the dramatic California landscape.

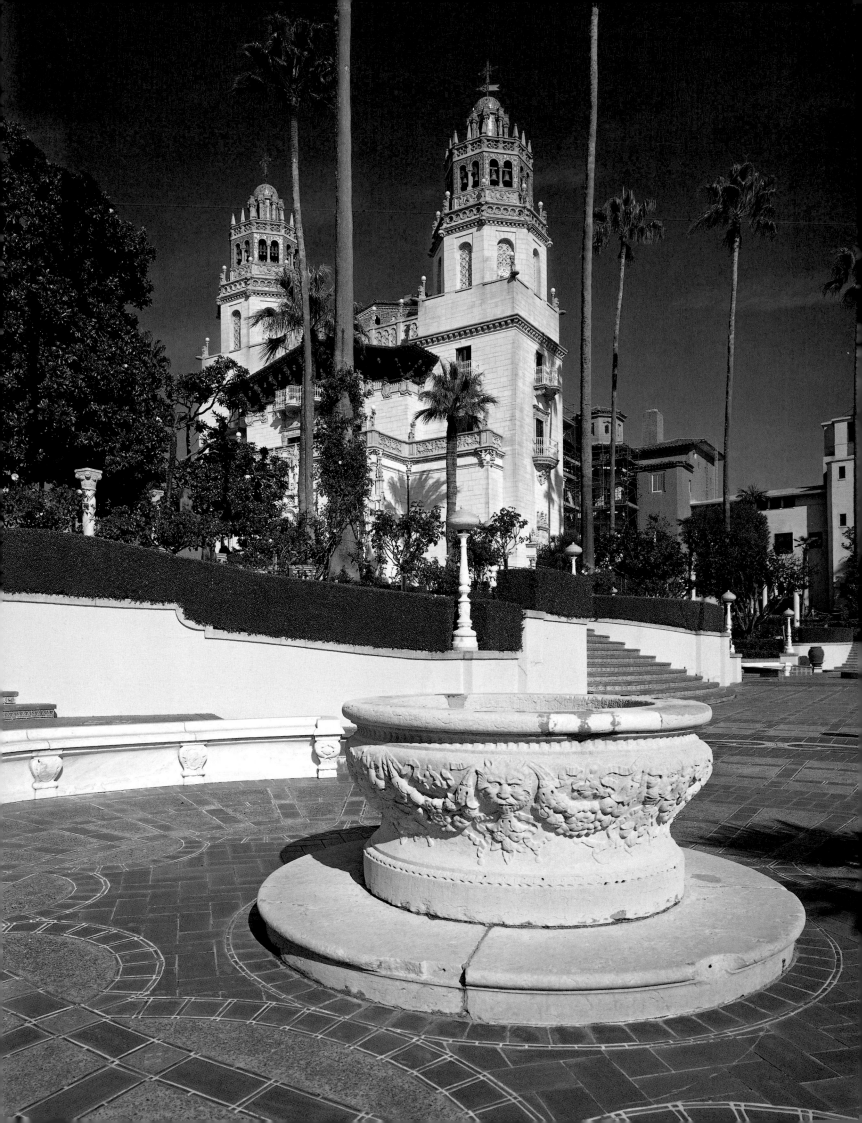

1

The Land in Its Place

In the early twentieth century California was seen by the rest of America as the land of sunshine. Embraced by easterners weary of cold winters, it was romanticized for its missions and their associations with a halcyon past. William Randolph Hearst carried impressions of that idealized history into the creation of his estate at San Simeon. He was the son of the celebrated miner George Hearst, a pioneer who had ridden west on horseback in 1850, singing "Oh Susannah," to create a better life than he could ever have as a farmer in the Merrimac River Valley of Missouri.[1] The forty-niner's dream of independence amid Arcadian beauty lived on at San Simeon, long after construction and "progress" obliterated it in other parts of California.

The land George Hearst began to purchase in 1865 had long been occupied. It is made up of narrow coastal plains south of the sheer cliffs of Big Sur. Jagged offshore rocks—remnants of ancient sea stacks—stand in the water near its marine terraces.[2] Crusted in guano, these rocks of cream-colored shale look white, and were thus named the Piedras Blancas by the Spanish. To the east rise the mountains of the Santa Lucia Range, stretching a hundred miles along the coast of central California.[3] Streams flow down the hillsides to the sea, and sheltered beaches dot the coast on both sides of San Simeon Bay. Offshore, underwater canyons bring nutrient-rich cold water surging up thousands of feet, resulting in a wide diversity of sea life. Onshore, the coastal scrub, grassy terraces, and streambeds bordered by riparian woodlands also ensure biodiversity. The temperatures are mild, with coastal fogs shrouding the shoreline through the summer months. These mists generally burn off by late afternoon, especially on the bright mountaintops more than fifteen hundred feet above sea level.

San Simeon has been the home of Native Americans for more than nine thousand years. They numbered more than twenty thousand in total population by the sixteenth century, when the earliest Spanish explorers arrived. They did not have a central social structure; they occupied

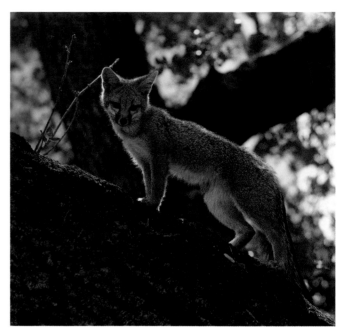

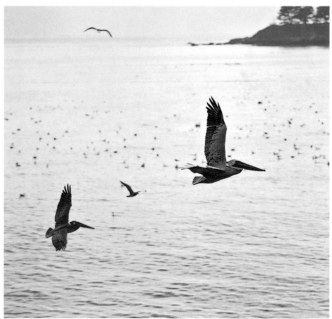

The gray fox (*Urocyon cinereoargenteus*), native to the region, is unusual among canids for its ability to climb trees.

Two California brown pelicans (*Pelecanus occidentalis californicus*) prepare to dive into San Simeon Bay. Once threatened by pesticides, this large seabird now flourishes on the California coast.

San Simeon Point, with the Hearst ranch stretching to the north. In 2005 the Hearst Corporation presented nearly one thousand acres of coastline to California State Parks, including thirteen beaches. The corporation retains additional coastal property with limited public access. This conservation agreement protects one of the last open stretches of California's shoreline from commercial development.

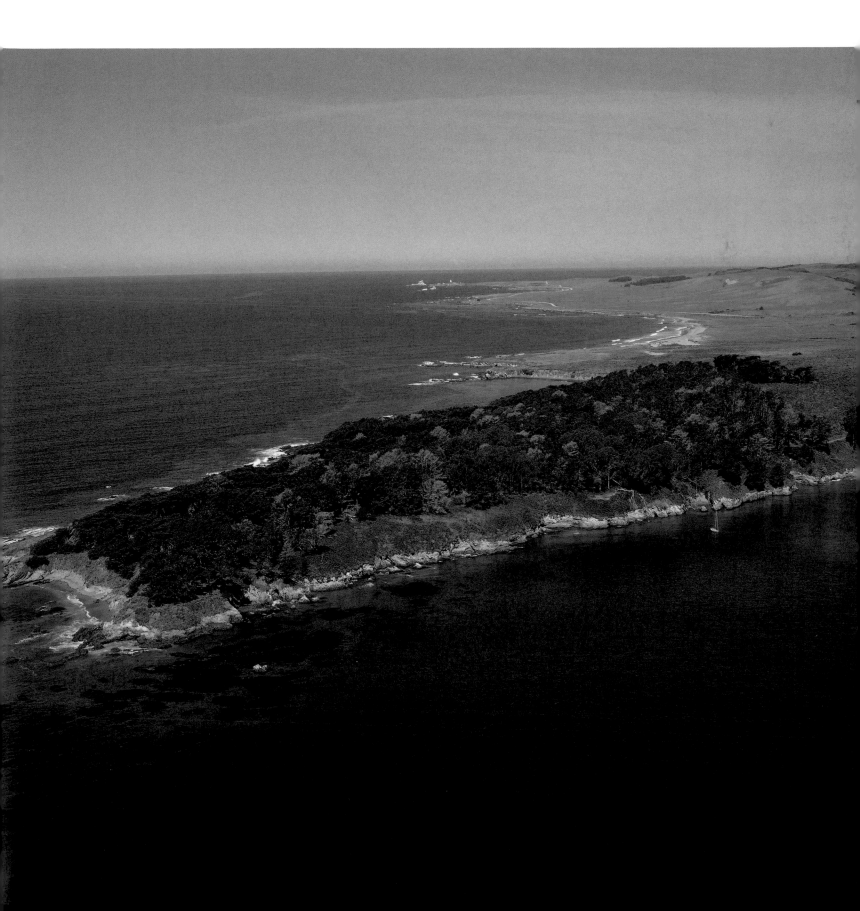

The oak-studded hills north of La Cuesta Encantada. The region has a
Mediterranean climate, characterized by cool, wet winters and hot, dry
summers, with mild temperatures and very few frosts.

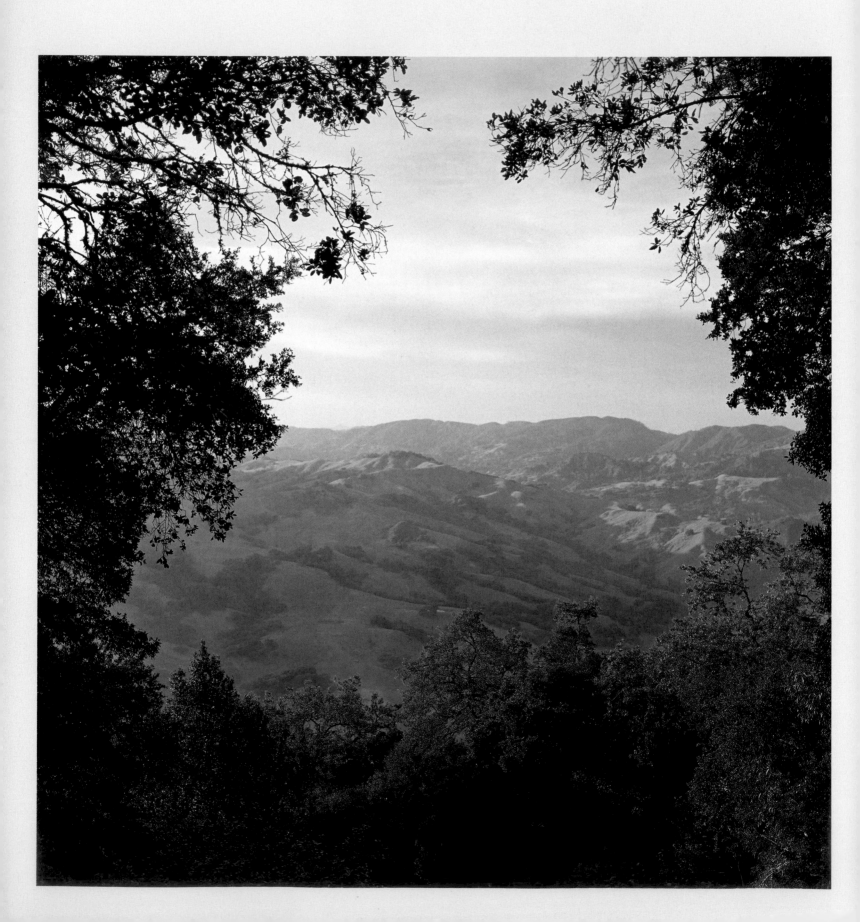

self-contained villages. The Chumash lived as far south as Santa Barbara, but their population extended northward to San Simeon. The Salinan, a northern group, also resided in the region. Known for their prowess as sailors and builders of canoes, they were also expert tenders of the landscape. Our notion of the land as untouched wilderness is erroneous. For thousands of years, native peoples thinned out undergrowth to encourage certain plants, returned seasonally to harvest other ones, and selectively burned large areas to aid plant growth and hunting access. Though they did not employ conventional agricultural methods or raise domesticated animals until eighteenth-century Spanish colonization, their practices undeniably altered the landscape and can be defined as a form of agriculture. During the Chumash era, San Simeon's natural forest and scrubland were transformed into coastal prairielands dotted with trees.[4]

The primary plant food source for these native peoples was acorns, from the same species of oak (*Quercus agrifolia*) that Hearst and Morgan later revered. Acorn processing was complicated. First the gathered seeds were spread on mats and dried in the sun. They were shelled with rocks, then dried again and skinned by tossing in a winnowing basket. Next the acorns were pulverized using a mortar and pestle; then the meal was soaked to eliminate the bitter tannins. It was mixed with water and cooked in baskets, the heat generated by dropping in hot stones from the fire. Chumash of different areas traded in dried oak acorns, using woven basket hats as their universal unit of measure. Naturalists theorize that the genetic diversity of oaks in the area today is partly a result of the aboriginal trade in acorns.[5]

Though many explorers sailed the coast past San Simeon, including Juan Rodríguez Cabrillo in 1542 and Sebastián Vizcaíno in 1602, the first descriptions we have of the indigenous people date to 1769, the year of the so-called Sacred Expedition. Juan Gaspar de Portolá was sent north by the Spanish government in response to incursions on Spanish territory by Russian fur traders.[6] On September 11, 1769, Portolá's group of sixty-three men (provisioned by one hundred pack animals) reached what is now called Pico Creek on the Hearst ranch.[7] The next day they traveled to an arroyo (north of the present-day San Simeon), which they named San Vicente, but which now goes by the name Arroyo de la Cruz (the Valley of the Cross).[8] The native peoples who met the Portolá expedition were friendly and welcoming. A small number greeted the caravan on its way up to Monterey and far more on the return journey to San Diego in December 1769, when the natives were tending the seasonal campsites they maintained along the coast. It is likely that the Native Americans had already come in contact with other cultures—either earlier Spanish explorers or the Chinese mariners who may have preceded them.[9]

A little-known description of the region comes from George Vancouver, an Englishman who sailed south past San Simeon in 1793: "This land was tolerably well wooded, even close down to the shore; and by the assistance of our glasses some of the trees were seen to be very large, with spreading branches; and being for the greater part distributed in detached clumps, produced a very pleasing effect, and a prospect more fertile than we had lately been accustomed to behold. . . . We soon discovered a canoe approaching us . . . navigated with great adroitness by four of the natives of the country. . . . Their exertions to reach us were very great, but as we were favored with a fresh gale, with all sails set, they were not able to come up with us; and I regretted that I could not afford some leisure for a better acquaintance with these people, who seemed, by the ingenuity displayed in their canoe, to differ very materially from those insensible beings we had met in the neighborhood of San Francisco and Monterey."[10]

Between 1769 and 1823, the Spanish established twenty-one missions in Alta California, including four nearby ones: San Antonio de Padua, San Luis Obispo de Tolosa, San Miguel Arcángel, and Nuestra Señora de la

Soledad. Throughout the area, the missions were hampered by a fundamental flaw: the absence of a social structure outside their realm. There were no supporting pueblos, no settlers who wanted to leave Spain to come to California.[11] The Franciscans were determined to save the souls of the Native Americans, and their fervor had catastrophic results. Portions of the native populations of missionized California were halved by 1830 through both oppression and communicable disease. Mexico received its independence from Spain in 1821—and from then until 1846, the Mexican government tried to secularize the missions, distribute land grants, and create a civil society. This effort was also laden with problems. In 1833 the Mexican Congress demanded that the missions be secularized and their lands distributed to new colonists. More than six hundred land grants were created to address this mandate.[12]

San Simeon's ranchlands today are made up of portions of three of these former Mexican land grants. Rancho de la Piedra Blanca (the Ranch of the White Rock) totaled more than seventy-six square miles (nearly forty-nine thousand acres), the maximum size permitted by the Mexican government for a single grant. Presented to José de Jesus Pico, the administrator of Mission San Antonio de Padua, it was made up of the mission's former pasturelands. Its boundaries extended from Pico Creek in the south to San Carpoforo Creek to the north, including the hilltop areas where William Randolph Hearst eventually built what is now known as Hearst Castle.[13] Rancho San Simeon (about forty-four hundred acres) was claimed by Mission San Miguel Arcángel and granted to José Ramon Estrada in 1842. It encompassed the area around San Simeon Bay, south of Rancho de la Piedra Blanca. Rancho Santa Rosa was also founded by Mission San Miguel Arcángel. Its approximately thirteen thousand acres stretched further to the south, from Santa Rosa Creek in Cambria to the tiny town of Harmony. It was granted to Don Julian Estrada in 1841.

The cattle-ranching tradition of this period was described by Luman R. Slawson, who stopped at San Simeon Bay in May 1850 on a steamer called the *Sarah Sands*. The crew had run out of coal, and they pulled into the bay to cut wood for fuel and wait for coal supplies to arrive from San Francisco. Two Mexicans came down on horseback, and "the captain made a bargain with them to furnish him with two beeves on the beach every day we staid there. They would drive them right down on the beach and lasso them wherever the butcher told them to. They were the fattest and best beef I ever saw, and no wonder, for there is over 20,000 acres of wild oats here, some in ravines higher than I could reach."[14]

This Spanish-Mexican period was the era of the Ramona myth spun by Helen Hunt Jackson in her 1884 novel *Ramona*. Though she attempted to tell a tale of oppression in the story of a half-Scottish, half-Indian girl and her sweetheart in Old California, what the public derived from this best-seller was a romantic view of the "good old Spanish days."[15] William Randolph Hearst lived at San Simeon like a latter-day don of the Mexican period, collecting silver saddles and Native American art. He remained lifelong friends with Don Francisco "Pancho" Estrada, the son of Julian Estrada, first owner of the Rancho Santa Rosa, and the last living representative of the Mexican era to occupy the Hearst ranch. Don Pancho rode in the local parades on a silver saddle and taught four generations of Hearsts to ride and to throw a riata. In the 1930s, Hearst led his own parades. Astride his horse on a silver saddle, he headed a caravan of Hollywood cowboys, starlets, and city-slicker journalists as they wound through his California ranchlands to Mission San Antonio de Padua, where he built a large hacienda beside the aging mission building.[16]

California was admitted into the Union on September 9, 1850, and the good fortune of the Mexican dons began to wane immediately. In 1854, José de Jesus Pico sold a large portion of the Rancho de la Piedra Blanca land grant to Captain Joseph Wilson for fifteen hundred dollars and deeded portions to his children to reduce his indebtedness

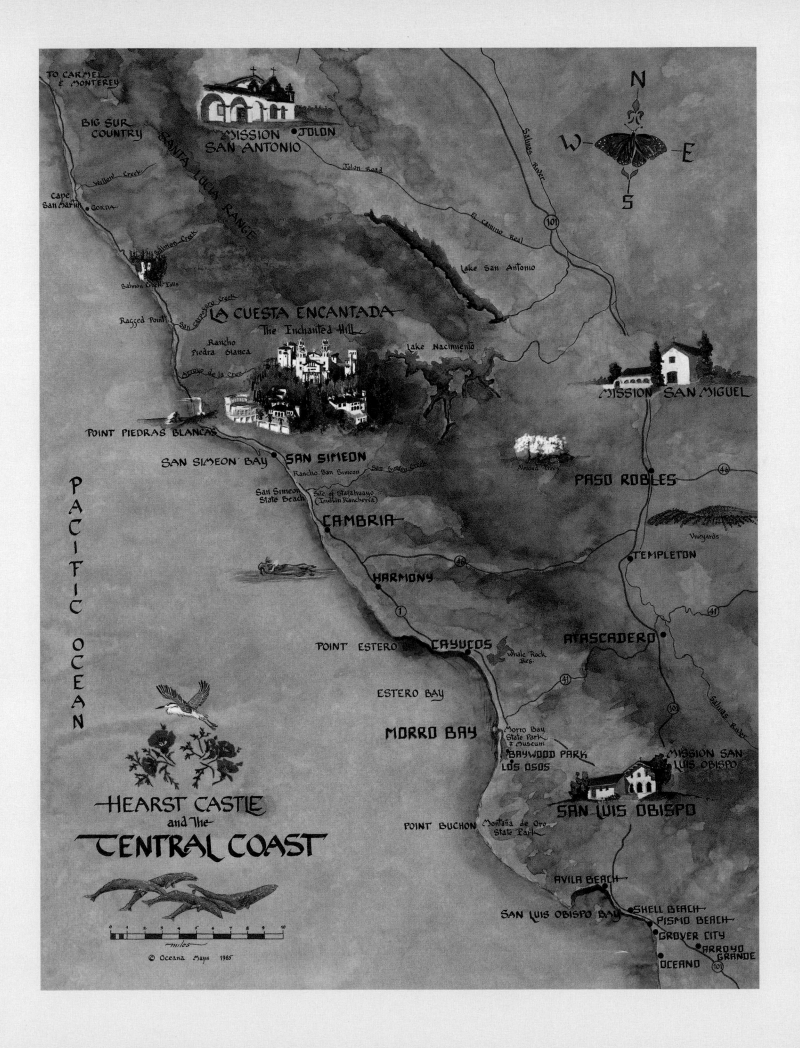

TO CARMEL
& MONTEREY

BIG SUR
COUNTRY

MISSION
SAN ANTONIO

JOLON

Jolon Road

Salinas River

N
W E
S

101

El Camino Real

Lake San Antonio

SANTA LUCIA RANGE

Vincent Creek

Cape
San Martin

GORDA

Salmon Creek

Salmon Creek Falls

Ragged Point

San Carpoforo Creek

LA CUESTA ENCANTADA
The Enchanted Hill

Rancho
Piedra Blanca

Lake Nacimiento

MISSION SAN MIGUEL

Arroyo de la Cruz

POINT PIEDRAS BLANCAS

SAN SIMEON BAY

SAN SIMEON

Rancho San Simeon

San Simeon Creek

Almond Trees

PASO ROBLES

46

San Simeon
State Beach

Site of Stajahuayo
(Indian Rancheria)

CAMBRIA

Vineyards

TEMPLETON

PACIFIC OCEAN

HARMONY

46

1

41

POINT ESTERO

CAYUCOS

Whale Rock Res.

ATASCADERO

ESTERO BAY

41

101

Salinas River

MORRO BAY

Morro Bay
State Park
& Museum

BAYWOOD PARK
LOS OSOS

MISSION SAN
LUIS OBISPO

POINT BUCHON

Montaña de Oro
State Park

SAN LUIS OBISPO

HEARST CASTLE
and the
CENTRAL COAST

AVILA BEACH

SAN LUIS OBISPO BAY

SHELL BEACH
PISMO BEACH

GROVER CITY

ARROYO
GRANDE

OCEANO

101

0 1 2 3 4 5 6 7 8 9 10
miles

© Oceana Maps 1985

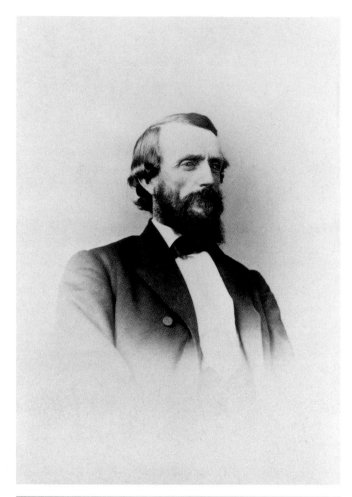

and comply with increasingly stringent U.S. laws. Requirements for taxes and proof of ownership kept the Californios in court and generated large legal bills. Even more catastrophic was the drought of 1863–1864—the worst drought in the history of Southern California. After a winter with virtually no rain, no grasses grew. Don Julian Estrada had been known as "the happy *caballero*" for his colorful costumes and silver-trimmed saddles. He rode through his Rancho Santa Rosa flanked by runners and mounted horsemen before and behind. During the drought, it is said that hundreds of his cattle and horses were driven off the cliffs to a quick death, rather than being left to starve in the fields. The Mexican landholders were ruined, and their long-horned Spanish cattle herds were not replaced. Instead Italian-Swiss dairy farmers moved into the region, bringing with them more profitable American cattle breeds.[17]

In 1865, immediately after the drought, George Hearst began buying land in the area. He was already a successful silver miner, having struck it rich with the Comstock Lode in Virginia City, Nevada, in 1859. He returned to his dying mother's bedside in Franklin County, Missouri, the next year and met again the seventeen-year-old Phoebe Apperson, whom he had known as a little girl ten years earlier, before he had departed to seek his fortune. George stayed in Franklin County for two years and became interested in the young, quiet "Phebe" (as she spelled her name then). Her calm visage reminded him of the face on a Virgin Mary sculpture he had seen as a boy, in a shrine kept inside a French mine in the region.[18] Phoebe's parents did not approve of her suitor initially, worrying about their twenty-two-year age difference. But George was persistent. He even signed over fifty shares of his Gould & Curry Silver Mining Company stock to Phoebe. They married on June 15, 1862.[19]

George and Phoebe left for San Francisco in the fall of 1862, journeying by train to New York, then boarding a steamship bound for the Isthmus of Panama, and then

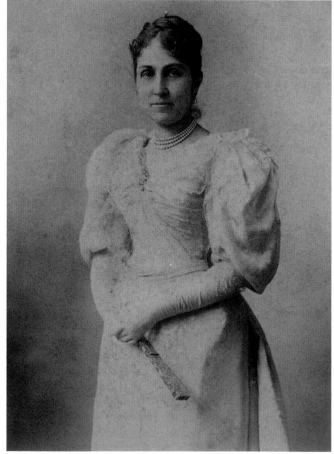

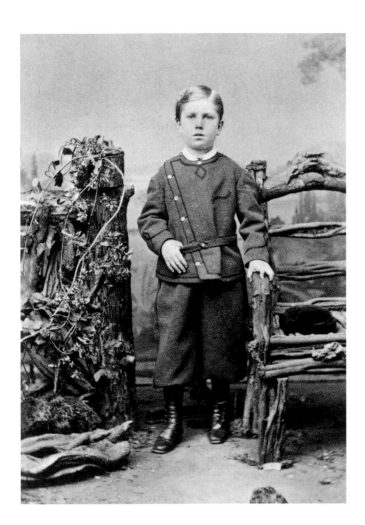

taking another steamship to San Francisco. A few weeks later George left the now-pregnant Phoebe and returned to the mines. Thus began the long absences that characterized their marriage. Willie was born on April 29, 1863, and was doted on by his young and adoring mother. One of his father's most important contributions to Willie's upbringing was taking him on camping trips to San Simeon as a boy. Many years later, William Randolph Hearst's biographer, Mrs. Fremont Older, wrote: "To this remote, romantic ranch Senator Hearst brought his son and his friends for fishing, hunting, and camping. On the crest of what is now called the Enchanted Hill, the Senator erected a cabin, and the elevation was known as Camp Hill."[20]

George Hearst's first acquisition in the area had been some thirty thousand acres of the Rancho de la Piedra Blanca, the first of many parcels he purchased nearby. According to Older, he paid seventy cents an acre. Though cinnabar—an ore-bearing mercury that is necessary for the processing of silver—had been discovered nearby in 1862, Hearst never mined in the area. Instead he began to fence in orchards and raise beef, dairy cattle, and poultry. In 1870 a richer grade of quicksilver ore was discovered along the ridge tops of the Santa Lucia Mountains. In consequence, the port of San Simeon began to attract a heavy shipping and mining trade. The first wharf (at the edge of San Simeon Point) was used only for an onshore whaling operation by Captain Joseph Clark. This flensing wharf was almost flush with the water at high tide and could not be used for shipping.[21] George Hearst went into partnership with Clark and with George W. Lull (a San Francisco businessman who built a sawmill and a general store near the Leffingwell Landing, south of San Simeon) in preparation for the boom time he anticipated would come to the central coast. The three partners secured the rights to build a warehouse and store, which they would operate jointly with a proposed pier.[22]

George Hearst envisioned subdividing the acreage bordering the beach at San Simeon Bay, but he needed

In 1878 W. R. Hearst's father, George, built his second warehouse, which still stands in San Simeon, to accompany the one-thousand-foot-long pier he built the same year. A narrow-gauge railway transported material directly from the pier to the warehouse.

George Hearst built this eighteen-room Victorian ranch house about a mile from San Simeon Bay in 1878.

to obtain complete ownership of the property. Captain Joseph Clark still owned twelve acres at San Simeon Point, including the whaling station. Hearst consolidated his purchases from the Estradas and another prominent Mexican-Spanish family, the Pachecos, and on March 23, 1868, he obtained the first commercial wharf license in the county. Beginning in January 1869, wharf fees were levied on all goods transported to and from the beach landing on Hearst's property. Local residents considered these fees exorbitant, and they resorted to traversing the property still owned by Pico with their *carretas*, thus circumventing trespassing on Hearst's land. The first commercial pier at San Simeon was completed in late 1869, and the warehouse and store were constructed by 1872. In 1869 George Hearst completed negotiations with the Wilson family and became the owner of all the property around San Simeon Bay except for twelve acres owned by Captain Clark's heirs and the two lots where Pico's sons lived. Hearst set up a dairy and leased his land to dairymen who paid him in heifer calves.

In 1878 George Hearst consolidated his wharf franchise by building another pier, which was one thousand feet long and built on six rows of piles. Extending into deep water and sheltered further into the bay, it had a twenty-foot-wide gangway connecting the wharf with the shore. A narrow-gauge railway was constructed to transport material straight from the wharf to the warehouse. At the same time, Hearst constructed an eighteen-room ranch house a mile inland from the bay.[23] It became known as the "senator's house" after Hearst's senate career began in 1886.

George Hearst loved fine horses and soon began to use his property for breeding racehorses, the preferred sport of late-nineteenth-century millionaires. Another avid devotee was Leland Stanford, whose Stanford University in Palo Alto originated as a horse farm. Hearst built a 3/8-mile training track east of San Simeon Bay and stabled his thoroughbred broodmares and stallions in the horse

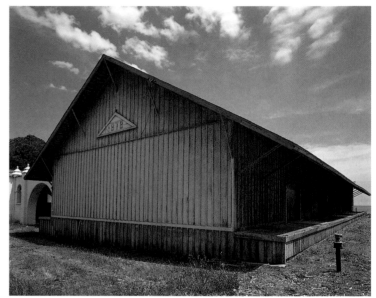

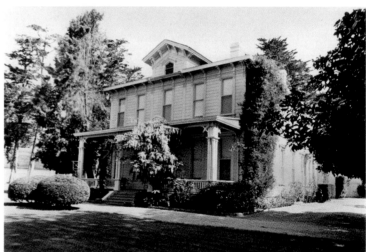

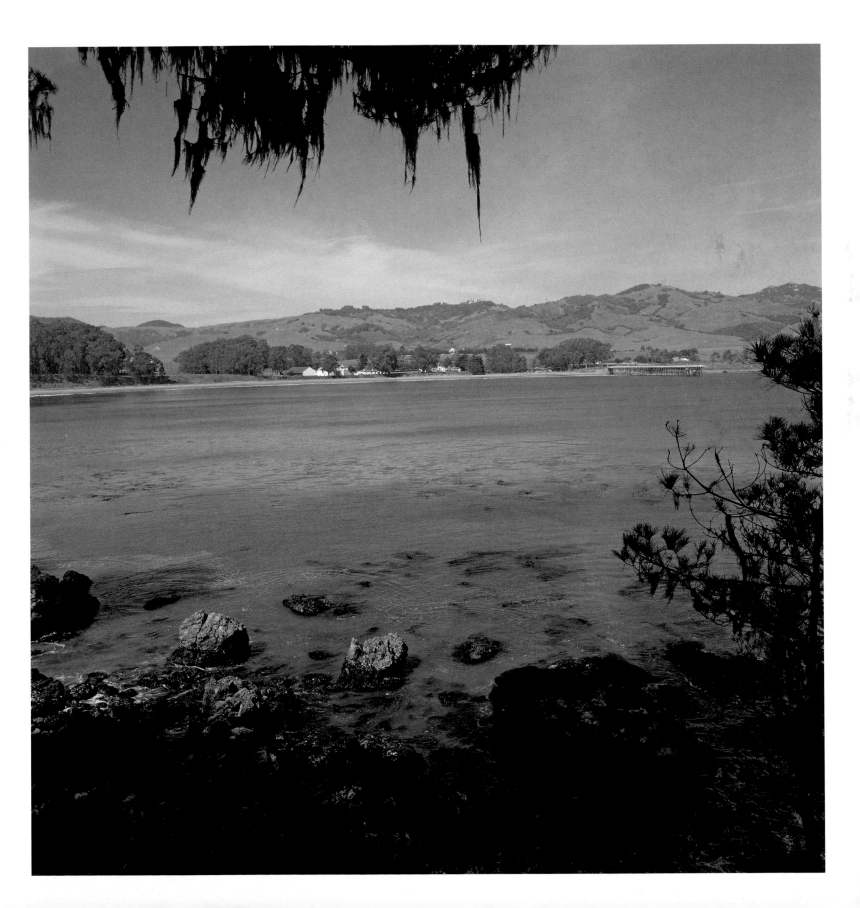

San Simeon Bay is a natural harbor, a rare feature on the California coast.

Piedras Blancas Lighthouse, north of San Simeon, was the only func-
tioning lighthouse between Monterey and Santa Barbara when it was
built in 1874. It is still in operation.

A 1921 map of the region around San Simeon, drawn up by the civil
engineering firm Punnett and Parez. The Hearst-owned Piedmont Land
and Cattle Company properties are shown in pink. From 1865 to 1919,
George Hearst and Phoebe Apperson Hearst gradually bought out the
region's landowners. William Randolph Hearst continued the practice.
The San Simeon ranch holdings eventually totaled more than 250,000
acres.

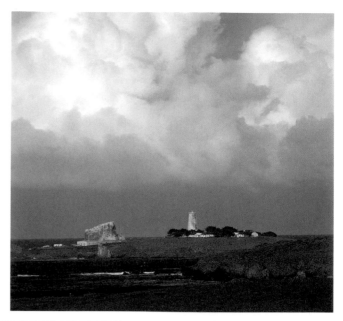

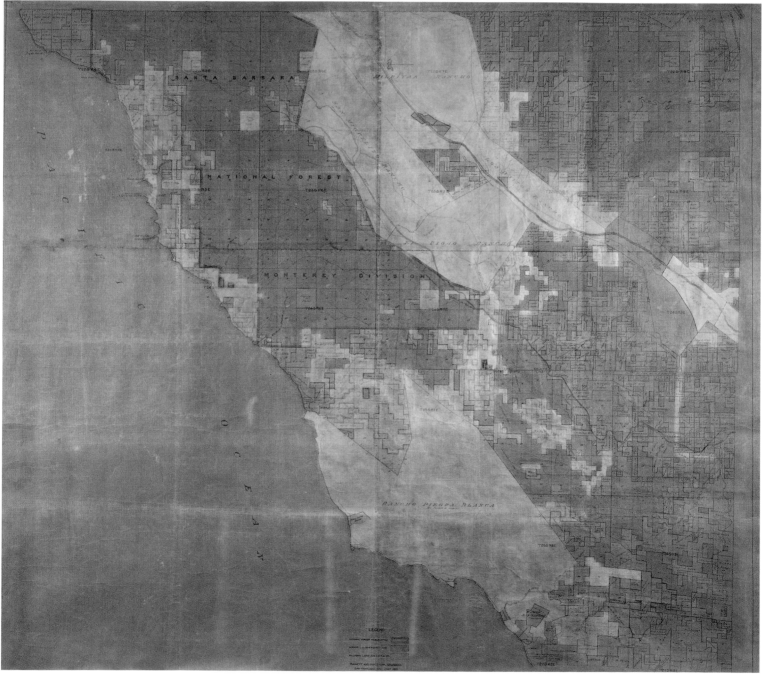

barns. It became one of the finest horse farms in California, establishing a family tradition of horsebreeding that continues today.[24]

At the time Hearst began acquiring the land around San Simeon Bay in the mid-nineteenth century, there was a large demand for whale products. Petroleum was discovered in Pennsylvania in 1859, but its fuel value as a replacement for whale oil was not immediately recognized. Baleen—the keratinous material near the mouth (referred to as "whalebone") that acts as a sieve to strain the whale's food from the water—was also valuable. Besides being used for whips, parasols, umbrellas, and many other household objects, it had the flexibility and strength to be perfect for women's corsets. As the vogue for the hourglass figure increased in the second half of the century, the market for baleen skyrocketed.[25]

In response to this demand, a shore whaling station had been established at San Simeon Point in 1864 by Joseph Clark, a young man of Portuguese descent who changed his name from Machado. Clark relocated from Monterey, where there were already four whaling stations, and set up his own operation after purchasing twelve acres from Don José Pico and the heirs of Captain Wilson. At this time there were eleven whaling stations along the California coast, employing sixty whalers. During the season, whalers kept an all-day lookout. A supplementary post was manned at Piedras Blancas Point, where a crewman in a crow's nest watched for the gray whales on their annual migrations between Baja California and the Gulf of Alaska. Joseph Clark's San Simeon operation captured an average of twenty-two whales each year during his first decade of operation. Harpooned by the crews in small boats, the whales were then towed into the bay. The carcasses were hoisted to shore on a pulley system and stripped of their blubber, which was reduced in large iron pots known as try-pots, creating clouds of thick black smoke and unpleasant odors. After Joseph Clark died in 1891, his cousin took over the whaling business and then sold it to the recently widowed Phoebe Apperson Hearst in 1894. She closed it down.[26]

The earliest sailors along the coast may have been Chinese, since their artifacts dating back three thousand years have been found in the San Simeon region. The immigration of Chinese laborers to the area began in 1848 and reached its peak in 1876. They lived along the ocean cliffs north of Cambria, where they farmed and supplemented their income by shipping dried abalone and seaweed to China. They harvested ulva, or sea lettuce, a type of bright green seaweed that grows on the rocks. In 1868 Ah Louis arrived from China and set up a shop in San Luis Obispo, forty miles to the south. He served also as a contractor, supplying Chinese laborers to work on the completion of the Southern Pacific Railroad and various road projects throughout the county. Chinese workers were employed at San Simeon Bay and on the hilltop as camp cooks. One of Ah Louis's sons, Young Louis, worked as the projectionist at Hearst Castle in the 1920s and 1930s.[27]

Landowners in the region continued to resent the Hearst family's thirst for complete acquisition at San Simeon. As a part of his early development plan, George Hearst arranged for water to be piped to San Simeon from mountain springs. By 1875 steamers were traversing the coast instead of sailing ships, and they were better able to anchor in San Simeon Bay. At this time, Hearst leased commercial sites to several town businesses for the pittance of two dollars a year.

The geographic isolation of the area was also a source of frustration to its early residents. Among the plans proposed in George Hearst's time was a wagon road that would extend the twelve miles north of San Simeon Bay to San Carpoforo Creek, then cut inland to Monterey County to "promote settlement and afford homesteads for thousands of families."[28] This did not happen. Because the majority of the land was in Hearst family hands, the nineteenth-century land-grant divisions were largely preserved, and access to the region remained difficult.

The thriving town of San Simeon in 1904, when the current Sebastian's
Store was known as the L. V. Thorndyke & Co. store. Two hotels sat
beside it: the Ferrari-Righetti Hotel and the Bay View Hotel.

San Simeon—early days

The Piedras Blancas Lighthouse was an important landmark that was not in Hearst family ownership. In 1867 Peter Gillis purchased 1,414 acres from Juan Castro, and in 1874–1875 constructed the lighthouse eight miles by road north of San Simeon Bay. By the 1870s, lumber, farm produce, and mining equipment were being shipped out of the port in large quantities. Prior to the lighthouse's construction, sailors had to rely on the white rocks to navigate San Simeon's natural harbor and avoid its rocky shoreline. After Gillis died in 1892, his heirs variously sold their portions to George Hearst. However, Piedras Blancas Point—where the lighthouse is located—was never acquired by the Hearsts and is now owned and operated by the Bureau of Land Management.[29]

George Hearst, Phoebe Apperson Hearst, and William Randolph Hearst all continued to acquire land in the area and fought the natural pressures for development of San Simeon, from 1865 until well into the twentieth century. They increased the rents on the dairy farm leases until the dairymen were forced to abandon their once-successful farms. Businesses based at San Simeon Bay were likewise squeezed out. The only independent landowners were the people who owned outright the title to lands that George Hearst was unable to buy. In 1894 the railroad was extended into San Luis Obispo, causing a decline in the importance of shipping along the northern coast. From this time on, the population of the region fell, and Phoebe Apperson Hearst and later William Randolph Hearst treated San Simeon more like a private park than a burgeoning commercial prospect. By 1910 only one store owner, L. V. Thorndyke Jr., remained in business. In 1914 he sold his store to Manuel Sebastian, who retired in 1948 and sold the operation to his son Pete, a longtime employee of William Randolph Hearst. Sebastian's store is still in business today, the last remnant of the coastal boomtown days.[30]

The English naturalist J. Smeaton Chase traveled on horseback through San Simeon in 1911 and wrote about its quietness: "The coast now curved to the pretty bay of San Simeon, fringed with islets of rock 'round which the sea coiled in dazzling whiteness of spray.... Inland, gray farms lay in bends and hollows of the mountains; wind-shorn oaks and laurels filled the narrower canyons; and whenever the road swung in to round the head of one of these, I found myself suddenly in a different world, among wild roses, ferns, blackberries, and phenomenal thickets of coarse flowering weeds. We loitered along so easily among these various attractions that it was near evening before we came to the village of San Simeon. This once promising little port has dwindled under the caprices of Fortune and local landowners until now only one small coasting steamer calls unpunctually at its wharf. I found myself the only guest in a hotel that would have housed double the whole population, with room to spare. But my host . . . and his good Welsh wife made amends by their friendliness for the physical drawbacks of the place."[31] Just eight years later, in 1919, William Randolph Hearst began to build on his beloved Camp Hill above the bay. This construction project turned San Simeon from a near-ghost town into a bustling estate village.

Place names given by the Spanish explorers survive in the region. The town of San Simeon was named for St. Simeon Stylites, a fifth-century Roman pillar-sitting ascetic. The cream-colored shale rocks directly north of San Simeon were covered in white guano, leading the Spanish to call them the Piedras Blancas, the white rocks.

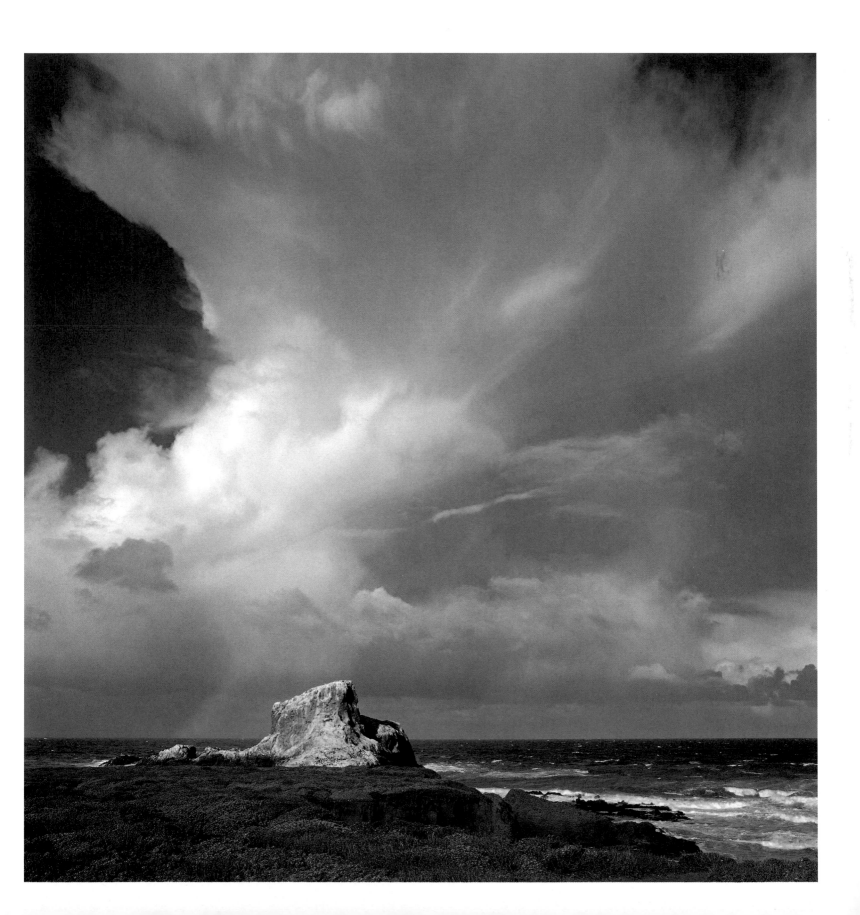

George Hearst and Phoebe Apperson Hearst: Early Pioneers

When George Hearst and his young son, Willie, journeyed together (as they did when they visited San Simeon, both by boat and overland), George told him: "When you travel don't play games. Look at the landscape. Study the soil and the conformation of the earth. Always learn what you can."[1] Hearst was one of the country's most successful miners, with a lifelong attentiveness to the land around him.

George Hearst was born in 1820 in Franklin County, Missouri. His father, William, was wealthy, eventually owning three farms and close to eight hundred acres. George grew up working the land and attended only two and a half years of formal schooling. Late in life, he described his independence, even in his youth: "I always had to have it my own way or not at all, and this has been my disposition all through life."[2] William Hearst died in 1846, ten thousand dollars in arrears, leaving the twenty-six-year-old George as sole family provider. George ran the farms, operated a country store, sold cattle, and struggled to repay the family debts.[3] He also worked in the nearby mines because he couldn't see a way to make a profit from farming. In 1850, the year after the California gold rush began, he headed west. The family was solvent again, and Hearst convinced his mother of the soundness of his plan by telling her he could earn as much as fifty dollars a day in the gold fields. He had never been farther than forty miles from home. Hearst traveled on horseback with a party of fifteen and came down with cholera in Nebraska. He survived the trek, but many did not. He said years later: "I don't suppose we saw more than half the graves, and yet we approached graves every mile." When he reached California, he spent his last one hundred dollars on a sack of flour. For the next ten years, he struggled—prospecting, running stores in Nevada City and Sacramento, and investing in real estate.

In 1859 his luck changed. In a mining camp in Nevada, later known as Virginia City, he bought a sixth interest in a played-out gold mine. The claim was called the Ophir,

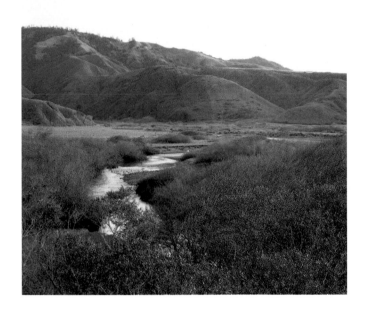

The Arroyo de la Cruz (Valley of the Cross) just north of San Simeon. Hearst wrote to his mother, Phoebe, while on a 1917 camping trip: "If you could see your son and your grandsons today on the ranch you would be highly entertained and pleased too. . . . We have been up to the Sancho Pojo and rode from there up the coast for ten or twelve miles. . . . We had breakfast and then came down to the Arroyo La Cruz and went in swimming in a big pool, first the children, then the girls and finally the men."

opposite
This 1913 Union Pacific railroad poster shows California's pastoral beauty. As a boy, William Randolph Hearst traveled cross-country by train, and in adulthood he regularly brought his own family west by train, writing with relief to Phoebe when they arrived in "God Blessed California."

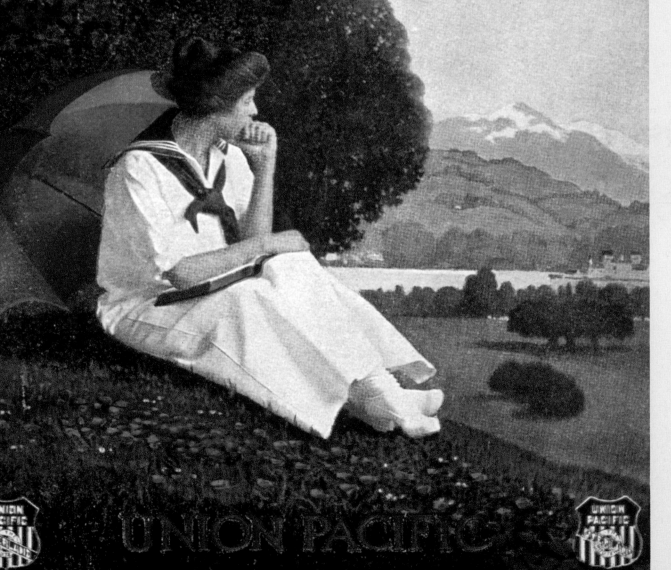

named after a source of gold mentioned in the Old Testament. George realized its black ore contained a great deal of silver. He and his partners dug forty-five tons of ore out of the ground that spring, then loaded it onto mules and carried it across the Sierra Nevada to California for smelting. They cleared eighty thousand dollars for their effort. It was part of the Comstock Lode, George's first big strike and the richest vein of silver ever found in North America.

When George returned to Franklin County in 1860, summoned back by his mother's illness, he brought gold nuggets and tales of adventure. Both made a big impression on seventeen-year-old Phoebe Apperson, who aspired to better things than a prairie life. She played the piano and spoke a bit of French. She was described as a girl who held a book in her left hand while she churned with her right.[4] When George proposed, her parents resisted, fearful that their daughter would be exposed to the rough life of the mining camps. But George and Phoebe were determined, and they married on June 15, 1862. Many years later, Phoebe told her grandson Bill Jr. she had been "lured by the prospect of a faraway land with a golden rainbow."

Phoebe never forgot her first glimpse of the misty and beautiful California coast after their long and difficult sea journey. The Atlantic had been rough, and her pregnancy compounded her seasickness. She was befriended on ship by Mr. and Mrs. David Peck and their two children, also en route to San Francisco. Orrin Peck, then two, became William's lifelong friend and referred to Phoebe as his "other

mother." The city of eighty thousand that awaited them was teeming and culturally diverse: Native Americans, Mexicans, Chinese, and Europeans all mingled with those from the American North and South. In the California tradition, everyone was from somewhere else, and all were seeking their fortunes in a new land.[5]

Phoebe learned to navigate the social currents of San Francisco largely on her own, as George was often in the mining camps. When he was present, his rough ways contrasted with her decorous ones. She therefore devoted her energies to her son, William Randolph Hearst, born on April 29, 1863. George was elected to the Sacramento legislature in 1865, the same year he began to purchase land at San Simeon.[6] While his fortunes fluctuated for the next fifteen years, he eventually gained spectacular wealth through his mining investments. The Ontario mine in Park City, Utah, yielded 14 million dollars in silver for Hearst and his partners, James Ben Ali Haggin and Lloyd Tevis. The three men also earned huge profits from the Homestake gold mine in Lead, South Dakota, and the Anaconda copper mine near Butte, Montana.[7]

In 1864 the Hearsts moved into a house on Chestnut Street in San Francisco, with a garden and a conservatory, the most luxurious residence of a number they occupied in Willie's childhood. Many years later, the little girl next door, Katherine "Pussy" Soulé, recalled Willie saying, "Pussy, come see the 'La France!'" She had never heard of such a thing, and she climbed over the fence to view it. "Why, it's just a rose!" she exclaimed, disappointed. "It's a 'La France,'" Willie corrected her. This large, fragrant, silvery pink rose had been introduced by the French rose breeder J. B. Guillot in 1867, and it is generally considered to be the first of the modern hybrid teas—the same rose that dominated Hearst's gardens at San Simeon fifty years later. "Pussy, if I wasn't afraid my mother would be mad, I'd cut the 'La France' and give it to you," Willie said.[8]

San Simeon's gardens were also influenced by another garden from Willie's childhood. Phoebe's parents, Randolph Apperson and Drusilla Whitmire Apperson, relocated from Missouri to the town of Alviso in the Santa Clara Valley, forty miles south of San Francisco. In 1936 Hearst's biographer, Mrs. Fremont Older, described their residence: "The roomy ranch-house had large pines at the entrance, and was approached by an avenue of poplar trees. A sunny courtyard formed by an L-shaped rear wing, and the living- and dining-rooms looked out on both eastern and western foothills. In this courtyard were geraniums, pinks, carnations, hollyhocks, lilacs, and lemon verbena. White, pink and yellow cacti climbed to the second-story window. Duchess roses were everywhere, and white and yellow banksia roses twined themselves round and were visible in pepper and cypress tree-tops. It was a garden that Sonny Hearst never forgot."[9] At this California ranch, young Willie played with the Newfoundland dog, Prince, and drove Doc, the old horse, "almost as wide as he was long." At age seventy-eight, Hearst reminisced about happy times there and its "great artesian well [that] poured out its waters in a crystal bell."[10]

His most formative experience came in 1873, when Phoebe took ten-year-old Willie to Europe for eighteen months. Though George's mining fortunes were precarious during this period, Phoebe was eager for self-improvement, and George urged them to go. Both mother and son were permanently affected by their adventures. The purpose of the trip was to explore the wonders of European art and culture, and both Phoebe and Willie became art collectors on this journey. The Irish castles, French gardens, and Roman ruins they viewed gave Willie an expanded sense of place and a direct knowledge of the importance of architecture and landscape. He also toured German zoos and aviaries, and he contemplated having his own zoo one day.[11]

In 1879, after another trip to Europe with Phoebe, the sixteen-year-old Will was sent to St. Paul's Episcopal School near Concord, New Hampshire. He hated the cold climate and longed for home.[12] His East Coast experiences solidified his feelings about California's superiority. He

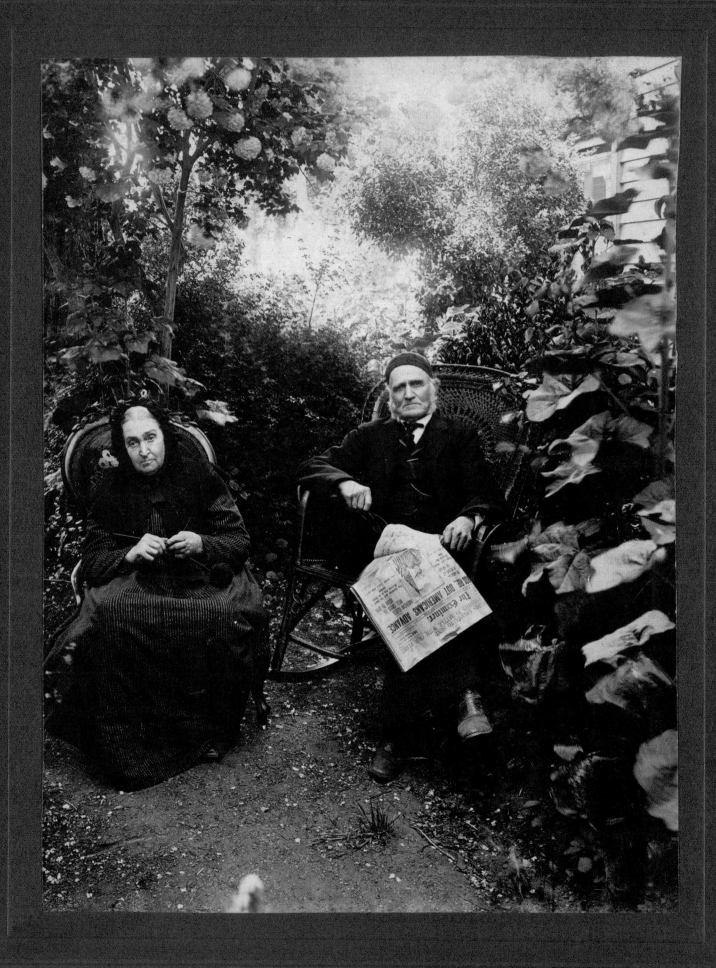

often said to George, "Father, it is too bad eastern people don't know what a wonderful state California is." And George would reply, "[I]f they knew, they would all come out here and crowd us old Californians into the Pacific Ocean. If the eastern coast had not been settled first, it never would have been settled at all. It's lucky for the East the Pilgrim Fathers never saw California."

In his teenage years, Will occasionally rode down the California coast from Monterey to San Simeon, camping with his friends as he had camped with his father years before. They were pretend pioneers, accustomed to city comforts. Once they ran out of butter, and Will rode into a nearby gold miner's camp to ask for some. The man stared at him, and said, "Butter! What the hell is that? I haven't seen any in twenty years." Once George Hearst had built the comfortable ranch house near San Simeon Bay in 1878, accompanied by the new wharf, Phoebe also made the journey. They invited Will's boyhood friend Eugene Lent and his family to join them on camping treks to a thicket of oaks on the crest of the hill, the future site of La Cuesta Encantada.[13]

After being accepted to Harvard in 1882, young Hearst had a respite in California, where he promptly fell in love with an opera singer, Sybil Sanderson, at the Hotel Del Monte in Monterey. Their brief summer romance took place in one of the finest gardens in America.[14] Known as California's Newport, its extensive acreage was landscaped by Rudolph Ulrich in 1880. Bright flower beds bloomed in symmetrical patterns amid sculpted low hedges, and meandering pathways wound among mature coast live oaks. As well as a celebrated cactus garden (known as an "Arizona Garden"), it had romantic features such as a hedge maze and a large lake with a fountain in the middle. Phoebe soon intervened to stop the relationship, dismayed at the prospect of a performer for a daughter-in-law. Will conducted another romance at the Hotel Del Monte four years later, in 1886. This time it was with a protégée of Phoebe's, the actress Eleanor Calhoun. Once again, Phoebe disapproved,

and Miss Calhoun was soon sent to study theater in London, far from Phoebe's precious boy.[15] The flower-laden grounds and venerable oak and pine trees of the Hotel Del Monte had had a powerful effect on Hearst, and they likely influenced his landscaping decisions at San Simeon thirty years later.

Hearst's academic career at Harvard was undistinguished. He began by studying philosophy, then changed to English, and was generally cavalier about course requirements. He was elected to the Hasty Pudding Club and kept luxurious rooms—and the habits of a college prankster, walking around the Harvard Yard with an alligator on a

leash. As business editor of the *Harvard Lampoon*, he discovered his lifelong fascination with journalism. In later years, Hearst claimed that a series of practical jokes and a boisterous political celebration he hosted on the occasion of Grover Cleveland's presidential victory prompted Harvard to request his early departure. While these may have been factors, Hearst had been on academic probation since his second year due to poor grades. Phoebe's efforts to rescue her son were ineffective, and Will left Harvard without a degree in the spring of 1886. George summed up Will's efforts: "He was four years at Harvard. I do not think, however, that he worked very hard there, because he was too fond of fun."

Will was unconcerned. His ambition was to run the *San Francisco Examiner*, which George Hearst had purchased in 1880 with an eye toward advancing his own progress within the Democratic Party. George said of the paper: "I knew no more about a newspaper than the man in the moon, and when I looked over the property, I said, this looks very like a quartz mill to me, and it will take a great deal of money to manage it." He also said, "Newspapers aren't a business. They are deficits."[16] George was appointed a United States senator in 1886 to fill the unfinished term of a deceased legislator, and was officially elected by the California state legislature to a six-year term in 1887. He offered Will several career alternatives to running the newspaper—including the chance to manage Babicora, the immense cattle ranch George had recently purchased in Chihuahua, Mexico, for forty cents an acre.[17] But Will was adamant, and George turned the *Examiner* over to him in February 1887. Thus began Hearst's career in sensation-laden journalism, eventually resulting in a media empire that included twenty-eight dailies at its height.[18]

George Hearst witnessed only the beginning of his son's journalistic achievements. He died in 1891 at age seventy, still a U.S. senator. His entire estate—valued at between 15 and 20 million dollars and including mines, ranches, stocks, even the *San Francisco Examiner*—was

left to Phoebe. It was a blow to Will, a sign his father felt more certain of his son's extravagant spending habits than of his business acumen. It also created new tension in his relationship with Phoebe, as Will had to beg her for cash to operate his enterprises. Her immense inheritance helped Phoebe become one of the greatest philanthropists in America. Much of the 21 million dollars she ultimately donated was spent on beautifying the California landscape and bringing culture to a rough American West.[19]

Early in her widowhood, Phoebe camped for two months in the Valley of the Moon near Sonoma. Her description of its comfortable outdoor arrangements hints at what San Simeon's hilltop campsite may have resembled: "June and July were comparatively restful months to me, for I fled 'far from the madding crowd' and from the numberless persons who, without even a pretence of acquaintance, pursued me at all hours and into all places, to extort

from me time, money, influence, sympathy, and whatever else they fancied I had. . . . I selected a hidden spot in the hills back of one of our vineyards in Sonoma County, and set up a camp home. . . . I had the tents made of a good size, . . . and board floors elevated enough to prevent the accumulation of dampness. A very opportune purchase of some Turkish rugs gave us the warmth and cheer that bare floors would have lacked and a home-like look and feeling were imparted by putting a little stove into the sitting-room tent. . . .The little canvas city was built upon a knoll that sloped up on three sides. . . . The soft light [from two hundred Chinese lanterns] thrown upon the dark foliage of the oaks . . . and the gentle breeze swinging the lanterns certainly were restful and exquisite."[20]

Phoebe's first philanthropic project after George's death was the gift of five women's scholarships to the University of California. It was the start of an extraordinary generosity benefiting not only young women but the university as a whole. In 1891 there were 164 female students on campus, including a young Julia Morgan, who had begun her studies the previous year.[21] In 1895 Phoebe decided she wanted to fund a building dedicated to George's memory for the College of Mining. Bernard Maybeck—recently arrived on campus as the drawing and descriptive geometry instructor and the only architect on the faculty—was enlisted to contribute a sketch. His early studies at the renowned Ecole des Beaux-Arts in Paris gave Maybeck a facility for architectural rendering, as well as an international perspective on design and planning. He created a rough drawing and presented it against a backdrop of drapery and potted plants—impressing Phoebe so much that she immediately decided to proceed with the building and to visit its site. Maybeck realized her potential as a patron and convinced her to propose an international competition to redesign the campus, at that time a modest collection of ill-assorted structures.[22] He was one of the early pioneers of the Mission Revival style, having contributed to the design of the Ponce de Leon Hotel in St.

Augustine, Florida, in 1887–1888 while working at the East Coast architectural firm of Carrère and Hastings. This building partly inspired the California State Building designed by A. Page Brown at the World's Columbian Exposition, the world's fair of 1893 in Chicago—and it, in turn, was an early inspiration for architects to build in the Mission Revival style. Shepley, Rutan, and Coolidge's 1887 design for the Mission-inspired Stanford University campus across the bay in Palo Alto was another early influence on the development of what became a characteristically Californian style.[23]

Phoebe's donations may have been motivated by a desire to compete with the Stanfords. However, her efforts went toward improving a public university open to all, rather than to building a private institution.[24] In 1896, she pledged unrestricted funds to underwrite the campus plan. The Phoebe Hearst Architectural Competition, as it

became known, was the most ambitious ever to have been undertaken in the country: It lasted four years and was done in two stages, much of it run from Europe. It greatly influenced urban planning, campus planning, and landscape architecture nationwide.[25] As coordinator, Maybeck traveled to Paris in 1897 to meet with colleagues at the Ecole des Beaux-Arts and publicize the competition. While there he visited Julia Morgan, who, at his urging, had traveled to Paris and applied to the Ecole as the first woman to study in its architecture department. The campus competition began on December 3, 1897, when a *programme*—printed in English, French, and German—was sent around the world. More than one hundred plans were submitted in response, and these were whittled down to eleven for the final round. On October 4, 1898, the committee met in Antwerp and selected the plan of Frenchman Emile Bénard. Upon realizing it would cost 50 million dollars, they instead

commissioned the fourth-place winner, the Beaux-Arts-trained John Galen Howard, to modify Bénard's scheme. Howard's design also followed the mandate to consider the site "a blank space, to be filled with a single beautiful and harmonious picture, as a painter fills his canvas," and to create "a City of Learning."[26] Howard reoriented Bénard's plan to better relate it to the low, rolling hills of Berkeley's topography. This repositioning placed the campus on axis with the Golden Gate, hearkening back to design recommendations renowned landscape architect Frederick Law Olmsted had made for the site in 1865.[27]

Though Maybeck—as the coordinator of the competition—could not contribute a campus design, in 1899 he did create one of the university's most extraordinary buildings: Hearst Hall, considered the most innovative design of his career. Both Gothic and Nordic, it prefigured his design for Phoebe Hearst's northern California retreat, known as Wyntoon, that same year. One of Phoebe's many young protégées, Helen Hillyer Brown, described the activities at Hearst Hall: "The usual program was three dinners for from 75 to 100 each a week, and musicals and food Sunday afternoons for sometimes several hundred." Hearst Hall became a haven for the female students until it burned in 1922. W. R., as Will became known, immediately commissioned Maybeck to create a fireproof replacement as a memorial to Phoebe. Maybeck designed a characteristically grand scheme with a large rotunda, similar to his elegiac Palace of Fine Arts in San Francisco, built for the 1915 world's fair. Maybeck's campus dome was to be built adjacent to an auditorium, on axis with the Campanile—part of the Howard 1899 campus plan—and was linked by courtyards, colonnades, and gardens. The Hearst Memorial was never built.[28] Maybeck had designed the Faculty Club in 1902 and the Phoebe Apperson Hearst Memorial Women's Gymnasium (with Julia Morgan) on the site of the former Hearst Hall in 1926, but his major contribution to the campus was the fostering of the Beaux-Arts scheme for the university itself.

Phoebe was also a patron of the archaeological and ethnographic resources of the university. In 1897 she became the first woman regent, a post she held for twenty-two years. In addition to funding expeditions to Egypt and Peru, she financed archeological work near the Mission San Antonio de Padua, later part of the Hearst ranch.[29] She supported the scholarship of Philip M. Jones and Alfred E. Kroeber, pioneer researchers of the Native American tribes of California.[30]

Phoebe's philanthropic interests included natural history as well as cultural history. She worked to save the coast redwoods (*Sequoia sempervirens*) as a member of the Sempervirens Club, founded in 1900 to protect the trees at Big Basin, near Santa Cruz. This effort resulted in the establishment of the California Redwood Park at the site—later known as Big Basin State Park, the first of California's nearly three hundred state parks. The California Club (of

which Phoebe was a founding member) heard Stanford University's first president, David Starr Jordan, describe eight thousand acres of giant sequoias (*Sequoiadendron giganteum*) near Calaveras as "the noblest forest in the world."[31] The Club launched a successful letter-writing campaign that ultimately saved that forest as well. Perhaps Phoebe's championing of the sequoias and redwoods influenced her son's decision to plant them at San Simeon many years later.

Phoebe also built two of California's most spectacular residences, both of which became homes for her son as well. The Pueblo-Spanish style Hacienda del Pozo de Verona (House of the Wellhead of Verona) was actually begun by W. R. He commissioned Albert C. Schweinfurth in 1894 to build a "hacienda" on a nearly-five-hundred-acre horse ranch George Hearst had purchased in 1881 in Pleasanton, across the bay from San Francisco. W. R.'s initial plans seem to have been drawn up with Phoebe's approval. He sent her a telegram early in 1895 inquiring about her "money limit" for his country house. He was interested even then in integrating California's history and landscape with its architecture. Schweinfurth wrote about their vision: "[E]verything about the design would express the land of *poco tiempo*." Hearst would be given a house "totally different in every way from the ordinary country home." In style it most resembled a Spanish monastery, organized around a long corridor leading to a courtyard. Pergolas were placed on each of the house's three levels, connecting the landscaping to the architecture. Schweinfurth referred to the Hacienda's decorations as "Spanish Renaissance" —exactly the style Hearst advocated twenty-five years later for San Simeon. According to Phoebe's niece, Anne Apperson Flint, Phoebe was incensed with W. R.'s taking over the property and staging parties there, and she appropriated it from him, but kept Schweinfurth on as its architect.[32]

The Hacienda became Phoebe's main residence, a fifty-three-room house where she entertained and show-cased her art collection. The botanist Luther Burbank, one of her visitors, wanted his own strains of gladioli grown there. An Indian tribe built its village on the property.[33] Porter Garnett's description of its landscape setting in his influential *Stately Homes of California*, published in 1915, seems to presage San Simeon: "Surmounting one of the low, wide-stretching hills of the Livermore Valley, a short distance inland from the Bay of San Francisco, stands a picturesque, castle-like structure, the 'Hacienda del Pozo de Verona,' residence of Mrs. Phoebe A. Hearst. The white walls of the building, accented by two commanding towers, rise above the trees. . . . Upon the gently undulating hills on the farther side of the valley, those portions which have not known the plowshare were, when the writer first saw them in early spring, like oak-studded lawns." Phoebe hired Julia Morgan to remodel the Hacienda between 1903 and 1910. Working at the site may have provided her first introduction to William Randolph Hearst. Another possibility for their initial meeting was the Greek Theater—Hearst's gift to the University of California in 1903—on which Morgan served as the assistant supervising architect, under the direction of John Galen Howard.[34]

Wyntoon, Phoebe's other California residence, was even more fanciful, evoking a fairy-tale association not directly connected to California's historic past. In 1901 Phoebe commissioned Maybeck to design a seven-story Bavarian castle on nearly one hundred thousand acres of pines near Mount Shasta, in northern California. Vast and baronial, it was set on the banks of the McCloud River and resembled the castles on the Rhine that Phoebe and young Willie had sailed past on their European travels. Here she could rest surrounded by the beauties of wild nature. Maybeck described his scheme to her: "The dark height of the room, the unobstructed archways, the deep blues, reds and yellows of the cathedral window, to which time had given maturity, the tapestries, the little flicker of fire, and the roaring of the river outside; and you, satiated, tired and inspired by the day's trip among hazel, dogwood, great

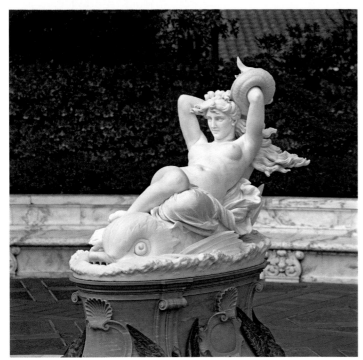

Leopoldo Ansiglioni, *Galatea on a Dolphin*, Italian, c. 1883. Marble and bronze, 72 x 54 x 39 in. (182.88 x 137.2 x 99 cm). Hearst Monument Collection, Central Plaza in front of Casa Grande. Phoebe Hearst was a benefactor to Ansiglioni. After visiting the Italian sculptor's studio in 1889, Hearst wrote to his mother: "Why didn't you buy Ansiglioni's 'Galatea'? It is superb. . . . I have a great notion to buy it myself, in fact. One thing that prevents me is a scarcity of funds, as it were. The man wants eight thousand dollars for the blooming thing and that is a little over my head." Hearst did purchase one of the three versions of this sculpture and gave it pride of place, in the middle of the Central Plaza, facing the entrance to Casa Grande.

W. R. Hearst commissioned Albert C. Schweinfurth to build a hacienda on Phoebe Hearst's land in Pleasanton, across the bay from San Francisco. The project grew so large that Phoebe appropriated it and made the Hacienda del Pozo de Verona her home. Its name (translated as the House of the Wellhead of Verona) derived from the Italian wellhead W. R. Hearst presented to her in 1900.

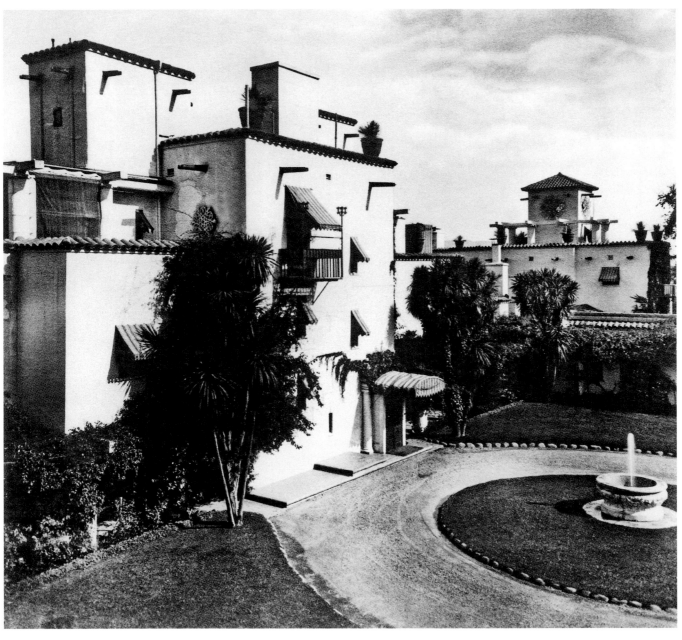

November 15 Cents

Hearst's
Magazine

SLEEPING BEAUTY Painted by MAXFIELD PARRISH

aged pines, rocks, cascades, great trunks of trees fallen years ago—a disheveled harmony—here you can reach all that is within you."[35]

While Phoebe established herself as California's preeminent benefactress, Hearst spent much of his time in New York, running his second newspaper, the *New York Journal*, and becoming involved in politics. He began to collect art seriously. He also began to admire the country and town houses of the architect Stanford White, who specialized in providing his wealthy clients with historically themed mansions filled with art and antiques. Representing the zenith of gilded-age tastes, White's multilayered interiors emphasized mood and effect over historical accuracy. Late in life, Hearst wrote longingly about this period of the "Gay Nineties," when "American art was at its highest and soundest point." He praised the paintings of John Singer Sargent and Maxfield Parrish, the latter of whom Hearst commissioned to design fairy-tale covers for his magazines.[36] Parrish's fanciful landscapes may well have been a later influence on San Simeon's romantic design.

In 1903, at age forty, Hearst married Millicent Veronica Willson, a twenty-year-old Broadway dancer from New York. Phoebe was initially unhappy with her daughter-in-law, but she soon grew fond of Millicent and hosted the newlyweds at the Hacienda.[37] Millicent quickly transitioned from stage performer to society matron and bore Hearst five sons: George in 1904, William Jr. in 1908, John in 1909, and twins—Randolph Apperson and David (christened Elbert)—in 1915.

The West represented a haven to Hearst. Taking his young and active family by train to San Simeon in 1906, he wrote to Phoebe en route: "We have just arrived in God Blessed California. The light is real sunlight, *not* artificial light, the heat is real sun heat, not steam heat, the Colorado river is real mud, the Yuma desert is real dirt, and the Indians are mostly real dirt, too. . . . I think California is the best country in the world and always will be no matter who comes into it or what is done to it. Nobody or no thing can

shut out the beautiful sun or alter the glorious climate. . . . Hurrah for dear old California."[38]

The fullest expression of California's role as a twentieth-century Eden came in 1915, with its two world's fairs. The smaller regional one (known as the Panama-California Exposition) was held in San Diego on the site now known as Balboa Park. Designed in part by the architect Bertram Grosvenor Goodhue in a largely Spanish Colonial style, it impressed Hearst enough that he cited it to Morgan as a potential model for San Simeon.[39] More extensive and influential was the Panama-Pacific International Exposition—known as the PPIE—held in San Francisco at the same time. Named to commemorate the completion of the Panama Canal in 1914, it represented a triumphant resurrection for the city after the destruction of the 1906 earthquake.

The 1915 San Francisco fair was built in a Moorish-Spanish style, evoking an exotic port city, with the nearby bay symbolizing the Mediterranean Sea. In contrast to the shining whiteness of the buildings at Chicago's 1893 fair, colors patterned on the California landscape tinted the pavilions—the roofs red tile, and the lath-and-plaster buildings earth toned. More than six hundred acres were organized on a central axis, around which five grand courtyards were arranged. Phoebe Hearst, W. R. Hearst, Bernard Maybeck, and Julia Morgan all contributed significantly to this fair.

W. R. was one of its earliest boosters. He had visited many world's fairs in America and abroad, starting when Phoebe took him at thirteen by train to the Philadelphia Centennial Exposition in 1876. Hearst was dazzled by the 1893 Chicago fair, called the World's Columbian Exposition in honor of the four hundredth anniversary of Columbus's voyage to America. Also called the "White City," it was designed in the Beaux-Arts style by Daniel Burnham. In 1891, Hearst had commissioned the architect Willis Polk to create plans for a world's fair for San Francisco, to be held in 1900. Polk took inspiration from California's missions;

Maybeck's elegiac Palace of Fine Arts was designed for the Panama-Pacific International Exposition, otherwise known as the 1915 San Francisco world's fair. Its temple, flanked by colonnades and fronted by a lagoon, was the favorite building of the fair and a likely inspiration for La Cuesta Encantada's Neptune Pool. After the fair, W. R. Hearst and Phoebe Hearst displayed their art collections in fourteen of its galleries, which were visited by two hundred thousand people.

This depiction of an exhausted Indian, James Earle Fraser's *The End of the Trail*, was the most popular statue at the 1915 San Francisco world's fair.

and although it was never realized, his scheme reflects an increasing awareness of the Golden State's unique regional identity.[40]

Unlike in Chicago, there was no dedicated Women's Building at San Francisco's 1915 fair, but there was a Women's Board, of which Phoebe was the honorary president. She was also a major patroness of the Young Women's Christian Association, which provided safe accommodations for unmarried girls leaving their rural homes to earn money as urban shop girls and secretaries. At the fair, the YWCA had a building, designed by Edward F. Champney. Because of the pressure exerted by Phoebe and other female board members, Julia Morgan was hired to design its interior, which served as a hospitality suite where women could rest during the day.[41]

The most dramatic and beloved of all the fair's buildings was Bernard Maybeck's Palace of Fine Arts, described at the time as "a splendid ruin, suddenly come upon by travelers, after a long journey in a desert."[42] A remarkable blending of structure and setting, its massive classical dome flanked by colonnades and fronted by a lagoon may have provided inspiration years later for Julia Morgan's design for San Simeon's Neptune Pool. Visited by more than 19 million people during the fair's ten-month run, it housed art collections of all the exhibiting nations. After the fair closed, Phoebe hoped San Francisco would keep Maybeck's Palace of Fine Arts as a permanent art museum. She and W. R. Hearst loaned enough objects to fill fourteen of its galleries, and more than two hundred thousand visitors viewed them in 1916. Though the building was preserved and remains one of the most treasured monuments in San Francisco today, it did not become a permanent art museum. Twenty years after the fair, Hearst attempted to re-create some of its magic at San Simeon by purchasing its plaster statuary and fountains, which had been stored since the fair in the Palace of Fine Arts. He planned to display them along the Pergola. However, this scheme was never completed.[43]

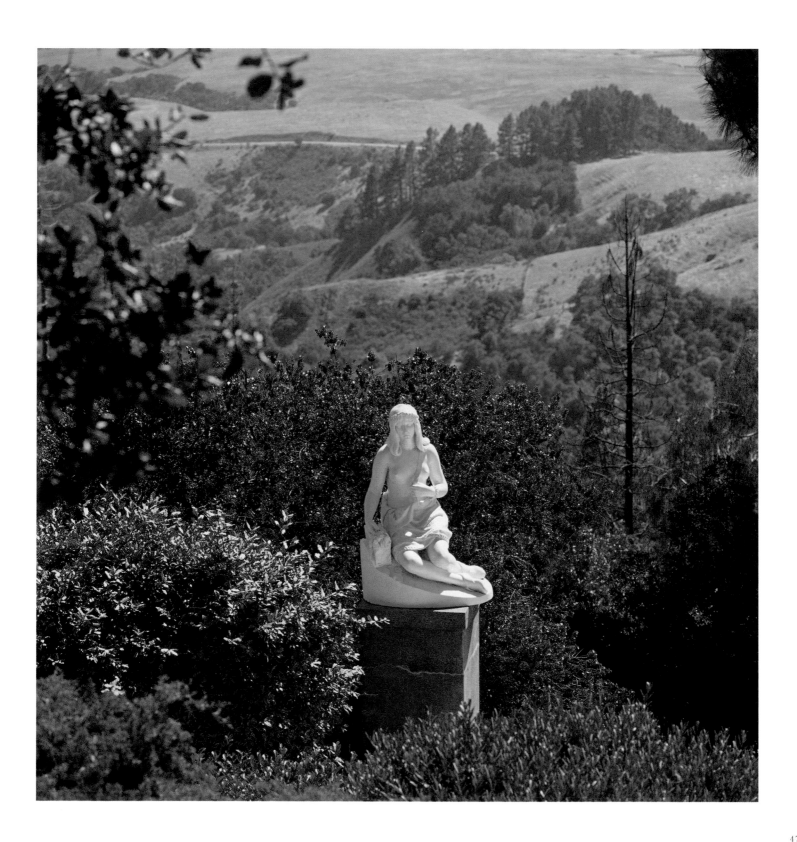

Joseph Mozier, *The Indian Girl's Lament*. Plaster reproduction of the original, height 46 in. (116.8 cm). Hearst Monument, C Terrace. A 1996 glass-reinforced gypsum-plaster reproduction replaces the original marble, which is now on display in the Hearst Monument Visitor Center exhibit area. W. R. Hearst collected Western-themed art by Frederic Remington in addition to this depiction of a young Indian maiden by Mozier. He placed it at the edge of the hilltop gardens where it would be framed by the natural landscape. The work echoes the romanticized treatment of Native Americans in the art of the 1915 San Francisco world's fair.

To the citizens of San Francisco, the Panama-Pacific International Exposition was tangible evidence of California's superiority to the rest of America. W. R. saw it as irrefutable proof that the New World had at last superseded the Old. He wrote: "It has been said and believed both here and abroad, that although the United States was a great country in a business way, it had not yet reached a state of development where it could either appreciate or express the highest ideas of art and architecture, and that for education in these finer things the people of this country would still have to go to Europe. But no other exposition here or abroad has ever displayed so much artistic and architectural loveliness."

Phoebe too believed in California's special advantages and wrote an article published during the fair, extolling its unique benefits for women: "And then the almost continuous open air life of the family, the health and vigor of the children, and the better nature of the man-of-the-house are all joys beyond estimation to the housewife. Whether it is their lot to live in city mansions or tenements, in country villas, or in board cottages colored only by the climbing roses, the California climate works constantly with and for the women, and the California spirit which illumines the home gives them strength and joy in the duties they are called upon to perform."[44]

Three years later, Phoebe caught a cold in New York while visiting W. R. and Millicent at Christmas in 1918. She was seventy-six and did not recuperate sufficiently. The cold developed into influenza in the spring of 1919, the era of the destructive swine-flu epidemic. Her grandson Bill Jr. recalled: "My brother Jack [John] and I were living with her in the hacienda at the time. . . . Shortly after my parents arrived, Phoebe died. It was Easter Sunday, April [1]3, 1919. This was the first time that I had looked death in the face. I wept for days. The whole world had fallen and crashed into smithereens for this eleven-year-old boy. I could not envisage life without her." The entire state joined the Hearst family in its mourning. All the courthouses in

California were closed, and all the flags on public buildings were lowered to half-mast in her honor. It was the first time in California a woman had been thus recognized.[45]

During that spring of 1919, when the country was regaining its commercial stature after the many economic and personal demands of fighting World War I, the fifty-six-year-old William Randolph Hearst at last began to build at San Simeon. He had known and loved the site since childhood. The project proceeded over the next thirty years and carried with it the same California-boosting spirit that inspired the University of California campus design and the buildings of the Panama-Pacific International Exposition.

3 La Cuesta Encantada: Landscape Beginnings (1919–1922)

John Galen Howard, architect of the University of California campus, wrote an analysis of country house design in the West for *The Architectural Record* in 1916. In discussing landscaping, he concluded: "It is only within comparatively recent years, in this part of the world, that owners have realized that the garden and landscape about a house are as much a part of the design as the walls and roof. The great artistic successes have been, I think, without exception, cases where the designer of the house has designed the setting as well."[1] Julia Morgan worked for Howard upon her return to California from the Ecole des Beaux-Arts, and perhaps her sensitivity to the landscaping of a site derived in part from his influence. In her nearly three decades as architect of San Simeon (1919–1947), Morgan designed both the structures and the landscape setting for one of the most extensive and elaborate country houses in America.

It was a remote and challenging location. Photographs prior to 1920 show a wildflower-strewn, grassy hill at sixteen hundred feet in elevation, dotted with clusters of coast live oaks (*Quercus agrifolia*), California bay trees (*Umbellularia californica*), holly-leafed cherry (*Prunus ilicifolia*), and toyon (*Heteromeles arbutifolia*). Rugged canyons leading to the mountaintop were covered with California chaparral. What looks from a distance like a soft, bluish-green carpet is actually a nearly impenetrable thicket of intertwining shrubs, all close to the same height, their growth dating from the last ravaging fire. Wild lilac (*Ceanothus* species), manzanita (*Arctostaphylos* species), and California sagebrush (*Artemisia californica*) grow on the steeper slopes. The more gradual inclines are covered with grassland and oak woodland.[2]

San Simeon's biological diversity is supported by its Mediterranean climate, marked by hot, dry summers and cool, wet winters. Less than three percent of the world's land surface shares this characteristic: the coastal areas of central Chile, the southern tip of Africa, southwest Australia, the Mediterranean basin, and California. These sites

The view from the hilltop stretches on clear days to Point Buchon, a promontory nearly forty miles south.

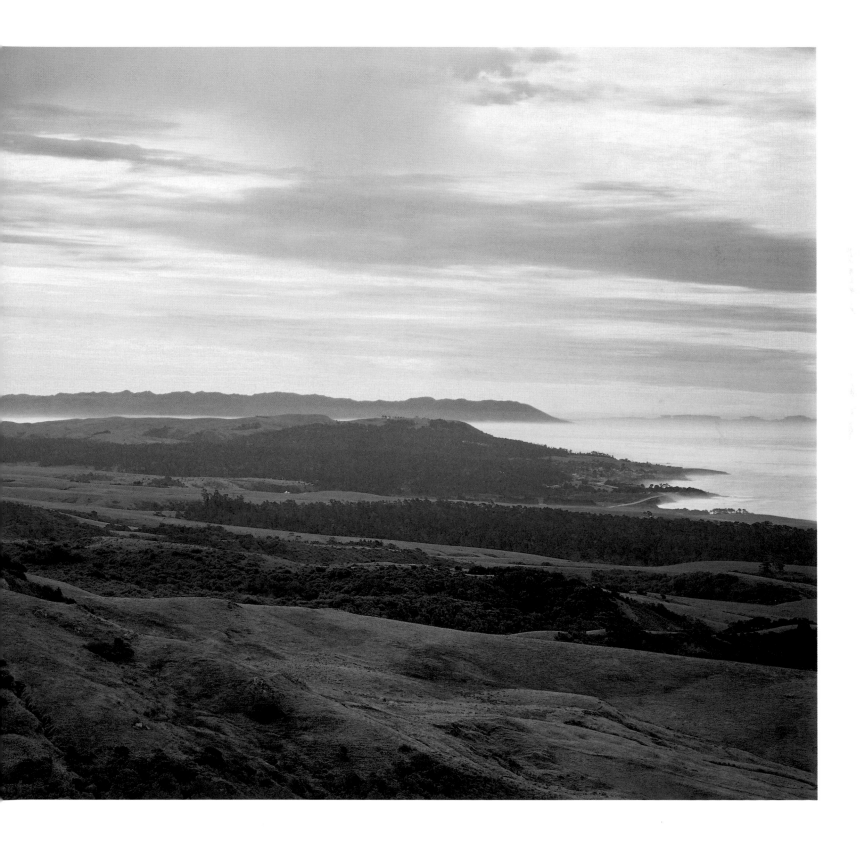

are all located on the western edge of continental masses at mid-latitudes, where nearby ocean currents produce cool air and mild temperatures. At San Simeon, the annual rainfall can average ten to forty inches, increasing with altitude. Fog moves in on summer evenings and burns off first at the higher elevations, often leaving the shoreline overcast while the hilltop is bright and sunny.[3]

San Simeon's wider setting—the Santa Lucia Range—consists of a row of steep mountains stretching along the coast from Monterey to San Luis Obispo, extending from sea level to nearly six thousand feet. The well-known San Andreas fault is located forty miles inland, where it marks the separation of the North American and the Pacific tectonic plates. There are numerous active faults along the Santa Lucia Range, including the San Simeon, the Nacimiento, and the Oceanic faults. The San Simeon portion of the Santa Lucia Range is located on the Nacimiento block and is made up primarily of Franciscan Complex shales, sandstones, cherts, and basalts, in a formation known as a mélange—a mixture of rock types. Water is scarce in the region, coming either from coastal groundwater basins under flood plains in the valleys, or from small aquifers that dry up in the summer and fall.[4] The rocky soil of the hilltop was unsuitable for planting, and richer topsoil had to be hauled—initially by wagons, then later by trucks—up the hill to create the lush garden beds.[5]

An early witness to Hearst and Morgan's on-site collaboration reported that it began with the challenge of scaling the remote hilltop itself. Steve Zegar, a taxi driver whom Hearst hired to manage the fleet of cars that chauffeured his guests to the hilltop, remembered meeting Hearst and Morgan at the train station in San Luis Obispo, forty miles south. After transporting them in his Cadillac to the senator's house at the bottom of the hill, he unloaded their luggage and drove them as far as the road extended. A suggestion was made that Hearst and Morgan mount horses to complete the climb. Morgan refused. So Hearst asked Zegar to get them up the hill in the Cadillac. Zegar

enlisted a cowboy to hitch a strong horse to the car, and the horse helped pull the car through the slippery grass and uneven terrain to the hilltop.[6]

Their early meetings determined one of San Simeon's most impressive aspects: its site selection. From the coastline, the hilltop complex dominates the skyline, but it is not on the highest elevation. Mountains twice its height rise to the east, supplying by means of natural springs the gravity-fed water that made the project possible. But those eastern hills are not apparent from the coast. Instead the buildings preside over the setting—distant but visible, tantalizing observers below. This view is surely what gave the formally named La Cuesta Encantada its more familiar nickname, "Hearst Castle." Its twin white towers—silhouetted against the sky and surrounded by miles of open country—stand dreamlike in their improbability. The vistas from the hilltop to the coastline are spectacular. But it is this view of the compound from below that puts the estate in a league with the most dramatic and picturesque of Europe's architectural treasures: Mont Saint-Michel in Normandy, Neuschwanstein Castle in Bavaria, the Alcázar in Seville.

It has long been thought that Hearst hired Morgan soon after Phoebe's death, which came on April 13, 1919. In fact, Morgan was on site while Phoebe was still alive—and technically still the owner of the property. Morgan's travel records have recently come to light, showing that she made a trip to San Simeon on April 8, 1919.[7] Though we cannot know for certain what this early visit entailed, it may indicate Hearst's eagerness to begin building on the site he had known and loved since boyhood.

Hearst's initial plan was for a single modest bungalow, but the scheme quickly evolved into a group of buildings, with the main building set on the highest elevation and three cottages flanking it. His early intention was to complete the main building first and live in it by the summer of 1920. Then he planned to construct the bungalows and occupy them in the summer of 1921.[8] Hearst departed

quickly from the bungalow style of the Arts and Crafts movement and decided instead on a Spanish style, continuing the theme of the Hacienda del Pozo de Verona in Pleasanton and a large Sausalito estate he had planned to construct with Morgan five years earlier. In San Simeon's case, they initially considered imitating the florid Spanish Colonial buildings constructed at San Diego's Balboa Park for the 1915 world's fair, known as the Panama-California Exposition. Instead they looked to the Spanish Renaissance and based the main building's twin-tower design on Santa Maria la Mayor, a single-tower cathedral in the small southern Spanish town of Ronda, in Andalusia.[9] Hearst wrote to Morgan: "The trouble would be, I suppose, that it has no historic association with California, or rather with the Spanish architecture in California."[10] Nevertheless, this Spanish Renaissance inspiration ended up being their choice for the overall style of the estate, including its earliest landscape features.

Morgan initially arranged for Hearst to pay her five hundred dollars a month to cover her 6 percent commission.[11] This quickly proved insufficient, as the scale of the project increased. Within a few years Hearst would be paying her twenty-five thousand dollars a month, from which she was expected to meet all disbursements, pay herself, and cover her staff's salaries. Even this amount was inadequate, although her commission was increased to 8½ percent.[12] Morgan fell behind in meeting expenses almost from the beginning, but the existence of a recently discovered archive of her financial records shows that in more than twenty years of work, she made a profit of one hundred thousand dollars on the project.[13]

Because of transportation difficulties, they decided to focus first on the more attainable goal of completing the cottages. An early challenge was to site them appropriately, locating them on the contour maps of the hill. The native oak trees were carefully noted on these maps, and the buildings were sited around them. Hearst deputized the painter Orrin Peck, his close friend since childhood, to

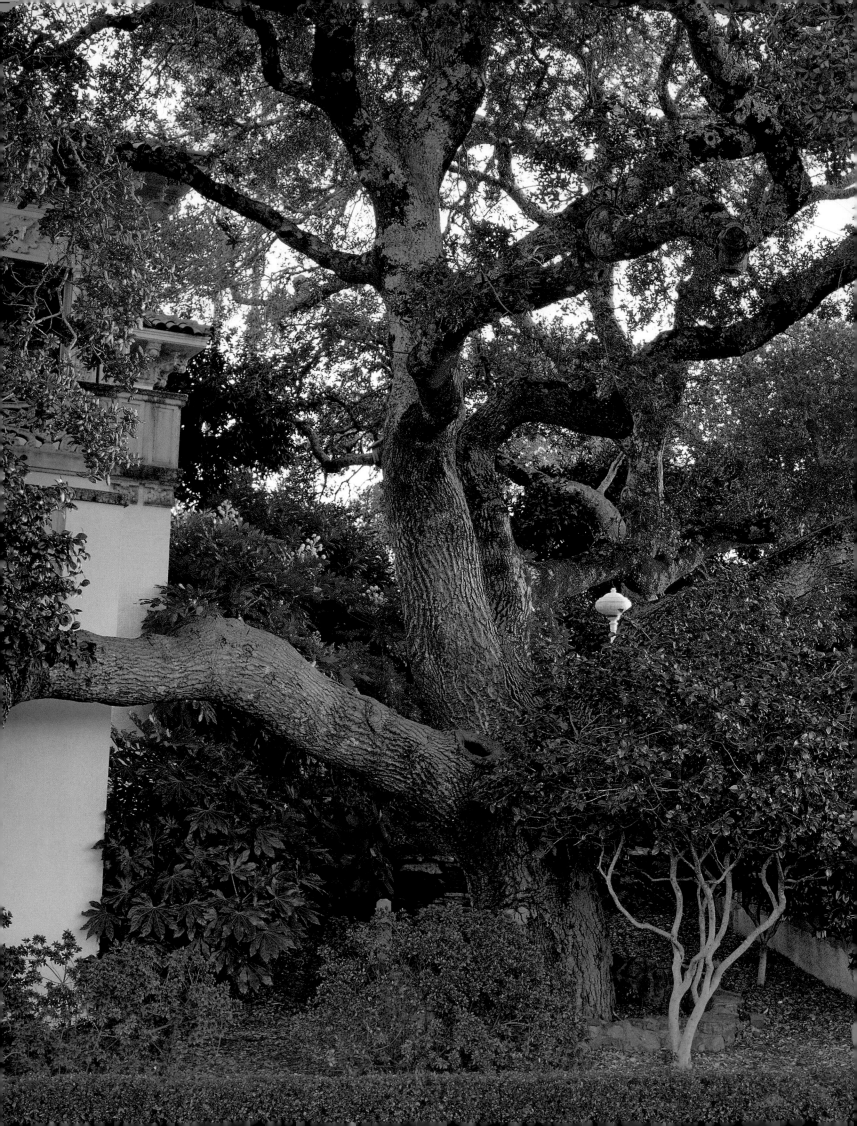

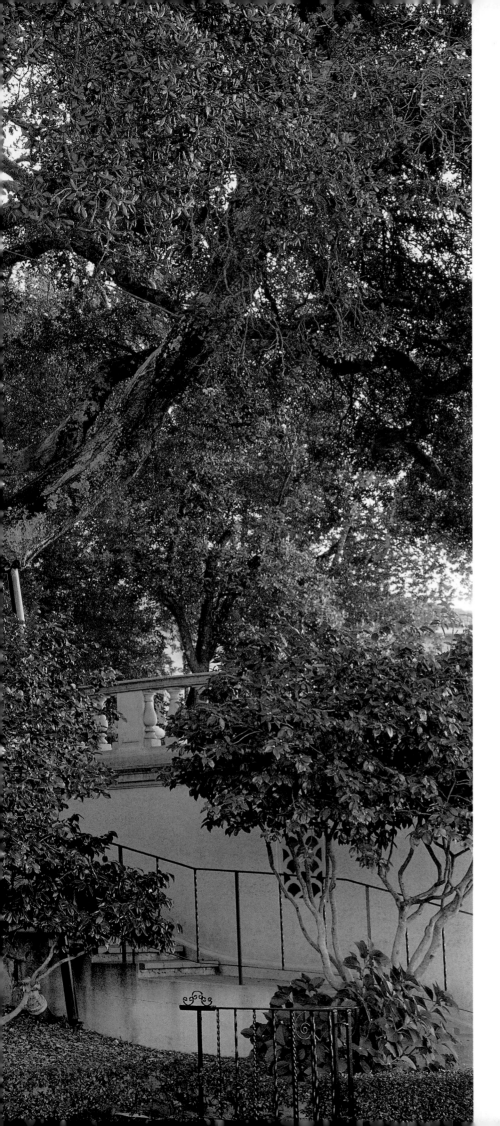

A coast live oak (*Quercus agrifolia*) beside House B. These majestic evergreens have spreading silver-brown branches and small, hollylike leaves. Morgan's plot plans noted the locations of these centuries-old oaks, and in the early years the hilltop buildings were sited around them.

In this 1923 photo of House B (Casa del Monte), the garden beds were planted with a dense mixture of annuals, perennials, trees, and shrubs, including climbing roses, Mexican fan palms, bananas, yuccas, and dracaena.

The earliest garden plans focused on the cottage entrance courts. Hearst wanted climbing roses and vines like bougainvillea to ornament their walls.

opposite
The back bedrooms of House B face the gardens, while the front bedrooms face the mountains. Each cottage features large windows, ensuring that the views could be seen from both beds and desks.

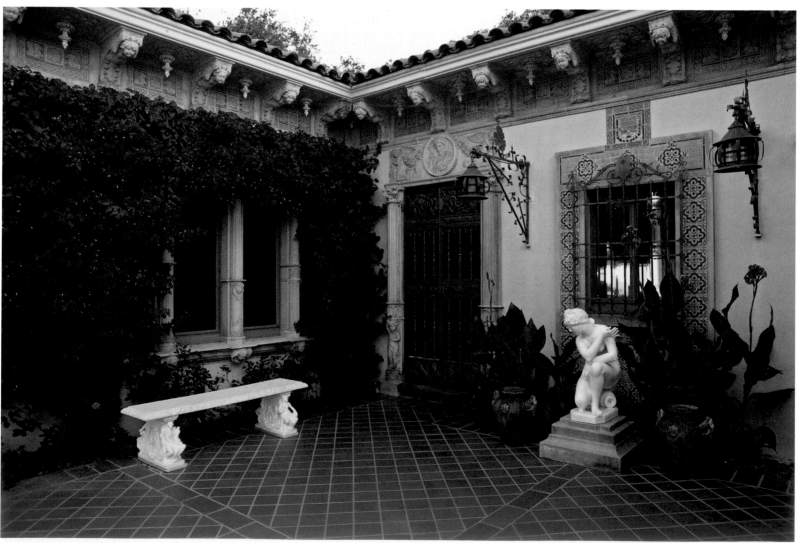

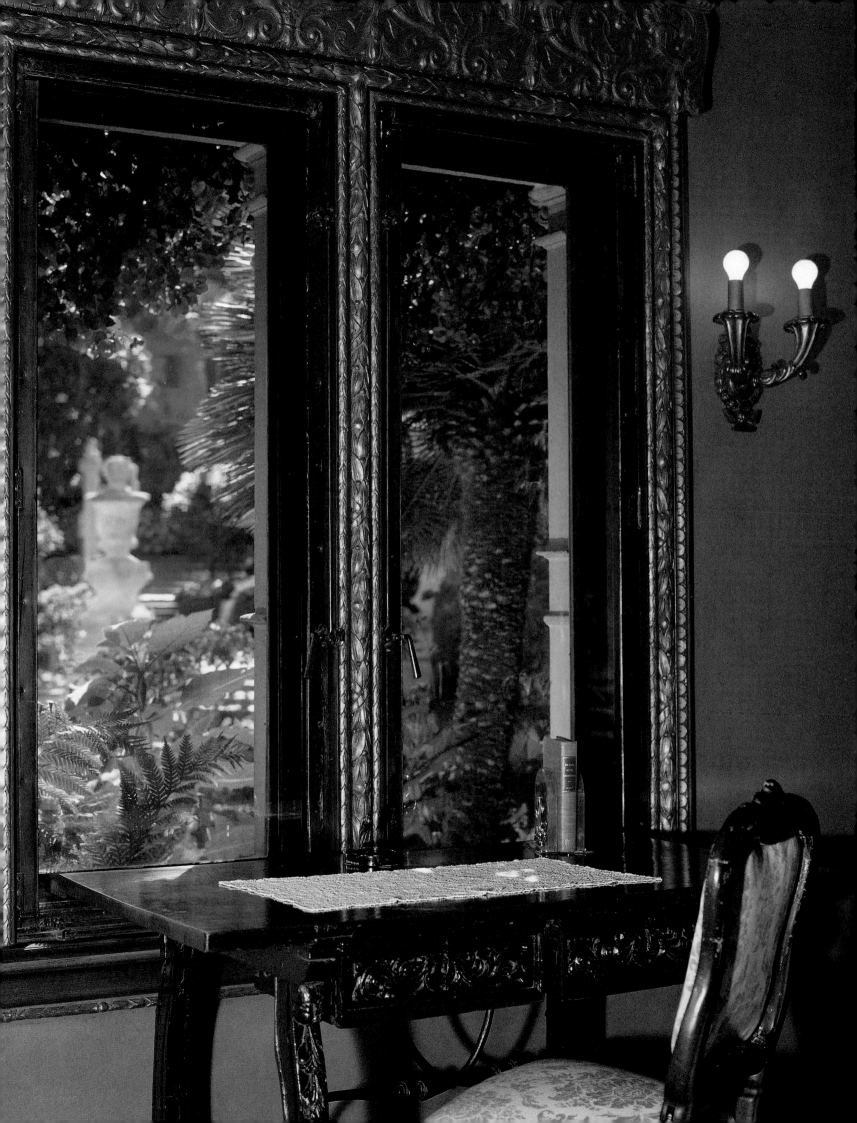

oversee the proceedings in person, while he remained in New York. Hearst wrote Morgan: "I will take the train and come West when the strike [by west-coast longshoremen] is over. . . . We can then locate the houses exactly, and even a scantling outline could be erected to give an idea of just how they would look on the landscape and how the landscape would look from them." He summed up by saying, "The main thing at the ranch is the view."[14]

The views gave the cottages their formal names (which were usually shortened to alphabet letters for ease): Casa del Mar (House A), with its ocean view to the south; Casa del Monte (House B), for its mountain vistas to the north; and Casa del Sol (House C), in the center and facing the western sunset. The entrance side of the cottages—facing the grounds and the main building—was considered the rear. The fronts of the houses were the view side—which, due to the steepness of the terrain, were far less accessible. Courtyards at the entrances and balconies at the view fronts were planned to unify and connect the structures with the landscape. Narrow pathways wound between the houses and below them, linked by staircases on the steep slopes.

Hearst's habit of making constant changes to the plans started early, including determining the proper elevation for the cottages. He wrote Morgan that he and his wife, Millicent, agreed that "the cottages and the big central building containing the assembly hall and refectory should be more or less intimately associated with each other in an architectural group; and that it would be a mistake to hide the cottages so far down under the hill that it would look as if the big building were ashamed of them and as if they had no part in the composition."[15] After considerable discussion they ultimately decided to place them about sixteen feet below the main building's central elevation. Hearst suggested that House C (located in the center of the semi-circular grouping of cottages) be set slightly lower on the hilltop than the two flanking structures, giving it a deeper courtyard. This was in part due to the presence of a large oak tree.[16]

Hearst was deferential to Morgan's ideas in theory, if not always in practice. He wrote in the early stages of the project: "I make a lot of suggestions and if any of them are impracticable or imperfect from an architectural point of view, please discard them and substitute whatever you think is better."[17] While this was his stated intention, in fact he generally preferred his own ideas. Morgan frequently influenced him obliquely by posing clarifying questions. Still Hearst often persisted in his preferences, even after her hints had been dispatched.

He did not plan an extensive garden when the project began. Instead, siting the cottages—on which they started construction in February 1920—prompted the start of landscaping plans as well. Among the earliest specific directions, Hearst telegraphed: "There should also be terraces around the houses where climbing vines and flowers can be planted."[18] He arrived to supervise matters firsthand in the summer of 1920, and not surprisingly Hearst's presence prompted many more plans for the landscape. His first formal order for San Simeon from a Santa Barbara nursery consisted of typical Mediterranean plants, ones that played an important role in the gardens thereafter: "24 roses, 72 geraniums, 2 magenta bougainvillea, 2 magnolias, 2 jacarandas, 6 10-foot Italian cypress, 6 rhododendrons, 12 cotoneasters, 6 camellias, 6 dracenas, 6 orchid cactus, 6 aralias, 1 big yucca, 2 small yucca, 6 wild lilacs, and 6 Washington fan palms."[19]

The 1920s, when Hearst and Morgan began building the estate at San Simeon, was the greatest decade of southern California's garden history. Both transplanted easterners who wintered there and wealthy movie folk who lived there year-round appreciated the mild climate, the abundant water supplies (diverted from the Owens Valley), and the fine nurseries in the region. Sometimes Mediterranean gardens of the period adhered strictly to style conventions. Among the most formal Italian Renaissance gardens was Greenacres, the extensive Beverly Hills estate created by A. E. Hanson for the film star Harold Lloyd.

Casa del Herrero (House of the Blacksmith) in Montecito had a formal Spanish-style garden designed in 1925 by Ralph Stevens. San Simeon's eclectic mixture of Italian and Spanish elements was more characteristic of the era than either of these strict historic interpretations. The landscape historian David Streatfield described southern California gardens of the era: "By 1920 the Spanish Colonial Revival and various Italian modes, all of which were often grouped under the rubric 'Mediterranean,' had been adopted as the dominant architectural styles in the Southland. But no comparable uniformity prevailed in garden design. The areas immediately surrounding Mediterranean houses were often designed as formal patios, parterres, and terraces—and often adorned with appropriate tilework, fountains, and statuary—but they invariably gave way to expansive naturalistic areas." In the typical Mediterranean garden of the period, plants were highly varied, and the focus was often on color.[20]

Hearst and Morgan considered hiring a landscape designer for San Simeon but never did so. Morgan was aware of the leading southern California practitioners, including Lockwood de Forest Jr., who worked on many estates, including Val Verde in Montecito. She wrote to Hearst: "Lockwood de Forest at Santa Barbara is the most promising one I know, but is not just right."[21] Morgan also favorably recommended Florence Yoch, but they did not hire her. The designer of the Italianate garden Il Brolino in Montecito in 1923, Yoch created nearly 250 other southern California gardens and movie-set designs, including those for *Gone with the Wind*. Morgan described Yoch to Hearst (referring to her as "Florence Jong") as a designer who "has done some very lovely work, on of course a much smaller scale. She has the real touch."[22] Charles Gibbs Adams—a landscape designer who worked on many gardens, including Arcady, a formal Italian-style estate in Montecito—supervised tree planting at San Simeon for a time, but did not work for Hearst as a landscape designer.[23] Isabella Worn, a floral designer who assisted with the color

Roses and petunias ornament the garden beds near House C. Hearst wrote to Morgan in 1928: "I like our petunias in all kinds of mixed colors, and I like the double petunia and the quadruple petunia, if there are any such thing."

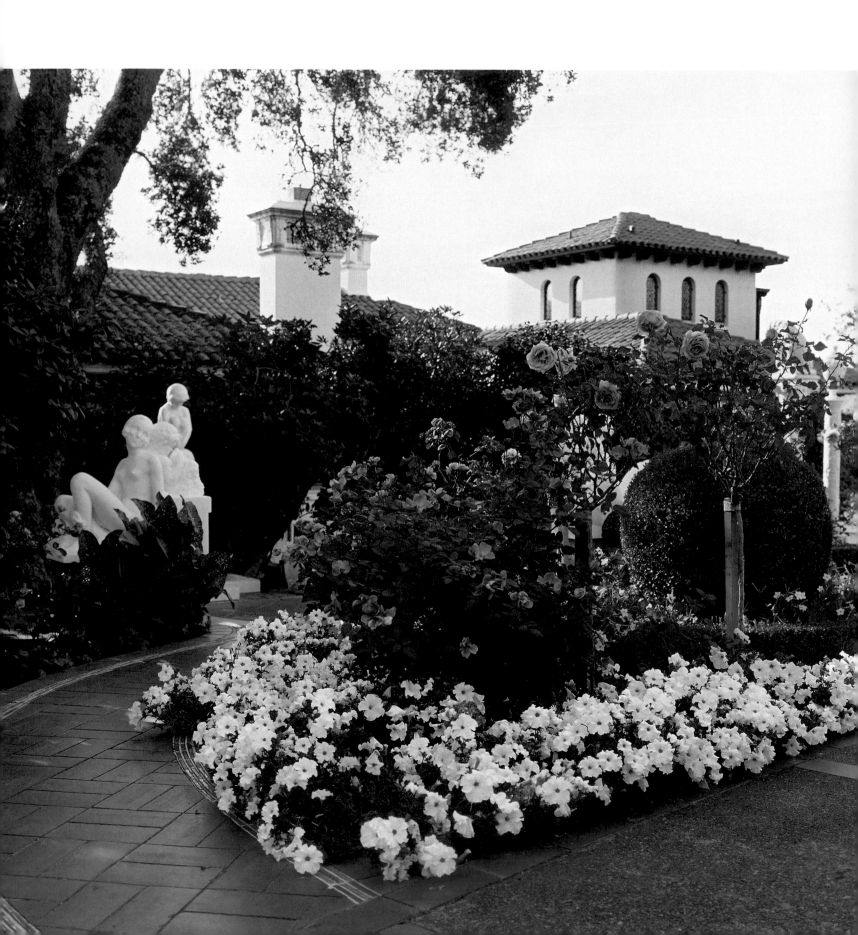

groupings of plants, was hired in the middle years of the project—from 1926 through 1938—to provide color-coordinated designs for the flower beds. But Morgan herself took on all the broad responsibilities of architect and landscape architect—for the hilltop garden areas, the orchards and outlying plantings, and the vast ranch complex and estate village of San Simeon below.

The landscape architect whose work Morgan most admired was Charles Adams Platt. Walter Steilberg recalled: "She referred us to Platt's work, much to the astonishment of those of us who had come from the University [of California] here, more than to [Charles Follen] McKim and [Stanford] White's work. McKim and White were much better known because of publicity; Platt's work had not been published much in the magazines until his book [*Italian Gardens*, 1894] came out. But she thought his work was very wonderful."[24]

Like Morgan at San Simeon, Platt designed both country house buildings and their gardens. He had studied the layout of Italian villas firsthand, and his 1894 book, which featured photographs and sketches, brought them to the attention of a wider public. This one small volume transformed the American country house movement.[25] *The Architectural Record* described Platt: "He had the peculiar advantage of being able to approach landscape design, not as a man whose training was exclusively architectural, but as one whose interest in garden design sprang directly from the observation of nature. . . . He was a landscape painter before he was an architect; and he made a special study of Italian gardens before he ever attempted to design them."[26] In his country-house landscape designs, Platt blended the picturesque and colorful traditions of English gardens with the classical organization principles of Italian garden design. In this mixing, he managed to elevate both approaches.[27] Morgan followed the same dual traditions at San Simeon, with the additional incorporation of Spanish styles due to the historical and thematic setting of the hilltop.

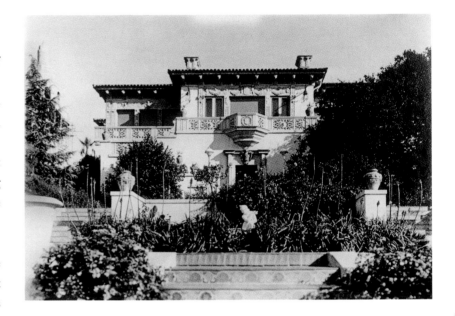

Their earliest hilltop construction superintendent was Herbert Washburn, who oversaw the first excavation efforts, until Camille Rossi was hired as construction superintendent in 1922.[28] Hearst and Morgan hired their first head gardener, Hugh Hazard, in 1921. Hazard met Hearst while working at the California Nursery Co. in Niles, near Oakland, which supplied many of San Simeon's plants. Hazard lasted only a year at the job due to personality conflicts. He was replaced by Albert Webb, who was an accomplished gardener but also temperamental. He stayed through 1925 and returned briefly in 1930.[29] From 1921 to 1937, there were six head gardeners at San Simeon, for an average length of three years each. Hearst was seldom satisfied with their efforts, finding the practical ones too unimaginative and the artistic ones too temperamental.

Hearst was eager for the planting to begin and had definite ideas about the floral and color schemes of each house. He sent Morgan a telegram early in 1921: "Proceed with planting also buy other plants and trees needed[.] Can you send me sketches of color floral schemes for houses for instance suppose we have white and pink climbing roses

for entrance side of house A red roses for B yellow roses for C with purple bourgouvillas [bougainvilleas] for towers [of C] etcetera lay out some definite plans and color combinations."[30] Morgan's response was accompanied by a general planting plan: "The color schemes are—For A pink and white, as brightest in effect with the dark blue and white frieze tile. For C, crimson and deep yellow. For B, blue, light yellow, and orange." Hearst penciled in his approval to these suggestions, which were Morgan's skillful elaborations on his own earlier ideas. He indicated his preference for old-fashioned plantings by penciling at the top: "Oleanders, Hollyhocks, Roses, Climbing roses, Bourgevillas [bougainvilleas], Heliotrope[,]. . . Magnolia[,] Flowering Eucalyptus."[31] He wrote soon after: "I think we should have . . . a lot of fine roses. Mrs. Hearst and I are both very fond of roses." He wanted climbing roses over the front walls of the houses and on the courts, concluding, "The roses would clothe the courts in a very pretty way, I think." Hearst was drawn to flowers based on sentiment—as when he wrote, "Large bushes like oleanders, which come I think in pink and also in white, are very effective. The prettiest thing at the Hacienda is the pink oleander outside my mother's window." He wrote, "You speak of some seasonal planting, and I think we should have this along borders of the beds in front of the houses. I largely favor the old-fashioned flowers or English garden flowers."[32]

Julia Morgan's greatest skill as an architect was her ability to work with Hearst's steadily widening vision for the estate, adjusting plans so that a perpetually increasing project looked balanced and harmonious as it grew. She described him to Arthur Byne, a friend of Morgan's and an art dealer to Hearst: "Our own relationships with him have been satisfactory.—Payment usually late, but always sure, the greatest trouble being his changeableness of mind—but in return, he compensates to some extent by allowing me to change mine now and then."[33] Morgan knew that Hearst's changes stemmed from his passion for the site and his desire that it be a success.

The hilltop gardens evolved from Hearst's initial conception for the cottages, which were created to maximize the views. Hearst's desire to take best advantage of the hilltop's incomparable setting and provide gathering spots prompted the placement of terraces, walking paths, and fountains. The location first planned for the main building was changed to place it in better relation to the cottages and to the central plaza. Hearst wrote to Morgan in February 1921: "I suggest, if the practical situation permits, that we change the axis of the main house and aim it directly at the middle of the central plot, and that we put a fountain and a pool in the middle of the plot in a way to make a very decorative feature for the terrace of the main house to look out upon. In fact, I imagine that the terrace of the main house could be made to merge right into this central motif so that this central plot or plaza would be the front yard of the main house, as it were."[34] An early drawing by Hearst shows the extremely important position of two groups of oak trees in the hilltop scheme. Hearst sketched the main house in a T-shape, with two circles on either side of the bar of the T, each circle indicating trees. The coastal live oaks on the south and north sides of the main house dictated its siting.

While Hearst and Morgan's vision for the gardens, fountains, and terraces of the hilltop evolved gradually, they began the wider planting scheme for the entire area almost immediately. In a lengthy letter to Morgan written in late 1921, Hearst noted: "This is a memorandum of the planting we have discussed." He then went on for more than nineteen handwritten pages, describing his general ideas for the ranch, including planting conifers near the garages: "Also redwoods and big trees (Sequoia sempervirens and Gigantea. You see I am learning 'em)." He mentioned planting oranges liberally over the hilltop: "They are agreeable trees near the houses and will not grow big enough to cut off the view." He planned orchards of stone fruits and figs west of the hilltop buildings, as well as nut trees and olive trees farther to the south. The specifics of

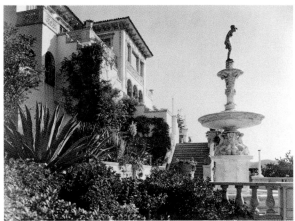

Each of the cottages had fountains on their view sides. Two fountains were placed below House A, both identical reproductions of the Italian Renaissance Fountain of the Labyrinth. This one is topped by Adolf Daumiller's 1920s sculpture *First Rose*.

Outside the formal gardens, they relied on hardy, drought-resistant plants like California poppies (*Eschscholzia californica*). Hearst wrote to Morgan in 1926: "The poppies are useful to us because they are apparently able to get along without water."

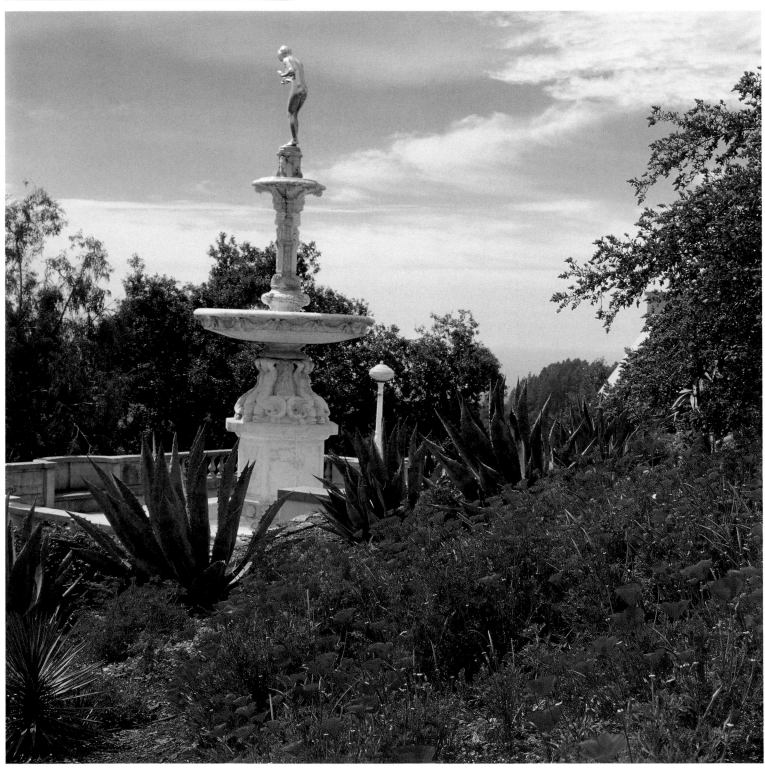

Bolivian fuchsia (*Fuchsia boliviana* 'Luxurians') grows on the shady
north side of the hilltop, including this spot next to the Neptune Pool.

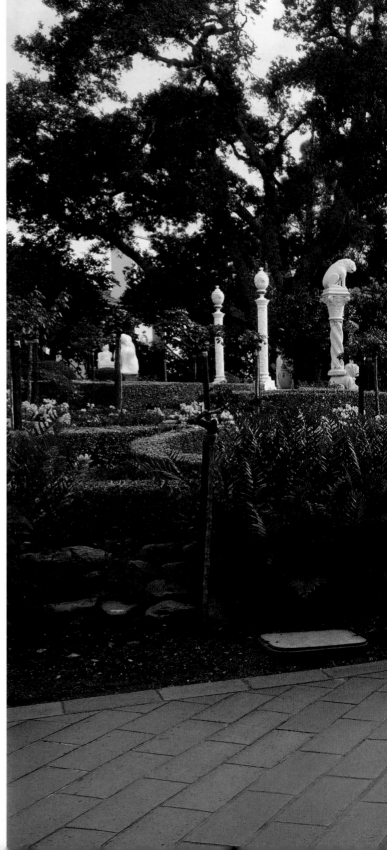

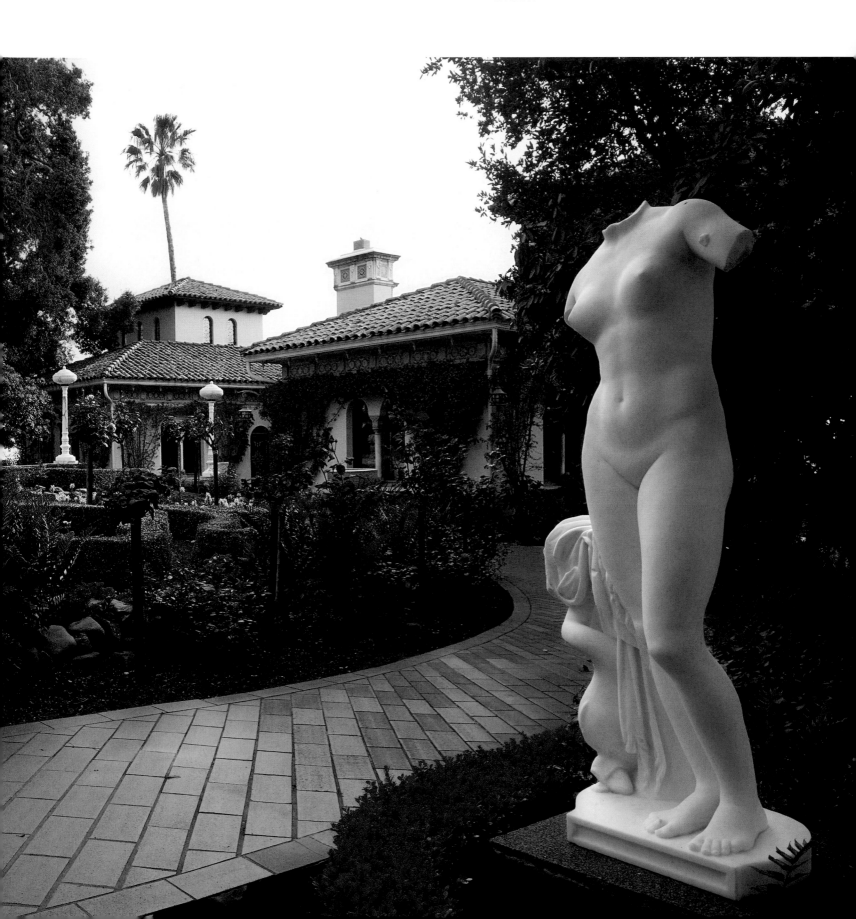

Venus of Cyrene (copy of the ancient statue found in the Baths of Cyrene, North Africa, and presently located in the Museo della Terme, Rome), Italian, 20th century. Marble, 56 1/2 x 23 x 18 in. (143.5 x 55.4 x 45.7 cm). Hearst Monument Collection, southwest of House B. Winston Churchill visited La Cuesta Encantada in 1929, accompanied by his brother John, his son Randolph, and his nephew John Spencer Churchill, who wrote: "The garden, laid out in open patio style, was surrounded by intriguing little paths that led amidst trees with every now and then more marble statuary. Strangely enough, it was in Hearst's garden that I first saw the famous Greek statue of the Venus of Cyrene, the original of which is in the Neapolitan Museum in Rome."

Sarcophagus Depicting Apollo, Athena, and the Nine Muses, Roman, A.D. 240–270. Marble, 28½ in. x 31 in. x 7 ft. 5½ in. (72.4 x 78.7 x 227.3 cm). Hearst Monument Collection, North Esplanade. All three cottages displayed Roman sarcophagi—ancient stone coffins—at their entrance facades. This example outside House B (Casa del Monte) features a central portrait of the deceased as Apollo, surrounded by the nine muses.

Busts (Hermes), Roman, A.D. 1st–4th century. Marble, height 21 in. (53.3 cm). Hearst Monument Collection, courtyard of House A. Making his purchases primarily in New York, Hearst selected the estate's art objects and determined their locations. He wrote to Morgan in 1921, after acquiring these two sculptures from the Anderson Art Galleries: "I am sending another [railroad] car containing various purchases. There are two Hermes, ancient Greek heads, the archaic style, from Lord Hope's collection [Thomas Hope, eighteenth-century British Regency designer]. I think they should go as decoration in the court of house A, where I have drawn the little circles."

opposite
Boyer, after Antonio Canova, *The Three Graces*, French, 19th century. Marble, height 64 in. (162.6 cm). Hearst Monument Collection, Esplanade, opposite House A. This celebrated sculpture group depicting the three daughters of Zeus was placed directly opposite the entrance to Hearst's earliest residence, House A.

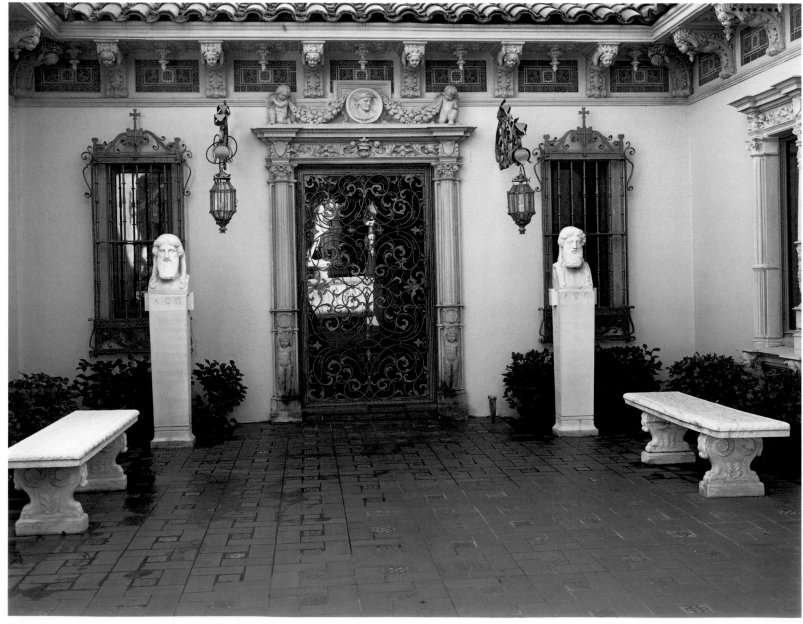

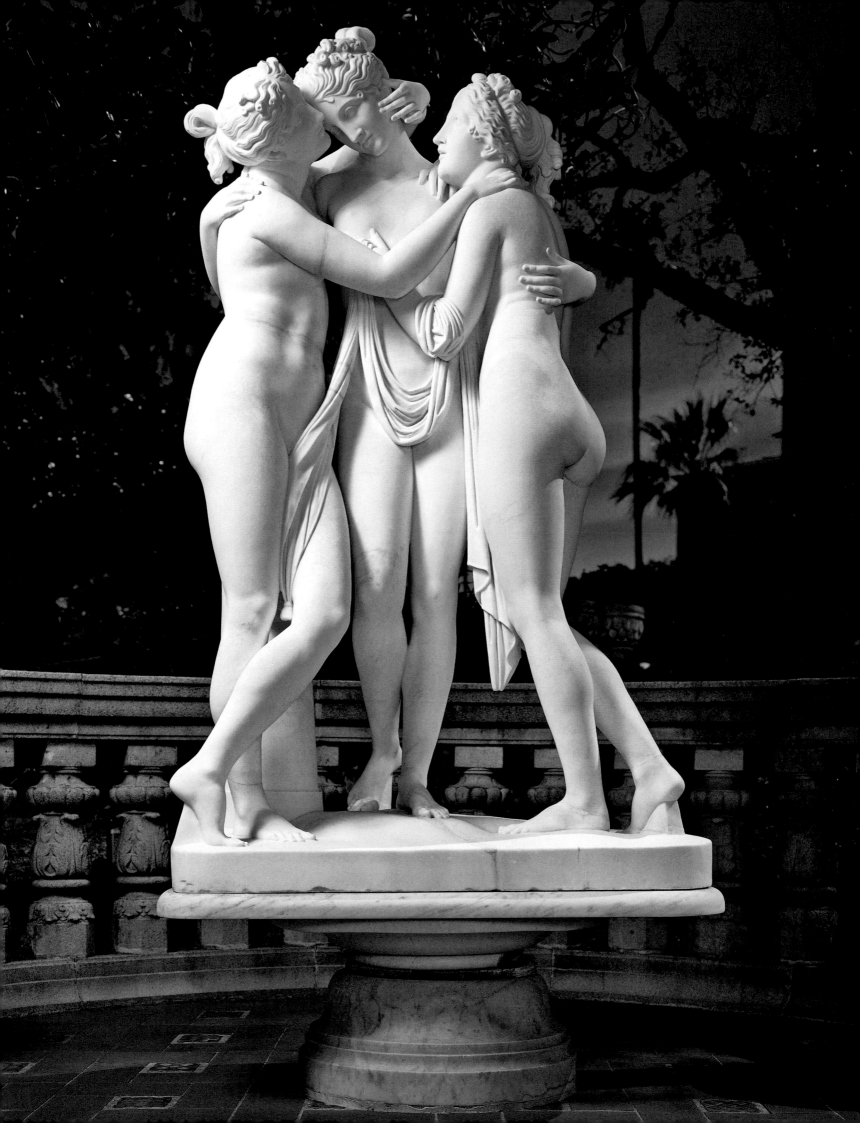

this letter extended to considerations such as mulberries, which he advocated planting alongside the cherries, to distract the birds from eating the cherries. "I am told chickens also like hollyhock seeds," he continued. "Therefore, hollyhocks around the farm both for beauty and use. You see, I am catering to the chickens." He advocated more informal plantings for the road, including heather, broom, and drought-resistant plants, with patches of "red christmas berry" for seasonal color. After discussing climbing vines for the cottages, he added, "Perhaps a pergola could go in here somewhere, or a bit of a cloister if I can find one. Sounds like we were going to plant it, but I dont [sic] mean that." He was enthusiastic about camellias and, as usual, effusive about roses. He advocated some flowering cacti, but wrote, "lets [sic] not make an Arizona garden. They are uninteresting." He recommended acacias, jacarandas, and magnolias in the areas where they did not plan to do much gardening, like near the garages, and flowering eucalyptus alongside the road. He finished with: "I guess that's all for today. Please excuse writing. The train is wiggling."[35]

In this early letter, Hearst introduced ideas he advocated consistently throughout the long building process: use drought-resistant plants; use old-fashioned, familiar flowers; be mindful in planting trees so that you do not obscure views in the future; plant plenty of fruit trees that can be harvested; and give a high priority to plants that provide color and require minimal care. This missive further demonstrates the personal nature of San Simeon's garden, where Hearst was responsible for the choice and placement of plants, much as he was responsible for the selection and location of art objects.

This letter was written just before Hearst and Morgan hired one of the Castle's most important employees: orchardman Nigel Keep. Hearst and Keep met in 1921, when Keep was working at the California Nursery at Niles in Alameda County. He advised Hearst against buying some inferior pear trees. Keep became Hearst's tree planter in 1922 and stayed through 1947, spanning nearly

the entire hilltop's construction history. "I took bare ground and rocks and rattlesnakes and made a beautiful place," he recalled at the age of ninety.[36] Keep wrote in 1946, at the end of his time at San Simeon: "I supervised all [the] planting at the Hearst properties for [nearly] 29 years. Dozens of kinds, from innumerable regions, were tried, and the most successful were then planted more extensively. . . . The astonishing fact about the San Simeon plantations is not their variety nor general success, but rather the tremendous scale of the physical undertaking, in true Hearstian style, for the plants set out were not one to three year old nursery stock, such as a forester would choose, but much larger material; nothing smaller than a five gallon can size was used. . . . The planting of the hills and slopes around the Castle . . . is therefore of a scale quite commensurate with that of the structures, and their contents and the plantations hold much of the beauty and interest."[37]

The most well-known consultant hired for San Simeon was Bruce Porter, a Bay Area artist who influenced the Arts and Crafts movement in many media: painting, poetry, stained glass, and landscape design. Known for the stained-glass windows he created for the influential Church of the New Jerusalem (or Swedenborgian Church) in San Francisco in 1894, Porter landscaped the Italianate New Place garden for William Crocker in Hillsborough in 1906, as well as the complex Irish Revival design for William Bowers Bourn II's Filoli garden in Woodside in 1915–1917.[38] Porter understood Spanish garden traditions as well, having written in his foreword to Porter Garnett's influential 1915 volume, *Stately Homes of California*: "Something remains of the Mission garden—hints of the plan of the quadrangle of flowers and shrubs in or beyond the cloisters, and yielding in turn to the no less formal alleys of the orchard; and this rightness of design is perceptible still about the old Spanish residences that, here and there, dot the valleys of California. Our present assumption of formalities, then, is but a resumption—a return to the earliest

precedents furnished by Southern Europe and the trans-planted memories of the missionaries."[39]

In January 1923 Porter submitted a report "For <u>William R. Hearst, Esquire</u>, Upon His Estate at <u>SAN SIMEON – AND ITS IMPROVEMENTS</u>," based on one visit he paid to the hilltop in December 1922. Many of his recommen-dations for siting and planting—both on the hilltop and the lower ranch areas—had already been conceived by Hearst and Morgan by this time. Still, this document is significant for Porter's grasp of the project's implications and for Hearst's handwritten marginalia. Porter said of the hilltop siting: "Even now, with but three of the build-ings completed—the[y] strangely magnify themselves into the bulk and importance of a city." Hearst approved all the varieties of evergreens Porter recommended but crossed out many of the deciduous trees, writing in the margin, "Evergreens <u>chiefly</u>. I very much prefer them. . . . I do not like to introduce many deciduous trees which will look scraggly in winter." To the long list of blooming plants

Porter recommends, Hearst appended: "This is so inti-mate that like the furnishing of the houses it should be done largely when family is on the grounds and in response to personal tastes and fancies." Hearst's general response was: "Very wonderfully good report many artists could have spent a lifetime on the property and not have made as good a one."[40]

In the early years, Hearst contemplated additional hilltop buildings in exotic styles, including English Gothic and Chinese. He proposed a "little English house" to be built where the northern wing of the main build-ing is today. In the interest of harmony, he proposed that it be of "imitation stone" instead of half-timbering, which he felt would clash too much with the other houses.[41] It started as a modest idea, but as plans expanded—for a banqueting hall twenty-two by fifty feet, and a twenty-two-by-thirty-foot entrance hall, as well as six ample bedrooms—the project grew so large that they decided to postpone building it and relocate it to the bottom of the

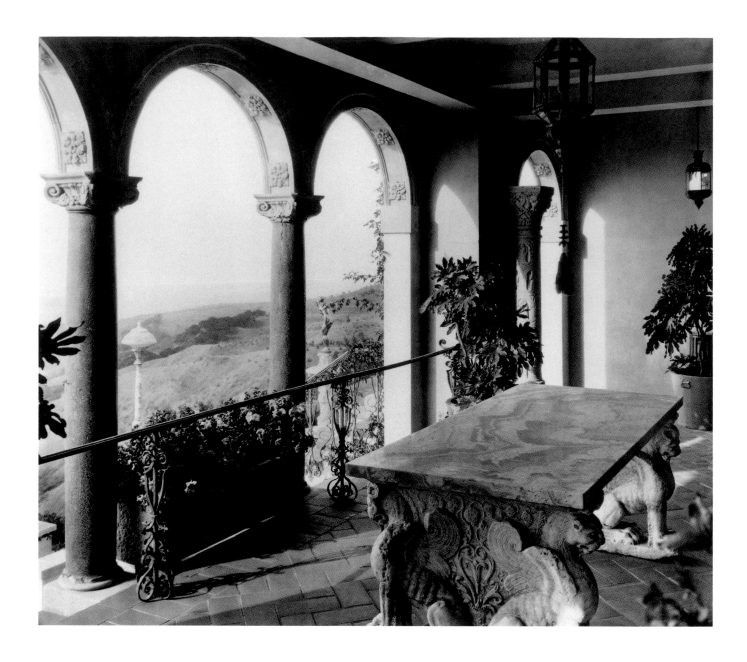

hill.[42] It was never constructed. Instead the immediate hilltop areas were all treated in a harmonious Mediterranean style.

At San Simeon, Hearst created a Spanish-style stage set and placed himself at the center of it as the grandee. In the early years, Millicent Hearst and their five sons were right there beside him. Hearst credited Millicent with a number of early planting suggestions, and she selected the estate's first formal name—Las Estrellas (The Stars). After Morgan mentioned that a nearby ranch already had that title, they discontinued using it.[43] They began using the more romantic La Cuesta Encantada—The Enchanted Hill—in 1924.

In 1921 San Simeon became a literal stage set for an elaborate movie Hearst filmed at the ranch, called—

in honor of the nearby Piedras Blancas Lighthouse—*The Lighthouse Keeper's Daughters: A Romance of the Ranchos*. It took full advantage of San Simeon's varied settings, with scenes along the water and on the hilltop. Hearst played the leading man, John Jenkins, as well as acting as director and screenwriter. Millicent played the heroine, one of the lighthouse keeper's two daughters. The Hearst sons, various guests, the Mexican grandee Don Pancho Estrada, and even Julia Morgan all had parts. The elaborate plot included a beach scene, a shipwreck, a horseback ride along the dusty trails, and filming on the hilltop itself, showing its new plantings and the three cottages in early construction. Hearst even wrote the amusing titles, including these typical stanzas:

Then through the shade
The cavalcade
Winds up the hill to where
John Jenkins is
Constructing his
Cloud castles in the air

And while with much
Aplomb and grace
He shows his friends
Around the place
And tells the tale
To every guest
Miss Milly soaks him in the chest

The architect
Her face is seen
Upon the screen
With steady gaze
She views the plans
That are no man's
Hers is the guilt
For what she built

Hearst played the dashing cavalier who danced
the fandango to "The Song of the Spanish Guitar" as
Millicent looked on admiringly in the closing scenes. The
ranch itself—even in these early years—was a picturesque
backdrop for his idealized tale. This continued to be the
case for all twenty-eight years of La Cuesta Encantada's
construction.

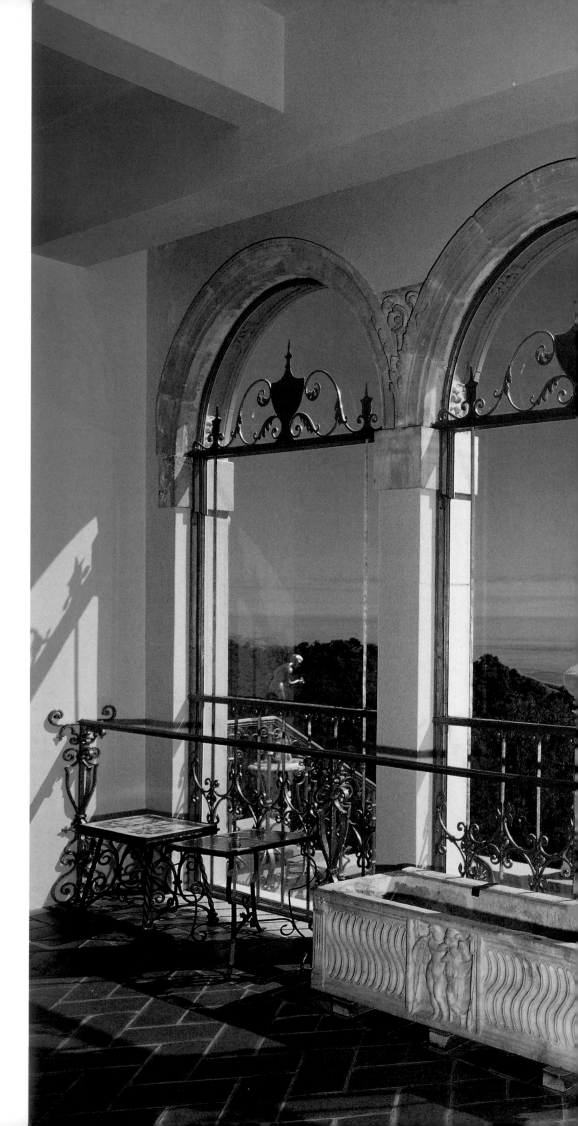

Hearst wrote to Morgan in 1922: "To my mind, the view is the important thing on the hill—that is the reason we come to the hill—and all our houses should be aimed at the view; that is, constructed so as to get the best view from the windows."

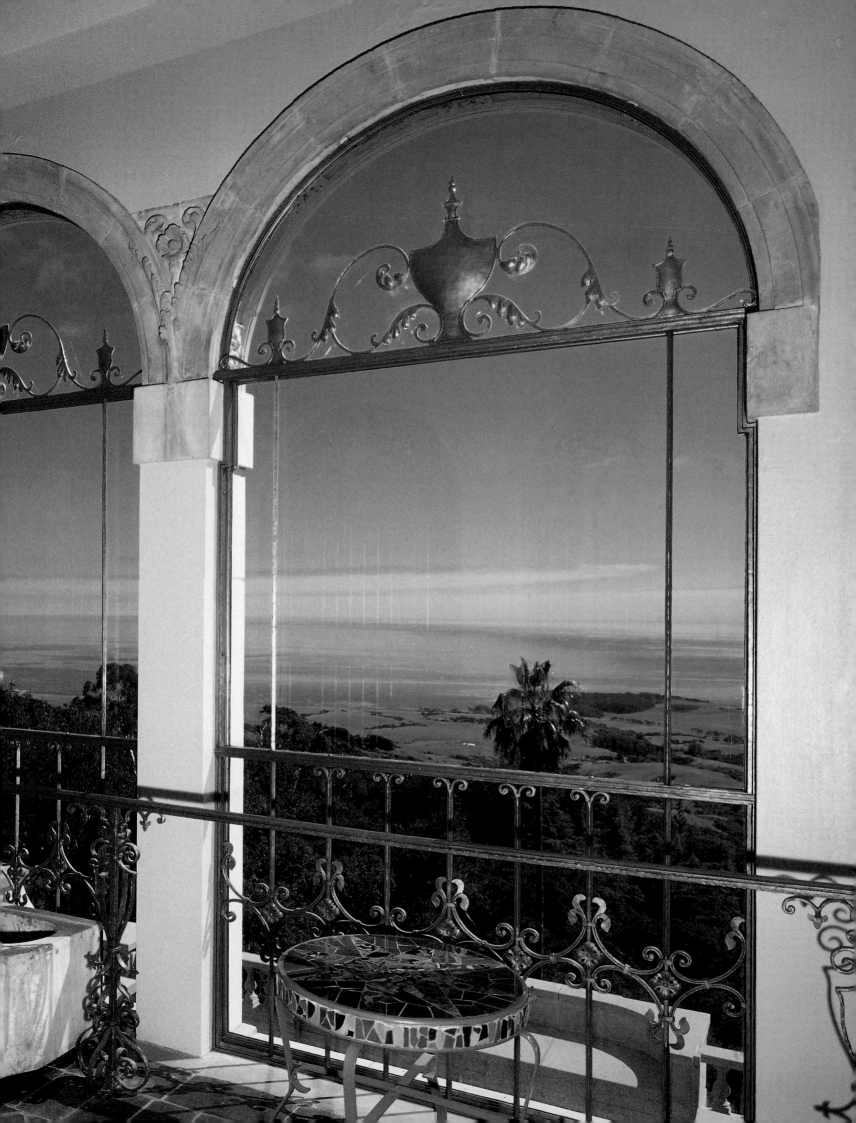

Morgan and Hearst: Native Californians (1919–1947)

Julia Morgan said many times that she felt fortunate to practice architecture in the same location where she had spent her childhood.[1] As a native Californian, she differed from other Bay Area architects, who were largely transplanted easterners and midwesterners. Bernard Maybeck and Albert C. Schweinfurth grew up in New York, John Galen Howard was from Massachusetts, and Willis Polk spent his youth largely in St. Louis. Like W. R. Hearst, Julia Morgan was a San Franciscan. Nine years younger than him, she was born on January 20, 1872. And like George Hearst, her father, Charles Bill Morgan, was a mining engineer—but not a successful one. Julia Morgan's maternal grandfather, Albert Osias Parmelee, made a fortune on cotton futures before the Civil War, and Parmelee money supplied much of the family's income.[2]

Morgan's youth was stable and financially comfortable. She was the second child, born two years after her brother Parmelee. Next came her sister, Emma, in 1874, then her brother Avery—with whom she was closest—in 1876, and finally her youngest brother, Sam (christened Gardner Bulkley), in 1887. When Morgan was a preschooler, her family left San Francisco for the quieter East Bay, moving into a spacious house purchased by her grandfather at 754 Fourteenth Street in Oakland. It remained the family residence for fifty years.[3] Like San Francisco, this part of Oakland near the bay was platted on a grid pattern of intersecting streets. But nearby were rolling hillsides dotted with the oaks that gave the city its name. In 1864–1865, landscape architect Frederick Law Olmsted laid out two of the area's earliest features: Berkeley's College of California, the future site of the University of California; and Oakland's Mountain View Cemetery—where Julia Morgan was eventually buried in 1957. Olmsted recommended that both sites be left unaltered as much as possible to conform to the natural topography of the area.[4]

Morgan was sensitive to nature. Like Hearst, in childhood she watched the American landscape roll by from a train, traveling cross-country to New York for family

Julia Morgan circa 1879, at age seven. She was the second-born of five siblings and had an intense and sensitive personality, even in childhood.

opposite
The climbing Cécile Brunner rose, often known as the sweetheart rose, twines up a Mexican fan palm (*Washingtonia robusta*). Hearst wanted climbing roses in abundance, telling Morgan, "They are particularly lovely and will make wonderful displays on the sides [of the cottages] facing the central plaza."

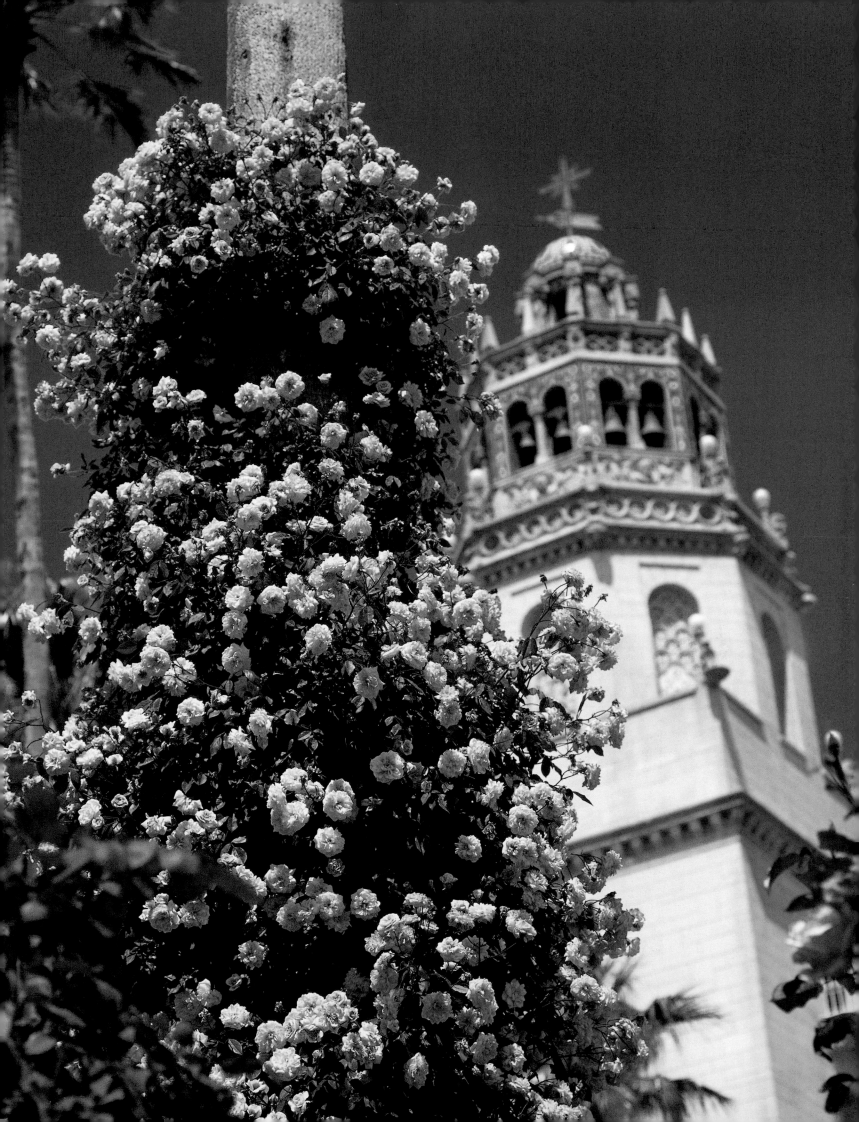

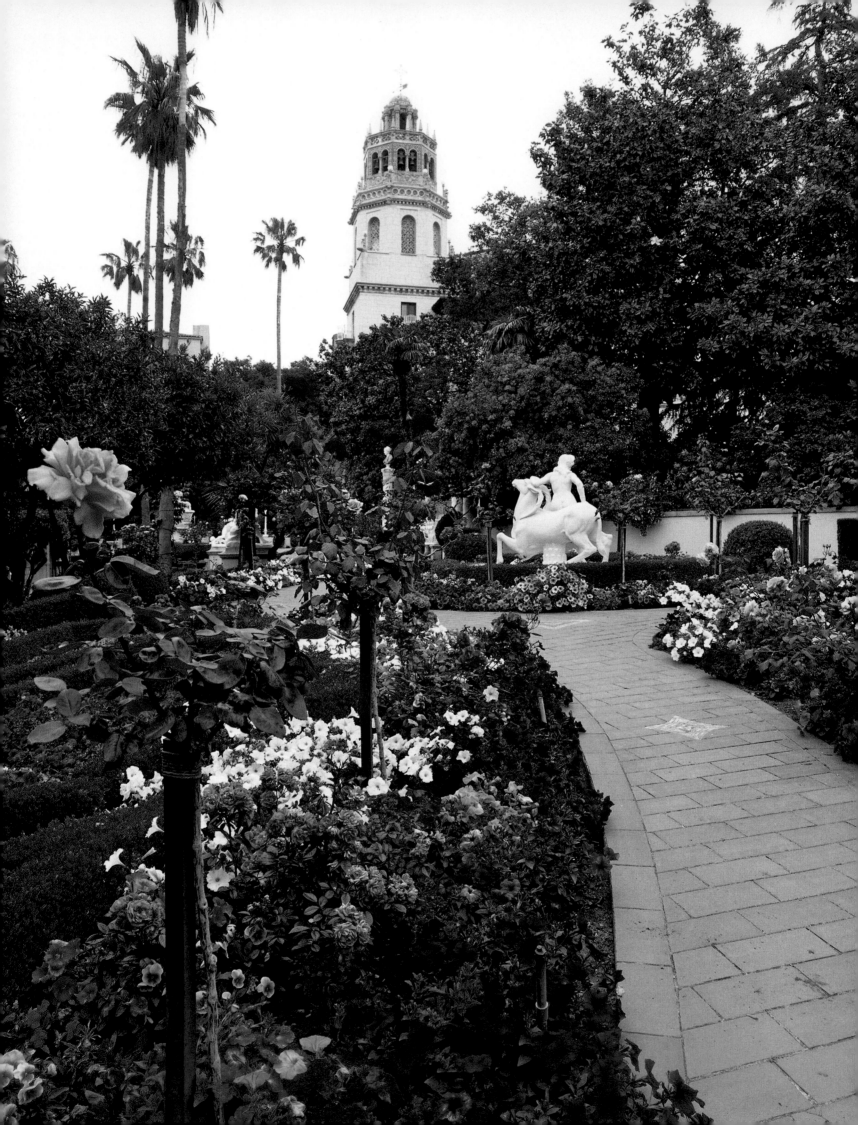

visits. Morgan also took trips to the seashore at Monterey, sparking memories still vivid in her late sixties, when she recalled tidepools she "hung over in the early Monterey days—saw all these kinds of life—took in too the quietness & peace under those mighty breakers."[5] She attended Oakland High School and then the University of California, where she was a Kappa Alpha Theta. This women's sorority was founded by twenty-seven female students in 1890. Morgan made lifelong friends there. Writing to one from Paris, she reminisced about a trip to Catalina Island the sorority had taken: "[S]uch wide, open, clear skys [*sic*] and seas, the meteors by hundreds shooting across the open as we lay outside the tents and my beautiful quiet sea peoples [marine life] in those clear depths below—I love, & loved it all."[6] Many years later, she described dusk at San Simeon with the same appreciation: "I was at the Ranch New Year's Eve, & never saw a lovelier sunset—or more beautifully colored mountain ranges—purples of all hues—blues beyond imagination."[7]

Morgan considered studying both medicine and music (she played the violin and piano throughout her childhood) before deciding to enroll in civil engineering at the University of California. There was no architecture department on campus at the time, and she was often the only female student in the required mathematics and science courses. When Bernard Maybeck joined the faculty in 1894, he quickly recognized her talents and hired her to work in his studio. Like many other American architects (beginning with Richard Morris Hunt in 1846), Maybeck had studied at the renowned Ecole des Beaux-Arts in Paris. He urged Morgan to apply there, demonstrating his great confidence in her skills.[8]

In the spring of 1896, Morgan left California for New York and then Paris, traveling with her friend Jessica Peixotto. A talented economics student, Jessica roomed with Morgan in Paris and studied for a year at the Sorbonne before returning to Berkeley, where she ultimately earned her doctorate—the second woman at the University to achieve that distinction.[9] She was the sister of Ernest Peixotto, a leading illustrator and interpreter of California's scenery. In 1917 he would paint landscape murals for the ballroom of Filoli, the estate south of San Francisco designed that same year by Willis Polk. Filoli's gardens were created by Isabella Worn and Bruce Porter, the two Bay Area artists who worked with Morgan at San Simeon.[10]

Morgan's timing in going to Paris was fortuitous. In 1897, after considerable lobbying, French women were admitted for the first time to the Department of Art at the Ecole (which had been established in 1671). Though no mention had been made of allowing women to study in the Department of Architecture, the precedent of acceptance in one program made exclusion in another more difficult.[11] Qualifying for the Ecole was grueling. Morgan wrote to her former sorority sister Beatrice Fox in 1896: "I speak French very badly, though I understand quite well. . . . I have little time for study, and hear really very little, except as the servants or shopkeepers speak. I go to three series of architectural lectures at the Beaux Arts, very fine courses, and it all helps a little—The stores are full of Christmas toys—never saw such dolls, mechanical toys etc—it seems very hard to have no chance to buy or give this year. I keep seeing some special thing some of the children [at] home would just be wild over. I expect a church service will be all my celebration this year. Thanksgiving was a miserable failure."[12]

Her family realized Morgan's homesickness and sent their encouragement. Her mother wrote news of the family garden: "Almond Quince & Peach trees are in blossom and my little yellow rose is full of blossoms—foolish. I know they'll be frozen like last year. Apples have been very good this year and I have thought of you so often. Emma does not care for them. So buy yourself a pair of good shoes and wear them out at once. . . . Hope you will get another drawing in if you want to, even if you are a girl."[13]

Morgan was closest to her brother Avery, who joined her at the Ecole for a year, studying in the atelier of Victor

Laloux in 1898 after completing his degree in civil engineering at the University of California. He was emotionally fragile and did not practice architecture professionally. In later years he served as Morgan's chauffeur, driving her to commissions all over the Bay Area. Avery cautioned her about her own tendency to overwork and overtax herself during those years of study in Paris: "Don't get too highly keyed up and break the main spring from which all energy comes. You have sisters who have done this so 'beware of the dog.' I would like to be with you as much as you would with me, sometime it may happen. With 'beaucoup d'Amour' from the 'Old Man.'"[14]

Her father also worried that she was overextending herself, writing: "I am afraid you are homesick, and if such is the case, I would not continue to stay away out of any mistaken pride in the matter. Life is not all architecture and while you may gain in one direction it is not needful to sacrafice [sic] too much for one object. If however, you find your life interesting and the homesickness is not abnormal, why then stay as long as you desire. . . . I hope that when you take the next examinations that you will have more confidence in yourself and will not worry over the result. Just show 'em what an American girl can do."

To at least one member of the family, Morgan's determination was baffling. Her cousin Lucy LeBrun was married to the New York architect Pierre LeBrun, who had in part inspired Morgan's choice to study architecture. Preoccupied with married life and child rearing, Lucy wrote, "Why do you bother with the Beaux Arts examinations? If they won't admit women, why they won't, that's all."[15]

Morgan failed the entrance examinations twice, which was not uncommon. While nerves accounted for her first rejection, the second time she was eliminated at least in part due to her gender. Still she persevered, and she was accepted on her third try.[16] It was a worldwide achievement. Hearst's newspaper, the *San Francisco Examiner*, wrote: "Another California girl is added to the long list of those who have won honor for themselves and for their

When Morgan became the first woman admitted to study architecture at the Ecole des Beaux-Arts, it was a worldwide achievement. She was soon joined in Paris by her brother Avery, and together they traveled throughout Europe during study breaks. Her student drawing of a well in a Mediterranean landscape may derive from such a trip.

State abroad. The latest on the list is Miss Julia Morgan, who has just successfully passed the entrance examinations for the Ecole des Beaux Arts, department of architecture. The honor is all the more marked in that Miss Morgan is the first woman in the world to be admitted to this special department. . . . The examination in mathematics is oral, given before a committee, and is of such a nature as to try the nerves of even strong men. . . . The honor of working in the Ecole des Beaux Arts and the facilities for a successful career are so great that hundreds apply for admission each year. It is an inviolable rule that only ten foreigners can be admitted each year. In the recent difficult examinations Miss Morgan scored a signal success, ranking third in the list of foreigners and thirteenth in the entire list of applicants. Of course the fact that the examinations are conducted entirely in French would add to the difficulty for an American."[17]

Morgan was admitted into the atelier of François-Benjamin Chaussemiche a few months before she qualified to enter the program. Under his guidance, she embarked on the Ecole's course of study, which involved submitting work anonymously for assigned competitions and accruing points toward a degree. Morgan attained her *diplôme* in February 1902, having won sufficient prizes to accumulate the necessary number of points before she was disqualified by age. All students were required to complete the program before their thirtieth birthday. Her achievement was even more impressive because it generally took six years to finish, while she had done it in just over three.[18]

The Ecole des Beaux-Arts permanently influenced Morgan's aesthetic philosophy. She learned to work quickly and thoroughly, integrating the interior and exterior of her designs, and to maintain an overriding focus on the plan. Central to the program was the concept of *caractère*: a building's form should embody its purpose.[19] Walter Steilberg, an engineer who worked for Morgan, felt her strongest talent was her ability to work "from the inside out. So many architects still work from the outside in." Maybeck

shared this skill. Steilberg recalled him saying, "The plan's the thing." When asked if Morgan's abilities applied to landscape as well as to structure, Steilberg said: "She was a landscape architect, and she knew just where the paths were to go. She was always very particular about that—'this is the main entrance to the building, and this is the service entrance here.'"[20]

Morgan returned to California in 1902 and became involved immediately in the Berkeley campus plan. John Galen Howard hired her as draftswoman and assistant supervising architect on both the Hearst Memorial Mining Building and the Hearst Greek Theater. These projects were a fitting start to her prolific career. Morgan designed more than seven hundred buildings in four and a half decades—an output matched by very few architects. Throughout her practice, she combined the rigorous formality and adherence to precedent she had learned at the Ecole with the more informal focus on landscape setting and indoor/outdoor relationships characteristic of the Arts and Crafts style.[21] The Mining Building (1902–1907) evoked Beaux-Arts classicism in its formal granite exterior, contrasted with a red tile roof that echoed the California vernacular of the missions. The Greek Theater (1902–1903) was modeled on an open-air theater built in Epidaurus, Greece, about 350 B.C. by the sculptor and architect Polykleitos the Younger. This modern version was set in a natural amphitheater on the sloping foothills of the eastern campus. The site was first used on Class Day of 1894, when members of Morgan's graduating class—clad in brown gowns and chanting a dirge—led a winding procession through the trees to a smoking altar made from a eucalyptus stump in a clearing. College president Benjamin Ide Wheeler realized that his campus, often described as the "Athens of the West," should have at this site a fitting classical theater in the Greek tradition. At Phoebe's suggestion, W. R. Hearst funded its construction as a gift to the university.[22]

John Galen Howard chose Morgan as project manager for the Greek Theater possibly because she had received

The 1903 Greek Theater, a gift to the University of California from
W. R. Hearst, may have provided Hearst and Morgan's introduction.
She was the project manager for its construction under the direction
of architect John Galen Howard.

Morgan rebuilt the Fairmont Hotel on Nob Hill in San Francisco after
the 1906 earthquake. At its reopening in 1907, Morgan was mistaken
by some members of the press as its interior decorator instead of
its architect.

training in reinforced-concrete construction at the Ecole. This knowledge also served her well in her first major independent commission, El Campanil—the 1903 bell tower for Mills College for women in Oakland. The campus had received a gift of ten bronze bells weighing ten thousand pounds. They had been cast in Cincinnati for the World's Columbian Exposition in 1893 and were brought to San Francisco the following year for the Midwinter Exposition, a small world's fair held in Golden Gate Park. Morgan designed a wide concrete tower for the campus with the bells hanging in storied arches, in the California mission style. A contemporary description praised the tower's siting: "The surroundings of 'El Campanil' are designed to bring out its beautiful lines and quiet yet effective color scheme, as it is flanked by huge oaks and eucalyptus trees and rises from a broad expanse of lawn." In spite of the bells' massive weight, El Campanil survived the 1906 San Francisco earthquake with no structural damage, a testament to Morgan's skill in working with steel-reinforced concrete.[23]

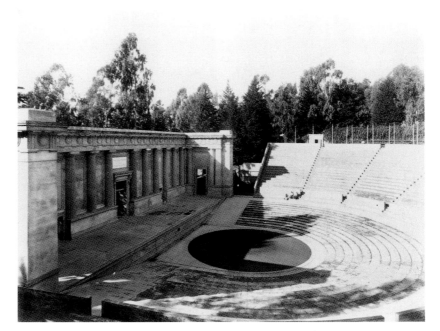

Morgan's first architectural office at 456 Montgomery Street in San Francisco was destroyed by the quake, along with Hearst's *Examiner* building and much of the city's downtown. Without an office, Morgan embarked on another major commission: the reengineering of the six-hundred-room Fairmont Hotel on Nob Hill, built in 1903 and also severely damaged by the quake. Her success at Mills College and the Berkeley campus may have led to the commission. She set up a construction shack on the hill behind the hotel—where the Italian garden was planned—and worked to rebuild a structure so altered that portions of the floors had settled seven feet from their former position. When asked by a reporter why she had persisted in restoring it when several other local architects had recommended tearing it down, Morgan replied, "No one asked me—they just said 'Fix it.'"[24] In April 1907, on the one-year anniversary of the quake, the Fairmont Hotel reopened.

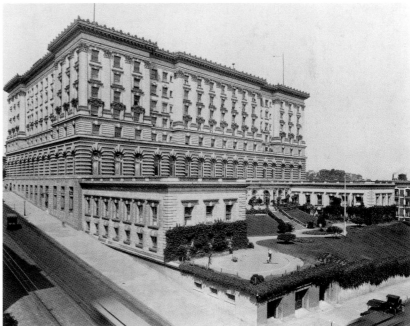

In the summer of 1907 Morgan moved her office to

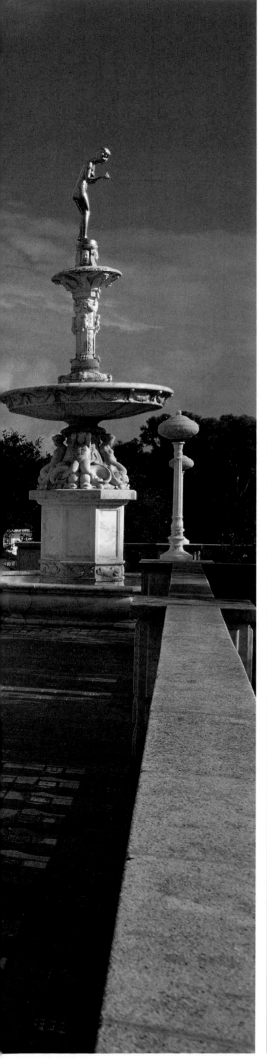

Ed Trinkkeller created many of the wrought-iron grilles, including this door to the lowest level of House A. Adolf Daumiller's 1920s gilt-bronze *Fairy Princess* tops the fountain in the distance. The narrowness of this terrace was due to the extreme slope of the hillside. Morgan wrote Hearst in 1920: "When they cleared away the brush on the lower side of your house we found that the ground fell away suddenly. . . . [The treetops] will be just above the balcony rail of the terrace."

Bougainvillea climbs beside a Juliet balcony at House A. In 1921 Hearst telegraphed Morgan that he "would like the south side of A to be [a] mass of beautiful bourganvilla [*sic*] visible from [the] bay side."

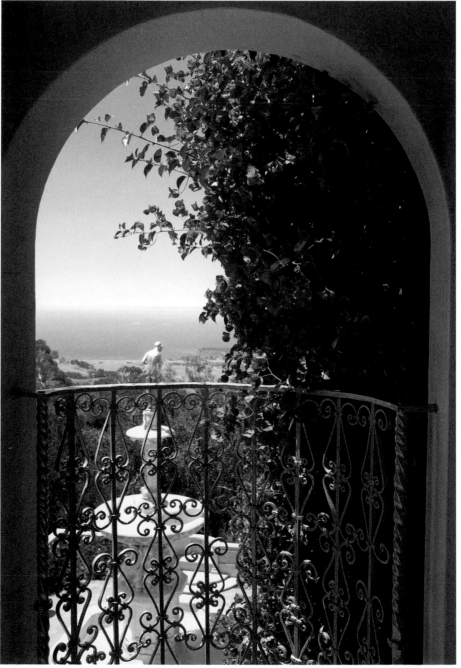

The hilltop gardens are laid out on five separate levels. The elevation changes necessitated many small and graceful staircases, which, inspired by Spanish garden steps, were often ornamented with tiles in the stair risers.

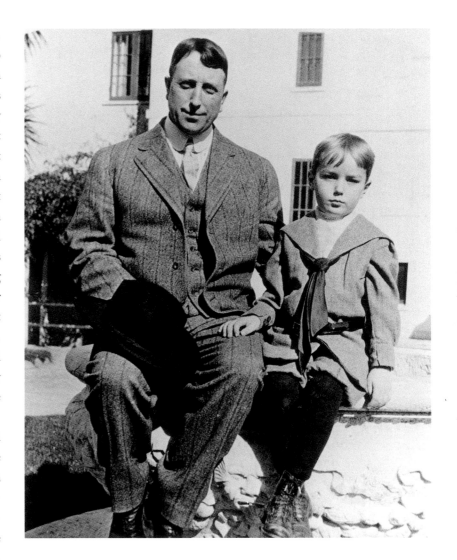

the Merchants Exchange Building at 465 California Street. She remained there for the next forty years. From 1904 to 1910, she had a junior partner, Ira Wilson Hoover. When he departed, she never took another partner. Her firm was known simply as "Julia Morgan Architect."[25] In the early years of her career, Morgan resided with her mother at the family house in Oakland. In the mid-1920s she bought two Italianate Victorian houses on Divisadero Street in San Francisco, remodeled them, and lived in one apartment while renting out two others. Around 1928 Morgan began to fear for her ailing mother's safety as the old Oakland neighborhood deteriorated. Her solution speaks volumes about her consideration for her clients and her lifelong attention to detail: Morgan remodeled one of her sister Emma's rooms in Emma's Berkeley home on Prospect Boulevard to exactly resemble their mother's bedroom. The family then took Mrs. Morgan on a long drive and led her down a darkened hallway to a completely new but totally familiar version of her surroundings. She never knew she had moved.[26]

Morgan's two female mentors were her mother and Phoebe Apperson Hearst. Morgan first met Phoebe while she was a Berkeley coed, and Phoebe visited Morgan in Paris during her studies. When Morgan returned to California, Phoebe hired her to make additions to her Pleasanton residence, the Hacienda del Pozo de Verona. Phoebe had reappropriated this project from her son, still retaining Albert C. Schweinfurth, whom Hearst had hired as architect in 1894. Hearst also commissioned Schweinfurth to design his Spanish-influenced *San Francisco Examiner* building in 1897. One of the most visionary and well-regarded designers in the San Francisco region, Schweinfurth's career was brief. He died of pneumonia in 1900 while still in his thirties.[27]

Morgan began working on the Hacienda in 1903 while she was employed in John Galen Howard's office. It is unclear how much she directly contributed to Schweinfurth's original design. The Hacienda had pergolas on all

Hearst and Morgan's reverence for the native oaks of San Simeon may have been influenced by the philosophy of Berkeley's Hillside Club, which included Bernard Maybeck and his wife, Annie, as charter members. The Club urged the preservation of existing trees and the importance of building roads and structures around them.

opposite
In 1926 Hearst and Morgan had two mature oaks moved to make space for the main building's North Wing; in 1928 they moved an oak to expand the terrace at the central plaza; and in 1946 they moved an oak to lengthen the South Wing. These enormous trees were encased in concrete and relocated using timbers and rollers. The oak shown in this 1926 photograph survives today.

of its major stories and was built around a courtyard with an Italian wellhead at its center. It was landscaped in typical Mediterranean fashion with Canary Island date palms (*Phoenix canariensis*) and giant dracaenas (*Cordyline australis*). Climbing roses were trained on the pergolas, and rose standards lined the paths. Spiky plants in pots ornamented the balconies. The complex was only one room wide to encourage cross-ventilation and take advantage of the views across the Livermore Valley. Charles F. Lummis, champion of the California missions and founder of the Landmarks Club, called the Hacienda the richest example of a patio house in America, praising its privacy, ventilation, and vistas.[28]

The Hacienda shared many similarities with Morgan's later work at San Simeon. It also had two swimming

pools, one outdoor and one indoor. Both pools were definitely designed by Morgan. Like San Simeon's Roman Pool, the indoor pool had windows on three of its four sides and was spanned by ceiling arches. The Hacienda was one room wide, as was San Simeon's Casa Grande, the earliest plans for which also called for pergolas on both sides of the ground-floor level.[29] Hearst inherited the Hacienda at Phoebe's death in 1919 but sold it in 1925 to a business consortium, which turned it into the Castlewood Country Club. The original structure burned in 1969; it was rebuilt in 1972 in a different architectural style. Only one original building remains on site.[30]

Throughout her career, the majority of Morgan's commissions were private houses, built in smaller scale than the Hacienda. Many of them were modest woodsy structures set in the Berkeley hills for clients she knew from her years at the university. Berkeley at the turn of the century was shaped by the tenets of the Hillside Club, founded by several women in 1898 as an exercise in community planning. Its philosophy crystallized in 1904 during the presidency of Charles Keeler. Author of *The Simple Home*, he urged residents to "build their homes along certain approved artistic lines . . . making the flowers and trees and gardens a more vital part of the home."[31] Bernard Maybeck and his wife, Annie, were among the founding members, described by their daughter-in-law Jacomena Maybeck as "seething with ideas of curving streets, irregular lots, no high board fences, and houses blended into gardens. . . . When I read the aims of the Hillside Club I can hear Mrs. Maybeck's voice, loud and clear: 'We wanted to make sure that no hill street would ever be straight.'" The Hillside Club decreed: "Roads should follow contour lines. . . . The steep parts can be handled in various ways, terraced in two levels as on Hearst Avenue, divided into narrow ways for driving with footpaths above and below and connecting steps for pedestrians." Respect for existing trees was also paramount: "The few native trees that have survived centuries of fire and flood lived because they had chosen

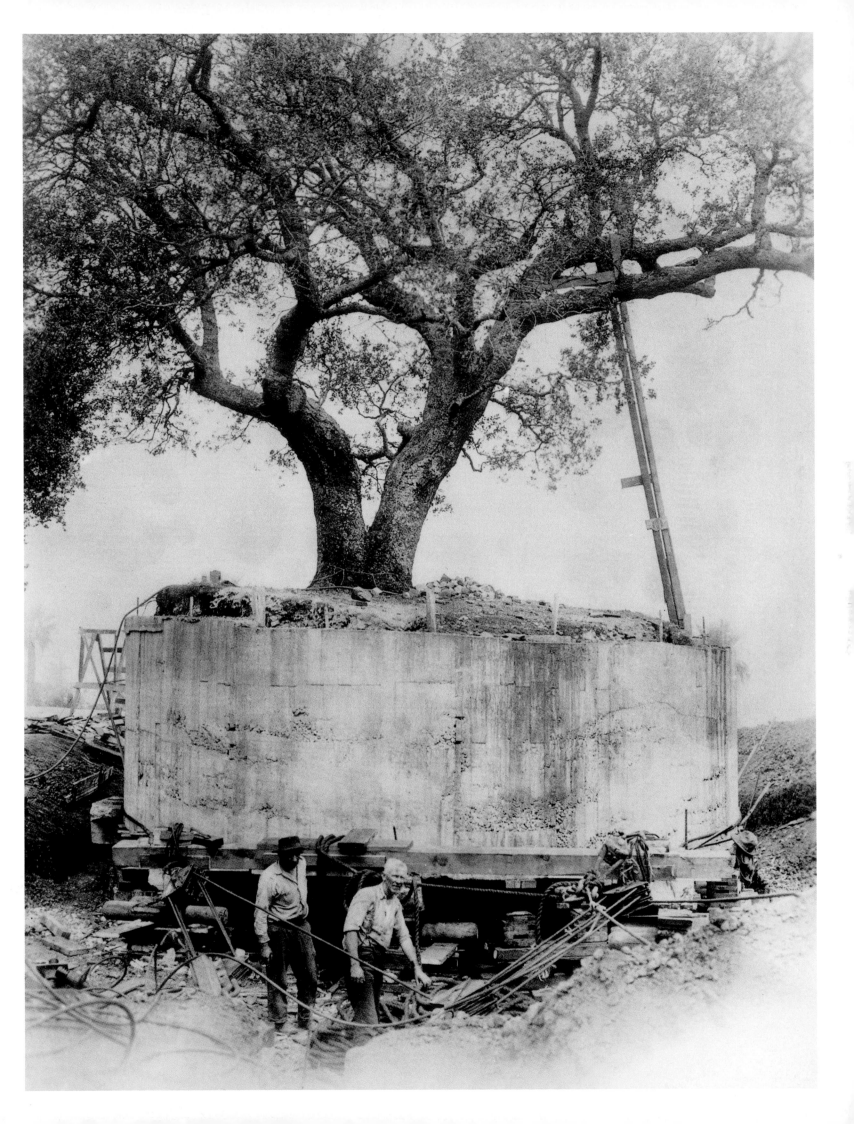

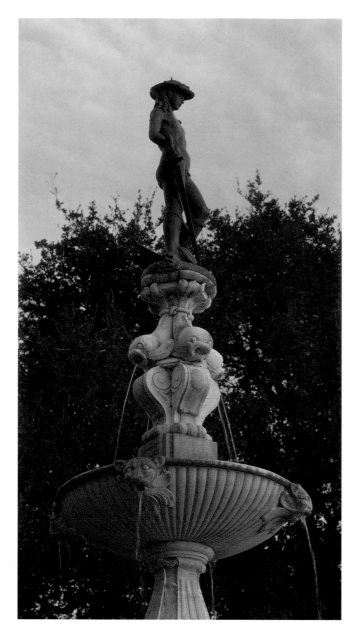

the best places. They should be jealously preserved. Bend the road, divide the lots, place the houses to accommodate them!"[32]

Hearst and Morgan followed this philosophy at San Simeon, dividing portions of the six-mile road from the ranch house to the hilltop for one-way traffic. They wound its route through the most picturesque viewpoints, bowing it outward to circle around venerable coast live oaks. They paid great attention to the hilltop's contour lines, siting the cottages in consideration of this aspect, as well as the views. And most important, they respected the mature trees by locating the buildings, gardens, and swimming pools around them. In later years, they took these practices even further by moving at least four enormous mature coast live oaks to more suitable locations on the hilltop, rather than cutting them down.

Walter Steilberg went to work for Morgan in 1910 and

David, after Donatello (c. 1430), c. 1920 reproduction. Cast bronze, height 61 in. (154.9 cm). Hearst Monument Collection, C Terrace. This reproduction of Donatello's renowned statue was placed atop a reproduction of a Spanish Renaissance fountain at the west side of House C (also known as Casa del Sol).

Morgan designed more than seven hundred structures during her prolific career. Her private office space at the Merchants Exchange Building in San Francisco was also her library, where she and her clients consulted historic photographs for design inspiration. The west facade of House C is patterned on a house in Cordoba, Spain, photographed in Austin Whittlesey's 1917 volume *The Minor Ecclesiastical, Domestic, and Garden Architecture of Southern Spain.*

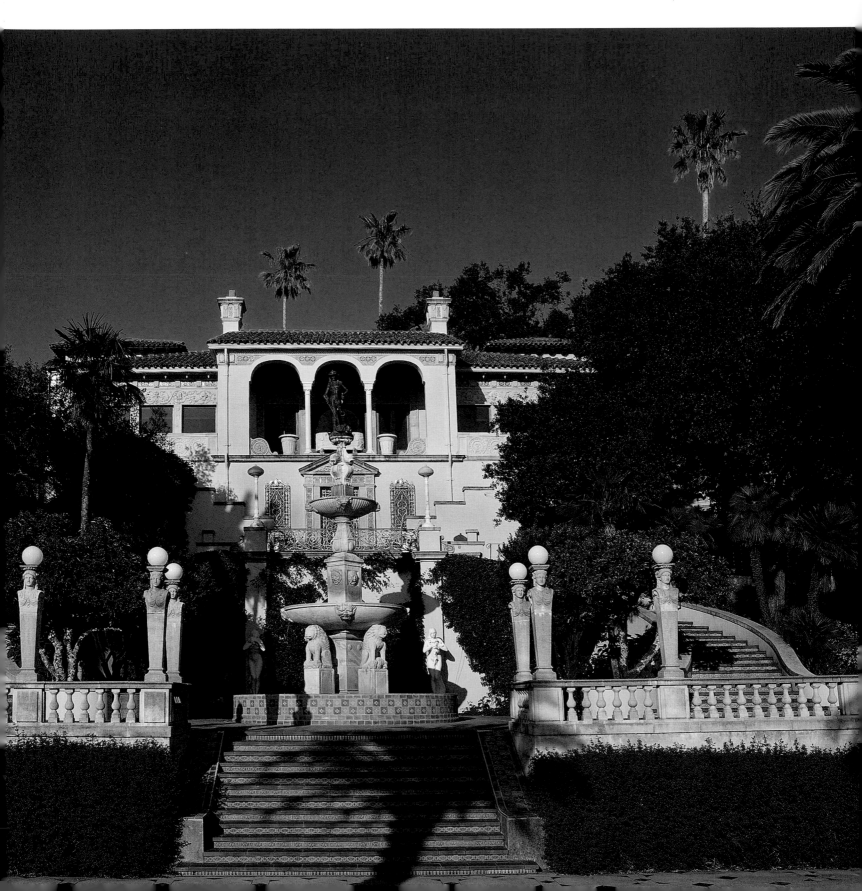

Morgan designed this simple wood bungalow for Hearst in 1914 on
property he owned on the south rim of the Grand Canyon. The land
later became part of the national park, and the cabin was torn down in
1941.

remained in her employ during San Simeon's early years. A close friend as well as a colleague, he was in a unique position to provide glimpses of Morgan's personality. He first applied for work at the office of San Francisco architect Arthur Brown Jr. When Brown told Steilberg to try Morgan's office instead, "I guess he saw my look of dismay at the idea of going to work for a woman architect and he said, 'Don't fool yourself, there is no man in the profession in this neighborhood who is any better as an architect.'"[33] Morgan hired him. He recalled: "About the third morning I was there, I went in quite early. She was on the 13th floor of the Merchants Exchange Building. I went on in to the library and there was a ladder going from the 13th floor clear out over California Street to a scaffold . . . and the scaffold was just a group of 2 x 12s with some 2 x 4s tacked to the edge and some chicken wire on the end. No such fancy scaffolding as you have today. Here was Miss Morgan, coming down this ladder, and when she got down she just stepped off and said, 'Oh, you must go up and see what they are doing.' . . . Well, I was scared to death. I crawled up this ladder and my only impulse was to lie down . . . and yell for help. . . . I think she was one of the most fearless people I have ever known."[34]

Steilberg described Morgan's sensitivity to color and her desire to integrate the interior and exterior of the design for a house, using a project she built for the Wells family in Oakland in 1910 as an example: "Miss Morgan was there trying to advise them on the colors. She had a horror of interior decorators coming in and spoiling a house and of landscapists who were not really trained. There was some argument and Miss Morgan, I could see, was getting a little warm about it. She looked out the window with a funny little smile on her face and said, 'Well, it seems to me that there's quite a nice vision right outdoors. The bark of the eucalyptus tree is very beautiful and so are the colors, and the leaves are two different colors. Couldn't you find something [to use as the interior color scheme] in that?' As they say, bring the outside inside."[35]

Morgan's goddaughter, Lynn McMurray, recalled how much Morgan's clients loved the houses she designed for them. The architect took their preferences into account and often integrated the setting into the scheme, featuring "little things like windows in the closets . . . and pairs of homes that have entries in the center driveway. Often relatives built across from one another and wanted to greet each other when they walked out the door. . . . A few homes have planter boxes with faucets in them, both upstairs and downstairs. She was an architect ahead of her time."[36]

As a woman architect in the early years of the twentieth century, Morgan was uncommon. But she was not unique. Among her contemporaries was Katherine Budd (born in 1860), who studied with Morgan in the atelier of Pierre de Monclos in Paris. (Morgan soon left for Chaussemiche's atelier.) Budd went on to teach and practice architecture in New York.[37] Hazel Wood Waterman (born in 1865) studied art at the University of California a few years before Morgan arrived on campus. Waterman became interested in architecture when she and her husband commissioned San Diego architect Irving Gill to design their house. After she was widowed in 1903, she went to work in Gill's office. She never became a licensed architect, but she designed houses and women's clubs. Waterman ended her days at the Berkeley Women's City Club, a residence for women that Morgan designed in 1929.[38] Mary Colter (born in 1869) studied art at the California School of Design in San Francisco and taught high school for fifteen years, beginning in 1892. She took a job with the Fred Harvey Company, which provided hospitality throughout the Southwest for the Atchinson, Topeka, and Santa Fe railway, and became its decorator and chief architect. Colter created several hotel train stations that combined Native American and Spanish influences—such as El Navajo in Gallup, New Mexico, in 1916—and designed the Bright Angel Lodge at the Grand Canyon in 1935, as well as several other distinctive hotels and national park structures.[39] Lutah Maria Riggs (born in 1896) studied architecture at the University of California

Hearst worked with Morgan on several projects prior to San Simeon, including a large house he contemplated building in Sausalito in 1910. It was reminiscent of Phoebe Hearst's Hacienda del Pozo de Verona. Morgan's elevation drawing indicates "The old oaks" on the left, which they apparently intended to preserve. This residence was never constructed.

In this early elevation drawing, Morgan ornamented House A with an outdoor fireplace and wooden shutters, neither of which was built. Within a few months, Hearst and Morgan abandoned these bungalow styles in favor of the Renaissance styles of southern Spain.

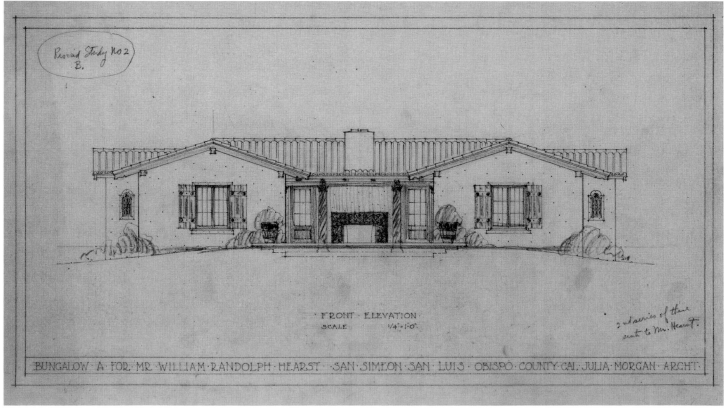

beginning in 1918, then left to take a drafting job with the painter and architect George Washington Smith in Santa Barbara in 1921. After Smith's death in 1930, Riggs practiced for another fifty years, working not only in his trademark Spanish style but also in the Art Deco style and the International Style.[40]

Morgan differed from these female contemporaries in several respects. Rather than learning as an apprentice in an office, she successfully completed the most rigorous and demanding architectural schooling in the world, making history as the first woman to do so. She did not specialize in a specific style, as Colter did, or confine her practice to domestic architecture and women's clubs, as Waterman did. In the quantity of her work and in its extraordinary range, she is almost unique—among both male and female architects. In addition to houses, she produced schools, clubs, hospitals, churches, hotels, gymnasia, stores, columbaria, office buildings, and radio towers. In her commissions for Phoebe Apperson Hearst and William Randolph Hearst, she designed some of the largest and most extraordinary country houses in America. Throughout her practice, Morgan was sensitive to both the natural landscape and the built environment. From her initial work for Phoebe in 1903 and her introduction to W. R. around that same time, Morgan worked nearly continuously on Hearst commissions for the next forty-five years.

Hearst and Morgan's first collaboration came in 1914, when she designed a cabin for him at the Grand Canyon on land that later became part of the national park. Built of frame construction, with two bedrooms in the rear and a living room in front, it totaled only twelve hundred square feet. The back porch looked out onto the canyon.[41] Though at various times Hearst planned more elaborate structures on this site—including a Hopi House to display his Native American art collection—nothing larger was built. The property was acquired in 1941 for the national park, and the cabin was torn down.[42]

More significant was their 1915 collaboration on the Los Angeles Examiner Building, which occupied a full city block downtown. Hearst described it as "thoroughly practicable for all newspaper demands . . . [combining] with its efficient qualities those pleasing traits reminiscent of an architecture which is identified with the beautiful and romantic history of Los Angeles and of California."[43] Its arcades, gambreled entryway, main tower flanked by smaller side towers, iron balconies, and blue and yellow tile all express the Mission Revival style, then at its zenith. Hearst and Morgan revisited this aesthetic at San Simeon in the 1930s, designing the outlying ranch structures and a storage warehouse in the Mission Revival style, long after its popularity had waned in the rest of California.

Hearst also commissioned Morgan to work for him in Sausalito. He first rented a house there in the late 1880s, when he was editor of the *San Francisco Examiner*. He soon purchased the more elaborate Sea Point, a large shoreline home built by Henry Cartans. Hearst occupied this residence with his companion Tessie Powers, whom he had met in his Harvard days. In 1890 he planned to build a grander house on the site below Sea Point, but only a retaining wall and gatehouse foundation were completed. Twenty years later he commissioned Morgan to design an elaborate Spanish-style residence, perhaps to console himself for losing the Hacienda del Pozo de Verona to Phoebe. One of Morgan's drawings indicates "The Old Oaks," a group of native trees that they planned to preserve on the site. That house was not built either. Instead, San Simeon took its place as Hearst's lavish Mediterranean residence.[44]

Steilberg witnessed the hilltop project's beginnings. He recalled Hearst "came into the office one afternoon. It was after office hours. I was one of the chief draftsmen. The door to the library was open and I heard this surprisingly high voice of Mr. Hearst, I recall it very well, saying, 'Well, I'm a little tired of camping out on that campground up on the hillside. . . . I want to build something a little bit more

A challenge for Morgan was Hearst's "changeableness of mind," as she described it to a colleague. The terrace west of House C was expanded twice to keep it in scale with the nearby Neptune Pool, which underwent two expansions.

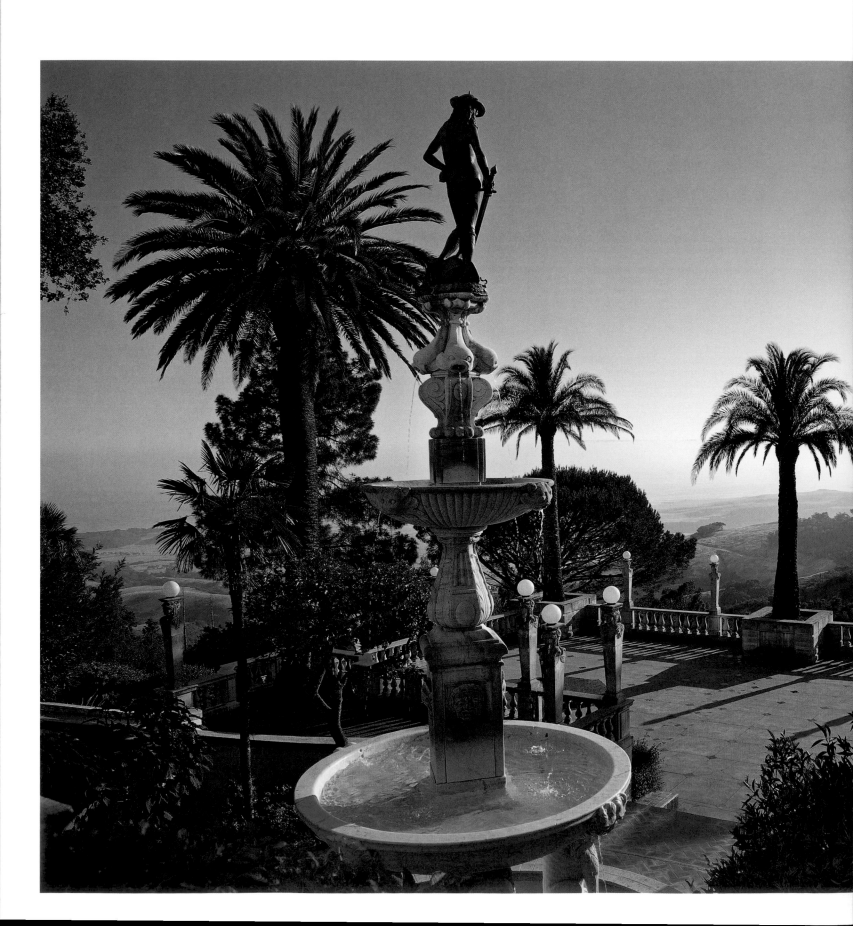

comfortable and I was in an old bookstore in Los Angeles the other day and I was looking over some of these 'bungalow sets.' . . . The one that appealed to me the most is this one. . . . I know you won't think much of the title, but nevertheless, this does rather please me in its general lines. It is this one that is called the 'Swisso-Jappo-Bungalow.' So, what you have now, is a 'Swisso-Jappo-Bungalow' in an art group! Well, that was the beginning of it."[45] The latter was a reference to the Arts and Crafts architecture of Charles and Henry Greene in Pasadena, based on a fusion of Swiss and Japanese elements, and resulting in such masterworks as the Tichenor House in 1904 and the Gamble House in 1908. The Greenes did not visit Japan, but they did study the Imperial Japanese Garden constructed for the Louisiana Purchase International Exposition, also known as the 1904 Saint Louis World's Fair.[46]

From the modest beginning Hearst described to Morgan, San Simeon's hilltop structures quickly grew. Many observers remarked on the incongruity between Julia Morgan's quiet appearance and the grandiose scale of her creation. Perhaps the best observer of this contrast was Hearst's ace reporter, Adela Rogers St. Johns, one of his many influential female employees and a frequent guest. She called Morgan a "double-take of unexpectedness. For she was a small, skinny, self-effacing lady whose iron will was *fem incognita* and *sotto voce*. Her graying hair was held in a small knob at the back of her head by bone pins, her gray tweed tailored suit was inches too long, and she used no make-up at all. At dinner [among the glamorous Hollywood guests] . . . Miss Morgan, in a blue foulard dress with white daisies, was like a small neat bantam hen among birds of paradise. Except that she always sat on Mr. Hearst's right."[47] St. Johns was astute enough to perceive the favored position Morgan occupied, at Hearst's right hand. These two native Californians drew on many shared influences in their respective histories as they created their homage to the California landscape at San Simeon.

5

The Mid-1920s and the Styles of Spain (1922–1925)

At the start of 1922, the three cottages were far from finished, the planting around them was lagging, and there were personnel problems with both the construction superintendent and the head gardener. Part of the difficulty was the weather. Hearst wrote to Morgan in March 1922: "I realize that work cannot be done in winter on the hill. . . . Let us do our work beginning the first of April and continuing until the first of December. This gives us eight months of good weather and good roads for main construction."[1]

But Hearst clearly felt that poor management was also a problem. He wrote to Morgan: "I telegraphed you about the necessity of doing work on the hill by contract. I believe this is absolutely necessary, as I think the people up there have got into a lackadaisical habit that nothing but the presence of the contractor on the job will correct."[2] Morgan dutifully prepared specifications for work on the garage and kitchen projects, but contractors were reluctant to make bids.[3] Hearst and Morgan also made personnel changes, firing the argumentative head gardener Hugh Hazard in March 1922.[4] A much more satisfactory head gardener, Albert Webb, was hired four months later. Morgan wrote: "He is a born gardener, and started actual gardening at eight years old on a fine English estate, working on several famous places before coming to America. He has all the technical knowledge of Hazzard [sic] . . . with practicalness. Also, his head is squarely set upon its base and I do not think will be easily turned."[5] She also sent Camille Rossi down from her office to work as a construction superintendent.[6] Rossi remained for the next ten years and was responsible for much of the hilltop's major construction, as well as for moving three mature oak trees. Morgan appreciated his initiative but grew to regret hiring him. He became disruptive and insubordinate in later years and tried to undermine her directives. Steilberg recalled: "[I]n a way, he was something like Mr. Hearst. He was always riding off in all directions at once."[7]

Hiring new employees was not enough of an improve-

Marion Simpson, one of Julia Morgan's employees, described her: "A tiny woman, gentle yet formidable. A rosy little face innocent of cosmetics. Snowy white blouse with a tie, grey coat and skirt superbly tailored, uncompromisingly long. . . . Her manner was simple. Pleasant, yet rather reserved. Eyes very direct. A low clear voice. I've seen strong men tremble when she said, 'No, it won't do.' But her smile could be radiant, her praise warm and generous."

opposite
The garden near House B, showing the mixture of colors. Hearst selected plants that were readily available from California nurseries rather than collecting rare and unusual plant species.

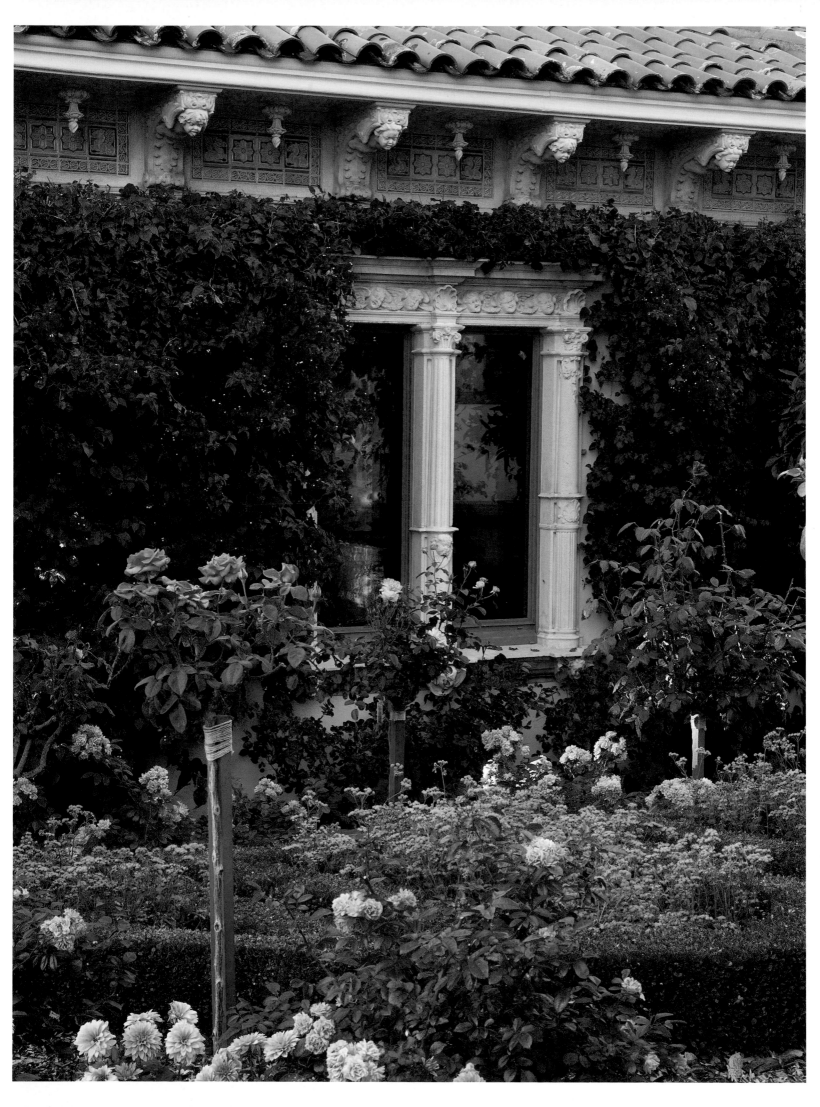

In June 1922 they began building Casa Grande. Palm trees were planted even during construction—a queen palm (*Syagrus romanzoffiana*) on the right and a Mexican fan palm (*Washingtonia robusta*) on the left.

Casa Grande was built in the shape of a T, accommodating the presence of mature oak trees on its north and south sides. This pre-1922 sketch by Hearst shows the floor plan largely as built, before the later addition of the wings onto the rear. At the front entrance, Hearst wrote, "Monastic effect." He noted the "Living room," then the "Dining Room Refectory," writing "Width and length dependent on trees." He sketched the oaks on either side of the dining room, noting "Trees." At the top right is his tiny sketch of the front facade: "Elevation. Don't laugh."

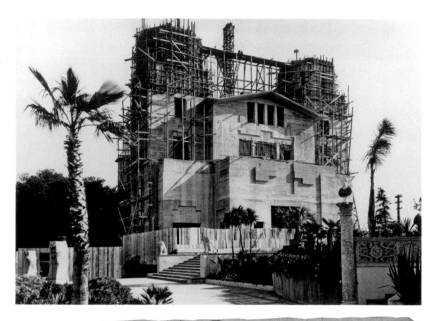

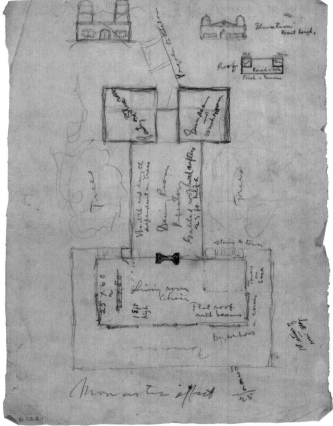

ment to satisfy Hearst, who was blind to his own role in slowing the construction with his continual changes. Hearst still wanted to hire a "representative on the ground" with the "right to hire and fire as occasion requires" in order to speed up the project.[8] Morgan rebelled. William Randolph Hearst Jr. recalled: "Underneath that impeccable attire and highly professional air was a steel-trap mind and a will of iron. . . . She and Pop had some real squawks, let me tell you, but both were so formal and low-keyed that an outsider would hardly have noticed. . . . Several times their views were so far apart that Julia quit, but Pop simply would not hear of it. They would come to some kind of compromise, and soon she would be drawing a new sketch. Julia was as totally committed to the project as my father."[9]

This was one of those disagreements. Morgan responded to Hearst's suggestion: "I do not now see just how the new scheme will work out. The buildings proper have always been a comparatively simple matter—it is the special work . . . that is difficult to handle. If it is not just right your Viollet-le-Duc eye is not satisfied, and to do the work with your approval (and mine, incidentally) requires artists' work and the handling of more or less temperamental people. If these people are chosen by some one else . . . there is every chance for friction and misunderstanding. . . . Please do not think I am not willing to fit in with your new plans or to resign, if you prefer, entirely. Thanking you always for the pleasure the work has been to me."[10] There was no more correspondence about hiring an overseer after this letter. Morgan remained the presiding authority on the hilltop.

Morgan and Hearst occasionally mentioned the French nineteenth-century architect Eugène Emmanuel Viollet-le-Duc in their letters. Viollet-le-Duc restored many monuments—including Mont Saint-Michel, Nôtre-Dame de Paris, and the medieval city of Carcassone—to a Gothic splendor beyond what they had possessed in their heyday. Hearst even referred to himself as "William Violet le Duc Hearst" in one missive to Morgan.[11] This romantic

and theatrical architect was a fitting patron saint for La Cuesta Encantada.

Their workload greatly increased after April 1922, when Hearst definitively decided to postpone construction on the English House and instead start on the main building (known as Casa Grande). He telegraphed Morgan late in April: "Have decided definitely to do big central house kindly start excavation and other preparations immediately."[12] Morgan had already determined that they should change the site of the main building, taking advantage of more room on the south side after an old oak had fallen. She had written to Hearst: "Before starting the kitchen wing, I had hoped you would see the site without the oak, lost this winter, and with the concrete pavement of the 'plaza' in, as you might think it advisable to move the main building back somewhat."[13] The main house was oriented to the western view and sited to accommodate the coast live oaks (*Quercus agrifolia*) on the north, south, and east sides of the hill. Hilding Kruslock, a carpenter who began work on the hilltop in 1920, recalled: "Before the Castle was constructed we had to build a temporary tower with steps and railings so Mr. Hearst could see the view 24 feet above the ground. He was anxious to see . . . what it would be like from that distance—from the 2nd floor level."[14]

In the mid-1920s, Hearst and Morgan's inspiration for the style of the hilltop gardens was still Spain, in keeping with their earlier decisions about the architectural style of the buildings. Hearst purchased photographs from the American architect Arthur Byne, who starting in 1922 also supplied Hearst with art objects, principally antique ceilings and fountains. Morgan wrote to Hearst in 1921: "I am sending you by this mail a 'Loan Collection'—the one of the Byne-Stapley garden photographs which arrived yesterday. The Sorella garden one might offer a suggestion for the finish at the foot of the 'A' terrace steps toward the Butterfly [a flower bed shaped in boxwood like a butterfly, and planted with bedding plants, located on the future site of the Neptune Pool]. Hazzard [*sic*] thinks pansies would

be about the only thing to make the Butterfly of. I have my fears regarding it, on account of the amount of sunshine that plot gets on a hot day. By outlining the creature in box [boxwood], the form at least would always be there, and could be refilled. It might possibly be that after the box edging grew sufficiently it would not be necessary to make the color of the flowers—just using rose bushes, etc. as in many of these Spanish examples."[15]

Morgan had known Arthur Byne's wife, Mildred Stapley Byne, since her school days and had purchased photo collections from the Bynes as early as 1914.[16] In 1921 Morgan wrote the Bynes, who had recently left their jobs as curators of the Hispanic Society of America and were new residents of Madrid: "We are building for [Mr. Hearst] a sort of village on a mountain-top overlooking the sea and ranges and ranges of mountains, miles from any railway, and housing incidentally, his collections as well as his family. Having different buildings allows the use of very varied treatments; as does the fact that all garden work is on steep hillsides, requiring endless steps and terracing. If you have any specially interesting garden plates, I would much like it if you would send me what you think would be helpful—say to the extent of $100 to $200."[17] Mildred Byne answered: "Your query concerning gardens is especially gratifying. Having collected a great amount of material on this subject it has been a great disappointment to us that no publisher considers it 'popular enough.' Under separate cover you will receive a number of photographs and a few tracings from sketch books, with color notes. The essential feature as you will see is the colored tile. The climate of the Eastern states does not permit its use, hence, perhaps, the lack of interest on the part of publishers. All tile accessories are made to-day in the same tradition as of old and if you decide on any we will go to the kilns and see that you get the right thing, provided of course you give us an outline of you[r] scheme."[18] Though in later years Hearst purchased antique curved terra-cotta roof tiles from the Bynes, he bought San Simeon's decorative tile in

California—principally from Gladding, McBean in Sacramento; Solon & Schemmel in San Jose; and California Faience in Berkeley.[19]

For ideas on Spanish tile design, Hearst and Morgan consulted *Spanish Maiolica*, a book featuring tiles from the Spanish Renaissance. Hearst wrote: "There are some fine tile designs in the little book—Spanish Maiolica. . . . I would like to get a luster as on some of our old samples. The escutcheons on 84 and 85 are fine. If we had one in the middle of each or one in each of the four corners of the panel they would give a lot of desired character. I like [figure] 87 very much indeed for C [House]. It has the Arabic quality."[20] They gave photographs to the tile craftsmen, who then created tile in the same spirit.

Hearst and Morgan consulted several titles on Spanish architecture, most notably Austin Whittlesey's *The Minor Ecclesiastical, Domestic, and Garden Architecture of Southern Spain*, published in 1917, with a foreword by the architect Bertram Grosvenor Goodhue, designer of the 1915 Panama-California Exposition in San Diego. Though the

Bynes' major books on Spanish gardens, *Majorcan Houses and Gardens* and *Spanish Gardens and Patios*, were not published by the Hispanic Society of America until later in the 1920s, Hearst and Morgan had the advantage of using their pre-publication photographs in the early years of planning La Cuesta Encantada's gardens.

America romanticized Spain in the nineteenth and early twentieth centuries, in large measure because of the work of Washington Irving, whose 1832 *The Alhambra* was the best known of many titles he wrote about the region. In his chapter titled "Spanish Romance," he wrote: "Spain, even at the present day, is a country apart, severed in history, habits, manners, and modes of thinking, from all the rest of Europe. It is a romantic country; but its romance has none of the sentimentality of modern European romance; it is chiefly derived from the brilliant regions of the East, and from the high-minded school of Saracenic chivalry."[21] Much of what was written about "Spain" as a whole was in truth referring specifically to the southern region of Andalusia and Seville. Mildred Stapley Byne pointed this out to Morgan in 1921: "Knowing, as we now do, the charm of the traditional Spanish house, we envy you architects of California your opportunity to create something fine in this line. We have promised to publish a series of Andalusian *cortijos*, or granges, for your benefit, Andalusia being that part of Spain that most resembles California; but the Spanish Romanesque, and Spanish Furniture [their current book projects], both under way, put the country house far off into the future."[22] In her recent analysis, *Vistas de España: American Views of Art and Life in Spain, 1860–1914*, M. Elizabeth Boone described the fantasized version of southern Spain prevalent in the period: "The city's climate is dry, its streets are narrow, and its whitewashed buildings shelter beautifully tiled courtyards cooled by trickling Moorish fountains."[23] This is the Spain Hearst wanted to evoke on his hilltop above San Simeon. Accordingly, they initially employed trickling fountains, unglazed terra-cotta paving tiles, wrought-iron grillework, and

This castle-themed riser tile is shown in the drawing below.

These tile designs, inspired by antique Spanish examples, were drawn in Morgan's office. The tiles were manufactured by California Faience and used to ornament the stair risers in the gardens.

Casa Grande's front facade faces west and takes the Spanish
Renaissance as its theme. The rear faces east and is Venetian in style,
as seen in this balcony for the Doges Suite, ornamented with carved
stone lions.

meandering pathways surrounding the cottages, in par-
ticular around Casa del Sol—House C—which was Moorish
in its inspiration.

Hearst especially favored citrus trees—for beauty and
use, and also for the Oriental, exotic mood they evoked.
Citrus trees were among the most numerous and promi-
nent features of the garden and invariably made an im-
pression on visitors from colder climes. Hearst and Mor-
gan planted them around the cottages, along the walkways,
and in an orchard below House C, which—as the house with
the Moorish architectural design—was the most Oriental
in mood. Hearst wrote to Morgan in February 1923: "In
planting our citrus fruits we have got to consider the feel-
ings, the predelections [sic], of these willful plants as well
as our own preferences. They must go where they will con-
sent to grow—if there is any such place. I don't want them
to cut off the views of the wall [near the northwest side of
the hill] but I would like to have somewhere they can be
seen from the houses as they are beautiful evergreens. Also

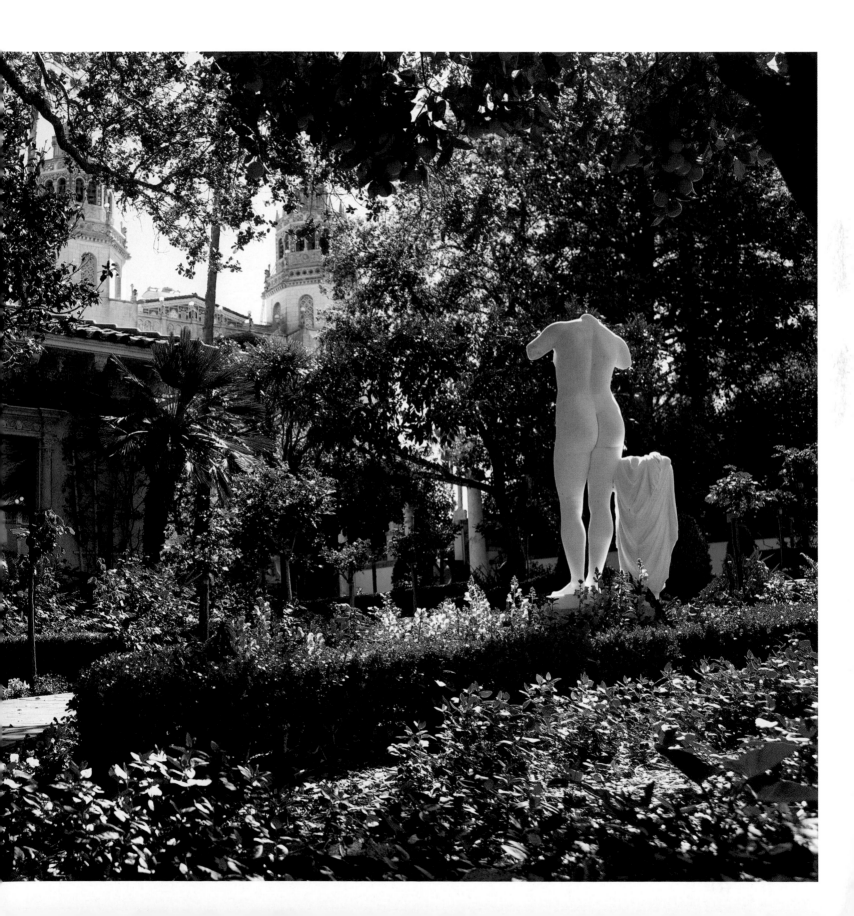

The three cottages defer to Casa Grande, like village buildings sur-
rounding a cathedral on the highest hill of a Mediterranean town.

as said above I would like some in our oriental courts and
gardens."[24] Morgan wrote Hearst about the citrus orchard
in April 1923: "The orange trees are nearly all in and look
very pretty. I do hope you will like the way the rows are
laid out."[25]

As the scale of the main building increased, Hearst
began to realize that the garden features, including plant-
ings and terraces, had to be enlarged as well to keep things
balanced. He wrote to Morgan in December 1923: "The
main building looms so large that the landscape architec-
ture should be built to scale with it. I advise making ap-
proaches, stair flights, walls, and general effects with [the]
big main building in mind. I think stairs on each side of
[the] temple [at the Neptune Pool area], also axis entranc-
es and approaches, also rear entrance, also effects seen
from distance, should be sufficiently monumental to tie in
the main central house motif. Is this all right?"[26] At this
time the garden consisted of planting around the three cot-
tages and the main building; fountains and small terraces
in the near vicinity of the buildings; two small terraces to
the north and south, known as the Well Terraces; and a plan
for a fountain feature at the site that became the Neptune
Pool. One of Morgan's solutions to bridge the change in
scale between the three cottages and the expanding main
building had been the creation of the "well terraces," ter-
raced areas near the cottages with Renaissance wellheads
as their focal features. She wrote to Hearst in March 1924:
"The repetition of these motifs, small in scale, all around
the Main Building would be a happy way to tie the small
house scale into that of the main building—which would
have at intervals its own scale repeated in the approaches,
entrances, and terrace fountain group [the central plaza
fountain of Galatea]."[27]

From the earliest days, Hearst wanted planting along
the road to the hilltop. In December 1922 Hearst noted
that the general plan was to "border the road with drought-
resisting, self-sustaining, summer-flowering shrubs, and
shrubs with winter berries of various kinds, but in definite

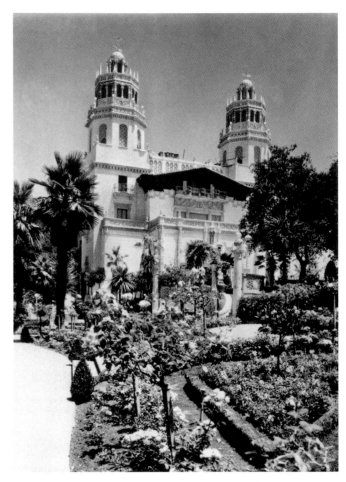

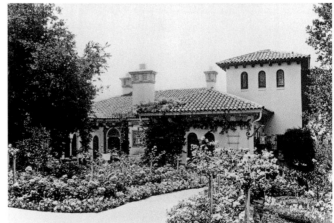

The upper part of the road to the hilltop is planted with fruit trees, like this persimmon. Conifers such as Canary Island pines (*Pinus canariensis*) were planted by the orchardist Nigel Keep.

Oranges, tangerines, limes, grapefruit, calamondins, and kumquats grew in the formal gardens. Citrus trees were among Hearst's favorites—fragrant, colorful, small enough not to obscure the views, and quintessentially Spanish. Their fruit was not picked. Nearby orchards provided produce for the table, so the bright fruit could remain on the garden trees year-round, a reminder of California's temperate climate and fertile abundance.

color schemes. I do not want to have to water or care for these shrubs beyond occasional pruning."[28] This scheme was used for the areas outside the wall that enclosed the hilltop buildings. Drought-resistant flowering shrubs were planted along the roads around Orchard Hill and China Hill, northwest of the hilltop buildings.

Beginning in 1922, Nigel Keep started planting the orchard areas. He explained the process: "One is apt to think of . . . San Simeon only in terms of structural and architectural creations and fabulous collections of rare art objects. The fact that it has also been the location of the introduction and planting of countless kinds of trees and other plants is much less well known. . . . Plant introduction . . . may be considered in three categories: (1) fruit trees of innumerable kinds, planted both as orchards and in an ornamental fashion in the vicinity of the famous Pergola, (2) the landscaping of the immediate environs of the Castle with ornamental gardens, and (3) groves and small forests of both conifers and broadleaf trees established at various places along the ridge and its spurs and slopes."[29] Among the tree varieties planted on Orchard Hill were apple, pear, plum, cherry, peach, nectarine, apricot, quince, avocado, fig, olive, walnut, and almond.[30] One of Keep's unusual gardening habits was to carry lizards in his shirt pockets on his morning rounds and then release one wherever he saw an insect infestation.[31]

Nigel Keep and Hearst worked together for decades, transforming the hills surrounding the buildings by planting groves, windbreaks, and orchards. Hearst wrote Morgan in 1922: "Will you please tell Mr. Keep that the important thing in the garden is to get flowers that bloom in the summer. We are seldom there in early spring or in the winter, but we are likely to be there from late spring to late fall. I have picked out a number of shrubs in the catalogue [from California Nursery, Niles] which seem to be attending to business at our time of year." He then discussed dozens of plants, including acacia. He mentioned two kinds of cotoneaster: "[C]otoneaster frigida from the Himalayas

opposite

Early on, Hearst and Morgan decided to prevent vehicle access to the cottages. Instead they created the Esplanade, the walking path that links the cottages and encircles the main building. Completed by 1925, the Esplanade provides an important unifying element. Hearst wrote that it "seems to give a finished touch to the big house, to frame it in, as it were." Its major portion is planted with a double row of distinctive Mexican fan palms (*Washingtonia robusta*), which from a distance appear to brush the towers due to their great height.

Hearst wanted pergolas to be an important garden feature. In this early elevation drawing of the main building, Morgan sketched pergolas or cloisters on both sides of the front facade. These were never built.

2.2.3.2.25

jeffreyi, radiata. I am coming to the sequoia last of all. I would like to buy a great number of the sequoia gigantea . . . and the sequoia sempervirens, and plant them in the big flat away below house A [*sic*] at the bottom of the hill. I think we could make a tremendous grove there of redwoods and big trees which in time would be a marvelous feature, perhaps the most attractive place in the neighborhood. It is desirable to get two hundred or three hundred trees of the sequoia in order to cover that flat. The other conifers for the bare hill can be ordered in smaller quantities—from twenty to fifty of each." He then concluded: "We must have plenty of bougainvillea. They are the most decorative of climbing plants and most suitable to the white walls of those Spanish houses. . . . That seems to wind up the proposition."[32]

The most successful circulation element on the hilltop was the Esplanade, the curved promenade connecting the three cottages and the main house, from which stairs and paths extend to provide access to the lower hilltop terraces and garden features. Hearst and Morgan discussed such a path as early as 1920, initially conceiving it as a pergola at the lower level of the cottages.[33] The difficulty of determining where automobiles should turn around in front of the cottage entrances prompted Hearst to write to Morgan in February 1921, suggesting, "[A] turn for automobiles on the right hand side of the main house just before the road enters the circle around the central plot. . . . [I]t seems to me rather desirable because we are making the road around the central plot more and more of a park and promenade and less of a road than we had originally intended, and the passage of any considerable number of automobiles around this path will certainly be a nuisance if not a menace. It ought to be possible for most of the automobiles which arrive to deliver their passengers and luggage . . . at the first turn . . . and then retreat without disturbing the inhabitants of the houses at all. Please try to work something out on those lines."[34] Hearst and Morgan were both very pleased with the Esplanade, which he

flowers well. . . . The cotoneaster pannosa from China is also interesting. . . . I am anxious to get a lot of eucalypti. . . . The pittosporum crassifolium is a shrub which is almost a tree and flowers attractively. It resists wind and grows well even on the Coast. . . . I think all these shrubs and trees should be bought in considerable quantities and planted freely all over the hills. The only thing to be careful about is not to plant trees where they will obscure the view when they are full grown. . . . Of course we can give these shrubs a start with water, but after that they must take care of themselves. Now in regard to the conifers—I have several I would like to suggest—the firs. . . . All these are good for the groves on the bare hill where the reservoir is. . . . The cypresses I am not so crazy about but the arizonica is probably worth planting. The incense cedar . . . I think is a good tree. The blue spruce are all wonderful—albacoerulea, excelsa pendula, smithiana, pungens kostriana are all fine. Then of the pines there are the hapepensis [halepensis],

The hilltop's main north-south axis was emphasized with two round terraces known as Earring Terraces, their curving marble benches resembling earrings. The North Earring Terrace frames the mountain view at sunset.

below
Located along the northern portion of the Esplanade, known as the Azalea Walk, this marble bench is supported by small copies of Michelangelo's Medici Tomb sculptures. It is draped with overhanging fuchsia.

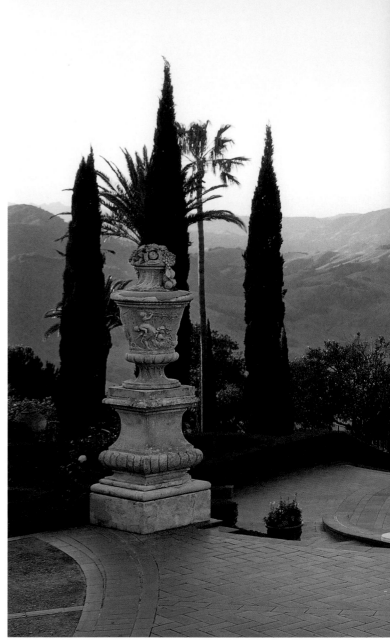

described: "It seems to give a finished touch to the big house, to frame it in, as it were."[35]

It was a tour de force of design work, the single greatest unifying feature on the hilltop, and Morgan seemed proud when she wrote to Hearst: "The lines and grades of the esplanade are finally established, and follow as nearly as possible your sketch on the blue print. It has been a real problem to get all around, miss all the roots and branches and not feel the fact that there are very considerable differences in grade. I have had real pleasure watching the vista open up—wish your architectural self could have had it."[36] Soon after, Hearst and Morgan planted a double row of mature Mexican fan palms (*Washingtonia robusta*) to outline the western portion of the Esplanade. These trees now stretch nearly one hundred feet above the walkway, their long slender trunks—clad in climbing roses—terminating nearly at the height of the Castle's bell towers. These starburstlike accents provide one of the hilltop's defining features, softening the hard lines of its architecture and providing a delightful sound when the wind rustles through their fronds.

Just before Morgan wrote Hearst about the Esplanade in June 1924, an article in the *New York Times* proclaimed that Hearst was working with the architect Addison Mizner to create another grand Spanish house: an estate in Florida "expected to be the most elaborate residence in Palm Beach. . . . Mrs. Hearst, according to reports, will sail for Europe early in the Spring, and will begin a quest for rare Spanish articles to be used in decorating the new home. It is reported that Alexander C. Moore, Ambassador to Spain, who recently spent several weeks here, has volunteered to aid Mrs. Hearst in her quest. Incidentally, it is said that Mrs. Hearst will be presented at the Spanish Court during her visit to the country."[37] Nothing came of this plan. It seems likely that it was an effort by Hearst and Millicent to create a San Simeon–like setting closer to the New York society in which Millicent played a part. It may have also been an effort to revive a marriage that had long been

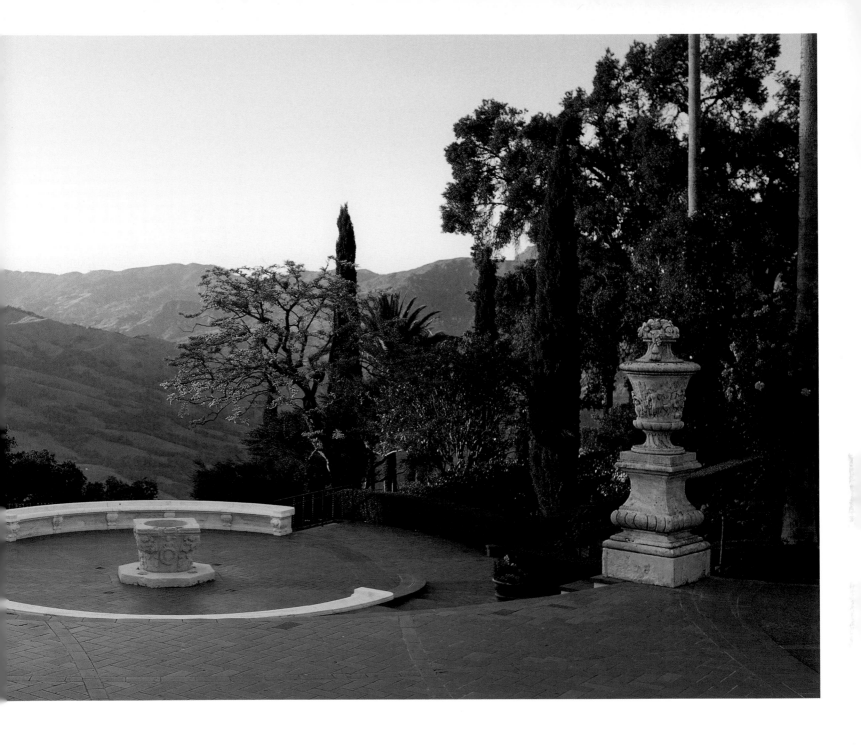

foundering. In any case, the Mizner house went unrealized and Hearst began to spend more of his time and energies at San Simeon, which he viewed increasingly as his major residence.

Creating a romantic Spanish-style country house in California was part of the goal. Creating a court of participants—over which Marion Davies could preside—was another part. After Hearst met Marion in 1915, he was never again the same. She was funny, generous, beautiful, and fragile—a wisecracking blonde with a tender heart. Their casual romance had turned by 1920 into a deep attachment. Hearst was married and she was not; she was thirty-four years his junior, with many admirers. Her biographer, Fred Lawrence Guiles, wrote: "By the 1920s when she was a star, her fame and her talents could have liberated her at any time, but she was much too emotionally involved [with him] to walk away. By then, Hearst was giving Marion his complete devotion. She was something that had become a part of him, like his castle complex, and everyone, including Millicent and his sons, had to accept this reality or face a sudden Hearstian storm that could be terrifying. If she had been less flirtatious and never got involved with other

men, she would not have been the Marion for whom Hearst would do everything short of dying. And if she had been a great beauty obsessed with her appearance, she would not have become Hearst's casual, vulnerable darling who dressed out of fashion, spoiled her nails with nicotine and over-drank."[38]

Though Hearst and Millicent never divorced, they separated in 1925. The separation was amicable, but they did not live together again. Charlie Chaplin, who remained friends with both women, wrote of Millicent: "She often talked confidentially with me about the relationship between Marion and W. R., but never with bitterness. 'He still acts as though nothing had ever happened between us and as if Marion doesn't exist,' she said. 'When I arrive [for a visit to La Cuesta Encantada] he is always sweet and charming, but never stays more than a few hours. And it's always the same routine: In the middle of dinner the butler hands him a note, then he excuses himself and leaves the table. When he returns, he sheepishly mentions that some urgent business matter needs his immediate attention in Los Angeles, and we all pretend to believe him. And of course we all know he returns to join Marion.'"[39]

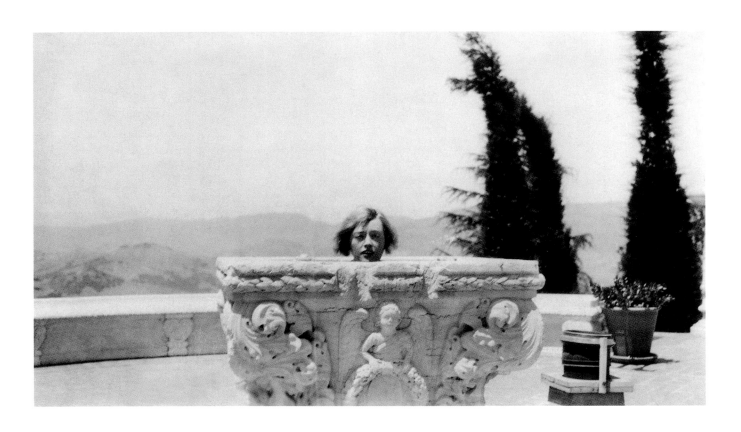

At La Cuesta Encantada, Hearst and Marion presided over a West Coast, unbuttoned version of "society," free-wheeling and based on achievement or celebrity rather than pedigree. He wrote a poem to her in 1920, one year into San Simeon's construction, when their relationship was still a carefully kept secret. Hearst described San Simeon as "the bungalow" and noted his frustrations with movie-making. He also wrote about the change in his life, in the years after World War I, from writing of war to writing of love—couching it all in the mythological metaphor of the marriage of Mars and Venus. He was fifty-seven and as ardent as any young lover:

> The Bungalow is on the bum,
> the studio is stupid.
>
> For life is slow unless there's some
> companionship with Cupid.
>
> Mars is all right to strive and fight
> and from our foes to screen us
> But there are times when thoughts and rhymes
> turn longingly to Venus.
>
> So while I write with much delight
> of armies and of navies
> The sweetest thing of which I sing
> The Muse to whom my soul I fling
> The idol to whose feet I cling
> is lovely MARION DAVIES.[40]

6

San Simeon's Construction Technology (1919–1947)

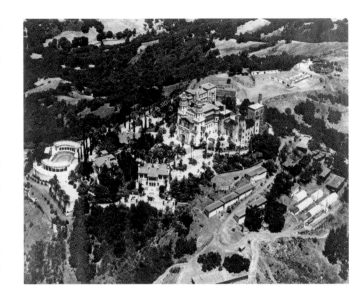

During twenty-eight years of construction at San Simeon, Julia Morgan oversaw countless technical details. The estate was a farm, a country house, an art museum, a garden, a communications center, an orchard, an airstrip, a cattle ranch, a port, a security compound, and a zoo. When the project began in 1919, electricity had not even been brought to the region. Considerable evidence survives to document the building process: more than one thousand letters and telegrams from Hearst and Morgan, supplemented by thousands more from their staffs. More than ten thousand construction drawings and hundreds of oral histories and published accounts augment this archive. Examining some of the material devoted to technology provides a better understanding of the difficulties Morgan faced as she presided over the efforts of as many as one hundred construction workers and dozens of household, ranch, and grounds employees.

Water made the estate possible. Three natural springs located at approximately three thousand feet in elevation on Pine Mountain to the east provided water for the hilltop complex, the ranch operations, and the town of San Simeon. Two of the three springs still supply the hilltop today. In the 1870s George Hearst had a pipeline constructed from the springs to the village below.[1] The town development he envisioned—served by that water supply—never occurred. But his arrangements allowed the hilltop construction to begin in 1919.

There was a continual shortage of water on the ranch. Hearst was certain in the early years that they could make do by routing the existing spring water supply over the hilltop, writing Morgan in May 1921: "We are to bring the water from the big spring, that now goes to the farmhouse, to the hill first and then to the farmhouse. We must do this by bringing a perfectly good line of four-inch pipe along the crest of the hills from the Marmalejo [Marmolejo] to some high point above the cattle trough just before that range of hills dips down into the valley."[2] This supply

This 1948 aerial view shows the hilltop's complexity. In the right foreground is the Hearst Camp, home to as many as one hundred laborers and artisans. Five greenhouses are also on the south side of the hill. At the top right, behind the garages, are dog runs for kennels that held as many as one hundred dogs. The circular building farther east housed a large number of the animal cages for the zoo.

opposite
The February 1925 survey of the hilltop by G. A. Tilton, Jr., is the only surviving hilltop plan that shows the structures and vegetation as they actually existed.

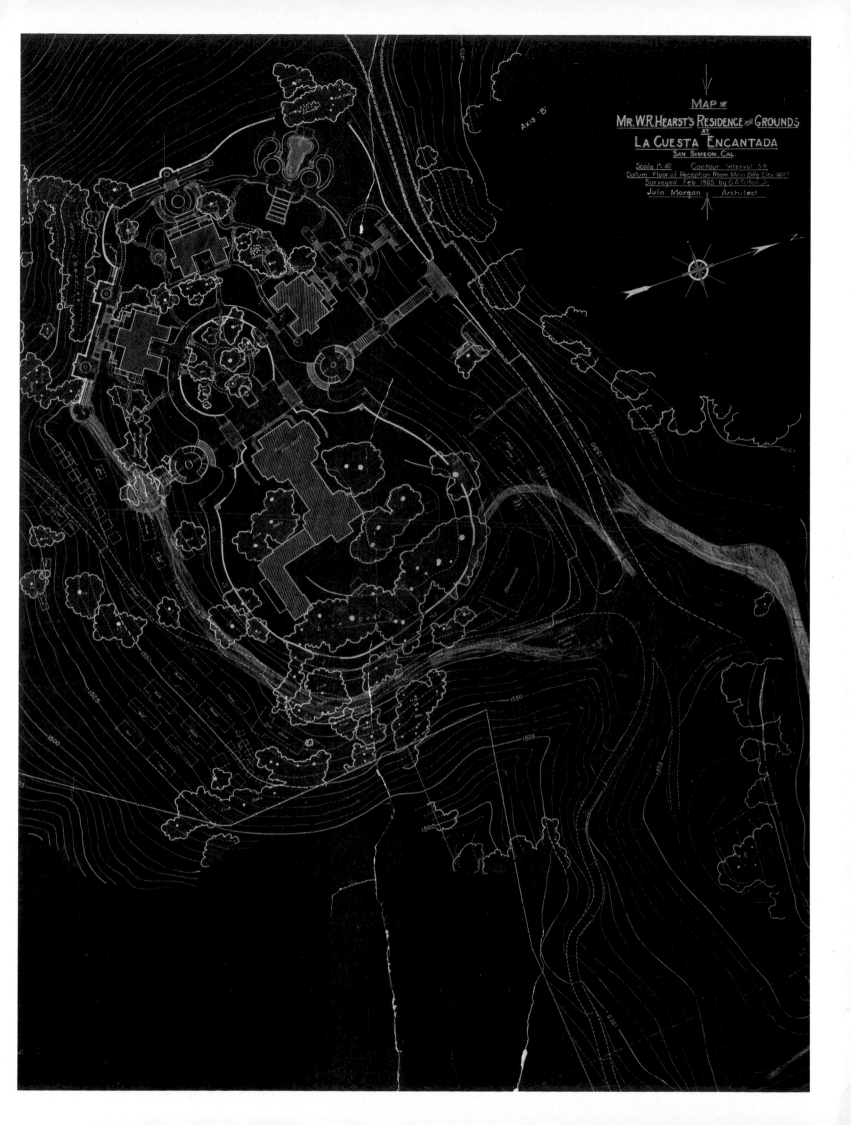

MAP OF
MR. W.R. HEARST'S RESIDENCE AND GROUNDS
AT
LA CUESTA ENCANTADA
SAN SIMEON, CAL.

Scale 1"=40' Contour Interval 5 ft.
Datum Floor of Reception Room Main Bldg Elev 1602?
Surveyed Feb. 1925 by G.A. Tilton Jr.
Jula Morgan Architect

Axis 'B'

A recent hilltop plan illustrates the coast live oaks that have grown on the site since 1951, the historic oaks that survive from Hearst's era, and the former locations of oaks that have perished.

The mold shop where many of the cast-stone elements were created was located east of the garages. This area is still used for workshops by the restoration staff. The rows of cast-stone objects take on a mysterious air when the fog rolls in.

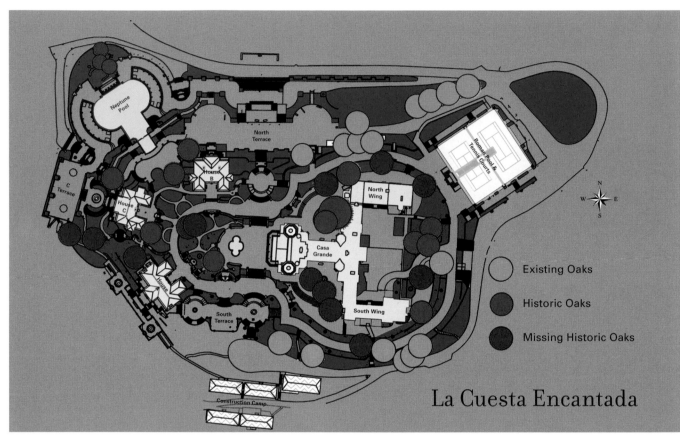

La Cuesta Encantada

Existing Oaks

Historic Oaks

Missing Historic Oaks

proved insufficient. Morgan wrote to Hearst the following month: "[A]fter the spring began to take on its summer flow, enough water has not been available to run the concrete mixer, take care of the planting and supply water for the kitchen, so a balance of the three has had to be maintained."[3]

In the early years of construction, water from Pine Mountain was piped by gravity to Reservoir B, located in a canyon below the hilltop, then to Reservoir A, located down the hill, just above the ranch buildings, where it was used for the ranch operation. Water for hilltop use was pumped from another spring, located on the adjacent "Old Spring Hill."[4] The original pipeline from the springs was made of redwood, spiral-bound with wire for strength. In 1922 they began building Reservoir C—a steel-reinforced concrete basin with a 100,000-gallon capacity—on a southern hill at 1,818 feet in elevation, now known as Reservoir Hill. While Hearst and Morgan intended to construct several reservoirs on this site as their water needs increased, in fact they only built one additional basin—with a 1.5-million-gallon capacity—in 1931. This large concrete reservoir was constructed on Reservoir Hill below the 1922-era Reservoir C, which became the settling tank for the larger reservoir.[5]

The spring water flows by gravity from Pine Mountain to the settling tank on Reservoir Hill, where any silt or sand falls to the bottom. It then runs through a weir to measure its flow and into the larger reservoir. There the water is divided into two parts, one flowing to the hilltop at 1,600 feet elevation and the other flowing to a lower reservoir at the ranch. Two 2,500-gallon water tanks made of monel metal (an amalgam of primarily nickel, copper, and manganese) sit in Casa Grande's bell towers, occupying the space between the bells and the tower bedrooms known as the Celestial Suite. The water flows from Reservoir Hill to these tanks. In Hearst's time they used tin-coated brass pipe; currently the operation uses eight-inch polyvinyl-chloride pipe. After it flows through a filter, the water is

dispersed by gravity throughout the hilltop. There are no pumps in the system.[6]

Hearst always wanted more impressive water effects at the ranch, for instance, writing to Morgan early in 1925: "I think since we are going to use the same water over and over we should have the water system on a very large scale providing plenty of fountains lakes pools cascades and every old thing."[7] The Roman Pool and the Neptune Pool are San Simeon's grandest water features, but Hearst and Morgan had planned an even more impressive one in conjunction with the water storage basins. Hearst proposed that they build "pools with a cascade between them . . . and we could have a handsome fountain in the first reservoir where the water comes out of the pipe from the springs."[8] They later expanded this idea into a scheme for five separate reservoirs—with a total capacity of 3.3 million gallons. Water from the four new basins was to cascade into the existing 1.5-million-gallon basin in the center, which was plumbed for an enormous fountain. An astronomical observatory was to be erected above the pools, and the whole composition was to be lit by floodlights. It would have been visible either from the hilltop gardens or from the newly built Highway 1 on the coastline.[9]

This dramatic water feature was never built. It would have upstaged the hilltop's two justifiably renowned swimming pools, both in drama and in scale. Hearst contemplated the idea for a decade, writing first to Morgan in 1925: "Shall we put the observatory on reservoir hill? Of course Reservoir hill is the ideal spot but rather hard to get to. Still it would give another point of interest, and a place to go to see. Then the water could be made a pleasant adjunct. What think? Sort of romantic isn't it! Reminds one of Washington Irving's 'Tales of the Alhambra.' The astrologer and the fair maiden."[10] Hearst and Morgan's practice of making ornamental features out of utilitarian necessities could have had no greater expression. But this 3-million-gallon fountain remains only a spectacular might-have-been—an indication of Hearst's grand, romantic intentions for La Cuesta Encantada.

The site of this proposed fountain is still visible. The settling tank (the original Reservoir C) sits atop Reservoir Hill today. The 1.5-million-gallon reservoir below it is hidden from view by a forest, made up primarily of Monterey pines (*Pinus radiata*) and Canary Island pines (*Pinus canariensis*) planted in the 1930s. Hearst's orchardman, Nigel Keep, recalled placing mature trees, rather than the typical one- to three-year-old stock that a forester would ordinarily use: "The 6,535 pines set out on Reservoir Hill were all in five gallon cans, and dynamite was detonated in each planting hole to assure penetration of the roots beyond the shallow soil."[11]

Initially the water supply provided the hilltop power as well, by means of a hydroelectric plant. A powerhouse with a 2,300-volt generator was built below Reservoir B, out of view of the buildings. A 120-horsepower gasoline engine was connected by direct drive to this generator, and a waterwheel with another 2,300-volt generator was built along the stream near the powerhouse. At midnight, when electricity needs dropped, the gasoline generator shut off and the waterwheel took over.[12] This power supply was insufficient for the hilltop, as Morgan wrote to Hearst in May 1921: "My own conclusion is that you will never have electricity enough from water power to take care of Las Estrellas' needs in a manner which will be satisfactory for you."[13]

In 1924, they brought in electric power from an outside source. Morgan wrote to Hearst: "[W]e have at last a proposition from the San Joaquin Light & Power Company that you pay the cost of the extension of the line on public property to San Simeon at cost—(a limit to this cost being $11,000)—and that they will return the entire sum at the rate of 20% of your total electric bill (ranch and Hill) per year until the entire $11,000 is returned to you."[14] The hilltop power lines were largely placed underground, while the utility poles nearby were positioned to ensure unobstructed views.[15] This additionally lessened the risk of fire from fallen lines during a storm or earthquake.

Detail of *Galatea* by the Italian sculptor Leopoldo Ansiglioni, c. 1883.

The Central Plaza, located in front of the west entrance to Casa Grande, was the first large plaza completed. Guests were driven to a south driveway entrance lower down the hill. They walked up three flights of steps to this terrace, often arriving at night when the statue of Galatea and the pool were lit.

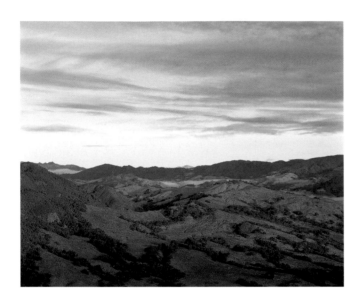

Night lighting was a part of their earliest plans, with Hearst writing to Morgan in 1920: "I have bought some more stuff at the last auction sale of the season. . . . I . . . bought twenty-six rather plain, iron and glass lanterns, but they are genuinely old and practical. . . . I thought we could use these on the court or entrance side of each house. . . . It might be a good thing to have a switch in the main building which could turn all of these on or off, so that when people leave the main building for their houses at night these lanterns could all be lighted by this switch and then turned out later when people are supposed to be in bed."[16] By the time of this letter, Hearst had already determined the houses' differing functions: The main building was the gathering place and the cottages were the residential areas. Night lighting was necessary for the guests to travel between these public and private spaces in the evening hours. Electrified alabaster globes on marble lamp standards were installed throughout the gardens in 1926 to augment the iron-and-glass lanterns.[17]

On the hilltop, nighttime illumination was not just practical but atmospheric and beautiful. It accentuated the fairy-tale quality of the estate—both up close and from afar. At night, the Castle's brightly lit towers punctuate

miles of surrounding darkness. Artist Ludwig Bemelmans understood the contrast, writing of his 1940s visit, "At a turn in the road I found myself close to the top of the hill, and there stood the castle. It was best described by a child who was brought up here late at night . . . and saw [it] lit up . . . [and] softly began to sing 'Happy birthday to you.'"[18]

Ensuring the estate's structural stability was even more important to Hearst and Morgan than obtaining sufficient water and power supplies. The vast majority of the estate—including the buildings, terraces, swimming pools, tennis courts, and Pergola—is constructed of steel-reinforced concrete. Walter Steilberg talked about the process of selecting the aggregate: "[We] had tests made of the stone which was quarried right on the site of the Castle, which had to be excavated, in any case. There was quite a chunk of this on the top of the hill to be cut out. We found that this softer stone gave us better concrete than the harder stone that we had proposed to take from more than a mile away at great labor."[19]

In the early years the concrete was mixed in mixers and transported in wheelbarrows to the forms for pouring. In 1922 Morgan reported to Hearst on their improvements to the technique: "Fine progress has been made in the last ten days and the basement walls [of the main building] have a good start. Mr. Rossi [the construction superintendent] had the ingenuity to move the mixer along the top of the walls and fill the forms directly from the mixer without the use of barrows or chutes, the small size of our mixer making this possible. It is saving much time."[20]

Adding to their challenges, the concrete was often demolished and poured again due to Hearst's habit of expanding finished areas of the hilltop. The Neptune Pool was rebuilt twice, leading to reports like this one from Morgan to Hearst in 1928: "This is just to say Mr. Rossi is following schedule, the plumbers and plasterers at work on interior of Neptune pavilion—which is cleared of the wood forms, Macklen's [Fred Macklin, head gardener from 1925 to 1928] men clearing off the space toward B Terrace, the

In 1922 Camille Rossi was brought from Morgan's San Francisco office to serve as the construction superintendent. He had a combative personality but was a skilled engineer. He remained on the job for ten years, overseeing most of the major hilltop construction, including the relocation of three immense coast live oaks.

The Mess Hall at Hearst Camp, the compound of sleeping quarters and common rooms for the resident craftsmen and laborers, was located on the south side of the hill just below the entrance driveway. Members of the household staff lived in the South Wing of Casa Grande.

curved concrete wall on this side of the pool nearly de-molished and considerable grading done. . . . The day was rainy with a regular winter wind, making work practically impossible outside. There is a very great deal to do before the torn up areas will be presentable—but I think real work has been done during the week."[21]

Morgan had extensive experience with reinforced concrete construction, dating back to the earliest years of her career. Though she did not engineer San Simeon per-sonally, she worked closely with the consulting engineer-ing firm Earl & Wright throughout the process. She was meticulous about the quality of the pour, writing to Hearst in 1923: "Work is progressing well,—the walls up to the sec-ond floor having been poured. It is necessary to wait until this concrete is set before pouring the great beams. The work is of fine quality. Mr. [Walter] Huber, our consulting engineer whom I took up with me last week, says it is as fine a piece of concrete work as he ever saw."[22]

Earthquakes have tested the hilltop's structural soundness on several occasions, once when Morgan herself was present. She wrote to Hearst in 1927: "While at supper Saturday at the tip end of the Refectory table, I felt seasick and looking up saw the silver lamps in the Patio Hall slowly swinging over a considerable arc. There was no jolt, but the quake on the previous morning everyone said was a real sharp and long tremor. The only damage noticeable was the cracking across of the unfinished semicircular basin below the Main Building, (balancing that below House B) and the opening of some old joints."[23] The strongest earth-quake recorded on the hilltop to date occurred at 11:16 A.M. on December 22, 2003. The San Simeon Quake had a 6.5 magnitude, its epicenter located about three miles north-east of the hilltop. Only minor structural damage resulted from this major temblor, a testament to the quality of the hilltop's steel-reinforced concrete.

Severe storms—caused by the site's elevation and ex-posure to Pacific winds—were a much more frequent chal-lenge than earthquakes. Morgan wired Hearst in Decem-

ber 1921: "Last reports houses standing perfectly but all men left working to save the palms."[24] Wind estimates for that particular storm were seventy-five to eighty miles an hour.[25] One tree did not survive, as Morgan wired Hearst: "Reports houses in good shape palms and planting little damaged but now the blow the big oak so carefully planned for on San Simeon side [of] dining tent went down irreparably."[26] Today there are more large oaks remaining on the north side of the hilltop, where the storms are less severe, than there are on the south side, with its ocean exposure.

Every winter brought weather-related difficulties. Morgan tried to explain this to Hearst in 1922, writing: "[Y]ou will have to expect three or four heavy wind and rain storms each year of real violence, storms that would not be felt so much at a lower level."[27] In 1927 Hearst witnessed a hilltop storm firsthand. He wrote to the construction superintendent Camille Rossi: "We are all leaving the hill. We are drowned, blown, and frozen out. The trouble is not merely with the weather. It is with the <u>houses</u>. In the various rooms of the small houses the weather strips wail like

a chorus of lost souls, the windows leak little rivers of running water and under the doors the cold draughts blow like thin hurricanes until the rugs flop on the floor. Everybody has a cold. . . . Before we build anything more let's make what we have built practical, comfortable and beautiful. If we can't do that we might as well change the names of the houses to pneumonia house, diphtheria house and influenza bungalow. The main house we can call the clinic."[28] Morgan wrote in response: "I enjoyed your description of 'A Night in House A,'—but am nevertheless very sorry." There was perhaps a hint of triumphant vindication in her closing line: "N.B. You always said you would like to see one of those famous storms on the Hill."[29]

Bad weather meant transportation challenges, since the construction material was brought by train to San Luis Obispo and driven by truck the last forty miles. Morgan wrote Hearst in February 1921: "This week I did get to The Top with the aid of a four mule road team part way"; and later that same month: "The road above Cambria . . . is almost impassable, but about a mile of new highway shows how

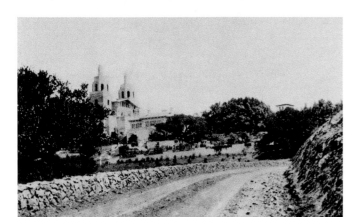

Morgan designed a concrete Mission Revival warehouse for the town of San Simeon in 1930. By then the Mission Revival had been largely eclipsed by the more ornamental Spanish Colonial Revival style. Hearst and Morgan employed the simpler Mission Revival style for all the outlying buildings they constructed during the 1930s, perhaps to make evident the supporting role these ranch structures played to the more decorated hilltop buildings.

The road to the hilltop was unpaved until the 1960s. This view shows Casa Grande's first towers, circa 1925. Hearst decided these towers looked too low when wings were added to the south and north of the building in 1927, and the towers were heightened as a result.

delightful the trip will be someday."[30] Prior to the completion of Highway 1 in the 1930s, the rutted roads could be harrowing, as Morgan implied when she wrote Hearst: "If you would like to break every bone in your worst enemy's body treat him to the trip between Cayucos to Cambria"—the two oceanside villages located south of San Simeon.[31]

Construction material was also shipped in by coastal steamer to San Simeon Bay. "The *San Antonio* brought in supplies regularly to the San Simeon pier," Hazel Eubanks, the schoolmistress of San Simeon, recalled. "It whistled when it was ready to dock, and that was the signal for Mr. Eubanks [her husband, the electrician Marks Eubanks] to go to the pier with a truck and help them unload the boat."[32]

Material was then transported nearly six miles up the road, one of La Cuesta Encantada's best-designed features. It winds through pastures and around oaks, as vistas of the hilltop buildings disappear and reappear at each wide turn. According to Nathan Tebbetts, who worked as a driver and road builder on the ranch beginning in 1914, the road was largely Hearst's own creation. Tebbetts recalled riding on horseback alongside Hearst, with his saddlebags full of stakes so he could place them at Hearst's direction. A few days later the road contractor came up to make an estimate on the job. Tebbetts recalled: "He asked me who had driven the stakes and marked the road. I advised him of my horseback ride with Mr. Hearst. He said he had never seen anything like it, as he had followed the stakes all the way down the mountain except for one place, where because of the elevation he had to change a few hundred yards to build a bridge over what was known as 'the water trough,' halfway down the mountain." Otherwise the road was built as Hearst had laid it out.[33] From the earliest days the road was one-way in certain areas to avoid collisions. William Reich, grandson to Nigel Keep, recalled the trucks traveling between eight and fifteen miles an hour, rumbling up and down all day long. "Sketchy brakes. And horrendous ruts in the road."[34]

Three children—Patience, Richard, and Johnny Abbe,

the child-celebrity offspring of photographer James Edward Abbe—described the road on their mid-1930s visit: "Mr. Hearst is no sissy, because he has a real ranch road. Dirt. . . . When we arrived we went through a gate and a man said, 'Mr. and Mrs. Abbe and three children,' so he let us pass. . . . We saw a sign painted in red, *Dangerous to pedestrians. Wild animals.* . . . Soon we saw some wild animals' eyes staring at us as we went along. . . . It was very dark, . . . [b]ut we kept seeing these shining eyes, and so we decided positively that this man we were going to see was positively no sissy."[35]

Day or night, everyone driving on the road shared it with the exotic grazing animals of Hearst's zoo. The fence surrounding the two-thousand-acre animal compound was made of heavy wire mesh, eight feet high and buried eighteen inches underground, so predators could not dig underneath. Several trip gates were set into the road to ensure the animals stayed in their respective compounds. Cars ran over one long piece of pipe to open the gate and another one to close it.[36] Ludwig Bemelmans wrote of driving up the road, activating the trip gates along the way: "There were wandering herds of zebra, of yaks, of water buffalo, springbok, and deer of every description in a landscape that must be as big as a county. The animals were used to cars, and as I went on, the heads of a dozen bison appeared a few feet from the windshield. It is strangely simple, like turning the pages of a children's book. . . . This simplicity is part of the whole establishment and comes at you again and again."[37] The incongruity of wild animals on a California cattle ranch was perhaps best described by British humorist P. G. Wodehouse: "No drinks are allowed after dinner, which must come as a nasty blow to many, though perhaps they might have refused them anyway after seeing that yak in the road. A man has to be a pretty tough toper not to knock off after the shock of finding yaks among those present."[38]

While the guests relaxed, Hearst ran his media empire, particularly after the hilltop telephone system was

opposite

Hearst oversaw the siting of the hilltop roads, riding with an assistant who placed stakes according to his direction. One of the glories of the estate is the way the buildings disappear and reappear as the road makes its way five miles up from the coast.

To avoid collisions, the road is divided into two one-way portions in several places, including the landscaped area around the Pergola, which features rock walls expertly made by hilltop workers.

Hearst wanted color in the gardens year-round and recommended the outer areas and roadsides be planted with Firethorn (*Pyracantha*) and other colorful, drought-resistant shrubs. In the background is an original employee barracks from the Hearst Camp.

installed in 1927. Prior to that, Hearst did not spend long intervals at the ranch. Telephone lines had been brought to the senator's house below in the 1890s. In October 1926 Hearst wrote Morgan, instructing her to "wire all houses as we agreed for telephones."[39] He explained: "In Summer the telephone system is not so important—we can run out and 'holler' or hunt for people; but in the Winter, especially if it is storming, it is very desirable to have a telephone system."[40] The Castle grounds and hilltop used eighty telephones, run by a PBX switchboard. Guests summoned servants from these phones, since there was no separate bell or button system for calling staff. There were an additional thirty-six magneto phones—operated by hand crank—that were used between San Simeon and the ranch. The cattle camps in the backcountry also had telephone service, via a wire that ran to the old dairy and out through the hills.[41]

Temporary telephones were available on the long trail rides. Byron Hanchett, a hilltop electrician from 1946 to 1958, remembered spending two days installing a phone in the backcountry. By that time, the eighty-three-year-old Hearst was riding in a car rather than on horseback. "He would call about a week ahead and tell us where he wanted a phone installed," Hanchett recalled. "We hung the phone under the shade of a tree, so the overhanging branches would protect it from the sun and weather. After hanging the phone, Marks [electrician Marks Eubanks] put mothballs in the battery compartment and indicated, 'This keeps the wasps and yellowjackets from building nests.' . . . There is a story told that on one picnic, while the guests were sitting in the shade, one of them commented, 'I wonder how the Dodgers are doing today.' Mr. Hearst got up and said, 'I'll go find out.' He walked into a grove of trees to the phone and called one of his newspapers. He came back to his guests, gave them the score, the inning, and told them who had hit home runs."[42]

Hearst had a particular interest in aviation and proposed as early as October 1927 (only five months after Charles Lindbergh's transatlantic flight) that they build a

In addition to a screened aviary near the tennis courts for birds of prey, many birdhouses were built to shelter the native birds.

Many species of grazing animals were spread over two thousand fenced-in acres, through which the road wound to the hilltop. Morgan designed log shelters to both protect the animals and keep them in view of the guests.

combination "flying field" and polo field at the bottom of the hill.[43] Hearst's newspapers sponsored an around-the-world flight of the Graf Zeppelin in 1929, with journalist Carl H. von Wiegand writing daily dispatches from the dirigible for Hearst's readers.[44] The first landing field was little more than a graded pasture located west of the road to the ranch headquarters.[45] Hearst wrote: "I think the field should be rather large, to be amply big enough for flying."[46] In 1932, a new runway was built a mile to the east, where the Hearst Monument Visitor Center is today. It was L-shaped, with the hangar nestled at the angle of the L.[47]

Morgan was also interested in aviation, as Walter Steilberg recalled: "She was flying long before any other people were flying." Morgan asked a stunt pilot to "take her up for an hour or so, to see what it was like."[48] She wrote to Hearst in 1930 about flying with Hearst's oldest son, George, from Hillsborough to the Hearst ranch at Jolon, then to San Simeon: "[A]fter getting that long coveted airplane picture first hand around the Hill top, [we] landed in your San Simeon airport just 23 minutes later. It seems incredible! The plane passed directly over the Red Butte, and circled over the new chicken layout which looked very neat and trim. After putting in an intensive afternoon on the Hill, the 'taxi' dropped me at the San Francisco field at 8:15 P.M. It made a full day—I am not quite sure as to the wisdom of repeating it—but it was well worth while this once."[49] Morgan knew the limitations of their first airstrip, which was dangerously close to a row of utility poles. She wrote after another flight with George Hearst as her pilot: "Mr. George Hearst's objection to the high tension poles is that it is necessary to begin to fall to the landing field only after passing them and that it shortens an already too short field by that amount. I've gritted my teeth several times thinking we would crash through the fence, so I know it is fact."[50]

The greatest tragedy to ever strike San Simeon was a plane crash on the airstrip on February 24, 1938. Lord and Lady Plunket and the Hearst pilot Tex Phillips all died at

the scene. Phillips had been transporting the Plunkets and the only survivor, the bobsled champion James Lawrence, from Santa Barbara. As the substitute pilot, he was inexperienced and did not discourage the Plunkets from flying, even though they were late arriving in Santa Barbara and the coastal fog was already setting in. When he tried to land at San Simeon in spite of the fog, he changed his mind at the last second and pulled up too quickly. There was a fiery crash. This terrible event affected Hearst and Marion deeply. Soon after, Hearst gave up airplanes for a time.[51]

After World War II, Hearst bought a much larger plane—a Douglas DC-3C with a large entrance door, modified from a cargo door. Hearst said, "This is the only plane I have ever entered without having to remove my hat." A paved landing strip eight-tenths of a mile in length was built in 1946 for two hundred thousand dollars. It was equipped with forty-eight surface lights for night landing and a new hangar with radio capabilities.[52]

Fire was a bigger concern on the hilltop than air disasters. The worst major fire in the area had occurred in 1889, when Cambria, located six miles south, ignited and the entire business district burned to the ground in late summer after a very dry season.[53] In Hearst's time, San Simeon experienced only one major fire, in August 1930. It burned the outlying areas only, doing no structural damage to the buildings. Zookeeper Carey Baldwin wrote: "One day, when everything was unusually dry, the temperature rose to 108 degrees, and a stiff, harsh wind sprang up from the East. Everyone was alert for fire. It was prohibited to smoke in the fields, and cars could not be driven across the dry-grass areas. In spite of all our precautions, this day it happened!"[54] A spark escaped through the wire-mesh grating of the trash incinerator, triggering an aggressive grass fire that spread along the southern outlying areas below the buildings. While construction workers rushed to cut a firebreak, zoo staff slashed open the fences to give the animals a means of escape. Most did not flee, feeling more comfortable in their enclosures. Baldwin wrote: "The water buffa-

los didn't seem to think there was much to worry about. It was a hot day, so they dug their mud hole a little deeper with their great horns, half buried themselves in the water and mud, and contentedly awaited the cooler evening. . . . In a few hours the flames had enveloped several thousand acres of land that had been covered with beautiful little forests of oak, laurel, and underbrush as well as hundreds of acres of grass land. . . . The transformation was hard to believe. Old landscapes did not look familiar. Even the air was stuffy and filled with strange odors. Odd as it may seem, only a few animals were injured severely. . . . it is fairly certain that no animal was killed outright by the fire."[55]

Hearst was in Bad Nauheim, a spa town in Bavaria, when he received the news. Wyntoon—designed by Maybeck for Phoebe Apperson Hearst in 1899—had burned to the ground only eight months before. He and Morgan were involved in constructing its replacement, a Bavarian village of houses, their exteriors painted with Brothers Grimm fairy tales. On learning of San Simeon's fire, Hearst's first concern was for the trees, as he telegraphed Morgan: "Think fire very serious would rather have build-

Native to the mountainous region between India and Tibet, a Himalayan tahr goat wanders the Santa Lucia Coastal Range today, a descendant of the grazing ungulates in Hearst's zoo.

Squeaky, a Malayan tapir, acted wisely during a 1930 brush fire on the lower part of the hilltop. The zookeepers quickly opened the pens to allow the animals to escape. When the fire was extinguished, no one could find Squeaky. She was eventually discovered in the Neptune Pool, where she had spent the afternoon swimming, safe from the flames.

Barbary sheep, also known as aoudads, make up the largest exotic animal population surviving on the Hearst ranch today. Native to Northern Africa, they have tawny coats that blend into the hilltop's summer grasslands.

ing burn than trees please arrange [to] replant all trees with small live oaks these will take long time to grow but sooner planted sooner will be grown."[56] Hearst and Morgan were able to see firsthand the hardiness of the venerable oaks. Morgan reported: "This is a less gloomy letter—I went down through the burnt area with Mr. McClenahan, the oak tree man, yesterday and found the fine oaks, even where a mass of scorched foliage, were putting out finger long new leaf shoots with vigor."[57]

They continued to improve their firefighting capabilities through the years. A 1945 Dodge firetruck with a 350-gallon water capacity was purchased and housed in the garage on the east side of the hilltop. A fire-alarm system with seven stations was installed in 1947 across the hilltop, and lightning rods were placed atop Casa Grande's towers. There was also a fire-alarm horn on the roof between the towers. The buildings, grounds, and town of San Simeon were all rewired in 1947.[58]

Sometimes Morgan's difficulties in presiding over so many technical construction processes involved actual physical endurance. George Loorz, the construction superintendent from 1932 to 1937, related such an incident to his wife, Grace. Among many other duties, he was responsible for building an all-weather road stretching more than twenty miles through the backcountry of the northern part of the Hearst ranch to the Milpitas Hacienda, the Mission Revival–style lodge Hearst and Morgan built in 1930. After a long day there, Loorz and Morgan got stranded on the way back when the car broke down. Morgan was sixty-five, beset with inner ear difficulties that robbed her of her equilibrium. In order to walk without losing her balance, she frequently needed to hold onto someone for support. Loorz recounted: "I met Miss Morgan as per schedule at noon yesterday in King City [to make preparations for Hearst's imminent arrival at the Hacienda]. . . . Well, we left there about 5 o'clock and headed back [to the hilltop] thru the Burnett Road. All went well until we got half way between the two dams and the rear end went out. It was nearly seven

o'clock then and I wanted to walk on in and send a car back for her but nothing doing. She said she was a good walker and if I'd let her put her finger in my rear pocket she'd like to walk as far as she could anyway. I agreed when she promised she'd let me know when she got too tired. As would be expected with her, she walked straight into camp [La Cuesta Encantada] with me. We arrived about 8 o'clock. We walked all that distance in about 1 hour and a half."[59]

Many observers praised Morgan's creativity, determination, and stamina. Presiding over the building of San Simeon's estate village, ranch structures, and grand country house called incessantly on all those skills. But she also possessed impressive technical expertise in a remarkably wide number of areas. Fred Stolte, Loorz's business partner, wrote him about Morgan in 1933: "She is so *little*. But 'boy' how she can see—and remember."[60]

127

7

Scaling Up: Formal Italian Style (1926–1937)

The unofficial "grand opening" party for La Cuesta Encantada may have come late in May 1926. Hearst entertained a large group of Hollywood guests for the weekend, likely with Marion Davies presiding as hostess for the first time. He had found his audience. Hearst shared his estate with newsmakers of all stripes, but his true constituency was the Hollywood crowd: people who imitated the opulent lifestyle of the upper classes but rejected their old-money social hierarchies. Hearst felt at home among these social outsiders, far from the drawing rooms and polo grounds of the East Coast elites. Marion Davies brought Hearst into that world—not the other way around. Her wit, insouciance, and sparkle gave him entrée to this more carefree society and kept him entranced for decades. Hearst was happy at the outcome of this weekend visit, one that presaged so many to follow. He had picked the right kind of uncritical, naïve, and emotionally sensitive people to invite to his estate. The tone of his letter to Morgan after the weekend differed greatly from his "We have got to establish a better system, Miss Morgan" letters of previous years.[1]

He wrote Morgan in longhand, perhaps on the train after leaving San Simeon. While he was pleased at some levels with the progress of the gardens, he was disappointed with certain effects: "The gardener [head gardener Fred Macklin, hired in 1925 to replace Albert Webb] has allowed the lantana to be almost completely obliterated by the ivy geranium in the plaza along the esplanade[.] Consequently the color scheme is destroyed. Can you please get him to maintain that color scheme[.] Furthermore I asked him to thin out the Heliotrope on B house and he has removed it entirely[.] He makes me cry! I loved that wonderful Heliotrope and it was as much a feature of B as the Bourganvilla [bougainvillea] is of C. Can we get the Heliotrope back?" Morgan had been present during the weekend, as Hearst indicated later in the same letter: "All those wild movie people prevented me from talking to you as much as I wanted to. Next time I shall go up alone and we can discuss

Madeleine Fessard, *Girl with Parrot*, French, c. 1929. White marble, 52 x 65 x 23 in. (132.1 x 165.1 x 58.4 cm). Hearst Monument Collection, against north side of House C. This piece is one of several Hearst owned that was created by a female sculptor. The surrounding star jasmine (*Trachelospermum jasminoides*) is a typical example of how landscape effects were used to enhance the garden sculpture.

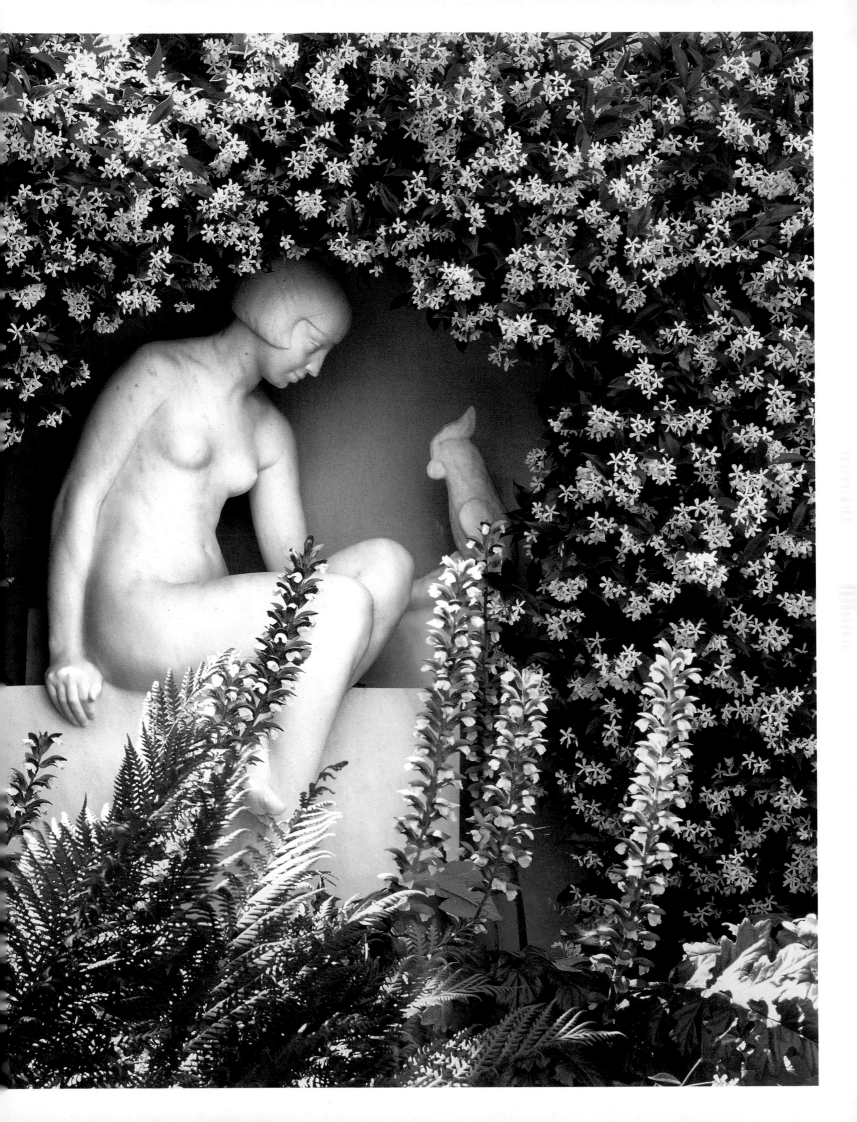

everything. Nevertheless the movie folk were immensely appreciative. They said it was the most wonderful place in the world and that the most extravagant dream of a moving picture set fell far short of this reality. They all wanted to make a picture there but they are NOT going to be allowed to do it."[2]

Morgan's reply was immediate and sympathetic: "Am sorry you had cause to weep. The gardener is very literal and very anxious to do as you want. When I discovered the heliotrope disaster, he explained that you had said to keep heliotrope to borders only so he was taking it out everywhere else! I had him put right back in small hardy plants that by fall should be quite perceptable [sic]. Will see to the thinning out of the pink geranium." Then Morgan revealed her excitement at watching the estate in use: "I liked and enjoyed very much the movey [sic] people. They are artists, and alive. It was a pleasure also to see the way those who did not go swimming went around absorbedly taking in detail.—To tell the truth, I was quite thrilled myself. . . . There are many details to go over, that do not seem fair to bring up when people all want you. It was a beautiful party."[3]

The gardens were paramount to the success of the estate. Hearst remained unsatisfied with Macklin, writing Morgan: "I am sort of discouraged about the gard[e]ner. First he makes a jungle of the garden. Everything is too thick and ranck [sic]. Second there isnt [sic] any order to the garden—not any apparent plan. Third there is no color scheme and no apparent feeling for color effects. Finally the flowers are everywhere beaten down by too much watering. The gard[e]ner waters them as if he were putting out a fire. I think it may be possible to retain this gard[e]ner on the place if we could get a tasteful gard[e]ner to come down once a month and give him a layout."[4]

This letter prompted them to employ a consultant whose influence shaped the hilltop's gardens thenceforward: Isabella Worn. With her sister Anne Perry, she had opened a floral decorating business, specializing in parties and weddings, in San Francisco at the turn of the century. Most significantly, Worn also worked as a horticulturalist for major estates on the San Francisco Peninsula, collaborating with Bruce Porter on the elaborate Italianate garden at New Place in Hillsborough for William Crocker in 1905 and on Filoli in Woodside for William Bowers Bourn II in 1915–1917.[5] Though she did not have formal garden training, she had natural ability and an artist's sense of color. The sixteen acres of gardens at Filoli are certainly equivalent to the gardens at La Cuesta Encantada in grandeur and scale, though their inspiration is Irish rather than Mediterranean. Isabella Worn was described by Lilian Roth, the second owner of Filoli: "She always gave you that feeling . . . when she suggested planting something. . . . She didn't plant it just because it was the proper thing to go in that place. She would be sure you liked it first. So it gave you a wonderful feeling of possession. . . . She lived across the Bay, came in an old hat, [had] the sweetest, dearest face. Everybody loved Miss Worn. But she in some ways was hard to get along with because she was very opinionated and wanted to do things her way. But as her way was always perfect, I didn't find anything to argue about and so we were great friends."[6]

Hearst and Worn became great friends, too. He referred to her as his "consulting floral engineer," and during her twelve years of involvement with the hilltop (1926–1938) he worried that she did not visit frequently enough.[7] He telegraphed Morgan in 1928: "[H]ad fine flower fest with Miss Worn its much more satisfactory when she stays longer because she gets more good ideas and they surely are good too."[8] Even with Worn's assistance, the problem of the lost geranium and lantana borders continued. Hearst wrote to Morgan in 1927: "Mrs. Hearst when she arrived felt the same way that I did about the pink geranium and lantana borders. They have all gone to pieces, and they were under Webb [head gardener Albert Webb, who had departed in 1925] so beautiful as always to excite comment from visitors. Putting in the red geraniums is,

I think, a mistake. The color scheme is no longer attractive. The pink geraniums were sufficiently vigorous under Webb, and the climate cannot have changed greatly since he left. I would like to get a little more neatness in the garden without having rigidity. You notice how beautiful some of the English gardens are. The garden is now getting so big that it must have a sort of harmonious scheme."[9]

The motivation to scale up the garden effects came soon after Hearst and Morgan's hiring of Isabella Worn in 1926. That same week, Hearst paid a call on Henry E. Huntington at his San Marino ranch.[10] Huntington had visited the ranch of James de Barth Shorb, known as San Marino, in 1892, and he had admired its views and siting. In 1903 Henry Huntington—the railroad magnate and nephew of Collis P. Huntington—bought the property and hired William Hertrich, who was working on the ranch at the time, as his supervising gardener. Together they created one of the finest gardens in America.[11] He also hired the architect Myron Hunt to build a grandly formal Italianate house (now part of the art gallery of the Huntington Library, Art Collections, and Botanical Gardens), completed in 1911. Huntington built his estate at San Marino in part to woo the newly widowed Arabella Huntington and to lure her away from her cosmopolitan life in New York and Paris and out to his California home. Henry had known Arabella for many years by 1903. She was a celebrated beauty and Collis P. Huntington's second wife. Collis died in 1900, and by 1913 Henry had convinced Arabella to marry him.[12]

San Marino's gardens represented residential grounds on a scale Hearst had not experienced. Arabella grew attached to them and died there in 1924. Huntington remained on site until his death in 1927, supervising its grand garden effects. There was a celebrated rose garden with a formal rose pergola, a palm garden, a large desert garden, and a Japanese garden. Fully grown trees were transported to the site—some of them standing fifty feet high and weighing ten to twenty tons each.[13]

Hearst's wealth peaked in the mid-1920s. His

One of Hearst's favorite planting combinations was this blend of purple trailing lantana (*Lantana montevidensis*) with pink ivy geranium (*Pelargonium peltatum*), in place along the Esplanade since the 1920s.

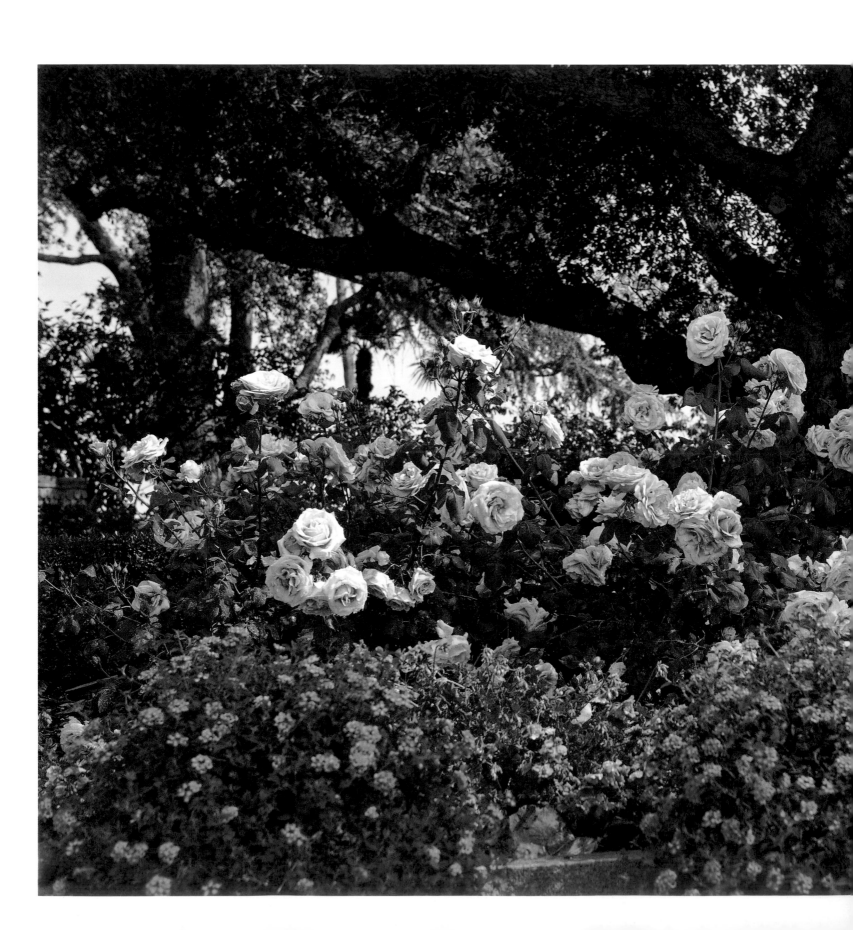

Hearst and Morgan planted magenta bougainvillea in the courtyard of House C to match the magenta glazes in the building's cornice tiles.

After viewing Henry Huntington's stately gardens in San Marino, California, Hearst decided that the hilltop needed wider terraces bordered with balustrades. The Neptune Terrace, built in 1928 above the dressing rooms for the Neptune Pool, was created as a part of this expansion.

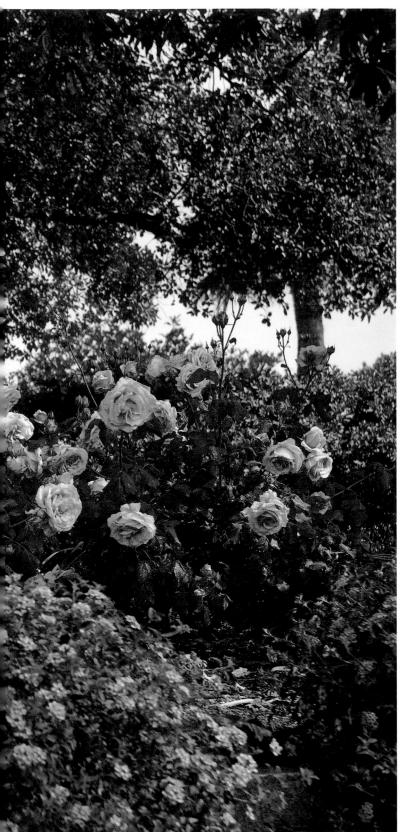

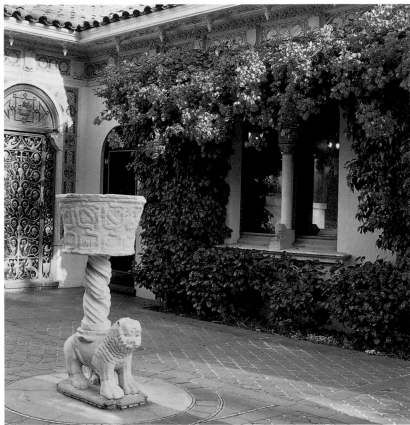

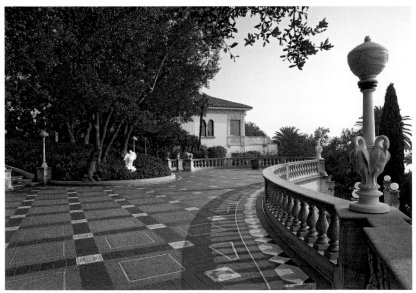

133

In 1927 Hearst purchased a residence in Sands Point, Long Island, for his wife, Millicent. Formerly owned by Alva Vanderbilt Belmont, it was called Beacon Towers, but Millicent rechristened it St. Joan's.

Nearly all of Hearst's major residences were built beside bodies of water, including St. Donat's, which overlooks the Bristol Channel. Here the Tudor gardens and rose garden end at the 150-foot-long swimming pool, which Julia Morgan assisted Sir Charles Allom in designing.

bottom
In 1926 Hearst bought three separate beachfront houses at 415 Ocean Front (now known as the Pacific Coast Highway) in Santa Monica. He hired architect William Flannery to remodel them into the Beach House, Marion Davies's Southern California residence.

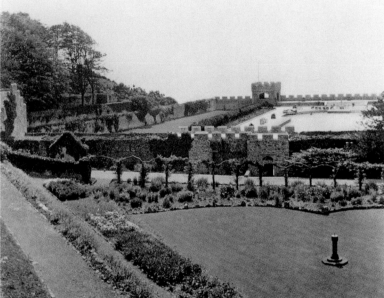

newspapers were flourishing, and his magazine holdings kept expanding (including his acquisitions of *Connoisseur* in 1925 and *Town & Country* in 1927). In 1925 Hearst purchased St. Donat's, a medieval castle in Glamorgan, South Wales, after having seen it advertised for sale in *Country Life*.[14] In 1926 he bought three houses along the ocean in Santa Monica and began to remodel them (under the direction of the architect William Flannery) as the Beach House, which became Marion Davies's chief Southern California residence. In what was likely not a coincidence, the following year he purchased Beacon Towers, the former home of Alva Vanderbilt Belmont, in Sands Point, on the north shore of Long Island, as a residence for Millicent Hearst, who rechristened it St. Joan's.[15]

All these factors—Hearst's growing wealth, his increasingly open relationship with Marion Davies and her Hollywood friends, his hiring of Isabella Worn, and his dawning knowledge of the potential of a California garden, as demonstrated by San Marino—likely influenced his decision to expand San Simeon on a grand scale. He wrote to Morgan in August 1926: "In comparing our place here with the Italian villas I find that the main advantage the Italian villas have over us are [*sic*] in the matter of wide terraces. Our walks and terraces are generally narrow and not formal, the Esplanade being the one notable exception. We have practically no large terrace areas in the nature of plazas except the one in front of the main house. Of course we will have another at the east end of the main house when we construct the patio, but I think the whole grounds would assume a more formal and finished aspect if we transformed our walks into formal Esplanades and paved them with tiles and bordered them more or less rigidly with vases or railings or statuary, etc. . . . All these things on a big scale will help to conform the landscape to the scale of the main house and in addition they will make the grounds much more livable as well as much more stately."[16]

This letter marked the start of an upscaling of the gardens that continued through the next decade, ceasing only

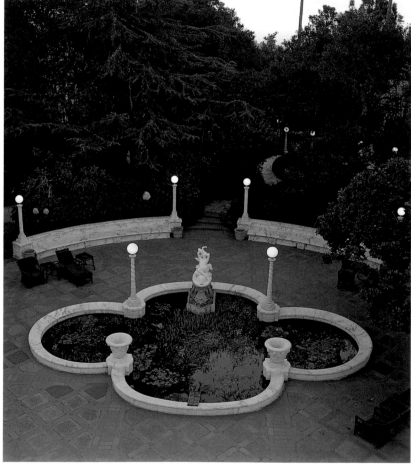

when Hearst's money began to run out in the later years of the Depression. Two large oak trees were moved in 1926 to allow the addition of the North Wing to Casa Grande in 1929–1930. Additionally, major terraces were rebuilt: The terrace in front of Casa del Sol (known as C Terrace) was enlarged in 1927–1928, and major stair entries were designed beneath it, leading off into the citrus grove area. The South Terrace was enlarged in 1928 and made into the south motor entrance when the driveway loop that terminated the road was completed. The Neptune Pool was poured in its second version in 1926, and grand effects were designed nearby, including the planting of fully grown Italian cypresses in 1928. That same year, the Neptune Terrace—which formed the roof of a structure housing seventeen changing rooms—was built overlooking the pool. On the Central Plaza in front of the main building, a large oak was moved in 1928 to allow for the terrace expansion. Marble benches and lamp standards were installed in 1930 to make this important terrace more ceremonial. On the east side of the hill, a ground-level tennis court was removed in 1927, and excavation began underneath it. The tennis courts were rebuilt in 1929 and served as the roof of the Roman Pool below.

They also planted full-grown trees at this time, including Italian cypresses (*Cupressus sempervirens*) and Canary Island date palms (*Phoenix canariensis*). Three mature oak trees (*Quercus agrifolia*) were moved as well. This extraordinary feat was an eloquent statement about how important the coast live oaks were to Hearst. He wrote to the construction superintendent Camille Rossi in May 1926: "When you move the big oak trees [in order to pour the North Wing of Casa Grande] please do turn them so that the longest branches will extend across the esplanade. This is very <u>important</u> in fact it is one of the chief reasons for this big work."[17] Morgan's office manager James LeFeaver described the procedure to Hearst in 1935: "Enclosed are the only photographs we were able to resurrect, showing the tree moving operations, although Miss Morgan

Two Sekhmet Figures and two Sekhmet Heads, Egyptian: head on the right, 18th Dynasty; figure at top, 19th Dynasty. Diorite. Upper figure with vein of feldspar, 5ft. 10½ x 20½ in. (179.1 x 52.1 cm); three-quarter figure, 45¼ x 17¾ in. (114.9 x 45.1 cm); chipped head, 19 x 19 in. (48.3 x 48.3 cm); head with sundisk, 23 x 10 in. (58.4 x 25.4 cm). Hearst Monument Collection, South Esplanade. From 1924 to 1930 Hearst purchased these four New Kingdom depictions of Sekhmet, the fierce lion-headed goddess and protector of the sun god Ra. Morgan designed an Egyptian fountain for them, ornamented with California Faience tiles of lotus blossoms and stepped pyramids in the stair risers.

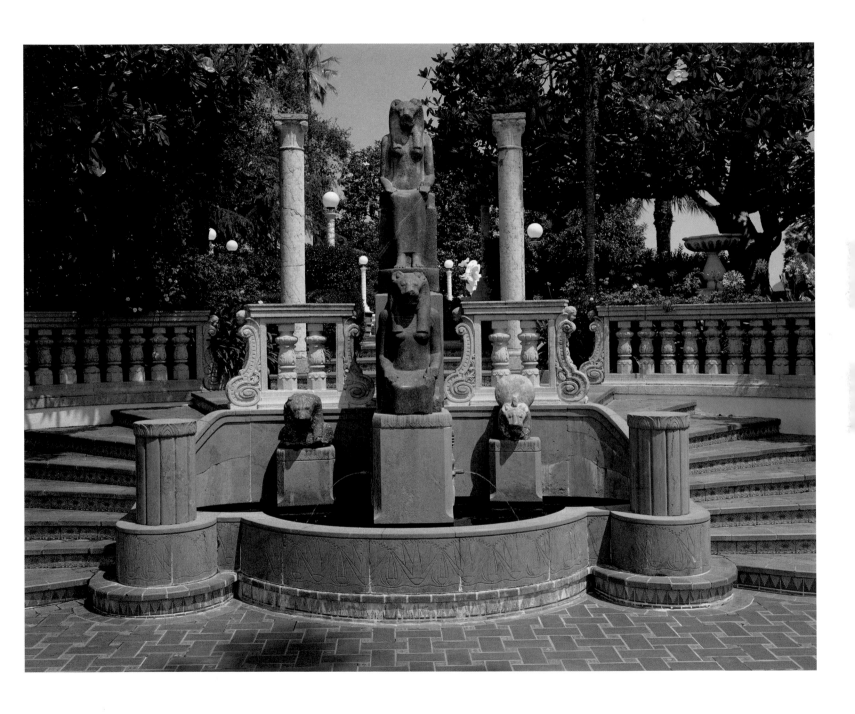

Fully grown Italian cypress trees (*Cupressus sempervirens* 'Stricta') line the roadway east of the Neptune Pool. Hearst purchased thirty-three trees, each approximately thirty years old, in 1928 and had them transported forty miles to the hilltop by Mack truck.

Mature Canary Island date palms (*Phoenix canariensis*) were among the fully grown trees trucked up the hill and planted at the edges of the enlarged terraces, beginning in 1928.

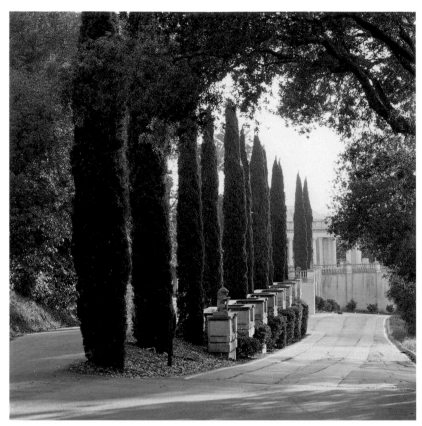

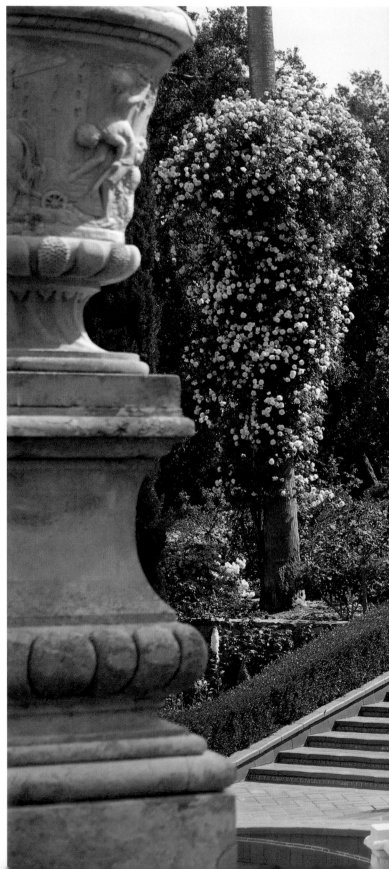

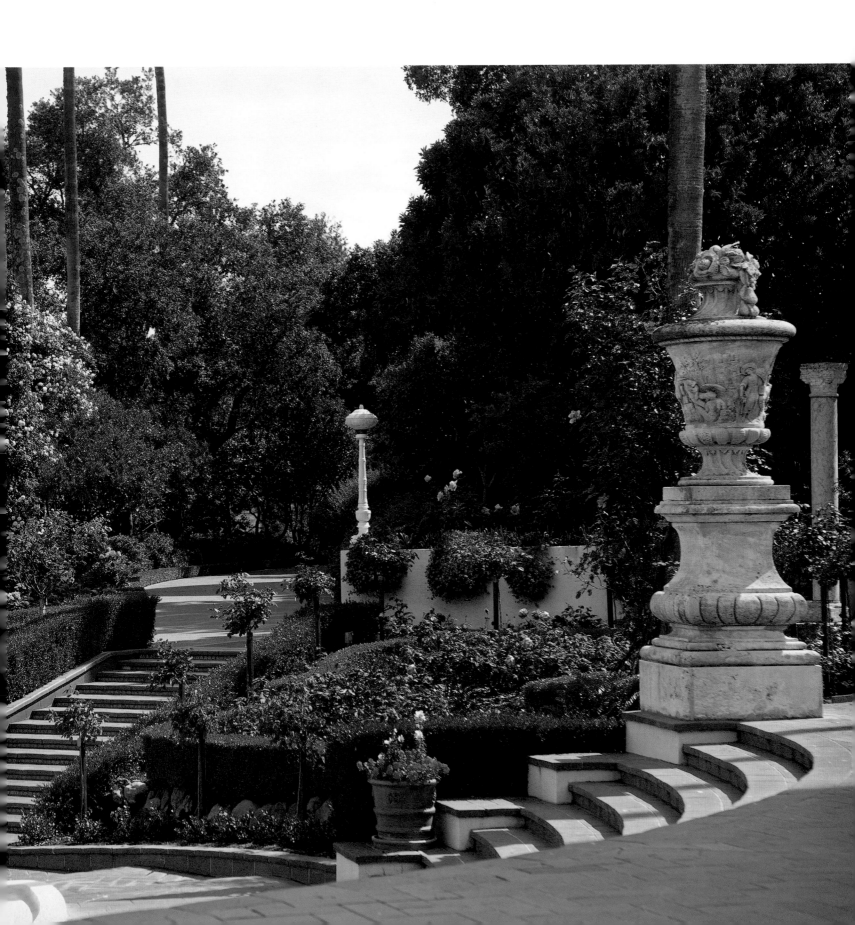

Hearst and Morgan planted fully grown trees in the formal gardens at San Simeon to create an impression of age and permanence. They softened the effect of the bare trunks of the tall palms by twining them with climbing roses.

probably has others in her private collection. These photographs were borrowed from the house movers, who performed the underpinning and moving operation. In general, the program consisted of tunneling under the tree and casting three or four parallel reinforced concrete girders under the main root area of the tree. A more or less circular trench was then dug around the tree and a reinforced concrete band was poured in this ring against the earth containing the roots. A bottom was then placed in this ring by undermining and lagging, using the concrete girders to support the lagging. Timbers and rollers were placed under the girders and the tree was then ready for either jacking up or moving laterally. In some cases the moving was done by means of rollers, and, in at least one case, where the movement was downhill, the moving was effected by means of greased skids."[18]

Through all these expansions and alterations of the landscape, La Cuesta Encantada began to look like a villa of the Italian Renaissance. Morgan and Hearst were influenced in their landscape decisions by not only Charles Adams Platt but also Edith Wharton, who had written *Italian Villas and Their Gardens* in 1904, a decade after the publication of Platt's *Italian Gardens*. Wharton's book began as a series of articles for *The Century Magazine*, with illustrations by Maxfield Parrish. Wharton knew of Platt's book and felt it could be improved on: For one thing, there were no dates or architects listed in his text. She described her goal as doing justice to a subject "which hitherto had been treated in English only in the most amateurish fashion."[19] She had known Italy since childhood, and in her vivid text she made its gardens come to life: "[A]ny one who studies the old Italian gardens will be struck with the way in which the architect broadened and simplified his plan if it faced a grandiose landscape. . . . The great pleasure grounds overlooking the Roman Campagna are laid out on severe and majestic lines: the parts are few; the total effect is one of breadth and simplicity."[20]

In spite of adopting more formal Italian garden ef-fects, Hearst remained very interested in English gardens in his choice of plants and their abundance, writing to Morgan in 1928: "I agree with Miss Worn that it is desirable to have a certain amount of mass color, but I think you will lose a great deal of charm and homeliness of a garden if you go too far in this direction and confine yourself to any degree to these masses of color. The garden plan then becomes a little too stiff and formal and we lose entirely the delightful character of [the] English garden, with its mixed color in what they call the herbaceous border. I think therefore that we should limit ourselves to the general color schemes of our various houses and to certain masses of color for different effects and otherwise have a garden of sufficient variety." He went on to enumerate many flowers, including "roses in all variety of colors," but said: "I am not inclined to pay much attention to the spring tulips and the other flowers that flash up for a moment in the very early spring and then disappear." Instead he wanted "a profusion of Japanese camel[l]ias, a profusion of pansies, a goodly number of wall flowers and winter blooming marigolds. . . . I want to make sure that we get all varieties of lilies and an abundance of them. In fact, I think the Hill should be a lily garden during the lily season. . . . Finally, I have a mania for hollyhocks and I would like to see them much more plentiful in the garden than they have been, especially against the walls of the houses. They begin early and last until late and are a very useful as well as a beautiful flower. They also have the home like character, of which I think it is necessary to retain some part."[21]

One of the glories of the estate in the late 1920s and through the 1930s was the zoo. It started modestly in 1923, with Hearst planning fences for elk and buffalo enclosures.[22] By 1925 he was writing to Morgan about a deer park at a lower point on the road up the hill, with a lodge and hay barns for the deer, and a buffalo and elk park to the south: "I think the barns and houses could be built to be good looking Spanish and give an impressive entrance to the enclosure."[23] These plans approximate the game parks

Hearst and Morgan planned an elaborate animal compound orna-
mented with a Chinese pagoda and gated walls for the hill north of
Casa Grande, but it was never built. Instead Menagerie Hill, east of the
garages, contained the caged zoo animals.

of British country houses. But within four months of this letter came a very different sort of reference, when Morgan wrote to Hearst: "The lions are beauties—about the size of St. Bernards and as well kept and groomed as human babies. It seems incredible that any living creature could contain the resentment felt by those wild cats. They have not been 'tamed' in the slightest."[24] Thereafter, instructions about more common animals such as pheasants and doves were interspersed with directives about far more exotic creatures. Morgan wrote a telegram draft to Hearst in October 1925: "Man [who] brought reindeer says [they] need iceland moss and careful feeding and watching until

used to new food."[25] The deer were temporarily housed on the tennis courts.[26]

Ruminants kept arriving, including buffalo. Morgan wrote Hearst in March 1926: "The buffalos have been put in the larger enclosure and looked very pretty browsing in the green grass."[27] Hearst had been responsible for bringing buffalo to San Francisco's Golden Gate Park, where they remain a feature today. Along with the grizzly bear, the buffalo is the animal that perhaps best symbolizes the American West. Grizzly bears fascinated Hearst as well. In 1889 he funded an expedition to find a grizzly bear, when they were nearly extinct in California. One was captured

Hearst, a lifelong animal lover, did not allow hunting on the ranch. His newspapers campaigned against animal cruelty—including bullfights, the abuse of horses in cowboy Westerns, and the practice of laboratory experiments on animals. The zebras adapted so well to the region and its climate that herds of them still graze on the ranch today.

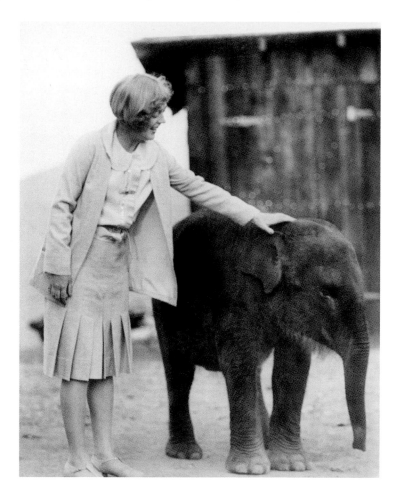

and named Monarch. Hearst called his *San Francisco Examiner* "The Monarch of the Dailies" on the masthead, in its honor.[28]

Hearst had grand ambitions for the zoo, dividing his attention between the animal cages at the east of the hilltop and a series of animal houses in a Chinese style, planned for the site directly north of the hilltop (but never built). He wrote to Morgan in the summer of 1926: "How about a maze in connection with the zoo. I think getting lost in the maze and coming unexpectedly upon lions, tigers, pumas, panthers, wild cats, monkeys, mackaws and cockatoos etc. etc., would be a thrill even for the most blase. If the space is big enough—and we will make it big enough by cutting off more hill if necessary—we could have a great maze with these 'animiles' [*sic*] and birds and with a pretty pool in the middle, with cranes and flamingos, etc., and a fountain and EVERYTHING. Lets [*sic*] do this. I think it is a novel idea. If it should not prove practical we can make a maze in connection with the big pools on Chinese Hill,—but I kind of like the animal maze."[29] Though they never built this dramatic feature, they did build animal pits, or shelters, beside the road north of the hilltop.

The most successful zoo effect was in place by 1927: groups of grazing animals gathered where guests could observe them while making their way up the hill. Rustic open-fronted shelters along the road at several spots encouraged the animals to linger where they could be easily seen. Morgan wrote to Hearst in the summer of 1927: "The animals arrived in beautiful shape. I had to rub my eyes last night when out of the semi darkness staring at the lights were grouped three ostriches, five zebras, five white deer two with big horns, a llama, and some speckled deer. All in a group!"[30]

This was the beginning of the exotic animal acquisitions. Hearst's close friend Alice Head, who was in charge of his British magazine operations and visited the ranch frequently, recalled in her 1939 memoir receiving a telegram from Hearst that instructed her to go to Tottenham

Court Road in London "and inspect the giraffes for age size sex quality and price." There were no giraffes at that London shop, but it was the business of a parrot and cockatoo salesman, who also served as a wild animal broker. When months later Head returned to San Simeon, Hearst said, "'I am going to take you [on] a little walk.' We drifted down the mountainside and came to an enclosure. 'And,' said Mr. Hearst, 'there are your giraffes.'"[31]

The zoo animals were invariably the most memorable aspect of the ranch and made their way into many photographs and reminiscences. Marion recalled: "Nobody was allowed to ride in the area where the wild animals roamed. There were lions and tigers; leopards and bears of all kinds; honey bears and spider monkeys; camels, deer, water buffalo, zebras and elk; emus and ostriches. W. R. thought it was picturesque."[32] The interactions between the zoo animals and the guests could be difficult. Louella Parsons, a longtime Hearst columnist, recalled being "driven up the hill by one of the Hearst chauffeurs. It was very late and we were weary after a ride on the midnight special from Los Angeles. A very defiant and bossy moose parked himself in the middle of the road and refused to move. We honked the horn. We yelled at him. We made horrendous noises—but he merely gave us a wicked look. . . . [T]he chauffeur refused to budge! He said Mr. Hearst would not like it if we did anything to frighten one of the animals. So we sat—and after an hour's wait, the moose moved nonchalantly out of our way."[33] The zoo, cattle ranch, and poultry ranch operations had another benefit, according to Nigel Keep's grandson William Reich: "[T]here's every kind of manure you can imagine. And this grew flowers that were just unbelievable."[34]

When San Simeon's demands were at their height, Morgan began to have health problems. She had experienced inner ear problems since childhood and in 1932 endured a series of operations that resulted in the removal of her inner ear, due to the surgeon's error.[35] She lost her equilibrium and suffered extreme facial disfigurement, or

Horses have been raised at San Simeon since the 1860s. There were three different stables in Hearst's time, the most elaborate one being this horse barn designed by Morgan in 1928.

The Pergola under construction in an aerial view from the mid-1930s. This columned arbor north of the hilltop extended more than a mile in length and was planted with espaliered fruit trees and grapevines. Meant for riding through on horseback or strolling on foot, it afforded spectacular views of the hilltop buildings as well as the coastline. Hearst planned to decorate it with sculptures from the 1915 San Francisco world's fair, but never did so.

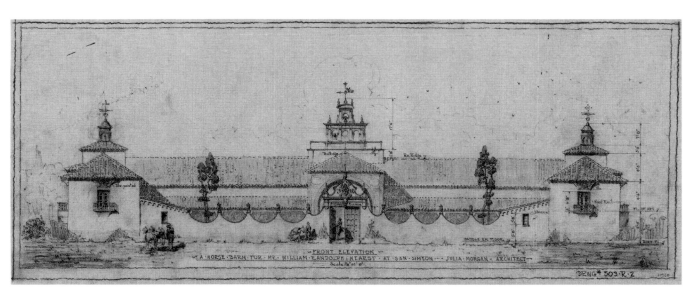

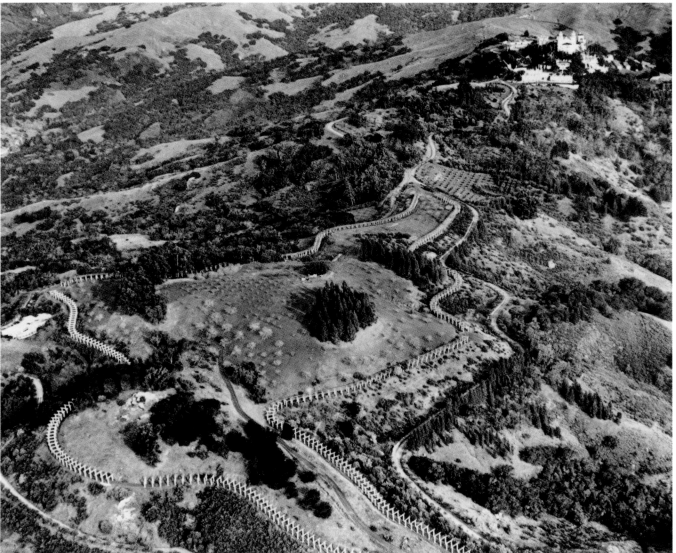

as she put it to an old friend she had known since her sorority days, "a wrecked face." Her nephew recalled Morgan saying she was "so unsymmetrical."[36]

Morgan's ongoing health problems made her heavy workload even more impressive, including her design for the most dramatic feature created in this decade of garden expansion: the Pergola. Hearst had considered using pergolas since the earliest years of building, discussing them for the cottage courtyards, for sites below the cottages, and as attachments to both sides of the main building, as they had been at the Pleasanton Hacienda. As the main building was poured from 1922 to 1925, Hearst's vision for the estate enlarged. He began thinking of wider-scale planting in the areas north of the hilltop, where the Pergola was ultimately sited. He wrote to Morgan on January 11, 1925: "I think we should have a second or lower wall with fruit gardens between it and the first wall—walks steps bowers arbors vistas terraces &c. . . . I think there should be some little temples at various view points along the new lower wall where walkers can stop and rest[.] There should be imposing entrance gates arcades statuary niches cloisters &c. Would like to plan for extending the orchard and some definite scheme for tree planting in clumps. I want to carry the lower wall to the juncture of the roads below (west) of Chinese hill. We dont [sic] need a gate there but we should have pillars and lights and trees planted in effective combinations on the East and West angles of the road[.] I want to carry a road to the north of orchard hill all around the hill to meet the present road south of orchard hill where the old road used to meet it. . . . I think there should be some architectural features in these various points—seats and perhaps a shrine etcetera."[37]

Ultimately the Pergola was sited quite a distance from the buildings, on Orchard Hill.[38] Construction began on it in late 1928 and continued sporadically through 1937, its design partly inspired by Italian pergolas in Amalfi and Taormina that were part of a clipping file Hearst sent to Morgan.[39] It was just over a mile in length; Morgan told

Hearst: "You certainly have the longest pergola in captivity!"[40] Morgan's biographer, Sara Boutelle, reported that Hearst said he wanted it high enough for "a tall man with a tall hat on a tall horse" to ride through without bumping his head.[41] Its many columns were made of upended concrete water pipes standing eleven feet high, each one with a grapevine climbing up it. In between the columns, espaliered fruit trees were trained on wires by Nigel Keep and his staff.

Hearst maintained his interest in the gardens as they matured. The fifth head gardener was Louis Reesing, who arrived in 1930 to replace James Chatfield, only on site for one year. In 1932, Hearst wrote to Morgan, "I have authorized Mr. Reesing to buy flowers to carry out some of the projects I have discussed with him up to a thousand dollars, . . . I think Mr. Reesing has a pretty good general idea of what is wanted, but it may be necessary to make sure that the proper taste is exercised in selecting the flowers for color effects."[42]

In the 1930s another important feature of the estate was completed: the Milpitas Hacienda twenty-three miles to the north. Built in Mission Revival style, it served as the rustic retreat from La Cuesta Encantada—a chance to recreate the mythical days of the dons in early California. Hearst had bought up the land adjacent to Mission San Antonio de Padua gradually, in much the same way his father had purchased the ranches around San Simeon fifty years earlier. It engendered much the same resentment. In 1940 the process was chronicled by a local observer: "With this ranch, Hearst now has ownership of 154,000 acres, having also purchased the San Miguelito, El Piojo and Los Ojitos as well as many private ranches of the region. A few old settlers, untempted by attractive prices, had refused to sell. . . . Inasmuch as Hearst's holdings extend through Jolon, this town is now 'kaput.' Witness that in '29 all the residences and outhouses of the Dutton's 160 acre estate were razed to the ground except the picturesque old hotel which, though vacated by the Dutton family upon its sale . . . is still

in good condition. Practically all that remains of the once lively little center is the Episcopal chapel, the community hall, a frame building or two and the old Tidball store that has been owned by the A. Duck family since 1913. Although it was once thought that the historic Dutton hotel would be converted into headquarters for the Hearst interests, this never happened. Instead, an elaborate Spanish-style ranch house arose on a hill southeast of the mission. . . . Hence, with their former owners departing the Jolon terrain, and with others who had previously left, many of our original Spanish families have faded from the scene." Part of this resentment was assuaged in 1939 when Hearst donated twenty acres of his land to the mission, bringing its total property to fifty acres.[43]

At the Hacienda, with its Native American rugs and sunny courtyards, Hearst and Morgan created a country idyll, a Petit Trianon—like retreat at which to live the romanticized life of a grandee among the pasturelands of old California. In 1930 Morgan wrote to Hearst: "The Jolon work is progressing well, I will hold back the tower toward the mission until you come, . . . the plastering of the interior was done as agreed, but the weather has been so very hot, no attempt has been made to plaster the exterior. . . . Many tourists are mistaking the new buildings for the Mission—it was really quite amusing last visit."[44] In the spring the Hacienda was surrounded by green hillsides spangled with wildflowers; in the summer its cool corridors and courtyards provided refuge from the unrelenting sun. With its rows of cloisterlike bedrooms and two central gathering halls, it was intended as the headquarters for the northern part of Hearst's ranch as well as a destination site reached by horse, by specially built road, or by airplane. The Milpitas Hacienda was in a sense the fourth "cottage," even though it was sited many miles north of the hilltop.

The late 1920s through the mid-1930s saw the hilltop gardens grow dramatically. Boxwood hedges, rose standards, and bright herbaceous borders filled the beds around the cottages. Tall Italian cypress trees and many

varieties of fully grown palms were planted. The terraces were much more formal than the earlier ones and utilized the hilltop's many views more effectively. The zoo, Pergola, swimming pools, and Hacienda were all constructed, providing La Cuesta Encantada with its most memorable architectural features. This decade was the zenith for the estate, much of it built as the Depression deepened. By the late 1930s Hearst's worsening financial conditions forced his retrenchment. Construction on the hilltop would never again be so lavish.

The Hacienda's location near Jolon was much warmer than coastal San Simeon, and its long shady arcades captured the cool breezes.

In the early 1930s Hearst and Morgan built the Milpitas Hacienda, a Mission Revival retreat twenty-three miles north of La Cuesta Encantada, where Hearst could re-create the idealized life of early California during the Mexican period.

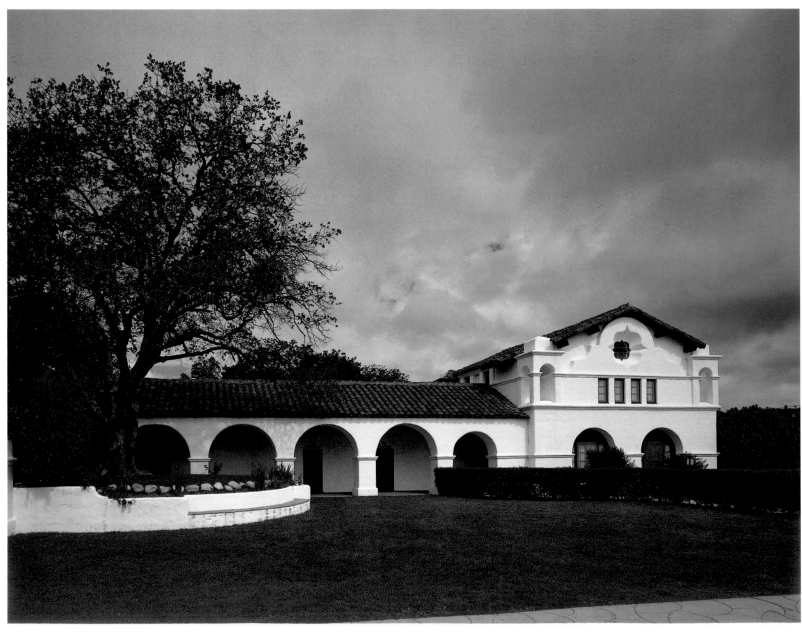

Hearst's own room at the Hacienda had a sweeping view of the northern mountains. He was at his happiest when riding north with Don Pancho Estrada to picnic with his guests on rough wooden tables.

Mission San Antonio de Padua, founded in 1771, sits just north of the Milpitas Hacienda.

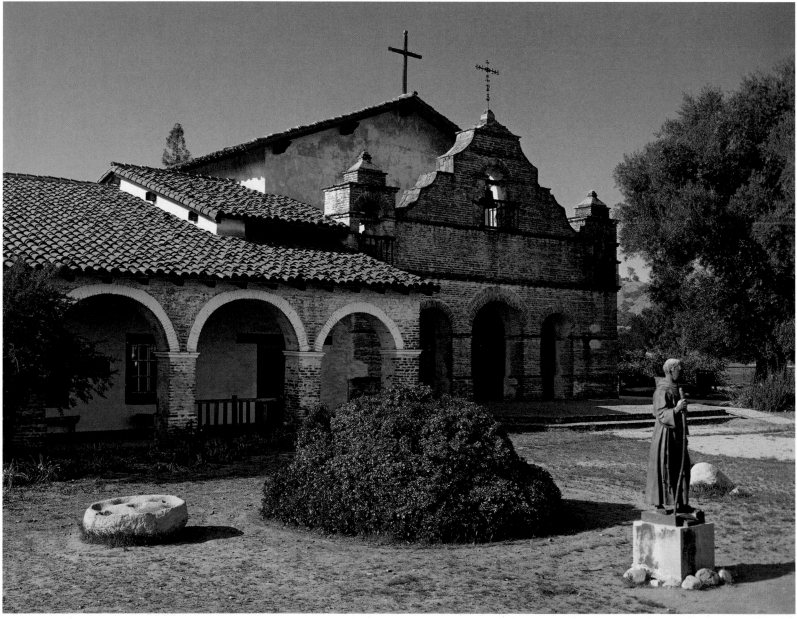

Visiting the Ranch (1919–1947)

Clive Aslet, a leading scholar of the American country house, called La Cuesta Encantada an estate of "Olympian elaboration." He noted Hearst's understatement in referring to his enormous compound as the "ranch" at San Simeon: "This, of course, explains the apparent incongruity of [Hearst's] keeping ketchup bottles on the banquet table and using paper napkins with the silver service: whether the setting was propitious to it or not, the mood was one of relaxed informality. . . . But as a backdrop for the Hollywood folk who went there, it was in every sense ideal. It was not built around a patio: there was no need, for the place extended itself through several separate buildings grouped around highly architectural courtyards. This form may derive from that of the original tents; certainly the stationery continued to bear the legend 'Hearst Camp.' It was the apotheosis of the indoor-outdoor life."[1]

The guests' amazement at the scale of San Simeon was perhaps best echoed by F. Scott Fitzgerald in his 1922 short story "A Diamond as Big as the Ritz." Fitzgerald was a guest at Marion Davies's Beach House but apparently never a guest at San Simeon. He based his story on his visit to a vast ranch in Wyoming. In the tale, the easterner John T. Unger visits his school friend Percy Washington's enormous family ranch, built atop a huge diamond in Montana. The boys arrived there at night, and Fitzgerald wrote: "On one of the towers, the tallest, the blackest at its base, an arrangement of exterior lights at the top made a sort of floating fairyland. . . . Then in a moment the car stopped before wide, high marble steps around which the night air was fragrant with a host of flowers."[2]

Throughout the 1920s and 1930s, most guests who came to Hearst's San Simeon ranch arrived by train, which "would leave Los Angeles at eight-fifteen and arrive at San Luis about three in the morning, and we'd motor on up. It was about an hour and a half's drive," Marion recalled.[3] At night guests were greeted with just the kind of floating fairyland of lit towers that Fitzgerald described. If

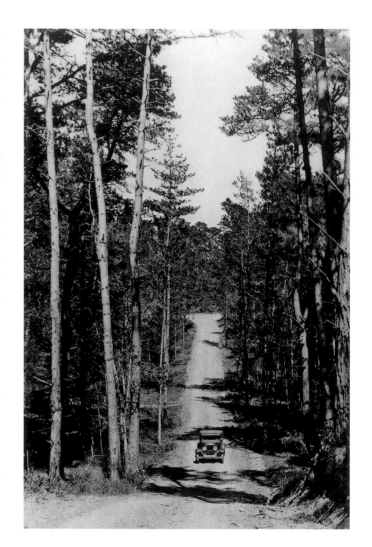

Guests traveled by train to San Luis Obispo, forty-five miles south, and were brought by car or taxi through the Cambria pines to San Simeon.

opposite
When fully illuminated at night, La Cuesta Encantada reminded some of the guests of a lighted birthday cake.

The long table in Casa Grande's Refectory, set with platters of fruit from the orchards and condiments in their store-bought containers. These bottles and the use of paper napkins often surprised guests, but these informal touches may have reminded Hearst of his early camping days at the ranch.

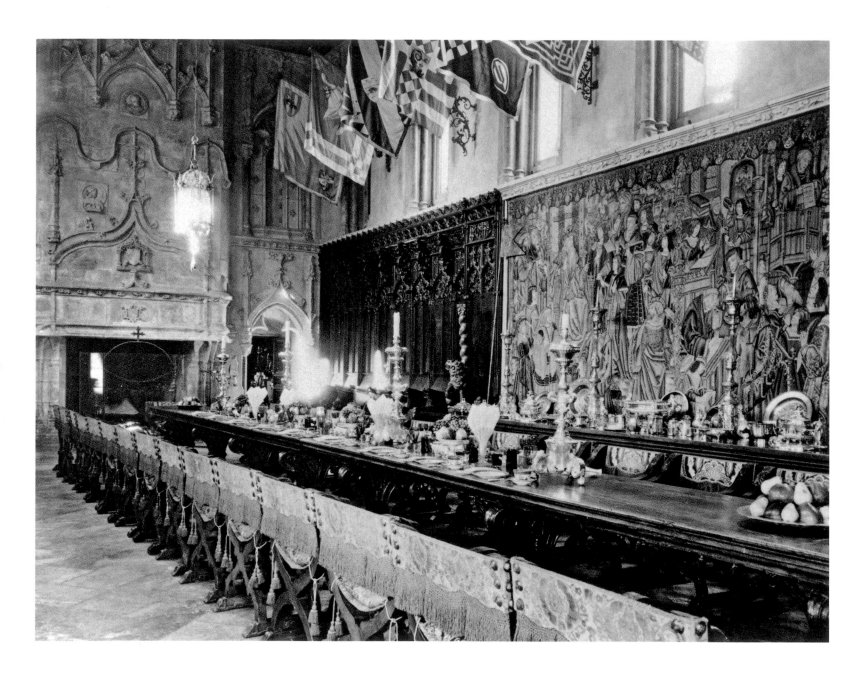

arriving in the daytime, it was a tradition to stop in the creamery town of Harmony to pick up cheddar cheese for the ranch.[4]

The Harmony Valley Creamery Association was founded in 1913, but dairies were first established in the region in the late 1860s, when it was realized that the abundant grasses that grew following the 1864 drought would perfectly support dairy cattle.[5] Principal among the dairy farmers were Swiss families, who began migrating south from Sonoma to settle in the region in the 1870s. They brought with them their custom of yodeling, which they used to call one another as they brought the cows in for the evening.[6] Perhaps it was his early days at San Simeon among the Swiss dairy farmers that taught Hearst the skill, for he too was a yodeler. One guest recalled that Hearst amazed him by yodeling during dinner.[7]

The Refectory—named for a dining hall in a monastery—contrasted austere Gothic elegance with a studied and surprising informality. The condiments were served in their store-bought bottles and the cutlery was silver plate rather than sterling. There were no linens on the gleaming sixteenth-century walnut tables. "He didn't like anyone calling it a castle; it was always the ranch," Marion recalled. "No tablecloths; always paper napkins. On that one, he thought it was more sanitary, and with so many guests he was probably right. It saves the laundry, too. And I've always used paper napkins. They don't look so good—but what's the difference?"[8]

Outfitted with a silver-trimmed bridle and saddle, Hearst led trail rides from the hilltop through the backcountry. He rang a cowbell to announce meals. On more than one occasion, Roy Rogers's country-and-western singing group, the Sons of the Pioneers, performed "Tumbling Tumbleweeds" for the guests in the Refectory—and Hearst asked to hear it again and again.[9] In essence, he was saying to his movie-star friends: You play a cowboy—I am a cowboy. He understood the outdoor life and wanted his guests to enjoy it too. Actress Colleen Moore said whenever

she and her girlfriends had gotten settled for a good gossip by the fire, Hearst would come in and shoo them out into the sunshine. "He would say, 'Come on now, get out and get the fresh air,' and he'd make us all go out and go horseback riding. It was just dreadful."[10]

Outdoor activities were a necessary diversion in such a remote spot. Actress Eleanor Boardman, Marion's friend since the Ziegfeld Follies days, remarked, "When you stick a lot of people on top of a mountain, you have to do something about it."[11] Marion reminisced: "We'd have picnics down at the beach, about five miles up the coast toward San Francisco, or we'd go on camping trips. . . . Anyone who had the courage to swim in the ocean was crazy. It was too ice-cold, all the year round. I'd just sit around awhile and then go back up the hill."[12]

Boardman recalled that Marion was frightened of horses. "Marion and I both hated anything that had more legs than we did."[13] They found the trail rides trying. They were an endurance contest, with Hearst in the lead. Boardman recalled reaching a camp far out in the wilderness, with dusk coming on, and seeing "a big bonfire going; there was a tent for every person with a card table with a wooden floor. . . . Bright and early the next morning, he yelled 'Whoopee! Everybody up! I'm going down to that creek to clean that tooth.' Then we'd come back, and we'd really be sore . . . [on the] long trek home. He wanted to show his prowess. He'd have dancing that night."[14]

One guest who could match Hearst at riding was Bill "Iron Eyes" Cody, a Native American who played many Indian roles in Hollywood. His description of a trail ride shows his appreciation for the landscape: "The ride through what must have been a very small portion of the ranch was wonderful. Hearst, a good horseman, led the pack over land that offered the best of California geography: rolling hills covered with shaggy golden grass, multicolored rocks, fissures and canyons carved from the earth by streams during the rainy season, cool ocean breezes and bright sunshine. . . . Late in the afternoon we returned, most everyone

Wildflowers near the Milpitas Hacienda. When Hearst invited Bernard Shaw to visit, he phrased his invitation: "Let me herewith extend you [a] formal and fervent invitation to be my guest and ride the range with me in California." Shaw did spend a night in 1933, but he did not ride horseback with Hearst.

exhausted except W. R. Of course, I'm used to this kind of
riding, but W. R. was in his seventies!"[15]

On one occasion Hearst carried the Wild West theme
even further, enlisting hilltop employees to enact a stage-
coach robbery. Ranch hand Archie Soto remembered:
"[O]ne time he had a guest coming from New York or
someplace in the East. She owned a railroad there. We
was supposed to meet her down at San Simeon. We was all
dressed up and were supposed to meet her with guns and
everything and hold the taxi up. . . . But it got to storming
and the taxi was late. So they finally decided we'd go up to
the hilltop and meet her there in the rain. . . . We all got wet
and we went without lunch. It didn't amount to very much.
We was there with our guns and we all had our horses there
so when she arrived we met her on horseback."[16]

A firsthand observer of many ranch entertainments
was the Hollywood screenwriter Frances Marion, who was
fond of Marion Davies and saw Hearst's love for her. She
also saw the stifling effect of Hearst's affection. Hedda
Hopper quoted Frances's description of Davies: "She was
a butterfly with glue on her wings."[17] Frances Marion wrote
about Hearst: "I might never have realized [his loneliness]
if I had not been a dawn prowler. So was Mr. Hearst. He
never saw me watching him as he walked through his gar-
den of rare plants and flowers, pausing to gaze at the hills
beyond in the early morning light. Sometimes he sat down
on a bench with his head thrust forward on his chest, and
held that pose for a long time. Was he reflecting on the fu-
ture? Or regretting some heart-wrenching incident in the
past?" She concluded that in his solitude he was unknow-
able, "A sad man, a man who really walked alone."[18]

Hearst's guests were often young, lively, and far from
introspective. John Spencer Churchill was only twenty
when he visited San Simeon with his father John, his cous-
in Randolph, and his famous uncle Winston in September
1929. The boys were dazzled by the female guests. Winston
Churchill was amused at the boys' interest—for a time. "His
benevolent attitude changed, however, when Randolph and

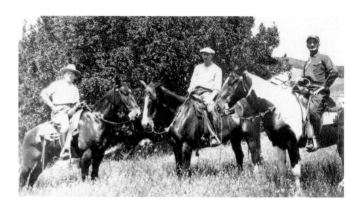

I decided to make an expedition into the night." Randolph attempted to enter one of the cottages but "made an awful error. It was his father's bedroom. Uncle Winston woke up at once and was exceedingly annoyed. Blasted by a withering reprimand, we both retired feeling very sheepish and fed up."[19]

Harpo Marx complained that he was perpetually seated at dinner in the equivalent of the doghouse, the seat nearest the blazing hot fireplace in the Refectory. "Every meal there was a race for me, to see if I could eat fast enough to make up for the weight I was sweating off." Once Harpo saw a more favored guest get similar treatment, when he and Marion's nephew, the screenwriter Charles Lederer, played a memorable prank in the garden. After a rare snowstorm, they borrowed ten fur coats from ten of the female guests and draped the furs over the statues. Harpo recalled: "The effect in the morning was quite spectacular—the snow on top of the fur coats on top of the statues. There was another effect too. It was the first time I ever saw Mr. Hearst get sore at Charlie Lederer. In front of everybody, at cocktail time, he demoted Charlie to a seat at dinner by the fireplace."[20]

Billy Haines (William Haines) was one of Marion's closest friends and a frequent guest. He credited Hearst with teaching him about decoration and antiques, knowledge he used to become a successful decorator in later years, when his openly homosexual lifestyle caused him to be blacklisted from films. He and his partner Jimmy Shields were welcome at the ranch. "He was a man of enormous generosity, once you broke the shell and got inside," Billy recalled. "He hated to be thanked for anything he gave. But he loved to get small gifts, like candy, and would open the packages with all the delight of a child." Haines recalled Hearst singing and playing the banjo, and dancing. "He used to do his favorite Charleston dance. He was a towering six-footer—a *mountainous* man—and he did the Charleston like a performing elephant. He had as little grace as an elephant, but he had the *dignity* of one."[21]

Arthur George Walker, *Adam and Eve*, British, c. 1925. Cast bronze, height 73 in. (185.4 cm). Hearst Monument Collection, House C Lower Courtyard. Hearst bought this depiction of Adam and Eve being expelled from Eden directly from the sculptor. The work is shown against California Faience tiles and framed by blood-red trumpet vine (*Distictus buccinatoria*).

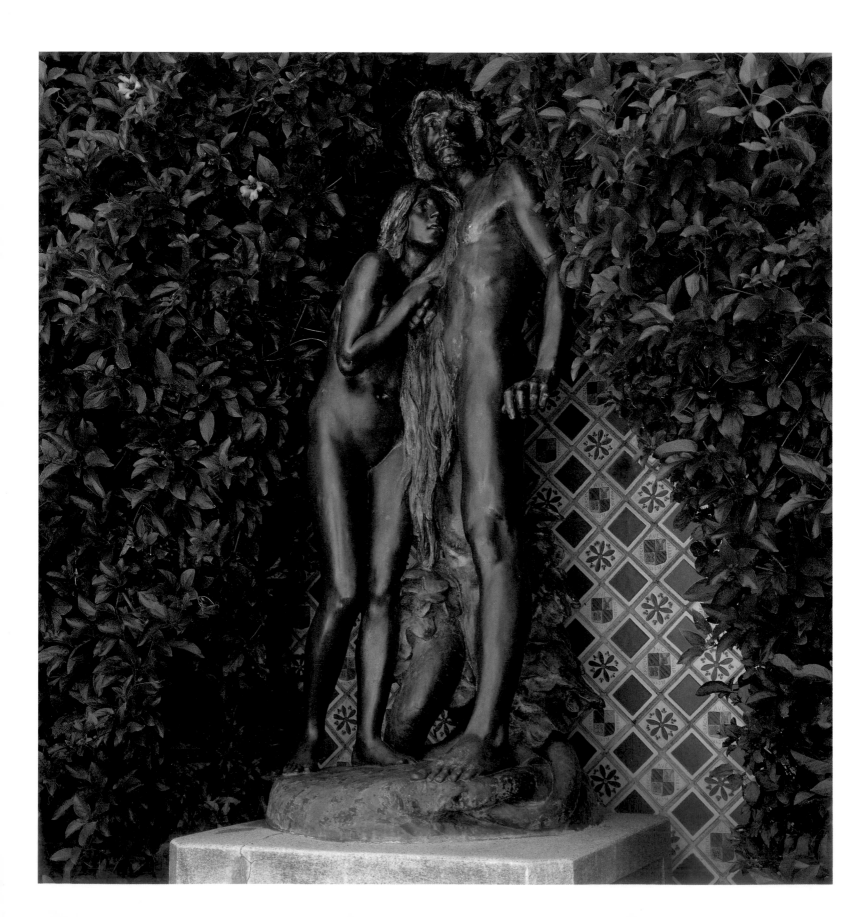

Marcel Louis Maurice Courbier, *Girl Feeding Lamb,* French, 1929. 43 x 65 x 23½ in. (109.2 x 165.1 x 59.7 cm). Hearst Monument Collection, North Esplanade. Hearst purchased this statue the year it was created. It was one of several contemporary Art Deco pieces used to ornament the gardens.

Alice Head, who oversaw Hearst's British magazine operations, wrote about her employer: "He has been variously described as a sphinx, an enigma, the incarnation of a Roman Emperor and a number of other rather puzzling complexities. The truth is, he is a man of profound learning with an absolutely first-class brain but with a number of engaging boyish characteristics. He is the soul of courtesy, in all circumstances of life he is always a gentleman, he is quixotically generous, and he has a gay and responsive sense of humour. I have heard it said that his eyes have a cold expression and that he is difficult to get on with. As for this criticism, the man has always a great deal on his mind and in consequence is frequently preoccupied. He is genuinely shy with strangers, but anyone who treats him as an ordinary human being and is not afraid of him will find him a most interesting and entertaining companion. No one with his love for children and animals could have anything but a kind heart."[22]

Hearst was an animal-rights activist in an age when such positions were considered eccentric, even laughable. For more than four decades, his editorials consistently inveighed against animal abuse. He campaigned against

bullfighting; against Hollywood's cruelty to horses in the filming of westerns; against the use of rare bird feathers in women's fashionable hats. But mainly he fought against laboratory experiments in animals—a campaign known as antivivisection. In a 1916 editorial he wrote: "We suppose that 99 per cent of these cruel experiments are useless and resultless. Of course, a small proportion may result in increased knowledge, but we are pretty sure the same knowledge could be gained by dissecting dead bodies. . . . It is always the weak and the helpless that are subjected to the torture of vivisection."[23] Marion Davies shared his conviction, recalling: "He really loved animals. I think it all started with the little white mouse that he had as a pet when he was a child. He'd carry it around in his pocket. I felt the same way about animals. . . . They said that people who were against the vivisection thing were not humanitarians. They didn't care about human lives, only about dogs. . . . I said that the way I felt about dogs also went for rats and mice and even as far as cockroaches. . . . Everything has nerves in its body, even the fish that you catch." When Marion founded the Marion Davies Clinic for Children at UCLA, she stipulated that there be no laboratory experiments on animals: "I had an agreement with the hospital to cut vivisection out. Dean Warren said, 'Nothing. Not even a mouse or a rat. We won't do it.'"[24]

Hearst's love of animals extended to his dogs, which guests encountered frequently. The Abbe children wrote: "When we went to the indoor swimming pool or over to the zoo in the morning an enormous army of dachshunds would come roaring down to meet you in their kennels, long-haired dachshunds, sausage dachshunds and also blue dogs [Kerry Blue Terriers] and Irish wolfhounds, which did not meet you. They were very afraid although very large."[25]

Norman Johnson was in charge of the dogs and also of Marianne, the elephant. The kennels, the zoo cages, and the elephant house were all east of the estate, on the site known as Menagerie Hill. He recalled: "A few of the other

breeds we had in our kennels at times were Kerry Blue Terriers, Boston Bulls, Sheepdogs, and Heuleguin [harlequin Great] Danes. We probably raised as many as 150 more puppies, . . . as we did not give many away. His newspaper officials were mostly on the list with a few motion picture celebs, and he always wanted to be sure the dogs would get a good home."[26] Hearst's personal pet for many years was a dachshund named Helen, of whom he wrote when she died in 1942: "An old bozo is a nuisance to almost everybody—except his dog. To his dog he is just as good as he ever was—maybe better. . . . So I do miss Helen, I was very fond of her. She always slept on a big chair in my room and her solicitous gaze followed me to bed at night and was the first thing to greet me when I woke in the morning. . . . I have buried her [at Wyntoon] on the hillside overlooking the green lawn—where she used to run—and surrounded by the flowers. I will not need a monument to remember her. But I am placing over her little grave a stone with the inscription—'Here lies dearest Helen—my devoted friend.'"[27]

Many of the staff were in awe of Hearst and attempted to avoid him. James Beck, who stayed at San Simeon as a teenager in the 1940s, recalled that the workers did not seem resentful of Hearst, but they perceived him as a "remote figure . . . and there was no impression one got of one big happy family, . . . much more feudal."[28] The employees—including the grounds staff—were invited to join the guests at 11:00 P.M. to watch the nightly film and newsreel shown in the fifty-seat Theater, an egalitarian tradition uncommon in the more formal country houses of the East Coast. Longtime gardener Norman Rotanzi recalled, "[Y]ou really felt at ease around him. He was a very brilliant man. He knew all the names of the plants and most of the pests we have to deal with. The gardeners were sort of his pets. He would like to come out and stroll around the gardens and talk to everybody. And it didn't make any difference who he had with him—Winston Churchill, or the president of U.S. Steel, or whoever it was, he would always introduce you to these people."[29]

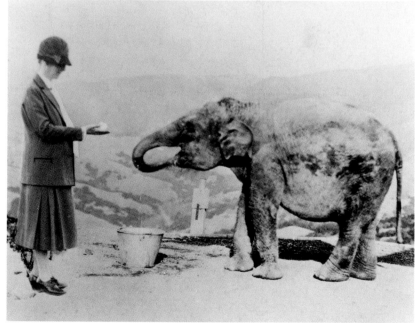

Guests could walk from the main building to the three cottages
by descending two large staircases on the north–south axis of the
Esplanade. Or they could wander along these narrow flagstone paths
bordered by bright azaleas to reach small staircases that terminated
at each cottage entrance court.

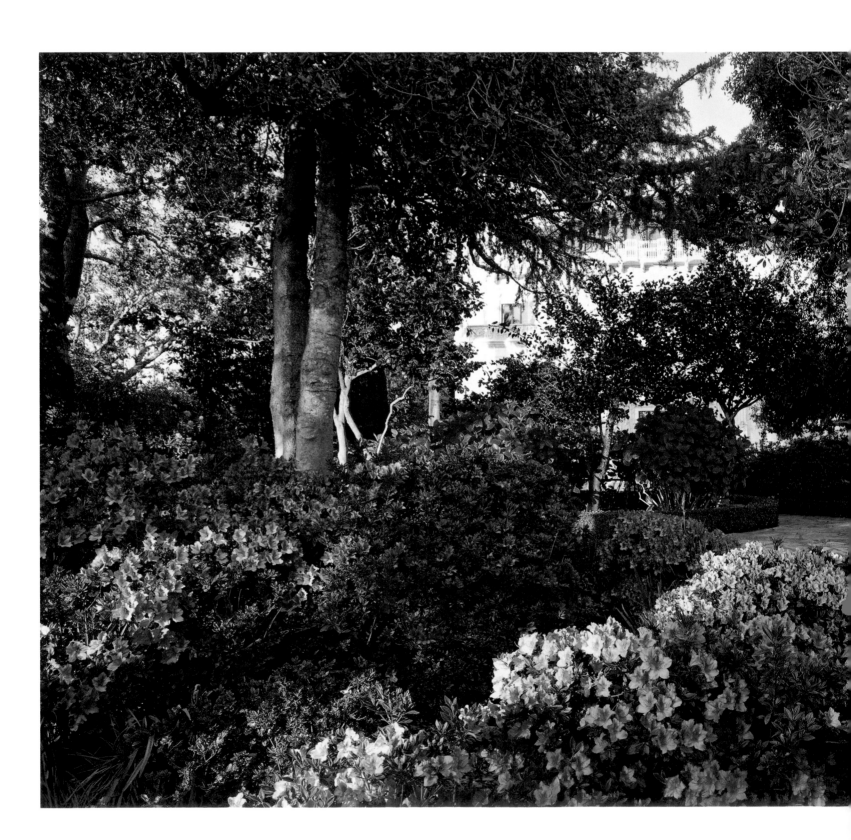

Roses were among Hearst's favorite flowers. There are currently approximately one thousand plantings of eighty cultivated varieties in the gardens, many of them modern hybrids that did not exist in Hearst's era. An effort is under way to plant historic varieties from the period, mostly early hybrid teas.

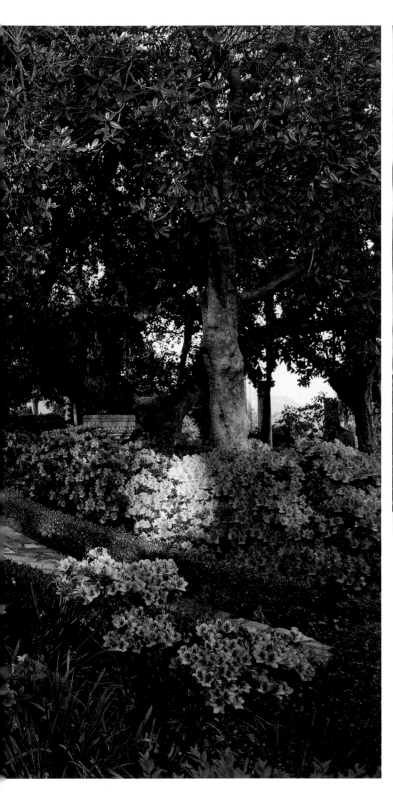

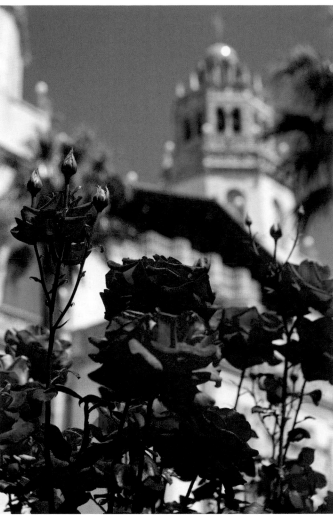

Tennis courts were built at the east side of the Esplanade in 1925 and then rebuilt in 1927, when the Roman Pool was constructed beneath them. The courts were lit for night matches and were used by tennis greats such as Helen Wills, Alice Marble, and Bill Tilden.

opposite
Cary Grant leans against an Italian wellhead on the North Terrace. He was a guest at La Cuesta Encantada many times and said he requested a different guest room each time he returned.

Winding paths through the gardens terminate at vista points like this rustic bench, which provided guests with a view of the ocean and a quiet spot for contemplation or romantic assignations.

Author Hugh Walpole accompanied H. G. Wells and Paulette Goddard to La Cuesta Encantada in the mid-1930s and described it as "A huge imitation stucco building like a German health resort, planted on a hill between the mountains and the sea. Magnificent tapestries and everywhere marble statues, sham Italian gilt, and a deserted library where the books absolutely weep for neglect."[30] The guests spent their time in more active outdoor pursuits, including tennis. Two tennis courts located on the roof of the gymnasium were first used in 1929 while the Roman Pool beneath them was still under construction. Tennis champion Alice Marble recalled partnering with Hearst, and Marion's concern for him. They played against Charlie Chaplin and Alice Marble's tennis coach, Teach Tennant. Alice was indignant to discover that Chaplin cheated, calling balls out when they were in. She wanted to object, but Teach caught her eye. She wrote in her autobiography: "When the score went to 5-all, Marion whispered to me, 'Let them win.' I shook my head. 'We're going to win.' It wasn't until later I realized her concern was Hearst's health, not diplomacy. We won, 10-8. Perspiring, the big man gave me a bear hug and said, 'Alice, you're the best partner I've ever had!'"[31]

There were places on the grounds for romance as well as for exercise. The gardens have flower-lined pathways, and winding steps lead from the major walks down to leafy hideaways ending at benches with vistas to the ocean. Cary Grant recalled a spot along a portion of the Esplanade that was called Azalea Walk. It was hidden from view of Casa Grande's windows by spreading oak branches and was known as "Lover's Lane."[32] But without question the most dramatic and romantic garden features of La Cuesta Encantada are its two swimming pools.

The Neptune Pool and the Roman Pool are pendant pieces—the Neptune Pool sited outdoors and meant for daytime swimming on warm days; the Roman Pool sited indoors and meant for nighttime swimming and inclement weather. They are also pendant pieces stylistically. Each pool pays homage to a different cultural tradition: the

The Neptune Pool in its first of three versions, circa 1924–1926. Early
plans for this site included a rose garden and pergola. The hot summers
and his five sons' eagerness for a pool motivated Hearst to build
this small basin instead.

opposite
This 1927 drawing shows a scheme for pergolas and a fountain cascade
for the second version of the Neptune Pool, begun in 1926.

The pool's second version was in place from 1926 to 1934. The long-
planned cascade was installed at this time, with nineteenth-century Italian
fountain sculptures of Neptune and the Nereids placed on the highest tier.
The bathhouse building behind it contained seventeen dressing rooms.

Eastern and Western influences whose entwined strands
formed the architecture of the Mediterranean.

The Neptune Pool faces west and evokes classical
Rome, the height of Western civilization. It had all the
modern conveniences: The large basin of turquoise-blue
water graduated in depth from three-and-a-half to ten
feet, and the water was filtered and heated to seventy de-
grees with oil-fueled boilers when necessary.[33] Colon-
nades with Composite-style capitals frame wide views of
the ocean and mountain ridges. Neptune, the Roman god
of the ocean, presides over the scene atop an ancient Ro-
man temple supported by first-century granite columns

with Corinthian capitals. The overall mood is of sunny,
sparkling brightness, created by the interplay of blue wa-
ter, green hills, and white marble.

The Roman Pool faces east and evokes instead the
Byzantine culture of the East. It is an homage to the Vene-
tian Republic and the influences that flowed from its trade
with the Orient. Dark and quiet, the pool honors the moon,
not the sun. Moonlike alabaster globes surround its still,
shining water, which is all a single depth of ten feet except
for the area behind the diving platform, where the depth is
almost four feet. The Roman Pool's deep lapis-lazuli blue
color comes from the shining glass mosaic tiles lining its

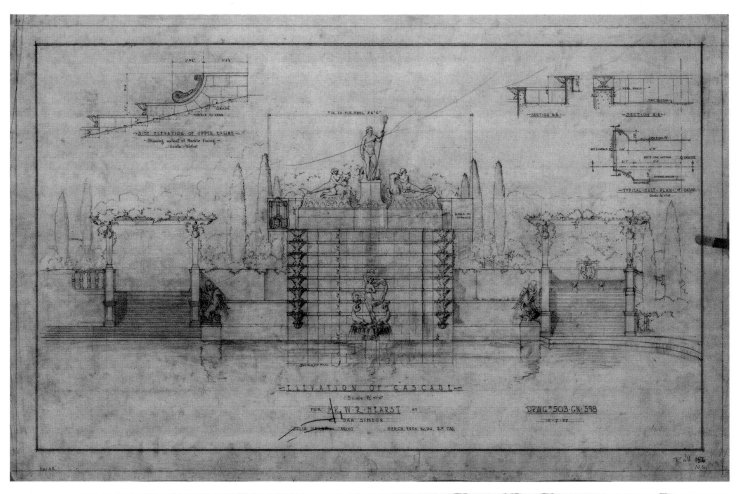

ELEVATION OF CASCADE
For MR. W. R. HEARST at
SAN SIMEON
DRWG # 503 GN 598

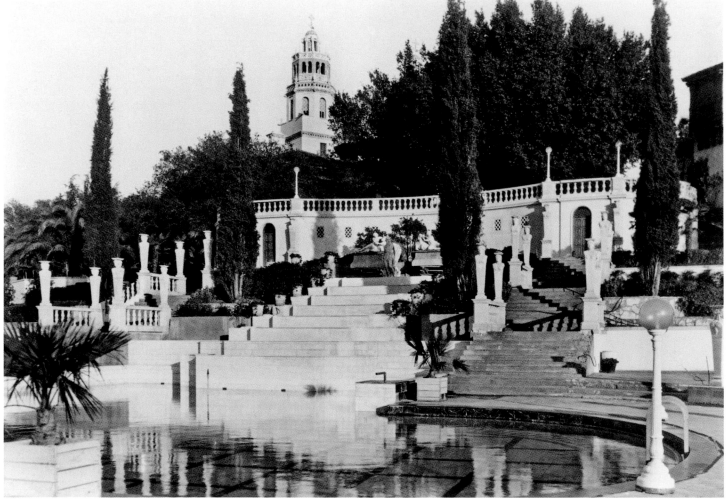

floor and walls. They catch the light, as do the gleaming gold and clear-glass tiles that sparkle among them. The surfaces shimmer like the domed ceiling mosaics of cathedrals and mausoleums in Venice and Ravenna.

Like so much else on the hilltop, each swimming pool started with a simple idea that grew into something much grander. In the earliest years, Hearst focused on creating the pools and fountains sited near the cottages and on the central plaza in front of the main building. His first plan for a swimming pool was for an indoor pool in a Moorish style.[34] Thus the Roman Pool was conceived first, though the early versions of the Neptune Pool were constructed first.

Hearst initially identified the Neptune Pool site as "the hill northwest of [house] C" in March 1921, saying it was "the place where any architectural effect would be best seen."[35] By late 1921 this site had evolved into plans for a rose garden, with a parterre hedge in the shape of a but-

terfly planted with low flowers, which was created in the spring of 1922. Hearst suggested "pergolas on each side of the butterfly," an idea that presaged the twin colonnades built around the pool basin in the mid-1930s.[36]

The two principal ornaments of the Neptune Pool—its Roman temple columns and the statues of Neptune and the Nereids—were acquired in 1922. Hearst wrote to Morgan about a sculpture of Neptune he was considering purchasing from the art dealer French & Co.: "I have been thinking what to do with that Neptune fountain. We ought to use it somewhere. I dont [sic] want too many decoletée [sic] ladies around the grounds and gentlemen as a rule aren't interesting. This Neptune fountain though not beautiful is quaint and although the nymphs are not over attired the dominant figure is an elderly gentleman with whiskers who lends respectability to the landscape—for those at least who dont [sic] know his record." Coming from another elderly gentleman who lent an air of respectability to the landscape, this observation is a good example of Hearst's dry sense of humor. He went on to discuss several possible sites for this statuary group, emphasizing: "he ought to be on the ocean side of the hill." He concluded: "I think I will get him. We can use him <u>somewhere</u>."[37] The following month, Hearst purchased the temple columns from the Sangiorgi Gallery in Rome, writing Morgan: "I have bought this and I thought it might be well to erect it in the rose garden against the trees where we were putting the pergola."[38]

The first real discussion of the Roman temple used in conjunction with a water feature came in February 1923, when Hearst wrote: "In front of the temple I think we should have a fine big pool to reflect it. Around this pool I think we should have our night garden and in the pool some night blooming water lilies." He said in the same letter: "[S]omewhere I would like a pergola or an arbor with grapes growing over it etcetera."[39]

At this time Morgan first suggested one of the Neptune Pool's most distinctive features, the cast-stone lamp standards of female heads, writing Hearst in February 1923:

opposite

Hearst wanted an indoor swimming pool, or "plunge," as early as 1920, when construction commenced on the hill. He intended to place it on the south side and to build it in a Moorish style. The slope of the hill made that site problematic, and in 1927 Hearst decided to build a "winter pool" on more level land to the east.

The Recreation Building, which housed the Roman Pool, was topped by tennis courts. Hearst and Morgan also planned Turkish baths and squash courts behind the basin, but these were never built.

"Would you care to use here the marble shafts with the Roman heads now in the Pleasanton warehouse?"[40] Instead of using historic elements, they modeled cast-concrete ones, basing the design on a first-century B.C. Roman bust in Hearst's collection.

The conception of the cascade came in Hearst's letter of April 1923: "I suggest that the fountain be kept separate from the pool—maybe at a higher level—and be surrounded by seats. From these seats the houses can be seen on one side and the pool and temple on the other. . . . There must be places where people can remain and rest and look. . . . I think [we] should be able to see the reflection of the temple in the pool."[41] Next month, he elaborated on this theme, writing Morgan, "I do not particularly like the idea of reflecting myself in the pool, as I think other reflections would be more scenic—but I do like the general plan."[42]

The idea of a reflecting pool changed to that of a swimming pool at Hearst's suggestion, in response to an upcoming family visit: "I am sending back the plan of the temple garden with the suggestion that we make the pool longer than it is . . . and that we make it eight feet deep so that we can use it as a swimming pool. Mrs. Hearst and the children are extremely anxious to have a swimming pool, and unwilling to wait until we can get the regular swimming pools built down on our Alhambra Hill. Therefore, if it seems practicable, please make this a swimming pool—temporarily at least."[43] Morgan designed a keyhole-shaped pool that was thirty-two by forty-eight feet, and ranged in depth from three-and-a-half to eight-and-a-half feet. Early photographs show a conventional-looking basin with two metal ladders and a brick decking surrounding it. But a closer look shows the Roman temple columns lying on their sides in front of the oak trees on the north, and a platform poured for the site of the Roman temple. The Neptune and Nereids statues were set up opposite the temple, and the cascade was under early construction by 1925. Two large Canary Island palm trees (*Phoenix canariensis*) planted in circular beds provided the framing for the scene (replac-

ing an earlier set of Colonial-style "sentry boxes," to which Mrs. Hearst had objected). Even in this first modest version, a grander scheme was intended.

The second version of the Neptune Pool was poured in the spring of 1926, expanding the earlier basin to a marble-lined oval of eighty feet by thirty-seven feet, augmented by a forty-foot by twenty-five-foot alcove. Its design was influenced by the swimming pool at the Phoebe A. Hearst Memorial Women's Gymnasium at the University of California, which Hearst commissioned Morgan and Bernard Maybeck to build on the site of Maybeck's former Hearst Hall. The Neptune Pool's cascade—planned from the earliest designs in 1924—was completed at this time, with the statues of Neptune and the Nereids placed atop it. This expanded pool prompted the second expansion of the terrace below House C to the west.

Though this version of the pool was in place only from 1926 to 1931, it influenced Hearst and Morgan's decision to build the dressing rooms, first planned inside the Roman temple structure but soon sited east of the cascade. Hearst telegraphed Morgan in September 1927: "Another good place for dressing rooms and perhaps the best place is [the] back of [the] Neptune fountain under the platform we plan to erect beneath the bay tree; there would be lots of space there; depending on how big we make [the] platform; steps could lead from these rooms down into pergolas thence to [the] pool; doors to these dressing rooms would be hidden by fountains and shrubbery." The Neptune Terrace, built on top of the seventeen dressing rooms, gave the guests their first view of the Neptune Pool—a dramatic overlook on the basin, framed by the mountains and ocean beyond. Traditional Italian Renaissance staircases led from the changing areas to the pool and also provided a ceremonial mood, turning the walk down to the water into a descent reminiscent of a Busby Berkeley musical. Hearst and Morgan's interest in completing this second version of the Neptune Pool accelerated the process for finishing the Roman Pool, also under construction at this time.[44]

Inspired by the mosaics of the fifth-century mausoleum of Galla
Placidia in Ravenna, Hearst and Morgan decided to create their indoor
pool in the tradition of an ancient Roman bath and line it in Venetian
glass mosaic tiles.

opposite
Light floods into the Roman Pool building from skylights on the rooftop
tennis courts.

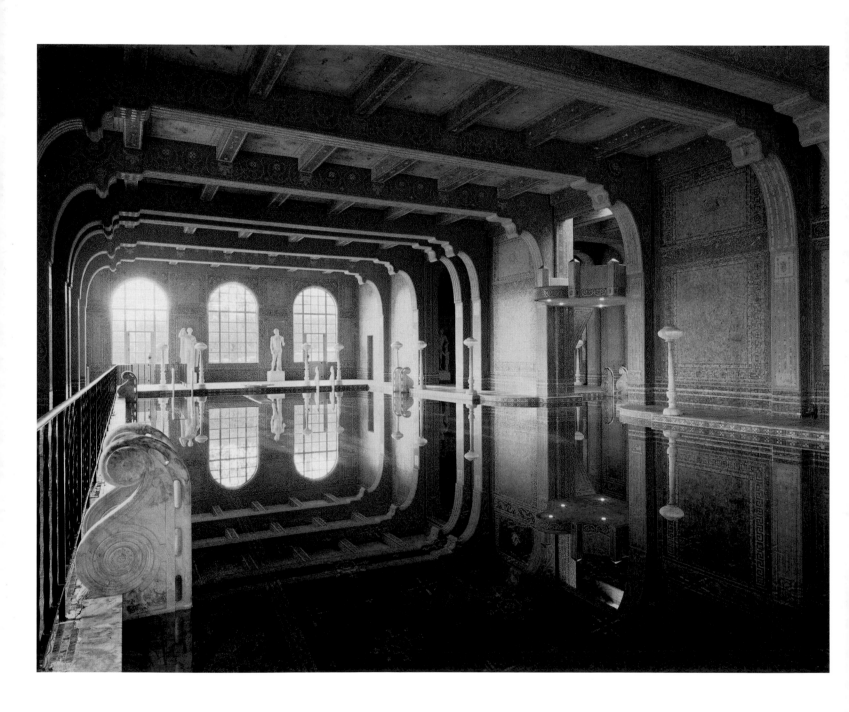

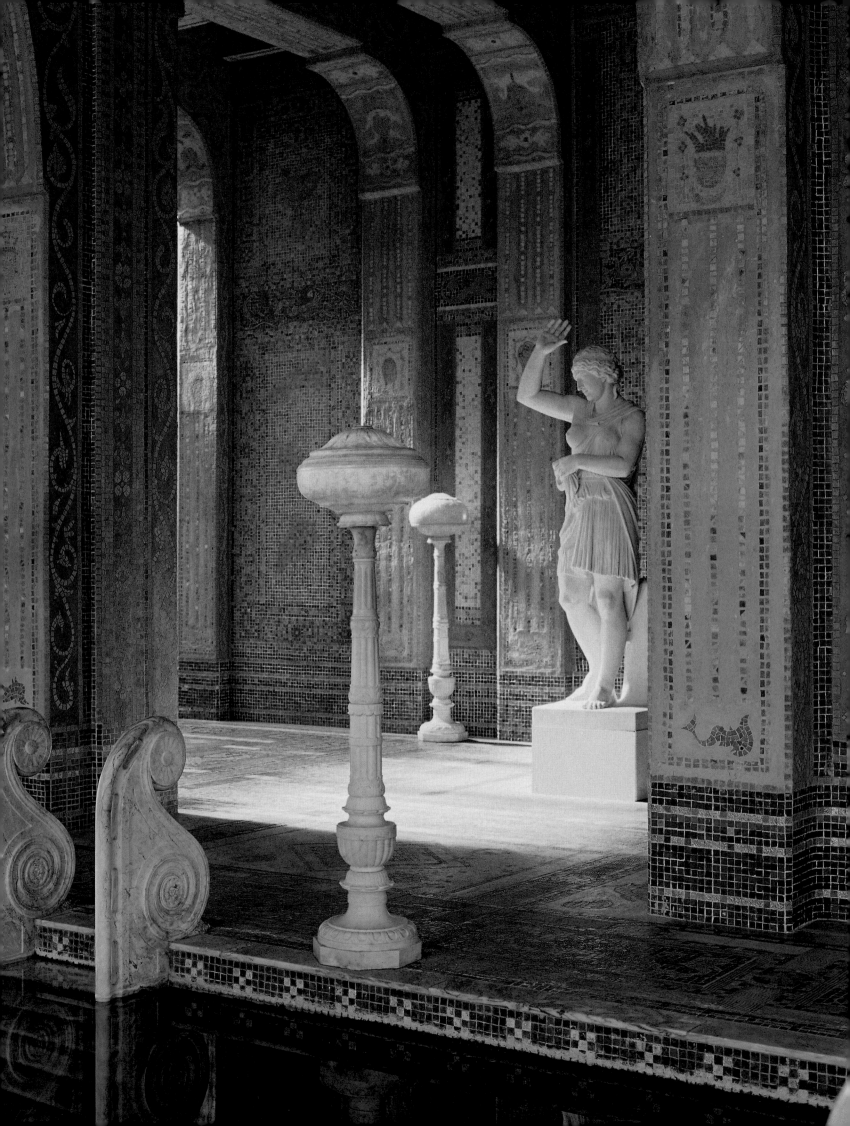

The Roman Plunge, as Hearst and Morgan referred to it, was first planned as a Moorish bathhouse with an antique Spanish ceiling surmounting it, to be located south of House A.[45] Hearst decided to build a saltwater swimming pool—first intended for the hilltop, later for the shoreline at San Simeon—in the spring of 1925. After much discussion it was postponed, due to the difficulties of either pumping saltwater up to the hilltop in the first scheme or sufficiently reinforcing a saltwater pool along the shoreline in the second.[46] Then in April 1927, Hearst conceived of a pool that was also a hothouse: "I have an idea for a winter pool. We could put a big hot-house down where we were going to build the Persian Garden, and in the middle of this hot-house we could have a big pool about the size of our present pool. In the hot-house, sufficiently back from the pool, we would have palms, ferns, and a whole lot of orchids. In fact, it would be mainly an orchid hot-house. . . . The temperature of the hot-house, and of the pool, too, would be warm on the coldest, bleakest winter day. We would have the South Sea Islands on the Hill. . . . We could have a dome over the middle. We would have to use a lot of glass, of course, but it could be green glass; and the iron frames could be gilded; and we could get a good oriental effect. I think the concrete walls could be made fairly high, and we could have latticed windows as in that picture of the harem that we were looking at when discussing the Turkish bath. Towards the sea there should be a big rest room, and a loggia. Here we could serve tea or poi, or whatever the situation called for. The pool, of course, would be the main attraction; and we might put a turtle and a couple of sharks in to lend versimilitude [*sic*]. This, except for the sharks, is not as impractical a proposition as it might seem. It is merely making a hot-house useful, and making a pool beautiful."[47] In the planning stages for both hilltop swimming pools, Hearst followed the philosophy he outlined here: make a utilitarian feature ornamental. The final result in both cases provided the guests with their most indelible memories of the hilltop.

The four-foot-deep alcove stretches behind the diving platform. No evidence exists to indicate that Morgan was an experienced swimmer, but her opulent designs for more than thirty swimming pools during her career suggest that she grasped their sensual potential as participatory architecture.

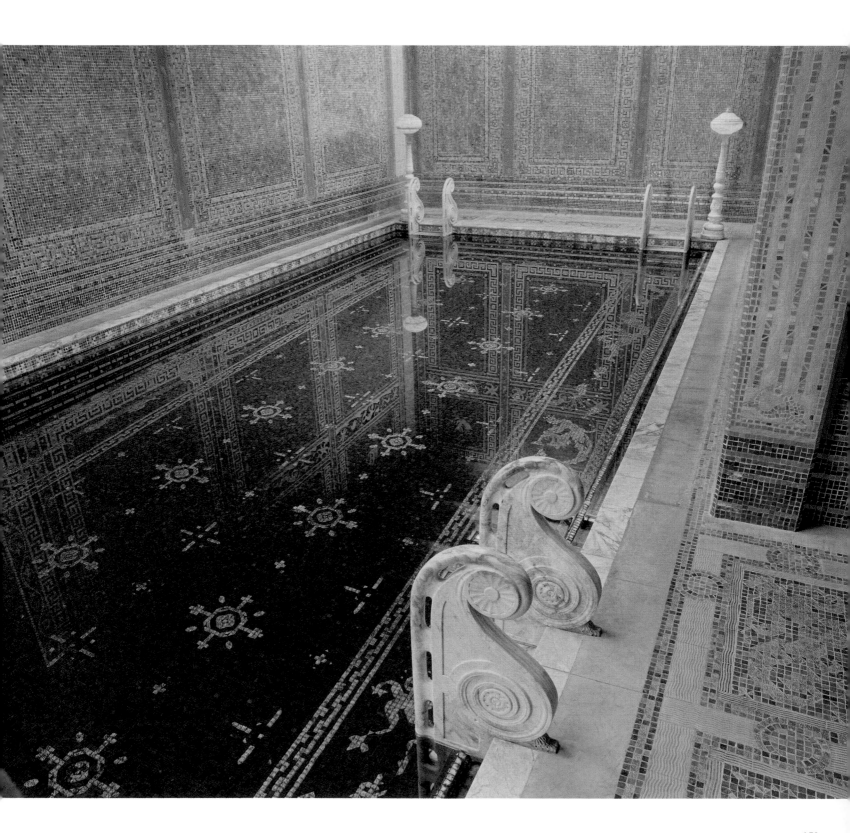

9

Final Plans (1936–1951)

The gardens were planted abundantly through most of the 1930s, in spite of Hearst's worsening finances in the Depression years. In 1934, Norman Rotanzi was hired to work in the orchards under the supervision of Nigel Keep. Rotanzi remained on the hilltop for fifty-eight years, until his death in 1992, providing important continuity for the gardens and a living link with Hearst's era. In 1977 Rotanzi recalled: "Well, at its peak year, we had five greenhouses in operation. We would propagate from 500,000 to 700,000 annuals per year. There was a complete change of the gardens at every season. The proper plants would be put in each Spring, Summer, Fall, Winter. There were large flocks of quail here and Mr. Hearst always carried wheat in his pocket to feed them, and we would go out there and plant maybe 2,000 annuals. The next morning we'd come along and maybe 500 or so would be missing because the quail would pull them out. So one day, Mr. Hearst came by and Mr. Keep described the quail problem to him. Mr. Hearst responded by saying, 'Well, Mr. Keep, I think you'll just have to raise more!' . . . Two of the [five green] houses were display houses for [tuberous] begonias. The other three were regular propagating houses and used for the raising of annuals. We had a great big lath house [where] we would harden the plants off for three weeks or a month before they would be planted out in the gardens."

Hearst's favorite planting arrangement was done in primary colors: tall yellow plants at the back, medium-size blue in the middle, and small red at the front.[1] Rotanzi recalled that when Nigel Keep tried a new planting scheme, Hearst objected: "Well, one time, Mr. Keep, instead of planting annuals in rows, the higher ones in back and graduated down, . . . was going to try out a new English style of landscaping—planting in circles, with the inner circle high and graduated down in lower circles. So we did two acres along the south esplanade. Mr. Hearst came out there, and he asked what all this was about! Mr. Keep told him he was trying out a new style of gardening. Mr. Hearst said, 'Well,

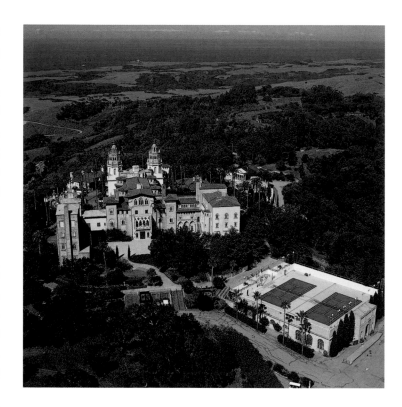

An aerial vista from the east shows the estate's sweeping coastal views and the main building's unfinished rear courtyard.

opposite
This 1990s aerial view of La Cuesta Encantada demonstrates Morgan's early training in axial symmetry at the Ecole des Beaux-Arts. Though the hilltop continued to expand during twenty-eight years of construction, Morgan skillfully kept its various elements in balance. Casa Grande faces due west, crowning the hill at its highest elevation and establishing the major axis. The north-south cross axes are delineated by four Italian eighteenth-century stone vases placed on the Esplanade just below Casa Grande. The starburstlike tops of the Mexican fan palms mark the Esplanade's circuitous path through the gardens. The three cottages are entered from the Esplanade side. The first elements constructed, they were oriented to their respective views rather than to strict axes. The native stands of oak and laurel also provided informal touches to the plan. The north side of the hill is less steeply sloped than the south side, and both swimming pools are therefore located on the north. Graceful steps were built down the hill, often with central fountains as their unifying feature. Every aspect of La Cuesta Encantada's gardens deferred to its incomparable setting between mountains and coastline.

174

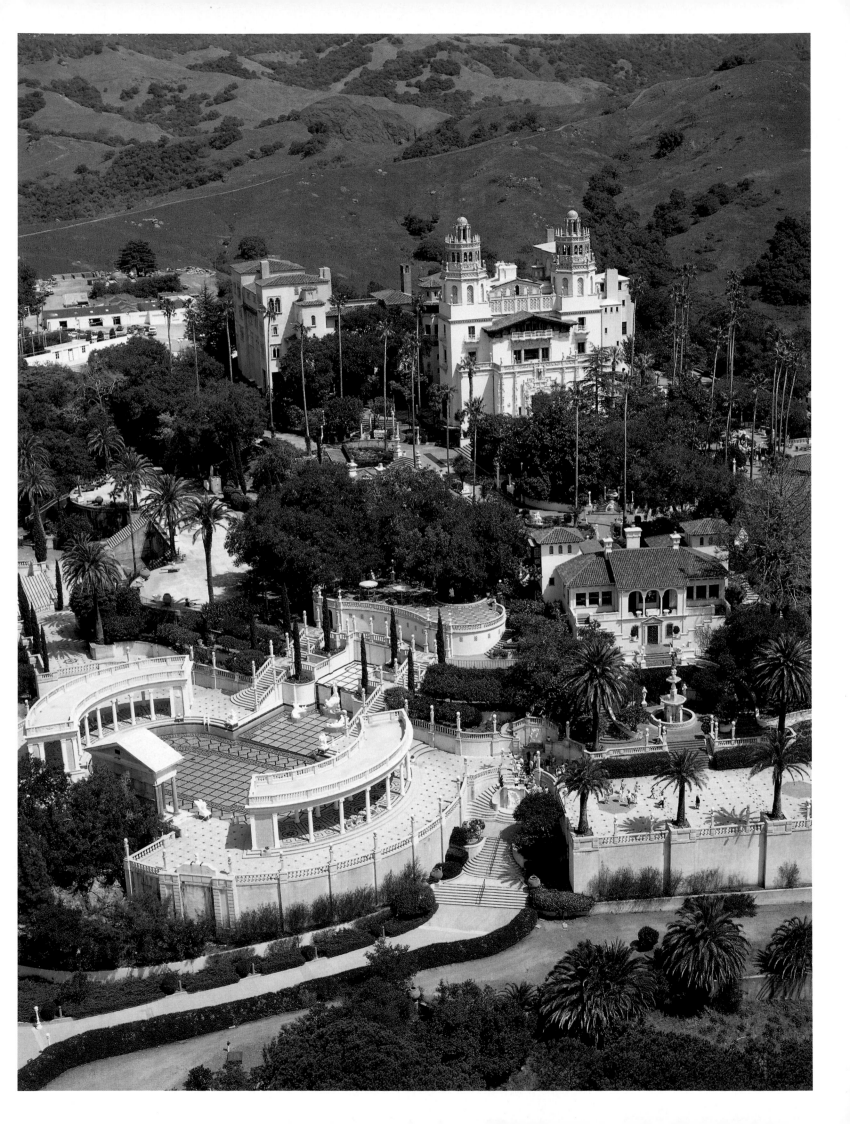

Two Lord & Burnham greenhouses remain of the original five located on the south hillside. There they grew thousands of flowering annuals for the formal garden beds and showcased gloxinias, tuberous begonias, and orchids.

The ranch superintendent's quarters and poultry ranch at the bottom of the hill, south of the senator's house. At the back were extensive buildings for more than fifteen hundred birds: ducks, pheasants, turkeys, guinea fowl, and chickens, many of them rare varieties.

Hearst at eighty-two and his orchardist Nigel Keep at seventy-two, at the Neptune Pool in 1945. Hearst wrote beneath this photograph: "This is a good picture of two very handsome young men."

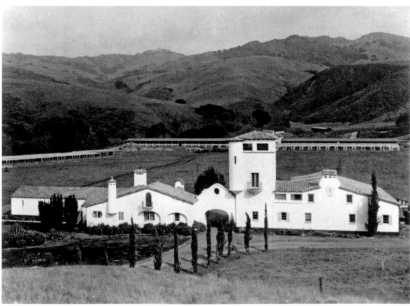

Mr. Keep, I'm sorry to tell you I don't like your new style; go back to the old style!' So we had to take all the plants out and put them back into rows."[2]

Planting schemes were only a small part of Hearst's intentions for the gardens at this time. Hearst and Morgan enlarged the Neptune Pool for the third time between 1931 and 1936, adding the colonnades that had long been planned for the east and west sides; building the Neptune Temple on the north side, placing the Neptune and Nereid statues in its pediment; and increasing the size of its marble basin to 104 feet in length and 98 feet in width. Hearst also commissioned a Neptune fountain group and a Diana fountain group from the Parisian sculptor Charles Cassou,

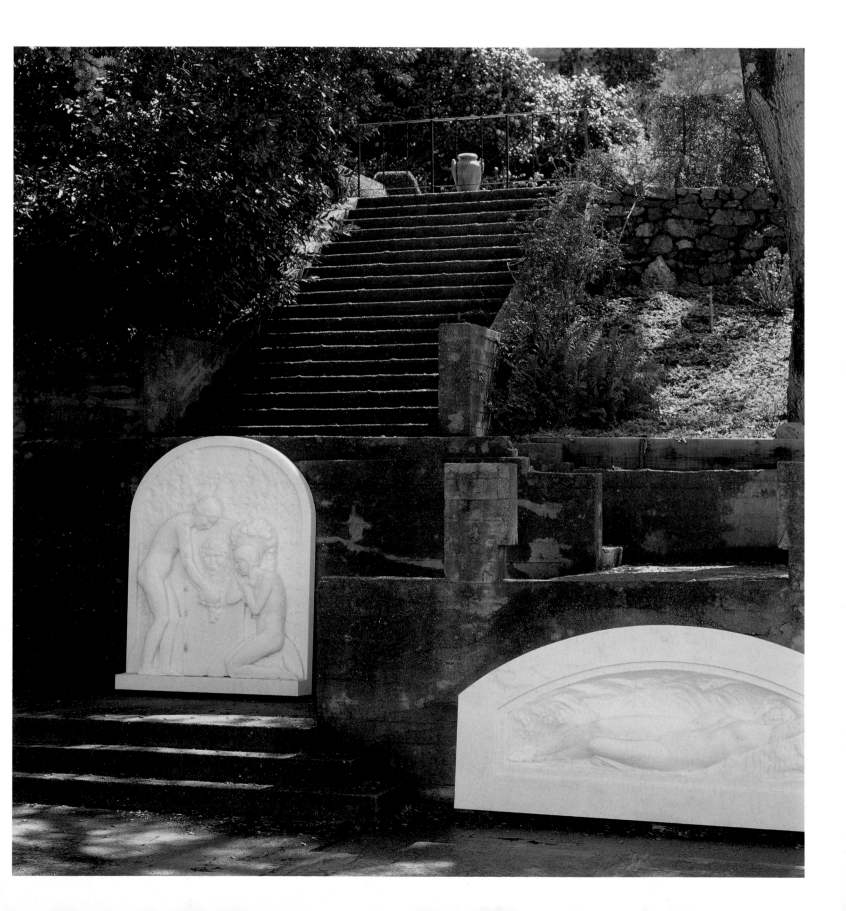

The three cottages were completed by 1924. In 1926 Hearst conceived of two additional cottages, larger and more lavish than their predecessors. Neither was built. These stairs lead to the site of the planned Casa del Canyon (House D), named for its view of the eastern canyon.

The east facade of Casa Grande remains unfinished, its bare concrete still exposed.

Morgan's sketch for a formal entrance at the lower steps of the North Terrace. A large space was poured for a fountain, which was intended to hold a sculpture group by Charles Cassou, but the fountain was never completed.

In 1923 Hearst planned a formal entrance for the east side of Casa Grande, but the presence of many mature oaks and a change in elevation prevented it. He later intended to build an art gallery across the east courtyard, linking the North and South Wings. It was never built, but several design versions exist, including Morgan's 1930 elevation drawing of the central dome.

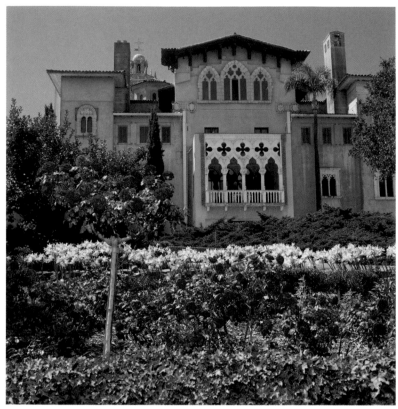

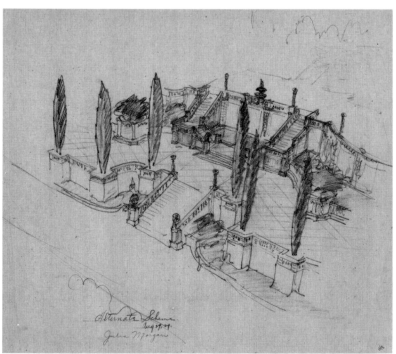

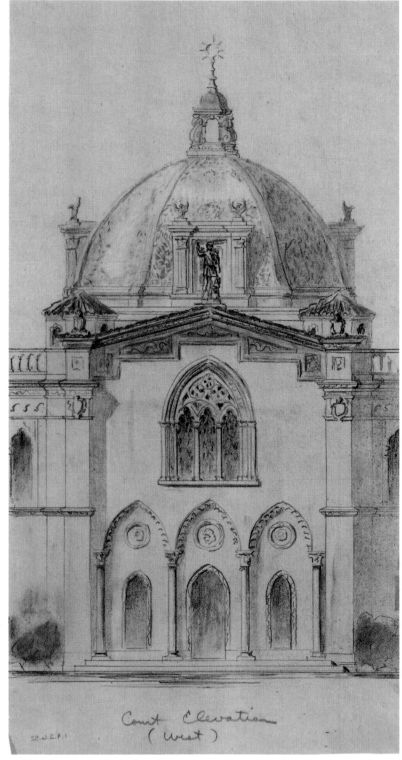

The North Terrace was poured in 1929–1930, covering over two small terraces near House B. It was created to bring the garden terraces closer to the scale of the Main Building, as well as to balance the expanding Neptune Pool. Though its concrete work was finished, planned balustrades and fountains were never completed. A bronze nineteenth-century Spanish mortar and an eighteenth-century French cannon ornament the east end of the terrace.

The Neptune Pool's third version was constructed from 1934 to 1936. Its upper fountain basin opposite the temple still remains unfinished. Its Roman temple facade is a combination of elements from the first to the fourth centuries A.D.—including columns, capitals, and entablature carvings—a nineteenth-century sculpture group of Neptune and the Nereids, and twentieth-century concrete extensions. It was likely inspired by the Temple of Aesculapius at the Villa Borghese, illustrated in Edith Wharton's 1904 volume *Italian Villas and Their Gardens*. The pool's basin is 104 feet long and 95 feet wide, including its alcove. It was heated with oil-fueled boilers for year-round swimming. Part ancient Rome, part Maxfield Parrish, the Neptune Pool shows Morgan's talent for turning disparate elements into an ornamental triumph.

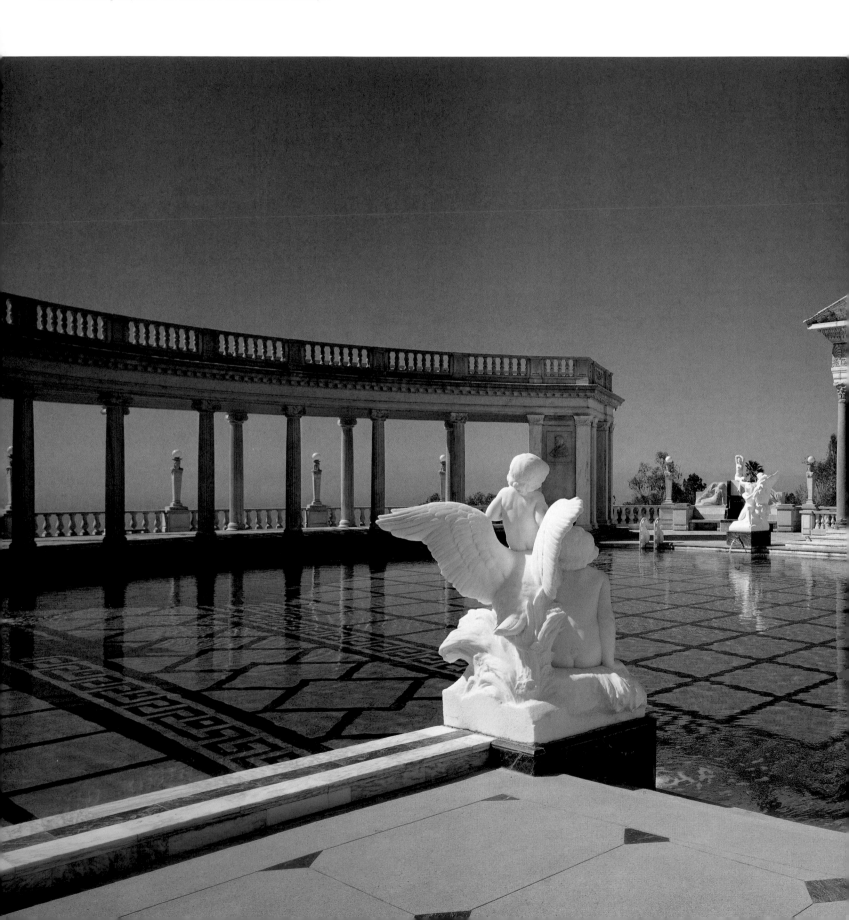

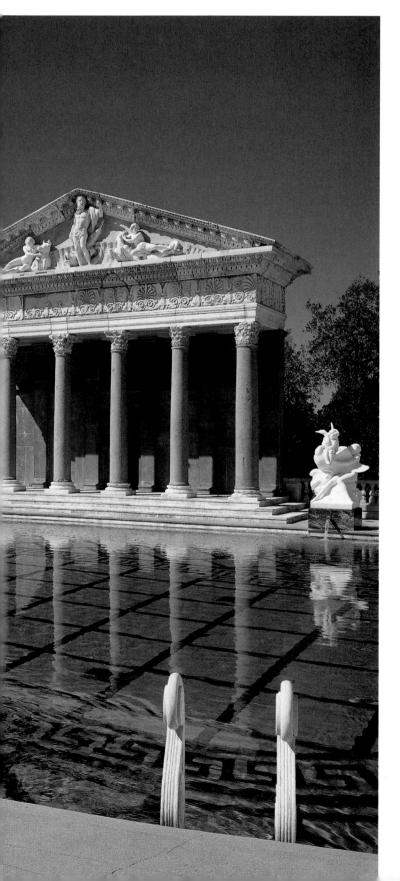

Marion Davies (center) poses at the Neptune Pool with her longtime friend Dorothy Mackaill (left), the actress and former Ziegfeld Follies dancer, and her niece Patricia Lake (right), the wife of actor Arthur Lake.

While the Roman temple facade was under construction, large columns were temporarily erected to flank it, similar to those at the Court of the Universe at the 1915 San Francisco world's fair.

Hearst commissioned Charles Cassou to create *La Naissance de Venus (The Birth of Venus)*. It was placed in the Neptune Pool alcove and flanked by statues of reclining mermaids.

Cupid, the god of love, was the son of Venus and Mars. He sits at his mother's feet in Cassou's ensemble, leaning against a giant seashell supported by tritons.

opposite
These staircases were inspired by the steps of Renaissance villas. At San Simeon, guests descended them, Busby Berkeley-like, to swim in warmed sparkling water. The Neptune Pool was a twentieth-century water feature, designed for participants, not just observers.

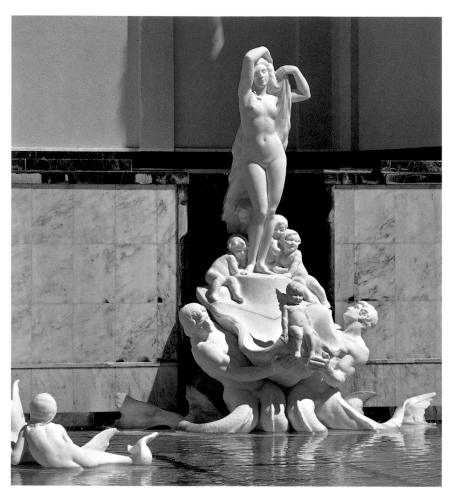

who had created the *Birth of Venus* and *Swans and Nymphs* groups for the Neptune Pool in 1930.[3]

Hearst spent the summer of 1936 in Europe with Marion Davies. Revisiting the great Italian Renaissance villas filled him with new inspiration for the hilltop. He wrote to Morgan from Rome: "One thing which San Simeon really needs is fountains. I mean fountains which <u>fount</u>. The new Neptune fountain should have a torrent of water. There should be a spouting fountain in the middle of the great north terrace in addition to the two night and day fountains on each side. We should and of course will have the big Diana fountain below—but with lots of water. On the

west terrace we should have a large spouting fountain in the middle—or else two on the sides. On the South side we will have to wait until the terraces are built there. But we should consider fountains in connection with these terraces. After seeing the Villa d'Este again I realize what water would do for San Simeon. It would double its beauty and charm. In the midst of a dry land we would have an oasis of beautiful fountains. The work must be done on a grand scale and there must not merely be statuary and basins but <u>water</u>— spouting tumbling water. All that is needed are reservoirs of sufficient size and pumps. I think the best way would be to build reservoirs on reservoir hill. Let the fountains be

The Neptune Pool's bathhouse contains seventeen dressing rooms,
ten for men and seven for women, each with its own stall shower and
changing area. Swimsuits in many sizes were available for guests to
borrow.

should erect at [the] upper gate, at cross roads, at various points on the pergola, and perhaps at [the] reservoir, the statuary and fountains, etcetera, which we can obtain from the old San Francisco Fair."[5] He wrote again the following week: "[T]here was the question of using World's Fair decorations and fountains for the corners between the walls and between pergolas. If we cannot get these, we could devise some simple architectural features of seats and statuary."[6] Hearst was referring to the plaster models created more than twenty years earlier for the Panama-Pacific International Exposition. Having admired them for years, he bought the statues in 1935 from the Palace of Fine Arts in San Francisco, where they were being stored. However, he did not use them on the hilltop.[7]

The Pergola was more than a picturesque landscape feature: it was a place to ride through on horseback. Some of Hearst's ranch hands referred to it as "the covered trail."[8] Hearst inherited his love of art and architecture from his mother, but he inherited his love of horses from his father. George Hearst initially used his San Simeon property near the bay as a stable and built a horse-racing track near the ranch house in 1878. Though W. R. did not participate in the typical Eastern equestrian activities at San Simeon (he did not race or show horses—nor did he fox hunt or play polo), he raised horses, particularly Morgans, Palominos, Apaloosas, and Arabians. He bred his Morgans with his Arabians and is credited with originating the name "Morab" for the new breed.[9] The ranch hands rode quarter horses, stabled both at the bottom of the hill near the airstrip, and in a forty-stall stable east of Casa Grande. These gentle horses carried the guests on trail rides. Hearst usually rode a large Arab mare that stood more than fifteen hands and weighed more than one thousand pounds. He was comfortable riding both English and Western.

The Arabians—which Hearst began to purchase in 1936—were the pride of the ranch. They were kept at the Pico Creek Stables, the most picturesque of three separate stables on the estate, located near the ocean three miles

run by gravity and then pump the water back to the reservoirs on the hill. Enclosed are some photographs of Tivioli. Maybe they will affect you as they did me."[4]

Water had always been scarce on the hilltop. Now Hearst's finances were also in short supply. Nevertheless, while in Europe, he was full of ideas. In the first half of the thirties the terraces on both sides of the Neptune Pool were enlarged and a large fountain for the North Entrance was planned. Hearst wanted to bring La Cuesta Encantada in line with the Villa d'Este at Tivoli—which had the grandest water effects in Italy—by the addition of abundant fountains.

He also wanted to finish the Pergola at this time and to ornament it with sculptures. He wrote to Morgan: "We

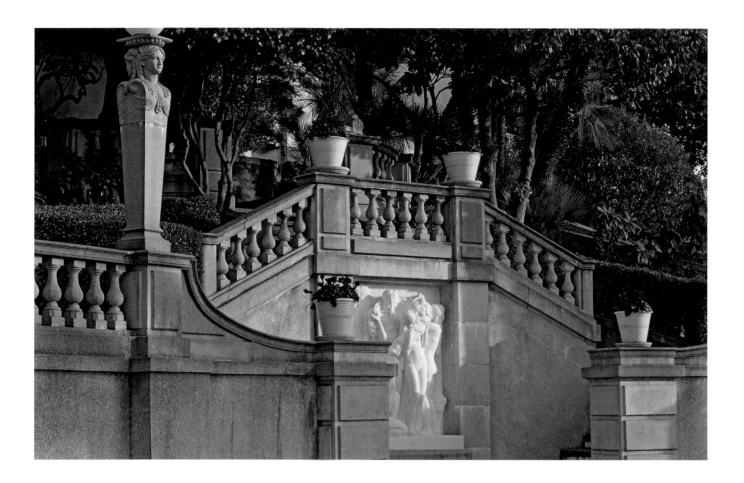

south of San Simeon. In 1946, when the Arabian breed was suffering from too much inbreeding, Hearst financed an expedition to the Middle East to purchase fourteen Arabians—six stallions and eight broodmares—to strengthen the strain. In 1947 the horses arrived safely at San Simeon, having survived an ocean hurricane during their twenty-eight-day sea voyage and a cross-country train trip from New York to California.[10] The most well-known guest to ride with the ranch hands was Will Rogers, who visited frequently in the early 1930s and joined the cowboys on a cattle drive.[11]

In the mid-1930s Hearst was eager to complete many landscape features long under construction, including the fountains, swimming pools, tennis courts, terraces,

and Pergola. But his plans were derailed. In May 1937 Hearst wrote to Morgan: "I have suddenly been called to New York."[12] Four days later, he wrote: "I have got to stop work entirely at San Simeon." Hearst's indebtedness had grown to 87 million dollars, a financial disaster resulting from his years of improvidence colliding with the economic realities of the Depression.[13] Hearst's financial advisor in 1933, Frej Emit Hagelberg, gave some indication of Hearst's chaotic business methods: "When I took over there were 135 separately chartered corporations in the Hearst chain. Whenever . . . someone had a new idea, a new corporation had to be formed. It took me twelve months to forfeit the charters or reduce to impotence all but eight operating companies. There were, at the time, about 25,000

After Maybeck's original Wyntoon burned in January 1930, Hearst commissioned Maybeck and Morgan to collaborate on designing its replacement. Their initial scheme called for another soaring Teutonic castle, with sixty-one bedrooms and a large circular study in the eighth-floor tower. Hearst reluctantly concluded it would be too expensive, and this design was never built.

Hearst instead rebuilt Wyntoon using Morgan's picturesque and more affordable design, still created on a grand scale. Here snow shrouds two of the three cottages—the unfinished Angel House (earlier known as Sleeping Beauty House) on the left and Cinderella House on the right, decorated in 1936 with paintings by artist Willy Pogany telling the Cinderella story.

WILLIAM RANDOLPH HEARST

people on the Hearst payroll. . . . One serious problem I quickly encountered involved the prerogative of Hearst, himself. He owned the common and controlling shares of all his corporations. Whenever he wanted money, his secretary, Colonel Willicombe, merely phoned the nearest Hearst office and specified the amount. The sums were usually substantial. With so many taps through which he could, without notice, drain large sums from the scattered treasuries, it was impossible to establish an effective control over finances."[14]

The resulting 1937 shutdown of hilltop operations was a catastrophe for many of the employees. George Loorz, construction superintendent from 1932 to 1937, wrote to Maurice McClure, a former hilltop employee, in May 1937: "Mr. Hearst and money seem to have parted company. . . . [T]he fact is that the construction on the hilltop will shut down entirely for the first time. . . . He said it was possible that we would start up again in three months but Miss Morgan says no—not this year again. . . . The household is reduced to nearly half. The garden department is cut to half. The orchard crew is trimmed. Two watchmen are laid off.

. . . [I am] deeply grieved for such men as Gyorgy, Frandolich etc. [a painter and a stonecutter]."[15]

San Simeon had changed from a sleepy town in 1915 to a lively estate village in the 1920s and 1930s. Morgan built a Mission Revival warehouse across from the nineteenth-century Sebastian's store in 1930 and also several charming Mission Revival staff houses down on the water for the lead employees: Nigel Keep, Camille Rossi, the elderly Don Pancho Estrada, and others.[16] San Simeon village also contained small residences for other employees (since torn down). Many of these people were thrown out of work when Hearst's difficulties began.

At the same time, another source of commerce was developing in the region. Highway 1 officially opened in June 1937, forming a link between San Simeon and Monterey, and marking the completion of a long-held dream. In 1897, a physician named Dr. John Roberts had walked from Monterey to San Simeon, mapping the land's contours as he went. In 1915, State Senator Elmer Rigdon asked Dr. Roberts to give a talk on the potential coast highway to the state legislature, which appropriated initial funds for the project in 1919. Construction began in 1922 with the grading of six miles of fairly level land near the Piedras Blancas Lighthouse and up to Salmon Creek, the northern boundary of Hearst's coastal property. Progress was slow and sporadic, punctuated by engineering feats such as the construction of the spectacular Bixby Creek Bridge, which when completed in 1932 was—at 714 feet—the longest concrete arch in the West.[17] Highway 1 spans eighty-five miles of coastline and includes thirty-nine bridges, indicating the difficulties of building a highway through a steep and stream-cut landscape.[18]

Loorz wrote to his family after Highway 1's grand opening ceremony, held midway between San Simeon and Monterey: "There certainly is a lot of traffic by here now. A continuous line of cars just as on the other highway [U.S. Highway 101]. The Sebastians have tripled their business I do believe. . . . I really believe a lot of work will come out

of the traffic by here. It is such a long trip from here to the next service place that they should do very well. Somehow it doesn't seem so isolated as before."[19] It never would again. Suddenly the world was able to travel past Hearst's hilltop and continue north to Monterey.

Morgan watched Hearst's financial struggles during this time and wrote him in May 1937: "I wish you would use me in any way that relieves your mind as to the care of your belongings. There never has been nor will there be, any charge in this connection, [it is] an honor and a pleasure."[20] While Hearst faced near insolvency and the liquidation of many of his properties and possessions, Morgan took the rare opportunity afforded her by the work slowdown to travel the Mediterranean in a freighter. Her trip diary (kept from the fall of 1938 through the spring of 1939), recently archived, contains several observations comparing the Mediterranean vistas she encountered with those of the hilltop. She often preferred San Simeon's scenery. In Italy she wrote: "Saw rocky coast & at first thought villages lining shores & up mountain sides [were] white stones, like we see on S. L. O. [San Luis Obispo]—S. S. [San Simeon] road (old land slides) finally saw they were Bldgs—& as . . . we drew near, town after town developed." In Sicily she noted: "The effect from the town center, a lovely circle of park cut into quarters & freely treed [sic] & planted as are all these section gardens, gives same effect as on the upper terrace of S. S.—of being directly over & above the sea—no foreground visible. It is about the same bird-line—(3 miles) but here when you look over the balustrade, gullys [sic] . . . break the des[c]ent to the really level lands of the coast. The S. S. effect is more lovely because more simple."

Morgan's diary shows her great sensitivity to color and craftsmanship and also her quick eye for social drama. Drawn to children and moved by the poverty she encountered in southern Europe in the months preceding World War II, she was also philosophical about her own difficulties. The effects of her facial disfigurement were still evident. She was recognized by a waiter she had previously

The nineteenth-century commercial town of San Simeon gradually subsided into a quiet estate village after Hearst began building La Cuesta Encantada in 1919. Morgan designed houses in San Simeon for high-ranking hilltop employees.

This 1930 duplex was built for Don Pancho Estrada, his daughter, and her husband, Roy Summers.

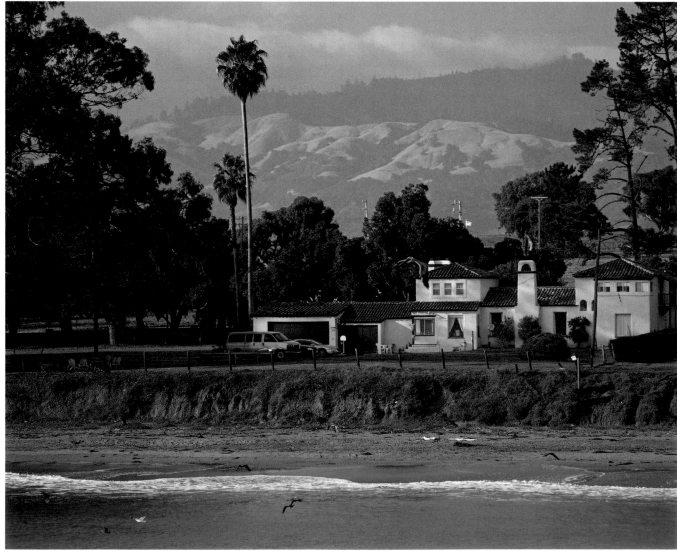

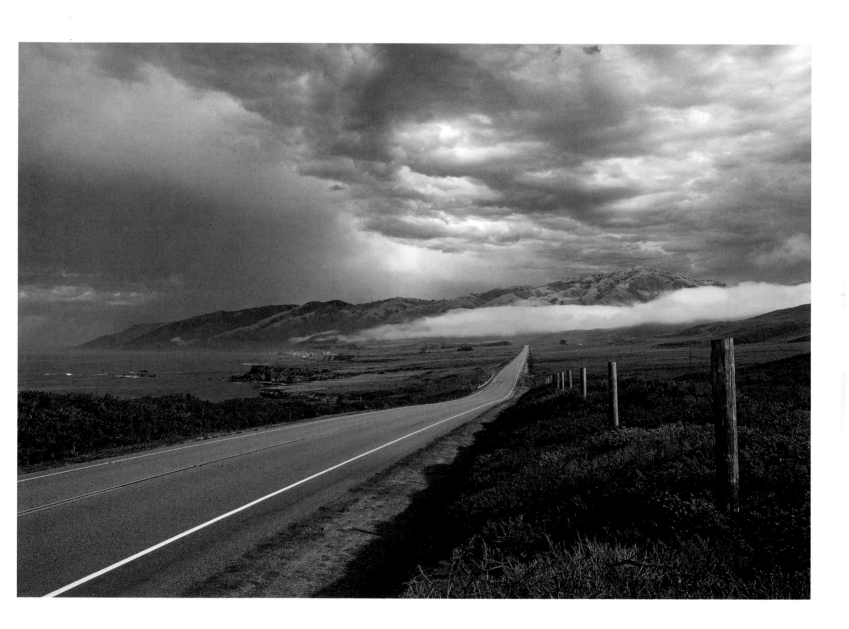

encountered in Naples on a 1935 trip: "The old waiter when
I remarked he must have been here many years replied—
'Yes, I remember you by your crooked face!' No use trying
to fool yourself when there are children or 'foreigners'
around."[21] This European journey coincided with the clos-
ing down of most of her San Francisco office operation.
She wrote to George Loorz in March 1939 on her return: "I
find I must keep busy—have too much strength & too many
ideas to drop out of an active life—Just how & what it will
result in is not clear."[22]

During the war years, Morgan had another great
worry: the disappearance of her favorite brother, Avery.
He appears to have been afflicted with Alzheimer's disease,
as Morgan's mother apparently had been as well. Avery
had wandered away from home at least once before, in
1931, when he was fifty. He did it again in 1943, as Morgan

wrote to a relative of one of her former employees: "As you suspect, my chief concern has been the search for my brother—It is over three months now with no trace of him—not strange perhaps among all the queerly garbed and acting people who have filtered over the state the past two years. His trouble is a species of amnesia which remembers its past but leaves its victim adrift in the normal present—I am hoping with the thinning out of the seasonal labor, we may succeed in locating him." Morgan's biographer, Sara Boutelle, erroneously reported that Avery died in 1940; there is no further record of him after this 1943 letter, and it is very likely that he was never found.[23]

Throughout this period, Hearst continued to make plans for expanding garden features but did not have the funds to act on them. George Loorz wrote to Morgan about Hearst's desire to build an extension to the Pergola, located closer to the house: "I just returned this noon from two days on the Hilltop. I went down in answer to a request from Mr. Hearst thru Mr. Keep. He wanted me to run a survey of China Hill [the nearest hill to the north of the Neptune Pool] and lay out a narrow Pergola Pathway around the hill. It is too far for him to walk to the present one and walking on China Hill is now nearly impossible. He always walks around the hill [China Hill] now on the road which is both dangerous and not too pleasant. I'm certain it was just another air castle but enjoyed the two days in the sunshine."[24]

In December 1940 Hearst sold the Milpitas Hacienda and the northern 153,865 acres of the San Simeon ranch to the United States government for 2.2 million dollars. The War Department oversaw the conversion of the property to the Hunter-Liggett Military Reservation.[25] This construction brought major changes to the area: "And so we watch while the tranquil San Antonio region evolves into a great armed, national defense area; as old settlers who, having steadfastly refused to sell to Hearst now are obliged to sell to the government; as ancestral adobes . . . are moved from the army's way; . . . as the elaborate Hearst ranch house is

converted into headquarters for the military; as the Jolon road eternally seethes with convoys traveling the Valley of the Oaks."[26]

Among the many losses of this period was the sale of a large portion of Hearst's art collection—not the items kept at San Simeon, but pieces from his warehouses and other residences, sold in unprecedented quantities at Gimbel's department store in New York. Hearst put a good face on it in the press, saying, "I am not disposing of all my art collection, only about half of it. The remainder I purpose [sic] giving to museums."[27] Many remained unconvinced. Journalist A. J. Liebling wrote: "Hearst letting go of objects emits a cry leading his handlers to feel like a team of surgeons with an unanesthetized patient."[28]

This well-publicized sale of art objects and property brought Hearst to the attention of many literary figures. John Steinbeck wrote about Hearst and San Simeon in *The*

Grapes of Wrath. The Joads made their way to California in their ancient converted Hudson jalopy, crammed with twelve people and all their possessions. It had been a long and dusty ride from the Oklahoma prairie, but the promised land of California—now gained—was offering them no hope. Along the way, they kept encountering people who were returning to the Dust Bowl because there were no jobs in the California fields. Their very first encounter upon entering the state was with a man who told them of someone who could have been no one other than William Randolph Hearst: "They's a fella, newspaper fella near the coast, got a million acres. . . . Got guards ever'place to keep folks out. . . . I seen pitchers of him. Fat, sof' fella with little mean eyes an' a mouth like a ass-hole. Scairt he's gonna die. Got a million acres and scairt of dyin.'" Casey, the former preacher who traveled with the Joads and served as the Greek chorus of the novel, was swift in his condemnation: "If he needs a million acres to make him feel rich, seems to me he needs it 'cause he feels awful poor inside hisself. . . . I ain't trying to preach no sermon, but I never seen nobody that's busy as a prairie dog collectin' stuff that wasn't disappointed."[29]

There were other voices, also censorious. John Dos Passos wrote in *The Big Money*: "And more and more the emperor of newsprint retired to his fief of San Simeon on the Pacific Coast, where he assembled a zoo, continued to dabble in movingpictures, collected warehouses full of . . . the loot of dead Europe,

"built an Andalusian palace and a Moorish banquethall and there spends his last years amid the relaxing adulation of screenstars, admen, screenwriters, publicitymen, columnists. . . .

"Until he dies

"the magnificent endlesslyrolling presses will pour out print for him, the whirring everywhere projectors will spit images for him,

"a spent Caesar grown old with spending
never man enough to cross the Rubicon."[30]

The Grapes of Wrath and The Big Money preceded Orson Welles's 1941 film Citizen Kane and, along with Aldous Huxley's novel *After Many a Summer Dies the Swan* (about a California millionaire journalist who was afraid of death), were key in shaping *Citizen Kane's* storyline.[31] The film's enduring depiction of San Simeon's landscape came largely in the opening and closing image: a padlocked iron gate, monogrammed with a "K," and the hilltop beyond, brooding and distant. It was not an actual vista but a painted still, done on glass. Kane's estate, known as Xanadu, was pictured as a single-spired, pyramidal form, recalling Mont Saint-Michel. Unlike San Simeon, with its white and sparkling twin towers framed by the rolling mountaintops of the California landscape, this fantasy Xanadu was ominous, dark, and melancholy. The image—which both began and ended the film—affected millions, who thereafter viewed San Simeon through its metaphorical darkness.

A later and less well-known novel devoted many pages to describing La Cuesta Encantada: Upton Sinclair's *A World to Win*, published in 1946 as "Book Seven" of the Lanny Budd series. Sinclair had long been a foe of Hearst's, most notably after Hearst's newspaper empire prevented the socialist Sinclair from winning the race for governor of California in 1934. In this novel, Lanny Budd works undercover as an agent for Franklin Roosevelt and travels to San Simeon to meet Hearst. Sinclair described San Simeon with vivid precision: "[He] had traveled three thousand miles, and here was his destination, the fabulous San Simeon, called 'The Ranch.' It was the ranch to end all ranchos, covering four hundred and twenty square miles, which meant that from the mansion you could ride some fifteen miles in any direction, except out to sea, and never leave the estate. You could ride a horse, as 'Willie' had done all through his boyhood; or if your taste ran to the eccentric, you could ride a zebra, or a llama, or a giraffe, a bison or yak or elephant or kangaroo or emu or cassowary. There were herds of all these creatures on the place, and numbers of central California cowboys to take care of them, and if

The beginning and closing shots of *Citizen Kane* were identical—a padlocked iron gate marked with a K, and Xanadu the distant and lonely edifice beyond. Orson Welles's highly subjective view of San Simeon was the portrait that stuck, though it had little to do with La Cuesta Encantada. It is fitting that the media mogul who slanted stories to suit his own ends should be remembered by a film rather than by historical events. The film was unfair in its cruel depiction of Marion Davies, whose reputation has only recently begun to recover from a caricature now more than sixty-five years old.

a guest expressed a desire to ride one, the cowboys would no doubt take it as a perfectly normal eccentricity of these Hollywood folk. There were also lions and tigers and pumas and leopards in cages, and if Lanny had announced he was a tamer of wild beasts and wanted to practice on these, the host would no doubt have seen to arranging it."

Sinclair described the aging Hearst, eighty-three at the time of this novel: "Here came the master of these treasures, the creator of this Arabian Nights' dream of magnificence. He had been tall and large in proportion, like men of those wide-open spaces, but now his shoulders were bowed and there were signs of a paunch. He had a long face and an especially long nose; his enemies called it a horse face and had made it familiar in cartoons. His strangest feature was a pair of small eyes, watery blue, so pale that they seemed lifeless: no feeling in them at all."[32]

These literary lions predicted Hearst's demise too soon. He spent the war years with Marion at his picturesque northern California estate, Wyntoon, which was considered safer, especially after the Union Oil tanker S.S. *Montebello* was sunk by a Japanese submarine on December 23, 1941, just six miles off the coast of San Simeon.[33]

San Simeon's zoo was largely dismantled during this time, and the animals were donated to other zoos in California. A skeleton garden crew remained on the hilltop under the direction of Nigel Keep.

During the war years, Hearst turned his creative attentions to his large Mexican rancho, Babicora. Morgan traveled there to supervise its construction in 1943 and 1944. It was a frustrating project for the seventy-two-year-old Morgan, though she enjoyed her long journeys by train to the high plateau of Babicora, seven thousand feet in elevation. But during the war, supplies and labor were both short, and her family recalled her saying, "Nobody is left in my office and I can't get any supplies, and how can I do anything?"[34]

An even grander scheme was Morgan's design for a medieval museum, planned for Golden Gate Park in San Francisco and created from authentic twelfth-century monastery stones Hearst had purchased in Spain from the art dealer Arthur Byne in 1931. The ensemble was described in the press as architecturally superior to the Cloisters in New York, which had been donated to the Metropolitan Museum of Art by John D. Rockefeller Jr. in 1938. Morgan drew up plans for a West Coast museum of medieval art, describing the building itself as the chief artifact, "a splendid example of the Spanish flamboyant style." Walter Steilberg was quoted discussing how the various portions of the monastery represented the full range of Gothic style: "The bodega shows its infancy; the refectory its youth; the chapter house its maturity; the chapel and cloister its old age. The refectory and chapter house are, of their period—the twelfth and thirteenth century—as fine as any Gothic building in Europe."[35] But this project too went unbuilt, after a frustrating series of delays that culminated in disastrous fires in 1941 and 1942.

Hearst returned to San Simeon in September 1945, at the end of the war. He was solvent again, after years of economic retrenching. Rotanzi recalled: "[T]here was a big crew brought in immediately, and everything was brought

Morgan and Hearst's last great collaboration was a museum they planned to build in San Francisco's Golden Gate Park, composed of elements from a medieval monastery in Spain that Hearst purchased in 1931. Due to fire damage and political opposition, their West Coast equivalent of the Metropolitan Museum of Art's Cloisters in New York was never built.

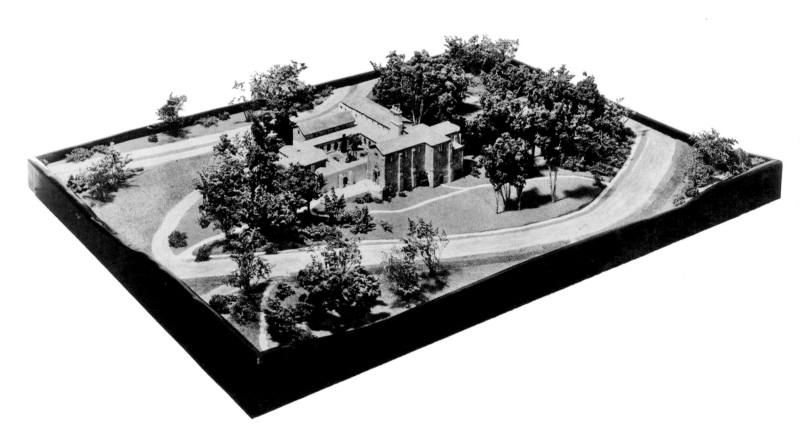

back to the way it was before."[36] In a significant action that hearkened back to the garden's formative days in the 1920s, another mature oak tree was moved in order to accommodate the remodeling of the South (Service) Wing in 1946.[37] Rotanzi noted that it "was moved approximately 25 feet at a cost of $18,000. The operation . . . consisted of six months preparation, cradling it, digging the new hole for it, timbering up underneath it."[38]

After the war, Hearst's attention was not only devoted to the formal gardens. The outlying orchards were also expanded. Rotanzi reminisced: "Today it is difficult to visualize the beauty of Orchard Hill and the Pergola as it was from '47–51. There were almost a thousand fruit trees of different kinds in the Orchard Hill area. In the spring of the year Orchard Hill was just a mass of color and blossoms. The Pergola had a thousand or more grape vines growing up and over it and, on the warm summer days, one would walk through what would seem to be a long and winding cool green tunnel. The areas between the concrete pillars

afforded views over different portions of the terrain. The trees espaliered between the pillars would add their foliage and, in season, their ripening fruit to the visual pleasure of those walking through the area." At least once a week, a car brought Hearst down to the Pergola and he spent an hour or two walking through it. As splendid as it was, he was interested in improving it further. Rotanzi remembered Hearst taking numerous notes on these walks, followed invariably by a memo outlining detailed suggestions of things he wanted done.[39] During that period, Rotanzi worked in the formal gardens. He recalled trimming the lavender lantana in a teardrop shape to cascade over the Esplanade walls. Hearst liked the effect, which has been carried on by the hilltop gardeners ever since.

Hearst lived with Marion in House A after the war. He was eighty-two years old at the time and still making plans for the future. According to his secretary, every night he listened to the same record album with this song by Paul Weston:

This coast live oak was moved in 1946 to allow for the lengthening of the South Wing of Casa Grande. Hearst had returned to solvency during World War II and lived in House A with Marion from 1945 to 1947. At age eighty-three, he watched this tree being moved. It survives today.

opposite
Hearst last saw San Simeon in the spring of 1947, when worsening heart problems caused him to relocate to Beverly Hills. During the last four years of his life, the staff raised food from the ranch and shipped it to him in southern California. He died of a cerebral hemorrhage on August 14, 1951, at the age of eighty-eight.

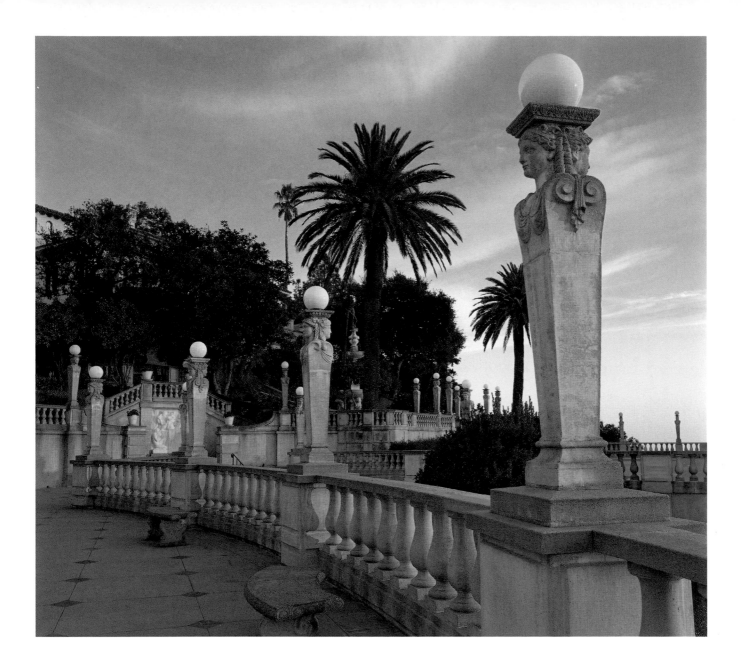

Dream when the day is through
Dream and they might come true
Just watch the smoke rings rise in the air
You'll find your share of memories there
So dream when you're feeling blue
Dream, that's the thing to do
Dreams never are as bad as they seem
So dream, dream, dream.[40]

In the spring of 1947 a worsening heart condition prompted Hearst to relocate with Marion Davies to 1007 Beverly Drive in Beverly Hills. Rotanzi became the head gardener at Nigel Keep's retirement in 1948 and remained in charge of San Simeon's gardens for another forty-four years. The seasonal changeovers stopped, and Rotanzi relied more on flowering shrubs, perennials, bush roses, and climbing roses. With a small force and these changes in planting, Rotanzi managed to maintain the gardens' beauty. La Cuesta Encantada never underwent a period of neglect or decline. Fruit from the orchards was shipped by train to Beverly Hills so that Hearst and Davies could continue to eat the produce from the ranch. Two to four times a year, photographs of the gardens were sent to Hearst, who never recovered sufficient health to return to San Simeon.

There were occasional reports that he would be returning, and the staff remained at the ready, just in case.[41] But Hearst died on August 14, 1951, at the age of eighty-eight, still in Beverly Hills. His love for San Simeon began not long after the Civil War. It ended at the midpoint of the twentieth century. This large span of American history saw much of California's landscape altered unrecognizably—but San Simeon's surrounding hillsides remained almost unchanged and its hilltop gardens abundant, both remnants from an earlier time.

10 The Legacy Continues (1951–2009)

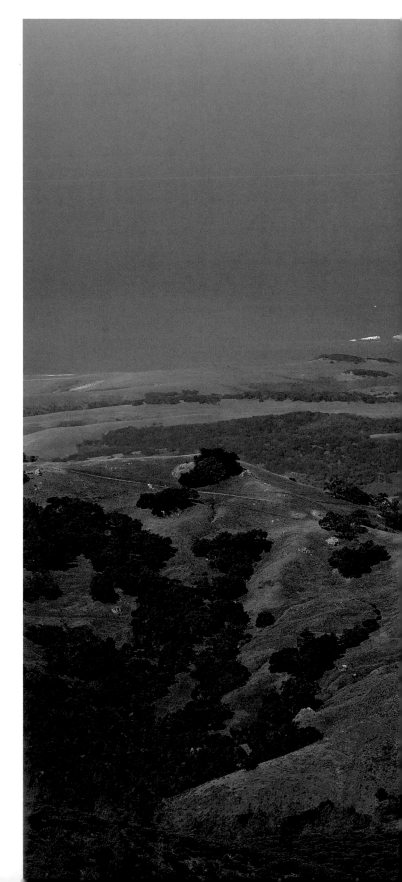

When William Randolph Hearst died in August 1951, the Hearst Corporation owned La Cuesta Encantada as a corporate asset. Hearst's financial retrenchment efforts in the late years of the Depression had been successful, aided by the booming economy during World War II and the nation's vital need for newspapers. His indebtedness of 87 million dollars in 1937 had changed into a surplus of 160 to 200 million dollars fourteen years later.[1] Hearst had his will drawn up in 1947 at age eighty-four. It established three trusts: one for his wife, Millicent, containing six million dollars in nonvoting Hearst preferred stock; one shared among his five sons (the Hearst Family Trust), giving them thirty thousand shares of nonvoting Hearst preferred stock; and the final and largest trust, setting up two charitable foundations still in existence. Hearst's heirs did not hold a controlling interest in the corporation upon his death.[2]

This 1947 will included Marion Davies only in a codicil, giving her ownership of the Beverly Hills house that was Hearst's final home. Late in 1950, however, Hearst had a separate trust agreement drawn up, giving her a far greater inheritance. Marion had lent Hearst one million dollars when he was nearly bankrupt in 1937. They had lived together for three decades, and he may have feared that her interests would be ignored after his death. The Hearst family closed ranks against her in Hearst's final days. Marion stayed away from his funeral at Grace Episcopal Cathedral in San Francisco, where Joseph Kennedy and Bing Crosby were among the honorary pallbearers. In its aftermath, Marion released a thunderbolt: a news scoop she provided to the gossip columnist Hedda Hopper, revealing that Hearst had bequeathed Marion total control over his publishing empire. She inherited thirty thousand shares of Hearst Corporation preferred stock (generating 150,000 dollars a year) and the voting rights for all of the corporate stock. A court fight could have ensued, with the Hearst family contesting Marion's right to inherit

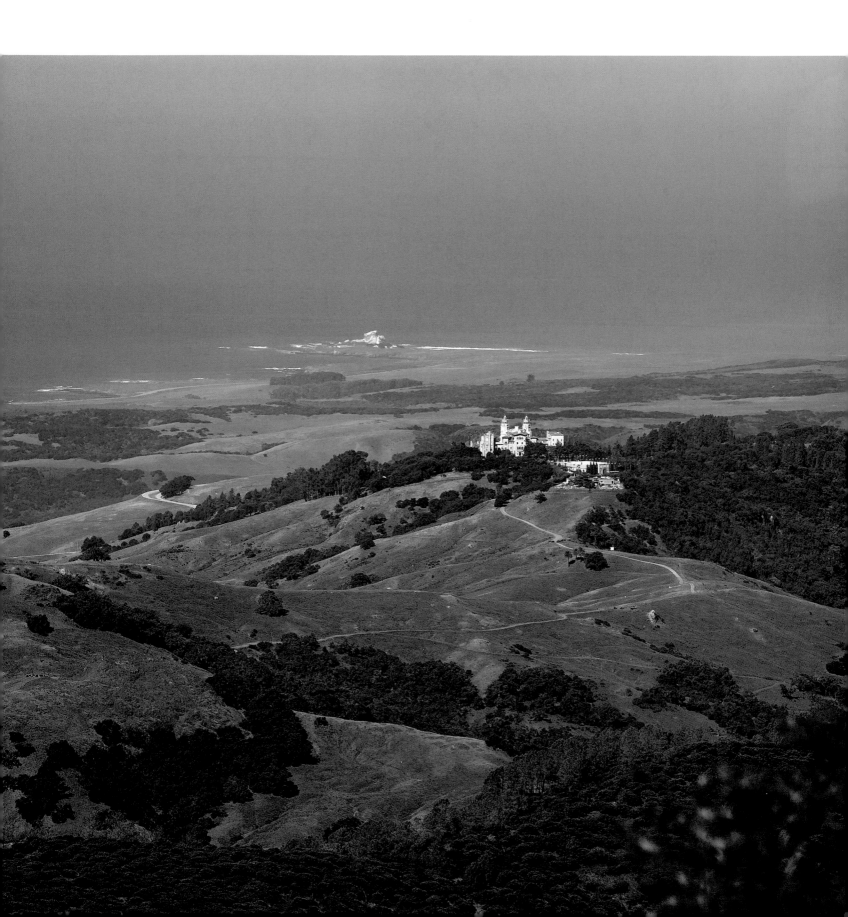

The grandeur of La Cuesta Encantada's coastal setting is best seen in this view from the east.

under California's community property laws. Instead an agreement was drawn up by attorneys for both sides, relinquishing Marion's voting rights for a token payment of one dollar and the ceremonial title of corporation advisor. On October 31, 1951, one day after signing this agreement and ten weeks after Hearst's death, Marion married Captain Horace Brown, a Hollywood stuntman and hanger-on who had briefly dated her older sister. Many described his uncanny physical resemblance to a younger Hearst. They wed in Las Vegas after obtaining a license from an all-night marriage bureau. Marion wore dark blue slacks and a blue sweater for the ceremony. The woman who could truly be described as "always a bridesmaid, never a bride" finally became one, at the age of fifty-four.[3]

Hearst's will included no specific directive about the disposal of La Cuesta Encantada. He intended that the estate would become public, though he put no formal mechanism in place for the transition. The corporation first approached Robert Gordon Sproul, president of the University of California, to explore the possibility of donating it to the university system, long a major Hearst family philanthropy. The University was unenthusiastic, saying it did not serve their purposes as an academic campus. So the corporation approached Newton B. Drury, head of the National Park Service from 1940 to 1951 and chief of the California Division of Beaches and Parks from 1951 to 1959, to discuss its becoming a state park, donated in memory of Phoebe Apperson Hearst.[4]

Jean Paul Getty, who had been Hearst's guest in the thirties, wrote in his 1976 memoir, when the property had already been a state park for nearly twenty years: "I guess I'm like Hearst in that I admire splendour. I like a palatial atmosphere, noble rooms, long tables, old silver, fine furniture. If San Simeon had been closer to a city, I would have offered to buy it in the 1950s. I think the house and 1,000 acres around it might have been purchasable in 1952 for one-tenth its cost. It would have been a marvelous investment, considering the appreciation of property values

W. R. Hearst is interred in the family mausoleum located at Cypress Lawn Memorial Park in Colma, south of San Francisco.

Hearst intended La Cuesta Encantada to be given to the University of California after his death. When the university refused the donation due to financial concerns about its upkeep, the hilltop estate was presented as a gift from the Hearst Corporation and Hearst family to California State Parks. This project, which cost Hearst under 10 million dollars to build and furnish from 1919 to 1947, thus became a priceless museum shared with millions of visitors.

in the years that followed."[5] But by 1953, it was settled that it should be in public ownership. Newton B. Drury drew up a declaration: "The Park Commission has passed a resolution that if the property is officially offered as a gift to the State (as we have an intimation it will be) and if the Legislature passes a joint resolution approving it . . . the Commission favors and will undertake its operation as a state historical monument."[6]

William ("Bill") Randolph Hearst Jr. had discussed the eventual disposition of La Cuesta Encantada with his father. He recalled years later: "Pop had known that the state would probably become its eventual owners. In fact, he wanted to give the place to the University of California. He told me that he would be delighted to have that happen. He didn't believe the company would wish to keep up the expense of the complex, particularly because it would no longer be a working part of the firm, and thus would be an added tax expense. Neither of us related these thoughts to anyone because it was not time to suggest he might be leaving. He was very serene about it. I remember rising from the conversation and being a little weak at the knees. He was smiling, however, and I knew that he had long reconciled himself and was pleased that so many people would one day enjoy the place."[7]

The transition from private house to public monument was bittersweet for Hearst's five sons, their families, and friends. David Niven wrote about the last weekend, when he and his wife were guests of Bill and Austine Hearst: "Except for the giant great hall with mammoth logs blazing for the last time, La Casa Grande was dark and cold, so the four of us were housed in the largest . . . 'cottage.' . . . For a few days we explored and played tennis and remembered the tournament organized with such helpful partners as Helen Wills, Bill Tilden, Fred Perry, and Alice Marble. We hiked and pretended we enjoyed ourselves, but Bill was obviously weighed down with a deep sadness which affected us all. . . . In silence, William Randolph Hearst Jr. drove us down the road from the Enchanted Hill."[8]

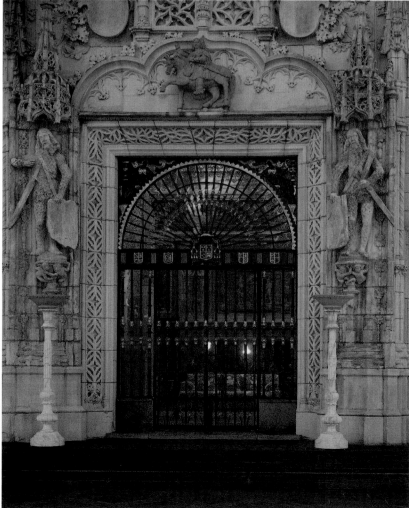

Bill Hearst Jr. wrote a syndicated newspaper column about the donation: "I am writing this column, sitting at my father's desk in his study on the third floor of his big castle at San Simeon. Out of the window I can look over the brown hills rolling miles down to the Pacific—1,500 feet below. At the horizon, the water blends into the lighter blue of the sky. My heart is heavy and aching and the beautiful panorama gets blurry once in a while, as I know this is the last time that we shall ever come here as our home. Later this year the castle and all of its treasures and lovely gardens will be given to the State of California, and from next summer on it will be open to the public to come and see and admire. . . . On the wall of my father's bedroom next door is the following quotation from Sir Edward Bulwer Lytton's 'The Lady of Lyons,' which could have been written about this place:

> A palace lifting to eternal summer
> Its marble walls, from out a glossy bower
> Of coolest foliage musical with birds.
> And when the night came—the perfumed light
> Stole through the mists of alabaster lamps,
> And every air was heavy with the sighs
> Of orange groves and music from sweet lutes,
> And murmurs of low fountains that gush forth
> In the midst of roses.

". . . For, to me, the place will always be Pop's master work, representing him as much or more than any of his newspapers or magazines or better known accomplishments. . . . I feel Pop's presence very strongly here—every block of stone, every piece of wood, every flower, every tree is here because he put it here. . . . I will miss living here as I miss him."[9]

Julia Morgan died at the age of eighty-five on February 2, 1957, just a few months before Bill wrote those lines. Marion Davies and Millicent Hearst were both still alive. It is unlikely that Morgan was aware that La Cuesta Encantada was to become a California State Park, since by this time she too was affected by the memory loss that had ravaged both her mother and her brother Avery. Frustrated by her growing forgetfulness, Morgan took measures to isolate herself in her final years. Her family related how she dismissed her long-term housekeeper and hired a stranger. Her nephew Morgan North and his wife, Flora, were busy with child-rearing. They spoke twenty years later of their regret at not seeing Morgan more often.[10] She "simply turned her face to the wall of her small bedroom, closing out the world," wrote her biographer, Sara Boutelle.[11] Walter Steilberg emphasized that Morgan knew the estate would eventually be viewed by the public: "She said, 'Of course, this is just temporary for his use. The country needs architectural museums, not just places where you hang paintings and sculpture.'"[12]

Marion Davies died of cancer of the jaw in September 1961, at the age of sixty-four. Marriage had given her the respectability she had never known in her thirty-two years with Hearst, but her relations with Horace Brown were often stormy.[13] In 1952, she began to tape a memoir, only a portion of which was ever published.[14] Marion described the hilltop: "When I first saw San Simeon, those back wings were finished and the hall part was completed. It was an awesome thing. I'd seen Versailles and palaces in Europe, but nothing could compare. San Simeon is so beautiful, with the view of the mountains and the ocean." She urged Hearst to donate it to the people of California: "He took great pride in San Simeon, watching over it and inspecting it. . . . W. R. asked me what he should do with San Simeon, but I wouldn't discuss it. I said, 'If you're talking about fifty or sixty years from now, I'll give you an honest answer. You should give it to California, as a museum.'"[15]

Millicent Hearst died in New York on December 5, 1974, at the age of ninety-two, having borne with grace the irregular circumstances of her marriage to William Randolph Hearst. She lived twenty-three years after Hearst's death and was active in many charities. Bill Jr. saw his par-

In 1931 Charles Cassou created three marble sculptures for San Simeon's North Entrance: Diana with deer and maidens in the center, flanked on the left by a nymph and the sleeping shepherd Endymion, and on the right by nymphs and a kid goat. They arrived in 1934–1936 from Paris but were not permanently installed on site. In 1956 Forest Lawn Memorial Parks purchased the sculptures and relocated them at the entrance gates of their Hollywood Hills cemetery.

Forest Lawn Memorial Parks also purchased this marble sculpture group of Neptune and other figures, carved by Charles Cassou for the upper basin of the Neptune Pool but never installed. It remained in Paris due to shipping restrictions during World War II. It was irreparably damaged in 1956 during a fire on the Brooklyn docks, which sparked a series of explosions.

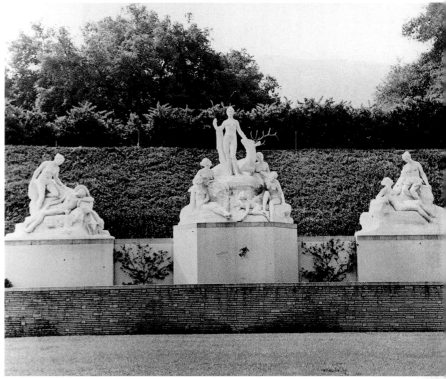

ents' separation not only as an indication of his father's love for Marion Davies but also as a sign of Hearst's attachment to San Simeon: "Mom loved her native New York. . . . As the years went by, the city and its leaders became less attractive to our father. Pop never entirely left the West. As his news organization became national and his eastern political battles rose in intensity, his love for San Simeon and California began calling him back. Mom liked California, but she never envisioned living there full-time. I've reflected on the reasons for my parents' separation for more than a half-century and have finally concluded that our father wanted to preserve the family name and tradition above any and all considerations. So did our mother."[16]

In 1956, during the transitional period before the estate opened to the public, more than a dozen sculptures that had been displayed in the gardens in the 1920s and 1930s were sold to Forest Lawn Memorial Park. Founded in 1906 in Glendale as a conventional cemetery, it was transformed in 1917 when taken over by Hubert Eaton. After attending the San Francisco world's fair in 1915, Eaton decided to create a pastoral memorial park with art as its theme. The old tombstones were removed and replaced by bronze plaques at ground level. Reproductions of famous Renaissance statues and sentimental contemporary sculptures mingled together, dotting the grassy hillsides. Uplifting music issued from speakers concealed in the tree stumps. Chapels modeled on British and Italian originals provided spots for solace and reflection, in recognition of Eaton's belief in "a happy eternal life."[17] Evelyn Waugh's Whispering Glades cemetery in his biting 1946 novel *The Loved One* satirized Forest Lawn's combination of commerce and cultural uplift.

In the mid-1930s, Hearst had commissioned Charles Cassou (sculptor of the Neptune Pool statues) to create three large marble sculpture groups of Diana, the sleeping shepherd Endymion, and forest nymphs for a fountain on the north side of the estate, adjacent to the Neptune Pool. Its large empty basin remains on the hilltop, a remnant

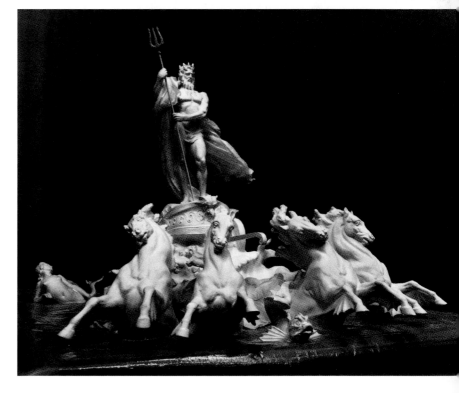

Here Governor Goodwin Knight is joined by members of the Hearst family at the historic ribbon cutting on June 2, 1958.

Laurence Olivier played the Roman general and patrician Marcus Licinius Crassus in *Spartacus*, the 1960 film about a Roman slave uprising with Kirk Douglas in the title role. The Neptune Pool served as Crassus's Roman villa. It was the only time the hilltop was used as the setting for a commercial motion picture.

of Hearst's plan to build "fountains which _fount_" on the hill.[18] These sculptural groups were eventually installed at the entrance gates to the second Forest Lawn, established in 1948 in the Hollywood Hills. A sadder ending awaited the largest sculpture group commissioned for San Simeon, also created by Charles Cassou, a massive eighteen-thousand-pound marble group depicting a standing Neptune driving a chariot, pulled by four rearing white marble sea horses. The statues were intended to ornament the upper basin of the final expansion of the Neptune Pool, but because of shipping restrictions during World War II, they did not leave Paris until after Hearst's death. Forest Lawn purchased the ensemble, but while it was sitting on the Brooklyn docks in December 1956, a five-alarm pier fire broke out, destroying the pieces. Detonators exploded in the flames, causing ten fatalities, nearly three hundred injuries, and more than 15 million dollars in damage. Cassou was nearly eighty at this time, too frail to sculpt a replacement.[19]

On May 21, 1957, Bill Hearst Jr. and Richard E. Berlin, then president of the Hearst Corporation, sent a telegram to California's governor Goodwin J. Knight offering to donate approximately 120 acres of the hilltop, plus a thirty-acre staging area at the bottom of the hill. An easement allowed for the passage over the ranchlands to the hilltop, and a Visitor Center was built south of the original entrance to serve as the public staging area. The gift deed included the provision that the estate remain unfinished, in homage to Hearst's ongoing plans for expansion. *Life* magazine gave the public its first widely circulated glimpse of San Simeon's splendor when it featured the Neptune Pool as its cover photograph.[20] The official date of the gift-deed transfer was January 30, 1958, and opening ceremonies occurred on June 2, 1958. Governor Knight flew in to preside, and the Hearst family and members of the California state legislature participated in the formal ribbon-cutting. Hearst San Simeon State Historical Monument opened for tours that afternoon.

Hearst had always aimed his media empire at pleasing the general public rather than the intelligentsia—and San Simeon was a similar popular success. Hundreds of people were turned away daily, and plans to close the Castle in mid-October 1958 for the off-season were canceled. Postwar art critics were generally scathing about the Castle's art collection and architecture, but visitors continued to pour in, the millionth one arriving in 1961. Though the gift deed specified no commercial use of the estate, one exception was allowed for the 1959 shooting of short scenes of *Spartacus* at the Neptune Pool. In the only instance when the estate was used as a commercial film set, Sir Laurence Olivier and Kirk Douglas starred in the story of a Roman slave uprising. Throughout this era, Norman Rotanzi oversaw the garden staff. Though not landscaped as abundantly as in Hearst's time, the gardens were well maintained. The Pergola and orchards, however, were not as well cared for. These sites were not included in the gift deed, and the

La Cuesta Encantada freely mixes Spanish and Italian elements. In this view a pair of sixteenth-century Spanish limestone lions overlook a modern reproduction of Donatello's *David*.

The buildings of La Cuesta Encantada sit amid thousands of acres of countryside, an improbable homage to southern Europe along California's coastline. Equally improbable is the sight of cattle and zebras grazing together at the ranch.

plantings began to deteriorate from lack of maintenance soon after the Castle opened for tours.[21]

After Hearst's death, La Cuesta Encantada established itself even more firmly in the cultural pantheon—both high and low—for the excesses of its art collection. P. G. Wodehouse included San Simeon in an incident in his 1953 novel *The Return of Jeeves*. The ever-resourceful Jeeves counseled an American heiress who loved a British country house, but not its soggy climate:

"Very good, madam. Might I venture to ask, madam, if you and Captain Biggar will be taking up your residence at the Abbey?"

Mrs. Spottsworth sighed.

"No, Jeeves, I wish I could buy it . . . I love the place . . . but it's damp. This English climate!"

"Our English summers are severe."

"And the winters worse."

Jeeves coughed.

"I wonder if I might make a suggestion, madam, which I think should be satisfactory to all parties."

"What's that?"

"Buy the house, madam, take it down stone by stone, and ship it to California."

"And put it up there?" Mrs. Spottsworth beamed. "Why, what a brilliant idea!"

"Thank you, madam."

"William Randolph Hearst used to do it, didn't he? I remember visiting at San Simeon once, and there was a whole French Abbey lying on the grass near the gates. I'll do it, Jeeves. You've solved everything."[22]

In a more esoteric tone, W. H. Auden in 1962 wrote "Thanksgiving for a Habitat," a poem about "territory, status, and love," prompted by Auden's purchase of a country house in Austria. The poem explored the nature of ownership, including this meditation on Hearst and San Simeon:

Only a press lord
could have built San Simeon: no unearned income
can buy us back the gait and gestures

to manage a baroque staircase, or the art
of believing that footmen don't hear
human speech[23]

Less common is any analysis about San Simeon's landscape itself. It was not until the 1980s that critics began weighing in on this aspect. Robert A. M. Stern wrote approvingly of the site and structure in 1986: "San Simeon was like a museum of architecture, its treasures subsumed by the Spanish and Spanish Colonial architecture—a not inappropriate choice of style, given the castle's location along the coast between important missions at San Luis Obispo and Carmel."[24] The Castle's Mediterranean Revival style drew censure from Witold Rybczynski in 1989: "Despite his architect Julia Morgan's skill and the beautiful landscaping, we remain unconvinced. What is this Italian villa doing in the California Coastal Range? . . . [T]his indiscriminate assortment of architectural fragments makes sense only as a costly piece of theatrical decor, a make-believe setting for the make-believe heroes and heroines whom he entertained. . . . A building that ignores its context . . . lacks a crucial ingredient—meaning."[25] In 2007, Rybczynski declared San Simeon to be a "Vizcaya-on-the-Pacific," referring to the 1917 Italian villa constructed on Biscayne Bay in Miami for International Harvester magnate James Deering. Rybczynski conceded that San Simeon contained "some beautiful parts, [but] it remains a flawed work of architecture," due to the lack of a moderating influence like that exerted by Vizcaya's decorator and chief designer, Paul Chalfin. Rybczynski did not mention San Simeon's landscape in this most recent evaluation.[26]

Norman Rotanzi began working in the hilltop orchards in 1934, was promoted to head gardener in 1948, and oversaw the gardens until his death in 1992. His fifty-eight years of devotion ensured that the estate remained beautiful during its transition from a private residence to a public monument. Due to Rotanzi's care, Hearst Castle's gardens retain far more historic integrity than many other estate gardens. He was responsible for trimming the trailing lantana (*Lantana montevidensis*) into the distinctive teardrop shape seen today.

Peace roses climb on House A. This rose was named to commemorate the end of World War II. The Hearst family continued to occupy House A until the mid-1970s.

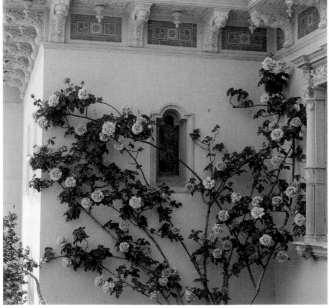

One of the well-known features of the current landscape, and an ongoing link with Hearst's era, is the estate's self-sustaining population of about fifty zebras, some of them descended from Hearst's original zoo.[27] Bill Hearst Jr. took partial responsibility for their presence: "I remember the time after Pop's death when a lot of the zebras, which had roamed free, were to be sold to an animal dealer. They were penned in preparation for being trucked away. We had been having great rainstorms at the time, and many of the foals were up to their bellies in mud. Austine and I slipped down to the pens and freed the lot of about twenty. We knew that Pop would have approved."[28]

Hearst would also have approved of head gardener Norman Rotanzi's faithful tending of the gardens, which continued for fifty-eight years, until his death in 1992. Rotanzi quoted a Hearst maxim, "The time for a man to retire is when God retires him," and walked daily through the Castle gardens until his eighty-fifth year, with his dog, Daphne, trotting along behind him.[29]

In the half-century after Hearst's death, the hilltop trees grew much larger, with many "volunteers" —particularly in the orchards and outlying areas—obscuring views Hearst and Morgan had carefully preserved. In 2004 a Cultural Landscape Report was commissioned in collaboration with the National Park Service, California State Parks, and the Frederick Law Olmsted Center for Landscape Preservation. This history of the Castle gardens includes an inventory of existing conditions as well as recommendations for future treatment, creating an ongoing restoration plan to ensure that the gardens will maintain their original character as they age. Future preservation possibilities include the restoration and relandscaping of the Pergola, currently in decay. An additional potential project is the decommissioning of the northernmost 153,000 acres of the Hunter-Liggett military base, sold by Hearst to the federal government in 1940. Its transfer to the ownership of California State Parks would represent the preservation of nearly all of La Cuesta Encantada's original 250,000 acres of ranchland.

Bed A-8, as it is known, is located between House A and House C. Its parterres, defined by small Japanese boxwood hedges (*Buxus microphylla japonica*), date from the late 1920s. A Cultural Landscape Report was completed in 2008 in collaboration with the National Parks Service and the Olmsted Center for Landscape Preservation. The on-site garden restoration is being overseen by the Hearst Monument's head groundskeeper, Christine Takahashi.

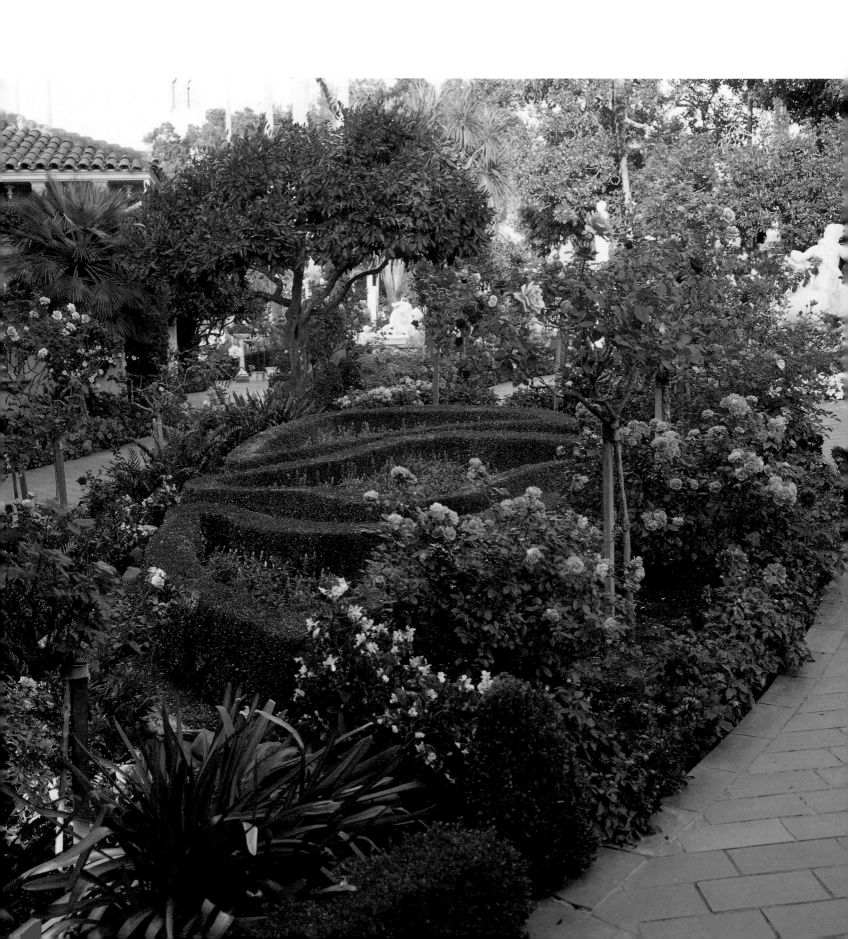

Hearst sold more than 150,000 acres of his northern ranch property to the federal government in December 1940. The army built Fort Hunter-Liggett on the site and turned the old Milpitas Hacienda into the officers' club. In the future it may be possible to transfer ownership of this landscape to California State Parks, meaning that virtually all of Hearst's original 250,000-acre ranch would be intact once again and preserved.

below
Due to water shortages and its exclusion from the original 1957 gift deed, the Pergola area has deteriorated. It has the potential to be restored to its role as one of the estate's most spectacular garden features.

These ambitious goals seem more possible because of a recent remarkable success: the permanent preservation of more than 80,000 acres of Hearst's San Simeon ranch. This process took more than forty years and was completed only in 2005. In 1964 A. Jack Cooke, then vice-president of the Hearst Corporation, announced a plan for developing eight villages along fifteen miles of San Simeon's coastline. With an anticipated population base of sixty-five thousand, the development plan included a yacht harbor, an airport, a convention center, an eighteen-hole golf course, a two-hundred-bed hospital, eighteen to twenty churches, eleven elementary schools, three junior high schools, three high schools, one or two private schools, and a college site. Approximately sixty thousand acres of the ranch were to be held back as a wildlife preserve, equipped with backcountry hunting lodges accessible only by pack train or helicopter. This scheme was presented to the county planning commission, which gave it their tentative approval but did not put it through a formal review process.[30]

The proposed development was not built, most probably because of the region's chronic water shortages. In the 1980s the Hearst Corporation started planning a resort, which by 1997 included a 650-unit hotel on San Simeon Point. It was approved by the County Board of Supervisors, but the California Coastal Commission—in place since the 1970s—wanted to limit the resort to 375 rooms clustered near San Simeon Village. The Coastal Commission also argued against a golf course, as there was not sufficient water to support it. Community opposition to the development plan was strenuous, culminating in a series of contentious public hearings and demonstrations in January 1998.[31] Stephen Hearst, a great-grandson of William Randolph Hearst and general manager for the Hearst Corporation's land and livestock division, significantly changed the strident tone in 1999. He said, "I looked at that plan, and said, Look—is this the only option we have? And I heard quite clearly after doing research that there were some different options. One of those was to pursue a conservation solution for the

property."[32] So deep was the suspicion against the Hearst Corporation and its possible ulterior motives that Stephen Hearst was unable to convince a single environmentalist to meet with him about the project in 1999.[33]

By 2002 the golf course and resort hotel planned for San Simeon Point had been abandoned. Instead the Hearst Corporation planned an inn for the old village of San Simeon, based on newly discovered plans that Julia Morgan had drawn up for the site in 1929.[34] But further complications occurred when talks with the Nature Conservancy fell through that year. The American Land Conservancy took over the negotiations, and by 2004 a proposal was hammered out, in what the New York Times called at the time "the largest and most complex conservation deal in the United States."[35]

This complexity stemmed from disagreements between environmentalists and the Hearst Corporation about how to balance the public's right to unfettered access to scenic areas with the corporation and family's right to benefit from their assets. The concluding deal may serve as a model for future land-protection agreements. The State of California paid the Hearst Corporation 95 million dollars: 80 million in cash and 15 million in state tax credits. Federal transportation money supplied 23 million dollars from a fund slated for scenic highway protection. The remainder came from conservation bonds, in exchange for preserving most of the 82,000-acre ranch. The Hearst Corporation gave up its right to develop much of the property but retained the right to build the historic one-hundred-room hotel in the town of San Simeon, fifteen houses for employees, and twenty-seven larger houses on parcels of at least 320 acres. Along the coast, about seven hundred oceanfront acres at San Simeon Point, Ragged Point, and Pico Cove remained in the ownership of the Hearst Corporation, with public access allowed on a restricted basis.

A coalition of environmentalists objected to the deal, viewing land use issues differently from the ranchers. "Hearst retained the most dramatic parcels," said Susan

In 2005 the Hearst Corporation donated almost one thousand acres along the coast to Hearst San Simeon State Park, preserving this matchless setting in its natural state.

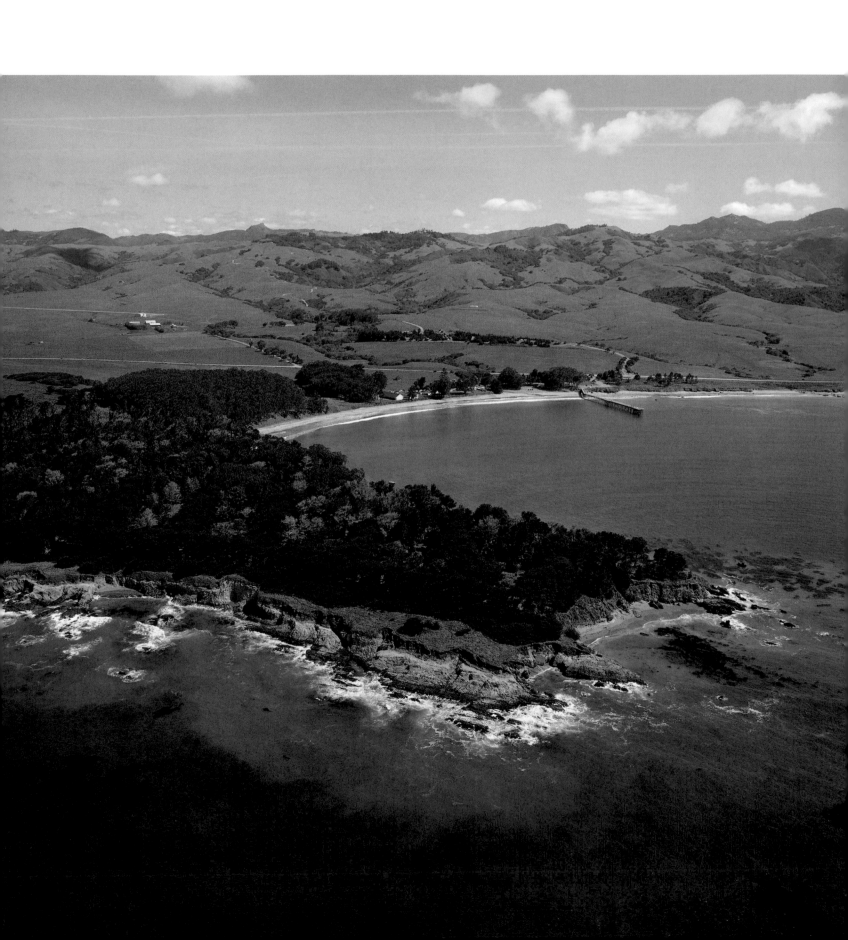

Jordan, director of the California Coastal Protection Network. Stephen Hearst and the Hearst Corporation attorney, Roger Lyon, countered that the land had been valued at 230 million dollars, meaning that the Hearst Corporation was donating the equivalent of nearly 150 million dollars.[36]

The deal finally closed escrow on February 18, 2005. It is a collaboration between the Hearst Corporation, the American Land Conservancy, the California Rangeland Trust, and the State of California. The land west of Highway 1 will be managed largely by California State Parks, and the conservation easement on eighty thousand acres of the ranch located east of Highway 1 is held and monitored by the California Rangeland Trust. It permanently restricts future development, while allowing for working ranch operations. West of Highway 1, the Hearst Corporation transferred more than 1,500 acres to state ownership, 949 acres for public parkland, and the remainder to the California Department of Transportation (Caltrans) as part of its effort to realign Highway 1 and prevent further erosion. The goal was threefold: to conserve the incomparable resources of the 82,000-acre Hearst ranch; to maintain the economic viability of the ranch as a working landscape; and to provide public access to one of the most pristine stretches of California coastline.[37]

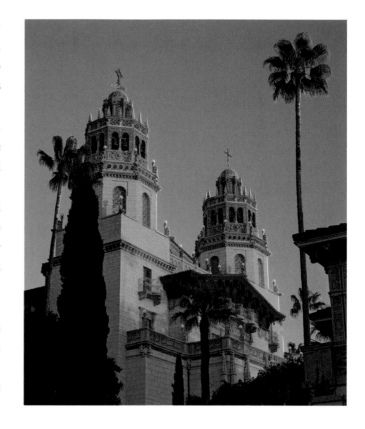

The conservation easement property is 126 square miles of land, five times the size of Manhattan. It possesses great diversity, including 20,000 acres of wetlands, 25,000 acres of grassland and coastal prairie, 15,000 acres of chaparral, nearly 30,000 acres of oak woodlands, and seven major watershed drainages. One of the most varied areas of natural habitat in California, it is home to several species that are either threatened or of special interest, such as the golden eagle, the yellow-legged frog, the steelhead, and the tidewater goby. The working Hearst cattle ranch sustains large herds on a natural, grass-fed diet, in the traditional way that cattle have been ranched in California for centuries. Additionally, the land still hosts many descendants of Hearst's old zoo: Aoudads (Barbary sheep), Himalayan tahr goats, Roosevelt elk, Sambar deer, and zebras. Kara Blakeslee, the representative of the American Land Conservancy who spearheaded the deal, said, "More than one thousand plant and animal species have been observed on the property, including rare and threatened species like the red-legged frog, the western pond turtle, and the California condor. It contains nearly every type of ecosystem in California—savannah, pine forest, oak woodlands, coastal environments. The normal animals like mountain lions live there abundantly, along with many exotic escapees. You expect bobcats, but you also see zebras. It has all the things that people love about the natural world . . . [and continues] the stewardship of one family for the landscape. With the preservation stakes this high, we knew we could not afford to fail."[38]

Stephen Hearst called the ranch at San Simeon "a family heirloom . . . the most emotional asset in the family trust.

The hilltop sunlight burns off the morning fog long before the shoreline clears. The magical effect of this vanishing mist was likely the reason W. R. Hearst named his estate La Cuesta Encantada, the Enchanted Hill.

A turkey vulture (*Cathartes aura*) soars over the Hearst ranch. This scavenger's dark outstretched wings make it particularly graceful in flight.

Northern elephant seals (*Mirounga angustirostris*), once common along the Pacific Coast, were slaughtered in large numbers for their blubber in the nineteenth century. In the 1990s they established a large rookery near Point Piedras Blancas. The males are as long as sixteen feet and weigh as much as five thousand pounds.

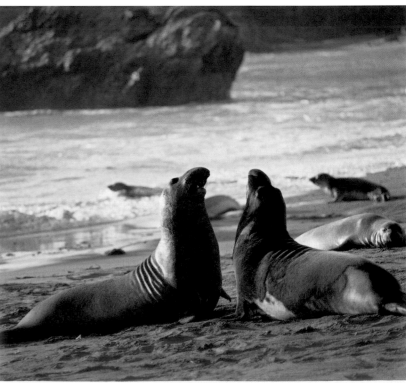

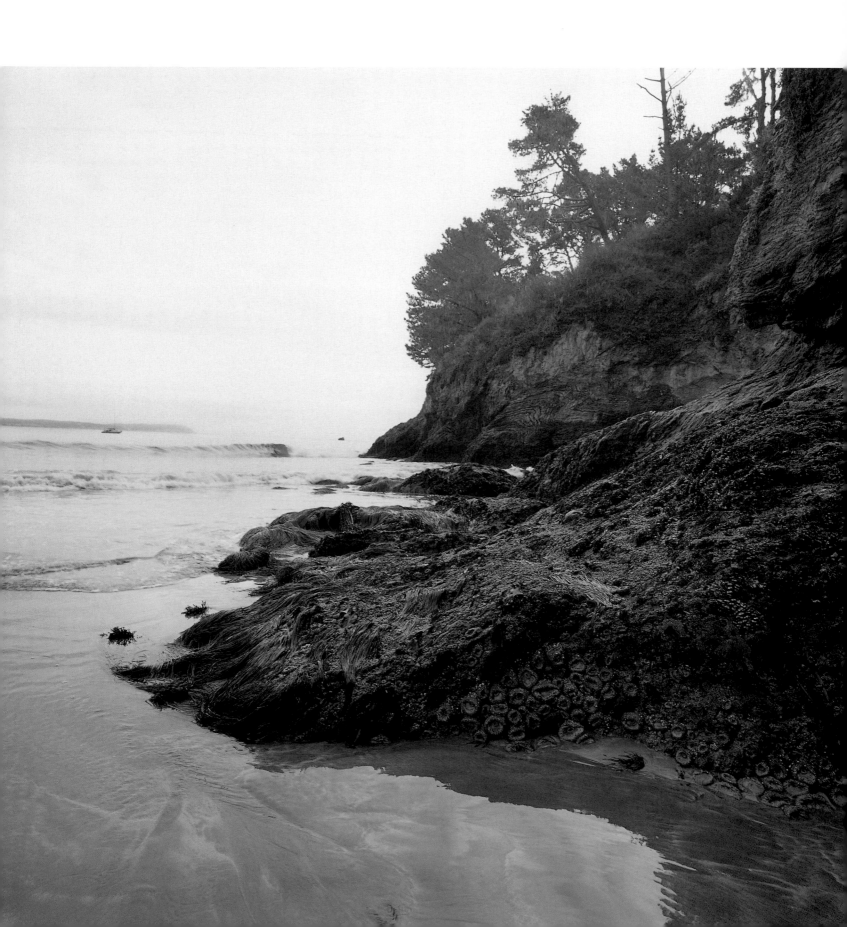

Sea anemones (*Anthopleura artemisia*) cling to the rocks at low tide in San Simeon Bay.

William Randolph Hearst donated San Simeon State Beach to California State Parks in 1932. This marked the beginning of an extraordinary legacy of generosity from the Hearsts to the people of California.

It goes clear back to the roots of the family . . . as far back in California as we go."[39] That means as far back as George Hearst, who walked west to follow a dream and bought his first parcel of Rancho de la Piedra Blanca in 1865. And as far back as Phoebe Apperson Hearst, who closed down San Simeon's destructive whaling operations in 1894 and who gloried in the ranch landscapes and hilltop vistas. And as far back as William Randolph Hearst, who built on this land he loved best, creating with Julia Morgan its matchless gardens and landscape features, then ensuring that La Cuesta Encantada would always be shared with the public.

Bill Hearst Jr. knew the ranch at San Simeon better than almost anyone, having watched the Castle estate throughout its building and its transfer to public ownership. He died in 1993, long before the ranchlands were protected and the property was permanently shielded from commercial development. We can be sure this outcome would have delighted him, as it would have delighted both Hearst and Morgan. California has been almost completely altered since 1865. Much of the land in private hands has been developed, and the current financial incentives to turn farmland and open space into residential and commercial plots have never been higher. But at San Simeon, one of America's most beautiful country houses—its gardens, swimming pools, and rolling ranchlands—passed safely from one family's hands to us all. Bill Hearst Jr. wrote at eighty-four, the same age his father was when he last saw La Cuesta Encantada: "It's never easy for me to go down the hill. It's like turning your back on a friend. I sometimes close my eyes until we turn left on the highway and head [south] toward Pico Creek. When I open my eyes, the ocean suddenly sweeps in front of me with the mountains at my left elbow. I usually get sentimental and think about the incredible legacy that my father and grandparents left for me, my wife, and my children. And for the people of America. It is a slice of paradise, and how fortunate we have been to be able to leave some footprints here on the hills and sand."[40]

Appendix: Plant List Arranged by Historic Use at San Simeon

Sandra Heinemann

This is a selected list of almost four hundred plants that are known to have been grown (or at least requested by William Randolph Hearst) at San Simeon during the historic period from 1919 when Hearst and Julia Morgan started to plan for the hilltop at San Simeon to 1951 when Hearst died. It is by no means a complete list, since surviving records are spotty.

Most of the plants on this list are recommended for restoration or re-creation of Mediterranean Revival gardens in California. However, invasive species should be avoided.

Plants are grouped according to their historic use at San Simeon (formal gardens, orchards, forestry, etc.). They are listed using current botanical nomenclature as much as possible, following the 1999 edition of *Botanica: The Illustrated A–Z of Over 10,000 Garden Plants*, edited by R. J. Turner and Ernie Wasson.

Hearst personally selected the majority of the plants used in the gardens at San Simeon, either buying them in person or selecting them from plant catalogs. He did not collect rare plants or send collectors to remote locations to acquire unusual plants. He purchased seeds and plants primarily from the large nurseries and seed companies in California. He preferred the "best" and "newest" plants with the largest, most fragrant, and most brightly colored flowers. Consequently this list is typical of the plants in other Mediterranean-style gardens in California at the time (1920s–1940s).

Historic plant catalogs from the nurseries in California that Hearst used were frequently consulted to determine the species and cultivars readily available in California at that time. The majority of plants used at San Simeon were acquired at the following California nurseries: Armstrong Nurseries, Ontario; Beverly Hills Nurseries, Beverly Hills; California Nursery Company, Niles; City and Kentia Nurseries, Santa Barbara; Leonard Coates Nurseries, San Jose; San Pedro Ranch Nursery, Compton; Santa Monica Forestry Station, Santa Monica; and West Coast Nurseries, Palo Alto. Seeds were purchased from Aggeler & Musser Seed Co., Los Angeles; W. Atlee Burpee, Seed Grower, Philadelphia; Hallawell Seed Co., San Francisco; Morse & Co., San Francisco; Sutton & Sons, London; and others. (Historic catalogs from these companies are available in the library at the Strybing Arboretum in San Francisco.)

The major source of information comes from the extensive surviving correspondence between Hearst and Morgan, who was also partly responsible for the landscape design. Correspondence between Hearst and his gardeners (Nigel Keep, Louis Reesing, and others) also provided many plant names. Some additional names were gleaned from historic design plans, invoices, memos, and historic photographs.

TREES AND PALMS IN THE FORMAL HILLTOP GARDENS

1.	*Brahea edulis*	Guadalupe Palm
2.	*Butia capitata*	Pindo Palm
3.	*Cedrus deodara*	Deodar Cedar
4.	*Chamaerops humilis*	Mediterranean Fan Palm
5.	*Citrus* cultivars	Citrus trees (see cultivar list in "Orchards")
6.	*Cordyline australis*	New Zealand Cabbage Tree, Dracaena
7.	*Cupressus sempervirens* 'Stricta'	Italian Cypress
8.	*Jacaranda mimosifolia*	Jacaranda
9.	*Livistona australis*	Australian Palm
10.	*Magnolia grandiflora*	Southern Magnolia
11.	*Phoenix canariensis*	Canary Island Date Palm
12.	*Phoenix roebelenii*	Pygmy Date Palm
13.	*Quercus agrifolia*	Coast Live Oak
14.	*Quercus lobata*	Valley Oak, White Oak
15.	*Syagrus romanzoffianum*	Queen Palm
16.	*Taxus baccata* 'Stricta'	Irish Yew
17.	*Trachycarpus fortunei*	Windmill Palm
18.	*Umbellularia californica*	California Bay, California Laurel
19.	*Washingtonia filifera*	California Fan Palm
20.	*Washingtonia robusta*	Mexican Fan Palm

SHRUBS AND HEDGES IN THE FORMAL HILLTOP GARDENS

1.	*Abutilon megapotamicum* and/or X *hybridum*	Chinese Lantern, Flowering Maple
2.	*Brugmansia* X *candida*	White Angel's Trumpet
3.	*Brugmansia sanguinea*	Red Angel's Trumpet
4.	*Buxus microphylla japonica* (for hedges)	Japanese Boxwood
5.	*Camellia japonica* cultivars	Japanese Camellias, many varieties

6.	*Camellia japonica* 'Herme'	Herme Camellia (Jordan's Pride)
7.	*Coprosma repens*	Mirror Plant
8.	*Cycas revoluta*	Sago Palm
9.	*Daphne odora*	Winter Daphne
10.	*Daphne odora* 'Marginata'	Variegated Winter Daphne
11.	*Erica* species	Heaths and Heathers
12.	*Euonymus japonica* (for hedges)	Evergreen Euonymus
13.	*Euonymus japonica* 'Aureomarginatus'	Golden Euonymus
14.	*Fatsia japonica*	Japanese Aralia
15.	*Fuchsia X hybrida* cultivars	Fuchsias, many varieties
16.	*Gardenia augusta*	Gardenia
17.	*Hibiscus rosa-sinensis*	Chinese Hibiscus
18.	*Hydrangea macrophylla*	Bigleaf Hydrangea
19.	*Hebe speciosa*	Showy Hebe
20.	*Ilex aquifolium*	English Holly
21.	*Ligustrum japonicum* (for hedges)	Wax-Leaf Privet
22.	*Ligustrum ovalifolium* 'Aureum' (for hedges)	Golden Privet
23.	*Luma apiculata* (for hedges)	Luma Myrtle
24.	*Magnolia X soulangeana*	Saucer Magnolia
25.	*Magnolia stellata*	Star Magnolia
26.	*Musa* species	Banana
27.	*Myrtus communis* (for hedges)	True Myrtle, Mediterranean Myrtle
28.	*Myrtus communis* 'Microphylla' (hedges)	Dwarf Myrtle
29.	*Nandina domestica*	Heavenly Bamboo
30.	*Nerium oleander*	Oleanders
31.	*Phormium tenax*	New Zealand Flax
32.	*Pittosporum tenuifolium* (for hedges)	Kohuhu Pittosporum
33.	*Pittosporum tobira*	Mock Orange Pittosporum
34.	*Pyracantha crenulata* (for hedges)	Nepal Firethorn
35.	*Rhododendron (Azalea)* cultivars	Azaleas, many varieties
36.	*R. (Azalea) altaclarensis*, mixed colors	Altaclarensis hybrid Azaleas
37.	*R. (Azalea) indica*	Indica hybrid Azaleas
38.	*R. (Azalea) indica* 'Mme. Petrick'	Mme. Petrick Azalea
39.	*R. (Azalea) indica* 'Mme. Petrick Superba'	Mme. Petrick Superba Azalea
40.	*R. (Azalea) indica* 'Pink Pearl'	Pink Pearl Azalea
41.	*R. (Azalea) indica* 'Simon Mardner'	Simon Mardner Azalea
42.	*R. (Azalea) indica* 'Van der Cruissen'	Van der Cruissen Azalea
43.	*R. (Azalea) indica* 'Vervaeneana'	Vervaeneana Azalea
44.	*R. (Azalea) kurume*	Kurume hybrid Azaleas
45.	*R. (Azalea) kurume* 'Chas. Encke'	Charles Encke Azalea
46.	*R. (Azalea) kurume* 'Hinodegiri'	Hinodegiri Azalea
47.	*R. (Azalea) mollis*, mixed colors	Mollis hybrid Azaleas
48.	*Rhododendron* cultivars	Rhododendrons, many varieties
49.	*Rosa* cultivars	Roses, many varieties, mostly early Hybrid Teas
50.	*Rosa* 'Charlotte Armstrong'	Charlotte Armstrong Rose
51.	*Rosa* 'Christopher Stone'	Christopher Stone Rose
52.	*Rosa* 'Climbing Cécile Brunner'	Climbing Cécile Brunner Rose
53.	*Rosa* 'Climbing Madame Caroline Testout'	Climbing Madame Caroline Testout Rose
54.	*Rosa* 'Comtesse Vandal'	Comtesse Vandal Rose
55.	*Rosa* 'Condessa de Sastago'	Condessa de Sastago Rose
56.	*Rosa* 'Etoile de Hollande'	Etoile de Hollande Rose
57.	*Rosa* 'General McArthur'	General McArthur Rose
58.	*Rosa* 'Golden Emblem'	Golden Emblem Rose
59.	*Rosa* 'Golden Rapture'	Golden Rapture Rose
60.	*Rosa* 'Gruss an Aachen'	Gruss an Aachen Rose
61.	*Rosa* 'Hinrich Gaede'	Hinrich Gaede Rose
62.	*Rosa* 'Kaiserin Auguste Viktoria'	Kaiserin Auguste Viktoria Rose
63.	*Rosa* 'Los Angeles'	Los Angeles Rose
64.	*Rosa* 'Mrs. E. Pembroke Thom'	Mrs. E. Pembroke Thom Rose
65.	*Rosa* 'Mrs. Sam McGredy'	Mrs. Sam McGredy Rose
66.	*Rosa* 'President Herbert Hoover'	President Herbert Hoover Rose
67.	*Rosa* 'Rose Marie'	Rose Marie Rose
68.	*Rosa* 'Rotary Lyon'	Rotary Lyon Rose
69.	*Rosa* 'Sensation'	Sensation Rose
70.	*Rosa* 'Texas Centennial'	Texas Centennial Rose
71.	*Rosa wichuraiana*	Memorial Rose
72.	*Solanum wendlandii*	Costa Rican Nightshade
73.	*Syzygium paniculatum* (for hedges)	Eugenia, Australian Brush Cherry

ANNUALS, PERENNIALS, AND BULBS USED FOR SEASONAL FLOWER COLOR IN THE FORMAL HILLTOP GARDENS

1.	*Acanthus mollis*	Bear's Breeches
2.	*Agapanthus praecox*	Lily-of-the-Nile
3.	*Ageratum houstonianum*	Floss Flower
4.	*Alcea rosea*	Hollyhock
5.	*Antirrhinium majus*	Snapdragon
6.	*Anemone coronaria*	Wind Poppy
7.	*Aster novae-angliae* and/or *novi-belgii*	New England Aster, Michaelmas Daisy
8.	*Begonia X tuberhybrida*	Tuberous Begonias (single, double, camellia, and/or fimbriata types)
9.	*Calendula officinalis*	Calendula, Pot Marigold
10.	*Callistephus chinensis*	China Aster, Annual Aster
11.	*Campanula medium*	Canterbury Bells
12.	*Canna X generalis*	Canna Lilies
13.	*Chrysanthemum X grandiflorum*	Garden Chrysanthemums, Mums
14.	*Clivia miniata*	Clivia, Kaffir Lily
15.	*Consolida ajacis*	Larkspur
16.	*Cyclamen persicum*	Cyclamen
17.	*Dahlia* cultivars	Dahlias, many varieties
18.	*Dahlia imperialis*	Tree Dahlia
19.	*Delphinium* species	Delphiniums
20.	*Dianthus barbatus*	Sweet William
21.	*Dianthus* (pinks)	Pinks
22.	*Dianthus caryophyllus*	Carnations
23.	*Erysimum cheiri*	Wallflower

24. *Euphorbia pulcherrima*	Poinsettia	6. *Ipomoea* species	Morning Glory
25. *Euphorbia pulcherrima* 'Henrietta Ecke'	Henrietta Ecke Poinsettia	7. *Ipomoea alba*	Moonflower
26. *Gazania longiscapa* or *rigens*	Gazania	8. *Jasminum* species	Jasmines
27. *Geum chiloense*	Avens	9. *Jasminum officinale*	Common Jasmine, Poet's Jasmine
28. *Geum coccineum*	Avens	10. *Lantana montevidensis*	Trailing Lantana
29. *Gladiolus* cultivars	Gladioluses	11. *Lonicera* species	Honeysuckles
30. *Heliotropium arborescens*	Heliotrope	12. *Lonicera sempervirens* 'Fuchsioides'	Trumpet Honeysuckle, Coral Honeysuckle
31. *Hyacinthus orientalis* cultivars	Hyacinths	13. *Macfadyena unguis-cati*	Yellow Trumpet Vine
32. *Iris* species	Irises, specific types not known	14. *Mandevilla laxa*	Chilean Jasmine
33. *Iris germanica*	Bearded Iris	15. *Passiflora* species	Passion Flower
34. *Lathyrus odoratus*	Sweet Pea	16. *Passiflora edulis*	Passion Fruit
35. *Leucanathemum superbum*	Shasta Daisy	17. *Passiflora manicata*	Red Passion Flower
36. *Lilium auratum, henryi, lancifolium, pardalinum, and/or speciosum*	Lilies, many varieties	18. *Pelargonium peltatum*	Ivy Geranium
		19. *Podranea ricasoliana*	Pink Trumpet Vine
		20. *Solandra maxima*	Cup-of-Gold Vine
37. *Lilium longiflorum*	Easter Lily	21. *Sollya heterophylla*	Australian Bluebell
38. *Lobelia erinus*	Edging Lobelia	22. *Tecomaria capensis*	Cape Honeysuckle
39. *Matthiola incana*	Stock	23. *Trachelospermum jasminoides*	Star Jasmine
40. *Mirabilis jalapa*	Four-O'Clock		
41. *Paeonia* cultivars	Herbaceous Peonies		

WATER PLANTS USED IN PONDS AND FOUNTAINS OF FORMAL GARDENS

42. *Papaver nudicaule, orientale, rhoeas* and/or *somniferum*	Poppies (Iceland, Oriental, Corn, Shirley, and/or Breadseed)	
43. *Pelargonium X domesticum*	Pelargoniums	1. *Cyperus alternifolius* — Umbrella Plant
44. *Pelargonium X hortorum*	Garden Geranium	2. *Cyperus papyrus* — Papyrus
45. *Penstemon X gloxinioides*	Garden Penstemon, Beard Tongue	3. *Nelumbo nucifera* — Lotus
46. *Pericallis X hybrida*	Cineraria	4. *Nymphaea*, day-blooming waterlily — Day-Blooming Waterlily
47. *Petunia X hybrida*	Petunias	5. *Nymphaea*, night-blooming waterlily — Night-Blooming Waterlily
48. *Phlox drummondii*	Annual Phlox	
49. *Phlox paniculata*	Perennial Phlox	
50. *Polianthes tuberosa*	Tuberose	
51. *Primula X polyantha*	Polyanthus Primrose, English Primrose	

HOUSE PLANTS AND GREENHOUSE PLANTS

52. *Tagetes erecta*	African Marigolds, American Marigolds	
53. *Tagetes patula*	French Marigolds	1. *Aspidistra elatior* — Cast-Iron Plant
54. *Tulipa* cultivars	Tulips (Darwin, Breeder, Cottage, Early, Striped, and/or Parrot)	2. *Begonia X tuberhybrida* — Tuberous Begonias (single, double, camellia, and/or fimbriata types)
55. *Viola cornuta* cultivars	Violas	3. *Fatsia japonica* — Japanese Aralia
56. *Viola odorata* cultivars	Sweet Violets	4. *Epiphyllum* cultivars — Orchid Cactuses
57. *Viola wittrockiana* cultivars	Pansies	5. *Hippeastrum* cultivars — Amaryllises
58. *Woodwardia* species	Chain Fern	6. *Howea forsteriana* — Kentia Palm
59. *Zantedeschia aethiopica*	Calla, Calla Lily	7. Orchid species — Orchids, many different species
60. *Zantedeschia elliottiana*	Yellow Calla	8. *Sansevieria trifasciata* — Snake Plant
61. *Zinnia elegans*	Zinnias	9. *Sinningia speciosa* — Gloxinia

VINES AND CLIMBING PLANTS USED IN THE FORMAL HILLTOP GARDENS

ORCHARDS AND VINEYARDS

		1. *Carya illinoinensis* — Pecans
1. *Bougainvillea* species — Bougainvilleas		2. X *Citrofortunella microcarpa* — Calamondin
2. *Clytostoma callistegioides* — Violet Trumpet Vine		3. *Citrus aurantifolia* cultivars — Limes
3. *Distictis buccinatoria* — Blood-Red Trumpet Vine		4. *Citrus aurantifolia* 'Bearss' — Bearss Lime
4. *Hydrangea petiolaris* — Climbing Hydrangea		5. *Citrus aurantifolia* 'Rangpur' — Rangpur Lime
5. *Heliotropium arborescens* — Heliotrope (old-fashioned climbing type)		6. *Citrus aurantifolia* 'Sweet Lime' — Sweet Lime
		7. *Citrus X paradisi* cultivars — Grapefruits
		8. *Citrus X paradisi* 'Marsh' — Marsh Grapefruit
		9. *Citrus reticulata* cultivars — Tangerines, Mandarins

10.	*Citrus reticulata* 'Clementine'	Algerian Tangerine
11.	*Citrus reticulata* 'King'	King Mandarin
12.	*Citrus reticulata* 'Satsuma'	Satsuma Tangerine
13.	*Citrus reticulata* 'Willow-leaf'	Willow-Leaf Mandarin
14.	*Citrus sinensis* cultivars	Oranges, Sweet Oranges
15.	*Citrus sinensis* 'Mediterranean Sweet'	Mediterranean Sweet Orange
16.	*Citrus sinensis* 'Robertson'	Robertson Navel Orange
17.	*Citrus sinensis* 'Ruby Blood'	Ruby Blood Orange
18.	*Citrus sinensis* 'Valencia'	Valencia Orange
19.	*Citrus sinensis* 'Washington Navel'	Washington Navel Orange
20.	*Cydonia oblonga*	Quince
21.	*Diospyros kaki*	Japanese Persimmon
22.	*Diospyros kaki* 'Fuyu'	Fuyu Persimmon
23.	*Diospyros kaki* 'Hachiya'	Hachiya Persimmon
24.	*Diospyros kaki* 'Okami'	Okami Persimmon
25.	*Diospyros kaki* 'Tamopan'	Tamopan Persimmon
26.	*Diospyros kaki* 'Tanenashi'	Tanenashi Persimmon
27.	*Diospyros kaki* 'Yemon'	Yemon Persimmon
28.	*Eriobotrya japonica*	Loquat
29.	*Feijoa sellowana*	Pineapple Guava
30.	*Ficus carica* 'Angelique'	Angelique Fig
31.	*Ficus carica* 'Black Spanish'	Black Spanish Fig
32.	*Ficus carica* 'Brown Turkey'	Brown Turkey Fig
33.	*Ficus carica* 'Celeste'	Celeste Fig
34.	*Ficus carica* 'Kadota'	Kadota Fig
35.	*Ficus carica* 'Mission'	Mission Fig
36.	*Ficus carica* 'White Genoa'	White Genoa Fig
37.	*Ficus carica* 'White Adriatic'	White Adriatic Fig
38.	*Fortunella japonica*	Kumquat
39.	*Juglans* cultivars	Walnuts, 9-plus varieties
40.	*Juglans hindsii*	California Black Walnut
41.	*Juglans nigra*	Black Walnut
42.	*Juglans regia*	English Walnut
43.	*Malus*, crabapple	Crabapple
44.	*Malus domestica* cultivars	Apples, 20-plus varieties
45.	*Olea europa*	Olives
46.	*Olea europa* 'Manzanillo'	Manzanillo Olive
47.	*Persea americana* cultivars	Avocados, Alligator Pears
48.	*Persea americana* 'Benedict'	Benedict Avocado
49.	*Persea americana* 'Darwin'	Darwin Avocado
50.	*Persea americana* 'Duke'	Duke Avocado
51.	*Persea americana* 'Ganter'	Ganter Avocado
52.	*Persea americana* 'Mary Martin'	Mary Martin Avocado
53.	*Persea americana* 'Zutano'	Zutano Avocado
54.	*Prunus armeniaca* cultivars	Apricots, 5-plus varieties
55.	*Prunus*, cherry cultivars	Cherries, 11-plus varieties
56.	*Prunus dulcis* cultivars	Almond
57.	*Prunus dulcis* 'Ne Plus Ultra'	Ne Plus Ultra Almond
58.	*Prunus dulcis* 'Nonpareil'	Nonpareil Almond
59.	*Prunus persica*, nectarine cultivars	Nectarines, 11-plus varieties
60.	*Prunus persica*, peaches	Peaches
61.	*Prunus persica* 'Indian Peach'	Indian Peach
62.	*Prunus persica* 'Strawberry'	Strawberry Peach
63.	*Prunus*, plum cultivars	Plums, 30-plus varieties
64.	*Punica granatum*	Pomegranate
65.	*Punica granatum* 'Nana'	Dwarf Pomegranate
66.	*Punica granatum* 'Wonderful'	Wonderful Pomegranate
67.	*Pyrus communis* cultivars	Pears, 9-plus varieties
68.	*Rubus*, blackberries	Blackberries
69.	*Rubus* 'Burbank'	Burbank Blackberry
70.	*Rubus* 'Himalaya'	Himalaya Blackberry
71.	*Rubus* 'Logan'	Loganberry
72.	*Rubus* 'Mammoth'	Mammoth Blackberry
73.	*Rubus*, raspberries	Raspberries
74.	*Vitis* cultivars	Grapes
75.	*Vitis* 'Amber Queen'	Amber Queen Grape
76.	*Vitis* 'Cornichon'	Cornichon Grape
77.	*Vitis* 'Dizmar'	Dizmar Grape
78.	*Vitis* 'Jefferson'	Jefferson Grape
79.	*Vitis* 'Moore Early'	Moore Early Grape
80.	*Vitis* 'Muscat Frontignan'	Muscat Frontignan Grape
81.	*Vitis* 'Malaga'	Malaga Grape
82.	*Vitis* 'Mataro'	Mataro Grape
83.	*Vitis* 'Pierce'	Pierce Grape
84.	*Vitis* 'Olivette Blanche'	Olivette Blanche Grape
85.	*Vitis* 'Ribier'	Rivier Grape
86.	*Vitis* 'Rose of Peru'	Rose of Peru Grape
87.	*Vitis* 'Thompson Seedless'	Thompson Seedless Grape
88.	*Vitis* 'Zinfandel'	Zinfandel Grape

HILLSIDE AND ROADSIDE PLANTINGS OF DROUGHT-RESISTANT, FLOWERING SHRUBS NEEDING LITTLE CARE OR MAINTENANCE

1.	*Abelia X grandiflora*	Glossy Abelia
2.	*Aesculus californica*	California Buckeye
3.	*Agave americana*	Century Plant
4.	*Agave americana* 'Marginata'	Striped Century Plant
5.	*Arctostaphylos* species	Manzanitas
6.	*Berberis darwinii*	Darwin Barberry
7.	*Berberis thunbergii* 'Atropurpurea'	Red-Leaf Japanese Barberry
8.	*Berberis wilsoniae*	Wilson Barberry
9.	*Brugmansia X candida*	White Angel's Trumpet
10.	*Brugmansia sanguinea*	Red Angel's Trumpet
11.	*Buddleia davidii*	Butterfly Bush
12.	*Carpenteria californica*	Bush Anemone
13.	*Ceanothus* species	Wild Lilacs
14.	*Ceanothus thyrsiflorus*	Blue Blossom Ceanothus
15.	*Cercis* species	Redbud
16.	*Cestrum fasciculatum*	Red Cestrum
17.	*Cestrum parqui*	Willow-Leafed Jessamine
18.	*Choisya ternata*	Mexican Orange
19.	*Cistus ladanifer*	Crimson-Spot Rockrose
20.	*Cistus albidus*	White-Leaved Rockrose
21.	*Cotinus coggygria*	Smoke Tree
22.	*Cotoneaster* species	Cotoneasters
23.	*Cotoneaster frigidus*	Himalayan Tree Cotoneaster
24.	*Cotoneaster horizontalis*	Rock Cotoneaster

25.	*Cotoneaster microphyllus*	Rockspray Cotoneaster	
26.	*Cotoneaster pannosus*	Silverleaf Cotoneaster	
27.	*Cytisus* species	Brooms	
28.	*Echium fastuosum*	Pride of Madeira	
29.	*Elaeagnus* species	Russian Olive, Silverberry	
30.	*Erica* species	Heaths and Heathers	
31.	*Erica erigena*	Mediterranean Heath	
32.	*Erica melanthera*	Heath	
33.	*Erica multiflora* 'grandiflora'	Heath	
34.	*Erica persoluta* 'rosea'	Heath	
35.	*Erica* 'President Felix Faure'	Heath	
36.	*Erythrina crista-galli*	Coral Tree	
37.	*Escallonia* species	Escallonias	
38.	*Escallonia bifida*	White Escallonia	
39.	*Eschscholzia californica*	California Poppy	
40.	*Genista* species	Brooms	
41.	*Genista X spachiana*	Sweet Broom	
42.	*Hakea laurina*	Pincushion Bush	
43.	*Heteromeles arbutifolia* (native to hilltop)	Toyon, Christmas Berry	
44.	*Hunnemannia fumariifolia*	Mexican Poppy	
45.	*Hypericum X moserianum*	Gold Flower	
46.	*Jasminum mesnyi*	Primrose Jasmine	
47.	*Kniphofia uvaria*	Red Hot Poker	
48.	*Lagerstroemia indica*	Crape Myrtle	
49.	*Leonotis leonurus*	Lion's Tail	
50.	*Leptospermum laevigatum*	Australian Tea Tree	
51.	*Mahonia* species	Barberries	
52.	*Mahonia aquifolium*	Oregon Grape	
53.	*Nerium oleander*	Oleanders	
54.	*Nyctocereus serpentinus*	Night-Blooming Cereus	
55.	*Opuntia* species	Prickly Pear	
56.	*Philadelphus mexicanus*	Evergreen Mock Orange	
57.	*Phormium tenax*	New Zealand Flax	
58.	*Pittosporum crassifolium*	Karo Pittosporum	
59.	*Pittosporum heterophyllum*	Chinese Pittosporum	
60.	*Pittosporum rhombifolium*	Queensland Pittosporum	
61.	*Pittosporum undulatum*	Victorian Box	
62.	*Pittosporum tenuifolium*	Kohuhu Pittosporum	
63.	*Pittosporum tobira*	Mock Orange Pittosporum	
64.	*Plumbago auriculata*	Cape Plumbago	
65.	*Prunus ilicifolia* (native to hilltop)	Holly-Leaf Cherry, Islay	
66.	*Pyracantha* species	Firethorns, Burning Bush	
67.	*Pyracantha crenulata*	Nepal Firethorn	
68.	*Pyracantha crenatoserrata*	Yunnan Firethorn	
69.	*Pyracantha koidzumii*	Formosa Firethorn	
70.	*Rhamnus california*	Coffeeberry	
71.	*Rhamnus crocea*	Redberry	
72.	*Rhaphiolepis umbellata*	Yeddo Hawthorn	
73.	*Romneya coulteri*	Matilija Poppy	
74.	*Sambucus* species	Elderberry	
75.	*Senna* species	Cassias	
76.	*Senna artemisioides*	Feathery Cassia	
77.	*Senna floribunda*	Smooth Senna	
78.	*Symphoricarpos* species	Snowberry	
79.	*Viburnum odoratissimum*	Sweet Viburnum	
80.	*Tibouchina urvilleana*	Princess Flower	
81.	*Yucca* species	Yucca	

FORESTRY

1.	*Abies* species	Firs, 5 species
2.	*Acacia* species	Acacia, 13 species
3.	*Araucaria bidwillii*	Bunya-Bunya
4.	*Arbutus menziesii*	Madrone
5.	*Calocedrus decurrens*	Incense Cedar
6.	*Catalpa speciosa*	Northern Catalpa
7.	*Cedrus atlantica*	Atlas Cedar
8.	*Cedrus atlantica* 'Glauca'	Blue Atlas Cedar
9.	*Cedrus deodara*	Deodar Cedar
10.	*Cedrus libani*	Cedar of Lebanon
11.	*Ceratonia siliqua*	Carob, St. John's Bread
12.	*Cinnamomum camphora*	Camphor Tree
13.	*Cupressus arizonica*	Arizona Cypress
14.	*Cupressus macrocarpa*	Monterey Cypress
15.	*Eucalyptus* species	Eucalyptus, 20 species
16.	*Jacaranda mimosifolia*	Jacaranda
17.	*Laurus nobilis*	Sweet Bay, Grecian Laurel
18.	*Picea* species	Spruce, 5 varieties
19.	*Pinus canariensis*	Canary Island Pine
20.	*Pinus coulteri*	Coulter Pine, Big Cone Pine
21.	*Pinus halepensis*	Aleppo Pine
22.	*Pinus jeffreyi*	Jeffrey Pine
23.	*Pinus pinea*	Italian Stone Pine
24.	*Pinus radiata*	Monterey Pine
25.	*Pistacia chinensis*	Chinese Pistache
26.	*Pistacia vera*	Pistachio
27.	*Platanus racemosa* (native to hilltop)	Sycamore
28.	*Quercus agrifolia* (native to hilltop)	Coast Live Oak
29.	*Quercus chrysolepis*	Canyon Oak
30.	*Quercus lobata* (native to hilltop)	Valley Oak, White Oak
31.	*Quercus suber*	Cork Oak
32.	*Sequoia sempervirens*	Coast Redwood
33.	*Sequoiadendron gigantea*	Giant Sequoia
34.	*Umbellularia californica* (native to hilltop)	California Bay, California Laurel

Notes

INTRODUCTION

1. Henry Miller, *Big Sur and the Oranges of Hieronymus Bosch* (New York: New Directions, 1957), 5–6.
2. William Randolph Hearst to Phoebe Apperson Hearst, c. summer 1917. William Randolph Hearst Papers, 87/232c, the Bancroft Library, University of California, Berkeley (hereafter "Bancroft Library"). Unless otherwise noted, all correspondence is by letter. Grammatical errors that do not affect meaning have been silently corrected throughout.
3. "Julia Morgan Travel Records (job list)," 10 Apr. 1919. Morgan-Boutelle Collection, MS 027, Special Collections, Robert E. Kennedy Library, California Polytechnic State University, San Luis Obispo, Calif.
4. "The Work of Walter Steilberg and Julia Morgan," vol. 1 of *The Julia Morgan Architectural History Project*, ed. Suzanne B. Riess, the Bancroft Library, Regional Oral History Office (Berkeley: University of California, 1976), 56–57.
5. William Randolph Hearst to Julia Morgan, 21 Dec. 1919. Julia Morgan Papers, MS 010, Special Collections, Robert E. Kennedy Library, California State Polytechnic University, San Luis Obispo, Calif. Unless otherwise noted, all correspondence cited from the "Kennedy Library" is in the Julia Morgan Papers.
6. Hearst to Phoebe Hearst, c. 1884. William Randolph Hearst Papers, 82/68c, Bancroft Library.
7. Anthony T. Mazzola and Frank Zachary, eds., *High Society: The "Town & Country" Picture Album, 1846–1996* (New York: Harry N. Abrams, 1996), 7.
8. Norman P. Newton, *Design on the Land: The Development of Landscape Architecture* (Boston: Harvard University Press, 1971), 371–372, 444.
9. "The Work of Walter Steilberg and Julia Morgan," Bancroft Library, 135a.
10. Walter Steilberg, "Address to the Historical Guide Association of California, Aug. 1966," transcribed by Morris Cecil (San Simeon, Calif.: Hearst San Simeon State Historical Monument, 1968), 12.
11. Taylor Coffman, *Building for Hearst and Morgan: Voices from the George Loorz Papers* (Berkeley: Berkeley Hills Books, 2003), 546–547.
12. Aaron Betsky, *Queer Space: Architecture and Same-Sex Desire* (New York: William Morrow, 1997), 102–103; Dan Levy, "Cornerstones of Desire," *San Francisco Chronicle Book Review*, June 22–28, 1997; Kathryn H. Anthony, *Designing for Diversity: Gender, Race, and Ethnicity in the Architectural Profession* (Urbana: University of Illinois Press, 2001), 73.
13. "Julia Morgan Travel Records," 1942, Morgan-Boutelle Collection, Kennedy Library.

CHAPTER 1: THE LAND IN ITS PLACE

1. Mr. and Mrs. Fremont Older, *George Hearst: California Pioneer* (Los Angeles: Westernlore, 1966), 44, 57.
2. Terry L. Jones and Georgie Waugh, *Central California Coastal Prehistory: A View from Little Pico Creek*, Perspectives in California Archaeology, vol. 3, Institute of Archaeology (Los Angeles: University of California, 1995), 5.
3. Paul Henson and Donald J. Unser, *The Natural History of Big Sur* (Berkeley: University of California Press, 1993), 8.
4. Jim Timbrook, *Chumash Ethnobotany: Plant Knowledge among the Chumash People of Southern California* (Santa Barbara and Berkeley: Santa Barbara Museum of Natural History and Heyday Books, 2007), 11, 12; Kat M. Anderson, *Tending the Wild: Native American Knowledge and Management of California's Natural Resources* (Berkeley: University of California Press, 2005), 165–166.
5. Timbrook, *Chumash Ethnobotany*, 157–162; Bruce M. Pavlik et al., *Oaks of California* (Los Olivos, Calif.: Cachuma Press and the California Oak Foundation, 1991), 3, 9; Sandra J. Heinemann and Victoria Kastner, *Basic Training Manual Tour 4* (San Simeon, Calif.: Hearst San Simeon State Historical Monument, 1998), E–5–5. There are eighteen species of oak (*Quercus*) in California, half of which are tree oaks. Oaks found in the San Simeon area include the evergreen coast live oak (*Quercus agrifolia*) and the deciduous valley oak (*Quercus lobata*).
6. Kevin Starr, *California: A History* (New York: Modern Library, 2005), 32; Geneva Hamilton, *Where the Highway Ends: Cambria, San Simeon, and the Ranchos* (San Luis Obispo, Calif.: Padre Productions, 1974), 106–113.
7. Hamilton, *Where the Highway Ends*, 108–109; Taylor Coffman, *Hearst's Dream* (San Luis Obispo, Calif.: EZ Nature Books, 1989), 10–12.
8. Fr. Juan Crespí, *Captain Portolá in San Luis Obispo County in 1769*, eds. Fr. Francisco Palóu and Paul Squibb (Morro Bay, Calif.: Tabula Rasa Press, 1984), 28–30. Father Juan Crespí's 1769 diary account described the abrupt change in the landscape at the start of the Big Sur headlands: "In front of us is the high, rugged mountain range covered with pines, which appears to be the Sierra de Piños or Santa Lucia, and judging by its rough aspect, it looks as though it would prevent our passage."
9. Hamilton, *Where the Highway Ends*, 109, 113.
10. Marguerite Eyer Wilbur, *Vancouver in California, 1792–1794: The Original Account of George Vancouver* (Los Angeles: Glen Dawson, 1954), 138–139.
11. Starr, *California: A History*, 37, 40.
12. Elise Wheeler, interview with author, 21 Jan. 2008. Further degradations to the Chumash occurred throughout the nineteenth century. By 1890 the population was reduced to a very small number (fewer than 2,000) due to mortality, intermarriage, and population dispersal. According to archeologist Elise Wheeler, there are currently hundreds of Chumash descendants in the central coast area. They continue to actively maintain their cultural traditions.
13. Hamilton, *Where the Highway Ends*, 130, 170–177, 190–193; Coffman, *Hearst's Dream*, 13, 17–18.
14. Russell E. Bidlack, "To California on the *Sarah Sands*: Two Letters Written in 1850 by L. R. Slawson," *California Historical Society Quarterly* 44, no. 3 (Sept. 1965): 234; Coffman, *Hearst's Dream*, 17, 19. Richard Henry Dana made no mention of visiting San Simeon in his 1832 account of the hide and tallow trade along the California coast, *Two Years Before the Mast*. Eugene Duflot de Mofras mentions visiting San Simeon in 1841 in his book on California, *Travels on the Pacific Coast*, and in 1842 Captain William Dane Phelps traveled on the *Alert* (Dana's ship at the earlier period) into San Simeon Cove.
15. Claire Perry, *Pacific Arcadia: Images of California, 1600–1915* (New York: Oxford University Press, 1999), 149; Richard Longstreth, *On the Edge of the World: Four Architects in San Francisco at the Turn of the Century* (New York: Architectural History Foundation, 1983), 259–260.
16. Mrs. William Randolph Hearst Jr., *The Horses of San Simeon* (San Simeon, Calif.: San Simeon Press, 1985), 65, 68, 69, 218–219; King Vidor, *A Tree Is a Tree* (Hollywood: Samuel French, 1989), 162–163; John R. Hearst Jr., "Life with Grandfather," *Reader's Digest* 76, no. 457 (May 1960): 158–159. Hearst's grandson John Jr. (known by the nickname "Bunky") noted that his grandfather was running one of "the last of the old time Spanish land grant haciendas." A sign on the highway below read "Hearst Hacienda," and the telephone exchange for the hilltop area was "Hacienda."
17. Hamilton, *Where the Highway Ends*, 133–134, 193–194, 202–204; Mr. and Mrs. Bill Washburn, interview by Steve Hamill and H. Woody Elliott, *Oral History Project* (San Simeon, Calif.: Hearst San Simeon State Historical Monument, 29 July 1994), 6; Dan Krieger, "Times Past," *The Tribune*, Sept. 19, 1999, and Sept. 26, 1999. Reports for other counties in the central coast area of California counted 97,000 head of cattle in the spring of 1863 and only 12,090 surviving in the spring of 1865—a loss of 85,000.
18. Judith Robinson, *The Hearsts: An American Dynasty* (Newark: University of Delaware Press, 1991), 45–50, 53; Older, *George Hearst*, 10, 92–96. In the 1850s a group of French miners lived fifteen miles from Phoebe's home, and their fine things made an impression. George wrote late in life: "My people lived in log houses, and these French things were extraordinary to us. We had tables and beds and chairs and that was about all, but these people had things which they brought from France which were very beautiful I thought."
19. Kathryn P. Hearst, "Phoebe Apperson Hearst: The Making of an Upper-Class Woman, 1842–1919" (PhD diss., Columbia University, 2005), 11, 47; Robinson, *American Dynasty*, 53–55.
20. Mrs. Fremont Older, *William Randolph Hearst, American* (New York: Appleton-Century, 1936), 527–528.
21. Coffman, *Hearst's Dream*, 22; Robinson, *American Dynasty*, 88; Older, *George Hearst*, 169; Mrs. William Randolph Hearst Jr., *Horses of San Simeon*, 106; Hamilton, *Where the Highway Ends*, 73–74, 123, 142. Miners were working in the quicksilver mines, mining cinnabar in the hills east of Cambria, and earning five dollars a day in the 1880s.
22. Hamilton, *Where the Highway Ends*, 2, 3, 9; Myron Angel, *History of San Luis Obispo County, California, 1883* (Fresno, Calif.: Valley Publishers, 1979), 332. George Hearst constructed the 1878 wharf for $20,000. Examining the shipments for the year 1880 provides an excellent picture of San Simeon's commerce: 3,934 boxes of butter, 930 barrels and firkins of butter, 26,385 pounds of wool, 250 boxes of eggs, 169 flasks of quicksilver,

94 coops of fowl, 374 beef hides, 5,350 calf hides and skins, 299 packages of whale oil, 725 tons of grain, 14 barrels of tallow, 104 neats of seaweed, 169 sacks of abalones, 1,209 live hogs, and 1,277 miscellaneous packages.

23. Hamilton, *Where the Highway Ends*, 134, 136–138, 152–154, 156. While Don Pico steadily resisted Hearst's efforts to buy portions of the Rancho de la Piedra Blanca and Juan Castro refused to deal with him, Hearst stood ready to deal with Pico's children to buy their parcels. Hearst allowed the Pico adobe to fall abandoned but did not gain ownership of the last pieces of the land grant until 1878, when the youngest of Mariano Pacheco's children reached adulthood. Juan Castro had been unable to convince these young people to become interested in managing the ranch. Thomas James Evans was a Welsh farmer who bought his ranch from Castro in 1869. He and his heirs waged a battle to retain their land for ninety years, first with George Hearst and then with William Randolph Hearst, who both aspired to buy the Evans property. This last holdout in the fourteen miles of acreage actually did not change hands until 1970, nineteen years after W. R. Hearst's death, when the Hearst Corporation purchased it from heirs of Thomas James Evans.

24. Mrs. William Randolph Hearst Jr., *Horses of San Simeon*, 103, 106–108, 114–116; Peter C. Allen, *Stanford: From the Foothills to the Bay* (Stanford, Calif.: Stanford Alumni Association/Stanford Historical Society, 1980), 9. Hearst's racing colors were an orange-yellow shirt with green sleeves and an orange-yellow and green cap. He raced many of his horses at the great East Coast tracks, including Saratoga, and was elected president of the Saratoga Racing Association. In 1890 Hearst hired the famed black trainer Albert Cooper, who brought Hearst's prize horse, Tournament, to many victories.

25. Ivan T. Sanderson, *A History of Whaling* (New York: Barnes & Noble Books, 1993), 253; Eric Jay Dolin, *Leviathan* (New York: W. W. Norton, 2007), 107, 338–339, 354, 356, 421.

26. Hamilton, *Where the Highway Ends*, 141–145, 148; Coffman, *Hearst's Dream*, 23; Mrs. William Randolph Hearst Jr., *The Horses of San Simeon*, 63; Dolin, *Leviathan*, 52.

27. Hamilton, *Where the Highway Ends*, 65, 77, 85, 88; Coffman, *Hearst's Dream*, 10; Lo On to G. Loorz, 20 July 1938, and G. Loorz to Lo On, 29 July 1938, George Loorz Collection, San Luis Obispo County Historical Society Archives, San Luis Obispo, Calif.; Young Louis, "Young Louis, Projectionist at San Simeon," interview by Tom Scott, ed. Rayena Martin, *Oral History Project* (San Simeon, Calif.: Hearst San Simeon State Historic Monument, 1990), 1, 4, 10; "Cattle Record 1897 San Simeon," HM 31155; "Piedra Blanca Rancho Payroll June 1892–January 1904," HM 31157, Huntington Library, San Marino, Calif. George Hearst said of the Chinese in 1889: "[T]hey can do more work than our own people, and live on less. . . . It is nonsense to say that the Chinaman is of no account, or that he is dirty; what I am afraid of is, that he is a better man than I am, and I want him out of the country, because I believe we cannot compete with him." Record books for portions of the Piedra Blanca Rancho exist at the Huntington Library in San Marino, California.

Payroll books for 1892–1904, including the Piedra Blanca Rancho and the San Simeon Rancho, contain listings for fifty-five employees. Judging from their surnames, the cooks were Chinese, the *vaqueros* were Mexican, and the gardeners, house staff, blacksmith, teamsters, housekeepers, dairymen, and laborers were Anglo-American.

28. Hamilton, *Where the Highway Ends*, 65, 154–155.

29. Ibid., 138–139, 167.

30. Billy D. Edson, "The Man Even Hearst Couldn't Buy," *The San Diego Union*, May 6, 1990, G 4; Hamilton, *Where the Highway Ends*, 32, 139, 161.

31. J. Smeaton Chase, *California Coast Trails: A Horseback Ride from Mexico to Oregon* (Boston: Houghton Mifflin, 1913), 162–163.

CHAPTER 2: GEORGE HEARST AND PHOEBE APPERSON HEARST: EARLY PIONEERS

1. Older, *William Randolph Hearst*, 43. The coastal steamer was met in San Simeon Bay by a small tug, and the transfer from the steamer to the small boat was harrowing but thrilling for a young boy like Willie.

2. George Hearst, *The Way It Was* (N.p.: Hearst Corporation, 1972), 5, 8–9.

3. Older, *George Hearst*, 22–23, 33–34; G. Hearst, *The Way It Was*, 9–10, 12. The bereaved family in 1846 included George's mother, Elizabeth, one sister, Patsy, and a crippled brother, Philip, who died soon after William Hearst. When George left for the gold fields of California on May 12, 1850, his mother and sister accompanied him on the first two days of the journey. He wrote: "[I]f it had not been for pride when my mother and sister left me I would not have thought of going."

4. G. Hearst, *The Way It Was*, 13–18; Robinson, *American Dynasty*, 45–46; George D. Lyman, *The Saga of the Comstock Lode: Boom Days in Virginia City* (New York: Charles Scribner's Sons, 1934), 53, 74; David Nasaw, *The Chief: The Life of William Randolph Hearst* (Boston: Houghton Mifflin, 2000), 6.

5. Older, *George Hearst*, 94–97, 100–102; William Randolph Hearst Jr., *The Hearsts: Father and Son* (Niwot, Colo.: Roberts Rinehart, 1991), 8; Robinson, *American Dynasty*, 56, 195; K. Hearst, "Phoebe Apperson Hearst," 58.

6. Robinson, *American Dynasty*, 65, 75–85; G. Hearst, *The Way It Was*, 34; Winifred Black Bonfils, *The Life and Personality of Phoebe Apperson Hearst* (San Simeon, Calif.: Friends of Hearst Castle, 1991), 148; Nasaw, *The Chief*, 19; K. Hearst, "Phoebe Apperson Hearst," 9. George Hearst described the ranch at San Simeon in his 1890 memoirs: "I may say that besides mining, I have been somewhat interested in stock raising and have a large ranch near Monterey, some forty-five thousand acres, where I raise cattle and hogs. The land is not very valuable, because it is too boggy; however, it makes a very good dairy ranch, and that is what I use it for." Hearst's 1934 biographer, Mrs. Fremont Older, says Phoebe camped at the site after the ranch house was built in 1878. Phoebe Apperson Hearst's biographer, Winifred Black Bonfils, said that Phoebe never could be induced to camp on the hilltop site. Mrs. Fremont Older is likely to

have been the more accurate source, as the Bonfils biography was written quickly, whereas Mrs. Fremont Older had direct access to W. R. Hearst and his family papers.

7. Marian Geil, *Anaconda's Treasure: The Hearst Free Library* (Anaconda, Mont.: The Hearst Free Library, 1998), 4–5; Robinson, *American Dynasty*, 105; Mary Hallock Foote, *A Victorian Gentlewoman in the Far West: The Reminiscences of Mary Hallock Foote*, ed. Rodman W. Paul (San Marino, Calif.: Huntington Library Press, 1972), 160–161.

8. Older, *William Randolph Hearst*, 11–12; Robinson, *American Dynasty*, 74; Stirling Macoboy, *The Ultimate Rose Book*, ed. Tommy Cairns (New York: Abrams, 2007), 116–117. Modern roses are the rose classes introduced on or after 1867, beginning with Guillot's 'La France.' A medium pink variety, it was the first hybrid tea rose. Bred from 'Madame Victor Verdier' and 'Madame Bravy,' it had "the general habit of a Hybrid Perpetual and the elegantly shaped buds and free-flowing character of a Tea Rose." It was nearly twenty years after the introduction of 'La France' that serious hybrid tea rose breeding began.

9. Older, *William Randolph Hearst*, 9; Morgan to Hearst, 3 May 1921, Kennedy Library. Morgan wrote to Hearst: "I am wondering if the yellow flowers in your grandmother's garden were not four-o'clocks. In any case, we will try to find them."

10. W. R. Hearst, "In the News," 6 Nov. 1941.

11. Robinson, *American Dynasty*, 125, 127; Older, *William Randolph Hearst*, 106. There are many stories of W. R. Hearst's lifelong love of animals. Typical is the telegram he sent to his editor Walter Howey from the train at Dodge City around 1915, about his son William Randolph Hearst Jr.: "In a box-car near a water tank about a mile west of Kansas City is a bawling, black and white calf. Bill wants the darned thing." They purchased the calf and sent it to the Pleasanton Hacienda, where it led a long and peaceful life.

12. Robinson, *American Dynasty*, 158–159, 161–164.

13. Older, *William Randolph Hearst*, 43–45; Edward A. Newton, *Derby Days & Other Adventures* (Freeport, N.Y.: Books for Libraries Press, 1969), 215.

14. Robinson, *American Dynasty*, 175; Older, *William Randolph Hearst*, 46.

15. Julie Cain, "Landscaping the Gilded Age: Rudolph Ulrich at Monterey's Hotel del Monte, 1880–1890," *Noticias del Puerto de Monterey, Monterey History and Art Association Quarterly* 53, no. 3 (Fall 2004): 3–7, 12–15, 27; Nasaw, *The Chief*, 28, 57–78; Older, *William Randolph Hearst*, 56–58; Phoebe A. Hearst to Orrin Peck, 22 Dec. 1886, Peck Family Papers, Huntington Library, San Marino, Calif.; Robinson, *American Dynasty*, 245. The Hotel was built in 1880 by the Pacific Improvement Company (PIC), a holding company managed by three of the railroad men known as the Big Four: Charles Crocker, Collis P. Huntington, and Leland Stanford. The fourth, Mark Hopkins, had died in 1878. Their goal was to increase the passenger trade of their Southern Pacific Railroad.

16. Nasaw, *The Chief*, 39, 43–44, 56–57; Ben Procter, *William Randolph Hearst: The Early Years, 1863–1910* (New York: Oxford University Press, 1998), 42–43; Robinson, *American Dynasty*, 173, 192–200; G. Hearst, *The Way It Was*, 34–35.

17. Robinson, *American Dynasty*, 85, 89, 187–188, 360–361, 378; Older, *William Randolph Hearst*, 64–65; Nasaw, *The Chief*, 59–60, 212, 228–229, 248; W. A. Swanberg, *Citizen Hearst: A Biography of William Randolph Hearst* (New York: Bantam, 1963), 34, 207, 297, 338–339, 631; Gray A. Brechin, *Imperial San Francisco: Urban Power, Earthly Ruin* (Berkeley: University of California Press, 1999), 327; Huntington Library FA box 84 (26) 12/1 1919–9/1/1922. George Hearst acquired the 900,000 acres of Babicora ranchlands in northern Mexico in 1884 as payment for surveying land for the Mexican government during the administration of President Porfirio Díaz. In 1911 Díaz was overthrown when he was unable to continue to protect American business interests. Francesco Madera succeeded him, but in 1913 he too was overthrown. Hearst began to advocate armed interference by the United States in Mexico. A revolution occurred in 1915 under the direction of Pancho Villa, who reappropriated Hearst ranchlands.

18. Older, *William Randolph Hearst*, 69; "Hearst," *Fortune* 12, no. 4 (Oct. 1935): 42, 48, 53; Procter, *The Early Years*, 47, 49.

19. Nasaw, *The Chief*, 88–89.

20. Susan Snyder, *Past Tents: The Way We Camped* (Berkeley: Heyday Books and the Bancroft Library, 2006), 37–39.

21. K. Hearst, "Phoebe Apperson Hearst," 218, 257, 295; J. R. K. Kantor, "Cora, Jane & Phoebe: Fin-de-Siècle Philanthropy," *Chronicle of the University of California* 1, no. 2 (1998): 6; Geil, *Anaconda's Treasure*, 12. Phoebe's philanthropic focus was generally education. She financed the Hearst Free Kindergarten in 1889 in San Francisco. She was an early and important donor to the Mount Vernon Ladies' Association (the first major historic preservation effort in America), financing a sea wall in 1890. She built the Hearst Free Library in Lead, South Dakota, in 1894, and the Hearst Free Library in Anaconda, Montana, in 1898 (both sites of successful Hearst mines).

22. Harvey Helfand, *The Campus Guide, University of California, Berkeley: An Architectural Tour and Photographs by Harvey Helfand* (New York: Princeton Architectural Press, 2002), 5, 10; Sally B. Woodbridge, *Bernard Maybeck: Visionary Architect* (New York: Abbeville, 1992), 75–76; K. Hearst, "Phoebe Apperson Hearst," 296; Laura Wood Roper, *FLO: A Biography of Frederick Law Olmsted* (Baltimore: Johns Hopkins University Press, 1973), 305, 308–309; Loren W. Partridge, *John Galen Howard and the Berkeley Campus: Beaux-Arts Architecture in the "Athens of the West."* Berkeley Architectural Heritage Publication Series, no. 2 (Berkeley: Berkeley Architectural Heritage Association, 1978), 6–8. In 1866 landscape architect Frederick Law Olmsted devised a campus plan built around the natural separation caused by the flow of Strawberry Creek. It had a central axial focus, orienting the campus to its view of the Golden Gate, seen then as a shining symbol of Arcadian beauty.

23. Leslie M. Freudenheim, *Building with Nature: Inspiration for the Arts and Crafts Home* (Salt Lake City: Gibbs Smith, 2005), 161–165; Karen J. Weitze, "California's Mission Revival," *California Architecture and Architects*, no. 3 (Los Angeles: Hennessey & Ingalls, 1984), 48–52.

24. K. Hearst, "Phoebe Apperson Hearst," 298; Peter C. Allen, *Stanford: From the Foothills to the Bay*, 9–11, 17–18; Roper, *Olmsted*, 406–408, 411–414; Perry, *Pacific Arcadia: Images of California*, 158. Leland Stanford purchased 650 acres of the San Francisquito Rancho, renamed it the Palo Alto Farm, and established a horse breeding operation there in the 1850s. After Leland Stanford and Jane Stanford's son Leland Jr., died of typhoid in Florence in March 1884, the grief-stricken Stanfords immediately decided to build a campus as their son's memorial. Shepley, Rutan, and Coolidge's design echoed the style of the California missions. It was a romanticized Spanish village.

25. Longstreth, *Four Architects*, 244–249; B. J. S. Cahill, "The Phebe Hearst Architectural Competition," *The California Architect and Building News* 20, no. 9 (Sept. 1899): 98.

26. William Carey Jones, "The First Benefactors," *The University of California Magazine* 5, no. 3 (Apr. 1899): 101–117; Helfand, *The Campus Guide*, 11; Kantor, *Cora, Jane & Phoebe*, 7; Cahill, "The Phebe Hearst Architectural Competition," 97–108.

27. Helfand, *The Campus Guide*, 15.

28. Woodbridge, *Maybeck*, 77–80; Helen Hillyer Brown, *For My Children and Grandchildren* (San Francisco: Hillside Press, 1986), 40; Helfand, *The Campus Guide*, 204–208; Robinson, *American Dynasty*, 371–373. Phoebe Hearst and Bernard Maybeck were also instrumental in the plan for Mills College, the only women's college in California. Julia Morgan designed its Mission Revival–style bell tower, El Campanil, in 1903. Phoebe's involvement began in 1916, when she hired Maybeck to design a campus plan. He created a scheme that integrated the natural landscape of the site.

29. William Randolph Hearst Jr., *The Hearsts*, 21; Robinson, *American Dynasty*, 290.

30. Robert C. Pavlik, "Phoebe Apperson Hearst and La Cuesta Encantada," California Department of Transportation, San Luis Obispo, Calif. (Aug. 2005), 8–9; K. Hearst, "Phoebe Apperson Hearst," 307–309; Bonfils, *The Life and Personality of Phoebe Apperson Hearst*, 90.

31. William Randolph Hearst Jr., *The Hearsts*, 21; Joseph H. Engbeck Jr., *The Enduring Giants* (Berkeley: University Extension, University of California, 1973), 95; Willie Yaryan, Denzil Verado, and Jennie Dennis Verado, *The Sempervirens Story: A Century of Preserving California's Ancient Redwood Forest, 1900–2000* (Los Altos, Calif.: Sempervirens Fund, 2000), 19–20.

32. Freudenheim, *Building with Nature*, 173, 175, 280–286; Robinson, *American Dynasty*, 175; Swanberg, *Citizen Hearst*, 68; K. Hearst, "Phoebe Apperson Hearst," 306; Longstreth, *Four Architects*, 279, 286. It is probable that Phoebe had permitted W. R. to build something small, which he had immediately expanded into a grand estate, just as he would later do at San Simeon. She appropriated the project. It is perhaps relevant to note that she did not permit any building on the site at San Simeon—perhaps in memory of this unpleasant disagreement between them.

33. K. Hearst, "Phoebe Apperson Hearst," 306. In later years, Phoebe became very active in sponsoring the Young Women's Christian Association (YWCA), including inviting three hundred girls to camp at the Hacienda in 1912. After this event, she donated funds for a permanent site in Pacific Grove, near Monterey, known as Asilomar. Julia Morgan designed more than a dozen of its buildings, from 1913 to 1928. It remains one of the finest examples of integrated Arts and Crafts style.

34. Porter Garnett, *Stately Homes of California* (Boston: Little, Brown, 1915), 21–22; Victoria Kastner, *Hearst Castle: The Biography of a Country House* (New York: Harry N. Abrams, Inc., 2000), 31.

35. Freudenheim, *Building with Nature*, 51–52. Phoebe's attorney Charles Stetson Wheeler had invited her to his residence, The Bend, built by Willis Polk in 1898. Phoebe wanted to buy a parcel of Wheeler's property. He conceded, as long as she built only a small cabin. She hired Maybeck in 1901 and built the enormous Wyntoon, at a cost of one hundred thousand dollars.

36. Wayne Craven, *Stanford White: Decorator in Opulence and Dealer in Antiquities* (New York: Columbia University Press, 2005), 236; Michael Conforti, "Stanford White at San Simeon," paper presented at the Society of Architectural Historians Convention (Cincinnati, 26 Apr. 1991), 10; Lawrence Grant White, *Sketches and Designs by Stanford White* (New York: Architectural Book Publishing, 1920), 24–25; Hearst, *In the News*, 25 Nov. 1941; Alma Gilbert, *Maxfield Parrish: The Masterworks* (Berkeley: Ten Speed Press, 1992), 72.

37. Nasaw, *The Chief*, 113–114, 164–165; Phoebe Apperson Hearst to Orrin Peck, 9 July 1903, Peck Family Papers, Huntington Library.

38. Nasaw, *The Chief*, 214–215. This insensitive remark is not typical for Hearst, who assembled an outstanding collection of Native American art objects. See Nancy J. Blomberg, *Navajo Textiles: The William Randolph Hearst Collection* (Tucson: University of Arizona Press, 1994).

39. Hearst to Morgan, 31 Dec. 1919, Kennedy Library.

40. Ben Macomber, *The Jewel City: Its Planning and Achievement; Its Architecture, Sculpture, Symbolism, and Music; Its Gardens, Palaces, and Exhibits* (San Francisco: John H. Williams, 1915), 15, 27; Woodbridge, *Maybeck*, 101; Robert C. Pavlik, "'Something a Little Different': La Cuesta Encantada's Architectural Precedents and Cultural Prototypes," *California History* 71, no. 4 (Winter 1992/1993): 464–466; Robinson, *American Dynasty*, 132, 157, 220. Besides viewing the major American world's fairs (the 1876 Philadelphia Centennial Exposition and the 1893 World's Columbian Exposition), both W. R. and Phoebe saw the Vienna World Exposition of 1873. Phoebe attended the Exposition Universelle in 1889—the Paris world's fair, for which the Eiffel Tower was created.

41. Sara Holmes Boutelle, *Julia Morgan, Architect*, rev. ed. (New York: Abbeville, 1995), 101–105; Robinson, *American Dynasty*, 359–361.

42. John D. Barry, *The City of Domes* (San Francisco: John J. Newbegin, 1915), 61.

43. Robinson, *American Dynasty*, 360; Phoebe A. Hearst, J. Nilsen Laurvik, and Arthur Upham Pope, *Catalogue: Mrs. Phoebe A. Hearst Loan Collection* (San Francisco: The San Francisco Art Association, 1917), iii; Hearst to Morgan, 9 Mar. 1937, and Hearst to Morgan, 14 Mar. 1937, Kennedy Library.

44. *The Legacy of the Exposition: Interpretation of the*

Intellectual and Moral Heritage Left to Mankind by the World Celebration of San Francisco in 1915 (San Francisco: Panama-Pacific International Exposition Company, 1916), 76; Robinson, *American Dynasty*, 360; Phoebe A. Hearst, "California as a Field for Women's Activities," *California Magazine* (July 1915): 373.

45. Robinson, *American Dynasty*, 380–383; K. Hearst, "Phoebe Apperson Hearst," 327–328.

CHAPTER 3: LA CUESTA ENCANTADA: LANDSCAPE BEGINNINGS (1919–1922)

1. John Galen Howard, "Country House Architecture on the Pacific Coast," *The Architectural Record* 40, no. 4 (1916): 355.

2. Ronald D. Quinn and Sterling C. Keeley, *California Natural History Guides: Introduction to California Chaparral* (Berkeley: University of California Press, 2006), 2–3, 90–92, 114.

3. Ibid., 22–23. A Mediterranean climate requires the convergence of three factors: a latitude of roughly 30 to 40 degrees on either side of the equator, a cold ocean, and a large high-pressure air mass extending from the ocean across the adjacent land and shifting north and south with the seasons.

4. California Coastal Commission, *Experience the California Coast: Beaches and Parks from Monterey to Ventura* (Berkeley: University of California Press, 2007), 107.

5. Steilberg, "Address to the Historical Guide Association," 18.

6. Jane Sarber, "A Cabbie in a Golden Era, Featuring Cabbie's Original Log of Guests Transported to Hearst Castle" (N.p., n.d.), 4–5, 8.

7. "Julia Morgan Travel Records," 1918–1919, Morgan-Boutelle Collection, Kennedy Library.

8. Hearst to Morgan, 8 Sept. 1919, telegram; Hearst to Morgan, 9 Sept. 1919. Kennedy Library. Hearst chose to build three cottages during the first few months of construction. By 1926 he was planning the unbuilt Houses D and E, perhaps because he felt three were insufficient.

9. Morgan to Hearst, 25 Sept. 1919; Hearst to Morgan, 12 Feb. 1921. Kennedy Library. Hearst asked Morgan to view the 1919 movie *Soldier of Fortune* with Allan Dwan, filmed at the Balboa Park, San Diego, fairgrounds.

10. Hearst to Morgan, 31 Dec. 1919, Kennedy Library.

11. Morgan to Hearst, 31 Sept. 1919, Kennedy Library.

12. Morgan to Hearst, 12 Feb. 1923; Morgan to Hearst, 28 Feb. 1923; Hearst to Morgan, 9 Mar. 1923, telegram. Kennedy Library.

13. Coffman, *Building for Hearst and Morgan*, 546–547. The eighteen-page "Commission Account" for San Simeon—part of the Morgan-Forney ledgers—was the records kept by Morgan's office secretary, Lillian Forney. The accounting indicates that Morgan cleared a profit of $115,893 on San Simeon, from 1919 through 1939. Researcher Taylor Coffman extrapolates from this number a twenty-one-year average of $20,373 in gross annual proceeds and $5,515 in net annual profit.

14. Hearst to Morgan, 25 Oct. 1919; Hearst to Morgan, 12 Aug. 1920, telegraph, Kennedy Library; O. Peck to Morgan, undated, c. May 1920.

Huntington Library; *New York Times*, 1 Mar. 1908; "Mr. Orrin Peck's Picture Exhibit," *New York Herald*, 20 Mar. 1901. Hearst rejected the idea of casement windows in the cottages, calling them "not desirable because of bisecting view." Peck's participation at San Simeon was short lived, as he died early in 1921. Had he survived, he would likely have been an important contributor to the plans. A review of Peck's London 1901 exhibition concluded: "The most striking portrait in the exhibition is that of Mr. William R. Hearst. The pose is easy and graceful—not in the least affected. As a portrait of Mr. Hearst as he was several years ago the result is a decided achievement. There is character in the face, and the modeling is exceptionally good."

15. Hearst to Morgan, 21 Dec. 1919; Hearst to Morgan, undated, c. Nov. 1919. Kennedy Library. In the early years, the cottages were known as Casa Rosa (for House A), Casa Heliotrope (for House C), and Casa Bougainvillea (for House B). The change of names from plants to viewscapes may have coincided with an enlargement of the cottages.

16. Hearst to Morgan, 31 Dec. 1919, Kennedy Library. They planted under the oak trees, which encouraged diseases caused by over watering. Morgan wrote to Hearst on 4 Feb 1921: "Under the large oak is a fine place for rhododendrons."

17. Hearst to Morgan, 27 Dec. 1919, Kennedy Library.

18. Hearst to Morgan, 19 Apr. 1920, telegram; Hearst to Morgan, 25 Oct. 1919; Morgan to Hearst, 10 Dec. 1919; Hearst to Morgan, 10 Dec. 1919; Hearst to Morgan, 18 Dec. 1919. Kennedy Library. Hearst changed his mind frequently in siting the houses, deciding that they were too low and should be moved back to their original locations.

19. Kentia Nurseries to Hearst, 6 July 1920; Hearst to Morgan, telegram, 8 Apr. 1921. Kennedy Library. Hearst instructed Morgan to pursue several nurseries in seeking plants. He emphasized the importance of "getting full-grown plants."

20. Carol Greentree, introduction to Winifred Starr Dobyns, *California Gardens* (Santa Barbara, Calif.: Allen A. Knoll, 1996), 9; Virginia Tuttle Clayton, ed., *The Once and Future Gardener: Garden Writing from the Golden Age of Magazines, 1900–1940* (Boston: David R. Godine, 2000), 206; A. E. Hanson, *An Arcadian Landscape: The California Gardens of A. E. Hanson, 1920–1932*, eds. David Gebhard and Sheila Lynds (Los Angeles: Hennessey & Ingalls, 1985), 19–25; David C. Streatfield, *California Gardens: Creating a New Eden* (New York: Abbeville, 1994), 104, 110–111, 113–118, 127.

21. Morgan to Hearst, 30 Aug. 1927, Kennedy Library.

22. Mac Griswold and Eleanor Weller, *The Golden Age of American Gardens: Proud Owners, Private Estates, 1890–1940* (New York: Harry N. Abrams, Inc., 1991), 329–330, 343; James L. Yoch, *Landscaping the American Dream: The Gardens and Film Sets of Florence Yoch, 1890–1972* (New York: Harry N. Abrams, Inc., 1989), xi, 31–40; Morgan to Hearst, 8 June 1926; Morgan to Hearst, 21 Mar. 1921; Hearst to Joy, 1 Oct. 1921; Hearst to Morgan, 28 July 1924. Kennedy Library.

23. Griswold and Weller, *The Golden Age of American Gardens*, 326–327; Hearst to Morgan, 10 Nov.

1930, telegram; Hearst to Morgan, 30 Dec. 1931, Kennedy Library. David Streatfield in *California Gardens: Creating a New Eden* identifies Charles Gibbs Adams as the assisting landscape architect of San Simeon. While incorrect, it is understandable, given Adams's own assertions in his article for *The Saturday Evening Post*, "Gardens for the Stars." According to the Hearst-Morgan correspondence, however, Adams appears to have been hired only for a brief period in 1930 as a tree planter.

24. "The Work of Walter Steilberg and Julia Morgan," Bancroft Library, 143.

25. Griswold and Weller, *The Golden Age of American Gardens*, 42.

26. Herbert Croly, "The Architectural Work of Charles A. Platt," *The Architectural Record* 15, no. 3 (Mar. 1904): 183.

27. Mark Alan Hewitt, *The Architect & the American Country House: 1890–1940* (New Haven: Yale University Press, 1990), 65.

28. Morgan to Hearst, 6 Apr. 1920; Morgan to Hearst 3 Aug. 1922. Kennedy Library.

29. Morgan to Hearst, 14 Jan. 1921; *The Board and Batten*, newsletter of the Pacific Grove Heritage Society (Pacific Grove, Calif.: The Heritage Society of Pacific Grove, Feb./Mar. 1994); Morgan to Hearst, 8 July 1922; Hearst to Morgan, 20 Oct. 1925. Kennedy Library.

30. Hearst to Morgan, 19 Jan. 1921, telegram, Kennedy Library.

31. Morgan to Hearst, 4 Feb. 1921, Kennedy Library.

32. Hearst to Morgan, 12 Feb. 1921; Hearst to Morgan, 20 Oct. 1921; Hearst to Morgan, 18 Feb. 1922, telegram. Kennedy Library. Hearst spent several months in a row at San Simeon in 1921, leading him to recommend that they create "lath roofs" for the courts of the cottages as a temporary measure, to protect the tender plants during winter months.

33. Morgan to Byne, 27 July 1922; Morgan to Hearst, 18 Jan. 1921. Kennedy Library. In an early letter from Morgan to Hearst, she crossed out "the painters are finally listening to reason" and wrote instead "The painters are putting in 8 hours," likely so he would not see her frustration.

34. Hearst to Morgan, 7 Feb. 1921; Hearst to Morgan, 10 May 1921. Kennedy Library. Hearst was interested in fountains for many purposes, including their distant effect in the landscape.

35. Hearst to Morgan, undated, c. 24 Dec. 1921, Kennedy Library. In 1926 Hearst purchased a twelfth-century Cistercian monastery in Spain known as Sacramenia. He purchased two other Spanish cloisters, Alcantara in 1927 and Mountolive in 1931. The dismantling of these cloisters and their shipment to America was presided over by Arthur Byne and his wife, Mildred Stapley Byne. None of the cloisters Hearst purchased came to San Simeon. Alcantara was shipped to Wyntoon; Sacramenia was sold in 1941 and reconstructed on the Dixie Highway in Miami, Florida; and Mountolive was planned as a medieval museum in San Francisco (never built).

36. Dan North, "How I Made a Forest out of a Desert: Nigel Keep, 90, Recalls Working for W. R. Hearst," *San Francisco Examiner*, 24 Feb. 1963. sec. 1.

37. Nigel Keep, "Trees of San Simeon" (San Simeon, Calif.: Hearst San Simeon State Historical Monument, 1946).

38. Griswold and Weller, *The Golden Age of American Gardens*, 318; Streatfield, *California Gardens*, 91.

39. Bruce Porter, introduction to Garnett, *Stately Homes of California*, ix–x.

40. Bruce Porter, "Report of Mr. Bruce Porter for William R. Hearst, Esquire, Upon His Estate at San Simeon: And Its Improvements" (Jan. 1923), 1, 6–7, 10–12, Morgan-Boutelle Collection, Kennedy Library. Bruce Porter drew a rough sketch in 1923 to accompany his report. At the recommended pool site—where the Neptune Pool was ultimately built—Hearst wrote: "Night garden around the pool[.] This should be a very romantic spot[,] a place for young lovers—and maybe old ones."

41. Hearst to Morgan, 5 Jan. 1922, Kennedy Library.

42. Hearst to Morgan, 15 Mar. 1922; Hearst to Morgan, 28 Apr. 1922, telegram. Kennedy Library.

43. Willicombe to Lee, 23 Mar. 1921; Morgan to Hearst, 8 Apr. 1921. Kennedy Library.

CHAPTER 4: MORGAN AND HEARST: NATIVE CALIFORNIANS (1919–1947)

1. Sara Holmes Boutelle, "Julia Morgan," in Robert Winter, ed., *Toward a Simpler Way of Life: The Arts & Crafts Architects of California* (Berkeley: University of California Press, 1997), 63.

2. Boutelle, *Julia Morgan, Architect*, 19–20; C. Morgan to J. Morgan, 5 Sept. 1897, Morgan-Boutelle Collection, Kennedy Library; Karen McNeill, "Julia Morgan: Gender, Architecture, and Professional Style," *Pacific Historical Review* 76, no. 2 (2007): 231.

3. Boutelle, *Julia Morgan, Architect*, 19. For an account of Eliza Woodland Parmelee's family residence and background, see Mary Woodland Gould Tan and Virginia Carroll, *Woodland Hall, Kent County, Maryland: Remembrances of the Family and Home* (Holly Hill, Fla.: Copy Cat Printing, 2007).

4. Roper, *Olmsted*, 263, 277; Freudenheim, *Building with Nature*, 16.

5. "Julia Morgan Travel Diary," 1938–1939, 42, Morgan-Boutelle Collection, Kennedy Library.

6. Morgan to Fox, 14 Aug. 1898, HM 54391, Huntington Library; Boutelle, *Julia Morgan, Architect*, 21, 23.

7. Morgan to Dahl, 1 Jan. 1927, Morgan-Boutelle Collection, Kennedy Library.

8. McNeill, "Julia Morgan: Gender, Architecture, and Professional Style," 233, 246; Boutelle, *Julia Morgan, Architect*, 23–24; Paul R. Baker, *Richard Morris Hunt* (Cambridge, Mass.: MIT Press, 1980), 25. While Morgan seems to have accepted Maybeck's colorful lifestyle, her mother disapproved of his bohemian dress, writing her: "Today Emma [Morgan's sister] saw the Maybecks on the Boat dressed in their worst Berkeley clothes—she escaped them as she considers them embarrassing acquaintances.... He is a kind nice looking man—when dressed decently."

9. Jane Turbiner, "Economics at Cal: At the Cutting Edge for 100 Years," *University of California, Berkeley, The Econ Exchange* 5, no. 1 (Spring 2002): 5.

10. Longstreth, *Four Architects*, 74; Christopher McMahon and Timmy Gallagher, *The Gardens at Filoli* (San Francisco: Pomegranate Artbooks, 1994), 16, 18; Ernest Peixotto, *Romantic Califor-*
nia (New York: Charles Scribner's Sons, 1911), 62–63.

11. Diane Favro, "Sincere and Good: The Architectural Practice of Julia Morgan," *Journal of Architectural and Planning Research* 9, no. 2 (Summer 1992): 114.

12. Morgan to Fox, 11 Dec. 1896, Huntington Library.

13. E. Morgan to J. Morgan, 14 Feb. 1897, Morgan-Boutelle Collection, Kennedy Library. The San Francisco architect Arthur Brown Jr., attended the Ecole des Beaux-Arts when Morgan did. His mother lived in Paris and befriended Morgan, as related by Jeffrey Tilman in *Arthur Brown Jr.: Progressive Classicist* (New York: W. W. Norton, 2006), 24: "When [Morgan's] brother Avery left Paris and Morgan was forced to live in smaller quarters, Mrs. Brown offered her salon; when no Frenchman would work for her . . . Mrs. Brown assisted Morgan in rendering her watercolor elevations *en charette*."

14. A. Morgan to J. Morgan, 7 Mar. 1897, Morgan-Boutelle Collection, Kennedy Library; Boutelle, *Julia Morgan, Architect*, 22; McNeill, "Julia Morgan: Gender, Architecture, and Professional Style," 236.

15. C. Morgan to J. Morgan, 5 Sept. 1897, Kennedy Library; E. Morgan to J. Morgan, 17 Jan. 1897; L. LeBrun to J. Morgan, 19 Jan. 1898. Morgan-Boutelle Collection, Kennedy Library; Boutelle, *Julia Morgan, Architect*, 20, 25, 33; McNeill, "Julia Morgan: Gender, Architecture, and Professional Style," 231. Several family letters allude to John Van Pelt, a friend of Morgan's and a resident of upstate New York, who studied architecture at the Ecole during Morgan's years there. He won the composition prize in 1902 and returned to Cornell to teach. Family members hinted at the potential of a romance between Morgan and Van Pelt, but there is no evidence that any ever occurred.

16. Favro, "Sincere and Good," 114.

17. *San Francisco Examiner*, 6 Dec. 1898.

18. McNeill, "Julia Morgan: Gender, Architecture, and Professional Style," 237.

19. Woodbridge, *Maybeck*, 18; Donald Drew Egbert, *The Beaux-Arts Tradition in French Architecture* (Princeton: Princeton University Press, 1980), 121; Robert M. Craig, *Bernard Maybeck at Principia College: The Art and Craft of Building* (Layton, Utah: Gibbs Smith, 2004), 21.

20. "The Work of Walter Steilberg and Julia Morgan," Bancroft Library, 90.

21. Boutelle, "Julia Morgan," in Winter, *Toward a Simpler Way of Life*, 63–64; Boutelle, *Julia Morgan, Architect*, 41, 249.

22. Helfand, *The Campus Guide*, 101, 253–254.

23. Rosalind A. Keep, *Fourscore Years: A History of Mills College* (Oakland: Goodhue-Kitchener, 1931), 98–99; Boutelle, *Julia Morgan, Architect*, 55–58.

24. Mark A. Wilson, *Julia Morgan: Architect of Beauty* (Layton, Utah: Gibbs Smith, 2007), 20; Boutelle, *Julia Morgan, Architect*, 42, 78–79.

25. Boutelle, *Julia Morgan, Architect*, 42. From the twenties on, Maybeck worked out of Morgan's office. They collaborated on the Phoebe A. Hearst Memorial Gymnasium at the University of California in 1927. Morgan has also been credited as Maybeck's codesigner of Principia College in Elsah, Illinois, from 1930 to 1938. New scholar-
ship demonstrates that Morgan was less involved in its design than previously thought.

26. Boutelle, *Julia Morgan, Architect*, 160; Morgan North and Flora North, "Julia Morgan, Her Office, and a House," vol. 2 of *The Julia Morgan Architectural History Project*, ed. Suzanne B. Riess, the Bancroft Library, Regional Oral History Office (Berkeley: University of California, 1976), 169.

27. Boutelle, *Julia Morgan, Architect*, 171 Longstreth, *Four Architects*, 56, 288. Phoebe supplied Morgan with fifty dollars a month while she studied in Paris. This was the same amount she sent to the male students from the university while they studied at the Ecole des Beaux-Arts. Albert C. Schweinfurth and Bernard Maybeck were both involved in creating the Swedenborgian Church—or Church of the New Jerusalem—for Reverend Joseph Worcester in San Francisco's Pacific Heights in 1894. Bruce Porter designed its stained-glass windows.

28. Charles Lummis, "The Greatest California Patio House," *Country Life in America* (Oct. 1904): 540, 560–564; Boutelle, *Julia Morgan, Architect*, 172–173.

29. Boutelle, *Julia Morgan, Architect*, 172–173; Longstreth, *Four Architects*, 283; Freudenheim, *Building with Nature*, 172–176.

30. Boutelle, *Julia Morgan, Architect*, 173.

31. Joan Draper, "John Galen Howard," in Winter, *Toward a Simpler Way of Life*, 34, 64; "The Work of Walter Steilberg and Julia Morgan," 55.

32. Jacomena Maybeck, *Maybeck: The Family View* (Berkeley: Berkeley Architectural Heritage Association, 1980), 15; Freudenheim, *Building with Nature*, 120–122. The best example of Maybeck's use of landscaping as architectural ornament is his 1910 Church of Christ, Scientist, in Berkeley, whose wisteria-covered trellis on the front facade is one of the building's most important features.

33. Steilberg, "Address to the Historical Guide Association," 11.

34. Ibid.

35. "The Work of Walter Steilberg and Julia Morgan," Bancroft Library, 133–134; "Julia Morgan Travel Diary," 65. Morgan-Boutelle Collection, Kennedy Library. A diary Morgan kept on a freighter trip through Europe in the fall of 1938–spring of 1939 has many examples of her sensitivity to color in architecture.

36. Lynn Forney McMurray, Foreword, in Wilson, *Julia Morgan: Architect of Beauty*, vii.

37. Susana Torre, ed., *Women in American Architecture: A Historic and Contemporary Perspective* (New York: Whitney Library of Design, 1977), 69; McNeill, "Julia Morgan: Gender, Architecture, and Professional Style," 248.

38. Torre, *Women in American Architecture*, 65; Sally Bullard Thornton, "Hazel Wood Waterman," in Winter, *Toward a Simpler Way of Life*, 219–227; Victoria Kastner, "Morgan and Associates: Julia Morgan's Office Practice as Design Metaphor," *20 on 20/20 Vision: Perspectives on Diversity and Design* (Boston: AIA Diversity Committee/Boston Society of Architects, 2003), 40–45.

39. Mary Elizabeth Jane Colter and Virginia L. Grattan, *Mary Colter: Builder upon the Red Earth* (Grand Canyon, Ariz.: Grand Canyon Natural History Association, 1992), 2–6, 82–91; Arnold Berke, *Mary Colter: Architect of the Southwest* (New York:

Princeton Architectural Press, 2002), 127–140, 209–220.

40. David Gebhard, *Lutah Maria Riggs: A Woman in Architecture, 1921–1980* (Santa Barbara: Capra Press, 1992), 1–13, 27–28, 43–45; Boutelle, *Julia Morgan, Architect*, 88–95; See also Russell L. Quacchia, *Julia Morgan, Architect, and the Creation of the Asilomar Conference Grounds* (Virginia Beach, Va.: Q Publishing, 2005).

41. "Report on Hearst South Rim Property," 30 Sept. 1949, Morgan-Boutelle Collection, Kennedy Library.

42. Hearst to Morgan, 22 Mar. 1926, Morgan-Boutelle Collection, Kennedy Library; Coffman, *Building for Hearst and Morgan*, 65n; "Report on Hearst South Rim Property," Kennedy Library; Loorz to Carl Daniels, 31 Mar. 1937, San Luis Obispo County Historical Society Archives. The original 1,230-square-foot cabin Morgan designed for Hearst at the Grand Canyon was built in 1914 at a cost of twenty-five hundred dollars.

43. Boutelle, *Julia Morgan, Architect*, 174.

44. Jack Tracy, *Sausalito Moments in Time: A Pictorial History of Sausalito's First One Hundred Years, 1850–1950* (Sausalito, Calif.: Windgate Press, 1983), 49–51.

45. Steilberg, "Address to the Historical Guide Association," 4.

46. Randall L. Makinson, "Charles and Henry Greene," in Winter, *Toward a Simpler Way of Life*, 125–126; Edward R. Bosley, *Greene and Greene* (London: Phaidon, 2002), 77.

47. Adela Rogers St. Johns, *The Honeycomb* (New York: Doubleday, 1969), 130.

CHAPTER 5: THE MID-1920S AND THE STYLES OF SPAIN (1922–1925)

1. Hearst to Morgan, 27 Mar. 1922; Morgan to Hearst, 6 Apr. 1922. Kennedy Library.

2. Hearst to Morgan, 27 Mar. 1922; Hearst to Morgan, 24 Mar. 1922, telegram. Kennedy Library.

3. Morgan to Hearst, 6 Apr. 1922, Kennedy Library.

4. Hearst to Morgan, 24 Mar. 1922, telegram. Morgan to Hearst, 18 Mar. 1922; see also Hazard to Morgan, 15 Mar. 1922; Hearst to Morgan, 24 Mar. 1922, telegram. Kennedy Library. Morgan showed patience in dealing with the head gardener, Hugh Hazard, who resisted her authority. She wrote Hearst: "I think Hazard has tried very hard to please you, and for that reason I have humored him along although some time ago he told me that 'his department on your orders' had, and would have, nothing whatever to do with me or my office people. This has had its bad effect, however, and while I wanted to put it off until you came, [I] will have to either let him go and let Nigel Keep finish out (who is fully capable), or else ask you to tell him to 'cooperate.' Regretting to bother you with this." Hearst's response was unequivocal: "Please dismiss Hazzard [*sic*]."

5. Morgan to Hearst, 19 July 1922, Kennedy Library.

6. Morgan to Hearst, 3 Aug. 1922; Morgan to Hearst, 19 Dec. 1921. Kennedy Library.

7. Steilberg, "Address to the Historical Guide Association," 8–9; Morgan to Hearst, 27 Nov. 1927; Morgan to Hearst, 20 Jan. 1932. Kennedy Library. Steilberg described Rossi's fearlessness, including the time in 1931 he brought a large

leopard out of its cage at the hilltop's zoo. Rossi put the big cat on a fragile leash and asked Steilberg to take his picture. Steilberg recalled: "Just about this time, the leopard mewed. I don't know whether you ever heard a leopard mew but it's something just about like a very small kitten and just something about it started me laughing and Mr. Rossi said, 'Oh, gosh, don't laugh, he doesn't like that,' and I quieted down right away."

8. Hearst to Morgan, 13 Jan. 1923, Kennedy Library.

9. William Randolph Hearst Jr., *The Hearsts*, 72.

10. Morgan to Hearst, 1 Feb. 1923, Kennedy Library.

11. Hearst to Morgan, undated, c. 10 Mar. 1927, Kennedy Library.

12. Hearst to Morgan, 28 Apr. 1922, telegram, Kennedy Library; Nancy E. Loe, *Hearst Castle: An Interpretive History of W. R. Hearst's San Simeon Estate* (Santa Barbara, Calif.: Companion Press, 1994), 21; Hearst to Morgan, 5 Jan. 1922, Kennedy Library. Hearst employed tree surgeons to tend to the old oaks. He alluded to their methods in early 1922: "I think, too, in view of these storms that the idea of putting the cement in the main trunks and the tamped cork and asphaltum in the upper limbs of the trees will be shown to be a good one."

14. Kruslock to Tognazzini, 6 Dec. 1980, Hearst Castle Staff Library.

15. Morgan to Hearst, 22 Dec. 1921, Kennedy Library.

16. M. Byne to Morgan, 9 June 1914, Kennedy Library.

17. Morgan to the Bynes, 19 Sept. 1921, Kennedy Library.

18. M. Byne to Morgan, 22 Oct. 1921; A. Byne to Morgan, 4 Nov. 1921. Kennedy Library.

19. Robert C. Pavlik, "The Tile Art of San Simeon: A Social and Cultural Perspective," *Tile Heritage: A Review of American Tile History* 4, no. 2 (Winter 1997): 3; Hearst to Morgan, 3 Apr. 1921; Morgan to Hearst, 18 June 1921, Kennedy Library. Hearst also wanted to use historic tile, writing to Morgan that he was sending "old Moorish tiles" from French & Co., a New York art dealer. "They are pretty important and rather extraordinary in such considerable quantities, and I think we should make an effect with them." Morgan wrote to Hearst, "The Persian panel is in place and looks 'scrumptious.'"

20. Hearst to Morgan, 15 Sept. 1920, Kennedy Library.

21. Washington Irving, *The Alhambra* (1832; Tarrytown, N.Y.: Sleepy Hollow Press, 1982), 383.

22. M. Byne to Morgan, 1 Oct. 1921, Kennedy Library.

23. Elizabeth M. Boone, *Vistas de España: American Views of Art and Life in Spain, 1860–1914* (New Haven: Yale University Press, 2007), 10.

24. Hearst to Morgan, undated, c. 2 Feb. 1923, Kennedy Library.

25. Morgan to Hearst, 24 Apr. 1923, Kennedy Library.

26. Hearst to Morgan, 21 Dec. 1923, Kennedy Library. Hearst showed a sophisticated awareness of the relationship between the scale of the landscape effects and the scale of the buildings—both up close and seen from the bottom of the hill.

27. Morgan to Hearst, 20 Mar. 1924, Kennedy Library.

28. Hearst to Morgan, 1 Dec. 1922, Kennedy Library.

29. Nigel Keep, "Trees of San Simeon," 1.

30. Sandra J. Heinemann, "Chronology of the Gardens," 2, Hearst Castle Staff Library.

31. Brayton Laird, "Working in the Orchards of the Hearst Ranch," interview by Bruce Brown, ed. Robert C. Pavlik, *Oral History Project* (San Simeon, Calif.: Hearst San Simeon State Historical Monument, 19 Dec. 1986), 6.

32. Hearst to Morgan, 16 May 1922, Kennedy Library.

33. Morgan to Hearst, 20 May 1920; Hearst to Morgan, 7 June 1920, telegram; Morgan to Hearst, 5 Jan. 1921. Kennedy Library.

34. Hearst to Morgan, 7 Feb. 1921, Hearst to Morgan, 28 Feb. 1921; Hearst to Morgan, 20 Sept. 1922. Kennedy Library.

35. Morgan to Hearst, 17 June 1924, Kennedy Library.

36. Hearst to Morgan, 31 Mar. 1924, Kennedy Library.

37. "Mr. Hearst Will Build Big Palm Beach House," *New York Times*, 16 Mar. 1924, 21.

38. Fred Lawrence Guiles, *Marion Davies* (New York: McGraw-Hill, 1972), 68–69.

39. Charles Chaplin, *My Autobiography* (New York: Simon and Schuster, 1964), 313.

40. Guiles, *Marion Davies*, 67.

CHAPTER 6: SAN SIMEON'S CONSTRUCTION TECHNOLOGY (1919–1947)

1. Hamilton, *Where the Highway Ends*, 152–155; Interview with Earl Moon, Water Superintendent, 1 Apr. 2008. Three peaks stand to the east, high above the 1,600-foot elevation where the Castle complex is constructed. The highest one is Pine Mountain, at 3,594 feet. There are three springs on Pine Mountain, between 2,600 feet and 3,100 feet in elevation, providing water for the complex and the ranch operations below. The Chisholm Spring is at 2,900 feet, with an estimated measured flow of 24 gpm (gallons per minute). The Cole Spring is at 2,640 feet, with an estimated flow of 5 gpm. It is not in use on the hilltop as of this writing because there is no permit for diversion. The Phelan Spring—also known as the Pine Mountain Spring—is at 3,160 feet, with an estimated flow of 30–40 gpm.

2. Hearst to Morgan, 11 May 1921, Kennedy Library.

3. Morgan to Hearst, 18 June 1921, Kennedy Library.

4. John Horn, "Mountain Springs Sustain San Simeon," 1996, 1, Hearst Castle Staff Library.

5. Morgan to Hearst, 25 Feb. 1921, Kennedy Library; Horn, "Mountain Springs," 1–2; Moon interview, 1 Apr. 2008. In 1943, a lower reservoir of 500,000 gallons was constructed near the poultry ranch. It was augmented in the 1980s by a 16 million-gallon reservoir, the large basin for which is easily visible from the hilltop. To address hilltop water shortages, a 750,000-gallon underground reservoir was constructed in 1996 on the hilltop area known as China Hill, the rise between the formal gardens and the Pergola hill. The China Hill Reservoir uses a pumping system to supply drinking water. The original water system was all gravity-fed. Nearly 150 years after George Hearst first diverted the Pine Mountain springs, water continues to be scarce at the ranch.

6. Morgan to Hearst, 11 Sept. 1923; Hearst to Morgan, 5 Oct. 1923; Morgan to Hearst, 18 Nov. 1923. Kennedy Library; Byron Hanchett, *In & Around the Castle* (San Luis Obispo, Calif.: Blake, 1985), 164–165.

7. Hearst to Morgan, 11 Jan. 1925, Kennedy Library.

8. Hearst to Morgan, 27 Aug. 1925, Kennedy Library.

9. Horn, "Mountain Springs," 2; Morgan to Huber, 28 Apr. 1931, Hearst Castle Archives; Hearst to Morgan, 21 Aug. 1936, Kennedy Library; Hanchett, *In & Around the Castle*, 164. Among the hundreds of references to this subject in the correspondence, some of the most informative letters are: Morgan to Hearst, 25 Feb. 1921; James Rankin to Morgan, 11 Sept. 1923; Hearst to Morgan, 11 Jan. 1925; Hearst to Morgan, 21 Aug. 1936, Kennedy Library.

10. Hearst to Morgan, 11 Jan. 1925, Kennedy Library.

11. Keep, "Trees of San Simeon," 1946; Hearst to Morgan, undated, c. 22 Nov. 1922, telegram, Kennedy Library; Hearst to Morgan, 23 Nov. 1922, Kennedy Library; William Nigel Reich, "Memories of My Grandfather Nigel Keep," interview by Tom Scott, *Oral History Project* (San Simeon, Calif.: Hearst San Simeon State Historical Monument, 1990), 12. They attempted to protect the orchard plants by establishing windbreaks of eucalyptus trees (*Eucalyptus globulus*) in the gullies below the citrus orchard.

12. Hanchett, *In & Around the Castle*, 101–102; Morgan to Hearst, 7 May 1920, Kennedy Library; Drawing V/05/A04/02, "Power and Water Supply" diagram, 27 May 1921, Kennedy Library.

13. Morgan to Hearst, 25 May 1921, Kennedy Library. In a telegram dated 24 May 1921, Hearst proposed installing more power plants to use the same water more effectively for electricity, but as Morgan explained: "No matter how many intermediate plants were put in between, the result would be only the same amount of electricity but increasing the cost by the number of extra plants."

14. Morgan to Hearst, 19 Apr. 1924, Kennedy Library; Glenn F. Myers to K. Stiegemeier, 29 Jan. 1969, Hearst Castle Staff Library; Hanchett, *In & Around the Castle*, 103. The San Joaquin Power & Light Company later became known as the Pacific Gas & Electric Company. It built a 12,000-volt line to the powerhouse in August 1924. In 1947 PG&E installed new lines, and at that time most of the original power lines were removed.

15. Hanchett, *In & Around the Castle*, 107.

16. Hearst to Morgan, 23 May 1920, Kennedy Library.

17. Hearst to Morgan, 9 July 1925, telegram, Kennedy Library; Rossi to Hearst, 24 Nov. 1926, Bancroft Library.

18. Ludwig Bemelmans, *To the One I Love the Best* (New York: Viking, 1955), 211.

19. Steilberg, "Address to the Historical Guide Association," 5.

20. Morgan to Hearst, 2 Sept. 1922, Kennedy Library.

21. Morgan to Hearst, 9 May 1928, Kennedy Library.

22. Morgan to Hearst, 16 May 1923, Kennedy Library.

23. Morgan to Hearst, 7 Nov. 1927, Kennedy Library. For an account of the 2003 San Simeon Earthquake, see Carolyn Lockheed, "6.5 Quake Razes Buildings, Kills Two in Paso Robles," *San Francisco Chronicle*, 23 Dec. 2003.

24. Morgan to Hearst, undated, c. 27 Dec. 1921, telegram, first draft, Kennedy Library.

25. LeFeaver to perhaps Morgan, 29 Dec. 1921, memo, Kennedy Library.

26. Morgan to Hearst, c. 27 Dec. 1921, telegram, second draft, Kennedy Library.

27. Morgan to Hearst, 9 Feb. 1922, Kennedy Library.

28. Hearst to Rossi, 16 Feb. 1927, Kennedy Library.

29. Morgan to Hearst, 17 Feb. 1927, Kennedy Library.

30. Morgan to Hearst, 4 Feb. 1921; Morgan to Hearst, 28 Feb. 1921; Hearst to Morgan, 7 June 1920, telegram. Kennedy Library. Hearst instructed Morgan by telegram in 1920 to "please make road and paths on hill top of concrete like state highways to prevent dust and washouts also to make them useable [*sic*] in wet weather." The road remained packed earth until the late 1940s.

31. Morgan to Hearst, 2 Jan. 1922, Kennedy Library.

32. Hanchett, *In & Around the Castle*, 18–19.

33. Nathan Tebbetts, "Working for W. R. Hearst's *San Francisco Examiner* and at San Simeon, 1913–1964," recorded 10 Feb. 1969 in Santa Barbara, ed. Michelle Hachigian, *Oral History Memoir* (San Simeon, Calif.: Hearst San Simeon State Historic Monument, 2003), 8–10.

34. Reich, "Memories of My Grandfather Nigel Keep," 27.

35. Patience Abbe, Richard Abbe, and Johnny Abbe, *Of All Places!* (New York: Stokes, 1937), 221–222.

36. Hanchett, *In & Around the Castle*, 80–81, 110.

37. Bemelmans, *To the One I Love Best*, 151–152.

38. P. G. Wodehouse, *Author! Author!* (New York: Simon and Schuster, 1962), 80.

39. Hearst to Morgan, 18 Oct. 1926, telegram, Kennedy Library; Smelzer to Loorz, 14 Nov. 1938, San Luis Obispo County Historical Society Archives; Coffman, *Building for Hearst and Morgan*, 397; Hanchett, *In & Around the Castle*, 5. It is likely that the telegraph system was installed prior to the telephones. Hearst sent telegrams from San Simeon from the early days of construction.

40. Hearst to Morgan, 16 Sept. 1927, Kennedy Library.

41. Hanchett, *In & Around the Castle*, 142–143. The telephone switchboard system was installed in December 1927. The name of the exchange was "Hacienda," which they had also used for Phoebe's Pleasanton estate, the Hacienda del Pozo de Verona. In an office memo to Morgan dated 3 July 1929, she is instructed: "Please call 'Hacienda' long distance operator."

42. Hanchett, *In & Around the Castle*, 155–156.

43. Hearst to Morgan, 2 Oct. 1927, Kennedy Library.

44. Ben Procter, *William Randolph Hearst: Final Edition, 1911–1951* (New York: Oxford University Press, 2007), 151.

45. Taylor Coffman, *Building for Hearst and Morgan*, 23–24; Hanchett, *In & Around the Castle*, 82–83.

46. Hearst to Morgan, 7 Oct. 1927, Kennedy Library.

47. Hanchett, *In & Around the Castle*, 83; Coffman, *Building for Hearst and Morgan*, 32–33.

48. Steilberg, "Address to the Historical Guide Association," 11.

49. Morgan to Hearst, 17 July 1930, Kennedy Library.

50. Morgan to Hearst, 30 Mar. 1932, Kennedy Library; Coffman, *Building for Hearst and Morgan*, 23.

51. Guiles, *Marion Davies*, 300–301; August Wahlberg, "Working for William Randolph Hearst as a Butler and Valet," interview by Metta Hake and Janet Horton-Payne, ed. Pendleton H. Harris and Laurel Stewart, *Oral History Project* (San Simeon, Calif.: Hearst San Simeon State Historical Monument, 18 Aug. 1983), 45–46; Hazel Eubanks, in Hanchett, *In & Around the Castle*, 20.

52. Hanchett, *In & Around the Castle*, 85.

53. Hamilton, *Where the Highway Ends*, 19–24.

54. Carey Baldwin, *My Life with Animals* (Menlo Park, Calif.: Lane Book Co., 1964), 101.

55. Morgan to Hearst, 1 Aug. 1930, telegram, Kennedy Library; Baldwin, *My Life with Animals*, 109–110.

56. Hearst to Morgan, 3 Aug. 1930, telegram, Kennedy Library.

57. Morgan to Hearst, 22 Aug. 1930, Kennedy Library.

58. Hanchett, *In & Around the Castle*, 32, 157–158, 161–162.

59. Loorz to Grace Loorz, 12 June 1937, San Luis Obispo County Historical Society Archives; Coffman, *Building for Hearst and Morgan*, 329.

60. Stolte to Loorz, undated, c. mid-Nov. 1933, San Luis Obispo County Historical Society Archives; Coffman, *Building for Hearst and Morgan*, 99.

CHAPTER 7: SCALING UP: FORMAL ITALIAN STYLE (1926–1937)

1. Hearst to Morgan, undated, c. 2 June 1926; Morgan to Hearst, 3 June 1926. Kennedy Library.

2. Hearst to Morgan, undated, c. 2 June 1926, Kennedy Library.

3. Morgan to Hearst, 3 June 1926, Kennedy Library.

4. Hearst to Morgan, undated, c. 8 June 1926, Kennedy Library.

5. Griswold and Weller, *The Golden Age of American Gardens*, 319–320.

6. Lurline Matson Roth, *Matson and Roth Family History: A Love of Ships, Horses, and Gardens*, oral history conducted 1980, 1981 by Suzanne B. Riess, the Bancroft Library, Regional Oral History Office (Berkeley: University of California, 1982), 114–115.

7. Hearst to Morgan, 29 Aug. 1927, telegram; Morgan to Hearst, 30 Aug. 1927; Hearst to Morgan, 9 Sept. 1927, telegram. Kennedy Library.

8. Hearst to Morgan, 18 Jan. 1928, telegram, Kennedy Library.

9. Hearst to Morgan, 27 Aug. 1927, Kennedy Library.

10. Hearst to Huntington, 12 June 1926; HEH 12280, Huntington Library. Hearst and Huntington were acquainted through their involvement in southern California. Hearst cabled his sympathies on 18 Sept. 1924 after the death of Henry Huntington's wife, Arabella. Hearst visited San Marino on 12 June 1926 and signed the guest book.

11. Myron Keimnach, introduction, in William Hertrich, *The Huntington Botanical Gardens, 1905–1949* (San Marino, Calif.: Huntington Library Press, 2003), xii.

12. James T. Maher, *The Twilight of Splendor: Chronicles of the Age of American Palaces* (Boston: Little, Brown, 1975), 298–303.

13. Hertrich, *The Huntington Botanical Gardens*, 34.

14. Alice Head, *It Could Never Have Happened* (London: William Heinemann Ltd., 1939), 68; Roy

Denning, ed., *The Story of St. Donat's Castle and Atlantic College* (South Wales: D. Brown and Sons with Stewart Williams, 1983), 71.

15. Robert B. MacKay, Anthony K. Baker, and Carol A. Traynor, *Long Island Country Houses and Their Architects, 1860–1940* (New York: W.W. Norton in association with the Society for the Preservation of Long Island Antiquities, 1997), 231.

16. Hearst to Morgan, 14 Aug. 1926, Kennedy Library.

17. Hearst to Morgan, undated, c. 13 May 1926, Kennedy Library.

18. LeFeaver to Hearst, 28 Feb. 1935, Kennedy Library.

19. Edith Wharton, in Vivian Russell, *Edith Wharton's Italian Gardens* (Boston: Little, Brown, 1997), 15, 17.

20. Edith Wharton, *Italian Villas and Their Gardens* (New York: Century, 1904), 10–11.

21. Hearst to Morgan, 26 Nov. 1928, Kennedy Library.

22. Hearst to Morgan, undated, c. 15 Sept. 1923, Kennedy Library.

23. Hearst to Morgan, undated, c. 11 Jan. 1925, Kennedy Library.

24. Morgan to Hearst, 22 Apr. 1925, Kennedy Library.

25. Morgan to Hearst, 20 Oct. 1925, telegram draft, Kennedy Library.

26. Frances Marion, "Screenwriter for Hearst," interview by Gerald Reynolds, ed. Nancy E. Loe, *Oral History Project* (San Simeon, Calif.: Hearst San Simeon State Historical Monument, 1 Sept. 1972), 3.

27. Morgan to Hearst, 15 Mar. 1926, Kennedy Library.

28. Mrs. Fremont Older, *William Randolph Hearst*, 107; Tracy I. Storer and Lloyd P. Tevis, *California Grizzly* (Berkeley: University of California Press, 1996), 249–257.

29. Hearst to Morgan, 12 Aug. 1926, Kennedy Library.

30. Morgan to Hearst, 27 July 1927, Kennedy Library.

31. Head, *It Could Never Have Happened*, 167–168.

32. Marion Davies, *The Times We Had: Life with William Randolph Hearst* (Indianapolis, Ind.: Bobbs-Merrill, 1975), 45; Baldwin Collection, Hearst Castle Archives. Former zookeeper Carey Baldwin's records list zoo animals at San Simeon, including birds such as pelicans, Pacific gulls, and vultures, and other animals such as African porcupines, bison, elk, yaks, ibexes, tahr goats, water buffaloes, camels, ostriches, cassowaries, emus, kangaroos, llamas, polar bears, sun bears, sloths, spider monkeys, java monkeys, chimpanzees, African lions, Sumatran tigers, jaguars, and even giraffes and an elephant.

33. Louella O. Parsons, *The Gay Illiterate* (New York: Doubleday, 1944), 95.

34. Reich, "Memories of My Grandfather Nigel Keep," 24.

35. M. North and F. North, "Julia Morgan, Her Office, and a House," 204, 225.

36. Morgan to Beatrice Fox, undated, c. 1935, HM 54397, Huntington Library; M. North and F. North, "Julia Morgan, Her Office, and a House," 225.

37. Hearst to Morgan, 11 Jan. 1925, Kennedy Library.

38. Hearst to Morgan, 27 Nov. 1928, telegram; Morgan to Hearst, 17 Dec. 1928, telegram. Kennedy Library.

39. "San Simeon Clippings," articles compiled by W. R. Hearst, Hearst Castle Archives.

40. Morgan to Hearst, 17 Oct. 1932, Kennedy Library.

41. Boutelle, *Julia Morgan, Architect*, 200.

42. Hearst to Morgan, 21 Sept. 1932, Kennedy Library; Older, *William Randolph Hearst*, 535; Stanley Heaton and Elmer Moorhouse, "Stanley Heaton and Elmer Moorhouse: Gardening and Road Construction," interview by Metta Hake, eds. William Payne and Robert C. Pavlik, *Oral History Project* (San Simeon, Calif.: Hearst San Simeon State Historic Monument, 1989), 2. Stanley Heaton worked as a hilltop gardener from 1924 to 1933 and recalled growing cuttings in the five greenhouses on the south side of the hill. They also shipped in plants, such as five thousand cyclamen or five thousand cineraria at once. Older wrote: "One of [Hearst's] garden surprises with a touch of mystical magic came on an Easter morning when guests at San Simeon awoke to find the ground under the oaks covered with tall, white Madonna lilies. All night by electric light a large corps of men had worked to prepare for the celebration of Easter at dawn."

43. Beatrice (Tid) Casey, *Padres and People of Old Mission San Antonio* (King City, Calif.: The Rustler-Herald, 1957), 42, 44, 46.

44. Morgan to Hearst, 12 Aug. 1930, Kennedy Library.

CHAPTER 8: VISITING THE RANCH (1919–1947)

1. Clive Aslet, *The American Country House* (New Haven: Yale University Press, 1990), 234.

2. F. Scott Fitzgerald, "The Diamond as Big as the Ritz," *The Best Early Stories of F. Scott Fitzgerald*, ed. Bryant Mangum (New York: The Modern Library, 2005), 198. In 1932 Fitzgerald wrote a short story, "Crazy Sunday," in which Marion Davies appears by name.

3. Davies, *The Times We Had*, 45.

4. Colleen Moore, "The Jazz Age's Movie Flapper at San Simeon," interview by Eileen Hook, *Oral History Project* (San Simeon, Calif.: Hearst San Simeon State Historical Monument, 25 Jan. 1977), 4.

5. Hamilton, *Where the Highway Ends*, 94–95, 104; Paula Juelke Carr, "Harmony along the Coast," *Heritage Shared Studies in Central Coast History* (Winter 2008): 34–35.

6. Hamilton, *Where the Highway Ends*, 96–97.

7. Garland Burns Porter, "Garland Burns Porter," interview by Metta Hake, ed. Michelle Hachigian, *Oral History Project* (San Simeon, Calif.: Hearst San Simeon State Historical Monument, 16 Sept. 1985), 11.

8. Davies, *The Times We Had*, 50.

9. Edna Calkins and Fred Calkins, "Ranching and Wrangling: From Piojo to San Carpoforo and Jolon to Pacific Valley," interview by KPRL Radio, *Oral History Project* (Paso Robles, Calif.: Hearst San Simeon State Historical Monument, 1988), 8; Sinnard to M. Hake, 7 Feb. 1977, Hearst Castle Staff Library.

10. Colleen Moore, "The Jazz Age's Movie Flapper at San Simeon," 9.

11. Eleanor Boardman d'Arrast, "Remembering W. R. and Marion," interview by Rayena Martin and Guy Roop, ed. Robert C. Pavlik, *Oral History Project* (San Simeon, Calif: Hearst San Simeon State Historical Monument, 3 Nov. 1987), 12.

12. Davies, *The Times We Had*, 51.

13. Eleanor Boardman, "An Interview with Eleanor Boardman," interview by Metta Hake and Robert C. Pavlik, *Oral History Project* (San Simeon, Calif.: Hearst San Simeon State Historical Monument, 1982), 18.

14. Eleanor Boardman d'Arrast, "Remembering W. R. and Marion," 5.

15. Iron Eyes Cody, *Iron Eyes, My Life as a Hollywood Indian: By Iron Eyes Cody as Told to Collin Perry* (New York: Everest House, c. 1982), 125; Bemelmans, *To The One I Love the Best*, 219–220. Ludwig Bemelmans viewed the scenery with his artist's eye: "The paths go along ridges. To the west is the view down to the ocean, and to the east, always in contrasting light, is an immense valley that reaches to the next ridge of mountains."

16. James E. Woodruff, "Archie Soto," *An Oral History Project Concerning the San Simeon Home of William Randolph Hearst* (B.A. thesis, California Polytechnic State University, 1977), 20–21.

17. Hedda Hopper and James Brough, *The Whole Truth and Nothing But* (New York: Pyramid Books, 1963), 199.

18. Frances Marion, *Off with Their Heads! A Serio-Comic Tale of Hollywood* (New York: Macmillan, 1972), 139–140.

19. John Spencer Churchill, *A Churchill Canvas* (Boston: Little, Brown, 1961), 89.

20. Harpo Marx with Rowland Barber, *Harpo Speaks!* (New York: Limelight Editions, 1965), 293–294.

21. William J. Mann, *Wisecracker: The Life and Times of William Haines, Hollywood's First Openly Gay Star* (New York: Viking, 1998), 130.

22. Head, *It Could Never Have Happened*, 80.

23. Marina Belozerskaya, *The Medici Giraffe: And Other Tales of Exotic Animals and Power* (New York: Little, Brown, 2006), 325–326.

24. Davies, *The Times We Had*, 56–57.

25. Abbe, Abbe, and Abbe, *Of All Places!*, 226–227.

26. Hanchett, *In & Around the Castle*, 121–122.

27. William Randolph Hearst, "In the News," 29 Apr. 1942.

28. James Montgomery Beck III, "Teenage Guest, 1943 and 1946," interview 2 Sept. 1988 by Robert C. Pavlik, eds. Michelle Hachigian and John Horn, *Oral History Project* (San Simeon, Calif: Hearst San Simeon State Historic Monument, 2003), 9–10.

29. Norman Rotanzi, "Fifty-Four Years at San Simeon," interview by Julie Payne, ed. Robert C. Pavlik, *Oral History Project* (San Simeon, Calif.: Hearst San Simeon State Historical Monument, 6 June 1988), 3.

30. Rupert Hart-Davis, *Hugh Walpole* (Phoenix Mill, Thrupp, Stroud, Gloucestershire: Sutton, 1997), 364.

31. Alice Marble with Dale Leatherman, *Courting Danger* (New York: St. Martin's Press, 1991), 36.

32. Nancy Nelson, *Evenings with Cary Grant: Recollections in His Own Words and by Those Who Knew Him Best* (New York: Warner, 1991), 76.

33. Hanchett, *In & Around the Castle*, 24–25.

34. Hearst to Morgan, 9 Feb. 1920; Hearst to Morgan, 11 Aug. 1920, telegram. Kennedy Library. I am indebted to Muna Cristal for her helpful insights on the positioning and imagery of the Roman Pool and the Neptune Pool.

35. Hearst to Morgan, 21 Mar. 1921, telegram; Hearst

to Morgan, 22 Mar. 1921. Kennedy Library.

36. Hearst to Morgan, undated, c. 24 Dec. 1921; Morgan to Hearst, 22 Dec. 1921; Morgan to Hearst, 19 Apr. 1922. Kennedy Library.

37. Hearst to Morgan, undated, c. 9 June 1922, Kennedy Library; Labeled photograph from French & Co., July 1921, Julia Morgan Collection, College of Environmental Design Archives, University of California, Berkeley. Photo no. 568 depicts the statue Neptune and the Nereids as presented to Hearst from the art dealer French & Co. in July 1921. On the back of the photo is the description: "A 19th century Italian fountain 'Neptune and Nereids' White marble & stone From Doria Palace And Maestro Verdi Collection Price $12000 Crates 1458 1463 19th car Shipped San Simeon July 17, 1923 P. W. French & Co., At the center Neptune stands with trident in his left hand; below are two undraped female figures reclining on sea animals."

38. Willicombe to Morgan, 24 July 1922; Morgan to Hearst, 31 July 1922, telegram draft. Kennedy Library.

39. Hearst to Morgan, undated, c. 2 Feb. 1923, Kennedy Library.

40. Morgan to Hearst, 25 Feb. 1923, Kennedy Library.

41. Hearst to Morgan, 3 Apr. 1923, Kennedy Library.

42. Hearst to Morgan, 11 May 1923, Kennedy Library.

43. Hearst to Morgan, 31 Mar. 1924; Morgan to Hearst, 7 Apr. 1924, telegram draft. Kennedy Library.

44. Hearst to Morgan, 28 Apr. 1926, telegram; Hearst to Morgan, 29 Apr. 1926, telegram; Morgan to Hearst, 3 June 1927; Morgan to Hearst, 12 Sept. 1927, telegram draft; Hearst to Morgan, 16 Sept. 1927; Hearst to Morgan, 20 Sept. 1927, telegram. Kennedy Library.

45. Morgan to Hearst, 25 Feb. 1923. Kennedy Library.

46. Hearst to Morgan, 14 May 1925, telegram; Huber to Morgan, 26 June 1926; Huber to Morgan 14 Apr. 1928. Hearst Castle Archives; Douglas Fairbanks Jr., "Douglas Fairbanks Jr.: Visits to the Hearst Ranch," interview by Metta Hake, ed. Rayena Martin, Oral History Project (San Simeon, Calif.: Hearst San Simeon State Historic Monument, 1990), 4–5. The Roman Plunge was used less often than the Neptune Pool, perhaps due to its depth and its distance from the buildings. Douglas Fairbanks Jr. recalled many years after his two visits that he played water polo in the Neptune Pool, but he was unaware of the existence of the Roman Plunge.

47. Hearst to Morgan, 24 Apr. 1927, Kennedy Library; Hanchett, In & Around the Castle, 25. Electrician Byron Hanchett wrote: "North of the outdoor pool down the hill are two large oil burning boilers that heat both pools. The boilers are located near large oak trees that conceal the smoke stacks. Insulated steam pipes run from the boilers to both swimming pools."

CHAPTER 9: FINAL PLANS (1936–1951)

1. Norman Rotanzi, "The Ornamental Gardens of San Simeon," interview by Gerald Reynolds, Oral History Project (San Simeon, Calif.: Hearst San Simeon State Historical Monument, 1977), 2, 4–5.

2. Rotanzi, "Fifty-Four Years at San Simeon," 34.

3. Loorz to Morgan, 14 Sept. 1934, memo; Cassou to Morgan, 16 Mar. 1936; Cassou to Morgan, 22 June 1936; Morgan to Cassou, 27 July 1936; Morgan to Cassou, 28 July 1936. Kennedy Library; Bruno Mariani to Wilmar N. Tognazzini, 18 Sept. 1974. Hearst Castle Staff Library. The stonecutter Bruno Mariani worked on the Neptune Pool colonnades between 1933 and 1935 in his studio in San Francisco. He recalled that Julia Morgan visited almost daily. They tore down the wood, plaster, and clay models several times before she was satisfied with the design. Then a master model was sent to the marble quarry in Vermont for the final marble carvings to be executed.

4. Hearst to Morgan, 21 Aug. 1936, Kennedy Library.

5. Hearst to Morgan, 9 Mar. 1937, Kennedy Library.

6. Hearst to Morgan, 14 Mar. 1937, Kennedy Library.

7. Loorz to Morgan, 12 June 1936, San Luis Obispo County Historical Society Archives; Coffman, Building for Hearst and Morgan, 174–175, 253, 312.

8. Robert B. Combs, "Horse Trainer: An Oral History Interview," interview by Robert C. Pavlik, eds. John Horn and Michelle Hachigian, Oral History Project (San Simeon, Calif.: Hearst San Simeon State Historic Monument, 27 Jan. 1987), 6.

9. Mrs. William Randolph Hearst Jr., Horses of San Simeon, 141.

10. William Apperson, "Hearst Ranch Superintendent's Son," interview and ed. by John Horn, Oral History Project (San Simeon, Calif.: Hearst San Simeon State Historical Monument, 1996), 12; Combs, "Horse Trainer," 6; Mrs. William Randolph Hearst Jr., Horses of San Simeon, 217–218; Loorz to Stolte, 22 Oct. 1935; Loorz to Morgan, 20 Feb. 1936. San Luis Obispo County Historical Society Archives; Coffman, Building for Hearst and Morgan, 220, 237–238.

11. Charles Parlet, "Charles Parlet: Life on San Simeon Ranch, 1921–1977," interview by Tom Scott, ed. Michelle Hachigian, Oral History Project (San Simeon, Calif.: Hearst San Simeon State Historical Monument, 1977), 8.

12. Hearst to Morgan, 21 May 1937, Kennedy Library.

13. Hearst to Morgan, 25 May 1937, Kennedy Library; Nasaw, The Chief, 531–532.

14. Frej Emil Hagelberg, "The Autobiography of Frej Emil Hagelberg: Reflections of Pushing a Pencil," eds. Allen Hagelberg and Barbara Condit (2005), 129–132.

15. Loorz to M. McClure, c. 26 May 1937, San Luis Obispo County Historical Society Archives; Coffman, Building for Hearst and Morgan, 324–325.

16. Morgan to Hearst, 17 June 1929; Hearst to Morgan, 14 Aug. 1929; Morgan to Hearst, 3 Dec. 1929, telegram; Morgan to Hearst, 27 Feb. 1930; Hearst to Morgan, 27 Oct. 1930. Kennedy Library.

17. Rick Adams and Louise McCorkle, The California Highway 1 Book: An Odology of America's Most Romantic Road (New York: Ballantine Books, 1985), 134–141.

18. Robert C. Pavlik, "Hearst and Highway One" (San Simeon, Calif.: Hearst San Simeon State Historical Monument, 1987), 4–8.

19. G. Loorz to Grace Loorz, 28 June 1937. San Luis Obispo County Historical Society Archives; Coffman, Building for Hearst and Morgan, 334.

20. Morgan to Hearst, 27 May 1937, Kennedy Library.

21. "Julia Morgan Travel Diary," 33, 107–108, 139, Morgan-Boutelle Collection, Kennedy Library.

22. Morgan to Loorz, 30 Mar. 1939. San Luis Obispo County Historical Society Archives; Coffman, Building for Hearst and Morgan, 404.

23. "Search for Missing Architect Asked," Los Angeles Times, 28 Mar. 1931, 5; Morgan to Mrs. Benedict, 11 Oct. 1943, Morgan-Boutelle Collection, Kennedy Library; Boutelle, Julia Morgan, Architect, 241.

24. Loorz to Morgan, 5 June 1939. San Luis Obispo County Historical Society Archives; Coffman, Building for Hearst and Morgan, 413.

25. "Draft Fort Hunter Liggett Special Resource Study & Environmental Assessment" (Oakland, Calif.: U.S. Department of the Interior, National Park Service, Pacific West Regional Office, 2004), 33.

26. Beatrice (Tid) Casey, Padres and People of Old Mission San Antonio, 46.

27. Jack Alexander, "Cellini to Hearst to Klotz," Saturday Evening Post 214, no. 18 (1 Nov. 1941): 86.

28. A. J. Liebling, "A Reporter at Large: Hearst With His Own Petard," The New Yorker (19 Nov. 1938): 42.

29. John Steinbeck, The Grapes of Wrath (New York: Viking, 1939), 281–282.

30. John Dos Passos, The Big Money (Boston: Houghton Mifflin, 1936), 546–552.

31. Aldous Huxley, After Many a Summer Dies the Swan (New York: Harper & Row, 1965), 29.

32. Upton Sinclair, A World to Win (New York: Viking, 1946), 154–155. Sinclair worked for the Hearst press in 1919, but by 1934 Hearst and the author were enemies. Hearst strenuously opposed Sinclair's bid for governor of California on the EPIC (End Poverty in California) ticket. See Greg Mitchell, The Campaign of the Century: Upton Sinclair's Race for Governor of California and the Birth of Media Politics (New York: Random House, 1992).

33. Suzanne Dewberry, "Perils at Sea: The Sinking of the SS Montebello," Prologue: Quarterly of the National Archives 23, no. 3 (Fall 1991): 260–264.

34. M. North and F. North, "Julia Morgan, Her Office, and a House," 178.

35. "A Priceless Treasure," San Francisco Call-Bulletin, 5 July 1941, 3.

36. Rotanzi, "Fifty-Four Years at San Simeon," 7.

37. Maurice McClure, "From Laborer to Construction Superintendent," interview by Metta Hake, eds. Bernice Joan Falls and Robert C. Pavlik, Oral History Project (San Simeon, Calif.: Hearst San Simeon State Historical Monument, 13 Sept. 1981), 28.

38. Woodrow Frey, "Making the Gardens at San Simeon," Pacific Horticulture 39, no. 3 (Fall 1978): 39–44.

39. California Department of Parks and Recreation, "A Unit History" (San Simeon, Calif.: Hearst San Simeon State Historical Monument, 1974); Lucille M. Sanders, "PBX/Telephone Operator, 1946–1947," interview by John Blades, ed. Michelle Hachigian, Oral History Synopsis (San Simeon, Calif.: Hearst San Simeon State Historic Monument, 21 July 1977). The hilltop PBX operator recalled Hearst's last months at the Castle in the winter of 1947: "It got lonely—the phones wouldn't ring. It was too quiet."

40. Roland M. Dragon, "Private Secretary to W. R. Hearst, 1946–1947," interview by Michelle Hachigian, eds. Michelle Hachigian and John F. Horn, *Oral History Project* (San Simeon, Calif.: Hearst San Simeon State Historical Monument, 24 Oct. 1997), 20.

41. Ann Miller, "San Simeon During Its Time of Transition," interview by Eileen Hook, *Oral History Project* (San Simeon, Calif.: Hearst San Simeon State Historical Monument, 13 Jan. 1982), 4.

CHAPTER 10: THE LEGACY CONTINUES (1951–2009)

1. Swanberg, *Citizen Hearst*, 531; "What 'The Chief' Left," *Newsweek*, Dec. 1954.

2. Swanberg, *Citizen Hearst*, 532; Nasaw, *The Chief*, 584–585.

3. Davies, *The Times We Had*, 202; Swanberg, *Citizen Hearst*, 531; Nasaw, *The Chief*, 413, 595–596. Rumors flourished for decades about Hearst and Marion having a child together, most often concerning Marion Davies's niece, the actress Patricia Lake. Hearst's biographer David Nasaw states: "In later years there were rumors that Pat was not Rose's and Van Cleve's child [Marion Davies's sister Rose and brother-in-law George Van Cleve], but Marion's and W. R.'s. But there has never been any evidence to support these rumors, aside from what some people regard as Pat's physical resemblance to Hearst."

4. Charles Lyden, "Charles Lyden, Asst. Monument Supervisor, 1958–1964," interview and ed. by Robert C. Pavlik, *Oral History Project* (San Simeon, Calif.: Hearst San Simeon State Historical Monument, 4 Feb. 1992), 5–7.

5. J. Paul Getty, *As I See It: The Autobiography of J. Paul Getty* (Englewood Cliffs, N.J.: Prentice-Hall, Inc., 1976), 253.

6. California Department of Parks and Recreation, "A Unit History," 1953.

7. William Randolph Hearst Jr., *The Hearsts*, 85.

8. David Niven, *Bring on the Empty Horses* (New York: G. P. Putnam's Sons, 1975), 278–279.

9. William Randolph Hearst Jr., "San Simeon: Story of a Great Builder," *San Francisco Examiner*, 17 Aug. 1958.

10. M. North and F. North, "Julia Morgan, Her Office, and a House," 211–215.

11. Boutelle, *Julia Morgan, Architect*, 242.

12. Walter T. Steilberg, "Some Examples of the Work of Julia Morgan," *The Architect and Engineer of California* 55, no. 2 (Nov. 1918): 62.

13. Nasaw, *The Chief*, 600–602, 604.

14. Guiles, *Marion Davies*, 337–341, 359–363.

15. Davies, *The Times We Had*, 45, 50, 144.

16. William Randolph Hearst Jr., *The Hearsts*, 239.

17. *Forest Lawn Art Guide* (Glendale, Calif.: Forest Lawn Memorial-Park Association, 1963), 270.

18. Hearst to Morgan, 21 Aug. 1936, Kennedy Library.

19. Oldham to Hake, c. Apr. 1972, Hearst Castle Archives; "Big and Fast Action for Nine-Alarm Fire in Brooklyn," *Life Magazine* 41, no. 25 (17 Dec. 1956): 56–57.

20. "First Complete Color Photographs: Fabulous San Simeon," *Life Magazine* 43, no. 9 (26 Aug. 1957): 68–84; Richard E. Berlin, president of the Hearst Corporation, and William

Randolph Hearst Jr., vice president of the Hearst Corporation, to Goodwin J. Knight, Governor of California, 21 May 1957, telegram, Hearst Castle Staff Library; Certificate of Approval by John M. Pierce, Director of Finance, State of California, consenting to the conveyance, 30 Jan. 1958, Hearst Castle Staff Library; Don Morton, rev. by Kathleen Camilla Wade, *San Simeon State Park: State Park No. 50* (Berkeley: Works Progress Administration for the State of California, Department of Natural Resources, Division of Parks, 1937). The State of California was a natural recipient, in part because Hearst had already donated San Simeon property in 1932 to the people of California. The Piedmont Land and Cattle Company, in collaboration with other property owners, gave the beach known as State Park No. 50, opposite the Castle's current entrance. The 1958 Hearst Monument offer of donation reads: "The property is to be preserved intact and operated by the State as a State Historical Monument, as part of the California State Park System. It is to be a memorial to William Randolph Hearst, who was responsible for its creation and whose hope it was that the State of California receive it in the name of his mother, Phoebe Apperson Hearst. It is our intent, as we know it is yours, that this property be operated in a manner consistent with its historical, aesthetic, and cultural character, with no commercialism or other activities that would detract from its dignity and impressiveness."

21. Michelle Hachigian, "Hearst Castle Tour History Overview, 1958–2001," 2, Hearst Castle Staff Library; Olmsted Center for Landscape Preservation, *Cultural Landscape Report for Hearst San Simeon State Historical Monument*, vols. 1–4 (Boston: Olmsted Center for Landscape Preservation, 2008), 32. Prior to the *Cultural Landscape Report*, the major published records of the plantings in Hearst Castle's garden were Dorothy May Boulian, *Enchanted Gardens of Hearst Castle* (1972); and Frey, "Making the Gardens at San Simeon."

22. P. G. Wodehouse, "The Return of Jeeves," in *Five Complete Novels* (New York: Avenel Books, 1983), 139.

23. W. H. Auden, "Thanksgiving for a Habitat," *The New Yorker* (17 Aug. 1963): 30.

24. Robert A. M. Stern, *Pride of Place: Building the American Dream* (Boston: Houghton Mifflin, 1986), 114.

25. Witold Rybczynski, *The Most Beautiful House in the World* (New York: Viking, 1989), 193.

26. Witold Rybczynski and Laurie Olin, *Vizcaya: An American Villa and Its Makers* (Philadelphia: University of Pennsylvania Press, 2007), 237.

27. Cliff Garrison, "Address to the Historical Guides of San Simeon," Nov. 2007, Hearst Castle Staff Library. Garrison was quoted in *Cowboys and Indians Magazine* (23 Jan. 2006): 5: "The biological and ecological diversity . . . [are the] good thing about cattle and cattle ranching. We are the guardians and stewards that make it thrive."

28. William Randolph Hearst Jr., *The Hearsts*, 88.

29. Norman Rotanzi, conversation with the author, May 1984.

30. "Eight Villages Proposed Along North Coast Area," *San Luis Obispo County Telegram Tribune*, 13 Nov. 1964, A1; "County Hears Plan for Hearst Rancho," *San Luis Obispo County Telegram Tribune*,

28 Jan. 1965, A1.

31. David Sneed, "Calm Before the Storm," *San Luis Obispo County Telegram Tribune*, 15 Jan. 1998; David Sneed, "Hearst Denied," *San Luis Obispo County Telegram Tribune*, 16 Jan. 1998, A1.

32. Mark Bedor, "Hearst Ranch," *Cowboys and Indians Magazine* (23 Jan. 2006): 146.

33. John Johnson and Kenneth R. Weiss, "The State; Hearst Plan Is Latest Twist in a Long Saga; Scaled-back Proposal for Ranch Pleases Some Longtime Critics and Environmentalists, but Many Questions Remain," *Los Angeles Times*, 8 Dec. 2002.

34. "Musty Attic Yields Plans for San Simeon Village, Castle Architect's Drawings May Shape Future Building Project," *San Luis Obispo County Tribune*, 5 Dec. 2002.

35. Nick Madigan, "Hearst Land Settlement Leaves Bitter Feelings," *New York Times*, 20 Sept. 2004.

36. Ibid.

37. Glen Martin, "A Crucial OK for Hearst Land Deal: 80,000 Coastal Acres to Be Saved from Development," *San Francisco Chronicle*, 16 Sept. 2004, A1. The thirteen miles of coastline donated in the conservation deal do not include four of the most scenic beach sites: San Simeon Cove, San Simeon Point, Ragged Point, and Pico Cove. The public has always had informal access to these beaches, and that continues, with certain restrictions.

38. Kara Blakeslee, Conservation Committee Chair of American Land Conservancy, in discussion with the author, 15 Apr. 2008; *Hearst Ranch: Conservation Easement Area Summary of Resources* (N.p., Oct. 2007), Hearst Castle Staff Library, 2–3.

39. Bedor, "Hearst Ranch," 144.

40. William Randolph Hearst Jr., *The Hearsts*, 88.

Bibliography

ARCHIVES AND LIBRARIES

Phoebe Apperson Hearst Papers. 72/204c. The Bancroft Library, University of California, Berkeley.

William Randolph Hearst Papers. 82/68c, 87/232c. The Bancroft Library, University of California, Berkeley.

Hearst Archives. California Historical Society. San Francisco.

Julia Morgan Collection. College of Environmental Design Archives, University of California, Berkeley.

Hearst San Simeon State Historical Monument Archives. San Simeon, Calif.

Warren McClure Papers. Hearst San Simeon State Historical Monument Staff Library.

Special Collections. Margaret Herrick Library, Academy of Motion Picture Arts and Sciences. Beverly Hills, Calif.

California Collections. Huntington Library, San Marino, Calif.

Peck Family Papers. Huntington Library, San Marino, Calif.

Julia Morgan Papers. Special Collections, Robert E. Kennedy Library, California Polytechnic State University, San Luis Obispo, Calif.

Morgan-Boutelle Collection. Special Collections, Robert E. Kennedy Library, California Polytechnic State University, San Luis Obispo, Calif.

George Loorz Collection. San Luis Obispo County Historical Society Archives. San Luis Obispo, Calif.

MANUSCRIPT AND DOCUMENTARY SOURCES

Apperson, William. "Hearst Ranch Superintendent's Son." Interview and edited by John Horn. *Oral History Project*. San Simeon, Calif.: Hearst San Simeon State Historical Monument, 1996.

Beck, James Montgomery, III. "Teenage Guest, 1943 and 1946." Interview by Robert C. Pavlik, edited by Michelle Hachigian and John Horn, 2 Sept. 1988. *Oral History Project*. San Simeon, Calif.: Hearst San Simeon State Historical Monument, 2003.

Boardman, Eleanor. "An Interview with Eleanor Boardman: An Oral History Interview." Interview by Metta Hake and Robert C. Pavlik. *Oral History Project*. San Simeon, Calif.: Hearst San Simeon State Historical Monument, 1982.

California Department of Parks and Recreation. "A Unit History." San Simeon, Calif.: Hearst San Simeon State Historical Monument, 1974.

Calkins, Edna, and Fred Calkins. "Ranching and Wrangling; From Piojo to San Carpoforo and Jolon to Pacific Valley." Interview by KPRL Radio. *Oral History Project*. Paso Robles, Calif.: Hearst San Simeon State Historical Monument, 1988.

Combs, Robert B. "Horse Trainer: An Oral History Interview." Interview by Robert C. Pavlik, edited by John Horn and Michelle Hachigian. *Oral History Project*. San Simeon, Calif.: Hearst San Simeon State Historical Monument, 27 Jan. 1987.

Conforti, Michael. "Stanford White at San Simeon." Paper presented at the Society of Architectural Historians Convention, Cincinnati, 26 Apr. 1991.

d'Arrast, Eleanor Boardman. "Remembering W. R. and Marion." Interview by Rayena Martin and Guy Roop, edited by Robert C. Pavlik. *Oral History Project*. San Simeon, Calif.: Hearst San Simeon State Historical Monument, 3 Nov. 1987.

Dyck, Bill. "Bill Dyck: Moving Cypress Trees, 1930." Interview by Wilmar Tognazzini, edited by Michelle Hachigian. *Oral History Project*. San Simeon, Calif.: Hearst San Simeon State Historical Monument, Nov. 2003.

Dragon, Roland M. "Private Secretary to W. R. Hearst, 1946–1947." Interview by Michelle Hachigian, edited by Michelle Hachigian and John Horn. *Oral History Project*. San Simeon, Calif.: Hearst San Simeon State Historical Monument, 24 Oct. 1997.

Fairbanks, Douglas, Jr., "Douglas Fairbanks Jr.: Visits to the Hearst Ranch." Interview by Metta Hake, edited by Rayena Martin. *Oral History Project*. San Simeon, Calif.: Hearst San Simeon State Historical Monument, 1990.

Hachigian, Michelle. "Hearst Castle Tour History Overview, 1958–2001." Hearst Castle Staff Library.

Hagelberg, Frej Emil. "The Autobiography of Frej Emil Hagelberg: Reflections of Pushing a Pencil." Edited by Allen Hagelberg and Barbara Condit, 2005.

Harris, Randy. "Randy Harris at Hearst Castle as a Child and as a State Employee." Interview by Michelle Hachigian, edited by John Horn and Michelle Hachigian. *Oral History Project*. San Simeon, Calif.: Hearst San Simeon State Historical Monument, 23 Feb. 2000.

Hawley, Bertha. "Bertha Hawley: The Poultry Ranch 1940s, Castle Waitress, 1950s." Interview by Tom Scott, edited by Laurel Stewart. *Oral History Project*. San Simeon, Calif.: Hearst San Simeon State Historical Monument, 1991.

Hearst, Kathryn P. "Phoebe Apperson Hearst: The Making of an Upper-Class Woman, 1842–1919." PhD diss., Columbia University, 2005.

Hearst Ranch: Conservation Easement Area Summary of Resources. N.p., Oct. 2007. Hearst Castle Staff Library.

Hearst, William Randolph Jr. "Memories of San Simeon and the Hearst Family." Interview by Tom Scott, edited by Robert C. Pavlik. *Oral History Project*. San Simeon, Calif.: Hearst San Simeon State Historical Monument, Aug. 1977.

Heaton, Stanley, and Elmer Moorhouse. "Stanley Heaton and Elmer Moorhouse: Gardening and Road Construction." Interview by Metta Hake, edited by William Payne and Robert C. Pavlik. *Oral History Project*. San Simeon, Calif.: Hearst San Simeon State Historical Monument, 1989.

Heinemann, Sandra J. "Chronology of the Gardens." Hearst Castle Staff Library, N.p., n.d.

———, and Victoria Kastner. *Basic Training Manual: Tour 4*. San Simeon, Calif.: Hearst San Simeon State Historical Monument, 1998.

Horn, John. "Mountain Springs Sustain San Simeon." Staff Reports. Hearst Castle Staff Library, 1996.

Jones, Terry L., and Georgie Waugh. *Central California Coastal Prehistory: A View from Little Pico Creek*. Perspectives in California Archaeology, vol. 3. Institute of Archaeology. Los Angeles: University of California, 1995.

The Julia Morgan Architectural History Project. Edited by Suzanne B. Riess. The Bancroft Library, Regional Oral History Office. Berkeley: University of California, 1976.

Keep, Nigel. "Trees of San Simeon." San Simeon, Calif.: Hearst San Simeon State Historical Monument, 1946.

Laird, Brayton. "Working in the Orchards of the Hearst Ranch." Interview by Bruce Brown, edited by Robert C. Pavlik. *Oral History Project*. San Simeon, Calif.: Hearst San Simeon State Historical Monument, 19 Dec. 1986.

Louis, Young, "Young Louis, Projectionist at San Simeon." Interview by Tom Scott, edited by Rayena Martin. *Oral History Project*. San Simeon, Calif.: Hearst San Simeon State Historical Monument, 1990.

Lyden, Charles. "Charles Lyden, Asst. Monument Supervisor, 1958–1964." Interview and edited by Robert C. Pavlik. *Oral History Project*. San Simeon, Calif.: Hearst San Simeon State Historical Monument, 4 Feb. 1992.

Marion, Frances. "Screenwriter for Hearst," Interview by Gerald Reynolds, edited by Nancy E. Loe. *Oral History Project*. San Simeon, Calif.: Hearst San Simeon State Historical Monument, 1 Sept. 1972.

McClure, Maurice. "From Laborer to Construction Superintendent." Interview by Metta Hake, edited by Bernice Joan Falls and Robert C. Pavlik. *Oral History Project*. San Simeon, Calif.: Hearst San Simeon State Historical Monument, 13 Sept. 1981.

Miller, Ann. "San Simeon During Its Time of Transition." Interview by Eileen Hook. *Oral History Project*. San Simeon, Calif.: Hearst San Simeon State Historical Monument, 13 Jan. 1982.

Moore, Colleen. "The Jazz Age's Movie Flapper at San Simeon." Interview by Eileen Hook. *Oral History Project*. San Simeon, Calif.: Hearst San Simeon State Historical Monument, 25 Jan. 1977.

Morton, Don, rev. by Kathleen Camilla Wade. *San Simeon State Park: State Park No. 50*. Berkeley: Works Progress Administration for the State of California, Department of Natural Resources, Division of Parks, 1937.

Olmsted Center for Landscape Preservation. *Cultural Landscape Report for Hearst San Simeon State Historical Monument*, vols. 1–4. Boston: Olmsted Center for Landscape Preservation, 2008.

Parlet, Charles. "Charles Parlet: Life on San Simeon Ranch, 1921–1977." Interview by Tom Scott, edited by Michelle Hachigian. *Oral History Project*. San Simeon, Calif.: Hearst San Simeon State Historical Monument, 1977.

Pavlik, Robert C. "Hearst and Highway One." Staff Reports. San Simeon, Calif.: Hearst San Simeon State Historical Monument, 1987.

———. "Phoebe Apperson Hearst and La Cuesta Encantada." California Department of Transportation, San Luis Obispo, Calif., Aug. 2005.

———. "A Tale of the Whale: Shore Whaling at San Simeon Bay." San Simeon, Calif.: Hearst San Simeon State Historical Monument, n.d.

Porter, Bruce. "Report of Mr. Bruce Porter for William R. Hearst, Esq., Upon His Estate at San Simeon: And Its Improvements." Jan. 1923. Morgan-Boutelle Collection. Robert E. Kennedy Library, California Polytechnic State University, San Luis Obispo, Calif.

Porter, Garland Burns. "Garland Burns Porter." Interview by Metta Hake, edited by Michelle Hachigian. *Oral History Project*. San Simeon,

Calif.: Hearst San Simeon State Historical Monument, 16 Sept. 1985.

Reich, William Nigel. "Memories of My Grandfather Nigel Keep." Interview by Tom Scott, edited by Robert C. Pavlik. *Oral History Project.* San Simeon, Calif.: Hearst San Simeon State Historical Monument, 1990.

———. "Report on Hearst South Rim Property." 30 Sept. 1949. Julia Morgan Papers. Robert E. Kennedy Library, California Polytechnic State University, San Luis Obispo, Calif.

Rotanzi, Norman. "Fifty-Four Years at San Simeon." Interview by Julie Payne, edited by Robert C. Pavlik. *Oral History Project.* San Simeon, Calif.: Hearst San Simeon State Historical Monument, 6 June 1988.

———. "The Ornamental Gardens of San Simeon." Interview by Gerald Reynolds. *Oral History Project.* San Simeon, Calif.: Hearst San Simeon State Historical Monument, 1977.

———. "The Ranch, Dairy, Orchard, and Grounds: An Oral History Interview." Interview by Tom Scott. *Oral History Project.* San Simeon, Calif.: Hearst San Simeon State Historical Monument, 1989.

Roth, Lurline Matson. *Matson and Roth Family History: A Love of Ships, Horses, and Gardens.* Oral history conducted 1980, 1981 by Suzanne B. Riess. The Bancroft Library, Regional Oral History Office. Berkeley: University of California, 1982.

Sanders, Lucille M. "PBX/Telephone Operator, 1946–1947." Interview by John Blades, edited by Michelle Hachigian. *Oral History Synopsis.* San Simeon, Calif.: Hearst San Simeon State Historical Monument, 21 July 1977.

"San Simeon Clippings." Articles compiled by William Randolph Hearst. Hearst Castle Archives.

Steilberg, Walter. "Address to the Historical Guide Association of California, August 1966." Transcribed by Morris Cecil. San Simeon, Calif.: Hearst San Simeon State Historical Monument, 1968.

Tebbetts, Nathan. "Working for W. R. Hearst's *San Francisco Examiner* and at San Simeon, 1913–1964." Recorded 10 Feb. 1969 in Santa Barbara. Edited by Michelle Hachigian. *Oral History Memoir.* San Simeon, Calif.: Hearst San Simeon State Historical Monument, 2003.

U.S. Department of the Interior. "Draft Fort Hunter Liggett Special Resource Study & Environmental Assessment." National Park Service. Pacific West Regional Office, Monterey County. Park Planning and Environmental Compliance Program, Oakland, Calif., 2004.

Wahlberg, August. "Working for William Randolph Hearst as a Butler and Valet." Interview by Metta Hake and Janet Horton-Payne, edited by Pendleton H. Harris and Laurel Stewart. *Oral History Project.* San Simeon, Calif.: Hearst San Simeon State Historical Monument, 18 Aug. 1983.

Washburn, Mr. and Mrs. Bill. Interview by Steve Hamill and H. Woody Elliott. *Oral History Project.* San Simeon, Calif.: Hearst San Simeon State Historical Monument, 29 July 1994.

Wilson, Barbara Read. "Asilo de Aves at the Hearst Ranch, San Simeon." Hearst Monument Staff Library.

Woodruff, James E. "Archie Soto." *An Oral History Project Concerning the San Simeon Home of William Randolph Hearst.* 7–34. B.A. thesis. California Polytechnic State University, 1977.

BOOKS, PAMPHLETS, AND ARTICLES

Abbe, Patience, Richard Abbe, and Johnny Abbe. *Of All Places!* New York: Stokes, 1937.

Adams, Annmarie, and Peta Tancred. *'Designing Women': Gender and the Architectural Profession.* Toronto: University of Toronto Press, 2000.

Adams, Charles Gibbs. "Gardens for the Stars." As told to Frank J. Taylor. *The Saturday Evening Post* (2 Mar. 1940): 18–19, 71, 72, 74.

Adams, Rick, and Louise McCorkle. *The California Highway 1 Book: An Odology of America's Most Romantic Road.* New York: Ballantine Books, 1985.

Allen, Peter C. *Stanford: From the Foothills to the Bay.* Stanford, Calif.: Stanford Alumni Association/Stanford Historical Society, 1980.

Alexander, Jack. "Cellini to Hearst to Klotz." *Saturday Evening Post* 214, no. 18 (1 Nov. 1941): 16–17, 84, 86–89.

Anderson, M. Kat. *Tending the Wild: Native American Knowledge and Management of California's Natural Resources.* Berkeley: University of California Press, 2005.

Angel, Myron. *History of San Luis Obispo County, California, 1883.* A facsimile reprint with an introduction by Louisiana Clayton Dart. Fresno, Calif.: Valley Publishers, 1979.

Anthony, Kathryn H. *Designing for Diversity: Gender, Race, and Ethnicity in the Architectural Profession.* Urbana: University of Illinois Press, 2001.

Aslet, Clive. *The American Country House.* New Haven: Yale University Press, 1990.

Auden, W. H. "Thanksgiving for a Habitat." *The New Yorker* (17 Aug. 1963), 30.

Baker, Paul R. *Richard Morris Hunt.* Cambridge, Mass.: MIT Press, 1980.

Baldwin, Carey. *My Life with Animals.* Menlo Park, Calif.: Lane Book Co., 1964.

Barber, Edwin Atlee. *Spanish Maiolica in the Collection of the Hispanic Society of America.* New York: Hispanic Society of America, 1915.

Barry, John D. *The City of Domes.* San Francisco: John J. Newbegin, 1915.

Bedor, Mark. "Hearst Ranch." *Cowboys and Indians Magazine* (23 Jan. 2006): 144–149.

Belozerskaya, Marina. *The Medici Giraffe: And Other Tales of Exotic Animals and Power.* New York: Little, Brown, 2006.

Bemelmans, Ludwig. *To the One I Love the Best.* New York: Viking, 1955.

Berke, Arnold. *Mary Colter: Architect of the Southwest.* New York: Princeton Architectural Press, 2002.

Betsky, Aaron. *Queer Space: Architecture and Same-Sex Desire.* New York: William Morrow, 1997.

Bidlack, Russell E. "To California on the *Sarah Sands*: Two Letters Written in 1850 by L. R. Slawson." *California Historical Society Quarterly* 44, no. 3 (Sept. 1965): 229–235.

"Big and Fast Action for a Nine-Alarm Fire in Brooklyn." *Life Magazine* 41, no. 25 (17 Dec. 1956): 56–57.

Blomberg, Nancy J. *Navajo Textiles: The William Randolph Hearst Collection.* Tucson: University of Arizona Press, 1994.

The Board and Batten. Newsletter of the Pacific Grove Heritage Society. Pacific Grove, Calif.: The Heritage Society of Pacific Grove, Feb./Mar. 1994.

Bonfils, Winifred Black. *The Life and Personality of Phoebe Apperson Hearst.* Reprint, with a prefatory note by William Randolph Hearst Jr. and an introduction by Winton Frey. San Simeon, Calif.: Friends of Hearst Castle, 1991.

Boone, M. Elizabeth. *Vistas de España: American Views of Art and Life in Spain, 1860–1914.* New Haven: Yale University Press, 2007.

Bosley, Edward R. *Greene and Greene.* London: Phaidon, 2002.

Boulian, Dorothy May. *Enchanted Gardens of Hearst Castle.* Cambria, Calif.: Phildor Press, 1972.

Boutelle, Sara Holmes. *Julia Morgan, Architect.* Revised and enlarged edition. New York: Abbeville, 1995.

Brechin, Gray A. *Imperial San Francisco: Urban Power, Earthly Ruin.* California Studies in Critical Human Geography, no. 3. Berkeley: University of California Press, 1999.

Byne, Arthur, and Mildred Stapley. *Majorcan Houses and Gardens.* New York: William Helburn, 1925.

———. *Spanish Gardens and Patios.* Philadelphia: Lippincott, 1927.

Cahill, B. J. S. "The Phebe Hearst Architectural Competition." *The California Architect and Building News* 20, no. 9 (Sept. 1899): 97–106.

Cain, Julie. "Landscaping the Gilded Age: Rudolph Ulrich at Monterey's Hotel del Monte, 1880–1890." *Noticias del Puerto de Monterey, Monterey History and Art Association Quarterly* 53, no. 3 (Fall 2004): 3–57.

California Coastal Commission. *Experience the California Coast: Beaches and Parks from Monterey to Ventura.* Berkeley: University of California Press, 2007.

Carr, Paula Juelke. "Harmony along the Coast." *Heritage Shared Studies in Central Coast History* (Winter 2008): 32–53.

Casey, Beatrice (Tid). *Padres and People of Old Mission San Antonio.* King City, Calif.: The Rustler–Herald, 1957.

Chaplin, Charles. *My Autobiography.* New York: Simon and Schuster, 1964.

Chase, J. Smeaton. *California Coast Trails: A Horseback Ride from Mexico to Oregon.* Boston: Houghton Mifflin, 1913.

Churchill, John Spencer. *A Churchill Canvas.* Boston: Little, Brown, 1961.

Clayton, Virginia Tuttle, ed. *The Once and Future Gardener: Garden Writing from the Golden Age of Magazines, 1900–1940.* Boston: David R. Godine, 2000.

Cody, Iron Eyes. *Iron Eyes, My Life as a Hollywood Indian: By Iron Eyes Cody as Told to Collin Perry.* New York: Everest House, c. 1982.

Coffman, Taylor. *Building for Hearst and Morgan: Voices from the George Loorz Papers.* Revised. Berkeley: Berkeley Hills Books, 2003.

———. *Hearst's Dream.* San Luis Obispo, Calif.: EZ Nature Books, 1989.

Colter, Mary Elizabeth Jane, and Virginia L. Grattan. *Mary Colter: Builder upon the Red Earth.* Grand Canyon, Ariz.: Grand Canyon Natural History Association, 1992.

Coodley, Lauren, ed. *The Land of Orange Groves and Jails: Upton Sinclair's California.* Santa Clara, Calif.: Santa Clara University, 2004.

"County Hears Plan for Hearst Rancho." *San Luis Obispo County Telegram Tribune,* 28 Jan. 1965, A1.

Craig, Robert M. *Bernard Maybeck at Principia College: The Art and Craft of Building.* Layton, Utah: Gibbs Smith, 2004.

Crane, Frances. "My Visit to San Simeon." *The New Yorker* (5 Apr. 1941): 37–38.

Craven, Wayne. *Stanford White: Decorator in Opulence and Dealer in Antiquities*. New York: Columbia University Press, 2005.

Crespí, Fr. Juan. *Captain Portolá in San Luis Obispo County in 1769*. Edited and augmented by Fr. Francisco Palóu and Paul Squibb, translated by Prof. Herbert E. Bolton. Morro Bay, Calif.: Tabula Rasa Press, 1984.

Croly, Herbert. "The Architectural Work of Charles A. Platt." *The Architectural Record* 15, no. 3 (Mar. 1904): 182–244.

Davies, Marion. *The Times We Had: Life with William Randolph Hearst*. Indianapolis, Ind.: Bobbs–Merrill, 1975.

Denning, Roy, ed. *The Story of St. Donat's Castle and Atlantic College*. Foreword by H. R. H. The Prince of Wales. Cowbridge, South Wales: D. Brown and Sons with Stewart Williams, 1983.

Dewberry, Suzanne. "Perils at Sea: The Sinking of the *SS Montebello*." *Prologue: Quarterly of the National Archives* 23, no. 3 (Fall 1991): 260–264.

Dobyns, Winifred Starr. *California Gardens*. New York: Macmillan, 1931; rev. ed., Santa Barbara, Calif.: Allen A. Knoll, 1996.

Dolin, Eric Jay. *Leviathan*. New York: W. W. Norton, 2007.

Dos Passos, John. *The Big Money*. Boston: Houghton Mifflin, 1936.

Egbert, Donald Drew. *The Beaux-Arts Tradition in French Architecture*. Princeton: Princeton University Press, 1980.

"Eight Villages Proposed Along North Coast Area." *San Luis Obispo County Telegram Tribune*, 13 Nov. 1964, A1.

Engbeck, Joseph H. Jr. *The Enduring Giants*. Berkeley: University Extension, University of California, 1973.

Favro, Diane. "Sincere and Good: The Architectural Practice of Julia Morgan." *Journal of Architectural and Planning Research* 9, no. 2 (Summer 1992): 112–128.

Fincher, Jack. "The Mogul, the Magnate, the Muckraker." *Los Angeles* (July 1985): 133–137, 252.

"First Complete Color Photographs: Fabulous San Simeon." *Life Magazine* 43, no. 9 (26 Aug. 1957): 68–84.

Fitzgerald, F. Scott. "The Diamond as Big as the Ritz." In *The Best Early Stories of F. Scott Fitzgerald*. Edited by Bryant Mangum. New York: The Modern Library, 2005.

Foote, Mary Hallock. *A Victorian Gentlewoman in the Far West: The Reminiscences of Mary Hallock Foote*. Edited by Rodman W. Paul. San Marino, Calif.: Huntington Library Press, 1972.

Forest Lawn Art Guide. Glendale, Calif.: Forest Lawn Memorial-Park Association, 1963.

French, Jere Stuart. *The California Garden: And the Landscape Architects Who Shaped It*. Washington, D.C.: The Landscape Architecture Foundation, 1993.

Freudenheim, Leslie M. *Building with Nature: Inspiration for the Arts and Crafts Home*. Salt Lake City: Gibbs Smith, 2005.

Frey, Woodrow. "Making the Gardens at San Simeon." *Pacific Horticulture* 39, no. 3 (Fall 1978).

Garnett, Porter. *Stately Homes of California*. Introduction by Bruce Porter. Boston: Little, Brown, 1915.

Gebhard, David. *Lutah Maria Riggs: A Woman in Architecture, 1921–1980*. Santa Barbara: Capra Press in association with the Santa Barbara Museum of Art, 1992.

Geil, Marian. *Anaconda's Treasure: The Hearst Free Library*. Anaconda, Mont.: The Hearst Free Library, 1998.

Getty, J. Paul. *As I See It: The Autobiography of J. Paul Getty*. Englewood Cliffs, N.J.: Prentice-Hall, Inc., 1976.

Gilbert, Alma. *Maxfield Parrish: The Masterworks*. Berkeley: Ten Speed Press, 1992.

Griggs Smith, Margarita. *The San Simeon Story: The Romantic Story of San Simeon, 1827–1958*. San Luis Obispo, Calif.: Star-Reporter Publishing Company, 1958.

Griswold, Mac, and Eleanor Weller. *The Golden Age of American Gardens: Proud Owners, Private Estates, 1890–1940*. New York: Harry N. Abrams, Inc., in association with the Garden Club of America, 1991.

Guiles, Fred Lawrence. *Marion Davies*. New York: McGraw-Hill, 1972.

Hamilton, Geneva. *Where the Highway Ends: Cambria, San Simeon, and the Ranchos*. San Luis Obispo, Calif.: Padre Productions, 1974.

Hanchett, Byron. *In & Around the Castle*. San Luis Obispo, Calif.: Blake, 1985.

Hanson, A. E. *An Arcadian Landscape: The California Gardens of A. E. Hanson, 1920–1932*. Edited by David Gebhard and Sheila Lynds. Los Angeles: Hennessey & Ingalls, 1985.

Hart-Davis, Rupert. *Hugh Walpole*. Phoenix Mill, Thrupp, Stroud, Gloucestershire: Sutton, 1997.

Head, Alice M. *It Could Never Have Happened*. London: William Heinemann Ltd., 1939.

Hearst, George. *The Way It Was*. N.p.: Hearst Corporation, 1972.

Hearst, John R. Jr. "Life With Grandfather." *Reader's Digest* 76, no. 457 (May 1960): 152–153, 155–159, 161–162.

Hearst, Mrs. William Randolph Jr. *The Horses of San Simeon*. San Simeon, Calif.: San Simeon Press, 1985.

Hearst, Phoebe A. "California as a Field for Women's Activities." *California's Magazine* (July 1915): 371–373.

————, J. Nilsen Laurvik, and Arthur Upham Pope. *Catalogue: Mrs. Phoebe A. Hearst Loan Collection*. San Francisco: The San Francisco Art Association, 1917.

Hearst, William Randolph. "In the News," 10 Mar. 1940–25 May 1942.

Hearst, William Randolph Jr. *The Hearsts: Father and Son*. Niwot, Colo.: Roberts Rinehart, 1991.

————. "San Simeon: Story of a Great Builder." *San Francisco Examiner*, 17 Aug. 1958.

"Hearst." *Fortune* 12, no. 4 (Oct. 1935): 42–55, 123–126, 128–130, 133–136, 139–140.

Helfand, Harvey. *The Campus Guide, University of California, Berkeley: An Architectural Tour and Photographs by Harvey Helfand*. New York: Princeton Architectural Press, 2002.

Henson, Paul, and Donald J. Usner. *The Natural History of Big Sur*. Berkeley: University of California Press, 1993.

Hertrich, William. *The Huntington Botanical Gardens, 1905–1949*. 2nd paperback ed. San Marino, Calif.: Huntington Library Press, 2003.

Hewitt, Mark Alan. *The Architect & the American Country House: 1890–1940*. New Haven: Yale University Press, 1990.

Hillyer Brown, Helen. *For My Children and Grandchildren*. San Francisco: Hillside Press, 1986.

Hopper, Hedda, and James Brough. *The Whole Truth and Nothing But*. New York: Pyramid Books, 1963.

Howard, John Galen. "Country House Architecture on the Pacific Coast." *The Architectural Record* 40, no. 4 (Oct. 1916): 323–356.

Huxley, Aldous. *After Many a Summer Dies the Swan*. New York: Harper & Row, 1965.

Irving, Washington. *The Alhambra*. 1832. Tarrytown, N.Y.: Sleepy Hollow Press, 1982.

Johnson, John, and Kenneth R. Weiss. "The State; Hearst Plan Is Latest Twist in a Long Saga; Scaled-back Proposal for Ranch Pleases Some Longtime Critics and Environmentalists, but Many Questions Remain." *Los Angeles Times*, 8 Dec. 2002.

Jones, William Carey. "The First Benefactors." *The University of California Magazine* 5, no. 3 (Apr. 1899): 101–117.

Kantor, J. R. K. "Cora, Jane & Phoebe: Fin-de-Siècle Philanthropy." *Chronicle of the University of California* 1, no. 2 (Fall 1998): 1–8.

Kastner, Victoria. *Hearst Castle: The Biography of a Country House*. New York: Harry N. Abrams, Inc., 2000.

————. "Morgan and Associates: Julia Morgan's Office Practice as Design Metaphor." *20 on 20/20 Vision: Perspectives on Diversity and Design*. Boston: AIA Diversity Committee/Boston Society of Architects, 2003.

————, and Jana Seely. "San Simeon's Collection of Ceremonial Objects." *Antiques* (Apr. 2002), 138–146.

Keep, Rosalind A. *Fourscore Years: A History of Mills College*. Oakland: Goodhue-Kitchener, 1931.

The Legacy of the Exposition: Interpretation of the Intellectual and Moral Heritage Left to Mankind by the World Celebration of San Francisco in 1915. San Francisco: Panama-Pacific International Exposition Company, 1916.

Levkoff, Mary L. *Hearst the Collector*. New York and Los Angeles: Abrams in association with the Los Angeles County Museum of Art, 2008.

Liebling, A. J. "A Reporter at Large, Hearst With His Own Petard." *The New Yorker* (19 Nov. 1938): 40–52.

Loe, Nancy E. *Hearst Castle: An Interpretive History of W. R. Hearst's San Simeon Estate*. Santa Barbara, Calif.: Companion Press, 1994.

Longstreth, Richard. *On the Edge of the World: Four Architects in San Francisco at the Turn of the Century*. New York: Architectural History Foundation, 1983.

Lummis, Charles. "The Greatest California Patio House." *Country Life in America* (Oct. 1904): 540, 560–564.

Lyman, George D. *The Saga of the Comstock Lode: Boom Days in Virginia City*. New York: Charles Scribner's Sons, 1934.

MacKay, Robert B., Anthony K. Baker, and Carol A. Traynor. *Long Island Country Houses and Their Architects, 1860–1940*. New York: W. W. Norton in association with the Society for the Preservation of Long Island Antiquities, 1997.

Macoboy, Stirling. *The Ultimate Rose Book*. Edited by Tommy Cairns. New York: Abrams, 2007.

Macomber, Ben. *The Jewel City: Its Planning and Achievement; Its Architecture, Sculpture, Symbolism, and Music; Its Gardens, Palaces, and Exhibits*. San Francisco: John H. Williams, 1915.

Madigan, Nick. "Hearst Land Settlement Leaves Bitter Feelings." *New York Times*, 20 Sept. 2004.

Maher, James T. *The Twilight of Splendor: Chronicles of*

the Age of American Palaces. Boston: Little, Brown, 1975.

Mann, William J. Wisecracker: The Life and Times of William Haines, Hollywood's First Openly Gay Star. New York: Viking, 1998.

Marble, Alice, with Dale Leatherman. Courting Danger. New York: St. Martin's Press, 1991.

Marion, Frances. Off with Their Heads! A Serio-Comic Tale of Hollywood. New York: Macmillan, 1972.

Martin, Glen. "A Crucial OK for Hearst Land Deal: 80,000 Coastal Acres to Be Saved from Development." San Francisco Chronicle, 16 Sept. 2004, A1.

Marx, Harpo, with Rowland Barber. Harpo Speaks! New York: Limelight Editions, 1965.

Maybeck, Jacomena. Maybeck: The Family View. Berkeley: Berkeley Architectural Heritage Association, 1980.

Mazzola, Anthony T., and Frank Zachary, eds. High Society: The "Town & Country" Picture Album, 1846–1996. New York: Harry N. Abrams, Inc., 1996.

McMahon, Christopher, and Timmy Gallagher. The Gardens at Filoli. San Francisco: Pomegranate Artbooks, 1994.

McNeill, Karen. "Julia Morgan: Gender, Architecture, and Professional Style." Pacific Historical Review 76, no. 2 (2007): 229–267.

Miller, Henry. Big Sur and the Oranges of Hieronymus Bosch. New York: New Directions, 1957.

Mitchell, Greg. The Campaign of the Century: Upton Sinclair's Race for Governor of California and the Birth of Media Politics. New York: Random House, 1992.

Moore, Charles W. Water and Architecture. New York: Harry N. Abrams, Inc., 1994.

Mullgardt, Louis Christian. "Country House Architecture on the Pacific Coast." The Architectural Record 28, no. 4 (Oct. 1915): 422–451.

"Musty Attic Yields Plans for San Simeon Village, Castle Architect's Drawings May Shape Future Building Project." San Luis Obispo County Tribune, 5 Dec. 2002.

Nasaw, David. The Chief: The Life of William Randolph Hearst. New York: Houghton Mifflin, 2000.

Nelson, Nancy. Evenings with Cary Grant: Recollections in His Own Words and by Those Who Knew Him Best. New York: Warner, 1991.

Newton, Edward A. Derby Days & Other Adventures. Freeport, N.Y.: Books for Libraries Press, 1969.

Newton, Norman P. Design on the Land: The Development of Landscape Architecture. Boston: Harvard University Press, 1971.

Niven, David. Bring on the Empty Horses. New York: G. P. Putnam's Sons, 1975.

North, Dan. "How I Made a Forest out of a Desert: Nigel Keep, 90, Recalls Working for W. R. Hearst." San Francisco Examiner (24 Feb. 1963): sec. 1.

Older, Mr. and Mrs. Fremont. George Hearst: California Pioneer. Los Angeles: Westernlore, 1966.

Older, Mrs. Fremont. William Randolph Hearst, American. New York: Appleton-Century, 1936.

Parsons, Louella O. The Gay Illiterate. New York: Doubleday, 1944.

Partridge, Loren W. John Galen Howard and the Berkeley Campus: Beaux-Arts Architecture in the "Athens of the West." Berkeley Architectural Heritage Publication Series, no. 2. Berkeley: Berkeley Architectural Heritage Association, 1978.

Pavlik, Bruce M., Pamela C. Muick, Sharon Johnson, and Marjorie Popper. Oaks of California. Los Olivos, Calif.: Cachuma Press/California Oak Foundation, 1991.

Pavlik, Robert C. "'Something a Little Different': La Cuesta Encantada's Architectural Precedents and Cultural Prototypes." California History 71, no. 4 (Winter 1992/1993): 462–477, 548–549.

———. "The Tile Art of San Simeon: A Social and Cultural Perspective." Tile Heritage: A Review of American Tile History 4, no. 2 (Winter 1997): 2–11.

Peixotto, Ernest. Romantic California. New York: Charles Scribner's Sons, 1911.

Perry, Claire. Pacific Arcadia: Images of California, 1600–1915. New York: Oxford University Press, 1999.

Platt, Charles A. Italian Gardens. Portland, Ore.: Sagapress, 1993.

Procter, Ben. William Randolph Hearst: The Early Years, 1863–1910. New York: Oxford University Press, 1998.

———. William Randolph Hearst: Final Edition, 1911–1951. New York: Oxford University Press, 2007.

Quacchia, Russell L. Julia Morgan, Architect, and the Creation of the Asilomar Conference Grounds. Virginia Beach, Va.: Q Publishing, 2005.

Quinn, Ronald D., and Sterling C. Keeley. California Natural History Guides: Introduction to California Chaparral. California Natural History Guide Series, no. 90. Berkeley: University of California Press, 2006.

Remy, Mary. "Historical Notes." The Women's Faculty Club Newsletter, University of California (June 2005): 2–3.

Reynolds, Donald Martin. Masters of American Sculpture: The Figurative Tradition from the American Renaissance to the Millennium. New York: Abbeville, 1993.

Robinson, Judith. The Hearsts: An American Dynasty. Newark, Del.: University of Delaware Press, 1991.

Roper, Laura Wood. FLO: A Biography of Frederick Law Olmsted. Baltimore: Johns Hopkins University Press, 1973.

Russell, Vivian. Edith Wharton's Italian Gardens. Boston: Little, Brown, 1997.

Rybczynski, Witold. The Most Beautiful House in the World. New York: Viking, 1989.

———, and Laurie Olin. Vizcaya: An American Villa and Its Makers. Philadelphia: University of Pennsylvania Press, 2007.

St. Johns, Adela Rogers. The Honeycomb. New York: Doubleday, 1969.

Sanderson, Ivan T. A History of Whaling. New York: Barnes & Noble Books, 1993.

Sarber, Jane. "A Cabbie in a Golden Era, Featuring Cabbie's Original Log of Guests Transported to Hearst Castle." N.p., n.d.

Seely, Jana, Keri Collins, and Gary Ashcavai. Faces of Hearst Castle. San Simeon, Calif.: Hearst Castle Press, 2007.

"The Seer of San Simeon." Newsweek 27, no. 18 (6 May 1946): 62–64.

Sinclair, Upton. A World to Win. New York: Viking, 1946.

Sneed, David. "Calm Before the Storm." San Luis Obispo County Telegram Tribune, 15 Jan. 1998.

———. "Hearst Denied." San Luis Obispo County Telegram Tribune, 16 Jan. 1998, A1.

Snyder, Susan. Past Tents: The Way We Camped. Berkeley: Heyday Books/Bancroft Library, 2006.

Spencer-Churchill, John A. A Churchill Canvas. Boston: Little, Brown, 1961.

Starr, Kevin. California: A History. New York: Modern Library, 2005.

Steilberg, Walter T. "Some Examples of the Work of Julia Morgan." The Architect and Engineer of California 55, no. 2 (Nov. 1918): 39–102.

Steinbeck, John. The Grapes of Wrath. New York: Viking, 1939.

Stern, Robert A. M. Pride of Place: Building the American Dream. Boston: Houghton Mifflin, 1986.

Storer, Tracy I., and Lloyd P. Tevis. California Grizzly. Berkeley: University of California Press, 1996.

Streatfield, David C. California Gardens: Creating a New Eden. New York: Abbeville, 1994.

Swanberg, W. A. Citizen Hearst: A Biography of William Randolph Hearst. New York: Bantam, 1963.

Tan, Mary Woodland Gould, and Virginia Carroll. Woodland Hall, Kent County, Maryland: Remembrances of the Family and Home. Holly Hill, Fla.: Copy Cat Printing, 2007.

Tilman, Jeffrey T. Arthur Brown Jr.: Progressive Classicist. New York: W. W. Norton in association with the Institute of Classical Architecture, 2006.

Timbrook, Jim. Chumash Ethnobotany: Plant Knowledge among the Chumash People of Southern California. Santa Barbara and Berkeley: Santa Barbara Museum of Natural History/Heyday Books, 2007.

Torre, Susana, ed. Women in American Architecture: A Historic and Contemporary Perspective. New York: Whitney Library of Design, 1977.

Tracy, Jack. Sausalito Moments in Time: A Pictorial History of Sausalito's First One Hundred Years, 1850–1950. Sausalito, Calif.: Windgate Press, 1983.

Turbiner, Jane. "Economics at Cal: At the Cutting Edge for 100 Years." University of California, Berkeley, The Econ Exchange 5, no. 1 (Spring 2002): 4–5.

Vidor, King. A Tree Is a Tree. Hollywood: Samuel French, 1989.

Weitze, Karen J. "California's Mission Revival." California Architecture and Architects. No. 3. Los Angeles: Hennessey & Ingalls, 1984.

Wharton, Edith. Italian Villas and Their Gardens. Illustrated by Maxfield Parrish. New York: Century, 1904.

White, Lawrence Grant. Sketches and Designs by Stanford White. New York: Architectural Book Publishing, 1920.

Wilbur, Marguerite Eyer. Vancouver in California, 1792–1794: The Original Account of George Vancouver. Los Angeles: Glen Dawson, 1954.

Wilson, Mark A. Julia Morgan: Architect of Beauty. Layton, Utah: Gibbs Smith, 2007.

Winter, Robert, ed. Toward a Simpler Way of Life: The Arts & Crafts Architects of California. Berkeley: University of California Press, 1997.

Wodehouse, P. G. Author! Author! New York: Simon and Schuster, 1962.

———. "The Return of Jeeves." Five Complete Novels. New York: Avenel Books, 1983.

Woodbridge, Sally B. Bernard Maybeck: Visionary Architect. New York: Abbeville, 1992.

Yaryan, Willie, Denzil Verado, and Jennie Verado. The Sempervirens Story: A Century of Preserving California's Ancient Redwood Forest, 1900–2000. Los Altos, Calif.: Sempervirens Fund, 2000.

Yoch, James J. Landscaping the American Dream: The Gardens and Film Sets of Florence Yoch, 1890–1972. New York: Harry N. Abrams, Inc., 1989.

Acknowledgments

Many people helped create this book. Without the efforts of California State Parks staff, most especially Hearst Castle Museum Director Hoyt Fields and San Luis Obispo Coast District Superintendent Nicholas Franco, it never would have happened. We are also grateful to Friends of Hearst Castle Executive Director Carol Schreiber; Jody Bell, ARAMARK manager, Hearst Castle Visitor Center; and Martin Levin at Cowan, Liebowitz & Latman, New York. At Harry N. Abrams, we would like to thank Vice-President and Editor-in-Chief Eric Himmel, Executive Editor Deborah Aaronson, our talented book designer Darilyn Carnes, and our wonderful editor Elisa Urbanelli.

We received helpful assistance from many research librarians, including Mary Morganti, Alison Moore, and Debra Kaufman at the California Historical Society, San Francisco; Susan Snyder at the Bancroft Library, and Waverly Lowell and Miranda Hambro at the Environmental Design Archives, all at the University of California, Berkeley; Cara Randall and Ellen Halteman at the California State Railroad Museum Library; Dace Taube at the Doheny Memorial Library, University of Southern California; Linda Mehr, Kristine Krueger, Faye Thompson, and Stacey Behlmer at the Margaret Herrick Library at the Academy of Motion Picture Arts and Sciences, Beverly Hills; and Laura Stalker, Juan Gomez, Jennifer Watts, Erin Chase, and Jennifer Goodman at the Huntington Library, San Marino. Our special thanks go to Nancy E. Loe, Denise Fourie, Ken Kenyon, and Catherine Trujillo at the Special Collections and University Archives of the Robert E. Kennedy Library, California Polytechnic State University, San Luis Obispo.

We are grateful to many researchers, including Itty Mathew at the New-York Historical Society; Eric Brocklehurst at the National Museum of American Illustration, Newport, Rhode Island; Stephanie Gress at the Suffolk County Vanderbilt Museum, Centerpoint, New York; art historians William and Abigail Gerdts of New York; Roni Lubliner, Christy Havranek, and Curtis Means at NBC Universal, New York; Greg Lowery and Virginia McKean at the Heritage Rose Foundation; Renee McKean at the Shasta County Historical Society; Martin Chapman at the Fine Arts Museums of San Francisco; Julia Bessinger, Verna Garibaldi, Heather Rizzoli, Cathy Thompson-Maranz, and Bill Apperson at the Amador-Livermore Histori-

cal Society, Pleasanton; Tom Rogers at Filoli, Woodside; Dennis Judd at Cuesta College, Paso Robles; John Bogacki at the Piedras Blancas Lightstation; Michele Roest at the Monterey Bay National Marine Sanctuary; Ronald E. Clarke at the San Luis Obispo County Historical Society; Robert Pavlik at Caltrans, San Luis Obispo; Chipper Cavendish, Gabe Cano, and Glen Hodges at Specialty Color Services, Santa Barbara; Marc Wanamaker at Bison Archives, Los Angeles; Mary Levkoff, Wendy Kaplan, and Tom Michie at the Los Angeles County Museum of Art; William C. Martin at Forest Lawn Memorial Park, Hollywood Hills; and Julie Heath at Warner Bros. Studio, Burbank. We especially thank Robert R. Page, Laurie Matthews, and Eliot Foulds of the Olmsted Center for Landscape Preservation, Brookline, Massachusetts.

All Hearst Castle staff assisted us, especially the firefighters/security officers, dispatchers, and historic guides. We would specifically like to thank Chief of Interpretation Diane McGrath and Guide Supervisors Brandi Bohey, John Fixler, Shannon Harmon, Debra Mendenhall, Susan Mowry, and Mary Stephenson. Thanks to Curator Frank Young and the Collections staff, including Joe Argentine, Steve Arteaga, Keri Collins Lewis, Ana Gallegos, John Gardiner, John Horn, Sandy Kincaid, Letty LaChance, Shirley LeFebvre, Dawn Michals, Jeff Payne, Nancy Requiero, Lydia Salinas, Jana Seely, Toby Selyem, and Shirley Smyth. Thanks to Restoration Supervisor Bruce Jackson and his staff, including John Bales, Marc Cremarosa, Alan Fitch, Dave Fontenot, Harold Hadley, Jared Jacobsmeyer, Ben Mercado, Earl Moon, Lawrence Ross, Kathy Tarby, Leonard Willhite, Debra Williams, and David Wilson. We especially recognize the Groundskeepers, who under the direction of Christine Takahashi work so hard to maintain the gardens: Bob Conlen, Dean Davis, Russell Harper, Jeremy Highhouse, Casey McDonald, Mary McDonald, Graham Mortimer, Landon Mortimer, Don Ruda, and Lisa Taylor. We are also grateful to Jim Allen, Adolph Antencio, Doug Barker, Terry Barnes, Donna Bishop, Gretchen Bolster, Mark Britell, George Cartter, Dana Claywell, Wayne Craveiro, Vince Cukrov, Tom Edick, Dan Eller, Felicia Guy, Pendleton Harris, Shawn Harris, Carol Ann Heiner, Karen Huller, Regiena Ibay, Jeff Keyes, Robert Latson, Tracy McConnell, Lisa McGurrin, Regena Orr, John Porter, Sheila Reid, Beverly Steventon, Larry Taylor, Eric Weiss, and Elise Wheeler. Our special thanks go to Staff Librarians Joanne Aasen, Judy Anderson, Sharon Anderson, Liz Caldwell, Michelle Hachigian, Sandra

Heinemann, Sandy Jennings, Denise Surber, and Jill Uruquhart, who all guided our research and answered countless reference questions.

We were inspired and assisted by many friends, including Marie Alexander, Jeanne Anderson, Robbie Anderson, April Balkind, Jo Barbier, Karen Beery, Robert Carlson, John Carpenter, Dani Cobb, Pam Conners, Jordan Cronenweth, Martha Deese, Rupert Deese, Frederick Dirbas, Lindi Doud, Bob Edwards, David Evans, Jodyne Forsmann, Stephanie Fuller, Stan Gainsforth, Karen Garmin, Karyn Gerhard, John Goldthwait, Alan Harris, William Hill, Jeannie Hobhouse, Kathleen Horst, Natalie Howard, Dane Howell, Jackie Howell, Brett King, Patrick McGibney, Jim McKenzie, Joyce McKenzie, William McNaught, D. R. Miller, Margie Noble-Englund, Bill Olson, Derek Ostergard, Katy Pose, Wendy Pound, John Rhoades, Marcia Rhoades, Jeff Rininger, Jack Rosazza, Trudi Rosazza, Richard Somerset-Ward, Tiffany Svahn, Celeste Varas de Valdes, Robert Wilson, Ann Wride, Evan Wride, Kevin Wulzen, and David Wurtzel.

We received special assistance from landscape architect Tom Craig, cartographers Kirby Shaw and Xandra Shaw, security specialist Jack Raymond, instructor Wendy Nielsen, designer Bartay of Bartay Studios, photographer Bruce Buck, attorney Marcella Ruble, author Kathryn P. Hearst, and Hearst Castle benefactor Anne Hearst. This book would not have been possible without our excellent research associates Muna Cristal, Sandra Heinemann, Ruth Latson, and April Smith-Hatchett, who contributed magnificently to the project.

We would also like to thank our families— Jennifer Dooley, Dena Kastner, George Kastner, Jason Kastner, Kevin Kastner, and Timmy Kastner; Cecilia White, Jesse White, Grae Halsne, and Jennifer Halsne; Bruce Smith and Yoshiko Yamamoto; Tina Neilson; Anita and Ronnie Miller; John and Diane Garagliano; and John and Virginia Garagliano. Lastly we would like to thank members of the Hearst family and the Hearst Corporation, and especially Stephen T. Hearst, attorney Roger Lyon, and conservationist Kara Blakeslee, whose recent efforts preserved this matchless landscape, ensuring La Cuesta Encantada will remain as Julia Morgan and William Randolph Hearst last saw it.

V. K. and V. G.

Index

Photograph Credits

All photographs are by Victoria Garagliano, except
for the following:

Academy of Motion Picture Arts and Sciences,
Beverly Hills, Calif.: [© Turner Entertainment Co.,
A Warner Bros. Entertainment Company. All Rights
Reserved] 16 bottom; 111, 157 top, 165 top, [Photo
by NBC Universal Photo Bank] 198; [Courtesy of
Universal Studios Licensing LLLP] 202 bottom.
Amador-Livermore Valley Historical Society, Pleas-
anton, Calif.: 43 bottom. Archives of the American
Illustrators Gallery NYC © 2007 National Museum of
American Illustration, Newport, Rhode Island: 44.
The Bancroft Library: 24 top, 25, 34, 39 bottom, 71;
The Environmental Design Archives [Julia Morgan
Collection, 1959-2] 79, 92 top; [Bernard Maybeck
Collection, 1956-1] 186 top; both collections located
at the University of California, Berkeley. California
Historical Society, San Francisco: [FN-24281] 15,
[FN-03995] 39 top, [FN-36533] 40, [FN-36534]
81 top, [FN-10680] 81 bottom, [FN-27945 131 top,
[FN-36532] 157 bottom. Julia Morgan Papers: 53 top,
74, 78, 91 top left, 96, 161 bottom, 181 bottom, 190;
Julia Morgan-Sara Holmes Boutelle Collection: 91
top right, 193; both collections located at the Special
Collections, Robert E. Kennedy Library, California
Polytechnic State University, San Luis Obispo. Cali-
fornia State Railroad Museum Library, Sacramento:
33. Forest Lawn Memorial-Parks & Mortuaries,
Hollywood Hills, Calif.: 201 top. Hearst San Simeon
State Historical Monument Archives: 26 bottom,
28 bottom, 38, 53 middle, 53 bottom, 56 top, 61, 63
top, 69, 70, 85, 87, 92 bottom, 98 top, 98 bottom,
101 bottom, 104 top, 104 bottom, 107, 112, 113, 115
top, 115 middle, 115 bottom, 119 top, 119 bottom, 121,
125, 127 top, 134 right, 134 bottom, 135, [Courtesy of
Oliver D. Tuttle] 136 top, 141, 143 top, 143 middle,
143 bottom, 144, 145 top, 145 bottom, 147, 150, 152,
154 top, 154 bottom, 156 top, 156 bottom, 160, 161
top, 167 top, 167 bottom, 168 top, 168 bottom, 176
bottom left, 176 right, 178 bottom left, 178 right, 181
top, 186 bottom, 188 top, 201 bottom, 202 top, 206
top. The Huntington Library, San Marino, Calif.: 24
bottom, 36, 37, 48. Victoria Kastner: 46 top, 46 bot-
tom. New-York Historical Society: [Neg. No. 72716]
59 top. Thomas R. Perry and Donald R. Worn: 131
bottom. San Luis Obispo County Historical Society,
San Luis Obispo, Calif.: 16 top, 30, 138 bottom, 166.
Shasta Historical Society, Redding, Calif.: 41. Kirby
and Xandra Shaw © 1985: 23. The Suffolk County
Vanderbilt Museum, Centerport, New York: 134 left.
University of Southern California, on behalf of the
USC Special Collections, Los Angeles: 91 bottom.
Marc Wanamaker/Bison Archives, Los Angeles: 14.
© RKO Pictures, Inc. Licensed by Warner Bros.
Entertainment, Inc. All Rights Reserved: 192

Additional Credits
Illustrations: Hearst San Simeon State Historical
Monument: 114 top

PROJECT MANAGER: Deborah Aaronson
EDITOR: Elisa Urbanelli
DESIGNER: Darilyn Lowe Carnes
PRODUCTION MANAGER: Jules Thomson

Library of Congress Cataloging-in-Publication Data

Kastner, Victoria.
 Hearst's San Simeon : the gardens and the land /
 by Victoria Kastner ;
photography by Victoria Garagliano ; preface by
 Nicholas Franco.
 p. cm.
 ISBN 978-0-8109-7290-2 (harry n. abrams, inc.)
 1. Hearst-San Simeon State Historical Monument
 (Calif.) 2. Hearst,
William Randolph, 1863-1951—Homes and haunts.
 I. Title.

 F868.S18K37 2009
 979.4'78—dc22

 2008044296

ENDSHEETS: The view north across the Santa Lucia
Coast Range at sunset in early spring
CASEWRAP: Aerial view of La Cuesta Encantada

Printed and bound in China
10 9 8 7 6 5 4 3 2 1

Abrams books are available at special discounts
when purchased in quantity for premiums and pro-
motions as well as fundraising or educational use.
Special editions can also be created to specification.
For details, contact specialmarkets@hnabooks.com
or the address below.

HNA ▮▮▮▮▮
harry n. abrams, inc.
a subsidiary of La Martinière Groupe

115 West 18th Street
New York, NY 10011
www.hnabooks.com

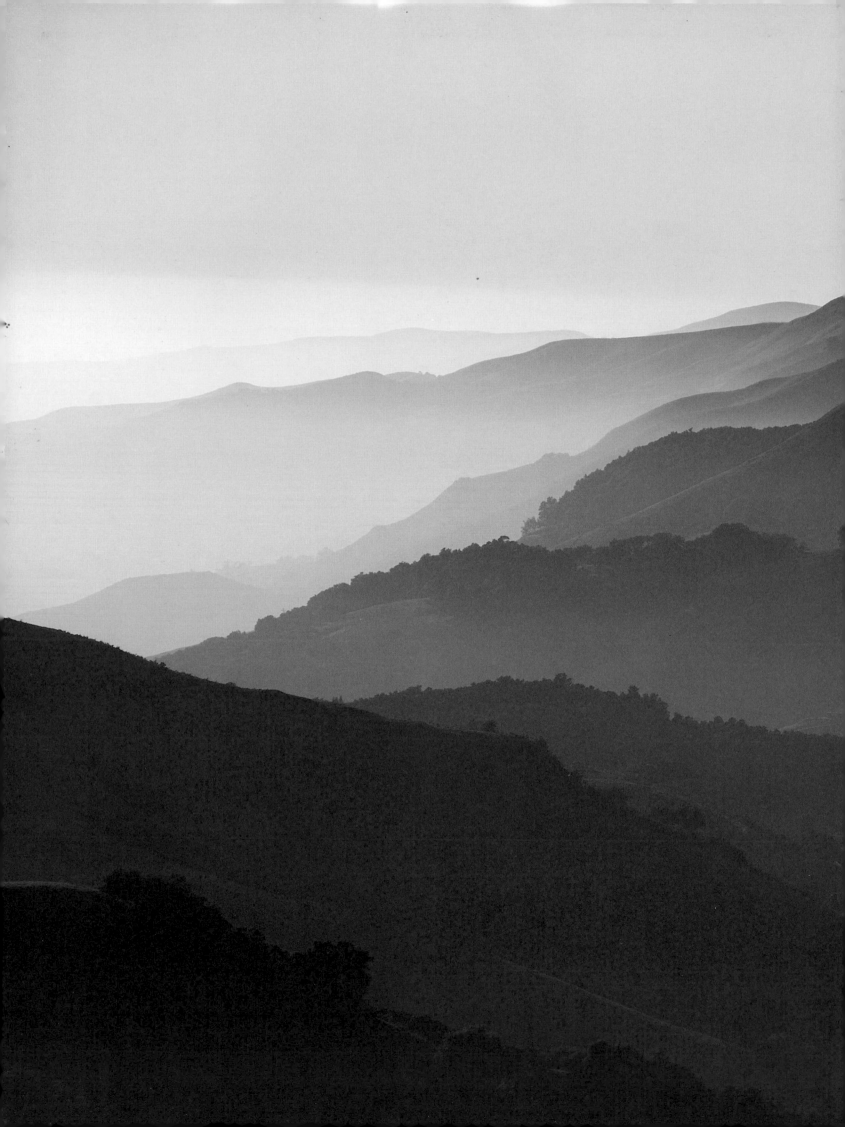

DIY AND HOME IMPROVEMENT

NEWNES ALL COLOUR REFERENCE
DIY AND HOME IMPROVEMENT

NEWNES BOOKS

Published by
Newnes Books, a division of The Hamlyn Publishing Group Limited,
84-88 The Centre, Feltham, Middlesex TW13 4BH
and distributed for them by The Hamlyn Publishing Group Limited,
Rushden, Northants, England.

Original Material © 1980-2, 1981-3 Marshall Cavendish Ltd

This arrangement © 1984 Marshall Cavendish Ltd
Prepared by Marshall Cavendish Books Ltd,
58 Old Compton St, London W1V 5PA

Any editorial queries concerning this book should be made to Marshall
Cavendish. Any trade enquiries should be addressed to Newnes Books.

ISBN 0 600 35106 8

Printed in Italy

Note: care has been taken to ensure that information in this book
is accurate. However, individual circumstances vary greatly, so
proceed with caution when following instructions, especially where
electrical, plumbing or structural work is involved.

CONTENTS

INTRODUCTION

A home should be the place where one can relax in comfort and enjoy the surroundings. However, all too often this is not possible because of concern about all those niggly repairs that need doing and how much they are going to cost. *The Newnes Do-It-Yourself Manual* is a thoroughly practical and comprehensive book which will help the DIY enthusiasts and novices to do repairs efficiently and cheaply, gives guidance on improvements projects, and advice with planning and decorating.

The book is divided up into different skills sections to cover all aspects of home maintenance and renovation. It starts by explaining how to overcome those fiddly, but relatively simple, repairs such as replacing a broken window pane or fixing the garden fence and progresses to plumbing and insulation techniques like installing a shower or double glazing. Other tasks carefully explained include bathroom planning and room redecoration. In time the house can really be improved by trying more demanding projects like fitting a roof window or building a carport, and full details are given about the planning permission which may be needed with more advanced projects. Security in the home, always a problem in these times of high crime, is also discussed.

Full colour step-by-step pictures are included in all the chapters plus comprehensive workplans and diagrams so that each project is clearly laid out and easy to follow. *The Newnes Do-It-Yourself Manual* is an invaluable reference for both the DIY beginner and the more proficient worker.

HAND AND POWER TOOLS

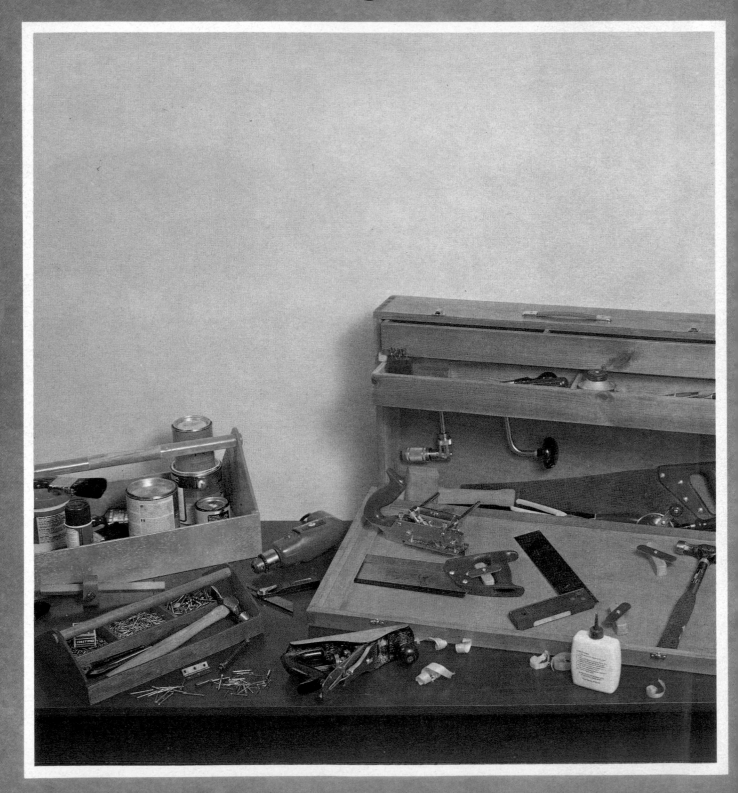

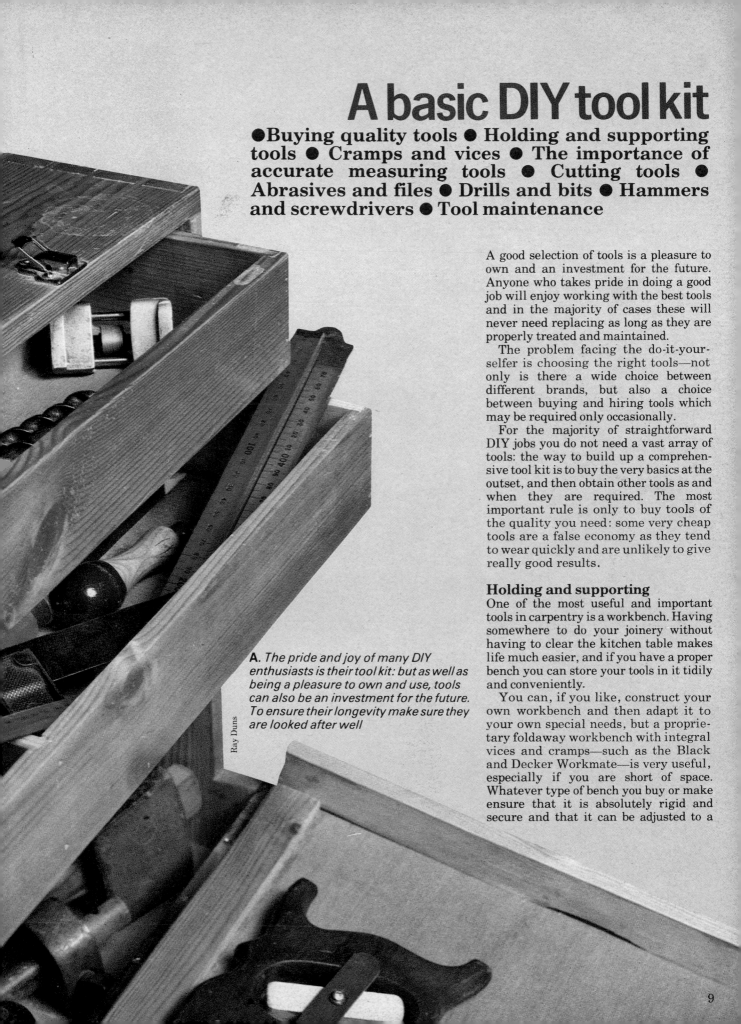

A basic DIY tool kit

●Buying quality tools ● Holding and supporting tools ● Cramps and vices ● The importance of accurate measuring tools ● Cutting tools ● Abrasives and files ● Drills and bits ● Hammers and screwdrivers ● Tool maintenance

A good selection of tools is a pleasure to own and an investment for the future. Anyone who takes pride in doing a good job will enjoy working with the best tools and in the majority of cases these will never need replacing as long as they are properly treated and maintained.

The problem facing the do-it-yourselfer is choosing the right tools—not only is there a wide choice between different brands, but also a choice between buying and hiring tools which may be required only occasionally.

For the majority of straightforward DIY jobs you do not need a vast array of tools: the way to build up a comprehensive tool kit is to buy the very basics at the outset, and then obtain other tools as and when they are required. The most important rule is only to buy tools of the quality you need: some very cheap tools are a false economy as they tend to wear quickly and are unlikely to give really good results.

Holding and supporting

One of the most useful and important tools in carpentry is a workbench. Having somewhere to do your joinery without having to clear the kitchen table makes life much easier, and if you have a proper bench you can store your tools in it tidily and conveniently.

You can, if you like, construct your own workbench and then adapt it to your own special needs, but a proprietary foldaway workbench with integral vices and cramps—such as the Black and Decker Workmate—is very useful, especially if you are short of space. Whatever type of bench you buy or make ensure that it is absolutely rigid and secure and that it can be adjusted to a

A. *The pride and joy of many DIY enthusiasts is their tool kit: but as well as being a pleasure to own and use, tools can also be an investment for the future. To ensure their longevity make sure they are looked after well*

Ray Duns

9

comfortable working height.

A solid and secure vice—either built-in, or of the clamp-on type—is indispensable for securing timber and other items on which you are working, and G-cramps will help to secure longer lengths of work in addition to their normal duties. An alternative to these if you intend working on long pieces of timber are sash cramps or, cheaper, a pair of cramp heads which can be attached to a 50mm x 25mm beam to form a cramp of any length.

Measuring tools

Accuracy in measuring and cutting is reflected in the quality of your finished work so you should always buy the best and most robust measuring instruments available in your price range.

Two types of rule are useful: a steel rule is the most accurate type and, in lengths of from 150mm to 1m, can also be used as a straightedge and a cutting guide. A folding boxwood rule for general measuring in joinery work is also handy, and can be anything from 600mm to 1m long, but is not a good straightedge.

Buy a good quality—and preferably a long—spirit level for checking levels and verticals. If you can afford it choose one with an adjustable glass which you can use for checking angles as well. A less accurate, but nonetheless useful, tool is a simple plumb bob and line which can be used for checking verticals on a larger scale. Such a tool is indispensable for other non woodwork jobs such as hanging wallpaper or building walls.

A woodworkers' try square is essential for checking right-angles and the accuracy of planed timber edges—look for one with a sprung steel blade and a stock protected by a thin brass strip. You will also need a combination square for marking angles and mitres: this has a stock which slides along a calibrated steel blade that is used as a depth gauge. A marking gauge is essential for scribing marked-up joints and for multiple marking-up on a large job.

These three tools should suffice for most jobs, but you may find a sliding bevel gauge—for marking bevels and angles—and a mortise gauge—for marking out mortise and tenon joints— useful if you intend to do a lot of accurate carpentry work. The other basic measuring tool you will need is an ordinary tape measure 2-3m long for measuring approximate dimensions over a long piece of timber or length of wall.

Cutting tools

Accurate cutting is an essential requirement of almost every DIY job so a variety of reliable cutting tools is essential. Two saws—a panel saw (hand saw) about 550mm long and a tenon saw (backsaw) about 250mm to 300mm long—are enough though separate rip and cross cut saws are better than a general-purpose panel saw.

When buying a saw find out how many points (or teeth) the blade has per 25mm. The more points per 25mm the saw has, the harder the timber you can cut with it. Basic requirements are around 14 points per 25mm for a tenon saw, and around eight for a panel saw.

A hacksaw always comes in handy, and a junior hacksaw will cope with simple tasks such as cutting through rusty bolts and screws. A larger adjustable frame unit with a choice of different blades is far more versatile, however, and can be used for heavier work.

Carpenter's chisels are almost indispensable, but they must be looked after properly if they are to give the best results. A selection of three or four bevel edged chisels is the best choice for a basic tool kit—6mm, 12mm, 25mm and 37mm blades are the most widely used. Whether your chisels have wooden or plastic handles you should never use anything except rawhide, plastic or wooden mallets to hit them with.

Bench planes are available in a wide variety of types and sizes, but an excellent basic choice is a unit about 250mm in length and about 50mm in width. Alternatively a replaceable-blade plane which does not need sharpening, and which will cut rebates (rabbets) as well, is an equally good choice for general work.

A block plane which can be used for finer cabinet work and for planing end-grain is a useful early addition to your kit, as is a handyman's knife with interchangeable and replaceable blades.

1 Cramps are vital in most carpentry jobs. Sash cramps can be expensive but cramp heads like these on a length of timber are a cheaper alternative

2 Accuracy in measurement and cutting are equally important. Buy the best and most accurate measuring tools you can afford

3 If you do a great deal of joinery work a mortise gauge saves a lot of time. A sharp knife for marking cutting lines is also extremely useful

4 One of the most important tools you can buy is a good steel rule. Use this not only for measuring up, but also as a straightedge and cutting guide

Abrasives

Files and rasps for shaping and smoothing metals and timber are a necessary part of any tool kit but because they are fairly expensive you should buy them only when you need them. From the wide variety of shapes and styles available a half-round file is probably the best choice as it can be used for both flat work and concave work such as smoothing the insides of holes. If you can afford it, buy a rasp or dreadnought file for rough work and a finer bladed file which can be used with abrasive paper for finishing work. Whichever files you buy, never use one without fitting a handle first.

A good selection of abrasive paper together with a rubber or timber sanding block is essential both for finishing timber and for preparing surfaces for painting and papering. Glass paper is fine for most timber finishing, while wet and dry paper is better suited to metal and glass fibre. Harder masonry or painted surfaces may call for something harder, such as silicon carbide or production paper. In each case a selection of coarse, medium, and fine grades is essential, although a power sander makes lighter work of most jobs.

Drilling

The most useful and versatile drilling tool that you can buy is of course a power drill. It is worth spending a little extra on a unit made by one of the more reputable manufacturers for which a full range of accessories is available. You can buy these as the need arises, but it is worth buying a multi-speed drill at the outset so that you can use all accessories properly on both metal and masonry.

Despite this, a hand-operated wheel brace is essential for times when there is no power or where an electric drill would be too powerful. Look for one with a sturdy chuck and accurate gearing so that there is less chance of play in the pinions causing premature wear. A ratchet brace specially designed to take wood auger bits is a useful addition, although you may find that you can buy sufficient bits with rounded shanks that can be used with a power or hand drill.

Drill bits, like files, can be bought as and when you need them, although you can buy sets of drills quite cheaply. Make sure that you buy the correct type for the materials with which you are working: a standard set of twist drill bits and a 4mm masonry bit should cover you for most jobs. Another essential item for use especially with metal is a countersink or rose bit—these are available for both hand drills and ratchet braces.

To mark the hole before drilling use a bradawl for timber, and a centre punch

5 Chisels are indispensable for joinery work. Keep them sharp and do not use anything except a wooden mallet to strike them with

7 Sanding requires a firm touch and the correct grades of abrasive paper. Use a sanding block of timber, rubber, or compressed cork

for metal—do not try to drill an accurate hole without one of these because the drill bit will almost certainly slip.

Hammers and screwdrivers

The choice of tools under this heading is vast, and you can spend a great deal of money buying tools that you rarely, if ever, use. For general work you can get by with three hammers: a claw hammer of around 680g is a good all-purpose tool, while a 225g cross pein hammer is best for driving in panel pins and small nails. An engineer's or ball pein hammer is the best for metalwork and for driving masonry nails.

For joinery work and chiselling you will need a carpenter's or joiner's mallet. Choose one that is made of beech with a head about 150mm deep.

Screwdrivers must be correctly matched to the screwheads they are

6 A block plane complements a bench plane as it can be used to plane end-grain and for finer cabinet work such as bevelling and trimming

8 Buy the best drill you can afford. Multi-speed units with a full range of accessories and a hammer action for drilling masonry are a good choice

turning, or you will end up damaging both. A comprehensive screwdriver kit which includes cross-head screwdrivers and both long and stubby flathead examples does not cost a great deal and can be used almost anywhere.

Decorating and masonry

A major home improvements project demands the use of a number of comparatively specialized tools for use with masonry and plaster. First on the list comes a 2kg club hammer and steel bolster for breaking up masonry and stripping old plaster. For raking out mortar joints and removing individual bricks, however, you may find a cold chisel or plugging chisel handier.

Laying mortar for brickwork calls for a bricklayer's trowel, and a steel float is essential when applying and smoothing render coats—whether mortar or plaster.

When renovating woodwork such as a door or window frame, you will almost certainly need a shave hook to strip old paint and lacquer, and a putty knife or filling knife for applying filler to a timber surface or putty to a window frame.

Other tools

As well as the tools mentioned above, you will find some others extremely useful. Chief among these is a pair of pliers: the most common are the bull-nosed (line man's) variety, but needle-nosed (long-nosed) pliers are extremely handy for electrical work. Buy a pair with a slot along the side of the jaws for cutting wire and a small blade for stripping cable insulation.

Self-locking pliers—such as a Mole wrench—are also useful when dealing with nuts, bolts, and compression joints in pipework. They can be adjusted to lock around a variety of nut and bolt head sizes and can be left in position while you go to do something else.

For plumbing work a pipe wrench is essential as most self-locking pliers and spanners are too small for the larger types of screwed connection. If you anticipate doing a great deal of plumbing work two pipe wrenches would be handy for large compression joints.

You will probably also find a small set of combined ring/open-ended spanners useful: these can be used in conjunction with pliers and pipe wrenches to secure or dismantle many household appliances. Buy them in a set ranging in size from 5mm up to about 20mm.

One of the first things you will need when you come to apply paint or paper to a wall or ceiling is a sturdy step ladder. Choose one which allows you to reach the ceiling without stretching, and which has a good-sized step at the top on which you can safely stand without kicking pots of paint or paste on to the floor. Do not buy scaffold boards—you can hire these and extra step ladders when you need them.

A general-purpose wallpaper brush is a prerequisite in decorating as is a selection of paint brushes. Buy a 25mm brush for fine work and retouching, and 50mm and 100mm brushes for covering larger areas. A 300mm roller and paint tray are handier for applying paint quickly and evenly over large areas.

Tool maintenance

No quality tool is cheap, but with proper care and maintenance your tool kit will probably outlive you. Specific maintenance techniques are covered in detail in the next section (see pages 15-26), but a few words here will not go amiss.

For a start, you should store your tools neatly; a specially designed tool chest or rack will protect them from accidental damage as well as making them more accessible. Before putting tools away after use clean any dirt or grease off them and make sure they are dry. To protect them from rust apply a little light oil with a lint-free rag to the cutting edges and all other exposed metal surfaces.

Keep all machinery properly lubricated, but do not attempt to strip and clean power tools yourself: leave this to a qualified service engineer to reduce the risk of accidental damage or loss of important components.

Check your hammer heads carefully before use: if the heads or faces are cracked or chipped replace them immediately as they could shatter and cause serious injury.

Check your screwdriver tips regularly to make sure that they are not burred or rounded over. If they show any signs of damage file them back into shape.

The tools most likely to need attention are, of course, the cutting tools. However well you look after them they will all need sharpening at some point. Saws and drill bits are difficult to sharpen at home, although this is possible if you can get the correct tools needed (see pages 21-26), but they should not need frequent sharpening if they are used correctly.

Chisels and planes, on the other hand, need regular sharpening with an oil stone (see pages 15-20).

Correct use of your tools cannot be over-emphasized: do not abuse them, look after them properly, resist the temptation to bodge a job with the incorrect tool, and your tool kit will repay its purchase price many times over.

9 *A selection of screwdrivers of varying sizes and both flat and crossheads is essential. Use a file or grinding wheel to keep them true*

10 *Club hammers and bolsters have innumerable uses in general masonry work, and can also be used to raise nailed-down floorboards*

11 *Pliers—whether self-locking or ordinary bull-nosed—are always handy, as is a set of spanners and a tin of penetrating or lubricating oil*

12 *Cutting tools require the most frequent attention. To ensure a good cutting edge, a honing guide and an oil stone are worthwhile investments*

Build a mitring jig

Ray Duns

This mitring jig is ideal for all kinds of projects, but will really come into its own for constructing picture frames using frame mouldings.

It has two fences to ensure that the parts are aligned squarely, and two sets of saw guides for square and angled cuts. There are two clamps to hold the workpiece securely in position, and an adjustable end stop to allow you to gauge the length of the sections accurately. This is especially useful when two or more parts must be cut to the same length.

None of the construction except for the clamps is very complicated, but the accuracy of assembly will determine the accuracy of the jig—so it is important to mark the parts out carefully.

Start by cutting out the baseboard and marking two square lines on it for the fences. Mark the cutting lines at the correct angles to this. Mark out and cut the slot for the end stop. Glue and screw the fences in position. These determine the position of the timber so get them dead square.

Make up the saw guides from lengths of dowel and tubing. Drill the baseboard and press them into position. Do not fix so they can be replaced when worn. Make sure they are set on the cutting lines.

Make up two clamps from hardwood blocks. The clamping mechanism is made from nuts and bolts and lengths of tubing as shown. Drill the blocks for fixing screws so they can be fitted in a range of positions.

To use, adjust the clamps to lock your timber in place, butt it against the end stop and cut through between the saw guides.

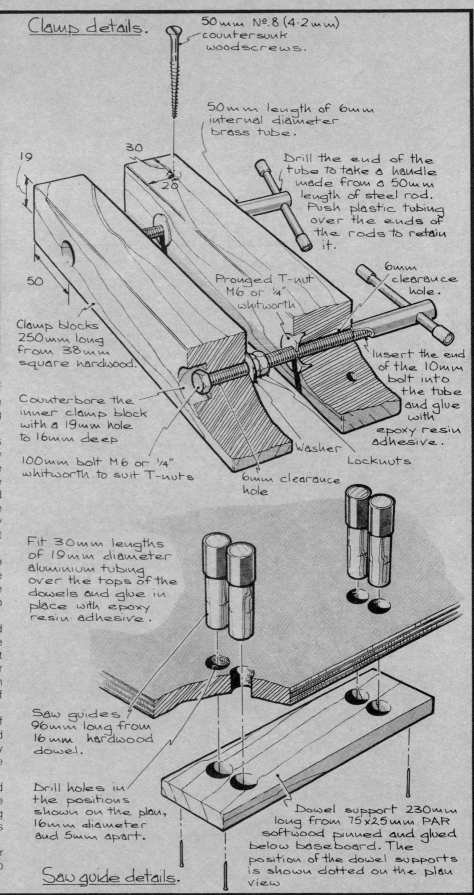

Clamp details.

50mm Nº8 (4·2mm) countersunk woodscrews.

50mm length of 6mm internal diameter brass tube.

Drill the end of the tube to take a handle made from a 50mm length of steel rod. Push plastic tubing over the ends of the rods to retain it.

6mm clearance hole.

Pronged T-nut M6 or ¼" whitworth

Insert the end of the 10mm bolt into the tube and glue with epoxy resin adhesive.

Clamp blocks 250mm long from 38mm square hardwood.

Counterbore the inner clamp block with a 19mm hole to 16mm deep

100mm bolt M6 or ¼" whitworth to suit T-nuts

Washer

Locknuts

6mm clearance hole

Fit 30mm lengths of 19mm diameter aluminium tubing over the tops of the dowels and glue in place with epoxy resin adhesive.

Saw guides 96mm long from 16mm hardwood dowel.

Drill holes in the positions shown on the plan, 16mm diameter and 5mm apart.

Dowel support 230mm long from 75x25mm PAR softwood pinned and glued below baseboard. The position of the dowel supports is shown dotted on the plan view

Saw guide details.

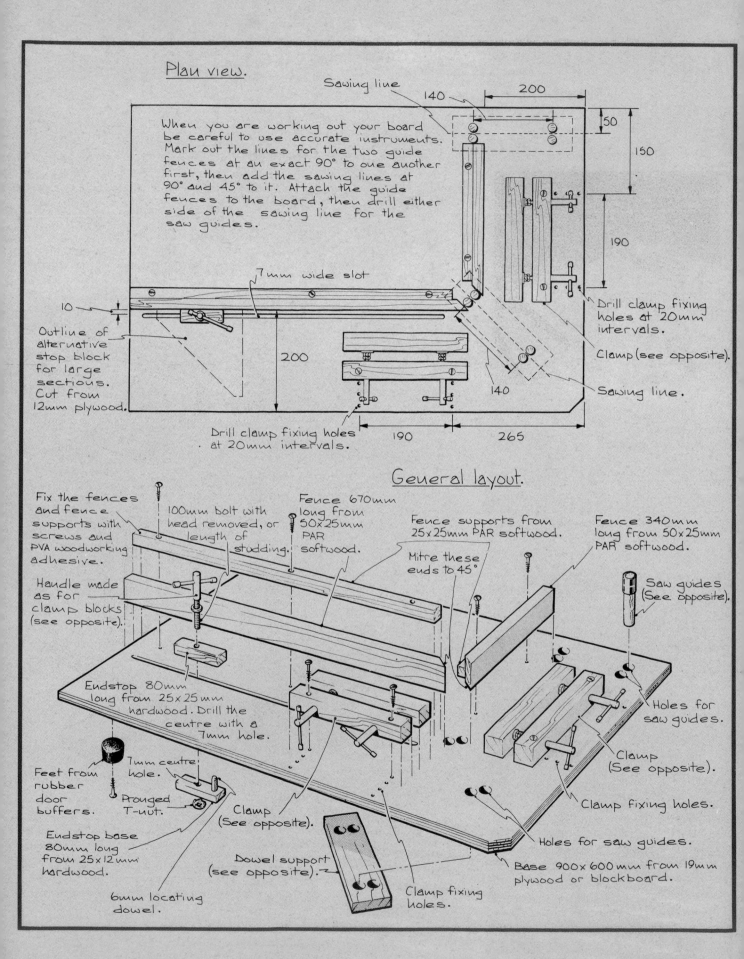

Plan view.

When you are working out your board be careful to use accurate instruments. Mark out the lines for the two guide fences at an exact 90° to one another first, then add the sawing lines at 90° and 45° to it. Attach the guide fences to the board, then drill either side of the sawing line for the saw guides.

Sawing line

140

200

50

150

190

Drill clamp fixing holes at 20mm intervals.

Clamp (see opposite).

Sawing line.

7mm wide slot

10

Outline of alternative stop block for large sections. Cut from 12mm plywood.

200

140

Drill clamp fixing holes at 20mm intervals.

190

265

General layout.

Fix the fences and fence supports with screws and PVA woodworking adhesive.

100mm bolt with head removed, or length of studding.

Fence 670mm long from 50x25mm PAR softwood.

Fence supports from 25x25mm PAR softwood.

Mitre these ends to 45°

Fence 340mm long from 50x25mm PAR softwood.

Handle made as for clamp blocks (see opposite).

Saw guides (See opposite).

Endstop 80mm long from 25 x 25mm hardwood. Drill the centre with a 7mm hole.

Holes for saw guides.

Feet from rubber door buffers.

7mm centre hole.

Pronged T-nut.

Clamp (See opposite).

Clamp (See opposite).

Clamp fixing holes.

Endstop base 80mm long from 25x12mm hardwood.

Holes for saw guides.

6mm locating dowel.

Dowel support (see opposite).

Clamp fixing holes.

Base 900x600mm from 19mm plywood or blockboard.

Tool maintenance

● The importance of properly sharpened tools ● The equipment you need for sharpening tools ● The different types of oil stone ● Sharpening marking knives, gouges, planes, scrapers, and marking and cutting gauges

No matter how skilled or experienced a craftsman you may be, it is difficult to achieve real excellence unless your tools are properly maintained. As damaged or blunt tools can lead to accidents as well as poor quality work, there are important safety considerations also at stake.

Very little in the way of equipment is needed to keep your tools in good shape but—as with the tools themselves—what you buy should be of the best possible quality. Good storage and proper treatment is then all you need to get the very best out of your equipment.

Equipment list

For maintaining most types of hand tool you need a set of sharpening stones together with lubricants and some files; each a high grade, fine cut tool to suit a particular job. Only occasionally do tools need grinding, and this is dealt with later in the course.

All cutting tools (planes, chisels, and the rest) are ground but not honed when you buy them. To put a sharp cutting edge on your tools before they are used, the first items you need are some *oil stones*.

There are two types of oil stone—*natural* or *artificial*. The former is many times more expensive than the latter but is capable of giving a far better edge to your tools. One ploy is to use artificial stones for coarse and medium honing and a natural fine grit stone for the final edge, thus extending the life of the expensive stone quite considerably.

Two types of natural stone are commonly available. *Arkansas* is available in hard and soft grades, the former being used mostly for the fine honing of instruments and carving tools. The other type, *Washita*, is more porous and grits range from coarse to fairly fine.

There are two types of artificial stone also: the relatively cheap *carborundum*, and the slightly more expensive *India*. Both types are available in three grades—coarse, medium and fine—and you can also obtain a combination form with coarse grade on one side and fine on the other. But unless you are only a very occasional user, separate stones are generally better.

As narrow and curved blades tend to cause stones to wear down unevenly, making the sharpening of broader blades difficult, it is a good idea to keep one side of a stone reserved exclusively for wide blades.

From time to time you may need to sharpen hollow cutters and for these you require special honing stones called *slip stones* or 'slips', available in the same types and grades of grit as the standard blocks but in a variety of shapes (fig. A).

For lubricant, water is used on coarse natural stone, and fine oil on the others. The best oil is said to be *neatsfoot* (available from saddlers) but any thin, light machine oil can be used. If necessary, use paraffin (kerosene) to thin this down. Do not use a drying oil such as linseed.

Before ever using a stone, steep it in a bath of the chosen lubricant until it absorbs no more. Store the stone in a purpose-made box (see page 20) to keep it moist and out of harm's way until it is required.

Always add fresh lubricant to the working surface of the stone during honing operations to keep it moist. Remove dirty oil immediately after use. Periodically scour the surfaces using fine wire wool with some petrol or ammonia (wear gloves).

To avoid excessively localized wear, use the whole surface area of a stone even when you are sharpening narrow bladed tools. When a surface becomes badly worn, it may be possible to restore the evenness by rubbing the stone over the flat surface of a thick sheet of glass or hard stone lubricated with water or paraffin mixed with emery powder. An alternative to emery powder is medium grade grinding paste (available from car accessory shops) but this needs to be thinned out with additional paraffin.

The hardest part of learning the knack of honing is to get the cutting angle right. You can overcome this by

Left: *For good results, it is vital to keep all cutting tools—like the plane blade shown here—honed to a fine sharpness. A honing guide helps to get the honing angle right*

15

1 Always steep oil stones in a bath of suitable lubricant before use. You can use neatsfoot or light machine oil but not drying oil

A. Slip stones are specially shaped oil stones used to hone curved and other awkwardly shaped blades—such as those found on paring gouges

Marking knives

A marking knife needs to be sharp in the same way as any other cutting tool, and a good habit is to hone it to fine sharpness after every job.

A *chisel ground knife*—which is ground for either left-handed or right-handed use—is one of three types of marking knife (fig. B). Sharpen it by holding the blade, bevel side down, flat on the stone with the cutting edge lying along the middle. Use the first and second fingers of the free hand to apply pressure on the blade, then twist the blade past the grinding bevel (20°–25°) to the cutting angle of between 25° and 30°.

using one or other of the several types of *honing guide* that are available. These hold the tool at the correct angle and allow you to run it up and down the stone on a roller.

But although very good, these gadgets do require time to set up, and tend to use just the centre of the stone. In the long run, it is perhaps better to persevere with practising the skill of tool sharpening entirely by hand and eye.

To complete the sharpening process it is well worth using a *leather strop* (an old piece of cowhide) rough side up, which has been soaked with light oil and impregnated with carborundum powder (or fine-grade grinding powder). For shaped tools the strop must be flexible, but for plane irons and chisels you can glue a piece onto a flat piece of wood before the hide is soaked in oil.

Always drag a blade along a strop rather than push it, otherwise you risk damaging the strop itself.

2 Flatten the surface of a badly worn oil stone by running it in an abrasive mixture of paraffin and emery powder on a sheet of glass

B. Three types of marking knife. From left to right: chisel ground, leaf ground and hollow ground

Maintain this angle, keeping an even pressure on the upstroke and reducing on the backstroke until a burr or *wire* (fig. E) is formed on the blade. Then turn the knife over, hold it flat against the stone and stroke off the wire in two or three goes. Repeat the operation on successive stones to obtain a really fine cut.

A *hollow ground knife*, another type, is sharpened in much the same way but as the blade is ground on two sides (fig. C), it is easier to have the knife at right-angles to the stone.

A variation is the *leaf ground knife*, which has a curved blade that requires a very different sharpening technique. Hold the knife at a tilt of 25° to 30°, near the far end of the stone, and repeatedly draw the blade towards you, at the same time raising the handle so that the whole curve of the blade is brought into contact with the stone (fig. 6). As you push the blade away, simply reverse the pulling action to cover the arc you have just covered.

All the time keep a firm and even pressure on the knife using the first and second fingers of the spare hand. To remove the wire, run the blade's reverse edge at right-angles to, and along, the middle of the stone.

Gouges
Gouges can be divided into *firmer gouges*, which are outside ground, and *paring gouges*—sometimes called 'scribing gouges'—which are ground on the inside.

Firmer gouges are ground on the outside edge to 25°. Honing is done to 30°, using an oil stone for the outside edge and a slip stone to remove the wire which forms on the inside.

Hold the gouge against the stone at the correct honing angle and, keeping firm pressure on the blade tip, move the blade up and down the stone rotating it with your wrists as you do so (fig. 7). Make sure that every part of the blade edge comes into contact with the stone.

Remove the wire by holding the gouge on the edge of the bench and rub an oiled slip stone backwards and forwards along the inside channel (fig. 8). Twist the slip from side to side to remove all the wire.

If a strop is used for fine sharpening, wrap it round a piece of wood or dowelling to finish the inside.

Paring or scribing gouges are ground to 25° on the hollow side, which is honed to 30° like the firmer gouges. Hold the gouge on a bench and hone the inside edge with a slip of the correct radius (fig. 9). Remove the wire by holding the back of the gouge quite flat on an oil stone. As the tool is moved back and forth, at right angles to the stone, twist it to remove all the wire (fig. 10).

Chisels
Chisel sharpening techniques are described on page 209. Remember the grinding angle is 25° and the honing angle is 30°, and that the chisel must be held absolutely flat against the stone when removing the wire.

If you damage a chisel handle, a replacement should be available from any large tool shop. Simply force this over the tang—the spiked end—of the damaged tool.

Planes
Sharpening plane irons is described on pages 130 to 132). All new planes require honing prior to use—bench planes to 30° from a grinding angle of 25°, block planes to various angles (generally 20° but very occasionally as acute as 12°).

But for the best work, you really need to surface the *sole* which, because of manufacturing distortions, may not in fact be as flat as it seems.

Take a thick sheet of plate or float glass and sprinkle on this some coarse emery powder, mixed with a little water or paraffin (grinding paste may

3 To sharpen a chisel ground marking knife, hold the blade bevel side down in the centre of the stone and twist at an angle of 25°–30°

4 A similar technique is used to sharpen a hollow ground knife, except that in this case you hold the blade at right-angles to the stone

C. A hollow ground knife like this is honed running with the blade, at an angle of 25°–30°. The wire is then removed against the blade

5 To sharpen a leaf ground knife, hold the blade as shown at an angle of 25°–30° and position it at one end of the stone

6 Then run the blade across the stone, following a curved path to end exactly as shown. This way, the whole of the blade makes contact

7 Hone the outside edge of a firmer gouge by running it up and down the stone, rotating your wrists as you do so to ensure even contact

8 You can then remove the wire on the inside edge by running up and down the gouge with a slip stone, twisting this slightly as you go

9 Hone a paring or scribing gouge from the hollow side, using a slip stone of the correct radius. Make sure you keep to an angle of 30°

10 Afterwards, to remove the wire, set the gouge at right-angles to the oil stone and hold it as shown on its leading edge

11 With your fingers pressed firmly on the inside of the blade, run the gouge down the stone—rolling as you go—and back again

Bernard Fallon

D. Make a blade holder like this from an offcut of softwood to hold small blades at their correct honing angle

be used as a substitute). Then, using both hands, firmly rub the plane over the glass in long, oval strokes, a dozen or so times. Wipe the sole clean and inspect it to see if the carborundum has worn away any high spots. If so, keep repeating the process until it is absolutely flat. Finish off with medium and then fine powder to get a really fine surface.

The cutting edge of special-purpose planes varies considerably from an acute 5° to 10° for *router planes*, to between 30° and 40° for those *sash rebate planes* with a cap iron and 40° to 50° for those without. *Bullnose rebate planes* have a cutting edge to 15°, set with the bevel side up. Router planes must be honed along the edge of the stone (which may mean removing the stone from its box). Remove the wire with the blade dead flat against the surface of the stone.

The blades of *moulding planes* are honed on the bevel side with slip stones, generally to an angle of between 35° and 40° but occasionally to 30°; some trial and error is therefore necessary to determine which is the correct angle.

Spokeshaves are sharpened in the same way as bench planes. Make a simple device from hardwood or metal to hold the small blades during sharpening should you be unable to find a honing guide small enough.

To sharpen the blade of a *hand-held scraper*, place it low in a vice (preferably a metalwork one) and use a fine, flat, mill file to draw the edges flat. Remove any file marks by rubbing the blade vertically on a fine oilstone, and the wire by placing the scraper flat against the stone and gently

honed angle
ground angle

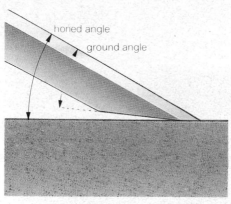

E. *An exaggerated example of the wire which is produced as a chisel blade is honed along an oil stone*

F. *Be sure not to confuse the ground angle—set by the tool manufacturer—with the honed angle. It is the latter that governs final sharpness*

12 *Flatten the sole of a plane in the same way as an oil stone, by rubbing it on a sheet of glass coated with an emery powder and paraffin mix*

rubbing the blade away from you.

Place the scraper back in the vice and with a burnisher (or back of a gouge), first flatten the edges and then turn them over 10° to produce a finely finished cutting lip.

Stock held scraper blades are ground and honed to 45°. Again, place the blade in a vice and proceed to burnish the edge at 15° to form a cutting lip.

Marking and cutting gauges

Marking gauges need very little maintenance although occasionally it is necessary to remove the stock from the stem in order to touch up the spur with a small, fine file—a saw file is ideal for this. Take care not to scratch the stem as this might damage a workpiece later.

The blade of a *cutting gauge* is removed for sharpening by first pulling

or tapping out the wedge. Hold the blade in a pair of pliers to hone the two bevelled cutting edges (the flat side can be held down firmly against the stone with your fingers).

Occasionally, the stock on a gauge sticks—maybe the result of using badly-seasoned wood, but more likely the result of keeping the tool in a damp workshop. Ease the stock off the stem and lightly glasspaper the stem until the stock is freed.

If the sliding bar on a *mortise gauge* is stiff, take the tool apart and use fine emery paper to smooth off the sides of the sliding bar. Wrap the emery paper around a flat piece of metal or hardwood.

Storing chisels and gouges

A good-quality tool is worth storing properly, which means keeping in a dry place. Rust formation is discouraged by wrapping a tool in an oiled silk, or by keeping bags of silica gel in the toolbox (this is moisture absorbent and can be recharged by drying it in an oven).

A purpose-made racked cupboard or tray can be made for storing your chisels, the edges of which are particularly vulnerable to abuse. Take particular care, in use and in storage, to prevent the stem of one chisel from damaging the edge of another. If necessary, wrap individual chisels in oiled cloths or line the partitions of your storage box with a soft material.

After storage, and before use, wipe the tool down and wash your hands to prevent oil from being transferred to your workpiece. Do the same if, during the course of work, you need to sharpen the tool you are using.

13 *Plane blades are best sharpened with a honing guide. Clamp the blade in the guide and adjust its position to give the required angle*

14 *Once this is done, you can run the blade up and down the oil stone as shown. Press on the guide to maintain the correct angle*

15 *Keeping the spur on a marking gauge sharp makes scribing much easier. Use a fine file for the job, and work right around the point*

Make an oil stone box

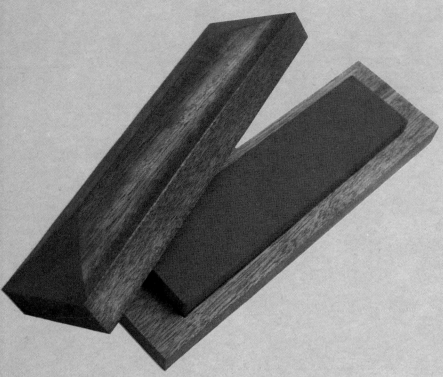

A good oil stone is essential if you want to keep your cutting tools in good condition. But it is just as essential to keep the oil stone itself in good condition if it is to give long lasting service.

The best way to do this is always to keep it in an oil stone box, which will protect the surface from knocks and scratches and help to keep the stone in position during sharpening operations.

All you need are two pieces of hardwood of approximately the sizes shown in the drawing. The dimensions given are for a standard oil stone but if yours is larger or smaller, you should alter the size accordingly.

Mark the size of the oil stone on both pieces, then use a drill and chisel to remove the wood to the depth given. If a router is available, this will make the work much easier. Make sure that the stone is a tight fit in the base section, but a slight clearance in the lid will make this easy to remove and refit.

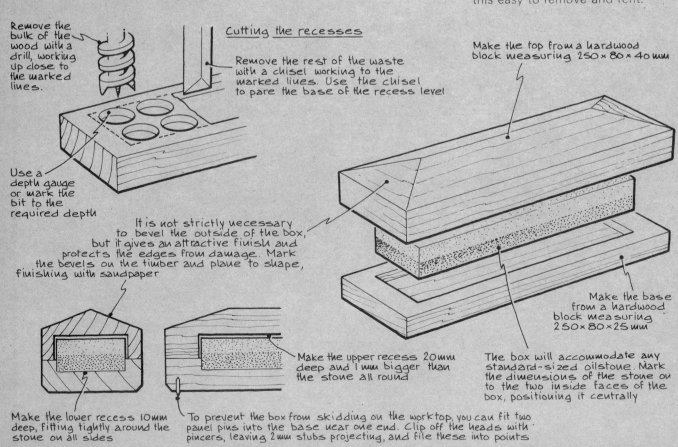

Remove the bulk of the wood with a drill, working up close to the marked lines.

Cutting the recesses

Remove the rest of the waste with a chisel working to the marked lines. Use the chisel to pare the base of the recess level

Use a depth gauge or mark the bit to the required depth

It is not strictly necessary to bevel the outside of the box, but it gives an attractive finish and protects the edges from damage. Mark the bevels on the timber and plane to shape, finishing with sandpaper

Make the top from a hardwood block measuring 250 × 80 × 40 mm

Make the base from a hardwood block measuring 250 × 80 × 25 mm

The box will accommodate any standard-sized oilstone. Mark the dimensions of the stone on to the two inside faces of the box, positioning it centrally

Make the upper recess 20mm deep and 1 mm bigger than the stone all round

Make the lower recess 10mm deep, fitting tightly around the stone on all sides

To prevent the box from skidding on the worktop, you can fit two panel pins into the base near one end. Clip off the heads with pincers, leaving 2mm stubs projecting, and file these into points

Further tool maintenance

A. *If your tenon saw (backsaw) becomes slightly buckled, you can repair it: stand the blade on a block of wood and tap both ends with a hammer. Provided the blade is not kinked, this will help to straighten it*

● Saw types and tooth sizes ● How to store a saw ● Sharpening saws ● Topping saw blades ● Shaping saw teeth ● Care of drills and bits ● Sharpening brace bits and flat bits ● Looking after hammers and hammer heads

There is a lot of truth in tne saying 'a craftsman is only as good as his tools'. Dirty, blunt or damaged tools make carpentry work more difficult and can easily ruin a workpiece. And with good quality tools now so expensive, it makes sense to look after those you have got. The previous section on tools (see pages 15 to 20) described how to sharpen cutting and scribing tools. This section deals with the rest, particularly saws which need quite comprehensive maintenance if they are to work effectively.

Types of saw
Wood cutting saws fall into three basic categories—hand saws, back saws and special saws. The latter type of saws generally always have replaceable blades and consequently need little or no maintenance, but hand saw and back saw categories can be further sub-divided.

The factors most often quoted when maintaining saws or buying replacement parts are saw length, and the size and shape of the teeth. Saw length is measured only along the

blade. Tooth size is still commonly measured in the UK according to the number of points per inch (25. 4mm) or teeth per inch. This is generally abbreviated to ppi.

Hand saws measure up as follows:
Rip saw: A coarse saw for cutting along the grain of timber. Length is generally 660mm with 5 ppi.
Cross cut: The saw for rough cutting across grain and also for cutting joints in heavier joinery work such as roofing timbers. Length is 610mm or 660mm with 7 or 8 ppi.

21

1 cross cut saw: knife points sever the wood fibres

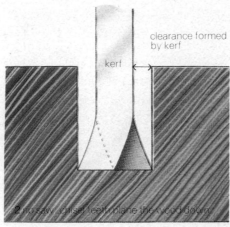

2 rip saw: chisel teeth plane the wood down

Bernard Fallon

B. Above: *The teeth of cross cut saw blades (1) have two knife edges which sever the wood fibres. Those of rip saws (2) act like a number of tiny planes*

Panel: A finer saw for accurate cutting across the grain, used also for converting man-made boards and cutting certain joints in lighter joinery work. Length is 510mm or 560mm with 10 ppi. Panel saws with 12 ppi are also available for very fine cutting work in the more expensive ranges.

Back saws are designed mainly for cutting across the grain but they can be used also for cutting along the grain over short measures in jointing work. Tenon saws for general carpentry work are available in lengths of 300mm to 410mm with 12–14 ppi. Tenon saws for cabinet and high class joinery work are more useful for the home handyman and come in lengths of 255mm to 300mm with 16–18 ppi. Dovetail saws, small tenon saws for fine work and dovetailing, are 200mm in length with 20–22 ppi.

Saw teeth

A saw must be able to cut through a piece of timber without sticking and for this reason the teeth are set—alternative teeth are bent outwards to make a cut, or *kerf*, which is slightly wider than the blade thickness. Higher efficiency is achieved when the blade is taper ground though this is found only on high quality saws. Here, the back edges or sides of the saw are ground down to make the major part of the blade thinner than the edge from which the teeth are cut.

Tooth shapes vary according to the type of saw and the use to which it is put. Saws for cutting across the timber grain have to act like two parallel knives, 1.5mm–2mm apart which can sever timber fibres. In this cutting action, the centre fibres crumble into sawdust which is carried away in the gullets between the teeth (fig. B).

Rip saws, on the other hand, have teeth like a row of small chisels alternately offset. This configuration enables the saw to shave away a kerf, in much the same way as a plane removes timber. Again, the shavings are carried away in the gullets between the teeth (fig. B).

Looking after saws

Like any other cutting tool, saws work properly only when they are sharp. Most modern saws are supplied with plastic, slide-on, tooth protectors which are satisfactory guards but can eventually blunt teeth. A far better proposition is to make up your own saw guard from a slotted piece of wood. This can be either screwed to your workshop wall or held on to the saw with strong elastic (fig. D).

Always keep your saws free from rust and store them in a dry place, covered in a coat of light machine oil. This is especially important if they are being put away for any length of time. If, by mischance, your saw does get rusty, remove the worst rusting with fine wire wool and oil, then finish the process with an abrasive polishing block.

When using a saw never force it and always use firm, even strokes. Remember to check timber, especially second-hand material, for nails and screws before starting a cut. If you do hit a piece of metal, stop sawing and cut the timber from the other side.

Buckled hand saws should be treated by a professional saw doctor —most good specialist tool shops run a saw doctoring and sharpening service. A buckled back saw can sometimes be straightened by supporting it on a piece of wood and tapping the back with a hammer, first at one end and then the other (fig. A). Hopefully this will force the saw into a slot and eventually straighten the blade. But if the treatment fails then you must seek the service of a saw doctor.

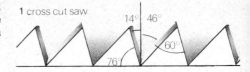

1 cross cut saw

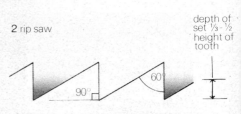

2 rip saw

depth of set ⅓ - ½ height of tooth

C. Above: *The profiles of cross cut and rip saws differ greatly, too. The cross cut saw (1) has finer teeth than the rip saw (2)*

D. Below: *It is always important to protect your saw blades: shown here are two types of saw guard, for fixed and portable use*

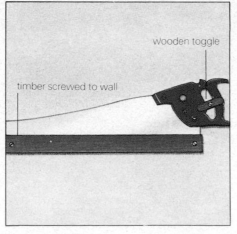

timber screwed to wall

wooden toggle

elastic

Saw maintenance

A saw that has seen a lot of service, especially if maltreated, will need one or more of the following treatments: *topping* (to ensure the teeth are level), *shaping* (to give the teeth the same profile), *setting* (to offset the teeth at the right angle), and *sharpening*. Usually a good saw can be sharpened several times before the set is worn away, so sharpen it little and often.

You will need a saw vice or *chops* to hold the saw—you can make these for yourself (fig. I)—a second cut mill file (used without a handle) and some slim taper saw files. For setting, you will also require a pair of special saw setting pliers.

Saw files are triangular in section and the size you use will depend upon the size of the teeth you are sharpening. Saw points per inch (25.4 mm): 3–5, 6, 7–8, 10–11, 12, 14–16. Taper saw file length: 200mm, 180mm, 150mm, 127mm, 100 or 115mm.

To avoid uneven wear on a file, the face should be just over twice the depth of the saw teeth (fig. E). When a saw with more than 16 ppi needs sharpening, or a saw with more than 12 ppi needs setting, you should seek the services of a saw doctor.

Topping: Set the saw in the chops with the teeth just exposed. Hold the mill file flat along the saw and, using light even pressure, run the file along the saw in a forward direction only until the teeth are all of even height (fig. 3). The file must be kept dead flat and not allowed to rock, so you might need a file clamp (fig. E).

Shaping: With no more than 6mm of saw showing above the chops, place the file firmly in the first gullet so that it follows the correct pitch of the teeth. Grip the file by the handle in your right hand, thumb on top and use your left hand to hold the nose (fig. 4). Shape the teeth by making two full

1 A saw vice will hold the blade of the saw firmly while you are working on it with a file or set, making your job easier and much safer

2 You must use the correct file when you are working on a saw. Make sure the face of the file is twice as high as the saw teeth

file length strokes across the saw, at 90° to it and parallel with the ground. Repeat the process in each gullet until the teeth are all evenly shaped.

Setting: Professionals do this on a saw doctors' anvil, relying on their eye and experience to set all of the teeth to the correct, even set. However, the amateur is best advised to use a set of saw setting pliers. These have a built-in hammer in the form of a plunger, and an anvil which can be adjusted to any setting between 4 and 12 ppi, which covers most saws.

To use the pliers you place them over the saw, align the hammer in front of the first tooth, then squeeze them so that the tooth is compressed between the hammer and the anvil. This operation bends the tooth to the required set. Continue down the saw, setting alternate teeth, then turn the saw around and set the remainder. Always set the teeth to their original sides—reversing the set may break them off (fig. 5).

3 Using the saw vice and a file clamp to hold the mill file steady, topping the saw becomes a comparatively simple operation

E. A file clamp (1), the correct angle for a sharpening file (2), and the correct size of needle file for blade sharpening (3)

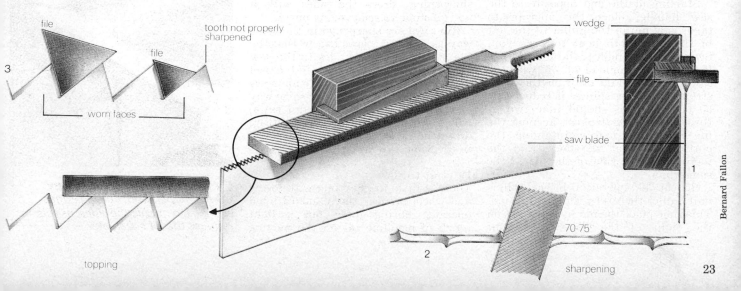

file

tooth not properly sharpened

file

worn faces

3

wedge

file

saw blade

1

topping

70-75

sharpening

2

4 To get the best results from any shaping operation you must hold the file steady and at the right angle using both hands

It is unlikely that irregularities will occur when using setting pliers but it is just possible. You can remedy the fault after setting is completed by laying the saw flat on a bench and running a fine oil stone down each side of the blade.

Note that some saws, mainly those manufactured in Scandinavia, have specially hardened teeth which are difficult to file and liable to snap when set. These must be returned to your dealer for sharpening and setting.

Sharpening: Cross cut saws must have the cutting faces of their teeth levelled to produce knife edges which will sever wood fibres. First fix the saw in the chops, handle to your right, with 6mm of tooth showing. Then top the saw very lightly, to ensure that the tops of the teeth are all the same level. Doing this will reveal a bright speck of new metal—a *shiner*—on each tooth which will act as a useful guide during the remaining sequence.

Starting at the end opposite to the saw handle, place the appropriate taper saw file in the gullet to the left of the first tooth bent towards you. Swing the file handle to the left until the file makes an angle of 70°–75° with the saw (fig. E2). File only on the push stroke until the 'shiner' is reduced by 50 percent—this should take two or three steady file strokes—keeping the file horizontal and maintaining the cutting angle at all times. File the teeth on either side of the file at the same time.

Repeat this operation in each alternate gullet then turn the saw around. This time place the file in the gullet on the right of the first tooth bent

5 Saw setting pliers are available from many manufacturers and can be adjusted to fit a wide range of hand saws up to 12 ppi

6 Gently filing the cutters of a brace bit with a needle file will maintain the edge: you should not file the underside of the bit

towards you and swing the file handle to the right to make the angle of 70°–75°. Once again, work down the saw filing in each alternate gullet. After sharpening, dress the sides with a fine oil stone to remove any burrs.

Rip saws are sharpened in the same way as cross cut saws except that the file is held at right-angles to the saw in order to produce the vital chisel cutting edge on the teeth. Tenon saws are sharpened in exactly the same way as cross cut saws but dovetail saws, which are used mostly for cutting down the grain, should be sharpened in the same way as rip saws.

Boring tools
There is little to go wrong with swing and wheel braces—the standard hand operated boring tools—but a light touch of machine oil on the moving

parts will ensure that they stay in good condition. Sometimes the springs in the chuck break, but these can be bought at most specialist tool shops and are easily replaced.

Brace bits
Among the types of brace bit commonly available are the hand dowel bit, centre bit, Jennings-pattern bit, solid centre auger bit, expansive bit and Forstner bit. All are quite easy to sharpen, except the latter which is very expensive and usually used only by professional cabinet and pattern makers. Conventional bits generally have either a screw centre or centering point, one or two outer spurs and one or two cutter blades. The outer spurs cut the circumference of the hole while the cutters lift out the waste timber.

7 Like the cutters, the spurs need only be sharpened on one side; in this case the inside edge of the spur receives attention

8 When sharpening flat bits, try to sharpen both cutting edges evenly. Do not file the sides, as this reduces the bit's diameter

To sharpen a brace bit you will need a 10mm medium cut flat needle file. Stand the bit on its centre on a piece of scrap wood and following the original angle, file down the cutters until a sharp edge is formed (fig. 6). The inside of the spurs should also be lightly filed to give a good cutting edge (fig. 7). Subsequent burrs on both cutters and spurs can be removed with fine oil slip stones. But on no account should you file or overhone the underside of a cutter or the outside of a spur.

Should you have difficulty holding the bits, they can be held in a metalwork vice protected by fibre or soft metal jaw liners.

Twist and flat bits

Proprietary tools for sharpening the twist bits used in power drills are produced by some of the major power tool and drill manufacturers. They can also be sharpened by hand on a grinding wheel—a technique covered further on in the course.

Spade or flat bits, too, are designed for use in high speed electric drills. To sharpen one, simply place it vertically in a vice and lightly file the top cutting edges to the original angle. Do not file the sides of the flat bit as this would unbalance it (fig. 8).

Hammers

Hammers should always be kept clean and free of chips and scratches. When using a hammer to assemble a glued frame or carcase, remember to remove any traces of adhesive from the head or handle before it sets.

A clean hammer head is less likely to slip off a nail head, so inspect it

before use and if necessary give it a polish with fine emery cloth. A good idea is to keep a piece of emery cloth stapled to one leg of your bench where it will be ready to hand for this and similar purposes.

The heads of wooden handled hammers sometimes become loose. To cure the problem hold the hammer vertically and thump it, handle down, on a block of wood until the head is firm on the handle. Then knock metal wedges into the wood in the eye of the head until the wood fills the whole of the eye (fig. 9). These wedges are available from tool shops in various sizes to suit most types and sizes of hammer (fig. F).

Should a hammer handle become split or broken, it must be replaced. Replacement handles in various sizes are also readily available but make sure you buy the correct type and size for the hammer you are mending. The best, probably, are made from ash or hickory.

Cut off the handle just below the head and place the head in a metalwork vice (if you must use a woodworking vice protect the jaws with scrap wood). Working between any metal wedges that may already be there, drill out as much wood as you can. Then knock out the remainder, together with the wedges, using a hammer and a large drift.

Take the new handle and shape the end to fit tightly into the eye of the head with a wood rasp and glasspaper. Then use a tenon saw to cut a slot in the handle to about two-thirds the depth of the head. At the same time prepare from scrap hardwood a suitable wedge (fig. 10).

To ensure a tight fit wrap the handle in a polythene bag, excluding as much air as possible, and leave it overnight in a fridge. When it is ready, pop the hammer head into a pan of boiling water for 10 minutes. These two processes shrink the handle and expand the head. Knock both components together with another hammer remembering to protect the handle with a piece of waste wood, then drive in the wooden wedge.

Finally, drive in two proprietary metal wedges at right-angles to the wooden wedge and clean off the head with a coarse sanding disc.

Screwdrivers

Screwdrivers for use with slot head screws become worn after a time, in which case they are liable not only to damage the screw, but also to slip and damage the workpiece. Place any such screwdriver, tip uppermost, in a metalwork vice and file the tip square with a fine flat file.

Pump action ('Yankee') screwdrivers tend to become clogged. Deal with this by cleaning the visible parts of the pump mechanism with 000 grade wire wool and lubricating it with a few spots of fine machine oil. On occasions the spring or ratchet on these tools wears out. In this case the manufacturers operate an overhaul service at reasonable cost.

Cramps and Clamps

Always remove adhesive from cramps, preferably before it sets. When the screw on a cramp becomes stiff, clean it with grade 0 wire wool and paraffin (kerosene) and then apply a few drops of light machine oil.

9 A hardwood wedge hammered into the slot at the end of the handle will help to hold the hammer head firmly in place

10 Finally, to secure the head of the hammer, drive two metal wedges into the end of the handle at right-angles to the wooden one

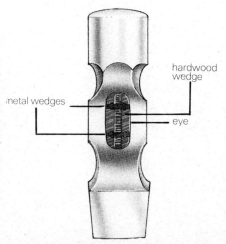

hardwood wedge

metal wedges

eye

F. The main features of a hammer head: the eye, the hardwood wedge, and the metal wedge in the handle that holds it in place

Bernard Fallon

Make a saw vice

Accurate saw setting and sharpening takes time and care. And it is essential that your saw is properly supported throughout its length to hold it in position and to stop the blade from flexing. You can do this by clamping it between a pair of battens in a vice, but the best tool for the job is a purpose-built saw vice.

The tool shown here is very simple to make. You can either use scraps of wood of the appropriate size, or make the whole assembly from pieces of 18mm plywood, cut out as shown in the illustration below.

380

180

Cut this curve to suit the shape of your saw handle

Assemble with 32 mm No. 6 (3·6 mm) counter-sunk chipboard screws and PVA woodworking adhesive

Jaws from 18 mm plywood or hardwood

Wing nut

Large washer

Coach bolt

100 mm × 9 mm coach bolt

des from 18 mm plywood

Blocks from 75 ×19 mm planed all round (dressed four sides) softwood

75 mm hinge

75 × 19 mm softwood blocks

100

Workshop safety

● **Simple safety rules** ● **Insurance** ● **What you should wear** ● **Working environment** ● **Using hand and power tools** ● **Fire precautions** ● **Toxic and corrosive substances** ● **Lifting heavy weights**

A. Above: *Make sure that your workshop never looks like this. Quite apart from the danger of accidents being caused by the untidy jumble of tools and materials, trailing leads and haphazard storage of inflammable liquids must be avoided*

Ray Duns

Any work you do yourself in and around the house will almost certainly save money over the cost of employing professional labour, and generally gives the satisfaction of seeing a job well done with the minimum of disruption to your household. But it is all too easy to wipe out these advantages by failing to observe simple safety rules, with the result either that the work in hand is ruined, or more importantly, you risk serious personal injury.

Safety in this context involves a number of factors, but your chief concern should always be to ensure that your working conditions and working techniques are as safe as it is possible to make them; obviously, there will be an element of risk if you are working up a ladder, or with power tools or toxic substances, but if the proper precautions are taken there is no reason why you should not tackle any job with confidence.

Insurance
One very important precaution before starting any job is to check your insurance policies. Find out whether you are covered – and adequately covered – both for personal injury and for any damage to property.

B. Above: *When grinding or sharpening tools make sure that there is a secure guard on the grinding machine and wear goggles to protect your eyes*

C. Above: *When starting a saw cut you can avoid injuring yourself by starting on the backstroke and guiding the saw blade with your raised thumb*

Third party insurance is important as well – for example if you allow a ladder to fall on your neighbour's property. In the

UK, the 1974 Health and Safety Work Act makes you liable for any damage caused through such accidents and it is in any case irresponsible to ignore the safety of those around you.

All the above points are generally covered by *house contents* policies. Make sure that you read all the conditions and exclusions (if any) on your policy, and if necessary consult your insurance company or broker for further advice.

What to wear
Choosing the right clothes for the job is an important preliminary consideration, and one that is easily overlooked. Obviously you do not want to change if you are doing no more than hanging a picture or drilling a couple of holes, but some basic precautions must nevertheless be adhered to.

You should not wear loose fitting garments which may snag or get caught on the materials you are working with. For the same reason, you should not wear a tie or scarf unless it is tucked into a jumper – particularly important if you are using power tools.

If at all possible, wear protective clothing – either overalls or an apron – which will ensure that your own clothes do not get ripped or stained. To guard against anything being dropped, shoes should have reinforced toe-caps and soles which are thick enough to prevent any nails or other items that you might step on from penetrating through to your foot.

As circumstances demand, wear heavy duty industrial rubber gloves to protect your hands, goggles to protect your eyes, a dust mask to protect your lungs and ear defenders to save your ears from excessive machinery noise. All should be available from any good tool supplier.

Finally, remove all jewellery and your watch before starting work. Quite apart from the fact that they may be damaged, even a comparatively small weight dropped on a ring could quite literally sever a finger as all the force is concentrated on one small area.

Working environment
Unless you are very experienced, you are likely to run into minor problems on most jobs. You should therefore try to make the work as easy as possible for yourself by paying attention to factors other than the obvious ones of physical building, assembling, or repairing work. Always make sure that the working area is kept as tidy as possible, and make a conscious effort to clean up whenever you stop work even if you intend to continue the next day.

One of the most common accidents results from tripping over objects that have been left on the floor. Keep the floor

free from obstructions by stacking timber or bricks, and by resisting the temptation to put tools on the floor, even for just a moment. Use a tool box or tool belt, or if you are in a workshop store tools in their proper places—do not leave them cluttering the bench.

Outside the workshop, common sense should dictate how different jobs are approached. If you have to work on the roof, a proper scaffold or tower is not only far safer than a collection of ladders, but is also more versatile and will probably make the job easier anyway. If you must use a ladder, make sure that it is sound before climbing it—even the best made timber ladder will eventually rot if it is stored out of doors unprotected.

Get an assistant to help you raise the ladder, and set it at an angle of 75°. It should be secured both at the top and the bottom carefully and strongly, and project about 1m above the eaves so that you still have something to hold on to when at the top. If you do have to get on the roof itself, use a crawler ladder and a safety belt or rope which should be tied around your waist and then made fast to a strong and permanent structure.

Precautions should also be taken at ground level. When digging footings or foundations, shore up the trenches if the ground is soft or uneven and there is any possibility of collapse. And if you have to leave the work—even for a short period of time—always cover the hole with old pieces of board to protect anyone from falling in.

Not everybody will be able to afford the luxury of a workshop, but even so it is quite possible to set aside areas in every home which are suitable for do-it-yourself activities. As they can be noisy places unused garages or old garden sheds can be ideal locations. A cellar is another good alternative. Whatever you decide always ensure that your workshop has enough light and adequate ventilation.

Proper lighting is essential if you are to be able to see what you are doing without straining your eyes, so if there are no large windows instal good lighting—fluorescent strip lights that do not throw shadows are probably best.

Ventilation is an important safety consideration as many of the substances with which you will be working are potentially dangerous in an enclosed area. Many adhesives, paints and solvents give off heavy—and often inflammable—vapours and it is essential that these are properly dissipated. Make sure that a window is open or that an efficient extractor fan is operating.

Using hand tools

There are two cardinal rules associated with the use of hand tools; always use the right tool for the job (resisting the temptation to 'bodge') and always make sure the tools you are using are in good condition.

D. Above: *Circular power saws can be particularly dangerous. Wear goggles and a face mask and always use a push stick to guide the work through the saw*

E. Below: *Long leads to a power tool should be trailed over your shoulder to keep them away from the work. Protect your eyes and use ear muffs if necessary*

Most accidents with hand tools occur because either the tool or the workpiece has slipped. This can nearly always be prevented by making full use of vices, cramps and jigs which will keep the workpiece firmly under control, and by ensuring that all tools are kept sharp; a blunt or damaged tool is far more likely to slip than one that has been properly cared for because you will have to employ excessive force to use it.

When using cutting tools—particularly chisels and gouges—always cut away from you and make sure that your other hand is well out of the way if you are using it to steady or support the workpiece. Start hand saw cuts on the back stroke, and guide the saw with the raised thumb of your other hand; remember that it only takes a moment's carelessness or lack of attention to cause a nasty cut. Finally, never test cutting edges of saws and other implements by drawing your thumb along them, and do not use your fingers to check the set of a plane.

Using power tools

The actual use of power tools, and the precautions that you should take when using them are covered in detail in the latter section of this first chapter. In particular, you should refer to the safety considerations on page 37.

Almost all the power tools that the DIY enthusiast is likely to use will be driven

by electricity, and this is a power source that must at all times be treated with the greatest respect. Before you even plug in an electric tool, check the leads, insulation, fuse and plug.

When using the tool, a long lead should be hung over your shoulder and not permitted to trail along the ground where it could get snagged, or where you might trip over it. Likewise, the lead must always be kept well away from the business end of the tool itself.

As soon as you have finished using the tool switch off at the tool (if, as is nearly always the case, a switch is fitted) before switching it off at the socket. If you ignore this simple procedure, the next time you come to use the tool the motor will start operating as soon as it is plugged in.

Take care when storing power tools, because the manner in which they are kept has a direct bearing on how safe they are to use. Store the tools in a dry place, make sure that nothing heavy is placed on top of them and coil the leads neatly so that they do not get knotted. Most important is that power tools do not get damp: if there is the slightest damage to the insulation of the tool or its lead, the damp may help the electricity find an easy path to earth—possibly through your body.

Extension leads: Because of the nature of DIY work, there will often be times when you need to use an extension lead. First of all, make quite certain that the lead itself is in good condition and that the fuse in the lead's plug is the correct rating for the appliance you intend to use at the other end.

Do not trail the lead through puddles, and try to route it so that the danger of anyone tripping over it is minimized. Never run a flex underneath a carpet or rug, however, because the pressures of people walking over it may wear down the protective coating of the flex and this could cause a short circuit and a fire. Also, you should never use an extension lead that is coiled, because this can generate enough heat to melt the plastic insulation of the lead; always undo all of a cable that has been coiled for storage.

Using machine tools
A number of do-it-yourselfers have access to machine tools—such as a lathe—and in using these, certain precautions have to be taken. Accidents are generally caused by electrical faults, mechanical faults, careless or incorrect working techniques, or a combination of two or more of these.

Therefore, start by ensuring that there are no obvious electrical problems (see above) and make sure that the machine itself has been properly serviced and is adequately lubricated. Mechanical faults

are nearly always caused by poor machine maintenance or lubrication, so make sure that this is not the case with your machine. Other mechanical faults can come about as a result of worn or damaged machine parts, overloading the machine, setting up the machine wrongly, and using the wrong cutting tools in the machine.

As for correct working techniques, it is essential that you are given some guidance before you attempt to use any machine tools. If possible get someone experienced to show you how the tool works, how it should be set up, and how you should operate it.

Fire precautions
There are a number of fire precautions that you can and should take. First of all, make sure that you have a fire extinguisher close by. A wide variety of extinguishers are available and many are suitable for domestic use. Choose a standard carbon dioxide (CO_2) unit as this can be used to put out most fires, including those caused by inflammable liquids; a water extinguisher is not suitable for inflammable liquids, nor for electrical fires, and so is less useful.

Many of the substances that you will be using are highly inflammable—spirit-based cleaning fluids, many adhesives, and some paints—and particular care should be taken when using these. An

obvious point is to ensure that there are no naked lights in the room.

Remember that many fluids give off an inflammable vapour that can hang in the air for many hours unless an extractor fan is in use; typically, such vapours have a volume some 150 times greater than the volume of the original fluid and this means that you could well be surrounded by an invisible but highly explosive gas while you are working.

Other potential causes of fire are blowlamps and soldering irons. Take great care when using either of these and never move around carrying a lighted blowlamp—always extinguish it before taking it to the next location. You should always be wary of any naked flame, even if you think that there are no inflammable substances around. Never resort to a candle or a match for light in a confined space—use a properly protected lamp.

Toxic and corrosive substances
Special care should be taken when using any of the many toxic or corrosive substances with which the DIY enthusiast is likely to come into contact. These include some adhesives, thinners, paints and preparations as well as acids, alkalis and bleaches.

F. Below: *A bright, well ventilated workshop is not only a safe environment, but also makes work easier*

As a primary rule, you should on no account store any poisonous or dangerous substances in unmarked bottles or containers. Use properly marked non-food containers, and store them all well out of the reach of children.

To protect yourself when using such substances, always work in a well-ventilated atmosphere if vapours may be given off and use either a proprietary barrier cream or (where feasible) gloves to ensure that they do not come into contact with your skin.

If you are using acids, and need to dilute a concentrated solution, always add the acid to the water—never the other way round. Pour the acid slowly into the full amount of water being used; if you fail to do this, the first few drops will cause a violent reaction that in many cases causes the acid to splash. If you do happen to spill any acid on your skin, wash it off immediately with copious amounts of cold water. Similar caution should be applied if you are using strong alkalis or bleaches—both of these substances can also cause nasty burns.

Take care not to create any poisonous fumes by carelessly or inadvertently mixing substances or liquids that react chemically together. Detergents, bleaches, and cleaning powders should never be mixed for this reason. In general, you should not mix any two or more substances for any purpose unless you are quite sure that it is safe to do so.

Lead and asbestos are notoriously

G. Above: *When using a hammer and bolster to remove old masonry, strike the bolster away from you, keeping your hand away from the bolster end*

H. Above: *Take special care with any inflammable or toxic substances. All containers should be clearly marked and should be kept well away from children*

dangerous in certain conditions, and both materials have been widely used in the construction of older houses (and still are in some more modern buildings, despite the widespread publicity that has been given to the dangers). Make quite certain that no lead is contained in paints that children might come into contact with. Primers are especially likely to contain

lead, so do check carefully before redecorating a playroom.

For adults who are unlikely to bring lead-painted objects into contact with their mouths, the major hazards come from lead and asbestos dust. If you have to sand or rub down lead paint, always work out of doors and wet the surface so that dust is kept to an absolute minimum. Similarly, if you have to cut or saw asbestos, do this out of doors, wet the asbestos first, and wear a good face mask.

Finally, a warning about cyanoacry-late 'super' glues, which bond skin instantly. Follow the manufacturer's instructions to the letter, never point the nozzle towards you and keep a bottle of acetone handy to neutralize spillages. If you get any of the adhesive in your eyes, flush them with copious quantities of water and call a doctor.

Lifting weights

Whatever the scope of your DIY work, there will be numerous occasions when you will have to lift heavy weights. These may be bricks, masonry, timber or any number of other materials, but whatever they are, every time you attempt to lift any heavy weight you risk damaging your back or causing a hernia unless you do it the right way.

If you have to handle anything that is sharp or dirty, wear heavy duty gloves to protect your hands from cuts and possible subsequent infection. Before actually lifting a heavy weight, consider whether there is any other way in which it might be moved (see below). When you must lift it, get an assistant to help you if there is any danger of you straining yourself.

When lifting, keep your back straight at all times, and do all the lifting with your legs. Feet should be slightly apart, with one a little way in front of the other to help you keep your balance. As you lift, pull the load into your body, keeping your chin up and back straight.

Any alternative to manual lifting is preferable, so try to arrange some mechanical help for yourself. If a great deal of heavy moving is necessary, consider hiring a small hoist similar to the units used to lift engines out of cars. Alternatively, you can hire lifting tackle, which consists of ropes and a series of pulleys arranged in such a way as to reduce the effort required to move the object. If neither of these alternatives is feasible make full use of levers. Any stout length of wood will do, and as long as you arrange the lever so that the weight is close to the fulcrum—the point around which the lever pivots—you can achieve quite significant mechanical advantages. This means that less effort will be required and that you are therefore less likely to injure yourself.

Choosing an electric drill

● **How an electric drill works** ● **Judging power and efficiency** ● **Two speed and variable speed drills** ● **Hammer drills** ● **The importance of chuck size** ● **Trying out the drill** ● **Accessories** ● **Safety considerations when drilling**

A few years ago an electric drill was considered a luxury item; now it is almost an essential part of any tool kit. Yet so many different models are available that it is often difficult to choose the one which is most suited to your needs. The temptation is always to buy the cheapest, which may work out more expensive in the long run.

When you are choosing and buying a drill, there are a number of important points to bear in mind. The drill must be safe and feel comfortable in use. It must be capable of drilling through most materials around the

home such as wood, masonry and mild steel. And, if it is to be used to its full potential, it should be capable of being fitted with a range of basic attachments so that jobs other than just drilling holes can be tackled.

A. *A general-purpose one or two speed drill—suitable for most materials around the home such as wood, masonry and mild steel*

B. *A two or four speed back handle drill is ideal for large capacity drilling and hole sawing where sustained pressure is essential*

C. *Heavy-duty industrial drills— capable of tackling almost any material—are best hired for special projects when needed*

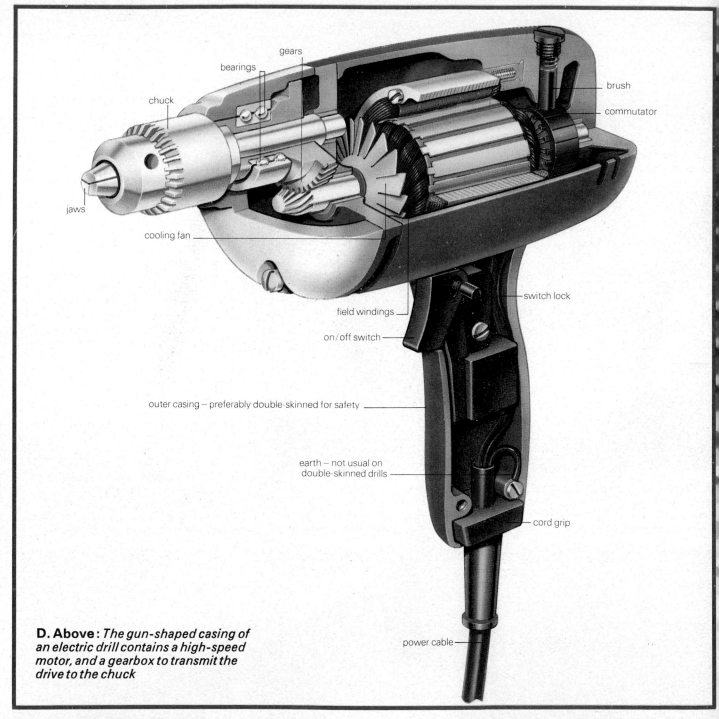

chuck

bearings

gears

brush

commutator

jaws

cooling fan

field windings

on/off switch

switch lock

outer casing – preferably double-skinned for safety

earth – not usual on double-skinned drills

cord grip

power cable

D. Above: *The gun-shaped casing of an electric drill contains a high-speed motor, and a gearbox to transmit the drive to the chuck*

How electric drills work

A few drills are powered by batteries, but these are mainly for use in areas with no electricity supply. The majority are worked from the mains supply, giving them greater adaptability and a range of speeds not available in battery-powered models.

Fig. D shows the component parts of a basic electric drill. At its centre is a high-speed electric motor which drives a spindle through a set of gears designed to increase or reduce the speed at which the spindle turns. Screwed to the front end of the spindle is a chuck with a number of fingers which can be tightened to hold drill bits and other attachments.

The motor and gearbox are housed in a gun-shaped casing, normally made of high-impact plastic, which has a fat handle grip under or behind it. Mounted halfway down the handle is a trigger which switches the motor on and off and controls the speed at which the drill turns.

Power and efficiency

The power of a drill is all-important and should be one of the first things you check. This determines whether the drill can be expected to tackle tough materials and also how efficiently and quickly it can do a job.

Most manufacturers give the electrical input that the drill should be able to take without overheating—but often fail to quote its output. Try to find this out before buying and if possible try the drill out on a piece of

tough masonry or brickwork. Run the motor at a variety of speeds and if it shows signs of overheating or stalls—especially at low speed—take this as a sign that the drill output is too low for general domestic use.

Speed controls

The speed of a basic electric drill is controlled by the amount of pressure on the trigger mechanism. It is up to you to adjust the speed of the motor—by increasing or lessening your hold on the trigger—according to the type of material being drilled.

It is often difficult to do this accurately by 'feel' and you may wish to buy a two speed or a variable power drill. These allow you to select one of a number of pre-set speeds suited to the material you are drilling.

Two speed drill: Many drills are fitted with a lever or knob which allows you to pre-select a high or low speed setting; some heavy-duty models have as many as four separate set-tings. Follow the manufacturer's instructions if you are in any doubt about which speed to select for a given material or task (fig. E).

When choosing a two speed drill, check first that the speed changes are achieved by adjusting the gearing rather than by some electronic means. If not, the motor is simply speeded up or slowed down without the necessary changes in turning force—or *torque*—and this is unsatisfactory.

As an alternative to a drill incorporating some type of lever mechanism, the speed can be adjusted by a separate gearbox attached to the end of the spindle. This is a useful device designed to extend the range of a one speed drill but it is better and cheaper to buy a two speed drill to start with.

Variable speed drill: This incorporates a mechanism—within the body of the drill or connected to the power line feeding it—which allows the drill speed to be adjusted rather like a dimmer switch in a lighting circuit (fig. F). Although this device does not change the gearing ratio in any way—to give greater torque—it is very useful in situations where you need to adjust the speed of the drill frequently. For instance, you may need to select a very slow speed when fixing screws into an electric screwdriver or when starting to drill brittle or slippery surfaces. Some drills also have a reverse facility, which can be useful for removing screws or extracting the drill bit from hard materials—such as masonry and sheet metal (fig. G).

E. *A lever or knob mounted on the body of the drill allows you to pre-select one of a number of separate speed settings*

F, *The speed of many drills can be finely controlled by finger pressure on the trigger—rather like an electric dimmer switch*

G. *Mounted on the body of some models is a switch enabling you to reverse the direction in which the drill spins*

H. *The chuck—which is available in a variety of sizes—is screwed to a threaded spindle protruding from the front of the drill*

I. *The chuck is tightened with a special key. Make sure that this engages correctly and is comfortable to hold and use*

Hammer drills

Most basic electric drills can cope with tough plaster or brickwork, when fitted with a suitable masonry bit. But harder materials—such as concrete or stone—need a special hammer drill.

As well as having a purely rotary action, these deliver rapid blows to the chuck and bit. This greatly speeds up the drilling process when used in conjunction with special hammer bits.

If you need to drill hard materials regularly, it is well worth buying a hammer drill of your own. But for occasional use it is better to hire one —preferably the heavy-duty industrial variety—which can cope with a far greater range of materials than almost any of the basic drills on the market.

As an alternative, some drill manufacturers include a hammer attachment in their range of basic drill accessories and this may be another point you need to consider.

Chuck size

An important item to check when buying any drill is its chuck size. This gives a rough guide to the largest hole that can be made.

Most electric drills are fitted with either a 10mm or 13mm chuck. Tightened fully, this will hold a 1.5mm bit allowing you to cope with very fine work. The largest bit you can use varies according to the type of material you are drilling—in mild steel roughly the same size as the chuck; in hard masonry around one and a half times its size; and in soft materials about twice the chuck size.

All electric drills have a key which is used to adjust the chuck. This has a serrated end which meshes with the teeth on the chuck allowing it to be opened and closed (fig. I).

When deciding which drill to buy check that the key engages smoothly with the teeth on the chuck and that it is comfortable to hold and use. This prevents long-term damage to the chuck which is expensive to replace. Special rubber straps are available to hold the key on the drill lead and prevent it being lost (fig. J).

Working with the drill

Apart from being safe and effective, an electric drill must be easy to use. Before deciding which model to buy, pick it up—as if you were drilling with it—and test whether it is comfortable to handle and not too heavy.

Most drills are designed to be held in a particular way and you should ensure that they can effectively be

J. *To stop the key getting lost, tie it to the power cable with a piece of string or mount it in a purpose-made rubber holding strap*

used in this fashion before buying.
Pistol grip: Most small drills are pistol-shaped so that they can be comfortably held in one hand with the forefinger controlling the trigger (fig. K). Others give you the option of switching to a palm grip—one hand wrapped around the back of the drill directly behind the bit (fig. L).

Try both of these positions to see which is more comfortable and at the same time allows you most leverage. Search for an alternative or smaller model if the one you are testing is awkward to grip or too heavy to hold in this position for long periods.

While you are holding the drill, check that the trigger is well-placed and easy to use. Some drills have a button mounted near the trigger which keeps the drill held fully on (fig. M). This should be easy to reach— preferably with the same hand holding the drill—so check this carefully if you are left-handed since the button may then be on the wrong side.

Many drills—particularly the pistol grip type—are fitted with an optional additional handle which can be mounted on either side just behind the chuck (fig. N). This allows greater control over the bit during drilling, especially if you find the machine a little heavy or bulky. On some models, the handle is adjustable; you might find this a great plus point if you have difficulty in holding drills generally.
Back handle grip: Many large industrial drills have two handles—one mounted on the back of the machine

K. *Always check that a drill is comfortable to hold and use. Some models are designed to be held in a firm pistol grip*

with the control trigger, and a second on the underside just behind the chuck (fig. B). If you want to purchase one of these, check that it can be held comfortably without strain.
Side handle grip: Heavy industrial drills often offer the alternative of two handles—one on each side of the machine. In addition a breast plate on the back allows you to exert pressure on the bit with your chest (fig. C). Test this type of model carefully since it is often bulky and difficult to hold.

N. *Nearly all models can be fitted with an additional handle. Generally, this can be bolted to either side of the body, just behind the chuck*

L. *Other drills give you the option of switching to a palm grip so that pressure can be exerted directly behind the bit*

M. *The switch lock—usually a button mounted near the trigger—should be easy to reach with the hand you use to hold the drill*

Fitting accessories

Before taking a final decision on which model to buy, find out whether any attachments can be fitted and how effective they are: even if you see no need for them straight away, careful consideration at this stage could save a great deal of trouble and expense in the long run.

Many simple attachments—such as sanding discs, millers and cutters—fit any make of electric drill. Others—like circular saws and orbital sanders

—have a threaded shaft which fits only certain models in their manufacturer's range of drills and many are designed around one particular style of drill or type of body.

Check, too, whether drill stands are available. These are essential for accurate drilling, especially in metal. On some types, horizontal studs allow the drill to be fixed flat on the bench and you can then use it with a grinding or buffing attachment in much the same way as a lathe.

Fit as many attachments as you can to the drill before buying and see if they are easy and comfortable to use. If possible, compare the price of each attachment with a comparable integrated model incorporating its own inbuilt motor. If, for example, you anticipate doing a lot of sawing, it may be better to buy a purpose made power saw and forget about saw attachments for your drill altogether.

Drill attachments and their uses are covered in the next section of this chapter.

Safety considerations

An essential consideration when buying an electric drill is deciding how safe it is to use.

To avoid the risk of electrocution the main housing should be double-skinned with the outer layer preferably plastic. Drills which are not double insulated must be wired with three-core cable so that they can be properly earthed and a safety fuse incorporated into the electric plug.

Bear in mind these other safety precautions when using a drill:
● Switch off and unplug the drill when it is not in use, or when making adjustments to the chuck or fitting attachments.
● Never leave the drill lying about on the floor or workbench. Make or buy a stand or wall bracket to hold it when not in use.
● Before plugging the drill into the electricity supply check that it is not switched on.
● Never pick up or carry the drill by its flex. Always keep the flex well out of the way when you are drilling to avoid possible accidents.
● Wear sensible clothes—avoid loose cuffs, jewellery and watches. Tie back long hair and when drilling concrete, hard masonry or metal always wear goggles or safety glasses to protect your eyes.
● Take care when drilling into walls and ceilings or through floors where there are electric cables. It is important to try and locate their exact positions beforehand, or—better still—isolate them without cutting off your own power supply. Wear rubber gloves as an extra safety precaution.
● Although the body of the drill offers some protection against damp, take care never to leave it out in the rain for any longer than is absolutely necessary to do the job.
● Have the drill serviced regularly. Most manufacturers offer their own service scheme which you can find out about where you purchase the drill.

O. *Once fitted, the extra handle allows greater control over the drill—especially if you are using it in a confined space*

P. *When drilling hard masonry, concrete, or metal, make sure that you wear safety glasses to protect your eyes from loose material*

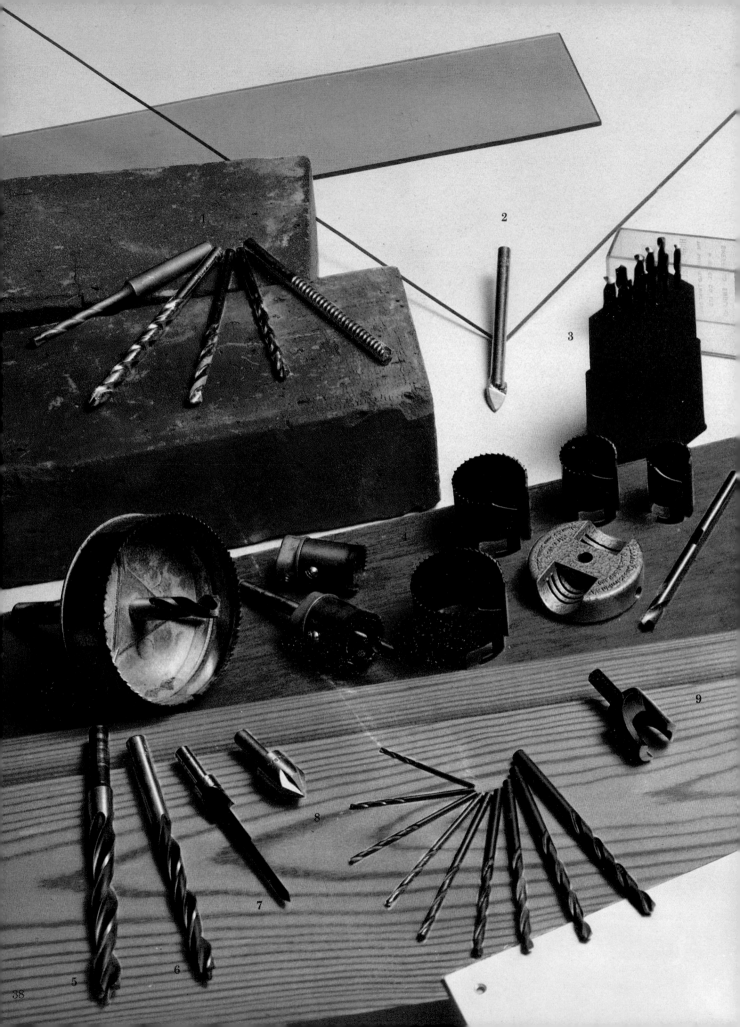

Choosing drill bits

● **Testing the quality of a drill bit** ● **Drill bits suitable for wood, metal, masonry and other materials** ● **Looking after your bits** ● **Bit failures: causes and remedies**

The effectiveness of any electric drill is to a large extent governed by the drill bit you use. Unless it is correctly matched to the material you are drilling, and is well maintained and sharpened, the motor will be under strain and the job may take a lot longer than you bargained for.

Choosing the correct bit

Most electric drill bits are manufactured from either high-speed or carbon steel. Chrome vanadium bits—

usually used in hand-operated drills—are not suitable for electric drills since they quickly blunt and wear out under high speed.

You can tell a great deal about the quality of a twist drill bit just by looking at it, so examine the bit carefully before buying (fig. B). The angle of the point is all-important: for wood it should taper at an angle of about 60°; for thick steel 118°; and for thin steel 130°. Most general purpose drills have a point angle of 120° which allows the

bit to be used for almost any type of work. Bits designed for masonry work have a specially strengthened, square-shaped point suitable for this type of work (see below).

The edges of the spiral around the point and shank also merit careful inspection (fig. B). They should stand out from the body of the drill bit so that it can turn more easily and cut smoothly through whatever material is being drilled.

The bit should have a shank which is deeply spiralled—or *fluted* (fig. B). This allows waste material to be carried away during drilling so that the bit does not jam. Make sure that

A. Left and below: *A complete range of bits suitable for use in a power drill* **(1)** *Masonry bits* **(2)** *Spearpoint bit for glass* **(3)** *Set of twist bits* **(4)** *Hole saw* **(5)** *Auger bit* **(6)** *Wood bit* **(7)** *Combination screw sink* **(8)** *Countersink bit* **(9)** *Plug cutter* **(10)** *Flat bit* **(11)** *Tank cutter*

Ray Duns

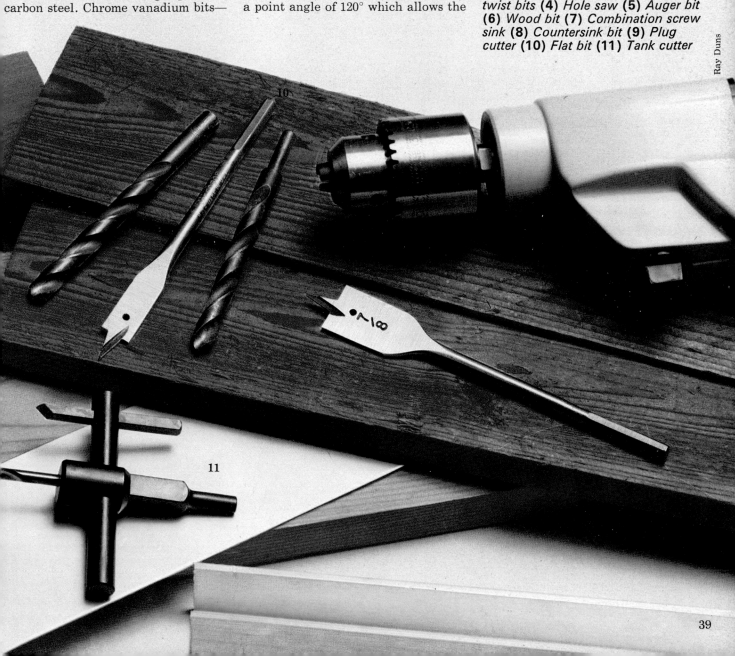

the flutes are smoothly cut without sharp prominences.

Bits are available in a large range of diameters and lengths, in both imperial and metric sizes. The diameter of the bit is usually marked on the top end of the shank and you should check this before you buy.

Bits can be bought separately or in sets containing various commonly-used sizes. Metric size drills in sets usually range in diameter from 1.5mm to 6.5mm. Try to purchase a good quality set suitable for most jobs and then supplement this with more specialized bits as the need arises.

Most drill bits are ten times as long as their diameter. This ratio—known as the jobber length—ensures that the bit never snaps under pressure. More specialized jobs may require different size bits—for especially deep holes or when working in a confined space, for instance.

Drill bits for wood

The material you are likely to want to drill most often is wood, and a whole range of bits is available to make various types of holes:

Twist bits: These are the most common type of drill bit used to make small holes in wood (fig. 1). The most commonly used sizes range from 1.5mm to 6.5mm, but larger and smaller bits available for special jobs.

Wood bit: These make holes up to 10mm in diameter. They are very much like the twist bit in shape but have a centre point which helps to position the bit more accurately (fig. A). Many have shanks with a reduced diameter top end so that they can be fitted into a drill with a small chuck size (fig. 2).

Countersink bit: Most screws have

1 Twist and wood bits are usually supplied in a boxed set. This one contains a range of bits suitable for most household jobs

2 Many wood bits have shanks with a reduced-diameter top end so that they can be fitted into drills with small chucks

countersunk heads so that they can be positioned at or below surface level. To allow you to do this without having to force the screw, a countersink bit should be used. This has a short shank and a tapered cutting point which drills a hole in the surface just large enough to accommodate a screw head (fig. 3).

Countersink bits are available in a number of different sizes, so you should make sure that you have the correct size for the size of screws you are using. Use a countersink bit only when you have drilled a pilot hole and a second hole for the screw itself (fig. 4). Do not allow the bit to drill any deeper than is absolutely necessary or too deep a hole will result.

6 Once you have drilled a number of plugs from a suitable piece of wood, these can be levered free with a screwdriver

Once the screw has been positioned, plug the hole with wood filler, or—for a really professional finish—use a plug cutter to drill a rounded sliver of wood to fill the gap.

As an alternative to using a countersink, the holes can be both drilled and countersunk at the same time using a combination screw sink (fig. 7). However, since you need a different one for each diameter and length of screw, it is not worth buying one specially unless you have a lot of screws of the same size on one job.

Flat bit: This is used for drilling large

Typical drill failures	Causes and remedies
Twisted or pitted shanks	Incorrectly fitted bit—retighten chuck
Splitting at point	Dropping or striking point before drilling/Using wrong type of bit
Worn outer corners	Excessive speed—slow down drill
Flaking outer corners and edges	Drilling thin material which is inadequately supported
Broken bits	Forcing the drill Incorrect bit
Bit chokes during drilling	Clear bit by withdrawing it Insufficient or damaged flutes
Bit slips in chuck after it is retightened	Check condition of chuck and replace

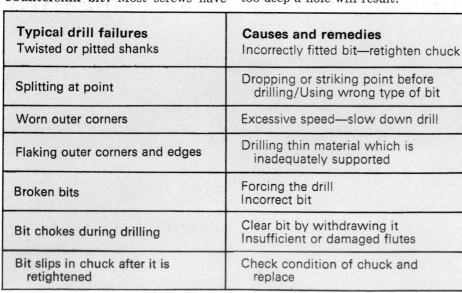

3 *Countersink bits are used to make tapered holes for screw heads. This ensures that the screws sit neatly below the surface of the wood*

4 *Countersink bits come in a range of sizes suitable for most screws. They have a short shank and a tapered cutting point*

5 *The plug cutter allows you to cut a rounded sliver of wood to fill screw holes and other gaps—without the need for wood filler*

7 *A combination screw sink is a three-in-one bit which makes a pilot hole, a screw hole and a countersink all at the same time*

8 *The combination screw sink is particularly useful if you want to drill a large number of holes of the same size on one job*

9 *Flat bits are useful when making rough holes in wood larger than 10mm in diameter—but they are not particularly accurate*

holes in wood. The bit has a flat, spade-shaped cutter with a central point to help position it when starting the hole (fig. 9).

Flat bits are especially useful for making rough holes in relatively thin timber and they are cheap when compared to other bits of similar sizes. Unfortunately, they tend also to be less accurate than the other types.
Auger bit: For accurate or deep holes of a wide diameter, auger bits should be used. These have a deeply fluted shank with a wide cutting edge and in front of this a spiralled point which

allows the bit to be positioned very accurately (fig. 10).

When using an auger bit in a power drill, make sure it is designed for high speed work and not for a hand drill. Look at the top end of the shank where it fits into the chuck—a square-ended shank shows that it is made for a hand-powered drill with a rounded shank for an electric drill.
Hole saw: This is a piece of saw blade wrapped in a circle around an arbor with a twist pilot drill at its centre (fig. 12). Once you have located the centre of the hole with the twist drill,

the saw attachment allows you to cut around the outside. Using this tool, you can cut holes up to 75mm in diameter in material up to 12mm thick.

Most hole saws are pre-fixed to cut holes of only one diameter but on some the blade can be adjusted to tackle a number of different sized holes. On others a number of saws can be fitted to the same arbor so that a hole of almost any size can be drilled.
Extra large holes: If you want to drill holes more than 75mm in diameter—to accommodate pipework for instance—this cannot be done with a

hole saw. Instead you should use a power jig saw and then a rasp or sanding tool to smooth around the edges of the cut. This is dealt with in more detail in the next section of this chapter.

Special bits: A number of drill bits designed for specialized jobs are now on the market: for example, the hinge boss used to make the housings for self-closing chipboard hinges. For this reason, it is always worth enquiring at a large hardware store if you have a particularly unusual hole to drill and no suitable bit.

Bits for metal
Only the best quality drill bits are suitable for drilling holes in metal. Made from high speed steel, they are often coated and tempered to make them more effective.

The size of holes you can make will vary according to the thickness of the metal you are drilling and the power of the drill. But if you use a good quality bit, holes up to 20mm in diameter should be possible.

To increase the effectiveness of the bit keep the drill at its lowest possible speed and lubricate the point with light machine oil. Make sure you wear goggles or safety glasses.

For larger holes use a hole saw with high speed blades. Try not to apply too much pressure to the saw but let it slowly find its own way through the metal. Use a tank cutter for thin sheet.

Drilling masonry
If you want to make holes in brick or blockwork it is essential to use special bits for the job. The bit you choose depends on whether you want to drill a small or a large hole:

Masonry bits: These are rather like

10 For very accurate, large diameter holes in wood an auger bit is essential. This has a spiralled point and a deeply fluted shank

11 In power drills always use an auger bit with a rounded shank. Those with square-shaped ends are designed for hand-powered drills

12 Hole saws are extremely adaptable tools. They allow you to drill holes in wood anywhere between 10mm and 75mm in diameter

13 The hole saw consists of two parts—an arbor with a twist pilot drill at its centre and a number of saws of various diameters

14 For large diameter holes in sheet metal, use a tank cutter. The length of the cutting arm can easily be adjusted with an Allen key

15 When drilling sheet metal or other pliable material, make sure that the workpiece is well supported and set the drill on a low speed

the twist bits used for drilling wood except that the drill point has a square shaped tip—made of tungsten carbide —slightly proud of the spiral (fig. 16). This enables the bit to cut into the masonry which would blunt an ordinary twist drill.

Some masonry bits are described according to their diameter in millimetres; others have a number corresponding to the size of screw they will accommodate. Most basic electric drills should be able to drill holes up to 15mm in diameter—especially if they have a hammer action. For larger jobs it is worth hiring a heavy-duty industrial drill with a larger power output and the necessary bigger chuck size.

Core drill: This is similar in appearance to a hole saw used for drilling wood or metal. It can cut holes to almost any depth—even the toughest masonry—and up to 50mm in diameter; a heavy industrial drill will be able to cope with 100mm holes.

Hammer bits: Most makes of hammer drill require special bits strong enough to stand up to the constant pounding which the drill imparts. These are capable of drilling holes to similar dimensions as twist bits and can be purchased where you bought the drill.

Other materials

Power drills can be used to make holes in other materials—such as ceramics and glass—but they must be capable of being run at very low speeds. A drill with a very low speed setting—or even better a variable speed drill—is

essential. If you have neither, avoid accidents by using a hand drill.

For drilling glass or ceramics you need a tungsten-tipped spear or spade-point bit (fig. 17). First lay the item to be drilled on a horizontal surface covered with some type of padding—such as a blanket. Then surround the area with a circle of putty or Plasticine and into this pour some type of lubricant to aid drilling. Break the glaze with the point of the bit to stop it skating across the surface. You can then accurately drill the hole in the normal way.

Caring for bits

You should maintain and store your bits carefully so that they remain effective and can be picked out easily when you need them.

During drilling, retract them from the hole frequently so that the flutes have a chance to clear. Never exert undue pressure on the bit in an effort to drive it through the material: apart from straining the motor, you are likely to bend the bit and make it unusable in the future.

After each hole has been drilled examine the bit to see whether it is clogged with the material you have just been drilling and clean out waste with a nail or awl before continuing. This will not only aid drilling but help the bit to maintain its cutting edge.

After use, rub down the bit with steel wool and then apply a thin coating of lubricating oil. Occasionally sharpen the bits yourself (see pages 21 to 26) or hand them into your

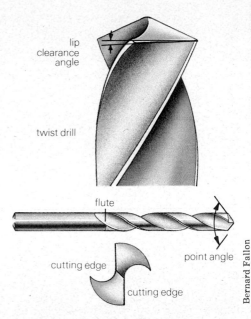

B. Above: *You can tell a great deal about the quality of a bit by examining it carefully—particularly the point and flute*

local hardware shop to be resharpened professionally.

Try to keep bits in a place where they can be traced easily without being knocked onto the floor. A small rack—made from a block of wood with holes of various diameters drilled in it—is easy to make and ensures that each bit is stored in its correct place. Alternatively, there are plenty of proprietary drill carriers on the market and you often get one when you buy a set of bits from a hardware store.

16 *Masonry bits have broad, spade-shaped points. Some have shanks with a thick top end so that more pressure can be exerted on the bit*

17 *When drilling glass or ceramics, surround the drilling point with a circle of putty or Plasticine and pour lubricant into the centre*

18 *Switch the drill to its lowest possible speed and mark the surface before you start drilling to stop the bit from skating*

43

Make a drill tidy

Keep your electric drill and collection of bits ready to hand with this simple drill tidy. It is designed to hang on the workshop wall, or you can carry it out to any job. It uses very little in the way of materials, and most of the parts can be made from offcuts or scrap timber. None of the timber sizes are especially critical, and you can substitute depending on what you have available.

Cut out all the parts to the dimensions shown. The cut-out in the centre shelf should be marked out according to the shape of the drill.

Assemble all the parts, using nails, glue and screws as specified. Note the use of washers on those screws which act as pivots. Sand, prime, then finish with gloss paint.

Cut keyhole slots in the backboard to fit over the screwheads.

Drill bit holder from a 237mm length of 100 x 25mm softwood tapered down to 50mm. Drill holes then fix with glue and pins.

Sides from 305 x 125mm pieces of 19mm plywood. Radius the front corners to 10mm.

Shelf from a 237 x 125mm piece of 19mm plywood. Fix in place with PVA woodworking adhesive and nails through the backboard and sides 120mm from the top.

Handle support bar from a 120mm length of 32 x 25mm softwood. Radius the top and cut a notch to fit a handle. Nail and glue to the shelf.

Cut out to fit the body of your drill.

Retaining clip from a strip of 6mm plywood, 19mm wide and 50mm longer than the cutout. Fix with two 25mm No.8 (4.2mm) domed head woodscrews. Cut a slot to fit over one screw and fit the other with washers to allow the clip to swivel.

Fix to wall with two No. 8 (4.2mm) domed head screws. Screw into fibre or plastic wallplugs and leave 7mm of the head projecting.

Backboard from a 305 x 275mm piece of 6mm plywood. Pin and glue to the sides and shelf.

Drill 19mm holes in the centre of the side panels, 10mm from the top. Fit the handle through and secure with glue and a pin.

Handle from a 275mm length of hardwood dowel.

Cut a 9mm slot in the side panel to align with the cable grip on the drill handle.

Cleats from 60 x 23mm pieces of 6mm plywood. Radius the ends and screw to the cable tidy with 25mm No.8 (4.2mm) domed head woodscrews. Fix the upper cleat rigidly, but fix the lower cleat with washers and a single screw to allow it to swivel for quick cable release.

Cable tidy from a 150mm length of 50 x 25mm planed all round softwood. Radius the ends. Glue and nail to the side.

Basic power saws

● The advantages of power sawing ● Attachments and integrals ● Choosing a circular saw ● Using the saw ● Choosing a jig saw ● Cutting with the jig saw ● Considerations ● Saw blades and cutting wheels for different materials

Sawing by hand is usually a time-consuming and tedious task – especially if you want to make long, straight cuts or intricate curves. But with a power saw or saw attachment, this type of work can be carried out with a minimum of effort and to a high degree of accuracy.

The circular saw and jig saw (sabre saw) are the two most popular types of power saw. Both types are used to make straight cuts with or against the grain and the jig saw can also cut curves and intricate patterns. Armed with these tools you should be able to tackle most basic sawing jobs.

Attachments and integrals

Both circular saws and jig saws can be purchased either as attachments to existing power drills or as integral units with inbuilt motors. And while there is no hard and fast rule about whether an attachment is better or worse than an integral tool, it is worth considering which is more suitable for your particular needs before purchasing.

If you plan to make only occasional use of a circular saw or jig saw, then an attachment may be all you need. But for more frequent use – particularly on tough materials – an integral is a better buy.

Choosing a circular saw

Integral circular saws are generally more powerful than attachments, and so permit greater accuracy and safety. Since they are already set up ready for use, they avoid the time-consuming necessity of switching back and forth from saw to drill that using an attachment often involves.

Whether you buy an integral saw or an attachment, check first that the saw is powerful enough to tackle basic jobs around the home. The power of an attachment is of course limited by the output of the drill itself so you should study the manufacturer's specifications carefully before buying.

Even with an integral saw most manufacturers give only the input power of any particular model – not the all important output power. Depending on the make of the saw and its efficiency the output is bound to be anything from 60-90 percent lower than the input so this should be allowed for when calculating the motor power of any saw.

A good guide to the power of any particular circular saw is the largest diameter blade that can be fitted into the machine – the larger the blade the more powerful the saw's motor is likely to be. The smallest domestic saws have blades with a diameter of about 125mm and a motor of at least 300-450 watts. The largest domestic saws with blades 180mm in diameter need a motor of about 1000 watts to operate efficiently. Larger saws suitable for heavy-duty work are much more expensive than domestic models and if you need one for a particular job it would probably make more sense to hire one for a short period.

Many manufacturers of integral saws and attachments state the maximum depth to which their saws will cut, and this can also be used as a guide to the power of the tool. A low-powered saw with a 125mm blade can be expected to make a 30mm cut and a high-powered saw with a 180mm blade a cut 60mm deep. Remember that the depth of cut will be less if you cut at an angle or want to cut hardwood or metals.

Once you have checked that the saw is powerful enough for your needs, make sure the model you choose is comfortable to hold and use. Attachment saws should be easy to assemble and take apart. All

A. Left: *A power saw or saw attachment takes a lot of the hard work out of sawing by hand and guarantees a neat, accurate cut every time*

1 *Both circular saws and jig saws can be purchased as integrated units. These are equipped with their own inbuilt electric motors*

2 *Alternatively, power saws can be fitted as attachments to electric drills; the method of attachment varies from drill to drill*

saws should have a safety guard around the blade to prevent accidents, but avoid those with plastic guards if you want to cut metal or masonry.

Many saws can be attached to a bench—giving them greater flexibility and accuracy—so you should check that the model you purchase can be adapted in this way if you want to make use of this facility at a later date. Saw benches can prove extremely useful if you are going to do a great deal of sawing.

Parts of a circular saw
Although integral circular saws vary in design from one manufacturer to another, most have the same basic features. At the centre of the machine is a motor with a horizontal drive shaft or arbor (fig. B). Flat circular blades 125mm-180mm in diameter are attached to the end of the shaft and held in place by a bolt fitted with a washer.

A spring loaded guard—made from metal or rigid plastic—is fitted around the outside edge of the blade. This comes down automatically to cover the blade as soon as the saw is moved away from the work and rises again when you start a cut in the material (fig. B).

To adjust the depth of cut, a calibrated knob is mounted on the side of the machine. On many saws there is also a second knob for locking the blade at any angle up to 45° in relation to the *soleplate* to allow for bevel cuts.

A sole or baseplate—fixed at right-angles to the blade—rests on the work-piece during sawing to ensure an

B. Right: *All circular saws should have a safety guard around the outside of the blade as well as a detachable fence and angular adjuster*

accurate cut. The blade itself is mounted 50mm-75mm behind the front of the soleplate to avoid accidentally cutting through obstructions.

Most circular saws have a detachable *rip fence* fitted to the side of the soleplate (fig. B). This can be adjusted to guide the saw paralled to the edge of the workpiece during straight cuts (see below).

Some circular saws are fitted with a *riving knife* or *kerf guide*. This follows behind the blade to keep the cut open and prevent the blade from snagging.

Fitting a new blade
A general purpose blade—suitable for cutting light boards—is usually supplied with the saw. Several other blades and cutting discs are available for more specialized tasks (see page 48).

Before you fit a new blade, make certain that the power is turned off and that the saw is resting safely on a flat surface such as a workbench. When un-screwing the old blade you need to jam it to stop the spindle turning. To do this either jam the blade against a block of wood or—better still—push a screwdriver through the ready-made hole in the surface of the blade Then, using a suitable spanner, unscrew the fixing bolt, carefully remove the unwanted blade and lay it to one side (figs 3 and 4).

When fixing the new blade into position make sure that it is fitted the right way round: almost all models cut on the upstroke, in which case fit the blade with the teeth pointing upwards. Also, make absolutely sure that the fixing bolt is threaded correctly and tightened fully. This will lessen the chance of inaccurate

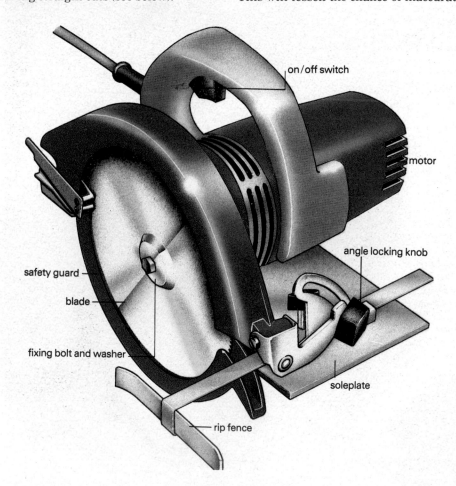

on/off switch

motor

angle locking knob

safety guard

blade

soleplate

fixing bolt and washer

rip fence

3 *Fit a new circular saw blade with care, making sure it is the right way round and that it is correctly centred on the spindle*

4 *Jam the blade using either a screwdriver or a block of wood. The fixing bolt and its washer can then be inserted and tightened*

5 *Before using the saw, always check that the safety guard is operating correctly and that it covers the full length of the saw blade*

cuts and might prevent a serious accident occurring.

Using the circular saw

The circular saw can be used in a variety of ways; freehand or with guides for ripping or cross cutting; with the blade angled for bevelled cuts; or with a shallow set to make grooves or saw kerfs.

When using the saw—even for rough offcuts—make sure that the workpiece is secured in a vice or with G-cramps. Also check that the blade will be unobstructed beneath the work before starting the cut.

Do not start the motor and then advance the saw towards the workpiece—this is a dangerous practice which could result in accidents. Instead, rest the front of the soleplate on the workpiece with the blade clear of the surface and line it up carefully before starting the motor. Wait until the motor reaches full speed before advancing it carefully through the work.

During cutting, do not push or force the blade as this will strain the motor or cause the saw to kick back. Once the cut is complete, turn off the saw and allow the blade to stop before removing it from the cut. This will prevent the blade from catching the wood on each side of the cut and thus cause splintering.

Straight cuts: For rough cuts, mark out the workpiece and use the saw freehand with the notch set in front of the soleplate as a guide. More accurate cuts can be made using the rip fence. Adjust the fence carefully allowing for the set of the teeth on the saw. Then rest the front of the soleplate on the workpiece and check that the blade is aligned correctly before making the cut (fig. 6).

If the cut is too far in from the edge for you to use the rip fence, clamp a long straightedge to the top of the workpiece and use this as a guide for cutting (fig. 8).

6 *To make fairly accurate rip cuts, fit the detachable rip fence and adjust it carefully allowing for the set of the teeth on the saw blade*

7 *As you make the cut, run the rip fence along the edge of the workpiece. Providing this is fairly straight, a neat cut will result*

8 *If the cut is too far in from the edge to reach with the rip fence, clamp a long straightedge to the workpiece to act as a cutting guide*

9 *The same principle can be used if you need to cut at an angle across the board—but make sure you do not saw through the bench*

Power saw blades

Circular saws

General purpose blade: This blade— normally supplied with the saw— combines the features of rip and crosscut blades. It usually has 24 points and can be used for cutting wood and lightweight boards across and along the grain.

Crosscut blade: Used for cutting timber to length.

Rip blade: For sawing timber along its length and parallel to the grain.

Planer blade: This gives a very smooth finish – use it on hardwood and thin board.

Tungsten carbide blade: A toughened blade used to cut materials with a high resin content, such as plastic laminate and thick chipboard.

Metal cutting blade: This fine-toothed blade is used for cutting most soft metals.

Flooring blade: Not just designed for cutting floorboards, but any tough material where there might be hidden nails or other obstructions.

Metal cutting wheel: Used for metals and plastics.

Masonry cutting disc: This will cut ceramic tiles, slate, marble, soft stone and non-ferrous metals.

Compo and wallboard blade: A fine toothed blade for cutting wallboard and composition sheet.

Reinforced abrasive wheel: For cutting marble.

Friction blade: For high-speed cutting of corrugated iron and flat steel sheeting.

Jig saws

General purpose fine toothed: Used for cutting fine wood and man-made boards—such as blockboard.

General purpose medium toothed: For plywoods and particle boards.

General purpose rough toothed: For rough cut wood.

Tungsten carbide tipped: Specially designed for cutting chipboard.

Special purpose blades: These are designed for cutting materials other than wood, such as metal, stainless steel and plastic.

Flush blade: This sticks out from the front of the jig saw so that you can cut right up to obstructions.

Scroll blade: Used for cutting tight curves and intricate shapes.

C. Below left, top to bottom: *General purpose blade, crosscut blade, rip blade, planer blade, tungsten carbide blade and metal cutting blade.* **Below right, top to bottom:** *Flooring blade, metal cutting wheel, masonry cutting* disc, compo blade, abrasive wheel and friction blade. **Bottom, left to right:** *Fine toothed, rough toothed, tungsten carbide tipped, metal cutting blade, flush blade and scroll blade (for cutting tight curves and intricate shapes)*

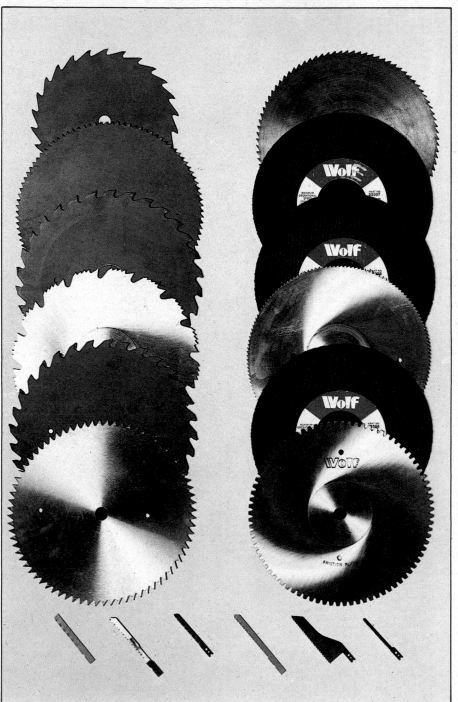

10 *Bevelled cuts are made using the angle adjustment knob. This serves only as a rough guide, so make a number of test cuts first*

11 *When making pocket cuts in the middle of a piece of wood, start the saw, hold back the guard, then lower the blade slowly on to the work*

The same straightedge can be clamped to the workpiece to cut at various angles (fig. 9). Once the straightedge has been secured and the cramps adjusted so that they do not restrict the motor, the cut can be made by running the edge of the soleplate along the straightedge.

Angled cuts: Bevelled or angled cuts are easily made using the angle adjustment knob mounted on the saw. This is calibrated to allow cuts to be made with the saw positioned anywhere between upright and 45°, but this is a fairly inaccurate guide so you should make a number of test cuts first and adjust the saw as necessary.

Once you have found the true angle of cut by trial and error either secure a straightedge to the workpiece or use the fence as a guide. Then carefully run the saw across the workpiece keeping the soleplate held flat at all times to ensure a neat, bevelled cut (fig. 10).

Cutting slots: A power saw can be used to cut long slots in wood. This is particularly useful when making joints in shelving or when constructing simple furniture, for instance.

Carefully mark the position of the slot on to the surface of the wood and adjust the blade to cut only partway through the board. Use the rip fence or clamp a long straightedge to the workpiece to act as a guide and cut carefully along each marked-out line in turn. Use a chisel to chop out the waste and clean up the bottom and sides of the slot.

Making slots in the middle of a piece of wood—often known as pocket cutting—

D. Right: *The integrated jig saw can be used to make straight cuts, but it comes into its own when you need to saw curves or intricate shapes*

can also be made easier with the help of a circular power saw. First mark out the position of the proposed slot on the face of the workpiece. Then move the saw into position above the marked-out slot and carefully start the motor. With care you should be able to slowly lower the saw, starting with the front of the soleplate,

until the blade starts to bite into the wood. Move the saw backwards and forwards until one side of the slot has been cut then switch it off, remove it, and cut out the other side of the slot in the same way (fig. 11).

This technique may require a little practice before it is mastered. Begin by making a number of trial slots on a piece of waste wood before you cut the slot itself. You may find that you have to help the blade to make contact by carefully raising the saw guard by hand—this should be done with great care since it is potentially dangerous. Make sure also that the body of the machine is held steady during the moment that the saw blade first comes into contact with the wood: it often jumps and kicks back at this important stage.

Wobble washers: These are a means of using the circular power saw to cut out neat slots in one pass without the need for chiselling afterwards. Special washers, fitted on each side of the saw blade, set it at an angle to the shaft so that it moves from side to side as it rotates. This makes a cut wider than the normal blade and in a number of runs you can cut out slots of practically any size.

However, wobble washers should be

switch lock

on/off switch

motor

soleplate

locking screw

blade

rip fence

used with care and preferably only in saws mounted on a saw bench – since they can unbalance the saw, making it more difficult to control.

Choosing a jig saw

Like circular saws, jig saws are available both as integrals – with their own motor – or as attachments to electric drills. It is worth spending time deciding which of these is best suited to your needs.

As with circular saws, a good guide to the quality of a jig saw is its depth of cut: it should be capable of making a cut 50mm deep in softwood and a 25mm cut in hardwood or particle boards.

Some saws have variable speed controls and bases which tilt allowing you to make angled cuts. However, one of the most important things to check is whether the saw cuts with a straight 'up and down' or an orbital action; the orbital action is to be preferred since it produces a cleaner cut with less blade wear.

Like the circular saw, you should make sure that the jig saw you choose is comfortable to hold and use. Check also the blades are readily available and easy to change. Some jig saws can be fitted to a saw bench, so if necessary ensure that the model you buy has this facility.

Parts of a jig saw

Fig. D shows the main component parts of a typical integral jig saw. At its centre is a motor driving a blade. The saw is controlled by a handle mounted above the motor which contains the on/off switch.

Power to the blade is provided by a series of gears within the main housing which drive the blade up and down. The blade is held in place by a small collar with a locking screw.

Again, like the circular saw, the jig saw has a soleplate which rests on top of the workpiece and a detachable rip fence used as a cutting guide.

Fitting a new blade

A number of different blades are available for use with the jig saw, enabling you to cut quite a wide range of materials (see page 48). It is important to ensure that they are fitted correctly.

Insert the blade into the holder mounted on the base of the main housing and push it firmly upwards to ensure that it is firmly seated; the blade should then be impossible to move if twisted from side to side. Tighten the blade locking screw with a screwdriver or Allen key (hex key wrench) and ensure the blade is secured by giving it a sharp tug.

Using the jig saw

Although the jig saw can be used for straight cuts, it comes into its own on curves and intricate shapes. In this case it

A colourful bedhead

This colourful bedhead will give you ample opportunity to explore the versatility and ease of cutting of the power jig saw. And, by using coloured inks to produce a stained pattern, the finished result is both unusual and attractive.

The basic construction is extremely simple, consisting of the headboard itself and two support battens, glued and screwed together. Many bed bases already have provision for fitting a headboard of this type and if yours is one of them, it will almost certainly be possible to adapt it. In other cases, locate solid parts of the base and bolt through them as shown.

The headboard is made from a piece of 12mm plywood, cut to a curved profile. Use the squared diagram to mark out the curve on the board, and then cut around the outline using a power jig saw. Note that there are points where a sharp angle is included – these will need two passes with the saw, meeting at the point. After cutting, use sandpaper to remove any remaining roughness or splinters. You can use wood filler to fill the end grain around the edges to produce a smooth finish.

Use the same squared diagram to mark out the coloured pattern on the plywood. Mark out the border of each area with a black ball-point pen, pressing hard enough to indent the surface lightly – this will prevent the stains running and mixing at the borders. Make sure that the underlying grid is thoroughly removed.

The easiest way to produce the colours needed is to use coloured artists' drawing ink. The colour key opposite gives instructions for mixing the required colours according to the letter code on the diagram. Only small quantities of each colour are needed. Fill in the colour areas carefully, using artists' brushes, working just up to the marked lines.

Allow the inks to dry thoroughly, then give the entire surface a coat of lacquer to protect it. To complete the bedhead, screw the headboard to the two battens.

Cut bedhead from 12mm birch-faced plywood as shown above. Fix supports with PVA woodworking adhesive and 25mm No. 8 (4·2mm) countersunk wood-screws.

Cut a slot 12mm wide and 100mm long to receive coach bolts.

Make supports from 50mm x 25mm planed all round softwood. The length of the supports will vary according to the depth of the mattress.

You may be able to adapt the existing fittings. If not, drill two 12mm holes in a solid part of the base and secure each support with two 10mm x 50mm coach bolts, washers and nuts.

Colour key

Use these formulae to mix the colours you require, according to the letter code in the diagrams. You will need one bottle of waterproof artist's ink in each of the nine colours used.

A. 4 parts white, 1 part cobalt
B. 3 parts white, 2 parts cobalt
C. 2 parts white, 3 parts cobalt
D. 1 part white, 4 parts cobalt
E. 4 parts white, 1 part ultramarine
F. 2 parts white, 3 parts ultramarine
G. 3 parts nut brown, 2 parts violet
H. 2 parts peat brown, 3 parts violet
I. 4 parts sunshine yellow, 1 part nut brown
J. apple green
K. 1 part apple green, 4 parts white
L. 4 parts emerald, 1 part peat brown
M. 2 parts emerald green, 3 parts peat brown
N. 2 parts apple green, 3 parts yellow
O. white
P. violet
Q. 1 part violet, 1 part peat brown, 1 part emerald green, 2 parts white
R. 2 parts sunshine yellow, 3 parts nut brown

Martin Palmer

12 *Jig saw blades often snap simply because they are fitted incorrectly. Push the blade into the holder and tighten the locking screw*

13 *Most curves can be cut freehand. Mark out the workpiece and saw carefully along the line, keeping slightly to the waste side*

14 *If you need to start a cut in the middle of a board, tilt the saw on its front end and lower the blade on to the surface of the work*

can either be used freehand or else in conjunction with the rip fence.

When cutting with the jig saw, always secure the workpiece face downwards so that the ragged edges formed by the exit of the blade will not show. The saw should be held down firmly against the item you are cutting to counteract the natural action of the saw – which cuts on the upstroke of the blade.

Never force the pace of the blade but let it work its own way through the workpiece. This will avoid strain on the motor as well as broken blades.

Also never attempt to cut curves which are too sharp: a circle with a radius of 13mm should be the maximum. If you need to make a tighter curve than this a special, narrow-back *scrolling blade* should be fitted (see page 48).

Freehand cutting: This is a fairly common method of cutting curves or shapes in wood using a jig saw.

Carefully mark the proposed position of the curve across the face of the workpiece. Lay the front of the soleplate on the board and line it up with the start of the curve. Start the motor and begin the cut, keeping slightly to the waste side of the cutting line. As you come to the end of the cut, support the two boards carefully to avoid splintering as they begin to separate (fig. 13).

Often you need to start a cut in the middle of a board. To do this, tilt the saw on its front end with the blade well clear of the work. Switch on and slowly lower the blade on to the point where the proposed cut starts. Do not force the blade but keep it pressed down against the surface until it finds its way through. The cut can then be continued for as long as

you like and the blade removed once you get to the end (fig. 14).

Circle cuts: If you need to cut a perfect circle, fit the rip fence on to the machine so that the fence is inverted and facing directly upwards. Then fix a nail in the surface of the wood at the exact centre of the proposed circle (fig. 16).

The end of the rip fence can now be slipped over the nail so that the saw pivots around it to make the cut. Most fences already have a small hole in the end designed for this purpose but otherwise one can easily be made with a twist drill.

Safety considerations

Power saws can be dangerous tools if used in the wrong way – safety should always be your first consideration.

● All the safety precautions which apply to power drills should be adhered to.
● Never adjust the saw or change blades without switching off beforehand.
● If you are using an attachment, never use the trigger locking button on the drill.
● Never use any saw without an adequate guard. Make regular checks that they are securely fitted and in perfect working order.
● Eye protection is essential to protect you from loose flying material when cutting. With very noisy machines, ear muffs should also be worn.
● When cutting, hang the flex over your shoulder. Check occasionally that the flex is undamaged and replace it if necessary.
● Always use a sharp blade – this makes cutting safer and more accurate. Circular saw blades should be sharpened regularly – most manufacturers provide this service on request. Jig saw blades cannot be sharpened and should be thrown away once they become blunt.

15 *Most jig saws have a detachable rip fence. This can be used to make straight cuts or be utilized as a guide for cutting circles*

16 *Complete circles or arcs can be cut by turning the end of the rip fence around and anchoring it to the workpiece with a nail*

Power sanding

● **Types of abrasive paper** ● **Drill attachments:**
sanding discs, drum sanders and flap wheels ●
Using an orbital sander ● **Working with belt**
sanders ● **Safety considerations**

A. Below: *The full range of power
sanding equipment (1) Orbital sander
(2) Belt sander (3) Alloy disc
(4) Drum belt sander
(5 & 6) Sanding discs*

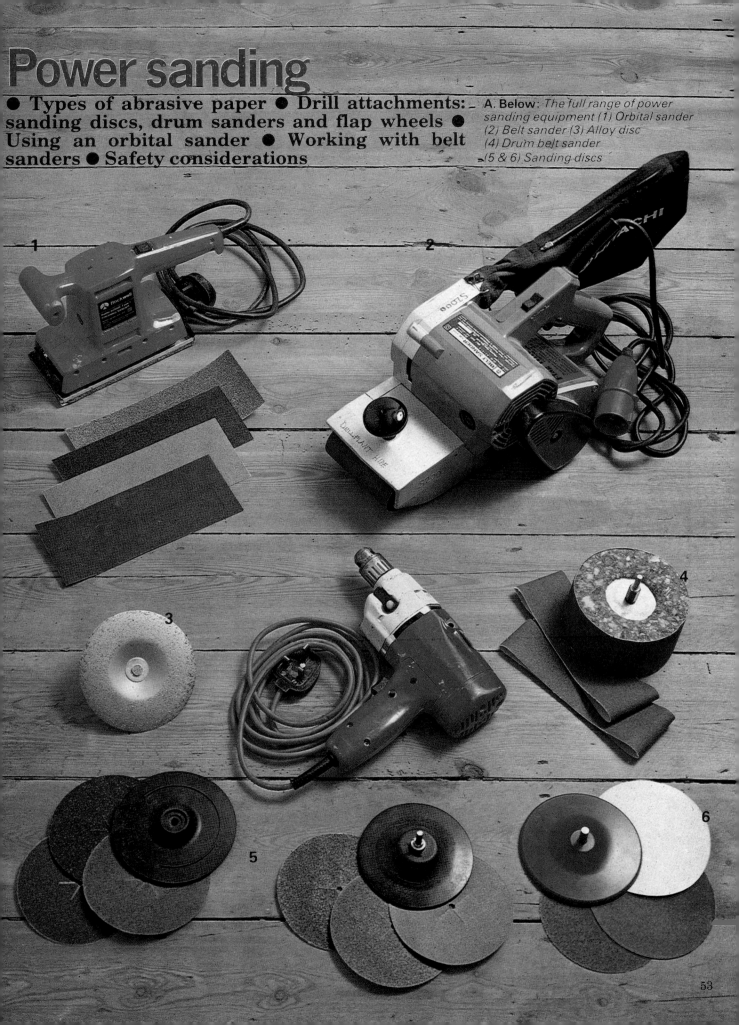

Sanding is an essential preliminary to painting or varnishing most surfaces and although it is quite possible to sand by hand, this is often a laborious and time-consuming activity; and even after a great deal of hard work, you cannot always guarantee a good finish.

Using a power sander makes the job very much quicker and easier, and it has an added advantage in that it allows you to undertake jobs that would be almost impossible to complete by hand—such as sanding floorboards or removing heavy rust deposits from gutters downpipes, and other metalwork items.

Preparatory considerations

Almost all materials—wood, plastic, masonry or metal—can be power sanded providing you choose the correct machine (see below). But both the surfaces and the surrounding areas must be prepared thoroughly before you start.

All nails or sharp objects which might tear the abrasive material or damage the machine must be removed—especially if you are working with wood. So go over the workpiece first to check for these, and keep an eye open for them while you are working.

Even if your sander is fitted with a dust bag there is bound to be some mess, so try to keep it to a minimum—particularly if you are tackling large areas. Moveable furnishings should be taken into another room and all fittings covered with dust-sheets or rolls of plastic sheeting.

Safety and health considerations are also important. Remember that you are dealing with machinery which can either be enormously helpful or potentially dangerous according to how it is used. Refer to page 37 and read the safety considerations given there before starting work. Safety goggles should always be worn in enclosed areas or when working with metal or masonry. If the machine is noisy or you are using it for a long period, it is a good idea to wear protective ear muffs at all times.

Types of abrasive

The effectiveness of any sanding machine and the results that you achieve are directly related to the quality of the abrasives employed. Even very good machines cannot work to their full potential if they are fitted with the wrong type of abrasive.

Although ordinary glasspaper can be used, it tends to wear out quickly and become clogged after only a short period of time. Try to find aluminium oxide or silicon carbide paper which is a lot more expensive but will last much longer and sand more effectively. The types with the grit spaced wide apart are best as they are less likely to clog when used at high operating speeds.

Abrasive paper is usually graded both by type and number—fine (100 to 120), medium (80 to 100) and coarse (50 to 60). In addition to these three basic grades there are a large number of intermediate abrasives available as well as extra coarse and extra fine grades.

Self-adhesive abrasive paper is now coming on to the market—types are available for use with disc or orbital sanders (see below). To use these, you must also have a special plastic backing plate which the abrasive sheet is stuck to. The papers can be peeled off and re-stuck on to the backing plate a number of times.

As well as paper and cloth-backed abrasives, rigid metal discs can be used as attachments to power drills (see below). These consist of a light alloy disc impregnated with tungsten carbide grains which are exceptionally tough and do not clog easily.

Attachments for drills

The most basic type of power sanding equipment consists of various attachments which can be fitted to your existing power drill. These allow you to tackle most simple sanding jobs without the need to buy or hire expensive sanding equipment.

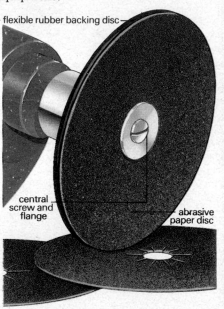

flexible rubber backing disc

central screw and flange

abrasive paper disc

B. Above: *The most common type of power sanding unit consists of a circular piece of abrasive paper fixed to a flexible rubber backing disc*

1 *Rounded abrasive paper discs used in a power drill are particularly useful for sanding rough timber or removing thick layers of paint*

2 *The abrasive papers are fitted to a flexible rubber backing disc. This allows pressure to be applied without damage to the workpiece*

3 *Choose the grade of paper you require and secure it on to the rubber pad. It is held in place by a central screw and wide flange*

Sanding attachments can be fitted ready for use in a matter of seconds. A shaft mounted on the back of the attachment is slotted into the jaws of the chuck—rather like a drill bit. The chuck is then fully tightened with a chuck key until the attachment is firmly held.

Sanding discs: These are flat, circular discs of abrasive material mounted at right-angles to the chuck (fig. B). They are usually used for fine sanding of wood or masonry. When the drill is running, the disc rotates to give a simple, circular sanding action.

Two types of sanding disc are used. The more common of the two consists of rounded pieces of ordinary abrasive paper fixed to a flexible rubber backing disc about 125mm in diameter. The paper is held in place by a central screw and wide flange mounted on the front of the backing disc (fig. 3).

Purpose made abrasive discs are available in a number of different grades from most hardware stores. But you can easily make your own from ordinary sheets of good quality glasspaper.

Try to choose abrasives with a strong paper or cloth backing since these will tear less easily during use. Place each sheet on a flat surface, abrasive side down, and use a felt marker to draw a circle around the outside of the backing disc. The paper can then be cut into discs with sharp scissors or a scalpel. Cut a slot in the middle so that the disc can be secured to the backing (fig. 5). Try to make up a number of discs of different grades—ranging from very fine to extra coarse—so that you can work on a variety of different materials.

The second type of disc is made from light alloy and may be rigid enough to

(label) central screw and flange

(label) rigid metal disc impregnated with tungsten carbide grains

C. Above: *For rapid stripping of thick paint or rust, use a light alloy disc impregnated with tiny tungsten carbide abrasive grains*

be used without a backing pad. Like the ordinary paper discs, these are available in a number of different grades from fine to coarse (fig. C). They are usually used for rapid stripping of materials which are encrusted with thick coats of paint or covered with rust.

Wear safety glasses or goggles when working with rigid abrasive discs—especially when stripping old paint or rust or smoothing down rough masonry.

Before working with an abrasive disc make sure that it is firmly held in the chuck; a number of unnecessary accidents are caused by discs spinning free during use (fig. 9). Choose a high speed setting, then pick the drill up and

hold it firmly by the handle before switching on the motor.

Never hold the disc flat on to the workpiece; it will only dig into the surface and remove too much material. Instead, keep it at an angle of about 30° so that only part of the disc actually touches the surface. Keep the disc on the move all the time, working it slowly backwards and forwards so that only a thin skim of surface material is removed.

Sanding discs should be used with care—especially on softwood—since they often leave circular 'swirl' marks which are difficult to remove. To avoid this, start off with a fairly coarse paper disc and then work your way down through a number of medium grades, finally finishing off with a very fine disc. If any swirl marks then remain they can be removed by hand—with a fine piece of abrasive paper rubbed along the grain—or with an orbital sander (see below).

(label) abrasive belt

(label) foam cylinder

D. Above: *The drill-mounted drum sander leaves few swirl marks and is especially useful when tackling gentle curves or shapes*

4 *Extra abrasive discs can be made from sheets of good quality glasspaper. First draw a circle around the outside of the backing disc*

5 *The paper can then be cut into discs with sharp scissors or a scalpel. Cut a slot in the middle of each disc for each fixing to the backing pad*

6 *Self-adhesive discs have a fairly long life. They are used in conjunction with a special 125mm flat backing pad supplied with the paper*

Drum sanders: These consist of a sturdy foam cylinder with a belt of abrasive paper wrapped around it. Fresh belts are easily fitted and are available in a number of different grades (fig. D).

Drum sanders are no good for very large flat areas, nor can they reach into tight corners. But they are ideal for fine sanding of all materials—particularly wood—since they leave few swirl marks and can be used along the grain. You can also use one to tackle gentle curves—a task that is practically impossible with any other type of sander.

Before starting work make sure that the belt is fitted correctly. It should be tight against the backing so that none of the foam is exposed (fig. 11). Most belts are seamless but others, with joins exposed, should be fitted the right way round so that the join does not catch or snag while the machine is in use.

Use the foam base to press the sanding belt gently against the surface of the workpiece during use. Occasionally withdraw the machine from the workpiece and allow it to speed up again before restarting work. Try to keep the drum on the move all the time and keep a constant check on the belt to ensure that it does not slip to one side.

Flap wheels: These allow you to sand internal corners and sharp curves which are almost impossible with either sanding discs or drum sanders. They consist of a large number of abrasive cloth strips attached radially to a central hub (fig. E). As the tool is used, the outside edges of the cloth leaves wear away exposing fresh abrasive surfaces. A large number of wheels is available, each with a different diameter and grade of grit from fine to coarse.

abrasive cloth strips

E. Above: *Because of their great flexibility, flap wheels are the only type of sander which can cope with internal corners and sharp curves*

Never apply excessive force or pressure when using the flap wheel. Advance it slowly towards the workpiece until just the outer edge of each leaf is brushing against the surface. As each part is sanded, withdraw the wheel and work from a slightly different angle until the whole area has been covered.

Orbital sanders
As their name implies, these work with an orbital—or oscillating—movement so they can be used equally well with or across the grain. They are designed specifically for fine-sanding large flat areas before they are painted or lacquered and should never be used for rapid removal of material; a disc sander will do this far more effectively.

Orbital sanders can be bought as attachments to your existing power drill or as integrals with their own in-built

motor. For the majority of jobs around the home there is little to choose between either of these options in terms of performance—although you may be discouraged from buying an attachment because of the time taken to secure it to a hand-held electric drill.

Orbital sanders are sold in two basic sizes—half sheet and one third sheet—describing the size of abrasive paper that can be fitted. A half sheet machine takes paper 115mm × 280mm (equal to a standard sheet of abrasive paper cut in half lengthways), while the one third sander takes paper 93mm × 230mm.

Specially sized sanding sheets are available in a variety of grades although you can easily make your own from good quality abrasive paper. The sheets should be the same width as the rubber pad mounted on the bottom of the machine but must be cut about 300mm longer to allow for fixing.

front handle
on/off switch
tightening clips
oscillating pad
abrasive sheet

F. Above: *Designed specifically for fine-sanding flat areas before painting, an orbital sander can be used along or against the grain*

7 *Light alloy discs impregnated with tiny grains of tungsten carbide can also be mounted on a drill—with or without the backing pad*

8 *These are particularly useful for rapid removal of thick layers of paint or for cleaning areas that have become covered in rust*

9 *When working with a disc, switch off occasionally so that you can check the condition of the abrasive paper and retighten the chuck*

Fig. F shows a fairly typical integrated orbital sander—although some models do have two handles, one mounted on each side of the main motor. Near the top of the machine usually on the underside of the handle is the on/off switch and switch lock control button.

The working end of the sander consists of a flat block mounted about 100mm below the handle. Below this is a rubber pad to which the abrasive paper is attached with either tightening screws or two adjustable clips. The only visible moving part of the machine is the rubber pad which oscillates at speed once the motor is switched on.

It is of vital importance to ensure that the abrasive sheet is secured correctly before starting work. Poorly fitted sheets quickly work their way loose or tear along the edges, causing damage to the rubber pad underneath. Make sure that the sheet is held as tightly as possible and that no part of the rubber pad is visible—especially along both outer edges (fig. 13).

Always switch on the machine before lowering it on to the workpiece. Hold the machine flat against the surface and work it slowly backwards and forwards in broad sweeps. Resist the temptation to press down too heavily: although this removes material faster, the abrasive paper will quickly become clogged and need to be replaced.

Stop the machine occasionally and check the state of the abrasive sheet. If it shows signs of wear and tear or is becoming clogged, replace it immediately with a fresh sheet. If a worn sheet is left on too long the sander will leave small swirls which are difficult to remove except by further sanding.

It is a good idea to start off with an abrasive sheet which is fairly coarse and work down to a fine abrasive sheet as the work progresses.

Belt sanders

A belt sander is a heavy machine that is intended for rougher work—such as stripping paintwork or levelling boards (see pages 230-233). It gets its name from the continuous belt or loop of abrasive paper which passes around two large wheels, one at the front of the machine, the other at the back.

Most belt sanders are large, heavy machines and it is more likely that you will hire one for special jobs rather than buy your own. However, there are a number of smaller models designed for domestic use.

If you want to buy a belt sander, look for one that is easy to use and control. Some have short handles fixed directly to the body of the machine, others have longer handles so that they can be used while the operator stands up (fig. 15).

It is essential to choose a model which is fitted with a dust bag. This is fixed behind the main body of the machine (see below) and collects dust, paint and other loose material from the surface that is being sanded.

Some models have a flat top so that the whole machine can be turned upside down and used as a bench-mounted sander. This can be a very useful device for rounding edges or for sanding small pieces of wood.

Fig. G shows a small domestic belt

10 Drum sanders consist of a sturdy foam cylinder with a belt of abrasive paper wrapped tightly around the circumference of the unit

11 Before starting work, try to ensure that the belt is fitted tightly against the backing and that none of the foam is exposed

12 Although they cannot reach into tight corners, drum sanders are ideal for sanding along the grain and for tackling gentle curves

13 Abrasive sheets are mounted on the underside of an orbital sander and are held in place by two tightening screws or metal clips

14 Orbital sanders are designed for fine-sanding large flat areas. With care they can be used on vertical surfaces as well as horizontal ones

sander and its component parts. It has a handle attached to the main body of the machine where the on/off switch and switch lock are situated. A smaller, rounded handle is fixed to the front of the sander so that it can be controlled more easily with two hands.

The sander has two rollers which carry the loop of abrasive. The front roller keeps the paper in line while the back roller provides drive from the motor mounted directly above it. On the side of the machine is a knob which adjusts the angle of the front roller to stop the belt wandering during use.

Abrasive belts are fairly easy to fit. Turn the machine over or support it at an angle on one of its bottom edges. Then release the tension lever between the rollers and push the two drive wheels together (fig. 16). Any old or worn belts can then be removed and a new one slipped into position over the rollers. Once the tension lever is retightened and the tracking knob adjusted so the belt runs smoothly and absolutely straight, the sander is ready for use (fig. 17).

Belt sanders are far more difficult to control than almost any other type of sanding machine and should be treated at all times with extreme caution. If your sander is of the smaller, domestic variety, pick it up and start the motor before lowering it carefully on to the surface; larger machines should be tilted on their back end before they are switched on.

Once the machine is in position, concentrate on keeping it in a straight line and on covering the whole area to be sanded. There is no need to press down on the sander—its own weight should be enough to keep it operating effectively. Switch off occasionally and check the condition of the abrasive belt. The dust bag can also be emptied at this stage if it is more than half full.

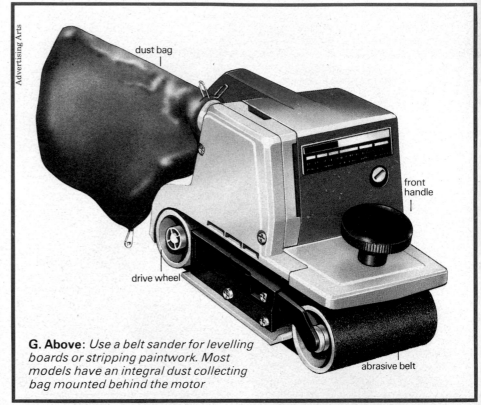

dust bag

front handle

drive wheel

abrasive belt

G. Above: *Use a belt sander for levelling boards or stripping paintwork. Most models have an integral dust collecting bag mounted behind the motor*

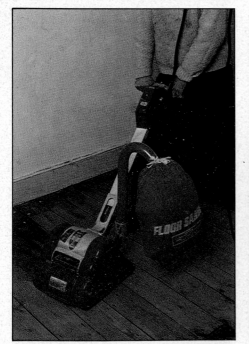

15 *Large belt sanders are ideal for levelling rough floorboards, but they are difficult to control and should be handled with extreme care*

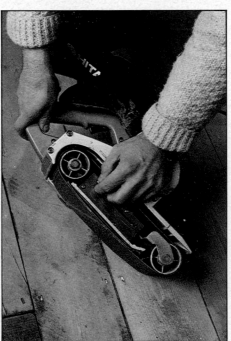

16 *Abrasive belts are simple to fit. Tilt the machine on to one side and then carefully release the tension lever between the rollers*

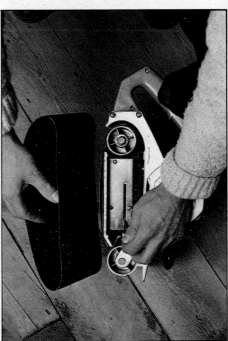

17 *A fresh belt can then be slipped into position over the rollers and the tension level retightened so that the belt is held firmly*

DECORATING

Wallpaper without fuss

Preparing the walls ● Stripping wallpaper ● The right tools for the job ● Matching the pattern ● Measuring and cutting ● Pasting and folding ● Papering around corners and sockets

A. *When papering over vinyl wallpaper, simply peel away the outer layer. The paper below can stay on the wall*

Wallpapering may look simple, but it is all too easy to get into a mess unless you know the right way to do it. Most of the techniques involved are easily mastered and will help give your walls a professional touch.

Preparing the room
Start by removing as much furniture from the room as possible, then remove all wall hangings—such as pictures, mirrors and lamps—together with their fixings.

To mark the future positions of the fixings in a masonry wall, stick a steel pin into each wall-plug—later, you can hang wallpaper over the pins and leave the fixings clearly marked. Protect the floor with dust sheets: polythene sheets tend to be too slippery and paper will make a mess if it gets damp.

Preparing the surface
Painted walls: Unless the paint is flaking or the surface is uneven, painted walls do not have to be stripped. However, make sure that the surfaces are completely free of grease and dirt. To give the new wallpaper something to grip on—especially if the surface is gloss—sand the surface and wipe clean.

Bare walls: Freshly plastered or rendered walls and walls that have been stripped to the plaster can be papered over with little trouble, providing they are free of damp. Your first task is to make good any chips or cracks in the surface with filler and to sand down bumps and bulges.

For the small blemishes normally

encountered when redecorating, use either a cellulose-based filler in powder form (such as Polyfilla), or a ready-mixed vinyl-based compound which comes in tubs.

Cellulose fillers are the cheaper of the two and are suitable for most internal uses, but the hard-drying qualities of vinyl-based fillers come in handy where the cracks result from expansion due to heat—around hot water pipes for instance.

The secret of using filler is to apply a little at a time, waiting for each layer to dry before you apply the next.

Sizing, or painting the wall with a suitable compound, evens out the absorbent qualities of the plaster or plasterboard (wallboard) and creates a smooth surface on which to wallpaper. If you are using a cellulose wallpaper paste (see below), use this as your sizing compound. For starch pastes a bone glue size is available. Vinyl wallpaper pastes require their own, special size. Leave the wall to dry thoroughly before you start hanging your paper.

Walls already papered: In most cases, it is inadvisable to lay fresh paper over an already papered wall—over-papering causes the paste between layers to interact, giving rise to

additional problems such as peeling, staining and blistering.

However, with vinyl-laminated paper, it is sometimes possible to peel away the vinyl layer from its paper backing strip. If the backing paper remains firmly and evenly pasted to the wall, you can paper directly on to it.

Stripping wallpaper
There are two methods of stripping wallpaper in general use: soaking and scraping—with or without a proprietary stripping compound—and steam-stripping, using a special tool.

Soaking and scraping tends to be a messy job and if just water is used to soften the paper it can also be hard work. So where medium and heavyweight papers are concerned, you can add either proprietary stripping compound or some vinegar or acetic acid—available from chemists—to the water.

Normally, the mix is simply painted on with a distemper brush. But if you are dealing with PVA-coated washable paper, you may need to score the surface with a wire brush so that the stripper can penetrate through to the wall. Leave the stripper to soak for

a few minutes, then use a stripping knife to scrape it away from the wall. Make sure that your knife is kept ground sharp. Ideally, it should be of the type which has a stiff steel blade incorporated into the handle—the cheaper varieties bend and gouge plaster out of the wall.

If a piece of paper proves particularly stubborn, paint on some more water, leave it to soak, then try again—on no account attack a stubborn patch with the scraper as you may damage the plaster. Like washable paper, thick layers of old paper can be shifted more quickly if you carefully score the surface first with a wire brush.

Steam stripping is about as fast as using water but requires much less effort, creates less mess and minimizes the chances of damaging the wall. You can hire a steam stripper quite cheaply from hire shops and, if your old wallpaper is particularly heavy, it is worth the cost.

To use the tool, you simply press the steam-generating pad against the wall with one hand (fig 1) and scrape off the loosened paper with the other. These operations soon become continuous with practice, although thick

1 A steam stripping machine makes light work of stripping heavier papers. Easy to use, it can be obtained from most hire shops

2 Taking the trouble to fill cracks in the wall before you paper over it will improve the overall finish. Build up the filler in layers

3 Sizing a plastered wall before you paper over it will stop the paste from soaking in too quickly and causing the paper to peel later

4 To mark up the wall for the first strip, measure the width of your roll along the wall from your chosen starting point and make a mark

5 Next, to give some overlap at the starting point, measure back 25mm from the mark. Repeat this procedure at the base of the wall

6 Now hang a chalked plumbline over the mark nearer the corner. Secure the line at top and bottom, and 'snap' it to leave a line on the wall

layers of paper may require more than one application.

Preparing to paper
A good working surface on which to cut and paste the wallpaper is essential. Ideally, you should use a pasting board about 25mm narrower than the paper you are hanging. Alternatively, use a sheet of chipboard or a flush-faced door—laid over a pair of trestles or the kitchen table. To help you reach the top of the walls, you will also need at least one pair of steps. Make sure that these are safe.

Arrange the equipment so that you can work on it comfortably and safely, not forgetting that you will often need both hands free to hang the wallpaper. At the same time, gather together all the other tools necessary for the job—plumbline, shears, tape measure, pasting brush, pencil and bucket. The shears are particularly important—try not to economize by using ordinary household scissors which are too small for accurate cuts on this scale.

One final preparatory step is to compare the shades of each separate roll of wallpaper. Where the batch numbers on the outer packing are the same, there should be no prob-lem. But especially if the numbers differ, check the colour of each roll and arrange them so that similar shades run next to each other when you come to paste them up on the wall.

Where to start
Where you start papering depends to a large extent on whether your wallpaper is subdued, or bold and striking. In the former case, follow the general rule that you should paper away from the light—otherwise any overlaps between strips will cast shadows.

Start at the end of a wall, or against a window or door frame, where you will have a straight run before tackling the more intricate bits.

Where the wallpaper you have chosen has a bold pattern, start with a feature wall or chimney breast which immediately catches the eye. Centre up the pattern so it is symmetrical, then work on from either side.

If your wallpaper pattern consists of strong geometric shapes, plan for the final strip to be hung in an obscure corner of the room—well away from the light—where the break in pattern is not too noticeable.

Measuring and cutting
The simplest way of measuring and cutting wallpaper is to offer each strip up to the wall as you go along. But use a plumbline to make sure that the first strip is straight or you will run into difficulties later on.

Having chosen your starting point, which should be in a corner or against a door frame, measure from this along the top of the wall 25mm less than the width of your roll and mark the spot with a pencil.

Secure a plumbline running from the top of the wall and through this point, rub it with chalk, then snap it against the wall as shown in fig 6. This leaves a vertical chalk line down the wall which in turn acts as a guide to help you position the side edge of the first strip.

Cut your first strip of paper about 50mm longer than the height from the ceiling to the skirting board (base-board). When measuring the next strip, use the edge of the first as a guide. Allow a 50mm overlap for trimming top and bottom, then mark and cut it as described above. If your wallpaper is patterned, make sure that you match the design from strip to strip—*before* you allow for your top overlap.

Wallpapers with patterns which match on each horizontal line can be matched in strips without difficulty.

7 Align your first strip of wallpaper against the chalk mark. Do not forget to allow for an overlap top and bottom

8 When you are cutting strips of wallpaper, take the overlap on to match the pattern. Fold the paper back on itself to keep the cut square

9 When pasting a strip, paste the edges of the strip off the table. This will avoid accidentally getting paste on the other side of the paper

10 Folding strips 'paste to paste' as shown makes them far easier to handle. The end you paste last will go at the top of the wall

11 Cutting strips lengthways is easier if you paste and fold them first. Mark cutting lines in pencil and slice them with the shears

12 When you have positioned a strip correctly on the wall, crease the overlaps, peel away the paper around them and trim

But if you find that you have to allow an overlap of about half a strip's length before the pattern matches, you have what is known as a 'half drop and repeat' pattern.

In this case, save on wallpaper by working with two rolls at a time. Take your first strip from the first roll, your second strip from the second roll, and so on.

At the end of the first wall, you will almost certainly have to cut a strip lengthways to get it to fit. Do this when the strip has been pasted and folded. Measure the width of the gap top and bottom, transfer these measurements to the whole strip, then mark the strip off with a timber straight edge. Cut down this line with the shears (fig 11).

Pasting and folding

When pasting wallpaper it is important to stop the paste from getting on the table (fig 9). Note that edges are only pasted when they overhang the table. Brush on the paste in a criss-cross 'herringbone' fashion, ensuring not only an even coverage but also that the edges receive plenty of paste. Work from the middle of the strip outwards.

When you have pasted about two-thirds of the strip, take the top edge in your fingers and thumbs and fold the strip down on itself. Make sure that the edges line up then slide the rest of the strip on to the table and paste it. Fold this back on itself as well, so that you are left with two folds—a large one at the top of the strip and a small one at the bottom of the strip (fig 10).

If your strips of wallpaper are particularly large, you may find that you will have to increase the size of the bottom fold. Short strips need be folded only once.

Ready-pasted paper must be soaked in water before hanging in order to activate the adhesive on the back. Having cut a strip to length and folded it to fit your water tray, immerse it for about a minute and move the tray to directly below the wall to be papered. You can then lift the strip straight out of the tray and on to the wall.

Hanging and trimming

Lift the folded strip off the pasting table, take the top edge in your fingers and thumbs and allow the top fold to drop. Lay the strip against the wall, in line with your chalk line at the side and with about 25mm of trimming overlap at the top. Brush

down the middle of the strip with the paperhanger's brush and unfurl the bottom fold.

Next, use the brush to form trimming creases at the top and bottom. Mark off the waste by running along the creases with the back of your shears, then pull the edges away from the wall again.

13 Where the paper goes over a switch or socket, crease an impression of the outline then make vee-shaped cuts to the corners

14 Trim away the flaps with a sharp knife. On circular switches, use the same procedure but make more cuts to the edges

15 When you are measuring thin strips before corners, do not forget to take measurements at both the top and bottom of the wall

16 Butt a strip before a corner up against the previous strip, then crease the overlap into the corner with the back of your shears

17 Always plumb a fresh line after turning a corner. As you hang the next strip, run the overlap into the corner, crease and trim it

18 On small sections of wall, there is no need to plumb a line. Align one side of the strip on the edge with the other overlapping

63

Cut along each crease mark in turn, pressing the finished edges down as you go. Run over the finished job with the brush to remove air bubbles —working from the centre of the strip out towards the edges and using short, light, strokes.

Butt subsequent strips up against each other so the side edges touch, but do not overlap. Make sure that the pattern matches at the top of the wall before you start trimming.

Switches and sockets
First offer up the pasted strip in the normal way, lining it up with your plumbed line or an adjacent strip. Brush the top part of the strip down against the wall to hold it in place, but leave the rest of the paper hanging freely over the obstruction.

Now press the strip lightly over the obstruction so that its outline is left indented on the paper. Pull the strip out from the wall again and pierce it with the shears, roughly in the middle of the indentations. Gently snip out to the four corners of the indented mark so you are left with

four triangular flaps (fig 13).

Papering around corners
When you come to an internal corner, paper into the corner with one piece and out again with another. As you paper in, allow about 25mm overlap and crease the paper into the corner with the back of the shears.

Whenever you paper out, plumb a fresh line on the adjoining wall first. As you hang the paper, align it with the plumbed line and make sure it goes well into the corner to cover the overlap on the previous strip.

Folding paper around an external corner is possible only if the corner is vertical and cleanly finished.

If you have any doubts, treat the corner as you would an internal one. Paper up to it with your first piece, allow an overlap of 25mm and fold this around the corner. Having plumbed a fresh line, hang your second strip, again allowing about 25mm over the corner for trimming. Make sure that the second strip is firmly stuck to the overlap of the first, then trim it flush with the edge of the corner.

Ideas for wallpaper borders

Used on their own, wallpaper borders add a touch of style and elegance to a plain painted room. It is also an inexpensive way of brightening up a room and achieving an original effect.

Available from most wallpaper and decorating shops, they are normally employed to finish off a semi-papered wall which has no picture rail. But the borders can often be used to better effect to highlight windows and alcoves, pick out fixed wall mirrors or extend architraves and covings.

The borders are pasted up in the same way as ordinary wallpaper. It is a good idea though, to pencil in the positions of the strips so that you can make alterations before they are stuck down.

To make the mitred (angled) joints between strips, cut them overlength so that they overlap one another. When you paste them up, put a piece of paper between the flaps then cut through the strips at the desired angle.

Papering a window reveal

Top right: *When papering into a window reveal or bay window, cut your first strip so that you can fold part of it round as shown*
Below: *Continue laying strips across the wall around the reveal. Leave the ends of the shorter strips hanging at this stage*
Below right: *Paper the top of the reveal, leaving enough overlap to turn each strip up onto the wall. Finally, stick the hanging ends down and trim them to length. Paper the remaining parts in the normal way*

Venner Artists

Elizabeth Whiting

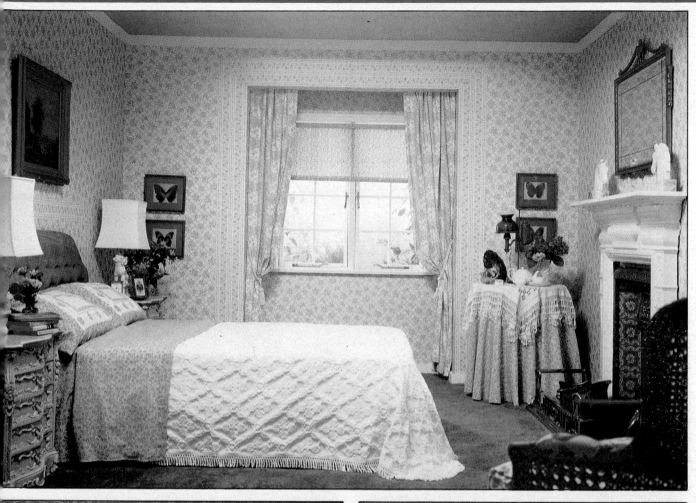

Papering ceilings

best for your chosen paper.

The ceiling must be sized, or lined with lining paper, to make it less porous before you start hanging. With cellulose wallpaper paste, you can use some of this, diluted, as your size. Cold-water starch pastes require a special glue size.

Lining paper
Lining a ceiling with lining paper is not essential but gives a more lasting finish—providing you hang it at right angles to the direction which the top paper will eventually take. Also, it prevents the ceiling plaster from showing through if gaps should appear between the joints of the top paper—embossed and Anaglypta papers have a tendency to shrink as the paste slowly dries out.

A final plus for using lining paper is that it absorbs paste more evenly than plaster, thus making it easier to apply the top paper.

Preparing the ceiling
Whether or not you decide to apply lining paper, the ceiling must be thoroughly clean and free from loose

● **Calculating paper requirements** ● **Preparing the ceiling** ● **Erecting a scaffolding system** ● **Chalking a guideline** ● **Single-handed papering** ● **Papering around light fittings and chimney breasts** ● **Cutting the final strip**

Papering a ceiling is not as difficult as it looks. With a sensible scaffolding arrangement and the right technique, the job is no harder than papering an ordinary wall.

How much paper?
First decide which way the paper is to be hung, as this determines how many lengths of paper can be obtained from one roll. A standard British roll of wallpaper measures about 10m long, is between 500mm and 550mm wide and covers an area of around 5.3m². A roll of Canadian wallpaper contains about 3.34m² of paper, so allowing for trimming, matching and cutting strips to size, around 3m² can be covered.

To estimate the number of rolls required for your ceiling measure the length of each wall (ignoring any protrusions such as chimney breasts) add the measurements together and match the total against the chart.

Other materials
All papers suitable for walls can also be used on ceilings. However, if you choose an embossed ceiling paper, remember that it turns yellow very quickly and must have at least one coat of emulsion paint applied after hanging. Heavily-embossed ones such as Anaglypta usually need two coats of paint for a good and even finish.

Different papers require different pastes for hanging and your wallpaper stockist can advise on which is the

How many rolls?

British measurements

Distance around the room in metres	No of rolls required
10.0—12.0	2
12.5—14.5	3
15.0—17.5	4
18.0—20.0	5
20.5—21.5	6
21.5—22.5	7

Canadian measurements

8.5— 9.5	2
10.0—13.5	4
14.5—16.5	6
17.0—19.0	8
20.0—21.5	10
22.0—23.0	12

or flaking paint. Gloss paint must be rubbed down with glasspaper and any cracks filled with a cellulose-based filler. Any old paper must be completely stripped off so the ceiling is left as smooth as possible for the application of the new layer.

Where to start

Where possible, all papering should start and work away from the natural daylight source. This system prevents shadows from obscuring the joints as you hang the paper. Obviously if there are windows at both ends of the room, either one may be used as the starting point. Where a bay window is involved, the first length should be hung across the opening of the bay. Then work back towards the top of the window.

Before you start papering, get yourself properly prepared so all essential equipment and materials are to hand. The erection of a proper scaffolding arrangement is the most important piece of preparation.

Scaffolding

Makeshift scaffolding is extremely dangerous. To be safe you need two pairs of sturdy stepladders and a wide scaffold plank.

Experiment with the positioning of the plank so you have it at a height which does not make you stoop or stretch as you apply the paper (fig. 1). Check the height by standing on the plank and reaching up to the ceiling—you should be able to touch it comfortably with the palm of your hand.

Marking a guideline

The scaffolding should be set up under a chalked guideline which marks the outside edge of the first strip. To work out where this line should run, measure the width of the paper and deduct 10mm. The deduction allows for bumps and other imperfections at the junction of the ceiling and the wall. Measuring out from the wall, mark off this measurement on the ceiling at either end of the first run of paper (fig. 2).

Next, fix a steel drawing pin into the ceiling at one of the measured points and tie a length of twine around it. Thoroughly rub the twine with coloured chalk then pull it taut across the ceiling to the other measured point and fix it securely. Pull the centre of the twine down from the ceiling, letting it snap back into place (fig. 3). This leaves an accurate guideline by which you can hang the first length of paper with just the right

A. *The most sensible scaffolding arrangement, shown here under the chalked guideline. Do not be tempted to use chairs or stools*

Bernard Fallon

amount of overlap at the side wall.

Cutting all the lengths of paper you need at one time is useful as it cuts down on the number of interruptions in your work flow. Measure the length of the first strip carefully against the wall allowing at least 100mm excess for trimming. Subsequent strips can then be measured and cut against it.

Pasting

To paste a length of paper evenly, slide it across the board so that it overhangs the edge furthest from you (the back edge) by about 10mm. This prevents the paste from being deposited on the board or on the other lengths of paper.

Apply a full brush of paste down the centre of the paper—the larger the brush the quicker the paste can be applied, thus avoiding the risk of drying before the paper is hung.

Brush the paste outwards over the back edge with an overlapping criss-cross action to avoid missing any patches of paper. Gradually draw the paper towards you, overhanging the front edge by about 10mm, as you apply the paste.

Folding

When you are sure that the length of paper has been completely coated in paste, fold it ready for hanging. Fold over the first 300mm paste to paste, lift the fold and place it on top of the next 300mm (fig. 4). Continue this pattern down the whole length to obtain a concertina-type series of folds. This enables you to release the paper in manageable lengths on the ceiling.

Before climbing up onto the scaffolding to hang the pasted paper,

make sure that you have a paper-hanging brush and a pair of sharp scissors or shears within easy reach—in the pocket of your apron or overalls. A cleaner cut is obtained if you take the trouble to clean the paste from your scissors after each length of paper has been trimmed.

Hanging the paper

Place a part roll of paper or cardboard tube under the concertina-folds of the pasted length—this supports the paper and should be held parallel and close to the ceiling at all times (fig. 6). If you are right-handed, take the roll, with its folded, pasted paper on top, in your right hand and hold the paper in place with your thumb—leaving the top fold free.

Pull this top fold open and lay it onto the ceiling against one end of the chalk line. Taking the brush, smooth down the centre of the section then to the edges to expel any air bubbles under the surface (fig. 7).

Make sure this first fold is running true to the line and then release the next fold and smooth it out in the same way. Any adjustments which are needed should always be made with the flat of the hand—never use fingers as the concentration of pressure may tear the wet paper.

When you have applied a few folds of paper, you can move around so that you are facing the roller and the folded paper. Walk along the platform, slowly releasing the folds and brushing them into place (fig. 8).

Continue hanging the paper in this way until the whole length has been pasted up. The surplus paper can now be trimmed off allowing 5-10mm to

remain hanging down the wall. This makes for a cleaner finish when the walls are papered. If you are papering up to coving (crown moulding), crease the paper against the edge to make a cutting guide, then trim off the excess.

Paste and fold subsequent strips in the same way as the first, applying them to the ceiling and using the edge of the previous strip as the guideline. Take care not to overlap the strips—they should only butt tightly up against each other.

To get a really neat finish and to ensure that the edges are well stuck down, use a seam or angle roller on the joints. The joints should be rolled after the paste has set—say every four lengths of paper.

The full face of the roller should not be used on embossed paper as the pressure will flatten out its design. In

B. *Butt the second strip of paper up against the first and hang it in the opposite direction for a smooth finish*

Bernard Fallon

1 *When you can comfortably touch the ceiling with the palm of your hand, then the scaffolding is in the correct position*

2 *Deduct 10mm from the width of the paper to find the right measurement for marking off the position of the guideline*

3 *Securely fix the chalked line at one end of the room. Hold the line taut against the other mark and snap it against the ceiling*

4 *Turn in the first 300mm of paper, lift this fold and put it on top of the next 300mm to make a concertina of the whole sheet*

5 *Thread string through the handle loops of the paste bucket and rest the brush on it. This keeps it free of excess paste*

6 *Support the folded, pasted paper with a roll of paper, leaving the top fold free ready to lay on the ceiling*

stead, use the edge of the roller directly on the joints.

Lights and chimney breasts
The paper will need to be cut so that it fits round obstructions such as light fittings. If the fitting is near the edge of a strip, you can cut from the edge of the paper inwards to the centre of the fitting (fig. 9). Make a few cuts outward to form a star pattern and press the paper over the fitting (fig. 10). Thread the loose electrical flex through the hole and smooth down the rest of the strip. Trim off the excess paper with a sharp knife.

Where the fitting comes in the centre of a strip, poke a hole through the paper with your scissors. Make star-shaped cuts outward from this point and finish off as above.

How you paper around a chimney breast depends on whether it is parallel, or at right-angles, to the direction of the ceiling paper.

When the chimney breast is at right-angles, make a cut along the length of the strip—equal to the depth of the breast minus the usual 10-15mm overlap—and smooth the paper into the corner. Repeat on the other side of the chimney breast.

If the chimney breast is parallel to the direction of the ceiling paper, smooth the paper right into the corner (fig. 11). This makes a crease mark indicating the depth of the chimney breast on that strip of paper. Crease another mark at the point where the side wall of the chimney breast and the ceiling meet.

Next, gently peel the strip back from the ceiling and cut down a line connecting the two creases. Replace the strip, checking as you smooth it down that the other side is lined up with your chalk line or correctly butted against the adjacent strip further out in the room.

As you continue along the face of the chimney breast, leave the excess paper to hang down the wall (fig. 12). When you get to the other edge, make a cut upwards from the waste edge of the strip. You can now smooth out the rest of the strip over the ceiling and trim in the usual way.

The final strip
The final strip of paper will almost certainly be narrower than a standard width. If this is the case, you will find it easier to hang and trim if the piece is measured and cut to size. Allow about 50mm extra on the strip then paste, fold and hang it as above.

7 *Lay the first fold of paper against the chalked line and smooth it out before applying the second and subsequent folds*

8 *Smooth the paper out as you go, expelling any air bubbles and always keeping the support parallel and close to the ceiling*

9 *Mark the position of the light fitting with your fingers and cut in from the edge of the paper towards the centre of the fitting*

10 *Make a few cuts outwards to form a star pattern which can be pressed round the fitting, and then trim off the excess paper*

11 *At the corner of the chimney breast, press the paper into place to make a mark and then peel it back so that it can be cut*

12 *The last cut should be a 'V' shape up as far as the mark to enable the rest of the paper to be pasted down the side of the chimney*

Liven up your ceilings

There is no reason at all for ceilings to be the most boring aspect of any room. Imaginative use of borders and bold patterns can liven up even the most bland ceilings.

The sunburst design **(below)** needs to be carefully marked out and masked off with tape after the ceiling has been given an all-over coat of paint.

To draw the circle in this design, you need a length of string and a piece of chalk. Tape the string to the centre of the ceiling rose and, with the chalk in the same hand, stretch it taut to the edge of the circle. Move slowly round until you have chalked a complete circle, keeping the string taut at all times.

The geometric design of the ultra-modern room **(right)** is composed of painted lines and a border paper. A novel way of creating impact on a ceiling, this also harmonizes neatly with the rest of the room.

Diminishing squares **(below, centre)** can be laid out either with different coloured paints, or plain and patterned borders. The same is true of the matching squares on the ceiling and walls **(below, right)**. In both cases, however, the effect is probably easier to achieve with wallpaper and borders as no masking off is involved.

All plain white ceiling paper should have at least one coat of paint to prevent it yellowing, which gives you an ideal opportunity to make it just that little bit different from the norm.

Elizabeth Whiting

Painting interior woodwork

Surface preparation ● Using a blowlamp ● Making good ● Which paint to use ● Painting doors ● The right way to set about skirtings and architraves ● Dealing with sash windows

particular attention to areas on doors which are handled often and to wax polished surfaces.

If the paintwork has been particularly exposed to grease, in a kitchen for example, use a proprietary paint cleaner. Rinse off with plenty of clean water and allow the surface to dry.

To key the surface for the new paint, old gloss must be abraded to remove its shine. Although glasspaper can be used for this, better results are obtained with wet and dry paper, used wet.

Dealing with damaged surfaces

Unless a damaged surface is thoroughly prepared beforehand, flaws such as blisters and bubbles will be accen-

1 *When treating woodwork that has been previously painted, abrade the old gloss to remove its shine and provide a key for the new paint*

Repainting the woodwork around the house will give your decoration a facelift for very little cost. And if you set about it the right way, you can be sure of a really professional finish.

Preparing the surface

Whether painting over new woodwork or a surface that has been painted previously, it is vital to make sure that the surface is sound, clean and dry.

With new woodwork, smooth the surface down with glasspaper, slightly rounding off any sharp edges. Treat knots or resinous patches with a knotting compound to prevent them from leaking sap through to the new paint. You can either buy this or make up your own from 70 parts of methylated spirit mixed with 30 parts shellac. Apply the knotting as accurately as possible, using a small brush or a pad of cloth wrapped round one finger. Fill cracks and open joints with a cellulose filler such as Polyfilla.

Above: *A light upward stroke of the brush will ensure that your painted surface is free from unsightly streaks and ridges*

To ensure that the paint adheres to the surface, new wood should be given a coat of primer. Primer also partially seals the wood surfaces, preventing leaking sap from spoiling the final coat of paint.

Check that the primer you use is suitable for the particular type of wood to be painted. Highly resinous wood should be treated with aluminium wood primer which has very effective sealing qualities. If in doubt about which primer to use for a particular job, consult your paint dealer.

In most cases, previously painted woodwork needs no more than cleaning and lightly rubbing down to prepare it. Remove all dirt and grease by washing the surface with warm water and detergent or sugar soap, paying

2 *When the old paintwork has been sanded, wipe over it with a cloth dampened in white spirit to remove any traces of dust and grease*

tuated and may spoil the finish.

Blisters and bubbles are usually caused by pockets of moisture or resin which become trapped beneath the surface of the original paint coat. Use a sharp knife to cut out the blistered paint, smooth off the hard paint edges with glasspaper then treat the area with multi-purpose primer.

Large or resinous knots and small resinous patches in woodwork should be treated with a knotting compound.

Flaking paint is most likely to be found on window frames which have been affected by the weather and by condensation. Remove as much of the loose paint as possible with a paint scraper or sharp knife (fig.3). Smooth down the area with glasspaper until all the remaining paint is quite sound. Any knots that have been exposed in this process should be dealt with as described above.

Cracks occur when wood joints have dried out or split. The most common problem areas are window frames, architraves—the mouldings around doors and windows—and the corner joints in skirtings (baseboards). Start by widening the cracks with a sharp knife, raking out any dust and dirt as you go. Prime the enlarged cracks and plug them with cellulose filler (fig.6). When dry, smooth with glasspaper (fig.7) and prime with a multi-purpose primer.

Particularly large or deep cracks should be filled in layers. Allow each layer of filler to dry before you start to apply the next.

Chips and dents develop through general wear and tear. Correct them as you would blisters and bubbles, using cellulose filler to level up the areas with the outer paint coat. When dry, sand smooth and prime.

Stripping paint

If a painted surface is particularly badly damaged, strip the paint off completely. Although paint can be stripped using just a paint scraper this can become tiring over large areas. More efficient methods of removing paint are chemical stripping or heat stripping with a blowlamp (propane torch) and scraper. However, use a low flame—and extra caution—when stripping window frames with a blowlamp as the heat may crack the glass.

If you decide to use a blowlamp, buy a special paint-stripping head which spreads the flame over a wider area (fig.8). Use a waste tin to catch the pieces of hot paint, making sure none falls on the floor.

Begin stripping at the bottom of an area and work upwards, covering only a small area at a time. Play the flame from side to side to avoid burning the paint and charring the wood. As the paint melts, scrape it off holding the scraper at an angle so that shreds of hot paint do not fall on to your hand. For stripping mouldings, use a shave

3 *Remove any flaws on the surface of old paintwork, such as flaking paint around removed door fittings, with a paint scraper*

4 *Paint on the areas around window frames and glass panels in doors often flakes. Scrape off as much of the old paint as possible*

5 *Use a paint brush to apply primer to any areas that are chipped or dented, or where old paint has been stripped altogether*

6 *Use cellulose filler to fill in any chips and dents in the wood, so that the damaged areas are brought up level with the existing paintwork*

7 *When the cellulose filler is dry, smooth the area with glasspaper wrapped around a wood or cork block, then prime the area again*

8 *Use a paint-stripping head when stripping paint with a blowlamp. Play the flame from side to side to avoid charring the wood*

hook (fig.9). When all the paint has been stripped off, prime the bare wood.

Undercoats

If you are painting new wood that has only been primed, or over paintwork of a different colour, it is advisable to apply an undercoat to provide a good key for the final coat of gloss. Check the paint charts when buying the gloss and undercoat to make sure they are compatible. Leave the undercoat until dry—the manufacturer's recommended drying time will be given on the tin—before applying the gloss top coat.

Gloss paint

Interior woodwork is traditionally painted with gloss or semi-gloss paint. Doors, skirtings and window frames all take quite a few knocks and gloss paint stands up to hard wear better than flat paints—as well as being easier to clean with a damp cloth.

Traditional gloss paint is oil-based and includes resin to give it hard wearing qualities. Acrylic paint is a water-based gloss which is jelly-like in consistency, and does not drip. It should never be stirred, however, as this will reduce its non-drip qualities. If applied incorrectly, gloss shows up blemishes and brush marks more than any other type of paint. It is therefore vital to use proper brush strokes.

Apply ordinary gloss quickly, evenly and in as full a coat as possible. Using acrylic paint, apply a little at a time and take care not to overbrush or runs will occur. For small areas of woodwork, your brush strokes should always run the same way as the grain of the wood.

In large areas, brushing in three different directions will help you obtain a smoother finish. Start by applying the paint in a random way, criss-crossing the brush: when a section has been covered, draw the brush over the paint horizontally.

Finally, 'lay off' the paint by running the brush upwards over the paint very lightly so that no mark is left (fig.10).

Painting doors

Doors are not as easy to paint as you might think. To make the job easier, start by wedging the door base against the floor with a wedge or screwdriver. This will stop it from swinging shut, and perhaps ruining a wet edge. Remove as much metalwork as you can including handles, knobs and key escutcheons.

When painting flush doors, start at the top and work down in rectangular sections using a 75mm brush. Work quickly so that the paint does not harden before you have completed an adjoining section. Blend the sections carefully as you go, to eliminate any overlap marks.

Apply the paint by making two or three separate down strokes. Without reloading the brush, fill in any gaps by

9 Use a shave hook when stripping mouldings. To prevent shreds of melting paint from falling onto your hand, hold the tool at an angle

10 To ensure that no brush mark is left on finished paintwork, 'lay off' the paint by running the brush upwards with a very light stroke

pencil (or wire)

string

Above: Two tips to stop your paintbrush getting in a mess and to keep the bristles in perfect condition

Bernard Fallon

11 For mouldings on panel doors, use a 12mm brush. Apply the paint sparingly so that it does not accumulate in ugly ridges

12 When painting panels, start brush strokes from the edges and work towards the middle. Blend the edges to eliminate overlap marks

13 To keep paint off glass, protect it with a paint shield. If paint does get onto the glass, wait for it to dry, then scrape it off

John Ward

A. *The painting sequence for a panel door. Panel doors should be painted in one session without pauses*

cross brushing then gently lay off the paintwork. When you are painting the edge of the door, use a brush slightly narrower than the width of the edge. If you use a wider brush, paint is likely to run down the front and back surfaces of the door.

Panel doors should be painted in a strict sequence (fig.A) and as quickly as possible—any pauses will result in the formation of a hard edge which is almost impossible to remove.

When painting mouldings in a contrasting colour to the rest of the door, use a 12mm brush to work the paint well in to each corner (fig. 11). Do not overload the brush or paint will accumulate in ugly ridges.

Skirting and architraves
Start painting skirtings (baseboards) at the top edge and architraves at the edge where they meet the wall.

To brush up, or 'cut in' to the wall at this point, use a cutting-in tool— a specially angled brush—or a 25mm

B. *To 'cut in' where a skirting board or an architrave meets the wall, use a shaped cutting-in brush*

brush on its side. Avoid overloading the brush, dipping it only about 13mm into the paint. Cut in with one, continuous stroke, supporting your 'painting' hand with the other hand to steady it.

If walls are to be papered, extend the paintwork about 10mm up the wall above the skirting.

Paint the remaining parts of skirtings and architraves with a wider brush—50mm or 75mm—following the grain of the wood.

Windows
The paintwork on wooden windows must be kept in good condition if the frames are to be prevented from rotting. You should therefore take the opportunity of painting the top and under edges of any opening frame at the same time as the visible ones.

Remove any window fittings such as sash fasteners and make sure that the surface is clean and sound. Clean the glass, to prevent any dust or dirt on it from falling on to the wet paint.

To keep paint off the glass, you can if you wish mask up each pane. This is best done with an aluminium or plastic paint shield (fig.13)—obtainable from do-it-yourself shops— or masking tape. If paint still penetrates on to the glass, wait until it is dry then scrape it off with a paint scraper or a sharp knife.

Casement windows, like panel doors, should be painted in a strict sequence (fig.C). Paint in the direction of the grain and use a cutting-in tool, or narrow brush on its side, to cut in where the paint meets the wall and the window pane.

To paint a double-hung window, begin by pulling the bottom sash up

and the top sash down to expose the meeting rail. When the bottom parts of the top sash have been painted, almost close the window then paint the remaining areas (fig.D). Finish off in the order shown for casement windows.

For safety at each stage of painting, fix the sashes in position with a small wooden wedge. Wait until the paint is quite dry before closing the window or it may stick fast.

C. *Casement windows should be painted in a strict sequence. Paint the top and under edges of the frame as well as the visible areas*

D. *The painting sequence for a double-hung window. Finish off in the order shown for casement windows*

Dress up your doors

Most people paint their doors in single plain colours. But, with a little imagination and the use of different colours and designs, a dull door can be made to enhance the appearance of a room. On panel doors you can paint the panels and mouldings in different colours or, if preferred in differing shades of the same colour. Stripes and designs can be painted onto flush and panel doors, with the use of masking tape, and extended across the adjacent walls. For a really modern look, try painting a design onto a door that matches, and draws attention to, a nearby picture on the wall.

Even more adventurously, a children's room can be transformed by a cartoon character on the door or, as in the picture below right, occupying a whole wall. Either way, you enlarge the cartoon by dividing it into a grid pattern of tiny squares and the wall into corresponding, larger squares.

Skirting boards can also be painted imaginatively to liven up the look of a room. For instance, if you decide to paint a coloured stripe across or around a door, try painting the skirting board in the same colour or a matching shade. Here are just a few ideas to brighten your home.

Elizabeth Whiting

Elizabeth Whiting

Left: *'Door with a difference' uses strips of the green wallpaper in the middles of the panels, with a border painted to match the bedspread*

Below: *A subtler scheme using dark blue, light blue and white to echo the colours of the wallpaper, carpet and furniture*

Above: *Bold, colourful stripes enliven a children's room. Each stripe must be masked off with masking tape and painted separately*

Below: *Adding adventure to a boys' room, a striking cowboy cartoon panel occupies not just the door, but the whole wall*

Camera Press

Bill McLaughlin

Painting
walls and ceilings

Long-lasting paintwork on the walls requires a methodical approach. The way to achieve a really professional finish is to prepare the walls carefully and master the art of using rollers and paint brushes

When you are painting walls and ceilings, bear in mind the preparation of surfaces for paint is the most important part of the process. Without a smooth, clean and dry surface, no amount of care in applying the paint is going to give a professional finish.

New plaster
Make sure that new plaster is absolutely dry before applying paint to it: water trapped in the plaster weakens the adhesion of the paint and may cause blistering. Some plasters have an alkaline nature and when the plaster dries out, white, fluffy alkaline crystals may be deposited on the surface. Remove these deposits with a dry brush before painting.

The plaster should, in any case, be dry-brushed before painting to remove surface dirt, and scraped to remove any plaster splashes. Make good any cracks or holes with a plaster-based or cellulose filler.

After preparation, the plaster must be sealed. If you are using emulsion (latex) paint, a coat of emulsion thinned with water is sufficient. With oil-based (alkyd) paint use alkali-resisting primer.

Wallpapered surfaces
It is advisable to remove existing wallpaper before painting, as it is never possible to know how well the paper is adhering to the surface and the finished work can be spoiled later by unsightly blisters or lifting edges. Also, it is not normally possible to wash ceiling and wallpapers so nicotine and other deposits on the paper may be left which stain the paint coating. This is especially true of emulsion paints, which are particularly good for dissolving nicotine. Stripping the wallpaper can be quite a difficult and time-consuming job. If you have a large area, hiring a steam stripper will save a lot of time.

Old plaster walls
After stripping the old wallpaper, it is important to remove any trace of paste and size left on the surface as these can cause newly-applied paint to flake. Remove old paste by washing the wall with warm water and, when the surface is dry, sanding it with glasspaper. Afterwards, fill the surface in the same way as you would do for new plaster.

If the surface is a mixture of bare plaster and painted areas, you can achieve a more uniform surface by first covering the wall with a heavy-duty, 600 grade lining paper. Make sure that it is stuck well to the surface before you start painting.

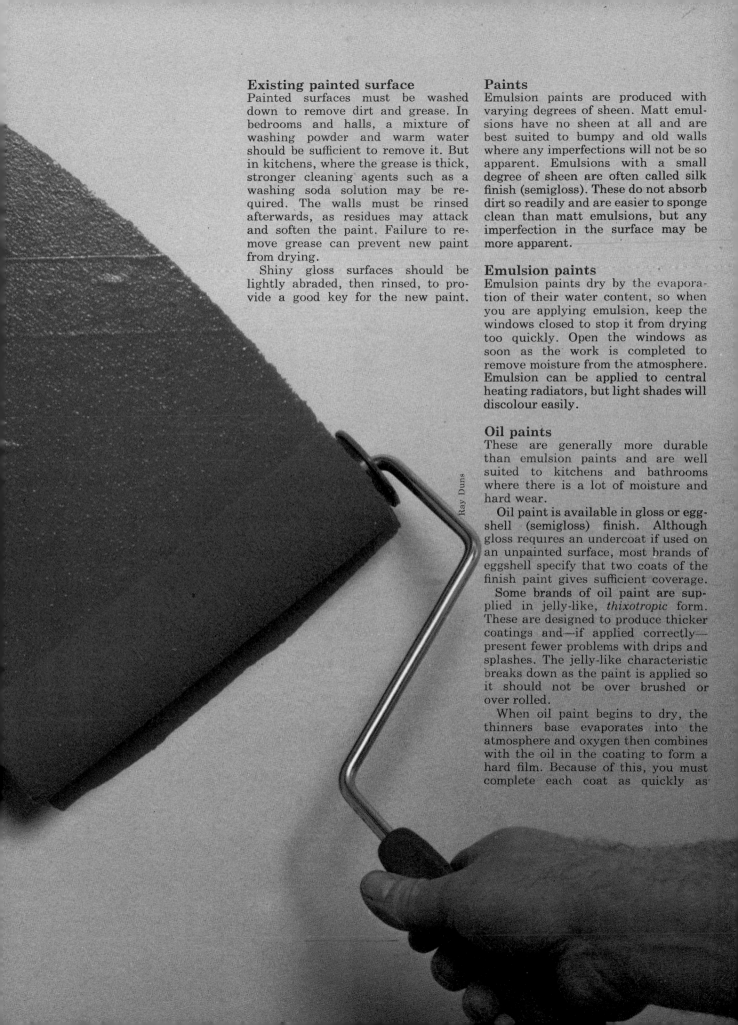

Existing painted surface

Painted surfaces must be washed down to remove dirt and grease. In bedrooms and halls, a mixture of washing powder and warm water should be sufficient to remove it. But in kitchens, where the grease is thick, stronger cleaning agents such as a washing soda solution may be required. The walls must be rinsed afterwards, as residues may attack and soften the paint. Failure to remove grease can prevent new paint from drying.

Shiny gloss surfaces should be lightly abraded, then rinsed, to provide a good key for the new paint.

Paints

Emulsion paints are produced with varying degrees of sheen. Matt emulsions have no sheen at all and are best suited to bumpy and old walls where any imperfections will not be so apparent. Emulsions with a small degree of sheen are often called silk finish (semigloss). These do not absorb dirt so readily and are easier to sponge clean than matt emulsions, but any imperfection in the surface may be more apparent.

Emulsion paints

Emulsion paints dry by the evaporation of their water content, so when you are applying emulsion, keep the windows closed to stop it from drying too quickly. Open the windows as soon as the work is completed to remove moisture from the atmosphere. Emulsion can be applied to central heating radiators, but light shades will discolour easily.

Oil paints

These are generally more durable than emulsion paints and are well suited to kitchens and bathrooms where there is a lot of moisture and hard wear.

Oil paint is available in gloss or eggshell (semigloss) finish. Although gloss requires an undercoat if used on an unpainted surface, most brands of eggshell specify that two coats of the finish paint gives sufficient coverage.

Some brands of oil paint are supplied in jelly-like, *thixotropic* form. These are designed to produce thicker coatings and—if applied correctly—present fewer problems with drips and splashes. The jelly-like characteristic breaks down as the paint is applied so it should not be over brushed or over rolled.

When oil paint begins to dry, the thinners base evaporates into the atmosphere and oxygen then combines with the oil in the coating to form a hard film. Because of this, you must complete each coat as quickly as

possible and have adequate ventilation as you apply the paint. Lack of ventilation allows the solvent fumes to be inhaled: this combined with a lack of oxygen can result in headaches and nausea.

Painting ceilings

The most important considerations when painting ceilings are to have a suitable scaffold arrangement (see pages 67-70), to avoid the temptation to over-reach and to ensure that there is sufficient light to show up the wet edge between the applied paint and the unpainted surface.

Painting walls

As with ceilings, it is most important that the wet edge is not allowed to set before more paint is applied. If this happens, the paint does not flow together and thick ridges appear.

Unless the walls are very high, a pair of stepladders are sufficient to reach all points. Start painting in the top corner, coating about one square metre at a time (fig. 8). When this is complete, paint a similar-size area directly below it and continue in this way, down to the skirting board.

This method gives you a metre-wide band the height of the room—which should be completed before the next section is started—and keeps the size of the wet edge to a minimum.

Recommended equipment

Brushes should be as large as you can handle—130mm or 150mm are the most suitable sizes for emulsion paints, while 75mm or 100mm brushes are better for applying the more viscous oil paints.

If you use a roller, mohair or short-pile synthetic coverings are suitable for smooth surfaces. For heavily-textured surfaces such as plastic texture paints or heavily-embossed papers, lambswool or medium-pile synthetic covers are more suitable. Foam rollers are not suitable for applying oil paints as the thinner in them may soften or dissolve the foam. Make sure that you have a proper roller tray, to match the size of roller you are using.

Applying the paint

Apply brushed-on emulsion in all directions, using long sweeping strokes to give a full, level coat of the paint. Use a smaller brush of about 25mm to apply the paint behind pipes and in other awkward areas.

A similar method is used for applying emulsion paint with a roller. Coat

1 Pull off any loose wallpaper first, then brush water liberally on to the paper which cannot be taken off easily by hand

2 Allow the water a few minutes to soak in, then use a paint scraper flat to the wall to remove the paper without damaging the plaster

3 Old varnishes are sometimes difficult to remove so use a stiff wire brush to bite into the surface of the paper

4 When you have removed all you can with the scraper and scratched the surface, brush more water on the paper and repeat

the roller evenly with paint and roll in all directions, making the final strokes lighter to cut down the texture imprint which is produced by the roller pile.

Brush on oil paints with much firmer strokes, making sure that there is not too much paint on the brush. Oil paints are more viscous and without good, firm strokes they will **run or sag.** Apply the thixotropic type paints firmly in all directions and leave them to flow out smoothly of their own accord.

Oil-based undercoats and gloss must be applied in three distinct phases:
● Spread the paint in all directions to give an even distribution.
● Cross the paint with firm, horizontal strokes.
● Lay off the paint with light, vertical strokes.

5 If you are using a steam stripper, work in straight lines from the bottom of the wall and let the steam rise up the wallpaper

These three phases must be carried out fully on each square metre at a time. The final laying off should be a vertical action which lightly leaves the surface as it extends into the finished area directly above it. This action is certainly worth practising.

Remember that paint can only be brushed while it is still wet—brushing after the thinners have evaporated results in an unsightly mess. It is for this reason that once a wall or ceiling has been started, you should complete it without a break. Having the correct scaffolding helps to maintain continuity and avoids wasting time moving furniture or short steps.

Drying
Most water-based paints can be given a further coat after approximately four hours, depending both on the temperature and humidity of the room and on the porosity of the surface.

Oil paints may appear dry after about three hours but if further coats are applied at this time, you will find that the existing coat starts to soften and pull off onto the brush. This is due to the action of the thinner in the paint which is being applied. If you are not certain that the coating is sufficiently hard to paint over, leave it until the next day.

If the paint is not dry after 24 hours, it is probably due to poor preparation of the surfaces—grease, in particular, retards the drying of emulsion paints. If an emulsion paint has been applied to a shiny surface, the coating may break up and expose the surface underneath. This is called 'cissing' and can only be remedied by washing off the emulsion while it is still wet and further abrading the surface to remove its gloss.

Joining colours
Attractive decoration schemes can be ruined when the divisions between colours are not precise—such as the meeting of the ceiling and wall, or the wall and skirting board.

To achieve a straight line between ceilings and walls, paint the ceiling colour a little way down the walls. When the paint is dry, measure down from the ceiling about 10mm at both ends of the wall and snap a chalked line between the marks (see pages 66 to 70) to produce a straight line. Carefully paint the wall colour up level with this. The same technique can be used if the walls are of different colours.

Though it is difficult to produce a long, straight line freehand with a brush, and even harder with a roller, the problem can sometimes be overcome.

Masking tape can be applied above and along the chalk line, but must be removed as soon as you have painted up to it. As well as being expensive and time consuming, this method only really works well on smooth surfaces: on textured surfaces, the paint tends to 'creep' underneath. Tape should never be used on walls which have paper underneath the paint as the adhesion of the tape to the surface will pull off the paint when it is removed.

A more successful method of painting a straight line is to run a small paint pad along a wooden straight edge. This method is suitable for both oil and emulsion paints.

Cleaning equipment
Remember that paint dries on rollers and brushes just as easily as on walls or ceilings, and is difficult to remove once it has dried. So, if you have to pause while painting it is important not to let the equipment dry out.

Stand brushes and rollers which have been used for oil paints in enough water to cover the bristles and prevent air from getting to them. Shake this water from the brushes before using them again.

Brushes and rollers which are being used for emulsion paint should never be soaked in water, as this will thin the paint contained in them. Instead, you must wash them out and dry them after every session of work, though for very short breaks, you can wrap them in plastic or a damp cloth.

6 When using a roller to paint the wall, use a small paint brush to cut in at the corners before painting the main area

7 When you have cut in the line at the edges, paint the first strip. Make sure the handle join of the roller is not against the corner

8 It is best to paint an area of 1m² at a time, working from the corners where you have cut in and overlapping and crossing the strips

9 Extend the strokes of the roller out from each completed area and get a smooth, even coat by criss-crossing each strip of paint

How to paint a mural

A mural in a child's bedroom gives the room an atmosphere of fun and enlivens the decoration—often making a small square room more interesting.

Painting murals may at first appear an awesome project, but is often surprisingly simple. The most important rule is to ensure that the image you want to portray has very straightforward lines, so that the process of painting the detail is not too complicated. The method illustrated here is almost as simple as painting by numbers except that you have to map out the paint areas yourself.

The size of the mural depends on the scale of enlargement you employ. This in turn depends on the size of the wall space available and how much of it you wish the design to cover.

First, site the mural where it will have the most effect. It is best to allow a border area of bare wall so the picture has some background relief. When you have decided on the location, mark out the grid with a soft pencil making sure that the point does not score into the surface of the plaster.

Mark the vertical line at the edge of the square using a plumbline or spirit level and a straightedge such as a metre rule. Lightly pencil in this reference line for the grid. For the mural shown here, the line must be broken up into 13 equal points for the horizontal lines. Make the vertical line, therefore, about a sixth longer than you wish the height of the mural to be, allowing for the area within the grid

at the top and bottom which is not painted. Divide the length of the line by 13 and mark the points for the horizontals. Then mark the top horizontal in the same way—with a spirit level and straightedge—and set the points for the vertical lines at the same distance apart (this time only 11 are needed) Draw in the grid from these points, taking great care to get them level.

When this is done, mark in the image lightly in pencil, following the pattern grid and working methodically from left to right along each row of squares. Use emulsion paint to fill in a large image and poster paints for a smaller one.

This process can be applied to enlarge any illustration to mural size.

Painting exterior wood and metal

● Choosing the best time to paint ● Tackling difficult areas ● Preparing surfaces ● Painting in the correct sequence ● Metal gutters ● Aluminium garage doors ● Timber surfaces

Above: *Before painting plastic gutters clean them with a piece of steel wool and a bucket of water*

Painting the outside of your house is by far the most demanding and time-consuming type of decoration you can do. It is obviously not work you want to repeat often so careful planning, the right tools and materials, and an extremely methodical approach are important. This way, you can be sure of an attractive and durable finish.

When to paint

Although spring is the traditional time to paint the outside it is not necessarily the best time. If the exterior wood and metal need painting in the spring, no doubt they needed it in the autumn; and the ravages of winter can worsen the condition of the paintwork and make your job far harder.

Early autumn is a good time for painting, providing you can be sure of finishing before winter sets in. Should the work be delayed by bad weather, conditions can only get worse and you will probably have to leave it until the following spring. Days are also shorter at this time of the year and evening painting is rarely possible as the light fails.

If you intend to paint in the spring, it is worth a weekend's work in the autumn scraping back peeling paint from the timber and metalwork. Coat the patches with an oil-based primer to protect the surfaces during the winter months.

Ideal conditions for exterior painting are rare. If you try to paint when it is raining, the water will prevent the paint getting a good grip on the substrate—the bare surface—and after a short period it will flake or peel off. Rain falling on a recently painted surface forms small craters which reduce the gloss and spoils the appearance very rapidly.

Even a heavy dew forming on a paint film before it is dry can cause the gloss to disappear completely. And if varnish is used in these conditions, it may turn milky.

In late summer or autumn, it is best to finish painting about two hours before sunset to reduce the risk of condensation.

Extreme heat causes the paint to set very quickly and reduces its flow as you apply it—resulting in severe brushmarks or a textured, 'feathered' finish. High temperatures also thin the paint film, reducing its effectiveness and covering power.

Painting in high winds should be avoided as they carry dust which deposits on the wet paint and spoils the finish. And winds make any ladder work very precarious.

Cold weather makes the paint thick and hard to mix, so runs are more likely to occur. It can also delay the drying time of the paint and you may have to wait up to two days before applying a second coat.

The worst areas

Exterior paintwork rarely deteriorates to the same degree throughout a building. You will probably find that the paintwork on the wall of the house which faces the sun breaks down quicker than on other aspects. It is here that you should concentrate your renovation work—a complete repaint is not always necessary.

The first sign that a paint film is coming to the end of its effective life is when the gloss disappears. The paint becomes porous, and severe winter frost and rain will quickly penetrate it. If you prefer to do the whole house at one time, try to make up for the relative levels of deterioration by putting an extra coat on the most exposed or sun-facing surfaces and on any other face which shows signs of rapid breakdown.

Checking for damage

Check all surfaces very carefully before starting preparations: the paint film which appears firm can often hide a decaying substrate. Usually, flaking paint indicates that the surface is wet, rotting or rusting.

Scrape the paintwork and prod the timber surfaces to ensure that there is good adhesion and sound material underneath. If the timber is rotten, it must be removed and replaced with sound, seasoned wood. Paint does not halt corrosion or wood rot and to ignore such defects will result in very expensive repairs in later years.

Investigate the sources of damp around affected timber and put them right before starting to paint. Damp may be entering through porous brickwork, a broken downpipe or maybe a perforated damp proof course. Replace andy broken windows or damaged putty and check all mastic or caulking seals.

Where to start

Always start work at the top of the house so that at no time are you painting, or preparing, above finished work. Your main objective is to avoid having to move the ladder or tower scaffold more often than is absolutely necessary. Plan your sitings carefully before starting so that you can safely reach as large an area as possible and carry out as many processes as you can in that position.

It is not a good idea to apply two coats of oil-based paint in one day, but you can leave the scaffold in position and apply the second coat the next day. Afterwards, move the scaffold in reverse order back along the house.

Priming or undercoating can usually be carried out as soon as the surface

has been prepared, so avoiding a scaffold move between preparation and painting.

Metal gutters and pipes

Cast-iron or mild steel gutters and cast-iron drainpipes rust if they are not properly protected. Always take the opportunity to clean out and paint the inside of gutters when you paint the outside.

Scour the surfaces of both sides of the gutters with a wire brush. If rust is left on the surface it will continue to form under the paint film and eventually cause flaking. Young rust can be detected when there is a dull shine on the metal. This should be removed as well (fig. 2).

When you have cleaned the surfaces, dry them thoroughly with rags or *carefully* pass a blowlamp over them. The bare metal areas are then ready for immediate priming before any moisture can settle and restart the rusting process. The primer should overlap the sound paint around the derusted areas by about 5mm.

Calcium plumbate is an excellent primer for both iron and timber but if there is any possibility of animals or young children coming into con-

1 *Clean out all the accumulated dirt from the inside of the gutter. Make sure that the down-pipes are free of any blockages*

2 *Use a wire brush to ensure that all rust is removed from the inside of the guttering. Try to clean down to bare metal*

tact with the paintwork, use a non-toxic metal primer with a zinc chromate base for protection.

When the primer on the bare area is dry—after 24 to 48 hours—wash all the surfaces with a detergent solution to remove accumulated grime and dry them with a rag or chamois leather. You can then apply an oil-based undercoat to the primed areas.

After the patches of undercoat are dry—at least eight hours later—apply undercoat to the entire surface. When

this is dry follow it with a coat of gloss paint. For gutters, 25mm is the handiest size of brush.

Although you can paint the insides of gutters in the same way as the outsides, it is cheaper to use either black bitumastic paint or a thick coat of any gloss paint left over from previous jobs (fig. 4). Be sure to prime all bare areas before applying either paints. If you use bitumastic paint, keep a tough brush solely for this purpose; traces left in the bristles can

Sequence for Exterior Painting

Start all preparation and painting work on a house exterior at the top and work downwards. Following the correct sequence ensures that the whole exterior is completed and no painting interferes with or spoils any other part.

1 Gutters: *Start at one end of the roof and work around the house*
2 Eaves: *Prepare and paint the eaves working from one end*

3 Fascia and barge boards: *Begin at the ridge and work down the board*
4 Downpipes: *Prepare and paint these working from top to bottom*
5 Brickwork: *This should be cleaned and pointed before painting*

6 Rendering: *Fill in any cracks and render walls where necessary*
7 Doors and windows: *Complete the sequence by painting any wooden walls, front and garage doors and windows as well as wooden railings*

Venner Artists

3 Wash out the inside of the gutter and dry it thoroughly with a cloth or with the flame from a blowlamp

4 Prime the bare metal. After 24 hours apply undercoat and finish off eight hours later with a top coat of black bitumastic paint

5 Downpipes and fittings should first be cleaned with a wire brush. This is a good opportunity to check fixings

6 Make sure that any areas of bare metal around fixings are liberally painted with primer as these areas are more likely to rust

seriously affect the colour and drying of oil paints.

Treat all downpipes (downspouts) as for gutters. If the pipes are black, check first if they are painted with bitumastic either by rubbing with white spirit, which will quickly dissolve bitumastic, or by applying a white undercoat to a small section to see if it becomes stained.

Pipes painted with bitumastic will not take an oil-based finish unless you seal them first with stop-tar knotting or aluminium paint. Do this after the surface has been derusted, primed and washed with detergent. Apply undercoats direct to the sealer when it is thoroughly dry.

You can also paint plastic gutters and downpipes. These need to be cleaned thoroughly with strong detergent solution, scoured with fine steel wool, dried, and painted with two coats of gloss paint. Gutters painted in this way then match metal ones.

Windows

Metal windows are usually made from galvanized steel and do not rust. But if they are very old and badly maintained, the zinc coating may fracture allowing the metal underneath to rust. In such cases remove the rust with medium grade steel wool or a flap-wheel drill attachment and prime immediately with a calcium plumbate or a proprietary zinc chromate metal primer.

Make sure that you remove all traces of steel wool before you prime, or they will rust under the paint and stain the gloss finish. If you use an electric drill with a flap wheel, wear safety goggles and make sure that the drill is correctly earthed.

If paint is flaking but the galvanized metal underneath is in good condition, this indicates that there is poor adhesion and all the paint should be removed. You can do this easily by dry scraping with a 25mm stripping knife or the flat side of a shave hook.

Use a spirit paint remover, suitable for use on painted metal, on the more stubborn areas. Most paint removers are rinsable, so a final wash with a detergent solution will remove all traces of the solvent and leave the metal clean for priming.

If there are no signs of rusting or flaking, wet abrade the old paint film with a grade 240 wet-or-dry paper. Put detergent in the water to make the rubbing down easier. When the surface is rinsed and dried, it is ready for undercoating.

Primed or washed and abraded surfaces need only one coat of undercoat and one coat of gloss. You can get a good straight line along the edge of the glass by using a well worn brush which 'cuts in' easily at the edges. Bring the paint about 1mm on to the pane to make a seal between the putty and the glass. Wash and clean the glass before you start painting.

Aluminium garage doors

If flaking is considerable—about 20 percent of the total area—strip off all the paint and start from scratch. Use a spirit paint remover as described above then, after washing and drying, prime the aluminium with zinc chromate—calcium plumbate is not suitable for aluminium.

If the paint is in good condition, use grade 240 wet-or-dry paper with detergent in the water to prepare the surface. On a large surface, such as a garage door, keep wiping the surface with a sponge so that the abrading paper does not become clogged.

On large, flat surfaces it is advisable to use a rubber or cork sanding block. Keep rubbing until the gloss of the old paint has all gone: the new paint will then key well.

One coat of undercoat and one of gloss is quite sufficient over primed or wet-abraded aluminium. If you are painting a large door, use a 50 or 75mm brush to get the best results, with a 25mm brush for getting into edges and grooves.

Timber surfaces

Exterior timber surfaces may be small in area—eg windows—or large—eg weatherboard or clapboard siding. Preparation is much the same, however. The existing paintwork will be in one of three conditions:

Severe flaking: This usually leaves large areas of the substrate exposed so you need to remove the old coatings completely. You will get rid of most of the paint by dry scraping it with a

75mm stripping knife. Remove the tricky areas with spirit paint remover, protecting the areas which are not being treated with plastic sheets or paper. Wash off the paint remover with medium grade steel wool and detergent, rubbing in the direction of the grain.

When the surface is dry, dry abrade it with grade M2 glasspaper to smooth the grain which will have raised slightly by the action of spirit and water on the surface.

Coat any knots in the timber with shellac knotting, or they may later release resin which would stain the paint. You can apply knotting with a piece of rag. Make sure that the whole area of the knot is covered and overlap it about 3mm on to the surrounding surface of the wood. The surface can then be primed.

Isolated areas of flaking: These are to be found most often around edges and joints. Scrape away the flaking paint with a stripping knife, shave hook or paint scraper until a hard, firmly-adhered edge of paint is left. Then use M2 or F2 glasspaper to dry abrade the exposed wood. Dust off and prime the wood, pushing the paint as deep as possible into the joints and overlapping the old paint by about 5mm all round.

Good condition: Paint in this state needs only to be wet abraded.

When the priming paint is dry, fill any holes or open joints so that no moisture can penetrate the wood and cause rotting. You could use linseed oil putty (mixed with a little undercoat to make it dry faster and be more flexible), mastic or caulking compound, or a proprietary filler, depending on the nature and size of the gap that you are filling.

Press the filler (or whatever) well into the gaps, and aim to leave a smooth surface as you work. With fillers, rub down smooth when hard.

Give timber surfaces which have been stripped at least three coats of paint over the primer to ensure good protection. This can be one undercoat and two coats of gloss or two undercoats and one coat of gloss.

Surfaces which have a covering of old paint in good condition need only one coat of undercoat and one of gloss.

All undercoats and glosses used on the outside of the house must have an oil base. The same undercoat and gloss paints can be applied to all primed or painted timber, metal or plastic surfaces; only the primer varies from material to material so that a good base is provided for painting.

Doors

Unless you require a special finish, you can treat and paint front and rear doors in the same way as timber windows. Doors, being larger areas, show up surface and painting defects more clearly, so you should take great care when preparing and painting them.

Because they are less exposed, doors rarely get into such a bad state that they need stripping. In any case, the extra thickness of old paint coats in good condition provides better protection for the timber and a smooth, hard foundation for high quality finishes. When the paint is completely stripped off a door it takes some time to build up a good enough finish with several coats.

You may have to strip your door completely if it is severely blistering or flaking, or if the paint coats already on it are too thick, making the door difficult to shut.

Whatever method of preparation you use, always remove the door furniture—handle, letterbox, key escutcheon—before starting work. This saves time 'cutting in' around them and produces a better finish.

The easiest, quickest and cheapest method of stripping the door is to burn off the paint with a blowlamp. Start on the mouldings, using a combination head shave hook to scrape away the peeling debris. Strip the flat areas with a 50 or 75mm stripping knife, working behind the flame torch and always pushing the knife in the direction of the grain. When the paint is completely stripped, prepare and paint the wood in the same way as you would timber window frames.

If the paint is not to be stripped, you should wet abrade the door. For paint coatings with very coarse brushmarks and deep chippings use a grade 180 wet-or-dry paper. If the paint has

7 Begin work on windows by cleaning old putty out of the rebate using a chisel. Dig out any areas of flaking paint

8 A blowlamp and scraper can be used to clean off areas of paint but use these with care near glass to avoid cracking it

9 Metal window frames should be cleaned with a wire brush. By opening the window you can clean the underneath of the frame

10 Primer should be applied to areas of the frame which are later to be covered with filler or filled with putty

a reasonable finish, a 240 grade paper will be sufficient.

Keep the surface wet and clean with a sponge dipped in the detergent water, rubbing the paintwork until all the gloss is removed and all the hard edges are erased. This may take a long time with regular changes of water and paper, but the effort is worthwhile. Keep a dust sheet or wad of newspapers under the door during the entire preparation and painting process: these absorb water and debris, and prevent dust being picked up during painting.

Apply the undercoat laying off very lightly with the tip of the brush in the direction of the grain to avoid brush-marks (see pages 71-74). When the undercoat is dry, abrade with a grade 1 glasspaper to remove any unevenness.

For a really smooth finish, fill the whole surface at this stage with either oil-based paste filler or vinyl-based fine surface filler.

If you cannot get the filler smooth with the knife, dry abrade it with F1 glasspaper. Use this method also between primer and undercoat for a door which has been stripped. A second coat of undercoat will seal the absorbency of the filler and provide a surface of even colour, but take great care when laying off the brush strokes. Two coats of undercoat will also ensure that any old colour will not show through.

Before applying the gloss paint, wipe over the surface with a tacky duster and lay clean newspapers under the door.

Remember to include the top edge of the door and, if possible, the bottom edge. If the door opens into the hall, paint the hinge end in the same colour as the outside. To achieve a glass-like finish, apply a second coat of gloss as soon as the first is hard. When the entire job is finished, you can replace any fittings.

11 *Press the putty into the rebate first using your fingers and then a putty knife. Flatten the putty into a smooth bevelled edge*

12 *All cracks in the surface should be covered with filler. Press it hard into the crack and smooth off with a knife*

13 *When the filler has hardened smooth down the whole frame with sandpaper which should be mounted on a block*

14 *When the putty has hardened apply undercoat and topcoat. Paint onto the glass for a few millimetres to prevent leaks*

Light up your house numbe

Brighten up the outside of your house with a number or a name which is as easy to read at night as it is in daylight.

All you need is an inexpensive exterior light fitting and some paint. It is important to use a light which is designed for outdoor use, and that all electrical work is done safely. (In Canada, the electrical work may have to be done by a professional.) Then, following the ideas below, you can simply add the numbers or letters.

Choose a light fitting with an opal cover of glass or plastic. You must use a waterproof fitting designed for exterior use, and fitted with a low power lamp such as a 25 watt pygmy bulb or a 8 watt fluorescent tube. There are many different types on the market

Choose shapes like these for numbers

Choose long shapes like these for names

You can use several methods to put your house name or number onto the light. In methods 1-4, the characters stand out against an illuminated background. Method 5 illuminates the characters themselves

① If you have a good eye, paint onto the lamp cover by hand. Draw up guidelines on the cover to help you position the characters. You will need several coats

② It is much easier to paint the characters using stencils and a stencil brush or paint spray. Use a guideline to help you get the letters straight

③ You can use self-adhesive P.V.C. lettering which is available in many different sizes and styles

④ Stick on moulded plastic lettering. Use plastic cement if the lamp cover is plastic or epoxy cement if it is glass

⑤ To leave the letters illuminated, stick on P.V.C. lettering as in method ③. Spray or paint the whole cover until it is opaque, then peel the letters off carefully to leave a clear shape behind

N.B. To paint on glass or plastic
① Make sure the surface is clean
② Use a gloss enamel paint, whether spray or brush applied
③ Use several coats, and check for opacity by holding up to the light

Connecting
Follow the lamp manufacturer's instructions for fitting the lamp to the wall. Outside wiring must be done using waterproof fittings. If in doubt, consult a qualified electrician.
In Canada, electrical work may have to be carried out by an electrician

Painting outside walls

- Preparation of new brick surfaces ● Previously painted surfaces ● Damp surfaces ● Mould infected surfaces ● Special masonry paints ● Applying the paint with a brush or roller ● Gaining access for application

As with all painting, the quality and integrity of the finish depends to a large extent on the preparation of the surface before you even open a tin of paint. And the preparation differs according to the surface to be painted.

New brick
Concrete, cement rendering and pebbledash should be treated in the same way as new brick.

To start with, remove any dust or loose material using a stiff brush, and scrape off any splashes of cement or concrete. Look out for any patches of white fluffy crystals; these are a result of efflorescence, and indicate that moisture is coming to the surface of the wall. If you paint over the patches the moisture will tend to lift the paint off. Clean the efflorescent debris off the walls with a stiff brush and wait about two weeks to make sure that no more patches emerge. Wash any mould growth or lichens with a proprietary mould inhibitor or bleach. Then scrape off these growths, and apply a further coat of inhibiter or bleach to the bare surface. Finally, make good deep cracks or holes in the surface with sand and cement.

Where new, shuttered concrete is to be painted it is important to degrease the surface because it may still bear traces of the release oil used on the inside faces of the shuttering.

An extension pole gives a paint roller a new dimension in versatility, allowing you to cover exterior surfaces without the encumbrance of a ladder

1 To start with you must remove all wall decorations such as shutters and tie trellis-trained plants well out of harm's way

2 Next brush away any heavy deposits of dirt with a stiff brush. Do not use a wire brush, however, because stray strands will cause rust marks

Previously painted masonry

It is always advisable to prepare painted surfaces before repainting, and in the case of exterior work it is essential if the new coatings are to protect the building in the way they are designed to.

Oil (alkyd) paints: Wash with a strong cleaning agent such as washing soda, then rinse with clean water. Scrape off any loose or flaking paint, make good any deep cracks and holes with sand and cement, and fill shallow cracks with an exterior filler. Note that interior filler must not be used for exterior work because it will rapidly deteriorate and cause the new coating to blister and flake off.

Emulsion (latex) paints: Wash with a detergent, then rinse with clean water. Anything stronger, such as washing soda, will damage emulsioned surfaces. Where water penetrates the surface, allow it to dry completely before you start painting. Again scrape off loose and flaking paint and then repair cracks.

Cement-based paints: These and other non-washable types of paint have been used extensively in the past on large areas of exterior masonry, mainly because they are fairly cheap. However, most cement paints tend to become very powdery with age, and washing, which only softens them further, must be avoided. Moreover, the water content of the new coating can cause these paints to soften, and this will prevent proper adhesion of the new paint. You must, therefore, thoroughly brush, and if necessary scrape, the walls until you have a firm surface. Finally, you must apply a masonry sealer or stabilizing solu-

tion to the cleaned walls. This will soak into the existing material, binding it into a solid film not soluble in water and resistant to it.

Wood

Preparing large areas of wood—eg weatherboard or clapboard siding—for painting was dealt with on pages 84 and 85. The amount of work needed depends mainly on the condition of the existing paintwork.

Damp surfaces

Walls which display signs of either damp or mould growth must be treated before you can paint.

Where surfaces are prone to damp, such as basement walls or garden walls, you must apply a coat of bituminous emulsion sealer and allow it to dry thoroughly.

3 Make up a strong bleach solution and apply it to all mould and plant growth in order to destroy it—wash off the bleach with water

4 The finished work can only be as good as the ground surface. You must go over the surface carefully and repair any defects like bad pointing

5 It is wise in most cases to apply a coat of stabilizing solution to the brickwork. Brush it on liberally, allowing it to soak into the bricks

6 Before painting cover all nearby plants, grass and tile steps or thresholds so that you avoid spoiling them with splashes of paint

Mould infected surfaces

Mould growths are common on exterior surfaces where moisture is present as a result simply of the atmosphere, structural faults or defective plumbing. To remove them first brush a coat of proprietary mould inhibitor on to the infected areas, and then strip all the mould back with a stiff brush and scraper. Do not use a wire brush, however, because any metal particles left behind can cause rust stains. Then apply a second coat of mould inhibitor to the surface and allow it to dry. These solutions contain strong fungicides and you must wear rubber gloves and goggles to guard against splashes.

This process must be carried out before any sealer is applied to the surface of the wall.

Masonry paints

Masonry paint is a water-based paint similar to emulsion (latex) but with the addition of other materials such as granulated quartz, mica, and in some instances fine strands of glass fibre. These additives render it highly durable, moisture resistant and give it the ability to resist cracks in the surface, while providing a very attractive fine texture. The coverage is usually about half that of emulsion; approximately 6m² per litre depending on the absorbent quality of the material. One or two coats will be needed depending on the existing colour and nature of the surface.

Applying masonry paint

Masonry paint may be applied by brush or roller. A roller is much faster than a brush, but for inaccessible corners a brush is unbeatable. On smooth surfaces the texture of the roller is more suitable than a brush. On heavily textured surfaces such as pebbledash or rough brickwork a long pile roller, which can penetrate into all the crevices is most suitable.

However, a conventional roller tray is not practical for use on ladders. It is necessary when painting from a ladder to use a roller bucket or scuttle, designed to hang on the underside of the ladder or scaffolding around you.

Brushes, if you decide to use them, must be as large as possible—100–150mm wide. Nylon or bristle and fibre brushes will stand up to the abrasive nature of exterior surfaces much better than pure bristle. Furthermore, the close pack of bristle will only hold small quantities of the rather thick masonry paint.

Access for application

In most cases exterior surfaces are larger and higher than interior surfaces. Consequently some form of scaffolding may be required, and a method of working which will result in even coverage after a number of sessions (see below).

Scaffolding can be obtained from your local hire shop. Do make sure, however, when erecting the scaffolding, that there is adequate space between the tower and the wall to enable you to prepare the surface and apply the material. If you erect the tower too close to the wall you will inevitably be left with small areas which will need touching in afterwards; and they will invariably show.

A. Below: *You must approach house painting in a methodical way—starting at the top, then working down. Try to end each session at a natural break*

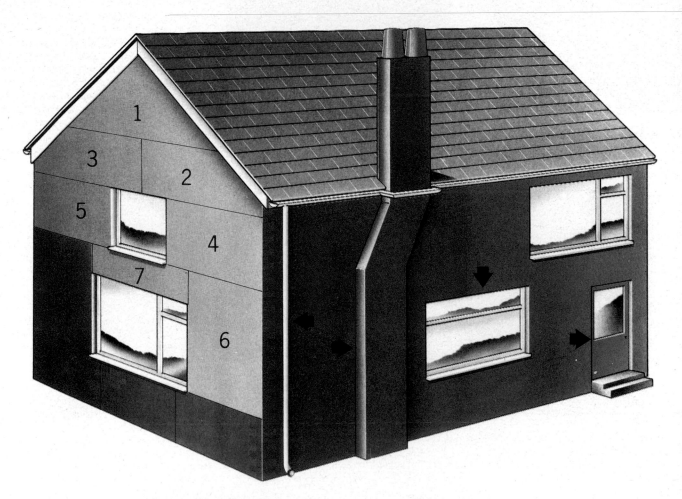

Bernard Fallon

Unless you have to contend with a large expanse of wall, a ladder will probably suffice. Use a ladder stay when working at heights; it will make the ladder more stable and make it easier to hang a bucket or roller scuttle on the underside with easy access for the brush or roller. Extend the ladder so that you can reach the top of the wall. But remember that it is unsafe to leave less than four rungs above your feet; this will allow you a safe hand hold. Position the ladder so that you can reach the extreme right hand side—or left hand side if you are left-handed—of the wall.

However, assuming that you are right-handed complete the panel to the right of the ladder, then move the ladder to the left, and work on the adjacent panel as shown in fig. A.

Continue horizontally across the

B. Above: *When you stop in the middle of a painting session put the brush or roller in a polythene bag to keep it moist*

7 *In order to avoid changes in colour, mix a sufficient quantity of paint to complete the job then fill a paint bucket with the mixture*

9 *It is not possible to use the roller when painting inaccessible areas. In these cases you must resort to a small distemper brush*

8 *A ladder stay is a very useful accessory which makes the ladder more stable. A paint bucket can be hung from it.*

10 *Always work from one side of the ladder only. Trying to cover both sides will result in difficulties because the ladder is in the way*

wall until you reach the left hand side of the wall, then adjust the ladder to allow access to the area below, and so on. If the light or weather forces you to abandon work before it is complete, you must try and break off at a point where the joining of the dry and wet film will show least; at a pipe running down the wall, a window, moulding or similar.

Painting

Try to plan exterior painting for warm, dry days. Extreme cold or frost can affect the water content of the paint, causing a complete breakdown in the film. Rain on the surface before the paint is dry can thin it disastrously.

The first coat on porous surfaces can be thinned—but follow manufacturers instructions carefully.

Charge the brush or roller with plenty of paint, and lay it or roll it in all directions. Do not apply the material too far, however, because correct covering and protection requires that it be twice as thick as ordinary liquid paints. Any spots and splashes must be washed off immediately with water because exterior grade paint sets rapidly. During short breaks, wrap the brush or roller tightly in a plastic bag to prevent the air curing the material. Do not be tempted to leave it in water because the initial application will be patchy.

When you have completed a session of work immediately clean all the equipment in detergent and water. But take care not to block sink wastes with the fine granulated quartz, or scratch enamel or stainless steel sinks.

Painting wood surfaces

On the wood that is already painted, or if you prefer a painted finish, then ordinary oil-based paint gloss can be used (alkyd paint, sometimes called house paint in Canada). Apply this using the techniques described above, except that you will need to use a brush rather than a roller. On horizontal, overlapping siding, paint the underneath projections before painting the vertical surfaces, making sure thay are completely covered—areas that you miss will be very obvious from ground level. Try not to break a painting session in the middle of a length of siding—make your breaks between adjacent boards.

Exterior wood stains and coloured wood preservatives can also be used, especially on shingles and shakes. But check manufacturer's instructions first: most products have to be applied to new, bare wood.

Preparing a floor for tiling

● **Making a floor good for tiling** ● **A smooth and level surface using a board underlay** ● **Tempering procedure for hardboard** ● **Finding the centre point of a room** ● **Making chalked guidelines for pattern design and tile laying**

Ray Duns

Below left: *Dry laying of tiles to check the fit. These vinyl-strengthened cork flooring tiles are being laid on floorboarding that has been covered with sheets of suitable hardboard. Chalked lines ensure accurate tiling*

Preparing wood floors
Nail or screw down any loose boards and drive in or remove insecure nails and screws. Wood floors should be covered with plywood or hardboard.

Vinyl flooring may be laid directly on chipboard used in place of floor-boarding provided the chipboard is of flooring grade and has a minimum thickness of 18mm. Be sure to remove any existing floor covering first.

Suspended wooden floors at ground level must always remain well-ventilated if damp and rot are to be avoided. A vinyl or tile floor covering will not allow timbers beneath to 'breathe' and this can only aggravate any borderline condition that may be present. Check that air bricks in the outside walls are not blocked and take the additional precaution with old, damp properties of raising a floor-board here and there to check for both dry and wet rot.

Preparing concrete floors
Provided concrete floors are dry, clean, level and free from anything which could conceivably react with the overlay (particularly grease and solvents which can have a marked affect on vinyl), they form an ideal base for flooring whether in tile or sheet form.

The most common problem is damp-ness, particularly on concrete floors laid directly on top of earth that have not been provided with a perm-anent damp-proof membrane. Even if a concrete floor looks dry, try a simple test to check whether or not it is so. Place a rubber mat, piece of cooking foil or plastic sheet on the concrete and tape the edges down as best as possible. Turn on the heating at a setting a little higher than nor-mal, then, after 24 hours, peel off the test sheet. The presence of any mois-ture on the underside indicates a damp floor.

If the floor is damp, it must be treated with waterproofer before being

A tiled floor can transform the appear-ance of any room, and for the most part the job is straightforward and quick. Badly-laid tiled floors can be an eyesore, but you can prevent this by taking a little extra care at the planning and preparation stages.

Vinyl floor coverings are by far the most popular choice, especially for kitchens and bathrooms, and it is not difficult to see why. Vinyl tiling is available in various forms and a seemingly infinite range of colours and designs. And although various types of fixing methods may be used, none presents a problem. The tech-niques of laying vinyl tiles are covered in the next part of this course.

Cork has some splendid character-istics which make it well-suited for use as a flooring material, and is almost as easy to lay and finish. And of course there is nothing to match the quality and durability of quarry or ceramic tiles. Laying these tiles is covered in a later part of the decorat-ing course.

You can tile a floor only if the surface is sound, firm and level. Loose floor-boards, damp or uneven concrete, old linoleum and pitted asphalt are typi-cal floor conditions that need to be checked and corrected before laying vinyl or any other form of tiling. Bumps and high points quickly cause wear or cracks in floor coverings.

overlaid with flooring of timber, cork or any other material that could be affected by moisture. A wet floor may have to have its surface relaid and a waterproof membrane inserted (regardless of the floor covering used).

A damp floor can be treated with waterproofing compound—usually an epoxy coating or a rubberized bitumen material.

Pitting and general unevenness can be rectified using what is known as a self-levelling compound. Pour this over the floor area to a minimum depth of about 4mm, following the maker's instructions closely as these may vary. You cannot, however, lay sheet material over some damp-proofing compounds—so check this point with your floor covering dealer.

To fill larger holes, make up a mortar mix of three parts soft sand to one of Portland cement. Add just enough water to make the mix maleable and a little plasticizer to minimize shrinkage during drying.

Damp the holes with water and apply the mortar with a bricklayer's trowel. Tamp it down with the end of a piece of timber and slice off any surplus with a timber straightedge.

Floors with a surface which is powdery but otherwise sound can be coated with a latex-based sealer before being overlaid by tiling.

Other floors

It is possible to lay vinyl and cork flooring over existing quarry or ceramic tiling provided that the gaps between the original tiles are filled with self-levelling compound. This is to prevent the old tile pattern from working through—a particular problem near doorways and other areas subject to continuous wear.

Also, take particular care to remove grease, dirt and grit: perhaps harmless to the original tiling but often damaging to vinyl and cork. A good wash with household detergent and hot water is normally sufficient.

You can also lay some types of vinyl and cork tile over existing linoleum and vinyl flooring where removal poses problems. Again, make sure the surface is clean and that all edges on the old tiling are stuck down properly. Where possible, do remove all old tiling as this helps avoid problems both in laying the new tiling and later. Old tiling must be removed if quarry or ceramic tiles are being used.

Laying hardboard

On an old, rough wooden floor, laying hardboard or plywood over the entire

1 Measure up the room and decide how best to use standard hardboard sheet sizes. Allow for cuts around obstacles

2 When cutting hardboard to fit a corner, pull the sheet as close as possible to this so that direct measurements can be made

3 Measure back the corner depth and use a straightedge to mark the cutting line, allowing a slanted cut if this is necessary

4 You will find it easier to cut the hardboard at floor level, propping up the edges as best as possible to enable sawing

surface is often the only way of easily achieving a smooth surface on which to lay tiles. Concrete floors sometimes require the same treatment but usually this is not essential, although you may prefer the additional insulation this underlay provides.

Standard-sized hardboard comes in sheets 2440mm × 1220mm, and for this job select the 6.4mm thickness.

Hardboard sheets have to be conditioned prior to use otherwise buckling may occur through localized shrinkage or expansion after they have been laid. Temper the boards by brushing the rough side with water and lay the sheets flat, smooth sides together, overnight or longer so the moisture is fully absorbed. The idea is that the sheets will dry out after being laid, in the process shrinking slightly to form a very tight, level surface.

5 When the board has been cut to shape, push it home and then use hardboard pins or screw-thread nails for permanent fixing

6 *Individual obstructions can be dealt with as they are encountered but remove only as much of the board as necessary for a tight fit*

The hardboard is laid rough side upwards as this gives a better key for any tile adhesive used. Stagger the joints to reduce the likelihood of strain at any particular point—which could lead to cracks or wear in flooring placed above—and avoid coinciding the hardboard joins with those of floorboarding below for the same reasons.

On a wooden floor, use 25mm hardboard pins to nail the board at 150mm spacings over the entire surface and at 100mm spacings along the edges. On a concrete or cement floor you have to glue the board in place using a suitable adhesive such as neoprene thixotropic. When sticking anything to concrete, check whether or not an initial coat of primer is required as concrete can very easily absorb some other types of adhesive.

Few rooms are truly square and you will need to use wedges and strips to fill the small gaps left after trimming the boards as they are laid. If these gaps are very small, it is worth using filler paste instead.

When you have laid the boards, allow them to dry out before overlaying vinyl tiles or sheet—a day or so is normally long enough. Spend the time correcting any tight-fitting doors which open into the room. Normally the gap between the base of the door and the floor is sufficiently large enough to accommodate a layer of thick floor covering or, in this instance, a layer of plywood or hardboard—but only rarely both together. So check the gap beneath the door both before and after laying covering boards.

If necessary, lift the door off its hinges and trim (by planing or sawing) 6mm or so from the base. You may find it easier to replace the existing hinges with rising butt hinges.

Where board laying continues through a doorway into an accompanying room, ensure that draughtproofing aids such as a threshold bar are removed. Sheet edges should be tightly butted here—and then covered with the threshold bar again if further draughtproofing measures are necessary, which seems likely.

Laying plan

Once the floor preparations have been completed, some idea of the lie of room is necessary for planning a design and for choosing tiles or tile sheeting.

In theory, all designs should radiate or progress from the centre of the room. Find this by measuring off the centre line of two opposing walls. Stretch a chalked string between the two and snap this against the boards on the floor. Repeat this for the two remaining walls so that another chalk mark is made: where they cross is the centre point of the room. This is a simple enough job for a normally-shaped room. Figure A shows the procedure for awkward rooms and you can adapt the method to suit your needs.

Border walls

Although any design is based on the centre of the room, border walls must be considered if an even pattern is to be achieved. Also, the tile direction should be square, or perfectly symmetrical, to the main doorway of the room. So in figure A you would base

7 *Nail boards at 100mm spacings at the board edges, and at 150mm centres over the whole surface area of the sheet*

8 *Use a measure to find the mid-point of each wall. By joining the opposing mid-points you can find the centre of the room*

9 *To produce a chalked mark for accurate tiling, stretch a chalked string between opposing walls and snap this against the floor*

10 *The crossed chalk lines at the centre of the room are used as the starting point for a trial, 'dry run' and later permanent fixing*

the tile pattern on either door 1 or door 2 in preference to door 3 even though the tile pattern falls at 45° to this, which is visually acceptable.

To mark out guide lines for laying, produce a chalked mark at right angles to the doorway (fig. B), far enough for another chalked mark to be made across the room and coinciding with the centre point (fig. C).

Make another chalked line at right angles to the second line, again passing through the centre point (fig. D). This line is of course parallel with the first. The resulting cross you have chalked on the floor is now used for the exact planning of a pattern, and also provides a guide for the tile-laying sequence which follows.

When, later, you have chosen your tiles and have designed a pattern for these, follow the cross-lines in a 'dry laying' sequence to check how the tiles finish off at the edges. Ideally the border round the room should be even and although this is not always possible as far as the pattern is concerned, it is certainly possible to re-arrange the position of the chalked cross so that tile widths are even on each pair of opposing walls.

Left: *To find the centre point of a perfectly square or rectangular room presents no problems, but awkwardly shaped floors need a different approach (A). Instead of totting up individual parts of each wall, measure across the room to take in the obstruction (shown by red line A_1B) and find the mid-point of this. Repeat the procedure for each of the three remaining sides of the room (red lines A_2D, DC_1, C_2B) and find the mid-point of each.*

Mark the floor at these points. Now stretch strings across the room in such a way as to join up each pair of opposing mid-points (green lines). Where the two strings cross is the mid-point of your room.

Your laying plan must be based both on the centre point and on the main doorway (taken here to be door 1) if the tile pattern is to look regular and symmetrical. To do this, first stretch a string at right-angles to the doorway to a point on the facing wall (B). Follow this with another string, at right-angles to the first and coinciding with the room centre point (C). A third string line, fixed parallel to the first, completes the cross (D). By rubbing the strings with chalk, a chalked cross can be snapped on the floor to act as your final tiling guide (E)

A tiled step feature

Jon Bouchier

All staging is constructed from 38mm × 38mm sawn softwood, using half housing joints as shown. Cut the housing 38mm wide and 19mm deep. Glue and screw using 50mm No. 8 (4·2mm) countersunk woodscrews, or glue and nail. Vertical supports are to the height of front panel less 38mm For 300mm tiles, this is 250mm to leave the staging at 288mm

Screw chipboard to staging using 30mm No.8 (4·2mm) countersunk woodscrews at 300mm centres

300

Top board is 1 tile wide

Vertical supports are at 600mm centres

When rostrum is complete, lay tiles in the normal way, matching the joins to those on the floor

When fitted top board overlaps facing board

Panels from 12mm flooring grade chipboard

Screw to staging using 30mm No.8 (4·2mm) woodscrews at 300mm centres

Skew nail frame to floorboards

Height of tile less 12mm. For 300mm tile, this is 288mm to allow top board to overlap bottom

Back batten from 38mm × 38mm sawn softwood. Screw to a masonry wall using plastic wallplugs and 60mm No.10 (4·9mm) countersunk woodscrews. On stud partition walls either locate the studs and screw to them, or build second staging against the wall

You can add interest to the edge of a tiled floor by constructing a dummy step like the one shown. In a bathroom or kitchen, this can be a useful way to conceal unsightly pipework, and will also provide a low storage shelf.

The basis for the step is a simple but strong staging frame covered with chipboard as a basis for tiling. Note that this type of construction is designed for a suspended wood floor, and is unsuitable for solid flooring.

Use the tiles themselves as a guide to the size. The dimensions given are suitable for standard 300mm square tiles but you can easily adapt the design for other sizes. Note, however, that you should not exceed 600mm wide with the materials used.

Laying floor tiles and sheet vinyl

● Dry-run laying ● Tile preparation ● Laying individual tiles ● Cutting tiles to fit ● Making a scribing tool ● Sealing cork tiles ● Fitting sheet vinyl ● Avoiding shrinkage problems

Above: *Cutting flooring to fit around complicated shapes like this is easier if you use a shape tracer to get an accurate pattern of the moulding*

Laying vinyl or cork floor tiles is one of the best ways of providing a room with a good-looking and tough floor covering. And provided that the floor preparation and design stages have not been skimped, the job is quick and uncomplicated. Laying hardboard on a wood, cement or concrete floor to provide a smooth and level base for all forms of tiling is covered fully on pages 92 to 95.

Finding the centre of the room is the first stage of p'anning a design and for calculating the number of tiles of any one type that may be required. The tile direction, and hence design, is also influenced by positions of the main doorways.

The centre of the room is also used as the starting point for tile laying. This ensures that the tiles are laid evenly and squarely in what is the most conspicuous part of the room and means that you end up by trimming and cutting tiles to fit. Even in small rooms or hallways, always start tiling in the middle.

Before tiling, do a 'dry run' to check for problems in laying and also that your design works. Tile fit can be checked across the length and the breadth of a room, in alcoves, and anywhere else where the basic shape of the room alters.

This is a particularly important job if a large, unusually shaped room is being tiled. Figures A to D show how to deal with a seven-sided room which, if hardly typical, highlights most of the problems you may encounter with a room of more normal shape.

Arrange two lengths of string to cross the centre of the room and to act as guides for tile laying. Fixed carefully to the skirting and stretched taut a little above the floor, these can then be chalked and snapped against the floor to produce the final laying marks (fig. C).

Before you go further, consider if moving the strings a little away from the middle actually reduces the amount of fiddly cutting needed at the edges: in the featured room (fig. A), there is too much of this so the line was moved. You could, of course, take up this border width by using feature strips incorporated into the overall design, so that the borders are highlighted, but this will still probably involve you in a lot of fiddly cutting. So, shifting the whole lot one way or the other so that at least a third or half a tile is left at the borders makes accurate cutting and shaping much easier.

In the featured room (fig. B), moving the tiles to the right a little avoids fiddly cutting at the 'window wall' border and leaves half-tiles on the 'inner wall' border. Only door 3 and the opposite corner present anything of a problem.

You may prefer, however, to shift the whole tile pattern to the left (fig. C). This time the half-tiles occur at the 'window wall' border, and less fiddly cutting is involved both at door 3 and the corner opposite to this.

Too much fiddly cutting means wasted tiles, particularly where a directional pattern has to be matched. Spending time on a dry laying run keeps this wastage to a minimum,

reduces the work-load and makes for a better-looking job.

Having finally established the laying guides, chalk these on the support flooring. Remove the strings but leave the skirting pins in place so that chalked marks can be remade if necessary.

Tile preparation

With vinyl tiles, by and large you get what you pay for. The more expensive forms contain a greater proportion of vinyl, are better wearing as a result, and are usually less of a problem to lay. All benefit from being left a day or so in a warm room or airing cupboard, after which time they become more pliable and easier to handle. Sheet vinyl, in particular, ought to undergo this acclimatization procedure. There is no need to do the same for cork tiling.

Laying individual tiles

Individual tiles are laid from the centre of the room and outwards. If tile adhesive is required, spread a little of this along the chalked cross lines. Always use the adhesive recommended by the tile manufacturer, and follow the specified instructions for applying this. With cork tiles, for example, you may have to apply adhesive to the underside of the tile as well as to the floor, perhaps leaving an interval for drying before bringing both together.

The important rule for tiling is to cover only a small part of the floor at a time. Lay the centre four tiles against each other to coincide with the crossed chalked marks at the centre of the room.

Take care not to push the tiles together if adhesive is used: this may force the excess up between the tiles. Wipe off surplus adhesive with a damp cloth before it has a chance to dry. Smears can be removed with soap and a brush—never use solvents.

Work outwards from the centre four tiles once these have set, applying only as much adhesive as is necessary for each small area before you tile. Deal with one quadrant of the floor before moving on to the next.

The physical finish of some tiles is directional and if this is not immediately obvious, check to see if there is a laying direction arrow printed on the underside. If light catches the surface of an improperly-laid directional tile it can considerably affect the overall appearance. To avoid slight shade differences from box to box, shuffle and mix the tiles.

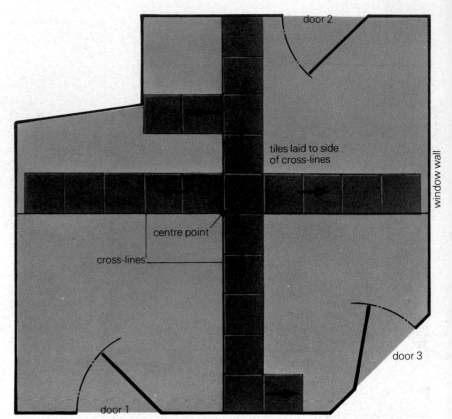

A. *Starting from the centre 'dry lay' outwards to check how the tiles fit. You can then see what cutting is required at window and interior walls*

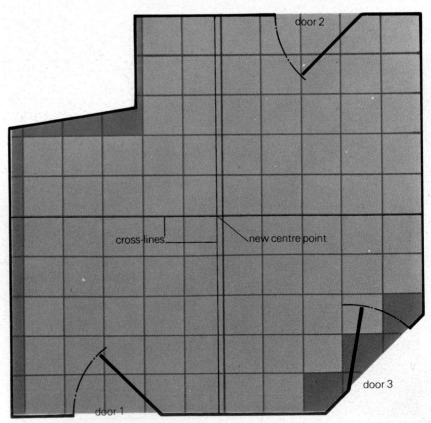

B. *By moving the string guide lines to the right, cutting (dark areas) is avoided at the window wall, with better widths on the inner wall*

C. *The best arrangement for this room means laying against a string cross where the 'vertical' is slightly to the left of the true centre*

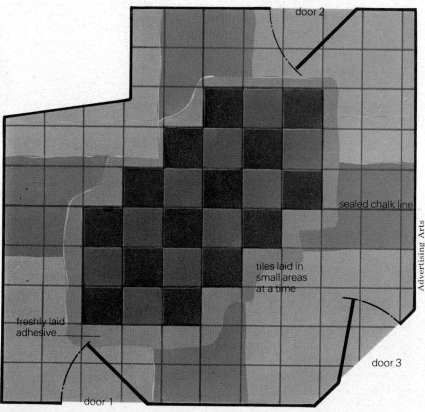

D. *Fix and let dry the centre four tiles, working to the chalked, crossed, lines. Work outwards from these tiles, doing a few squares at a time*

Cutting tiles to fit

Eventually you will come to the border where, unless the fit is arranged to be perfect, the tiles need cutting to shape and width. This is an easy enough job if you are familiar with scribing techniques, but if these are new to you it may be worthwhile sacrificing a few spare tiles to practise on.

Place a tile squarely on top of the last one before the border. Take another and place this partly on top but firmly butted against the wall. The inner edge is then used to mark a cutting line on the middle tile—you can score this using a cutting knife and then complete the cut elsewhere using a cutting board, steel rule and safety blade. Make sure the middle tile is of the correct type and in the right direction before cutting.

1 *You can lay tiles on a level and smooth concrete floor if an underlay is not required. Use a bolster to remove surface flaws*

2 *In a small room there is no need to mark the floor for tile laying but do go through a dry lay routine to check the tiles for fit*

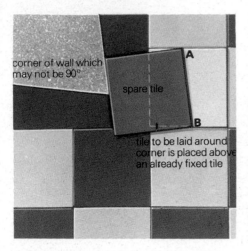

corner of wall which may not be 90°

spare tile

A

B

tile to be laid around corner is placed above an already fixed tile

spare tile

A

C

D

B

tile laid above another fixed tile without turning it

tile now fixed around corner

E. *The procedure for scribing a tile. Use a matching tile as the transfer ruler, and pencil the cutting mark*

F. *Without twisting the tile, scribe the second mark and then remove the waste corner*

G. *The finished tile fixed into place. The procedure for internal corners and edges is identical*

3 *Use the recommended adhesive and fix a small area of tile at a time. Remove adhesive squeezed up between tiles before this sets*

4 *Use a steel rule, heavy-duty handyman's knife and—just as important—a cutting board when you trim sheet or individual tiling*

5 *Take special care in cutting tiles to fit door frames and other awkward obstacles. A card template or special tool is useful*

6 *By mixing your packets of tiling, slight differences in colouring become less noticeable when tiles are laid on the floor*

When you are laying into and around a corner, tiles need to be cut both widthways and lengthways. Use the same procedure as for a straight border but repeat this for the two sides of the corner without turning the middle tile (figs E to G).

Even on what looks to be a straight and even border, mark up tiles for cutting individually so that you take care of any irregularities. For odd shapes—such as mouldings, radiator pipes, and beam uprights—carefully nibble away the tile freehand until you can slide it into place (fig. 5). A template cut from card saves wasting too many tiles.

You can also use a shape-tracing tool or template former with metal teeth similar to a comb. These teeth take the form of any firm object against which they are pushed and once tightened in place, the outer ends can be used as a cutting guide. The tool is particularly useful for dealing with the often intricate shapes of door architraves (see page 97) and other fixed obstacles.

Sealing the tiles
Vinyl tiles do not require any surface treatment after laying. Some cork tiles are pre-finished with a vinyl coating and also need no further work. Untreated tiles can be treated with oleo-resinous and polyurethane varnishes which are available in eggshell, matt or gloss finishes.

Of these, polyurethane has the advantage of being extremely hard wearing as well as being resistant to both heat and most chemicals. At least two coats are required for cork tiles as a single coat will tend to soak into the cork, leaving a patchy appearance.

H. *A scribing tool made from a square-ended piece of battening. Cover the end with cloth or felt. Start the sequence for cutting sheet vinyl by measuring back from the wall, marking a point on the edge of the sheet* (**I**). *Pull the sheet back enough to back-mark the edge by the same distance and place the scribing nail on this* (**J**). *Scribe the cutting line* (**K**) *and remove the waste* (**L**). *Where two sheets overlap* (**M**) *cut between the edges*

It is not a good idea to wax cork tiles as they then require frequent re-waxing—at least twice each year.

If cork-tiling a bathroom, it is advisable to lay pre-sanded tiles in preference to coated ones. The sealer, when applied, will then cover the cracks at the joins as well.

Avoid walking on unsealed tiles as these damage easily and marks can be very difficult to remove and disguise. If a high-gloss varnish is used, make sure dust is not allowed to spoil the appearance by thoroughly sweeping the floor beforehand.

Fitting sheet vinyl

Sheet vinyl is the modern answer to the once popular linoleum flooring and is warmer, if not quite so hard wearing. It provides a simple solution to those who require a good-looking floor covering—possibly highly patterned—but cannot be bothered with the planning that laying individual tiles involves.

Sheet vinyl comes in rolls from 2m wide, so have a clear idea of the way it is to unroll and be laid before choosing a particular pattern. As with individual vinyl tiles, allow the roll to acclimatize before laying—about two days loose rolled is enough.

Vinyl sheet flooring can sometimes shrink, so the makers usually advise cutting oversize when the material is first laid: follow these cutting instructions closely. After about two or three weeks of use, final trimming can take place at join overlaps and edges.

The possibility of shrinkage must always be considered when planning and laying down cuts and joins. Where possible you should keep these well clear of doorways, so if you are

7 *Lay down hardboard sheeting on uneven floors before laying sheet vinyl tiling (see pages 92 to 95 for the procedure)*

8 *Cut sheeting to fit into every nook and cranny as the whole sheet is laid down. Use a cutting board and handyman's knife for safety*

laying sheet in two adjacent rooms, arrange to have the sheet straddling the doorway threshold,

You will need a scribing tool for marking cutting lines at the sheet edges and ends. Make this by driving a nail partly through a wooden batten, 50mm from the end, so that the point protrudes about 3mm (fig. H).

Allowing a little extra for shrinkage and trimming, cut a length of sheet from your supply roll. Lay the sheet to allow an overlap of up to 150mm at sides and ends. Follow the scribing techniques outlined (figs. I to M) for final trimming. Use the same procedure for trimming sheet edges as you lay. To do this, make a pencil mark on the edge of the vinyl sheet 250mm from the wall (fig. I) and draw the sheet back from the wall so that it lays flat.

9 *Slit the sheet edges so that a good fit, but a coarse trim, is obtained at the base of all obstacles and fittings—trim no further yet*

Now measure back 250mm towards the wall and make another mark (fig. J). By carefully sliding the sheet, arrange it so that the point of your scribing tool coincides with the second mark when the batten end is held against the skirting board (fig. J). Take care not to twist the sheet out of alignment in the process. Finally, scribe along the sheet as described above, cut off the waste and push the sheet tight against the skirting.

This method of scribing should also be used where a narrow strip is being fitted, such as in a hall or small kitchen.

Where two sheets meet at the middle, the overlap can be trimmed quickly and easily by running a handyman's knife along the double thickness. If possible coincide the cut with a pattern line in order to conceal it. Raise both edges and lay double-sided tape beneath if this is thought necessary (fig. M).

The pattern direction should be laid square to the room or doorway, however, if this wall is in any way angled.

Lay the end of your scribing tool at right-angles against the skirting and mark the sheet along the length of the wall (fig. K). Take your time over the job, and try not to scrape the skirting board paintwork in the process.

The mark left on the sheet should mirror the shape of the wall and skirting. Individual obstructions are best dealt with as they are encountered. Slit the sheeting (fig. 9) but do not nibble away any more of the sheet than is necessary for fitting—trimming is best left to much later (fig. 10).

Cut the sheet edge to shape using a handyman's knife, steel rule and cut-ting board, then push it against the wall. The surplus at the ends can be turned up against the adjoining walls.

The sequence is repeated for the other sheet and rough cuts made again where fittings and protrusions occur, such as at a corner, chimney breast or radiator.

The alignment of the second sheet should of course match that of the first. Also check that trimming to fit the wall still leaves an overlap of at least 30mm with the first (fig. M). This may mean a little bit of calculating before the second sheet is laid down and coarsely trimmed.

Trimming sheet vinyl

After the two-week ageing period, final trimming can take place. Use a metal straightedge to force the sheet firmly against skirting boards and fittings before making the trimming cuts (fig. 10).

To trim the surplus at the roll ends, you can again use the straightedge to force the sheet flat as you cut. But as you can only do sections at a time, the appearance may suffer as a result.

A better method—especially if the wall is angled or uneven—is to duplicate the scribing technique used for the edges.

After the final trimming, vinyl sheet that needs to be glued in place can be raised and the adhesive applied. Use the products and techniques suggested by the manufacturers if you have to do this (fig. 11).

With modern, 'lay flat' vinyl sheet, gluing is not normally necessary. Specially designed double-sided tape can be used in areas where a raised edge may cause problems, such as at doorways and joins.

10 *After settling and shrinkage the vinyl sheet can be properly trimmed. Use a float or other metal straightedge as a cutting guide*

11 *Use suitable adhesive to fix edge joins and elsewhere that may cause problems if curling occurs—particularly at doorways*

Decorating with tiles

● **Estimating quantities** ● **Types of tile** ● **Preparing the surface** ● **Getting the tiles square** ● **Cutting and shaping tiles** ● **Tiling around windows** ● **Tiling in awkward places**

As coverings for walls, tables and working surfaces, ceramic tiles have several distinct advantages over other materials. As well as offering a superb range of colours, patterns and glaze finishes, they make a hard-wearing, easy to clean, practical surface.

They also have a high resistance to both acids and alkalis and a permanent colouring, unaffected by prolonged exposure to sunlight or steam.

The one drawback to ceramic tiles is that they are brittle, making them slightly more difficult to work with than vinyl or cork.

Types of tile
Ceramic tiles come in a wide variety of plain colours, patterns and shapes. The three most common sizes are 108mm square by 4mm thick, 152mm square × 6mm, and 152mm × 76mm × 6mm. Mosaic tiles—group arrangements of tiny tiles on a backing sheet—are also available. Always take a ruler and actually measure a sample tile before you buy, particularly if you are buying contrasting tiles from different shops. Otherwise, you could finish up trying to match plain 100mm tiles with patterned 108mm—and then find the thicknesses are different as well!

The field tile used for most tiling usually has lugs around the edges which butt against adjacent tiles and ensure an equal 2mm gap all round.

When tiling food preparation surfaces in the kitchen, you should always check with the manufacturer or retailer that the tiles are suitable for the purpose—some have a potentially toxic heavy lead glaze. Tiles used near heat sources such as cookers and fireplaces should be heat resistant or at least 9.5mm thick.

The basic tool kit
Cutting tools, adhesive and grout are readily available from any do-it-yourself shop.

You will need a simple wheel cutter or a scriber with a tungsten-carbide tip. A wheel cutter with breaker wings, for scoring and breaking in one action, costs a little more. A carborundum file is useful for smoothing down the edges of cut tiles.

Materials
Tile adhesive is available either in powder form, to which water is added, or else ready-prepared in cans: five litres will cover about 6m² on a good surface.

However, use a water resistant adhesive for areas around sinks, baths and showers and one which is heat resistant where temperatures are likely to be high, such as around cookers and fires.

Grout is a cement-based paste which is rubbed into the gaps between tiles to provide a neat finish. As a rough guide 500g of the powder, mixed with water to a fairly stiff consistency, will grout about 2m² of small tiles or 4m² of larger ones.

How many tiles?

To estimate how many tiles you will need for a wall or worksurface, measure the length and height in metres then use our formula

108mm square tiles: Length x Height x 86 = No. of tiles
152mm square tiles: Length x Height x 43 = No. of tiles
152mm x 76mm tiles: Length x Height x 86 = No. of tiles

If necessary, add on the required number of special border tiles or subtract tiles to allow for fittings. Add on an extra 5 or 6 tiles to cover breakages.

Cutting tiles is not as hard as it seems. To make a straight cut, simply score a line with a tile cutter, then snap the tile over a matchstick

A non-toxic grout should always be used on tiled food preparation surfaces and a water resistant grout around sinks, baths and showers.

Preparing the surface
The quality of any tiling job is largely dependent on the surface to which the tiles are fixed. This should be firm,

level, clean and dry.

Most surfaces require only a little preparation before they are tiled. A few, though, need more extensive treatment.

Plaster: Minor bumps and cracks can be filled with a proprietary plaster filler. The entire surface should then be given a coat of plaster primer, to

1 Make a pencil mark a tile's height from the top edge of the skirting board. This will show you where to draw the baseline

2 Drawing the baseline. The spirit level ensures that the baseline is level and acts as a straight edge for marking the line

3 Pin the batten along the bottom of the line to provide a level base for tiling. The bottom row will be filled in later

4 Check the batten with the spirit level to make sure it is horizontal. If it is not, it will have to be unpinned and re-adjusted

5 Mark tile widths along the batten to give an even cut at each end of the wall. This ensures the symmetry of the tiled wall

6 Use the spirit level to draw the vertical line at the last tile mark. The line acts as a guide to keep the tiling square

provide a non-porous base for the adhesive. If the surface is very uneven, it should be replastered and left for a month before being sealed and tiled.

However, rough surfaces can often be relined with plywood, chipboard or plasterboard (wallboard). To do this on a brick wall, you will need to plug and screw wood battens—50mm × 25mm will do—to the wall at regular intervals. Make sure that each batten is vertical, using wood chips to pack any gaps between the wood and the old wall surface. Space the battens to suit the width of the lining material.

Before screwing your panelling material to the battens, give each strip a thorough coat of wood sealant. As you secure the panels, plan your work so that adjacent ones butt up against each other over the centre of a batten.

Wallpaper: On no account should tiles be laid on to wallpaper. Strip the wall back to the bare plaster or wallboard, then fill and level as described above.

Painted walls: Providing these are smooth and firm, tiles may be applied direct. But flaking or rough paint should be partially stripped with medium glasspaper and brushed clean.

Timber walls: These must be sanded or planed level and treated with wood primer before the tiles are applied.

Existing ceramic tiles: The ideal tiling surface, providing the tiles are clean, firmly fixed and not chipped.

Constructing a baseline
Before you start tiling you will need a horizontal baseline from which to work—floors and skirting boards are not suitable, as they are seldom completely level and can throw the tiling out of true.

BMV

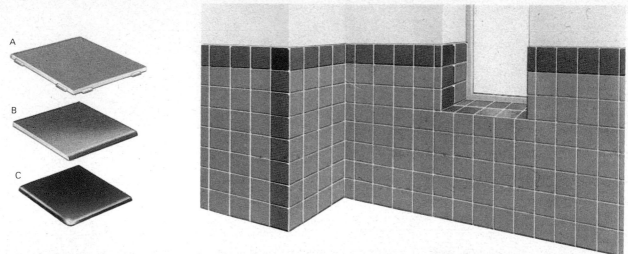

A. *The three most common types of tile are (A) Field tile (B) Single round-edged tile, usually referred to as an 'RE' tile (C) Double round-edged, or REX, tile. The colour-coded picture shows where each type is used*

B. *When tiling around a window, work from a line down the centre of the reveal—not from the edge of the wall on either side*

C. *On a wall with two windows, work from a line midway between the two. This will give your tiling a neat visual balance*

Tiling around windows

When tiling window reveals and sills, arrange the tiles to achieve a good visual balance, with cut tiles of equal size on each side of the window. Fit any cut tiles at the back and in the corners where they are not so obvious. Make sure the patterns are kept continuous, and the finished surfaces smooth, by placing the spacer lugs of any cut tile against those of the adjacent tile.

At the fronts of sills, and the lines where the edges of reveals meet the main wall line, use round-edged tiles. Lap them over the edges of the wall tiles to form a smooth, rounded edge. Where work surfaces protrude from walls, use REX tiles at the corners.

This patented tile cutter speeds up the work because it measures and cuts in one operation. First you set the gauge to the width of the tile section you require

Next, holding the scriber like a dagger, roll it through the centre channel to score the tile. The scriber tip must point upwards; otherwise you will blunt the wheel

Now depress the base of the tool to snap the tile. Used carefully, this tile cutter will make a dead straight cut without the edge lines tending to 'wander'

7 *With adhesive spread over about 1 m², fix the first tile at the intersection of the batten and the vertical line. Press the tile home*

8 *When fitting cut tiles into corners and other awkward areas it is easier to apply the adhesive to the backs of the tiles*

9 *Once you have tiled the rest of the wall you can remove the batten and fix the bottom row, carefully scribing each tile to fit*

10 *Use a tile cutter to score through the glazed surface of a tile. The try square ensures that the score mark is straight and even*

11 *Place a matchstick under the score mark on the tile. Exert downward pressure and the tile should snap cleanly along the mark*

12 *An alternative method of cutting tiles is with the Oporto cutter. The tile is snapped by breaker wings*

To draw a baseline, measure the height of a tile from the floor or skirting board and make a mark (fig. 1). Using the spirit level as a straight edge, check for level and draw a line through this mark (fig. 2).

Pin the top edge of a batten along the line so it forms a level base, right along the length of the surface to be tiled (fig. 3). Check that you do not have *more* than one tile's depth at any point below this line. If you do, lower the batten slightly.

Later, when you have tiled above it, you can remove the batten and fill in the space below (fig. 9). The tiles here may have to be cut or trimmed.

Marking a side line
To keep the tiles exactly square to the baseline, you will also need a vertical line at one side of the surface. Find the centre point of the batten and mark out the tile widths along either side of it. Draw your line where the last full tile ends on the lefthand side, using the spirit level—or a plumb line—to give you an accurate vertical line (fig. 6).

Fixing the tiles
Begin tiling at the intersection of the horizontal batten and the vertical line (fig. 7), filling in the bottom row and working upwards.

Adhesive should be applied thinly to the wall over an area of not more than 1 m² at a time. If applied to the backs of the tiles themselves, the finished surface could be uneven. If adhesive is applied over a greater area, some may dry before it has been tiled over. Drive the serrated edge of the spreader over the adhesive, forming ridges to provide good suction and adhesion.

Press the tiles firmly into place without sliding them, wiping away any adhesive which squeezes onto the surface of the tiles with a damp cloth. The alignment of the tiles should be checked with the spirit level on completion of every three or four rows.

When the tiles have set, the corner tiles may be fixed and the batten re-moved before filling in the bottom row —butter their backs with adhesive and fit them firmly home. Always fit cut tiles so that the spacer lugs—that is the uncut sides—face those of the adjacent tile (fig. 9).

Butt the spacer lugs of the tiles on the adjacent wall against the surface of the cut corner tile at right angles to it—thus allowing a grout line to run down the junction of the two walls.

Cutting and shaping tiles
Straight cuts in ceramic tiles can be made either by scoring and snapping with a standard tile cutter (figs. 10 and 11) or by scoring and breaking with an Oporto tile cutter (fig. 12).

Notches and curved cuts must be 'nibbled' by hand with a pair of pincers (fig. 13). In the case of curved cuts, make a straight cut first as near to the curve as possible—the tile will snap if you attempt to pincer out larger areas.

The guidelines for curved cuts can

13 *For a shaped cut, score the area that is to be removed then nibble out small pieces of the tile with a pair of pincers*

14 *When the shape has been nibbled out of the tile, smooth off any unevenness on the cut edges with a carborundum file*

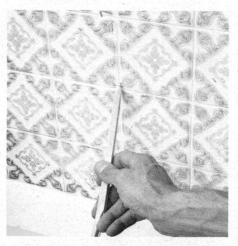

15 *Once the tiling has been completed and the adhesive has set, rub grout firmly into the joints with a sponge or piece of rag*

16 *When the grout is almost dry, draw a stick with a round point along the joints to give a neat appearance to the finished tiling*

with tiles cut to fit.

Where the fitment is in the middle of a wall—such as a basin or wc—tile around it as closely as you can with whole tiles, then fill in the spaces with cut tiles when the rest of the wall is completed.

Grouting

When the tiling is finished, leave it to set for 12 to 24 hours, then rub grout firmly into the tile joints with an old sponge, squeegee or cloth (fig. 15). Remove excess grout with a damp sponge: when it has almost set, run a blunt stick across the joints to leave a neat finish (fig. 16). Allow the grout to dry and then give the tiles a final polish with a soft, dry cloth.

be drawn in either by eye, or—more satisfactorily—with a cardboard template. Trim the template to shape in situ then transfer it to the tile and draw around it in felt-tip pen.

Pipes present some of the trickiest tiling problems. The safest way to tile around them is to cut the relevant tile in two and to cut a semi-circle out of each half.

All cuts in ceramic tiles look neater and more professional if they are smoothed afterwards with a carborundum file or block (fig. 14).

Tiling around fitments

Where the fitment runs the length of a wall—a bath or kitchen unit for example—treat the top edge as you would a floor or skirting board. Fix a horizontal batten along this edge and leave it in place while you tile the wall above. When the tiles are dry, remove the batten and tile down to the edge

D. *Two of the simple techniques used to cut awkward shapes out of ceramic tiles*

Bernard Fallon

Stylish tile-topped tables

A tile-topped table, if carefully made, can look superb in any setting. You do not need to make a new table; you can use a second-hand or shop-soiled one—even a cut-down kitchen table if its proportions are right.

Before buying tiles, take home some samples and make a test pattern on your table top. Check that

1: You will not need to cut square tiles; on a table cut ones are unsightly.

2: In a pattern using two or more colours, you will finish up with the same colour in all four corners.

3: You will not need a wide, ugly border strip around your tile pattern.

When tiling, always work from the centre towards the edges, following a carefully-drawn grid.

Roughen old paint or varnish around the edges before fixing the edge battens. Fix these with PVA adhesive and, preferably, frame cramps.

Far right: *Green and white tiles make a handsome table for a patio, sunroom or conservatory*

Right: *With medallion tiles, you can space tightly or—as here—use strong grout lines for emphasis*

Below: *Tiles of this sort should be laid out so that patterned, not white, ones fall in the corners*

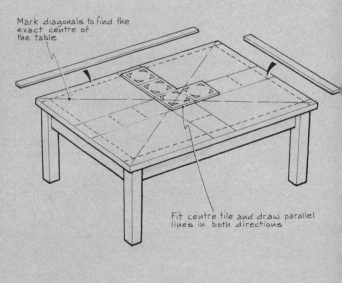

Mark diagonals to find the exact centre of the table

Fit centre tile and draw parallel lines in both directions

CARPENTRY

Using a chisel

Types of chisel for different uses ● Using a chisel safely ● Cutting a housing ● Vertical paring ● Cutting a mortise ● Working with a paring chisel ● Sharpening chisels

Knowing how to use a chisel correctly is one of the most important aspects of carpentry. And once you have mastered the skills and techniques involved, a whole new range of do-it-yourself projects becomes possible.

Types of chisel
The chisel is the basic wood-shaping tool and is used for paring, cutting joints and chopping out areas of wood for hinges and other fittings. There are various types of chisel for different uses, the basic types being:
Bevel edged chisels have tapered edges which allow the chisel to get

easily into tight corners. They are ideal for cutting dovetails and shallow housings, such as hinge recesses, and for vertical paring. But because much of the steel in the blade is ground away to form the bevel, the blade lacks strength. A bevel edged chisel should not be used for heavy work or for work that involves any lever action.
Firmer chisels have strong blades of rectangular cross-section which make them stronger than bevel edged chisels and thus more suitable for heavy work such as fencing, frame construction and notching out for

Above: *To use a chisel successfully and safely, when paring vertically or horizontally, it must be kept under complete control. A chisel should be sharpened regularly to maintain its cutting edge*

pipes running over joists.
Mortise chisels are the strongest chisels of all and are designed to withstand both continual striking with a mallet and the levering action required when cutting the mortises for mortise-and-tenon joints. The heavy square cross-section of the blade prevents the chisel from twisting in the mortise, thereby ensuring neat and accurate finished work.

Mortise chisels of good quality have a leather washer between the shoulder of the blade and the handle to reduce the jarring caused by striking with the mallet.

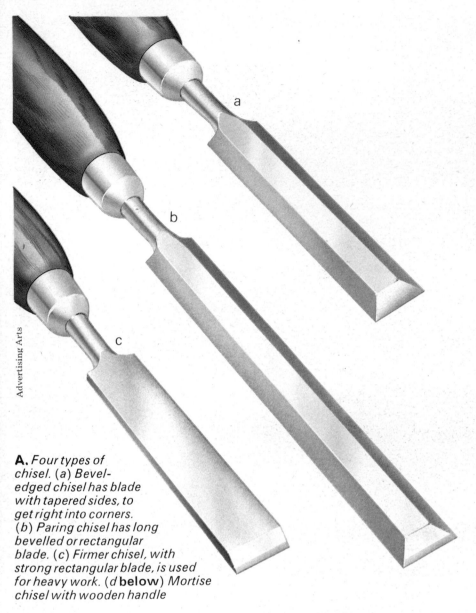

A. *Four types of chisel. (a) Bevel-edged chisel has blade with tapered sides, to get right into corners. (b) Paring chisel has long bevelled or rectangular blade. (c) Firmer chisel, with strong rectangular blade, is used for heavy work. (d below) Mortise chisel with wooden handle*

Paring chisels have long blades of either firmer or bevel edged type. The long blade is so designed for reaching into awkward corners and for paring out long housings such as those used in bookcase and staircase construction. Because they have long blades, paring chisels should never be struck with a mallet or used with a lever action. This can cause the brittle metal to snap and may be dangerous.

Buying chisels

Bevel edged and firmer chisels are available in a wide range of widths from 1mm to 38mm. Initially, a set of 6mm, 12mm and 25mm chisels should be adequate for most requirements. Mortise chisels do not come in such a range of sizes and it is unlikely that anything other than 6mm, 8mm and 12mm mortises will ever be required. Buy paring chisels only when the need

for a particular one arises.

Always select chisels that have smooth handles and make sure that the handles feel comfortable in your hand. Modern chisels usually have handles made of shockproof, splinterproof plastic. Traditionally, chisel handles were made of boxwood or beech and although these are still obtainable, they are an expensive alternative to plastic. If you prefer wood, some chisels have handles made of beech which is much cheaper than boxwood but not as tough.

Always check that the blade is secure in the handle and that the blade and handle are in line. If the blade is wrongly aligned, the chisel will be incapable of producing good work. Check also that the blade is flat across its face—if it is not, it will be impossible to sharpen correctly.

Chisel safety

Chisels are often supplied with plastic guards which fit over the end of the blade. If the chisels you choose do not come supplied with guards, it is well worth buying a set. Always replace the guard when you have finished using a chisel in order to protect the cutting edge, and to prevent accidents.

When working with a chisel, always keep both hands safely behind the cutting edge. Except for vertical paring, when the work is secured by your hand, hold the work firmly in a vice or cramp it to the work bench.

Trying to force a chisel leads to lack of control and a possible accident, so always use two or three thin cuts rather than one thick one.

Horizontal paring

Horizontal paring is a technique used when constructing joints—such as housing joints for supporting the ends of shelves and halving joints used in framework. These consist of slots across the grain of the wood and are normally made with a bevel edged chisel which is able to get into the corners of the joints.

When making such a joint, define the area of the slot by marking out

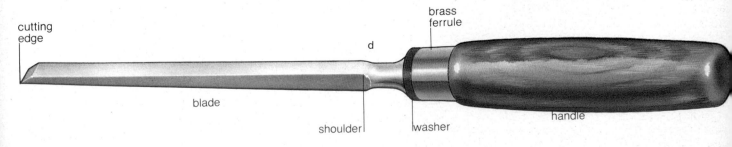

cutting edge

brass ferrule

d

blade

shoulder

washer

handle

1 For horizontal paring, hold the wood securely in the vice so that it does not move as you chisel. Rest your elbow on the bench

2 Hold the chisel with both hands, keeping them behind the cutting edge and pare angled cuts adjacent to the sawn guide lines

3 When the angled cuts are half way across the wood, turn it around in the vice and finish the cuts from the other side

4 Turn the chisel over so that its bevel edged side is facing down, and slap the handle with the palm of your hand to remove the waste

5 Turn the wood in the vice again, and remove the remainder of the waste from the other side. The bevel edge should be facing up once more

6 When most of the waste has been cleared, work the chisel across the joint with its blade flat against the wood to remove fine shavings

7 To sever any remaining fibres in the corners, work the blade into each corner with the chisel held in one hand

8 For vertical paring, place the wood on a bench hook and support the end with a timber offcut. Keep your head over the work

9 Remove slivers of wood, gripping the blade between your fingers. Hold your thumb over the handle to provide downward force

width lines on top of the wood, and width and depth lines on both sides. Make a saw cut, slightly to the waste side of each width line and cut down to the depth line. If the joint is particularly wide, extra saw cuts can be made in the waste to make chiselling-out easier.

Hold the wood securely in the vice so that it will not move as you work

and make sure that it is horizontal (fig. 1). Hold the chisel in both hands, safely behind the cutting edge, with the elbow resting comfortably on the bench. This gives extra control over the chisel's movement.

Start by chiselling out the waste adjacent to the sawn lines, making angled cuts to half way across the wood (fig. 2). Push the chisel firmly,

holding it at a slight angle, keeping your arm horizontal and level with the work. When the cuts are half way across the joint, reverse the wood in the vice and complete the angled cuts from the other side (fig. 3).

Now turn the chisel over so that the bevel is facing downwards and remove the bulk of the remaining waste by slapping the handle of the chisel with

10 When cutting a mortise, cramp the wood and protect it with a timber offcut. The tail of the cramp should be beneath the work

11 Keep your body right behind, and in line with, the work and drive the chisel firmly into the wood with a mallet

12 For paring out long housings, use a paring chisel. The long blade can be worked flat over a long distance for an even finish

the palm of your hand (fig. 4). Because the bevel side is facing down, the chisel blade works its way up to the surface and no levering action is needed to clear the waste. Again chisel only half way across the joint, then turn the wood around and work from the other side with the bevel side of the chisel facing upwards once more (fig. 5). If you chisel right across the joint, the wood will break and splinter out on the other side.

When most of the waste has been removed, work the chisel across the joint, keeping it absolutely flat across the bottom, to shave off the last fibres of wood (fig. 6). Finally, hold the chisel vertically in one hand and work the blade into the corners to clean them out and sever any remaining fibres (fig. 7).

Vertical paring
Vertical paring is necessary when you wish to round off a corner or to make a curve in a piece of wood.

Hold the wood on a bench hook, to protect the surface of the work bench, and support the other end, if necessary, with a timber offcut of the same height as the hook (fig. 8). Hold the chisel upright in both hands with the thumb of the upper hand over the top of the handle to give control and downward force. The lower hand steadies the work and also grips the blade of the chisel between the index finger and the knuckles of the other fingers. Keep your head over the work as you pare away the wood.

Mark the required curve on the wood and cut off the corner, to an angle of about 45°, with a tenon saw. Holding the chisel as described, pare off the corners left by the saw cut. Keep paring off the corners, taking off thin slivers of wood not more than 1mm thick (fig. 9). If you take off thicker cuts than this, the extra effort involved may cause you

to lose control of the chisel.

Work as closely in to the curve line as possible, then finish off by smoothing with a file.

Cutting a mortise
A mortise is a rectangular slot cut into a piece of wood into which a tongue—called a tenon—from another piece of wood is fixed. The mortise and tenon make a strong joint which is used to form T-shapes in frames. The mortise should always be made with a mortise chisel—the width of the chisel's blade determines the width of the mortise.

To mark out a mortise accurately you need a mortise gauge. Using a chisel of the exact width of the planned mortise, set the gauge to the chisel blade and mark out the width lines on the wood. With a try square as a guide, draw the two setting-out lines which determine the length of the mortise.

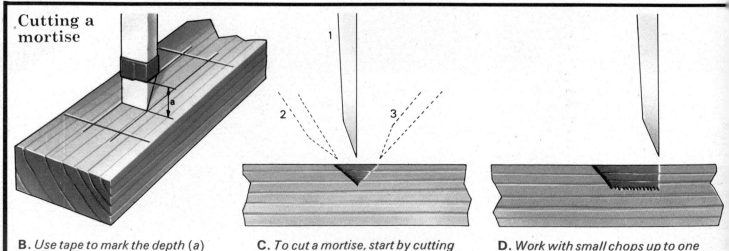

Cutting a mortise

B. Use tape to mark the depth (a) that you want the mortise to be

C. To cut a mortise, start by cutting a wedge between the lines

D. Work with small chops up to one of the setting out lines

13 To sharpen the blade of a chisel, hold it at an angle of about 30° onto an oilstone. Rub the blade in a figure of eight motion

14 When a wire edge begins to form, turn the blade over. Rub it over the oilstone keeping the blade flat upon the surface

When cutting a mortise, the wood should be held securely on a solid part of the bench rather than cramped in the vice: as the chisel is struck with a mallet, it would dislodge the wood from a vice. Use a G cramp (C clamp) to hold the wood in position and protect the top with a timber offcut (fig. 10). Make sure that the tail of the cramp is beneath the work or injury may result. Drive the chisel into the wood with a mallet—never use a hammer to hit a chisel as this may damage the handle, making the chisel uncomfortable and unsafe to use.

Start by driving the chisel into the mortise to dislodge a deep wedge of waste. Use three separate strokes of the chisel to remove the wedge, making it equal on both sides. Keep your body behind, and in line with, the work (fig. 11). Work, with a series of small chops, from the centre towards one of the setting out lines keeping the chisel in the same vertical plane at all times.

Stop at the line, turn the chisel round and approach the other setting out line with a further series of chops.

Clear out the waste and dislodge another wedge in the centre to the depth of the finished mortise. A band of tape wrapped around the chisel blade to the required depth makes a good depth indicator. Chop up to both setting out lines, again to the required depth.

If you are cutting a mortise to go right through the wood, chop to half way from one side then turn the wood over and work from the other side. Never chisel all the way through to the other side or the wood will split.

Sharpening chisels

No matter how correct your technique or how expensive your chisels, you cannot produce good work with a blunt chisel. You should always check that cutting edges are sharp before use and hone them if necessary.

Chisels are sharpened on oilstones which are made in three grades of grit—coarse, medium and fine—and come in two sizes—150mm × 25mm × 25mm and 200mm × 50mm × 25mm. Coarse grade stones remove large particles of steel and are therefore needed only when a cutting edge is chipped or badly damaged. Medium stones are used for normal sharpening of the blade and for dealing with small nicks in the cutting edge. Fine stones hone the blade to a sharp edge. For sharpening on oilstones, you also need oil—not to act as a lubricant, but to carry away particles of metal before they become embedded in the stone.

Chisels have two angles to their cutting edge: the ground angle of 25° and the honed angle of 30°. The ground angle is formed on a powered grindstone and only occasionally needs regrinding.

To hone a chisel, apply a liberal amount of oil to the stone and hold the blade at an angle of about 30° against the stone (fig. 13). Keep the blade square to the stone and rub it in a figure of eight motion to distribute wear evenly over the stone. When a burr—known as wire edge—begins to form on the flat side of the blade, turn the chisel over, Rub the flat side across the stone to remove the wire edge, keeping the blade perfectly flat upon the stone (fig. 14). If you raise the chisel handle, however slightly, the flat side of the blade becomes bevelled and the chisel cannot be sharpened to a fine edge.

When the wire edge has been removed, return to the bevelled side of the blade. Rub each side of the blade in turn, using less and less pressure, until a razor sharp edge is produced.

E. Reverse the chisel and start again from the centre

F. Work towards the other setting out line with a further series of chops

G. Place tape on the blade and repeat down to the required depth

Simple stained trinket box

David Jordan

Simple constructional techniques are used to make this attractive trinket or jewellery box, and very few materials are needed.

The main constructional feature is the box joints used for the corners. These require careful marking and cutting out with a narrow chisel to give a neat finish to the corners.

The material used throughout is solid 4mm hardwood sheet. Ply should not be used, since the corner joints are not suited to this material. Possible sources of suitable wood are model shops and specialist craft suppliers.

Bear in mind that if you use a darker wood, such as mahogany, it is not possible to stain it to a bright finish, but it will look equally attractive in a natural clear varnish.

If the wood you use is not exactly 4mm in thickness, use the same overall dimensions, but cut the base to the correct size to fit inside the box when the sides are assembled, and use the thickness of your wood instead of the 4mm measurement when marking out the corner joints.

Stain and varnish the outside of the box and line the inside with black velvet glued in place.

Minature brass hinge

4mm × 4mm base support block glued inside the sides

Cut out the marked and sawn sections of waste wood using a narrow chisel. Make sure all the edges are square to ③ the face

Place pieces together to check that all joints match, then cut down the vertical lines with a tenon saw. Hold the work steady in a vice and cut carefully down as far as the scribed line ②

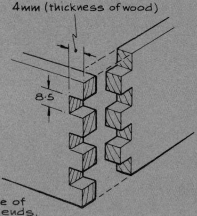

4mm (thickness of wood)

8.5

Mark out the joints using a ① mortise gauge, always working from the same edge. When marking out, make sure that one of the sides has fingers at both ends. All the fingers are of an equal size. Mark the waste wood to be cut out for the joints

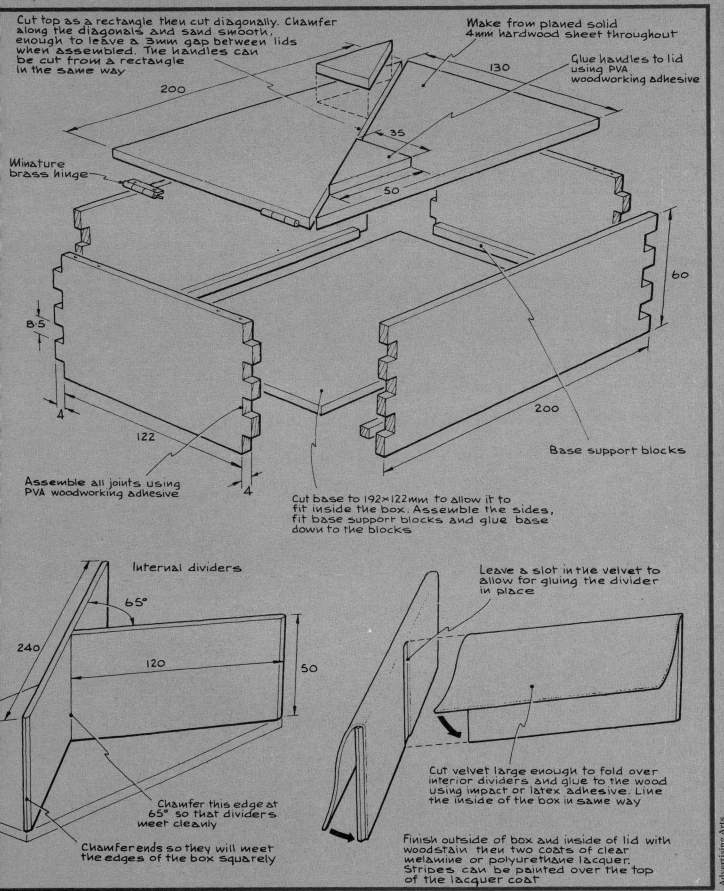

Cut top as a rectangle then cut diagonally. Chamfer along the diagonals and sand smooth, enough to leave a 3mm gap between lids when assembled. The handles can be cut from a rectangle in the same way

Make from planed solid 4mm hardwood sheet throughout

Glue handles to lid using PVA woodworking adhesive

130

200

35

Minature brass hinge

50

60

8·5

4

122

200

Base support blocks

Assemble all joints using PVA woodworking adhesive

4

Cut base to 192×122mm to allow it to fit inside the box. Assemble the sides, fit base support blocks and glue base down to the blocks

Internal dividers

65°

Leave a slot in the velvet to allow for gluing the divider in place

240

120

50

Chamfer this edge at 65° so that dividers meet cleanly

Chamfer ends so they will meet the edges of the box squarely

Cut velvet large enough to fold over interior dividers and glue to the wood using impact or latex adhesive. Line the inside of the box in same way

Finish outside of box and inside of lid with woodstain then two coats of clear melamine or polyurethane lacquer. Stripes can be painted over the top of the lacquer coat

Fixing wood to wood

Gavin Cochrane

The correct tools ● Using a hammer ● Nailing tips ● Removing nails ● Drilling screw holes ● Drilling techniques ● Countersinking ● Driving screws ● Nail and screw buying guides

Nails and screws are the two most important fastening devices used in carpentry, but how well they do their job depends almost entirely on how correctly they are used.

Tools
The two hammers used most frequently in carpentry are the claw hammer and the cross-pein, or 'Warrington'. The first is useful for levering out old nails and lifting floorboards while the second is more suited to finer nailing work.

If you are starting a tool kit, opt for a 450g claw hammer and a 280g Warrington. Later, you can add a 100g 'pin' Warrington for light, accurate nailing and pinning.

For burying nails below the surface of the wood, you need a set of nail punches (nail sets). These come in various sizes—to suit different sizes of nail—and help to avoid bruising the wood with the hammer head.

Some kind of drill is essential for screwing work. A power drill is the obvious choice because of its versatility but where there are no power points or access is limited, a wheel brace (hand drill) will serve well.

To drill larger holes by hand, you need a swing brace (fig 1) and a set of special bits—not a priority for the beginner's basic tool kit.

Good quality screwdrivers are essential to any tool kit and cabinet screwdrivers, with blades of about 300mm, are the most useful. Two of them—one with an 8mm tip and one with a 6.5mm tip—should cover you for most jobs. To deal with crosshead, Philips or Posidriv screws, you need screwdrivers with the appropriate tips.

Using a hammer
Using a hammer properly requires a little bit of practice. Take a firm grip right at the end of the handle and form your arm into a right-angle, looking straight down on the work as you do so. Start the nail by tapping it lightly, keeping your wrist controlled but flexible and letting the hammer head do the work. Increase the power of your stroke slightly as the nail goes in but at no time let your arm waver—if you do, you will either miss, or bend, the nail.

On well-finished work, remember not to drive nails right in—leave a

1 *If you are drilling large holes by hand, use a swing brace. When the point emerges, turn the wood over and drill from the other side*

For rough carpentry work: large ugly head ensures a firm grip. Liable to split wood

Commonly used in carpentry. Oval cross section makes it unlikely to split wood if the long axis follows the grain

General carpentry nail. Head can be punched below surface and the hole filled

Small nail for securing light pieces of wood; usually used in conjunction with glue

Large headed for fixing roofing felt, sash cords, wire fencing to wood. Galvanized for outdoor work

Used to hold down floorboards. Good holding power and unlikely to split wood

Headless: used to hold glass to picture frames and lino to floorboards. Will not grip if driven too far in

Hardened steel nail for fixing wood to soft brick, breeze block and concrete

Special head shape countersinks itself in hardboard and can be filled over

Decorative head used to cover tacks in upholstery work

Special-purpose nails

Carpet nail

Small nail with broad head. For fixing carpets and fabrics to wood or floorboards

Annular ring nail

For fixing plywood, blockboard and other sheet materials. Very strong grip but difficult to remove

Roofing nail

For securing corrugated iron or asbestos roofing to wooden rafters. Galvanized for outside work

Pipe nail

Used to fix guttering and other rainwater hardware directly onto masonry or brick

Wire staple

Used to secure wire fencing, upholstery springs and similar hardware to wood. Galvanized for outside work

Wood cleat (corrugated fastener)

For butt- or mitre- joining wood quickly and easily. For light duty work.

Sealing roofing nail

Used on corrugated metal roofing. Has a plastic or lead washer under the head. Drive through the high part of the corrugation

Duplex nail

Used for assembling concrete boxing or formwork. Lower head grips the timber; upper head facilitates removal

Flooring nail— N. American type

Used to nail floorboards to diagonal sub-floors. Holds like a screw, but easier to drive

Sue Rodger

2 Start short nails with a cross-pein hammer. Tap gently with the wedge end until they stand firm, then drive in with the hammer face

3 Very small nails and pins should be held with a pair of pliers. Use the cross-pein hammer to hit the nail with fairly gentle taps

4 Use the claw hammer to remove any partially driven nails. Slide the claw under the nail head then give it several short, sharp pulls

bit protruding for the hammer and nail punch to finish off.

Start light nails or tacks with the cross-pein by tapping gently with the wedge end of the hammer head. Drive them home with the hammer face using a number of fairly gentle taps rather than trying to knock them in with one blow, which will probably bend the nail. Very short nails can be held with a pair of thin-nosed pliers until driven in far enough to stand on their own.

Nailing techniques

For accurate, well-finished work, nails alone do not normally make a strong joint. However, if the nails are angled in opposition to each other, a reasonable joint can be made. When used in conjunction with one of the modern, woodworking adhesives, a very strong joint can be achieved. The panel on page 76 shows some common nailing techniques. Seldom are nails driven straight—a stronger joint can be made if they go in at an angle or *skew*.

When nailing two pieces of wood together, nail the smaller to the larger. Avoid nailing into hardwoods altogether: if you must, drill a pilot hole first, slightly smaller than the shank of the nail.

Removing nails

The claw hammer is used to remove partially driven nails. To avoid damaging the surface of the wood, place a small offcut under the hammer head before you start levering (fig 5). Extract nails with a number of pulls rather than trying to do the job in one.

Use pincers to remove small nails and pins which are difficult to grip with the claw hammer.

Drilling screw holes

All screws must have pilot holes made before they can be driven home. For screws into softwood smaller than No. 6 gauge, make these with a bradawl. Drive it into the wood with its chisel point across the grain, to avoid splitting.

Screws into hardwood and screws into softwood larger than No. 6 gauge need two pilot holes. One is for the thread—the pilot hole—and one for the shank—the shank hole.

For all except the largest pilot holes, use twist drill bits. Those for pilot holes should be the same size as the screw core to which the threads are attached. Those for the shanks should match them exactly.

When drilling pilot holes, mark the required depth on the drill bit with a piece of masking tape. This will tell you when to stop and cannot damage the workpiece should you overdrill.

As with nailing, where two pieces of wood are to be fixed together, screw the smaller to the larger. Drill the shank hole right through the smaller

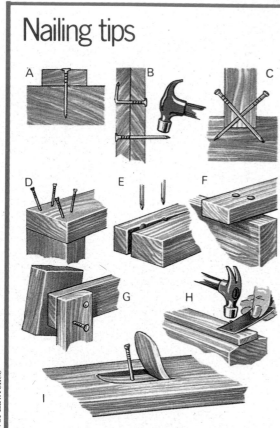

Nailing tips

A. *Use nails about 3 times as long as the workpiece. Always nail smaller to larger.* **B.** *On rough work, clench-nailed joints are much stronger.* **C.** *Skew-nailing is one of the best ways of securing a housing joint.* **D.** *When nailing into end-grain, drive in nails at opposing angles.* **E.** *Driving more than one nail along the same grain line risks splitting the wood.* **F.** *Nail small battens overlength to avoid splitting the end. Afterwards, saw or plane off the excess.* **G.** *Avoid 'bouncing' by placing a block under the workpiece.* **H.** *Small nails can be positioned with the aid of a cardboard holder.* **I.** *Secret nailing. Prise up a sliver of timber with a chisel. Glue down after nailing*

Trevor Lawrence

5 To remove large nails and to avoid damaging the wood, slip a block of wood under the head of the nail. This increases the leverage

6 Use pincers to remove nails which are difficult to grip with a claw hammer. A series of sharp pulls avoids leaving a large hole

7 For flat-head countersunk screws, use a countersink bit. Drill a hole of the same diameter as that of the screw head

Screws: types and uses

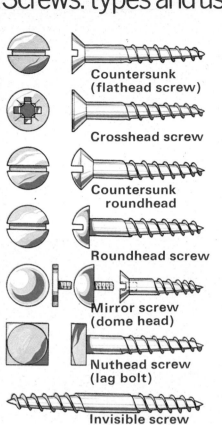

Countersunk (flathead screw)
Used for general woodwork. The head sinks in flush with or slightly below the wood surface

Crosshead screw
Used for general woodwork, but needs a special screwdriver which does not slip from the head

Countersunk roundhead
Used for fixing door-handle plates and other decorative fittings with countersunk holes. The head is designed to be seen

Roundhead screw
Used for fixing hardware fittings without countersunk holes. The head protrudes from the work

Mirror screw (dome head)
Used for fixing mirrors and bathroom fittings. The chromed cap threads into the screw head to hide the screw. Do not overtighten

Nuthead screw (lag bolt)
Used for fixing heavy constructions together and heavy equipment to timbers. Tighten with a spanner

Invisible screw (dowel screw)
Used for invisible joining of two pieces of timber.

Panel screw
Used for fixing thin sheets of metal and plastic. Cuts its own thread as it is screwed in. Various types of head are available

Chipboard screw
Used for securing chipboard and its derivatives. Various types of head are available

piece so it is pulled down tight as the screw is driven home. If the shank hole goes only part of the way through you will find it very hard to pull the top piece of wood down tight and may risk breaking or damaging the screw. Brute force should never be used—it indicates that either the thread hole or the shank hole is too small.

Countersinking
Countersinking is normally the easiest way of recessing screw heads flush with, or below, the surface of the wood. The recess is made with a countersink bit (fig 7) after the pilot has been drilled, to the same depth as the countersunk screw head. Take particular care if you are countersinking with a power drill or the recess may accidentally become too large.

8 *Always hold a drill at right-angles to the surface so that you drill a straight hole. Rest a try square next to the bit and use it as a guide*

9 *When you are drilling horizontally with a hand-operated wheel brace, grip the handle with your thumb towards the wheel*

10 *A pump action screwdriver should be held with both hands. Make sure the screwdriver is squarely on the screw head*

Drilling techniques

Using the correct drilling technique makes all the difference to the quality of the finished work. Whether your drill is power or hand operated, you should always hold it at right angles to the work surface so that the pilot hole is straight. If you find this difficult, rest a try square upright near the bit and use it as a guide.

With bit drills, operate the drill in bursts and lift it frequently to allow debris to escape. To give yourself as much control as possible, always hold the drill with both hands and never press too hard—you are bound to overdrill.

Keep the chuck key taped to the cable, so it is handy whenever you want to change bits.

Using a hand-operated wheel brace requires slightly more effort, but gives more control than a power drill. When drilling vertically, grip the handle with your thumb on top. Turn the wheel steadily to avoid knocking the drill out of line.

To drill horizontally, grip the handle with your thumb towards the wheel (fig 9). Alternatively, where a side handle is fitted, grasp this in one hand while you turn the wheel steadily with the other.

Driving screws

Always make sure that the tip of your screwdriver is in good condition and that it fits exactly into the slot in the screw head. A blade which is too narrow or rounded damages the slot, while too wide a blade damages the wood as the screw goes in.

When using a pump-action screwdriver, hold it firmly in both hands—one on the handle, the other on the knurled collar just above the bit—and make sure that you are not off-balance (fig 10). Any loss of control could cause the blade to slip out of its screw slot and damage your wood.

To make screwdriving easier, the screws can be lubricated with wax or candle grease before driving. Brass screws are quite soft and to prevent damage when screwing into hardwood, the resistance can be lowered by driving in a steel screw first.

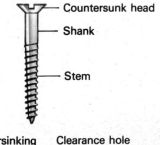

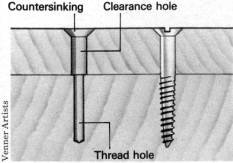

Venner Artists

A. *Drill two pilot holes for each screw—the top one to accept the shank in a 'push fit', the bottom one usually two sizes smaller*

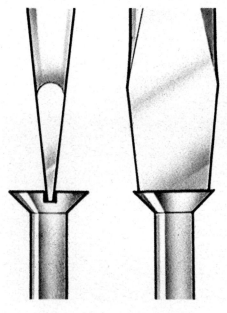

B. *See that the screwdriver blade fits the screw head exactly and that the tip is kept ground square. If not, you risk 'chewing up' the screw*

Build a bunk be

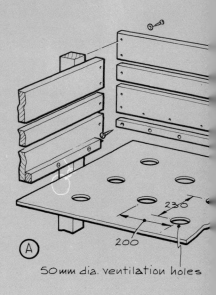

50mm dia. ventilation holes

230

200

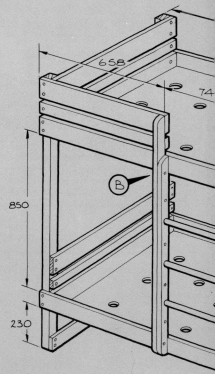

658

74

850

230

Start by cutting all timber to length except the bed bases. Build up the two end frames first then stand them upright and add the back frame. Saw and rasp the ladder stile ends to a radiused finish. Stand the assembly on its back before adding the final side frame, ladder and safety rails.

25mm spacing between all rails

No.6 25mm woodscrews

wood

2065

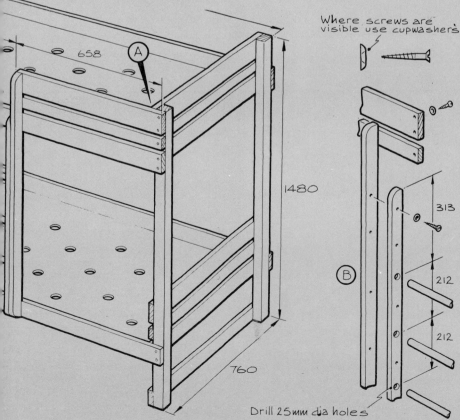

658

A

1480

760

Drill 25mm dia holes

Where screws are visible use cupwashers

B

313

212

212

Cutting list

The list quotes finished lengths of timber. When buying the timber, add on at least 15mm to each length to allow for cutting wastage.

Legs: 4 No. 50mm x 50mm x 1480mm

Side rails: 4 No. 100mm x 25mm x 2065mm; 2 No. 100mm x 25mm x 726mm; 2 No. 50mm x 25mm x 726mm

End rails: 8 No. 100mm x 25mm x 760mm; 4 No. 50mm x 25mm x 708mm; 2 No. 75mm x 25mm x 708mm

Base support rails: 4 No. 50mm x 25mm x 716mm; 4 No. 50mm x 25mm x 1921mm

Outer ladder stiles: 2 No. 50mm x 25mm x 1250mm

Inner ladder stiles: 2 No. 50mm x 22mm x 1050mm

Plywood leaves: 2 No. 760mm x 1921mm x 9mm

Ladder rungs: 3 No. 25mm chromed steel tube x 649mm

Use 32mm No. 8 countersunk wood screws and white PVA adhesive on the frame: on the bed rails, use the covered type (page 75). Use 25mm No. 6 screws on the bed bases.

Advertising Arts

Gluing and cramping

Types of glue and adhesive ● Which glue to use for the job ● Different types of cramping device explained ● How to apply glue to woodwork ● Making a web cramp ● Cramping techniques

Below: *You can improvise a cramp for simple gluing jobs simply by using terylene (polyester) cord and a short piece of dowel—which is used as a turn-key to tighten the web*

Modern adhesives have made it possible for amateur carpenters to construct wooden furniture which in the past only skilled craftsmen could have tackled. Work which would have once needed precise joints can now be joined simply with strong wood adhesive—using cramps to hold the wood in place while this is drying. You can choose from a variety of cramps according to the size of the wood.

The term glue properly refers to pure animal or vegetable glue. Other types, which are resin based. are known as adhesives. The success of your gluing depends on choosing the right kind of glue for the job.

Choosing the right adhesive
The glue or adhesive you use will depend on the type of wood you want to join together, the surface conditions, the kind of stress the join will be subjected to and whether a temporary or permanent join is wanted.

Pay particular attention to the temperature in the workshop. Most adhesives need a warm atmosphere in which to set. Make allowances too, for hard or resinous woods: these require a sap-resistant adhesive.

Polyvinyl acetate (PVA)
PVA adhesive ('white glue') is among the most useful for general-purpose woodwork. Available ready mixed in easy-to-use plastic bottles, it is applied directly to the wood which is then cramped. At normal room temperatures, the setting time varies from 30 minutes to three hours depending on the brand used.

PVA is a strong adhesive. It does not stain timber but, if smears are left on the surface, it will show through varnish as a light patch. So any smears must be wiped away quickly with a damp cloth. It is not completely waterproof and will not adhere very readily to resinous or very hard wood such as teak. It is not suitable for outdoor work.

Urea formaldehyde adhesive

This is a good adhesive for hard, resinous woods. Its gap-filling properties also make it ideal for gluing loose-fitting joints—such as those found in furniture making and repairs. It resists moisture better than PVA.

Resorcinol formaldehyde

This woodwork adhesive provides the greatest strength and is the most water resistant, so it is ideal for outdoor work and boatbuilding. It is also a good gap-filling adhesive.

When adhesives have to be applied to timber treated with preservative, use urea formaldehyde or resorcinol.

Animal glue (Scotch glue)

This old fashioned glue is made from animal pelts and bones. It comes both in cake or granular form and in liquid form. The cake or granular varieties need to be melted down in a glue pot with water at a temperature of 65°C and used while still hot. These do not stain timber and dry to a medium brown colour which matches most polished or stained woods. They are not waterproof.

Unlike the granular variety, liquid animal glues can be used cold. Again they are not waterproof and do stain some woods—especially oak—so excess glue should be wiped off with a damp cloth before it can do any damage to the wood.

Animal glue has largely been made obsolete by more modern adhesives but is still the best to use when constructing frameworks for upholstered furniture. The stresses which the frame undergoes while being upholstered may cause adhesive-made joints to fracture.

For mending or renovating antique furniture, use an alburnum (sapwood) based Scotch glue. This has the same expansion and contraction rate as old-fashioned Scotch glue, which is different from that of modern adhesives. Never mix old and new glue on one piece of furniture.

Synthetic resin cements

This type of adhesive is almost completely waterproof and comes in a variety of forms—powder, semi-liquid or two-part (adhesive and hardener). It can be used for outdoor work and small boat-building. The setting time depends on the temperature of the surroundings—the warmer the air around the workpiece the faster it sets.

Impact (or contact) adhesives

Wood stuck to wood with this type of adhesive tends to move after a time. It is therefore not strong enough for furniture making and is better suited to fixing laminates and tiles.

The surfaces to be stuck together are both coated with the impact adhesive and are then left to dry separately according to the manufacturer's instructions. Afterwards, the two surfaces are brought together to make an instant, strong bond.

Impact and contact adhesives are the only types which do not require cramping while they set. But as a bond is formed instantly, you should ensure that the mating surfaces are aligned.

Epoxies

Almost any material can be stuck with epoxy adhesives but for woodworking, PVA and formaldehyde adhesives often prove to be both cheaper and easier to use. Epoxies are made up of two parts —a resin and a hardener—which must be mixed together. Setting time can vary between one hour and 24 hours.

Cyanacrylate adhesives

Extra care must be taken when using these new 'super glues'. Manufacturers claim that one small spot of the adhesive and a little pressure will stick almost anything to anything in just a few moments. They will certainly stick skin to skin permanently, so be careful and make sure that children do not get anywhere near them.

Bernard Fallon

A. *This G cramp ('C cramp' in North America) is ideal when you want to hold smaller pieces of wood or awkward shapes as the glue sets*

between 25mm and 250mm or 300mm and are mainly used for cramping pieces of wood to a bench and for holding down veneer or laminate while the adhesive dries.

Variations on the basic G cramp include deep-mouthed cramps—which reach further across the workpiece— and small, sliding bar G cramps. The latter are smaller and easier to use than conventional G cramps and are useful for holding small pieces of timber in place.

Sash cramp: Sash cramps are used to cramp larger pieces of timber, such as doors and window frames. Consisting of two adjustable stops on a long bar, they come in different lengths up to 3m long with extensions (fig. B). One stop is adjusted by sliding it along the bar and securing it with a pin: the other tightens like a vice jaw. Because of their size, sash cramps are expensive to buy. They are, however, obtainable from hire shops.

Web cramp: This consists of a 3.6m loop of nylon webbing, running through a ratchet, which can be tightened and released using a spanner or screwdriver (fig. 7). The web cramp cannot apply as much pressure as a sash cramp, but it is cheaper and is quite adequate for light and medium weight gluing jobs.

You can make an improvised form of

Types of cramp

The type of cramp you should use depends on the size of the wood you are gluing.

G cramp: Called 'C cramp' in North America, this most versatile type of cramp gets its name from its shape. G cramps have a mouth capacity of

B. *Large scale gluing of things like long pieces of wood requires one or more sash cramps to hold the work really securely along its whole length while the glue is setting*

web cramp by using strong cord and two short pieces of dowel (fig. 8). Tie a double thickness of the string around the object to be put under pressure then use the dowel to twist the strands together until the tension cramps the wood firmly. Use the second piece of dowel to hold the first in place.

Preparation

If you are using liquid animal glue, make sure that it is fresh—most have a limited life and will cease to work properly if they are old.

Most, but not all, adhesives are effective only on surfaces which are free from moisture, dust and grease. Unless the instructions with your adhesive specify special gap-filling properties, the surfaces should also be reasonably smooth.

Always 'dry assemble' your work to begin with. Blow out dust from any inaccessible corners of the work, then fit the pieces together. Having made the necessary adjustments and re-cleaned the joints, mark each part to

eliminate the possibility of getting things in the wrong order on final assembly. Make sure that you sand and finish off any areas which would prove too inaccessible after gluing.

Mixing and applying adhesives

Before you start mixing and applying your glue or adhesive, make sure that all the necessary cramping equipment is well to hand—it will be too late to search for it once the glue is mixed.

If there are any small holes or cracks in the wood, fill them at this stage. A good filler can be made by mixing a thin glue or adhesive with some sawdust: if you use sawdust from the same wood, the finished joint will be barely noticeable.

When making up a mixed glue or adhesive, use a small piece of wood and an old china teacup or saucer. Follow the manufacturer's instructions to the letter, taking particular care when water has to be added.

Use another, preferably flat, piece of wood to apply your glue or adhesive or apply it straight from the container. Again, you should follow the instructions carefully and make sure that each surface to be coated receives an even covering. Glue invariably shrinks as it dries—causing stresses and strains which will weaken the joint unless the coat is even.

Cramping techniques

Unless you are using impact adhesive, you should cramp the wood as soon as

the joint has been made. Whichever type of cramp you use, you must be careful that the surface of the wood does not get scratched and damaged by the action of the cramp while the glue is setting. You can either use some newspaper or alternatively, to prevent the metal cramp jaws from bruising the surface of the wood, ensure that there is a small block of wood between the two (fig. 3). Make your blocks, or *cushions*, from offcuts.

When using a G cramp, make sure that the jaws and cushions are positioned as far over the joint as possible (fig. 3) then tighten the cramp to finger-tight. Where two pieces of angled, or wedge-shaped, wood are being cramped, position a second cramp at right-angles to the first (fig. 5) to stop the parts slipping.

Use a sash cramp in the same way as a G cramp. Make sure the sash is exactly square to the workpiece or distortions may result. During cramping, the bar of the sash will tend to bow in towards the workpiece, so place small wedges underneath to keep it straight.

When using a web cramp, or its improvised alternative, ensure that the webbing runs around firmly fixed parts of the workpiece. Otherwise, you may break one joint as you are trying to cramp another.

If you are making an improvised web cramp, make sure that it is of a really strong material like terylene (polyester) cord.

C. *A web cramp is ideal for light- or medium-weight gluing jobs such as a chair leg or similar straight-forward furniture repair jobs*

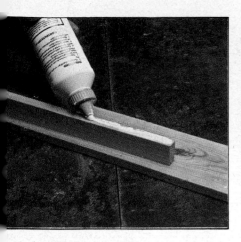

1 Mix glue to the right consistency, if necessary, then apply it with a stick or straight from the glue bottle onto the surface of the wood

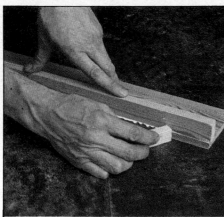

2 With the wood on the bench, wipe off any excess glue to prevent it staining and place the wood in whichever cramp you are using

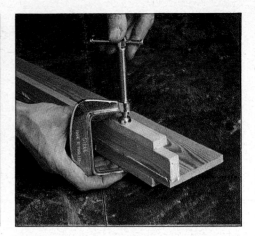

3 Place a block of wood between the wood you are gluing and the cramp to cushion the work and protect it while it is in the cramp

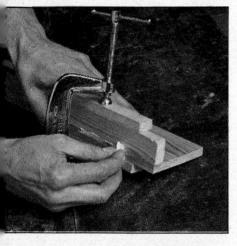

4 Tighten the cramp and if any excess glue is squeezed out of the joint wipe it away. Leave the wood in the cramp for the required time

5 If cramping wedge-shaped pieces of wood together, use a second cramp at right-angles to the first to stop the wood slipping

6 If gluing long pieces of wood, use several sash cramps on alternate sides of the wood. Protect it with cushion blocks and paper

7 For light- or medium-weight gluing jobs use a web cramp. Run the webbing through the ratchet and tighten steadily

8 Make an improvised web cramp using polyester cord and a short piece of dowel. Use double-thickness cord around the object being glued

9 Use the dowel to twist the strands together until the tension cramps the wood firmly. Use a second piece of dowel to hold the first

Martin Palmer

Making a picture frame

These attractive wooden frames can easily be made in a few hours using only simple gluing and cramping techniques.

A variety of woods can be used to blend beautifully with any type of interior. The frames are ideal for enhancing the look of a modern picture or poster, or for giving an authentic look to old-fashioned prints. They can even be used for your family photographs—the design is flexible enough to suit whatever you want to display.

If you want to brighten up a dark corner of a room or hallway, consider putting in an ordinary mirror, secured to the back with special mirror bolts. The mirror also adds interest to a small, square room or makes a narrow hall look wider than it actually is.

If you hang the frame opposite a window where it can reflect the light, you will get an even more spacious feel. You could also hang the mirror in the bathroom with a simple fluorescent strip light above it to turn it into a shaving or make-up mirror.

Alternatively, add a touch of elegance to a room by hanging the frame with dark, smoked glass. While looking dramatic, it will still give the same reflection as ordinary mirror glass.

To assemble a frame, work on a dead flat surface such as a laminated workbench. Either use G cramps or lay the components on the surface, cover them with a sheet of blockboard, and weight them with bricks.

If you want a stained frame, stain the components before assembly. But if you are using gloss paint or a combined stain-varnish, leave the colouring until after the adhesive has set and hardened.

(A) (B) (C) Make the corner joints by stepping the frame strips — then glue and pin them together

(B) (A) (C)

Use suitable sizes of planed timber for the size of frame you wish to build. The top strip A should be half the width of the middle strip B and one third the width of the bottom strip C.

If you wish to put in a glass front get a glazier to drill the appropriate holes — mirror screws must be used.

The glass is screwed to the deepest step in the frame (strip C).

Make the picture frame from three sizes of whitewood strips, arranged as shown to form a stepped set of rebates which can be used to hold the picture mask or a glass mirror.

(A) (B) (C)

Glue the wood with PVA adhesive and secure the strips in a G cramp until the adhesive has set — this varies from 30 minutes to three hours at normal room temperature

Glue and cramp the strips with PVA woodworking adhesive. Use wood offcuts (shown shaded) to protect the wood and to spread the pressure evenly

Advertising Arts

The art of planing

Bench and block planes ● Care of the blade ● Taking apart and re-assembling ● Preparing the wood ● How to hold the plane properly ● Using the plane ● Planing end grain

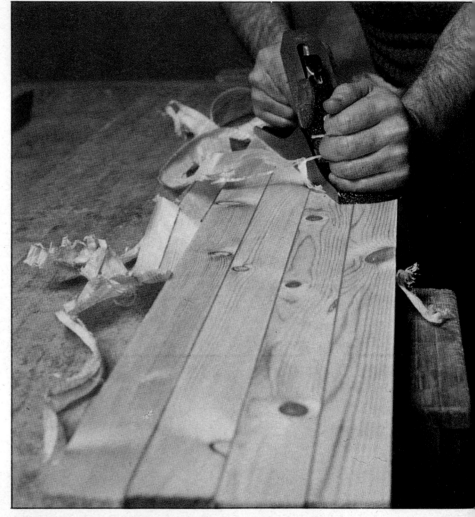

Below: *A fairly long plane used for long pieces of wood so the plane levels out the timber rather than following any profile it might have. The plane is held comfortably with the body weight over the top of it*

A plane's job is to slice off unwanted portions of wood, reducing the wood to the exact size required and leaving it smooth and flat.

Bench planes

These are made up of the same parts and have the same adjusting and sharpening procedures. They come in four lengths. The jointer plane is the longest, measuring approximately 550mm, the fore plane is about 450mm, the jack plane is 350-375mm and the smooth plane 200-250mm.

A long plane cuts flatter than a small one because the short one rides the bumps instead of just straddling them. The jack is good for straightening up and levelling pre-finished timber of any length. The jointer plane is used for getting a dead level, straight surface, especially on long, narrow pieces of wood.

The plane blade has two angles forming the cutting edge—the ground angle of 25° and the honed angle of 30°. The plane's ground angle is already formed on a new plane and will need only occasional renewing on a grinding stone but the honed angle has to be sharpened before you can use the plane. If the blade is not sharp it will tear the surface of the wood making it unsightly and sometimes completely unusable.

Taking apart and sharpening

Referring to the diagram below

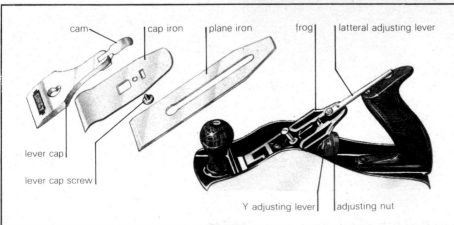

cam | cap iron | plane iron | frog | latteral adjusting lever

lever cap

lever cap screw

Y adjusting lever | adjusting nut

David Watson

remove the lever cap by releasing the cam and sliding the cap upwards until it will lift off. Remove the plane blade and the cap iron. Place them on a flat surface and undo the cap iron screw. Slide the blade forward. twist it through 90° and remove from the cap iron.

If you have a honing guide for sharpening the blade, set this up according to the manufacturer's instructions. Alternatively, use an oil stone box with a medium stone.

Use enough oil to keep the surface

Left: *A new plane is easily taken apart for sharpening the blade*

f the stone moist. Hold the plane iron so the blade is at 90° to the stone with the bevel side of the blade down on the stone. Tilt the iron until you feel the bevel flat on the stone—this will be about a 25° angle. Tilt through another 5° to get a 30° angle. Then rub the blade evenly up and down the stone, maintaining the angle.

Continue doing this until you feel a burr or wire (a roughness) on the flat side of the blade. When you feel it burred evenly all the way across, turn the blade over and place it flat on the stone. Holding it flat with both hands, move it up and down at a slight angle until the burr has been removed from the edge.

Repeat on a fine stone and then, if you want a very sharp edge, do the same again on a leather strop impregnated with motor car valve grinding paste to provide a good abrasive.

Re-assembling

To put the plane together again, hold the cap iron screw side up and place the blade at right angles to it over the screw. Slide the blade so that the screw goes three quarters of the way up the slot, then twist it back through 90° and slide it back until only 1.5mm of blade projects beyond the cap iron.

Finger-tighten the screw and re-adjust the blade to a clearance of 0.5-0.7mm. Hold the blade flat on a bench and tighten the screw. Place the blade back on the plane—taking care not to damage the sharpened edge—so that it lies flat on the frog. then replace the lever cap. Look along the bottom of the plane from the front at eye level and move the lateral adjusting lever to the right or left, if the blade is not level. It must be exactly level to give an even cut.

Block planes

These are very like the bench planes but they are smaller. They are made up of similar parts but there are fewer of them. They have to be taken apart and the blade sharpened in exactly the same way as the bench plane.

The standard type has the same cutting angle as a bench plane. Others have a cutting edge of 20° and 12° which make it easier to use on small items. They can be used one-handed quite easily.

Block planes are particularly suitable for using on small pieces of timber, for working on the end grain of timber and for trimming plastic laminates.

Preparation

If the wood you are going to plane is covered with old paint it is worth taking this off with paint stripper

1 Moisten the stone with oil. Tilt the iron to a 30° angle and then rub the blade evenly up and down the stone maintaining that angle

2 When the blade is burred on the flat side turn it over and place it flat on the stone. Move up and down at a slight angle to remove burr

3 Hold the cap iron, screw side up, and place the blade at 90° to the screw. Slide the blade so the screw moves up the slot and twist

4 Slide the blade back until 3mm projects beyond the cap iron and then finger-tighten the screw. Then re-adjust blade to show 0.5-0.7mm

5 Hold the blade flat on a bench and tighten the screw. Having placed the blade back on the plane, you can replace the lever cap

6 Look along the bottom of plane from the front and adjust it until the cutting edge is level and protrudes less than 0.5mm

before you start, otherwise the plane will not be able to bite into the wood. Remove any nails as they would damage the blade.

Put the wood on a solid, level surface so that it will not move while you are planing. Have the end of the wood against a stop.

If you are supporting the workpiece in a vice, make sure that it is sandwiched between two offcuts to prevent the jaws from bruising the wood.

The frog part is adjustable, which means that the mouth of the plane can be altered according to the type of material you are planing. For rough planing and soft timbers, the blade should be set with half to three-quarters of the mouth open. For fine finishing of hard woods and for planing end grain, the frog should be adjusted to give a very fine mouth opening of about 1.5mm.

Method

Hold the plane firmly but comfortably with both hands and with your body balanced over the top of the plane. Push the plane forward over the wood keeping the cuts shallow and even. Never plane against the grain of the wood or the blade will catch on the ends of the fibres.

If you are planing correctly you should be producing ribbon-like shavings of equal width and thickness.

When planing long edges apply more pressure on the front knob of the plane at the beginning of the stroke, even out the pressure in the middle of the stroke and at the end of the stroke apply more pressure at the back of the plane (fig. 10). Make the stroke the whole length of the wood each time.

As you plane, make *sure* by frequent checking with the try square that the edge you are working on is at right angles to the other surfaces. And use the edge of the try square, or a steel rule, to see that the edge is straight.

End grain

If you are planing end grain, cut the wood 6mm longer than it needs to be. Put the piece of wood upright in a bench vice, with a waste piece of wood behind. Plane across both pieces of wood—that way any splitting will occur on the waste wood rather than the wood you want to use.

Alternatively, you can bevel all the four corners and then plane from one end towards the middle. Turn the wood around and plane from the other end towards the middle. Remove the piece left in the middle very carefully. The plane needs to be very sharp and finely set for this or you will be left with an uneven surface.

7 Hold the plane with both hands and with body balanced over the top. Push the plane over the wood, keeping cuts shallow and even

8 When planing a long, square edge move your front hand. Use your fingers to support the plane and help keep it in a square position

9 If you are planing correctly you should be producing long ribbon-like shavings of equal thickness and width. Do not stop in mid-stroke

10 When planing across a wide width of wood twist the plane at an angle to help reduce the resistance of the wood to the plane

11 To plane end grain put the wood in a vice with an offcut behind it then plane across both pieces. This avoids splitting

12 Alternatively, bevel all the four corners then plane from one end to the middle. Turn over the wood and repeat on the other side

Easy-make pine sofa

Sawing, screw-assembling and a modest amount of end-grain planing are all the skills you need to make this attractive, functional pine sofa.

A sensible order of work is :

Assemble the back first, ensuring that the spacing between boards is correct and that the whole is square. Include the corner blocks at this stage (note that they are *two* thicknesses of timber in from the edge) but not the seat support rail.

Next, assemble the front and its corner blocks. Fix the seat supports to the front and then to the back, ensuring that these are level.

When spacing out the sides, make sure that the armrest will slide into the space provided in the back.

With all four sides fixed together, make up and attach the plinth before you fit in the seat slats—otherwise you will have trouble getting your screwdriver into the corners.

Cushions are of 130mm foam plastic.

Above : *Extra-wide seat cushions provide plenty of room for lounging, while the clean lines of varnished pine enhance any modern decor*

Below : *The sofa without its cushions, showing the simple construction. All the timber components are of softwood in standard sizes*

Workplan

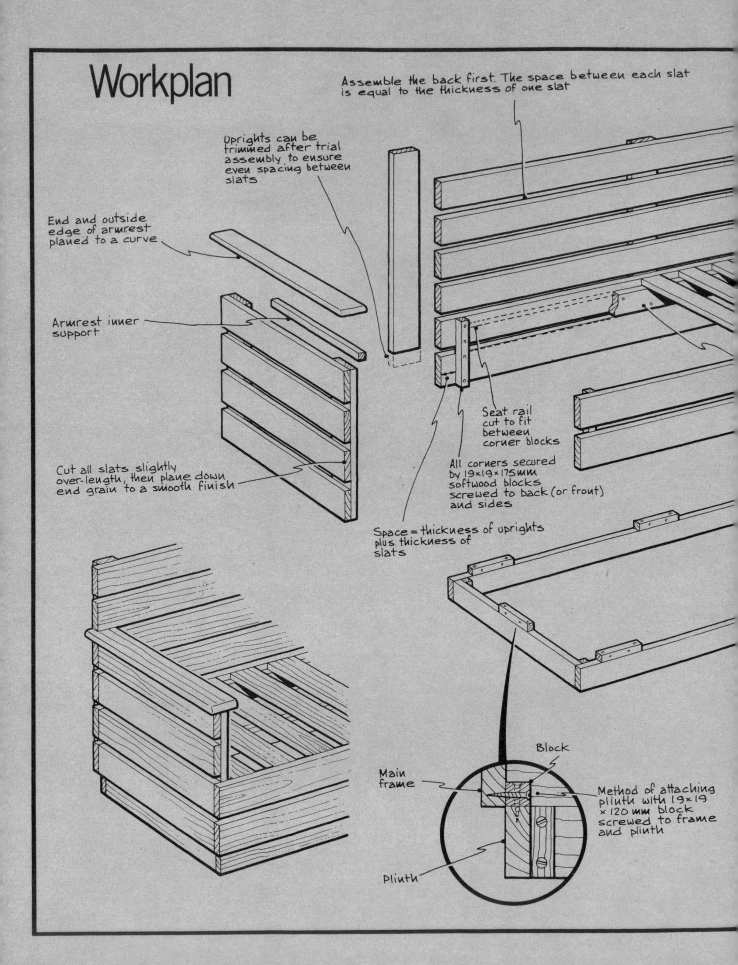

Assemble the back first. The space between each slat is equal to the thickness of one slat

Uprights can be trimmed after trial assembly to ensure even spacing between slats

End and outside edge of armrest planed to a curve

Armrest inner support

Cut all slats slightly over-length, then plane down end grain to a smooth finish

Seat rail cut to fit between corner blocks

All corners secured by 19×19×175mm softwood blocks screwed to back (or front) and sides

Space = thickness of uprights plus thickness of slats

Block

Main frame

Method of attaching plinth with 19×19 ×120mm block screwed to frame and plinth

Plinth

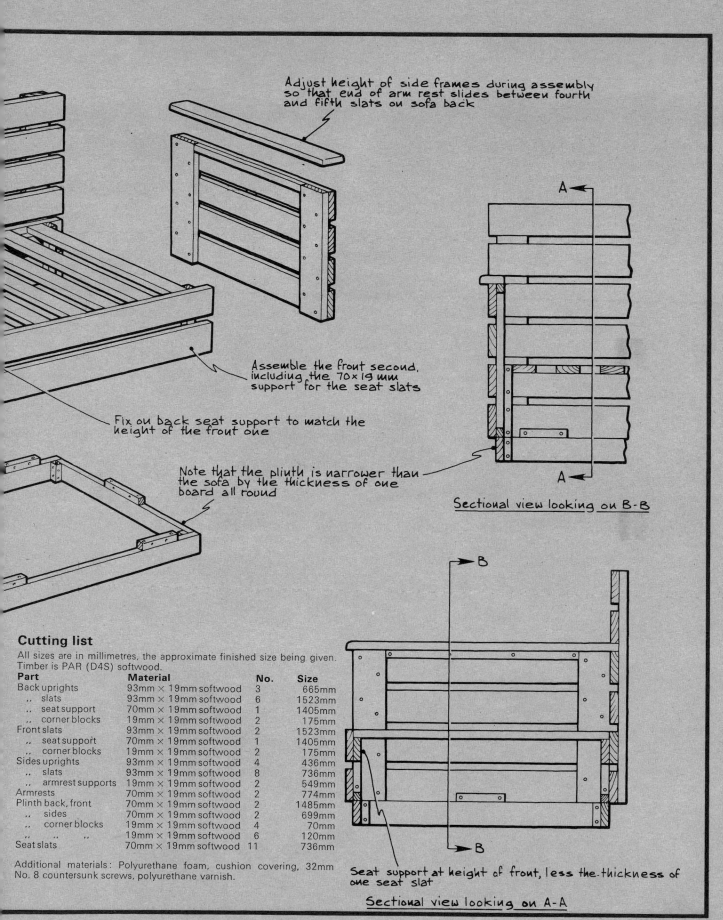

Adjust height of side frames during assembly so that end of arm rest slides between fourth and fifth slats on sofa back

Assemble the front second, including the 70 × 19 mm support for the seat slats

Fix on back seat support to match the height of the front one

Note that the plinth is narrower than the sofa by the thickness of one board all round

Sectional view looking on B-B

Sectional view looking on A-A

Seat support at height of front, less the thickness of one seat slat

Cutting list

All sizes are in millimetres, the approximate finished size being given. Timber is PAR (D4S) softwood.

Part	Material	No.	Size
Back uprights	93mm × 19mm softwood	3	665mm
„ slats	93mm × 19mm softwood	6	1523mm
„ seat support	70mm × 19mm softwood	1	1405mm
„ corner blocks	19mm × 19mm softwood	2	175mm
Front slats	93mm × 19mm softwood	2	1523mm
„ seat support	70mm × 19mm softwood	1	1405mm
„ corner blocks	19mm × 19mm softwood	2	175mm
Sides uprights	93mm × 19mm softwood	4	436mm
„ slats	93mm × 19mm softwood	8	736mm
„ armrest supports	19mm × 19mm softwood	2	549mm
Armrests	70mm × 19mm softwood	2	774mm
Plinth back, front	70mm × 19mm softwood	2	1485mm
„ sides	70mm × 19mm softwood	2	699mm
„ corner blocks	19mm × 19mm softwood	4	70mm
	19mm × 19mm softwood	6	120mm
Seat slats	70mm × 19mm softwood	11	736mm

Additional materials: Polyurethane foam, cushion covering, 32mm No. 8 countersunk screws, polyurethane varnish.

Mortise-and-tenon joints

Ray Duns

● **Types of mortise and tenon joint** ● **Rules for dimensions** ● **Using a mortise gauge** ● **How to mark up mortises, tenons and haunches** ● **Cutting a mortise** ● **Cutting a tenon** ● **Wedged joints** ● **Trimming and finishing**

The strength of a joint connecting two pieces of timber depends on three factors: the size of the gluing area, the way in which one piece of timber encases the other, and the accuracy of the finished work. A strong joint is one in which one component encases the other in such a way as to ensure a large gluing area without either component being unduly weakened. The mortise and tenon joint satisfies these requirements best of all.

Types of mortise and tenon
Mortise and tenon joints are used in a wide variety of work, ranging from course carpentry through joinery to the finest cabinet work. Their most common applications are in roofing, window frames and door frames, stud

partitions, and tables and chairs.

The component parts of the joint are known as the *stile*—the vertical member which usually holds the mortise—and the *rail*—the horizontal member usually with a tenon at each end. In the simplest mortise and tenon joint, used only in the roughest carpentry work, the rail fits straight in to a mortise in the stile (fig. B). More usually, though, the rail is trimmed to leave 2-6mm shoulders on either face (fig. A). These effectively hide any gaps—such as those caused by a slack-fitting tenon or by careless cutting-out of the waste in the mortise.

This type of mortise and tenon joint is called a plain joint. It can also be classified according to the way in which the mortise and tenon meet.

Above: *A typical mortise and tenon joint incorporating a secret haunch to stop the components twisting*

A. *A conventional haunched through joint of the type found on many older window and door frames*

horn

haunch

cheek

shoulders

waste

B

shoulders

waste

C

D

The four traditional forms are shown (figs C to F)—*through*, *stub or 'blind'*, *through wedged*, and *foxed wedged*.

An additional complication—*haunching*—is sometimes introduced to stop the rail from twisting, and to take strain off the tenon (fig. A). And on large rails, the gluing area can be increased by employing a double tenon with haunching (fig. G)—the strongest mortise and tenon joint.

Some of the above permutations are occasionally combined, making the whole business of mortise and tenon joints look far more complicated than it really is. For example, on high-quality door frames you may find that some of the joints are of the foxed wedged double tenon type.

In fact, the only joints which are really difficult to make are those where the stile and rail are moulded —requiring you to scribe and cut complicated shapes. These are described further on in the course.

Rules for dimensions

The thickness of the tenon should be around one-third of the thickness of the stile, but should be set finally to match the width of the nearest available size of chisel.

The width of the tenon should not exceed five times its own thickness, which in turn will determine whether a single or double tenon is used. But if the joint is positioned at the top of the stile, it is usual to divide the tenon width into three parts—two for the tenon and one for the haunch (fig. K). Where the frame of which the joint is a part is to take a panel of some sort and is grooved, the haunch forms part of this. Otherwise, it is customary to make a groove to match a *secret* haunch (fig. 13).

Where the rail is wide—over about 75mm—it is usual to employ a double tenon. In this case, you can either divide the rail width by four and take each tenon width as one-quarter (fig.

B. *A simple stub joint in which the tenon has no shoulders. This is used only for the simplest frameworks*

C. *In the plain through joint, the tenon passes right through the stile and is trimmed off after assembly*

D. *For a stub joint, the mortise in the stile must be cut to exceed the length of the tenon by 3-5mm*

E. *For a through wedged joint, wedge room must be cut on either side of the mortise. The wedges are driven in after the joint has been assembled*

F. *The foxed wedged joint, which incorporates secret wedges, is little used today thanks to the strength of modern woodworking adhesives*

G. *A double haunched joint has exceptional strength. The waste between the tenons is cut with a coping saw taking care not to weaken the tenons*

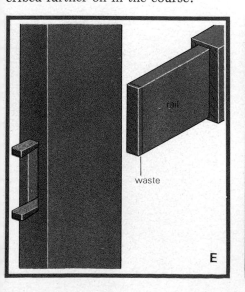

waste

E

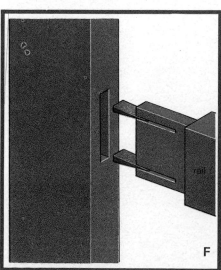

F

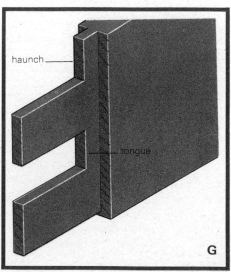

haunch

tongue

G

Bernard Fallon

137

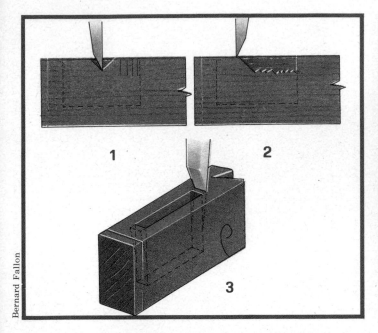

H. *Start a mortise from the centre (1) working outwards. Move back to the centre (2) then out to the other end (3) Trim to the edges then cut wedge room if needed*

I. *Initial marking out on both the stiles and rails is best done with the relevant pieces of timber cramped together. Mark the waste first, then the rail width*

1 *To mark out a tenon, the mortise gauge must be set to the nearest convenient chisel size. Roll it away from you down the workpiece to mark*

2 *To find the middle of a piece of timber with a mortise gauge, try it from both sides until you get the pin marks to match up*

3 *After you have marked the tenon on the rail and mortise on the stile, reset the gauge and mark out the tenon width*

4 *Use a conventional gauge to mark out where the haunch will be cut. Make sure that you have set it to the correct width*

G) or divide it by three and make the distance between tenon centres one-third of the rail width.

If you are making a stub tenon joint, the depth of the mortise should exceed the length of the tenon by 2mm. The gap allows for excess glue and minimizes the risk of the joint failing through hydraulic action. When you are cutting the mortise for a stub tenon, make sure that there is at least 4.5mm of wood between it and the outer edge of the stile.

When marking and cutting a mortise at the end of a stile, it is customary to leave excess waste material known as a *horn*—between 25mm and 35mm is usual on a standard-sized door frame. The horn helps stop the stile from splitting as the mortise is cut and also protects the frame in transit to its final position, where the waste is trimmed off.

Marking up a simple frame

If you are making a framework which incorporates joints at the ends of stiles, do not forget to allow for the extra length taken up by the horns when you compile your cutting list.

Rail lengths for a framework are normally taken as the overall width of the frame, allowing you plenty of waste material. But if you are using through mortise and tenon joints, add on 12mm to the overall frame width: this gives you 6mm waste on each end, removed when the joint is finally 'cleaned up'.

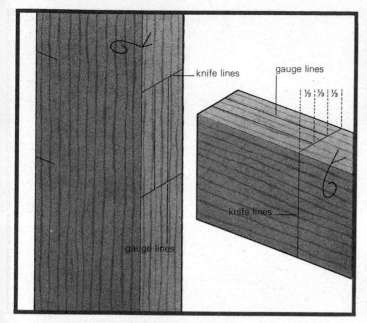

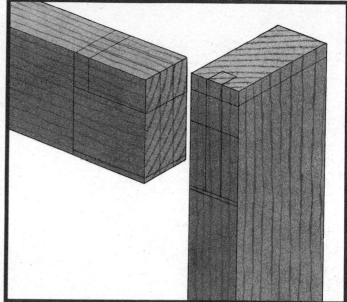

J. *A marked-out plain through mortise and tenon joint ready to be cut. The lines marking the mortise and corresponding tenon width are made with a mortise gauge*

K. *This more complicated haunched stub joint is at the top of the stile. If you get confused when marking out, shade in the waste areas in pencil*

With your timber to hand, test each piece for true and mark on face sides and face edges. Lay the pieces out as they will appear in the finished frame, face edges innermost and face sides uppermost.

Designate and mark the stiles 'left' and 'right', and the rails 'top' and 'bottom'. You can also mark the joints A-A, B-B and so on, though the marks should be on waste wood which will be removed later.

Next, place the stiles side by side on the bench, face sides uppermost and face edges outwards, and cramp them together with a small G cramp. Remember to place offcuts between the jaws of the cramp and the workpiece to protect the latter from becoming bruised (fig. I).

With a try square, marking knife and rule, mark off one waste end or horn—whichever is appropriate—on both pieces. Follow by marking the finished lengths of the stiles. The material left represents either waste or another horn.

Your next job is to mark the positions of the mortises and, if you are making a wedged joint, the 'wedge room' on either side of them. Again, use the try square, marking knife and rule but score deeply only those areas which are to be cut. Mark very fine lines on the rest of the timber.

If you are making a through tenon joint, separate the stiles and mark around them individually. Start at the face edge and work around the timber

so as to end up at the edge below it.

Make fine lines at each edge of the workpiece to enable you to continue around it without having to score across the whole surface.

When you have finished marking the stiles, cramp the rails in the same way and mark off the overall lengths. Do not forget to add an extra 12mm waste if you are making through mortise and tenon joints. This will be planed off when the joint is assembled.

Mark the lengths of the tenons as described above—together with the haunches where necessary (figs I and K). Finally, separate the rails and continue the lines right around each workpiece.

Marking mortises

At this stage, you are ready to mark the widths of the mortises on each stile. By far the easiest way of doing this is with a mortise gauge (fig. 1), a tool similar to a marking gauge but with an adjustable scribing pin in addition to the standard fixed one. You are well advised to go to the trouble of buying or borrowing a mortise gauge, rather than trying to 'make do' with existing tools.

Start by releasing the set screw on the stock and adjusting the distance between the pins to match the width of the chisel you are using to cut the mortise out. Next, you must adjust the stock so that the distance between

5 *The saw cuts for the haunch groove are best made with a dovetail saw but if you do not have one, use an ordinary tenon saw*

6 *After you have made the saw cuts, chisel out the waste wood in the groove with an appropriately-sized bevel edged chisel*

it and the moveable pin allows you to centre the pins on the timber.

To check this, place the stem of the gauge flat on the workpiece with the stock face to the face side, then roll the gauge until the pins make indentations in the surface. Repeat the operation from the side opposite the face side. If the two sets of marks coincide, the pins are centred and you can tighten the stock. If they do not, adjust the stock until they do.

With the pins centred and the stock back against the face side, roll the gauge away from you to mark the mortise widths on the stiles (fig. 2). Keeping the gauge on the same setting, mark around the rail ends to give you the necessary width of the tenons.

If shoulders or haunches are included in the joints, reset the gauge to the appropriate dimensions and mark them out with the stock against the face edge (fig. 3). Use an ordinary marking gauge to mark the depth of the haunch to be cut across the end of the stile (fig. 4).

If you must use an ordinary marking gauge instead of a mortise gauge, always work from the same face side and edge—resetting the gauge for each mark you make.

Cutting the mortises
The techniques for chiselling out a simple mortise are described earlier in the book in detail (see pages 111 to 115). Briefly, the procedure (fig. H) is as follows:
● Cramp the workpiece securely to a solid part of the bench.
● Drive the chisel into the marked-out mortise to dislodge a deep wedge of waste. Use three separate strokes of the chisel.
● Work in a series of small chops from the centre of the mortise to one end, removing waste as you go.
● Turn the chisel around and work back to the other end in the same way.
● For a stub (blind) mortise, wrap a piece of tape around the chisel blade to give you the required depth. Continue removing waste in the same way then trim all sides.
● For a through mortise, continue chiselling until you get half way through the wood then turn the workpiece over and restart the mortise from the other side.

Where necessary, the 'wedge room' outside the mortise must also be chiselled. Line up your chisel on the appropriate line with the bevel pointing towards the centre of the mortise. Chop downwards at an angle of about

7 *The easiest way to start off large mortises is to drill a series of holes within the confines of the marking out lines on the stile*

85° to finish the wedge room 3-5mm from the end of the mortise.

For a haunch groove, you need to make two saw cuts: one to the waste sides and one to the depth of the groove (fig. 5). You can use a tenon saw (backsaw) for these, though if you have one, a dovetail saw is easier to manage. Once you have made the cuts, remove the waste with a suitably-sized bevel edged chisel (fig. 6).

When cutting large—over 12mm wide—through mortises, you can save yourself a great deal of hard work by drilling a series of overlapping holes before you start chiselling. The bit should be slightly smaller than the width of the mortise and of the woodworking, high-speed, flat type if used with an electric drill. For a brace and bit, use a Jennings-type woodworking bit (fig. 7).

9 *On large section timbers, use a panel saw or crosscut saw to make cuts with the grain. Make sure that the timber is well supported*

8 *Afterwards, remove the rest of the waste wood with a mortise chisel, held as shown and used in the correct sequence*

To avoid splintering the wood, drill through from one side until the tip of the bit just breaks the surface of the other. At this point turn the workpiece over and finish the holes from the reverse side. Use wide and narrow mortise chisels or heavy firmer chisels to remove the rest of the waste.

Cutting the tenons
The procedure for cutting a simple tenon is the same as that for cutting the pin in a halving joint. Make the longitudinal cuts first, then the cross cuts, cutting to the waste side of the line at all times (figs. 9 to 12). Afterwards, clean up the tenons with a bevel edged chisel.

Where a rail is too long to place vertically in the vice, arrange it at an angle, parallel to the bench and firmly clamped. Many craftsmen prefer

10 *Crosscutting—such as cutting away the shoulders around the tenon—can be done with a dovetail or tenon saw and a bench hook*

this set up for all tenon cutting, so it is worth trying in any case.

Haunched tenon: Make the longitu-dinal cuts as normal, but remember that one will be shorter than the other to allow for the haunch itself. Afterwards, cut the haunch, the cheeks and finally the shoulders.

Double tenon: To remove the space between double tenons, first make the longitudinal cuts. Remove the waste with a coping saw (fig. 14), then saw off the cheeks and the shoulders. As with all tenons, clean up the finished cuts with a chisel.

Assembling non-wedged joints

When you have cut all the joints, assemble the frame (or construction) in a dry run—without glue—to check the fit. The joints should require no more than light tapping with a hammer—using an offcut to protect the work—to get them to interlock.

If greater force is needed, dismantle the frame and make small adjustments. While the frame is together, set out whatever cramps are necessary and cramp up the frame without adhesive. Check that it is square by measuring the diagonals, which should be equal in length.

Tidy up the inside surfaces of the frame with a finely set plane and glasspaper. You can, if you wish, apply a finish to the inside edges of the frame timbers at this stage. But mask off the mating surfaces of the joints first to keep them clean for when you apply the glue.

Finally, glue and sash-cramp the joints (see pages 124-127) with off-cuts of timber to protect the work-pieces. Wipe off any excess adhesive while it is still wet.

Wedged joints

Cut wedges for the joints from offcuts of waste wood. Do this as carefully as possible, since you cannot test them in a dry run with the tenon in place. Make adjustments to the widths of the wedges where necessary then clean, glue and cramp.

In the case of a through wedged joint, drive the wedges in once the tenon is in place in its mortise (fig. 16).

Finishing

When the joints are thoroughly dry, remove the cramps. Cut off all the waste—horns, pieces of wedge, through tenon ends—with a fine saw, cutting no closer than 1mm to the work. Afterwards, use a finely set plane and glasspaper on a sanding block to complete the finish.

11 *Make the angled cuts with the workpiece once more secured in the vice. Here, the secret haunching above the tenon is being cut away*

12 *Take extra care when you cut out the final pieces of waste. Even at this stage, a slip can still ruin the finished joint*

13 *The finished rail, showing the sloped secret haunch which will become invisible when inserted into its matching slot on the stile*

14 *When making a double joint, use a coping saw to cut away the waste between tenons. Take care not to stray outside the marked lines*

15 *Assembly of all mortise and tenon joints is made easier if you first bevel away the edges of the waste on the tenons with a sharp chisel*

16 *On a through wedged joint, the wedges are tapped in as far as they will go then the waste on the tenon is trimmed off*

Heat-resistant teapot stand

Side rail

tile

150mm square ceramic tile. The size may vary slightly, so use the tile to measure out the wood

6mm plywood to support the tile. Glue this to the batten

10mm square batten pinned and glued in place

Set the support batten to allow the tile to rest flush with the surface

25 12

25

25 25

12

Take these measurements directly from the tile

25

Side members from 25mm square hardwood such as mahogany or utile

After assembly, sand all edges smooth and finish with melamine or polyurethane lacquer

Accurate marking out and cutting is very important. A pillar drill or dowelling jig will help you to align the mortise accurately.

Assemble the joints with PVA woodworking adhesive

6.5

37 12

18.5 12 12 12

6.5 12 12

6.5

Practise the mortise and tenon joint by making this hardwood frame which turns an attractive tile into a practical teapot stand. The tenons are extended to make a decorative feature at the corners.

Careful marking out and cutting are essential. Use the tile to measure the dimensions shown. Ensure accurate mortises by using a drill stand or dowel jig to drill a pilot hole at right angles. Square this with a chisel. Cut the tenons with a fine-toothed tenon saw and assemble the frame with care.

Making mitre joints

Marking out a mitre ● Cutting and trimming for accuracy ● Joining and cramping mitred frames ● Making strong mitre joints ● Veneer keyed joints ● Dowelled mitre joints ● Using a mitre box and shooting board

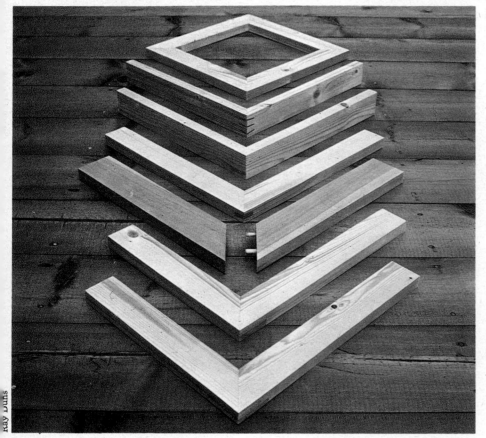

A mitre joint is a neat way of joining two pieces of timber at an angle. The ends of the pieces are cut so that the line at the butt joint is a diagonal across the corners of the meeting members. For example, if two sections of timber meet at 90° the mitre cut would be 45° (fig. A).

The simplest and most common mitre joint uses timbers of equal section butt joined together with adhesive and pins. It is typically found in decorative objects—such as picture frames.

Marking out

To mark out a mitre you will need a pencil, marking knife, rule, try square and a means for marking angles— either a combination square or a sliding bevel.

The *combination*, or *sliding, square* (fig. 1) is capable of marking angles of

90° and 45° and has a sliding rule which may be adjusted to give projections from 1mm to approximately 260mm. It is extremely useful when the blade of an ordinary try square is too long, because it can double up as an adjustable try square.

The sliding bevel—with the aid of a protractor (fig. 2)—can be set to any angle, the blade being locked in position until released.

Start marking by deciding the overall dimensions of the frame to be made and then add 5–6mm to both ends of each separate component to allow for waste. Measure and rough-cut the individual pieces of wood, marking each face side and edge with the proper marks (see pages 16 to 19). Then, using a rule, marking knife and try square, carefully mark out the overall dimensions on the face edge of each work-

piece, allowing enough for waste.

If the frame is longer one way than the other, mark opposite pairs together to avoid confusion.

If the mitre is to be cut across the wide surface, or 'side' of the piece, use one of the angle marking aids and a marking knife to set out the cut on the face side. Slide the combination square or sliding bevel up to the knife and score across the timber. Mark across the next edge at 90° to the side then finally mark the angle across the surface opposite the face side.

If the mitre is to be cut across the narrow surface, or 'edge', of the piece start by marking the overall dimension line with a try-square allowing for waste across the face edge; and then mark the face edge to the mitre angle with the sliding bevel or combination square. Next mark the sides at right angles with a try square, and use the bevel to mark the surface opposite the face edge as a mitre.

Cutting the mitre

It is quite possible to cut a mitre by holding the workpieces at an angle in a vice and sawing them direct. But for greater accuracy and ease of handling use a mitre block or, better still, a mitre box (fig. C). Both of these devices are available from tool shops but generally cut only 45° angles.

Cramp the block or box in a vice, or fix it to a worktop with large G-cramps. A fine toothed saw should be used to cut into any moulding on the workpiece and not out of it. This ensures

Above, left: *Mitre joints are mainly used for making frames. They can be strengthened by the various methods shown, including dowels, veneer inserts and tongue strengtheners*

A. *The simplest mitre joint is where two pieces of wood meet at right-angles. In this case the mitre angle is 45° across the join*

143

1 *Essential tools when marking out mitre joints are a protractor (a) and either a sliding bevel (b) or combination square (c)*

2 *Set the required mitre angle on the sliding bevel with the protractor and use it to mark out the cut lines on the workpiece*

B. *Using a try square and a sliding bevel to mark up a mitre. It is important always to allow a short length for waste when marking up*

C. *A mitre block (above) and a mitre box (right). Mitres need to be cut very accurately if the resulting frame is to be square. Sawing guides*

such as these help a great deal to keep the saw steady

3 *Use a mitre box to guide the saw when cutting 45° mitres. Hold the workpiece tight. Packing underneath it will protect the base of the box*

4 *Adjustable mitre jigs are not expensive and they can be used to guide the saw on cuts at a number of different angles*

5 *Use a mitre shooting board to trim off the waste from a mitre which has been cut across the face side of the workpiece*

6 *Use a donkey's ear and a plane to trim off the waste from a mitre which has been cut across the face edge of the workpiece*

7 Use a picture framer's cramp to hold the components of a mitre in position while you pin them together and let the adhesive set

8 Alternatively use the Ulmia cramp system. The tool sets strong springs into the wood and leaves small indents which are later filled

that the rag of the saw cut is at the back of the joint and not on the face.

Always remember to saw slightly to the waste side of the cut and trim off the excess afterwards with a plane.

Trimming off the waste
Large sections can be angled in a vice and trimmed freehand, taking great care and using a fine-set No. 4 smooth plane or a block plane.

Small sections may be more accurately trimmed with the aid of a *mitre shooting board* (fig. 5) for mitres in the width or side, and a *donkey's ear* (fig. 6) for mitres in the thickness, or edge, of the work piece.

As neither of these work aids are readily available, designs for each one are set out on pages 148 and 149. When using the mitre shooting board, plane away from your body to trim right-

hand mitres and towards you for left hand mitres.

The donkey's ear will give the best results if you first of all plane away from you, to just beyond the centre of the work, then place the work on the other side of the stop, reverse the plane and trim towards you. Finally, reverse the procedure for a last, straight-through trim to finish the mitre neatly and cleanly.

Joining mitred frames
The big problem when joining simple mitres is that the adhesive acts as a lubricant—causing the pieces of the frame to slide about, making the use of sash cramps impossible.

Light frames can be joined together using adhesive and pins. Use a picture framer's cramp to hold the mitres in position whilst the pins are driven home, then tap them below the surface with a fine pin punch and fill.

Another method of clamping mitres

D. Make sure that the cut lines for the mitres in a picture frame cross the rebate so that the glass fits exactly in the frame

Bernard Fallon

E. Strengthening a mitre joint with a tongue insert. The extra gluing area provided makes the mitre less susceptible to warping or splitting

in light to medium section timbers is with Ulmia spring clamps (fig. 8). This clamping system, which is relatively cheap and easy to use, employs three sets of spring clamps in different sizes to suit different sections. The springs —which are set into the frame using a special tool—hold the mitre together by closing spiked ends onto the frame, one at each corner, rather like a hawk's talons. The indentation they produce is relatively small and can be either ignored or filled.

Larger frames can be joined together with a web cramp or a simple straining twine (see pages 126 and 127). Both of these tools should be used with L-shaped wooden blocks, the outer corners of which must be well rounded to allow the web or cord to move around them.

Place clean paper between the block and the workpiece to stop the block sticking to the work. Once the web or cord is tensioned, check the frame for square by measuring the diagonals, which should be equal.

Stronger types of mitre joint
The *cross-tongued* or *feathered-mitre* joint gives a greater gluing area in the mitre and is used where sideways movement is likely to occur (fig. E). Grooves are cut in the faces of the mitres into which a tongue, or feather, is then inserted. The tongue should be cut either from matching timber—in which case the grain must run at right angles to the mitre faces—or from multi-layer plywood.

The thickness of the tongue can vary between one quarter and one third of the thickness of the timber and will considerably strengthen the joint.

9 To make a cross tongued mitre, mark out the width of the tongue with a mortise gauge and use a dove-tail saw and chisel to remove the wood

10 *When the tongue groove is cut, glue the frame together with the strengthening tongue inserted as shown above*

11 *Using a coping saw to trim out the waste tongue when the glue has set lessens the likelihood of disturbing the mitre joint*

12 *For a really neat finish, pare away the last few slivers of the tongue insert with a sharp, bevel edged chisel*

The width of the tongue depends upon the size of the frame section, but a measurement based on one fifth of the face width is about right.

To mark out the grooves, set a mortise gauge to the width of the chisel you will use which should also match, exactly, the thickness of the tongue. Then set the gauge so that the two points are evenly spaced across the thickness of the mitre and mark parallel lines along the mitre face (fig. 9). To mark the groove depth, use a marking knife and combination square or sliding bevel and make a faint line on the face across which the mitre has been cut parallel to the edge of the mitre. The line should be half the tongue's width plus half a millimetre from the mitre edge. Use a try square to carry these lines across both edges of the piece.

Set the piece in a vice so that the mitre face is horizontal and use a dovetail saw or fine tenon saw (backsaw) to make two saw cuts to the waste side of the groove. Chisel out waste.

When all of the grooves are cut, piece the frame together to ensure everything fits. Make any adjustment necessary for a good fit and, when all is well, glue the frame together. The best cramping method to use for this type of joint is the Ulmia system used in conjunction with G-cramps across the thickness of the section. Trim off the waste after the adhesive has set completely (fig. 12).

Veneer keyed mitre joints

Keyed mitres are used to strengthen edge mitred joints, especially those which are to be veneered. Cut the mitres and check that each side is of of the correct length, then assemble

Bernard Fallon

F. *Edge mitres are best strengthened by using veneer inserts like these. Always make sure that the grain of the veneer crosses that of the mitre*

the frame without glue to ensure it goes together well. Mark each pair of mitres on the face side, A-A, B-B and so on until all are marked.

Next, take a pair of mitres and place them in a vice, ensuring that the correct angle is maintained—use a try square or sliding bevel to check this. Using a fine saw with a veneer thickness kerf of approximately 2mm, make opposing angled cuts across the corner of the frame (fig. 13). Check that the cut will take the veneer you propose to use; if the veneer is too tight a fit, open the cut slightly using either a thin file or a piece of glass paper fixed to a steel rule with double-sided tape.

When all of the joints are cut and ready, apply adhesive to the mitres and assemble the frame using either Ulmia or sash cramps. If sash cramps are

13 *For a veneer keyed mitre joint, cramp the mitre in a vice and use a panel saw to cut angled slots for the veneer*

14 *Cut slivers of veneer so that the grain runs across that of the work piece, glue them in place and trim off the waste*

G. *Dowel inserts provide the best way of strengthening a mitre joint and are completely invisible when the work is finished*

15 *To strengthen a mitre with dowels first mark the position of the dowel centre line across the mitre as shown*

16 *Extend your original line across the face of the mitre to mark out the sites of the dowels which you are inserting*

17 *Use a marking gauge to find the exact centre of the mitre face and mark where the scribed line crosses the track of the gauge*

18 *Drill out the holes for the dowels at these points. Use masking tape on the drill bit to control the depth of the hole*

19 *Insert the dowels, check for fit then score them, to let the adhesive flow. Finally, glue the frame together and cramp it*

used (see page 125 and 126) they must be prepared with protective waste blocks before you apply the adhesive. Two cramps should be placed underneath the frame close to the mitres; the other two go on top of the frame at right-angles to the first pair and also close to the mitres.

When the frame is in place tighten the cramps so that they are just squeezing the protecting waste blocks against the frame.

Check that the mitres are correctly placed and insert the pre-cut veneer slips—which should be coated with adhesive—with the grain running at right angles to the mitre. Carefully tighten the cramps and ensure that the mitres slip evenly, if at all, so that the frame remains entirely square and does not twist.

When the adhesive has set, remove the frame from the cramps and cut off any excess veneer with a dovetail saw.

Dowelled mitre joints

This is the neatest of the strong joints discussed in this section, and also one of the strongest.

To make a dowelled mitre without a specialized dowel jig start by marking, cutting and trimming the mitres. The number and size of the inserted dowels will obviously depend upon the section of the frame and how strong you wish the joint to be. The diameter of the dowel should not be greater than one third of the thickness of the timber. And as the length may also vary, it is preferable to have a long dowel on the inside of the frame and a short dowel towards the outer corner.

Place one pair of mitres together and with a rule and sharp 2H pencil, mark the position of the dowel or dowels (fig. 15). Use a try square to continue these lines across the face of the mitre.

Take a marking gauge and set this to half the thickness of the section. Next, mark a line down the length of the mitre face (fig. 17) and place the work in a vice with the mitre face horizontal and with a centre punch, 'dot' the dowel hole centres; that is, where the gauge line crosses the pencil lines exactly.

Select the appropriate dowel or drill bit and drill the holes. Wrap some masking tape around the drill to act as a depth guide and preferably get an assistant to watch that the drill is kept vertical to the mitre face. Then cut the dowels to length and groove the sides with a tenon saw to allow air and excess adhesive to escape from the holes. Assemble the frame as before.

Make your own mitre tools

The three mitring tools shown here are invaluable for cutting quick, accurate mitres. Making them is itself useful practice in mitring, and once made, they should last you for many years.

All three can be made from odd pieces of wood, as most of the dimensions are not critical. The best wood to use is a hardwood, such as beech, but if this is not available, use any timber which is well seasoned—and warp- and knot-free. Make sure that it is planed squarely.

The easiest tool to make is the mitre box. Assemble the basic U shape—you can extend the front to provide a clamping strip if preferred—taking care that everything is square. Then mark and cut the three angled cuts, making sure that both your marking and cutting are very accurate. Use a tenon saw (backsaw) for the cuts, cutting the slots on each side simultaneously.

With a mitre box, the mitre shooting board is quite easy to make. Make up the base and the running stop, checking that the edge of the running stop is planed quite straight. Use the mitre box to cut the V-block accurately then fit this in position. You can cut the V-block without a mitre box by careful marking and cutting with a tenon saw.

Make the donkey's ear by careful marking out and cutting in the same way as for the other two tools. The stop is quite simple to cut with a saw, or using the shooting board. Plane the long edges of the base and running stop to accurately marked, 45° lines.

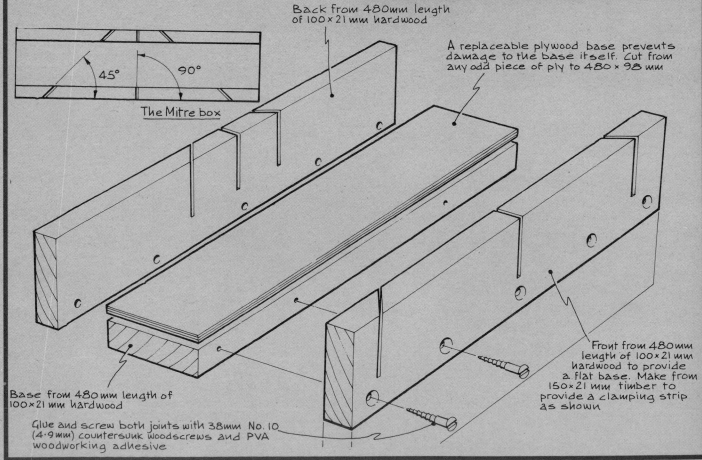

Back from 480mm length of 100×21 mm hardwood

A replaceable plywood base prevents damage to the base itself. Cut from any odd piece of ply to 480 × 98 mm

45° 90°

The Mitre box

Base from 480mm length of 100×21 mm hardwood

Glue and screw both joints with 38mm No. 10 (4·9mm) countersunk woodscrews and PVA woodworking adhesive

Front from 480mm length of 100×21 mm hardwood to provide a flat base. Make from 150×21 mm timber to provide a clamping strip as shown

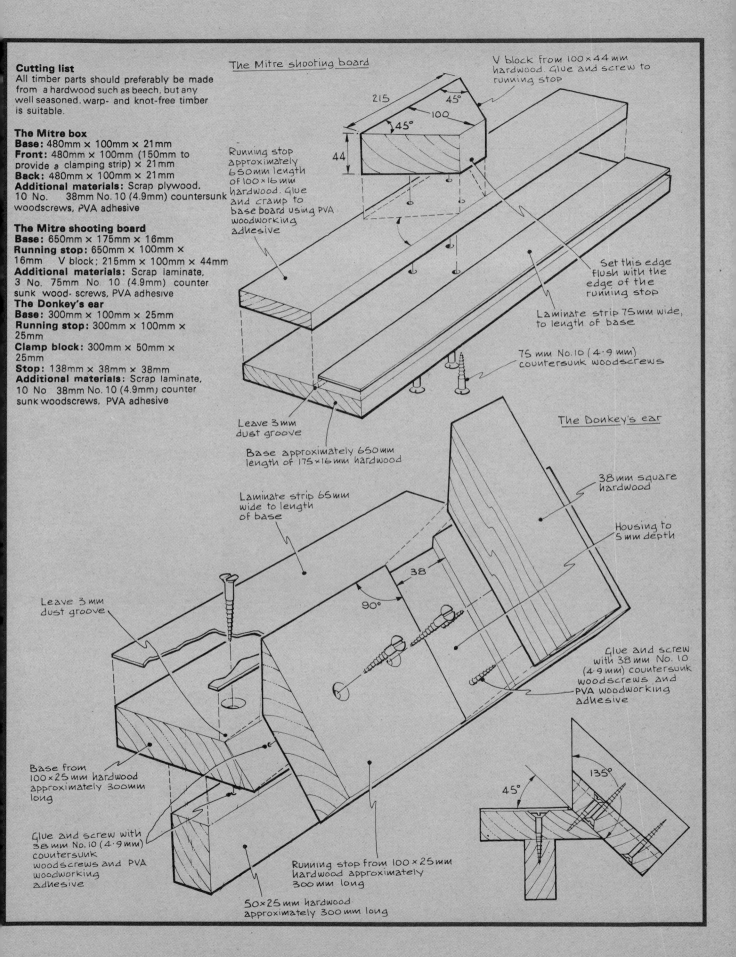

Cutting list

All timber parts should preferably be made from a hardwood such as beech, but any well seasoned, warp- and knot-free timber is suitable.

The Mitre box
Base: 480mm × 100mm × 21mm
Front: 480mm × 100mm (150mm to provide a clamping strip) × 21mm
Back: 480mm × 100mm × 21mm
Additional materials: Scrap plywood, 10 No. 38mm No. 10 (4.9mm) countersunk woodscrews, PVA adhesive

The Mitre shooting board
Base: 650mm × 175mm × 16mm
Running stop: 650mm × 100mm × 16mm V block; 215mm × 100mm × 44mm
Additional materials: Scrap laminate, 3 No. 75mm No. 10 (4.9mm) counter sunk wood-screws, PVA adhesive

The Donkey's ear
Base: 300mm × 100mm × 25mm
Running stop: 300mm × 100mm × 25mm
Clamp block: 300mm × 50mm × 25mm
Stop: 138mm × 38mm × 38mm
Additional materials: Scrap laminate, 10 No 38mm No. 10 (4.9mm) counter sunk woodscrews, PVA adhesive

The Mitre shooting board

V block from 100×44mm hardwood. Glue and screw to running stop

215 45°
100
45°
44

Running stop approximately 650mm length of 100×16mm hardwood. Glue and cramp to base board using PVA woodworking adhesive

Set this edge flush with the edge of the running stop

Laminate strip 75mm wide, to length of base

75 mm No.10 (4·9 mm) countersunk woodscrews

Leave 3mm dust groove

Base approximately 650mm length of 175×16mm hardwood

The Donkey's ear

38mm square hardwood

Housing to 5mm depth

Laminate strip 65mm wide to length of base

38

90°

Leave 3mm dust groove

Glue and screw with 38 mm No. 10 (4·9mm) countersunk woodscrews and PVA woodworking adhesive

Base from 100×25mm hardwood approximately 300mm long

Glue and screw with 38 mm No. 10 (4·9 mm) countersunk woodscrews and PVA woodworking adhesive

Running stop from 100×25mm hardwood approximately 300mm long

50×25 mm hardwood approximately 300mm long

135°
45°

Squaring up, sawing and sanding

● Types of saw ● Measuring and marking up
timber ● Scribing with a marking gauge
● Measuring and marking ● Starting a saw
cut ● Sawing techniques ● Hand-sanding

Nigel Macintyre

It is surprising just how much you can
undertake in the way of carpentry
projects simply by mastering the most
basic skill of cutting timber squarely
and accurately to length.

Many different types of saw are
available, all designed for specific
cutting jobs. In general woodwork
the most commonly used are the hand
saw and the backsaw (fig. 9). These
are further classified according to
the number and shape of their teeth.

Handsaws can be broken down into
rip saws, crosscut saws and panel
saws, all of which cut at different
speeds and with varying degrees of
roughness. For the beginner, a panel
saw will prove the most useful.

Backsaws can be divided into tenon
saws and dovetail saws (fig. 9). Again
for the beginner, only the tenon saw
is really necessary—use it for joint-
cutting and for cutting battens below
100mm × 25mm in size.

A solid working surface is essential
for quick and accurate saw cutting.
If you do not already have a work
bench of some sort, an old table
covered in 6mm hardboard and used
in conjunction with a home-made
bench hook (figs 11 and 12) should
see you through most of the cutting
jobs you will encounter.

For detailed work at a later stage,
you may need to add a vice to the
bench. Alternatively, you could invest
in a collapsible work bench which
serves as a work surface, large vice
and drilling rig all in one. Making a
purpose-built work bench is covered
further on in the course.

Measuring and marking up

Any slight errors made in measuring
and marking will multiply when you
come to start sawing and may ruin
your project. The best way to avoid a
mistake is to check every measure-
ment twice.

Having selected the piece of timber
to be worked on—the workpiece—
inspect it carefully. With a try square,
determine which are the straightest
adjacent side and edge and mark them
in pencil (figs. 1 and 2). Always work
from these when using any measuring

Left: *The correct position for sawing
across a piece of timber with a panel
or crosscut handsaw. Movement of the
sawing arm is unobstructed, the saw
is held at about 45° and the head is
looking straight down over the blade*

150

or marking tool—this will ensure that the marks are consistent. A try square is an essential marking tool and costs very little.

For measuring, use a steel rule or boxwood rule where possible: you may need a steel tape on longer pieces of timber or boards, but this is not so accurate.

Mark out distances in pencil, using a 'vee' mark as shown in fig. 2—this tells you exactly where you have measured to and is another tip for avoiding errors. Where possible, cut out marks altogether by using the try square and rule as shown in fig. A.

Where accuracy is essential, mark cutting lines with a sharp knife—preferably a marking knife—not with a pencil. The scored line made by a knife is thinner, and therefore more accurate, than a pencil line. Also, it serves to break the outer fibres of the timber, thereby stopping the saw cut from fraying.

As you scribe a cutting line, use the try square to guide you (fig. 3). Your free hand should control the try square without obstructing the marking knife. Keep the stock of the try square flush against the face or edge of the workpiece, with the blade flat on the surface you are marking. The edge of the blade should line up exactly with the points of the vee pencil marks.

Using a marking gauge

Scribing with a marking gauge (fig. 6) often saves a great deal of laborious measuring and marking. Marking gauges are cheap and make life easier when marking out joints. The technique takes a bit of practice to master, so you should experiment on wood offcuts before starting any serious scribing work.

To scribe a mark, arrange the workpiece with the gauge nearest you. Make sure that the sliding block is flush against your face side or edge, then roll the gauge towards you until the needle touches the wood (fig. 6). Keeping the gauge at this angle, run it away from you down the workpiece to scribe the line. Avoid applying excessive pressure as you do this: if the needle digs in too far, a wavering line will result.

To scribe a line down the middle of a workpiece, set your marking gauge to roughly half its width and make a mark from the face edge. Make a mark from the opposite edge in the same way, adjust the gauge, then continue making marks from either edge until the two marks coincide.

A. *Where possible, measure your timber with just a rule and try square. This saves time and is more accurate than lining up the square with pencil marks*

B. *Marking timber—the wrong way. If you mark continuously right round the workpiece, your lines may not meet when you get back to the starting point. With thick or rough timber, this leads to crooked cuts*

C. *Marking timber—the right way. Mark the face first, then the two edges, then the back. Note that both sets of parallel marks are made in the same direction, not in opposite directions*

Tip from the trade

Q **Why do the shelves in my bookcases and alcove shelving always come out slightly different lengths? The difference is not great, but it is noticeable.**

A Probably because you are measuring and marking each shelf separately. When you make multiple components—shelves, fence pickets or whatever—it is safest to cut one, mark it 'pattern', and use it as a template to mark out all the others. As you do this, make sure you put the *front* edge of the pattern directly over the *front* edge of the piece to be marked. This will keep the most visible edges consistent, even if there is a slight bow in the timber which would otherwise throw your cuts out of square.

Solving marking problems

Occasionally, you may come across a piece of timber which is difficult to mark up because of its shape and size.

To find the length of a workpiece longer than your rule or tape, measure a certain distance along it from one end then measure the same distance from the other end. Mark both points and measure between them. Add this to your two original measurements to get the overall length.

If you need to find the centre of this piece, simply divide your third measurement by two and mark off.

Dividing a piece of hardboard into equal strips can become extremely confusing unless the overall width divides exactly. Provided that no great accuracy is called for, you can get round the problem by running your tape or rule across one end of the workpiece and angling it until you get a measurement which is easily divisible by the strips required (fig. 7).

Mark off each division then repeat the process at the other end of the workpiece. Scribe the cutting line for each strip against a rule or straight edge, lined up with these marks (fig. 8). If the board is narrow enough do this with the marking gauge.

Before you start cutting the strips, bear in mind that some wood will be lost during the cutting process—using a panel saw, about 1.5mm per cut. This wastage is known as the kerf. For really accurate work, make allowances for it on each strip.

Sawing timber

The first important rule about sawing timber is that you should always saw on the waste side of the cutting line. Where accuracy is vital—as in furniture or shelf making—this means that you should always allow 5mm-10mm waste wood between one piece of timber and the next. For this type of work never be tempted to economize by simply dividing the timber into the required lengths—inaccuracies creep in, compounding as you work down.

Your sawing position is also crucial: get this right and you are well on the way to getting a perfect cut every time. The main picture shows the correct stance. Note that you should stand slightly 'sideways on' to the workpiece, not straight in front.

1 Slide your try square up and down the workpiece as shown to find out which two sides form the most perfect right-angle

2 Having decided this, mark the two sides as 'face edge'—with a vee mark—and 'face side'—with an 'f'. Always work from these

3 To scribe a cutting line, hold the try square as shown. If you are working to pencil marks, ensure that you line up the square properly

4 Set a marking gauge against your rule as shown. When the slide is as near as you can get it, tighten the lock slightly to hold it

5 Make final adjustments by holding the gauge as shown and tapping it sharply on the bench. Check with the ruler after each tap

6 To scribe with the gauge, tilt it towards you until the needle just touches the wood then run the gauge away from you down the timber

Starting the cut

Make sure that your workpiece is firmly held and will not 'jar' as you saw. If you are using a bench hook, arrange the workpiece so that as much of it as possible is supported on the bench. Use your free hand to press the timber against the raised lip of the bench hook as you saw.

To start the cut, line up your saw blade against the cutting line and rest it against your thumb (fig. 11). Keeping your thumb still and the saw at the optimum angle of 30 to 45 degrees, make a few short strokes towards you until you have grazed the wood. As you do this, look along the saw blade and keep your face side and face edge cutting lines in view.

As you get into your stroke—that is, start sawing in both directions—try to saw in a 'bowing' motion to keep the cut firmly fixed on both cutting lines. Keep the saw at right-angles to the workpiece, to ensure an accurate cut across the timber.

Well into the cut, lengthen your stroke to make as much use of the saw blade as possible. At the same time, bring down the heel of the saw to ensure that you follow the lines on the two visible surfaces. Use short, sharp strokes to stop the undersurface of the wood from fraying as you finish off the cut.

Sawing with the grain

The need to saw a piece of timber lengthways with the grain can usually be avoided, simply by buying the correct-sized timber to start with.

But if long-grain sawing is unavoidable, place the timber or board across two trestles at about knee height. Support the timber with your free hand and knee. Position your body so as to give free movement to your sawing arm with your body weight balanced over the cut.

Use a cross-cut or panel saw for boards up to 15mm thick, and for plywood and hardboard; use a rip saw on heavier timber.

If the timber begins to pinch the saw blade—causing inaccuracies—open up the kerf with thin wedges.

Although the optimum cutting angle for long grain cuts is normally 45 degrees, cut thin sheet material and plastic-faced boards at 10-15 degrees to the workpiece.

If the saw wanders to one side of the line, gently bend the blade back in the opposite direction until the correct cutting line is achieved, occasionally turning the board upside down to check that your line is straight.

Making 45 degree cuts

To make 45 degree cuts quickly and accurately, carpenters use a mitre block (fig. 12) or mitre box. These are available quite cheaply from do-it-yourself shops and builders' merchants.

Hold your workpiece firmly against the block as you cut. Rest the block itself against a bench hook or, alternatively, clamp it in a vice.

Always use a backsaw to do the cutting, keeping the blade flatter than usual—although the cut may take longer, you will avoid accidental damage to the box itself.

Hand-sanding timber

Nearly all hand-sanding work should be done with a cork sanding block—available cheaply from most do-it-yourself shops. You have a wide choice of woodworking abrasive paper—including garnet paper, glasspaper and silicon carbide to name but a few. But each carries a grading number on the back referring to its grit size, which is a guide to its abrasive properties. Often, there will also be a more general classification—coarse, medium or fine.

Coarse grade paper is too abrasive for most sanding work, so you should rely only on the medium and fine grades. Try out the fine grade paper first and, if it works, stick to it for the whole job.

The key to sanding along the length of a piece of timber is to use long, uniform strokes—keeping with the grain at all times. Short strokes tend to create hollows and ridges.

To sand the end grain, use the technique shown in fig. 13. Always start by smoothing down the four edges, keeping your paper flat on the bench. This will stop them from fraying as you block-sand the rest of the grain.

7 Measurements which do not divide exactly can be made divisible by angling your rule. Mark off, then repeat on the other side

8 Having marked the divisions, use a rule, straight edge or—where possible—a marking gauge to turn the marks into cutting lines

9 A handsaw and two backsaws. From top to bottom: general-purpose panel saw, tenon saw, and dovetail saw—used for intricate work

10 When you are dealing with damp or unseasoned timber, waxing the saw blade first with a candle will make sawing easier

11 Start saw cuts with the blade up against your thumb. Use short, sharp strokes to begin with then lengthen them as the cut grows

12 Using a mitre block. Steady the block as you saw, by holding it against a bench hook or clamping it in a vice

Tip from the trade

Q When sawing wet timber, my crosscut saw keeps jamming. Any ideas?

A The saw will run more freely if you lubricate the whole blade by rubbing it over, either with the end of an old candle or with a small lump of raw lamb fat. If you have a large quantity of wet or green timber to cut, have your saw re-sharpened with the teeth set to a coarser angle—ie, with their points splayed farther apart.

13 Chamfer the edges of a piece of timber as shown before you sand the end-grain. This will prevent the wood from fraying

Easy home-made wine rack

A wine rack is an asset in any home, but the commercially-made ones will not always fit into the space you happen to have available.

This wine rack is designed to be 580mm wide x 460mm high, but its dimensions can be varied—within reason—to take more or fewer bottles. Or you could stand it on its side to fit a tall, narrow space.

Only measuring, marking, sawing and sanding, plus a modest amount of work with a chisel, are needed to make it.

When buying the timber, take your marking gauge with you to check that all the boards are of a consistent thickness.

To mark out the slots, set your marking gauge to half the width of any board. Then mark all boards from the front edge—not half from the front and the intersecting ones from the back. This will ensure that all the front edges of the finished rack are flush, even if the width of the boards varies.

When you have sawn the slots, remove the waste wood by paring it out with a chisel, working alternately from both sides of the board.

Below: *The finished wine rack can be made up to any size from three bottles wide by three deep to five wide by four deep (or vice versa). Above that size, extra front-to-back supports would be needed*

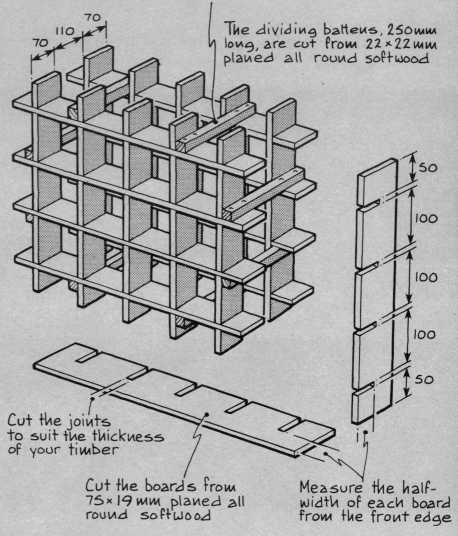

The dividing battens, 250mm long, are cut from 22 × 22 mm planed all round softwood

70 110 70

50 100 100 100 50

Cut the joints to suit the thickness of your timber

Cut the boards from 75 × 19 mm planed all round softwood

Measure the half-width of each board from the front edge

Join the battens and boards using 38 mm No. 6 (3.6 mm) brass screws and screw cups

Diane Lewis

Simple security

The rules for securing your home against unwelcome intruders are quite simple. Make it difficult for the criminal to break in and he will go and look for easier pickings elsewhere

According to police, burglars fall into three basic categories. The professional thief who knows what he is after —valuables like antiques, jewellery, paintings and cash—likes to work quickly and cleanly.

The spur-of-the-moment sneak thief is the one who grabs at the chance of stealing ready cash and any easily transportable valuables if he sees a housewife pop next-door and leave the door open.

The third category is the young vandal, bent on causing as much damage as possible, who rips out telephone wires, slashes furniture and breaks everything he can lay his hands on.

Strong security locks on the doors and windows will deter the last two categories. Professional burglars are more difficult to stop, but if your house is going to be very difficult to break into, they will usually decide to try elsewhere.

Securing doors
Most front doors are fitted with a nightlatch, which normally presents little trouble for a thief. A far more effective deterrent is a mortise deadlock. The bolt on this is fixed dead when locked and cannot be sprung back like an ordinary nightlatch.

Mortise locks come in a wide range of shapes and sizes but not all are of a guaranteed quality. It is best to buy locks which have been tested by an independent standards organization.

A good quality mortise lock is designed to be stronger than any wooden door into which it is likely to be fitted. This means that the woodwork would fail before the lock itself. When it is locked, the bolt is enclosed in a steel box protecting the head of the bolt against possible attack from a jemmy or similar tool.

Good security locks cannot be opened with skeleton keys and it is virtually impossible to pick them as they incorporate an anti-picking device. The deadbolts are reinforced to frustrate any attempt to cut right through the bolt.

Left: *All you need to make a door burglar-proof. A mortise lock provides an effective deterrent to most burglars, being difficult to force, or pick open. Fitting one is a fairly simple procedure—you will need a drill, chisel, padsaw and screwdriver*

Your house – the weak points

Specially designed mortise locks are available for patio doors. Alternatively, you can secure them with window bolts. Leave valuables well out of sight if you go on holiday

Thieves like back doors because they often have easily overcome locks. Secure them with a No. 3 or a No. 5 lever mortise deadlock

A Downpipes can be painted with anti-climb paint
B Small windows should not be ignored—thieves often use small children to climb through them
C Remember to padlock sheds and outhouses—some thieves specialize in outside things
D Make sure that basement doors and windows are secure—thieves work out of sight there

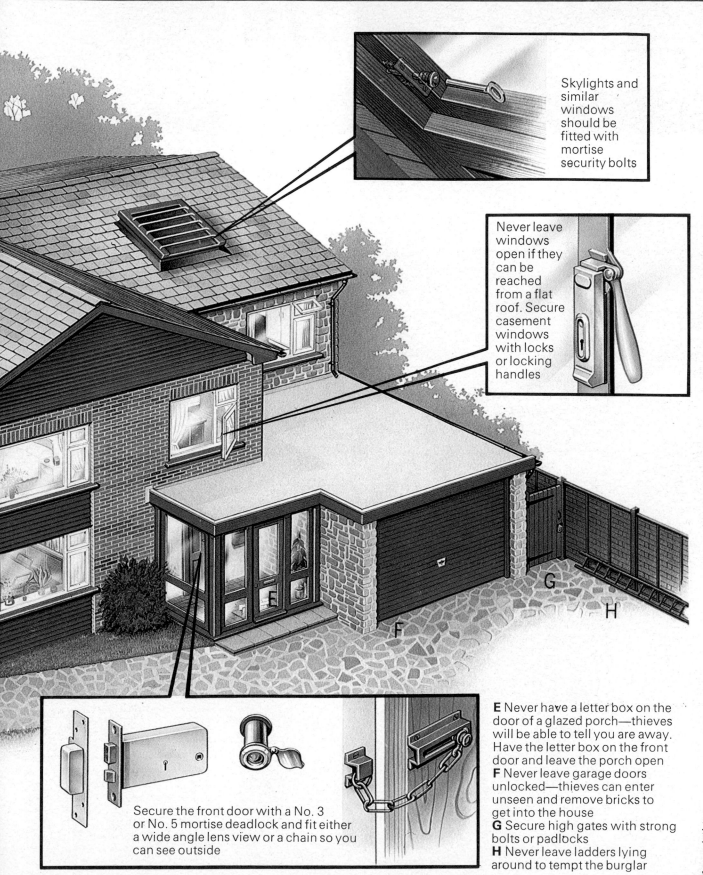

Skylights and similar windows should be fitted with mortise security bolts

Never leave windows open if they can be reached from a flat roof. Secure casement windows with locks or locking handles

Secure the front door with a No. 3 or No. 5 mortise deadlock and fit either a wide angle lens view or a chain so you can see outside

E Never have a letter box on the door of a glazed porch—thieves will be able to tell you are away. Have the letter box on the front door and leave the porch open
F Never leave garage doors unlocked—thieves can enter unseen and remove bricks to get into the house
G Secure high gates with strong bolts or padlocks
H Never leave ladders lying around to tempt the burglar

Venner Artists

157

1 Use the lock body as a template to mark the position of the hole in the edge of the door. Follow the same procedure on the sides

2 With a marking gauge set to half the thickness of the door, scribe a line down the door edge to mark the positions of the drill holes

3 The drill holes should run almost together along the centre line on the door edge. This leaves you with a minimum of chiselling work

4 Use the chisel carefully, paring away only a small amount of wood at a time. Open out the holes into a perfect rectangle

5 Having chiselled out the rebate for the facing plate around the hole, use the lock body again to help mark the position of the keyhole

6 Form the cut-out section of the keyhole with a padsaw. Check the key for fit from both sides before you instal the lock body

Fitting a mortise lock

When you buy a mortise lock you are supplied with several parts that have to be assembled in a certain order. The parts include the main lock body —inset into the edge of the door— a plate that is screwed over this to hold it in place, a striking plate and box that fits into the outer frame, screws, keys, and the keyhole covers.

Marking the position

The mortise lock can be placed at any height on the door, though a central position will obviously give the strongest fastening. When you have decided where to place it, take the lock body and use it as a template to mark the width and depth on both sides of the door. Remember that the facing piece of the lock is sunk approximately 6mm into the door so that the cover plate is flush with the surface of the edge.

Use a try-square to mark the width of the lock body on the edge of the door. Then, with a marking gauge, score a line down this width—to fall exactly in the middle of the depth of the door (fig. 2).

To make the hole for the mortise lock, drill, then chisel flat, four holes in the edge of the door. For this,

you need a 19mm wood drill bit and a 19mm wood chisel. Wrap a short length of masking tape round the drill bit at the depth of the hole you require. When the holes are drilled, pare away the excess wood with the chisel, removing only small pieces at a time. Work progressively through the hole, making sure that the back surface is absolutely flat to avoid fitting problems later (figs. 3 and 4).

Chiselling out the rebate

Your next job is to chisel out the area into which the facing piece of the lock is inserted. A quick and easy way of doing this is to screw the cover plate in place and score carefully round it with a handyman's knife.

Unscrew and remove the plate then chisel out the area within the lines you have cut. You will probably find that you can score deeply enough with the knife to attain the depth of 6mm that you require. The neatness and accuracy of this chiselling is very much a matter of sleight of hand and eye, but be careful not to cut too vigorously or you may go too deep. When you have finished try the lock body and the cover plate in position and make sure the plate lies flush.

Cutting the key-holes

Hold the lock body in position against the lines you have marked on the side of the door then mark a central point for the key-hole by placing a scriber or small drill bit through it (fig. 5). Repeat this operation on the other side. You then require a 12mm drill bit to bore two holes through to the centre from either side of the door. You will be able to determine, with your particular key, the length of the downward cut that you need to make for the key shape. Cut out this shape with a padsaw (fig. 6). Again make sure that you do this on both sides.

Now you can place the mortise lock back into position and screw on the cover plate. Your last task on this part of the door is to fix the key-hole covers on to the holes you have cut in the sides. You are provided with two covers, one with swivelling plate attached and one without. The swivel attachment is for the prevention of draughts and is therefore fixed on the inside of the door.

Mark the screw holes for these covers with the key comfortably set in the turning position. If you do not do it this way you may find you have key-fitting problems after the cover has been screwed in place.

7 *Having located the lock body in position and made any necessary adjustments to the depth of the rebate, screw on the cover plate*

8 *The only work left on the door itself is to fix the keyhole covers. Make sure the one with the draught cover goes on the inside*

9 *With the lock closed and held against the door frame, you can mark the depth of the striking plate rebate and bolt box*

10 *Cut out the hole for the bolt box and striking plate in the frame. Before securing the plate, make sure that the door will close properly*

11 *Both sides of the finished lock. The design is such that the woodwork around the door will fail before the lock itself*

12 *Key-operated casement window locks are simple security devices. To fit, first secure the shaft plate to the casement*

13 *The next step is to secure the locking plate on the window frame, making sure that it fits comfortably over the shaft plate*

14 *The window lock has a threaded barrel which screws onto the shaft plate. The barrel can be removed only with a special key*

Fitting the striking plate

All that now remains is to fit the striking plate and bolt box onto the door frame.

To mark the position of the rebate, turn the key in the mortise lock so that the bolt protrudes in its locked position. Then close the door and, using the bolt as a guide, draw lines either side of it on the side of the door frame. Remember that the box that houses the bolt is wider than the bolt itself, so allow at least 3mm on either side of the bolt's width when you run these lines on to the inside of the door frame.

Next you must measure the length from the edge to the centre of the bolt on the lock body and translate this length on to the door frame, again using a marking gauge to scribe a central line on the wood.

It now remains to drill, as before, the box hole with two consecutively-placed holes (or three at the most) using the 19mm drill bit. This done, chisel and pare away the excess wood until the finished hole is formed.

It may not be necessary to make the striking plate flush with the level of the door frame's surface—it depends on how tightly the door fits in the frame. If it is a very close fit you must repeat the operation of screwing the plate into position, scoring round it and chiselling out a recess. If there is a gap where the door meets the frame, simply screw the striking plate into position. If, however, the screw holes on the striking plate are *plunged*—punched into a slight bowl-shaped recess—you may have to countersink the holes in the door frame slightly to allow for this.

Securing windows

Although the glass in windows always makes them vulnerable to straight-forward breakage, an intruder will always search for a quieter method of entry first. Like the nightlatches on doors, most conventional window catches are surprisingly easy to force, so you need some extra security devices to act as a deterrent.

A number of lockable window catches are available, to suit all shapes and sizes of window. Figs 12 to 14 show how to fit one of these.

Once in place, window locks should deter all but the boldest intruder. But for the sake of safety in the event of a fire and for your own convenience, remember to leave the keys near the window. Choose an accessible site, but one out of a burglar's vision.

BUILDING PROJECTS INSIDE

Making a staircase

● Designing a straight run staircase ● The important design considerations ● Traditional and simplified designs ● Setting out your design ● Transferring the design to timber ● How to assemble the staircase

Left: *Building a timber staircase requires no special carpentry skills or tools, although the integrity of the construction demands care. The most difficult part of such a project is getting your design to comply with local building regulations*

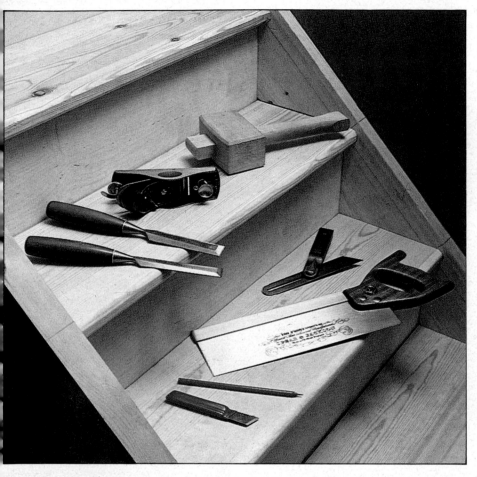

Flight rise (total rise): The vertical distance between two floors or a floor and a landing.

Open tread: A stairway having no risers (the vertical board underneath each tread) sometimes called open plan or ladder stairs

Common stairway: A stairway, either inside or outside, for use by the occupants of more than one dwelling

Construction

Stairs can be constructed between walls, which give a continuous support, or they may be open on one or both sides.

The treads are supported in all cases by stringers. Wall stringers can be 32mm planed all round (dressed four sides) timber, but outer stringers should be 44mm to 50mm because of the greater strain they bear.

Where a stair width exceeds 900mm you must make an intermediate support or *carriage* from 100mm × 50mm timber. This should be fixed at the top and the bottom of the staircase either by nailing it to a joist or by making a birdsmouth cut over the battens nailed across the floor and the landing trimmer of the higher level.

It is usual to fill in the underside of the staircase with a plasterboard soffit. But if you wish to do this you must either use thicker stringers to allow the plasterboard an area of purchase or screw 25mm bearers to the insides of the stringers so that you extend their thickness locally.

The width of the timber for the stringers depends both on the angle or *pitch* of the stairs and on the size of the treads and risers. Allowing for a 38mm—40mm margin, 225mm wide boards are normally sufficient. But if you do need to use wider boards which are not available in softwood, you should join two boards with moulded tongued-and-grooved joints.

In the case of a wall stringer attached to a wall which is to be plastered later, you must rebate the upper outside edge of the board to take the plaster and mould the inside

The most economical way to connect two different levels is with a staircase. And there is no reason why, armed with basic carpentry skills, you should not design and build your own staircase. The staircase described is a simple design to follow with a straight run.

The design of staircases, like many other major projects, is controlled by statutory regulations concerning strength, stability, fire resistance and general safety factors—some details are given on page 165.

So that you can understand the regulations and any construction drawings you may need to use, make sure you are familiar with the following terms used in staircase design and also the names of the component parts shown in figs A, B and C.

Pitch line: A line joining the front edges of the treads (nosings)

Pitch or slope: The angle between the pitch line and the floor or landing

Headroom: The vertical distance between the nosings and any overhead obstruction

Walking line: The average position taken up by a person climbing or descending the stairs, usually taken to be 450mm from the hand rail

Going (run): The on-plan measurement of a tread between the nosing of that tread and the nosing of the tread or landing above

Rise: The vertical distance between the upper surfaces of two treads

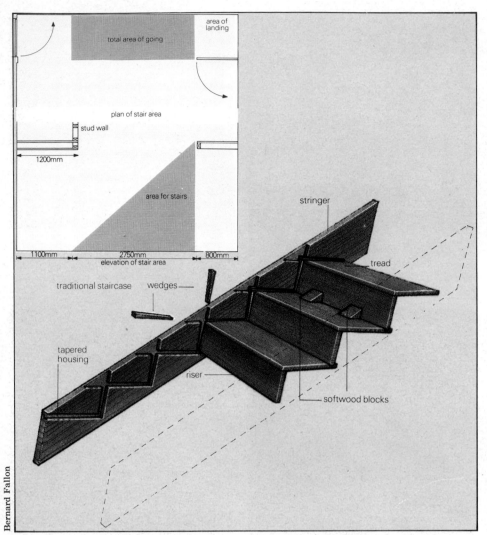

Bernard Fallon

A. Above: *To assemble the traditional design of staircase, softwood wedges are inserted into the tapered housing spaces beneath the treads and risers then triangular blocks are glued and pinned into place.* **Insert:** *The first stage is to make a plan of, and section through, the proposed staircase*

edge to match any skirtings (base-boards). To match perfectly, the stringer must project beyond the plaster by the same amount as the skirtings. This requires skill, and you can simplify the project by building the staircase of a different, contrasting material to the skirtings. The polished wood of the former will then complement the painted finish of the latter.

The treads are usually made from 32mm planed all round timber and the risers from either 25mm timber or 12.5mm plywood. You can use soft-wood or hardwood, but if the steps are to be left uncarpeted the latter is the natural choice. Open tread stairs have no risers to support the treads,

therefore the boards must be at least 38mm thick.

If your project is along traditional lines, you may well be able to find pre-shaped and grooved boards for the stair treads at your timber yard.

The nosings must never exceed 25mm to avoid catching toes when mounting the stairs. There are three shapes of nosing in common use—square, half round, and tapered.

The housings in the stringers for the treads and risers are usually between 9mm and 16mm deep, though the average depth is 13mm. Traditionally they are made wider than the tread and riser boards, and are tapered so that they can be wedged (fig. A).

The wedges are first dipped in adhesive and inserted from the back of the risers and treads. They are then driven home, so forcing each tread and riser against the outer, visible edge of the housing. Finally, triangular blocks of wood are glued and pinned at the junctions of the treads, risers and stringers to make the assembly rigid.

Open tread stairs cannot be wedged and blocked, so alternative methods of construction must be employed. Normally, the treads are housed in the stringer and held in position with screws or dowels. Dowels are stronger than screws, but if you do not want to see the dowel end grain you should use thin screws and plugging pellets (fig. 11). If you opt for the screws, you must pre-drill the end grain of the treads to accept glued fibre wall plugs.

You can strengthen an open tread staircase by tying the stringers together using 10mm or 13mm steel rods—with sunk and pelleted ends—at the back of every fourth tread. You can also use this technique on a simplified version of the traditional staircase (as shown in figs 1 to 11).

Handrails are set at a minimum of 840mm above the pitch line. On the wall side they can be fixed with brackets, screws and plugs at 915mm–1220mm centres. If you use the bracket type, the rail should be at least 38mm from the wall to ensure an adequate hand hold.

Handrails running parallel to an outside stringer are supported either by newel posts at the top and bottom or by a newel post at bottom and a wall fixing at the top of the stairs. The newel posts are mortised to both the stringers and the handrail and the bottom post is let into the floor where it is screwed or bolted to a joist.

Setting out a staircase

To make a staircase it is first of all necessary to make an accurate drawing of the location using as large a scale as is convenient.

1 *Having marked the face side and edges, clamp the two stringers together and mark the template spacings with dividers and a try square*

2 *Separate the stringers, continue the marks to the nosing line then put the template in position over the marks and draw around it*

3 *Use a 1.5mm twist bit to drill marker holes right through the stringers at the point where the screw holes will be drilled later*

4 *Using the bradawl to position the template accurately over the previously traced housing, repeat the tracing to the end of the stringer*

5 *To remove the waste wood, you can drill a series of holes inside the housing marks using a depth stop to ensure an even depth*

6 *Use a suitable firmer chisel to take small, vertical bites of the waste wood then clear the rest of the waste from the housing*

7 *Finally use a hand router to cut the housing to an even depth and tidy up the inside faces with some glass paper wrapped around a block*

Start by drawing up a plan view of the area in which the staircase is to be situated. You will then be able to work out how much access you need to the staircase and how much room you need to move around the stairs. Also you will be able to see the total going (total run) available to you.

Draw a side elevation of the area, taking care to measure the overall rise from the lower floor level to the floor level of the landing above. Show also any overhead obstructions which may affect the clearance and head-room above the stairs.

To calculate the size of the treads and the risers for any staircase, use the following formula:

$$\frac{\text{Total going}}{\substack{\text{Proposed number} \\ \text{of treads}}} = \textbf{Actual going}$$

To find the rise, use the formula:

$$\frac{\text{Total rise}}{\substack{\text{Proposed number} \\ \text{of risers}}} = \textbf{Actual rise}$$

The UK building regulations relevant to the construction of stair-cases state that one going plus two risers must not be less than 550mm and not more than 700mm. So, by adding the actual going and twice the actual riser height obtained from your calculations, you can check if your design is acceptable.

For example, consider a fairly steep staircase with a restricted overall going of 2750mm and an overall rise of 2388mm. A reasonable rise is 140mm to 180mm, and a reasonable going is 230mm. Given that there is always one more riser than

tread because the landing acts as the top riser, this staricase needs about 11 or 12 treads; or 12 or 13 risers.

Following the formula described above:

$\frac{2750}{11}$ (total going) (projected number of treads)
=250mm—which is acceptable.

On the other hand:
$\frac{2750}{12}$ = 229.16mm—which is better.

Moving on to the rise:
$\frac{2388}{12}$ (overall rise) (projected number of risers)
= 199mm—which is just acceptable.

And:
$\frac{2388}{13}$ = 183.69mm—better.

In the case of 11 treads, the one going plus two treads sum is $250+199+199=648$; in the case of 12 treads, however, the sum is $229.16+183.69+183.69=596.54$. Both are allowable, but 13 risers will make an easier staircase than 12.

In the example you could therefore start to draw up a staircase with 12 treads, a going of 229.16mm, and 13 risers of 183.69mm.

Having completed the calculations, fill in the outline of the basic steps, and add the details—such as the stringers and the thickness of the nosings—afterwards. Check the headroom, clearance and pitch on the plan, either by using a protractor or with mathematics.

Although it is possible to work solely from this drawing, it is always advisable to finish by drawing up part of the staircase full size—say three risers and two treads—so that you can show as much detail as possible.

Transferring the design to wood

Buy only well seasoned, straight grained timber several weeks before it is needed and lay it up in the room where ultimately it will be situated.

Make up a housing template (fig. 2) of 6.5mm hardboard, cutting it as

B. Below left: *A traditional run of stairs using a wedged construction*
C. Below right: *In the simplified design, metal tie rods recessed into the treads hold the run together*

accurately as possible. Make the dimensions of the 'tread' part of the template 1.5mm less all round than the ends of the tread timbers, and the 'riser' part 1mm less all round than the ends of the riser plywood, to allow for cleaning up and sanding the treads before assembly.

Start by marking the stringers with a face side and edge and use a marking gauge to scribe the nosing lines on them. Then cramp the stringers together, face sides inward and face edges uppermost. Use a pair of dividers, a try square and a marking knife to space out and lightly mark the template spacings along the combined face edges (fig. 1). Then separate the stringers and continue these marks across the face sides to meet the nosing lines.
Simplified design: Use the template as shown in fig. 2 to mark out the positions of the housings, screw holes and rod holes.

Then use a 1.5mm twist bit to drill marker holes right through the stringers at the points where screw holes and counterbores will later be drilled.

The next stage is to remove the waste timber from the tread and riser housings. The quickest way to do this is with a template and a router—covered later in the Power tools course.

The alternative method is to remove as much waste wood as possible by drilling a series of holes inside the housing marks. Then remove the rest of the waste with a suitable firmer

chisel, and finish off to an even depth with a hand router.

Now you must cut all the risers to size. Make sure that the grain runs longways. And note that the bottom riser must be one tread thickness narrower than the rest. Follow by cutting the treads to length.

Mark the positions of the riser housings on the treads with a mortise gauge and if possible use a plough plane or multiplane to cut away the waste wood (fig. 8). Then cut the 10mm grooves for the tie rods in the back of every fourth step (fig. 9). And, if your design demands that one or both of the stringers be mortised into the newel post you must prepare the mortise tenons at this stage. Finally, clean up all the cut surfaces and seal the timber as desired.

Assemble the staircase 'dry' and make any necessary adjustments. Then cramp it up and drill through the guide holes into the treads.

Dismantle the completed unit. Locate every screw and rod hole, and counterbore and drill the shank holes for the screws and rods in the outer faces of the stringers. You must also enlarge the pilot holes in the treads so that they are large enough to take 50mm × No. 12 fibre plugs. Finally coat the plugs with PVA wood adhesive and insert them in the holes. Finish by sanding down and sealing the inside surfaces taking care not to seal contact surfaces.

Traditional design: In the case of a

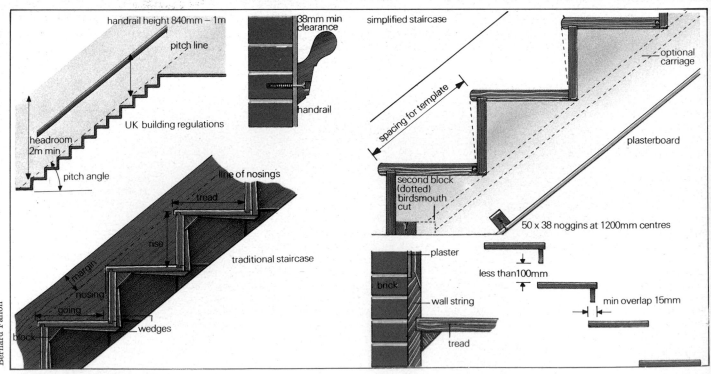

handrail height 840mm – 1m
pitch line
38mm min clearance
simplified staircase
headroom 2m min
UK building regulations
pitch angle
handrail
optional carriage
line of nosings
tread
rise
margin
nosing
going
block
wedges
traditional staircase
spacing for template
second block (dotted) birdsmouth cut
plasterboard
50 x 38 noggins at 1200mm centres
plaster
brick
wall string
tread
less than100mm
min overlap 15mm

8 *Mark the position of the riser housings on the treads with a mortise gauge and use a plough plane or multiplane to cut out the waste*

9 *Mark the 10mm groove for the tie rod on the back of the relevant tread and cut it out with a plough plane or a multiplane*

10 *When screwing into the end-grain, drill a hole and insert a fibre plug smeared with glue in order to stop the timber from splitting*

11 *Once you have assembled the staircase you can insert the tie rods, tighten them, then cover the hole with a suitable wooden plug*

Gavin Cochrane

40mm oval nails, punched well below the surface. Then insert the screws and rods, tightening them down as much as possible. Leave the whole unit cramped up for at least 12 hours.

When the adhesive has cured completely you can remove the clamps. Cut plugs or pellets to suit the counter-bores, smear them with adhesive and insert them in place. When the adhesive has set, plane the plugs flush with the surrounding surface and finish the outsides of the stringers with sandpaper. The stairway is now ready for installation.

staircase incorporating wooden wedges transferring the design to the wood is identical except for the housings in the stringers. In the simplified design the housings are parallel, but in the traditional design they must be tapered to accept the wedges. Consequently the template must also be given a taper.

Cut tapered housings in the same way as the parallel type, starting them with a powered router and finishing off with a hand router or chisel.

Assembly
You will need eight sash cramps, some timber blocks and a suitable adhesive.
Simplified design: Working on one side at a time, glue and assemble the run in the sideways position, cramp up, then remove the excess adhesive.
Traditional design: In this case lay one of the stringers 'upside down' on the bench and glue into it the top and bottom treads and risers. Apply adhesive to the housings in the other stringer and set this in place with sash cramps. Now make up a number of softwood wedges just thicker than the remaining gaps in top and bottom tread/riser housings. Dip eight of these in adhesive and tap them into the top and bottom sets of housings until the treads and risers are held firm.

You can now slide in and wedge the intervening treads and risers in the same way. As work progresses, the assembly should resemble that shown in fig. A. When the run is complete, glue and pin triangular section blocks at each tread/riser joint. Then re-cramp the entire assembly and leave it to set.

Nail the risers to the treads with

Staircase regulations
These are the *main* requirements of the Building Regulations (with the equivalent requirements for the Canadian National Code in brackets) for straight flights of stairs within a single dwelling.
● Maximum rise is 220mm (200mm; or 230mm for stairs serving only storage or laundry rooms). In the UK, minimum rise is 75mm.
● Minimum going is 220mm (210mm; or 200mm for storage and laundry rooms).
● In a flight, risers must all have the same height, and treads must all have the same going.
● Minimum width for a main staircase is 800mm (860mm).
● To ensure that the pitch of a staircase is acceptable, it must be designed so that the sum of twice the rise plus the going is between 550mm and 700mm. (There is no similar rule for interior stairs in dwellings in Canada.)
● In the UK, open risers are not allowed, but risers can have holes in them as long as they are small enough so that a 100mm sphere cannot pass through them.
● Minimum headroom above the pitch line is 2m (1.95m in Canada).
● There must be a secure handrail fixed at a height of between 840mm and 1m (800mm and 900mm). In the UK, the ends of the rail must have a proper termination, such as a scroll. If the staircase is over 1m wide (1.1m) a handrail is required on both sides.
● Both sides of a staircase must be adequately guarded (in Canada, a staircase leading to a cellar can have one unprotected side) to a height of 840mm (800mm). In the UK, holes in the guarding must be small enough so that a 100mm sphere cannot pass through them.

Fitting a suspended ceiling

● **Suspended ceiling kits** ● **The various panels which can be fitted** ● **Planning the work for a neat finish** ● **Fluorescent light fixings** ● **Installing the framework** ● **Fitting the panels and installing the built-in lighting system**

High ceilings—particularly those in small or confined spaces—often make a room look dark and unfriendly. One easy solution is to fit a new false—or *suspended*—ceiling below the existing one. This not only makes the whole room look better, it also allows you to cover up an old, untidy ceiling with a brand new, lightweight structure.

Suspended ceiling kits

The traditional method of building a suspended ceiling is to erect timber joists across the room and to line the underside of them with plasterboard. This is a time consuming job and the heavy timbers often impose an almost unbearable strain on the existing ceiling and/or roofing joists.

A much easier method—especially for the do-it-yourselfer—is to use a proprietary kit. These are available from most large hardware stores and provide all the components necessary to construct a suspended ceiling. They are easy to erect and use lightweight materials which can span any reasonable distance without strain. But their major advantage is that a whole range of panels can be fitted to them, to give the ceiling an entirely new look.

Ceiling kits consist of a number of basic parts. A grid or frame of lightweight aluminium is erected to support the ceiling panels. This is made up of angled pieces fixed around the outside of the room which provide support for both the main runners and cross bearers (fig. C).

A huge variety of ceiling finishes are available. The panels—which are fitted on top of the aluminium grid—are manufactured in a range of basic sizes—usually 610mm square or 610 × 1220mm. They can be clear, translucent, or opaque.

Clear panels: Generally these are made from 2mm thick rigid plastic, although 2.5mm panels are available for heavy-duty use. Some are virtually smooth, others—such as the 'cracked ice' variety—are heavily textured (fig. D). The panels are self-coloured, but when used with different coloured fluorescent lights mounted above they can create an illuminated, 'patchwork' ceiling.

Translucent panels: These come in the same variety of textures and colours as clear panels and are also widely used in the installation of illuminated ceilings.

Opaque panels: These are available in a number of types. Some—designed purely for decorative effect—come in different colours and various textured finishes. Others—known as *acoustic* panels—can be used to cut down noise from above. They are made in a variety of sound-deadening materials up to 16mm thick and are plain, textured or sometimes coloured. Some opaque tiles are specially designed to aid heat insulation; ask at the place where you buy the kit if you want panels for this purpose.

Planning the work

Before you start work, check carefully that the room is suitable for the installation of a suspended ceiling. Most building regulations insist on

A. Left: *A brand new suspended ceiling can transform virtually any room. Supplied in kit form, it can be fitted in just a few hours*

Howard Ceilings

minimum ceiling heights in many rooms—your local authority will be able to give you guidance on this. For example in the UK, living rooms, bedrooms and all but small kitchens must generally have a ceiling height of at least 2.3m.

In determining the height of your new ceiling, bear in mind that it should be at least 50mm below the existing surface for a decorated or acoustic ceiling, and 100mm below for an illuminated ceiling. Remember, too, that these are the minimum distances: a more satisfactory and safer finish will be achieved with a greater gap between the old ceiling and the new suspended one.

Before ordering the materials, draw up an accurate, scale plan of your ceiling on a large sheet of graph paper. Divide up the paper into squares, with each square representing one ceiling panel of your chosen size. Then transfer the dimensions of the room on to the plan, including any unusual angles or features such as a chimney breast.

You may be lucky enough to discover that the ceiling can be covered by an exact number of whole

B. Below: *The ceiling rose provides a convenient source of power for the fluorescent lights used when installing an illuminated ceiling*

junction box

ceiling rose

fluorescent lights

panels, but it is far more likely that you will have to cut them to fit around the outside.

To avoid having the cut panels all along one side—so giving an untidy, lopsided finish—try to find the centre of the room and mark this on the plan. Do this by measuring carefully across

the room between both opposite walls. If the room is an awkward shape, stretch two lengths of string across the room and adjust their positions until they meet exactly at the centre point. The position of each panel can then be planned from this point so that the cut ones are distributed evenly around the outside of the whole room.

At this stage you should also plan how the ceiling is to be lit. For illuminated ceilings, strip lighting can be supplied in a number of different lengths to fit your particular

C. Below: *Position the support grid carefully, particularly around internal and external corners. An interlocking system can simply be snapped together*

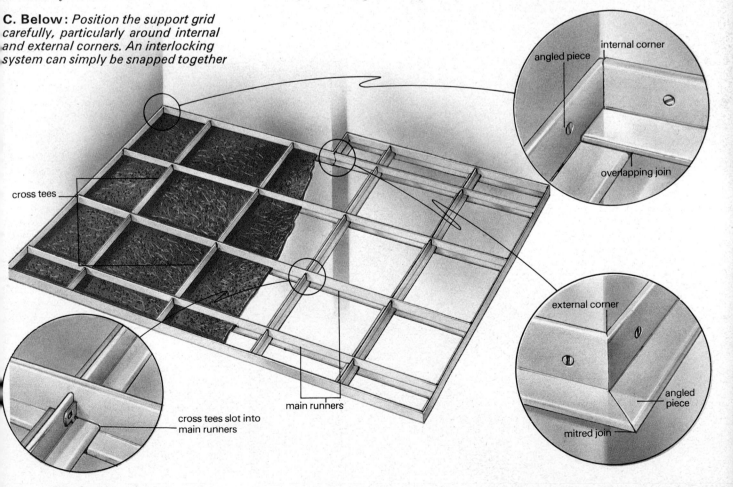

internal corner

angled piece

overlapping join

cross tees

external corner

angled piece

mitred join

cross tees slot into main runners

main runners

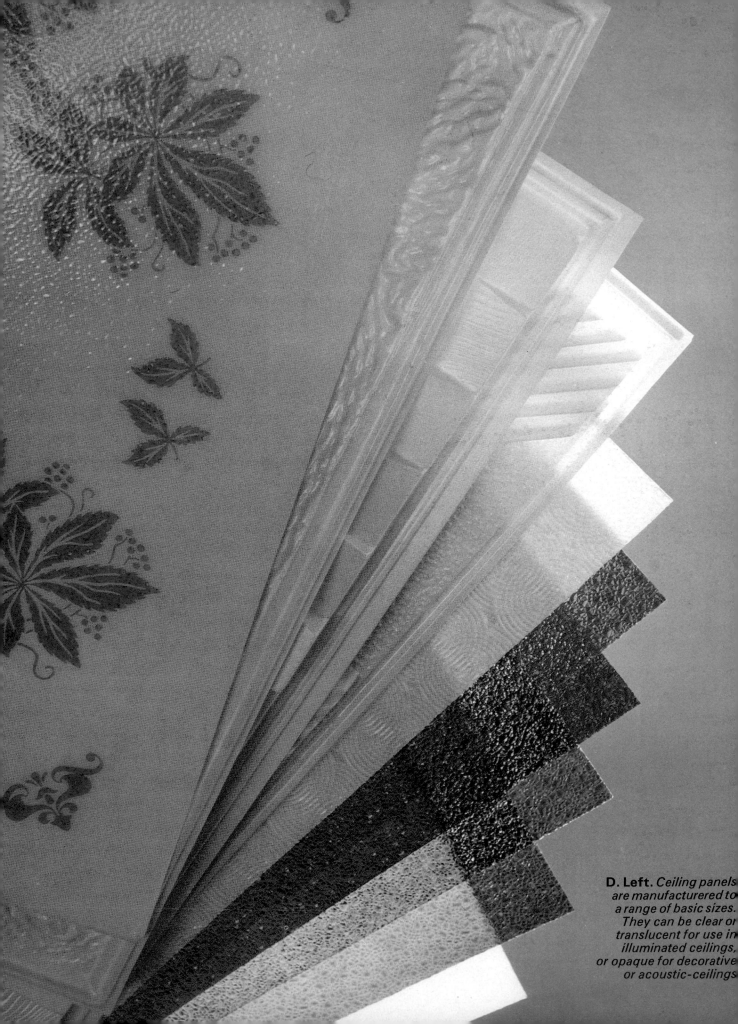

D. Left. *Ceiling panels are manufacturered to a range of basic sizes. They can be clear or translucent for use in illuminated ceilings, or opaque for decorative or acoustic-ceilings.*

room—allow about 15 watts per square metre of panel when you order. If you plan to fit opaque, plain, or textured panels, you may choose instead to install the type of downlighters that are completely recessed). And as an alternative to a totally illuminated ceiling you could introduce just a few, illuminated panels.

Before fixing any lights, check that the old ceiling is sound and that plaster and paintwork are stable. Small cracks and splits must be filled and the surface carefully and methodically sanded down. Flaking paintwork should be rubbed down thoroughly with a piece of sandpaper mounted on a block and the whole ceiling coated with stabilizing solution.

If you intend to install an illuminated ceiling—particularly with light coloured panels—give the whole ceiling a coat of brilliant white emulsion paint to aid reflection.

Light fixings

If you are installing an illuminated ceiling, your first task is to fix the strip lighting to the old ceiling. Downlighters should be fixed once the framework of the new ceiling is fitted. In Canada, check that you may do your own wiring.

Ensure that the fluorescent tubes are fixed parallel with the proposed positions of the main runners or cross tees on the framework (see below) and are spaced an equal distance apart for even light distribution. If the gap between the old and new ceiling is less than 100mm, the tubes should be placed directly above where the struts will go to avoid damage to the panels from overheating; if the gap is greater, they can be fitted directly above the panels.

Conventional fluorescent strip lights consist of a tray containing the choke, starter and terminal board, the lighting tube and two fixing clips. Secure the clips to the ceiling using wall plugs. Then slot the tray on to the clips and tighten them so that the whole fixing is held securely (fig. 1).

Wire up the lights to the mains supply before you fit the top cover and lighting tube. Unless the total wattage of the new lights exceeds 300 watts, the existing ceiling rose should provide a convenient source of power. Turn off the supply at the mains and disconnect the rose so that the cable is exposed. Then use a junction box to connect all of the lights to the supply (fig. B). Fitting and connecting fluorescent lights is quite straight-

1 For illuminated ceilings, the fluorescent lights should be fitted first. These connect to the mains power via a junction box

2 Fix the angled pieces around the outside of the room next. Use a chalked line or spirit level to mark their proposed position

3 Drill fixing holes at roughly 500mm intervals all along the angled pieces and continue them into the wall behind

4 Secure the angles with wall plugs. Slight distortions in the wall can be evened out by loosening or retightening each screw

forward and should not entail too much strenuous work.

Installing the support framework

Start by marking the proposed positions of the supporting angled pieces around the walls. Do this on each wall by fixing a chalked line at the desired height, at one end of the room. Stretch the line to the other end, then get an assistant with a spirit level to adjust it until it is horizontal. When it is, snap it against the wall to reproduce a clear fixing guide on the surface.

If you have no chalked line, use ordinary string and mark off the wall in pencil at 50mm intervals. But note that it is absolutely essential to do the job accurately, or the new ceiling will be unalterably out of alignment. Cut the angled pieces carefully to length with a hacksaw. Adjoining sections

can overlap at the internal corners of the room, but where there are external corners—such as a chimney breast—the angled pieces should be mitred for a neat finish (fig. C).

Drill fixing holes in the cut sections roughly 500mm apart and at each end (fig. 3). Lightly file off any burrs afterwards, especially those on the back of the angles which might prevent them lying flat against the wall. Use the prepared angles as templates to mark plug holes on the walls aligned with the fixing guides. Then drill, plug and screw the angles firmly in position (fig. 4).

After you have fixed each section, check that it lies flat against the wall. Slight distortions caused by an uneven wall surface can be evened out by releasing some of the screws until the angle piece straightens out, and then packing the gap with small pieces of

5 If you need to cut any parts of the grid to length, first carefully mark the position of the cut using a combination square

6 Then support the length you are cutting on a firm surface and trim it to size using a hacksaw fitted with a fine toothed blade

7 Rough cut edges on the inside of each length could cause the panels to lie unevenly. Remove them with a fine toothed file

8 Next cut the main runners to length and position them across the room. Make sure they are spaced correctly to accept the panels

must arrange a central support between each runner and the ceiling. First drill a hole through the main runner just below the rounded bead on the vertical upstand (fig. 15). Then fix a screw into the ceiling directly above this point using a toggle plug suitable for use with plasterboard. Finally, cut a piece of stout wire to length and secure this between the runner and the screw, adjusting the latter until the wire takes the weight of the frame.

Next, cut and fit the cross tees in place; if you have fixed the main runners correctly, they will simply slot into the indents provided. Once they are in position, use a try square to check that they are at right-angles to the main runners and are correctly supported on the wall angles at the edges of the room.

Fitting the panels

To fit the panels, you simply pass them up through the framework and then adjust them to rest on the lips of the main runners and cross tees. However, try to handle the panels with clean hands or with cloth pads as they are easily marked. Clips are supplied with many panels to prevent them rattling in draughty conditions, but these are worth fitting almost as a matter of course. Around the outside of the room you may have to cut the panels to size. This should be done in a warm atmosphere if possible.

Measure the size of the cut-out panels carefully and then trim them to size. Polystyrene lighting and acoustic panels should be scored heavily several times on the smooth face with a sharp handyman's knife. They can then be carefully snapped in two. If this proves difficult try heating

wood. Once the ceiling has been fitted, the gap can be neatly filled and then finished off.

The next step is to fit the main runners which stretch across the longest span of the room. Cut these carefully to size, bearing in mind that each runner may have some indents designed to hold the cross tees and that these must coincide with the proposed positions of the cross tees on the original plan.

You may find that the main runners are too short to cover the span of the room, particularly if this is over 4m. In this case, you can extend them by slotting extension pieces in the ends and then cutting these to length.

If the main runners span more than 3m, they may tend to sag once the panels are fitted. To avoid this, you

9 Then fit the cross tees into position. On interlocking systems these snap neatly into ready-made slots on the main runners

10 Polystyrene and acoustic panels can be scored with a knife and then snapped apart or else cut with a fine toothed saw

11 To fit downlighters, first mark a hole in the centre of a panel fractionally smaller than the light's external diameter

12 Then carefully cut around the outside of the marked-out area using a padsaw. Try the light for size and adjust as necessary

13 Fit the downlighter into position. Some models can be fitted directly to the panel while others are supported on battens

14 Move the panel containing the downlighter into position. Adjust the outside of the light so it points in the desired direction

15 If the ceiling sags, support it with a length of wire. Tie the bottom end to the main runner and screw the top end to the old ceiling

16 Working systematically, fit each panel into place. Then shake the grid gently to ensure that all the panels are well seated

the blade slightly and try again; alternatively, use a fine-toothed saw. Cracked ice panels should be cut with a standard laminate cutting tool.

Panels with reinforced edges must be treated with care if they are to be trimmed to size. Cut each one 25mm oversize and then score a line marking the true size along the back face using sharp scissors. Try to cut no more than half way through the panel, then bend the waste edge upwards, at right-angles to the surface, and fit it carefully into place.

Once you have positioned all the panels, shake the framework gently to help them settle. They can then be washed using a soft brush or cloth and warm water. The aluminium grid should be cleaned using a mild abrasive cleaner on a damp cloth.

Recessed lights are fitted once the ceiling has been completed. Having carefully planned the position of each light, remove the relevant panel and cut a hole in the centre fractionally smaller than the external diameter of the light itself.

Now place long wooden battens across the tops of the main runners on each side of the light panel. Push the body of the light through the hole in the panel and adjust its fixing prongs so that these rest securely on the battens. You can then assemble the rest of the light and link it up with the mains supply at a convenient ceiling rose (see pages 458 to 461).

E. Right: *Downlighters can be fitted directly to the ceiling panel or else supported on top of wooden battens*

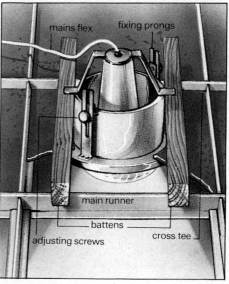

mains flex fixing prongs

main runner

battens

adjusting screws cross tee

Trevor Lawrence

Laying quarry tiles

● **The longest lasting floorcovering** ● **Sizes and types** ● **Suitable surfaces for quarry tiles** ● **Tiling with adhesive** ● **Laying tiles in a sand and cement screed** ● **Cutting tiles** ● **Grouting** ● **Finishing and cleaning**

Ray Duns

A. Below, left: *Though you can sometimes fix quarry tiles with adhesive, it is far better to lay them in a sand and cement screed. To do this, you divide the room into sections then screed and tile each section before moving on to the next*

Size and type

The most common sizes of quarry tiles are 152mm × 152mm, 203mm × 102mm and 228mm × 228mm, though smaller and irregularly shaped tiles are also available. Thicknesses range from 8mm to 25mm and in the case of the more expensive hand-made tiles, vary slightly within a batch. In fact, the true size of hand-made tiles can also vary making regular jointing impossible. Machine-made tiles often have space lugs to help keep the joints between them to an even thickness.

Many quarry tile ranges include special border tiles for edging work. Bull-nosed tiles are used where the edge meets another covering—such as a carpet—or ends at a step. Coving tiles are used against skirtings to make a clean join and to prevent water from splashing the woodwork when you clean the floor.

Suitable surfaces

Because quarry tiles are heavy and brittle, it is important that they go on a solid, level surface. Though a concrete floor obviously provides the most suitable base, the tiles can be laid on wooden floor providing this is covered first with sheets of plywood or flooring grade chipboard.

Make sure that the sheets are flat before you lay them. Pin them to the floorboards at 100mm centres to prevent twisting or warping later (see pages 92 to 95).

Quarry tiles can be fixed in one of two ways: with a heavy-duty ceramic tile adhesive—such as Ardurite—or in a bed of sand and cement mortar. The first method is much the easier but is suitable only for surfaces which are dead level—such as a recently laid screed. Neither is it suitable for laying hand-made tiles with variations in thickness, because the adhesive cannot take up the different levels.

Using a mortar bed is the more traditional way of fixing quarry tiles and is particularly well suited to rough, dusty concrete floors where it enables you to level and cover the floor at the same time.

Quarry tiles—unglazed, baked, vitrified clay tiles—were once the standard hardwearing floorcovering in the UK for kitchens, hallways and factory floors. Though they have since been superceded by modern vinyl coverings, they are now coming back into fashion because of their rustic, natural appearance and hardwearing properties.

Modern quarry tiles come in all shapes and sizes, and in a variety of colours. Natural reds, buffs, browns and blue-greys are all available, together with pigmented tiles which each contain several hues. Texture varies too, from perfectly smooth to rough and irregular, though most fall somewhere between the two.

The chief advantages of quarry tiles are that they are hardwearing and easy to keep clean—making them ideal for kitchens, laundries and utility rooms. The drawbacks are that they are hard —meaning that anything which falls on them is liable to break—and cold, though the latter is unlikely to present problems in a centrally-heated home or a warm climate. Laid properly, a quarry-tiled floor is practical, easy on the eye, and will last a lifetime.

Using adhesive

The procedure for laying tiles with adhesive follows closely that for vinyl and cork tiles (see pages 92 to 95). Having chalked a cross in the centre of the room, based on the main doorway or entrance, plan a dry run of tiles and make small adjustments to minimize the amount of cutting to be done at the edges.

Make sure that the adhesive you use is suitable for the base surface. Flexible surfaces such as plywood and chipboard require a special, flexible adhesive which your stockist will supply.

Spread out the tile adhesive with a notched trowel, to an area of about 1m² around the centre of the cross, then start laying the tiles.

If the tiles have no spacer lugs, mark off six tile widths with 3–4mm spacings for the joints on a length of planed batten and use this as a guide.

After you have laid the first 1m² of tiles, spread down more adhesive and continue laying in this way until you

B. Right: *Plan your tiling once you have screeded the first bay. Adjust the runs to minimize cutting*

C. Below: *The secret of a successful screed is to keep the battens level with each other at all times*

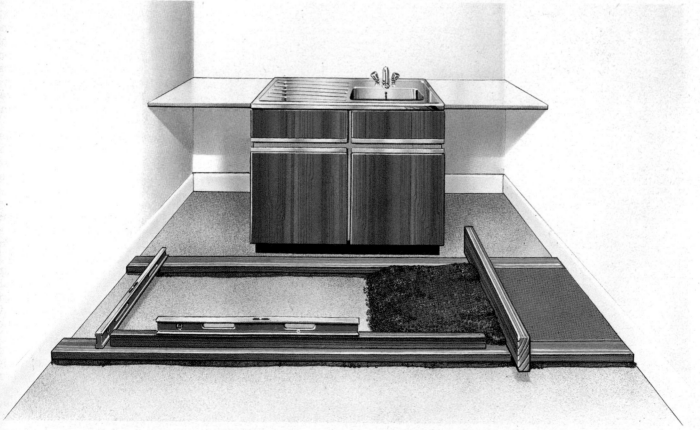

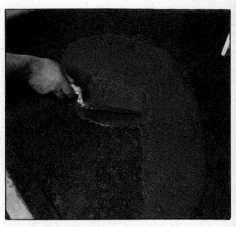

1 *After you have planned your tile runs in both directions, mark where they fall on the screed and use this as a guide when you begin tiling*

2 *To improve adhesion of the tiles, make up a mix of neat cement and water then pour this on to the level surface of the screed*

3 *Use a small trowel to spread the cement mix in a thin layer over the surface. Take care not to obscure your guide marks*

are left only with the edges to fill. At this stage you will probably have to cut the tiles to fit (see panel).

After the tiles have been laid and allowed to set, fill in the joints between them with a proprietary grouting compound suitable for flooring use (see pages 103 to 107). Rub the joints flush with the surface of the tiles, rather than run through them with a stick.

Alternatively, should you prefer to give the joints a coloured finish, use a mixture of fine white sand, cement and colouring additive.

Laying tiles in a screed
For quarry tiles to rest on a thin screed of mortar, they must be laid in sections or 'bays' across the room working back towards the main doorway or entrance. Each bay must be screeded, levelled, tiled and then levelled again before you start work on the next.

Though several forms of screed can be used to bed the tiles, the most commonly used is the *semi-dry* screed. In this, the mortar—three parts sharp, washed sand to one of Portland cement—is mixed with only enough water to bind the ingredients together. That is, it should be damp and crumbly.

A semi dry mix takes longer to go 'off' than other types, allowing you plenty of time to level it, lay the tiles and adjust them. Yet if properly compressed, it holds its shape well enough to allow you to walk lightly over the tiles on the same day that you lay them. Drying time for the screed with the tiles on top is normally 24 to 36 hours.

Setting out the first bay
The first bay should run across the room, as near to the far wall as you

can get it. Any awkward areas created by obstructions such as kitchen units (fig. C) can be bypassed and then filled back from the bay.

To mark the edges of the bay, you need two 50mm wide battens long enough to stretch across the room. Their thickness should be equal to that of the mortar screed—normally 12mm at the highest part of the floor.

Before you place the first batten, run over the floor with a spirit level to check that it is not substantially higher near the main entrance than at the first bay. If it is, make allowance for this when you bed the batten in position. Make sure that all subsequent battens are level with the high point.

The batten must rest on a thin bed of the screed mortar. Lay this out roughly then press the batten on top and weight it with your straightedge. With the spirit level also laid on top, check the batten for level. Make small adjustments by tapping it down or packing more mortar underneath as necessary (fig. C).

The second batten—marking the edge of the bay—is bedded in exactly the same way. You then stretch the spirit level between the two battens and adjust them until they are level with each other (fig. C). Do this on both sides of the room. Position the second batten so that the bay is large enough to give a good tiling area but narrow enough to allow you to stretch to the far side without risk of falling off-balance.

Screeding the first bay
Shovel the semi-dry mix into the bay and spread it out roughly level with the battens using a float. Fill any indentations which appear on the

Cutting quarry tiles
Quarry tiles, because of their thickness and strength, are generally very difficult to cut. Though the thinner ones—below 6mm—can sometimes be cut in the same way as ordinary ceramic tiles, the thicker types demand more substantial methods.

For these, you need a tile cutter—normally available for hire from tile stockists—a pair of tile nippers or pincers, and a pin hammer. Even with these, you cannot expect to make really intricate cuts and still keep the tile in one piece. Where such cuts are called for, use two or three pieces of tile instead of trying to cut one to fit.

To make a straight cut through a tile, first measure it against the gap and mark it. Set the tile in the cutter so that the groove aligns with the marks. Then pull the sliding lever up wards and across the tile to score the cutting line.

Afterwards, set the lever about 10mm in from the edge of the tile and press down hard (fig. 2). If you cannot get the tile to split after repeated attempts, remove it from the cutter, hold it as shown in fig. 3 and tap the back sharply with the pin hammer.

To trim off a thin piece of tile, hold it with the back side up against your leg and gently hack away small pieces of material using the hammer (fig. 3). When you have chipped out about half the thickness, turn the tile over and remove the remainder.

If you have to make cuts into a tile, never try to remove too much in one go. Start off the cut with the hammer, working alternately from both sides and finish off with the pincers.

surface and make sure that the mix is well compressed.

Keep adding and compressing mortar until the whole bay is covered and the mix is slightly proud of the battens. Then draw your straightedge along the battens so that the mortar is scraped off level with them (fig. C).

Afterwards, flick away any loose mortar around the edges, lightly compress the scraped surface with the float, then check it all over with the spirit level. Correct any humps or depressions in the mortar and, if necessary, run over it again with the straightedge. When you have got the bay dead level, fill in and level any awkward areas behind it in exactly the same way.

Finally, dig out the embedded first batten. Fill the narrow gap left behind

with mortar and level this off with the surrounding surface.

Planning

When you are laying quarry tiles on a screed, it is not possible—or necessary —to lay from chalked lines in the centre of the room so that the lines of joints end up 'square'. Instead, you must lay a dry run of tiles square to the main entrance of the room, back towards the far side where you will begin tiling.

Run the tiles up over the wet screed in the first bay, adjust the run so that you are left with equal tile cuts of half a tile or more at both ends, then mark a line to indicate where the last full tile ends. You can do this by scoring guidelines in the screed with a trowel and a straightedge (fig. 1).

Afterwards, lay a second dry run parallel to the line across the bay. Again, adjust the run so that the tiles to be cut along the walls are a half tile size or more. And as before, mark the position of the first full tile.

When you are laying the dry runs, be sure to allow for the width of the joints. For thin, machine-made tiles these can be as little as 4mm; for hand-made tiles leave between 6mm and 8mm to allow for the slight variations in size between tiles.

Tiling must begin from the lines you have marked: towards the main entrance as you tile the first bay and back towards the far wall as you fill in any awkward areas (fig. B). Remember that no matter how many times you alter the positions of the lines, you will never be able to eliminate intricate

1 Mark tiles for cutting individually against the spaces in which they are to go. Use a felt-tip pen or similar marker

2 Special cutters, which score and snap the tiles in one, are virtually indispensible for cutting the thicker types of quarry tile

3 When trimming tiles to fit, start by chipping away the back of the tile to the required depth. Note how the tile is held

4 Afterwards, tap gently on the face side to remove the excess. Never try to remove large pieces in one go or the tile will fracture

5 More intricate trimming must be done with a combination of hammer and pincers. Again, remove only small pieces at a time

6 In situations like this, it would be impossible to cut a slot in a single tile: you must trim one to an L shape and fill in with an offcut

4 *Positioning the first tile is critical, so make sure that it aligns exactly with the guide marks you have made on the screed*

5 *Press each tile firmly into the bed, check it for level, then make small adjustments by tapping it with the trowel handle*

the differences in tile sizes while still maintaining a good overall effect.

When the tiles are in their final positions, beat them down hard with a sturdy piece of timber to remove any high spots and pack them into the bedding (fig. 8). At the same time, make constant checks for level with the spirit level.

Finally, to provide a good base for grouting later, make up a very dry mix of the mortar. Brush this over the surface of the tiles so that it fills all the joints to an even depth (fig. 9), then sweep away the excess.

Subsequent bays

With the first bay completed, continue by screeding and tiling a second. Use the second batten from the first bay to form the first batten of the second and

6 *As you progress, equalize the joints as best you can. Adjust the joint spaces by tapping the edges of the tiles with your trowel blade*

7 *With the first bay—and any awkward areas behind—completed in whole tiles, you are ready to fill in the borders of the room*

8 *Beating the surface of the tiles with a wood block helps to bed them in and removes any high spots still remaining*

cuts completely: simply do your best to ensure that these are confined to unobtrusive areas.

Laying the tiles

As quarry tiles do not adhere readily to a semi-dry mix, the surface must be covered with a thin bonding layer after you have scored your planning lines.

Make the bonding from a mix of one part cement to one part water, further diluted until it forms a very thin paste. Pour it over the surface of the screed and level it out with a trowel or float until it just covers the mortar (fig. 3). Position the first two or three tiles on the screed, in line with your planning lines, then tap them down firmly with a trowel handle. If necessary check them for level with the spirit level and measure the width of the intervening joints.

After this, simply continue filling the bay with whole tiles. Where necessary, work back from the planning lines to fill awkward areas behind the bay (fig. B). When you have laid all the whole tiles, fill in the cut tiles at the borders. Each cut tile must be marked and cut individually to fit (see panel) as quite large variations in size are bound to occur.

When the bay is completely tiled, you can begin evening up the joints. As the tiles are unlikely to all be the same size, this job is best done by eye. Make adjustments by tapping the sides of the tiles this way and that with the blade of your trowel (fig. 6). When you are happy that each is in the right place, tap it down firmly with the trowel handle. By levelling up the joints on every third row only, you enable the joints in between to take up

11 *Afterwards, remove the excess with a sponge. As you wipe, make sure the joints are well filled and neatly rounded*

so on. Be sure to check every new batten for level against the previous one or the screed will become uneven. On all but the largest floors, further dry runs and planning lines are unlikely to be necessary—as you tile, simply keep to the line of tiles and joints set by the first bay.

Grouting
When the entire floor is tiled and beaten, and the joints filled, you are ready to grout. Normally, a grouting compound of one part cement to one of water—mixed into a thicker paste than that used for the bonding coat—is perfectly acceptable. But if you prefer, you can use a mix of one part cement to one of fine white sand with colourant added to match or contrast with the colour of the tiles (see pages 519 to 523).

Using a semi-dry screed, you should be able to walk on the tiles at this stage without them becoming displaced. However, be sure to wear soft shoes and avoid treading on the edges. To spread the weight of your body when grouting, kneel on a piece of 500mm × 500mm plywood or chipboard or balance on a wooden beam.

Spread the grout over the surface of the tiles with a squeegee, working over an area of about 2m² at a time. Force the compound well into the joints so that it fills them completely and do not be deterred if the tiles get in a mess—they are easily cleaned.

After the squeegee, wash away the excess grout with water and a sponge. As you do so, make sure that each joint is rubbed smooth and that there are no gaps left unfilled (fig. 11).

Changing levels
An important point to bear in mind when quarry tiling is the change in level brought about by the screed, tiles and possibly also a plywood base. Though doors are easily altered to fit, the step caused by different floor levels presents more of a problem: it is a hazard and as such, may not satisfy building regulations.

Where carpet meets tile, the usual answer is to continue the screed under the carpet so that it slopes down gently to the original floor level over a distance of about 500mm. Set the slope roughly by eye then use the straightedge and spirit level to smooth it to an even finish.

An alternative solution, particularly suited to where the tiles meet another solid floor at a different level, is a wooden ramp. This can be sawn and planed to shape, drilled and plugged into the floor and then polished or coated with varnish.

Finishing
After grouting, the tiles will be badly discoloured with cement and grout. By far the best way of removing this is to rub over them with dampened sawdust once they have dried (fig. 12).

Rub the sawdust thoroughly over each tile with a circular motion then brush it away. If there is still some discolouration, apply a second batch and repeat the process.

When the tiles are clean, you can bring up their shine and natural colour with polish. Use a proprietary wax tile polish on the smooth, even-coloured type of tile; on the textured, mottled variety such as those shown use a thin application of linseed oil (fig. 13).

9 After tiling, the next step is to fill the joints with a dry mix of 1:1 sand and cement. Brush this well in then sweep away the excess

10 Start grouting when you have tiled the whole floor. Spread the neat cement and water mix over the entire surface and rub well in

12 Rubbing over the tiles with damp sawdust gets rid of the stains left by the excess grout and polishes off the joints

13 A final polish with linseed oil brings up the natural colours of these tiles. Alternatively, you could use a proprietary tile polish

14 The finished floor, showing just the kind of random, multicoloured effect that has brought quarry tiles back into fashion

Knocking a hole in a wall

Gavin Cochrane

● Checking a wall for loadbearing ● Cutting an opening in a brick or plasterboard wall ● Selecting and inserting a lintel ● Preparing the opening for its lining

Home improvements can often be made just as easily by demolishing bricks and mortar as they can by building up. Knocking a small hole through a wall is a good way to master the basic techniques—and makes space for a serving hatch, window or two-way bookshelf.

Demolishing masonry normally entails using supports—temporary ones as you do the work and permanent ones afterwards, to keep the wall structurally sound. For holes under 1.5m wide, only simple supports are needed. Demolishing larger holes—and complete walls—calls for more complex supports and is covered further on in the course.

External walls, and most internal walls, take the weight of the structure above them. When a hole is knocked through, this weight can bear down on the space and cause the structure to collapse.

This is prevented by installing a lintel—a beam of concrete, galvanized steel or wood—over the hole.

The lintel must be strong enough to take the place of the missing masonry. In the case of a small hole up to 450mm wide, a strong wooden frame built into it may be sufficient—the top of the frame acts as the lintel. Such a frame may also suffice where the wall is simply a dividing wall and does not bear the weight of any structure above it.

Checking the wall

To find out if the wall in question is masonry or timber framed, tap it sharply with your fist. A brick wall gives out a dull, solid sound whereas a stud wall sounds loud and hollow. If you are in any doubt, cut a test hole within the area of the proposed opening in the wall.

If the wall is a non-loadbearing one, it usually ends slightly above the ceiling level. However, if it continues on an upstairs floor, it is loadbearing. It is also loadbearing if struts which help support the roof rest on it, or if the wall supports the ceiling joists of the

Checking for cables

If there is a power socket on the wall in which you intend to make an opening, there is a possibility that the cable may be routed across the proposed site of the hole.

Before starting any demolition work, check that the way is clear or you may sever a cable.

First, turn off the mains supply—and leave it off, even after you have established the direction of the cable.

Then, carefully chisel away the plaster from a small area around the power socket until you can see which direction the cable takes. Normally cables go up or down—rarely straight across the wall. If a cable is routed across your proposed opening, it must be re-routed before any demolition takes place. This will probably require a longer cable which should be carefully installed.

In some older houses, gas pipes may also be set into the walls. The procedure for establishing their direction is the same as for power cables.

room itself.

In all cases, check out the wall by looking into the roof space or, in the case of a two-storey house, by checking on the direction of the floorboarding above. When the floorboards lie in the same direction as the wall the joists below are being supported by that wall.

Choice of lintels

Lintels come in a variety of types. If you are knocking through an exterior wall in a house with a solid wall of standard 225mm brickwork, the easiest to use is a pre-stressed concrete lintel 220mm wide and at least 65mm thick (depending on the width of the opening). You set it flush with the outside edge of the opening so that the concrete is visible.

In newer houses with a cavity wall —two layers of leaves of 112mm brickwork with an air space between—a proprietary steel lintel is better.

For an interior wall of single skin brickwork, a timber or concrete lintel

100mm x 75mm thick will suffice for small openings.

Lintels come in different thicknesses for different loadings. Since the right size to use depends not just on the width you are spanning but also on what is above it—right up to the roof—most Building Regulations do not specify sizes for particular jobs.

Only an engineer can calculate the loadings accurately but your Building Inspector will advise you on the safest lintel to use if you show him an accurate drawing of the wall.

Whichever size you buy, the lintel must be at least 305mm longer than the opening you wish to span, so that it has an adequate grip or bearing on either side.

Selecting a site
When selecting an exact site for the hole, bear in mind that it should be at least two bricks' length from any angle in the wall—such as a corner. Any closer than this and you may weaken the structure.

Temporary supports
A brick wall is exceptionally stable within certain limits—even with a hole in it. If you go carefully, you can cut an opening up to 1m wide in sound brickwork without any temporary support at all. Most of the bricks over the opening will just hang there during the time it takes to insert the lintel.

However, for a wider opening you should start by cutting only the slot for the lintel (fig. A), at the same time supporting the wall above with lengths of timber known as needles. When the lintel is in place and the mortar around it has hardened, you can cut away the brickwork below it (fig. A).

Needles are made from lengths of 100mm x 75mm timber and for a 1-1.5m hole, two only will be needed. The needles are inserted through holes in the wall immediately above the proposed position of the lintel and then propped on either side with Acrow props (jack posts) to carry the weight of the whole wall down to the floor or ground. Lengths of timber—at least 200mm x 50mm—are placed between the supports and the ground to spread the weight over a greater area.

You can hire both the needles and the steel supports from larger hire shops. Before you start to erect them, get your lintel into position at the foot of the wall—you may not have the room to manoeuvre it in later.

Cut the 100mm x 75mm holes for the needles with a club hammer and

1 Mark in the measurements of the proposed opening, using a spirit level both as a straight edge and a guide that the line is straight

2 Plaster must be chipped away with a club hammer and bolster to expose the brickwork. Start in the middle of the cutting area

3 Use firm hammer blows and keep the bolster steady to cut out neat areas of plaster. Keep half a brick's length inside the markings

4 At this stage, enough brickwork is exposed to judge whether or not the proposed cutting edge will line up with any mortar joints

plugging chisel or cold chisel. Work from both sides of the wall if necessary and keep the holes as rectangular in section as possible, so the needles lie flat. Having wedged them through the wall, erect supports on both sides (fig. A).

Marking the cutting area
Having selected the approximate position of the hole, take its overall measurements and transfer these to the wall (fig. 1).

Assuming that the wall is still plastered or rendered, you must now chip away this layer to reveal the brickwork underneath (fig. 2). Use a club hammer and bolster, keeping at least half a brick's length inside the marked lines (fig. 3).'

When the brickwork in the centre of the cutting area is exposed, you

can tell—without removing all the plaster—whether or not your proposed cutting edges correspond with vertical and horizontal joints (fig. 4). Do this by measuring from an exposed joint to the marked edge (fig. 5). If the proposed edges do not line up with any joints, move the markings of the cutting area over until they do. This keeps the number of bricks to be cut from the opening to a minimum. Check the joints for level and plumb (fig. 6).

The position of the lintel must also be marked, directly above the top cutting line (fig. 7).

A certain amount of wall vibration is inevitable at the cutting-out stage and you will certainly create thick clouds of dust. Because of this, it is a good idea to remove all breakables from the vicinity and to remove or cover up furniture.

5 *Measure from an exposed joint to the edge. Move the cutting area over if it does not correspond to a vertical and horizontal joint*

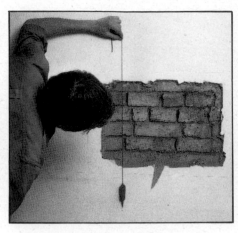

6 *When the cutting edge corresponds to a mortar joint, use a plumbline to check that it is level and ensure the opening will be square*

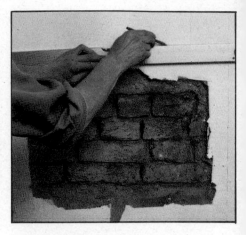

7 *Mark in the position of the lintel directly above the top cutting line. Again, use a spirit level to keep the line straight*

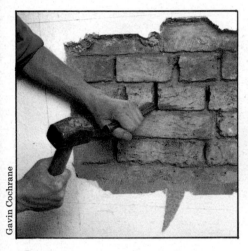

Gavin Cochrane

8 *Using a club hammer, drive a plugging chisel into the vertical joint in the centre of the cutting area to gradually loosen it up*

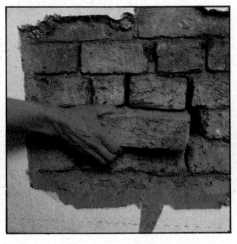

9 *When the mortar all around the brick has been loosened, try to ease it out. A stubborn brick can be broken up with the bolster*

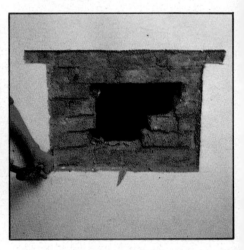

10 *Subsequent bricks should be easier to remove. Then chip away the remaining plaster so that all the brickwork is exposed*

Cutting out the opening

The secret of demolishing brickwork is to work carefully and steadily, removing only a little at a time. Start with a vertical joint in the middle of the cutting area and drive in a plugging chisel with a mallet (fig. 8). Loosen the mortar around one brick and try to ease it out. If it will not move, smash it out (fig. 9).

After you have removed one or two bricks in this way, you can exchange the plugging chisel for the bolster. By driving it into the mortar joints, you should be able to lever bricks away rather than have to smash them out. Continue using the plugging chisel on vertical joints.

A. *Walls with openings of more than 1m must be supported until the lintel is fitted in place*

Enlarging the opening is a gradual, careful process and only small sections of masonry should be knocked out at a time. Too big a 'bite' with the chisel will result in uncontrolled cracking and possible major structural damage—so be careful.

Chisel cuts about 20mm apart should be completed step-by-step fashion (fig. 10). By angling the chisel blows into the line of the wall outside the cutting area, the blows are absorbed by the wall bulk and the vibration shock is lessened. This helps reduce the chance of uncontrolled cracking.

When the wall is hit at right-angles none of the vibration is absorbed and there may be loosening of nearby fittings, such as wall cupboards.

You should continue chiselling until you have cut the slot for the lintel (fig. 11).

needle support

Acrow props

lintel ready for insertion

firm base

Bernard Fallon

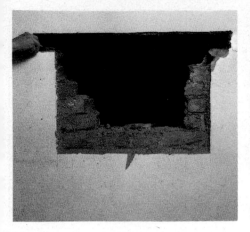

11 *Using a club hammer and bolster, knock out the brickwork at the top of the opening ready for the lintel to be inserted in the hole*

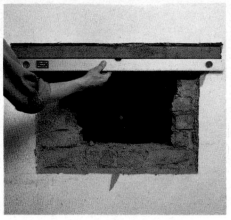

12 *Lay down bedding mortar for the lintel and slide it into place. Before packing it into place, use a spirit level to check its position*

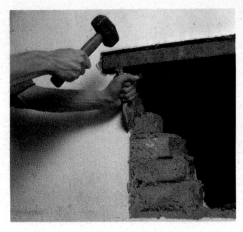

13 *The remaining bricks can now be cut out of the opening—this time using the club hammer and a bolster chisel*

14 *Big gaps between the lintel and its supporting brickwork must be packed with bits of slate. Trim them to size when the mortar has set*

15 *Use the same mortar as that for bedding the lintel to fill the space around it. Pack the mortar well in with the edge of a trowel*

16 *The opening is complete and ready to receive whatever finish has been decided on. Leave the mortar to dry for about a day*

Inserting the lintel

Make the bedding mortar for your lintel from three parts of soft sand to one of Portland cement with just enough water to make it workable. Slide the lintel into place and let the mortar under it harden overnight before you proceed. Check that the lintel is plumb and level (fig. 12), before the mortar dries—then you can cut the rest of the opening (fig. 13).

If the space is deeper than a normal joint (10-15mm), reinforce it by driving in bits of slate, knocking off the projecting pieces with a hammer when the mortar has dried (fig. 14). Fill the space above the lintel with the same mortar, pushed well into the gap.

B. *A stud and plasterboard wall may require replacement studs to be fitted at the edge of the opening*

plasterboard

cross timber

replacement stud

stud

architrave

Bernard Fallon

Cutting the main hole

The plaster must be gradually stripped back to the line of the final cut and cut neatly with the bolster. A neat job at this stage reduces the amount of making-good needed when the framework is installed (fig. 16).

In a solid wall you must cut off all the half- and quarter-bricks that project into the opening. Tap them firmly on top with the hammer and bolster, then a bit harder from the face side to cut them off squarely.

In an outside cavity wall, the procedure is slightly different. Square off the opening in the outside leaf as you would for a solid wall. But do not cut off the protruding bricks or blocks on the inner leaf—they will be needed to close the cavity later. Closing a cavity wall is covered further on in the book.

Openings in stud partition walls

The first step in making an opening in a stud partition wall is to find the studs. Bang on the wall with your fist; where you hear a 'solid' sound there will be a stud.

The next step is to site the opening so that you will do as little damage as possible to the plasterboard (wallboard). You will anyway have to cut the opening over-depth so that you can nail the timber lintel to the studs on either side. Try, by siting the opening neatly between two existing studs, to avoid having to cut over-width as well —otherwise you will have a lot of plasterboard patches to fit.

Mark out the proposed opening, plus the depth of the lintel and bottom bearer (fig. B), in the same way as for a masonry wall. Cut the plasterboard on one side with a handyman's knife and steel rule. Then poke a nail through the wall, at each of the four corners, to show where to cut the other side.

Next, saw through the middle stud or studs at the top and bottom. To help keep your saw cut straight, use a pencil and try-square to mark right round the studs, and saw alternately from each of the four edges.

Skew-nail the lintel to the studs on either side of the opening, and nail in the bottom bearer. You may also need vertical packing pieces between the lintel and bearer, to give you nailing positions for the plasterboard patches around the opening.

When you cut and fit the plasterboard patches, try to have a dead straight 'factory' edge where a patch meets an existing sheet of plasterboard. This will make stopping and levelling easier after you have nailed it on.

David Jordan

Build a serving hatch

A hole in the wall can be easily and cheaply converted into a practical and attractive serving hatch.

After knocking a suitable hole through the wall and inserting a lintel, make up an open box, or frame, which is a loose fit within the opening. Level this frame in the hole using wooden wedges. Check with a spirit level, then screw through the sides only—not the top and bottom too, or you may pull the box out of shape.

Fit a hardwood surround to give a neat appearance to the hatch, and hang the doors.

There are many alternatives to the basic design. For example, the hatch can be made without doors, or, for extra privacy, with doors on each side of the opening. The picture opposite shows how a fluorescent light has been recessed into the wall above the hatchway to add attraction to this area after mealtimes.

The dimensions and details given in the plans are suitable for a small kitchen hatch through a single brick wall. If your wall is thicker or thinner than that shown, the width of the boards forming the main carcase should be modified to suit. All other dimensions remain the same.

Catch plate

398

522

Door made from 16mm veneered chipboard to match carcase

35mm 170° opening concealed cabinet hinge

Conceal the fixing screws with matching plugs cut from waste wood with a special plug cutter. Cut plugs in the carcase, then drill and sink the screws into the recess which is left. Glue plugs over the screwheads and plane flush after the glue has set

815

50 | 50

75×100mm
softwood lintel

50×100mm
rough grounds

75

550

50

85mm No.10 (4·9mm)
countersunk woodscrews
into plastic wall plugs

Wooden wedges used
to level the frame

Magnetic
catches

70×15mm planed all round
hardwood architrave to
match carcase. This is
fixed to the carcase
with 30mm panel pins
punched below the
surface and filled
with matching filler

Make main carcase
from 20mm thick
solid planed all round
timber. The width
depends on the
thickness of the
wall

70

534

522

70

30mm
No.8 (4·2mm)
countersunk
woodscrews

70

815

70

808

45° angle

This waste wood is
removed after the
housing is cut

Main carcase

Brick

Plaster

50×100mm
stud

70

3mm gap
around door

3mm gap
between doors

Section through hatch opening

The carcase may be constructed
from almost any timber, but a
hardwood such as mahogany, sapele
or utile is attractive and readily
obtainable. Finish with two coats
of cellulose brushing sanding
sealer plus two coats of melamine
or polyurethane clear lacquer

Main carcase corner joints

6

14

20

20

6

6

6

10

Demolishing loadbearing walls

● **Loadbearing and non loadbearing walls** ● **Wall construction** ● **Checking whether a wall is loadbearing** ● **Types of support: concrete lintels, beams and rolled steel joists** ● **Methods of fitting supports**

Knocking down internal walls can transform your home by turning two or more cramped rooms into one integrated and spacious area. But knocking down a wall—any wall—is not a job to rush into without detailed preparation and expert advice if the work is to be completed both safely and effectively.

Before starting work on such an important structural alteration to your home, it is essential to check with your local authority what permissions are needed. For example, in the UK a structural alteration like this will need Building Regulations approval (in London, these are replaced by building by-laws); in Canada, your local building codes will determine what you are able to do.

Types of internal walls
Before demolishing any internal wall it is essential to first discover whether or not it is loadbearing. Some internal walls simply divide one room from another, do not support loads, and

can safely be removed without risk. But others need more elaborate techniques since they support weight from above—the ceiling, another upstairs wall, the floor above, or a combination of all three.

Non-loadbearing walls can be removed without the need for temporary or permanent support of any kind. Loadbearing walls, on the other hand, must have the weight from above temporarily held up by props while a support is inserted in the wall above the proposed gap. Only then can the wall below be safely knocked down.

Wall construction
Internal walls may be made of brick or some other type of building block, or may be made of timber framing covered with plasterboard (wallboard). The type of wall construction on its own does not tell you whether or not a wall is loadbearing (although in the UK, an internal masonry wall is much more likely to be loadbearing than a timber-framed 'stud' partition wall is).

Checking for loadbearing is much the same whether a wall is masonry or timber framed, and in both cases, the wall has to be temporarily supported during demolition and permanently supported afterwards. But the methods of knocking down, and the types of permanent support needed, are different. This part, and the next, of the Masonry course give details of the procedure for masonry walls: the details for timber-framed walls will follow in a later issue, after an explanation of how these walls are built.

Checking for loadbearing
Finding out whether a wall is loadbearing is not as easy as it may seem. It is impossible to tell just by examining the outside of the wall and extensive tests must be carried out to determine its exact function. These may take a great deal of time and effort but are essential if serious structural damage or even collapse is to be avoided.

Below: *To decide whether a wall is loadbearing, raise a number of floorboards in the room above and expose the joists for inspection*
Right: *An unusual type of non-loadbearing wall where the upstairs room is divided by a stud partition*

To find out, check the area where the wall meets the ceiling joists or roof supports and follow the line of this to the room above or up into the loft. You will find either that the wall disappears, having ended just above the ceiling, or that it continues up through the room you are in.

In either case the only way to determine the purpose of the wall is to lift a number of floorboards to expose the top of the wall and the joists around it (see pages 224-229). When a number of floorboards are removed you should get a clear view of where the wall joins the joists and be able to tell whether the wall bears the loads from the joists or not.

Never take the direction of the floorboards as an indication of how the joists below might run. You may be under the impression that floorboards always run at right angles to joists. But in some cases, new boards have been laid over the original ones to give a more attractive floor so always lift the floorboards to find out what lies below.

Non-continuous wall: If the floor joists run in the same direction as the wall and do not support any roof structure, it will be clear at once that the wall cannot possibly be loadbearing (fig. A). It can, therefore, be removed without risk of the floor above collapsing and without the need for a new support.

But if the joists cross the line of the wall—and especially if they lap each other—they are likely to be supported by the wall beneath them (fig. B). In this case, it is essential that they are supported in some other way before the wall is demolished. Before you make a decision, bear in mind that the wall could be a later addition to the house and therefore non-loadbearing even though the joists cross it. A probable indication of this is that the covering on the ceiling also continues through the wall to the next room (fig. C).

Continuous wall: If the wall you intend to remove continues into the room above, it is bound to be loadbearing. But floorboards on both sides of the wall should still be removed in order to check on the building construction underneath. The exact technique used will determine the width and length of the support needed to carry the weight from above after removal of the wall.

A. *A non-loadbearing wall where the floor joists run parallel to the wall beneath and do not support any of the roof structure*

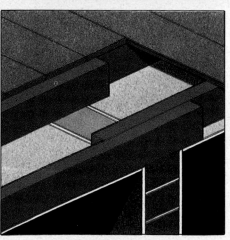

B. *Even with a non-continuous wall, when the joists run at right angles to it the wall is loadbearing and a support must be inserted*

C. *The continuous ceiling lining indicates that the wall is a later addition to the house and is non-loadbearing*

D. *In this situation the support which is inserted need only be wide enough to take the weight of the continuous wall and not the joists*

Nigel Osborne

185

E. *The support must be strong enough to replace the loadbearing wall which continues above and also bears the weight of the joists*

F. *In some properties the support used must take account of the fact that the joists stop at the wall and are supported by wall plates*

G. *As an alternative to wall plates, joist hangers may be used and this must be taken into account when choosing a replacement support*

When the joists run parallel to the wall, the support need only be wide enough to carry the wall since the joists have their own independent support (fig. D). But if the joists cross the wall, the support used must be wide and strong enough to hold up both the weight of the wall above and the floor (fig. E).

In some cases, the joists stop at the wall and are supported by wallplates or by joist hangers (figs. F and G). If either of these are in evidence the support which replaces them must be wide enough and strong enough to take the weight of the floor and the wall above.

Types of support
There are three types of support which can be used for loadbearing masonry walls—pre-stressed concrete lintels, reinforced concrete beams and rolled steel joists (RSJs).
Concrete lintels: These are factory-made from cast concrete, reinforced with highly stressed high tensile steel wire. They come in standard sizes and are available from most large builders' merchants.
Concrete beams: These consist of reinforced thick steel rods embedded in a block of concrete and because of this they are much heavier than pre-stressed lintels. The beams are usually cast on-site.
Rolled steel joists: In cross-section this type of support is usually shaped like an 'H' on its side and is made in a number of sizes to suit almost any span or load. But if you decide to use an RSJ, both sides of the joist will probably need cladding to comply with fire regulations.

H. Above, left: *A support resting on parts of the existing wall*
I. Above, right: *Support provided by piers and an inner cavity*
J. Bottom: *Building brickwork piers to take the load from above*

The type of support used and its exact size must be carefully worked out according to complex calculations and it is most important that you take professional advice on this point from either an architect, a surveyor or a structural engineer before proceeding.

It is also important to set the position of the lintel or beam so that the reinforcing rods or wires take the strain correctly. Although many factory-made lintels are marked to show which side should be uppermost, it is not always simple, and, again, it is essential to take expert advice.

Fitting a support

There are three ways in which a support can be inserted to take the weight from above. The first involves resting the support on specially-built brickwork piers which are completed before the wall is finally demolished. Though the job sometimes requires that the foundations be modified or extended to take the load of the piers, this is usually the best way of spanning a wide gap because it can take by far the greatest weight. It is rarely necessary for narrow gaps where the piers would look awkward and bulky.

The second—and most popular—way of inserting a support is to leave the ends of the wall you are demolishing in place and rest it on these. In this case, the support itself must be at least 300mm longer than the gap you intend to span and must be well secured to take the weight from above.

Bear in mind that if you are using this method, demolition may weaken the wall ends and they may have to be strengthened, rebuilt or tied in to the adjacent walls.

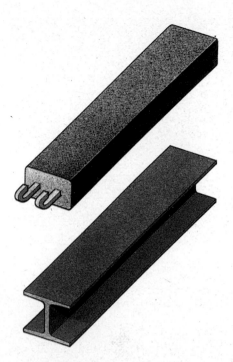

K. Top: *A concrete beam strengthened by reinforced steel rods*
L. Bottom: *An 'H'-shaped rolled steel joist support*

The third method—demolishing the wall entirely and resting the support ends in the adjacent walls—gives by far the neatest finish but is not always feasible. To give adequate support, the walls must be cavity walls or at least a double thickness of brick. In the former case, the supports then rest on the inner leaf, but in a solid wall it is not always possible to insert them far enough to do the job. And remember that if one of the walls is a party wall, your neighbour must be consulted before building takes place.

Whatever support method you may think you need to use, it is essential to take expert advice before you go further. An experienced architect or surveyor will be able to assess what is the simplest and safest method just by inspection, as well as providing important information on the size of support needed—and the job may turn out to be easier than you think.

Temporary supports

At no time must a loadbearing wall be interfered with without first supporting the weight above. And in the case of demolition, this means inserting temporary props to take the load until the permanent support is in place. The technique of doing this and of knocking down the wall itself are covered completely in the next demolition section.

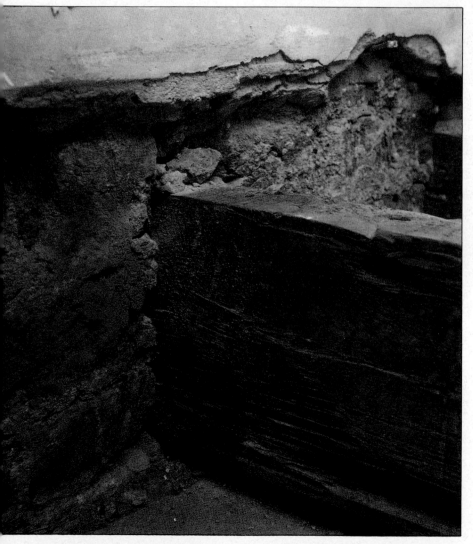

Above: *Take great care if the floor above is supported by joists whose ends are inserted into brickwork. Check and strengthen the ends before starting work on removing the wall below*

The actual demolition

● **Erecting temporary props for non-continuous and continuous walls** ● **Cutting out a slot for the support** ● **Inserting lintels and RSJ's** ● **Removing the props** ● **Finishing off** ● **Floor repairs**

pose if you have no suitable timber double them up if necessary to obtain the minimum thickness.

In certain cases (see below) yo may also require a supply of needle —1.5m lengths of sturdy 100mm× 75mm timber. You can either cut thes yourself or hire them along with th props and scaffold boards.

Erecting temporary supports
Before you make any attempt to set u the temporary support, make sure tha your permanent support or lintel i in place on the floor underneath wher it is to go. And as the work proceeds make certain that access for raisin the support is unobstructed by prop **Non-continuous wall:** Where th wall to be demolished does not cor tinue upwards but merely supports th floor above, temporarily supportin the latter is relatively straightforwarc Simply assemble two rows of adjus able steel props and planks as show below, parallel to each other o both sides of the wall (if it is ar external wall, you may need onl one). The rows must be 0.6m awa from the wall and the props them selves 1.2m apart.

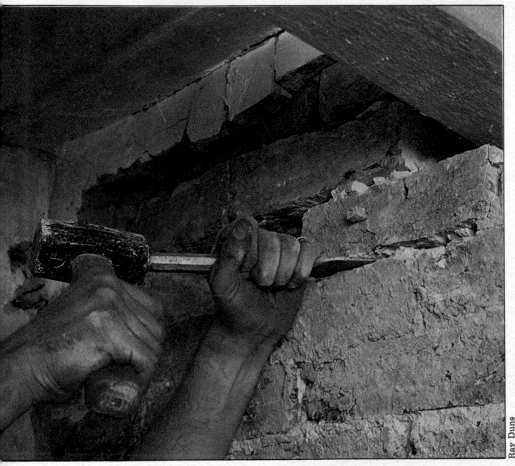

Ray Duns

Above: *Once the temporary prop is bearing the full weight from above, you can cut away a full course of bricks to accommodate the support*

Temporary supports
The temporary supports most often used for this kind of work are expandable steel props, commonly known in the UK as Acrow props. These are available for hire quite cheaply and can be adjusted to fit the heights of most domestic rooms. To spread the load on the props—both top and bottom—you also need a number of wooden planks. These must be at least 200mm wide by 50mm thick and should preferably stretch the length of the wall you are working on. Scaffold boards can be hired for this pur-

The last section on loadbearing walls described how important it is to take professional advice before demolishing a loadbearing masonry wall and also showed many of the variations you may come across. Using the consultant's report and the evidence of your own inspection, you should already have obtained a suitable support or lintel—in the case of a cavity wall you will need two—to take the weight above the wall and decided how this is to be inserted.

Except where your support is to rest on piers (fig. A), the next stage is to work out what temporary supports you need while demolishing the wall: it is absolutely essential to collect everything together before you start work.

Ceiling supports

Below: Where the wall to be demolished is non-continuous but takes the weight of the floor above, erect a row of temporary props on each side of the wall and tighten them hard against the ceiling

188

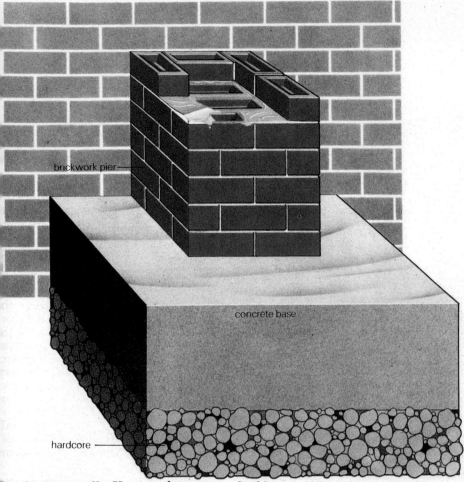

brickwork pier

concrete base

hardcore

Continuous wall: You need to employ a different approach where the wall continues into an upper storey: if you supported only the floor, the upper wall would collapse during demolition. Support for the wall is provided by the timber needles (see above). These are inserted through holes cut in the wall just above the line of the lintel and are themselves supported at both ends by props and planks (figs 6 to 8).

The holes for the needles should all run along the same course of brickwork at intervals of about 1m, and should be about the size of one brick. Where necessary, strip away plaster from the wall with a club hammer and bolster so that you can plan the hole cutting properly.

Start the holes from one side of the wall, again using the hammer and bolster and making sure that you are wearing safety glasses or goggles. If you are dealing with a cavity wall, or one that is particularly thick, use a large masonry bit to drill through to the other side and then finish the cutting from there.

Finally, slide the needles through the holes in the wall until they pro-

A. Above: *When the support is to rest on brickwork piers, they should be solidly built with good foundations*

trude by equal amounts on both sides. Erect props and planks at both ends of the needles as shown in fig. 8, then tighten the props slowly and by equal amounts until the timber is pushed hard against the brickwork. Do not overtighten the props—they are there to support, not to lift—and make very sure that the needles remain horizontal.

Cutting out

With the temporary supports in position, you are ready to cut a slot in the wall to take the lintel or support. But before doing so, check that there are no power lines or service pipes running across the wall under the plaster. These, together with any power sockets, must be rerouted before demolition can proceed.

Once this is done, mark out the proposed position of the lintel with a spirit level, plumbline and chalk. The hole should be fractionally larger all round than the proposed support so that the latter can be fitted comfort-

ably into place once you have cut away the brickwork.

Use the club hammer and bolster to cut away the bricks and be sure to wear goggles or safety glasses. Try to remove only a few at a time and avoid using brute force if possible as this is likely only to break away or loosen bricks accidentally.

If a brick proves difficult to move, drill a number of holes in the mortar around it using a masonry bit. It should then be possible to remove the brick with the hammer and bolster. As you progress, try to control your chisel blows and angle them into the wall so that you disturb no more masonry than is necessary (see pages 178 to 182).

Where your proposed support is to rest in the adjacent walls rather than simply on the ends of the wall you are demolishing (see pages 184 to 187), cut into these to the required depth once you have finished the rest of the slot. If one or both are cavity walls, take care not to let debris fall between the leaves as this may stick to the wall ties allowing damp to bridge the gap.

As the support will be longer than the wall you are demolishing, it may be necessary to cut extra masonry out of the side walls so that you can twist it into position. But if the wall is external, you may find it easier to feed through the support from the outside and then gently ease it into its eventual resting place. This, of course, means cutting a larger slot on the outside of the wall.

Once the slot for the support is finished and you have smoothed out the cut edges as far as possible, check that the sides are completely vertical with a plumbline and rebuild any brickwork which is loose or broken. Finally, check the dimensions carefully to make sure that the hole is the correct size to receive the lintel.

Inserting the support

The method you use to bed the support into position depends on whether you are using a lintel or a rolled steel joist (see pages 184 to 187).
Lintels: These must be lifted and twisted, slid or fed carefully into position. Because of the weight of the lintel and the need to position it accurately, it is essential to have several people to help you do this.

Lay a bed of fairly dry 1:3 mortar on all parts of the lintel that are likely to come into contact with the wall above the opening before you slide it into its final resting place. Before you go any further, make sure

1 To demolish a loadbearing wall, start by marking out the area of brickwork to be removed using a spirit level and plumb line

2 Once this is done, use a hammer and bolster to remove the plaster from a line of bricks about three courses down from the ceiling

3 Remove enough plaster so that you have a choice of which bricks to remove to insert the temporary needle supports

4 Before cutting out any bricks, move the permanent support into position at the foot of the wall so that it is ready for use

Removing the props

Do not be in a hurry to remove the temporary supports—they are best left where they are for at least another two days so that the bedding around the lintel or joist can harden fully. When you do remove them, bring down the weight on the support gradually by loosening off the props a little at a time. And while you are taking the props away, look carefully at the area around the top of the support to make sure that it is not suffering from any undue stress.

Finishing a rolled steel joist

Because of their shape, rolled steel joists do not look particularly attractive when left uncovered. In most cases, the easiest way to improve their appearance is by covering them with a shell of plasterboard.

In order to do this, you need to make up wooden noggins to act as supports for the board (fig. B). Cut these fractionally longer than the distance between the upper and lower lips of the joist then tap them into place at 300mm intervals.

Most joints protrude slightly from the wall surface, which makes it difficult to cover them neatly. But with care, a piece of plasterboard can be made to 'bend' around the three protruding sides (fig. B).

The length of plasterboard needed for this will be determined by the length of the joist plus a slight overlay at each end. But to find the width, measure the widths of the protruding sides, add these together and then add a further overlap allowance of 600mm.

Lay the plasterboard face downwards on a flat surface and transfer these measurements to the material then, using a sharp handyman's knife and a steel straightedge, cut through the cardboard backing and separate

Next turn the material over so that the face is uppermost and mark pencil lines across the material corresponding to the top, bottom and side edges of the joist. Use the steel straightedge and knife to score along these lines, but make sure that you cut through only the paper face and do not damage the plasterboard itself. Because the backing is made of a much stronger material than the face, you find that you can then wrap the sheet around the joist (fig. B).

Hammer flat-headed galvanized nails through the plasterboard to the noggins below to fix the covering in position. The surrounding area can then be skimmed flat with a layer of fresh plaster (see pages 207 to 210).

that the lintel lies exactly as specified in the plans.

The next step is to cut away more holes underneath the lintel and insert two or more needles—with props —so that you can jack it up against the wall above (fig. 15). Pack any gaps above the lintel with mortar before you do this, and make sure that the lintel remains horizontal at all times.

Then, with the lintel forced upwards by the needles, pack the gaps underneath both supporting ends with pieces of slate tapped firmly into place with a hammer. Finally, point all around the cracks between the lintel and brickwork with mortar ready for replastering.

Rolled steel joists: These are not bedded in cement but instead set on 'pads' of natural stone or pre-cast concrete (see pages 184 to 187). Pads are available at most large builder's merchants and are usually sold along with the joist. Depending on the size of the joist, they should be at least 50-70mm thick and long and wide enough to guarantee good support at both ends. The pads must rest on a firm, level base and this may involve renewing or adding to the brickwork piers which support them.

Use a trowel to spread an even bed of 1:3 mortar below the pads and leave this to set for at least 48 hours so that there is no risk of movement. Then lift the joist into place with the help of your assistants and position it accurately. Gaps around the outside of the joist should be packed with slate and pointed in a similar way to the pre-stressed lintel.

5 Select bricks about one metre apart on the same course to take the supporting needles and remove them with a hammer and bolster

6 Once the bricks have been chopped out, slide the wooden needles through the holes so that they protrude on each side

7 To support the needles, erect expandable steel props on both sides of the wall and set them on planks to spread the load

8 Once the props are in position, raise them slowly so that the needles press hard against the bricks above and take the weight

9 With the roof held up, start to demolish the wall, first removing items such as wooden architraves around doorways

10 When dealing with a brick which is difficult to remove, use a large masonry bit to loosen the mortar around it

Making good the floor

How you make good the floor depends on whether your floor is suspended or solid, and if the former is the case, on which way the joists run.

Suspended floor: Where the floor joists run at right-angles to the wall you are demolishing, they will either be supported on sleeper walls running parallel to it (only one if the wall is external) or on the wall itself by means of hangers or ledgers (see pages 224 to 229).

In the first case, demolish the wall down to below the level of the joists and fit new lengths of joist between the sleeper walls in the newly-adjoining rooms. These should rest securely on the base of the old wall and be skew-nailed to the joists that are already in place.

If the wall itself supports the joists, demolish only as far as just below the floorboards. Where the wall is external, you can then arrange to fit a

suitable hearth and step. But if it is internal, arrange for short lengths of joist-size timber—noggins—to rest on notches cut into the base of the wall and extend underneath the floorboards on both sides of the gap. Once you have nailed the noggins to the existing floorboards, they will make suitable supports for the additional boarding that will be required for you to cover the hole.

Where the joists run parallel, demolish the wall below the level of the boards. This will leave you with a gap—ragged because the existing floorboards are certain to be staggered. If the floorboards are not to show, it may be possible to cut them back to—and over the middle of—the nearest joists. You can then fit boarding—such as flooring grade chipboard —across the gap. However, if you want the floor completely floorboarded, you have no choice but to take up the existing ones and stagger them in a

different way so that when relaid they span the gap.

In both cases, carefully level the base of the demolished wall to just below floorboard level so that it acts as an extra 'joist' to support the boards over the gap. If this proves impossible, demolish it a little further, fit an extra joist on top and secure this at the adjacent walls.

Where the wall is external, use the remainder of it as a base for your hearth or step. To bridge the rest of the gap you again may have to take up some or all of the existing boards and relay them in a different pattern.

Solid floor: Here, the procedure is much simpler in that you do not have to arrange for supports—simply demolish down to the base level of the oversite concrete, then carefully pour in fresh concrete to fill the hole.

The only difficulties you may encounter are where it is necessary to disturb a damp-proof membrane (DPM)

11 *Then use the hammer and bolster to chop away the rest of the mortar and lever the brick upwards until it is free*

12 *Once the slot has been cut out, lay a bed of fairly dry 1:3 mortar along the top of the support using a trowel*

13 *Then, with the help of other people, lift the support lintel carefully into position, taking care not to scrape off the mortar*

14 *Once the support is in place, use a spirit level to check its horizontal alignment so that it can be adjusted if necessary*

15 *Insert extra needles underneath the lintel. Use more props to jack up the support so the ends can be packed with slates*

16 *With all the props still in position, knock down the rest of the wall. The props should then be removed and the wall finished off*

located below the surface screed. In this case it may be necessary to break up more of the floor so that you expose the existing DPM and fit a strip of the same material over the gap before you concrete over. The new section of the DPM should fold back twice.

Where the problems are more complex, it is likely that your architect or surveyor will have allowed for and dealt with them in his specification. If not consult your building inspector.

Making good the piers
The first job is to firmly mortar in place all loose and suspect brickwork. Where bricks have broken badly, giving a ragged vertical edge to your piers, cut them out entirely, and replace them with neatly cut ones.

Then replaster each side of the pier separately, nailing wooden guide battens to the vertical edges to give you something to plaster up to, and to help get corners neat.

RSJ

timber noggins

plasterboard

B. *To give a smooth finish to a rolled steel joist, wrap a plasterboard shell around it supported by timber noggins*

Nigel Osborne

Building a stud wall

- Stud wall applications
- Planning a stud wall
- The anatomy of a stud wall
- Setting out the frame
- Prefabricated assembly
- Building in situ
- Doorways and openings
- Cladding the partition
- Finishing off
- Archways

Many of the internal walls in houses are made from a framework of timber members covered with some sort of building board—often plasterboard (wallboard). In brick-built houses, such timber-framed walls (often called stud construction) are usually used only for non-loadbearing purposes. In timber-framed houses, internal timber-framed walls are of course used for both loadbearing and non-loadbearing purposes—see page 184 for descriptions of loadbearing and non-loadbearing walls.

Building a non-loadbearing partition wall is relatively straightforward, and is a good introduction to the techniques involved in building any sort of timber-framed construction. The skills needed are not complicated and can be quickly and easily acquired.

Stud wall applications

One of the main uses for a stud partition is to provide an additional room by sub-dividing one large room into two units with independent access. This avoids the expense associated with a new rear, or roof, extension. And, although you must consult the local authority before proceeding to ensure that your project complies with building, fire and public health requirements, the additional loading imposed by stud partitions can always be carried by existing joists—providing that no load-bearing walls are demolished to accommodate the new stud wall.

Other common uses for stud partitions include the closing off of unwanted alcoves like those on either side of a chimney breast; the provision of built-in cupboards, which can also be incorporated in a full-width partition dividing one room into two, and the creation of a dining or work area within a larger room, sheltered by a divider extending into the room.

Other popular uses include the straight division of one room into two spaces where no independent access to the second room is required, as, for example, an extra bathroom leading off the bedroom.

Planning a stud wall

Stud partitions are straightforward to construct and can easily accommodate doors, hatches, decorative arches or borrowed lights (internal windows).

The main design problem when planning a partition is the need to provide access if each new room must be a self-contained unit. The normal solution is a small lobby with two doors (fig. B), entered by the existing door and lit by borrowed lights above each new door. This, of course, requires two partitions.

In most cases, the room you create must have its own windows. The only exceptions to this rule are 'non-habitable' rooms—what this means differs from country to country, but it usually includes bathrooms and small kitchens. In such rooms, you will have to provide adequate mechanical ventilation instead—see pages 446 to 451.

If you are lucky, you may be able to arrange for one existing window to serve both rooms, by building the partition so that it runs through the middle of the window—but this solution almost always looks like a poor job, and in any case, the amount of light received by each room might not be enough to satisfy regulations.

In some circumstances, you may feel that large, borrowed lights in the partition give adequate natural lighting, but again you must comply with building regulations and codes.

British Gypsum

Left: *To fit a light switch or other fitting to a stud wall first nail a support noggin in place behind the proposed site*

A. Main picture: *The upright frame shows the anatomy of a stud wall. This is how the frame will look if you prefabricate it. If you build in situ, you will not need the extra bottom plate (see fig. B). The frame in outline shows how you lay out the members on the floor for pre-fabrication*

top plate

hea

rough sill

stud

face nail

skew nail

extra noggin

B. Left: *A prefabricated frame has an extra bottom plate. The frame is face-nailed to this extra plate; the plate in turn is skew-nailed to the floor*

dwarf stud

header

noggin

bottom plate

extra bottom plate

C. Above: *For electrical fittings an extra noggin has to be fixed to the studs*

D. Above: *Door and window linings should be wide enough to cover the depth of the stud*

two headers, nailed side by side

rough sill nailed side-on

face nail

skew nail

E. Above: *The header is of two pieces nailed together. Dwarfs stud are needed*

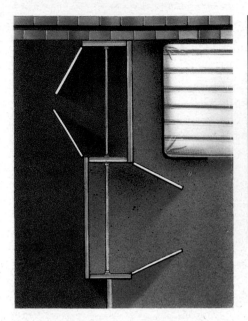

F. Left: *One of the advantages of the stud wall is better use of available space. Here, a separating wall gives more cupboard space*

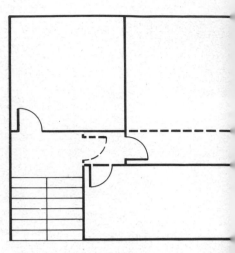

G. Above and above, left: *Two plans for separating two rooms into three. The two stud walls allow access through a central lobby*

The anatomy of a stud wall

The main elements of a stud partition are two full-width horizontal timber members (the *header* or *top plate*, fixed to the ceiling, and the *floor*, *sole* or *bottom plate* fixed to the floor); and vertical members between the top and bottom plate (*studs*). In the UK, it is customary to further strengthen the framework by nailing short cross-members (*noggins*) between the studs. The usual size timbers used for the main framework, especially in Canada, is 50mm × 100mm sawn timber, but for small partitions—the framework of a built-in cupboard for example—this can be reduced to 50mm × 75mm.

Additional cross-members are used above doors (*headers*), and above and below openings such as hatchways (*headers* and *rough sills*). These provide a rough framework in which a finished frame or lining can be fitted. Fig. A, previously, shows all these elements.

At this stage, thought should be given to any fittings which you may want to hang on the wall—toilet cisterns, radiators for a wet central heating system and so on. Heavy items like these will have to be fixed to the frame members, not to the wall covering, so additional supporting timbers may be necessary. Electrical fittings may need supports, too (fig. C).

To reduce heat loss, and to some extent to provide some noise insulation, you may want to fill the cavity between the cladding with some insulating material such as glass fibre.

Wiring and plumbing should be installed in the wall. and then the framework can be covered. The covering may be gypsum board laths, or larger sheets of plasterboard (wallboard)

covered with a skim coat of plaster, or plasterboard used as 'drywall' where only the joints are covered with filling plaster. Or you may prefer to use one of the other many decorative wallboards which need little or no finishing off. Or you might want to use fibre or insulation boards. Skirting boards (base boards) and architraves (mouldings) round doors and so on complete the job.

Setting out the frame

The first practical consideration is to find the direction of the existing ceiling joists (fig. H). If the proposed partition runs parallel to the joists, the head must be positioned beneath a joist for easy fixing. If this is not possible, bridging pieces must be run between the appropriate joists to take the head. Access for this work may be obtained by lifting floorboards in the room above. First establish the line of the chosen joist and then mark its run; this will determine the position of the head.

When the partition runs across the joists it may be positioned anywhere. Find the centre of one joist by poking a bradawl in the ceiling and, using that as a guide, establish and mark the position of every second joist along the partition line—the joists should be at about 400 or 460mm centres.

Having marked the position of the head on the ceiling, mark the walls vertically with a plumb line, and draw a line across the floor to indicate the position of the plate (fig. I).

Once the basic job is marked, plan the stud arrangement in detail on the basis of the size of the cladding material. The aim is to ensure that the vertical edges of adjacent cladding sheets fall over the middle of a stud

(this eliminates unnecessary cutting, and that there are sufficient studs between the edges of the boards to support the boards properly so that they do not flex.

Most boards are made in sizes that allow studs to be set at 406mm centres (that strange measurement converts almost exactly to the old imperial 16in measurement) or 400mm centres; some boards require studs to be set at 457mm (exactly 18in) or 460mm. So decide on the boards you intend to use, and the way round you intend to fix them, and check their exact measurements before setting out the studs. Of course, it is unlikely that the partition width will divide exactly into your chosen stud spacing—so the spacing at one end of the wall, or at one side of a doorway will probably be less than the standard.

There are then two methods of constructing the frame—prefabricating it or building in situ.

Prefabricated assembly

This is the easier method, particularly with two people. But it does rely on the walls, floor and ceiling being perfectly straight and at right angles to each other for best results. Small variations from the rectangular, or slopes that you can accurately measure, are allowable—but if the walls, floor or ceiling are very irregular, use the in situ method (see below).

To prefabricate a frame, you need a space on the floor the width of the partition, and a bit longer than the partition is to be high. Lay out the framework on the floor, with the bottom plate lying on the floor, more or less along the line where it is finally to go, but resting on its short edge. Lay

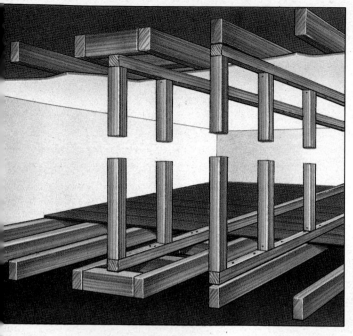

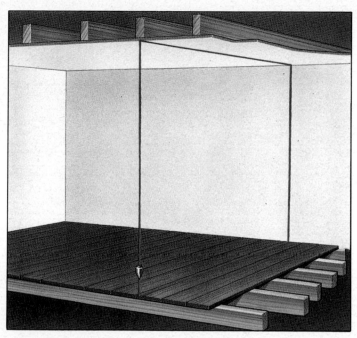

H. Above: *Frames running parallel to joists are best located directly under a joist; otherwise the bearers will have to be added to adequately support them*

he studs at right angles to this plate, gain on their short edges, and finally ay the top plate in place.

Before you do this, of course, you will have to cut the studs to the correct ength. This is the height of the room, *ess* the thickness of the top and bottom plates (usually 50mm each), *less* a urther amount equal to just under the hickness of the bottom plate again—a otal, usually, of just under 150mm. Make sure you cut the studs accurately quare: there are no housing joints in his sort of framework to help rigidity. The top and bottom plates will normally e the width of the room, but you can nake them a little smaller if you have o allow for any irregularities.

It is probably easier to leave out tuds round doorways and other openngs, so that you can get them ccurately positioned after you have aised the framework.

Now nail straight through the top nd bottom plates, into the ends of the tuds (this is called *end nailing*, or *face ailing*). Use round wire (common) ails about 90mm long; two into each nd of each stud. It is easiest if two of ou do this simultaneously, working ne on the top and one on the bottom of ach stud in turn. If you synchronize our hammer blows then the framevork should not move out of position. f you cannot manage this, or if there is nly one of you working, then you will

need to fix some sort of stop to the floor to hold the plates in position and stop the framework jumping apart as you nail.

Stand the assembled framework up— you will need more than one helper if the wall is large—and drive an extra length of bottom plate under the entire length of the wall. If you have cut your studs accurately the framework should now be wedged quite firmly in place, and you can adjust positioning with light mallet blows until it stands plumb and square in the correct place.

The next stage is to *skew-nail* (*toe-nail*) the lowest bottom plate to the floor (fig. B). Skew nailing is shown on page 120. Then nail the upper bottom plate to the lower one. Finally, fix the top plate to the joists. Nailing it should be fine, but if you find that you are starting to damage the surround ceiling plaster badly (as you might with an old lath and plaster ceiling) then switch to screwing.

Building in situ
In many cases, prefabricating will just not be possible and you will have to build the framework vertically, directly in its final position.

The position of the top plate is probably the most critical, especially if it has to lie along the line of a joist rather than at right angles to them. So fix this in position first.

Using plumb lines, mark out the position of the bottom plate on the floor, directly under the top plate. Fix this plate in place. Then mark off the stud positions on both top and bottom plates, taking into account any door-

I. *In order to lay out your stud wall accurately, first locate the upper joist and then drop a plumbline. Do the same at the other end and then mark out the wall site*

ways or other openings.

Cut the studs to length—all at once if the ceiling-to-floor height is regular; one by one if the distance varies. These studs have to be skew-nailed into place and you will find that, as you start hammering, they will shift out of place. Prevent this by fastening a G-cramp (C-clamp) or temporarily nailing a small wooden stop to the plate on the opposite side of the stud to which you are nailing. Or get a helper to hold the stud as you nail.

Doorways and openings
Door frames (sometimes called door linings) hatchways and window frames and so on all need fixing to a solid sub-frame. For a non-loadbearing wall these are easy to make.

The vertical sides of the subframe or rough frame are simply studs running the full height of the wall. Nail these in place if they are not already there. The lintel or header forming the horizontal top of the opening (if it does not go to ceiling height) is usually formed of two 50mm × 100mm timbers nailed together to form a beam 100mm square. Face-nail this to the studs at the correct height, making sure it is level and positioning it so that the timbers are edge-on—that is, with the 50mm dimensions of the two timbers lying horizontally. At least one short stud will have to be fixed above the header,

skew-nailed in place.

If the opening does not go right down to floor level, then you will need a rough sill—the horizontal bottom member. This can be a length of 50mm × 100mm timber, laid broad side horizontally. Fix it by face-nailing—nail horizontally through the studs into the ends of the sill. Fix dwarf studs under the sill, skew-nailed to the bottom plate, and face-nailed to the sill. Fig. E shows all these details.

Fit all the aperture linings with countersunk screws disguised with wooden plugs (see pages 118 to 122) or oval (finishing) nails punched beneath the surface which are subsequently filled, ensuring that linings protrude by an equal distance on each side of the studwork to ensure a flush finish with the thickness of the cladding (fig. F).

Cladding the partition
Before you hang the sheet material

you must run any electrical cables (for power points or light switches) through specially drilled 12mm holes in each stud. If necessary, you must add a special noggin to hold the new box in the desired position (fig. E).

Any plumbing pipes should also be run through the framework (this stage is often called *rough plumbing*). If you have to cut notches in the studs for these, strengthen them with metal plates, nailed over the notch.

It is not necessary to scribe insulation board to butt tightly against uneven walls or ceilings because a scribed timber fillet should cover the join. Likewise, time is saved by hanging unscribed plasterboard, then filling any irregularities with bonding plaster before the finish plaster (if the board is skimmed) is applied.

To scribe the timber fillets, or plasterboard, if a perfect fit is desired, hold the work upright and as close

J. *Door linings should be braced with scrap battens as shown to keep them square until they are fitted in place in the opening*

K. *To ensure a strong joint on the corners of timber linings, glue and pin with a housing joint, Use a try-square to check alignment*

L. *After cladding and fitting any glazing panes, trim with a mitred architrave moulding fitted to the lining and pinned in place*

to the wall as possible. To keep it firm, plasterboard may be lightly tacked to the studs, with the timber fillets braced with a couple of packing pieces against the wall. Set a pair of compasses at 10mm and run the point down the wall from top to bottom. The pencil will mark the work to the exact contour of the wall, and you can then either saw or plane it to shape.

Now hang the cladding, working outwards from the door lining to the walls. Plasterboard should always be hung with the grey side outwards if it is to receive a skim coat of plaster, and it is wise to tack each sheet lightly to permit realignment in the event of subsequent errors. Use 40mm galvanised or sheradized plasterboard nails to secure the sheets. You may leave a gap of 2-3mm between the sheets, and a 12mm gap at the bottom. This aids easy positioning and will be covered by the skirting board.

To cut plasterboard use a trimming knife. Score the board along the desired line, then snap it open and cut the paper on the other side for a clean break. Alternatively, use a fine-toothed saw. Insulating board may be cut

to size in a similar fashion. The last sheet, which finishes against the wall, may be sized by turning it over and overlapping the previous sheet with the opposite edge against the wall. Mark the sheet top and bottom against the previous sheet, then cut and turn the right side out again. The sheet will then slot neatly into place.

If you do not wish to use insulating board because of the visible fillets, but cannot tackle the finish coat on plasterboard, it is possible to build a 12mm plasterboard partition that can be decorated direct. To do this, use linings that finish 25mm wider than

the studwork, as for insulating board. Hang the plasterboard ivory side out, fill and tape the joins and coat the partition with special sealant so it can take wallpaper paste. You can then wallpaper the plasterboard.

Once all the cladding is positioned, cut the holes for electrical boxes with a trimming knife and run the cables through them. Now fix the cladding firmly in place. Nail plasterboard at 150mm intervals along the studs and noggins, and nail insulating board at 100mm intervals along the edges and at 200mm intervals elsewhere. Avoid the line of the cables when nailing

the board, and cover the nail heads with filler. Fill the gaps between the plasterboard sheets with special joint filler and cover them with linen sealing tape to prevent possible cracking of finish plaster along the join lines. You may apply the skim coat of finish plaster as soon as the filler has set.

If you are drylining, then you fill the gap much as above, but of course, do not then skim with plaster.

Finishing off

The partition is finished by completing the aperture detail. Hang the door (allowing adequate clearance at the bottom if it opens over fitted carpet) and add a door stop. Glaze the borrowed lights—set the glass in putty between glazing beads to avoid rattling. Add sliding or hinged doors to the apertures, if desired, and fit all the apertures with architrave (moulding). Then nail a skirting board (baseboard) that matches the rest of the room in place.

In the case of insulating board partitions you must add the timber fillets that cover the joins. After scribing the fillets to the walls and ceiling, nail the ceiling then the vertical fillets in position using 40mm oval (finishing) nails. Finally punch the nail heads beneath the surface and fill the holes.

Using a preformed arch

The best method of creating a decorative arch is to purchase a preformed arch fabricated in heavily galvanized light steel mesh. There is a good range of sizes and designs available. Select the desired arch and construct the studwork as for a door. However, no lining is required; the two vertical studs and door head suffice for plastering over (fig. M).

After hanging the plasterboard, fasten the two halves of the arch in position with galvanized clout nails. Then nail a strip of expanded metal lathing down each side of the aperture from the preformed arch to the floor. Finish with a plasterboard bead—a right-angled metal lath that overlaps a plasterboard and expanded metal lathing to provide a sharp edge for the finish plaster. Apply a thin coat of metal lathing plaster to the galvanized surfaces before the finish plaster is applied.

M. *If you are making an arched doorway form the outline of the arch with preform mesh and then plaster over the mesh*

Felt covered stud wall

You can use prefabricated felt panels as an attractive alternative to plasterboard for cladding a stud wall. This technique can also be used as a cladding for masonry walls, where it is useful for covering deteriorating plasterwork.

The idea is not complicated. Use standard 12mm chipboard, and cut the boards into lengths which will fit from floor to ceiling leaving a 140mm gap. Rip saw the boards into two lengthways to give you 610mm wide panels. Tack the panels temporarily to the studding to ensure a good fit, scribing to walls and ceiling as necessary. Cut smaller panels to fit round doors into corners.

Remove the panels and cover each with felt as shown. Fit a 150mm plain skirting to lie flush with the back of the fitted boards.

Screw the panels in place using mirror screws with a decorative caps. For a neat flush, ensure that these are set level and at regular intervals on each panel. Add linings to door or window openings.

Wrap the felt over the chipboard panel and tack it along the edges using a staple gun or wire staples and a hammer. Pull tightly as you tack the second side

Chipboard panel

Felt

On solid walls use three horizontal battens to provide a support. You can also clad a stud framework

Fold the corners as shown for a neat finish and continue stapling. Staple the loose edges to the back

Cut smaller pieces of chipboard to fit into corners and around door frames

Fix a skirting board which is the same depth as the battening. Allow the panels to overlap this slightly

Fix the complete panels to the battens using decorative mirror screws with caps as shown. Space them out evenly

Use standard 12 mm chipboard panels, normally available up to 1220mm wide and 2440 mm long or 3000 mm long. Ideally, cut them to reach from floor to ceiling in one piece and cut them in half lengthways to give 610mm wide panels. Scribe them to walls and ceilings as for plasterboard and ensure that they butt together tightly. Then cover with felt

Butt battens into right-angled corner after hanging the panels on one wall

Line the door after cladding. Let the lining protrude about 2mm beyond the surface of the felt for a neat finish

Building a fireplace and chimney

● **Planning the work** ● **Building regulations** ●
**Fireplace construction: recess, hearth, chimney
and chimney stack** ● **Building the construc-
tional hearth and recess** ● **Recess to chimney**
● **Chimney stack construction**

Many people decide that they would like an open fire or solid fuel appliance in their home only to find themselves handicapped by the fact that they have no suitable chimney or fireplace. Either existing fireplaces are in the wrong place or—in the case of modern homes—they are not part of the original house construction.

The best solution is to construct a new fireplace recess and chimney from brick. This is suitable for all types of inset open fire and can be used also with most modern free-standing and the closed fires. As an alternative you may with to fit a prefabricated flue and chimney. This is fairly complicated and advice should be sought before commencing work.

Building regulations
Whatever type of solid fuel appliances you install—wood or coal burning, open or closed—the fireplace recess and chimney must be soundly constructed so that there is no fire risk inside the house. It must also be carefully sited against a suitable outside or inside wall that is strong enough to take the weight of the flue and the chimney stack.

If the fireplace is to be built on the ground floor, you should consider carefully how the chimney breast is to be fitted through the first floor, the upstairs ceiling and the roof (see below): This will involve cutting through roof and ceiling coverings as well as some of the joists.

Building regulations governing fireplace and chimney construction vary from country to country and even from one region to another so it is essential to discover those which apply to you; your local building inspector or a competent architect can help if you are in difficulty. You should then draw up detailed plans of all the work and submit them to your local authority for approval before proceeding.

Simon Butcher

Fireplace construction

All brick fireplaces and chimneys are constructed in the same way, despite the fact that dimensions and materials vary according to the building regulations. The sizes and materials quoted below give rough estimates only and you should check carefully that these are acceptable before starting work:

Fireplace recess: The box which forms the fireplace must have sides and a back of solid non-combustible material—usually brick—at least 200 mm thick. If you build the fireplace against an external or party wall, check first that this is thick enough to form the back. Either a solid wall 200mm thick or a cavity wall where each leaf is 100mm thick will satisfy UK building regulations.

Walls less than 200mm thick should have an extra leaf added directly against the back wall to make up the required thickness. Erect this before the sides and insert metal ties across both walls to hold and strengthen them.

Hearth: Once the fire is in operation the floorboards, joists and floor coverings need to be protected by a hearth against accidental damage. This consists of two solid slabs, one beneath floor level—called the *constructional* hearth—and a second, which sits on top of it—called the *superimposed* hearth (fig. A).

The constructional hearth must be at least 125mm deep and should project 500mm in front and 150mm to each side of the opening. Most constructional hearths are completely solid but if you are building a fire with underfloor air ducts you must allow for these on your building plan.

The superimposed hearth consists of brick, concrete or some other non-combustible material at least 48mm thick. It should project at least 300mm in front of the opening (225mm for a closed room heater) and 150mm on each side of the fireplace.

Unless you are installing a fire with underfloor ventilation, a solid concrete back hearth must be fitted inside the recess and finish level with the top of the superimposed hearth in front of the opening.

Chimneys: Great care must be taken when building the brick chimney and forming a flue inside it. The brickwork around the flue should be at least 100mm thick—except where the chimney is built against a party wall when the brickwork between the flue and next door must not be less than 200mm thick (see above).

You may need to build the chimney with a bend or *crank* in it—to avoid internal projections or built-in furniture, or to make sure that the chimney pot ends up on the correct part of the roof. Keep bends angled at less than 60° to the horizontal and remember that an angled chimney is much more difficult to build than the straightforward upright variety.

Chimney stacks: A hole may need to be cut in the roof to accommodate the new chimney assembly. The chimney stack can then be built above this and a pot cemented on top. The chimney pot must be at least 200mm in diameter

1 Before starting work on the recess, mark its proposed position across the back wall using the building materials as a guide

2 Construct one side of the recess at a time, carefully following the lines marked on the wall to ensure a neat finish

3 On every second or third course, chop a half brick gap out of the back wall so that you can tie in the sides of the recess

4 Continue upwards until you reach a point level with the top of the opening. Then carefully point the brickwork around the outside

5 The other side of the recess box should then be built up to the same height and tied into the back wall as you progress

internally and should be sited at least 1m above any nearby ridge of the roof to avoid down draughts.

Fireplace opening: The size of opening you build will vary according to the type of appliance you are installing and the area you particularly want to heat up. You may, however, wish to construct a larger opening so that almost any type of appliance can be installed in the future without the need for complicated structural alterations to the chimney breast.

The brickwork above the opening must be supported by a reinforced *throat forming* lintel made of concrete (fig. B). This is triangular in shape and is fixed so that the chamfered side faces inwards towards the back of the opening—an arrangement which allows the fire to draw air but avoids unnecessary draughts.

The size of lintel you use will vary according to both the design of the fire and the size of the opening, but it should be at least 300mm longer than the opening so that it can bear on the adjoining brickwork by 150mm.

To allow the fire to draw correctly, the lintel must be wide enough to create a gap (throat) of around 100mm between it and the fireback (fig. B). Fit a *throat restrictor*—this will reduce the throat size when necessary for better performance, and even shut it off altogether to reduce draughts when the fire is not in use.

The back and sides of the opening need protection from the heat of the fire. This is usually provided in the UK by a fireback (fig. B); in Canada the opening is lined with firebricks laid in high temperature cement.

Clearances: Even with the thickness of masonry required by the regulations, combustible material (joists, wall-framing timbers, even exterior wall cladding) must be kept clear of the outside of the construction. Clearances vary, but are often around 50mm.

Preparatory work

You are bound to create a lot of disruption and mess during building, so ensure that you clear rooms as much as possible and cover furniture you cannot move.

You could start by cutting holes in the floors and roof to accommodate the chimney; do not forget to allow the necessary clearances. However, if you cannot install a temporary cover over the roof opening, build up to near roof level before cutting it. This will avoid the risk of rain or roofing materials falling on to the working area.

Before you cut away any of the floor or roofing timbers, carry out careful checks by removing floorboards to see which way the joists are running and how they are supported on the adjoining walls. You may have to erect temporary props to take the weight from below while you cut away the timbers and secure them with trimmers.

To cut a hole through to the outside of the roof you need to get into the

6 *Check carefully using a spirit level and straightedge that both recess sides are identical and are correctly aligned with the surrounding walls*

7 *The fireback—which allows the fire to burn without damaging the surrounding masonry—is supplied in two pieces*

A. Below: *If the fire is to burn safely, both the constructional and superimposed hearths must meet minimum building regulations*

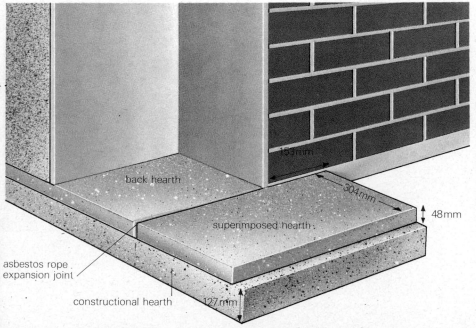

back hearth

153mm

304mm

superimposed hearth

48mm

asbestos rope expansion joint

constructional hearth

127mm

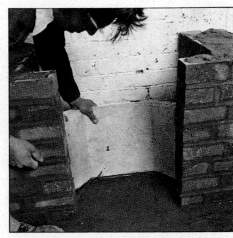

8 *Fit the lower part in position first, bedding it down on a thin layer of vermiculite cement to prevent cracking during expansion*

loft and cut away any roofing felt and battens before removing slates and tiles. If any rafters are in the way of the chimney, you must cut them away and add a false rafter to take the necessary weight.

Constructional hearth

Although it is possible that a solid ground floor will meet the requirements for a constructional hearth, it is more likely not to—and you will certainly have to construct one if you want to build a fireplace in a room with a suspended wooden floor.

Start by carefully marking out the area to be covered by the hearth. Remove the floorboards inside and around the edge of this area, continuing until the two joists on each

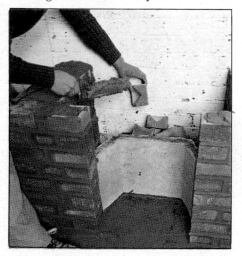

9 Then fill in around the back and sides of the fireback with a combination of bricks, rubble and a weak mortar mix

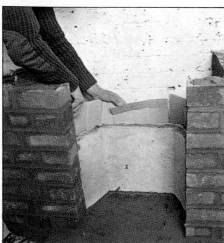

10 Between the fireback and the infill, insert two thicknesses of corrugated cardboard. This allows the fireback to expand safely

side of the proposed hearth are clearly exposed.

The intervening joists must be cut away and replaced by a single wooden trimmer along the front edge of the hearth. Temporarily support them by building up with bricks from the ground to the underside of each joist.

Once you have sawn away the joists and worked them loose from their fixings on the wall, cut a trimmer from wood of the same dimensions long enough to span the gap across the front of the hearth. Skew nail it to the ends of the joist you have sawn through and to the full joists on both sides of the hearth.

To build the hearth, first erect timber formers around the outside of the hole. Fill the base of the box with hardcore and tamp it well down. Make up the rest of the hearth with a concrete mix of one part cement to six of 10mm all-in ballast and level this off with the existing floor. Leave the concrete to set for at least three days before building on top.

Building the recess

If the wall behind the recess is less than 200mm, your first step is to line it with an extra leaf of bricks to make up the required thickness. This should be built hard against the back wall and secured with metal wall ties mortared into the existing joints.

Fix the metal ties in place on the back wall before you start building.

B. Below: *The inside of the recess is lined with a two-piece fireback. Above this, combustible gases are fed through a 100mm throat formed by a specially shaped lintel*

Space them at regular intervals between every third or fourth row of bricks and about 300mm apart. Use a plugging chisel and club hammer to cut slots in the bedding mortar large enough to accommodate the ties. Then mix up fresh mortar and fix each of the ties in position, leaving one end protruding from the wall. Allow the mortar to set for two to three hours.

Build the extra leaf on the back wall to the exact dimensions required by the building plan. As you build upwards, keep each course of bricks on the new leaf in line with those on the back wall so that the ties can be incorporated in the joints. Leave half brick gaps at both ends on every second or third course, so that you can bond in the sides of the recess.

Once the back is complete, build up the sides and then the front according to the dimensions you have decided upon. Bond the sides into the back using the gaps you have left, and tie them into the existing brickwork at the front corners by chopping half brick gaps with a hammer and bolster.

Recess to chimney

The most difficult part of the recess construction is to provide a smooth transition from the wide opening where the fire burns to the narrow flue which carries away smoke and combustible gases. If this part of the chimney—known as the throat—is not built correctly, the fire will not burn efficiently and is likely to smoke.

Although the special lintel will form the front throat angle, this must be matched on the back wall of the recess by building up the rendering to form a mortar flaunching.

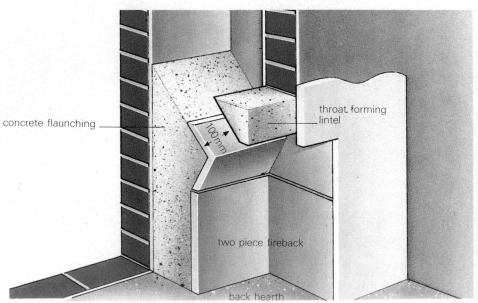

concrete flaunching

100mm

throat forming lintel

two piece fireback

back hearth

11 *Join the two parts of the fire-back with fireclay cement and lay a length of asbestos rope across the top and down the sides*

interlocking concrete flue blocks

chimney stack

joists cut to accommodate chimney and false rafter added

C. Above left: *Interlocking concrete blocks can be used to build the flue*
D. Above: *Holes must be cut through both floors and the roof to accommodate the flue and chimney*

12 *Fit the top half of the fireback into place and then fill around the back and sides with rubble and mortar (see figs 9 and 10)*

Once you have built the sides and front of the recess to the required height, lift the throat forming lintel into position and check the distance between it and the fireback. Allowing for the protruding mortar flaunching, work out exactly where the lintel must be placed to produce the required throat of 100mm. Make a note of the relevant dimensions then lay the lintel to one side until it is needed.

Continue downwards and fit the fireback in position (unless you are simply lining the opening with fire-bricks laid in special mortar). Most manufacturers provide simple instructions specifying how a fireback should be fixed and you should follow these carefully.

Before inserting the fireback, try it for size to get some indication of the amount of mortar render and packing material you will need to place behind it. Then fill in around the back and sides, starting with bricks and mortar if the gap is large.

Just as you approach the correct depth, wrap two thicknesses of corrugated cardboard around the back of both sections of the fireback. This will provide enough room for the fireback to expand without cracking once the fire has been lit. The face of the backing material can be given a thin coating of fire-proof render—consisting of one part cement to four parts vermiculite—to protect it from excessive heat.

Fit the bottom section of the fireback into place first, adjusting the backing material as necessary. Join this to the top section with fireclay cement and try to adjust the position of the top section so that it joins neatly with the bottom edge of the flaunching.

Then form the concrete flaunching at the back of the throat. Start about 300mm above the throat and gradually thicken the render until it is deep enough to form an angle matching that of the lintel.

Once the recess is complete, mortar the lintel in place. Make sure that there is the correct gap of 100mm between it and the flaunching (in which case the front of the lintel should be flush with the chimney breast). Leave the mortar to set for two to three hours before continuing work.

13 *Check the gap between the lintel and the back wall carefully and then build up the flaunching to form a perfectly smooth throat*

14 *Move the throat forming lintel into position next—some types sit on the front of the fireback, others rest on the brickwork*

205

chimney pot

concrete flaunching

top two courses protruding by 30mm

flashing

Bernard Fallon

D. Above: *Position the chimney pot at least 1m above the ridge. The concrete flaunching and the brick oversail help to protect the stack from intruding damp*

Chimney to roof level

The chimney construction starts above throat level, and consists of a flue liner (usually of clay, but sometimes of fire-bricks in Canada) surrounded with brickwork. Each section of flue should be fitted as you progress, and the brick-work built up around it.

The minimum internal flue size in the UK is 185mm for square linings, and 200mm for round linings. This is suit-able for stoves and roomheaters, and for open fires with openings up to 500mm square; larger open fires should have larger flues. In Canada, minimum flue sizes for roomheaters are 150mm for round flues and 200mm for square ones; but open fires must have flues at least 225mm diameter if round, or 200mm × 300mm otherwise.

Start at the top of the throat and fit the first flue section in position. Then construct a brick box, of the required thickness, around this lining. Tie the box into the wall as you progress, either with metal ties or by chopping out bricks from an existing brick wall on every second or third course. To join sections of clay liner together, use fireclay cement or a 1:3 cement/sand mix.

The liner need not touch the chimney brickwork (and in Canada, if the chimney walls are less than 190mm thick, it may not do) but the space could be filled with a 1:4 cement/vermiculite mix to provide additional thermal insulation.

Continue upwards in this way until you reach roof level. Once the chimney is complete as far as the roof, make good the ceilings and floors. Note that floorboards, architraves (mouldings) and so on usually do not count as 'combustible material' for the purposes of the regulations about clearance distances.

Building on the roof

You should not start work on the roof without making sure that proper safety precautions have been observed. A securely tied ladder or scaffold tower as well as a crawler board attached to the ridge are essential pieces of equipment.

Continue the chimney above roof level using the same techniques as you used below. Where the chimney passes through the roof, the slates or tiles need to be carefully replaced and the flashing firmly fixed all around the brickwork).

Finish the brickwork so that the chimney pot can be positioned at the regulation height above roof level. The top two courses should project—or *oversail*—the others by 30mm so that rainwater is thrown clear of the brickwork beneath (fig. D). Alter-natively, you could use a prefabricated concrete capping of the type which incorporates a drip groove as well as an oversail.

Mortar the chimney pot into place next. Cut off the metal flue or top flue block as it appears through the top of the brickwork and fit a pot of the same diameter on top. Surround the base of the pot with a DPC of bitumenous felt and on top of this lay a thick, sloping concrete flaunching (fig. D).

Finishing off

The work is completed by building a superimposed hearth over the top of the constructional hearth. This can either be built in brick to match the chimney or formed in concrete and covered in a mixture of decorative quarry tiles.

Erect formwork around the outside of the hearth and fill this with a weak mortar mix. Before the mortar sets hard, push a length of dust-suppressed asbestos rope between the hearth and the base of the fire recess (fig. A) to allow both to expand without cracking. When the hearth has set point over the rope with fire cement.

Once the grate or stove has been installed, the fire is ready for use. You can leave the chimney breast as it is, or—if you want it to match the recess—build a false breast in brick.

15 *Now build up the superimposed hearth in brick, concrete, or some other non-combustible material in accordance with building regulations*

16 *Push a length of dust-suppressed asbestos rope between the superimposed hearth and the base of the fire recess to allow for expansion*

17 *Fill the bottom of the recess with mortar to form a back hearth. Bring this level with, or just below, the top of the superimposed hearth*

First steps in plastering

Types of plaster ● Essential tools ● Preparing the surface ● Mixing the plaster ● Repairing a damaged section ● Applying the base coat ● Finishing off ● Patching corners

Ray Duns

Above: *Plaster is applied to a wall with a laying-on trowel. When you are spreading plaster, keep the trowel's top edge tilted towards you.*

Plaster can be applied to solid surfaces, such as bare brick, cement rendered brick, building blocks or concrete, and to surfaces to which a key for the plaster—such as metal lathing or wooden slats—is attached. On most solid surfaces two coats of plaster, known as the floating coat or undercoat and the setting or finishing coat, are applied. When lathing is fixed to the surface, an additional first rendering coat is necessary called a pricking up coat.

Plasters
The main constituent of ready-mixed plasters is gypsum, calcium sulphate, which has been partly or wholly dried in a kiln. The extent to which the gypsum has been dried, and the addition of further constituents during manufacture, determine the type and grade of the plaster. However, as water is detrimental to gypsum plasters after they have set, they should not be used for external work.

Gypsum plasters, incidentally, should not be confused with cement render—a surfacing material made from sand, cement and lime and generally used externally. Render looks and feels like bricklaying mortar, which has similar constituents.

Lightweight, pre-mixed gypsum plasters are the most commonly used nowadays, by both professionals and amateurs. They come in several types, each used for a specific purpose.

Browning is a floating coat (undercoat) plaster used on semi-porous surfaces such as bricks, clinker blocks (breeze blocks) and concrete blocks.

Bonding is a floating coat plaster used on less porous surfaces such as poured concrete, where getting good adhesion is difficult.

Finish plaster is used for the thin surface coat that is applied over the undercoat.

Special plasters are also available for stopping and skimming plasterboard.

If in doubt on which undercoat plaster to use, ask the advice of your builder's merchant.

Always store plaster in a dry place. If any water comes into contact with plaster before it is used, the properties of the plaster will be altered. You should use plaster as soon as possible after buying, as the retarder—the

constituent which governs the setting time—grows less effective with time. Plaster is usually date stamped on the bag and, whenever possible, you should use the plaster within six weeks of the date.

Tools for plastering
Most of the tools you need for plastering can be made yourself. They include:

Spot board: This can be a piece of exterior grade ply about 1m² and is used for holding the mixed plaster. A couple of coats of exterior grade polyurethane wood lacquer will help to preserve the wood. The board should be placed on a stand—a wooden crate or sturdy stool will do—at a convenient height from the floor. The board should overhang the stand slightly so that the hawk can be held under the edge when transferring the plaster on to it.

Hawk: A board about 300mm × 300 mm for carrying plaster from the spot board to the work area and for holding the plaster as you work. Professionals use aluminium hawks with moulded-on handles, but you can get by quite comfortably with a home-made one. Cut your square from an offcut of timber or plywood and screw on a handle about 200mm long cut from 50mm × 50mm timber with the edges rounded off.

Laying-on trowel: Used for applying and spreading the plaster. It has a rectangular steel blade about 280mm × 120mm attached to a wooden handle. Some trowels have curved handles

Tip from the trade

Q My cellar wall is of unplastered brickwork, painted over with gloss paint. Can I plaster it, or must it be dry-lined with battens and plasterboard first?

A You can plaster painted walls, provided you first paint them all over with a thick coat of PVA adhesive, applied neat. Then you apply bonding and finish plaster in the usual way. The walls, however, must be dry and the paint adhering firmly, so experiment with a small area before you commit yourself.

which are easier to grip. A trowel of good quality is important as it is hard to obtain a smooth finish with a worn or inferior blade.

Gauging trowel: Available in a variety of sizes and used for repairing areas too small to be worked with the laying-on trowel. It is also useful for mixing small quantities of plaster.

Skimming float: Used for levelling the floating coat. Plastic skimming floats, light in weight and non-warping, are available. But you can make a serviceable float from a smooth, flat, straight-grained piece of wood about 280mm × 120mm × 10mm, with a wooden handle.

Scratcher: To ensure the adhesion of the next coat of plaster, the surface of an undercoat is scratched over. A suitable scratcher can be made by driving a few nails into a piece of wood and then cutting off their heads with a pair of pincers or pliers.

In addition, you will need two buckets—one for mixing the plaster in and one for holding water—a distemper brush and straight-edged rules of various lengths depending on the size and nature of the job. Also required, for chipping off old plaster, are a hammer and a bolster.

Preparing the surface

Before you start, clear the room of furnishings as much as possible, as the plaster dust will fly everywhere and can scratch polished surfaces. Cover what you cannot remove with old dust sheets. Have ready a suitable receptacle for the old plaster.

If the wall behind the plaster is of new brickwork it will need only brushing down and damping with clean water before you start to apply the new plaster.

Concrete wall surfaces require special preparation as their smoothness provides a poor 'key' for plaster and their density gives low suction. Before you plaster, paint the concrete with a PVA adhesive such as Unibond, applied neat.

Mixing the floating coat

When mixing plaster of any type use only water that is fit for drinking. Any impurities in water may be detrimental to the properties of plaster.

Pre-mixed lightweight undercoat for plastering small areas should be mixed a third of a bucket at a time. This is sufficient to cover a patch of about 300mm × 300mm to a depth of about 10mm. If the area to be plastered is larger than this, it is better to mix further amounts later. Pour water into the bucket first, then add the

1 Before you begin to replaster a patch, use a hammer and bolster to cut straight lines round the area. This makes plastering much easier.

2 Scrape some of the mixed plaster from the spot board onto the hawk with the laying-on trowel. Then trim off any excess plaster

3 Hold the laying-on trowel at an angle over the hawk and tilt the hawk slightly in order to snatch up a manageable amount of plaster

4 Hold the trowel against the wall surface, keeping its upper edge tilted backwards at an angle of about 30°. Draw it upwards over the patch

5 Apply further undercoat plaster until the patch is filled in and the new plaster is level with the old surrounding plasterwork

6 Take a straight-edged length of wood that is a little longer than the patch and draw it upwards to make the plaster flush with the edges

7 Use the laying-on trowel to trim away any excess undercoat plaster around the edges of the patch and on the surrounding wall area

Ray Duns

plaster. If the plaster is put in first, it clogs when the water is added and sticks to the bottom of the bucket. Add the plaster, while stirring the mixture with a stick, until a stiff but workable mix is obtained.

Whenever you have finished mixing any plaster, pour it onto the spot board. Then clean the bucket out immediately, or any remaining traces of plaster will set and then be extremely difficult to chip off. Traces of old plaster in the bucket will also speed up the setting time of subsequently mixed coats.

Applying the floating coat

Mix the floating coat plaster and place it on the spot board. Hold the hawk beneath the overhang of the spot board—if you are right-handed hold the hawk in your left hand and vice versa. Use the laying-on trowel to scrape some plaster onto the hawk then trim away any excess (fig. 2). Tilt the hawk and 'snatch up' a small amount of plaster onto the trowel (fig. 3). Keep the trowel horizontal until the edge connects with the wall,

Above: Tools for plastering include (A) home-made scratcher (B) laying-on trowel (C) gauging trowel (D) hawk, and (E) skimming float

8 To make room for the final coat of plaster, run over the surface of the undercoat using the skimming float to flatten and cut it back

9 Draw the straight-edge across the patch once more to check that the undercoat surface is level and lower than the surrounding plaster

10 Run the scratcher lightly across the undercoat surface to form ridges. This keys the surface, ensuring that the finishing plaster adheres

11 Mix up the finishing plaster and apply it to the patch using the laying-on trowel. Use firm pressure and upward strokes

12 As the finishing plaster begins to set, dampen it slightly with the distemper brush. Take care not to use too much water at this point

13 Wet the laying-on trowel and smooth it over the surface in circular movements. Finish off with light, upward strokes

Above: *If a patch has to extend round a corner, nail a thin piece of batten to one side of the corner and plaster up to it*

Above: *When the plaster is dry, remove the batten and pin it to the replastered edge. You are then ready to replaster the other side*

then tilt the outer edge upwards until it is at an angle of about 30° to the wall (fig. 4).

Begin in the centre of the patch and work upwards, exerting slight pressure. Keep the laying-on trowel at an angle, with its upper edge clear of the wall, so that plaster is fed to the wall all the time (fig. 5).

If the patch is 10mm deep or less, fill it until the new plaster is level with the old surrounding plaster. If the patch is more than 10mm deep, do not attempt to fill it in with one coat as this results in the plaster shrinking back from the edges and cracking. Instead, fill the area to half its depth, then use the scratcher to key the plaster with criss-cross lines. Apply a second layer of plaster when the first layer is dry.

Now, take a straight-edged rule a little longer than the patch and, working from the bottom upwards, draw the rule from side to side over the plaster to make it flush with the edges (fig. 6). Fill in any hollows with more plaster and draw the rule over the surface again.

To make room for the finishing coat, the plaster in the floating coat must now be cut back to a depth of 2mm lower than the surrounding plaster. First, flatten and cut back the floating coat with the skimming float (fig. 8). Next, run the scratcher over the surface of the floating coat to provide a key for the finishing coat (fig. 10). Then, go over the plaster with the skimming float again to flatten the

burrs left by the scratcher. The scratch marks should remain but their edges should not protrude too far.

Clean the surrounding wall area to remove any adhering plaster and leave the floating coat to set. Ready-mixed plasters take between 1½ and 3 hours to set.

Before mixing your finishing coat, clean all tools and the spot board.

Mixing the finishing coat

Lightweight finishing plasters are applied thinly so they can always be mixed in a bucket. Pour water into the bucket until it is about a quarter full. Slowly pour in the plaster until it appears above the water and stir with a stick. Once the plaster has settled, add more and keep stirring until the paste reaches the consistency of thick cream. Then pour it onto the spot board.

Applying the finishing coat

Lightweight finishing coat plaster dries very quickly. So until you are experienced, mix and apply only enough to cover a small area at a time. Scrape some plaster from the spot board to the hawk and lift a small amount with the laying-on trowel. Use firm pressure to apply the plaster, using upward strokes as much as possible (fig. 11).

When the finishing coat is level with the existing plaster at the edges, draw the straight-edge over it until it is flush, filling in any hollows. As the plaster begins to set, dampen it with the distemper brush (fig. 12) to keep it

workable while you trowel it smooth. Do not use too much water as this can kill the gypsum plaster in the surface and cause crazing. Wet the laying-on trowel and, keeping it as nearly flat as possible, run it over the surface in circular movements, finishing off with light upward strokes (fig. 13). If you do not achieve a smooth, flat surface at the first attempt, dampen the surface and try again.

Patching corners

If a patch extends around an external corner, nail a batten with a smooth, straight edge to one side of the corner so that its edge is level with the existing plaster on the other side. Plaster up to the corner so that the new plaster is flush with the edge of the batten.

Tip from the trade

Q My newly-applied plaster keeps cracking, I think because the old, porous plaster is drawing the water out of it. Is there a remedy?

A Yes. Mix one part of PVA adhesive with four parts of water. Paint it onto the exposed brickwork and thoroughly soak the edges of the existing plaster. You should hear a 'fizzing' noise as the plaster soaks up the mixture; if not, the mixture is too rich. Apart from forming a water barrier, this treatment helps stiffen the old plaster.

Tip from the trade

Q After every plastering job, I seem to finish with half a bag left over. Must it be thrown away?

A No. On its own, it will become unusable within days of being opened. But if you mix it with a proprietary cellulose filler (such as Polyfilla) you can use it for filling holes in plaster up to about 150mm across and 12mm deep. Use three parts of plaster to one of filler, and add water to make a fairly stiff mix. Unlike the cellulose filler, it will not 'slump' out of the hole. Kept dry, plaster for this purpose will keep for about six months.

Using plasterboard

- **The practical alternative to plastering for a really professional wall finish** ● **Types of plasterboard** ● **Drylining a timber-framed wall** ● **Problems to avoid** ● **Lining exposed rafters**

Drylining means cladding a wall or ceiling with a prefabricated building board called plasterboard (wallboard or drywall) which consists of a layer of aerated gypsum plaster sandwiched between two sheets of heavy-duty paper. Plasterboard comes in several different forms suitable for a variety of cladding tasks, and is used in many forms of modern building and renovation in place of plastered finishes.

Plasterboard is quickly and easily fixed into place and, when properly jointed and finished, equals the smooth and appealing looks of a plastered finish. By comparison, plastering requires considerable practice and skill, and is probably the most difficult of the trade skills the handyman is ever likely to attempt.

A further significant advantage of

drylining walls is that almost no drying-out time is necessary—which means you can decorate almost as soon as jointing is complete.

Plasterboard types

Plasterboard is available in different forms, the most common being *wall-board*, a general-purpose gypsum plasterboard suitable for building partitions and for drylining walls and ceilings. It is suitable only for internal use and in situations that are not subjected to continuously damp or humid conditions—such as a badly-ventilated bathroom or washroom.

Wallboard is manufactured with three different types of long edge (fig. A). *Tapered-edged board* leaves a small recess at the contact region of two boards; this is filled and smoothed

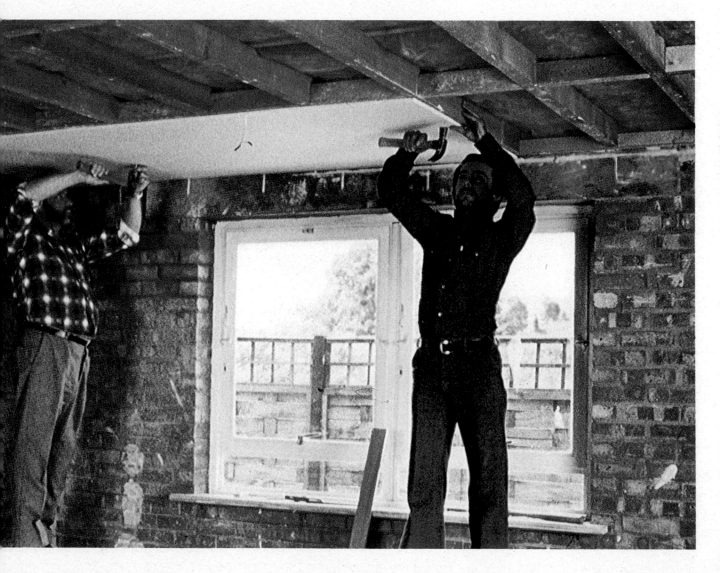

Below: *Drylining with plasterboard easily and quickly transforms the appearance of a room. However, you will need assistance in handling the plasterboard to prevent its damage, especially when cladding a ceiling*

tapered edge

square edge

bevelled edge

A. *Plasterboard used for walling is manufactured with a choice of three types of long edge. The tapered form is best for drylining*

for a seamless joint which then needs only light decoration or painting for final finishing. *Square-edged board* for cover strip jointing, and *bevelled-edge board* which is V-jointed, are normally used when it is almost certain that wallpapering is to be used for decoration. The surface is primed before wallpapering.

The taper is, in fact, very slight and hardly noticeable. This makes tapered-edge board suitable for general purpose use even when the plasterboard construction employs exposed butt-joints, such as at corners.

Wallboard for drylining has an ivory-coloured surface on one side, and this requires the minimum amount of preparation for most forms of decoration. The reverse side, normally mounted inwards against the wall, is grey. Mounted outwards, this surface is used when a skim coat of finish plaster is to be used for decoration, a typical situation being to match an unusual plasterwork pattern in the remainder of the room. Light designs can be moulded or brushed in relief on the skim coat while this is still in the plastic state.

Wallboard is usually available in sheet widths of 600mm and 1200mm, thicknesses of 9.5mm or 12.7mm, and lengths normally between 1800mm and 3000mm. You may have to place a special order for the larger board sizes.

Insulating wallboard is the first of several variations on the standard board and differs only in having a veneer of aluminium foil on one surface, which is mounted towards the cavity to reduce both cold penetration and room heat loss. A far superior form is *thermal wallboard* consisting of standard plasterboard bonded to a backing of expanded polystyrene,

available with or without a vapour check paper membrane sandwiched between the two, and in various thicknesses. It is used to line external walls and roofs where thermal insulation is the main requirement of lining. It has one distinct advantage over the others in that it can be fixed directly (without support) to a flat wall, a much-employed method of providing low-cost insulation to a masonry wall.

A useful board for drylining external walls and roofspace ceilings is *vapour check wallboard* which consists of standard plasterboard with a backing of polyethylene film.

Although standard plasterboard has good fire safety characteristics, some situations call for better fire resistance. A special wallboard, consisting of a core of aerated gypsum plaster incorporating glass fibre and vermiculite is available for such cases.

Two other types of board can be useful for some work: *plank* and *baseboard* (or *lath*). Plank simply describes an especially thick form of plasterboard (19mm). Because of its thickness, plank is especially useful in certain laminated partition systems.

Baseboard is, as suggested by its name and its two grey surfaces, designed specifically as a base for further plastering. Lath is a thin-width form of baseboard (406mm compared to 914mm). Tapered-edge wallboard and thermal insulating wallboard are considered adequate for most do-it-yourself work, and you may have difficulty in obtaining other than these from your local supplier.

Drylining with timber battening
There are several methods of drylining a wall with plasterboard. Wallboard is normally mounted onto some form of timber framework—for example, the studs of a timber-framed wall (see pages

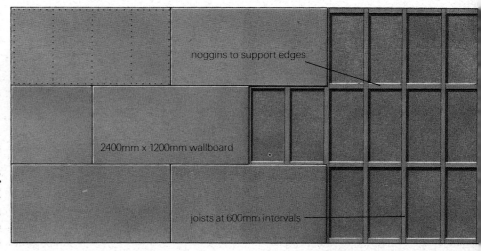

noggins to support edges

2400mm x 1200mm wallboard

joists at 600mm intervals

B. *Wallboard can be laid horizontally in a brick-bond pattern, frequently adopted for lining ceilings also. All edges must be properly supported*

C. *A typical arrangement for timber battens is shown below. This takes into consideration full board widths and the presence of a window*

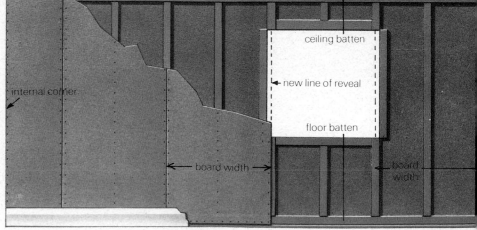

internal corner

board width

ceiling batten

new line of reveal

floor batten

board width

93 to 199). On masonry walls timber battens can be used; an alternative, covered later, is metal furring or a system of support pads.

Timber battening is the most popular method with the home handyman on account of its relatively low cost, but alignment problems caused by skewing framework can be a particular problem unless special care is taken when dealing with walls which are of less than perfect trueness. Good quality, properly seasoned timber must be used, in conjunction with sound, dry walls.

A typical arrangement is shown in figure C. For old walls, start work by stripping all the old plaster from the walls unless this is perfectly sound. Remove all surface fixtures, marking the nearby wall or ceiling with their position so they can be replaced after the drylining.

Concealed pipework and electrical cables or conduits must be arranged before framework is fixed, with chasing of the wall if the cavity depth is insufficient. Bear in mind the total thickness of the wallboard and timber battening when accounting for new fixtures and wiring lengths.

Carefully plan out the framework arrangement that best suits the room features, bearing in mind that the wallboard sheets you use have to be supported at centres not exceeding 450mm (9.5mm board) or 600mm (for 12.7mm board). Wallboard is usually fixed vertically, and the board width must correspond with the spacing of the vertical support framework while at the same time observing these recommended maximums. Plan on starting work from one particular end of the wall in order to transverse the wall in complete sheet widths, if necessary ending with a cut edge which can be disguised by the butt joint of an internal corner.

Timber battening—good quality 50 mm × 25mm must be used for wall drylining—spaced at 600mm centres vertically (as shown in fig. C) would be sufficient for 12.7mm wallboard. Provide additional supports around window and door frames.

Heavy items like sinks and cupboards must be mounted through the drylining and fixed securely to some form of inlaid timber support. If the fixing centres for these cannot be arranged to co-incide with the drylining support framework, you must consider providing further noggins and struts.

Methods of construction around corners and frames (see below) may also influence the precise framework de-

1 To dryline a wall first mark the batten positions on the wall and check these one by one to determine the high spot of the wall

2 Start constructing the support battening by fixing the floor batten a little above floor level, flush to the high point guide line

sign, and should be borne in mind.

You will find that a sketch of your proposed design will be very useful in subsequent stages.

Setting out
Very few walls are truly even, and to lay battening on these without further ado is asking for trouble when it comes to fixing plasterboard on top.

Setting out is the procedure for making corrections to the effective lie of the wall so that one common level is adopted across the whole area, regardless of all the minor imperfections that may or may not exist beneath what is then taken to be the high point of the wall.

Start by marking the wall at points which by plans and measurement corresponds with the board widths you have chosen to use. Also mark the positions of intermediate battening and any other support timbers you have included as part of the overall framework. If these are door or window openings, work from these.

The next stage is slightly tricky in that you have to find the high point of the wall. This is perhaps easiest done by running a suitable straightedge vertically along the length of the wall. Use a spirit level to keep this straightedge in true plumb, noting at what points—and by how much—protrusions force the straightedge away from the wall. Make sure to cover all the areas where battens are to be fixed.

When you have established the high point, mark the corresponding positions at ceiling and floor. Substitute a particularly straight length of battening for the straightedge you have

used and, keeping it perfectly plumb with the help of a spirit level, mark the ceiling and floor again to establish the face plane of this and all other battening of the framework.

Individually transfer these reference marks to all other batten positions by using careful measurement and ruling.

Making the frame
Start making the frame by fixing a floor batten along the length of the wall, about 25mm above floor level. Use plugs and screws for fixing the batten at 600mm centres, ensuring at all times that its facing surface is quite true to the setting out marks. Use wood packing where necessary (fig. 2).

Then fix the ceiling batten in a similar fashion, checking that it, too, is true with the setting out marks of the high point batten, and also that its face is in perfect alignment with the batten near the floor (fig. 3).

The two horizontal battens are then used for correct alignment checks on all the vertical battens as these are individually fixed, with support padding being provided where necessary. The physical appearance of the framework is not important, but do pay particular attention to see that the facing surface is straight and true.

Adopt the same procedures if further support timbers are to be added. Later, when fixing short board lengths or widths, it may become necessary to add noggins or struts at points where the cut sheet edges do not co-incide with the main components of the support frame. All edges must be supported, and fixed, to prevent local-

3 Then fix the ceiling batten. Use wood packing to take up any small gaps that may occur at odd points behind the timber

4 Check that the top and bottom battens are perfectly true. (If a ceiling is to be lined, note that this is done before drylining the walls)

5 Fix the vertical battens at the positions marked, packing out where necessary so the framework remains flush with the high spot

6 Check each vertical batten is plumb before proceeding to the next. Keep a stout section of timber aside specifically for this job

7 The completed timber batten frame must be perfectly true before the plasterboard is fixed in place

8 Narrow widths of plasterboard should be reserved for use at window reveals, and fitted in place before the facing boards

ized weak spots which may lead to board fracture, holes or edge chipping. Plasterboard continued into the reveal, soffit and head of a window must be supported also.

Board fixing

If you have planned to use wallboards in the normal, vertical mode, buy sheets the length of which either just exceeds the wall height, or that are between a third and two-thirds longer again than your wall height. In this way, wastage is minimized: the near-size board can be trimmed to size and the waste simply discarded; the over-long boards will still yield easily usable offcuts.

Trim the sheets at their base, about 25mm shorter than the full floor to

9 Fix the plasterboard to the battens, cutting holes for outlets and fixtures where these are encountered

10 Use a whole width of board to mask any board you have had to cut for an internal corner. However, a rough cut can be masked by jointing

214

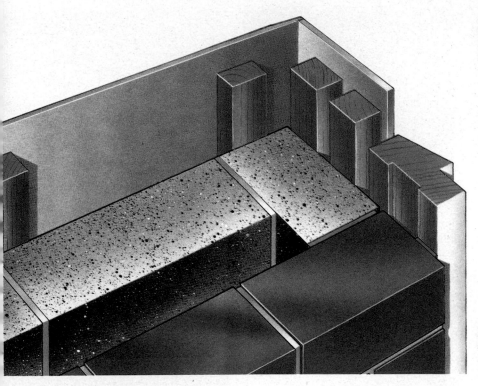

D. *Detail of timber battening arrangement to employ at window or door reveal. The main board 'faces' the narrow width used to line the reveal*

11 *If you choose to saw plasterboard, use a fine-toothed saw and cut the board through its reverse side so burring on the face side can be sanded*

12 *If you are drylining a ceiling—a job done before lining a wall—reduce the strain of working by fixing up a suitable work platform*

ceiling height of the wall—the gap will be concealed by skirting. Use a fine-bladed handsaw or, much easier, a handyman's knife for the job; with the latter, score the ivory side, break the board over a suitable straight-edge, then finally cut through the backing paper on the reverse side. Use a combination of bradawl and pad-saw to make the necessary apertures for switches, sockets, through pipes and other fittings at this stage. Smooth the frayed paper edges with fine sandpaper.

Carefully edge the first sheet into position—ivory side outwards—at the starting point at one end of the wall. Use a foot-lift to raise the board hard against the ceiling while you push the sheet carefully but firmly home against the first part of the framework so preventing a loose, uneven fixing. Using assistance if you have it, maintain this position while the board is fixed to the support battening.

Use 30mm or 40mm galvanized or sherardized plasterboard nails at approximately 150mm centres, no less than 12mm from the board edges, to fix the sheet into place at all support points. Start at the middle and work radially outwards. In order to simplify later 'nail spotting', drive the nail heads down as far as possible without fracturing the bonding paper.

A special drywall hammer for nailing plasterboard nails can be purchased. The rounded head of this does not break the paper but drives the nail below the surrounding level while at the same time forming a checkered pattern which acts as a key for the minute amount of plaster or filler used to conceal the nail during spotting. A ball-pein hammer can be just as effective if used with care.

Offer up the next sheet in a similar manner, lightly butting this against the fixed wallboard. Avoid tight butting—leaving a 3mm gap between adjacent boards—as forcing a board into place results in bowing which may in turn lead to misalignment and unsatisfactory fixing.

Continue fixing this and other sheets in order until you come to the frame of a doorway or window—or any other obstruction which requires the board to be cut to something other than length. With planning, it is possible to arrange for the untrimmed board edge to form the new line of the reveal of the window (fig. C), but trimming is likely, if only for the sill.

Plasterboard for the reveals—cut perhaps from short-length offcuts—should protrude to a point level with the battening face so that the edge of the adjoining wallboard can be trimmed to face this off (fig. 8). As this trimming is better done from direct measurement of an existing arrangement (and not from sketched plans unless these—and the work—are accurate), finish the wallboarding of the window and door reveals before you cut the main sheets to fit the window or door frame area.

At the later finishing stage, the joint areas are bound with tape and concealed prior to decoration. This aspect is covered in the next plasterboard section.

Lining a ceiling

Wallboard can also be used in a variety of ways to clad a ceiling, often to repair a section of lath and plaster which has been damaged. However, it can only be fixed directly to joists if these are perfectly true and level. In many cases, it is easier to remove the

13 Insert cross noggins at the proper separations so that all edges are supported when the boards are fixed in place

14 Additional noggins should be provided for fixtures such as light fittings. Wiring connections must be made now

15 Mark the positions of the joists and cross noggins so that boards can be nailed accurately and neatly in place

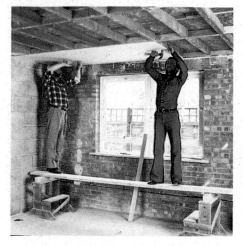

16 Place the first board in position at one corner of the room with the papered edges at right-angles to the joists

17 Nail at 150mm centres, using 60mm galvanized nails, five nails to each width. Start at the board centre and work outwards

18 The long edge of the next board is lightly butted to the fixed board. Note that a cut board is used so ends are staggered

entire damaged ceiling in order to expose the joists or rafters rather than attempt a patch.

Wallboard (or thermal insulating board) is easily mounted if sheet sizes can be arranged to match ceiling joists. But edges, cut or otherwise, must always be supported and this means providing cross noggins to complete the framework (fig. 13).

The joist separation and the best pattern of laying the wallboard across the ceiling are two important factors to consider when choosing the most suitable size and thickness of board. You cannot use 9.5mm board if the joists are further apart than 450mm, or 12.7mm board if the separation exceeds 600mm, unless you install many additional cross noggins to reduce the effective fixing centres to within these limits.

When you have established a suitable framework, based on laying sheets in 'brick bond' pattern (fig. B), mark the position of the joists to aid subsequent nailing of the boards to them. It is important that the boards are fixed in this staggered pattern to reduce the strain along a line of joints.

Board is then laid, ivory face down, with the papered-covered long edge at right-angles to the joist and supported by the cross noggins (fig. 16). You will need assistance—or the aid of a *lazy man*—ceiling prop—to support the board while it is being fixed into correct position.

Use 40mm plasterboard nails and work from the middle outwards, nailing at 150mm spacings along the joist and noggin supports. Use previously-made wall marks—and later, the visible lines of nails—to guide you. Force

the heads below surface to simplify nail spotting later.

The second and subsequent sheets should be lightly butted together, if possible leaving a very slight gap. Where necessary, cut the board to shape and length as you would normally, making sure the ends are staggered and that they co-incide with a joist or cross noggin.

For widely separated joints (up to 750mm) plasterboard plank can be used. At least five 60mm plasterboard nails must be used across the width of the board at every support to ensure adequate fixing.

But if the joists are not level and true, you have to consider using alternative fixing forms (which in effect create a form of suspended ceiling), or resort to the traditional methods of lath and plastering.

More uses of plasterboard

Left: Thermal board is plasterboard which has a backing of expanded polystyrene. It can be used instead of standard plasterboard in all normal applications as well as to line walls that need some form of thermal insulation. A further advantage is that it can be mounted directly— without support battening—on walls that are sound and level

1 *To fix thermal board lining first clean off the wall and then apply special adhesive such as (Gyproc 863) using a plasterer's trowel*

● **Drylining with thermal board for low cost wall insulation** ● **Applying adhesive to the wall** ● **The procedure for jointing gaps** ● **Dealing with cut edges and corners** ● **Finishing off and decorating**

Drylining with plasterboard (wallboard) is a relatively low-cost method of getting top-quality walling, and for most applications it is not a difficult task to construct a suitable timber framework (see pages 211 to 216). But in certain instances it may be possible to dispense with even this.

Drylining with thermal board
With its backing layer of expanded polystyrene, thermal board is particularly useful for drylining 'cold' external walls and for improving the thermal and acoustic insulation of internal walls. With minor variations in the actual methods of fixing

employed, it can be used as an alternative to standard wallboard and can be mounted in the same ways.

But when the thermal board is used specifically for its insulating qualities, on walls that have already been properly finished, there is often no need to go to the elaborate lengths of providing a support system. Instead, a special adhesive (Gyproc 863) can be applied directly to the wall and the boards are pushed firmly against this while secondary fixing takes place.

Obviously this method can be used only on smooth-faced concrete, masonry or plastered walls which are dry and perfectly level.

Start the preparations by removing any skirting boards (baseboards) marking fixing positions on the floor adjacent. Any wall fittings that are removed and which have to be replaced—may have to have their fixings relocated to accommodate the additional depth of the cladding. For example, the fixing boxes for electrical switches and sockets will have to be removed and then reset only partly into their wall recesses. To avoid cumulative errors, mark and cut the corresponding apertures in the thermal wallboard just prior to fitting the relevant section on the wall.

Suitable apertures can also be cut for heavy fittings such as a cistern or sink. If these are removed, they must be remounted on the support wall in a way that does not strain the plasterboard cladding or the wall itself.

If at this stage, it looks as if the window sills will need replacing, remove these now. However, it may be

possible to plane the edges square and then extend them by gluing and screwing on new fillets of timber so that they satisfactorily overhang the new wall depth.

When you have dealt with the fittings, remove old wallpaper and other surface decorations. Old paintwork need not be removed, but it is a good idea to scour this with coarse sandpaper or a wire brush, so that you provide a good key for the adhesive. Run over the whole wall with a damp cloth afterwards to remove dust and grime to improve adhesion.

wards by the skirting (baseboard).

The adhesive is then applied to the wall, enough for one board at a time. Take the first of the marked 1200mm centres as a guide to where the edge of the board will be fixed and trowel on adhesive 50mm inside this line. Use a notched applicator—which you could make from an offcut of hardboard or plastics—to spread the adhesive in a band some 200mm wide for the complete vertical length of the board. Then apply adhesive along the opposite vertical, again 50mm inside the marked line. The last vertical band

of adhesive should be applied along the intermediate line, approximately half way between the two edge bands. Finally, apply adhesive to the horizontal gaps at the top and bottom

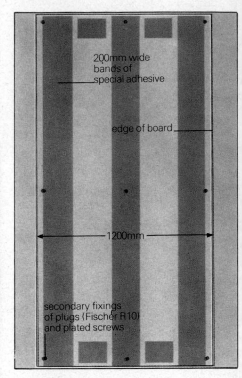

200mm wide bands of special adhesive

edge of board

1200mm

secondary fixings of plugs (Fischer R10) and plated screws

A. *The special adhesive for thermal board lining must be applied in 200mm wide bands in the pattern shown, covering an area sufficient for just one board at a time. Push the board firmly against the adhesive and make secondary fixings*

2 *Apply three vertical bands, each about 200mm wide, within the space of one board width and no closer than 50mm to the edges*

3 *Then apply adhesive at the top and bottom between the vertical bands to complete the all-over adhesive pattern shown in fig. A*

Fixing thermal board

Thermal board is available in widths of 1200mm and, as is usual for walls, the boards are fixed vertically. The next stage is therefore to mark up the wall, bearing in mind the measurement of the boards.

Start the marking out procedure from a suitable wall or door and arrange for a cut edge to coincide with an internal corner (see construction details page 212). Allow the thickness of the board plus 2mm (for the layer of adhesive) when determining a new window reveal's measurements.

Mark the wall at 1200mm intervals and at intermediate positions half way between.

You can then cut the board lengths (2400mm to 2700mm) to the correct height. Use a fine-blade saw and cut the board with the plaster surface uppermost. Arrange to have the cut end nearest the floor so that any irregularities can be concealed after-

4 *Use a notched applicator to comb out the adhesive and provide a good key for the thermal board lining*

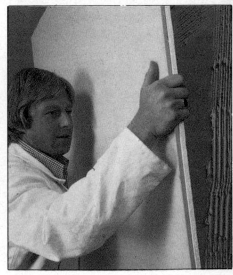

5 *Place the thermal board in position and tamp it into the adhesive firmly, ensuring the edges are plumb and true*

6 *A secondary fixing is used to help maintain the fixing in the event of fire. Drill holes for the plugs and plated screws*

7 *Immediately fix the thermal board using the plugs and screws; assistance is helpful at this stage*

8 *Having secured the board, apply adhesive for the next board and fix this in place. Cut holes for services and fixtures as you go*

9 *At external corners, cut back the layer of polystyrene of the facing board by the thickness of the plasterboard (see fig. C)*

10 *Then align the facing board edge with the edge of the fixed board (typically a window reveal) to form a perfect corner*

to complete coverage (fig. A).

To fix the first board, push it hard against the adhesive and check that the vertical edges are plumb. If necessary, use a foot lift or packing board to keep the board tight against the ceiling while the secondary fixings are made. This job must be done immediately, and you may find assistance useful at this stage.

Drill holes to coincide with the top, middle and bottom of each of the vertical adhesive bands (fig. A). Use suitable plated screws and Fischentype plugs to fix the board to the walls

at these nine points, allowing for at least a 25mm wall penetration to be sure of a strong enough fixing. (On a timber stud wall, drive suitable screws directly into the studs.)

Then, without breaking the surface, screw in the heads to form a slight recess at the fixing point. These

Apply adhesive to the wall for the next board. Lightly butt this against the fixed board when you position it, but ease off slightly to leave a 2–3mm gap. Use plugs and screws to fix the board in place as before, then repeat the fixing sequence for the remaining

boards, cutting holes and trimming to shape only as you come to each individual board.

To complete a wall, you will probably have to line a window or door reveal. Adopting the construction method shown in fig. C, remove the polystyrene backing carefully when you come to deal with the butt joint at external corners. Adhesive alone is normally enough to fix thin strips of thermal board used in this way but use screw fixings as well if you are in any kind of doubt.

Filling plasterboard joints

If you are using plasterboard (in any of its forms) as a substitute for traditional plasterwork, the nearest you will get to the difficult skill of plastering is the process of jointing, whereby you conceal the tell-tale gaps between boards. But you must take extra care over this job if the plasterboard is going to be decorated only with a paint finish.

Plasterboard jointing entails using special paper jointing tape, a cement-like filler and finishing compound. Specially reinforced tape is used for external corners.

You will need to make, buy or hire a 200mm rigid-blade applicator and a narrow 50mm decorator's knife for taping, although a paint scraper of similar appearance is nearly as efficient. An essential item is a purpose-made *jointing sponge*, a circular plastics foam sponge mounted on a wooden handle. This tool is used in various stages of jointing to remove excess material, 'feather' edges and to yield a

smooth surface finish. All these materials and accessories can be obtained through your builders' merchants.

The edge profile of the boards to a certain extent influences the jointing procedure. Bevelled edge joints are close-butted to produce a characteristic V-joint which can be filled with only a finger-smear of joint finish (fig. B). With square-edged—best used when the plasterboard is to be skimmed with plaster or covered with wallpaper—the joints can simply be taped. Use anaglypta or similar paper strips along with a suitable adhesive.

However, the process of jointing plasterboard is normally associated with tapered-edge board, and here it is possible to get really smooth joints that are virtually seamless.

Before you begin jointing, complete all fixings and remove all surface dirt and dust in the joint area. Mix up a little *joint filler* according to the directions on the packet.

Sprinkle the powder into water as you mix and aim for a thick, creamy consistency (typically obtained by adding 3kg powder to 1.5 litres of cold water). The mix has a working life of about half an hour, so mix only as much as you think you may need to avoid waste. Do not use filler which has started to set, and make a point of cleaning your mixing utensils before preparing a fresh batch of material to prevent soiling.

Use the special applicator to apply a continuous band of the filler along the tapered recess where two boards join (fig. 11). If large gaps have inadver-

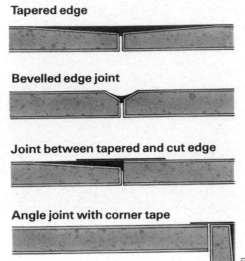

Tapered edge

Bevelled edge joint

Joint between tapered and cut edge

Angle joint with corner tape

Bernard Fallon

B. *Joint filler and finish is used to bring the gap between board edges flush with the surface of the plasterboard, except in the case of a bevelled edge finger-wiped joint*

tently formed during the cladding operation, these should be partially filled beforehand making sure that the filler is rammed well home.

Cut the required length of *jointing tape* and use a taping knife (or equivalent) to push this into the band of filler—which acts as a bedding compound—so that it straddles it and acts

as a reinforcing membrane. Make sure that there is sufficient filler beneath the tape to ensure good adhesion and avoid trapping bubbles as these may cause cracking and blistering later.

As soon as the tape is correctly in place, apply a second layer of filler to the full depth of the tapered recess so that the filling compound can be levelled at the shoulder of the taper by the scraping action of the applicator (fig. 13). Before the filler has a chance to set, moisten the jointing sponge and use this to wipe surplus material away from the edges of the joint band, taking care not to furrow or mark the remaining filler.

Rinse the sponge frequently during cleaning off stages, and clean the sponge well when you have completed the job. If you accidentally damage the filler layer, let this dry off and then apply an additional dressing layer.

If, during the course of drying, the filling subsides to a depression along parts of the joint, this indicates that the filler is over-diluted or that you have left insufficient drying time between coats. This can be easily corrected in the future, and depressions can quickly be levelled with a further coat of filling compound.

After about an hour, when the filler has set, proceed by applying a layer of *joint finish* over the whole joint area. Mix this according to the instructions so that you get a consistency similar to that of thick cream (typically, by mixing 5kg powder to 2 litres of water). During subsequent evaporation, this consistency can be

11 *Joint and angle treatment begins with filling the gap region—normally of two tapered edges—with joint filler*

12 *Cut off a suitable length of jointing tape and press this into the layer of joint filler you have just applied*

13 *Follow immediately with another coat of joint filler to bring the taper level with the face of the plasterboard*

restored by again adding water, although the mix should really not be kept overnight.

Use the taping knife to remove odd tails of material that may have dried proud of the surface and joint area.

Use the applicator to apply a thin layer of the finishing compound, about 200mm in width (fig. 14), then immediately 'feather' the edges using a slightly dampened jointing sponge. Let this first coat of finish dry completely and then apply a second in a band about 250mm wide, taking special care over feathering the edges.

14 Wait an hour or so for the filler to set and apply a thin layer of joint finish over the whole area of the joint

Dealing with edges and corners

Straight plasterboard joints are easily mastered but you may experience a little more difficulty when jointing cut edges and corners.

Cut edges should ideally occur only at internal angles, but they do sometimes occur between two boards in the middle of a flat piece of wall. Start by abrading the edges lightly to remove paper burrs. Next brush on PVA emulsion sealer to reduce the suction effect of the exposed plaster.

Next fill the joint, taking care to force the filler right back to the frame. When this is dry follow with a thin layer of finishing compound (not filler) and bed the joint tape in this. Finally apply two layers of finish, allowing for drying, and carefully feather the edges to a smooth finish.

Internal angles (fig. C) are often the meeting point for cut edges, one of which will be concealed by the butt join. In this case, start by packing the gap between the two boards with joint filler, then apply a thin layer of joint finish to each side of the join. Cut a suitable length of jointing tape and push this tightly into the corner, folding it as you go and using the applicator or a brush to force out trapped air bubbles.

After this, immediately apply a thin layer of joint finish—to a width of about 75mm on each side of the joint—and use a dampened jointing sponge to smooth the edges. Allow this coat to dry fully before applying the final coat, which should cover a band of 100mm on each side of the join.

External corners (fig. B) need a slightly different approach, using special corner tape with metal reinforcing strips along the edges. Start by using PVA sealer to dress exposed cut edges and to reduce the suction effect of the dry plaster.

Cut the tape to the correct length and crease it along its centre line, then apply a 50mm wide band of joint filler to each side of the corner and press the tape firmly into position carefully checking to see that the external corner edge forms a perfectly straight line.

Straightaway apply a broad band of joint filler—about 125mm—over both sides of the corner, feathering the edges with dampened jointing sponge. When the filler has set, apply a slightly wider band of finishing compound, again feathering the edges. When this is dry, apply a final coat of joint finish, about 200mm wide, on each side of the corner.

For maximum protection of corners it is advisable to use special, angled beading made of perforated galvanized steel.

Use 50mm bands of filler on each side of the corner to bed the angled beading, removing any material which oozes through the perforations when the strip is pushed home firmly. To prevent movement, permanently anchor the beading with two nails poked between the joint gap.

When this fixing coat has set, apply another coat of filler on each side of the corner, using the applicator and the feathering sponge to produce a

15 Feather the edges using a dampened plastering sponge and leave the finish to dry completely, then repeat

16 Nail heads can then be filled, or 'spotted', in two thin coats, the first of filler, the second of finish

17 The small gap between the top of the plasterboard and the ceiling can be hidden behind matching coving

reasonably fine corner. Leave the quarter-round metal bead at the extreme corner exposed to provide a resistant corner edge.

Finishing off and decorating

Nail and screw 'spotting' is carried out while the main joints are setting or between stages. The depressions are filled flush with the board surface with two thin coats, the first of filler, the second of finish.

When final coat of joint finish has dried, the uneven surface textures can be corrected by covering the whole wall with a thin slurry of joint finish—a mixture prepared by adding approximately 2.5kg powder to 2 litres of water.

You can use the jointing sponge for applying and smoothing out the slurry, working in a continuous circular motion.

Matched pre-formed plasterboard coving can be used to conceal the small gap between the walls and a plastered ceiling. Corners which remain exposed should be treated in the same way as internal wall corners, but first apply a narrow strip of PVA sealer along the contact area to prevent suction by the dry plaster. Care should be taken when fitting covings to give a neat finish.

To finish the plasterboard wall at floor level replace the old skirting or fit boards using the previously marked fixing points.

When the jointing and the top-coat of slurry have dried, proceed immediately to decorate the wall using

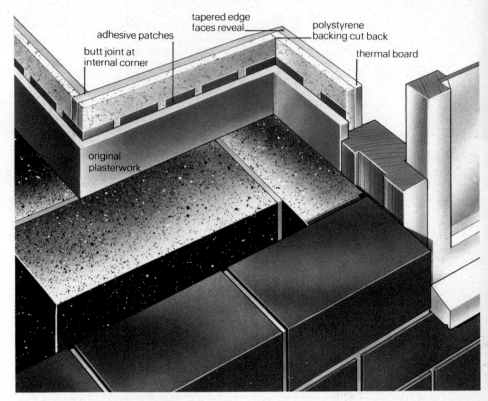

only products specifically recommended for plasterboard. If you are papering the wall a special primer must be used if the paper is to be removed at a later date without damaging the plasterboard surface.

If you are painting, an initial coat of the same primer helps you obtain a more uniform paint finish over the different surfaces and reduces absorption by the plaster.

C. Detail of external and internal angle treatment showing how thermal board is trimmed. Boards in the window reveals are fitted first and then faced by the wall board. Corners are reinforced with tape or metal beading during jointing

Below: *Plasterboard used for walls and ceilings can match the appearance of traditional plasterwork*

18 *Remember to allow for corner mitres when estimating and then cutting coving to the necessary length.*

19 *The plasterboard surface must be treated with a slurry coat of joint finish so the entire surface matches.*

British Gypsum Ltd

HOME REPAIRS AND RENOVATIONS

Fixing floorboards

Floorboard repairs are straightforward and require few special tools. But repairs are essential for safety and for preserving the good condition of the joists beneath, and the floor covering above the boards

Although solid and hardwearing, floorboard timbers are prone to all sorts of minor faults and irritations. For instance, creaks under the carpet are annoying but not dangerous; rotten boards which collapse underfoot can be dangerous as well as annoying. Even if your floorboarding is in perfect condition, it may still need work to improve draughtproofing—or to get to wiring underneath.

Types of floorboard

Most floorboards are made of softwood, usually pine. In a single-skin floor as used in Britain, the boards are fixed at right-angles to the joists which support them, and may be nailed or screwed in

place. The board ends are arranged to coincide with the joists, so that the join lies over the centre of the joist, for maximum support. In a double-skin floor as used in North America, the sub-floor is usually of plywood or wafer board, but the main floorboards are still at right angles to the joists.

Floorboards fall into two basic types: square-edged, and tongue-and-grooved (fig. D). Tongued-and-grooved (T&G) boards and their derivatives are designed to eliminate draughty gaps but are more difficult to take up than their square-edged counterparts.

If you are in any doubt which of the two types is used for your flooring, choose two boards with a slight gap between them and slide a knife blade in

as far as possible—compacted grime or draughtproofing in the gap may have to be scratched out first. If the blade is stopped, the boards are either tongued or rebated.

Lifting square-edged boards

For your starting point, choose the most convenient free end of the board you wish to lift. If the board extends right across the room and under the skirting (baseboard) on both sides, you have to start lifting it in the middle and work gradually towards the ends. When all the nails are loose, you spring the board free by pulling it upwards into a bow shape.

To lift the board, insert a bolster into the joint gap between it and the board

A. *Joists of a suspended floor are supported on small sleeper walls or piers on a concrete base*

B. *Metal joist hangers built into the inner wall are one method of supporting an upstairs floor*

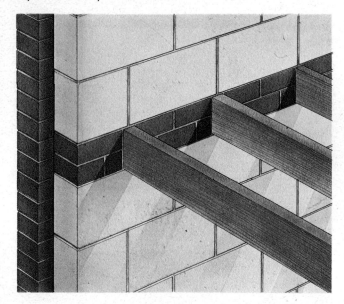

C. *Flooring joists can also be built into the inner of two masonry walls*

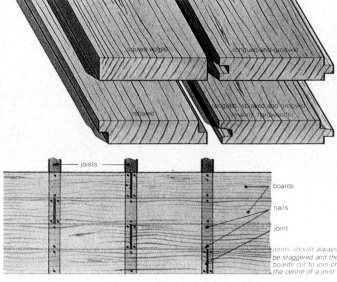

D. *Types of floorboard. Square-edged boards are found in older British houses, tongued boards elsewhere*

Hayward Art Group

on one side, in line with the nails at the free end. Use a club hammer to drive it home. Then stamp on the bolster to push it down towards the floor (fig E). Do the same on the other side of the board.

As the board is levered up, insert the claw of a hammer under the end and continue levering up from here until the board comes completely free of the joist.

To help lift the rest of the board, insert a metal bar, length of stout timber or piping underneath the free end. Use the bolster and hammer to loosen the board at each line of nails, then lever it clear with the metal bar. For safety, immediately remove any exposed nails—particularly those left upright in the joists. A crowbar is much easier than a claw hammer for this job.

If a board proves particularly stub-born, try to free one end and insert a metal bar under it. Using the bar as a levering support, stamp on the free end. After each stamp there should be some 'give', so move the support along the board towards the next joist until the nails give way here.

Lifting T&G board
Start by choosing a suitable free end and section of board, well clear of the

225

skirting. To break the tongue, insert a bolster into the join between two adjacent boards at the end of the board you wish to lift (fig. A). Give the bolster a few sharp taps with a hammer, until you feel or hear the tongue below start to split. Continue until the split extends at least 75mm from the nails, or until you otherwise judge it to be clear of the joist. You can then replace the bolster with a saw, knowing that its blade will escape damage from floorboard nails.

You can use almost any type of saw but a compromise between the awkward length of a panel saw and the short length of usable blade on a tenon saw is a purpose-made *flooring saw* (fig. E).

If a power saw is used, set the sawing blade depth to about the thickness of the board to avoid any damage to the sub-floor (if any), or to pipes or wires suspended below the flooring.

Continue cutting between the two boards until you are about 75mm from the next line of nails, and once again use the bolster to break the tongue along the stretch over the joists.

When the tongue is fully severed, use the bolster, claw hammer and

metal bar to lever up the board as you would do to lift a square-edged one. In this case, though, concentrate your levering activities at the end and along the severed side of the board at each joist. You should be able to lift the nails and tilt the board enough for the interlocked side to slide free of the adjacent board.

Well-fitted tongued-and-grooved boards may be so tightly cramped together that splitting them apart with a bolster and hammer may not be possible without causing extensive damage to both boards. In this case, the board you wish to remove must be split lengthways at the middle. A power saw is best for this job.

Cutting across floorboards

In a single-skin floor of the sort used in Britain, it is best to cut across a floorboard either over a joist or to the side of one, so that support for the new board ends is readily available. Cutting over a joist is a little more difficult than cutting beside one, but enables you to nail the cut section straight back in place. A double-skin floor can be cut anywhere, but try to avoid having two cut ends side-by-side on the floor.

1 *To remove a damaged section, first locate a joist position. Mark a cutting line either over the middle of the joist or to one side of it*

Cutting on a joist: It is important to make the cut along the centre of the joist, otherwise one or other of the two freshly-made board ends is not going to be supported properly.

The centre line of the joist can be pin-pointed by following on the line of nails of adjacent boards and board ends. Use a try square to pencil a cutting mark on a line joining the farthest possible reference points on each side of the board you are cutting. You can do this by eye or, better, by stretching a piece of string over the distance between the two points. If you are cutting alongside a board with a clearly indicated joist, just continue the line of the board end (or fixings) when marking the cutting line. If the nails are staggered, take a common centre-line from as many boards as possible.

To make the cut, you can leave the board in place and use a padsaw, compass saw or power jig saw. But if the board is long enough, it is easier to lift it up into a 'hump' and cut with a tenon saw or flooring saw. To do this, you lever the board upwards with the bolster and then support it with two offcuts of timber wedged beneath it.

Cutting beside a joist: First locate the side of the joist. You may be able to do this by inserting a knife or metal rule into the gap between the floorboards, sliding it along until it hits the joist. Mark the board at this point, and use a try square to complete the cutting line. Alternatively, and if there is a gap between the floorboards on the other side, repeat probing and simply join up the two points marked on the board (fig. 1).

Drill an 8mm hole up against and at

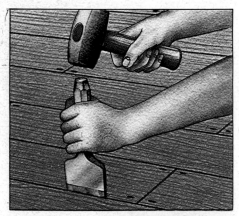

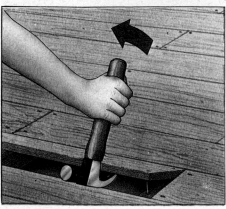

E. *A bolster (top pictures) is used both to break the tongues of T&G boards and to loosen the edges of* boards. *A claw hammer is useful for lifting boards, and a flooring saw for cutting out shorter lengths*

2 Using a piece of wood as a guide, scratch and then tease a cut with the first few teeth if you are using a tenon saw to cut on the joist

3 If you are using a padsaw or power jig saw to make a cut beside a joist, drill a small hole the width of the blade

4 Use a padsaw or compass saw to cut right across the board or, if you prefer, just to give you a slot in which to start off your handsaw

5 A padsaw can be used to sever the tongue of a tongued-and-grooved board if other forms of sawing are impracticable

6 Remove nails from the joist using a claw hammer. Protect the board alongside with an offcut. Do not hammer old nails into the joists

7 When making an extra support, start by cutting a generous length of stout timber. The extra width ensures that the board is firmly fixed

8 Mark the floorboard gap on the upper surface of the bearer. As you can see the bearer straddles the gap and acts just like the joist

9 Partly skew-nail the support, to the point when the nails are just about to break through on the other side of the timber

10 Complete the nailing while pushing the bearer against the joist and upwards against the fixed boards on both sides

227

one end of the cutting line (fig. 3) then use a padsaw or power jig saw to cut next to, and along, the cutting line. The padsaw can be replaced with a handsaw or circular-blade power saw when convenient, and re-used if necessary at the end of the cut.

Fitting an extra bearer

If you have removed a section of floorboard by cutting along the side of a joist, you must fit an extra bit of timber to the joist, in order to provide support for the new board end.

Make this bearer from an offcut of softwood, whose minimum dimensions ought to be no less than 38mm by 50mm. Cut it to length, slightly longer than the width of floorboarding removed and use either nails or screws for fixing it in place (fig. 9). If you choose nails, use two or three about 75mm long for each floorboard width, and hammer these partially into the broader side before positioning the bearer. If you use screws, two for each board width are enough, but drill pilot holes before fitting them.

Position the bearer against the joist and make sure that the top edges of both pieces of timber are exactly flush. Pull the bearer upwards, tightly against the floorboards on either side, while you hammer or screw it securely in place (fig. 10).

Replacing square-edged boards

There are few problems in replacing square-edged boards. New ones of the same thickness are cut to length and—in the case of non-standard sizes—to width. If part of the board has to be tapered or otherwise shaped to fit, use the discarded board as a template when

you saw to shape the new one.

If a single board is to be replaced simply slot it into place and nail down. A number of boards covering a large area are best fitted individually—if possible in the same flooring 'pattern' as originally. No two board ends should lie side by side on the same joist.

When fitting a number of boards, do a 'dry run' first to check the width fit, and whether tight butting of the boards is possible. Where the boards are to remain visible, keep to the original spacings for the sake of appearance.

If a complete floor area is being replaced, make a point of butting all boards as tightly as possible before fixing. This is done with a floor cramp —available from hire shops—and substantially improves underfloor draught-proofing (fig. 18).

If part of the original floorboarding is to be replaced, cut off any wood which is badly split where nails were removed. Do not re-use old nail holes. These, and new holes along the length of the board, should be made good with a filler paste.

Replacing T&G boards

Replacing tongued-and-grooved boards is not quite so straightforward. If you are re-using the old board, this can be replaced by fitting the remaining tongued or grooved side into the adjacent board. A small gap will remain on the other side—this must be plugged for complete draught-proofing.

To fit a new tongued and grooved board, you may have to plane off its tongue to get it to fit, but leave its grooved side intact.

11 If fitting a thicker board than the rest, a cut-out has to be made where the board crosses a joist. First mark the joist's position

12 Transfer the marks from the underside of the replacement floorboard to its edges. Repeat this step at every joist position

13 Carefully cut the board in order not to exceed the required rebate depth—this can be gauged by sight or by direct measurement

14 Use a chisel to remove wood between the cutting lines. The chisel face should be down. Work in stages to end with a level cut

15 Check that the rebate fits snugly and is of the required depth. Continue chiselling if the board is proud of those alongside

If a number of adjacent boards have been removed, any necessary combination of used and new boards may be used when reflooring. The technique is to loosely fit these together over the floor area to be covered, in the process forming a low arch by making the boards slightly over-sized. Lay a spare plank over this, and press or stamp the boards down: the tongues and grooves knit together in the process. The flattened boards can then be fixed in place. Alternatively, you can use an off-cut and mallet as in fig. 17.

Replacing short sections

If you are cutting out and replacing a short section of floorboard you may want to use up a spare piece of timber lying about the house. Alternatively, you may have difficulty getting a replacement board which exactly matches the thickness of your existing ones. Either way, the new board will be better too thick than too thin.

Having cut your new section to length, lay it beside the gap in the floor and mark off on the underside where it is to pass over a joist. Chisel out rough rebates between the marks, to the same depth as the board is oversize (fig. 14).

When you lay the board, the rebates should fit over the joists and allow it to rest flush with the others.

Dealing with creaking boards

Loose and creaking floorboards may be caused by incorrect nailing, by the joists below them settling, or by warping and shrinkage. It is usually possible to cure a loose board simply by re-nailing or screwing it back in place.

But before you do this, check that the loose joint coincides with the centre of the joist below, taking the board up if necessary. If it does not, widen the joist with a new bearer (figs. 7-10), or replace the whole board.

To nail floorboards, use 50mm lost-head nails or flooring nails. Position them next to, and about 12mm away from, the existing nails. When you have finished, drive all the nail heads well below the surface of the board with a nail punch (nail set).

To secure floorboards with screws, use 40mm countersunk steel screws. Drill pilot holes for them 12mm from each existing nail, taking care that the holes go no deeper than the thickness of the board. When all the screws are in place, make sure that none of them protrudes above the surface.

16 *If the replacement board is too thin, use sheet wood to make up the difference. Do not use newspaper folds for this job*

17 *When replacing tongued boards the last two will need force before slipping into fit—use a mallet and protective wood offcut*

18 *Nailing boards into place. A pencil line ensures accuracy. A floor cramp—worth hiring for big jobs—keeps the boards tightly packed*

19 *If you decide to use nails for fixing a floorboard in place, hammer in the heads using a punch. Use filler and stain to conceal the hole*

20 *If you choose to screw down a board, drill a hole to accept the screw body only. This minimizes the effort needed in fixing boards*

21 *Use a countersink bit to drill a recess for the screw head and— if necessary—fill the hole once the board has been screwed to the joist*

Stripping floorboards

Sanding and lacquering old floorboards transforms the character of any room. And if you take your time over the job, you will not only have a superb floor but will also save a fortune on carpeting costs

A modern power sander can strip the floor of an average-sized room in a few hours and the boards can be lacquered, or varnished, and polished in the space of a weekend or a couple of evenings.

A plain lacquered floor is most effective in rooms which do not have much traffic—such as bedrooms and dining rooms. But in a living room or hallway, which might have to take more wear, you can still enjoy the airy natural look of a lacquered floor by using it as a background for colourful rugs or small carpets which will take most of the heavy traffic.

As an alternative, some of the modern two-part resin wood lacquers —though very expensive—can withstand most traffic and merely need the occasional wipe with a damp cloth to keep them clean and shiny.

The colour and texture you achieve with a sanded floor will depend on the original condition of the floorboards, and on the type of lacquer or stain you decide to employ.

Custom-laid floors which were originally designed to be sanded and polished—such as parquet floor—look best with a medium to dark stain and a varnish that can be highly polished. The overall effect is one of luxury and sophistication—an effect that blends perfectly with antique or 'weathered' furniture, old wall prints, and soft lighting. A more modern, cooler look is usually obtained by sanding pine-boarded floors (fig. A) and furnishing with bamboo or pine furniture and coarse rugs or furs.

Sanding a floor is best done in conjunction with redecorating a complete room when you should have a good idea of the look you want to achieve before you start. A well-sanded floor will provide a good visual anchor for the rest of the decor, so it

A. Left: the luxurious lustre and long-lasting character of refurbished floorboards looks good with either the timeless beauty of period pieces or the stark simplicity of modern furniture. In a room which suffers heavy traffic, you can use a high quality two-part resin lacquer if you do not wish to furnish with rugs

Elizabeth Whiting

is worth taking some trouble choosing the colour of the floor and the type of furnishings you envisage.

Hiring the equipment

Floor-sanding equipment is obtainable from hire shops at quite reasonable cost. For the complete operation, you will need a heavy-duty sanding machine and a smaller, hand-held edge sander, plus a supply of the appropriate abrasive papers. The hire shop should be able to supply you with varying grades of paper from fine to coarse, so take a selection. Beware, though, of using coarse paper: the medium and fine grades are more than sufficient for most sanding jobs.

The hire shop should also be able to recommend, and supply, a suitable polyurethane lacquer. But if you are not sure exactly what finish you want, do not be rushed into buying it. Instead, obtain a selection of smaller tins and experiment on an unobtrusive part of the floor.

Inspection and preparation

The sander strips away all the dirt and grime from the original floorboards and reveals defects and blemishes in stark detail. A preliminary inspection of the floor is essential before work can begin in earnest.

Look for cracks and indentations, frayed or splintered boards, warped and bent sections, or stains and paint marks which may prove difficult to remove.

You can fill small cracks and splinters with a proprietary wood filler, but remember that the final colour of the varnished floorboards will bear no relation to the original grimy appearance. The filler should of course be matched to the final finish of the floorboarding.

If you are in any doubt about the kind of finish you are going to end up with, sand down a small area of floor— which will be covered by furniture or a rug—and experiment with wood fillers of different make and type. Lacquer over the fillers with your chosen finish, and go for the filler that looks most satisfactory.

231

1 *This is what you need to sand and lacquer floorboards. The large power sander and orbital sander are available from any good hire shop*

Severely warped, bent or damaged boards should be replaced with boards of the same material and width. Replacing floorboards is not as simple as it first appears, and the new ones are bound to be in better condition than the old, existing boards. A patchy effect can easily result unless you take care in matching new with old. In fact, it is well worth hunting around for second hand boards of the same dimensions, grain and colour.

If large areas of the floor need replacing, you should seriously reconsider the idea of sanding—it is usually cheaper to go for an alternative floor-covering.

Floorboards tend to swell in humid conditions and shrink in a dry atmosphere. Badly laid floorboards which have not been properly cramped together will often have considerable gaps between them, especially noticeable when the weather is dry. If these gaps are even across the whole floor surface, the visual effect after sanding and lacquering can be quite attractive. But the finished job will look awful if they are uneven and ragged—so take steps to plug the worst offenders.

In houses which are not centrally heated, wide gaps can also be a source of strong draughts—so bear this in mind when deciding whether or not to fill them in.

For serious gaps the whole floor will have to be relaid, with the boards cramped closer together, adding an extra board to fill the large gap in the middle of the room that this will leave you with (see pages 225 to 229).

Narrow gaps between boards (less than 6mm) can be filled quite effectively with papier maché. Again it is advisable to experiment in an obscure corner

2 *In the case of gaps between the floorboards larger than 6mm it is best to make a wedge-shaped timber fillet, and glue it in place*

3 *Remove any excess fillet timber with a planer file, then punch all nails 4–6mm below the surface, and hide the holes with a filler*

of the room and match the colour of the maché to the boards. First, tear newspaper or cheap brown paper (this helps get the colour right) into small pieces about the size of a postage stamp, then mix them scrap by scrap into a bucketful of hot water kept as near boiling as possible. Keep adding the paper, pounding the mixture with a blunt-ended piece of timber as you go, until it forms a thick paste.

Make sure that all the paper fibres have broken down and that there are no remaining scraps of paper to be seen. Allow the mixture to cool for an hour or so and then pour in a bone glue size. Now take a fistful for use as a test sample and divide this into smaller lumps for stain testing.

Having left the mixture to cool thoroughly, trowel it well down between the floorboards, and smooth off

with a scraper. When it is completely dry, sand down the proud mix with the edge sander.

You can now continue to prepare the floor for sanding using whichever stain mixture gives the best results. Papier maché, being both compressible and flexible, is ideal for filling this type of gap which changes width as the humidity of the air varies.

Wider gaps between floorboards must be plugged with tapered wood strips. To make one of these, first measure your gap and transfer the measurement plus 2mm to a marking gauge (see page 151). Next, find an offcut of timber the same thickness as your floorboard and cut off the required length to fit the gap. Use the marker gauge to scribe a cutting line along the strip (page 18), then saw the length of the timber, angling the cut slightly to give your

4 *Once the floor surface has been prepared, fit a medium grade abrasive belt to the power sander, and make the first, diagonal, run*

strip a wedge-shaped cross-section. If you have a small bench circular saw, this job can be done very easily by setting the blade to an angle of 80°–85° and carefully sawing.

With a putty knife, clean away all the dirt and debris from between the boards, coat the plug thoroughly with PVA woodworking adhesive and insert it into the gap. With an offcut of wood on top to protect the surface, tap it gently into place using a medium weight hammer. Any excess timber can be removed with an old plane or planer file; a fine edge will be damaged.

Sanding the floor

First, punch in all protruding nail heads, 4–6mm below the surface, using a nail punch and a hammer, then fill in the holes with a suitable filler. If you leave any nail heads proud of the

boards, they will tear the sanding belt. Next, fit an abrasive belt to the rotary drum on the power sander. This is easier with two people: one to hold the sander in position and the other to fit the belt. Make sure that the electricity supply is disconnected before you open the machine.

The action of the sander exerts a very powerful pull on the operator and continually holding it back will quickly tire the arms. To avoid this tie an old dressing gown cord or similar length of material to each handle of the sander and loop it behind your back. This way your body will take the pull from the sander, leaving your hands free to guide the machine.

Because the sander occasionally throws up pieces of grit, you should always wear protective safety goggles. If these are not supplied with the

the grain of the boards. To avoid damaging the skirtings, protect them with offcuts of hardboard held in place with masking tape.

The power sander will not be able to get right into the edges or corners of the floor. These must be finished off with an edge sander, which can also be used to sand any difficult patches not previously dealt with.

The small edge sander is particularly useful for removing paint spots, and for cleaning off old stains or tough patches of varnish. If it proves impossible to completely sand out such blemishes, try a little paint stripper instead. Apply this cautiously though, as some varieties of stripper can stain floorboarding.

After the sanding is complete, sweep up all the loose dust then give the floor a thorough vacuuming with a regular,

domestic cleaner to prepare the surface for the varnish or stain. Use your narrowest nozzle to get all the dust up from cracks and crannies, especially those left between the boards and at the edges of the room.

Lacquering

When you come to apply the lacquer, make sure that you follow the manufacturer's instructions carefully. It is usually a good idea to thin down the lacquer for the first coat—helping it to seep into the fibres of the boards and provide an even, well bound base on which to set the subsequent coats. Certain lacquers require special thinners, so make sure you get the appropriate product from your stockist.

Apply the lacquer with a three inch brush, working from the side of the room furthest from the door and making sure that you coat each individual board separately.

Leave this first coat to dry for as long as you can—preferably overnight—then lightly rub down the surface by hand with a fine grade abrasive paper: this will key the surface for the next coat of lacquer. Having thoroughly cleaned away all the dust, apply a second, unthinned, coat in the same way as before.

As with the first coat, leave this overnight to dry and then sand down and clean as before. A third coat of unthinned varnish should now be sufficient to complete the job, but you can of course apply as many as you feel are necessary—always remembering to let each intermediate coat dry thoroughly before you apply the next. The more coats, the more lustrous and deep the surface will appear—and the longer it will last.

5 Make the second run at 90° to the first, and then finish off with a third, slow run along the grain of the floorboards

6 Use an edge sander to get into the corners and edges and any particularly difficult patches. Finish with an orbital sander

machine, either hire or buy them: as they are necessary for many other jobs around the house—such as drilling masonry and knocking in masonry nails—they are a good investment.

Although most modern power sanders have a vacuum section, which sucks the dust into a large bag slung on the body of the sander, quite a bit of dust still gets into the air of the room—so a face mask is also essential.

Start by sanding diagonally across the grain pattern, working with the run of the floorboards. Use the power sander to clean off as much of the floor as possible—you will find that boards which are bowed or warped will not sand evenly, but these can be finished off later with the edge sander.

Make the second run with the sander, right-angles to the first run. Finish off with a third run, sanding slowly along

7 Once the sanding is complete, sweep up all the loose dust, then give the floor a thorough vacuuming with a domestic cleaner

8 Apply at least three coats of lacquer to the floorboards. All but the last must be thinned and evenly sanded by hand when dry

Gavin Cochrane

Repairs to floor joists

Left uncorrected, damage to flooring timbers is potentially dangerous. Every effort must be made to remedy the problem before the trouble reaches unmanageable proportions and you are faced with huge repair bills

A. *In a typical modern house, two or more types of floors are likely to be used and the methods employed can easily be adapted for use in the renovation of older properties. Not shown is solid concrete flooring for ground floors and extensions*

Although a seemingly major task, the repair and renovation of damaged joists and flooring is well within the capabilities of any competent do-it-yourselfer. It is not the sort of job you have to do often, but may encounter if you decide to renovate an old or neglected property.

Suspended floors

Most houses feature some form of suspended wooden floor. The system used in modern houses in Britain is shown in fig. A.

For the downstairs floor, floorboards are laid across loadbearing timbers called *joists*. These in turn are laid at right-angles on low, supporting brick-work of one brick width (102mm) in the form of piers, or in some houses, *sleeper walls*.

The sleeper walls are laid at maximum intervals of 1.8m across the length or width of a room, on a supporting base which consists of at least 100mm of compacted hardcore, levelled with a layer of sand called *blinding*, and topped with a 100mm coat of concrete which is usually finished with a thin layer of levelling screed. This solid base covers the whole floor area between the inner wall foundations, and is usually referred to as the *oversite concrete*.

The lack of an oversite concrete base and consequent dampness in old houses leads to most of the problems you are likely to encounter with flooring. The problem is aggravated by inefficient underfloor ventilation (see below), and the use of a single course sleeper wall which is very prone to trouble and a bad characteristic of early suspended floor design. Nowadays, three brick courses are normally employed for sleeper walls.

The brickwork of sleeper walls is usually laid in a honeycombed construction, always a little away from main walling, so that underfloor ventilation is improved. A special variation, a *fender wall*, supports the hearth of a fireplace as well as joist ends. The thickness of this varies between 102mm and 215mm (one or

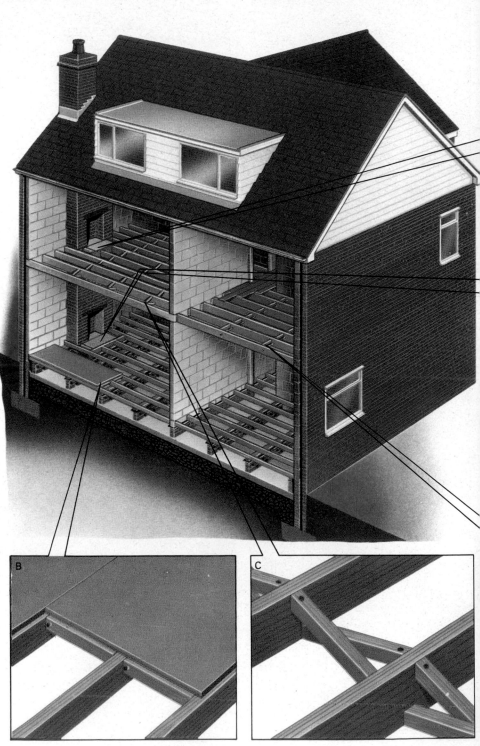

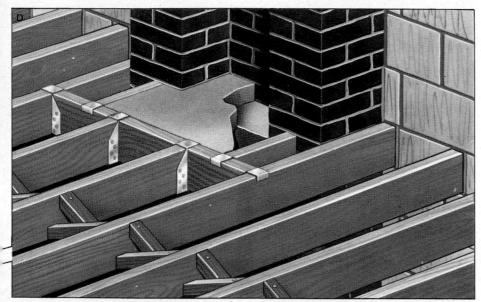

D. *Typical construction of an upstairs fireplace showing the use of trimming joists and metal hangers to support the concrete hearth*

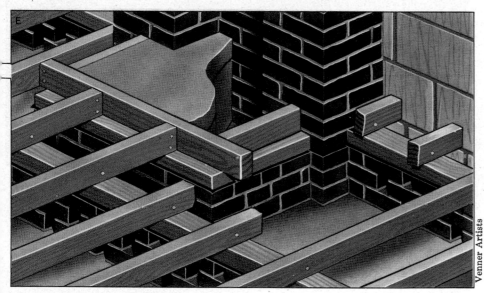

E. *This downstairs hearth is supported by a fender wall, and contained by both joists and matching. Nearby sleeper walls are honeycombed*

B. *Chipboard of flooring grade quality is a popular method of covering suspended wood flooring but the short edges must be supported by cross-pieces called noggins. All sheets are staggered so that joins do not run continuously*
C. *Herringbone strutting, used for bracing floor joists on upstairs flooring, is easily constructed and effective in use*
F. *A variation for strutting upstairs bridging joists is straight strutting, but this must be braced to be effective*

two brick widths) according to the wall height and load which has to be supported, but is otherwise built like any other brick walling.

The honeycombed construction does not have to be precise or to any specific pattern. The aperture can be achieved simply by leaving out a brick every so often when making the wall, but a better method is to leave a third-brick gap between each brick (fig. N). This ensures a plentiful quantity of ventilation holes as well as providing a strong construction.

Each sleeper wall is topped by a stout timber member (75mm × 100mm or 115mm) which acts as a bearing for the joists. Called a *wall-plate*, this strip of wood is firmly bedded on lime mortar, nowadays above a bitumen felt DPC so that rising damp does not spread to woodwork above. The depth of the mortar bed can be adjusted to level the timber.

The wall-plate acts as the fixing point for the joist ends as well as uniformly distributing floor loads along the length of the sleeper wall.

There is unlikely to be a DPC on sleeper walls of very old properties and this, combined with the lack of oversite concrete, often results in rotting floorboards and joists. In replacing these, you must be sure to incorporate a DPC—in the form of a strip of bitumen felt—underneath each wall-plate to be protected.

Joists are attached to the wall-plate by nails angled through their sides. Housing joints can be made in the wall-plate to level the joist if the sleeper wall or bedding mortar has caused a slope in the wall-plate. But under no circumstances should pieces of slate, wood or newspaper be used for levelling a joist (or, later, for levelling floorboards on an uneven joist). If necessary, use a deeper joist in conjunction with housing joints where the joist depth has to be increased at one end.

You may encounter more complicated forms of jointing such as *notching* and *cogging* (fig. M) but the resulting joints are rarely used in modern building work.

Although hardwood such as oak can be used—quite probable in old buildings—high cost and restricted availability makes the use of softwood more or less a necessity today. Redwood is considered the most satisfactory wood for both wall-plates and joists.

The maximum clear span for a 50mm

Venner Artists

G. *Metal hangers can be used instead of traditional jointing methods for connecting a trimming joist*

H. *When used as supports, the lips of the hangers are built into the wall as this is constructed*

I. *The modern equivalent of the corbel is this metal hanger which supports a timber wall-plate*

×100mm joist is about 2m when the joists are at 400mm centres and this is suitable for supporting floorboarding of up to 25mm thickness, in anticipation of 'normal' floor loadings and grades of timber. For spans greater than 2m, deeper joists have to be used —but in practice all you have to do is match the size of existing joists when it comes to getting a replacement. You can, of course, use unplaned timber.

Floorboards or flooring-grade chipboard is fixed to the joists to complete the flooring (see pages 225 to 229). The long edges of chipboard are supported on the joists, but short battens—*noggins*—must be nailed between the joists to support the short edges (fig. B) between boards.

All supporting timber must be treated with a suitable insecticidal and fungicidal preservative before construction or replacement begins.

Ground floors in Canadian houses are often above a basement. Instead of sleeper walls, the joists are usually carried on beams which are in turn supported on columns. Both beams and columns may be wood or steel. The ends of the joists around the perimeter of the house are often supported on wooden wall-plates (sill-plates) which are bolted to the foundation (ie basement) walls.

Joist depth depends on span and the grade and species of lumber used: 50mm × 200mm, for example, can span between three and four metres.

Upstairs floors
Problems with upstairs floors are much less common.

Joists are supported in one of a number of different ways—see figs. G to L for methods in British houses. The joist ends can be supported by recesses in the inner main walling but the use of metal hangers of various types is now much more common.

In old houses, joists actually built into the wall are a prime target for rot caused by rising damp in the wall. In replacing these joists, provide a

larger cavity—if necessary by removing additional brickwork—so that the new joist end receives at least some ventilation. Use a metal wall-plate in preference to a DPC resting on a mortar bedding. Rising damp is much less of a problem in modern houses with cavity walls and effective DPC so built-in joists are perfectly feasible (fig. J).

The use of *corbels*, protruding ledges of brick or stone, and *offsets*, stepped ledges formed by decreasing the wall width as each floor is reached are other traditional forms of upstairs flooring which you may encounter in old houses. If a DPC is not included in the wall, make sure to add this below a wooden wall-plate when fitting the replacement timber.

Modern construction methods tend to rely ever increasingly on the use of galvanized metal hangers. These are available in all joist sizes, and can be used in a variety of ways. Normally they are mortared into the brickwork on the inner main walls (fig. J) or hung over internal party walls to connect adjacent joists (fig. G).

One type—*the corbel bracket*—simulates the function of a corbel. Built into the walls at joist space intervals, they support short lengths of wall-plate timber which in turn support the joists (fig. I).

You are highly unlikely to encounter problems with metal hangers, but they are useful in repair work as alternatives to the more complicated traditional supports.

Also, in old, damp houses, temporarily inserting hangers into brickwork above or below the existing joist supports enables you to raise or lower the floor and make good damaged corbels, cavities and offsets.

Upstairs joists can be supported only by their ends and unless a supporting internal party wall is featured, they may extend the width of the room (the shortest span). The joists are therefore relatively large, and often more closely spaced (300mm)

than those used for the ground floor.

Another difference is that bracing is used to minimize the tendency of long lengths of wood to bow and of deep joists to twist or tilt. Two types of bracing are commonly used, at spacings not exceeding 1.8m.

The simplest is *solid strutting* (fig. F), though this must be used in conjunction with a bracing rod otherwise it is completely ineffective. Short lengths of floorboard are nailed in line between the joists, in effect to maintain an even and constant joist separation when the nearby iron rod

K. *A corbel provides a ledge on which a wall-plate can rest. In old houses shaped stone is used*

L. *An offset constructed in brick duplicates the function of a corbel and is sometimes preferred*

J. *Joists can be built directly into a wall, resting on a wall-plate, with an air space left above*

is screwed tight. This method is now very rarely used, but you may encounter it in repairs to older houses.

Herringbone strutting (fig. C) is much the better of the two methods and consists of pairs of inclined pieces of timber fitted as tightly as possible between the joists. Timber 50mm× 32mm or 50mm is used for the job and is simply nailed into place once a suitable sloping face has been cut.

Another feature of upstairs floors is *trimming*. This describes what happens when a joist cannot, for some reason or other, be supported at both ends by walls of the building—normally the problem is a fireplace or stairwell. In this case, support must be provided by imposing on any nearby

joists which do not have to terminate short of their wall support. These then become known as *trimming joists*. A fixing bracket is used to carry a *trimmer joist* which is used to support trimmed joists (fig. D). To carry the extra load, these joists are usually thicker, or may consist of two joists nailed face-to-face.

In Canadian houses, the joist ends of upper floors are usually supported on the top plate of the wall framing of the floor below (see pages 193 to 199 for details of wall framing). Intermediate support is on the top plate of partition walls, or on beams as for ground floors. Herringbone strutting is called 'diagonal bridging'; solid strutting is 'blocking'.

Trouble spots

If you suspect trouble in your flooring, raise all the floor covering and start by prodding boards and skirting with a bradawl to check for exterior signs of wet and dry rot (see pages 256 to 259). Proceed by raising a floorboard here and there to check the state of joists and sleeper walls.

However, to most of us the first sign of trouble is a broken or rotten floorboard. Start by removing this, along with all surrounding flooring which seems to be similarly affected.

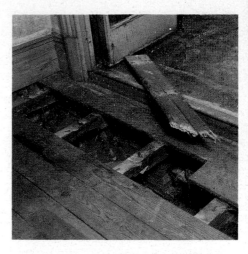

1 *Damage to flooring is most likely to occur near external doorways. Start by removing all the damaged and rotten wood*

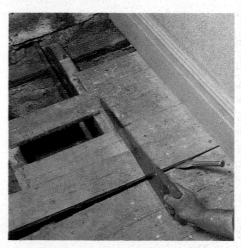

2 *Cut boards on a joist, as shown, to make relaying them easier. Avoid cutting too near the areas of rot being removed*

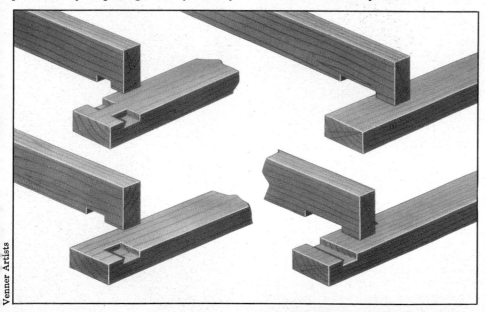

Venner Artists

M. *It is best to avoid using complicated joints where possible, but you may come across some traditional ones (top left, clockwise: double cog, single notch, double notch, single cog*

N. *To ensure adequate underfloor ventilation, it is now normal to arrange sleeper walls in a honeycomb pattern—typically as shown*

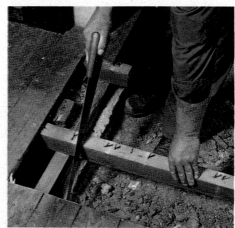

3 *If the floor joist has to be removed, cut this at a point just wide of the wall-plate which supports it*

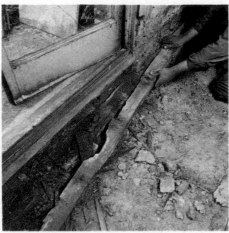

4 This wall-plate shows signs of rot and must be removed. Support the remaining length of joist and lever the wall-plate clear

5 Supporting woodwork near the doorway is removed and burnt if signs of rot are present. Clean and treat the recess

6 A fungicidal and insecticidal wood preservative must be sprayed thoroughly over all new flooring timbers

Before going any further, identify the cause of the problem. In some instances you will be able to do no more than replace old with new. If rot seems to be the trouble at least you know what needs to be done, but professional advice should be sought so that the problem can be properly cured before you proceed further.

Sleeper walls are usually fairly trouble-free, but dampness or ground subsidence can occasionally cause them to disintegrate.

In this case, there is no alternative but to take up the floorboards, temporarily support or remove the joists and rebuild the affected sleeper wall.

The floor above a basement in Canadian houses sometimes sags. This can often be corrected without having to rebuild the whole floor by jacking it back into place, taking very great care. Use a short house jack, extending its height with a wooden post and spreading the load well, both on the basement floor and on the ceiling of the sagging floor above. Screw up the jack no more than a quarter of a turn a day until the sag has gone. Then support the joist permanently with beams and columns, properly sized and fixed.

The lack of an oversite concrete base encourages the presence of damp and if ventilation is in any way restricted, moisture has little chance to clear and rot sets in. The reverse can happen too: dry rot can readily form in an enclosed space which remains unventilated.

The most common cause of inadequate ventilation is a blocked-up airbrick. Particular care must be taken not to obscure airbricks without providing alternative ventilation when adding an outside extension or patio

7 Roll out a length of DPC for fixing between the wall-plate and its sleeper wall. Allow for a slight overlap at both ends

8 Position the DPC and slide the wall-plate home, then remove the joist supports and let the sleeper wall take the weight

—a frequent oversight. And clearing airbricks of dust and accumulated rubbish must be included in your list of routine household maintenance tasks if long-term flooring problems are to be avoided.

Take additional precautions to see that surface rainwater drains away from the building and, in the case of doorways, well clear of the floor woodwork. As an outside doorway is subjected to higher than average exposure, the first signs of trouble are likely to be in this area.

Repairing a damaged floor
Start by pulling up the floorboards that obviously must be discarded and burnt, then check the extent of hidden damage. Bear in mind that you will have to remove a certain amount of the sound wood around any rot that

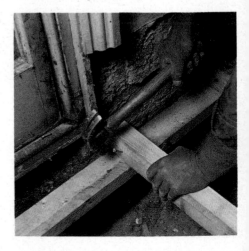

12 Fix joists to wall-plates by skew nailing through the sides of the joist. Remove skirting boards if these interfere

may be present: a margin of about 0.6m is normally sufficient for wet rot and 1m for dry rot.

If, for example, a wall-plate contains an area of rot, carefully check the surrounding joists and floorboarding to see if the damage has spread to these too; replace everything if there is the slightest sign of contamination.

A joist can also be removed in sections. Cuts should be made at the recommended distance from the rot affected area (see pages 256 to 259), to coincide with wall-plates. You will need to remove a slightly larger area of floorboarding in order to gain sufficient access (see pages 225 to 229).

Separate the joists from the supporting wall-plate by sliding a hacksaw beneath the two in order to cut the fixing nails—unless, of course, the nail head is exposed and can be removed with a claw hammer.

Wall-plates are best removed in short sections but as you do so, carefully support the remaining joists with bricks. You may find that the replacement wall-plate has to be fitted in two sections in order to give you sufficient manoeuvrability. All the new timbers must be treated with a suitable preservative to guard against insect and fungal attack.

To level a wall-plate, use a wooden wedge to prop up one end and infill the nearby gap with suitable mortar. Allow this to dry, remove the mortar and complete the filling. Do not use any form of loose packing.

With upstairs floor repairs, it is difficult to avoid damaging the ceiling below. Plasterboard can be pushed gently downwards to disengage from the joist underside enough for you to slide in a hacksaw blade and sever the fixing pins. You will need an assistant with a 'lazy man' (ceiling prop) to avoid damaging the loosened sheet if this is to be saved.

There is no simple and effective way of replacing just portions of the upstairs joists, so you have to resign yourself to the fact that new, full-length joists must be fitted wherever rot is detected in the old ones. Make a point of replacing strutting in the vicinity of the damaged area.

Where joists are set into the walls and obviously suffering from damp, use shorter new joists and support them on hangers. Cut the slots for the hangers with a hammer and bolster then use a 1:3 mortar mix to set them in place, propped at the correct height. Do not fit the joists until you are sure that the mortar has completely set.

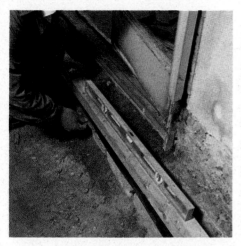

9 Position the new wall-plate for the doorway on top of a length of DPC and check the level, making good as necessary

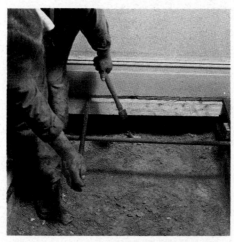

10 When you come to install a new length of joist, a crowbar is useful for twisting this into the upright position

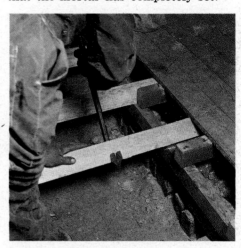

11 Joists located beneath non-loadbearing walls have to be eased into place by a combination of leverage and hammering

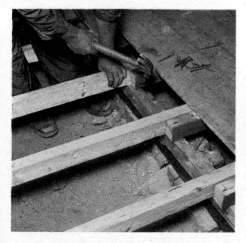

13 New sections of joist are arranged alongside the old to give additional support at the joints. Skew nail both joists

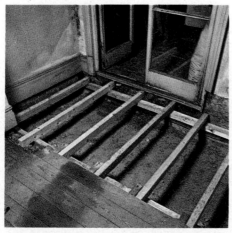

14 A new section of joists and wall-plates may have to extend well past the initial signs of damage or rot

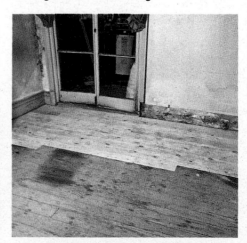

15 When all the new timber is in place, check that debris is removed and air vents are cleared before covering with floorboarding

Repairing window frames

It is essential to keep timber-framed windows in prime condition—if neglected, the wood will quickly deteriorate. And if signs of decay are left uncorrected, rot may set in

Below: *Sash cords are fitted into grooves in the side of the sash and held in place by four or five clout nails. Sash cords inevitably fray through constant use and age and eventually need replacing*

A neglected window spoils the appearance of a home, causes draughts and damp, and can tempt intruders. If the signs of decay are not detected and dealt with at an early stage, further deterioration will make repair more difficult.

Types of window
The two basic types of timber-framed window are the casement type (fig. C) and the double-hung sliding sash window (fig. B).

The sliding sash window operates by means of cords, pulleys and weights which counterbalance the sashes—the

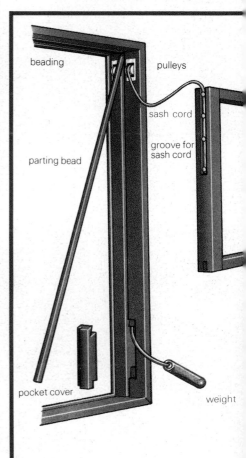

A. *Components of a sash window. The sash cord is nailed to the edge of the sash and tied to a weight*

beading

pulleys

sash cord

groove for sash cord

parting bead

pocket cover

weight

opening parts of the window—as they slide up and down. Two sets of beadings —thin lengths of wood—hold the sashes straight in the frame. Covers or caps in the lower part of the inner edge of the frame are usually provided to allow access to the compartments containing the weights. Where this is not so (eg in some Canadian windows) you will have to remove the inside frame cover.

A casement window is attached to the frame by hinges and is held open by means of a stay which is designed to allow progressive adjustment.

Working considerations
The most common problems affecting timber-framed windows are decay from wet rot, loose joints in the sashes and —in the case of sash windows—fraying or broken sash cords. To repair these faults you have to remove the sash so that you can get at the individual components of the window or work on the sash itself—difficult or impossible if it were left standing in the frame.

Where a section of a sash is decayed, you can strengthen it by cutting out and renewing the affected part of the wood. If the joints which hold the sash together are working loose, you can reinforce these by knocking them apart and re-assembling them with fresh adhesive. But if the decay is particularly widespread, rot may have irreparably harmed the timber fibres and the only solution is to discard the sash and fit a new one.

If you have modern casement windows, replacing a decayed section of the casement may be difficult because there is insufficient wood to work with. In this case, it may be quicker and probably more effective to replace the faulty casement altogether.

If you are dealing with a window affected by rot, it is best to carry out the work during dry weather as the timber remains swollen in damp conditions, making any repairs less than perfect after eventual shrinkage in dry, warm conditions.

Before starting work, identify the type of rot. Wet rot is more common in window frames but you may find dry rot in which case treatment must be more drastic (see pages 256 to 259).

Removing a casement window
Older types of casement windows are constructed from thick timber and are therefore heavy. So, if you have to remove the casement for replacement or repair, the work must be tackled with great care.

Begin by passing a strong cord around the window, under the top hinge, and tie this to the upper part of a step ladder to prevent the casement from falling to the ground.

Before you attempt to remove the screws holding the hinges in place, use an old paintbrush to dab a small amount of proprietary paint stripper on any paint around the screw heads.

If the screws prove particularly obstinate and difficult to turn, try to tighten them slightly first to help loosen the threads, or give the end of the screwdriver a few sharp taps with a mallet. If all else fails, apply some penetrating oil and leave it to soak into the screw holes overnight.

Remove the screws which fix the hinges to the frame first—those in the casement are easier and safer to remove once you have taken the window

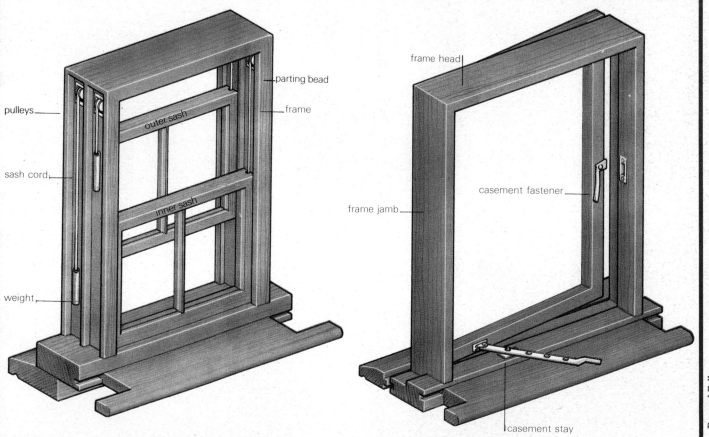

B. *The weights counterbalance the sashes, allowing them to slide up and down. The sashes are held in place by lengths of beading pinned into grooves*

C. *A casement window. The casement is attached to the frame by hinges. A casement stay holds it open and a fastener allows it to be shut tight*

Bernard Fallon

241

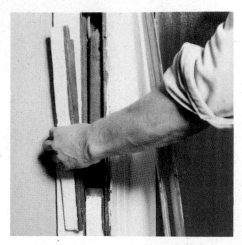

1 To replace a sash cord, take the sash and parting bead from the frame, then remove the pocket cover to gain access to the weight compartment

2 Lay the cover aside, then remove the weight from the compartment and pull the old, decayed sash cord away from the frame

3 Tie some string to a small weight such as a nail, then thread this over the pulley wheel and out through the pocket opening

4 Tie the new cord to the string, pull this down through the pocket, then tie the end of the cord securely to the original weight

5 Pull the free end of the cord so that the weight is raised—25mm for the outer sash or almost to the pulley for the inner one

6 To hold the weight temporarily in position, half-drive a nail through the cord, securing it to the edge of the frame

7 Fit the new sash cord into the groove in the edge of the sash and fix it into place with four or five clout nails

out of the frame. Loosen each of the screws by one full turn and then un-screw two from each hinge, leaving one screw in each.

Now, starting with the upper hinge, remove the remaining screws. Give the casement extra support with one hand under the outer corner and then swing it sideways into the room or, if you are working on the ground floor, lower it to the ground.

Removing a sash window

If a sash window is neglected, it be-comes difficult to open and close pro-perly and eventually its cords may fray and snap. To cure these problems, it is usually necessary to remove both sashes from the frame.

Start by removing the fixing beads around the inside edge of the frame. Beginning with a long piece, use an old chisel to prise it away starting from the middle of its length. Bring it out to a distance of about 25mm from the frame and then tap it smartly back into place. This should cause the bead's fixing pins to rise up through the surface so that you can remove them with a pair of pincers.

Repeat this procedure for the re-maining pieces of beading, then take out the inner, or lower, sash and rest it temporarily on the window sill. Ease the parting bead which runs between the two sashes from its housings then slide out the outer sash.

Sashcords are usually nailed into grooves in the sides of the sashes. To detach the cords of the inner sash, make pencil marks on the front of each sash to show where the ends of the cords reach to, then make corres-ponding marks on the outer frame.

Afterwards, remove the clout nails which hold the cords into place and—unless you intend to replace the cords—immediately tap the uppermost nails into the edges of the frame to prevent the weights on the other end of the cords from falling down behind the stile boards (fig. 6).

With both cords removed from the inner sash, you can take it from the frame and repeat the procedure for the outer one.

Replacing sash cords

If the frame of a sash window needs attention, it is likely that the sash cords are also in a poor condition and need to be replaced. And if one of the cords has already snapped, it is possible that the others are frayed and about to break, so it is best to replace all four at the same time.

For renewing the cords, buy a slightly longer length of pre-stretched wax cord than you need to allow for waste. You will also need a lump of lead or a large nail to act as a weight for dropping the new cords down into the pockets.

Remove the sashes from the frame, as described above, and begin work on the cords of the outer sash. To get to the weights to which they are attached, unscrew the pocket covers—or lever them out if they are simply nailed or wedged into place—then pull the weights through the pocket openings and remove the cords.

Check the pulleys to make sure that they run smoothly and, if not, apply a little oil to the pivots. If the window is in particularly bad condition, the pulleys may have rusted and you will have to replace them altogether.

To fix the first new cord, tie your nail or lead weight to a piece of string about 1.5m long and feed it over the groove of the outer pulley wheel until it falls down behind the stile. Tie the new sash cord to the other end of the string and pull it over the pulley and out through the pocket opening. Now untie the string, secure the cord to the original weight and replace this inside its compartment.

Pull the weight up about 25mm and half drive a nail through the cord, into the edge of the frame to hold the weight temporarily in position. Cut the cord so that it is level with the pencil mark on the frame, made when you first removed the sashes.

Next position the outer sash so that you can fit the cord into its groove, align the end of the cord with the pencil mark on the front of the sash, then fix the cord in place with four or five clout nails. Repeat the procedure for

8 If the mortise and tenon joints of a sash become loose, remove the sash from the frame so that you can re-assemble the joints

10 Knock the loose mortise and tenon joints apart, making sure that you protect the frame with a piece of waste timber

the other cord, remove the temporary nails and lift the sash back into place within the frame.

The procedure for renewing the cords of the inner sash is almost the same but in this case pull the weights up further, almost to the pulley, before fixing the temporary nails (fig. 5).

Then replace the pocket covers, parting bead, the inner sash and then the outer beading. Grease the channels with a little candle wax to aid smooth running.

In some windows, the cord may be knotted into a hole in the side of the sash. The method of replacing is much the same, but tying the knot in exactly the right place might require some trial and error.

Strengthening a sash

If the mortise and tenon joints of a

9 With the glass removed from the sash frame. use a shave hook to scrape away all traces of putty from the timber

11 Clean all the old glue from the tenons with wire wool, then clean the area in and around the mortises with an old, blunt chisel

12 Having made sure that the pin and socket of each joint are clean and dry, coat the tenons with waterproof woodworking adhesive

13 Slide the tenons into position, then glue replacement wedges and fit them into place. Drive them home until the joint is secure

15 When all the joints have been re-assembled, check that the sash is square, then cramp it using an improvized web cramp

sash become loose, water will eventually penetrate the gaps causing decay in the sash and possibly the surrounding timber as well. Extensive and costly repairs could then be the result of an initially minor fault.

Do not be tempted to strengthen a loose-jointed sash simply by filling the gaps. To do the job properly, remove the sash from the frame and chip away the putty holding the glass in place. Remove the glazing pins and the glass, then use a shave hook to scrape away all the remaining putty from the edges of the timber (fig. 9).

Now knock the joints apart, using a mallet with a timber offcut to protect the sash, and clean all the old glue from the tenons with wire wool. The joints in sashes are usually reinforced with two small wedges in each mortise to ensure a firm fit. Remove these and clean the inside of the mortises with an old, blunt chisel.

14 When the wedges have been fitted firmly into position, trim off their ends with a chisel so that they are flush

Using the removed wedges as a guide, mark up and cut replacements slightly longer than the originals to allow for trimming. When you have cut all the replacement wedges, coat the tenons with a waterproof woodworking adhesive and slide them into position in the mortises (fig. 12).

Tap them home with a mallet, again protecting the timber with a piece of waste wood, then apply some glue to two of your new wedges. With the angled edge of each wedge facing inwards, tap them into place with the mallet then trim off the ends with a chisel (fig. 14).

Fit the remaining wedges, and check that the sash frame is square by measuring the diagonals—which should be equal. Cramp the sash carefully as described previously. Once the glue has set, you can reglaze the window and rehang the sash.

Renewing decayed timber

If part of a sash is affected by wet rot, make a probe into the wood with a bradawl to check the extent of the damage. Providing the decayed section is small and is spread over no more than half the thickness of the rail, you can cut out the affected wood and replace it with new timber.

Knock apart the joints as described above to remove the rail which needs repair from the rest of the sash frame. Use a combination square to mark a 45° angle at each end of the decayed area (fig. 16). Then mark horizontal lines slightly below the depth of the decayed section. Make these lines on both sides of the rail.

Next, secure the timber in a vice and saw down the angled lines to the depth line with a tenon saw. Use a

keyhole saw or a jigsaw to cut along the depth line and, with the waste wood removed, smooth down the sawn edges with a bevel edged chisel.

Use the cut piece of wood as a pattern to measure up the replacement timber, then mark the cutting lines with the combination square.

Angles of 45° are easiest cut using a mitre box to guide the saw blade, but if you do not have one, continue the cutting lines around all the faces of the timber, then secure it in a vice and cut the replacement section. Plane down the sawn edges of the new wood and check its fit in the sash rail. If it is slightly oversize on any of its faces, sand down the unevenness.

The replacement wood is fixed into place by two or three screws, countersunk below the surface. Drill holes in the new section for these, staggering them slightly, then apply some glue to the underside and angled faces and cramp the section into place. Extend the screw holes into the sash rail to a depth of at least 12mm, drive in the screws and sink their heads well below the surface of the wood.

When the glue has set, remove the cramp and plane down the surfaces of the new wood until it is flush with the surrounding timber. Afterwards, fill in the screw holes and reassemble the sash, as described above.

Sticking windows

Apart from the faults already described, casements and sashes can stick because of a build-up of old paint or because the timber in the frame swells slightly.

The former problem is easily solved by removing the offending frame, stripping off all the old paint and then repainting. But swelling is a problem which can come and go with the weather. On casement windows, where it occurs most often, swelling can usually be allowed for by adjusting the casement hinges—a far less drastic solution than planing off the excess.

Mark the swollen part of the casement and judge whether increasing or decreasing the depth of one of the hinge recesses will bring it away from the window frame.

To increase the depth, pare away 2mm or so of wood from the recess with a sharp chisel. Try the casement for fit again before you start to remove any more.

To decrease the depth, cut a shim of cardboard or thin hardboard to the shape of the recess and fix it in place with a dab of glue. Punch or drill screw holes through the shim then replace the casement. Do this with great care to ensure a proper fit.

16 To replace a small section of decayed timber, mark a 45° angle at each end of the area of rot using a combination square

17 Mark horizontal lines slightly below the depth of the decayed section, then use a tenon saw to cut down the angled lines

18 Take care not to extend the cuts beyond the depth line, then saw along the horizontal line with a pad-saw or a jigsaw

19 With the waste wood removed, use a bevel edged chisel to smooth down the cut edges and sever any remaining fibres

20 Use the waste wood as a pattern to measure up replacement timber, then mark the cutting lines with the combination square

21 Cut out the replacement piece of timber, then drill holes for its fixing screws, down through the face of the new timber

22 Apply some glue to the new wood and lay it in place. Extend the screw holes into the sash rail, then drive the screws home

23 When the screws are in place and the glue set, plane down the faces of the new timber until it is flush with the surrounding wood

24 Now fill in the screw holes with wood filler, leave this to dry, then reglaze the sash and rehang it in the frame

Door repairs

Hinging and rehanging a door successfully is easy if you follow a few simple rules. And even more complicated jobs, such as changing the direction in which a door opens, are not as hard as they seem

Below : *This small kitchen is made even more cramped by a door which opens inwards. By rehanging the door to open outwards more space is immediately created in the kitchen and easier access provided into and out of the room*

There is nothing more annoying than a door which is difficult to open and close. And although the trouble can usually be put right quite easily, neglecting such a door may cause more extensive damage which is costly and difficult to repair at a later date.

Before attempting any repairs, it is worth considering what hinges are available and how you hang a door properly. Indeed, when a door hangs badly, the hinges are often at fault: either they are fitted badly or the wrong ones have been used.

Choosing hinges

Plastic, nylon, or—better still—pressed steel hinges are suitable for light internal doors, but if you are fitting hinges to a heavy, outside door, use the strong type made of cast steel. If you want a finish which is rust free, jam free and decorative, brass hinges look good but are more expensive and less durable.

By finding out the thickness, weight and height of your door, you can estimate what size of hinge you require. For example, a lightweight door, 32mm thick, would need a 75mm × 25mm hinge whereas a heavier door, 45mm thick, might require a 100mm × 38mm hinge. Be careful not to buy a hinge which is too wide for the door as this will result in a weak, narrow strip of wood where the hinge is fitted. To find the size of a hinge, first measure its length and then the width of one of its leaves to the middle of the knuckle where it swivels.

Most doors are fitted with butt hinges and you can buy either the fixed or the rising variety. The rising butt hinge allows the door to rise as it is opened but shut down closely on to a carpet or threshold as it closes. This means that though the door does not scrape against floor coverings, it will stop draughts and reduce fire hazards once it is shut.

Rising butt hinges are either right or left handed, so decide which way you want your door to open before you buy a set. Avoid confusion by getting the difference clear in your own mind.

Marking and fitting

Before you fit the hinge decide which side you want the door to open. Panelled doors can be hinged on either edge but most modern flush doors can only be fitted with hinges on one edge.

On some doors the hinge positions are marked on the edge of the door and these areas are usually reinforced, so it is advisable not to try to fix hinges to any other spots.

Once you have decided which edge of the door is to be hinged, arrange it so that it is resting on the opposite edge. Support the door by wedging it into a corner, cramping it to the leg of a table, or by holding it in a vice (fig. 1).

The best positions for the hinges are 215mm from the top of the door and 225mm from the bottom, but make sure that this does not leave them over any joints or the door may be weakened.

Use a marking knife and try square to mark the hinge positions on the door edge, starting from the knuckle edge where the hinge will swivel. Mark across all but 6mm of the edge then continue on to the face of the door, marking the thickness of one hinge leaf (fig. 2).

Next, open one of the hinges and lay it in position on the door edge to check that the lines you have drawn are accurate. Hold the hinge in position and use a marking knife to mark each end (fig. 3). Then scribe the width and depth of a hinge leaf on to the door edge and frame (figs 4 and 5).

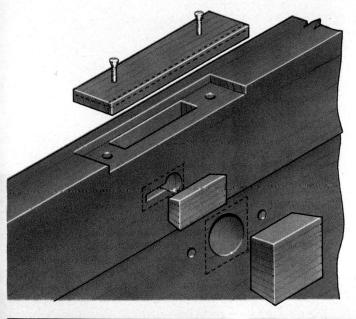

Cutting out

The hinge recesses are now ready to be cut out. Use a bevel edged chisel and start by chopping downwards across the grain in a series of cuts 5–6mm apart (fig. 6). Leave a thin uncut border of about 2–3mm around the three edges (fig. 6). Now hold the chisel flat, bevel side up and pare away the chipped-up timber. Finally, keep the flat side of the chisel parallel to the door edge and clean out the rest of the recess (fig. 7).

The hinge should now press firmly into place flush with the surrounding timber. You may have trouble with some types of hinges which are bent slightly due to pressure in their manu-

1 Before fixing hinges, stand the door on edge and support it securely with a vice firmly clamped to one end of the door

2 Position the hinges 215mm from the top of the door and 225mm from the base, keeping them well clear of any joints

3 Use a marking knife and try square to mark the hinge position on the door edge. Here, the leaf thickness is marked on the face

4 Then set a marking gauge to the width of a hinge leaf and scribe this on the door edge between the two lines previously marked

5 Reset your marking gauge to the depth of one hinge leaf and mark this on to the face of the door frame between the two knife cuts

6 Use a bevel edged chisel to cut out the hinge recesses. Make a number of cuts 5-6mm apart, to leave an uncut border around the edge

247

facture. If this is the case, pare away a further 1–2mm from the recess.

Fixing hinges

Once the hinge is comfortably in position, carefully mark the screw holes with a sharp pencil then remove the hinge and remark the screw centres with a centre punch. Try to mark these a little off centre—towards inside of the recess—so that once the screws are inserted, the hinge will be pulled snugly into position (fig. 8).

Drill pilot holes to the depth of the screws and then clearance holes deep enough for the screw shanks. For heavy butt hinges use No. 7 or No. 8 × 38mm screws. Insert the screws so that they finish level with or slightly below the hinge plate (fig. 9).

If you are using brass screws, put in a steel screw first. This will cut a thread in the wood and avoid the possibility of shearing off or damaging the soft brass screw heads.

Fitting the door

Position the door in its frame by supporting the base with wooden wedges made from offcuts (fig. 10). Both door and hinges should be in the fully open position unless you are using rising butt hinges, in which case they should be closed.

With all types of hinge, make an allowance at the base of the door for any proposed floor covering and adjust the gap as necessary by altering the positions of the wedges. When you are satisfied that the door is in the right place, scribe around the hinges with a marking knife to mark their positions on the door frame.

With the door removed from the frame, mark out the hinge recesses—their length, width and depth—accurately with a marking knife and adjustable try square. Use the same technique to cut the recesses as you used for those on the door.

Replace the door and position it exactly using the wooden wedges, then tap the hinge leaves into place in the waiting recesses. Finally, mark and pre-drill each screw hole then insert one screw in each hinge so that you can check that the door opens and closes properly. If it sticks at any point, make minor adjustments by chiselling away more of the rebates before you drive home the remaining screws.

Sticking doors

If a door sticks and you can find nothing wrong with the hinges, it may be that part of the door frame has swollen. Where the swelling is slight and there is plenty of clearance between door and frame, investigate the possibility of bringing the swollen part away from the frame by either packing or deepening one of the hinge recesses. Be sure to make only the slightest adjustments in one go, or the door may stick elsewhere around the frame.

Where the swelling is more severe, you have no choice but to plane off the excess and redecorate the door. The planing can be done with the door in situ providing you first wedge the base to take the weight off the hinges.

Older doors and those particularly exposed to damp may warp or become loose at the joints, causing them to fit badly in their frames. In the case of

B. Right: *Badly weakened areas need to be cut out and replaced with dowelled sections. Start by cutting along line A-A, then B-A*

7 *Cut out the chipped-out timber in the hinge recesses with a chisel —held bevel side up—until the recess is clean and smooth*

8 *Mark the screw holes slightly off centre towards the inside of the recesses. This allows the hinge to bed securely once it is fixed*

9 *Once you have drilled pilot and clearance holes, insert the screws so that they are slightly below the level of the hinge plates*

10 *Wooden wedges made from offcuts can be placed under the foot of the door so that it can be positioned to fit the frame exactly*

11 *Broken or damaged joints can be strengthened by first drilling out the old wedges to a depth of 75mm using a 15mm twist drill*

12 *The holes can be filled with glued 15mm thick dowels, chamfered at one end and with longitudinal cuts*

slight warping, one answer is to make a small adjustment to one of the hinge positions so that you take up the twist. Do this on the frame—not on the door.

However, a more satisfactory solution is to remove the door so that you can cramp and strengthen the frame. Take off all the door furniture—the hinges, knob, lock, key escutcheon—place it flat on a workbench, then cramp the frame square using a sash cramp with a long bar.

Where gaps appear in the joints, scrape out any dust, accumulated grime and old glue with a chisel or knife. Then bring the joints together by cramping across the frame in two or more places. Use softwood offcuts to protect the door from being bruised by the cramps.

Next, drill out the old wedges holding the tenons at each frame joint to depth of 75mm (fig. 11); use a 15mm twist drill bit. Make up some 85mm lengths of 15mm dowel with longitudinal cuts in them to allow for compressing (fig. 12) and chamfers at one end to give a snug fit.

Liberally smear each piece of dowel with external grade waterproof woodworking adhesive then drive them home into the drill holes with a mallet. Check that the cramps are still holding the frame square by measuring across the diagonals—which should be equal—and leave the adhesive to set. When it is dry, cut off the excess dowel with a tenon saw and finish the edges in the normal way.

Repairing a damaged stile or rail
If a stile or rail is split, it is usually possible to open this up, force in some adhesive then cramp it closed again. In this case, where necessary, place some

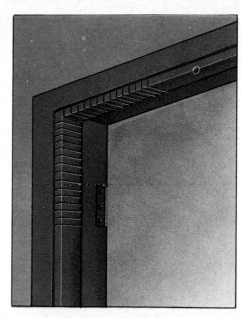

newspaper between the split and the cramp protective offcuts to stop the latter from sticking to the frame. When the adhesive has set, fill any remaining cracks with wood filler and finish with a block and glasspaper.

Very badly damaged or rotten areas must be cut out completely and replaced with new timber. Using an adjustable bevel and marking gauge, determine and mark out the extent of the damage along the frame. Mark the width of the damaged area with a marking gauge on the face of the door.

You must now cut out the timber. In the example shown in fig. B, you would make the internal cuts A-A by drilling through the wood then finishing with a padsaw or powered jig saw. Make the cuts B-A with a tenon saw, remove the damaged section, and smooth the cut edges with a wide, bevel edged chisel.

13 *When removing a planted door stop, first use a blunt, wide chisel and a mallet to prise the stop away from the door frame*

14 *By inserting the claws of a hammer into the gap, the door stop can then be worked loose and away from the frame*

C. Left: *Remove a rebated door stop by first making a series of cuts around the corners of the frame*
D. Right: *When changing the direction of opening, the hinge recess has to be moved to the opposite edge*

Mark out and cut a replacement section, making it slightly wider than the frame so that it can be planed flush after fixing. Secure the section with woodworking adhesive and oval nails, the latter punched well below the surface level.

If the replacement section is over a joint, the tenon in that joint will have been seriously weakened by the repair. The remedy is to drive two or three dowels through the new timber into what is left of the tenon (fig. B). Drill and glue the dowels as described above.

Changing direction

It is often useful to change the direction in which a door swings—to make more space in a small room for example —or to hang it from the opposite side of the frame.

Making a door open in the opposite direction involves removing and resiting the door stop, altering the hinge rebates and possibly changing the door furniture. You may or may not have to change the hinges, depending on what type you have. Ordinary butt hinges can simply be used the other way up.

How you go about the job depends on whether your door stop is simply planted—nailed to the frame—or rebated into it.

Removing a planted stop: Remove the door from the frame and clear the space around you. Then use a blunt, wide chisel and mallet to cut into the joint between stop and frame and lever

Bernard Fallon

the latter away (fig. 13). The stop is bound to be securely fixed and you may have to use considerable force. The job becomes easier when you can insert the claws of a claw hammer and ease the stop away, working upwards from the base of the door (fig. 14).

Once the door stop has given way, remove any old glue or chipped wood with a chisel, plane and glasspaper.

Removing a rebated stop: Start by measuring by how much the stop protrudes then mark this amount down and around the outside face of the frame with a marking gauge.

Next, take a tenon saw and make a series of cuts 12–18mm apart in the top corners of the door frame (fig. C). Remove the waste between these with a wide chisel in the same way as you would when producing a halving joint. This done, you can insert a rip saw or

power saw and cut downwards through the remainder of the door stop. Afterwards, plane the cut timber flush with the rest of the frame and use a chisel to clean up the corners (fig. 15).

Rehanging

When you come to rehang the door, the hinge recesses may well have to be moved. Do this by chiselling them across to the other side of the frame. Then make up wood blocks to fill the now unused parts of the recesses and pin and glue these in place (fig. 16).

Refit the door stops—or make up new planted ones in the case of rebated stops—in accordance with the new door position. Make sure that the stops are firmly pinned and glued (fig. 17).

If the door lock or latch is handed, you must exchange it for a new one and fit it according to the manufacturer's instructions. Alter the position of the striker plate and make good the old recess as you did the hinge recesses. Finally, rehang the door as described above; start by fitting the hinges.

Changing sides

If you decide to change the side on which the door hangs, all the above operations will be necessary and you will have to swop over the door furniture to the other side.

As this is often handed, make sure that it is still suitable for the new door opening. Indeed, this is a good time to exchange the furniture for a new set.

Make good the holes left in the door by driving in tapered and glued wood blocks, cut oversize so that you can plane them flush with the surface. When you have done this, fill any remaining gaps with wood filler and repaint the door (fig. A).

15 To remove a rebated stop, make a series of cuts around the corners. Chop out the waste and cut away the remainder of the stop

16 When rehanging a door which was hinged on the other side pin pieces of wood block to fill the gaps and plane smooth

17 If the door is rehinged to swing in a different direction, a new door stop must be added so that the door will close properly

Mending carpets

You can make sure your carpets have a long life by careful and thorough maintenance. Repairing them before it is too late will always save you a lot of trouble and expense

Above: *There are various ways of replacing a worn patch of carpet depending on the type of the carpet. Here, a latex adhesive is being applied to the edges of a new piece of tufted carpet*

A carpet usually covers such a wide area of a room that it is painfully obvious when any part of it becomes damaged, stained or worn. But this everyday, minor damage need not be the disaster you might at first imagine. Most of it can, with care and patience, be repaired to a highly professional standard. Repairing carpets is a fast dying art and there are very few professional craftsmen who will undertake such a job as re-tufting a carpet. So if you have good carpets, you are even more duty bound to repair them yourself—or buy new ones.

Re-tufting
Tufts clawed out by pets, burned out by cigarettes or torn out by carelessly-used knee kickers when laying are among the most common forms of surface damage to a carpet.

To make a repair, your first requirement is some matching pile yarn. If the carpet is still in production, you can get this through the retailer from the manufacturers, who will need to know the range name and pattern number—sometimes a small cutting of waste suffices to verify the colours. Most manufacturers are very helpful

about supplying matching yarn and often do so free of charge.

If you cannot obtain the correct match, something fairly close is usually available in a knitting wool of a similar gauge. The only equipment needed for re-tufting is a medium-sized pair of very sharp scissors and a half-round needle with a diameter of about 50mm.

Start by isolating the damaged tufts and snip them off level with the backing, taking care not to cut the backing in the process.

Now thread the needle with about

450mm of the yarn and simply sew it from the surface, in and out of the weft backing. This forms a simple U-shaped tuft of the same proportions as the previous one, except that it should be cut off about 25mm above the surrounding unworn pile.

Continue in this way until the whole patch is filled in. With a patterned carpet, different coloured yarns should be used and the tufts correctly located in accordance with the design. Having sewn in all the tufts, smooth them out in the direction of the pile and snip them off level with the rest of the pile.

Complete repairs

If damage to a carpet extends below the level of the pile into the backing structure, a new piece of carpet has to be set in. For this you need a sharp handyman's trimming knife with a few heavy-duty blades, a thin, metal straightedge and a curved needle. The method of repair varies for each type of carpet.

Axminsters and Wiltons: Mark out the extremities of the damage with pins, pushing them right through the backing. With the carpet folded over, the pins enable you to locate the area of damage from the reverse side.

Use your handyman's knife to cut out the damaged portion in a square or rectangular shape, following the line of the weave. The cut must be deep enough to cut and separate the backing without damaging the overhanging pile, which will be needed later to cover the join.

Next place the damaged cut-out on the replacement piece, with the pattern matching, and mark the position with pins pushed right through. Turn it over and cut out the piece required for the repair, following the weave and cutting only just through the backing as before.

1 Cut a square section from a piece of spare carpet as a replacement piece making sure that the pile direction is the same

2 Place the section squarely over the damaged area and cut round the template piece with the knife blade angled inwards

3 When the damaged piece has been removed, apply a latex-based adhesive liberally along each of the edges of the replacement piece

4 Stick a piece of one-sided self-adhesive carpet tape under each side of the square and press the carpet down to make the tape stick

5 Position the replacement piece down at one end making sure that the pile runs in the right direction and push it into place at the seams

6 To get the foam rubber seams to stick firmly together push down into the join with the back of the blade of a handyman's knife

Before securing the new piece of carpet in position, seal all raw edges with a proprietary latex compound and allow this to dry. Then place the new piece of carpet into the prepared cut-out, making sure it is the right way round, with the pattern matching and pile direction corresponding.

The edges must be sewn firmly together on the backing section with an over and over stitch using the curved needle and a stout thread. Most carpet suppliers sell carpet thread specially for this purpose.

Finally, apply a 35mm wide coat of latex compound to the back of the seam and cover this with a fabric tape. Apply gentle pressure on the area and allow it to dry.

Tufted carpets with non - foam backing: The repair method for these is similar to that for Axminsters and Wiltons except that there is no weave structure to follow when cutting out the damaged and replacement sections. Some tufted carpets appear to have a weave structure but this is only a layer of woven material which is stuck on the back and should be disregarded.

The best way to repair this type of carpet is to cut a generous amount of replacement piece into a square or rectangle and place it directly over the worn section. This becomes a template around which you cut into the carpet with the handyman's knife angled inwards. Follow figs 7 to 13.

Foam-backed (cushion-backed) carpets: These are just tufted carpets with a foam backing and can be repaired as above—but do not use sewing or fabric tape. Instead, having cut out the replacement piece and placed it in the squared-off damaged area, bond the edges of the foam together with a fine bead of impact adhesive. Then complete the joints with a 50mm-wide self-adhesive carpet tape and allow this to set for about two hours before turning the carpet back into position (see figs 1 to 6).

Vacuuming and maintenance

Regular vacuuming is an essential part of carpet maintenance and is the only effective way to remove damaging grit which becomes embedded in the pile. If you leave this grit for a long time rapid deterioration occurs at the base of the pile.

It is worth having your vacuum cleaner regularly serviced, as it performs a very important job. Upright vacuum cleaners, for instance, need a new drive belt and brush inserts in the beater about every six to 12 months but this you can do yourself.

7 For a larger area of damage knock nails through the corners of the replacement piece and underlay to hold it in place

Carpets fall into two categories according to the type of vacuum which best suits them. Shag-pile carpets are a special case.

Wool carpets: Vacuum cylinder-type cleaners can be used on this type of carpet as and when required at any time during the carpet's life. However, the upright type of cleaner with revolving beater bar and brushes should not be used on a new wool carpet for about six months. Prior to this, the fibres in the yarn will not have had a chance to interlock sufficiently and may be pulled out.

Upright vacuum cleaners are easier to use and often more efficient but they are a little harsher on the pile than cylinder types and so should not be used more than once a week during the initial period.

Man-made fibre carpets: These can have an upright vacuum cleaner used on them from the day they are laid but limit this if possible to once a week. A cylinder-type vacuum cleaner can be used as often as required without risk of damage.

Shag-pile carpets: This type of carpet requires special care as the pile becomes tangled and flat if it is not regularly combed out with a special shag rake. You can buy one of these from any good carpet shop and it takes only a few moments to rake an average room. Shag-pile carpets are not designed for heavy use, but if they are subject to a lot of wear they should be raked every day. For vacuuming, use a suction-only cleaner or a heavy-duty upright with a high pile adjustment.

8 Cut round the template in the manner shown in fig. 2. This is made much easier by the nails that are holding the template in place

Lifting crush marks

Crush marks from heavy furniture can sometimes be removed by gentle brushing with a small, stiff brush but if this fails, the controlled application of steam can work wonders.

First vacuum the area to make sure it is quite clean, then cover the crush mark with a wet, white cotton cloth. Set a steam iron to suit the material of the carpet and hold it over the cloth so that it just touches. The resulting steam will then start to lift the pile—an action which you can assist by gently brushing against the pile after each application.

Steam only for a few minutes at a time, checking the effect as you go—oversteaming causes the yarn to untwist. Never allow the iron to be in direct contact with the pile and re-wet the cloth at frequent intervals. Leave the pile sloping in the right direction and allow it to dry. The carpet will soon look new again (see fig. B).

High tufts and loose ends

These are sometimes present in new carpets, but are more likely to be caused by snagging with a sharp object. Never pull out a loose end or tuft standing above the level of the pile: this only causes more damage. Instead, simply snip them off level with the other tufts using a sharp pair of scissors.

Carpet cleaning

Before embarking on cleaning a whole carpet, clear the room of furniture and vacuum away all loose dirt and grit. Two methods of cleaning are

9 *For this non foam-backed tufted carpet you need to cut four lengths of hessian carpet tape to stick under each side*

10 *Spread the latex adhesive solution liberally on one side of the hessian carpet tape and let it dry for a few minutes*

11 *In order to get a really firm bind, spread more of the latex adhesive along the underside edges of the carpet*

easily possible at home: shampooing which can either be done by hand or special machine, and hot water extraction (steam cleaning).

Though simple, shampooing is not particularly satisfactory as it tends to leave a sticky residue in the pile which is very difficult to remove. The residue in turn attracts more dirt and the carpet soon becomes dirty again.

By comparison, the hot water extraction method leaves no residue at all. The system works by forcing a jet of partly vapourized hot water into the pile of the carpet via a hand-held

nozzle. This will loosen and break down the particles of dirt, which are then drawn out of the pile by a powerful vacuum in another section of the same nozzle.

Hot water extraction machines can be hired by the day from carpet shops. They are fairly simple to use, though overwetting of the carpet must be avoided as it causes shrinkage.

Treatment for spillages

Never start by rubbing the affected area, as this only drives the stain further into the carpet. Deal with the

spillage immediately and gently—scoop up as much as possible with a spoon and then mop with white tissues.

With fairly fluid stains, remarkable results can be obtained by placing a thick wad of tissues over the affected area, weighted down with, say, a heavy book. During a period of 20 minutes or so, natural capillary action draws much of the stain into the tissues. For heavy stains, change the wad of tissues several times. When you are dealing with old or stubborn stains it is probably wisest to call in professional assistance.

A. *To soak up spillages a blotting device is often the most efficient method. Blot the spill two or three times using clean tissues under a heavy book*

B. *To lift crushed pile iron very lightly over a damp piece of cotton cloth, then remove the cloth and comb the pile in the same direction as the rest*

12 *Place the adhesive also on underside edges of the replacement piece and, with the hessian tape in position, join together*

13 *Push the seams into place in the same way as in fig. 6, then knock along each join lightly with a hammer to bed the edges to the tape*

Particularly important points to remember when attempting to remove the various types of carpet stains are:
- Always work with a clean, white cotton rag or white tissues
- Gently dab or wipe the stain, working inwards
- Never use excessive pressure as this only rubs the stain further in
- Change the tissue or rag as soon as it becomes soiled
- Avoid over-wetting and keep stain removers out of the backing
- Leave the pile sloping in the right direction
- Allow carpets to dry before walking on them
- Always test stain removal treatments on a spare piece of carpet.

Dealing with stains

STAIN	TREATMENT
Beer	A squirt from the soda syphon; sponge, rinse and blot dry
Blood	A squirt from the soda syphon; sponge, rinse with cold water and blot dry
Candle wax	Scrape off as much as possible. Melt and absorb the remainder by covering with blotting paper and applying the toe of a warm iron. Do not let the iron come into direct contact with the carpet or use this method with polypropylene or nylon carpets. Dab with methylated spirit to remove any remaining colour
Chewing gum	Treat with any proprietary chewing gum remover or dry cleaning fluid
Coffee	As for beer, but remove final traces with a dry cleaning solvent
Egg	Remove with salt water and blotting paper
Ice cream	Mild carpet shampoo solution; sponge, rinse with warm water and blot dry. Finish with a dry cleaning solvent
Ink	A squirt from the soda syphon; sponge, rinse with warm water and blot dry. Finish with dry cleaning fluid if mark persists
Lipstick	Gently wipe away with paint remover, rinse with warm water and blot dry

STAIN	TREATMENT
Milk	A squirt from the soda syphon; sponge, rinse and blot dry. Follow with mild carpet shampoo solution; sponge, rinse and blot dry. Finish with dry cleaning fluid
Soft drinks	Sponge with mild carpet shampoo solution; rinse with warm water and blot dry
Soot	Vacuum up as much as possible and treat with dry cleaning fluid
Tar	Gently scrape up the deposit. Soften with a solution of 50 per cent glycerine and 50 per cent water. Leave for up to an hour, gently wipe, rinse and blot dry. Obstinate marks can sometimes respond to treatment with dry cleaning fluid or eucalyptus oil
Tea	A squirt from the soda syphon; sponge, rinse and blot dry. Finish with peroxide, 250mls to 250mls water
Urine	A squirt from the soda syphon; sponge and rinse. Sponge with mild carpet shampoo solution, rinse and blot. Then rinse several times using cold water with a few drops of antiseptic added. Blot dry
Wine	Remove with glycerine or peroxide diluted in an equal proportion of water

Wet and dry rot

● Wet and dry rot ● The life cycle of the dry rot fungus ● Guarding against rot attacks ● How to identify dry rot fungus ● Treating dry rot infestation ● Detecting wet rot ● How to deal with attacks of wet rot

Above: *The fruiting body of the dry rot fungus. The floorboards have been destroyed by the rot attack*

Wet and dry rot can seriously weaken the structural stability of a house and may drastically reduce its value. This section on the subject deals with general causes, why they happen, and how you can go about sorting them out and curing them.

Even masonry-built houses contain substantial amounts of timber—in the roof, floors and so on. So it is vital to identify signs of decay and deal with them as quickly and thoroughly as possible. Early detection and cure becomes even more important with timber-framed houses.

Wet rot, which often attacks window and door frames as condensation drips down the glass, is relatively easy to spot and treat. But dry rot is more insidious: it may start undetected in the roof or beneath the floor then spread from here throughout the entire house.

By far the best way to deal with these attacks is to get some idea of the nature of the various types of rot. As with most things, once you know how they work, they become much easier to stop.

Dry rot

Dry rot is caused by a fungus (in the UK, *Serpula Lacrymans*; in Canada, the similar *Poria Incrassata*). These send out root-like threads called hyphae which can penetrate mortar, and pass over pipes and masonry to find timber. Here, the fungus lives on moisture within the structure of the grain, making the timber dry, brittle and structurally useless.

The ideal conditions for growth of the fungus are warm, damp, badly ventilated areas, including wooden floors, cellars and basements, and behind skirtings (baseboards). In such conditions the growth can easily spread at an alarming rate. Whole houses have become infected throughout in as little as three months.

Because dry rot is extremely infectious, it is difficult to isolate. A mature dry rot fungus produces a flat pancake-shaped fruiting body, called a sporophore, which emits millions of tiny rust-red spores (see opposite). These are carried through the air spreading the decay if they land on further damp wood. Even if the affected wood is removed, residual fungal strands may continue growing and eventually infect sound timber.

The treatment for dry rot differs considerably from that for wet rot. If dry rot is mistaken for, and treated as wet rot, some of the affected area will be missed and the spores will be able to carry on their destructive work until detected at some future date. Eradication will then be a much more costly exercise.

With dry rot, an advanced attack produces a distinctive mushroom smell, and the surface of badly affected timber is covered by matted fungal strands—the mycelium—in a thin web-like sheet. This sheet, which grows rapidly in humid conditions, is greyish white with lilac tinges and resembles cotton wool. It develops bright yellow patches where it comes into contact with drier air or is exposed to light.

Unlike wet rot, which grows only on damp timber, dry rot carries its own water enabling it to travel unseen through the middle of timbers, through, behind and under brickwork, plaster and concrete. When the fungus is growing in particularly damp conditions, it forms globules of water like tear drops on its surface.

Deep cracks in the wood break the timber up into cubes. It becomes darker in colour, loses its characteristic resinous smell and eventually breaks into powder when rubbed between the fingers.

Wet rot

Wet rot is a general name for the damage caused by any of several fungi, the most common of which are Coniophora cerebella and Fibroporia vaillanti. These fungi require more moisture than dry rot fungus and develop where timber is in direct contact with wet or damp surroundings. Exterior joinery, where the paint film has cracked allowing water to penetrate, is a typical starting point for wet rot. The remaining paint film prevents any water drying out by evaporation, so the wood swells, joints open and wet rot spores enter the cracks.

To detect the first signs of wet rot inspect any cracked paint on window sills or door frames. A thin veneer of surface wood may conceal a soft, dark

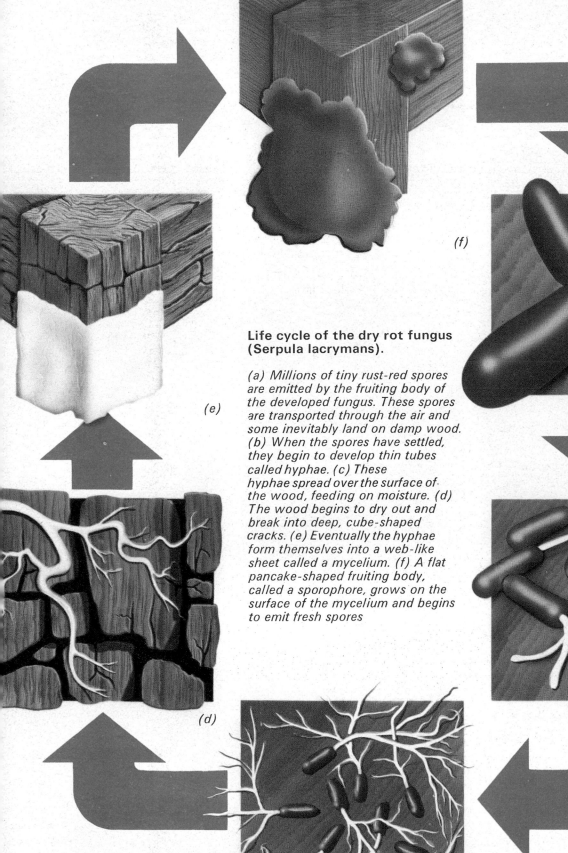

Life cycle of the dry rot fungus (Serpula lacrymans).

(a) Millions of tiny rust-red spores are emitted by the fruiting body of the developed fungus. These spores are transported through the air and some inevitably land on damp wood. (b) When the spores have settled, they begin to develop thin tubes called hyphae. (c) These hyphae spread over the surface of the wood, feeding on moisture. (d) The wood begins to dry out and break into deep, cube-shaped cracks. (e) Eventually the hyphae form themselves into a web-like sheet called a mycelium. (f) A flat pancake-shaped fruiting body, called a sporophore, grows on the surface of the mycelium and begins to emit fresh spores

If the roofing of a house is neglected the structural timbers can become damp thus providing ideal conditions for dry rot growth

The space below a wooden staircase is often badly ventilated and warm, and therefore particularly prone to dry rot attack

When checking for dry rot, lift floorboards to examine the condition of the joists. Here a sporophore is on the underside of a floorboard

Here the rot infestation has spread from its original site beneath the floor and is attacking the skirting boards above

When replacing floor joists that have rotted, coat the ends of the timbers with bituminous paint to protect them from further attack

mass of rotted wood dust beneath. The fungal strands of wet rot fungus are thinner than those of dry rot and are dark brown in colour. When growing over wood, these strands often develop a fern-like shape.

Treating dry rot

Because of improvements in building techniques and the almost universal requirements that all new buildings should have a damp-proof course, dry rot is seldom seen in houses in the UK built after 1945. But because there is no absolute guarantee against dry rot infestation, it is essential to check all possible sources of damp regularly. If the house has been flooded, or timbers have been soaked by burst pipes, be sure to check that the wood has thoroughly dried out—especially in concealed corners and against walls.

If you are unlucky enough to find signs of dry rot in your home, the source of the damp causing the infestation must be corrected before the rot can be eradicated. Check for faulty plumbing, defective dampproof courses **broken or overflowing guttering and check for broken roof tiles, slates and flashings.**

Bad ventilation will accelerate the progress of dry rot throughout the house so, you should check airbricks as well, replacing any that are broken and clearing blocked ones.

Once the source of the damp has been located and rectified, make a systematic investigation inside the house. Look for signs of surface buckling in all wood and raise floorboards to check the condition of joists

and wall plates. Also, look in cupboards and in roof space, where rain may have been leaking in steadily for some time.

Wherever there is evidence of an attack, consider that point as being the centre of a circle with a radius of about 1m and make a close examination in every direction within this area. Wherever continued evidence of decay is found, extend the circle until the limits of the dry rot growth are established and encircled.

Treatment of affected timber must be drastic and thorough. Rotted wood should be cut out well beyond the last visible sign of decay and then burned to avoid spreading infection.

Cut away all timber in the affected area 1m beyond the last point of decay, but make sure that this will not weaken the building's structure. If the area of damage is large and there is a risk of weakening the structure by removing the required amount of wood, call in expert help. When all the affected timber has been removed, apply two liberal coats of fungicide to all wood within 1.5m of the area of decay.

When you replace wood which has been removed, use only dry, well-seasoned timber and give it two coats of fungicide on all surfaces. Steep any sawn ends into the fluid for five minutes to make sure the fungicide soaks well into the end grain. Also, treat any new joints or holes drilled in the timber. If you are replacing a rotten floor joist, give the new timber further protection by coating its ends with bituminous paint before resetting it into the wall.

Treating walls and plaster

Where plaster is within 1m of a dam-

In this partition wall there is a gap between the facing panels but little ventilation. The fungal strands have formed themselves into a mycelium

A fruiting body growing on the surface of brickwork. The remedy here is to pour dry rot fluid into holes drilled in the surface

A sporophore can grow on masonry and brickwork as well as on wood. From here the decay can spread to structural timbers

Damage by wet rot. The paint film of the piece of timber has cracked, thus allowing water to penetrate and wet rot spores to enter

The end grain of this piece of wood clearly shows evidence of decay due to wet rot. The timber has swollen and the grain has cracked

aged area, or where fungal strands are growing over plaster, hack away the plaster with a hammer and bolster and rub down all brickwork and surrounding timbers and pipes with a stiff wire brush. Collect the plaster dust with a vacuum cleaner, remove it from the house and spray it with a fungicide to prevent the spread of infection. Returning to the affected area, apply two coats of fungicide to all the surfaces you have brushed clean of dust.

Allow the wall to dry out thoroughly before making good the plaster or before attempting to redecorate. When you come to re-plaster an area, apply a floating coat of zinc oxychloride plaster, about 6mm thick, to inhibit future fungal growth. Areas which only need repainting should be treated with two coats of zinc oxychloride paint before hand.

If masonry is affected, drill a series of 10mm holes, 150mm deep and sloping downwards at an angle of 45°, at 225mm intervals across the contaminated area. Pour dry rot fluid through a funnel into the holes to irrigate the area. The amount of fluid you need varies according to the brickwork or stone, but for an ordinary fletton (common brick) wall you should allow about 50 litres per m². If the masonry is particularly badly affected, call in expert help.

Treating wet rot
Outbreaks of wet rot are much more frequent than those of dry rot but are seldom as difficult to treat. The fungus stays around the original site of damp wood in which it germinated, making it easier to isolate.

The treatment itself is less drastic than that required for dry rot. If the cause of dampness is rectified and the timber is allowed to dry out, there should be no further growth. Therefore, it is necessary only to cut out affected wood which has been seriously weakened by the rot.

However, it is essential to make sure that timbers around affected areas are treated with fungicide. As the timber dries out the moisture content falls until conditions are just right for dry rot to occur.

To check the extent of damage in decaying wood, prod all timbers in the affected area with a strong, pointed tool such as a bradawl. If the bradawl sinks right into the wood, then it is badly decayed.

Cut out and burn all timber that has suffered breakdown and remove all dust, dirt and debris. Select thoroughly dry, well-seasoned timber for replacement, cut it to size and treat it as for dry rot. Also treat the surfaces of adjacent timbers and brick, block and concrete areas with fungicide before installing the replacement wood section.

Expert help
Detecting rot—especially dry rot—is often a job best left to specialist firms, many of whom offer a free surveying service. Bear in mind too that if specialists carry out the work, they will give you a guarantee—a positive benefit when you come to sell your home.

In Canada, do-it-yourself treatment is not really possible, as hardly any fungicides are available over the counter. On the other hand, there is much greater use of already-treated timber.

Dealing with woodworm

Woodworm attacks structural timber as well as furniture—making it a danger you cannot afford to ignore. Only prompt and thorough treatment can save woodwork from further damage and ensure that the pest never returns

There are two major threats to the structural timbers of a house: rot and woodworm. And if you are unlucky enough to discover signs of damp or rot in your home. It would be very advisable to you carefully check also for woodworm—some of the wood-boring pests responsible tend to prefer damp, and sometimes decayed, wood.

A mild attack of woodworm can be dealt with effectively simply by painting the damaged area with proprietary woodworm fluid. But if the damage is severe, and the inside of the wood has been seriously weakened, the timber must be cut out and replaced before the infestation spreads.

Types of woodworm

Woodworm is the collective name given to a variety of wood-boring insects whose grubs, or larvae, feed on timber. In the UK, most woodworm damage is caused by the common furniture beetle (*Anobium punctatum*) which despite its name does not limit its attacks only to furniture.

The adult furniture beetle is a small brown insect, about 3mm long, which can fly into a house or be introduced by old packing cases, wicker baskets or secondhand furniture. The female beetle lays up to 60 eggs in cracks and crevices of structural and joinery timbers and furniture. After about three weeks, grubs hatch from these eggs and bore down into the wood leaving no trace (figs A and B).

Inside the wood they tunnel, feeding on the wood continually, for three years or more. They then make small cavities near the surface of the wood in which to pupate. After two to three weeks, the fully formed adult

Above, *Woodworm fluid is available in aerosol form for treating furniture through the old bore holes*
A. Below, left: *The larva of the furniture beetle bores unnoticed into the timber and lies dormant for months*
B. Below, right: *Having eaten away much of the timber, the pupa is ready to emerge as an adult* (**right**)

Rentokil Ltd

beetles emerge; biting their way out of the wood to leave the characteristic round 'flight' holes about 2mm across. Fresh holes show clean, white wood inside. A small amount of bore dust, or 'frass', may be detectable on the surface around the holes (fig. C).

There are many other types of woodworm, most of which are much less common in the UK. Some examples are:

The **death watch beetle** (*Xestobium rufovillosum*) is much rarer than the furniture beetle as it is flightless and limits its attacks to old hardwood. However, it has a very long life cycle: the grub bores in the wood for up to 15 years before emerging, during which time it can do immense damage.

The **house longhorn beetle** (*Hylotrupes bajulus*) is found throughout the world. In the UK, outbreaks of

Lyn Cawley

infestation are rare. But increased cultivation and use of pine in Australia calls for greater vigilance.

The **woodboring weevil** (*Pentarthrum huttoni*) is also found throughout the world, especially New Zealand and port areas of Australia, and is on the increase in the UK. It attacks most types of wood but fortunately the female lays only one egg and the larval stage is short—from six to eight months.

The **powderpost beetle** (*Lyctus species*) confines its attacks to the sapwood of hardwoods, so only fresh wood is at risk. It, too, has a relatively short life cycle, only boring in wood for about ten months.

Checking for woodworm

The problem with woodworm is that an attack becomes apparent only after the adult beetle leaves the timber (in Europe this is mainly April and May). Once flight holes appear you know that at least one generation of woodworm has attacked the timber and has gone on to repeat the cycle, usually within the same vicinity.

If your house is more than about 20 years old, an extensive examination is quite likely to reveal signs of

1 To treat a piece of affected furniture, start by cleaning it down thoroughly with a damp rag to remove all traces of dust

2 Paint every surface with fluid to provide an even outer coat. Do this systematically to avoid accidentally missing an area

C. Left: *Although the death watch beetle is much rarer than many people think, its long life cycle—15 years or more—enables the grub to do immense damage to the wood* **Below:** *A piece of timber which has been badly affected by woodworm. The channels formed by the boring grubs can be clearly seen, as can the dusty remains of chewed-up pieces of timber. The small holes belie the damage below*

Ray Duns

3 Take particular care when you coat undersurfaces and other unpolished areas where the woodworm may have taken hold

4 Pay special attention, too, to the ends of legs where cracking of the grain can provide an ideal egg-laying spot for the beetle

5 As well as painting the leg ends, it is a good idea to soak them in a pot of the fluid. This gives extra protection from future attack

woodworm. Start by looking for signs of frass on and under floorboards and joists, skirting boards (baseboards), cupboards—particularly those under stairs—and furniture. Pay particular attention to any timbers which may be damp, such as those under sinks and baths, in cellars, garages and garden sheds. A common site of infestation is roofing timbers, so make sure you check the joists and rafters in and around the roof space.

Frass looks like white wood dust and is made up of tiny pellets of wood, chewed and excreted by the larva. Where these tell-tale piles of wood dust are discovered, closer examination should reveal circular, perfectly formed flight holes with clean wood inside. If you find flight holes with dull, weathered wood inside and there are no signs of frass nearby, the attack is probably not active.

Treating furniture

Woodworm in furniture should never be neglected, as it can easily spread from here to the structural timbers of the house. Old-fashioned remedies such as wiping furniture with turpentine, although reasonably effective in the short term, do not give lasting protection.

Effective woodworm-killing fluids which consist of an insecticide in a light and penetrating solvent are now readily available in the UK. These should deal permanently with all stages of the woodworm life cycle in one thorough treatment. Bear in mind, though, that it is not sufficient to treat just those areas where flight holes are visible, for grubs may be tunnelling anywhere in an infested item.

Certain woods used in cabinet making, such as Cuban mahogany

6 The final stage is to inject fluid from an aerosol into the bore holes. Be sure to wear rubber gloves when you do this

7 You may find that some of the fluid squirts out of another hole as you spray, so be sure to keep well out of the way

D. This example of how woodworm can be selective underlines the importance of checking structural timbers carefully for tell-tale holes

E. *The first stage of treating structural timber is to clean the area as thoroughly as possible. You may want to hire an industrial cleaner for this*

and teak, are immune from woodworm attack. Beech is thought to become susceptible only after about 40 years and oak after about 60 years, so all secondhand or old furniture should be inspected very carefully for signs of infestation. Pine and plywoods, on the other hand, are susceptible to attack at any time.

As a precaution against woodworm in furniture which has not already been attacked, it is well worth using a proprietary insecticide polish: these give protection against infestation as well as producing a good, deep shine. But bear in mind that you will have to apply the polish to unpolished surfaces—such as the back and underside of a chest of drawers—as well as to the visible ones, to give the furniture full protection.

To treat an affected piece of furniture, begin by cleaning it to remove any dust and dirt, then remove any drawers and shelves. Woodworm fluid does not penetrate paint, so if painted furniture has been attacked, it is best to strip all the paintwork from the item with a stripping compound before treating the wood. Before you start to apply woodworm fluid, remove any carpets or upholstery in contact with the furniture, as the chemicals can eat into such materials. If a piece of

furniture has to be stood on a carpet within two weeks of treating, lay some protective cloth under the legs.

When the wood is clean and dry, use a paint brush to coat all the surfaces with fluid. If the furniture is polished, make sure that the fluid is suitable as some types can cause damage to polished surfaces. Coat the insides of drawers and the back and underside of the piece of furniture, as well as the visible surfaces. Pay particular attention to the bottoms of chair and table legs, which are usually left roughly cut (figs 4 and 5).

This initial surface treatment should penetrate the wood to a depth of about 3mm. To kill larvae deeper in the wood, follow this by an injection treatment. There are several types of proprietary injectors available for this purpose. They consist of either an aerosol with a plastic tube attached to the outlet, or a soft plastic squeezable bottle with a nozzle fitted. Use the injector to pump fluid into the flight holes, following the manufacturer's instructions, so that it is forced along all the galleries formed by the larvae (figs 6 and 7).

When you have treated all surfaces and flight holes, leave the article for a few days to let the wood absorb the fluid thoroughly. Then wipe off any

excess fluid from the surface with a dry cloth and fill the flight holes with wood filler. If you decide to repaint furniture, mix a proprietary insecticide powder with the undercoat to discourage further activity.

Treating skirting boards

Woodworm is particularly fond of the back parts of skirtings, so if a skirting board is attacked you must remove it for treatment.

Carefully remove the damaged skirting board from its fixing on the wall then strip the paint from its surfaces with a proprietary paint stripper or a blowlamp to leave it clean and smooth. Brush woodworm fluid liberally on to all the surfaces, paying particular attention to the end grain.

Leave the timber for a few days, then wipe unabsorbed fluid from the surfaces, refix the wood and paint it.

Structural timbers

If you find evidence of woodworm attacks in structural timbers such as roof rafters or floor joists, treatment should be thorough: prolonged infestation can seriously weaken the stability of a house.

But before you treat these timbers you must first establish the extent of

F. *Be sure to reach into every crack and crevice as you clean. Any remaining debris may prevent the fluid from achieving full coverage*

the damage by making a probe into the wood with a bradawl. Where damage is severe, the affected part of the wood should be cut out and replaced with wood pre-treated with preservative.

Any cuts or holes you need to make in the course of fixing new timbers must also be treated. If severe damage is spread over a large area, removing the wood may pose a threat to the structure of the building, so you should call in expert help. If the damage is less severe, the timbers should be given a thorough insecticide treatment (figs E to H).

Painting structural timbers with woodworm fluid, as for furniture might not eradicate all the pests or provide enough protection. For this reason, low-pressure spraying equipment, which can be hired or bought from builders' merchants, has to be used. High-pressure point sprays are not suitable.

For small areas, a simple garden spray-lance, about 600mm long with a hand-pump attachment will do. Over large areas hand-pumping can be tiring, so a pressure-operated unit is preferable. The nozzle should be set to produce droplets rather than a fine spray (figs G and H).

G. *Take adequate safety precautions when spraying the fluid. Start on the upper surfaces, making sure that every corner gets a coat*

If you are dealing with timbers over a wide area, such as in the roof, you will need plenty of woodworm fluid. Two 25 litre drums should be sufficient for an average-sized roof, but if the timber is particularly dry it will soak up more fluid. In the UK, fluid is obtainable from builders' merchants.

Safety precautions

Woodworm fluids are often toxic and the solvents can attack the skin, as well as materials such as rubber and polystyrene. Therefore, it is essential to wear protective clothing and gloves when operating spraying equipment.

To avoid inhaling the solvent in the confined space of a roof, wear an industrial light fume mask, available from some chemists and builders' merchants. Wear goggles designed for working with chemicals to protect the eyes, and rub a barrier cream over any exposed skin, especially around the face and wrists.

If your electric cables are of the old rubber-insulated type, these too must be protected. Cover any exposed cables of this type with sheets of polythene or, better still, paint them with a wood sealer. Protect any junction boxes with polythene or mastic putty.

If you are working in the roof space, remove any loft insulation and do not replace it until evaporation of the fluid is complete: this can take up to a week in a confined area. Cover open-topped cold water storage tanks as well, and keep them covered for one month after spraying.

As most of the solvents used are flammable, on no account smoke or use the spray near a naked flame; nor let any flame come into contact with the area until evaporation is complete. Turn off the electricity in the area and leave it off for at least 24 hours after spraying—if you need light to work by, hire a fume-resistant fireproof light unit such as those used by garage mechanics.

Finally, make sure that the area is as well ventilated as possible during spraying, and afterwards as well to help the fluid to evaporate.

Spraying the timber

If you are using spraying equipment in the roof space, it is dangerous to work while balancing on the joists. Lay down planks across the joists, to give yourself easy access to all the areas and a platform on which to place your equipment. Before spraying, clean down all the timbers with a stiff yardbroom and a small, stiff handbrush then collect the debris with a heavy-duty, preferably indus-

H. *Finish with the underfloor timber, gaining access by removing two or three boards every metre. Use the long nozzle to reach under the rest*

trial, vacuum cleaner. Where timbers are seriously weakened at the edges, scrape off the decayed wood to a maximum depth of 12mm then vacuum away the remaining debris.

When the area is clear you can start to spray, following the manufacturer's instructions and taking care to direct the spray only at the timbers. Spray the liquid evenly over the timber surface, gradually building it up until it runs (figs G and H).

Use the lance to reach into inaccessible areas such as the apex and eaves of the roof. As you spray, the fine 'fall out' of fluid will be sufficient to protect really awkward corners.

If you have woodworm in floorboards or joists, take up every fourth or fifth board (see pages 224 to 229) so that you can reach between the floor joists and the undersides of the boards. When you have sprayed this area, replace the boards and spray the top surface. Leave plenty of time before you replace carpets or linoleum and follow the manufacturer's advice on how you can best protect your floor coverings from the fluid.

Should you accidentally stain the plaster with fluid while spraying timbers, leave it for a week or two and if the stain still shows, coat it with an aluminium primer before redecorating.

Fire precautions in the home

● How domestic fires occur ● Using fire resistant materials in house construction ● Smoke alarms: which to choose and where to fit them ● Putting out a blaze ● The main fire danger points room by room around your house

A. Below: *Serious fire damage can usually be prevented—but only if you take adequate precautions beforehand. Fire extinguishers spread around the home at strategic points are essential, particularly in workshops and garages where naked flames are often used*

Accidental fire is probably the greatest single hazard facing any household. In all domestic fires—even the smallest—there is a real risk to life and almost certain damage to expensive fixtures and fittings. It is folly to wait fatalistically for a fire to occur hoping either that you can contain it or that damage will somehow be fairly limited. With a little foresight and planning you can prepare yourself for practically any outbreak—no matter how large or unexpected—and greatly reduce the risk to life and property.

How fires start

Your first step in fire prevention should be to learn all you can about fires themselves and how they start. Armed with this knowledge you can then attempt to avoid situations where the risk of accidental fire is particularly high.

The panel on page 270 gives a list of the more common fire danger points, plus how to avoid and prevent them. Just under half of all domestic fires originate in the kitchen. Most are caused by pans, usually full of oil or fat which are left unattended on a cooker or stove. Many other fires are started by faulty electric fires and storage heaters.

In living rooms open fires are most often the culprit. If the fire is overloaded a hot coal or piece of burning log can easily slip out on to the floor. Alternatively, a spark from the fire can set a sooty chimney alight. Even more serious (since it usually involves burns and risk to life) is when someone stands too close to an open fire and a piece of their clothing catches alight suddenly.

Faulty wiring which is old or badly installed can be a cause of fire in almost any part of the home. Bad practices—such as overloading socket outlets, using the wrong fuses or running cable under carpets—are all equally dangerous. In the bedroom, badly maintained or faulty electric blankets are a common cause of fires and should be checked regularly.

But a large number of fires are simply due to carelessness, malicious damage or the misuse of certain materials. A surprisingly high proportion of accidents in this category are caused by children playing with matches and cigarette lighters or adults smoking in bed.

Another point of danger in any home is the large amount of combustible material used in the manufacture of some furnishings and fittings. While you may not be able to replace these straight away you can at least be aware of the dangers involved and take steps to move the furniture pieces away from any potential fire hazard if you can.

Most interior furnishings—such as rugs and carpets—are reasonably fire resistant. But many chairs and sofas

B. Above: *Living room danger points (1) Mirrors and other objects above a fire attract attention (2) Lighted cigarettes near combustible materials (3) Carpets in front of open fires (4) Electric cables running under rugs*

C. Above: *Children's room danger points (1) Matches and aerosol cans which can be sprayed on to fires (2) Clothes drying too close to a fire (3) Inflammable toys left carelessly strewn across the floor*

D. **Above**: *Understrairs danger points* (**1**) *Storing combustible materials – such as newspapers, paint, petrol and timber* (**2**) *Storing or using paraffin (kerosene) heaters*

E. **Above**: *Kitchen danger points* (**1**) *Badly maintained gas water heaters* (**2**) *Matches and electric leads near cooker ring* (**3**) *Towels left over cooker* (**4**) *Saucepan handles over heat*

F. **Above**: *Workshop danger points* (**1**) *Overloaded sockets and trailing leads* (**2**) *Untidy piles of timber* (**3**) *Wood shavings and lighted cigarettes* (**4**) *Bottles and cans without stoppers*

G. **Above**: *Bedroom danger points* (**1**) *Cloth covered lampshades* (**2**) *Spray cans* (**3**) *Overloaded power points* (**4**) *Fabrics overhanging fires*

should be treated with care, particularly if they are made from certain varieties of foam. Foam can ignite very quickly (cutting down escape time) and as it burns it gives off toxic gases containing invisible but highly dangerous carbon monoxide. To avoid this hazard in the future you should always insist on buying foam furniture which has been made with fire retardant materials.

Expanded polystyrene tiles, used for lining walls and ceilings, can also be potentially dangerous. If you want to use them, ensure that when they are applied the adhesive is spread all over the base of each tile rather than in a few spots around the outside. This ensures that if the tiles do catch fire they will burn in position rather than 'rain' down in burning droplets. As an added precaution the tiles should be coated with emulsion paint or – better still – with a reliable flame retardant paint (see below).

Building and lining boards vary greatly in terms of fire resistance. Plasterboard is generally non-combustible and you can buy specially prepared boards containing glass fibre and ground vermiculite for added protection against fire (see below). Other lining materials – including softwood, hardboard, fibre insulating board, chipboard and expanded polystyrene sheets – have a far lower fire resistance and if you need to use them it would be best to treat the surface with a proprietary fire retardant paint (see below).

Retarding fires
You may never be able to prevent each and every fire no matter how hard you try but you can at least retard its development and keep it to manageable proportions. To do this you should try to build in fire resistance to every part of your home whether you are building from new or just renovating part of it. A large number of specialized products are available to

help you do this and you should select from these according to the layout of your home and the materials you intend to use.

Cladding walls and ceilings: A number of manufacturers produce special fire-check boards designed to give good fire resistance when cladding walls and ceilings. These usually contain some fire resistant material—such as ground vermiculite, or calcium silicate—which can withstand high temperatures yet is light and easy to handle. Just like plasterboard the boards can be cut with normal woodworking tools and can be nailed into a stud framework without having the unnecessary inconvenience of predrilling.

To slow down the spread of fire, make sure you incorporate a number of fire

H. Below: *Whenever possible use fire resistant materials in home construction. These may not always prevent fires starting but they will at least retard the development of a blaze and keep it to manageable proportions*

stops (thick horizontal timbers) into the stud wall. Position one near the middle of the wall, one just above floor level and a third just below the level of the ceiling (fig. H). This will prevent flames shooting up between the outer wall and the cladding once a fire starts.

Ceilings can also be covered with fire-check boards. Butt them closely together and then either nail or screw them directly to the ceiling joists.

Treating floors: One of the greatest dangers if a fire starts on the floor below comes not from the spread of the flames themselves but from smoke seeping through the gaps between the floor-boards. The smoke can quickly overcome and suffocate anyone in the room, particularly if they are asleep and are not alerted by the sound of burning timber.

Floorboards can easily be sealed by nailing sheets of hardboard over the top. Clear the whole room of furniture before you start and lift all floor coverings. When nailing down the hardboard try to butt each sheet hard against the next to

ensure that no gaps are left through which smoke could escape. If you can, push the sheet under the skirting board around the edges of the room so that the room below is completely sealed off. Once the whole floor is covered you can re-lay the carpets and replace the furniture.

Fire doors: Interior doors are normally made from hardboard or softwood and will do little to retard any fire once it catches hold, but you can easily instal special fire-check or fire resisting doors instead. These are usually described as providing either half an hour or one hour fire-check (the length of the time they will normally hold back fire).

The doors come in standard sizes complete with special fire-check frames as well as intumescent strips (see below) to seal off gaps around the door. They are installed just like ordinary doors for inside the house and should be fitted with automatic door closers to ensure that they are never left open.

Some manufacturers supply specially treated fire resistant plywood which can

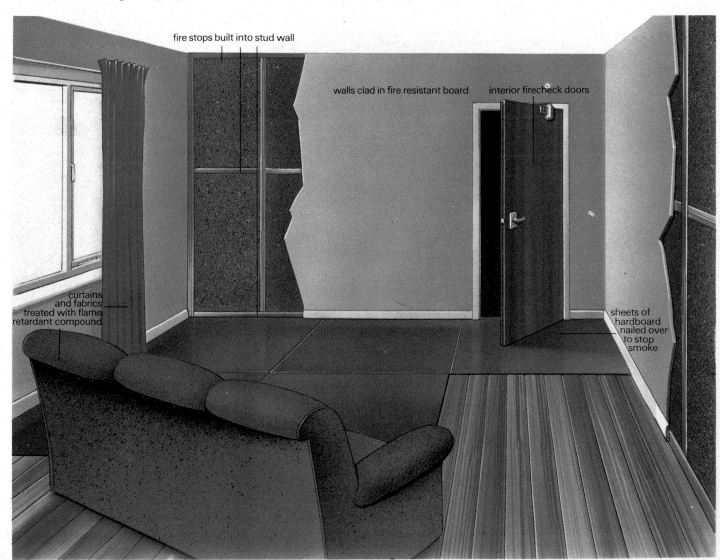

fire stops built into stud wall

walls clad in fire resistant board

interior firecheck doors

curtains and fabrics treated with flame retardant compound

sheets of hardboard nailed over to stop smoke

1 *Smoke alarms are an essential part of fire detection. They can either be ceiling-mounted or fixed to a wall around 100-300mm from the ceiling*

2 *Try to position the alarms in areas where smoke might collect in the event of a fire. One likely spot is in a hall above a stair landing*

3 *A smoke alarm should also be sited in the kitchen—but try not to mount it directly above a cooker or other heat source to avoid false alarms*

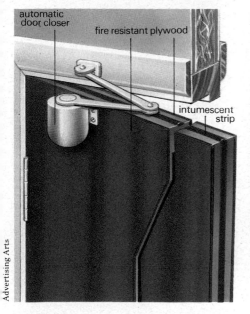

automatic door closer
fire resistant plywood
intumescent strip

Advertising Arts

I. Above: *You can construct your own fire-check doors using fire resistant plywood and an intumescent strip*

Chubb Fire

4 *The simplest alarms are battery powered. Many units give off an intermittent signal when the battery is low and needs to be replaced*

5 *Fire extinguishers should be positioned where they can be reached quickly and easily. In a kitchen a fire blanket is useful for oil blazes*

be used to modify existing doors and give them some fire retardant properties. The existing doors should be in sound condition and be at least 35mm thick. Cut the treated plywood to size and face both sides of the door with it using 32mm × No. 8 (4.2mm) screws at maximum centres of 300mm on vertical edges and 250mm on top and bottom edges (fig. I).

To complete the seal, rout a groove out all round the edge of the door and insert a length of intumescent strip. This will expand and seal off the gap if the door is subject to extreme heat. When installing the door you should also make sure that the door stop is at least 25mm deep. Again, an automatic door closer should be fitted to each door you renovate to ensure

that it stays shut when not in use.

Flame retardant paints: The dry films of most ordinary paints—even emulsions—are extremely inflammable so it obviously makes sense to use special flame retardant paints on any surface which is likely to catch fire.

Flame retardant paints are manufactured in a range of different finishes and can be applied by brush, roller or spray just like ordinary paints. Some are specifically designed for outdoor use while others should only be used indoors.

Chemical treatments: Certain furnishings are particularly susceptible to fire—particularly curtains and fabrics. These can be treated with a flame retardant compound to reduce the spread of surface flame and thus slow down the fire. The compound is a clear solution made from water-soluble powder; lightweight fabrics should be dipped in

the solution while heavyweight fabrics may be sprayed. Nearly all natural fibre fabrics—cotton, linen, velours, velvets and carpets—can be treated, but the compound is not effective on wholly man-made fibres.

Fire alarms

These are small wall or ceiling-mounted detectors which sound an alarm once the room in which they are situated heats up excessively or fills with smoke. The more sophisticated alarms may be either battery operated or powered from the mains and can usually be incorporated into standard home security systems.

Try to choose an alarm that gives off a signal loud enough to wake a sleeping person: 75 decibels should be enough but you can only make certain by experiment. It should also be possible to test the alarm: some models have a press button

6 *Workshops, garages and out-buildings are areas where fires can easily start. Position an extinguisher – preferably a dry powder type – nearby*

mounted on the unit while others have an operating light which flashes from time to time to show the unit is working.

For best results buy two alarms: one for downstairs (preferably in the kitchen) and one for the upstairs landing. The alarms can either be ceiling-mounted or fixed to a suitable wall (where the unit should be sited 100-300mm from the ceiling). When fixing an alarm in a kitchen try not to mount it directly above the cooker or other heat source to avoid false alarms. Try also to choose a position where the alarm can easily be reached for testing or for changing the batteries when this becomes necessary.

Putting out a fire

If a fire does break out despite all the precautions you have taken you have to make an immediate decision on whether to attempt to put it out or to leave it to the local fire brigade. In all cases, make sure that everyone else leaves the house immediately: then, if the fire is small and has not got out of control, you can attempt to tackle it. Never take unnecessary risks – your life is far more important than saving property.

To put out a fire in the home, it is essential both to have a fire extinguisher and fire blanket to hand and to know how to use them to best effect. The most common types of extinguisher for domestic use are water extinguishers (water propelled by CO_2) and dry powder extinguishers (sodium bicarbonate dust propelled by CO_2). Neither need frequent maintenance and do not create the toxicity hazards associated with either foam or vapourizing extinguishers. Water extinguishers will only put out fires involving wood, fabrics and furnishings while the dry powder-type will put out practically any type

including oil/petrol and electrical fires. Remember that water extinguishers should never be used on electrical fires, or on those involving inflammable liquids.

Try to position extinguishers so they are easy to get at; there is little point in rummaging through a cupboard while a fire is burning. It may be a good idea to have more than one extinguisher (one in the kitchen and another in the garage/workshop, for instance) so as little time as possible is spent in getting the blaze under control.

When using the extinguisher, direct it at the base of the flames. As the fire recedes, step in a little closer and douse the whole area with water or powder to prevent it flaring up again. If electricity is involved switch off at the mains as soon as possible. Be aggressive but never fool-hardy; it is far better to save your life rather than your property – especially in the face of a large fire.

Fire blankets, made of glass fibre, are cheap and extremely effective in smothering small fires. They are ideal for putting out oil/petrol fires and in situations where articles of clothing are alight. Keep one of these next to each fire extinguisher so you can tackle all types of blaze quickly and effectively.

The blanket should be positioned reasonably close to the cooker, but not so close as to be inaccessible if the hot plate is a mass of flames. If a fire breaks out pull the tab sharply downwards to remove the blanket from the container. Stand well back from the flames, holding the top edge of the blanket unrolled in front of you. Keep your fingers away from the edge and turn your wrists back to protect your hands.

Raise the blanket to protect yourself and advance towards the flames. Lower the blanket over the blazing pan and leave it resting there until the fire dies down completely. Leave the blanket over the oven until the pan has cooled; removing it too early could easily cause re-ignition.

BUILDING PROJECTS OUTSIDE

Basic bricklaying

● **The basic tool kit** ● **Mixing mortar** ● **Planning a small project** ● **Cutting bricks** ● **Handling a bricklayer's trowel** ● **How to lay bricks quickly and accurately** ● **Turning corners**

Although there is no need to collect a full set of bricklayer's tools just to build a simple project, a few are essential and will stand you in good stead later on.

Bricklaying trowel: absolutely vital for spreading the mortar, these are available in both right-hand and left-hand forms.

Spirit level: another essential tool, make sure that you buy the 1m bricklayer's level.

Ball of twine: for setting out your project.

Shovel: for handling and mixing the mortar.

Bucket: for carrying materials.

Brick hammer and bolster: for cutting bricks.

Measuring tape: for checking, as the work proceeds.

Materials

Always buy a few more bricks than you need: some may get damaged in transit and others are certain to be spoilt when cutting them.

As well as bricks, you need the materials which go to make up mortar —soft sand and cement—plus a square of blockboard or similar material, to carry the finished mix.

Setting out

It is essential to make sure that the main wall in any project runs in a straight line and remains level throughout—you can do this by constructing a marker line, to indicate the edge of the proposed wall. First, tie a length of twine, at least 1m longer than your proposed wall, around a brick. Place the brick on-site at one end of the line of the wall: put two others on top to weight it, then stretch the twine out in the direction of the wall. Finally, tie the twine to another brick, weight it and pull the line taut. You should now have an arrangement similar to that shown in fig. 1. The main wall of your project can start anywhere along it.

When you come to mark your first course—each layer of bricks is called a 'course'—your marker bricks will be laid to one side of the line, as close to it as possible without actually touching.

Mixing the mortar

You can mix the mortar on any clean, hard surface near the site. Start by thoroughly mixing four shovelfuls of sand with a shovelful of cement. Turn the mixture over with the shovel until it is thoroughly mixed.

Next, mix up some clean, soapy water, using washing-up liquid. The soap acts as a plasticizer, binding the mortar and keeping it malleable when you come to trowel it. Form a crater in the mortar mix, then add a little of the water. Turn the mix over carefully, adding more water as you go, until the mortar is shiny wet, but not

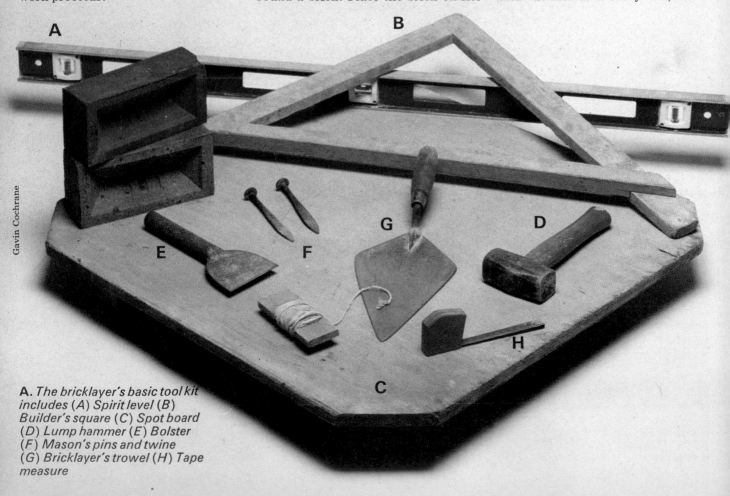

A. *The bricklayer's basic tool kit includes* (A) *Spirit level* (B) *Builder's square* (C) *Spot board* (D) *Lump hammer* (E) *Bolster* (F) *Mason's pins and twine* (G) *Bricklayer's trowel* (H) *Tape measure*

Gavin Cochrane

Tip from the trade

Q Every time I do a bricklaying job I find myself having to point up the joints afterwards. This is slow and messy. What am I doing wrong?

A Probably your mortar is too dry. It should be wet enough to squeeze out between the bricks with just light taps of the trowel handle. This lets you make a well-filled flush joint just by lifting off the surplus with the edge of the trowel, and saves re-pointing later.

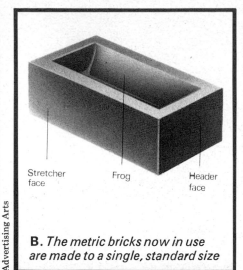

B. *The metric bricks now in use are made to a single, standard size*

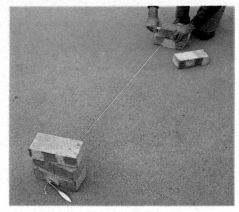

1 *To set out a simple project such as the barbecue, stretch a length of twine taut between stacks of bricks and then use it as a guide line*

so soft that it slumps (flops out of shape) when you pick up a small piece on the trowel. Finally, transfer the fresh mortar to your spotboard ready for use.

Simple bonding
In order to create a rigid structure and to spread the load on any one point, bricks are laid so that they overlap one another or are *bonded*. The simplest and most common bond is the *half-bond*, *stretcher bond* or *running bond* (fig. 17). With this arrangement, the bricks in any one course overlap those above and below by half a brick's length.

Always work to a pre-drawn bonding pattern: if you try to work the pattern out as you go along, you are certain to become confused.

Gauging
How successful a brick structure is depends a great deal on the continuity of its size or *gauge*. This not only applies to the bricks themselves, but also to the mortar joints between them. The ideal width of a joint is 10mm. Although you may not be able to achieve this on your first course, great care should be taken on subsequent courses to get as close to this as possible.

On the first, bedding, course you will have to vary the thickness of the mortar slightly to take up variations in the level of your foundations.

Cutting bricks
In order to achieve a proper bonding pattern, you will inevitably be faced with the task of cutting bricks. Bricklayers simply judge by eye the length they need, then whack the brick with the laying trowel until it severs. To begin with, though, it is easier to mark

2 *If you have a lot of bricks to cut, a wooden template speeds up the job. For beginners, it is best to mark right round the brick*

the length required in pencil, allowing 10mm for the mortar joint. Then, using the hammer and bolster, tap the brick firmly on its top, both edges and bottom at the point where you want the break to be. A final, hard whack across the top will sever it.

To speed up the measuring and marking process, bricklayers use a marking plate—three pieces of wood, stuck together as shown in fig. 2 to give rebates of quarter, half and three-quarter brick sizes.

If you have a lot of bricks to cut, it is well worth making up a plate and cutting all the bricks before you begin laying.

Using the trowel
If possible, practise the knack of handling the trowel for at least 15 minutes before you start laying any bricks—it will save a lot of mess later on and greatly speed up the bricklaying process.

3 *To cut a brick neatly, first tap it with the bolster on the top, bottom and both sides. A final tap on the cutting line will sever it*

Arrange the mortar into a neat pile on one side of the spotboard. If you are right-handed, the left hand edge of your trowel as seen from above will be a straight edge. Use this to cut a section of mortar from the pile (fig. 4), keeping the blade of the trowel angled slightly towards you.

Roll the mortar down the spotboard towards you, smoothing it to form a sausage shape with tapering ends (fig. 5). This section of mortar is known as a *pear*. To pick it up, slide the straight edge of the trowel under it and then up again in a sweeping movement (fig. 6). Practise doing this until you can pick up the whole of the pear in one sweep.

Marking your first course
Start by arranging the bricks which go to make up your main wall 'dry'—without mortar—along the setting-out line (fig. 7). Adjust them until there is a gap of about 10mm between each one.

4 To trowel a pear of mortar, start by separating a trowel-size section from the heap on the spot board. Form it roughly into shape

5 Roll the pear down the spot board in a series of chopping movements. Practise until you can do this smoothly and quickly

6 Pick up the rounded pear by sliding the trowel sideways—slipping it under the mortar and up again in one movement

7 To start the first course, line up the bricks which will form the base of the main wall in a dry run. Make sure that they fit your plan

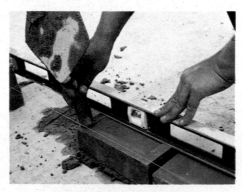

8 Taking the brick at one end of the run as your first marker, flick a pear of mortar into the exact position you intend to lay it

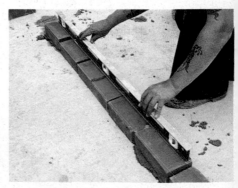

9 Before you lay the marker brick on top, flatten out the pear slightly and make a small depression so that the mortar will spread

The first job is to lay a series of marker bricks to which all the others can be aligned and levelled. Take up the brick at one end and in its place, lay down a pear of mortar. Flick it off the side of the trowel to start with (fig. 8), then flatten it out to the area of a brick (fig. 9). Before you lay the brick on top, trowel a depression in the middle of the mortar to help it spread flat.

Use the spirit level to check the brick for level in both directions, making small adjustments with gentle taps of the trowel handle (fig. 10). Stretch the level out along the dry run of bricks so that one end remains on the brick you have just laid. Now lay the brick at the far end of the level. Check it for level as before. Then stretch your spirit level back to the first laid brick and check that the two bricks are level with each other (fig. 11).

Follow this by checking them both for line, with your level pressed against the side faces. When you are satisfied that they are in the right position, lay a third marker brick, 'one level's length' from the second.

Continue laying marker bricks until

10 With the brick in place, use your spirit level to check it for true. Make small adjustments with gentle taps of the trowel handle

you reach the end of the dry run. You should end up with a series of laid, squared, level, marker bricks at intervals along the first course. On a small project like the one on page 276, you will only need three marker bricks to span the first course. Make a final check to ensure that they are all level and in line with one another, then remove the intervening bricks.

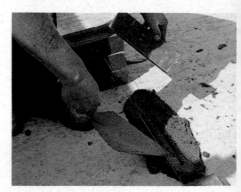

11 Lay your second marker brick at the other end of the spirit level. Once it is level, match it up to to the level of the first brick as shown

Laying the first course
Start by stretching your setting-out line tautly along the edge of the marker bricks (fig. 12). Use the line as a guide for the positions of the intervening bricks. The procedure for laying them is as follows:
● lay down a pear of mortar
● flatten and indent it
● take up your brick, gripping it as

shown in fig. 13
- draw off another piece of mortar, about the size of a cocktail sausage
- scrape it hard against one heel edge of the brick (fig. 13)
- do the same for the other heel edge
- lay the brick in position, against the adjoining one
- check it with the spirit level for level and see that its top edge aligns with your setting-out line
- scrape off the excess mortar and return it to the spotboard

Turning a corner
On large projects, bricklayers use a builder's square (fig. A) to help them judge corners correctly. For small projects a spirit level will suffice. Having laid your corner brick, butt the level up against the heel of the end brick and then tap the corner brick into line (fig. 15).

Alternatively, if you have one, you can use a large steel square such as a carpenter's roofing square to check the corner.

Laying subsequent courses
Subsequent courses of brickwork are laid in much the same way. Before each course, re-position your setting-out line one course higher than before. As you lay down a pear, make sure you cover the cross joint between the bricks below (fig. 16). If a bit of mortar slips down, simply replace it with more.

As you work on the second course, take particular care to ensure that the gauge is correct—if you lay your mortar to a depth of 12mm, this should flatten out to the required 10mm when a brick is laid on top. Be systematic with your checking: as work pro-

12 When you have laid all the markers, weigh down your line to touch them. Use the line to align the rest of the bricks in the wall

14 There is no need to check the rest of the bricks for level— just tap them into line so that they are level with the marker brick

16 As you are laying your mortar for the second course, make sure that it completely fills in, and covers, each cross-joint on the first

13 Scrape hard as you 'butter' the end of an adjoining brick— otherwise the mortar will crumble and fall off as you place the brick

15 Judge small corners such as those in the barbecue project by holding the spirit level against the end brick as a straight edge

17 With a brick laid on top, the bed mortar for the second course should be about 10mm deep. This shows the stretcher bond

gresses, you will need to check constantly for level, line and plumb (with the spirit level on end) and also that the joints are of the ideal 10mm width.

Finishing the joints
Finishing the joints, half an hour after they are set, will improve the overall appearance of the project and protect the mortar from erosion.

For small projects, a *round tooled* finish is the most suitable. Bricklayers do this by scraping a special tool along the half-dry joints and then brushing away the excess mortar. But you can achieve almost as good a finish by rubbing over the joints with a piece of 12mm diameter rubber hose. Do the vertical joints first, then the horizontal ones, which are more conspicuous.

Build a barbecue

To build the barbecue you need about 300 standard size bricks, 2 bags of cement and 30kg of sand.

The seats shown are each made from 3 boards about 1585mm x 75mm x 50mm, battened under either end, sanded and varnished.

For the fireplate, use mild steel plate, about 450mm x 450mm x 6mm, with a piece of angle iron bolted to the front edge. Make the grille above from steel lattice of the same size. Allow a gap of 20mm all round between these and the surrounding brickwork.

Build supports into the bedding mortar to hold the plates in place. Fashion these from 25mm flat iron or 6mm mild steel dowel cut into 100mm lengths. Use 4 per plate.

Overall dimension: 2·25m approx depending on size of bricks used

PLAN VIEW

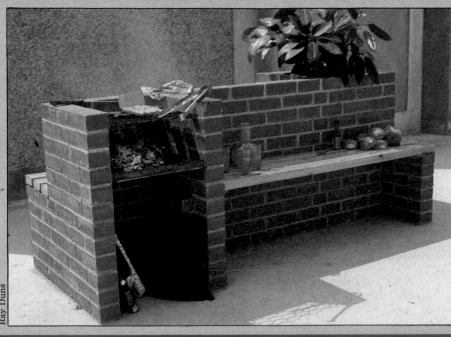

Ray Duns

½ bats

¾ bats

½ bats

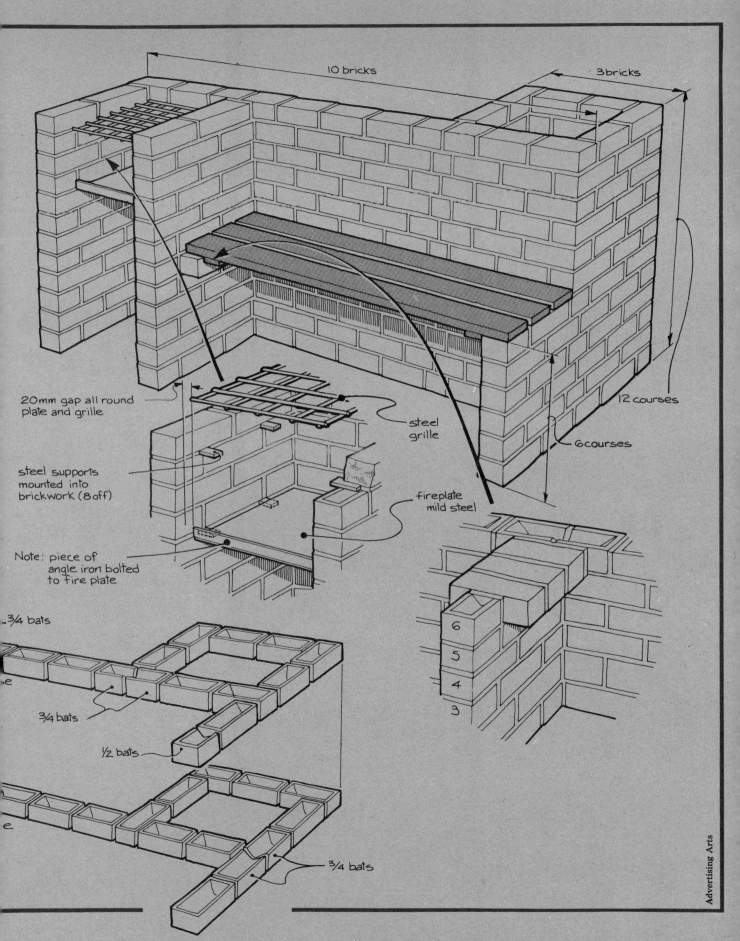

10 bricks

3 bricks

20mm gap all round plate and grille

steel grille

steel supports mounted into brickwork (8 off)

fireplate mild steel

Note: piece of angle iron bolted to fire plate

12 courses

6 courses

6
5
4
3

¾ bats

¾ bats

½ bats

¾ bats

Turning a corner

Bricklaying terms explained ● Different types of bond ● Types of bricklaying mortar ● Setting out a quoin ● Building quoins ● Building the intervening walls

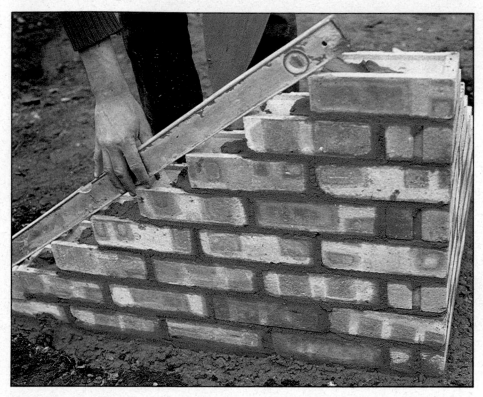

Above: *A completed quoin must be straight on all its edges—the quality and accuracy of the quoins determines that of the entire structure*

Once you have learned how to lay bricks quickly and accurately (pp 272-277), the next stage of bricklaying is to become familiar with the various patterns—or bonds—in which bricks are laid. At the same time, you will come across quite a few bricklaying terms: it is important to learn these, as they crop up time and time again.

Brick terminology
In bricklaying, bricks cut to different sizes are all given different names. Cut in half across its width, a brick becomes a *half-bat*. Cut to three-quarters of its length, it becomes a *three-quarter bat* and to a quarter of its length, a *quarter-bat*. A brick cut in half along its length is known as a *queen closer*. This is used for building strengthened corners, or *quoins*.

The way in which bricks are laid also has its own terminology. A brick laid so that one of its longest sides is visible in the finished wall is known as a *stretcher*. If it is laid so that one of the ends shows, it becomes a *header*.

Bonding
All bricks conform to a specified arrangement to ensure maximum strength, load-bearing property and a uniform appearance. This arrangement is called a *bond*.

As a general rule, no brick should be laid directly on top of another: instead, it should overlap the joints between the bricks above and below it so that there are no straight joints running up the wall. The various bonding patterns in use all follow this rule and ensure that the vertical joints between bricks are staggered over the whole wall.

Stretcher bond (running bond): This is the simplest of all bonds. It is used in walls which are half a brick (102mm) thick—the minimum thickness of any brick wall (fig. A). Each brick overlaps the one above and the one below it by half a brick's length to provide a simple, strong bond which involves cutting half-bricks only at the ends of courses. About 50 bricks (75 in the US and Canada) are needed for each 1m² of brickwork.

English bond: This bond (fig. B) makes a wall one whole brick (215mm) thick. The strongest of all bonds, it is used wherever high load-bearing qualities are called for—such as foundations and man-holes. About 100 bricks (150 in the US and Canada) are needed for each 1m² of brickwork. It consists of alternate rows, or courses, of headers and stretchers.

As the bricks overlap by only a quarter of a brick's length (56mm), care must be taken to keep the perpendicular joints aligned and staggered on each alternate course. Otherwise the bond tends to 'creep' as the courses progress and form straight joints where a crack may appear when stress is applied.

To keep the bond aligned at its corners, a queen closer is laid end-on next to the corner brick (fig. B).

Flemish bond: This bond (fig. C) also makes a wall one whole brick (215mm) thick. But because it has numerous internal straight joints, it is not as strong as English bond and is used more in decorative work, such as garden walls. When British houses had solid 9 inch brick walls instead of cavity walls, it was the bond most used to build them.

Flemish bond consists of alternate headers and stretchers along a single course. Each stretcher has a header above and below it forming what is called the 'Flemish star' and the decorative properties of the bond are accentuated if this is laid in different coloured bricks.

This bond takes a long time to build and also has a tendency to creep if sufficient care is not taken in aligning the vertical joints of alternate courses. To start each course correctly, it too requires a queen closer next to each corner brick.

English garden wall bond: More complex and not as strong as standard English bond, this incorporates two overlaps—one of half a brick's length (102mm), the other of a quarter brick's length (56mm). It is an arrangement of

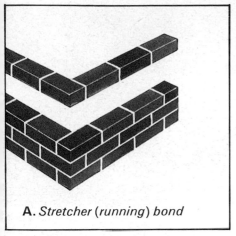

A. *Stretcher (running) bond*

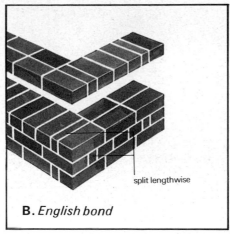

B. *English bond*

split lengthwise

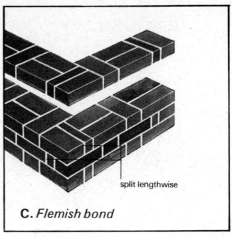

C. *Flemish bond*

split lengthwise

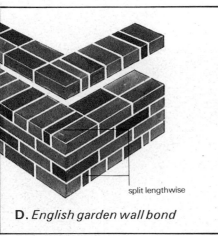

D. *English garden wall bond*

split lengthwise

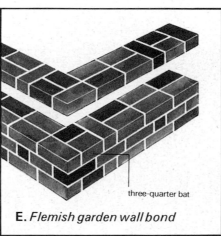

E. *Flemish garden wall bond*

three-quarter bat

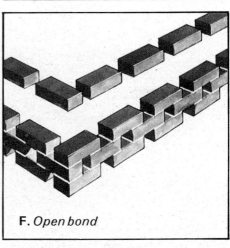

F. *Open bond*

three or five courses of stretchers for every course of headers. Care must be taken to ensure that the joints on the header courses align vertically.

The English garden wall bond is economical because it incorporates a lot of stretchers, so there is less wastage from cutting bricks.

American bond: This is similar to English garden wall bond, except that it has one course of headers to every five or six courses of stretchers, and—because of the deep perpendicular joints between the bricks on the face of the wall and those at the back—is correspondingly less strong. Like English garden wall bond, it is used only for decorative outdoor brickwork, not for building construction.

Flemish garden wall bond: This is a complex arrangement used in decorative brickwork and consists of three or five stretchers followed by a header repeated along the same course (fig. E). The headers are arranged so that they are centred in the block of stretchers in the course above.

Open bond: This bond is purely decorative. Consisting of stretcher courses with a quarter-bat spacing (fig. F), the spacing is decreased at the corners to maintain the bond. The top of the bond can be finished with either a solid course of stretchers or with a course of coping slabs.

Mortar composition

Mortar, the material which binds bricks, is composed of a binding material—such as cement or lime—and a fine aggregate—such as sand—and water. Bricklaying sand for general use should be graded either 'soft' or 'fine' for best results.

For all mortars, the specified quantities must be mixed to correct and constant ratios over the whole of the project. Where this rule is not observed, cracking caused by uneven expansion and contraction occurs and the difference in the mortar mix shows through as colour changes in the finished work.

For general and normal house construction four parts of sand to one of cement is the correct ratio—but variations on this mix can be used according to the needs of the bond. Take advice from the brick supplier to ensure that the mortar is neither stronger nor weaker than the bricks it is being used with.

To test the water content of a mortar mix, press a trowel into it. If the impression made remains for a minute or more, the mix is of the correct consistency. If the edges around the impression crumble, the mix is too dry. If the impression fills up with water, the mixture is too wet and more cement and sand in the correct ratio should be added.

Water gives mortar its bonding power. When making up the mix, it is most important to use only fresh, clean water. Dirty water or water from a rain barrel will cause the mix to quickly break up

Gauged mortar

Many companies now are producing a form of ready-mixed mortar—gauged mortar—which is sand and lime mixed to a ratio of approximately six of sand to one of lime. As this mixture does not contain any cement, it does not set hard and will retain its water content for extended periods. The cement is added according to the manufacturer's recommendations.

1 Bang two pegs firmly into the ground at each corner of the foundations. The twine stretched between the pegs must be taut

2 When the twine is in place, check that the angle between the two lines is square with a builder's square

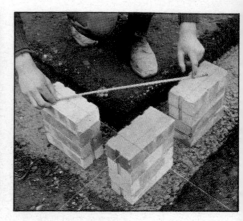

3 Another way to check the angle is by 3-4-5. If two sides of the triangle measure 3 units and 4 units, the diagonal must measure 5 units

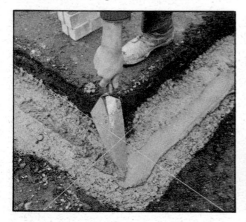

4 Directly under the twine, at each corner, lay down a thin screed of wet mortar extending about 600mm along the foundations

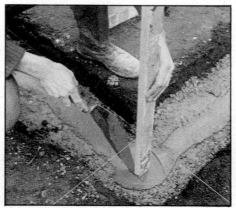

5 Carefully hold a spirit level against the twine, check that it is plumb, then score a line where its base touches the screed

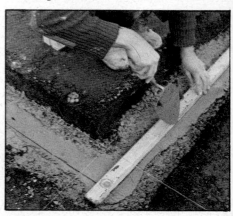

6 Join up the scored lines at both the front and side edges. Once the pegs and twine are out of the way, these provide the building line

Plasticizer

To make the mortar easier to use during bricklaying, additives called plasticizers are added. These aerate the mortar and spread the water content evenly throughout the mix, making it more malleable and easier to use for longer periods.

For non-structural brickwork, washing-up liquid makes a suitable plasticizer. For structural brickwork, a proprietary plasticizer — available cheaply from builders' merchants— should be used. The correct quantities to use for different jobs are printed on the back of the container. Gauged mortars contain lime and do not need a plasticizer. Similarly, the *masonry cement* sold in the US and Canada already has a plasticizer added.

Foundations

Strip foundations are very simple and are really only suitable for garden walls. Foundations for houses or garage walls are much more elaborate, and vary from area to area. In countries subjected to hard frosts in winter such as the UK and Canada, for example, they must extend at least 1200mm below ground level (below grade) to avoid 'frost heave'. Building such foundations is described later on in the course.

Setting out a quoin

With the foundations laid, the following simple setting out procedure must be carried out before construction of the quoin begins.

● Set up two upright pegs at each corner of the foundations. Stretch twine between them along both the front and side of the proposed structure (fig. 1 and fig. G).

● Check that the corner angle is square using either the 3-4-5 method or a builder's square (figs. 2 and 3).

● In the corner of the foundation, lay down a screed (thin layer) of wet mortar—extending about 600mm along the foundation (fig. 4).

● Hold the spirit level vertically against the string—without bending it—and score a line with the trowel where the bottom of the spirit level touches the screed (fig. 5). The mark must be directly under the string. Repeat this about 500mm along the screed and using a straight edge join up the two marks (fig. 6). Do the same along the side of the foundation so that both the building lines have been transferred down from the twine to the concrete.

● The upright pegs and twine can now be removed so that they do not interfere with the bricklaying.

● Lay the bricks 'dry' outside the line of the main wall, following your chosen bonding arrangement.

The idea is to adjust the width of the vertical joints, or *perpends*, between the bricks until the wall 'works brick'—that is, until there are just a

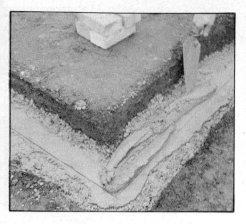

7 Carefully lay down a mortar joint, in preparation for laying the first bricks. Take care not to cover the building line

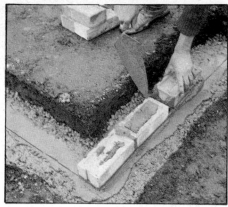

8 Promptly, but carefully, lay the first three bricks. Align the face of each with the scored line on the foundations

9 Only when these bricks have been checked for level should the remaining bricks of the quoin's first course be laid down

10 The side bricks of the quoin can now be laid, using the spirit level on end to check that all the bricks are in line and level

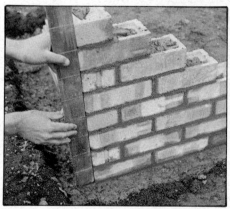

11 Each course after the first should be shortened by one brick and the quoin built up so that it ends in a single brick on top

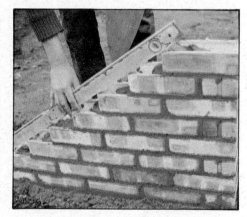

12 At this stage, the 'racking back' of the quoin should be checked along its diagonal edge to ensure that the structure is level

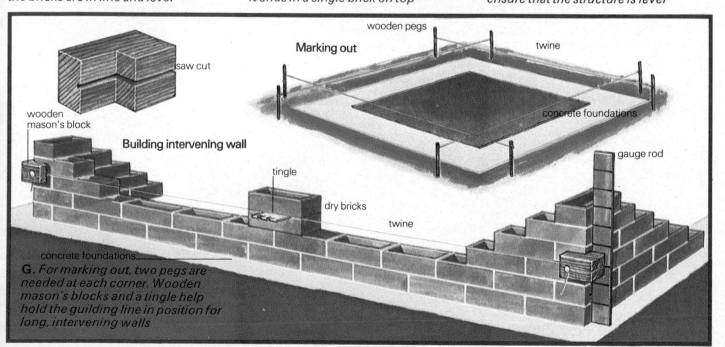

G. For marking out, two pegs are needed at each corner. Wooden mason's blocks and a tingle help hold the guilding line in position for long, intervening walls

small number of cut bricks or, better still, none at all. A cut brick in the wall is a weak point and too many will destroy the bond altogether.

This complete setting out procedure must be carried out for each corner of your proposed project. You are then ready to start building your quoin.

Building a quoin
● Lay down a mortar joint inside the scored line, taking care not to cover it (fig. 7).
● Carefully lay the first three bricks from your dry run along the mortar joint, keeping the face of the bricks aligned with the scored line of the foundation (fig. 8).
● Using the spirit level, check these bricks for horizontal (fig. 9) and then lay the remaining bricks forming the first course of the quoin.
● Repeat this procedure down the side of the corner to form a right angle. The corner is then described as being 'set out' (fig. 10).

Racking back
You can now continue building up the quoin following your chosen bond. Shorten each course after the first one so that you 'rack back' the quoin to eventually end in a single brick (fig. 11).

As you build, constantly check the quoin for plumb, line and level using your spirit level (fig. 10). You must also check the width of the horizontal, or cross, mortar joints. (fig. 11) Do this with a gauging rod—a straight piece of wood marked off at intervals of 75mm. The 75mm corresponds to the height of a brick and one mortar joint.

A final check across the diagonal racking back with a spirit level (fig. 12) should confirm that the quoin is properly aligned. When all the quoins of your proposed structure have been completed, you can fill in the intervening walls.

Building intervening walls
To build the intervening wall between two quoins, you need a set of mason's lines and blocks (fig. G). The tension on the line between the blocks holds them in position (see previous page). The line should be in the same place as the proposed mortar joint and act as a guideline between the quoins. With this in place you can build up the wall following your chosen bond.

On very long walls, the line may tend to sag in the middle. In this case, you need a tingle—a piece of metal supported on 'dry' bricks (fig. G)—to support it in the middle.

Brick types

Most general building bricks are made of clay or calcium silicate. Others are made of concrete, pottery waste, clinker and even crushed and moulded cinders. This variation in brick-making methods gives rise to an enormous variety of different types of bricks, few of which will all be available in the same area.

A more convenient way to classify bricks is by use. Here, four different types can be distinguished.

Common bricks: These are general-purpose bricks, used for such jobs as internal house walls and external walls which are to be rendered. Common bricks are usually roughly and unattractively finished and are also subject to frost damage. They should not be used for large areas of bare brickwork.

Face bricks: More expensive than a stock brick, these are used wherever bare brickwork is to be left showing. Face bricks are available in various colours and textures, are well finished and have a fairly good resistance to water and frost. The mortar joints on face brickwork should always be finished off neatly with a pointing tool.

Loadbearing bricks: These may be either face bricks or commons in appearance, but will conform to specified compression strengths and stress loadings. They are used, for example, where a load-bearing internal wall has been knocked down and brick pillars are to be erected to support the steel joist put in its place to take the load.

Engineering bricks: These are the hardest bricks of all and are made of clay, burnt at high temperatures in large kilns. They are designed to carry heavy loads and can also be used where exposure to the elements is likely to be a problem. The term does not apply to calcium silicate bricks, which are hard, but may not quite reach the specified strength and compression requirements of engineering bricks.

A point to remember when stacking bricks is that they should all be stacked on edge, in opposing directions, on each alternate row. Otherwise, bricks could topple off the stack and damage their edges—expensive if the whole pile collapses.

An open bond wall

The decorative open bond has been used to build this sturdy but attractive garden screen wall. It is made up of seven stretcher courses with a quarter-bat spacing. The spacing is reduced slightly at the corner and middle plinths to give the bond its strength.

Here, the top of the bond has been finished off with coping slabs and corner copings. But a solid course of stretchers could also be used to good effect.

If you decide to use the coping slabs—and they do help to protect the wall—treat them as carefully as possible. The uniform appearance of the copings is instantly lost if they are cracked. Go gently with the hammer and bolster chisel when cutting them to size—several gentle blows are better than one massive hit which could easily crack the coping in entirely the wrong place.

Although a generous, but even, amount of mortar is needed to secure the coping slabs in position, take care not to get any mortar on their top sides. The mark left by the wet mortar is almost impossible to remove.

Also, take time to remove any excess mortar from the bond's open spaces—untidy lumps of mortar will detract from the finished look.

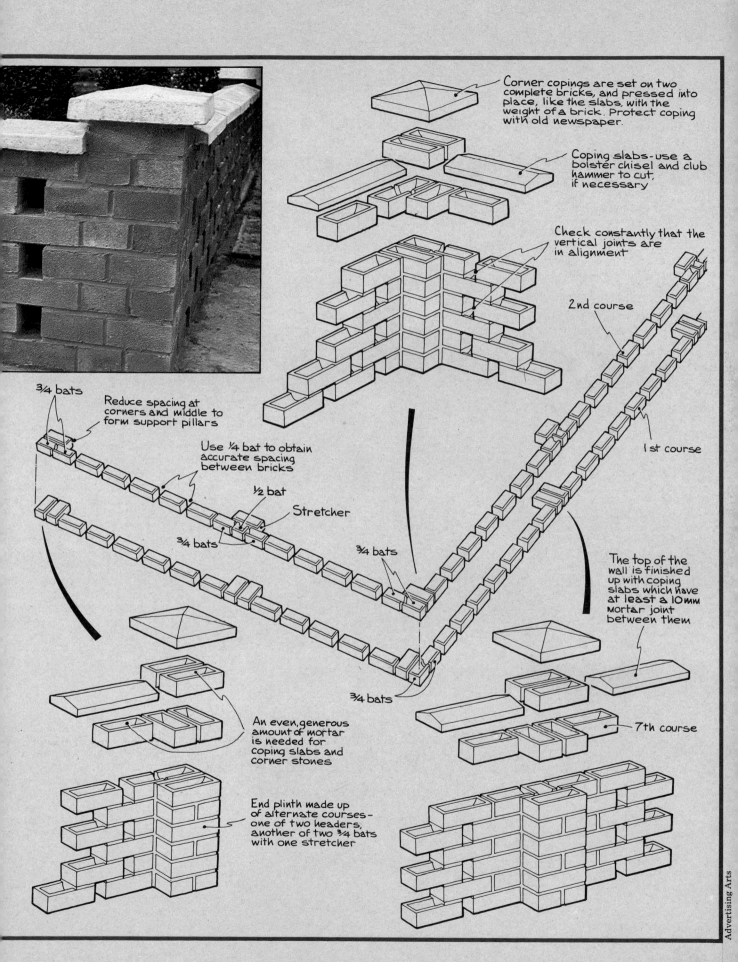

Corner copings are set on two complete bricks, and pressed into place, like the slabs, with the weight of a brick. Protect coping with old newspaper.

Coping slabs- use a bolster chisel and club hammer to cut, if necessary

Check constantly that the vertical joints are in alignment

2nd course

1st course

3/4 bats

Reduce spacing at corners and middle to form support pillars

Use 1/4 bat to obtain accurate spacing between bricks

1/2 bat

Stretcher

3/4 bats

3/4 bats

3/4 bats

The top of the wall is finished up with coping slabs which have at least a 10mm mortar joint between them

7th course

An even, generous amount of mortar is needed for coping slabs and corner stones

End plinth made up of alternate courses- one of two headers, another of two 3/4 bats with one stretcher

Laying raft foundations

● **Planning and setting out the project** ● **Preparing the site** ● **Constructing the formwork** ● **Laying mesh for loadbearing foundations** ● **Tamping the sections of concrete**

Ray Duns

Raft foundations are the large slabs of concrete on which rest garden sheds, greenhouses and outhouses. Their function is to spread the load of the structure above, together with its contents, over a wide area.

Laying a stretch of concrete—for a patio, path or driveway—is a good introduction to the concreting techniques used in making rafts. It also leaves some margin for error if you have never worked with concrete.

Above: *The final section of a large raft foundation is filled and tamped after the concrete in the adjacent bays has been laid and set*

Planning the project
Make a scale drawing of your proposed project before you start work. If you are planning a patio, path or driveway it will be much easier to run this right up to one wall of the house. Multiplying the final area of

the project by the required thickness of concrete gives you a guide to how much concrete you need. For a drive, aim for a minimum thickness of about 100mm concrete over 100mm well-tamped hardcore. This can be reduced to 75mm concrete for paths and small patios or a minimum 50mm concrete over 75mm well-tamped hardcore. But if your soil is particularly soft, consult the local building inspector.

Ordering the concrete
For work of this kind use a mix of one part cement to $2\frac{1}{2}$ parts sand to four parts aggregate or gravel, plus enough water to bind the ingredients together. If your estimates call for more than 1m³ of concrete. Consider having it delivered ready-mixed by a local concrete firm. The extra cost may be more than offset by the savings in time and effort.

Remember that if you are concreting in large 'bays', you need two loads of concrete delivered on separate occasions. Allow for the cost of this in your estimates.

When ordering ready-mixed concrete, bear in mind that the company's truck will need access to the site. Be sure both of the mix and quantity of concrete you want and if there is more than one firm in your area, shop around for a competitive quotation.

If you are mixing the concrete yourself, the volume of concrete you will get will be roughly equal to the volume of the aggregate (only). Do your mixing on level ground as near as possible to where the drive or path is to be laid.

Setting out
You will find it helpful to choose a site which is more or less level: ground which is heavily sloping calls for more involved concreting techniques, covered further on in the masonry course.

If you are working from an existing house wall, take this as your base setting-out line and take other measurements from it. If not, drive in two wooden pegs and stretch a length of masons' line or twine between them. Ensure that the pegs are well outside either side of the work area.

Your second setting-out line will run at right-angles to the baseline and mark one side of the project (fig. C). Having measured and marked where the line will cross the baseline

A. *Make a builder's square by nailing together offcuts of wood—vertical 300mm, horizontal 400mm and the diagonal 500mm*
B. *A length of 100 x 50mm timber and offcut handles makes a good tamping beam for compressing wet concrete*

(or wall), set it up with pegs and line. Use a builder's square (see above) to ensure that the angle between the two lines is exactly 90 degrees.

The third line—marking another side of the project—should run parallel to the baseline. Measure out from both sides to the baseline to ensure that this is so then set up the pegs and line. Again, use the builder's square to check that the corner with the second line is 90 degrees.

The fourth line—marking the final side of the project—runs parallel with the second. Measure and set it out in the same way as the others so that you have an arrangement similar to that shown in fig. C.

As a final check to ensure that the corners of the project will be square, measure across the diagonals. If the measurements are not exactly the same, adjust the positions of the pegs accordingly.

Preparing the site
Start by removing all obstructions and traces of vegetation—such as weeds and roots—from within the boundaries of the site. If there are some areas of existing concrete on-site, these must be broken up into rubble with a pick.

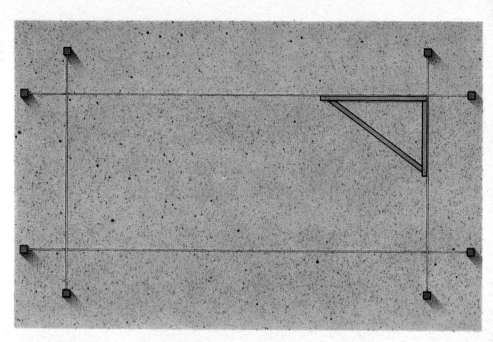

C. *Use the builder's square to ensure that the setting out lines are perfectly square*

To get the site level, you need a straight piece of timber 2-3m long and a supply of wooden pegs, about half as long again as your proposed depth of concrete.

Decide where you want the final level of the concrete to be—normally **against a lawn or base of the house**—then drive one of the pegs into the ground on the edge of the site. The top of the peg will mark the final level of the concrete and is known as the datum. Ensure that the finished level of the concrete is a minimum of 150mm below any adjacent damp proof course—also that the concrete slopes away from the house in about a 1:60 fall to deal with surface water.

Use the straight piece of timber and

a spirit level to check the height of the peg against the point you are taking your level from.

The site can now be excavated to the required depth, working away from the datum peg. As you progress, more pegs must be driven in to help you keep an eye on both the level and depth of the site. The pegs should be no further than the length of your straight edge away from each other—or from the datum peg.

You can then check each peg for level with a straight edge and spirit level.

Once the whole site is pegged out in this way, you can measure down the pegs to the required depth of concrete and level off the ground at this point. Keep the edges of the site sharp and in line with the setting out lines.

Foundations such as driveways which are going to bear the weight of

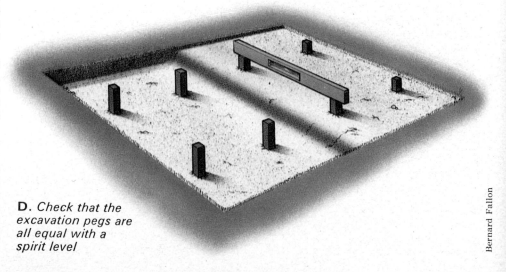

D. *Check that the excavation pegs are all equal with a spirit level*

Bernard Fallon

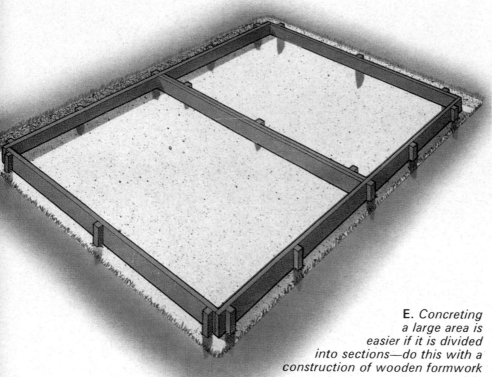

1 If necessary, the wire mesh for loadbearing foundations can be cut to size. Before concreting, box in obstructions such as drains

E. Concreting a large area is easier if it is divided into sections—do this with a construction of wooden formwork

a car need to be strengthened. This is done with wire mesh of about 3mm diameter which can be cut to size with bolt cutters (fig. 1).

At this stage, any obstructions on the site, such as drains, should be boxed off to prevent them being concreted over (fig. 1). Remove the box and concrete round the edges when all the foundations are down.

Lay the mesh down on lengths of timber—which are level with your setting-out lines—prior to concreting. Nail another length of timber on top of the first to hold the mesh in place while concreting the various sections (fig. 2). These lengths of timber act as the sectioning formwork necessary for concreting large areas. They should be removed after the adjacent section has been concreted.

Constructing the formwork
The purpose of formwork (fig. E) is to stop the wet concrete from spilling haphazardly over the boundaries of the site. It can also be used to split large sites into smaller areas, which can then be concreted in stages.

Make the formwork from lengths of timber, as wide as the depth of your concrete and about 25mm thick. Place them around the boundaries of the site, butted end to end so that there are no gaps.

To hold the timber in place, drive in more wooden pegs against the

outside faces (fig. 3) then nail all the pieces together.

If a large area is to be concreted or if the concrete is to run up to an existing wall, more formwork must be used to divide the site into sections of about 2m². This will enable you to lay and level one section before starting on the next.

Where a path is being laid along a wall, the site should be divided into 'bays' (fig. E). Alternate bays can be filled, levelled and left to harden: you can then stand on them to fill and level the intervening bays.

Construct the sectioning formwork in the same way as that for the boundaries of the site. Remember to drive in the support pegs on the opposite side of the sectioning formwork to that being filled.

When all the formwork is in place (fig. 4), use the straight edge and spirit level to check that the top edges of the boards are level with the tops of your marker pegs (fig. 5).

Concreting
The actual job of concreting will be much easier if you have an assistant to help you. If the concrete is being delivered ready-mixed, make sure that the formwork is ready and the ground fully levelled off.

Shovel in the concrete by hand and level it off roughly 15mm above the height of the formwork (fig. 6).

2 Lay the wire mesh on lengths of timber which have been checked for level and then another length on top to hold the mesh in place

3 Drive in wooden pegs against either side of the formwork and then nail all the pieces together to make a secure construction

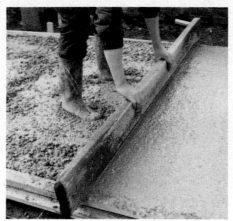

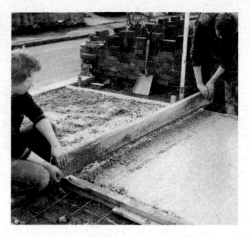

4 *All the formwork is in place— including the sectioning timber— ready for the first bay to be filled with the prepared concrete*

7 *Use a heavy length of timber as a tamping beam. To be effective, the beam must be at least 150mm longer than the width of the bay*

8 *With the help of an assistant, run the beam over the freshly concreted section in a chopping motion to give a rippled effect*

When you have filled a section, the concrete must be compressed, or tamped.

The tool for doing this is called a tamping beam. You can make one from a length of 100mm x 50mm timber with wood offcut handles at either end. The tamping beam should be at least 150mm longer than the width of the section (fig. 7).

With the aid of an assistant, run the beam over the freshly concreted section in a sawing, chopping motion. The weight of the beam should be enough to tamp the concrete down to the height of the formwork, while the 'chops' will give the surface a

rippled effect (fig. 8).

The distance you leave between 'chops' depends on how rippled a surface you want: the normal allowance is half the thickness of the beam.

If the tamping shows up any low spots, fill them immediately and re-tamp. When you are happy with the surface, two passes of the beam should be sufficient to complete the tamping process.

The final surface

This can be left as it is—rippled—roughened, or smoothed. For a rough surface, brush over the concrete with a stiff broom. To smooth the surface

5 *Use a straight edge and spirit level to check that the top edges of the boards are level with the top of the marker pegs*

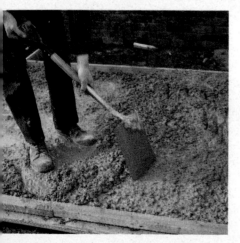

6 *Shovel the concrete into the first bay and level it off to about 15mm above the formwork. It can then be tamped down level*

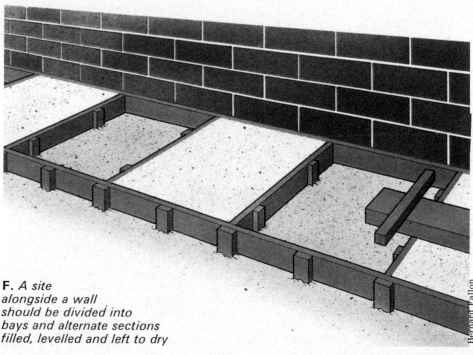

F. *A site alongside a wall should be divided into bays and alternate sections filled, levelled and left to dry*

Bernard Fallon

287

9 When one section is finished, remove the sectioning formwork between the first and the next. Then concrete this section as before

10 After the concrete of these alternate sections has set, remove all the formwork and fill in the last intervening bay

11 A steel edging trowel should be used to smooth off the edges of the concrete to give the foundation a good, smooth finish

12 Freshly-laid concrete needs at least a week to dry out—longer in damp weather—and heavy loads should be kept off it for ten days

skim it over with a piece of timber or (better) a plasterer's wooden float.

Concreting subsequent sections

If you must complete the concreting in one go, you will need to provide expansion joints so that the concrete does not crack as it dries out. To do this, make up your sectioning formwork in the usual way. With the first section poured, place a thin (say, 9mm) board against the next length of sectioning formwork and check it for level. When you have poured the second section, carefully remove the formwork, but leave the thinner board permanently in place. Repeat this procedure for subsequent sections.

If you are concreting in 'bays' fill in alternate sections with the sectioning formwork left in place. After the concrete has hardened (see below), remove the formwork and fill in the intervening sections (fig. 10).

Use a steel edging trowel to flatten down the edges of the concrete for a really neat finish (fig. 11).

Drying

The freshly-laid concrete (fig. 12) should be given at least a week to 'cure'—longer if the weather is especially cold or damp. Heavy loads should be kept off it for seven to ten days.

In warm weather, the concrete must be prevented from drying too quickly. Do this by covering the whole site with dampened sacking or a similar material. Every day, sprinkle the covering with water to keep it moist.

In cold, wet weather, the concrete will be more in danger of frost than of drying too quickly. To guard against this, cover it with sheets of heavy-duty polythene or waterproof building paper.

Laying crazy paving

Laying crazy paving provides an id opportunity to demonstrate your art tic abilities, to use up oddments paving slabs and form an attract design with random shapes.

It is a most economical way laying a path as even the small oddments of paving slab can be us up. These should, however, be ke towards the centre of the path with larger pieces around the edges, that maximum support is given to structure.

The foundations are laid in the sa way as for all raft foundations a since these provide a good, firm ba almost any type of paving slab can used to form the crazy, jigsaw patte

If the site of the path is on very fi ground and it is not likely to take a great load, the 100mm of concr need not be laid. The paving slabs be put straight down on the bed lime and damp sand.

The most important part of all su foundation work is to constar check that the site is level. Check it you excavate the site, as you lay hardcore and the mortar bed, a finally as you lay down the pav slabs. Careless work at this stage ruin the finished look of the path.

To make doubly sure that the p is level across its length as well as width, use the spirit level and bo across pegs A-B as well as A B-B, C-C and so on.

It is even more important that path is allowed to set for a few d before any weight is put on it, oth wise the foundations may be disturb and all your good levelling work g to waste.

Crazy paving looks good in garden—front or back—and can made even more attractive by giv it curves. A curved crazy path is more difficult to lay than a straight o It just takes a little more patience find the right pieces to fit the jigs puzzle.

Crazy paving is also one of the f external constructions which loc better as it gets older. Moss a lichen may grow between the point but this only makes the path look m attractive.

① Use wooden pegs 50×50×450mm and building line to set out path. Line is fixed at identical distances from top of all pegs. The line indicates top outer finished edges of path

50mm

N.B. 100mm concrete (1 cement : 5 all in ballast) should be laid over hardcore before laying lime mortar and paving. For extra strength steel reinforcing mesh will ensure stability and long life, especially if the path is to be load bearing

A

A

B

B

5A

② Excavate required depth of path, approx. 250-270 mm

③ Back fill with 100mm well tamped hardcore, leveled with shingle or clinker

④ Lay screed 38-50mm thick of damp sand/lime mix (8 sand - 1 lime)

⑤ Using pieces of stone with straight edges set out edges tamping down each stone until level with building line.

5A Use a small boat level to assist accurate laying

⑥ Fill with more stone using board and spirit level to maintain horizontal plane

⑦ Allow to set for 2 or 3 days

⑧ Point inbetween stones with 1:4 cement/sand

⑨ Clean stones with dry brush before cement sets

Bill McLaughlin

Advertising Arts

289

Rendering a wall

● Checking render damage ● Preparing the wall ● Setting out with boards ● Internal and external corners ● Door and window reveals ● Applying the render ● Giving the wall a decorative or extra protective finish

Render, sometimes called stucco, is a sand and cement covering applied to the outside walls of some houses—both for decoration and for protection. Most types of exterior wall can be covered with render—brickwork, blockwork, concrete, even timber-framed constructions. Once prepared the wall then can be given a number of attractive finishes ranging from plain stucco to pebbledash (see pages 343 to 348).

Damaged render
Even if it has been applied correctly, render has a habit of working its way loose over a time. Small cracks caused by frost or accidental damage can quickly develop into large 'blown' areas where the material has broken away from the backing.

If you have an existing rendered wall in need of repair, your first task is to assess the extent of the damage. Large surface splits and areas of missing render are easily spotted. What is less obvious are the places where the render has 'blown' or parted company with brickwork but without falling down or splitting.

Check the whole wall carefully, working systematically from top to bottom. Tap the render with the handle of a hammer: a hollow sound will indicate areas where the material has 'blown'. You should also make a note of where the surface is pitted or —in the case of decorative finishes such as pebbledash—where the decorative chippings are missing.

If, after extensive checks, you discover that damage is fairly limited, repairs can easily be carried out by hacking away the affected render and then making good (see pages 343 to 348). But if practically all the render on the wall is defective, you have no option but to start from scratch.

Removing old render
Before removing the old surface

A. Right: *A rendered wall can be given a decorative finish—such as pebbledash—which also helps to waterproof and strengthen it*

material, make sure you have a safe platform to work from. Except for the very smallest and very largest areas of wall, a scaffold tower is probably the best and safest type of equipment to use.

Damaged rendering will usually hack off easily with a bolster chisel—for quickest results, and to avoid damaging the surface underneath, hold the chisel almost parallel to the wall as you make your blows.

Preparing a timber-framed wall
Whether you are rendering a wall for the first time or carrying out repairs to one that has already been rendered,

it is important to prepare the wall thoroughly. If the substrate is unsound, the render cannot be applied properly and all your work will be completely wasted.

On a timber-framed wall, render is held in place by being forced through a fine wire mesh. The mesh is fixed to the framing studs with plenty of large-headed galvanised nails or staples. There should at least be a sheathing of building paper behind the mesh, and preferably a timber sheathing as well.

Check that these components are present, and in good condition, and renew as necessary. Now is also a good time to check the framing itself for decay and dampness. If timbers need to be renewed, make sure they (and the rest of the framing) are properly treated with preservative.

Preparing a masonry wall
A sound surface is just as important on

290

a masonry wall. First, clean off any small pieces of render that remain stuck to the wall by raking the blade of the bolster across the surface. If any of the bricks are loose or broken these should be replaced before you continue the work.

Broken pointing does not need to be repaired—unless it is in a very bad state—since the first coat of render will fill all the available holes.

The next stage is to check that the wall is not unduly damp and that the DPCs are in position and working properly and efficiently. If you need to insert new DPCs, leave the wall to dry out for two to three weeks and check again for signs of damp before continuing with the work.

If the brickwork is smooth and flat, roughen it slightly with a hammer and bolster—this will help the render to adhere better. Work across the surface making a series of criss-cross patterns as you go until the whole wall is covered (fig. 2).

A badly flaking wall can also lead to poor adhesion. To prevent this brush the wall thoroughly with a wire brush

and then coat the surface with a proprietary stabilising solution suitable for brick and masonry. Leave this to dry according to the manufacturer's instructions, and apply a second coat if the surface is particularly bad.

Setting out
To guide your rendering work, divide up the wall into a number of bays using 12mm thick softwood battens. These will guarantee a smooth, level finish for the undercoat and can be removed once it has been applied.

Start by examining the face of the wall in close detail. If it bulges badly you should 'dub' out the low points with a thin skim of render first and leave it to dry before setting out the wall with battens.

If and when the wall is reasonably flat, lay a long straightedge across the face at various points, and by trial and error find and carefully mark the high spot. The first batten should be fixed vertically to the wall and run over the high spot so that all the other battens can be aligned with it. This ensures that the render is of uniform depth.

1 *Before rendering, check that the wall is free from damp. Flaking paint and loose dust should be removed with a wire brush*

Plan the layout of the battens carefully before fixing them in place. Ideally, they should be spaced roughly 1.5m apart—although the distance between battens will obviously vary near corners and around openings. With timber-framing, set the battens on every third or fourth stud.

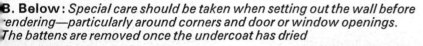

B. Below: *Special care should be taken when setting out the wall before rendering—particularly around corners and door or window openings. The battens are removed once the undercoat has dried*

internal corner

2 *If the wall is smooth and flat, roughen the brickwork slightly with a hammer and wide bolster to improve adhesion*

3 *In preparation for the undercoat, set out the wall with 12mm thick wooden battens. Space these at rough 1.5m intervals along the wall*

4 *Carefully align each batten using a spirit level before fixing them at top, bottom and in the middle with screws and wall plugs*

5 *On external corners, a batten should be fixed to the adjacent wall and its outside edge then aligned with the rest of the battens*

6 *Door and window openings are set out with battens fixed around the outside of the reveals—overlapping the leading edge by 12mm*

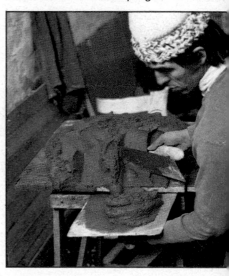

7 *Mix up the undercoat render on the spot board and transfer a manageable amount to a hawk using a plasterer's laying-on trowel*

The battens are secured in three places—top, bottom, and in the middle —using screws and fixing plugs drilled into the wall behind. This method may seem unnecessarily involved, but it does allow you to make minor adjustments to the distance from the wall of each batten so that it is aligned.

Fix one batten at a time, checking carefully that it is vertical with a spirit level. Then, as you work along the wall, check that the front edge of each new batten is level with the others by placing a long straightedge between them. If you find some of the battens are too hard against the wall, loosen the screws slightly and pack

small pieces of wood behind them to make up the difference.

Many walls contain doors and window openings as well as awkward corners. These need to be set out with special care to ensure a neat, professional finish.

Where two walls meet to form an internal angle, set them out as described above but make sure that the end battens are placed so that they butt against the adjoining wall (fig. B). If both walls are to be rendered, two battens should be positioned—one at the end of each wall.

Where two walls meet to form an external angle, setting out is more

complex. To guarantee a neat, right-angle finish, the end batten should be fixed to the adjacent wall using masonry or galvanized nails. This ensures that the undercoat can be taken right up to the corner and that the batten is easy to remove.

Use a piece of 50mm×12mm soft wood for the corner batten and secure it to the adjacent wall with masonry nails. Adjust its position carefully to ensure that it is proud of the external corner by about 12mm before you start driving in nails (fig. 5). Make sure that it is well secured to the adjacent corner and aligned with the rest of the battens on the wall.

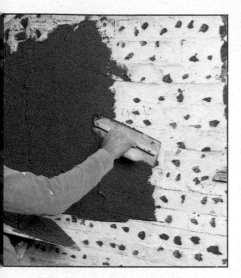

8 *Move to the wall. Starting near the centre of each bay, use the blade of the trowel to apply the render in wide sweeps*

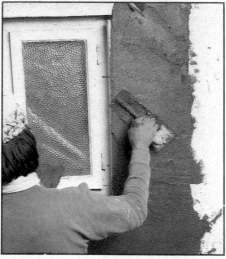

9 *Around door and window openings, work right up to the edge of the reveals using the setting-out boards as a guide*

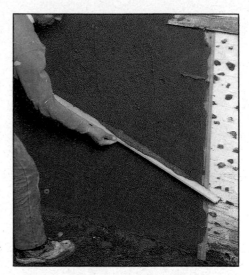

10 *As you complete each bay, place a straightedge across the front. Slide it backwards and forwards to remove excess render*

11 *The surface of the undercoat must be scratched to aid adhesion. This can be done as the render dries or once it has set*

12 *Leave the render to harden for two to three hours. Then remove each of the battens, taking care not to disturb the material*

13 *Use a laying-on trowel to carefully render the insides of the reveals. Try to maintain a smooth, clean line around outside corners*

Door and window openings are set out with battens fixed around the outside of the reveals. These should overlap the leading edge of a reveal by 12mm so that they can be aligned with the battens on the wall (fig. 6). The outside wall can then be rendered right up to the edge of each opening using the battens around the reveal as an accurate guide.

The inside of the reveal must be tackled when the render on the outside wall has dried. A builder's square, consisting of three pieces of wood formed into a right-angle, should be used to guide and assist your work. This is held against the door or window frame so that the render can be checked.

Applying the undercoat

Once the wall is correctly set out, the next stage is to mix up the mortar for the undercoat. The amount you need depends on the area to be covered, but as a rough guide 10 litres of mortar should cover about 5m² of wall. If you have a large wall to render, it may be worth hiring a cement mixer to make the work easier.

Care taken at the mixing stage will ensure that the mortar adheres well and is waterproofed correctly. The standard mix for roughcast or tex-tured render is one part cement to four of sharp, washed sand. For a finer, stucco finish use one part cement to six of sand—with one part hydrated lime to make the render less brittle. Whatever the mix, add a waterproofing agent to the mixing water in accordance with the manufacturer's instructions to prevent the intrusion of damp.

To apply the render mortar you need the same tools as those that are necessary to completely plaster a wall. Mix up a manageable amount and transfer all of it to a spot board placed conveniently close to the site. Then scrape about a third of it on to a

hawk, using a plasterer's laying-on trowel (fig. 7).

Move to the wall, tilt the hawk upwards and scrape a small pat of mortar on to the trowel, holding the blade horizontally so that the load is carefully balanced on top. Start near the centre of each bay and work out towards the edges. Use the blade of the trowel to push the plaster on to the brickwork (fig. 8) or force it right into the wire mesh. Build up the correct thickness in layers.

Once you have filled each bay, you can level off the material and refill any low spots. To do this, hold a straight-edge across the battens on each side of the bay. By sliding it backwards and forwards over the whole area, you should be able to remove excess mortar and spot low areas which need to be refilled (fig. 10).

After the whole wall has been covered, leave the mortar to dry for about one hour and then carefully remove the setting out battens (fig. 12). Take care that no material is pulled away while you are doing this, particularly around corners and door or window openings.

The inside of the reveals should be covered next. Apply a thin coat the same thickness as that on the main wall using the laying-on trowel.

After two or three hours—or when the mortar is nearly dry—fill the gaps left by the battens with fresh material up to the level of the existing under-coat (fig. 15).

With timber-framed walls a second undercoat, applied 24 to 48 hours after the first, is usually necessary. Before applying the second undercoat (or a topcoat) scratch the underlying surface to improve adhesion (fig. 11).

In hot, dry climates, the undercoats should be kept dampened with a very fine mist of water for a couple of days to ensure proper curing, and left to dry for a further five days before the top-coat is applied.

Never apply rendering during cold weather unless you can keep the mix warm.

Top coat application

Once the surface has been thoroughly roughened, wet it down to help the topcoat to adhere even better. Try to dampen the surface without soaking it—a large paint or distemper brush and a bucket of clean water are ideal for the job.

The topcoat should be applied directly to the undercoat without using any setting out battens as guides. And if the undercoat has been applied correctly, the topcoat need be only a few millimetres thick to give a perfect, level finish.

Mix up enough material—in the same proportions as the undercoat—to give roughly a 5mm overall covering. Make the mix slightly creamier so that it is easier to spread across the surface (fig. 16).

Transfer all the material to the spot board and from there scrape a manageable amount on to the hawk. Apply the mortar with the laying-on trowel using firm, upward sweeps until the whole area—including the reveals—has been covered.

To give a smooth finish, wet the laying-on trowel and run it over the surface to remove any small ridges. Take special care around corners and where reveals meet the outside wall. Special corner tools can be used to guarantee the correct angle on internal and external corners.

Finishing off

Unless you want a stucco—or *flat*—finish, the wall should be textured or covered with stones before the mortar dries. Try to prepare the tools and materials needed for this before you apply the topcoat; if the wall dries out too quickly, wet it down again with a brush and a bucket of clean water.

14 *Hold a builder's square against the door or window frame to check that the render is correctly aligned—and adjust as necessary*

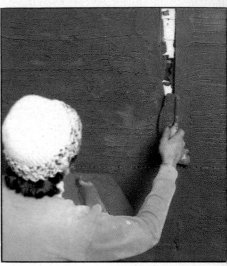

15 *Once the render has set, mix up some fresh mortar and use it to fill the gaps left by the removal of the setting-out battens*

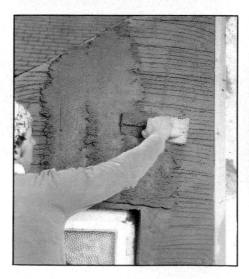

16 *Apply a 5mm thick topcoat. If you want a decorative finish —such as pebbledash—cover only a small area at a time*

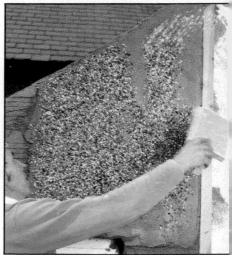

17 *Before the render dries, stand close to the wall and throw the stones hard at the render which you have just applied*

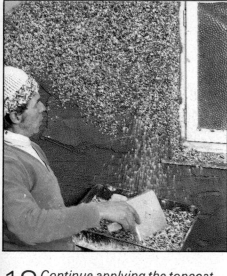

18 *Continue applying the topcoat render and small stones until the whole wall has been covered evenly and smoothly*

19 *The pebbledash finish may not adhere well around door and window openings: press the stones into the render with a laying-on trowel*

20 *Stray render on door and window frames should be left to dry out and then cleaned off with a large paintbrush and clean water*

Render defects

Damaged topcoat

Pebbledash and roughcast renderings are very durable but like many building materials they eventually weather and need to be repaired. Wind and driving rain can—over a period of time—work the small chippings loose, creating bald patches.

If the rest of render is sound cut each of the bald patches back to sound brickwork and repair (see pages 343 to 348). In cases where nearly all of the chippings on one stretch of wall have worked their way loose, a thin coating of render should be added over the top and the wall given a fresh decorative coating.

Blown render

If weathering is allowed to run its full course—or the wall behind the render is excessively damp—both the topcoat and the undercoat may part company with the wall.

'Blown' render can be tackled only after extensive tests have been carried out to determined whether the whole wall is affected or only small parts of it. Tap the wall with the handle of a hammer: a hollow sound will indicate where the render is loose. Each of the affected areas can then be cut back with a hammer and bolster. The DPCs on the wall below should be carefully checked before repairs take place—rising and penetrating damp can damage even new render.

C. *The effect of wind and driving rain on pebbledash: 'bald' patches develop (left) and on external corners the topcoat breaks away (right)*

D. *If the brickwork is damp or the render is applied incorrectly, either the topcoat (left) or both coats (right) can part company with the wall*

Cement Marketing Co. LTD.

Building a flat roof

● Calculating the best pitch ● Component parts of a flat roof ● Planning the work ● Setting the wall plate in position ● Fixing joist hangers ● Erecting rafters ● Securing and strengthening the roof timbers

Flat roofs are common on a large number of small buildings such as house extensions, garages and porches. Their popularity lies in the fact that they are easily constructed—the same lengths of timber serving as both rafters and ceiling joists—and are relatively inexpensive to build since fewer materials are required.

They are equally suited to buildings which stand on their own or to those, such as house extensions, which are attached to an existing building. And unlike pitched roofs they can be finished in a number of relatively inexpensive materials. Felt, for instance, is more easily laid than the more traditional slates or tiles but provides a resilient and waterproof roof covering.

Here the erection of the wall plates and rafters is covered. The next section of this project, deals with the actual roof covering.

Pitching a flat roof

Despite their name, flat roofs are never completely flat—they are built with a slight pitch or slope allowing rainwater to run off quickly. The exact amount of pitch varies greatly. The minimum pitch is 1:60, and may be as much as 1:6 or more before the roof technically becomes a lean-to.

However, the best pitch to aim for on most types of flat roof is around 1:36. This will allow rain to run away freely and at the same time provide a roof which is pleasing to look at.

Parts of a flat roof

Before attempting to build a flat roof, it is essential to understand the component parts:

Wall plates: These are lengths of timber 100mm wide and 50mm deep which are bedded on top of the side walls to form a level surface on which to support and secure the rafters. With masonry walls of the cavity type, the plates should be laid on top of the inner leaf and the brickwork on the outer wall built up level with the top of the timber plate to provide adequate support (fig. C). In a timber-framed house, the wall plate is simply another length of timber nailed to the top plate (see pages 193 to 199 for details of timber-framed walls).

Joist hangers: With many projects, your flat roof will be built against an existing wall of the house.

In the UK, the modern method of attaching the ends of the roof rafters to the side of this wall is by the use of special steel joist hangers which are built into the existing wall. These are available in a number of sizes, from large builders' merchants or timber yards, to accommodate any size of rafter (fig. A).

A second type of joist hanger is used to join rafters running at right-angles to one another. These are utilized to form a frame around a projection on the existing wall, such as a chimney or an external corner (fig. B).

Where the existing building is timber-framed, there are other methods

of attaching the roof joists to the side of the wall. If the building is brick-clad, with full-size bricks, then joist hangers may be used if these are available. An alternative method might be to remove the covering from the wall (this is easier if the wall covering is weatherboard or siding) and nail noggins—short horizontal timbers-between the studs of the wall. Then rest the ends of the roof rafters on the noggins and nail them securely in place.

Rafters/joists: On a flat roof, the same timbers usually act both as roof rafters and ceiling joists. They are normally set at 400mm centres; use only sound, well-seasoned timber.

Most rafters are 50mm thick, but their depth has to be carefully calculated according to the span of the roof

A. Below: *Use joist hangers to support rafters on an existing wall. Build each hanger into the wall and then nail or screw it to the end of the rafter*

rafters joist hangers

galvanized screws

1 *Begin by setting the wall plate on top of a thick bed of 1:3 mortar laid on top of the inner leaf of the cavity wall*

2 *Once the plate is in position, bed it down with gentle taps and carefully check for alignment with a spirit level*

UK RAFTER SIZES

Sizes of rafters for a flat roof if the rafters are spaced at 400mm centres

Roof span	Size of rafter
2.5m	100×50mm
3.0m	125×50mm
3.5m	150×50mm
4.0m	175×50mm
4.5m	200×50mm
5.0m	225×50mm

These dimensions are for roofs where limited access is required. For a sun roof you need rafters one size larger.

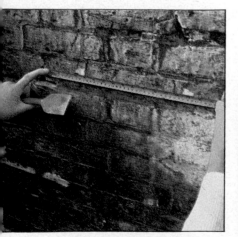

3 *Start from the middle of the adjoining wall and work outwards, marking the position of each hanger at 400mm centres*

4 *Use a plugging chisel and hammer to chop neat, well-tailored slots out of the brickwork to accommodate the hanger brackets*

and the load they are intended to bear. The panel above gives sizes for the UK; in Canada, joist sizes depend on the snow loads in your area, and on the quality and species of timber you use—they could be as much as twice those shown in the panel. Consult your local building code to find out the right size.

Another consideration is space for insulation. This is usually placed within the thickness of the rafters, and there must be a clear space between the top of the rafters and the bottom of the roof covering for ventilation—to prevent condensation forming and leading to rot. In the UK, 75mm to 100mm of insulation plus a 50mm air gap is usually sufficient, and all but the smallest rafters are deep enough to accommodate this (for the smallest spans you would have to use oversized rafters).

In Canada, though, the air gap should be at least 150mm, and insulation may be 200mm or more in thickness. Rather than use a solid rafter,

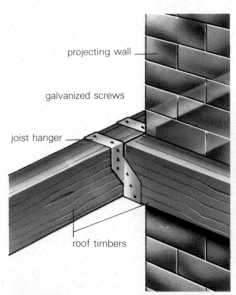

projecting wall

galvanized screws

joist hanger

roof timbers

Bernard Fallon

B. Left: *Use special joist hangers to connect any timber noggins running at right-angles to the main rafters*

Firring pieces: These are tapered lengths of timber the same width as the rafter to which they are fixed. They give the required pitch to the roof and mean that while the outside of the roof slopes to carry away rainwater, the internal ceiling actually remains level.

Where the pitch of the roof runs at right-angles to the rafters, you must decide which way you want the roof to slope and nail the firring pieces across the timbers accordingly.

Firring pieces can be cut on site using a circular power saw but this is often a tedious business and it is difficult to judge such fine angles accurately. It is far better to carefully work out the pitch of the roof beforehand and then ask the timber yard to cut a number of firring pieces for you while you are ordering the rest of the timber. Many timber merchants supply ready-cut firring pieces in a number of standard pitches and these must simply be cut to length.

Sarking: Decking or sarking is the name given to the timbers which cover the rafters and are used as a base for the final covering. Rough sawn timber of a suitable length, measuring roughly 150mm×25mm is usually employed, though tongued-and-grooved boarding gives better results. Sheets of 18mm chipboard coated with bitumen can be used as an alternative.

Fascias: These are wide boards fixed around the edge of the roof and nailed firmly to the ends of the rafters. As well as having a purely decorative function, they protect the roofing timbers from the intrusion of damp and provide a secure fixing for the guttering.

Soffits: These are timber coverings fixed to the underside of the rafters where they protrude beyond the wall of the building. They protect the roof timber from damp as well as stopping birds from nesting under the eaves and between the rafters.

Restraint straps: In a high wind, even the most solidly built roof is likely to suffer damage. Steel restraint straps—available from most builders' merchants—can be fixed across the tops of the rafters immediately above the line of the wall plates to help keep the roof intact under such conditions.

5 *Douse the inside of the slots with water, pack them with mortar and insert the hangers. Then point around the outside*

6 *Slot the head of each rafter into its hanger and secure it firmly with a number of galvanized nails or screws*

which could be getting on for 400mm deep, you could use flat trusses. Or you could nail a second set of rafters at right angles over the first, putting the insulation between the lower set, and having the air space in the upper set.

Strutting: Even wood which has been well seasoned will tend to warp when it is used as a rafter—to prevent this, wood or metal struts are used to make the whole structure more rigid. Special steel struts or pieces of 50mm×50mm timber can be used, fixed in an 'X' shape—see figs. D and 11. Solid timber *blocking* fixed squarely between the joists can also be used—but the timber must be less deep than the joists so as to maintain the right size of air gap (see above). Fix blocking so that its lower edge is flush with the lower edge of the joists.

7 *As you do this, make sure that the rafters run parallel to one another and that their position is marked on the wall plate*

8 *Insert noggins between rafters to accommodate roof windows or form a frame around projections on the adjoining wall*

The straps are about 25mm wide and are made in a variety of sizes so that the roof can easily be spanned using a number of them.

Planning the work
Time spent in calculating the type and amount of materials you need—as well as planning the type of roof you require—prevents expensive mistakes later on.

Start by working through the list of components (see above) and jot down the materials you require. Then calculate the pitch of the roof using a ratio of 1:36 and relating this to the span which needs to be covered. From this you can work out the angle of the firring pieces.

When calculating the number and type of rafters that you need, remember always to order one size larger if you are in any doubt about the load they might have to bear (see panel). All of the rafters should be at least 150mm longer than the span of the roof so that they can protrude over the edge and help stop damp and rain intruding into the upper brickwork.

Once you have compiled your list of necessary materials, try to select sound and well-seasoned wood from the timber yard—especially that for the rafters. Timber with large knots should be avoided and if the wood has not been tanalised or treated against rot and woodworm—leaving it a tell-tale green colour—it should be coated before fixing with a suitable wood preservative. Care needs to be taken to treat any wood which is cut during construction in the the same way. Pay special attention to end grains which are particularly prone to dry and wet rot

Setting the wall plate
Start the building work by putting the wall plates into position on top of the inner leaf of the supporting walls. Two plates are needed when dealing with a detached building and only one plate where the roof joins an existing wall.

It is best to prepare for the wall plates by leaving the inner leaf one course of bricks lower than the outer skin. Once a thick bed of mortar is laid on top of the inner leaf, the wall plate should be exactly level with the outside wall when it is in place.

Mix up a 1:3 mortar and trowel it thickly across the top of the inner leaf, taking care not to allow any mixture to drop into the cavity (fig. 1). While the mortar is still wet, lift the plate into position and place it

squarely on top of the inner leaf. By tapping it gently with the heel of the trowel handle it should be possible to bed it correctly (fig. 2).

Use a spirit level to ensure that it is perfectly aligned with the outer leaf and then scrape away excess mortar with the blade of the trowel. If the plate is found to be too low, remove it and add more mortar before continuing work.

Fixing joist hangers
While the mortar sets beneath the wall plate, you can fix joist hangers along the existing wall, if this is the method of attachment you are using. First, measure the distance from the floor to the top of the wall plate on the opposite wall. If the floor is level this measurement should be transferred across to the other wall and used as a guide for positioning the joist hangers.

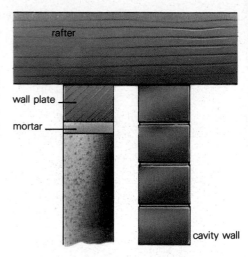

C. Above: *At the eaves, each rafter rests on a plate bedded on the inner leaf. Make the top of the plate exactly level with the outer wall*

9 *To fit the noggins use special hangers designed to connect roof timbers meeting at right-angles to one another*

10 *Strengthen the roof timbers with steel or wooden struts nailed between the rafters in a line midway across the span*

11 *Form these into an 'X' shape using two wooden battens. Taper their ends to make it easier to nail them to the rafters*

12 *Further strengthen the roof by adding a restraining strap across its lower end. Lay this in place and carefully mark its position*

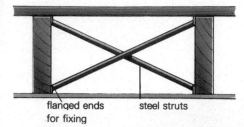

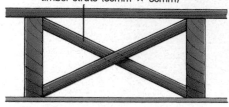

flanged ends for fixing steel struts

timber struts (50mm × 50mm)

Bernard Fallon

D. Top: *Ready-made steel cross struts for roof strengthening*
Bottom: *Cross struts made up from pieces of solid timber*

13 *Saw down through the marks according to the depth of the strap and chop out a channel across the rafters*

14 *Once the channel has been cut, drop the restraining strap into position and secure it with more galvanized screws*

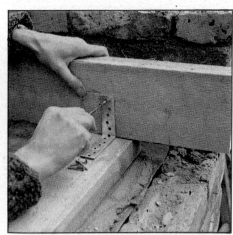

15 *At the lower end of the roof, attach each of the rafters to the wall plate with right-angle steel brackets*

Start from the centre of the wall and work towards both ends, marking where the holes are to be cut out. The centre of each hanger should be 400mm apart and the bottom of each hanger exactly level with the top of the wall plate on the opposite wall.

Once you have marked and checked each of the hanger positions and are confident that they are aligned exactly, start to cut out the slots using a plugging chisel and a hammer. Be sure to wear safety glasses when doing this to protect your eyes from dust and flying masonry (fig. 4).

The holes should be about 75mm wide, the depth of a hanger bracket and run about 65mm into the brickwork. Try to widen them towards the back so that mortar can more easily be inserted once the hangers are positioned.

If any holes prove difficult to cut due to the hardness of the brick, use a power drill fitted with a masonry bit to make a number of holes along the line of each slot. Then use a plugging chisel and a club hammer to cut away the brickwork joining the holes to leave a neat, well-tailored slot to accommodate the bracket.

Once all of the holes have been cut, and the hanger tried for size, make sure that each cavity is free of dirt and loose particles. Any dust that is difficult to reach can be removed by using an old plastic detergent bottle as a bellows to blow the hole clean. Then fill the container with water and use it to douse all of the brickwork around the inside of the hole. This will wash away any traces of loose dust and help the mortar to adhere once it is pushed into the slots.

To bed the hangers into position, prepare a 1:3 mix of mortar and use a trowel to feed the material into each hole until it is about 10mm from the opening (fig. 5). While the mixture is still pliable, drive each of the hangers in turn into place and adjust their final position by inserting pieces of slate coated with mortar around the edges of the aperture.

Once you are certain that the hangers are aligned correctly, point around the outside with mortar and leave both the wall plates and hangers to set for at least 24 hours before fitting the rafters.

Erecting the rafters
Once both the wall plate and the joist hangers are firmly in position, each of the rafters in turn should be slotted into place, fixed into the hangers, and rested on top of the plate. Leave the rafters overhanging the eaves by at least 150mm so that they can later be cut to length.

Check that the rafters are correctly aligned and exactly parallel to one another by measuring the distance between them at top and bottom (fig. 7). Mark their positions with chalk on the top of the wall plate in case they are accidentally displaced later while you are working.

The rafters should be secured with pairs of struts nailed between the facing sides (fig. 11). Position the struts in a line mid-way across the span and fix them with galvanized nails, hammered through into the rafters themselves (fig. 12).

The structure should be further strengthened at this stage by fixing restraining straps across the top of the rafters directly above the line of the wall plate. The straps should be indented into the woodwork so that a level surface is maintained for the decking. Do this by marking where each of the straps crosses the rafters and then chiselling a channel to accommodate them (fig. 13). Secure the straps to the rafter and the wall using sheradized screws and wall plugs.

Finally, to prepare the roof for almost any eventuality—such as a high wind—strengthen it further by attaching the foot of the rafters to the wall plate. Although this is often done by skew nailing through the lower end of each rafter into the wall plate below, a much neater method is to use right-angle steel brackets. Place these in position and use galvanized nails or screws to fix them both into the side of each rafter and to the top of the plate (this is shown in fig. 15).

Completing the roof

Below left: *Layers of roofing felt, bonded to each other and to the boards below with hot bitumen, make a practical and long-lasting roof covering*

Cutting and trimming rafters ● Fascias and soffits ● Securing firrings and sarking ● Butting a roof against an adjoining wall ● Using roofing felt and hot bitumen ● Insulation

The previous roofing section on constructing a flat roof showed how to set up the wall plates and joist hangers and erect the rafters. In this, the second and final part, the decking is fixed in place, bitumen felt laid and the roof made watertight.

Trimming the rafters

If the rafters have been erected correctly, they should protrude well beyond the eaves and your first job is to cut them to length. The exact distance depends on a number of factors including the height of the building, the area and pitch of the roof, and also how the building is to look once it is finished. If you are building an extension, the figure should be specified in the plans. But as a general guide, the roof should run about 100mm beyond the eaves. This protects the top of the wall from penetrating damp. In Canada, the overhang is typically 450mm to 600mm.

It is important to mark and cut the rafters accurately so that the roof line is left level and square. To do

this, first measure and mark the two end rafters to the correct length using a try square and plumb line as a guide (fig. 1). Then stretch a chalk line along the top of the roof between these two marks.

If the line is pulled tight and then plucked, it will leave a mark across the top of the rafters so that each can be squared off accurately. This mark can then be transferred onto the vertical face of each rafter—again using a plumb line—so that the timber can be sawn accurately (fig. 2).

Where your building plans specify that the roof projects on more than one side of the building, this can be achieved by skew nailing stub noggins the same size as the rafters at right-angles to the main roof. These are spaced at 400mm centres and laid on a wall plate bedded on the inner leaf of the side wall (see pages 296 to 300). A new rafter is then nailed across the ends of the noggins, which are cut to length so that the new roof protrudes over the eaves by the right amount (fig. B).

Fascias and soffits

To provide a clean cut finish to the edge of the roof and to help protect it from the rain, fascia boards and soffits should be fixed to each overhang before the timbers are covered. You can use floorboarding for these, providing they are at least 25mm deep to give them protection against the weather. Further waterproofing should be provided by applying a clear preservative and an undercoat of paint to the timber before it is fixed in place —a topcoat can be added once the roof is finished.

Attach the boarding with galvanized nails across the bottom of the roof and under the eaves, but leave a small 10mm gap between the back of the soffit board and the wall to help ventilate the roof. Finally, fix a batten of wood 25mm deep and 50mm wide along the top edge of the eaves. This will be used later to secure the felt tightly around the front edge of the roof.

A. Top right: *Where the roof slope is in line with the rafters, tapered firring pieces must be fixed along the rafter tops.* **Bottom right:** *Where the fall is across the rafters, firring is secured at right-angles to them*

Ray Duns

1 *A chalked cutting line is marked along the top edges of the rafters. Transfer this to one side face with a try square*

2 *With cutting lines marked on two sides of each rafter, you are ready to saw them to length. Make sure the cuts are kept square*

3 *Firrings can be positioned either at right-angles or in line with the rafters, depending on which way the roof is to slope*

4 *If you are using bituminized roof boards, cut them with a power saw set to the depth of the timber only and work from the underside*

Firrings and sarking

Once all the main roof timbers are in position, fix the firring pieces with galvanized nails (fig. 3). These can run at right-angles to the main timbers or be placed directly on top of the rafters, according to how you want the roof to slope. But if you nail them across the rafters, spacing should not be more than 300mm because of the increased loadbearing factor.

With the firring pieces positioned, nail sarking (sheathing) on top to form a firm base for the felt covering. The sarking can consist of boarding or impregnated roofing chipboard or, in Canada, sheathing-grade plywood.

When using flat or tongued-and-grooved boarding, start from the bottom of the roof and work upwards, driving two nails into each board where it crosses a rafter. If you hammer each nail in at an angle, the boards will be held more securely and the head will sink into the surface (fig. 8). Tongued-and-grooved boarding should be cramped during fixing to stop the joints from spreading.

Flat boards have a tendency to ride up and warp even if they are nailed securely, but this can be avoided by nailing them heart side downwards.

If you are using chipboard or plywood to cover the roof timbers, this is usually supplied in standard sheet

B. Below: *Both rafters and stub-noggins are set on wall-plates and overhang the end wall. Once in place, these must be cut to size*

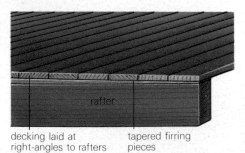

decking laid at right-angles to rafters

tapered firring pieces

rafter

decking laid parallel to rafters

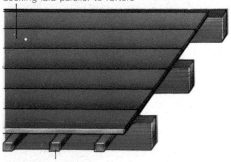

firring pieces laid at right-angles across rafters

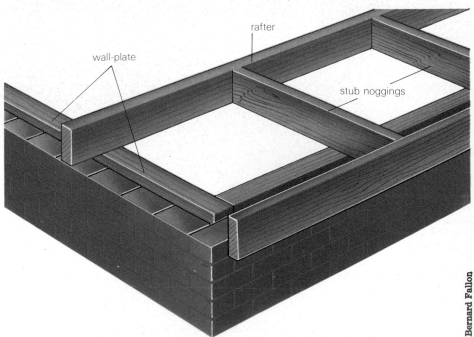

wall-plate

rafter

stub noggings

Bernard Fallon

5 Afterwards, sever the felt layer with a sharp handyman's knife. Bend up the waste edge of the board to act as a cutting guide

6 The final section of boarding must butt tightly against the others. If necessary, use scribing techniques to ensure this is so

7 A jig saw is indispensable for cutting access holes for pipes and other fixtures. Make these once the sarking is in place

sizes and must be tailored to fit. The sheets should meet half way across a rafter and be fixed at regular intervals with galvanized nails in a similar way to the boarding.

Tying in the roof

If the roof butts against a masonry wall, you should, at this stage, cut a channel—or *chase*—into which you can insert flashing once the roofing felt has been laid. Doing this before you apply the final covering stops dirt and dust getting mixed up with the felt and bitumen.

The chase must run through a bed joint in the brickwork of the adjoining wall, approximately 150mm above the sarking to prevent rain splashing up from the roof during a heavy storm and intruding into the wall below.

Cut out the chase with a hammer and a plugging chisel or bolster, wearing safety glasses to protect your eyes. Dig out the mortar and chop away the brickwork with a bolster above the joint to form a channel 25mm wide and about 40mm deep (fig. D). Once you have cut a neat groove all along the wall, and made sure that it is brushed free of any dirt and loose material, you can proceed to lay the roofing felt.

Applying the felt

Although sheet metal is often used to cover a flat roof, felt is far more popular since it is inexpensive, easy to lay and yet provides a resilient waterproof covering. It is usually laid in at least three courses: an underlay fixed with nails, followed by two layers bonded with hot bitumen.

The felt will be more manageable

8 Hammer the galvanized nails that secure the decking to the rafters at a slight angle. This makes the fixing more secure and buries the heads

9 In some cases quadrant beading will have to be placed against vertical walls over which the felt is to run. Use a mitre-block to cut it

and contain less creases if it is unrolled and left for 24 hours before fixing. To save space, cut it roughly to length as you unroll it then stack the lengths, one on top of the other, in some suitable outdoor space.

Do the cutting with either a sharp handyman's knife or the blade of a plasterer's trowel. By running either of these along a metal straightedge, the felt can be scored and then picked up and cleanly broken.

In order to make the roof completely watertight, a number of flashings are required; these can either be bought ready-made in a number of standard sizes or formed from bendable rolls of galvanized zinc. For a typical roof adjoining another building, you need three flashings—two 150mm wide and another 250mm wide —long enough to stretch the width of

10 Secure the beading hard against vertical faces and nail firmly to the decking. Always use galvanized nails and nail at a slight angle

the roof. These should be prepared before you lay the felt so that they are ready to fix in position.

Since a large quantity of bitumen must be heated to fix the flashings and top layers of felt, hire a specially-made gas burner, pot and galvanized bucket for the purpose; attempting to fix up some type of home-made equipment is dangerous and makes the whole job more difficult.

When mixing and handling the bitumen—which comes in the form of large hard lumps before it is heated—take special precautions to prevent any of it accidentally spilling and coming into contact with bare skin. Wear a sturdy pair of boots to protect your feet and heavy-duty rubber gloves with sleeves rolled down to cover your hands and arms. Use the galvanized bucket to carefully trans-

fer the material once it is heated.

How you fix the felt at the edge of the roof depends on how your roof is designed. If the sides are capped by parapet walls, try to keep all three layers of felt as close to the base of the parapet as possible so that a flashing can be inserted once the roof has been covered (see below). Where the roof protrudes at the sides or is detached, lap each layer of felt over the edge by 75mm and nail it to the fascia.

Lay the first layer of felt directly on top of the sarking. Start from the edge of the roof and unroll it in the opposite direction to the fall, random nailing as you go with galvanized nails spaced at 150mm centres.

Lengths should overlap each other by at least 75mm, each overlap being nailed firmly to the sarking below. Once you reach the top of the roof,

cut each length to size and allow it to ride up the adjoining wall by 25mm.

The next stage is to fix the two smaller flashings in position at right-angles, one along the top of the eaves, the other where the roof butts against the adjoining wall. Pour a small quantity of the hot bitumen onto the flashings, then carefully lift them into place and push hard against the roof surface to bed the material securely.

Now lay the second layer of felt, starting from the top of the flashing you have just fixed at the eaves. Pour a thin coating of bitumen on top of the roof just in front of where you are working and unroll the felt slowly on to it, adding more bitumen as you go. Take special care to overlap adjoining lengths neatly so that you do not leave unsightly lines which might show through once the roof is finished.

11 *Where bituminized boards are used, butt joints first need to be covered. Amply coat the joints with bitumen and work it into the gaps*

12 *Allow plenty of overlap for the covering strips. Make sure each strip is well bedded in hot bitumen and avoid creating wrinkles and bumps*

13 *Before you lay any roofing felt on the decking, make sure that the surface is absolutely clear of dirt, by brushing with a stiff broom*

14 *When scoring roofing felt, use a sharp handyman's knife and always work against a straightedge. On long runs, secure the latter with cramps*

15 *Once scored, the roofing felt can be broken along the cut line by turning the edge on to the cut side. Make sure the scoring is deep enough*

16 *Cut the individual pieces of felt and loose-lay them to ensure a correct fit. Allow a minimum overlap of 75mm between each piece*

17 The first layer of felt is laid level with the quadrant fillet. The second and third are taken higher— level with or into the flashing slot

18 Each layer of felt should be laid tightly on top of the previous one. You must work quickly, to ensure good bonding before the bitumen sets

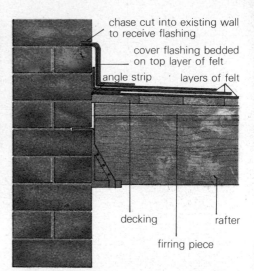

chase cut into existing wall to receive flashing

cover flashing bedded on top layer of felt

angle strip layers of felt

decking rafter

firring piece

19 Pour a small quantity of bitumen in front of you as you unroll the roofing felt. Take care to avoid any creases and bumps in the material

20 Small 'drip rolls' must be laid along the fascia as shown. Bed them on to hot bitumen and secure with large-headed galvanized nails

D. Above: *The butting end of a flat roof showing how flashing is chased into the wall. Note how the roofing felt and angle strip are interleaved*

Watertight finishes

To prevent surface water blowing across the roof and penetrating the brickwork, a DPC must be inserted into any parapet walls which exist. This must be at least 150mm above roof level, and the base bedded on top of the roof with hot bitumen.

The outside of the roof is now finished except for the installation of guttering (eavestroughs) along its lower end (see pages 408 to 413). But if you want to use the area as a roof garden or seating space, special asbestos tiles must be applied over the felt to help spread the load. Remember that if the roof is to be used regularly for this purpose, safety rails must be constructed around the outside of the area and stairs or a first floor door built to provide safe access. All of this will require building permission.

When you reach the top of the roof, continue over the flashing and cut each length of felt so that it can be tucked into the bottom of the chase.

The third and final layer is now laid, starting at the bottom edge of the roof and ending at the foot of the wall at the top. Again, this should be bonded to the surface below with hot bitumen and each length overlapped by at least 75mm.

The final step is to position the large cover flashing across the junction between the roof and the adjoining wall. This should be tailored to fit so that it tucks into the top of the chase above the second layer of felt.

To finish off the chase and make it completely waterproof you must point the gap left above the cover flashing with 1:3 mortar. But to hold the flashing temporarily in position while you do this, first cut a number of wooden wedges and push them in to the chase.

Next wet the opening thoroughly and push the mortar into the gap using a small pointing trowel. Leave this to harden for at least 24 hours then, when you are confident that the flashing is held securely, remove the wedges and finish off the chase with fresh mortar. Figs. C and D show how the felt might be applied over eaves and against masonry walls (or masonry-clad timber-framed walls). In fig. D, the junction between wall and roof is reinforced with angle strips, as an alternative to the quadrant fillets described above.

Against timber-clad walls, it is usual to take all the layers of felt at least 150mm up the wall behind both the siding and the wall-sheathing paper. The building paper and siding are then replaced, leaving a gap of about 50mm between the bottom of the siding and the top of the quadrant fillet (cant strip).

C. Right: *Rafters should overlap the eave end of the roof. Note how the felt is laid and the way flashing is layered and turned over the fascia*

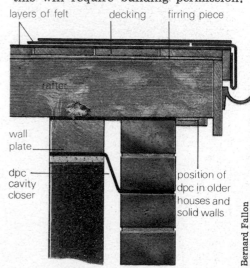

layers of felt decking firring piece

rafter

wall plate

dpc cavity closer

position of dpc in older houses and solid walls

Bernard Fallon

Installing a roof window

● Planning a roof window conversion ● Window designs ● Tools and equipment ● Preparatory work ● Marking out and cutting an opening ● Fixing the window in place ● Fixing U-type and L-type flashings

Below: *Installing a roof window is an economical and practical way of adding light and ventilation, enabling you to open up space in the home— such as a loft or attic—which might otherwise go to waste*

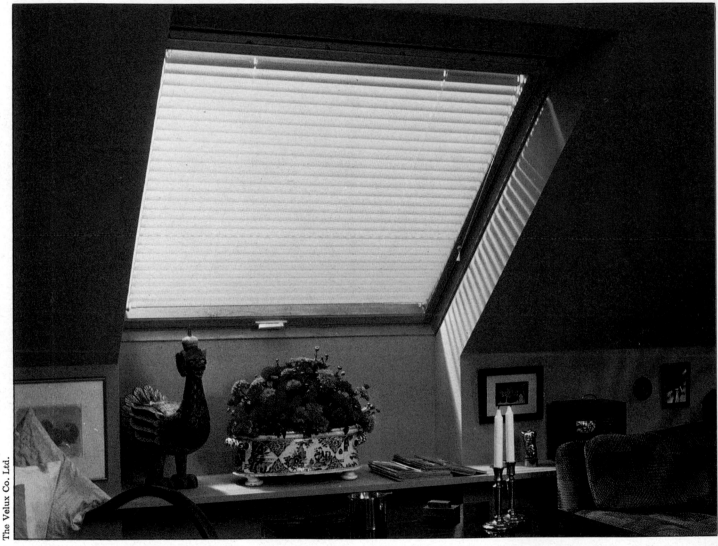

The Velux Co. Ltd.

Parts of the home like the space under the roof are often under used—simply because of the lack of light or ventilation. Installing a roof window gets around these problems and enables you to create an extra room with a minimum amount of work—without the need for major structural alterations to the house.

Although roof windows are most usually fitted in attics, their use is by no means restricted to the main roof of the house. They can just as easily be installed in garage, shed or extension

roofs providing the pitch of the roof is somewhere between 20° and 85° and the timbers are sound.

Planning a roof window

You will almost certainly need building regulations approval for a roof window —this means drawing up plans of your proposals and submitting them to your local council. You may also need permission under the planning regulations, which are different from building regulations: see the panel opposite for details.

If you simply want to introduce more light and ventilation into an attic which is already used as a room, then obtaining the necessary permissions is relatively straightforward. But if you want to convert an ordinary attic into a habitable room the procedure is more extensive. From the planning point of view, you will be creating an extension, which may or may not require planning permission. From the building regulations point of view, you will have to make sure the attic will satisfy the regulations for a habitable room—for

example you must leave enough head room; and a strong enough floor Converting your loft in this way is a major undertaking and should not be undertaken lightly.

Since the weight of even the largest roof window is spread over a wide area, the rafters do not have to be particularly wide; but they should be at least 100mm deep. Check also that they are well seated at the eaves and at the apex of the roof by standing near the middle of each rafter and shaking it vigorously. If you detect excessive movement, the rafters concerned must be strengthened and reseated before the window is installed in the roof.

Choosing a roof window
Recent developments in the design of roof windows have greatly extended the range and effectiveness of the old-style 'skylight'. This consisted of a simply constructed metal- or wood-framed window, hinged at the top and opened and closed by means of a long handle attached to the bottom of the fixed frame.

By contrast modern roof windows are usually double-glazed and hinged centrally on both sides, allowing the sash to pivot through 180° for easy cleaning and maximum ventilation. They can be fitted with locks, and also with integral ventilation flaps and blinds which open and close between the double glazing.

1 Start by measuring the external dimensions of the frame and transfer these measurements to the outside of the rafters

2 Check the thickness of the trimmers and measure this distance up from your top mark and down from the bottom mark

3 Then, to allow for the splay, use a level to draw horizontal and vertical lines from your top and bottom marks respectively

4 Remove tiles well clear of the marked-out area, starting from the centre and working slowly towards the outside

5 With the roof covering off, erect temporary supports and then remove the rafter by cutting at the lines previously marked

6 Fit trimmers across the frame and check they are correctly aligned before nailing them to the adjoining roofing timbers

The Velux Co. Ltd.

307

7 *To complete the frame, carefully mark the position of the false rafter on the trimmers. Cut this and then fix it in place*

8 *Cut a slot in the battens and place the frame on the ouside of the roof. Mark the frames position and then withdraw it*

9 *Using the marks made on the outside of the roof as a guide, cut back the battens. Allow enough clearance for the flashings*

For roof windows which are out of reach, and therefore difficult to open and close, electrically-operated models are available. And for areas which are hemmed in, an emergency exit window can be fitted which pivots both sides—like the ordinary model—and along one edge to allow easy escape.

Once you have decided on the type of model most suited to your needs, take care to choose the size which gives optimum light and ventilation without looking unduly large compared to the room in which it is fitted. As a rough guide, the area of the window—including any air bricks—should be at least 10 percent of the floor area of the room. Another important point to bear in mind is that two small windows can often be used

B. Below: *Careful positioning of two small roof windows (right) can often reduce a great deal of the work involved in installing on large roof window (left)*

instead of one large one. Such an arrangement gives as much ventilation and light as one window but can avoid the need to cut through rafters during fitting (fig. B).

Because a roof window is more exposed to the elements than a window mounted on a vertical wall, it is usually protected with flashing around the outside of the frame. This is supplied with the window but before purchasing, check that you have the flashing compatible with your particular type of roof. Two types are available: U-type flashing for profiled roofing such as tiles, and L-type for thin or flat roofing materials such as slates or bituminous felt.

Essential equipment
Very few specialized tools are necessary to fit a roof window successfully and you will probably have most of them already. To mark out the area to be removed you need a tape measure and a pencil or felt tipped pen as well

13 *To support the top flashing, fill the gap above the frame with battens spaced at 20mm intervals and nailed across the rafters*

as a spirit level and plumbline. A sharp handyman's knife is necessary to cut away any felt which might be on the roof under the covering.

Many tiles or slates are difficult to prise loose—particularly if they are firmly nailed—and a small plasterers' trowel or slate ripper will make this task easier. A panel saw is also needed to cut the rafters and battens once the tiles or slates are removed.

Once the window is set in place a screwdriver is needed to fit the side profiles securely. Then, to ensure that the flashing is flattened against the surrounding tiles or slates a lead dresser or soft-faced hammer is useful. Finally, to trim and shape the roofing material to fit around the window you need slate cutting tools and pincers, plus a supply of fixing nails.

false rafter

new trimmers

10 Reposition the frame and check it carefully for squareness. Then screw the angle brackets into the rafters at each side

11 Next fit the bottom flashing section into place and secure it by slotting the bottom profile over the top and screwing it tight

12 Next fit the side flashings and secure them by adjusting the sliding clips so that they can be nailed into one of the battens

14 Then slide the top and side profiles into position and fix them securely with screws to the frame below

15 Finally, clip the top flashing into place and make sure that it is firmly attached to the top profile you have just fitted

16 Check all connections for tightness and then dress the bottom flashing—made of pliable lead—against the roof covering

The Velux Co. Ltd.

Preparatory work

Although all of the work involved in installing a roof window can be safely carried out from inside, it is very easy to drop tiles and timber on un-suspecting passers-by. So, before you start work, cordon off the area immediately below where you are working with clearly marked signs and improvized barriers.

If fitting the window involves cutting away rafters, prepare for this before you start work. To support the ends of each severed rafter, make up two pieces of timber long enough to stretch from the floor and cut the top ends at an angle to fit the rafter slope at top and bottom.

Once the rafters are cut through, timber noggins—called trimmers—of the same dimensions as the existing rafters are fixed at top and bottom across the gap to strengthen the frame. Prepare for this by measuring the distance between rafters that will accommodate the width of the window.

Next, unpack the window and remove the wooden sash by rotating it through 180° as if you were opening it. This will expose the hinges so that you can fully tighten the retaining screws and lift the frame away.

Strip the sash free of all metal components except for the two aluminium profiles near the hinge—most can be screwed loose then pulled free. Check that all the woodwork is clean and free of defects then give it a protective coat of polyurethane lacquer, allowing this to dry before starting work on the roof; further coats can be added later.

Positioning the frame

You may already have a good idea where you want to instal the window but check this exactly at this stage by lifting the frame into position against the roof. Take into account that you will want the control bar within easy reach at the top of the window and perhaps also a view from where you are likely to be sitting.

Once you have worked out the exact position in which you want to fit the window, measure its outside dimensions and carefully transfer these on to the rafters with the help of a spirit level (measurement 'A' in fig. C). Align the base of the marked-out area with the bottom of a course of slates or tiles—this will help to fix the flashing more neatly once the window is in place

17 Replace the tiles or slates down both sides, trimming them to size so that they fit neatly under the edge of the flashing

18 Then replace the top ones, leaving a gap of 60–100mm above the window. Fit a tilting fillet to support a short bottom course

The Velux Co. Ltd.

19 Once the roof covering is complete, carefully pick up the sash (taking care not to break the glass) and fit it into the frame

20 Check that the window opens and closes easily. If it sticks, retighten all the screws and make sure the sash is correctly aligned

Next examine the installation instructions supplied with the window. These specify the clearance required between the frame and the roofing material to ensure a neat fit. Take careful note of the dimensions, marking them onto the roof timbers in a different colour if necessary, so that you know how many tiles or slates to remove (measurement 'B' in fig. C).

Note also that the trimmers which need to be inserted above and below the frame to give it support are not tight against the frame itself: they are set further back to enable the internal window linings to be splayed and so allow a greater spread of light.

First check the thickness of your trimmers and measure and mark this distance above and below the frame position to allow for their width

(measurement 'C' in fig. C). Then allow for the inner splay, using a spirit level to draw horizontal and vertical lines from your new top and bottom marks respectively to the inside of the rafter (measurement 'D' in fig. C). It is at these points that the rafter will be cut and the trimmers nailed into position.

Cutting an opening

Once you have rechecked that the inside of the roof is correctly marked out, start to remove the roofing materials. How you proceed depends on both the structure of the roof and its covering:

Tiles and slates: Start by cutting away any internal roofing felt with a sharp handyman's knife so that you expose the tiles or slates themselves.

Remove these one at a time, starting from the centre and working slowly towards the outside (fig. 4). If they are nailed to the battens, work each tile or slate free with a slate ripper or wedge a trowel under the top edge to break it loose. Continue in this way until you have a space well clear of the area to be occupied by the window.

Felt roofs: Using the marks you have made on the inside on the roof as a guide, drill a 20mm diameter hole right through both the wooden decking and the covering felt. Then insert a padsaw and carefully cut around the outside of the marked-out area. When the cut is completed, the inside of the area will drop away and can be lifted clear of the working space.

Once you have removed the roof covering, the next step is to cut away any rafters running across the area to be occupied by the window. But before you do so, make sure that they are supported at top and bottom with timber wedges, placed well away from the area in which you intend to work (see above).

Saw each rafter along the two lines previously marked, trying to keep the cut at the correct angle to the roof. Then prise the freed section away from the roof, taking care not to break or damage any of the battens or roof timbers (fig. 5).

To take the place of the missing rafters fix your trimmers across the top and bottom of the frame. Check carefully that these are correctly aligned with the existing roof timbers and square at each corner before nailing them securely through the uprights and on to the ends of the cut rafter (fig. 6).

With the trimmers set above and below where the frame is to go remove the temporary support and fix a false rafter down one side. Fit this according to the installation instructions so that there is a gap on each side of the frame to allow for the roofing material. Cut the rafter to length, check carefully for alignment and square, then nail it firmly to the trimmers top and bottom (fig. 7).

The window frame should now be placed on the outside of the roof and checked for fit. Do this by sawing down through the centre of the battens or sarking so that you have a slot wide enough to allow the frame to be pushed through sideways (fig. 8). When the frame is on the roof adjust its position exactly—remembering that you will have to replace all the roofing materials around the outside once it is fixed. When you are satisfied that it is

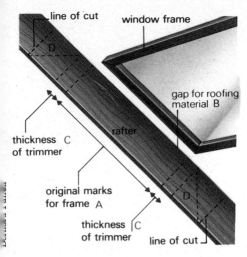

line of cut

window frame

D

gap for roofing material B

rafter

thickness C of trimmer

original marks for frame A

D

thickness C of trimmer

line of cut

C. Above: *Take great care when marking out the height of the frame (A), clearance for roof materials (B) thickness of trimmers (C) and the internal splay (D)*

set exactly as you want it, mark this position on the roof battens underneath (fig. 8).

While the frame is still in place, locate the four angle brackets and screw them to the outside of the frame—two on each side. Use the line marked on the side of the frame as a guide and adjust the position of the brackets accordingly to ensure a watertight seal once the window is in place. The line should coincide exactly with the top surface of the battens or sarking.

Once you are satisfied with these adjustments, take the frame back inside and replace the roof covering up to the bottom of the marks made for the frame. Make sure you do this exactly so that the frame can be set back into position without gaps between it and the surrounding roofing material. Use pincers to nibble away sharp corners along the top of the tiles or slates so that the flashing is not damaged once it is applied—especially along the bottom edge.

Next, you must cut back the battens using the marks you have made on the outside of the roof as a guide. But study the installation instructions before doing so since the exact position of the cuts varies according to whether you are using U- or L-type flashing (fig. 9).

Set the frame back in position and check the clearance at all sides, adjusting as necessary by cutting away more of the battening or adding small battens where there is too large a gap. Afterwards, check that the frame is square by measuring both the

diagonals and along the outside edges (fig. 10). Then secure the frame by screwing the angle brackets into the rafters at each side.

With the frame firmly held, fit the bottom flashing section into place and secure it by slotting the lower frame profile over the bottom of the window and screwing it tight (fig. 11). The rest of the flashing should then be fitted.

Fixing the flashing

The technique used to fit the flashing and ensure a weathertight seal around the window, depends on whether you are using U-type flashing for a profiled roof or L-type flashing for a flat or slated roof:

U-type flashing: Fix the side flashings first. They have a raised lip along the edge furthest from the window to hold the tiles at a correct

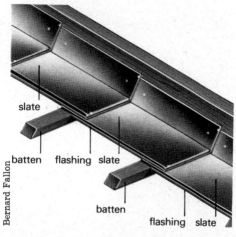

slate

batten flashing slate

batten

flashing slate

Bernard Fallon

D. Above: *Flat or slated roofs are made watertight by laying pieces of flashing under the roofing material*

distance from the frame, so check you have them the right way round. The side sections are secured with clips ready-fitted to them. Locate these and nail them to the battens below (fig. 12), then fix the bottom section in the same way.

The gap above the frame must now be filled to provide good support for the top flashing. Do this by nailing a number of battens across the rafters spaced at about 20mm intervals (fig. 13). Then replace the top and side profiles by sliding them into place and screwing them to the frame (fig. 14). Finally, clip the top flashing into position, making sure that it is firmly attached along its bottom edge to the top profile you have just fitted (fig. 15).

With all the flashing in place, double-check that it is fitted correctly and that all of the screws are

tightened around its outer edges. Then, using a lead dresser or a soft-faced hammer, flatten the bottom flashing—which is made of soft pliable lead—against the roof covering as shown in fig. 16.

When you are satisfied that the flashing is fitted so as to give an all-round weatherproof finish, replace the tiles or slates around the outside. Start with those on each side of the frame, trimming them to size so that they fit neatly just under the edge of the flashing (fig. 17). Then replace the top ones, leaving a gap of 60–100mm above the window depending on where the bottom course finishes. If you have to cut across the tiles or slates to establish this gap—and so end up with a bottom course of shortened tiles—fit a tilting fillet of wood below the bottom course before you fix them in place (fig. 18).

L-type flashing: Secure the bottom flashing section—which should already be in place—by fitting the lower frame profile and screwing it tightly to the frame. Then fill the gap above the window with wooden battens, spaced at roughly 20mm intervals and nailed into the rafters, so as to provide a solid base for the flashing and roof covering above the window.

The roof on each side of the window is then made watertight by fixing the short sections of flashing—called soakers—to the edge of the frame with nails and alternating these with slates or pieces of roofing felt. Start at the bottom edge of the frame and fit a soaker. Lay a slate on top of this and then another soaker and continue in this way until you reach the top (fig. D). Depending on the size of the window, the top soaker may have to be cut to length in order to fit below the top slate.

Once the sides of the window are made watertight, fit the top frame cover and side profiles and screw them down firmly. Finally, replace the slates or felt above the window so that the top frame is slightly overlapped. The window and its surrounds should then be checked to ensure that they are fitted correctly and screwed tightly in place.

Replacing the sash

Refit the sash into the frame and make sure that it is firmly held. If you have fitted it correctly and the frame is square, the window should open and close easily. But if it sticks, check that all screws are tightened and that the sash is correctly aligned before trying again.

Studio window conversion

Add interest, light and space to your home by building this studio window conversion. Its sloping glazing panels admit plenty of light, and are double glazed to retain heat

A studio window is one of the best ways to make most use of available light. The sloping glazing panels in this design are upturned to the sun to present the largest possible heat collection area. Using this design, you can construct an attractive rear extension, which will really open up the view into the garden, and create an ideal environment for a conservatory housing indoor plants. Sealed double-glazing panels are used throughout, so there will be no problem with heat loss or insulation efficiency.

The drawings overleaf show the type of situation which is ideal for conversion and is common to many homes. The rear entrance is housed in

a small lean-to extension with a sloping roof and existing small window. But there are many other ways to use the design. You can just as easily build on to a flat roofed extension, or, as shown below, directly on to the wall of the house. In each case, all you need do is provide a low retaining wall for the lower part of the window frame, and a secure fixing for the top bearer bar which can be bolted to the wall and covered with a flashing.

Before you begin work, you should plan your window carefully. The first thing to check is that your proposed alteration will not infringe building regulations or local planning restrictions. You should also consider the siting. Ideally, to admit the maximum light, it should face south. If this is not possible, aim to find the brightest location available avoiding obvious shady areas. You should not site it too near trees for this reason, and also because falling leaves will have to be cleaned off the glass in autumn.

The first thing you will need is a foundation for the new structure; set this out then lay a concrete slab to form a floor and provide footings for the retaining walls. How deep this slab must be will depend on local soil conditions; check this point with the building inspector. Build the retaining walls on to this, tying in to the existing brickwork where necessary. The sloping side walls can be extensions of existing walls as shown, or completely new structures tied in to the house. You can glaze the sides as shown below if you prefer.

Enlarge the wall opening as required to provide access to the new structure, supporting it with a lintel.

Build up the glazing frames on the brickwork, using the sections shown. If you are building up against a side wall, you can tie in to this as shown.

Fit flashings, bargeboards and soffits, and install sealed double-glazing units, which you can have made to measure. Paint or varnish all the timber for maximum protection, and make sure that you have sealed thoroughly around the edges of the frame to prevent leakages, using a waterproof mastic throughout.

John Ward

Elizabeth Whiting

Alternative idea

You do not have to build a complete extension to take advantage of this design. The picture shows how you can adapt the idea by building directly on to the rear wall to form a glazed conservatory.

All you need is an opening in the walls, supported by a lintel, but you may be required to extend the house foundations under the new structure. Build the low retaining wall around the perimeter and erect the timber supports for the glazing. The details of this are much the same as those shown overleaf. Just fix the upper bearer to the lintel, and form a flashing to the wall to prevent rain from entering.

Workplan

You can make the conversion on any type of rear wall, possibly by knocking out an existing window or patio door, but a typical location is shown below, with an existing small rear addition. Before you begin work, you should check that the proposed extension does not contravene building regulations or local planning restrictions

Detail of tiled roof slope

New roof joists

Underfelt

Battens

Tiles hung on battens

Barge board

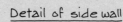

Existing rear addition with pitched roof, back door and window. You can base your extension on this kind of structure, or build it as a lean-to on a flat wall

Detail of side wall

Tiled roof slope. Hang tiles on battens fixed across the new roof joists

Area of new brickwork extension tied into existing brickwork

Front retaining wall

This drawing shows the completed extension. Compare this with the drawing opposite to see how the original walls have been extended and the roof has been tied in to the sloping double glazing panels. Use double glazed sealed units for heat retention. You will need to extend the foundations to support the new structure and form a floor. If you are building against a flat wall, you can support the upper end of the glazing bars on a bearer batten fitted to the wall and build a small brickwork buttress and retaining wall on each side, tied into the original brickwork

Existing house wall. You can make a small access doorway if none exists, or enlarge the opening and fit a lintel to create a large through space as an extension of the room behind

Barge board

Underfelt Roof joist

Batten

Tiled pitched roof

PVC guttering

Barge board

Existing retaining wall. You can extend the brickwork on this side if necessary

New glazing bars

New sill

Rainwater drainage

Tiled roof slope to border the double glazing. If there is no bordering wall on the opposite side, you can border the glazing on both sides with tiles

New retaining wall

New double glazing units

Extend the foundations to support the new retaining wall

Lay a concrete slab to form the basis for a new floor

This drawing shows details of the timber framework to support the glazing. If building onto a flat wall, fit the upper bearer to the lintel over the opening and fit a flashing over the upper edge of the glazing

Detail of hardwood glazing bar

Machine to this profile from 125×38 mm hardwood

Taper is for visual appearance only. Omit if preferred

25mm No 8 (4·2 mm) brass screws

50

12

38

15

125

50

Bed the glazing unit in mastic

38×6 mm hardwood beading strip

Sealed double glazing unit

Notch roof joists and nail to bearer

Ceiling joist notched and nailed to bearers

50×50 mm softwood bearers nailed in place

Notch glazing bars and nail to bearer

225×50 mm softwood bearer

Battens

Tiles hung on battens

Underfelt

PVC guttering held to bargeboard with gutter brackets and screws

Barge board from 225×25 mm softwood nailed to roof joists

Top glazing bar. Bed the glazing bar on mastic into the rebate

Soffits from 6 mm plywood (exterior WBP)

Sealed double glazing unit fitted into rebate

Retaining bead

Glazing bar (see above)

Double glazing units made to measure

Bed the base of the glazing unit in mastic into a rebate in sill (see left)

Window sill section

This is a standard moulding obtainable from builders merchants

Notch to suit glazing unit

75

175

Glazing bar

Fit the end of the glazing bar into the housing, and nail and glue in place

Window board moulding 225×25

60°

External sill moulding 175 × 75 mm

Retaining cavity wall. Two leaves of brickwork, four courses high

DPC

DPC

Chop out a housing for the foot of the glazing bar, using a tenon saw and chisel

Window board fits into a groove machined in the sill moulding

Finish interior wall if you prefer

Support the brickwork on a concrete foundation

Detail of fixings to bearer battens

Roof joist

Bearer fitted into brickwork

Notch to accomodate joist

Ceiling joist

Notch ceiling joist to fit bearer

Bearer

Notch glazing bars to fit bearer and nail through. These fixings are hidden by the soffit

John Ward

If you are building up against an existing retaining wall, machine a rebate on one side of this glazing bar only. Fix the flat side to the wall with expanding masonry anchor bolts and cover the joint with a flashing apron

Finish: Seal all hardwood surfaces with at least 3 coats of external quality polyurethane lacquer. Finish exposed softwood surfaces with primer, undercoat and gloss paint

Fitting the glazing bars

Glazing bar

Dowel joint the glazing bars together using a waterproof adhesive such as urea formaldehyde

Upper glazing bar

Make the upper glazing bar from 50×50 mm hardwood. Machine a rebate as shown to take the upper edge of your glazing panel

Glazing panel

Glazing bar

Notch to take lower end of glazing bar

Window board

Rebate cut into sill to accomodate lower edge of glazing panel

Sill

Brickwork

Erecting a close-boarded fence

● **Construction materials** ● **Preserving timber**
● **Preparation** ● **Installing the posts, gravel
boards, arris rails and vertical boards** ● **Build-
ing a fence on a slope** ● **Masonry plinths**

Above: *Building a timber fence like
this is surprisingly easy, providing you
use the right materials and tackle the
work in a logical order*

A garden fence built from overlapped
vertical boarding is an attractive
addition to any home. Close-boarded
fencing—as it is called—is not difficult
to build and uses pre-cut material,
making it a realistic alternative to the
cheaper but less durable 'woven panel'
fencing now so popular for garden use.
The tenon joints used in its construc-
tion do not have to be perfect, and the
rail ends which slot in to them are
simply rough-hewn to shape.

Three things make all the difference
between a shoddy fence and an attrac-
tive, solid, long-lasting one. First and
foremost the posts must be adequately
supported. Many people try to save
money by skimping on the length of the
posts or the amount of concrete used to
bed them, but this is false economy, as
the first gale may quickly demonstrate.
Also, the timber must be adequately
protected against rotting. Although
fencing timber is sometimes sold pre-

treated against rot, it pays to give it
the extra protection of a good soaking
in preservative before erection. Addi-
tionally, all cut ends and every joint
must be well soaked in preservative
before they become inaccessible.

Finally, the fence should be straight
and its post tops level or, if on sloping
ground, descending in steps of equal
sizes. If your land slopes, you need to
work out in advance whether to have
a sloping or stepped fence, and
whether you will use gravel boards or
a plinth beneath it

Construction materials

Though oak is the traditional fencing material, purpose-cut, low grade softwood is used in preference nowadays because of its lower cost. This can be perfectly acceptable provided the timber is properly treated with preservative. The posts are of 75mm × 75mm sawn timber—sometimes available as prepared 'fencing posts'—which are sunk at least 600mm into the ground and sleeved in concrete. Two or three arris rails—depending on the height of the fence—fit into mortises in the posts. These are triangular in section usually 100mm on one side, 75mm on the other two.

The vertical boards are feather-edged softwood, 100mm wide and tapering from 20mm at one edge to about 6mm at the other. When erected, they are overlapped by about 25mm.

To prevent the bases of the boards rotting, a horizontal gravel board is fixed between the posts just above ground level. Lengths of 100mm × 25mm timber are suitable, and should be fixed to 38mm × 38mm wooden cleats. As an alternative, you can use a masonry plinth—a dwarf wall—of either bricks or concrete walling stones set on a concrete pad.

You can make your fence even more durable by fixing capping pieces and a weathering strip (fig. C).

Preservation

Fencing timber is particularly susceptible to rotting, especially the softwood type. The most vulnerable area is the 100mm or so at, and immediately below, ground level; sometimes this will rot through, leaving the wood above and below it more or less intact. This is why it pays to carry your supporting concrete at least 50mm above ground level and give it a finishing 'crown' to run off the water. Pressure or vacuum-impregnated timber (such as the Tanalised variety) is best for fencing but is expensive and sometimes difficult to obtain.

If you cannot get pre-treated timber, treat the wood yourself by soaking it in a bath of exterior timber preservative. To make the bath you need about two dozen old bricks and a 3m wide sheet of heavy-duty polythene (fig. A).

Find a suitable flat surface and arrange the bricks on edge to form a rectangle—slightly longer than the largest fencing post and wide enough to take all the timber. Lay the polythene over the bricks to form a bath then carefully pour in the preservative, taking care not to cut or otherwise puncture the sheeting. Steep the

fencing materials for up to a week if possible. Cover the bath during this time if children and pets are around.

If you have to store timber out of doors for any length of time, lay it on a flat surface and cover to prevent warping. Leave plenty of ventilation space between individual boards.

As you erect the fence, paint preservative on all timber surfaces that you will not be able to reach later—for example, where the vertical boards overlap. Give all end grain an extra coat to protect it.

Initial preparation

Begin by using a line and pegs to set out a straight line for your fence. Nylon fishing line is best for this, and especially for some of the levelling you may need to do later, as it does not sag when damp.

Decide how far apart your posts are to be—but to save cutting, base this on the length of the arris rails. If your arris rails are 2440mm long, set the posts 2440mm apart, measuring from the centre (not the outside edge) of one post position to the centre of the next. If this means that one fencing panel must be narrower than the others, arrange for it to be at the least conspicuous end, or corner, of the run of fencing.

Next, prepare your posts. The mortises are cut to take 100mm × 75mm × 75mm arris rails. Cut slots 75mm high × 25mm wide, inset 20mm from the

A. *If you are building an entire fence, it is well worth constructing a bath for timber preservative. Leave timbers to soak as long as possible*

face of the post, for the gravel boards.

For a fence on level ground, begin the upper mortise 250mm from the fence top, and the lower one 300mm above ground level—that is, 900mm from the bottom of the post if this is bedded to a depth of 600mm.

If the fence is to be more than 1200mm high, add an extra mortise at the mid-point to accept the third arris rail which is necessary to strengthen the construction. Mark out the mortise positions with a try square and pencil, drill from both sides with a brace and 25mm bit, and use a 19mm or 25mm mortise chisel to square the holes neatly.

For a stepped fence on sloping ground (see below), the mortises on the 'uphill' and 'downhill' sides of the post will have to be offset, and drilled only halfway through the post.

If you do not intend to use post caps (see below), cut the top of each post so that it slopes away at 45° on the side to which you will be fixing the boards. This ensures that rainwater runs off the vulnerable end grain.

Next, using a small hand axe, taper the ends of the arris rails enough for them to jam into their respective mortises. For a level fitting, try to leave the face of the longest side intact and cut instead into the top edge, bottom edge and back. An exact fit is not necessary, but the neater you are the easier the assembly becomes. Remember to dab preservative around the insides of the mortises and the cut ends of the rail. Also, try to make all the cut ends of the arris rails of equal length—this greatly enhances the overall appearance of the fence (fig. 14).

heavy duty polythene sheet

preservative bath

timber submerged in preservative

dry-laid brickwork to make bath surround

use bricks to weigh down edges

Advertising Art

Making the post holes

Once you have checked that your rails go halfway through the posts—and that your proposed post spacing is therefore accurate—you can mark the positions of the post holes.

Post holes need to be wide enough to allow for a decent sheath of concrete around the posts, but not so wide that they waste material. A narrow hole 600mm deep is hard to dig with a spade; a better tool is a post hole borer—sometimes called a *ground auger*—available from a tool hire shop. To use it, you just drive it in like a corkscrew.

Use the spade to trim the hole to about 200mm square. If you have the

B. Below: *Gravel boards are secured to fence posts with hardwood cleats.*
Bottom: *Protect the tops of fence posts using one of these methods*

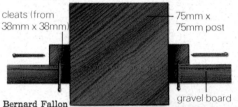

cleats (from 38mm x 38mm)
75mm x 75mm post
gravel board

Bernard Fallon

strength and the ground is soft enough, you may be able to 'pile drive' the post into its final bedding depth. Remove any loose material from the bottom of the holes.

If you are planning to build a masonry plinth (see below), dig the footings at this stage.

Next prepare shuttering from scraps of timber or plywood so that you extend the concrete sleeve above ground level and so protect the post at its most vulnerable point. Quite how far you extend it depends on whether the fence is beside loose soil, gravel, or concrete, and whether you are using a plinth. Do not go too far or it will be difficult to fix the cleats for the gravel boards.

Erecting the fence

When installing posts, ramming material around the base of a post loses much of its effect unless the bottom of the hole itself is really hard. So use a half brick or lump of concrete as a sole pad in each hole.

Erecting fence posts is much easier if there are two people, because one can hold the post plumb while the other rams in the concrete.

But if you are alone, stand the first

post upright, fit a timber brace on each side, then use a plumbline or spirit level to check that it is vertical. When it is, fix the other ends of the braces to pegs driven into the ground.

Use a concrete mix of one part cement to six of all-in ballast. Pour it into the hole a little at a time and ram it well down with the end of a length of timber (fig. 8), checking as you go so that you are not knocking the post out of plumb. Slightly over-fill the shuttering with concrete, then use a trowel to slope it to a smooth finish like the flaunching around a chimney.

Leave the concrete to set enough to hold the first post firmly and stand the second post on its sole pad. Fit the first set of two (or three) arris rails between the two posts. Check that the top rail is level. If it is not, scrape out more dirt from the second post hole or pour a little concrete under the sole pad. Then pour just enough concrete to steady the second post while you check that it is properly vertical. When it is, pour, ram and trim off the rest of the concrete.

Continue in the same way until you come to the final panel. Then measure off the last arris rails to the required length and erect your last post.

metal capping timber capping

double bevel single bevel

C. Right: *Constructional details of a close-boarded fence. Note that where a slope is involved, you can either slope the panels to match or step them and use masonry plinths to provide a firm base*

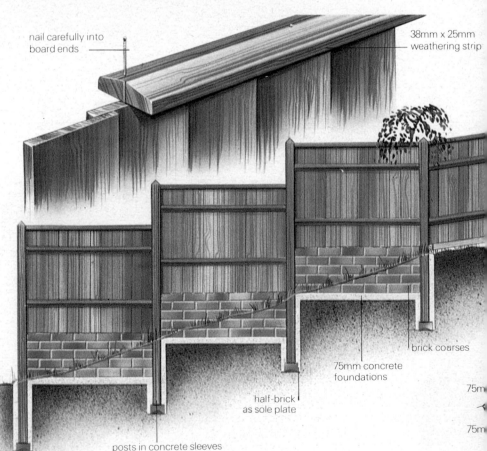

nail carefully into board ends

38mm x 25mm weathering strip

brick courses

75mm concrete foundations

half-brick as sole plate

75m

75m

posts in concrete sleeves

1 *Start cutting the mortises for the arris rails by drilling two or three large holes. Afterwards, finish off with a mortise chisel*

2 *Even if the fencing timber is already coated with preservative, you should apply more of the compound to all cut areas*

3 *Use a small axe to trim the ends of the arris rails roughly to shape. You can use a saw instead, but this does take longer*

Installing gravel boards

The next stage is to install the gravel boards or build a plinth (see below). Unless you are deliberately sloping the gravel boards, keep the top edges a constant distance from the tops of the posts. Doing so means you need only measure once—not several dozen times—when you come to cut the vertical boarding to length. Mark the height you want on a rod or an offcut of timber, measuring from the top downwards, and use this to gauge the height required on all posts.

Make the cleats to hold the gravel boards from 38mm × 38mm timber, the same length as the boards are wide. Inset them 25mm on the posts so that the faces of the gravel boards lie flush with the posts, and secure them with 65mm galvanized nails. Cut the gravel boards to length and nail them to the cleats. Ensure, in the future, that soil does not build up against them.

Close boardings

To keep the vertical boards level at the top of the fence, stretch a nylon line between the posts 25mm below their tops. Then cut a quantity of the feathered-edged boards to length.

Nail the first board in place, using 50mm galvanized nails, so that its thick end is against a post and the top is just brushing against the nylon guideline above.

Successive boards look neater if

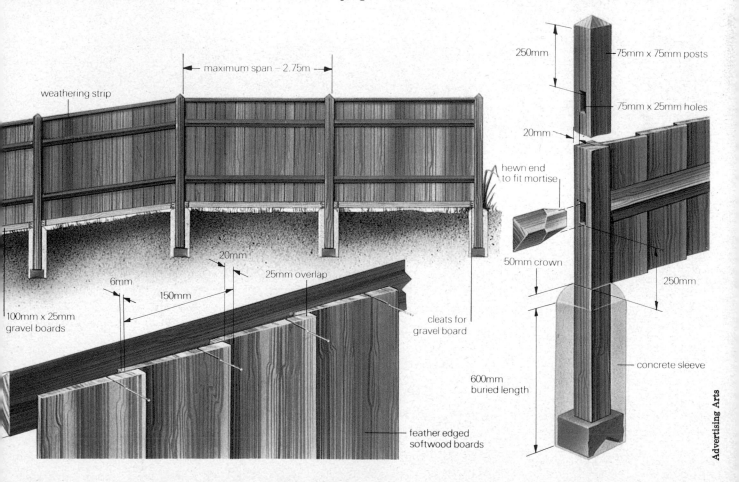

maximum span – 2.75m

weathering strip

100mm x 25mm gravel boards

6mm

150mm

20mm

25mm overlap

cleats for gravel board

feather edged softwood boards

250mm

75mm x 75mm posts

75mm x 25mm holes

20mm

hewn end to fit mortise

50mm crown

50mm crown

250mm

600mm buried length

concrete sleeve

4 Be sure to try each arris rail for fit in its mortise, otherwise you will run into difficulties during assembly of the fence

5 Make certain that the cut ends of the arris rails get an extra coat of preservative, or they may become a focus for rot in the future

6 A line is used to mark the positions of the post holes. After you have dug them, set up a post and rail to form a first panel

overlapped by a consistent amount, and although there is nothing to stop you gauging progress by eye, it is wiser to measure and mark on the arris rails the positions of the individual board edges. Alternatively you can use a measuring gauge for this. To make one, take a spare board and rule lines across it at intervals the width of your boards, less 25mm to allow for the overlap.

Tack-nail the board in place between the two posts, or lean it against the gravel board. Then line up each vertical board with the appropriate pencil mark as it is nailed firmly in place. Nail each board through its thicker end only, so that the nail just misses the overlapped board below it (fig. 13).

Try varying the overlap slightly in the later panels if it looks as though you must trim the final board. A variation of 3mm in the overlaps will not be noticed from one panel to the next but, over the width of 2.5m panel, this can give you over 100mm of margin for adjustment—that is, plus or minus 50mm.

Caps and weathering strip
Wooden capping pieces are useful for protecting the end grain on the tops of the posts, and are sometimes supplied with them. If not, you can make your own from 100mm × 25mm timber (as used for the gravel board), sawing it into 100mm squares. These are secured with galvanized nails.

Also useful is a weathering strip along the tops of the boards. You can make this by cutting 38mm × 25mm battens to length. Nail them on at the thick end of the board edges, carefully, to avoid splitting (fig. C).

Dealing with slopes
Whereas most other types of fence and, indeed, constructions of all kinds must be stepped on sloping ground, a vertically-boarded fence can have a sloped top if the ground below it slopes only slightly. To maintain a consistent slope at the top of the fence, the procedure is to erect and plumb the highest post first, then temporarily erect the lowest post, plumb it, and hold it in position with cross braces. Stretch a nylon line between the two posts and use this as a height guide for the intermediate posts.

Otherwise proceed as for a level fence. Posts and boards must both be vertical. The arris rails are sloped, but the slight step between successive boards which this creates is barely perceptible.

On steeply sloping ground it is still possible to slope the top of the fence, but a stepped top looks much better. Slightly longer posts are needed, however, and the first thing you need to know is by how much the ground falls away. It is no use trying to estimate this by eye, because ground falls are highly deceptive and usually greater than they look.

Start by temporarily erecting the highest and lowest posts. Sink them in the ground by only the usual 600mm and when plumb, use temporary braces to steady them.

Next, take a nylon line and fix it between the top of the lower post to an approximately level position, partway down the higher post. Measure the exact centre of the line and mark it with a dab of paint or tape. Then carefully level the line at the centre spot using a spirit level. Finally,

9 Secure the arris rails as shown, by nailing through the mortises in the fence posts. Use a club hammer to stop the post from jarring

measure the height from the line to the top of the higher post: this is the amount by which the ground falls between the two posts.

Now divide the total fall by the number of panels—not posts—your fence will contain between the highest and lowest posts. If, for example, your fence is to have eight panels, and the ground slopes by 1850mm, you will want eight steps of about 230mm.

To achieve this, make the mortises on the 'uphill' side of each post at the normal level, as described above, and those on the 'downhill' side 230mm lower. (The first post, of course, has mortises only on its 'downhill' side, and the last post only on its 'uphill' side.) This means that, in this example, all the posts will need to be 230mm longer than standard.

7 Use a spirit level to check that the post is plumb as the first panel comes together. Hold the base of the post with pieces of hardcore

8 Once you have fixed shuttering around the post hole, ram in more hardcore then pour in the concrete and allow it to set hard

10 The gravel boards can be fixed as soon as the framework of the fence is complete. Nail them to cleats secured to the fence posts

11 Before you fix the vertical boarding, calculate the spacings needed to fill the panel then mark these on the arris rail

12 Use a line, stretched taut between the first and last boards of a panel, to gauge the heights of the intervening boards

13 Once you have got started, use a wooden former to judge the overlap between boards: adjust this to save having to cut the last board

At the bottom of a stepped fence like this, you must make some provision for following the slope of the ground, and you have a choice between sloping gravel boards or a masonry plinth.

Sloping gravel boards

On sloping ground, gravel board ends must be angled so that the boards follow the ground contour (fig. C). This calls for slightly longer gravel boards than would otherwise be necessary and you will need vertical boards of varying length, which rules out the use of a standard fence kit. The only alternatives are to use two or more gravel boards one above the other—which looks ugly—or build a masonry plinth.

To mark the gravel boards correctly, start by running a nylon line along the length of the fence and about 150mm above the ground. Lay each board against a pair of posts, aligning its top edge with the nylon line. Then use the posts themselves as marking guides while you scribe each board end to the correct length and angle. Number each board to ensure that it goes in the right place.

Fix the gravel boards to their cleats, as described, and then stretch a line across the post tops in the normal way. Stand each vertical board against the gravel board with the top just brushing the nylon line, then mark the correct length and angle. Use the spirit level to check the plumb of every other board.

Masonry plinths

A masonry plinth is almost as easy to construct as gravel boards, and certainly more durable. On sloping ground, it has the advantage that the top of each section can be level, so you do not need to scribe a lot of boards to varying lengths.

A plinth can be constructed of brick or walling stone. It is laid only between the fence posts (not continuously), and because it carries no weight, it needs only the lightest of foundations—concrete 75mm thick if the ground is reasonably firm.

To build a plinth on anything but dead level ground, you need to step the foot between post positions (fig. C). Make the height of each step equal to one course of the building materials you choose to use, and the length a straight multiple of the brick or block length.

When you do this, do not forget to allow for a mortar bed between the foundation and the bottom course of masonry—and a double thickness of

14 *A panel of close-boarded fencing. The overall appearance is improved by regular spacings between boards and neatly cut rails*

15 *To weatherproof the tops of the fence posts, you can either cut them at a 45° angle or fit hardwood capping pieces as shown*

concrete where one step joins the next—or you will have nothing to bind the two steps together.

To avoid wasting material, cut the trench with a garden trowel or bricklayer's trowel—the average spade is too wide—and use the soil itself as shuttering. A couple of pegs driven into the bottom of each trench length and levelled with the spirit level will help to keep the foundation concrete level. And an offcut of timber hammered into the ground can be used to retain the end of each step.

If the soil is of a badly uneven consistency—topsoil patches, clay patches, rocky patches—and settlement seems likely, you can stabilize the wall by incorporating a length of galvanized expanded-metal wall reinforcement into the mortar joint between concrete and masonry.

While the concrete is hardening, stretch a nylon line across the fence posts above. Then, as you lay the masonry, use a gauge rod to keep each course at a constant height.

A dustbin screen

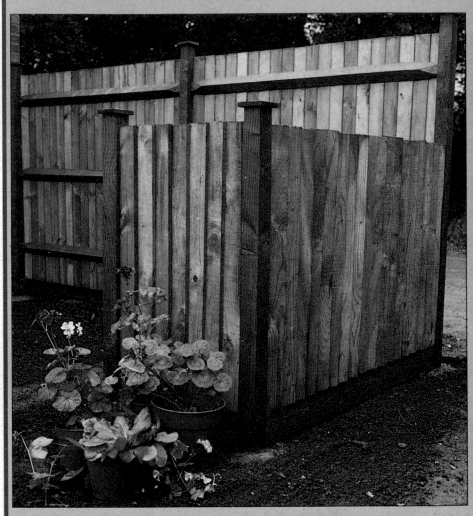

This practical dustbin screen will help to keep your garden neat and tidy. Simply build it as an extension to your close-boarded fence, using the techniques outlined in the preceding pages. You can easily adapt the basic design to the layout of your garden and the access to it.

The first thing to decide is the most suitable location, taking into account where you need access to the dustbins and on which sides you want them screened. The drawings on the right show four typical alternatives.

The screen is supported on one side by joining into one of the main fence posts, or in some cases, into two of them. When you are setting out the fence, you should take this into account, and site the posts accordingly. Cut extra mortises in these posts to take the arris rails for the screen. Stagger these to avoid weakening the timber unduly.

Set in the additional posts and fit the arris rails. Add the boarding, gravel boards and caps, treating all the timber with preservative. For a neat finish, you can pave over the enclosed area.

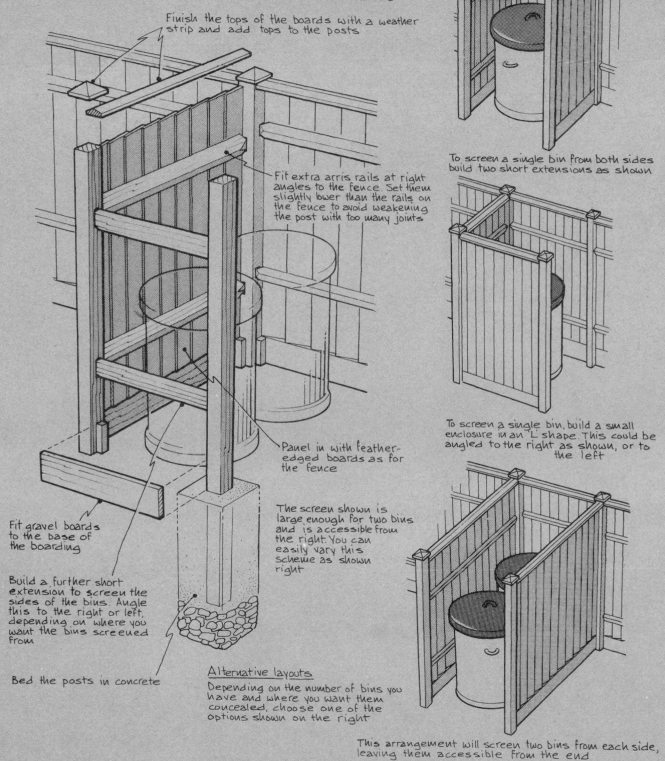

This simple dustbin screen is a useful addition to your fence. You can build it using the techniques and materials outlined on the previous pages. You may even be able to build it using left-over materials from the fence such as offcuts from the arris rails. You can build it to the same height as the fence as shown here, or economise on materials by building it lower, around 150mm taller than the bins

Finish the tops of the boards with a weather strip and add tops to the posts

Fit extra arris rails at right angles to the fence. Set them slightly lower than the rails on the fence to avoid weakening the post with too many joints

Panel in with feather-edged boards as for the fence

Fit gravel boards to the base of the boarding

Build a further short extension to screen the sides of the bins. Angle this to the right or left, depending on where you want the bins screened from

Bed the posts in concrete

The screen shown is large enough for two bins and is accessible from the right. You can easily vary this scheme as shown right

Alternative layouts
Depending on the number of bins you have and where you want them concealed, choose one of the options shown on the right

To screen a single bin from both sides build two short extensions as shown

To screen a single bin, build a small enclosure in an 'L' shape. This could be angled to the right as shown, or to the left

This arrangement will screen two bins from each side, leaving them accessible from the end

Build a carport

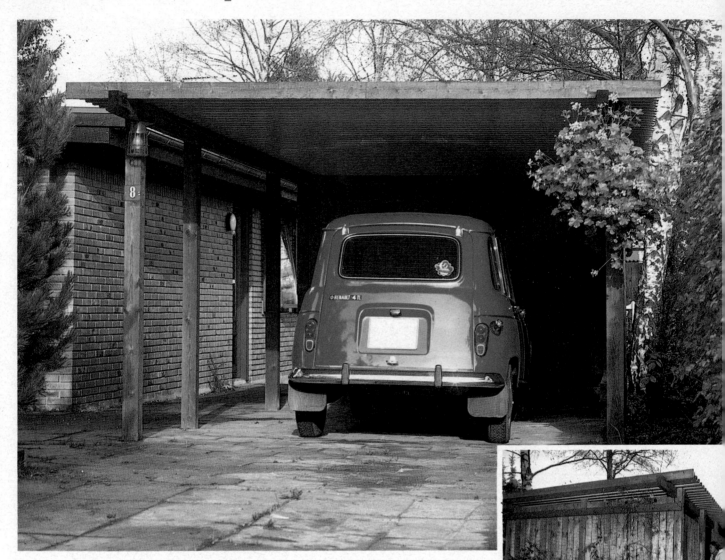

This attractive carport forms a practical alternative to a full garage, being both simple and cheap to build. It includes an enclosed outhouse in which you can store bicycles, tools and garden implements

Most car owners have to fight a constant battle to keep the car's body work from deteriorating due to rust caused by exposure to the elements. One way to minimize this is to keep your car under cover. But garages are expensive and complicated to build, and you need a fair amount of space. An alternative, which avoids most of the problems, is to build a carport.

And this design includes a practical outhouse which will provide secure cover for bicycles or tools.

Before you begin work, think about siting carefully. You must, of course, have access for the car, but also, if it is near the house, beware of cutting out light to the windows, or of blocking access to the garden. If there are trees nearby, think about whether it will be difficult to clear fallen leaves from the roof. Think too about access to the shed with wheelbarrows or bicycles. If there is a fence, you may be able to incorporate it into one of the sides. You must have a slight slope on the roof, so that rainwater will drain, so think about which way

it is best for the water to run off.

Construction is simple if you set out carefully. Treat all timber with wood preservative before use. Install the uprights, then pave or concrete the base. Fit the cross beams and rafters, then add the roofing. Board in the shed and the side as required. Door height depends on which way the roof slopes (the larger is given).

Every two years retreat the timber with wood preservative. Clear fallen leaves from the roof and make sure no weeds grow around the timbers.

Alternative ideas

The design on page 326 shows how you can build a carport complete with an outhouse in which to store bicycles or garden implements. But you can easily adapt the basic design if you would prefer a simple carport, or if your space is limited.

These pictures show two of the possibilities. On the right, the carport is built as a lean-to on the house wall. This is ideal if you only have a limited space at the side of the house, and it also saves on materials, since you only need the timber supports on one side. In this design, you must arrange for the roof to slope down from the house.

Below, the illustration shows another idea for a free-standing carport. This is similar to the one on page 326 but omits the shed enclosure. In the picture, one side of the carport is fenced in. If you prefer, you can leave this out, or enclose both sides with cladding.

You can build both of these designs with very little modification to the basic construction. Where they do vary substantially, details are given on page 330

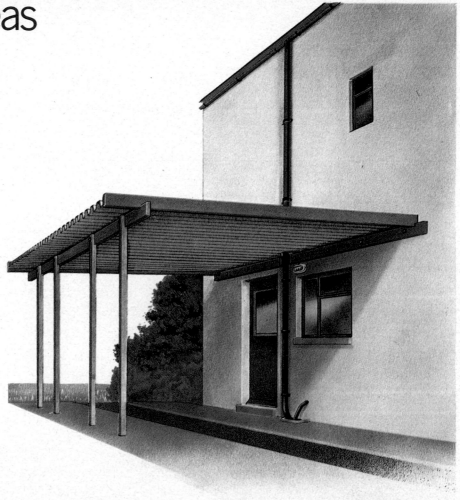

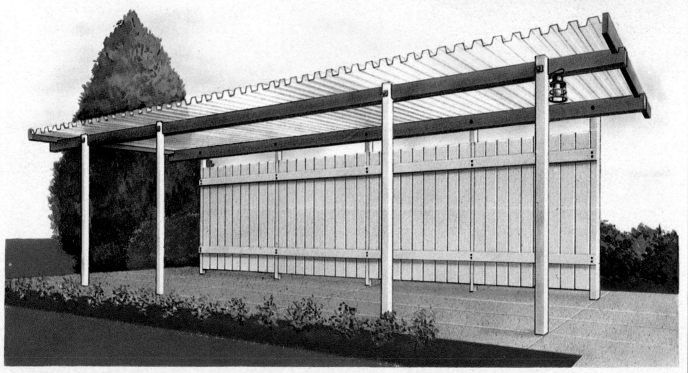

Workplan

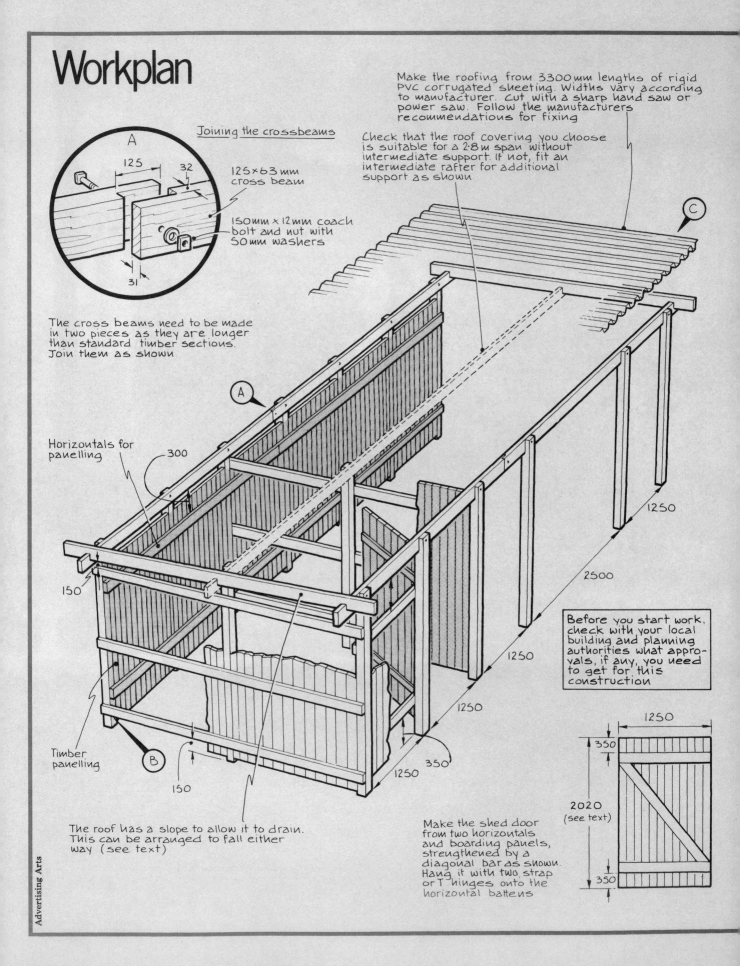

Make the roofing from 3300 mm lengths of rigid PVC corrugated sheeting. Widths vary according to manufacturer. Cut with a sharp hand saw or power saw. Follow the manufacturers recommendations for fixing

Check that the roof covering you choose is suitable for a 2·8 m span without intermediate support. If not, fit an intermediate rafter for additional support as shown

Joining the crossbeams

A

125

32

125×63 mm cross beam

150 mm × 12 mm coach bolt and nut with 50 mm washers

31

The cross beams need to be made in two pieces as they are longer than standard timber sections. Join them as shown

A

C

Horizontals for panelling

300

150

Timber panelling

B

150

1250

2500

1250

1250

Before you start work, check with your local building and planning authorities what approvals, if any, you need to get for this construction

350

1250

The roof has a slope to allow it to drain. This can be arranged to fall either way (see text)

1250

350

350

2020 (see text)

350

Make the shed door from two horizontals and boarding panels, strengthened by a diagonal bar as shown. Hang it with two strap or T hinges onto the horizontal battens

Cross section of shed

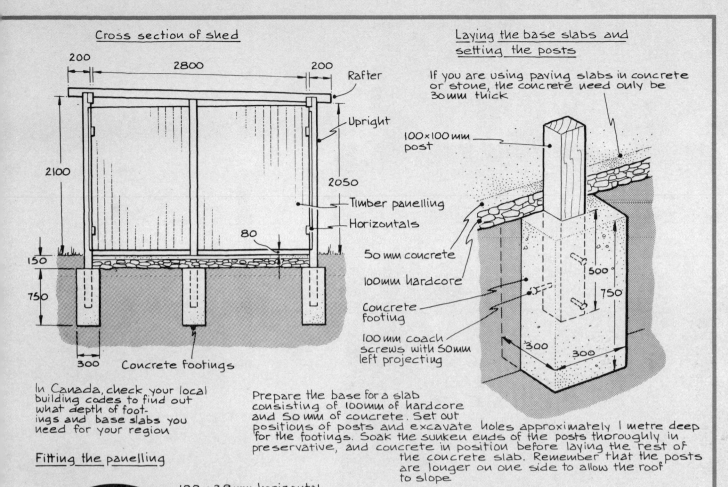

200 2800 200

Rafter

Upright

2100

2050

Timber panelling

Horizontals

80

150

750

300

Concrete footings

In Canada, check your local building codes to find out what depth of footings and base slabs you need for your region

Laying the base slabs and setting the posts

If you are using paving slabs in concrete or stone, the concrete need only be 30mm thick

100×100mm post

50mm concrete

100mm hardcore

Concrete footing

100mm coach screws with 50mm left projecting

500

750

300 300

Prepare the base for a slab consisting of 100mm of hardcore and 50mm of concrete. Set out positions of posts and excavate holes approximately 1 metre deep for the footings. Soak the sunken ends of the posts thoroughly in preservative, and concrete in position before laying the rest of the concrete slab. Remember that the posts are longer on one side to allow the roof to slope

Fitting the panelling

100×38mm horizontal

100×19mm boarding panels nailed to horizontal with 50mm galvanized round wire nails

Cover the gap with a skirting board which can easily be replaced if in time it should become rotten

B

Leave 80mm gap at floor level

Join and fix the roofing panels using only the manufacturers recommended fixings which are designed for corrugated PVC roofing. Nails are not suitable because it is not possible to control the tightness with which they are hammered home, and there is risk of shattering the sheet. Also the nail head is not large enough to give a firm fixing.

Drill all holes using a normal metal working twist drill bit

C

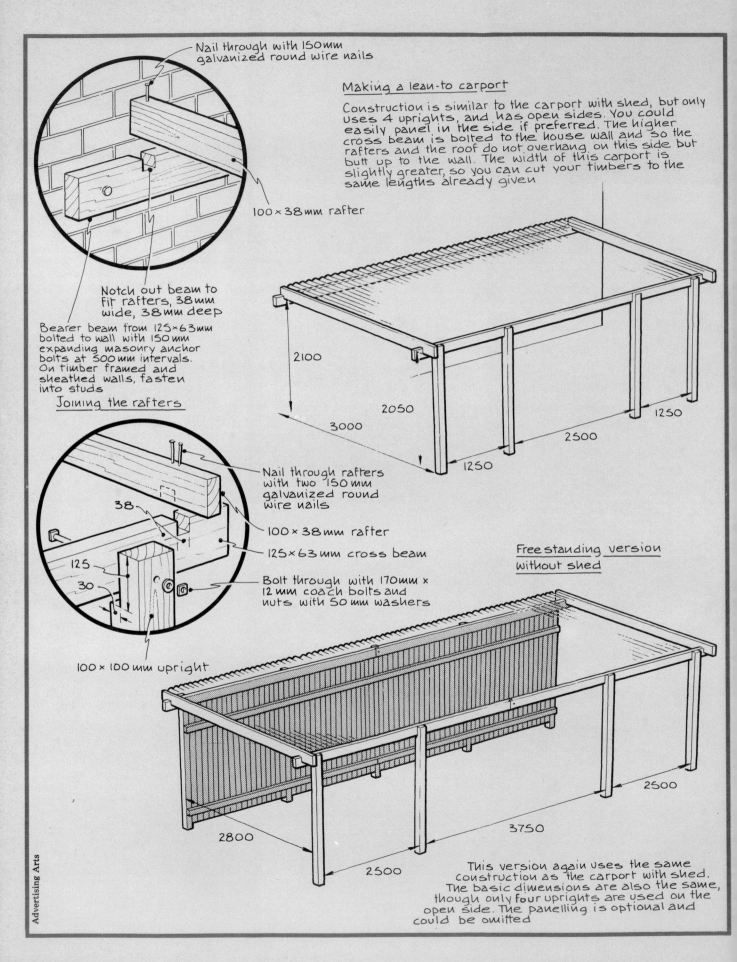

Nail through with 150mm galvanized round wire nails

Making a lean-to carport

Construction is similar to the carport with shed, but only uses 4 uprights, and has open sides. You could easily panel in the side if preferred. The higher cross beam is bolted to the house wall and so the rafters and the roof do not overhang on this side but butt up to the wall. The width of this carport is slightly greater, so you can cut your timbers to the same lengths already given

100 × 38mm rafter

Notch out beam to fit rafters, 38mm wide, 38mm deep

Bearer beam from 125×63mm bolted to wall with 150mm expanding masonry anchor bolts at 500mm intervals. On timber framed and sheathed walls, fasten into studs

Joining the rafters

2100

2050

3000

1250

2500

1250

38

Nail through rafters with two 150mm galvanized round wire nails

100 × 38mm rafter

125 × 63mm cross beam

Bolt through with 170mm × 12mm coach bolts and nuts with 50mm washers

125

30

100 × 100mm upright

Free standing version without shed

2500

2800

3750

2500

This version again uses the same construction as the carport with shed. The basic dimensions are also the same, though only four uprights are used on the open side. The panelling is optional and could be omitted

OUTSIDE REPAIRS AND RENOVATIONS

Repairing window sills

Above: *Obvious signs of rot which can cheapen the appearance of your entire property*

Window sills are constantly at the mercy of the elements and so need occasional maintenance and repair, not only to look good but also to perform their job properly. Repairing most types of sill is not as difficult as it seems

The purpose of a window sill is to protect the wall underneath the window from rain. Although this may not seem necessary—after all, the rest of the wall is not protected in this way—rainwater striking the glass panes forms a concentrated, downward-running cascade which could penetrate a masonry wall or start rot in wooden siding.

Putting a projecting ledge—a sill—of some material between the window and the wall below stops this happening and prevents penetrating damp. But this means that the sill itself has to cope with the water flow and so it is constantly exposed to wear.

Damage to sills is often the result of faults in the basic design or construction of the window and sill and reaction to former repairs.

Some typical sills are shown below. They project well beyond the frame of the window itself so that rainwater is directed well clear of the supporting wall. Note that any projection beyond the width of the window opening is for the sake of appearance only—and does nothing to improve the function of the window sill itself.

In older houses, particularly, the window frame is often deeply recessed—perhaps flush with the inside surface of the wall. In this case, and where the window frame itself has no sill, a separate sill has to be provided and these are prone to trouble.

It is important that the top surface is sloped (or 'weathered') away from the window so that rainwater does not settle. A rounded sill edge also encourages water run-off. For wooden and smooth stone or concrete sills, the

Types of window sill

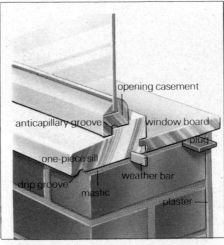

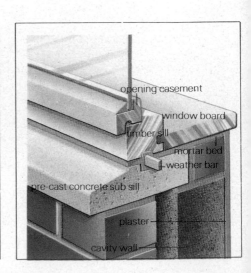

slope need not be very great; for the rougher clay tile or brick sills, a steeper slope is necessary.

Unless rainwater runs off quickly, wooden sills may rot and stone or cement sills crack through frost action. Paint finds it difficult to adhere to damp surfaces and combined with the action of sun it can easily blister and peel, leaving the sill even more vulnerable to attack from the rain.

A drip groove on the underside of the sill is a small but important feature. Whatever the angle of slope on the top surface, some rain inevitably creeps around the front face of the sill; accummulated drips then work along the bottom edge and onwards to the wall—where they can attack the joint with the sill. The drip groove prevents this by halting the water's progress, causing it to form into larger droplets that then fall harmlessly to the ground.

Some sills are formed in one piece with the rest of the window frame. Others—either by design or following a repair—are installed separately and if any joint between the two is left unprotected or badly sealed, you can expect trouble. One type of sill which is particularly prone to damage at the joint with the frame is shown in fig. A where a repair has been made.

In other designs, a galvanized steel *water bar* may be used to prevent water from tracking along constructional joints to the inside. This will be bedded on edge in a lead-packed groove in the main section of a stone or concrete sill. The bar fits a corresponding groove in the underside of a fixed wooden frame or top sill to give complete protection from draughts and wind-driven water.

Irregularities in the design of the window frame may also spell trouble for the sill beneath it. The basic rule is that each part of the frame ought to overhang the part beneath it, and that all 'horizontal' surfaces should slope slightly towards the outside.

Other sill types

Fig. 24 shows a stone subsill—widely used with sash windows in masonry walls—where the frame itself is recessed in the window opening, and where the frame's own sill is too short to reach the outer surface of the wall let alone project from it. This type of sill, which has a weathered top surface and a drip groove—also called a throat—is wider than the frame and is built into the brickwork on each side.

Another type of sill makes use of plain clay roofing tiles or quarry tiles.

Hand-made tiles are rough-surfaced and fairly porous, and so should be laid at a comparatively steep slope of about 30° to the horizontal; machine-made and quarry tiles need less. Two staggered layers of tiles are laid to prevent rainwater seeping through to the brickwork beneath—the bottom course is laid with the tile nibs along the outer edge, hanging down to form a crude drip groove.

Dealing with design faults

If you want to avoid recurring problems, it is important to correct any design faults during the course of routine maintenance or repair work.

Start by checking the drip groove. Appearance can be deceptive: there may be a drip groove, but well hidden under layers of paint. Probe around to see if you can find one and, if you

1 Use a pointed tool and knife to explore the extent of rot in the wood. Expect trouble at exposed joins in old sills

2 Carefully mark an angled cut line on each side and well clear of the rot, and use a tenon saw (backsaw) to remove the rotten section

3 Chisel into sound wood to the rear, levelling the wood as you proceed, so that the replacement pieces fit snugly

4 From direct measurement, cut the replacement sill sections. Carve or rout a drip groove to join the existing one

5 Where sill rot has spread to nearby framework, a replacement section must be fitted. Build this up from suitable pieces of timber

6 *It is sometimes easier to shape wood in situ. Use countersunk fixing screws, and a plane to reduce the wood to matching section*

7 *Before permanent fixing, apply liberal quantities of wood preservative to the contact areas, working it well into the cracks*

There is little you can do to correct poorly made tiled sills except remove and replace them. But only do this once you are sure that it is the slope which is causing the trouble.

Similarly, there is little you can do about design faults in a window frame without replacing the frame completely. Where the upper frame sections do not overhang lower ones properly, it may be possible to fix additional thicknesses of wood to the frame. But unless this is done carefully and the joints between the timber very well sealed, it may prove more of a problem than the original fault.

However, if the joints between a wooden sill and the frame are exposed and letting in water, simply rake out the old jointing material and pack the cleaned gap with suitable mastic or filler before repainting.

8 *Apply suitable adhesive to the contact areas between the old and new parts of the sill. Use a water resistant adhesive*

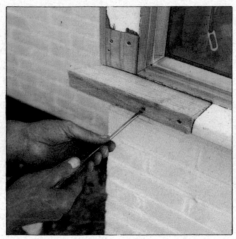

9 *Carefully position the new section and immediately drill holes for a secondary fixing using countersunk plated screws*

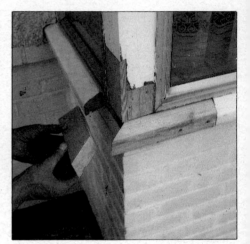

10 *Check the accompanying pieces for accuracy of fit, and then glue and screw these into position. Use filler to make good gaps*

do, scrape the recess completely clear then prime and paint it, taking care not to repeat the fault.

Where there is no groove, you might be able to rout or chisel one. But a stop of some form is a much easier solution which should work just as well. You can make the stop from a length of quadrant (or even square) beading and fix it to the underside of the sill with impact adhesive, about 35mm back from the front edge. Make sure that the sill is sound and properly painted around the site of the stop and repaint the entire underside once the stop is in place.

Next check that the sill slope is steep enough. Puddles of water on the upper surface indicate real trouble and will quickly cause rapid decay. Prod a wood sill with a pointed blade or bradawl to check for wet rot, and

look for fine cracks and flaking on stone or concrete sills—typical signs of an inadequate slope.

A wooden sill is easily corrected by planing it to a suitable slope, though you can do this only if the timber is sound and deep enough.

A stone sill can be repaired and sloped by forming a mortar fillet on top. But this usually means that the back edge of the sill would come close to wooden parts of the window frame; you should first carefully chip away part of the sill in order to lower it.

Remove all dust and loose particles, then paint the surface with PVA adhesive so that the new mortar mix of one part cement to three of sand adheres properly. Run over this with an offcut of timber to give the slope you want, then remove the former and shape a rounded front edge.

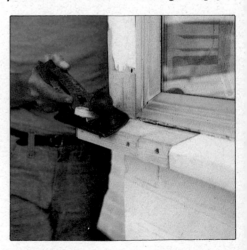

11 *Plane the new sill pieces to the same section as the existing sill, then sand down wood and filler ready for painting*

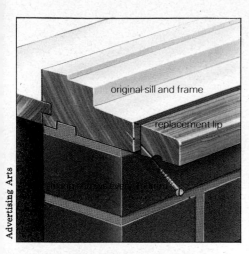

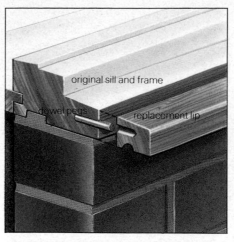

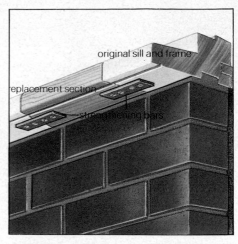

A. *To renew a lip, form a matching piece and fix this using glue and countersunk fixing screws angled in behind the drip groove*

B. *An alternative method is to use dowel pins to fix the new lip section in position, in which case in situ sill shaping is advisable*

C. *New sections can be reinforced by fixing strengthening bars to the underside. Ideally, these should be countersunk, filled and concealed*

Rotten window sills

If you have caught the rot in good time you may need to do nothing more than burn off all the paint on the sill, scrape the surface back to sound timber, and flood the area with wood preservative before repainting.

But if the damage is at all extensive, it is sensible to cut out the affected part and replace it. Some joinery stockists sell ready-shaped sills and if you can find one which has the same profile as your sill (or nearly so), it can be used for patching gaps. Otherwise you have to trim a piece of suitable timber to the correct shape.

As an alternative, replacing the whole sill with new material often makes better sense; patching involves making joints that may themselves let water in, thus creating further rot problems to repair.

Most modern wooden sills are made of softwood—usually redwood—which is perfectly suitable providing it has been properly treated with pressure-impregnated preservative.

Hardwood is a better material for sills because of its resistance to decay, but there are problems. Susceptibility to surface 'checking' may make traditional materials difficult to paint while some hardwoods such as Ramin have poor resistance to decay.

You may be able to find a suitable all-plastics sill. Obviously, this cannot rot but the wood at the joint between it and the existing frame will still be susceptible to damage. Do not cover wooden sills with a plastics covering such as sheet laminate. Almost certainly you will not be able to make the edges and joints completely watertight and any water entering these could cause rot very quickly.

12 *A damaged concrete sill is better removed in its entirety using a club hammer and bolster. Remove sections at a time*

13 *Failure of a concrete sill may mean that accompanying woodwork has to be removed also. Chisel this away until you reach sound timber*

14 *Paint the existing timber with two coats of preservative and one coat of primer, allowing time for each coat to dry*

15 *Measure and cut a piece of replacement timber and nail or screw this into place. Apply two coats of preserver, one of primer*

Replacing a sill

If the sill is formed in one piece with the window frame, you must cut it free at a suitable point in order to replace the whole sill. If possible, arrange the cut so that the joint with the new sill will be covered by the next window frame member up. Otherwise simply cut off a generous width of sill, well beyond the depth of rot. Power sawing tools are useful for this operation—perhaps an electric drill with circular saw attachment.

Clean up the cut face of the remaining part of the sill by chiselling and planing until it is smooth and flat. Treat the face generously with preservative (fig. 7).

The new sill is bonded firmly to this surface. Although galvanized screws driven in at angles from below through the two pieces might do in some cases, a better solution is to make dowel joints between the two as shown in figs A and B.

Whatever main method of fixing you choose the two surfaces must also be glued together, using a urea or resorcinol formaldehyde adhesive. When the wood is well bonded, rake out all the gaps between the new sill and the wall or the old sill and flood them with preservative. Finally, pack the gaps with a suitable waterproof mastic.

To repair just a small section of sill, cut out the affected part with a saw and chisel then use this as a template to cut the patching timber to size. Thoroughly treat the new wood—especially the cut ends—with preservative, then glue it in place with a urea or resorcinol formaldehyde adhesive—not ordinary PVA woodworking adhesive. Finally, screw the patch to the existing sill using galvanized screws countersunk well below the surface. Cover the heads with mastic or filler and if even greater strength is needed, fix a metal strap to the underside of the sill (fig. C).

Stone or concrete sills

Non-timber sills rarely need much more than patching. Stone and concrete sills are easily patched with a 1:3 mortar mix, using a timber formwork arrangement similar to that used for increasing the surface slope. Tiled sills are best patched by replacing the damaged tiles themselves, on an individual basis.

However, badly cracked or decayed sills may need replacing altogether and the best way of doing it is to cast a new concrete sill in situ, using shuttering.

16 Remove any loose bricks from the support area so that they may be remortared. Remove all traces of the old mortar and dampen the area

17 Prepare some mortar and then replace the line of bricks that you have removed. Allow the mortar to dry for 24 hours

18 The next stage is to make the shuttering for casting the new concrete sill. Use a bevel gauge to transfer angles in the brickwork

19 Construct the shuttering from suitable pieces of timber. Use a length of half-dowel to form the drip groove in the sill underside

20 Drill 25mm holes in the mortar of the support bricks so you can use 100mm nails for fixing the shuttering in place

21 Offer up each section of the shuttering to check for fit and then nail these into place to form a snug box round the window

22 Secure the box by tacking bracing struts between the window frame and the shuttering, but take care not to damage the woodwork

Although the job can be very tricky with the existing window frame in place, the chances are that it too will need replacing if the sill is beyond reasonable repair (figs 12–28).

Painting

Prevention is much better than cure, so making sure that your window sills are properly painted is a good investment and an important household maintenance job.

Perhaps the most important point is to ensure that the woodwork is not damp when it is painted, as this quickly leads to blistering and peeling.

The old paint will probably have to be removed completely if it is in poor condition and in this case burning off is better than using stripper because it keeps the wood dry. Sand the surface smooth afterwards and treat any

knots with knotting compound to seal them. Rub a fine wood filler into the surface to seal the grain—do not forget the ends of the sill. Finally paint with primer, undercoat and two top coats, making sure that no bare timber is left overnight.

Hardwood sills often develop small cracks, causing subsequent fracture and flaking of paint. The answer is good preparation; one treatment is to scrub thinned wood primer into the grain and then seal it with filler before applying another coat of primer.

Painting stone or concrete can also cause problems. Ordinary oil paint will mix with the alkali salts in the stone and soften or flake, unless you use an alkali-resistant for the first coat. It is far better to use emulsion or masonry paints, both of which resist alkalis fairly well.

23 Dampen the brickwork and trowel in the mortar. Chop and tamp this into place to fill even the smallest cavity

24 Slope off the top, then leave the mortar to dry for 48 hours before removing the box. Cover to protect from rain if necessary

25 To repair a stone sill, rake out all loose material and use a wire brush to scrape all surfaces as clean as possible

26 Mix up some exterior stone filler and fill cracks and surface indentations, carefully forming edge sections in stages

27 When the filler has dried, use sandpaper to smooth this down, feathering the edges where it meets the original stonework

28 Dust the sill carefully and apply one coat of stabilizer over the entire sill. Allow this to dry before decorating

Replacing broken glass

Apart from the danger of exposed broken glass, a smashed window in the home is an open invitation to an intruder. You can reduce both risks by reglazing the window yourself. The job requires care but is straightforward and quick.

If you are reglazing a downstairs window it should not be necessary to remove the window from its frame. But if the window is upstairs, you need an extension ladder to reach the outside of the window. In this case, the job will take longer and you may find it more convenient to take the window out of its frame and reglaze it on a workbench at groundlevel.

A hinged sash can be removed from its window frame by unscrewing the hinges. Use a bradawl to scrape out paint from the screw heads. To remove a sash from a double-hung window means removing woodwork, so in the case of an upstairs window, it may be better to work from a ladder.

If you decide to work from the ladder, secure it at the top by looping a safety rope through the rungs and around a suitable anchor point. Additionally, make sure the feet of the ladder are well anchored.

A useful tip is to wear an apron or workman's overall which has large tool pockets so that you can carry everything likely to be needed for the job. This will save countless trips up and down the ladder during the course of the installation.

Removing old glass

Take particular care when you are removing old glass from its frame. Always use heavy-duty (leather) gloves to pull out loose pieces (fig. 1).

Uncracked sections and stubborn slivers must be smashed out with a hammer. But before you do this, cover both sides of the glass with thick cloth or blanket to prevent chips flying through the air. For additional safety, wear spectacles, or old sunglasses at all times.

If you have removed the window from the main frame, cover it and lay it on several sheets of newspaper

It is sensible to replace the glass of a broken ground-floor window as soon as possible to deter would-be intruders. You can use replacement glass of the same type or choose instead from the many decorative and strengthened types now available

Reglazing is an occasional household maintenance job that you can easily do yourself if the need ever arises. And with the number of decorative forms of sheet glass available, it is a novel way of changing appearances

Ray Duns

Below: *Cross-section showing the normal method of glazing with putty. Triangular-shaped nails called sprigs are used to hold the pane in place against the back putty. These are then covered by more putty*

glass

putty

glazing sprig

Below: *Wooden beading can be used in place of the set of sprigs. This results in a neater looking finished job which many prefer to the more common putty glazing method where greater skill is required*

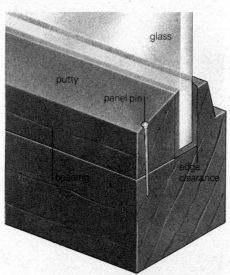

glass

putty

panel pin

beading

edge clearance

1 *Carefully work loose the large fragments of glass, then tap out the smaller pieces. Wear heavy-duty gloves when handling the glass*

2 *Use an old chisel or a hacking knife to remove hardened putty. Be especially careful of slivers of glass that may be embedded in this*

before you knock out the glass. This will make it easier to gather up the splinters afterwards.

After you have hammered out the glass, carefully remove the covering cloth and work loose fragments left in the frame. You should be able to prise out the glass quite easily, but if the putty is very old and hard and the glass refuses to be teased loose, cover the window with a cloth again and smash the fragments down to the level of the putty. Then, wearing eye protection, use a hammer and chisel to knock out the remaining putty with the glass embedded in it.

The old putty can be removed with a *hacking knife*—a tool specifically designed for this job—but a chisel will do the job nearly as well. Make sure that the chisel is an old one, well past its useful life, as it will become quite blunt when used in this way. Remove all the putty, including the *back* or *bedding layer* and take care not to damage the wood with whatever tools you use (fig. 2).

Measuring up the pane

When measuring up for the new pane of glass, always take the measurements twice: a mistake of only a few millimetres can make the pane unusable. Also, measure each opening within the main frame separately as small size differences between any two can go unnoticed until it comes to reglazing.

When you have determined the final height and width measurements, subtract about 3mm from each to allow

sufficient clearance in the frame—increase this to 6mm in the case of slightly warped frames.

When giving measurements to the glass merchant, it is customary to give the height before the width. This way, if you are buying frosted or patterned glass, the pattern will be the correct way up (vertical) when you install it.

The glass

Glass is now graded by thickness in millimetres—it was formerly graded by weight per square foot—and for most applications 4mm is adequate, although 3mm is sufficient for smaller windows. *Float glass* is now the most commonly used for general purpose work but cheaper *horticultural glass* may be used where viewing distortion is no problem—such as in a greenhouse.

For help and advice on the choice and safe use of glass, do not be afraid to consult your local glass supplier. Several types of glass can be used around the house and it is important to use a strengthened form where there is risk of breakage. For example, UK recommendations state that only toughened or laminated glass should be used for balustrades which protect a difference in floor levels or which are used for shower screens.

Wired and laminated glass can both be used for floor-level windows, and those near to stairs (such as in a hall) can also benefit from these types.

A wide variety of decorative glass is available in addition to standard

frosted patterns; using these in place of clear glass for extra privacy is well worth considering.

Before you install the glass, place and check it for fit in the frame and, if necessary, get the supplier to make small adjustments. You can sometimes accommodate very small irregularities by turning the sheet upside down or around in relation to the frame and then trying it again.

Using putty

Putty needs to be of the right consistency if it is to hold the glass in place and form a watertight seal. And when first taken from the tin it is inclined to be too wet, rather sticky

3 Take particular care to clean out the upper rebate in a vertical sash window, but beware of glass slivers stuck in old putty here

4 Apply small nodules to the frame rebate so that sufficient back putty depth results. Use the heel of your hand to force putty home

5 Push the replacement pane into position but apply pressure at the edges only. The back putty seal should be even and unbroken

6 Use a hammer or old chisel to tape the glazing sprigs home and slide the head along the glass to avoid cracking the pane

7 Trim off the back putty by a straight cut with the putty knife. Then apply the facing putty and smooth this down to finish

8 When the putty has matured, four weeks or so afterwards, it must be painted over to prevent it from drying out completely

and consequently difficult to handle. Knead it gently between the palms of your hands or place it between folds of newspaper to remove excess moisture and oil (fig. 3).

There are two types of putty: linseed oil putty for wooden-framed windows, and metal casement putty for use with metal frames. The latter should also be used as a bedding seal if metal-framed glass—such as insulating glass—is fixed into a wooden frame. In this case, linseed oil putty is used to finish off the outside seal.

In Canada, a glazing compound is widely used instead of putty—you apply it to the window frame in much the same way.

Installing the glass

Once you have checked the glass for fit, lay a strip of back (bedding) putty around the window frame (fig. 4). Where hacking off the old putty has exposed areas of bare wood, prime these and let them dry before you apply putty over them. Use the heel of your hand to smear the nodules of putty around the insides of the rebates.

Place the glass in the frame and push it gently but firmly against the bedding putty. Push around the outside of the frame—not the middle—with a pad of cloth to protect you against any slivers of old glass left in the frame. As you do this, the putty will ooze out on the other side.

The bedding putty is necessary not only for providing a good watertight seal, but because it also takes up small irregularities in the trueness of the backing frame. A final depth of up to about 5mm is recommended, and you can ensure an even depth around the frame by locating small wooden spacers such as match wood.

The sheet of glass must be centred within the frame—you should already have had it cut to measurements slightly smaller than the frame's inner dimensions. The best way of doing this is to stick matchsticks between the glass edge and frame at odd points around the window; or use folds of thin wood or card to build up greater

depths. Spacers should not be necessary if you can work on the window flat.

When the sheet of glass is properly bedded, by which time it should remain in position by itself, secure the glass on each side of the frame by tapping home a couple of *glazing sprigs* (fig. 6) These are small, headless nails, buried by the face putty when the glazing is completed. On larger windows, use more sprigs at 150mm spacings around the frame. Start with the bottom edge and then deal with the top and side edges.

To avoid breaking the glass, if you choose a hammer, hold the sprig next to the glass and then slide the hammer head along the glass to tap the sprig down and below the level of the facing putty later added. Never lift the hammer from the glass surface, nor try to force a sprig home.

When this is done, you can apply the final (facing) putty. Start where you like and feed in little nodules of putty as you proceed around the edge, using the heel of your hand to press it fully home. The finished height of the facing putty must be no higher than the inside level of the frame, and therefore not visible from inside.

Finish the job by trimming off waste putty with a putty knife. Hold the flat edge against the pane of glass and run the knife along the edge of putty, pressing firmly downwards as you go (fig. 7). If the knife sticks, wet the blade with water. Should the putty become unstuck as you drag the knife over it, push it back in firmly and continue trimming with the knife.

Finally, rake off the putty that has oozed out at the back of the glass level with the frame. When trimming be careful of small splinters which may still be left in the putty.

Wooden beading

Some windows use wooden beading in place of facing putty (fig. 11) and you can usually use this again when you set the new pane. Remove the side beading first—because it is longer and therefore more flexible—by bowing the ends towards you.

Then remove the small fixing nails afterwards by pulling them right through the beading—do not try to knock them back through the beading as this may split the wood. When you have removed all the nails, clean the beading with a medium grade of glass-paper. Any old putty on the back must be removed, as must the jagged edge left by the broken paint line where the bead joins the frame.

If the old beading is damaged and needs replacing, ask your supplier for *staff beading* in the length required. It is normally available in two sizes, so take along a piece of the old beading.

The mitred joints at the ends of glazing beads are most easily cut on a mitre block. If you do not have one, lay the new length beside the old one and use the latter as a cutting guide. It helps if both are taped or clamped together before cutting.

Beading is positioned as the sheet of glass is pushed home on the bedding putty. Fix the shorter (top and bottom) lengths first, using nails at 100mm intervals (fig. 12). For a really professional finish, punch in the glazing pins first so that the heads will not be visible when the beading itself is later decorated.

Use the point of a putty knife to remove bedding putty that has oozed out of the back and sides.

Decorating

Leave the freshly-bedded putty to mature for about four weeks before you paint it. But do not delay this final job for too long or the putty will shrink and crack, causing all sorts of problems later. When painting, carry the paint layer just beyond the edges of the putty and on to the glass in order to provide a better waterproof seal and to keep the putty moist.
Allow for this overlap when gauging the depth of putty required.

9 For a beaded window, start by carefully levering off the wooden beading, especially if this is to be re-used for re-glazing

10 Much the same procedure is used as far as glass and putty removal is concerned. After making good, apply the bedding putty

11 Push the glass home against the bedding putty. Apply a small amount to the front glass and the nearby framework

12 Seat the wooden beading on this bedding seal and use small nails to fix the beading tight in place. Trim excess putty

Cutting glass

A. *Lay the glass on a cleaned and perfectly level work surface, such as a sheet of chipboard here. Measure off the cutting line accurately, positioning a wooden set square or other suitable straight-edge at the mark. Do not use a wax pencil for marking as this may affect the efficiency of the cutter*

B. *Score a line by running the cutter along the straight edge in a single continuous stroke. A score line is made on one side only. You can lubricate the cutter and the cutting line with white spirit (turpentine) beforehand, but this is considered necessary only for thicker glass. Cut decorative glass on the smooth side*

C. *Place the straightedge beneath the glass and tap firmly along the score line to 'spread' the cut. This stage is particularly important as it reduces the risk of an incomplete break along the score line, which can be difficult to rectify afterwards. To concentrate the effect of the score line, run the cutter only once.*

D. *Arrange the glass sheet so the cutting line coincides with the straightedge, place a sheet of newspaper or card over the glass sheet and push the 'waste' end sharply and firmly downwards to break the sheet along the score line. Small tail pieces can be nibbled away carefully, using pliers or the indentations on the cutter*

Repairing stucco and render

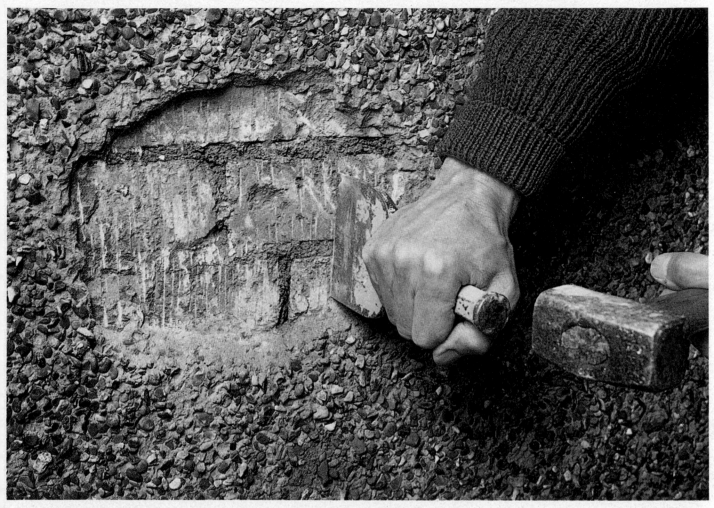

Ray Duns

● **The purpose of rendering** ● **Minor repairs** ● **Repairing damaged patches** ● **Which mortar mix to use** ● **Applying the undercoat** ● **Applying the topcoat** ● **Different types of rendered finish** ● **Pebbledashing and roughcasting**

Above: *When a patch of rendering or pebbledashing is badly damaged, the only solution is to cut it back to solid material with a hammer and a bolster, clean the area, then apply an undercoat and topcoat of freshly mixed repair mortar*

Rendering or stucco applied to the outside walls of a house is both decorative and functional: it brightens an otherwise shabby or crumbling surface, but at the same time helps to waterproof and protect the wall.

Many types of finish can be produced, some of which are smooth while others are textured or mixed with pebbles. They can be applied to almost any surface—bricks, blocks, concrete or even timber-frame construction— so repairs are relatively easy provided the base is prepared adequately and the new render matched carefully with the original.

You should carry out regular checks on walls which are rendered so any faults can be noted and cured before they worsen. Cracks or splits in the material are usually easy to spot but you should also test for render which has 'blown' or broken loose from the wall. Tap all over the surface with the handle of a hammer: a hollow sound indicates where the render has blown and how extensive the fault is. Bear in mind that if the damage is severe or over a wide area; it would be better to re-render the entire wall. This is often the case on older houses which have the traditional rendered finishes— particularly the type of finish known as stucco.

Minor repairs

Small cracks or splits less than 5mm wide are easily repaired providing the render around them is sound and the wall below is undamaged. Start by clearing away loose material and dust with a brush, making sure that each crack is perfectly clean. Then, before repairs are carried out, douse the inside and around the edges of each gap with water. This will stabilize dusty patches and help provide a good key for the filling.

Repairs to a small number of cracks are best made with a good quality, exterior-grade filler; but where there is extensive splitting, mortar is more

suitable and less expensive. Make up a fairly dry mix of one part cement to five of sharp sand, adding proprietary waterproofer to the mixing water.

Load a manageable amount on to a plasterers' hawk so that it can be carried more easily to where it is needed. Then use a pointing trowel to scrape the mortar from the hawk and press it hard into each crack. Take care to scrape off any excess mortar once you are level with the surrounding wall. Deep splits may have to be filled in two stages, allowing plenty of drying time between applications.

Leave the repair mortar to dry for about one hour then, while it is still fairly wet, run a damp sponge over the top to smooth it completely flat. Afterwards texture the repair or add pebbles to help it blend with the rest of the wall (see below).

Repairing damaged patches

Where large cracks have appeared or the render has broken loose from the wall, you have no choice but to cut away the defective material with a bolster and hammer until you reach a sound edge. It is essential to wear safety glasses when doing this to protect your eyes from the loose chippings of hardened mortar which are bound to fly around.

It is not necessary to use excessive force or leverage to break away the loose render. If it has already come away from the wall, a gentle tap with the hammer on the bolster should be enough to bring it down.

Start from the centre of the damaged area and hold the bolster at right-angles to the wall. Carefully break away the render until you reach sound material around the edges and then clean off the masonry underneath by scraping it with the bolster.

Once all of the render has dropped away, work around the outside of the hole undercutting the edge so that it is wider at the back than the front. This

1 Damage like this, where the top coat of rendering has fallen away due to weathering, is a common feature of older rendered walls

2 To make a repair, start by cutting away a square or rectangular patch large enough to embrace all of the damage. Use a hammer and bolster

3 When the patch is complete, cut in at the edges as shown to provide a lip against which the repair mortar can tightly bond

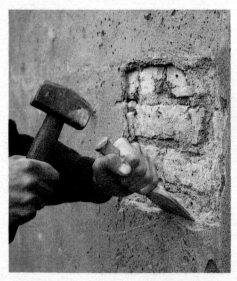

4 Follow by scraping the exposed surface of the brickwork with your bolster to remove high spots and pieces of crumbling mortar

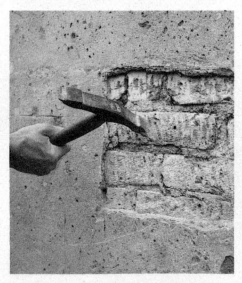

5 Finally, to provide a good key for the repair mortar, chip at the exposed brickwork with a pick hammer or similar masonry tool

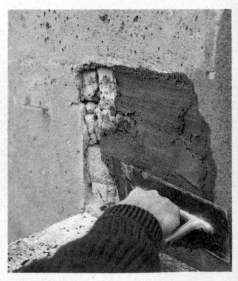

6 Transfer the base mortar from the hawk to the patch in an upward sweep. Force it well in as you do so and scrape away the excess

will make it easier to refill the hole with new render and help it to adhere well around the edges (fig. 4).

With reasonably rough surfaces—such as bricks, blocks or concrete—no further treatment is required before refilling, but smooth and dense masonry—such as engineering bricks or flattened concrete—should be roughened to provide a good key. Do this with the hammer and bolster by cutting a shallow criss-cross pattern across the face of the wall (fig 5). Alternatively, use a comb hammer if you have one. Be sure to wear goggles or safety glasses to protect your eyes from flying chips of masonry.

Undercoating

Rendering a wall is rather like plastering—an undercoat or *scratchcoat* must be applied first, left to harden and then a top or finishing coat added.

In Canada, rendering is often applied in three coats. This is especially so when rendering on timber-framed walls, where the first coat is pushed through a wire mesh netting stapled over the surface of the wall: the wire mesh provides the key which holds the undercoat in place.

Once the wall, whether masonry or timber, is cleaned and prepared, mix up the undercoat mortar—using a 1:6 mix for smooth stucco render, and a 1:4 mix for roughcast or textured render. Do not add too high a proportion of cement, as this will lead to surface cracking during drying.

Measure and mix the mortar carefully, adding waterproofer to the mixing water to stop it cracking. Load a small amount onto the hawk and transfer this carefully to the wall. By holding the hawk near the hole to be repaired it will be easy to scrape a small amount of mortar off it on to the wall with a plastering float. Push the float hard against the wall and move it smoothly upwards in wide sweeps so that the mortar sticks to the surface (fig. 6).

Build up the undercoat in layers until it is about 5mm from the outside surface of the edge of the hole. Then, while the mixture is still wet, stipple the surface so that a good key is created for the top coat. To do this, dab a coarse, hard brush—such as a scrubbing brush—all over the surface and raise it into small peaks (fig. 7).

The mortar should then be left to dry for at least two—and preferably three to five—days. Do not hurry the process or apply the topcoat before the mortar has completely hardened or splits could occur. In hot weather cover the drying mortar with tarpaulin or polythene sheeting and douse it regularly with water so that it hardens gradually.

Rendered finishes

When repairing defective patches of render the topcoat must be applied with care so that it matches the existing wall. So, before you mix up

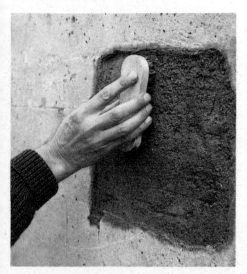

7 Leave the mixture to go 'off' slightly, then stipple over the surface with a stiff brush to raise it up into a series of small peaks

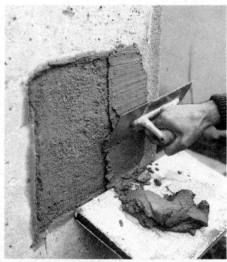

8 Apply the topcoat in the same way as the undercoat, once the latter has dried. Upward sweeps of the trowel stop mortar falling off

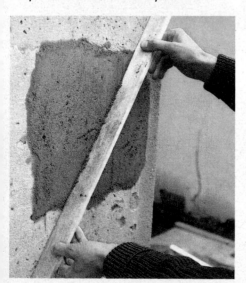

9 Use a timber straightedge to get the topcoat absolutely level with the surrounding wall, scraping either diagonally or horizontally upwards

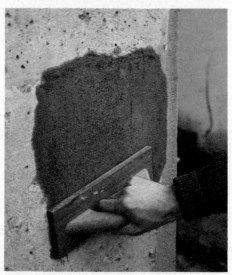

10 Do the final smoothing with a wooden float—using a steel one may cause cement and water to rise to the surface, so weakening the mix

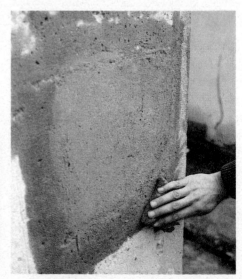

11 Finish by feathering the edges of the new patch into those of the surrounding render, using a just-damp sponge or cloth

Types of rendering

Fashions in rendered finishes come and go like building styles, but it is nevertheless useful to know how each is applied—nothing looks worse than a patch of repaired, but badly mismatched, rendering.

Stucco and ashlar finishes are often to be found on late 18th and early 19th century town houses in the UK. However, the mortar originally used is not noted for its hardwearing properties and as a result, many houses retaining their original finishes are long overdue for complete rerendering. Pebbledash and tyrolean finishes are both characteristic of more recent property, especially semidetached houses built in the UK between the wars and so may only require minor repairs.

A. *Stucco finishes have employed many different mortar mixes over the years. The smooth, regular top coat of mortar is almost always painted*

B. *Textured finishes vary according to the tool used to make them. The most commonly employed are hacksaw blades and stiff brushes*

C. *Tyrolean finishes must be applied with a special tool. It is advisable to experiment on an offcut of board before attempting a matching repair*

D. *The cottage texture is made by random sweeps of a wooden float over the finish coat of mortar. Try to match those already on the wall*

E. *For the pebbledash finish, small stones are thrown at the finish coat of mortar, collected, and then thrown again, until they adhere*

F. *Roughcast is similar in appearance to pebbledash, but here the small stones are added to the final mortar mix before it is applied to the wall*

G. *The criss-cross finish, found on some older stucco, is made by scoring through the finished mortar using a trowel blade and a straightedge*

H. *The same applies to an ashlar finish, originally applied to add relief to a plain stretch of rendered wall and simulate stone blocks*

the mortar for this stage, check carefully exactly what type of finish you already have on the wall:

Stucco: This is a plain, smooth rendering with no gravel or pebbles added to strengthen or waterproof it. Although it is neater in appearance than roughcast or pebbledash it has less resistance to weathering and must be applied carefully to avoid cracking or crazing as it dries.

Prepare a mortar mix of one part cement to six of sharp sand and apply it to the wall with a hawk and plasterers' float. When you reach the top edge of the wall, level the mixture by placing a long wooden straightedge across the repair. By keeping each end on the existing wall and moving it up and down in a sawing motion, excess mortar will be scraped off and the repair levelled (fig. 9). Use the straightedge horizontally working upwards, or diagonally moving across the work, but never work downwards or the render will fall out.

Finally, smooth the surface with a wooden float and when the mortar is nearly dry, feather the edges into the surrounding render with a damp sponge (fig. 11). Leave the patch to harden for two or three days before repainting the whole area.

Textured finishes: These are created by applying a topcoat in the same way as for the stucco finish and then texturing the surface with one of a number of different tools (fig. B).

Once the topcoat mortar has been levelled it should be textured before it has had a chance to dry. A number of special tools can be used for this but generally a large hacksaw or saw blade is raked across the surface to give it a lined, pitted appearance.

When creating this texture, take care always to scrape the wall in the same direction and to keep the saw in contact with the surface. If pieces of mortar drop off around the teeth of the saw, the surface is too wet and should be left to dry for a short period before retexturing.

Tyrolean finish: This is a type of textured finish which is supplied in a number of standard colours. It is applied to the wall on top of the finishing coat with a special hand-operated machine available from most hire firms. This throws the paint at the wall in a random fashion to create a deep textured pattern (fig. C).

Apply the topcoat in the same strength using the same techniques as used for the stucco finish, then smooth it level with a wooden float. Mix up the texture paint according to the manufacturer's instructions; it is usually supplied in powder form and needs to be mixed to the ratio two to three parts clean water to one part powder.

Load the machine with the mixture and carry it carefully to the wall. To cover the wall thoroughly and achieve the correct texture pattern, apply three coats to each patch.

Take care that the mouth of the machine is never directed towards windows, downpipes or doors. Where this is unavoidable, use a dry brush followed by a damp sponge to remove any finish that lands on the woodwork or glass. Better still, mask the areas beforehand using polythene or newspaper and masking tape.

The first coat should be applied working diagonally downwards from right to left at an angle of about 45° to the horizontal; the second coat downwards from left to right at 45°, and the third coat working from the bottom of the repair vertically upwards.

Cottage texture: This is a finish which is textured by hand rather than with tools or by machine. The random, rugged effect which is produced looks purposefully old-fashioned—hence its name (fig. D).

First, apply a topcoat of render in the normal way, smoothing it off with a wooden float and allowing it to set

12 The damage here is to a pebble-dash finish, identifiable by the layer of plain rendering below the outer covering of small stones

13 Before making any repairs to pebbledash, cover any gullies or other openings which could block up when you apply the stones

14 Cut away the damage in the same way as for ordinary rendering and angle-cut the edges so that the repair mortar will grip

15 When you apply the repair mortar, take care to confine it only to the patch and keep it just below the level of the surrounding stones

hard for two or three days. Then mix up more mortar to the same strength and coat this in a random pattern across the repair using a hawk and plasterers' float.

Try to mimic the existing texture finish on the wall when you do this by holding the hawk close to the wall and pushing a small amount of mortar from it against the patch with the float. Use a scraping action away from your body to deposit a blob of mortar on the surface. Then, with an upward twist of the wrist, feather the blob away to leave a diagonal trail running upwards across the wall.

While you are doing this, try to

16 *Before you apply any stones to the patch, sweep the area below clear of debris so that you can gather fallen stones and use them again*

pick up the same amount of mortar each time and space it evenly across the wall so that you maintain a regular pattern. For a rough, deeply contoured pattern use more mortar and try to spread it over a shorter distance; for a more delicate effect keep the mortar to a minimum and spread it out across the wall with wide sweeps of the float.

Pebbledash: This is a finish in which small pebbles or crushed stones—varying in size from about 6mm to 13mm—are thrown at the still wet topcoat. Once the mortar dries, the stones are held tightly and left uncovered to provide a rough weatherproof surface with attractive variations of natural colour (fig. E).

As an alternative to pebbles, white spar chippings can be used. These provide a durable finish with a fresh, clear appearance in contrast to pebbles which get dirty after a few years and need to be cleaned or painted regularly.

When applying pebbledash, it is most important that the topcoat of render on to which they are thrown is wet and not packed too tightly. Prepare the topcoat mortar with plenty of water and apply it to the repair with the float, leaving it about 10mm below the existing wall surface to accommodate the pebbles. There is no need to use a wooden float to get the surface absolutely smooth as this will pack the mixture too tightly—simply sweep away any loose mortar or dirt from the ground beneath the patch and pebbledash the wall as soon as is practically possible.

Load the stones in a bucket and throw them at the mortar by hand or with a small hand shovel. Continue until all of the patch is covered evenly. Any stones which do not stick to the wall can be picked up and used again (fig. 18).

Roughcast: This is a finish similar in appearance to pebbledash, but instead of the pebbles being thrown at the mortar on the wall, they are mixed with mortar before being applied. It is particularly suitable for walls which are slightly uneven or have poor surface adhesion.

Prepare a 1:5 mortar mix with the pebbles spread evenly throughout it and apply this directly to the undercoat. Once this has set load the mixture on to the hawk and push it hard against the wall with a trowel so that it is held firmly. Build up the mixture in a number of layers until it is level with the existing wall surface, feathering it away around the edges with a damp sponge or cloth once the mortar has partially dried.

Other finishes: Some existing walls may have finishes other than those mentioned above and you may have to do a great deal of experimentation so that you can reproduce the exact finish you want. A great number of renders are textured with special brushes or rollers or are scored in a criss-cross fashion with the blade of a trowel. If the wall you want to repair shows any of these unusual finishes, experiment on a small, unobtrusive patch of wall until you get the exact texture you want before attempting more widespread rendering.

17 *The stones are applied by throwing them hard, at close range, at the still-wet mortar. Do this a handful of stones at a time*

18 *When the mortar is covered evenly, gather up the fallen stones and repeat the process. Continue until no more stones will adhere*

19 *A few 'bald' patches may still be left at this stage. Patch them by pressing in more of the stones by hand, one at a time*

Repairing raingoods

Gutters and downpipes play a vital role in protecting your house from the effects of rain. But unless guttering is regularly maintained it will deteriorate, causing leaks or overflows. The damp in turn causes structural damage which often costs a fortune to repair

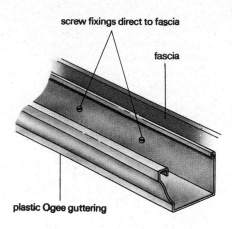

A. *Guttering of Ogee-section is often screwed directly to the fascia boards*

Guttering (eavestroughs) should be inspected twice a year, in late autumn and again in the spring. It will almost certainly be necessary to sweep out any accumulation of leaves and dirt with a hand brush and trowel or, in the case of plastic guttering, with a shaped piece of hardboard.

Keep the debris well away from the downpipe (downspout) outlet. If the outlet does not have a cage or grille fixed to prevent debris from entering and blocking the downpipe, roll a piece of galvanized wire netting into a ball and insert it in the neck of the pipe. Do make sure that the wire ball is sufficiently large not to fall down the pipe.

With cast-iron or galvanized iron guttering, check carefully for any rust. Use a wire brush to remove loose flakes of paint and rust and treat the surface with a rust inhibitor. The surface should then be given one or two coats of bituminous paint to form a strong protective layer.

On Ogee-section guttering (fig. A), or galvanized guttering fixed on with through spikes, rust may well be found around the fixings to the fascia—in which case the damaged section may have to be removed for treatment.

Clearing blocked downpipes

Before unblocking a downpipe, put a plastic bowl or large tin under the base of the pipe at the discharge into the drain to prevent any debris entering the drainage system.

When cleaning hopper heads (fig. B), use rubber gloves to protect your hands against sharp edges.

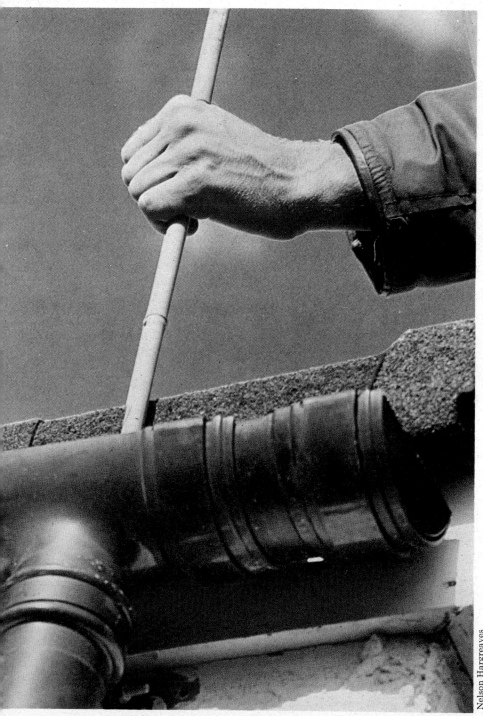

Left: *Clearing a downpipe. A blockage in a downpipe can cause the system to overflow with damaging results*

Nelson Hargreaves

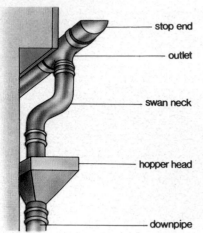

B. *This downpipe connects to the gutter run via a swan neck*

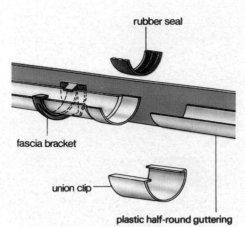

C. *A section held by a fascia bracket. This joint type is sealed in the socket*

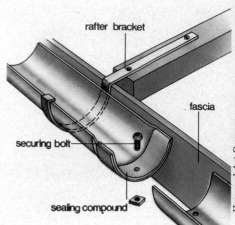

D. *A joint in cast-iron guttering. The gutter is supported by rafter brackets*

Hayward Art Group

To clear a blockage in a straight downpipe, tie a rag firmly to one end of a long pole and poke it down the pipe. Once the blockage has been dislodged, flush the pipe thoroughly with a hose.

If the downpipe is fitted with a hopper head carefully clear by hand any debris which has collected. Try not to compress the debris, or it may cause further blockage in the downpipe.

With plastic hopper heads, wipe the inside with a cloth and soapy water once the debris has been cleared.

With some systems, the guttering is positioned some way out from the wall and water is directed into the downpipe through an angled section known as a *swan neck* (fig. B). To clear a blockage here, use a length of fairly stiff wire in place of the pole so that the bends may be negotiated.

If a blockage is beyond reach, the lower part of the downpipe will have to be dismantled.

Sagging gutters
If a gutter sags, water may overflow or the joints may crack and leak. A bucket of water poured in at the highest point of the system reveals any such defects.

The commonest causes of sagging are broken or bent brackets, or loose fixing screws or spikes. Most guttering is supported on brackets screwed either to the fascia boards underneath the eaves of the roof (fig. C) or to the ends of the roof rafters.

To rectify a sagging gutter, remove the defective sections and examine the brackets to see if they are firmly fixed. If they are not, use longer screws to secure them. Where brackets are bent or corroded, replace them with matching new ones.

Replacing a rafter bracket (fig. D) normally involves removing the roof

covering directly above it, though this problem can often be overcome by fixing a fascia bracket adjacent to the faulty rafter bracket to give the necessary extra support.

Ogee section guttering differs from other types in that it is screwed or spiked directly on to the fascia. Sagging here is usually caused by the fixing devices rusting and then pulling away from the fascia. In this case, plug the holes and re-fasten with new screws or spikes.

A common fault with guttering occurs where the slope or fall towards the downpipe outlet becomes distorted —because of faulty installation or settlement of the house itself. Too steep a fall causes water to overflow at the downpipe outlet. Too shallow a fall results in a build up of water and sediment along the run.

To determine the correct fall for an incorrectly aligned section, tie a length of twine along the top of the gutter—from the high end to the outflow point—and use it as a guide to reposition the intervening supports. The gutter should fall 25mm for every 3m of its length.

Leaking joints in cast-iron
The joints in cast-iron gutter systems are held together by nuts and bolts which are usually screw-headed. A proprietary sealing compound—often a mixture of putty and red lead or a mastic sealer—is sandwiched between the two ends to make the joint watertight (fig. D).

A leaking joint may be patched up by cleaning the area with a wire brush and applying one or two coats of bituminous paint. However, for a more permanent repair the section on one side of the leaking joint must be removed, cleaned and replaced. If the

removed piece is in the middle of a run, two new joints have to be made—one at each end of the section.

Start by removing the bolts which hold the joints together. These may well have rusted and seized—in which case apply penetrating oil to loosen them. If this fails, saw through the bolts with a junior hacksaw. With Ogee-section guttering, remove the screws holding the section to the fascia as well.

Lift out the loosened section—making sure as you do so that its weight does not catch you off balance —and take it to the ground (fig. 2). Returning to the guttering, chip off all traces of old sealing compound from the hanging end (fig. 3) and scour it thoroughly with a wire brush. Repeat the cleaning operation on the removed section (figs. 4 and 5).

Apply fresh sealing compound to the socket section of the joint, spreading it in an even layer about 6mm thick (fig. 6). Relocate the removed

1 This leaking section of cast-iron guttering is on the end of a run. The guttering is secured by screws in the fascia rather than by brackets

2 When the bolt in the joint at the other end of the section has been loosened and removed, you can pull the section away from the wall

3 The leak is at the joint with the adjoining section. Using hammer and screwdriver, gently chip off traces of old sealing compound

4 Repeat the cleaning operation for the section that has been removed. Scrape off old sealing compound from the joint end

5 When the old sealing compound has been removed, scour clean the two ends of the joint thoroughly with a wire brush

6 Apply new sealing compound to the socket section of the joint, spread in an even layer about 6mm thick over the socket area

7 Having replaced the removed section and fitted the joint together, take a new bolt and insert it in the hole in the joint from above

8 Screw the securing nut onto the end of the bolt and tighten with screwdriver and spanner so that joint closes and squeezes out compound

9 Use a putty knife to trim away all excess sealing compound squeezed onto the surface above and below the gutter

10 *This cast-iron downpipe is fixed to the wall by pipe nails driven into wooden plugs which have loosened. Remove the nails with a claw hammer*

11 *With the pipe nails removed, pull away the lower section. Joints sealed with compound will have to be loosened first*

12 *Having dug the loose plugs out of the masonry, extend the holes with a 12mm masonry drill to make sure replacement plugs fit*

13 *Using a hammer, firmly drive your replacement wooden plugs into the holes until they are flush. Make sure the plugs are firm*

14 *When both plugs have been fitted, replace the lower section so that the bracket holes are level with the plugs. Hammer in two new nails*

15 *To prevent the downpipe cracking, force some fresh jointing compound into the joint, then wipe it smooth with a rag*

gutter section, screwing it to the fascia or laying it on its brackets and fitting the joints together.

Insert a new galvanized bolt into the joint from above (fig. 7). Screw on its securing nut, tightening gently so that the joint closes up and squeezes out any excess compound (fig. 8). Trim away the excess with a putty knife (figs 9 and 10), wipe over the area with a damp rag, then repeat the operation for the other joint. Finally, repaint the joints with one or two coats of bituminous paint.

Leaking joints in plastics

Leaks from plastics guttering can be just as damaging as those from cast-iron and should be attended to as soon as possible.

In most plastics guttering systems, the sections are connected by union clips, lined with replaceable rubber seals (fig. E). In some cases, the seal is positioned in the end of one section of gutter with a separate clip used to secure the joint (fig. C). When the clips are sprung home, the gutter ends compress against the pad to form a watertight joint—but this can leak if silt finds its way in.

To replace a seal, undo the clip holding the ends together, lift out the old seal and thoroughly clean the surfaces which come into contact with it. Fit a new seal of the same type and clip the joint back together by squeezing the ends of the gutter slightly and snapping the union clip over each edge of the section.

On systems which use combined union brackets, silt bridged joints are used (fig. F). The silt bridge clips into the union to prevent debris working its way into the joint and causing leaks. Leaks in such joints will be due to cracks—either in the bridge or in the union bracket itself—and can be remedied by replacing the defective part with a matching new one.

To fit a new silt bridge, hook one end under the front of the union clip and snap the other end under the lip at the back of the gutter.

Replacing a cast-iron section

If the whole system has eroded, it may be advisable to replace it with plastics guttering.

However, if the rest of the run is still in good condition, replacing a corroded cast-iron section is well worthwhile.

Where possible, take the old section to a builder's merchant and obtain a matching replacement. As well as the shape and diameter, check that the

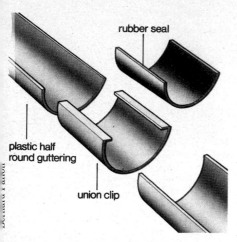

E. *This section of plastics guttering is connected by a sealed union clip*

new section matches the existing joints. If not, buy the appropriate union at the same time.

Cast-iron guttering is normally sold in 1.8m lengths, so the new section may have to be cut to fit. When measuring it up, take into account any overlap for the joints or new joint unions.

To cut it, lay the old section over the top of the new and use it as a guide. Mark the new section in pencil and lay a strip of masking tape along the mark, towards the waste side, to give a clearer guide. Cut the section with a large hacksaw.

Mark the positions of the joint bolt holes and punch and drill them to a diameter of 8mm before you fit the new section into place.

Cast-iron downpipe repairs

Cast-iron downpipes are usually attached to walls by pipe nails driven into metal, lead or wooden plugs. The nails run through cast metal brackets (fig. 11) some of which have spacers behind to prevent contact between the pipe and the wall. Brackets often come loose, making the pipe dangerous.

To secure a loose bracket, start by removing the bracket nearest to the ground and repeat the operation up to and including the bracket that is loose. To remove a bracket, lever out the nails with a claw hammer (fig. 10). Use an offcut of timber held against the wall to obtain the necessary leverage. Withdraw the section of corroded downpipe. Where the joints have been sealed and do not fall away easily, heat them with a blow lamp to loosen the sealing compound or chip the compound away by hand.

Remove the loose plugs by digging them out of the masonry, and make up replacements—slightly larger all round than the holes—from pieces of 12mm dowel. If necessary, extend the holes with a 12mm masonry drill (fig. 12). Drive the replacement plugs into the wall until they are flush (fig. 13),

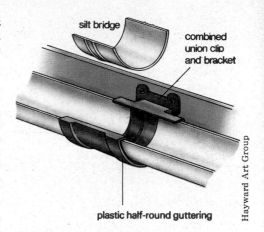

F. *The joint in this gutter is sealed by a silt bridge clipped into the union*

check that they are firm, then refit the downpipe (fig. 14).

In many houses, downpipe joints are unsealed. If dirt collects in an unsealed joint, water may gather and freeze and crack the pipe. Avoid this by filling any unsealed joints with a mixture of red lead and putty or a proprietary mastic. Wipe it smooth with a rag (fig. 15) then seal the joint with a coat of bituminous paint. Do the same with sealed joints that have become loose, having first chipped off the old compound.

Replacing an enamelled section

Gutters made from thin-section aluminium or galvanized steel, finished with white baked-on enamel, are less subject to rust than cast-iron gutters. But they are apt to dent sometimes just by your leaning a ladder against them.

The procedure for replacing a damaged section is much the same as for plastics. First, jam a block of wood inside the gutter while you draw the fixing spikes with a claw hammer, and disconnect the damaged section at the nearest joints. Cut the new section with a hacksaw, using the old one to measure the correct length, and file off the burrs on the cut edges. If you are using spike supports, drill holes through the new section to receive them.

Next, clean off the old sealing compound from the undamaged sections, as described above. Fill the joint connectors with sealing compound, slip them into place, and fit the new gutter section, spiking it into place. Finally, bend over into the gutter the top ends of the connectors if these are designed with fold-over tabs.

At external corners, as with other types of gutter, you need two fixing spikes—one into each length of fascia.

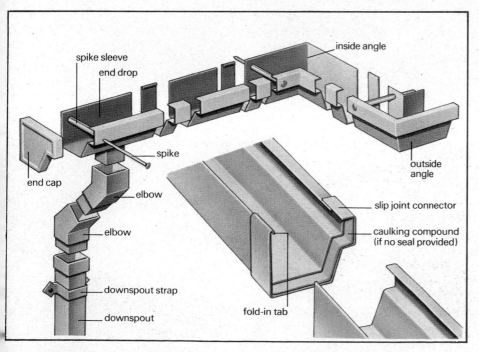

G. *Snap-together metal gutters come in several patterns, and in plain or enamelled aluminium or galvanized iron. Take an old section with you* *when you buy a replacement length to ensure the pattern matches. If there are no rubber seals where sections join, use plenty of caulking compound*

Mending a slate roof

Replacing broken or missing slates is an essential part of roof maintenance and timely repairs will prevent rainwater penetrating the timber and roofing felt below

Slate is the most hardwearing of all roofing materials and provides a sound, waterproof protection against the weather for at least 50 years before it needs to be renewed. But over this time, individual slates may be shaken loose by high winds, vibration or movement of the roof structure. When this happens it is important to act at once and carry out repairs before rainwater finds its way into the roof timber below.

Roof layout
It is essential to understand how slate roofs are constructed and how the slates are fixed in position before attempting any repairs. Not all slates are the same size and many will have been shaped and cut according to their position on the roof.

Slates are laid from the eaves upwards, and each row—known as a course—is overlapped by the one above. The vertical joints of each course of slates are staggered—like brickwork—so each slate partially

Above: *Carry out regular checks on your roof from the eaves. Loose or broken slates can easily be spotted and either refixed firmly in position or replaced by new slates of the same size and thickness*

1 *The slate ripper has two cutting blades facing the handle which are used to break defective slates free from their fixing nails*

covers the two slates below it.

The slates are nailed to wooden battens which run horizontally across the roof at right angles to the rafters beneath. The battens are spaced according to the pitch—or slope—of the roof and the size of slate being used.

Most building regulations now require that new roofs are fitted with roofing felt laid horizontally across the roof between the battens and the rafters. This is to improve insulation and to help keep the roof watertight in the event of a slate breaking.

The slates on the first row at the eaves, and those on the last row below the ridge tiles, are shorter than those used on the rest of the roof (figs B and D). This preserves the bonding and overlapping arrangements of the slates, and so helps keep the roof watertight along these two particularly vulnerable areas.

Gable: At the gable end of the house each course of slates should come to a neat, well-tailored finish, level with the row of slates above and below. To do this, the gap left at the end of every second row is filled, either with a special wide tile-and-a-half slate or with a normal slate cut in half lengthways (fig. A). If the roof is angled at the edge, the slates should be accurately cut to fit.

On the edge of many gable roofs there may be narrow clay tile known as a verge or creasing slate, which is laid under the slates at the end of each row (fig. A). These tiles, and the bedding mortar holding the tile in place, give the edge of the roof a slight inward tilt and prevent rainwater running down the wall below.

Ridge: Running along the ridge of the roof are a row of V-shaped ridge tiles usually made out of concrete or clay (fig. B). They are laid in position

2 *To remove a broken slate, slide the cutter under it and hook the end firmly around each of the fixing nails in turn*

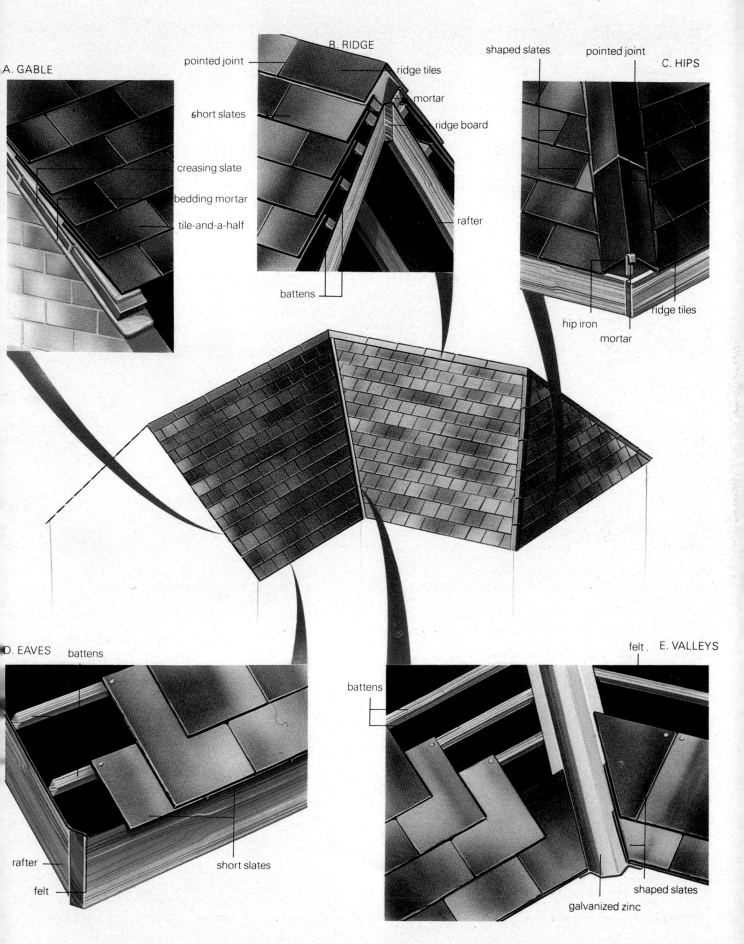

A. GABLE

pointed joint

short slates

creasing slate

bedding mortar

tile-and-a-half

B. RIDGE

ridge tiles

mortar

ridge board

rafter

battens

shaped slates

pointed joint

C. HIPS

hip iron

mortar

ridge tiles

D. EAVES

battens

rafter

felt

short slates

battens

galvanized zinc

shaped slates

felt

E. VALLEYS

355

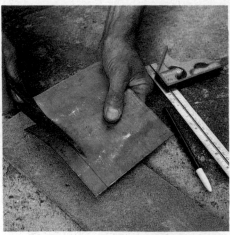
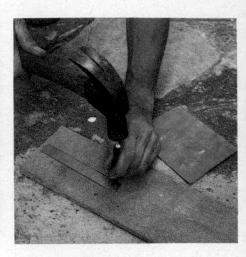

3 *Pull down sharply on the handle so that the nails are split in two. The damaged slate is then free and can be lifted clear*

4 *To fix a new slate in place use stout copper wire or cut 20mm strips from galvanized zinc or lead sheets using shears*

5 *Then place each strip on a firm base and drive a punch through one end of it to form a hole for the fixing nail*

across the apex of the roof straddling the two top courses of slates on each side and are bedded into place with mortar.

Hips: External angles formed by two roof surfaces meeting—called hips—are joined by shaping slates and then covering them with a row of hip or ridge tiles bedded in mortar (fig. C). At the bottom end of the row of hips a hip (hook) iron is driven into the wood to help secure the whole structure.

Valleys: Internal angles where two roofs meet—known as valleys—are formed in a similar way. Slates are shaped to form the correct angle and a thin sheet of galvanized zinc placed under them to carry away damaging rainwater (fig. E).

Checking for damage

There are a number of ways in which you can assess the number and type of slates which are damaged and missing before starting work.

One of the simplest is to view the slates from a point far enough outside the house so that the whole roof is clearly visible. By looking up at the roof from all possible sides of the house it should be possible to get a good idea of the number of slates that are missing or badly cracked. If necessary use binoculars or a telescope, from a distance, to assess the damage. Check your findings by taking a closer look with the aid of a ladder erected up to the eaves. But remember when doing this that the ladder must be fitted with a stay to prevent damage to the guttering and that it should be anchored to the ground and fixed tightly and securely at the top.

Next closely examine the inside surface of the roof from the attic or loft for any signs of damage. Make a check on roofing felt if it is fitted, and look for rips or signs of general wear. If nearly all of the felt is badly perished there is little alternative but to renew it when the whole roof is being reslated. But if only small patches are affected, a number of slates should be removed from the outside and the felt renewed.

Where no roofing felt is fitted, small chinks of daylight showing through the roof covering may indicate where slates are missing or damaged. These should be traced to the outside and new slates inserted at the point where damage has taken place.

Look also for defective battening, caused by a badly leaking roof. If only a few of the battens are affected, they can be repaired by removing slates and replacing the rotten wood with fresh timber.

Damp on the ceilings of upstairs rooms is also another tell-tale sign of damaged or missing slates—although you should never let things get to this stage if you carry out regular checks and repairs on the roof. When trying to trace leaks back to their source do not imagine that you will always find the cause of the leak directly over the damp patch on the ceiling. Water penetrating the roof often runs down a rafter or batten until it reaches a knot in the timber and then drops to the ceiling below—so a more extensive search may have to be carried out.

Choosing replacement slates

Once you have assessed the full extent of the damage you should be able to calculate the exact quantity and type of new slates that need to be pur-

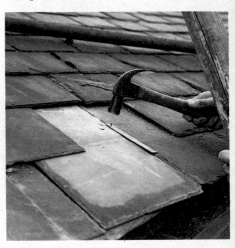

6 *Nail the fixing strip to the batten which should just be visible under the vertical join between the two lower slates*

chased. Replacements can be obtained from specialist slate suppliers or secondhand from demolition sites, but take great care that they match your existing ones.

Slates do not vary in colour and texture as much as tiles but to make sure that they are the same size and thickness as the originals take an old slate along when purchasing replacements. Attempting to repair a roof with slates thicker than those already used will tend to raise the adjacent slates and produce unsightly bumps which allow water to penetrate.

Slates obtained from demolition sites are perfectly adequate for roof repairs and are often easier to match since they are weathered on one side like the originals. However, they should be checked thoroughly to ensure that both nail holes are still

sound and that the slates are not perished, or flaking too badly on either face before buying.

Tools and equipment

As well as a number of tools which you probably have already, a few pieces of specialized equipment are essential to carry out slate repairs successfully. These can usually be purchased at a fairly cheap price from most builders' merchants.

Slate ripper: This is a tool designed to slide under a defective slate and break it free from its fixing nails. It is made of thin steel and is about 750mm in length with a handle at one end and a curved hook at the other which has two cutting blades facing the handle. Keep the curved hook well lubricated with thin oil during use so that it can easily slide under the slates.

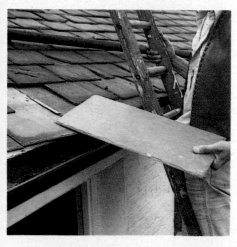

7 Slide the replacement slate into position pushing it upwards so that it is correctly aligned with slates on the same row

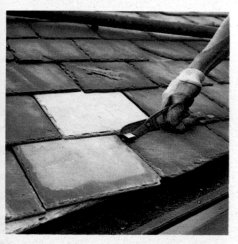

8 Once the slate is in place, use the shears to trim the fixing strip to length so that about 30mm protrudes from beneath

Pick hammer: This is a slater's tool with double-sided heads mounted at one end of a central wooden shank—a pointed head for making holes in the slates, and a hammer head with a roughened striking surface for driving in special roofing nails.

The pick hammer is cheap to buy and can easily be hired but holes can also be made in slates using a hole punch or a galvanized nail. Drilling holes is not advisable as this tends to cause the slate to shatter.

Slate cutter: Slates used to be cut to size either with a slater's axe or by using the blade of a trowel to score the slate until it broke in two. Both of these methods are difficult to perfect without a great deal of practice and waste, and a far more exact cut can be obtained by using a slate cutter. This is similar in appearance to a metal worker's shears except that the upper blade closes between two jaws mounted on the lower part of the cutter.

Trowel: Certain slates, particularly those around the ridge, hips and eaves need to be bedded into place with mortar. An old trowel, about 150mm long is useful for this purpose.

Fixing strips: When replacing individual slates it is not possible to use the batten which held up the old slate to fix the new one in place since this is hidden by the row of slates above. Instead, the new slate needs to be held in place by a thin metal strip nailed into the next batten down and then wrapped around the bottom of the slate.

A number of materials are available to fix new slates but the best is stout copper wire and copper or galvanized nails. This is preferable to sheet lead or galvanized zinc which tend to break after a short period of time allowing the slate to slip. Copper wire also has the advantage that it cannot be seen from the ground and can more easily be fixed into small gaps on battens already occupied by other slates.

Fixing nails: Where a large area of damaged slates is to be replaced it will be possible to fix all but the upper row of slates with nails. Galvanized or sheradized nails should be used for this purpose since other types of fixings corrode—allowing the slates to become easily dislodged.

Safety on the roof

When working on the roof it is essential to use the correct equipment in order to work in safety and comfort. Ladders must be erected carefully and they should be secured firmly at the

top and bottom. If a large number of slates need to be replaced it may be necessary to build a tower scaffold to allow easier and safer access to the roof.

Replacing defective slates

When individual slates are damaged the slate should first be separated from its fixing nails using the ripper and then a new slate inserted to be held in place by thick copper wire.

To remove a defective slate slide the end of the ripper under it and hook one of the cutting edges around a fixing nail (fig. 2). By pulling sharply down on the handle it should be possible to pull the nail free of the batten or to split it cleanly in two. Repeat the procedure with the other nail and then remove the slate by balancing it on the blade of the ripper and pulling it gently downwards.

If any nail proves difficult to break loose, locate the hook behind the nail and try to remove it by tapping the shank of the ripper smartly downwards with a club hammer. If the nail remains fixed even after this treatment never resort to excessive force to shift it or the ripper will be damaged. Instead, withdraw the tool, resharpen the cutting edge, and try to work the nail loose from a different angle.

Once the slate has been removed the vertical join between the two slates on the row beneath should be visible as well as the top half of the batten they are nailed to. To hold the new slate in place you have to fasten the copper wire around a nail fixed in the batten just above where the two slates divide.

To do this, cut a piece of wire about 150mm in length, loop one end of it around the shaft of the copper nail, then tighten the loop before driving the nail fully home with the pick hammer (fig. 6). Straighten out the wire so that it hangs downwards ready to receive the new slate.

Balance the replacement slate on the blade of the ripper and with the help of your other hand push it upwards into place until it is correctly aligned with the slates on either side (fig. 7). Using pliers bend the loose end of wire around the bottom edge of the slate and pull it upwards so that the slate is held tightly (fig. 8). Flatten the loose piece of wire against the slate to complete the fixing. Finally, remove the ripper and gently press down on the face of the new slate to bed it firmly into place.

Making holes

When a large number of slates are damaged and need to be replaced, it

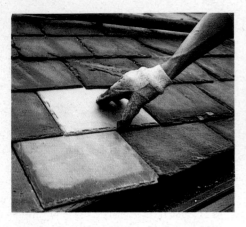

9 Then, using pliers if the material is stiff, bend the loose end up and over the bottom edge of the slate to hold it securely

10 Finally, flatten the end of the strip and gently press down on the face of the slate to bed it neatly into position

11 Fixing holes in slates should first be marked using an old slate as a guide and the holes made with a slater's tool or punch

12 When cutting new slates to fit at the end of each row, use one of the old edging slates as a template to check dimensions

13 Then place the new slates face downwards and trim them to size with a slate cutter or by scoring with the point of a nail

14 If the excess does not immediately break away after scoring, cut along the edge of the slate with the blade of a trowel

is possible to nail them into position on the same battens the damaged slates occupied except that the top row must be fixed with copper wire. Holes must be made in all of the new slates which are secured with nails.

When making holes in slate, select a flat surface and lay the slate face downwards. This ensures that a small piece of slate around each hole is broken away from the bottom side forming a dent which accommodates the head of the fixing nail.

Fixing holes can be made in slates either on each edge or at the top. To ensure that the holes are aligned accurately lay one of the old slates over the top of the new one and use a nail to mark the positions of the holes (fig. 11). The pointed end of a slater's hammer can then be brought sharply down on to each of the marks to form the holes. Continue in this way, holing all the slates you need to repair a particular area before carrying them on to the roof.

Cutting and shaping

A large number of roofing slates need to be trimmed and shaped to fit before fixing. Mark and cut the slates face downwards; again this leaves a flaked edge on the underside of the cut which helps to waterproof the slate and allow rain to run away once the slate is fixed the right way up.

To mark slates accurately before cutting, use an old slate as a guide, or form a template out of hardboard. Then run the point of a nail along the edge of the template to mark the slate clearly, before trimming it with the cutter (fig. 13). Any rough edges which still remain should be smoothed level by rubbing a piece of carborundum stone along the slate.

Ridge and hip slates

These are especially prone to damage and displacement as they occupy an exposed position on the roof. Although many were originally made from slate, they are now more commonly

manufactured from concrete or clay in a range of colours to match existing slates and other roofing materials.

Ridge and hip slates are fixed in place on a bed of mortar and this needs to be loosened before the damaged slate can be removed and a new one put in its place. To do this, hold a bolster parallel to the roof and with the help of a hammer chip away at the mortar around the base of each slate until it comes loose and the slate can be carefully lifted clear. Then use the bolster to clean away loose mortar clinging to the slates around the apex.

To fix new slates, make up a 1:3 mix of mortar and use a trowel to spread it evenly and thickly in place.

While the mortar is still fairly wet lay the new slate in place and gently tap it level with the surrounding slates. Once the mortar has set, the joints between the slates should be pointed with mortar to prevent the intrusion of rainwater into the roofing timbers below.

Canadian roof shingles

Roofs of Canadian houses are usually covered with asphalt shingles. Unlike tiles or slates, these are flexible and so have to be laid on a smooth continuous surface, rather than on spaced battens. This smooth surface, called roof decking, is usually provided by covering the rafters of a house roof with sheets of plywood or particleboard; strips of lumber, laid side by side, may also be used.

The most usual type of asphalt shingle consists of a metre-long strip of asphalt-saturated and coated felt strip, with notches cut into it to form three 'tabs', which are coated in mineral granules of different colours. When the roof is covered, only the tabs are exposed, and these give the roof the appearance of separate slates or tiles. Shingles are available in bundles of 21, covering three square metres of roof.

For low-pitched roofs, shingles with a greater amount of overlap are available, and for areas of the country subject to high winds you can get shingles with special interlocking tabs.

As with slates, the vertical joints in adjacent rows of shingles are staggered —you do this by using a half-width shingle (that is, one with one and a half 'tabs') at the edge of alternate courses.

Extra protection against damp penetrating the roof decking is needed at the eaves. This is provided by 'roll roofing'—an asphalt-impregnated felt

F. *Plain asphalt roofing shingles are laid to give the impression of individual slates or tiles*

material that is available in roll lengths of about 10m, and widths of about 1m. This is rolled out on the roof decking, parallel to the eaves and overlapping the roof edge by about 13mm, and is stuck down to the roof decking all around its edge with plastic roofing cement. This eaves protection should continue back up the roof to at least 300mm inside the inner face of the exterior wall, and preferably 600mm. Depending on the amount by which your roof overhangs the wall, you may need more than one strip. Overlap all joints by 50mm to 100mm, and seal them with roofing cement. Further protection can be provided around eaves and edges by fitting metal drip edging strip to the roof decking before the eaves protection.

Over the rest of the roof, an underlayment is sometimes used to provide additional protection.

Valley flashing is often built up from heavy-duty roll roofing. A strip about 500mm wide is first laid in the valley, nailed along its edges at 400mm intervals. (If you use mineral-coated roll roofing for this layer, fix it mineral-side down). A second strip about 1m wide is then placed on top, mineral-side up. Use roofing cement to seal along the edges of this strip; and nail with just enough nails to hold the flashing in place until the shingles are laid. In some areas, such as Quebec, flashing is of 600mm wide galvanized metal, crimped in the centre. This is completely embedded in roofing cement, and nailed along the edges.

Shingles are laid, as with other

roofing materials, starting at the eaves. A 'starter strip' is first fixed; this could be a row of shingles placed with the tabs facing *up* the roof, or a strip of heavy-duty roll roofing. The starter strip should overlap the edge of the roof by about 13mm. Nail the first row of shingles directly on top of this starter strip, using 25mm large-headed nails, placed about 13mm above each notch, and about 40mm in from each end. Overlap each shingle in adjacent rows so that none of the material above the notch is showing. All the tabs should be stuck down onto the shingle below, by applying a 25mm dab of roofing cement underneath each tab before nailing in position. Some brands of shingle are self-adhesive; but even with these you should apply extra cement on mansard roofs, in areas with high winds or blowing dust, or when roofing in cool or cold weather. Shingles used on low-pitched roofs should be set in a bed of roofing cement.

Ridges are capped with single shingles, cut out of the strip by extending the notch. Each shingle is wrapped over the ridge, and nailed at one end. The next shingle to be laid then overlaps the previous one (by the same amount as they do on the roof) to cover and protect the nail-hole.

Repairing shingled roofs

Lifting or curled shingle tabs must be attended to before they allow water or snow to creep up underneath, and penetrate the roof decking. Stick them down with a dab of roof cement under the lifted area. As with all shingle repairs, this is best done in warm weather when the shingles are pliable: if you try to manipulate cold shingles, they may crack.

Badly torn or damaged shingles can also be stuck down again, covering the damage with a liberal application of roofing cement, but it is better if possible to remove and replace them. To remove a damaged shingle, carefully lift the tabs of the shingle above, to expose the damaged shingle's nail heads. Remove the nails with a chisel, and pull the old shingle out. Slide a new one into place—cutting off the corners may help. Then nail it into place. Finally, stick down the tabs of the shingle above—lifting them is likely to have made them curl.

Shingles do not last for ever, and after some years, the roof will need recovering. If the whole roof is to be re-done, then there is no need to remove the old shingles; the new ones can be nailed straight on top (use nails about 38mm long).

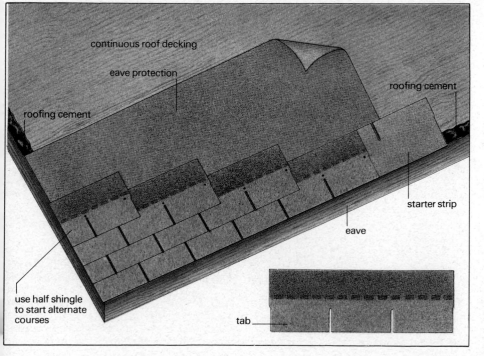

continuous roof decking

eave protection

roofing cement

roofing cement

starter strip

eave

use half shingle to start alternate courses

tab

Fixing fences

Ray Duns

Left: *The galvanized steel bracket is extremely useful for a number of fence repairs.*

Preservatives

Most new posts have already been impregnated under pressure with a solvent to protect against wood-boring insects and fungus infections. But if there is any doubt as to whether this is the case, soak the post for at least two days in a preservative before putting it in the ground.

One external wood preservative that can be used is creosote. This has a tar and oil base, and in the UK a brand to BS 144 is recommended for fencing. In Canada, a preservative containing creosote and pentachlorophenol is often used.

The main drawback to creosote is that it stains the wood a dark, not very attractive colour. Also, once the wood has been coated with creosote it cannot normally be painted over.

Creosote must be applied to dry wood—either by soaking or applying with a brush. If you brush it on, bear in mind that it will penetrate only about 3mm into the wood and that the whole process will have to be repeated in a couple of years. Remember also that creosote and other solvents are poisonous to all life forms.

A more expensive form of preservative but one which can be painted over is the organic solvent—a preservative chemical which has been dissolved in white spirit or petroleum oil. Organic solvents can even be used

Getting your fences in good order goes a long way to making the garden more attractive. You can replace them, repair them or even add new sections quite simply and cheaply

For wooden fences to be an asset in a garden, they must be regularly treated with preservative and repaired as soon as damage becomes apparent. Like any cut wood which is exposed to the elements, fences are susceptible to rot and infestation—so unless renovations are conscientiously carried out, they can quickly fall into a state of disrepair.

1 *Remove the concrete spur from the supporting post using the bolts as handles to lever and ease it out of the ground*

2 *Replace the rotten supporting post having cut new mortises for the arris rails. Angle-cut the top for water to run off*

3 *Set the concrete spur to overlap about 100-150mm below the bottom of the post and mark the new positions for the bolts*

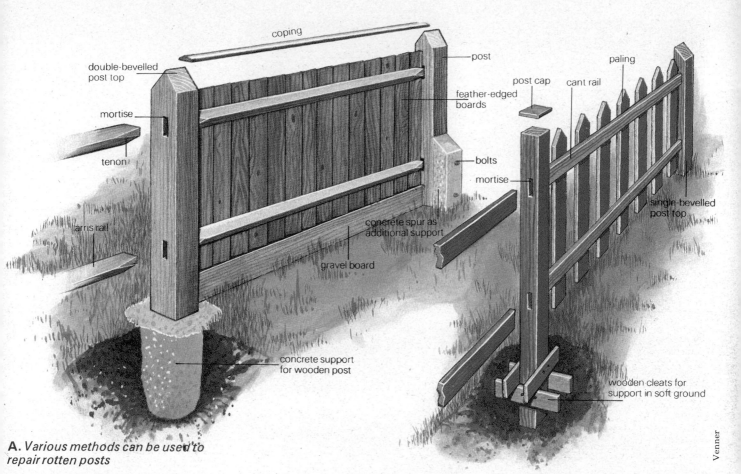

coping

double-bevelled post top

mortise

tenon

arris rail

post

feather-edged boards

bolts

mortise

concrete spur as additional support

gravel board

concrete support for wooden post

post cap

cant rail

paling

single-bevelled post top

wooden cleats for support in soft ground

Venner

A. *Various methods can be used to repair rotten posts*

to treat wood which has already been attacked by fungus or insects.

Whenever a post or piece of fence is being replaced, the new section must be treated with a preservative, or it will quickly rot.

Paint acts as an effective barrier for wood only if a new coat is applied immediately the old one shows signs of flaking or blistering.

Remember when using wood pre-

servatives to wear protective clothing and eye protection. Always apply the preservative in the open air or at least in a well ventilated room.

Repairing a post

The most likely place for a fence post to become damaged is at, or below, ground level. At this point, the wood is almost permanently damp, causing it to rot. Once a post is rotten, it can

give no support and the section of fence butting up to it tends to lean out of alignment.

To repair the post you must cut off the affected part and attach a supporting spur (fig. A). This involves temporarily supporting the fence and then digging a hole around the post about 600mm square and 300mm deep. Saw off the rotten part of the post once it is completely exposed and bolt on the

4 *When the base hole is dug and the timber preserved, set the post and spur in position and find the vertical with a spirit level*

5 *If the arris rail tenon is also rotten make a mortice from timber blocks and screw them firmly to the post around the arris rail*

6 *Pack a mix of concrete firmly into the hole at the base to give a solid support for the spur and the fence post*

7 Saw off a particularly weak arris rail tenon at the mortise joint, removing the end board of the fence to get access

8 Position a galvanized steel joining bracket to bridge the gap between the solid part of the arris rail and the supporting post

9 You can also temporarily repair an arris rail that has broken between two supporting posts by using a steel bracket

10 Make sure the fence is back in alignment then place the bracket centrally over the broken section and screw it in position

concrete spur—150mm or 200mm coach bolts are suitable.

The straight face of the spur should be against the post (fig. A). When it is in position, use a spirit level to check it is upright. Hardcore should then be packed around the bottom of the spur and the hole filled with a 1:3 cement and coarse sand mix. In Canada, set the cement below the frost line.

This method of repairing a post will withstand fairly severe weather conditions. Another method for a fence post which is not exposed to strong winds is the use of a metal spike.

After the rotten part of the post has been cut off, the ground must be tightly packed back into place. The metal spike is then driven hard into the ground, while gently holding the fence out of the way. Then bolt the spike to the post.

Repairing an arris rail

An arris rail—the horizontal bar of a fence—can be repaired temporarily if broken at the tenon (pointed end) or in the shaft by using a metal bracket to bridge the broken part (fig. 8).

If the tenon is broken, first level it off and then soak it with a preservative. Using galvanized or sheradized screws, fix the arms of the bracket to the post in the same place as the rail was originally fixed. With the bracket in place, screw both sides of it to the shaft of the arris rail.

When using a metal bracket to repair the shaft of an arris rail, screw it to one side and then with the aid of an assistant push the other side inwards and screw the bracket to that.

It is most important to use galvanized or sheradized screws in external woodwork. Ordinary screws will simp-

ly rust away—causing unsightly stains —or fuse with, and split, the wood.

Fitting a new arris rail

When ordering a new arris rail, measure the distance between the two upright posts and add at least 75mm for the tenons. You may need to whittle away at the rail so that it fits into the mortise (rectangular slot) in the post (fig. A). Treat tenons and mortises with preservative.

If you cannot force the posts far enough out of line to enable you to spring the ends of the rail into the post, you will have to use metal brackets or wooden chocks.

For the latter you need four 25mm × 20mm offcuts of wood to fit around the mortise. They must all be coated with preservative and then all but the top piece screwed into position. With this done, the rail can be slotted into place and the fourth strip of wood screwed tightly down for a firm grip around the tenon. Do this at both ends of the rail.

New boards in feather fencing

A feather fence is one which is made up of slightly overlapping vertical strips of wood (fig. A). It is a simple matter to replace either one single board or to erect a whole series to form a complete new section.

When only one board needs replacing, remove the nails which are securing it and make sure that those securing the boards on either side of the damaged board are well banged in. Then slide the thin edge of the new board under the thick edge of the old one and nail through the overlapping edges with galvanized nails.

If a whole series of boards needs to be fitted, follow exactly the same procedure except for using a spirit level every fourth board to check that they are vertically level.

Gravel boards

As all wooden fences are at their most vulnerable where they touch the ground, a gravel board is usually fitted to minimize the risk of damp rising through the fence (fig. A).

Most gravel boards are made of 150mm × 50mm hardwood. Alternatively, the fence can either be set on a single course of bricks topped with a strip of roofing felt, or on a custom-designed concrete panel.

To fit a wooden gravel board, clear away any soil or debris from around the base of the fence to form a recess for the board. Treat the board with preservative and either fit it into pre-cut mortises in the wooden posts

Venner

B. *Follow this method and you can add any length to a woven panelled fence with little difficulty*

or nail it through wooden blocks attached to the inside of the post. The blocks can be of the same wood and need to be set back from the edge of the post so that the gravel board will be flush with it.

If the posts are concrete, drive pegs into the ground butted right up to the post. The pegs should be made from treated 50mm × 50mm hardwood and at least 600mm long. Leave about 150mm protruding from the ground and—after measuring and cutting the board so that it fits tightly between the posts —nail it to the pegs.

Concrete gravel boards are also available, designed for use with concrete posts. Such posts have a groove on the inside surfaces, into which the

concrete gravel can be slotted. Fencing panels are ideal for use with this system because they too can then simply be slid into position.

Panelled fencing

Interwoven panelled fencing (fig. B) is the simplest type of fencing to erect but it has the drawback that even the slightest damage to a panel usually means that the whole section has to be replaced. Being very light and often tall, woven panels are especially susceptible to damage from strong winds. Since it is an expensive business to replace entire panels, such fencing should always be set on a gravel board.

The slats which make up woven fences are very difficult to obtain individually—unless a second-hand panel is available from which slats could be taken. It is usually always necessary to buy an entire panel. They are sold

in standard sizes.

Panels can be cut to size, if necessary. To do this, hold the panel in the correct position and mark off the overlap. Carefully remove the end battens with a claw hammer. These will be longer than the middle battens because they extend up level with the top rail. They should be re-nailed inside the marked lines and underneath the top rail so that the excess protrudes from the bottom. It can be sawn off when the batten is in position. The surplus part of the panel can also then be sawn off, using the end batten as a guide (fig. B). With this done the panel is ready to be positioned alongside another and hammered into its correct place.

Do not forget that panel fences, like other wooden types, must be regularly treated with preservative if they are to stay in good condition.

James Johnson

11 *In order to replace a rotten picket fence first measure the height of the palings and the length of the arris rails*

12 *When the rails and palings are removed, mark the positions for the tenons at each end of the new arris rail*

13 *Mark out the shape of the tenon on the new rail and cut it out by sawing or whittling with an axe. Treat the cut end with preservative*

14 *Set the new rail tenon into the mortise in the supporting post and paint the post liberally at this stage with a wood preservative*

15 *Mark out the triangular shape at the top of the paling timber and saw the first one carefully to use as a template for the others*

16 *When the palings have been painted with preservative, set the first one in position and check it for spacing and plumb*

17 *Set the second paling at the exact height at the other end of the section then secure both palings with galvanized nails*

18 *Stretch a string attached to nails in the supporting posts to act as a guideline for the horizontal line of the palings*

Removing a wooden post

It is sometimes very difficult to remove an old wooden post which has been set into concrete. However, the job can be made easier by using a strong rope-leverage system.

First, temporarily support the fence by tacking a sturdy batten to the top arris rail on either side of the post. In the case of a slatted fence, remove one board from either side of the post. Afterwards, dig out as much soil as possible to completely expose the base of the post in its bed of mortar.

Hammer in a 100mm nail about 300mm from the ground on either side of the post then tie a strong rope round the post immediately below the nails, leaving enough of the rope to tie around a suitable levering post. The levering post must be of very sturdy wood. Two nails should be hammered into it about 30mm from the end to provide a grip for the rope.

Stack some bricks under the levering post about 100mm higher than the nails in the post. Push hard on the stick to ease out the post, adjusting the height of the bricks as necessary for maximum leverage.

The new post should already be pre-treated. Insert it in a hole at least 600mm deep and after packing in some hardcore, fill in the hole with a 1:3 cement and coarse sand mix. The top of the new post should either be cut slanted at an angle of 30° and painted with creosote or have a hardwood or metal cap screwed on to it. Either of these methods helps prevent penetrating damp by protecting the exposed end-grain of the wood.

C. *With an assistant holding the post, lever extraction is easy*

Rays Duns

Above: *Raising a heavy paving slab can be difficult. Use two pieces of wood and form them into a lever and fulcrum to make lifting easier. Dig out the earth so that the lever can be inserted under the slab*

Damaged paths and drives are dangerous as well as unsightly. Yet maintenance and a few simple repairs are usually all that are necessary to make them last a lifetime

The most common materials used for paths and drives—concrete, tarmac and bricks—should last for years providing they have been properly laid and finished off. But even so, continuous use, frost and subsidence can all take their toll by causing surface damage. This is best put right before it becomes too extensive.

Concrete paths and drives
Structural defects in concrete can cause it to crack, chip easily or become uneven. The most common reasons for this are: an inadequate or unsuitable hardcore base which leads to subsidence, expansion of the concrete in warm weather which leads to buckling, an inadequate thickness of concrete, badly laid or poor quality concrete and badly laid or poor quality surface screed.

Not only do broken edges and cracks detract from the appearance of the path, drive and surroundings, they can also be dangerous. And if they are not repaired, the faults will spread, obliging you to break up and relay large sections. Prompt action saves both time and money.

Filling cracks
Providing there are no signs of serious subsidence, you can patch up cracks in paving concrete with a 1: 6 cement-sand mortar mix. To ensure a good bond with the original concrete, you also need a supply of PVA bonding agent, which you can buy from builders' merchants.

To provide a good key for the mortar, chip the crack out to a width of about 25mm with a hammer and bolster (fig. 1). Be sure to wear goggles

to protect your eyes from flying bits of masonry. Afterwards, brush away the debris with a wire brush and paint on a coat of the bonding agent (fig. 3).

Add a little more of the bonding agent as you make up the mortar, but remember that this means you will need less water in the mix. Force the mix well into the crack using a pointing trowel and smooth it level with a flat piece of wood or a wooden float. Where a crack extends to the edge of a path or drive, take particular care that the mortar does not fall away after application. You may find that a timber former (fig. 7) helps to give the edge a clean finish.

Where cracks or chipping at the edge of the concrete are confined to a small area—possibly the result of lawn-mower damage—hack away the damaged material back to firm concrete

and brush it out. Check that the base below is sound, tamping it down and adding a little more hardcore if necessary—you can use the old, chipped concrete for this.

Use a timber former as shown in fig. 7 to form the new edge, paint on some bonding agent, then fill the hole with mortar as above. Leave the repair for at least a week before treading on it.

Surface chips and flakes often appear in screeded concrete or in concrete which has been laid too wet. In the latter case, the flakes are due to *laitance*—a thin layer of watery cement and fine ballast—which forms on the surface of the concrete leaving a rough aggregate surface below.

If the damage is not too extensive, you can patch it with a 1:5 mortar mix including a proprietary hardening additive. Chip away all the loose—or potentially loose—debris so that the repair mortar has a substantial hole in which to settle.

Where the screed shows signs of being too thin and badly laid, or where there is excessive laitance, you have no choice but to rescreed the entire area. Excessive laitance is a common fault in concrete laying and is mainly caused by over-trowelling with steel tools. When steel is applied to the surface of wet concrete it causes water to rise to the surface, bringing with it raw cement. It is this water-cement scum on the surface, which, when dry, becomes laitance.

Also remember that laitance means less cement in the concrete body, which of course means a weak concrete mix. Excessive laitance can be avoided by using wooden floats to level and solidify the concrete, as these keep the mixture well bound together.

Cracking and subsidence
If this becomes apparent, the most likely reasons are that the concrete is too thin or that there is something wrong with the hardcore base on which it has been laid.

The minimum recommended thicknesses for concrete are 75mm for paths and 100mm for drives, laid on a base of well-tamped hardcore. In the case of drives, it is preferable—especially on a light soil substrate—to reinforce the concrete with steel reinforcing mesh which is obtainable from builders' merchants.

The mesh should be 100mm x 100mm formed from 6mm wire and should be set 40mm above the hardcore. If your concrete does not match up to this, the only permanent solution is to relay it. However, as a temporary measure, it is well worth filling in the cracks in order to stop any water from entering the concrete and cracking it still further.

Subsidence—likely wherever the concrete cracks and sinks—will probably be confined to a localized area. The only remedy is to hack away the subsiding material back to firm concrete and relay.

Once you have removed the old concrete, inspect the base carefully. It may be that no hardcore was used, the base was not properly tamped, or that the ground is indeed slipping. Less likely, but still possible, is that the original hardcore contained plaster or rotting waste which has eaten away at the cement in the concrete.

Unless you are confident that the ground is firm, it is a good idea to dig out the old base and make a new one with fresh hardcore. Use only clean brick, aggregate or old concrete for this. *Hogging*—waste sand from gravel pits—is ideal if you can get it, being easier to compact and level than ordinary broken brick.

When you come to lay the fresh concrete, coat the edges of the existing concrete with bonding solution and make sure there are no crumbling patches left.

Cracks due to expansion
Sure signs of this are when the concrete appears to have lifted slightly around the cracks. Although concrete shrinks when it is drying out, hot weather may later cause it to expand considerably. If there is no room for movement at the edges, it forces upwards, cracking in the process.

In addition to filling in the cracks, it is necessary to provide expansion

1 Chip out cracks in concrete paths using a hammer and bolster. Clean the crack out carefully to a width of about 25mm

2 Use a wire brush to clear away any loose dust and debris. Do this thoroughly or the mortar will not take proper hold

4 Jam stones, rubble, or pieces of brick into the larger cracks. This will form a solid foundation for the application of mortar

5 Force the mortar well into the cracks using a pointing trowel. Smooth it off with a piece of wood or a wooden float

joints to allow for future movement. Do this at the edges by chipping away about 25mm all round, especially if the path butts up against a wall, then cut another 25mm groove across the width of the affected area.

Fill the joints with strips of 13mm bitumen-impregnated insulation board, then pack any gaps with pitch or a 1:6 mortar mix. Finally trowel, the filling level with the surrounding area. Any further movement will be confined to the filled joints—which can be patched up easily.

Surface damage
Superficial surface damage caused by general wear and tear can often be patched with a proprietary surface sealer. These are available from builders' merchants in polyurethane, epoxyresin and vinyl-based forms and

3 *To help the mortar to adhere well, paint a liberal coat of bonding agent all around and inside each of the cracks*

are easy to apply—just follow the manufacturer's instructions.

Before you apply a surface sealer the surface must be free of flakes, dust, vegetable growth, lichen and grease or oil. De-greasing agents are available from builders' merchants, motor spares shops and some garages. Lichen must be scrubbed off with a stiff wire brush and the concrete should then be treated with a proprietary lichen inhibitor, also available from builders' merchants.

Faded concrete and concrete slabs can be revived by washing off the dirt and then removing the surface layer of cement, which has usually decayed slightly. Use a dilute solution of hydrochloric acid—available from large builders' merchants, and apply the liquid with a stiff brush, taking care not to contaminate nearby soil.

When the surface has stopped fizzing, hose the path down thoroughly with plenty of cold water. You must wear protective rubber gloves when using acid and protect your eyes with goggles. Keep children and pets away from the area you are treating.

Brick paths and drives
Only hard bricks should be used for drives and paths, the most suitable being purpose-made paving bricks. Such bricks are only half the thickness of ordinary building bricks, but their length and breadth are the same. Commonly known as *paviours*, they are rarely kept as stock by brick merchants and may have to be specially ordered to your requirements.

Ordinary household bricks are not noted for their resistance to wear when used for paths and drives: water enters cracks in their surface, expands in cold weather and eventually causes the bricks to break up completely. For safety's sake it is a good idea to replace those bricks which have crumbled to the stage where they leave a hole.

Dig out the remains of the old brick carefully, taking care not to damage those around it. Bed in the replacement with a strong 1:3 mortar mix, slightly on the wet side to allow for adjustment. If you find that the brick is out of level with the others, remove it and start again—do not try to force it, or it is likely to split.

Fill the mortar joints around the brick—together with any other joints which have crumbled—with the usual 1:5 mortar mix. Maintaining the joints in good condition goes a long way towards stopping the bricks from breaking up and turning to dust.

6 *Use a hammer and bolster to cut the edge of a worn path back to solid foundations. Try to get a regular, straight-edged finish*

Tarmac and asphalt
Drives and paths made from tarmac or asphalt, the latter containing a higher proportion of bitumen binder to aggregate, improve with age as the surface becomes more consolidated. But after a while the binder loses its adhesive properties, releasing bits of aggregate and causing the surface to break up.

If you catch it in time, you can treat this problem by applying an emulsion, or tack coat, of binder and fine grit. Both materials are available from builders' merchants who will usually deliver them to your door. Be sure to quote the area you wish to cover when ordering.

Having swept the area clean, and clear of loose chippings, brush on the tack coat as evenly as possible. Shovel the grit on top of this, adding just enough to cover the tack coat and fill any depressions.

When the tack coat starts to harden, run over the area with a garden roller dampened with water to prevent the binder sticking to it. A week or so later, brush away any surplus grit.

Repairing the edges
The edges of tarmac and asphalt drives and paths are best lined with kerb stones to stop them crumbling. The procedure for mending the edges follows closely that for repairing concrete edging, except that in this case you need a supply of ready-mixed tarmac or asphalt.

Use a hammer and bolster to cut back the edge to firm material, forming a regular, straight-sided hole (fig. A). Having brushed away the debris, and flattened and levelled the base, secure a timber former along the old edge and tap it down level with the surface

7 *Brush away the debris and build a timber former along the edge of the path. Fill the gap with mortar and level off with a float*

8 When replacing or laying paving slabs, clear away the ground beneath so that it is deep enough to accept the hardcore and mortar

9 Build up a solid foundation of hardcore and tamp it down firmly. Cover this with a thick layer of 1:3 mortar mix

10 Make gentle ridges in the mortar when you lay it. This allows the flagstone to be tamped down more easily when it is replaced

A. Above: Cut back the worn edges of a tarmac path to form a regular shape, brush away the loose debris, then flatten and level the base

B. Below: Secure a former against the path then fill the patch with fresh tarmac. Tamp it level with the existing surface using a punner

of the existing tarmac (fig. B). Make sure that it is firmly fixed.

Warm the ready-mixed tarmac according to the manufacturer's instructions and shovel enough into the hole to protrude slightly above the surrounding surface—if you heat your spade beforehand, the tarmac will not stick to it. Wait until the mixture has started to harden, then roll it flat with the dampened roller. Remove the timber former when the tarmac has fully hardened.

If you do not have a roller, you can compress the tarmac using a special tool called a *punner* (fig. B). Make this from a 150mm x 150mm piece of blockboard nailed to a broom handle or other suitable length of timber.

Use the punner to press on the fresh tarmac, making sure that you cover the whole area. If small indentations

Unusual paths

Lay a new path or freshen up an old one using one of these ideas.
Left to right: *Create a natural look with broken paving slabs or irregular-shaped flagstones, surrounded by gravel and bordered by rough-stone walls. Bricks used on paths and borders create interesting effects—a herring-bone pattern is shown here. Sawn-off 'rounds' of timber can be set into concrete and surrounded by gravel with borders formed out of durable hardwood that will not easily rot or disintegrate*

Bernard Fallon

11 *Position the new flagstone using wedges and tamp it down gently, checking for level with a straight edge*

12 *Fill in the surrounding joints with a pointing trowel using 1:6 mortar. Allow the mortar to dry fully before using the path*

C. *Use a spade or shovel to dig out any hollows which form in gravel drives, clearing away enough material to leave a solid base*

are left between strokes, fill them with more tarmac and repeat.

Holes and damaged patches

Use a hammer and bolster to chip holes and damaged patches back to firm tarmac so that you are left with a larger, square or rectangular hole (fig. A). Check that the base below the tarmac is firm and level, adjusting the height where necessary, then fill and roll as above.

Flagstone paths

Cracks in flagstone paths are rarely worth patching: it is better to replace the damaged stone. Take great care when you prise this away or you will damage those around it.

Inspect the base under the stone for signs of subsidence or inadequate hardcore and correct as necessary,

bringing it up to the level of the hard-core under the other stones.

On top of this, lay a bed of strong, 1:3 mortar and smooth it out as level as you can. Gently position the new stone, then check it for level with a straightedge. Make small adjustments by lightly tapping the stone with a piece of heavy, but soft, timber. Finally, fill in the surrounding joints with 1:6 mortar (figs 8 to 12).

Gravel drives

Normally the only problem with these is that hollows develop, leaving 'bald patches' of the base material. Rather than try to distribute the existing gravel, it is better to enlarge the hollow to form a completely clear patch then fill it with fresh gravel. Use a garden rake to blend the old and new gravel together.

D. *Fill the hole with fresh gravel, raking it out so that it blends well with the old material and gives a flat, smooth finish*

Bernard Fallon

Advertising Arts

PLUMBING

Fixing a tap

Dripping taps are a source of constant irritation for any household. But for a repair as small as mending a leaking tap or faucet, calling in a plumber is an expensive proposition

Since the leak is usually caused by a worn-out or perished washer, one way of solving the problem is to replace the whole tap with a new one of the non-drip, washer-less type. A far cheaper way is to learn to mend the tap yourself. Replacement parts cost only pennies and can usually be fitted in a few minutes, once you know how to take the tap apart.

How taps work

Most taps which have washers work in the same basic way: turning the handle raises or lowers a spindle with the rubber or nylon washer on the end in its seating. When the spindle is raised water flows through the seating and out of the spout; when it is lowered, the flow is cut off. But when the washer becomes worn and disintegrates, water can still creep through, irrespective of the position of the spindle. This is what usually causes the tap to drip. If the seals around the moving spindle are worn as well, leaks will also appear around the handle and the outer cover. Because you will have to dismantle the tap to replace either the washer or the seals, it is usually worth doing both jobs at the same time. If fitting new ones fails to cure the drips, the washer seating itself is probably worn. This is a common problem with older taps, especially in hard water areas, and the cure is to regrind the tap seat.

The most common type of household tap is the upright *pillar tap* (fig. A). The *bib-tap* (fig. B) is similar in operation, but fits into the wall above an appliance or on an outside wall. The patented Supatap is a British type of bib-tap incorporating a valve which enables you to complete repairs without having to turn off the water supply. Modern baths and sink units often have a mixer tap with a fixed or a swivelling nozzle. This is really two pillar taps combined and they are repaired in the same way.

Replacing a washer

To replace the washer on a conventional type of tap, start by turning off the water supply to the tap. Turn the tap on fully to drain away any water left in the pipe. Plug the basin, sink or bath to prevent any of the tap com-

Left: *Dripping taps are not only a noisy nuisance, they can be expensive as well, especially if it is hot water leaking away*

handle

cover

gland nut

O-ring seal

head

spindle

cover seal

jumper

washer

body

spout

ponents slipping down the plug-hole.

The assembly which holds the tap washer and the spindle is known as the head. On older taps, it is covered by an outer shield which screws into the tap body. Newer taps have a combined shield and handle which must be removed as one unit.

To remove a conventional shield, make sure that the tap is turned fully on. Loosen the shield with a spanner or a wrench, unscrew it and leave it loose. You can avoid damaging the chrome plating by covering the jaws of whichever tool you are using with a piece of rag.

Modern shield/handles are either simply a push-fit on to the spindle or else are secured in place by a screw through the top. Check the former first by gently pulling the handle upwards (fig. B).

If it stays fast, dig out the plastic cover in the top to expose the securing screw. With this removed, the handle can be pulled off (fig. 1).

The next stage is to remove the head. Locate the hexagon nut at the bottom of the assembly and loosen it, again using the wrench or spanner. Unscrew the head from the body of the tap and remove it. At the base, you can see the washer (or what remains of it) seated in its *jumper*.

On older taps the head assembly will be made of brass and the washer will be held in the jumper by a small nut. Loosen this with the pliers, remove the old pieces of washer and put on the new one, maker's name against the jumper.

On newer taps, the entire head is made of nylon and the washer and jumper are combined in one replaceable unit which slots into the bottom of the assembly. To replace the washer, you simply pull out the old jumper and push in the new one.

Once you have fitted the new washer, you can re-assemble the tap and turn the water supply back on. If the new washer is seated correctly, there will be no drips from the nozzle and you should be able to turn the tap on and off with little effort.

Supataps
When replacing a washer in a Supatap, there is no need to turn off the water supply—this is done automatically by the check-valve inside the tap. To gain access to the washer, hold the

A. *Exploded view of a typical pillar tap showing its components. On older types the washer may be bolted to the jumper plate*

handle in one hand while you loosen the gland nut above it with the other. Holding the gland nut and turning in an anticlockwise direction, unscrew the handle from the tap. As you do this, there will be a slight rush of water which will stop as soon as the handle is removed and the check-valve drops down.

Protruding from the dismantled handle, you will see the tip of the flow straightener. Push or knock this out on to a table and identify the push-in washer/jumper assembly at one end. Pull off the old washer/jumper and replace it with a new one. Before you re-assemble the tap it is a good idea to clean the flow straightener with a nail brush.

Stop-valve taps
There is normally little difference between a crutch-type stop-valve tap and the more conventional type of pillar tap. However, you should remember, in addition to turning off the main supply to the valve, to

also turn on any outlets controlled by it. This will drain any water left in the pipe to which the valve has been fitted and minimize the risk of creating an airlock.

Normally, stop-valve taps have no outer shield and the head is exposed. Loosen the nut securing it with a spanner or wrench and then unscrew the head to expose the washer assembly. Stop-valve washers are usually held in their jumpers with a small retaining nut like the older type of pillar tap described above.

Leaking spindles
If the leak is coming from around the spindle of the tap rather than the nozzle there are two possible causes. Either the O-ring seal around the spindle has worn out or else the gland nut which holds it is in need of adjustment. Both problems tend to be more common on older taps with brass heads: the newer sort with nylon heads have a better record for remaining watertight.

B. *Designs of washer-type taps vary widely, but dismantling procedures will follow one of these: a) old pillar tap, b) old bib tap, c) Supatap, d) and e) new-style pillar taps*

To service the spindle, you have to remove the tap handle. On newer types of tap, this may have been done already in order to replace the washer, but on older cross-head taps the handle will still be in place.

The cross-head will be held on either by a grub screw in the side or by a screw through the top, possibly obscured by a plastic cover. Having undone the screw, you should be able to pull off the handle. If it will not move, turn the tap fully off and unscrew the shield below to force the handle loose.

Once you have done this, mark the position of the gland nut at the top of the tap head against the head itself with a screwdriver. Next loosen the nut and unscrew it completely. Check the condition of the O-ring

373

1 On this type of tap, remove the cover to expose the securing screw. Undo this and pull the loosened handle upwards to expose the spindle

2 When you undo the locking nut, try to wedge the body of the tap against the nearest firm support to avoid undue strain on the pipe

3 Unscrew the head assembly to get at the washer. Check the seating in the tap body for corrosion while the tap is dismantled

4 On some types of tap, the washer is held to its jumper by a small securing nut on the base of the head—undo this with pliers

5 You can then dig out the old washer and replace it. For a temporary repair you can reverse the old washer

6 To replace the spindle O-ring seals, dig out the circlip holding the spindle to the tap head. Take care not to damage the circlip

7 Once the circlip is loosened, you can slide the spindle out. You can see the various O-rings used on this particular design

8 If the seals are worn, prise them off with a pin. Slide on new ones and make sure these are properly seated before re-assembling the tap

9 To replace a Supatap washer, start by loosening the locknut above the nozzle assembly. There is no need to turn off the water supply

Nigel Messett

or packing around the seating below and, where necessary, replace it. If an O-ring is not available, use string smeared with petroleum jelly.

If the seal around the spindle appears to be in good condition, the leak is probably due to the gland nut above working loose. Replace the nut and tighten it gently so that it just passes the mark that you made against the head. Temporarily replace the handle and check that the tap can be easily turned. If it is too tight, slacken the gland nut. But if, with the water supply turned on, the tap instead continues to leak, then the gland nut will require further tightening to solve the problem.

Taps without gland nuts
Some taps do not have conventional gland nut assemblies, even though their heads are made of brass. Instead, the spindle is held in the head by means of a circlip (snap ring). The seal between them is provided by two or more O-rings around the spindle body, and if these are worn they must be replaced. Follow the procedures above for removing the tap handle and unscrewing the head. Dig out the circlip around the top of the spindle as shown in fig. 6 and you will find that the spindle drops out. The O-rings around it can then be rolled off and replaced.

Leaking swivel nozzles
Mixer taps with swivelling spouts are often prone to leaks around the base of the spout itself, caused by the seals in the base wearing out. Providing you are working on the spout alone, it will not be necessary to turn off the water. Start by loosening the shroud around the base, which will either screw on or else be secured by a small grub screw at the back.

Around the spout, inside the base, you will find a large circlip (snap ring). Pinch this together with the pliers and remove it, then pull out the spout.

Dig the worn seals out of the exposed base and discard them. Fit the new ones around the spout: if you fit them into the base, you will have great difficulty in getting the spout to go back in the correct position. With the seals around the spout it should slot in easily and you can then replace the circlip and the shroud.

If you have to make a temporary repair to a tap seating—necessary if dripping continues even when the washer has been replaced—use a new plastic washer and seating kit.

10 The flow straightener can be knocked out using light taps from a hammer. The washer and its jumper are on the other end

11 The combined washer and jumper is prised from the flow straightener and a new one of the same size slotted in its place

12 To cure a leaking nozzle, undo the shroud at the base. This either unscrews or may be released by a grub screw at the back

13 Pinch together the large circlip at the base. Use pliers for this and take care not to scratch the chromed finish of the nozzle

14 Pull the spout from its seat and then dig out the worn seal in the exposed base. Remove all bits before fitting new ones

15 Place the replacement seal on the spout before refitting this. Replace the circlip and then screw on the shroud

Understanding your water system

John Harwood

The layout of most water systems is a mystery to many householders. Get to know how the plumbing system works and you will be able to save on plumbing and emergency repair bills

Domestic water systems come in two main types:

High-pressure systems, in which water at 'mains pressure' is supplied directly to all the taps (faucets) and other water-using appliances.

Low-pressure systems, in which the water supply to most taps and appliances is via a cold-water storage cistern in the attic, only the kitchen tap(s) being supplied directly from the mains.

This article described low-pressure systems, the most usual in the UK. High-pressure systems, the most common in Canada and the US and in parts of the UK, are covered later on in the course.

Where the water comes from

Cold water comes to your house from the water authority mains via a smaller, service pipe. This pipe may have been installed specifically to serve your house or you may share it with a neighbour. Either way, it will be controlled by a water authority stopcock somewhere on the edge of your, or your neighbour's, property. The stopcock is sunk below ground (usually about a metre) and is encased in brickwork, concrete, or a stoneware pipe to provide access. To mark the site, a small cast-iron casing is usually fitted at ground level.

From here, the service pipe runs to your house and becomes known as the rising main. At the point where it enters, a further stopcock—known as the consumer's, or house, stopcock—is fitted. This one is your own property and, because it controls all water entering the house, it is as well to know where to find it.

The most common place is under the kitchen sink, where a branch of the rising main directly supplies the kitchen cold tap with drinking water. The other most likely locations are under the stairs, or below floorboards immediately inside the front door.

The cold storage tank

After the branch to the kitchen cold tap, the rising main runs to a cold storage tank or cistern, normally in the roof space. Older storage tanks are made of galvanized iron, which is both heavy and prone to rust. These have now been replaced by the lighter, more hygienic, plastic tanks.

The storage tank helps to iron out irregularities in the mains supply and also provides an emergency reservoir if the supply is cut off.

The rising main's supply of water to the top of the tank is controlled by a ball-valve similar to the one in a WC cistern. At the base of the storage tank you will find the main water outlet. The stored water flows through here under the pressure of gravity and then branches off to supply the rest of your house's water requirements. These will include the WC, the bathroom cold taps and the hot water cylinder.

A stopcock is normally fitted somewhere near the outlet, so that you can turn off most of the water, but still leave your kitchen cold tap in operation to supply the family's needs while you are working.

The hot water supply

In household plumbing, cold water is converted to hot either directly or indirectly. Direct heating means that the cold water comes into direct contact with a heater—normally a boiler or an electric immersion heater—then flows straight to the taps.

With indirect heating—usually combined with central heating—the water heated by the boiler is itself used to heat up fresh cold water. In this system, the two hot water circuits are separate and heat is transferred from one to the other by means of a heat exchanger.

The hot water cylinder, a copper tank heavily insulated to guard against heat loss, is common to most hot water installations.

In direct systems, it houses the electric immersion heaters—if fitted—and acts as storage tank to keep your hot water supply as constant as possible. In an indirect system, the cylinder has the additional function of housing the heat exchanger.

The direct flow

The flow of water in both direct and indirect systems relies on the principle that hot water always rises above the cold water around it. So, in a direct system, the flow starts with cold water running to the base of the hot water cylinder.

If a boiler is fitted then the flow continues from the cylinder down to the base of the boiler. As the water is

Key:
- Hot water feed to radiators
- Cooled water return from radiators
- Cooled water from heat exchanger
- Hot water feed to heat exchanger
- Rising supply main (cold)
- Cold supply from storage cistern
- Hot water supply from cylinder

Left: *A typical modern plumbing system incorporates two hot water loops for the hot water cylinder and radiators. The water enters the house via the rising main and feeds the system from the supply tank*

heated it rises out through the top of the boiler, up to the top (crown) of the hot water cylinder and then on to the hot taps.

If immersion heaters are fitted instead of a boiler, the flow is greatly simplified. The water runs from the storage tank to the base of the hot water cylinder and is heated: it then rises straight out of the cylinder and on to the hot taps.

The great disadvantage of direct systems is that water, when it is heated above 60°C (140°F)—or 80°C (180°F) in soft water areas—deposits scale similar to kettle fur.

The scale can block up pipework and boilers alike unless adequate precautions are taken. These include keeping the water temperature down below the 'scaling point' and using scale-inhibiting additives in your cold storage tank.

The indirect flow

The easiest way of understanding an indirect hot water flow is to visualize two independent 'loops' of water. The first loop consists of the water used to feed the hot taps.

This flows from the cold storage tank to the base of the hot water cylinder, where it comes into thermal contact with hot water on the other loop (via the heat exchanger). As the water is heated, it rises out of the cylinder and on to supply the taps.

The other loop supplies the boiler, heat exchanger and—if fitted—the radiators. Here, fresh water flows to the base of the boiler from either the storage tank or from another separate tank, known as the 'expansion tank'.

Once in the boiler, the water is heated and then rises out to feed the heat exchanger and radiators. After the water has given up its heat, it flows back to the boiler for re-heating.

Because the water in this loop is hardly ever changed, the problems of scaling are greatly reduced. The first time it is heated, the water gives up its scale; from then on, it is unable to do further damage.

The expansion tank

The indirect arrangement works best when an expansion tank is fitted to supply the boiler loop. This makes the loop almost completely independent of the one supplying the hot taps.

The tank is supplied with water from the rising main via another ball-valve. So, if the loop needs topping up with water because of evaporation, the process is automatic. In practice, changes in the water level inside the

When a pipe bursts

If you are unlucky enough to have a leak or a burst pipe, your first step must be to cut off the water supply. Do this as near to the offending area as possible so that inconvenience is kept to a minimum.

Hot water pipe or tap: Look for a stopcock on the pipe which runs into the base of the hot water cylinder or boiler. Before you turn it, make sure that all heating apparatus is off.

Cold water pipe or tap (low pressure systems): Trace back along the relevant pipe until you come to a stopcock. If there is none between the burst and the cold storage tank, you will have to block the tank outlet. To do this, nail a cork slightly larger than the outlet hole on to the end of a piece of timber (fig. C). By 'remote control', you can now insert the cork into the outlet and prevent further water from leaving the tank.

Should the outlet prove impossible to block, drain the tank

A. *A leak in the tank can often be fixed by plugging the hole with a bolt. Use a soft washer between the two metal rings for a watertight fit*

B. *Temporary repairs can be made to a split lead pipe by plugging the crack with a sliver of matchstick, waxing the plug, then taping firmly*

expansion tank are barely noticeable.

To guard against the build-up of high pressures in the hot water system, overflows or vents are fitted.

In a direct system, only one pipe is needed. This runs to the top of the cold storage tank, either from the crown of the hot water cylinder or from a branch off the hot water service pipe.

In an indirect system, an additional vent is installed at the top point of the primary circuit.

Turning off the hot water

Whatever your hot water system, the hot water which reaches the taps comes from the top of your hot water

cylinder. It does so because of the pressure of the cold water entering the cylinder beneath.

So, if you cut off the cold water supply at the base of the cylinder, no further hot water will rise from the top. Most hot water cylinders have a stopcock for this purpose, fitted at the cold water inlet. Those that do not, invariably have a stopcock somewhere on the pipe between the inlet and the cold storage tank. Before touching this stopcock make sure that all heating apparatus is turned off.

Wet central heating

Wet central heating, in which hot

instead. First tie back the ball valve to a piece of timber stretched across the tank: this will stop fresh water from entering. Now, turn on your bath and washhand basin cold taps, until the tank is fully drained.

Cold water pipe or tap (high pressure systems): Turn off the water authority stopcock.

Leaking galvanized storage tank: A leak here will probably be due to a rust spot which has eaten its way right through the metal. Once you have tied back the ball valve and drained the tank, you can cure the leak by drilling out the rust spot and fitting a nut, bolt and washer into the hole (fig. A).

Burst lead pipe: A crack in a lead pipe can be temporarily stopped by ramming in a matchstick and then rubbing the area with candle wax. Follow this by binding up the repair with strong tape (fig. B) and keeping any relevant stopcocks at half pressure until a proper repair can be done.

Storage tank outlet

Hot water cylinder cold feed

Pipe [st]opcock

Water authority stopcock

C. *Your plumbing system is fitted with several stopcocks to isolate various sections of the system in the event of a leak*

House stopcock

John Harwood

water is used to heat the house via a system of radiators, adds an additional complication to plumbing installations. But if you can imagine the radiators and their pipes as being part of the boiler 'loop' in a basic hot water system, the whole thing becomes easier to understand.

Some older installations work on the direct principle in which hot water heated by the boiler flows to the radiators as well as to the hot taps. Because this system is uneconomical and causes scaling, it has been replaced by indirect installations.

Here, the water which flows to the radiators is on a pump-driven loop like the one used to supply the heat exchanger. Consequently it is always fairly hot and requires less heating, which in turn makes it far more economical than a direct system.

In some indirect systems, the water which supplies the boiler loop is drawn direct from the storage tank. But most incorporate a separate expansion tank to keep the loop independent of the rest of the water supply.

Radiator systems

The pipework used to supply the radiators may take one of two forms. In the simpler, one-pipe system, hot water flows from the boiler to each radiator in turn and then back to the boiler again. Although this cuts down the amount of pipework needed, it allows hot and cooled water to mix near the end of the run. Consequently, the last radiator in the run often remains cool however hard the boiler is working.

In the two-pipe system, the pipework is arranged so that cooled water leaving the radiators cannot mix with the hot water entering them. The radiators therefore heat up faster, as well as remaining at the same temperature.

Sizing of inward and outward piping in the radiator circuit is matched to the given radiator load—so pipe sizes vary throughout the systems.

Planning a shower

● **Where to site a shower** ● **Problems of water supply** ● **Coping with temperature fluctuations** ● **Problems of drainage** ● **Installing a shower base and instantaneous shower**

Taking a shower is the ideal way to freshen up, much more convenient than having a bath and considerably cheaper. Among the other benefits of a shower are its constant running temperature, and the possibility of fitting it away from the bathroom to avoid early-morning congestion.

You have the choice of converting existing room space to form an enclosure (fig. A), or of buying one of the many prefabricated enclosures (fig. B) now on the market—many of which come complete with fixtures and fittings.

If you plan to make your own enclosure, base the design of this on the use of a prefabricated shower base. This considerably simplifies the all-important drainage arrangements, which are often the greatest problem where the bath is not used. From a

safety point of view, make sure you provide adequate lighting and room for movement.

On the plumbing side, hot and cold water supply pipes have to be laid on as well as drainage, and these points go a long way towards influencing your choice of site. At the shower, the hot and cold water can be mixed by independent taps or by a single control. Supply pipework and the shower head connection can be concealed beneath tiling, perhaps behind a false panel fixed to the wall.

Another alternative is to provide a shower over a bath, either by fitting combination bath/shower mixer taps (faucets) which can be readily bought, or by laying on piping for an independent shower. With this arrangement, you have no shower base or drainage to worry about.

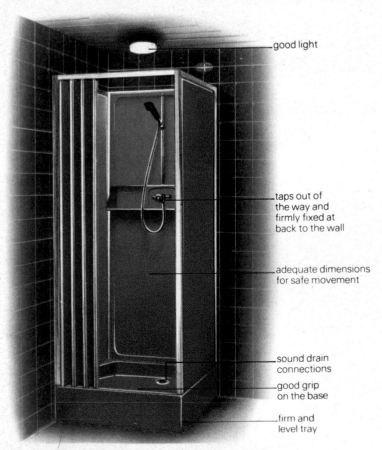

Gary Warren

A. _Purpose-built shower enclosure, here incorporating an 'instant' electric heater_

good light

taps out of the way and firmly fixed at back to the wall

adequate dimensions for safe movement

sound drain connections

good grip on the base

firm and level tray

separate mixer unit

existing connections

bath

hot supply

cold supply

wall

Concealing the pipes

softwood battens

plywood

hot and cold pipes inside

B. Left: _A prefabricated shower base can be located wherever plumbing and drainage present no problem. Observe commonsense safety precautions_
C. _If you choose to use your bath as a shower base, an independent hot and cold water supply permits some freedom in locating this. Box off exposed piping as shown_

D. *Interrupting existing hot and cold water supplies in order to feed the shower control requires some care. Mixer controls should be fed by independent hot and cold water supplies wherever possible to avoid water starvation—hence temperature fluctuations—when taps in other parts of the system are turned on. To ensure equal hot and cold water tap pressures at the mixer, see that the cold water supply comes from the same system as supplies the hot water system, or from one alongside it. The two diagrams show two typical supply interruption points. Adequate water pressure is essential: the head of water must be at least a metre, but preferably more for optimum flow. Raising the supply cistern is one way of achieving this*

head of water
(1m minimum)

cold storage tank
raised to increase
the head of water

new section
of piping (lagged)

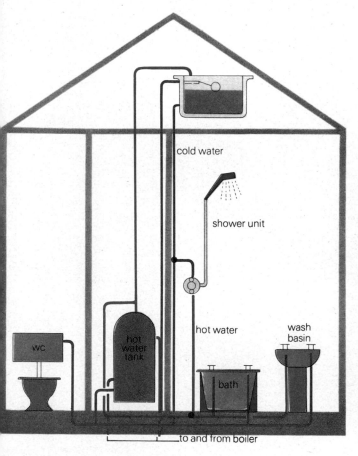

cold water

shower unit

hot water tank

hot water

wash basin

WC

bath

to and from boiler

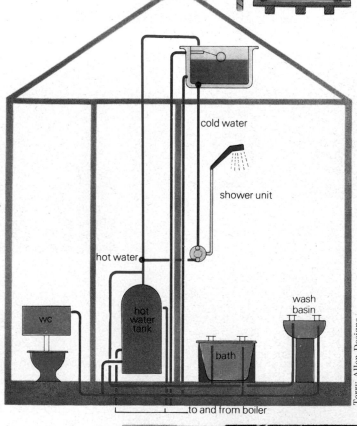

cold water

shower unit

hot water

hot water tank

WC

bath

wash basin

to and from boiler

Terry Allen Designs

If it is difficult or impossible to lay on a suitable hot water supply, then an electric 'instantaneous' shower or gas heater may provide the answer, although both have disadvantages compared to a properly fitted shower. The instantaneous electric shower has a poor flow rate, and the gas shower needs ducting to the outside (it is usually attached directly to an outer wall).

The water supply

For proper operation of a shower, there must be sufficient water pressure at the shower rose. In many British houses, the water pressure at most taps (both hot and cold) is provided by a cold water storage cistern, mounted above the level of the water outlets. The higher the cistern above the outlet,

the greater the pressure will be; the vertical distance measured from the bottom of the cistern to the outlet is called the *head*. For a shower, the head is measured to the rose and ideally should not be less than 1.5m, though in simple plumbing systems a head of 1m may be sufficient.

If the head is between about 1m and 1.5m, then an adequate shower may be achieved if you can keep connecting pipework runs short, and with very few bends.

For heads of less than a metre, or where it is not possible to have short simple pipe runs, there are three main solutions. The first is to install a *flow booster*—a type of electrical pump which increases the pressure. Operation is automatic.

The second solution is to *increase the*

Gary Warren

height of the cold water storage cistern by raising it up on a sturdy wooden platform. But there may not be room in your loft to do this. Another solution is to use an *instantaneous shower* connected directly to the cold water mains.

In some areas of the UK, houses do not have cold water storage cisterns; instead, all cold taps and so on are supplied direct from the mains. Hot taps are usually supplied from a conventional hot water cylinder fed from its own small cistern. This particular method of obtaining water is what is known as a direct system. With this arrangement it is not possible to fit a conventional mixer type shower: it would contravene water regulations. You can either fit an instantaneous shower or perhaps modify your plumbing so that the shower is fed from a suitable, conventional cold water storage cistern.

In Canada, the whole water system, including the hot supply, is fed direct from the mains, and showers designed to work with this system are readily available. In Britain, a fully direct system like this will almost certainly use a 'multipoint' type gas heater: you should consult both your gas board and your water authority about the possible problems of connecting a shower to such a supply.

Temperature fluctuations
Water starvation in either hot or cold supply pipes can cause temperature fluctuations in the shower, which could be annoying or even dangerous. It is very sensible to buy a shower that is thermostatically controlled, or at least has a temperature limiting device so that the water never gets dangerously hot.

For showers in an indirect plumbing system, it is a good idea to use separate hot and cold supply pipes that do not feed any other fittings—then turning on any other taps in the home will have no effect on the flow.

Drainage considerations
Although deciding how to supply water to a shower can be tricky, it is usually possible to get over the problems one way or another. Leading the dirty water away, though, to a soil stack or waste water drain often presents far more constraints. PVC piping, being easy to work with, is the logical choice for this sort of job. But breaking through walling, both internal and external, is usually necessary if the discharge pipe is to remain completely

F. *A built-in shower enclosure is a desirable feature of any well-appointed bathroom, but can of course be incorporated wherever there is room to spare. Note the hinged screen of strengthened or laminated glass*

hidden from view. And unlike hot and cold supply piping, the discharge branch cannot be taken under the floorboards unless the run is between, and almost parallel to, the joists underneath.

Your choice of site for the shower must therefore take into consideration drainage arrangements almost to the exclusion of everything else.

Following the recognized and approved guidelines on drainage, the branch discharge pipe length is limited to a length of 3 metres and to a slope of between 1° and 5° (equivalent to a drop of between 18mm and 90mm per metre length).

An 'S' trap can be employed if a pipe drop is required (fig. G), such as when underfloor drainage is possible, but otherwise a 'P' trap is preferable. Use pipe of 42mm diameter.

If the shower base discharge pipe can be arranged to go directly through the wall and connection has to be made to an outside soil stack or waste hopper, much of the fall can be arranged externally.

Use professional help if you have

to break into a cast-iron stack, though it is usually easier to replace the whole stack with the PVC equivalent so that the shower and any future additions to the system involve the minimum amount of work.

Installing a shower base
The first stage of the job is to prepare structural work—such as a timber frame for the enclosure—if this is necessary. Thereafter the sequence is:

In the UK, alterations to existing plumbing installations are strictly controlled by local water authority by-laws. Because of this, you should inform your local water board of your plans at least seven days before work starts. As well as giving practical advice, they will warn you against any possible infringement of their regulations.

In Canada, you should check local building ordinances to make sure that the work you are undertaking complies with them.

Run hot and cold water supply pipes to the point where a connection is made with the shower controller.

Follow carefully any recommendations made by the shower manufacturer as to where to break in to the supply. Use 15mm copper piping and 'T' connections to connect with your existing hot and cold water pipes, keeping bends to a minimum and pipe runs as short as possible. Use either compression or capillary fittings—the latter are cheaper, and neater looking. The skilled techniques of joining and bending copper pipes should not be attempted without prior experience.

Remove the shower base (or tray) and its accessories from the protective wrapping, taking care not to scratch or damage these parts. Lay fixing accessories on the floor close at hand —but not in the immediate working area—in a logical order ready for use.

Lay the shower base on a protective groundsheet, and locate the tubular legs in the sockets welded on each side of the steel shower support frame. Fix the frame to the wooden shower support, which may be flooring grade chipboard (particleboard) or similar.

Secure each leg to its socket upstand using self-tapping screws.

Assemble the adjustable feet but hand tighten only as later adjustment is necessary. Place the shower base on its feet.

Fix the waste outlet to the shower base, incorporating the sealing washers provided and using a waterproof mastic to complete the seal. Use a holding spanner while tightening the larger nut with an adjustable spanner.

Attach a short length of pipe to the trap and temporarily secure the trap to the waste outlet, then mark on the wall the exit position of the pipe.

Cut a hole through the wall for the discharge pipe at this point (see pages 178 to 181). You will find it easier to remove a small section of skirting first if this is in the way.

Reposition the shower base, then using a bradawl, mark the floor fixing points of its supporting board.

Check the level of the shower base, ensuring that the trap has sufficient ground clearance, and tighten the fixing nut on each leg.

On solid floors it is difficult to drill and plug for eight screws and still have perfect alignment—especially as the holes have to be angled so that the shower base does not impede the actual screwing process. It is easier to fix the support board on its own to the floor, attaching the feet later.

Temporarily link together the trap with a short length of pipe, arranged to protrude through the wall near to where it is to discharge into a hopper or stack. If you have the choice, direct the pipe to a hopper rather than attempt entry into a stack.

If discharge is made to a soil stack, mark a point on the stack which is level with the protruding pipe ('A' in fig. G) and another point a little below this so that a drop of between 18 and 90mm per metre is obtained ('B') for satisfactory discharge.

Assemble a replacement triple socket, boss branch and pipe socket and then gauge the length of the piping which has to be removed from the stack in order to fit these. Transfer the measurement to the stack in such a way as to embrace points 'A' and 'B' (fig. G), with the pipe socket coinciding with the latter.

Cut out the stack length with a fine-toothed saw, taking precautions or using assistance to keep the upper and lower lengths in position afterwards.

Dismantle the triple socket from the boss branch and pipe socket. Push the triple socket into the top part of the stack as far as it will go. Then fix the boss branch and pipe branch on to the lower part of the stack. Complete

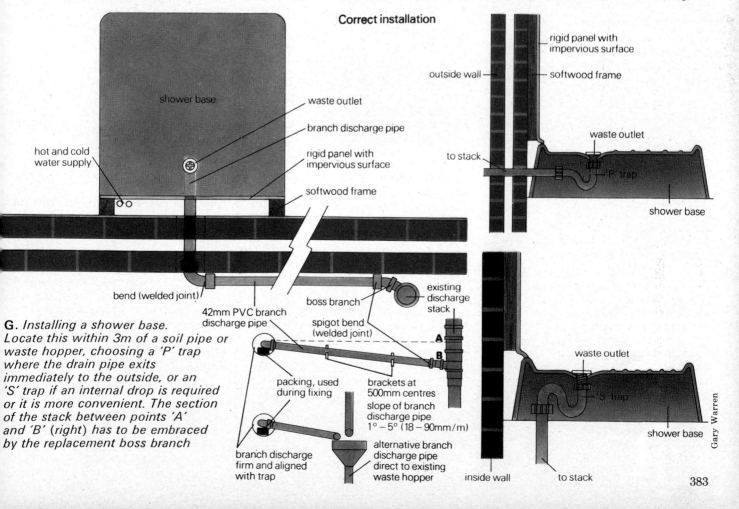

Correct installation

shower base

waste outlet

branch discharge pipe

rigid panel with impervious surface

softwood frame

hot and cold water supply

bend (welded joint)

42mm PVC branch discharge pipe

boss branch

spigot bend (welded joint)

packing, used during fixing

brackets at 500mm centres

slope of branch discharge pipe 1° – 5° (18 – 90mm/m)

branch discharge firm and aligned with trap

alternative branch discharge pipe direct to existing waste hopper

existing discharge stack

rigid panel with impervious surface

outside wall

softwood frame

to stack

waste outlet

'P' trap

shower base

waste outlet

'S' trap

shower base

inside wall

to stack

G. *Installing a shower base. Locate this within 3m of a soil pipe or waste hopper, choosing a 'P' trap where the drain pipe exits immediately to the outside, or an 'S' trap if an internal drop is required or it is more convenient. The section of the stack between points 'A' and 'B' (right) has to be embraced by the replacement boss branch*

Gary Warren

H. *A shower enclosure can be incorporated in an under-stairs conversion where other simple washing facilities may also be provided for use by occasional guests. Lack of privacy may pose a problem, however*

the fitting by pushing the triple socket down into its final position.

Insert the spigot bend into the boss branch, attach brackets to the outside connecting length of the discharge pipe and fit this into the spigot bend. Twist the boss branch until the supporting brackets on the discharge pipe make contact with the wall.

The discharge pipe from the inside of the house should by now meet the discharge pipe attached to the stack, and the two can be marked for cutting so that you can fit a 45° bend where the inner pipe leaves the wall. Remove both pipes and cut these to final length.

Replace all pipes, the longer (outside) one with its fixing brackets in place. The shorter (inner) length is fixed first to the trap and then to the bend. Screw the trap to the waste outlet of the shower base. It is essential that all pipes and fittings are perfectly aligned and that no force is used to keep them in place. Make minor adjustments if necessary.

Mark and fix supporting brackets, normally required only for the outside length. Make alignment marks at each of the fittings.

Dismantle pipework and fittings that require solvent welded joints, prepare the joints and reassemble as before.

If the discharge pipe is to be led to an outside hopper, cut the protruding pipe length to fit a slow (45°) bend. Attach this to whatever length of pipe is necessary to complete the run at a convenient point above the hopper, and provide support brackets.

Make good the hole through the wall using a proprietary filler paste. There are now aerosol foam sprays on the market which are waterproof, allow for expansion or contraction, and are easier to work with than the more traditional compounds.

Test the pipework, first for stability (proper support and correct joining) and then for watertightness, using a pail of water until connection is made with the supply system.

Connection of the hot and cold water supply pipes to the shower controller (or regulator) is made in the course of assembling the shower enclosure, and the procedures should follow exactly those stipulated by the manufacturer. The valve and spray piping are attached to a mounting panel attached to the wall or set into the wall along with piping. With self-contained shower enclosures, the mounting panel is attached to the rear of the cubicle with a waterproof gasket arrangement.

Completing the enclosure

Once the shower base installation is complete, you can attend to the completion of the shower enclosure. This is a relatively simple job if you are using a prefabricated kit, which often requires little more than a few minutes with a screwdriver. Built-in enclosures requiring woodwork, tiling and other jobs (not forgetting suitable sealing at the joints) take much longer to make but can be matched completely to the design of the room.

Install an electric shower

An instant electric shower is an attractive proposition if use cannot be made of conventional hot and cold water supplies. In most instances, connection of the heater is direct to the mains water supply—so a shower of this type is especially useful if a hot water cylinder is not incorporated within the system. Pressure and flow variations within the system may have a marked effect on temperature stability, however. The heater needs direct and permanent connection to the electricity supply through a double-pole linked switch. The appliance must be earthed, and protected by a 30amp fuse. For additional safety, site the heater well away from the direct spray at the shower, and locate the switch outside the bathroom.

You can interrupt the rising main at any convenient point. Remember to keep the pipe run as short and as straight as possible. This Deltaflow unit requires a cold water supply which has a minimum static pressure of one bar (equivalent to a water head of about eight metres) which should be available from most mains supplies. In most houses, though, you cannot use a cistern-fed supply because the head will not be great enough.

If in any doubt, seek professional help. In some parts of Canada, you may need to have the electrical work done for you.

7 *Mark the shower rail position and screw the rail firmly into position, with the top of the rail no higher than the heater*

1 Components of the Deltaflow Showerpack instant electric shower heater. Installation involves plumbing and electrical skills

2 Remove the cover and mark the position of the fixing holes, and drill for fixings as required. Knock through for connecting wires

3 Cable entry to heater is best made through the rear. Ensure this is correctly wired, tightening the cable clamp securely afterwards

4 The double-pole linked switch is located safely on the other side of the wall and connected to the heater via the wall aperture

5 Pipe connections near to the heater can be tailor-made to fit. Use capillary fittings up to the point the heater fitting is used

6 Interrupt the cold water supply wherever is most convenient, using a 'T' connector. In a loft, lag the pipe well

8 Connect the flexible hose to the water outlet of the heater, turn on the water mains and the flow tap and then check pipework for leaks

9 Repeat the procedure with the heater on. Where water pressure is too high, the restrictor may need adjusting to reduce the maximum flow

10 When tests have been completed to your satisfaction, finally replace the cover and connect the two neon spade leads

Gavin Cochrane

Repairing a WC

Problems with the WC, or toilet, may be just plain annoying—such as a slow-filling cistern—or more serious—such as a cracked outlet joint. But none requires much more than basic plumbing skills and common sense to put right

Below: *Replacing a cracked WC pan is not as daunting a task as it seems—with care, basic plumbing skills and the aid of modern materials, it becomes a simple repair which can be completed rapidly*

1 A crack in the rim of a washdown WC prevents the flushing action from working efficiently. The only solution is to replace the pan

2 Where the pan outlet is cemented to the soil pipe, you must break the S-trap at the joint. Take care not to damage the soil pipe

Gavin Cochrane

3 If the pan is set in concrete on a solid floor, you must break the pan with a hammer and cold chisel using purposeful blows

4 Once the pan is free of the floor and the soil pipe you can lift it out, then chisel away any remaining pieces of porcelain

The WC (also called water closet, toilet, or lavatory) is a particularly hardworking, and fairly complex, piece of plumbing apparatus. So it is prone to a number of faults. Though these are rarely difficult to put right, the various jobs are made a lot easier if you know something of how a WC works, and what happens when you pull the lever and the pan is washed automatically clean.

There are two main parts to most WC systems—the pan itself, and a cistern above it which holds the water to flush the pan.

The WC pan
There are two basic types of pan. The *washdown* uses the force of the descending flushing water alone to push the contents into the soil pipe. In the more modern *siphonic* system, the impulse of the water flush creates a vacuum in the pan so that atmospheric pressure will force the contents out of the pan. The flushing water merely serves to refill the bowl. The siphonic suite is more complex, and therefore more costly, but it is quieter in operation.

All pans have a built-in trap to prevent unpleasant gases coming back up the soil pipe from the sewer or cesspit. The shape of this varies according to the type of pan, but it always includes at least one 'U' bend which remains filled with water.

Traditional UK pans have their outlet either vertically downwards (called an S-trap) or nearly horizontal (a P-trap). Modern UK pans often have a short horizontal outlet at the back to which you can fix a number of patterns of connector pipe—this makes it possible to accommodate the vagaries of most existing waste systems when fitting a new pan. Whatever the type of outlet, it is always at the back of the pan.

Canadian pans have vertical outlets that appear from underneath the pan itself. This makes for a neater external appearance, and means that the large, ugly, soil pipe is hidden from view below floor level.

The WC cistern
The purpose of the WC cistern is to hold just enough water to clean out the bowl.

Modern cisterns are usually either *low-level*, with the cistern just above the pan and connected to it by a short flushing pipe, or *close coupled*, in which the cistern and pan form a single unit. Old-fashioned suites may be *high-level*, with the cistern as much as 2m above floor level.

UK cisterns usually have a siphonic-type flushing valve—pressing the lever jerks up a diaphragm within a U-shaped tube, pushing water over the top of the U (which is normally above water level) and down into the pan. Siphonic action keeps the flap up and water flowing until the cistern is empty; then the inlet valve opens and refills the cistern.

Canadian flushing systems look less complex. The lever lifts a simple valve cover—a flapper or ball—at the base of the cistern. The rush of outflowing water prevents the valve cover from closing again until the cistern is nearly empty. Then the inlet valve opens and refills the cistern; some of the incoming water is diverted through an overflow tube to replenish the trap-sealing water in the pan. Alternatively, there may be no cistern at all; just an automatic valve (called a *flush valve*) connected direct to the water supply. This lets through a metered amount of water, then closes.

There are several types of inlet valve. They are strictly called 'float valves', because they all have a member which floats on the surface of the water and is connected to the actual valve mechanism. As the cistern empties, the movement of the float opens the valve to allow the cistern to refill. In most cases, the floating part is a ball, connected to the valve by a long arm—so these valves are usually

known as ball cocks, or ball valves.

Cisterns need an overflow warning pipe, in case the ball valve fails to shut off when the cistern is full. In the UK, the overflow pipe usually discharges outside the house. In Canadian cisterns, the overflow tube discharges direct into the WC pan.

Faults with a WC can be divided into plumbing faults (such as flushing problems, and usually the result of wear and tear) and accidental damage (such as a cracked pan).

Failure to flush

First check the water level in the cistern; if this is very low, the fault lies with the ball valve. Try pushing the float below the water level. If water rushes in then the valve is

A. Below: *In the washdown system, the force of the water descending from the cistern flushes the pan. In the single-trap siphonic system, the pan fills completely and its contents are emptied by atmospheric pressure as the movement of the water into the second section induces a partial vacuum. In the double-trap siphonic system a vacuum is created in the air space as the cistern empties*

working correctly, but the float is closing it at too low a water level. You can correct this by gently bending the ball arm upwards (or with some patterns, altering the position of the float on the arm or guide).

If no water enters the cistern when you push down the float, then the inlet valve is blocked: for repair, see *Overflowing cisterns*, below.

If the water level in the cistern is not low, then you have a fault with the outlet flushing valve. Before you dismantle it, though, check that the various levers and wires are intact, and that moving the handle actually does move the valve flap. Broken or stretched linkages are usually easily replaced.

To replace a worn diaphragm, first tie up the ball valve arm to stem the water supply. Then empty the cistern—first by flushing it, then by mopping up any remaining water with a sponge.

On a close-coupled suite you must next remove the cistern from the pan. In all cases, undo the nut under the cistern securing the flush pipe to the siphon unit, and also the nut securing the siphon to the cistern body, then remove the whole siphon unit. Note the position of the parts as you con-

tinue disassembly.

Replace the diaphragm with one of the correct size and reassemble the siphon unit. You can obtain a new diaphragm from hardware shops or builders' merchants, or cut one from a piece of heavy PVC sheet using the old one as a template.

Check that the plunger moves freely in the siphon unit, then replace the unit in the cistern.

Flush fails to clean pan

In the case of the flush not efficiently clearing the pan, either the pan is not level or the flush pipe is blocked.

The washdown system is more sensitive to the pan not being level because of its dependence on the momentum of the flushing water. This should flow around each side of the flushing rim and meet centrally at the front of the pan. But if the pan is tilted slightly, the flush will be stronger on one side than the other and the result will be a 'whirlpool' effect which is inefficient.

Use a spirit level to check that the pan rim is level. If it is not, loosen the pan base retaining screws, and pack pieces of wood or linoleum under the lower side. Also, check the channel

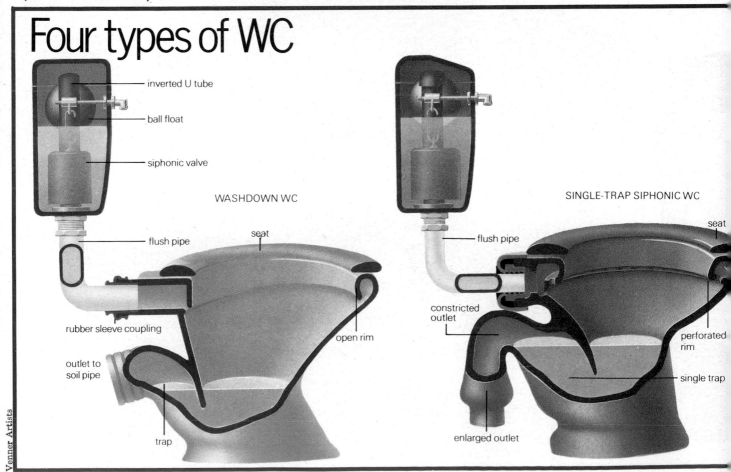

Four types of WC

inverted U tube

ball float

siphonic valve

WASHDOWN WC

flush pipe

seat

rubber sleeve coupling

open rim

outlet to soil pipe

trap

SINGLE-TRAP SIPHONIC WC

flush pipe

seat

constricted outlet

perforated rim

single trap

enlarged outlet

Venner Artists

under the flushing rim for obstructions and clean it if necessary.

If the pan is level, check that the flush pipe enters the pan squarely and that there is no obstruction at this point.

With a Canadian flush-valve toilet, there is a regulating screw which adjusts the amount of water in each flush. If altering this fails to cure an ineffective flush, then the valve will have to be dismantled and cleaned (see below).

Overflowing cistern

If water pours out of the cistern overflow pipe, it is likely that the float is perforated and waterlogged. In this case you must replace a faulty float with a new one, though as a temporary cure you could shake out the water and tie a plastic bag around it.

If on the other hand water is only trickling from the overflow pipe, it is more likely that the ball valve washer needs replacing—although sometimes the trouble is due to a speck of grit preventing the washer from seating properly on the valve nozzle. In both cases, it is necessary to dismantle the valve.

There are several different types of ball valve, but the most common UK ones are the Portsmouth, Croydon, Garston, Equilibrium and Torbeck (fig. B). To dismantle any valve, the first step is always to isolate the water supply to the WC cistern.

In the case of a Portsmouth or Croydon valve, remove the split pin on which the float arm pivots and place the float and arm on one side. With a Croydon valve the plug will simply drop out of the valve body. To extract the plug from a Portsmouth valve, insert the blade of a screwdriver into the float arm slot and push the plug out of the end of the valve body, taking care not to let it fall.

At this stage, if possible, get an assistant to turn the water supply briefly on and off to your command so that the pressure ejects any grit that may be blocking the valve nozzle. Reassemble the valve and attach the ball arm and float, then turn on the water supply and see if the valve seals off the supply effectively. If it does not, the washer is defective and you must replace it.

The plugs of both types of valve are in two parts, but the cap that retains the valve washer is often difficult to remove. You can try applying some penetrating oil and warming the end of the plug gently, but you must not damage it by rough handling. If the cap refuses to budge, pick out the old washer with the point of a penknife and force the new one under the flange of the cap, making sure that it rests flat on its seating.

Clean the plug with fine emery paper, then wrap the paper around a pencil and clean the inside of the valve body. Smear a thin coat of petroleum jelly inside the valve before you reassemble it.

Some modern cisterns are fitted with a Garston ball valve. In this case, shut off the water, remove the split pin and the ball arm as before, then unscrew the cap and pull out the rubber diaphragm. Check that there is no grit or foreign matter in the nozzle as described above. Otherwise, replace the diaphragm and reassemble the valve in the reverse order.

If a plastic Torbeck valve sticks, the most likely cause is dirt on the valve seat. Slowly raise and lower the ball arm a few times. If this fails to remedy the fault, shut off the water, unscrew the front cap, and wash the diaphragm in clean water. When you reassemble the valve, make sure that the dia-

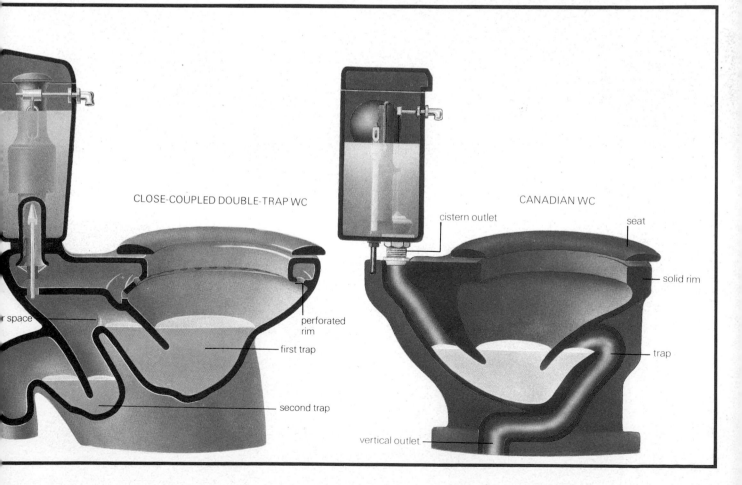

CLOSE-COUPLED DOUBLE-TRAP WC

CANADIAN WC

cistern outlet

seat

solid rim

space

perforated rim

first trap

trap

second trap

vertical outlet

Four outlet valves; two inlet valves

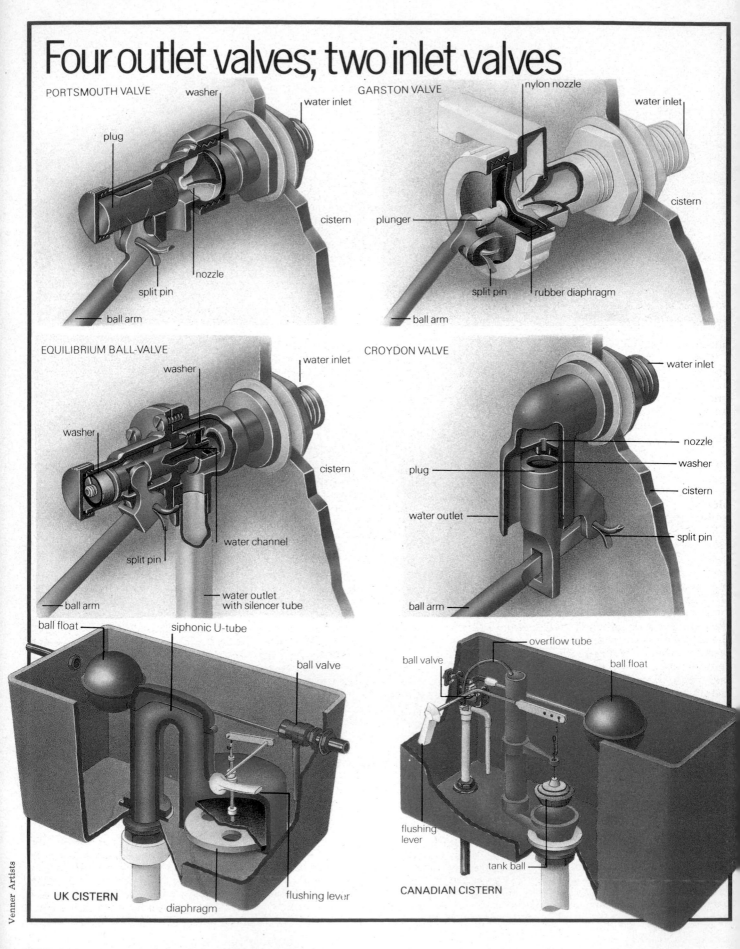

PORTSMOUTH VALVE

- plug
- washer
- water inlet
- cistern
- split pin
- nozzle
- ball arm

GARSTON VALVE

- nylon nozzle
- water inlet
- cistern
- plunger
- split pin
- rubber diaphragm
- ball arm

EQUILIBRIUM BALL-VALVE

- washer
- washer
- water inlet
- cistern
- split pin
- water channel
- ball arm
- water outlet with silencer tube

CROYDON VALVE

- water inlet
- nozzle
- washer
- cistern
- plug
- water outlet
- split pin
- ball arm

- ball float
- siphonic U-tube
- ball valve
- overflow tube
- ball valve
- ball float
- flushing lever
- tank ball

UK CISTERN

- diaphragm
- flushing lever

CANADIAN CISTERN

5 Stuff some crumpled newspaper or rags into the top of the soil pipe socket to stop debris entering and causing a blockage

6 Use a hammer to carefully break away the concrete surrounding the soil pipe socket and the remains of the old spigot

7 Liberally smear waterproof jointing sealant around the inside flange of the soil pipe to prevent water leaking from the joint

Gavin Cochrane

phragm is the right way round.

The main type of Canadian valve operates vertically, like a Croydon valve, at the end of a vertical water inlet which enters the cistern through its base—this makes the plumbing look neater. To dismantle, remove the two pins holding the rather complicated linkages which connect the valve piston to the float arm, and pull the piston upwards. There are two washers to replace—one in the bottom of the plunger and another one held in a groove around the circumference.

There is also a diaphragm type of valve, which also sits on the top of a vertical inlet tube. The cover is usually held in place with four screws; otherwise repair is much the same as for a UK Garston valve.

Canadian flush-valves are either of the diaphragm or piston type. Though the mechanism is usually a little more complex than for their float valve counterparts, disassembly, cleaning and repair is much the same. You can usually get kits of replacement parts.

Slow filling
The cistern should refill within two minutes of flushing. If it fails to do so, there is almost certainly something wrong with the ball valve. In this case dismantle the ball valve as described above and clean it.

One problem in the UK is that a high

B. Left: The four inlet valves are all float valves, which are controlled by the level of the water in the cistern. The outlet valves are specially designed so that they stay open while the cistern is emptying, then automatically close to allow it to refill

pressure valve might have been fitted—this is rarely needed unless the cistern is fed direct from the mains. Normally, a low-presure valve should be fitted, but in the event of the storage cistern being less than a metre or so above the WC cistern, then a *full-way* valve should be used.

Excessive noise
A WC can create excessive noise during refilling or flushing. Noisy refilling may be due to ball bounce and vibration, and this can often be reduced by tying a plastic flower pot to the float arm so that it is suspended, right way up, in the water a few centimetres below the float itself. The pot serves as a kind of 'sea anchor', and prevents the float rising and falling with every ripple.

The best solution, however, is to change the ball valve for either an Equilibrium or a Torbeck valve.

With a Canadian valve, check that water from the refill tube goes squarely into the overflow pipe.

The best solution to noisy flushing is to replace the suite with a double-trap siphonic type.

Leaking outlet joint
In the case of a leak here, use a hammer and plugging chisel to rake out the existing jointing material. Bind two or three turns of proprietary waterproof tape around the outlet pipe and caulk this down hard into the soil pipe socket. Then fill the space between the outlet pipe and the socket with a non-setting mastic, and complete the joint with two or three turns of waterproof tape over the mastic filling.

Cracked pan
The only solution to a badly cracked pan is to fit a new one. Before removing the old one, make sure the replacement will fit by checking the size, position and angle of the soil pipe where it goes into the pan. In Canada, you need to know only the *rough-in* distance—usually taken as the distance from the wall to the centre bolts holding the pan to the floor.

Tie up the float valve, flush the cistern, and scoop out the water in the bottom of the pan—all this helps prevent water damage in the case of accidents.

If you are replacing the pan of a close-coupled suite, the cistern will have to be removed and you will have to turn off the water so that you can disconnect the suite at the inlet pipe. Otherwise disconnect the flush pipe at the pan. Disconnect the pan at the outlet pipe. Both these joints might just pull apart, or the jointing material might be non-hardening and you can dig it out with a sharp tool. If cement or similar has been used for the joints, your best bet is to break the pan, taking care not to break the flush pipe or soil pipe. Bits of the pan then left attached to the pipes can usually be carefully chipped away (stuff rags into the top of the soil pipe first to keep out debris). Unscrew the pan from the floor (again, you may have to smash it free) and lift it away.

Offer up the new pan, with its top surface horizontal both from side to side and front to back, and the inlets and outlets should mate perfectly. There is usually little leeway on the flush pipe—drastic alterations can affect flushing performance—so discrepancies may

8 *The flexible plastic 'Multikwik' connector is easy to use. Simply position it inside the soil pipe socket and snap it into place*

9 *Make up a mix of one part cement to three of sharp sand and trowel this over the keyed floor in an area larger than the base of the pan*

10 *Where a P-trap pan is being fixed to a floor soil pipe, you must use an appropriate adaptor. Locate this in the 'Multikwik' connector*

11 *Manoeuvre the pan into the correct position, then press it down on to the still-wet mortar mix on the floor, rocking it gently as you do so*

12 *Use a damp cloth to clean away the excess mortar around the pan then scrape the floor clean with a trowel and wash it with water*

13 *Finally check that the pan is level—both sideways and back to front—and make any necessary adjustments before the mortar sets*

have to be taken up at the soil pipe connection. Many problems of mis-fit with UK soil pipes can be overcome with a flexible plastic connector, such as one of the 'Multikwik' range. With Canadian systems, there is no room for manoeuvre here: you will probably have to try a different pan.

There are three methods of fixing the pan outlet to the soil pipe in the UK: with a rigid plastic connector and rubber insert; with a flexible plastic connector of the 'Multikwik' type; or with a traditional cement and gaskin joint.

The plastic connectors simply push over both ends. If you are fixing the

outlet directly to the soil pipe with a traditional joint, first lay two or three turns of gaskin (hemp rope) around the joint socket to stop cement running down the soil pipe. Tap this purpose-fully into place. Then make up a mix of plumbers' quick-setting cement (such as 'Promt' cement and trowel this into the collar until it protrudes just above the collar rim. Trim the cement until the angle rises about 30° from the collar rim to the pan outlet.

A Canadian pan is sealed to the drain, which lies flush with the floor, with a toilet bowl gasket which fits around the pan outlet (called a 'horn'). Lower the bowl over the drain flange,

pushing down with a twisting motion to seat the gasket properly; avoid lifting the bowl once it is in position.

On a wooden floor, screw the pan in place using brass screws, taking great care not to overtighten, and making sure the pan stays level.

On a solid floor, make a key in the floor by cutting grooves in it with a bolster. Make up a mix of one part cement to three of sharp sand and trowel this over the key. Then lower the pan over it, making sure that the pan outlet enters the collar of the soil pipe or connector. Rock the pan slightly to settle it, and make sure that it is level with a spirit level.

Plumbing in a washing machine

● **Choosing the best site** ● **Breaking into the existing water supply** ● **Connecting the hot and cold supplies** ● **Installing the branch discharge pipe** ● **Connection to a back inlet gulley** ● **Connection to a soil stack**

Left: *Though the way in which the hot and cold water supplies are connected varies from machine to machine, hoses are often used at the machine end. This gives you more flexibility in your choice of site and permits easy removal for cleaning*

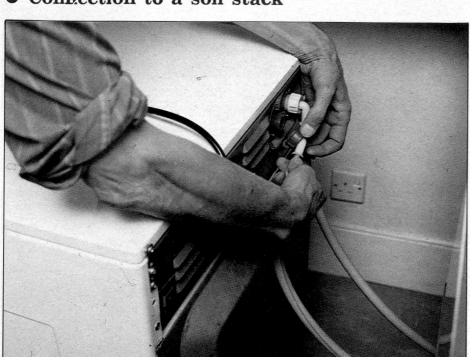

Though an automatic washing machine is a boon to any household, many people are discouraged from buying one because it has to be plumbed in—both to the water supply and the drains. But providing you choose the site carefully and set about the work in a logical order, the job is not half as hard as it seems.

The work can be divided into four stages: positioning the machine; connecting up the cold water supply (probably hot, too, though many machines are cold-fill only); installing a branch discharge pipe to the drains; and electrical installation. This latter stage should only be attempted when you have acquired some electrical skills.

Choosing a site

Your first decision here is in which room to site the machine. In the UK, the choice is normally between the kitchen and bathroom, both of which have hot and cold water supplies and drainage outlets. In Canada, the usual site is in a basement utility room.

You have next to consider the type of machine, the space that will be needed around it, the existing layout of the room and the design and materials used in your plumbing system.

Of these, the plumbing system must inevitably take priority. It is no use choosing the ideal space-saving site only to find that you cannot then plumb in the machine without demolishing the house.

Drainage: In the UK, for a washing machine in a ground floor kitchen, the most suitable outlet for the discharge pipe is a back inlet gulley, separated from the main discharge stack and connected to the main drain by a branch underground. This is often easier to break into than the main stack and, as it is usually there to serve the kitchen sink discharge pipe, it is likely to be in the most convenient position already.

In older houses, the sink waste sometimes discharges out over the open type of trapped gulley.

You will probably be allowed to run the washing machine discharge pipe to here also, provided that the end of the pipe is below the grid.

If the pipe has to connect to the main stack, the latter will need a branch fitting. Though this is relatively easy to fit to a plastics stack, on the older, cast-iron or galvanized steel types the job is best left to an expert. Indeed, it is probably better to take the opportunity of replacing the stack with a new one. A connection to a hopper head may not be allowed.

Water supply: Breaking into the hot and cold water supply generally presents less of a problem, as the final connections to the machine are usually made with flexible hose. Nevertheless, the supply must be near enough to the site to allow you to keep pipe runs as short—and as uncomplicated—as possible.

In the UK a cold-only supply might come direct from the rising main (usually the easiest arrangement if the machine is in a kitchen), though some water authorities do not allow this.

A hot and cold fill machine is best supplied via the cold water storage cistern or tank. In this case, as with some showers, low water pressure is sometimes a problem on upper floors or in flats and bungalows. Manufacturers

1 When you find a suitable place to break into the supply, trace back along the pipes until you find the stop valves which isolate them

2 Having isolated and drained down the pipes, sever them with a fine toothed hacksaw. Make the cuts as cleanly as possible

3 When you plan your new pipe run, do not forget to include two extra stop valves so that you can isolate the supply to the machine

generally specify a minimum 'head' of water—that is, the distance from the base of the storage tank to the point where the supply enters the back of the washing machine—and you should bear this in mind when choosing a site for your machine. If you cannot meet the minimum head requirement, consult both the manufacturer and your local water authority.

In Canada, a machine will be connected direct to high pressure supplies.

The pipe run must be arranged so that the branches do not cross one another, with the stop valves easily accessible. When you are planning the run, consider the best place to fit tee pieces to the supply pipes; it may be better to have a slightly longer run in order to avoid disturbing existing fixtures and fittings.

Breaking into the supply

Having chosen your supply pipes, turn off the nearest stop valves and drain the pipes by opening the taps (faucets) at the end of them (see pages 376 to 379). With cistern-fed supplies, if there are no local valves, look for a cold supply stop valve on the pipe running out of the base of the storage tank and a hot supply valve on the cold supply pipe running into the base of the hot water cylinder.

If you still have no luck, you must tie up the ball valve on the storage tank and drain down the system. It is sensible to turn off the boiler or heat source before you turn off any water services. If you are taking the cold supply from the rising main, turn off at the mains.

To break into the supply, you must either cut out sections of pipe large enough to take tee fittings or remove

4 With careful planning, you can keep the run simple and the number of joints to a minimum. Use compression or capillary joints

and replace existing fittings. Opt for whichever gives the simpler pipe run.

Using the former method, measure and mark the cut sections very carefully against the tee fittings. Be sure to allow for the extra pipe taken up by the joints. If there is a joint already near a cut section, it may be easier to loosen this, make one cut and remove the pipe altogether (fig. 2). You can then trim it to the new length required on the bench. Make the cuts with a fine toothed hacksaw, ensuring that the pipe ends are kept square.

Having prepared the pipe ends, fit the tee pieces as for compression or capillary joints depending on what type you are planning to use.

Connecting to the machine

Somewhere between the tee pieces and the washing machine inlets, stop valves

5 With some types of valve, the flexible hose ends may simply screw on, as here. With other types different fixings will be needed

must be fitted so that the supply can be disconnected at any time. Some manufacturers provide these with their machines while others leave the choice of valve entirely up to you. Suitable fixing points for valves are normally the wall or the side of a unit.

Mark the points clearly then measure back and fit pipe runs—using 15mm copper tube in the UK—between these and the tee pieces. Where necessary, support with wall brackets every 1.2m. Fit the valve holders to the ends of the pipe runs before you fix them to the wall.

Finally, screw the valves provided into the holders and secure the flexible connections to the machine. On no account should you attempt to shorten the flexible fittings supplied with the machine: these are designed specially to length in order to balance out irregularities in the water flow.

hot-water supply pipe
cold-water supply pipe
air chambers
stand pipe
valves

6 In Canada, air chambers (one size larger than the supply pipe pipes and about 600mm long) may be needed to prevent water-hammer

If you are fitting your own valves, simply fit these to the ends of your pipe runs and connect them to the flexible hoses (figs 4 to 6). But as above, make sure that the valves are so positioned that the hoses do not cross or kink.

In both cases, test the pipework and all joints for leaks at this stage.

Plumbing for a Canadian system follows much the same lines, except that the supply pipes should be equipped with *air chambers* (fig. 6). These prevent water hammer in the high-pressure supplies, when the machine's valves snap shut after filling. Air chambers for washing machines are usually one pipe size larger than the supply pipes, and about 600mm long.

Installing the discharge pipe
For the pipes themselves, follow the

sizes and plastics type specified in the manufacturer's handbook. Most often these will be 32mm CPVC with solvent wielded joints.

Connection to a back inlet gulley:
The simplest way to connect to a gulley is to run the pipe just below the surface of the grid. To do this, replace the grid (if it is a metal one) with a plastics type, and cut a hole in it of the right size to take the pipe.

Alternatively, you may want to take this opportunity to replace an old gully (whether back inlet type or not) with a modern plastics back inlet gully. To do this, start by digging away the soil around the gulley so that you expose the upper part (fig. A). Remove the water in the trap beside it with a plunger.

Next, using a vitrified clay (V.C.) cutting tool, cut away enough of the pipe to accommodate your new PVC gulley fitting. Bear in mind as you mark up for the cut that the new gulley must finish above ground level and be far enough away from the wall to allow you to fit the discharge pipe (fig. B). Before you sever the pipe completely, support the gulley from below to take the weight of the trap.

Remove the old gulley and fittings above the cut completely. Using a V.C.

A. Above, right: On ground floors, you may want to connect the discharge pipe to a back inlet gulley with a multiple branch outlet (see text)

B. Below, right: A typical completed installation. Note that in some areas, taking the cold supply direct from the rising main is not allowed

7 When you come to make the hole in the wall for the discharge pipe, make sure that it is large enough to allow for slight adjustments

8 PVC drainage piping is easy to work with, but cutting it quickly blunts saw blades—use either an old saw or a medium toothed hacksaw

9 Here, the discharge pipe is being connected to a stack with a spare branch outlet. The plug on the outlet is opened up with a padsaw

10 Connection is then simply a matter of running the new discharge pipe down from the hole in the wall and jointing it to the boss

11 Solvent weld the joints only after you have assembled the pipes in a dry run and checked that the fall on the discharge pipe is correct

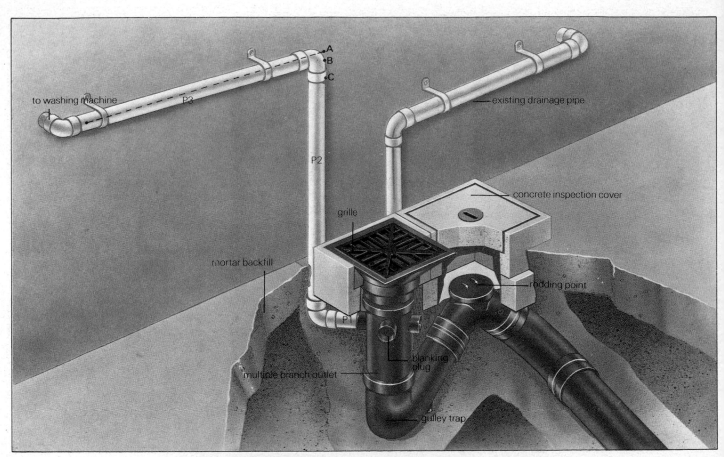

to washing machine

P3

A
B
C

P2

existing drainage pipe

concrete inspection cover

grille

mortar backfill

rodding point

P1

blanking plug

multiple branch outlet

gulley trap

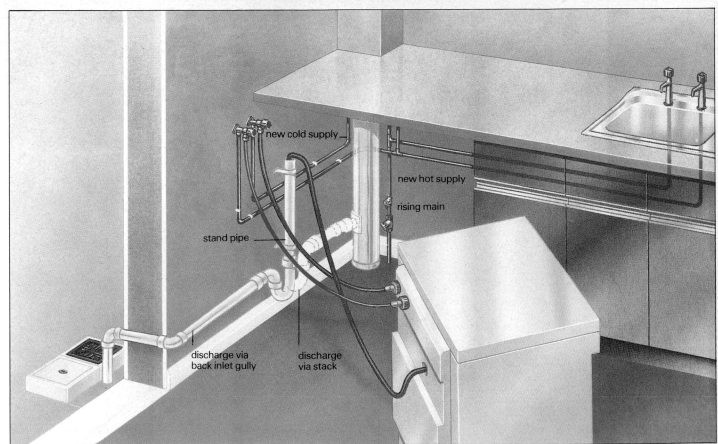

new cold supply

new hot supply

rising main

stand pipe

discharge via back inlet gully

discharge via stack

12 *When the pipe run is jointed and in position, fit support brackets where necessary—either with masonry nails or plugs and screws*

13 *Back inside the house, connect the waste trap for the standpipe at the point where the discharge pipe comes through the wall*

14 *Cut the standpipe to the required length, screw it to the trap and fit the support bracket. Now is the time to check the run for leaks*

15 *Finally, when you are happy that everything is functioning as it should, make good the hole in the wall with appropriate filler*

16 *Roll the washing machine into place being very careful that you do not tangle the flexible hoses or press them against the wall*

chamfering tool, chamfer the remaining cut end to accept a flexible V.C.-uPVC connection. Afterwards, fit the new uPVC section carefully and make sure that it is sited correctly in the gulley trench.

You can now (at least temporarily) assemble the rest of the gulley and fittings.

Connecting the discharge pipe to the back inlet may call for a little trial-and-error. Start by connecting the bend and short length of pipe P1 (see fig. A), adjusting the length of P1 so that P2 stands out from the wall the correct distance to accommodate pipe brackets. Then fit P3 and its bends, so that the fall of the pipe is between 18mm and 45mm per metre, and so that the lower bend is vertically over the bend connected to P1. Finally, cut and fix P2.

Now continue the pipe run through the wall following the same cutting and measuring sequence. Do not permanently solvent weld the joints until you have checked the run.

After the run has been fitted as far as the wall, fill in the space between the gulley and the wall with a 1:3 mortar so that the concrete gulley frame is held firmly in place. Finally, solvent weld the gulley hopper joint and fill in the ground around the gulley with earth.

Connection to a stack: Aim to run the discharge pipe to an existing branch outlet (fig. 10). If this does not have a spare outlet, then you can either fit a new multiple connector in this position, or a boss adaptor (of the type that can be fitted to an existing stack) to a length of plain stack pipe—whichever allows the discharge pipe to have sufficient fall. If you buy new components, make sure they are compatible with the existing ones—shapes and sizes vary slightly from brand to brand.

If you are connecting to an existing spare outlet, simply cut away the blanking plug and fit the new pipe in position. A boss adaptor is almost as easy to fit: consult manufacturer's instructions. A new connector is a little more tricky: the old connector will probably have to be sawn off, and the new one may not be big enough to bridge the gap. You might have enough 'slack' in the stack to take up the gap, or you may need to fit a slightly longer piece of stack pipe.

In Canada: You can connect to existing drains in much the same way as described above. You can even connect to a basement floor drain, as long as this is connected to a sewer or septic tank. However, do make sure that you are complying with your local building ordinances—if you are in any doubt at all about how to connect to your drainage system, then get appropriate expert help.

Final connection

At this stage, you should have run the discharge pipe through the wall and almost to the site of the machine. The final connection is made as shown in fig. B with a 'P'-trap and stand pipe fitted to the discharge pipe length. The height of the stand pipe will be specified in the machine's handbook; in most cases, the outlet hose from the machine simply hooks into the top. This provides an anti-syphonage air break in the discharge piping.

Solving drainage problems

● Drains explained ● Curing minor blockages in the house ● Clearing a blocked WC ● Locating a blockage in the main drains ● Rodding through the drains ● The causes of syphonage and compression ● Checking air vents

Ray Duns

A. Below left: *Drainage problems are a nuisance and can be extremely unpleasant, but many are easily solved. Often they are the result of blocked waste pipes which can be cleared in a few minutes by pumping a plunger over the blocked outlet*

Should this fail, be wary of poking sticks or stiff wire into the trap as these might get lost or may damage the pipe. A better solution is to buy or hire a purpose-made cleaning wire (closet or drain auger). These have a screw cutting at the business end which you can revolve from a spindle on the handle and are particularly effective on WC wastes.

Persistent blocking in and around waste traps—particularly the WC—is often the result of plaster or concrete debris having been poured down the drain at an earlier date. Again, a clearing wire is a good investment

1 *Clear blockages in metal traps by opening the clearing eye and using a length of wire to loosen and hook out accumulated debris*

5 *Fit the smallest plunger to one of the rods and screw a second rod to this. Always wear heavy duty rubber gloves when using rods*

Drainage problems are inconvenient and can be extremely unpleasant to put right. But often the cause is simple and, if you can face the job, it is worth trying a cure yourself, rather than calling in experts—it could save both time and money.

Minor blockages

These plague all households at some time or another, so always have a simple plunger (rubber force cup) close to hand. In the case of a blocked sink, basin or bath first remove the waste plug. If you have the pop-up type, it may simply lift clear, perhaps with a quarter-twist; or you may first have to detach the horizontal pivot rod from underneath. Block the overflow with a damp rag, and place the plunger directly over the waste outlet. Pump vigorously for a few seconds. Should

the blockage fail to clear, turn your attention to the waste trap below the unit and place a bowl beneath it.

If the trap is a modern plastic P or S type, unscrew the component parts and release the trapped debris. The same applies in the case of a bottle trap, though here you have only to unscrew the base. If the trap is of the older metal type, it should have a clearing eye somewhere on the U bend. Unscrew this carefully with a wrench then use a piece of coathanger wire to hook out the debris. When you replace the eye, wrap a piece of PTFE tape around the thread and take care not to overtighten it.

If the WC is blocked, you will not be able to get full suction except with a special large plunger but you may be able to create enough of a disturbance to dislodge the blocking material.

because you can use it periodically to erode the blockage and restore the pipe to its full diameter.

Another solution, which is often effective on kitchen sinks where persistent blocking is due to an accumulation of grease deposits in the pipe, is to pour down a proprietary clearing compound of the caustic soda type. Take great care when you do this however, and use the compound strictly in accordance with the manufacturer's instructions.

Main drain blockages

The first signs of a major blockage are usually unpleasant smells in the kitchen or bathroom, strange gurgling noises whenever you discharge any waste, and the backing up of waste in open gullies—or even into WCs or other fittings.

Be methodical in finding the location of the blockage—the rule is that the blockage must be below (ie, closer to the sewer than) any point where there is trapped water and above any point where there is no water. In the UK,

there are inspection chambers, or 'manholes' along the line of the drains, to help you.

Start with the chamber nearest the main sewer. (If you share this with a neighbour, ask their permission—and perhaps their help—before proceeding.) This may have its own interceptor trap, which is often the cause of a large amount of major blockages. Suspect the interceptor if this chamber is full of effluent.

If the interceptor chamber is clear, the blockage lies further back along your drainage system—probably at the secondary chamber nearer the house. This marks the junction of various parts of the above-ground pipe work—generally the soil and waste pipes or the combined soil/waste and a gulley. Most houses have only one secondary chamber, though if the drainage system is particularly complex or where there are sudden changes in level, there may be more.

In some instances—in the case of an extension, for example—the chamber may actually be inside the house. In

this position, it must be fitted with a double sealed cover and you will have to remove the fixing screws in order to open it up.

To clear a blocked secondary chamber, you must rod through the outlet on the main drain side and push the blockage down towards the interceptor chamber. At this point you may have to rod again to clear the blockage completely (see below).

If the interceptor chamber itself is blocked, the blockage is likely to be in the trap and will have backed up to the secondary chamber or even further. In this case, the first step is to contact the health department of your local council who may clear the chamber free of charge.

If you must do the job yourself, look for the drainage stopper in the chamber wall at the downstream end. This may well be obscured by the effluent in the chamber but you should still be able to see the chain that holds it to the upper part of the chamber wall. Pulling on the chain will release the stopper and open the cleaning or

2 Clear blockages further down the pipe with a clearing wire. Force it down the pipe and turn the handle to make the screw cutter revolve

3 To rod the drains, you will need a key to raise the inspection cover and attachments for the rods to suit the appropriate pipe size

4 If you cannot see the bottom of the inspection chamber, use a rod to feel for the position of the outlet to the main drain

6 Turning the rods clockwise all the time, work them backwards and forwards vigorously to clear the blockage in the drain

7 When the drain is clear and the effluent disperses, clear any residual waste out of the chamber by flushing it with plenty of water

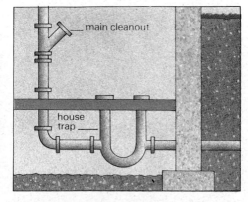

B. In Canada you can rod the main sewer line from either the house trap or the main cleanout by carefully unscrewing the cleanout plugs

'rodding' eye that by-passes the trap. If the trap itself is blocked the effluent will disperse through the eye and leave the chamber clear for you to work in. And if the blockage is further down towards the main sewer, you can rod directly through the eye to clear it.

In some cases, there may be no stopper chain. If so, feel with a stick to see if the stopper is in place. If it is, bale out enough effluent to make it visible then remove the stopper by hand and proceed as above.

If feeling with the stick reveals that the eye is open, and you are very unlucky, the stopper may have fallen down into the trap (in which case it is probably responsible for the blockage). In this case you must bale out all the effluent, get down into the chamber, and try to extract the stopper by hand. If you cannot do so, the trap must be excavated—using powered tools to break up the stopper will more than likely damage the rest of the drain.

If the interceptor and the secondary chambers are both clear—which is very rare in the case of blockages—the blockage must be still further up the system and it should be quite obvious which waste pipe and appliance are affected. Unfortunately, unless you can clear the blockage by plunging from the appliance end, it would be best to seek professional help. Problems of this sort are nearly always due to a fault in the waste pipework—in which case only an expert will have the necessary experience to decide on a remedy.

Rodding drains
Rodding the drains is a simple, if unpleasant, job providing you can get hold of the proper equipment. Sets of rods can be hired quite cheaply, together with plunger and screw head attachments, from most hire shops.

When you begin, start with two or three sections and add more as you progress down the drain. Use the plunger head first, then the screw if you have no success. Pull the rods quite vigorously backwards and forwards in the pipe, at the same time constantly twisting them in a clockwise direction to keep the joints screwed tightly together.

Where to rod
The golden rule about rodding drains is always to rod in the direction of the main drain. Failure to do this can only result in the blockage becoming considerably worse.

Where the blockage is at the interceptor chamber, always rod through the cleaning eye rather than through the interceptor trap itself. The latter is best cleared by hand after the chamber has been emptied, using an old ladle or scoop. Be sure to use the plunger first; and when the blockage dislodges, flush and clean the chamber with water from a garden hose.

If the blockage is at the secondary chamber or in the pipework between this and the interceptor, rod towards the interceptor and flush through with plenty of water. When the secondary chamber starts to clear, move to the interceptor and rod this in the same way to remove the last traces of blocking material.

You may be working from a full or partially full chamber, which can be confusing as well as unpleasant because you cannot see the outlets. So make sure you are fully conversant with the layout of an inspection chamber before you start, and use the plunger attachment to 'feel' for the outlet. In some chambers, the outlets are flared or chuted to make this job easier, but in any case it is not as difficult as it sounds.

Should you at any time encounter a solid blockage which even the screwhead cannot shift, you would be well advised to call in expert help. It may well be that the drain has collapsed, in which case it must be given a smoke test to pinpoint the damage and then be excavated.

Gullies: If you notice backing up at an open gulley, the first thing to check is the inspection chamber into which it drains. If this is clear, the gully itself is probably blocked with debris and must be cleared out by hand. Only very rarely does the pipe between a gulley and a chamber become blocked, and clearing it is a job which is best left to an expert.

In Canada Instead of inspection chambers outside the houses, there is a *main cleanout* at the base of the soil stack in the basement, and beyond it a U-shaped *house trap* also fitted with cleanout eyes (fig. B).

If there is a blockage in the main sewer line (or between the trap and the cleanout) you can rod it clear with a hand or powered auger through either of these points.

You remove the cleanout eyes by unscrewing them with a large wrench: use penetrating oil if an eye is difficult to turn. Unscrew the eye very gently: if the blockage is beneath this point, all the waste that has blocked up from it will attempt to take this way out. Be prepared for the dirty water with mops and buckets.

Syphonage and compression
The design of household drainage systems is a complicated business about which there are strict rules. The most important of these specify sizes and maximum and minimun lengths for the discharge pipes joining outlets to the waste or soil stacks. More rules outline the correct slope or 'fall' for each type of discharge pipe and state where pipes can join the stacks in relation to one another.

Providing these design rules are obeyed, your drainage should function perfectly as long as it is not blocked. But all too frequently, badly planned drainage leaves a number of faults inherent in the system. These are often to be found in house extensions or in additions to the usual facilities such as bidets and showers.

Syphonage: When the discharge pipe from an outlet is too small, too long, or of too steep a slope, waste water passing down it can create a vacuum and suck out the water in the trap beneath the unit. This is immediately noticeable as a gurgling noise when the outlet is drained, and may result in foul air entering the room because there is no longer a water seal to stop it.

Similar problems can occur if two discharge pipes are connected opposite each other at exactly the same point on the stack: water leaving one then sucks out the water in the trap at the top of the other (fig. D).

The most obvious solution to the problem of syphonage is to dismantle the offending pipework and re-assemble it according to proper design rules. But this is not always feasible; if it were, it would probably have been done in the first place.

An alternative step, with a high chance of success, is to fit an anti-syphonage trap to the particular

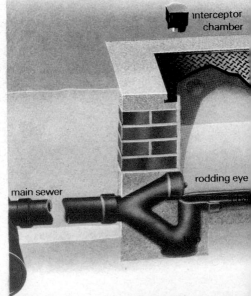

interceptor chamber

rodding eye

main sewer

outlet. These units are made in a wide range of sizes to match the various types of conventional trap in existence, and they are fitted in exactly the same way.

Compression: This is another symptom of a badly designed drainage system but it can also occur in complicated arrangements, even though the design requirements have been met. It is particularly common in one form or another on sub-stacks—the short downpipes that connect one or two outlets on a ground floor or extension to the main underground drains.

Compression is quite simply the build-up of abnormally high pressures somewhere in the discharge system, but it can manifest itself in a number of ways. For example, if a discharge enters the stack high up and another one enters lower down at the same time, the air between the two is compressed. This could result in one discharge 'blowing back' down the discharge pipe of another outlet—the reason why bath water can mysteriously appear in a downstairs shower. Alternatively the pressure may prevent the upper discharge from leaving the outlet at all—a condition which could last for several hours and mistakenly be taken for a blockage.

Always check for blockages first if you suspect compression problems: the condition sometimes arises artificially if there is less than full flow through the drains. Only when you are sure of the fault (take expert advice if you are not) should you embark on the solution—fitting a vent pipe to the afflicted discharge pipe. Canadian above-ground drainage systems (called DWV, for drain-waste-vent) usually already have such revent pipes.

vent

down pipe inside house

back inlet gulley

gentle radius

inspection chamber

airtight cover

benching

channel

C. *A modern, single stack domestic drainage system showing the down-pipe, waste outlets and the surface drainage. Nearer the main sewer are the inspection chamber and interception chamber, the two places you are most likely to have to use rods*

Venner Artists

401

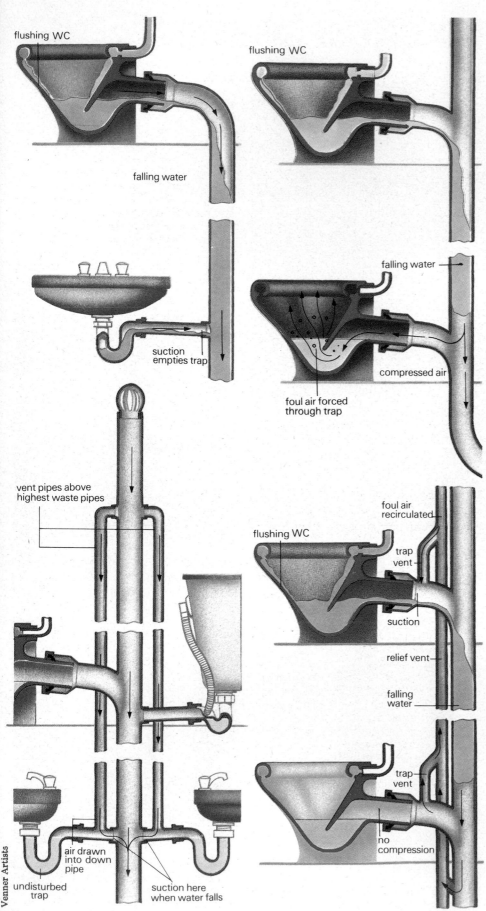

flushing WC

falling water

flushing WC

falling water

suction empties trap

compressed air

foul air forced through trap

vent pipes above highest waste pipes

foul air recirculated

flushing WC

trap vent

suction

relief vent

falling water

air drawn into down pipe

undisturbed trap

suction here when water falls

trap vent

no compression

Venner Artists

D. *Syphonage (far left) is caused when water rushing down a pipe sucks a trap dry. The cure is to vent the waste outlets to the downpipe (below far left). Compression (left) is caused when falling water traps air and pushes it up a waste outlet. The cure is again to vent the waste outlets to the downpipe (below left)*

The vent pipe, which need only be 27mm wide, must be connected into the discharge pipe near the outlet end using a 45° "T" connector. The angle of the connector must run against the flow of the drain, that is, upstream. From here, the pipe must rise vertically to above the spill-over level of the outlet.

Thereafter it can be run directly to the relevant discharge stack, to connect with it well above the highest existing connection. Or, if it is easier, it can fall again in a U shape and join the stack below the existing connections. In the first case, the horizontal run of the pipe should rise by about 18mm per metre. In the second, it should fall by the same degree.

The ease with which you can install a vent depends a great deal on the materials used for the discharge pipe and stack. Where these are both PVC, it is a relatively simple job. If either is metal, it is more difficult, and it may be better to replace the whole lot in PVC, particularly if the system needs repair in any case.

Air vents

All drains must be properly ventilated, or foul air rising from the chambers and stack will quickly make itself noticed. Whenever you can, inspect the terminals of waste and soil stacks where they emerge at roof level. Make sure that they are fitted with wire cages to prevent debris intruding and that the cages themselves are not blocked in any way.

In older drainage systems, a pipe often rises from each inspection chamber to a vent terminal at ground level. Inside the terminal is a simple valve which admits fresh air to the drain but prevents foul air escaping.

Unfortunately most such terminals are now in a poor state of repair and it is more than likely that the valves have ceased to function. If you find that the smell around a terminal is particularly unpleasant, the solution is to replace both terminal and valve with a modern PVC type or to buy a replacement breather valve to fit the existing terminal assembly.

Maintaining central heating

Maintenance of the system
Although all central heating systems should be serviced at least once a year by qualified engineers, you can keep the system running reliably by correct use and regular maintenance.

It is not advisable to switch off heating at night during cold weather. A small amount of heat—to ensure that the temperature throughout the

1 *To check a room thermostat, turn it to its lowest setting. Turn it back up again, listening for a click as the pump is switched on*

Operating your system for maximum efficiency
● Regular maintenance ● Troubleshooting checks ● Dealing with noise ● Draining the system ● Clearing airlocks

When a central heating system ceases to function properly, it becomes an expensive liability. But it does not always take an expert to repair it. Many common faults can be cured just as easily by the householder.

The most complicated part of the average domestic central heating system is the boiler (furnace). This may require specialist knowledge and tools to put it right should it fail—but failures in boilers which are regularly serviced are rare. More prone to trouble are circulation pumps, thermostats and radiators which only have a limited life.

Faults here are usually easy to identify and even if a specialist has to be called in, being able to pinpoint a problem will help keep repair bills to a minimum.

Wet central heating systems
In order to identify a particular fault in a central heating system, it is worth having some idea of how the system works. The theory of both indirect and direct wet central heating systems is described on pages 376 to 379.

In most modern systems, hot water flows from the boiler to the radiators and hot water cylinder, releases its heat and returns to be reheated. The flow is created artificially by an electric circulation pump which is normally mounted adjacent to the boiler. The pump is controlled by a time clock and, in most cases, by a room thermostat as well.

At pre-selected times, the mechanism in the clock switches on the pump. The pump then sends hot water to the radiators, heating the house.

2 *To find out whether a circulation pump is working, hold one end of a screwdriver against the casing with the handle to your ear*

house never falls below 10°C (50°F)—cuts the time needed to reach full operating temperature and may, in the long run, save fuel. It will also help to reduce condensation and prevent frost damage to the system.

The boiler should never be run at too low a thermostat setting. There is no economic advantage to be gained and it can shorten the life of the boiler. The boiler thermostat in a conventional small bore system should be set at up to 82°C (180°F) in winter. In summer, when the system is required for hot water only, it should be kept at not less than 54°C (130°F).

If the system is oil-fired, the oil tank should be examined annually. Any external rust should be removed with a wire brush and glasspaper and then painted over with black bitumen paint. Keep the vent pipe on top of the tank

clear, removing any obstruction with a stiff piece of wire. A piece of fine wire mesh can be fitted over the end of the vent pipe to ensure that leaves do not enter the tank and restrict the flow of fuel to the boiler.

To clean the oil filter on an oil tank, turn off the stop cock and remove the filter bowl. Clean the element with paraffin, dry it and refit. At the same time check the oil line from the tank to the boiler for leaks, tightening joints where necessary.

When a solid fuel boiler is not in use it should be left clean. Remove sooty deposits from the combustion chamber and flue and leave the damper and boiler doors open to allow a current of air to pass through. Have the flue cleaned at least once a year.

If a central heating system has to be left drained for any length of time

and stop valves are fitted on either side of the circulation pump, you can close the valves, remove the pump and dry it thoroughly to prevent rusting.

Once or twice a year, the circulation pump valves and all the radiator valves should be turned as far as they will go in both directions and then back to their original setting. This will prevent them becoming fixed.

Overheating

Overheating is one of the most common faults found in wet central heating systems. In all cases of overheating, if the fault cannot be rectified at once, the supply of gas or oil to the boiler should be cut off as a precaution. If you can run the circulation pump with the boiler off, keep it circulating water so that the heat is dissipated through the radiators. With

3 On pumps with all-metal casings, you may have to drain the system and remove the unit before you can unscrew the casing

4 If the rotor has seized, you may be able to free it by inserting a screwdriver into one of the slots and levering gently

5 To free an air lock in the pump, unscrew the vent valve located at the top. When water begins to trickle out, close the valve

6 To check the boiler thermostat, turn the dial down and then back to its maximum setting. If there is no click, the thermostat is jammed

7 If the sender bulb on the end of the copper capillary has come out of place, reposition it and replace its securing clip

8 Make sure that the level of water in the expansion tank is not more than 150mm from the valve outlet. If it is, add more water

a solid fuel boiler, rake the fire into the ashpan and remove it.

If the house feels abnormally hot, check the time clock and, if there is one, the room thermostat. These may be failing to turn the pump off when they should or have had their settings accidentally advanced. Start by turning the time clock down to the present setting. If the radiators do not cool down at the time they are supposed to, the mechanism of the clock has probably jammed and will have to be replaced with a new one.

To check a room thermostat, turn it down to its lowest setting and then back up again. A click should be heard as the switch inside turns the pump on. If there is no click, the unit will have to be replaced.

If the whole system is overheating seriously, the radiator pipes may make prolonged knocking or hissing noises and there will be excessive temperature in the boiler delivery pipe. One possible reason for this is failure of the circulation pump.

To find out whether the pump is working, hold one end of a screwdriver against the casing with the other end to your ear and listen for the hum of the rotor inside (fig. 2): if there is no noise, this is probably stuck. On pumps with a screw-on glass inspection cover, the rotor can be freed quite easily. Turn the pump off, unscrew the cover and insert a screwdriver into one of the slots in the rotor. If the rotor does not spin freely, it should be possible to free it by levering gently with the screwdriver (fig. 4).

On pumps which have all metal casings, the water supply must be cut off before opening the cover. In most cases, there are stop valves on each side for this purpose but where no such valves are fitted, the system will have to be drained before carrying out any work on the pump.

If the pump is heard to be working but water is evidently not circulating, there is probably an air lock. At the top of the pump you will find a vent valve—operated either by a key or a screwdriver—from which the pump can be bled (fig. 5).

To do this, turn the pump off and leave it for a few hours to allow the water in the system to settle. Then open the valve to bleed the air off. A hiss of air will be followed by a trickle of water: when the trickle becomes constant, close the valve.

If the fault is not in the pump, the boiler thermostat may have failed. The thermostat, a small box with a dial on the top, is located behind the boiler casing. Remove the casing and check

that the electrical connections on the thermostat are sound. Check also that the sender bulb on the end of the copper capillary from the thermostat to the boiler has not fallen out of its socket (fig. 7). If so reposition it and replace the securing clip.

Note the setting on the boiler thermostat dial and turn it down low. After a few minutes turn it back towards its maximum setting and listen for a click. If there is no click, it may mean that the thermostat has jammed and you should call in a qualified engineer to check it.

If the boiler thermostat appears to be working, check to see whether the boiler flue outlet outside has become blocked in some way. Depending on the nature of the blockage, expert help may be needed in order to clear it.

If the flue is free of any obstruction, the next thing to check is the expansion tank. The ball valve supplying it may have become jammed or seized, in which case there may not be enough water in the system to absorb the heating action of the boiler. If the level in the tank is more than 150mm from the valve outlet, free the valve and introduce more water into the system. Where the valve is completely seized, replace it with a new ballcock, arm and piston unit.

Central heating too cool
If all the radiators are cool and the boiler is working correctly, the fault probably lies with one of the thermostats, the time clock or the circulation pump. Carry out checks outlined above under 'Overheating', paying special attention to the position of a room thermostat if fitted. This reacts to the temperature around it, and a nearby heat source can cause it to give a false reading even though the mechanism may be perfectly sound.

To work efficiently, the thermostat should be mounted on an internal wall at least 1.5m above the floor and away from draughts, radiators and direct sunlight. It should not be placed in rooms which are in constant use—such as lounges—because people generate extra heat, nor in kitchens, because of the heat from cooking and appliances. However, it should be accessible so that changes in setting can be made conveniently.

Draining the system
Before doing any major repairs or modifications to your central heating, you will have to drain, or partially drain the system. Start by turning the boiler off and leaving the system for a few hours to cool down. Turn off the

9 *Before draining a central heating system, turn off the electricity supply to the time clock and also to the immersion heater, if fitted*

10 *To shut off the water supply to the boiler, close the stop valve tap on the pipe which leads into the expansion tank*

electricity supply to the time clock and the immersion heater—if the system includes one (fig. 9).

Shut off the water supply to the boiler by closing the stop valve on the pipe into the expansion tank (fig. 10). If no stop valve is fitted, lash the ball valve in the expansion tank to a piece of wood laid across the tank.

When the system has cooled, return to the boiler and identify the main drain cock. This is usually at the front end of the boiler near the pump where it is always built into the lowest pipe. Alternatively, it may be found on a ground floor radiator. Attach one end of a garden hose to the nozzle and run the other to an outside drain. Open the drain cock by turning the nut beneath with a spanner or adjustable wrench and allow as much water as you require to drain away (fig. 12).

11 *When the system has cooled down, attach one end of a garden hose to the nozzle of the main drain cock on the boiler*

12 *Run the other end of the hose to an outside drain, then open the drain cock by turning the nut beneath with an adjustable wrench*

Refilling the system
Before refilling, close the main drain cock securely. Open the valve on the pipe leading to the expansion tank, or untie the ball valve, to admit fresh water into the system. Regulate the position of the valve so that the tank fills slowly—keeping the risk of air locks to a minimum. Also check the drain cock for leaks.

Noise
Noise is another common problem with wet central heating systems. Creaking under the floorboards and around radiators is caused by pipes—which expand and contract according to the temperature of the water—rubbing against the floor joists on which they rest. Creaking can also occur where a pipe rises through the floorboards to feed a radiator.

The creaking can often be reduced by turning the boiler thermostat down so that the radiators remain switched on for longer periods instead of constantly heating up and cooling down.

If the noise persists, take up the floorboards around the suspect area. Eventually you will find a point where one or two pipes cross a joist and are notched into the woodwork. If the notch is so small that it causes the pipes to rub against each other, enlarge it to give a better clearance. Make sure, though, that the notch does not exceed one sixth of the depth of the joist or it will seriously weaken the timber. Use a piece of rubber pipe lagging, felt or carpet, trimmed to the approximate size of the notch, to cushion the pipes (fig. 13).

Where a pipe rises through a gap in a floorboard, either enlarge the gap by filing it away or pack the space around the pipe with padding (fig. 14). Metal pipe brackets—another common source of noise—can be bent back slightly, and stuffed with felt to prevent them making direct contact with the pipes (fig. 15).

Creaking behind radiators is usually caused by the hooks on the back of the panels rubbing against their corresponding wall brackets. For serious cases, on smaller radiators, special nylon brackets can be fitted in place of the normal pressed steel type. A simpler solution is to place pieces of felt or butyl (rubber) between each hook and bracket. This can be done, with the help of an assistant, by gently lifting the radiator away from its brackets, slipping the pieces of felt into the hooks and then replacing it.

Immersion heaters
In many systems, hot water for sinks and baths is heated by a thermostatically controlled immersion heater in addition to the boiler-fed heat exchanger (pages 376-379). The thermostat is pre-set to turn the heating element off when the water reaches the selected temperature. If the water is unbearably hot, the thermostat may simply need adjusting.

The thermostat control is found at the top or on the side of the hot water cylinder (fig. 16). To adjust it, turn off the electricity supply to the heater then unscrew the element cover where you will find a small dial marked centigrade, fahrenheit, or both. By hand, or with a screwdriver, turn the regulator screw to the desired temperature—normally 60°C (140°F) in hard water areas or 80°C (180°F) in those with especially soft water.

If the water heats up slowly, or the

13 *Pipes often creak where they run through a notch in a floor joist. Cushion the pipes with felt or carpet to stop the noise*

14 *A pipe may rub against wood where it rises through the floor. Pack the gap round the pipe with pieces of suitable padding*

15 *Metal pipe brackets are another common source of noise. Bend them back slightly and stuff pieces of felt into the gaps*

hot tap cools too quickly, check that the cylinder is sufficiently lagged and that the lagging is in good condition. If it is, try adjusting the thermostat. When water fails to heat up at all, either the thermostat control or the heating element are defective and will have to be replaced.

Radiator controls

Most radiators are fitted with two valves—a *handwheel* and a *lockshield* valve. The handwheel allows radiators to be shut down individually or the temperature of a radiator to be reduced by restricting the flow of water. The lockshield valve is set when the system is installed, to give a balanced flow of water through the radiator.

There is no basic difference between the two valves except that the lock-shield valve is locked into position to prevent casual adjustment. A lock-shield valve should normally need adjusting only when a radiator has to be removed for decoration or repair. When this is necessary, both the lock-shield valve and the handwheel should be closed. To close a lockshield valve, unscrew the cover and turn the valve with a spanner or a wrench.

In some cases, thermostatic radiator valves are fitted in place of hand-wheels. A radiator thermostat can be pre-set to maintain any desired temperature and is controlled by temperature sensitive bellows. As the water temperature falls, the bellows contract to allow more hot water into the radiator. Radiator thermostats are usually only suitable for use in a two-pipe system (see pages 376 to 379).

Above: *Most radiators are fitted with two valves, called a handwheel and a lockshield valve, which control the flow of water. The vent valve at the top is opened to release air*

Bleeding a radiator

When air accidentally enters a wet central heating system, it can find its way to a radiator and prevent this from functioning efficiently. All radiators should be bled of air once or twice a year to clear the small amounts that inevitably get into the system. But if a radiator becomes cold whilst others are functioning normally, the cause is probably a substantial air lock and the radiator should be bled immediately. The top of a radiator remaining cold while the bottom is scalding also suggests an air lock.

On most radiators a square ended hollow key—obtainable from iron-mongers—is needed to open the air vent valve at the top. To prevent air being sucked into the system, turn down the room thermostat and switch off the time clock so that the pump stops working.

Place a towel underneath the radiator to catch any drips, then open the valve by turning the key anticlockwise until a hiss of escaping air is heard. As soon as water begins to flow, re-tighten the valve.

If air locks occur frequently in a certain radiator, you can fit a screw bleed valve or an automatic air eliminator. These save you from constantly having to bleed it by hand.

16 *To adjust the thermostat control of an immersion heater, unscrew the element cover on the top or side of the cylinder*

17 *Remove the cover to locate the temperature dial. Turn the dial by hand or with a screwdriver to the desired temperature mark*

Renewing your guttering

James Johnson

● **PVC rainwater systems** ● **Planning a new PVC guttering assembly** ● **Dismantling iron gutters and downpipes** ● **Assembling PVC gutters** ● **How to cut guttering and downpipes** ● **Erecting a new downpipe**

However well they are maintained, old metal gutters (eavestroughs) and down pipes (downspouts) may eventually begin to show signs of decay. If decay is far advanced, it is well worth replacing the system with PVC guttering.

PVC rainwater systems have several advantages over the various metal types. They do not corrode, nor do they require painting for protection — though they can be painted to suit colour schemes. Because PVC guttering is light, sections of it are easier to handle than their metal counterparts—an important consideration

when you are working on a ladder. Being cheaper than cast iron, PVC has virtually replaced it for home building and renovation in Britain.

Planning the new assembly

Sections of PVC guttering can be joined together in a variety of different ways (see pages 349-353). But with all types of half-round guttering, you fix the system to the exterior of the house in more or less the same way. The gutter sections are clipped into brackets screwed to the fascia boards beneath the eaves of the roof. The

Above: *When you come to fix the downpipe of a PVC gutter system, secure a plumbline with a nail or drawing pin to the fascia board immediately behind the outlet. This gives you a guideline for positioning the pipe clips down the wall*

downpipes have wrap-around pipe clips which are screwed directly to the walls. Some other systems require no brackets for the gutters because they are screwed directly to the fascias (see page 349).

You can use sections of guttering in full lengths where there is enough space for fixing, or cut it to any length required using a fine-toothed hacksaw.

Before you take down the existing guttering, measure it carefully to give you the lengths for the new gutters and pipes (fig. 1). Count and measure, the stop-ends, outlets, shoes, swan

stop end

fascia brackets

outlet

union clip

swan neck

pipe clip

downpipe

shoe

angle piece

Venner Artists

James Johnson

A. *The components of a PVC guttering system. To make sure that the system is supported adequately, space the fascia support brackets no further than 1m apart and the pipe clips for the downpipe a maximum of 2m apart*

necks, and internal and external angles to work out the number and size of each part you will require.

When you are calculating the number of support brackets and pipe clips needed, bear in mind that the existing system may not have been fitted with an adequate number. Gutter support brackets should be spaced no further than 1m apart, and pipe clips a maximum of 2m apart.

Make a rough sketch of the proposed layout of the new assembly. This will help when you come to calculate the parts required and is also useful when you are carrying out the actual installation.

Removing cast or galvanized iron guttering

When you have bought all the replacement PVC components, you can start to dismantle the existing system. If your house adjoins another property, start at the joint nearest the dividing line between the two houses. If not, start at any convenient point along the run.

Remove the bolt holding the first joint together, using a junior hacksaw if necessary (see page 349). Repeat the process for the joint at the other end of the length and then remove the section (fig. 3). When removing a long piece of guttering, take care not to let

1 *Before you take down the existing guttering, measure it carefully to give you the lengths for the new gutters and downpipes*

2 *The bolts holding the old gutter together may be corroded. In this case saw through them using a junior hacksaw*

3 *Lift the freed guttering out of its brackets and take it to the ground making sure that the weight does not catch you off balance*

4 *If the fixing screws of a fascia bracket are too corroded to unscrew, use a claw hammer to lever it away from the board*

5 *You should be able to remove the swan neck of a downpipe by hand but if not, knock it out gently with a hammer*

its weight catch you off balance while you are on the ladder.

When you have removed a section and taken it to the ground, unscrew the supporting brackets from the fascia board. If the fixing screws of a bracket are too corroded to unscrew, use a claw hammer to lever them away (fig. 4). Do not knock upwards with the hammer when you are trying to dislodge a stubborn support or you may crack the tiles immediately above.

If you are dealing with Ogee-section guttering, either unscrew the fixing screws holding the lengths to the fascia board, or, if they are corroded, cut through them with a junior hacksaw. If these methods fail, use a bolster to lever between the gutter and the fascia boards.

Some cast iron systems are supported by brackets which are screwed to the roof rafters (see page 349). To gain access to the fixing screws on such brackets, you may have to remove the slate or tile immediately above it with a slate ripper. In this case, it may be easier to saw through the brackets and fit the new system directly to a fascia, if you can add one.

When you come to dismantle a downpipe, start by removing the outlet section at the top and if fitted, the swan neck. You should be able to dislodge these by hand by pulling upwards but if not, use a hammer to knock them from place (fig. 5). Remove the downpipe brackets by levering out the pipe nails with a claw hammer. Where necessary, hold an

offcut of timber against the wall so that you get more leverage on the hammer (see page 351).

Assembling the new system

Before you erect the new guttering, check that the fascia boards are in a sound condition. It is well worth taking the opportunity to repaint the fascias before fixing the new guttering.

Scrape off any paint that has formed in ridges around the old guttering, then wash down the fascia and when dry apply primer to any bare wood. When this has dried, key the surface by rubbing it over with a medium grade of glasspaper. Paint the boards with two undercoats and one top coat then leave them to dry out before erecting the new guttering.

Boards in particularly bad condition may have to be replaced altogether. This is not always a particularly easy job, and you may find it involves disturbing the lowest course of slates or tiles on the roof.

To assemble the system, begin by fixing the supporting brackets. Place one bracket at the top end of a run to correspond with the old one, and one at the bottom end in a similar position (fig. 7). Attach a length of string between the two brackets and make sure that it is taut. Check the string with a spirit level to make sure that it slopes towards the outlet position—the correct slope need be as little as 25mm in a 15m run—then use it as guide for positioning the intervening brackets. It may be that you can fix all the new brackets in the positions of the old ones. But check constantly that both the spacings and the fall are correct.

6 *Before you start to assemble the new guttering, use a spirit level to check that all the fascia boards are horizontal*

7 *To assemble the system, begin by screwing the supporting fascia brackets firmly into place along the fascia board*

When you come to an internal or external angle at the corners, hold the appropriate part in place and mark the appropriate bracket positions: these vary according to the brand of system that you are installing.

When you have marked all the bracket positions, drill holes for the mounting screws into the fascia boards and screw each bracket home. With all the brackets in place, you can start to position the guttering lengths within them.

Cutting and fitting

When you are cutting new gutter lengths, it is important to make sure that the cut ends are square. You can do this by fitting a spare section over the piece to be cut and using it as a template to draw the cutting line (fig. 9). Once you have sawn through a section, smooth the cut edges with a medium file.

Start fitting the guttering at the top end of a run. Clip the lengths into position in the brackets and join sections together, following the manufacturer's instructions.

Because PVC tends to expand and contract, even with quite small temperature variations, some systems make allowance for movement at each joint. In this case, the union clips holding sections together have marks on either side with which the ends of adjoining gutter sections are aligned. The resulting gap between sections allows for maximum expansion and contraction without weakening the new seal.

If you are faced with the problem of connecting the new guttering to a neighbour's iron system, special adaptor fittings are available for joining the two materials. Dry out and clean the end of the iron section, using a wire brush to remove any traces of rust. Apply sealing compound to the area (see pages 350 to 353) then press the adaptor into place (fig. 12). You can now join the PVC section, following the manufacturer's instructions.

Fitting a downpipe

Unlike cast iron systems, the swan necks for PVC guttering are not manufactured in one piece. Instead they are made up of an offset socket, an offset spigot and an offcut of pipe (fig. A). The length of pipe determines the angle of the bend, thus giving you more flexibility in positioning the downpipe than you would have with cast iron or galvanized metal.

To erect the downpipe, fix a plumbline with a nail or drawing pin to the fascia board behind the outlet. You can then use the string as a guideline down which to mark the pipe clip screw positions.

Place one of the clips around the bottom of the offset spigot, hold it temporarily in place on the wall, and mark its screw holes. Next, measure and cut the length of pipe to fit between the socket and spigot. To

8 When cutting a new piece of gutter to length, make a pencil mark on the underside of the section at the correct distance from the end

9 Fit a spare gutter section over the piece to be cut. Align its edge with the pencil mark and draw the cutting line

10 Hold the length of guttering in place and cut through the line with a hacksaw. Smooth the cut edges with a medium file

11 To join PVC guttering to a cast-iron system, clean the end of the iron piece, then apply some sealing compound to the area

12 Fix the special adaptor fitting into the end of the iron gutter and clean off the underside with the point of a screwdriver

James Johnson

make sure that the cut end of the pipe is square, mark the length to be cut then wrap a paper template around the pipe at the mark (fig. 13). Bore the holes for the pipe clip screws into the wall (fig. 14), plug the holes with wall plugs, then fit the swan neck in position (fig. 15).

Fit the downpipe down the wall, joining the sections according to the manufacturer's instructions, and fix a pipe clip at each joint to support the pipe. Finally, fit the shoe piece that lets into the drain or soakaway at the bottom of the pipe and attach the last clip (fig. 17).

Once the whole assembly has been fitted and joined, test the system by emptying a bucket of water into the gutter at the highest point of each run to check that there are no leaks.

13 *When cutting a piece of downpipe to length, wrap a paper template around the pipe to make sure the cut edges are square*

14 *Attach a plumbline to the fascia board behind the outlet and use it as a guide to mark and drill the pipe clip screw holes*

15 *In masonry walls, plug the holes with wall plugs, place a clip around the pipe, then screw it into place on the wall*

16 *Working down the plumbline fix the downpipe sections to the wall. Fit a pipe clip over every joint of the pipe*

17 *Finally, fit the shoe piece that lets into the drain or soakaway at the bottom of the pipe and attach the last clip*

James Johnson

Make the most of rainwater

Rainwater is ideal for watering indoor or outdoor plants. Instead of letting it run to waste, you can divert some of it into a storage barrel ready for use.

You can buy a purpose-built plastic barrel with a tap from garden stores, or use a metal oil drum and fit a tap.

The rainflow from a whole roof will fill a barrel very quickly, so use the flow from a garage, shed or outhouse. Build a brick plinth to support the barrel alongside the old soakaway. Shorten the original pipe and fit a swan neck bend to divert the flow into the barrel. Fit a clip at the point where you join in the new section.

You must fit an overflow pipe to the barrel. This should be routed to the original drain. If there is sufficient rainfall this arrangement should maintain a constant supply in the barrel, ready for use.

The plinth makes it easy to fit a bucket or watering can under the tap. To prevent the area from becoming muddy, you can lay a small concrete slab in front of the plinth, on which to rest the bucket or can.

Stand the barrel on a plinth so you can fit a bucket under the tap. You can make a simple plinth like that shown by laying bricks on a concrete footing

Alternatively, use concrete blocks or even heavy timber, but remember that when full, the barrel will be very heavy

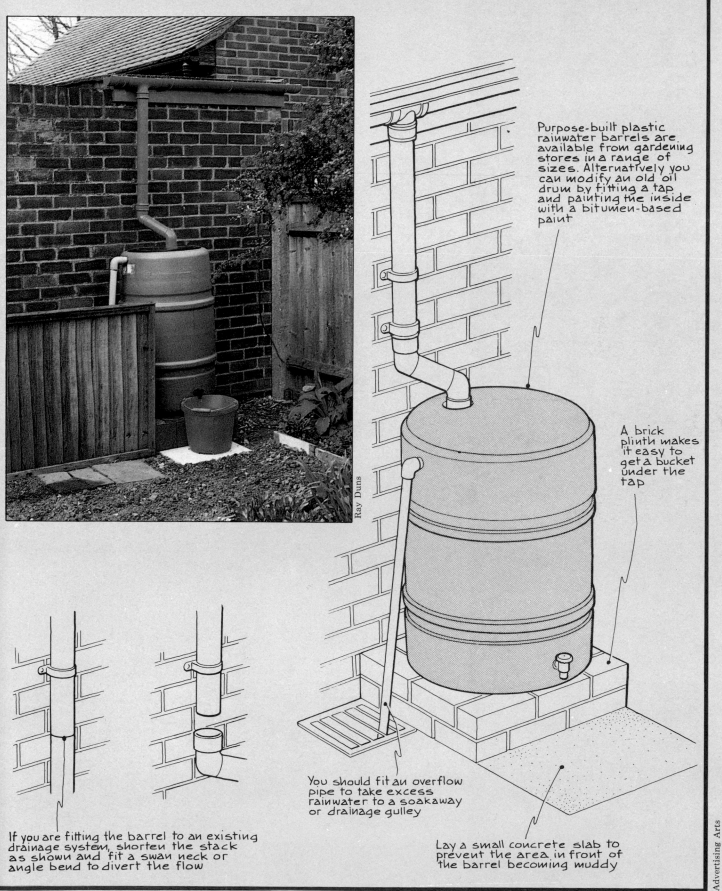

Ray Duns

Purpose-built plastic rainwater barrels are available from gardening stores in a range of sizes. Alternatively you can modify an old oil drum by fitting a tap and painting the inside with a bitumen-based paint

A brick plinth makes it easy to get a bucket under the tap

You should fit an overflow pipe to take excess rainwater to a soakaway or drainage gulley

Lay a small concrete slab to prevent the area in front of the barrel becoming muddy

If you are fitting the barrel to an existing drainage system, shorten the stack as shown and fit a swan neck or angle bend to divert the flow

Advertising Arts

HEATING, INSULATION AND VENTILATION

Keeping the house warm

Heat loss around the house ● Jobs you can do yourself ● Insulating the roof ● Choosing the right insulating materials ● How to calculate quantities ● Filling in awkward corners

About three-quarters of all heating in an uninsulated house is lost to the atmosphere, much of it through the roof (fig. A). Insulating your roof space is a cheap way of counteracting this loss and will noticeably cut your heating bills. Insulation also helps keep the house cool in summer.

Regardless of the exact type of material used by the house builder, there is nearly always room for improvement. And because of fast-rising fuel costs, in the long run you will save money whatever the actual cost and quantity of your insulation.

A. *Typical heat losses and cold down-draughts in an uninsulated home*

Insulating materials

The cheapest and simplest way of insulating the roof space is to place insulating material between, or over, the ceiling joists. Various types of natural and man-made material are available, either in rolled blankets or in granulated form. But as there is little to choose between them in terms of effectiveness you should base your choice on the cost and selection of what is available locally.

Mineral-fibre or glassfibre matting and blanket comes in roll form, cut to fit the average space between floor joists. On its own, this is normally adequate for insulating a roof; awkward nooks and crannies can be filled with off-cuts from the rolls once the main insulation is laid.

However, in older houses, where the ceiling joists are likely to be more narrowly spaced than is usual today, laying a standard-width roll material is a wasteful business—every bit has to be turned up at the edges. In this case, loose-fill insulation is much easier.

Tip from the trade

Q My newly-insulated loft is starting to smell damp and a bit musty. Have I done something wrong?

A The loft insulation in an unheated loft will start retaining moisture if the loft is inadequately ventilated. Check that your insulation has not blocked the natural flow of air into the loft from around the eaves. If you have installed batts between the rafters, they must have a vapour barrier—sheets of battened-on polythene will do—below the rafters to prevent moisture penetration from above.

Loose fill comes in bags, either in granule form or as pieces of loose fibre. Among the materials used are polystyrene, vermiculite—an expandable mica—and mineral wool (rock wool).

Besides being handy where the space between floor joists is narrow, loose-fill insulates inaccessible corners more effectively than offcuts of rolled material. In draughty lofts however, the granules blow about unless the floor joists are covered over.

Whichever type of material is chosen and however this is laid, depth of insulation is the crucial factor. About 100mm is considered a satisfactory compromise between cost and effectiveness. Roll materials are available in thicknesses of about 75mm or 80mm for topping up existing insulation, and of about 100mm for dealing with a loft which has no insulation.

Calculating quantities

Inspecting the loft gives you a chance to estimate both the quantity of material required and the extent of work involved. To help you move around, and to avoid accidentally damaging the ceiling below, place stout planks across the floor joists.

If you are considering adding to existing insulation, think in terms of bringing it up to the 100mm depth of loose-fill or blanket insulation recommended for uninsulated roofs.

In Britain, a typical roll of blanket material of 100mm depth measures about 6.25m in length. 'Topping up' rolls, with depths of about 75mm or 80mm, are slightly longer at about 8m —and usually more expensive. The easiest way of working out your needs is to add together the total length of the strips of ceiling to be covered, and divide this by the length of the roll material you are using to do the job.

Add to this number of rolls a generous surplus to take care of trimming and overlap. Remember to allow for the turn up at the eaves (see below), and add extra to wrap around the water tank and its piping, and to cover the trapdoor.

If you are using loose-fill material, your requirements are best based on the manufacturer's own tables and recommendations—on the assumption you will be adding insulation up to the depth of 100mm.

While you are in the loft, inspect the areas below the flashings which exclude water at the junction of the roof and other surfaces, such as around the chimney.

On no account should you proceed with insulation if there is any evidence of roof leakage or wet rot, as loft insulation can aggravate both these problems considerably.

At the same time, take a look at the electrics. Wiring perishes in time —especially the older cloth-covered rubber-insulated type—and in any

Home Insulation Act 1978

Under the provisions of this Act, UK residents may qualify for a grant of 66% or £50—whichever is the less—towards the cost of insulating a loft. The grant is payable by your local authority providing certain straightforward conditions are met. One of these is that application for a grant is made prior to starting any work. The application procedure is simple and approval is normally very quick. Full details can be obtained from your local council offices.

Vapour barriers

In cold, dry climates such as the Canadian winter, warm, moisture-laden air from inside the house tends to 'migrate' towards the colder, drier air outside. To prevent insulation materials from becoming wet as a result, a vapour barrier is essential. This can be of foil, asphalted paper or sheet plastic, and is always laid on the 'warm' side of the insulation—that is, the side nearest the inside of the house. Some insulation comes ready-wrapped in vapour-proof blankets.

The illustration shows the various way of insulating (left) an unused loft an (right) another in the process of bein converted into a living space. Althoug the basic forms of insulation material are identical for each, they are used i slightly different ways.

Blanket insulation such as glassfibr rolls or batts is inexpensive and effec tive. In most instances the roll end need only be taken up to the joist en or wall-plate (1) but they will need t be folded up against the roofing draughts are excessive. Roll the blanke inwards from the eaves, allowing generous overlap where a new lengt meets an old (2).

Other uses for blanket materia include lining and draughtproofing the loft door (3) and insulatin between rafters (4). A double thickness further improves insulation, being par ticularly effective for sound-proofing noisy floor (5) that forms part of a lo conversion. It is important that n insulation is laid directly beneath th water tank (6). If the loft area is used a a living room, the water tank itself nee not be insulated.

Loose-fill 'rock wool' or vermiculit is much more convenient for insulatin a 'bitty' ceiling, in areas well clear o draughts (8). Again, increasing th depth improves both heat and soun insulation (9). For insulating within water-tank box loose-fill insulation i much more satisfactory than a delicat blanket lagging, but you will have t construct a softboard box (10) aroun the tank.

Lagging pipework

In an open loft remember that an pipework has to be lagged also. Yo can use blanket insulation offcut, hessian wrapping, preformed neopren (11) or polystyrene tubing for the job.

A draughty roof can be insulate with a special lined blanket materia placed between the rafters (12). This i attached either to the tile battens, or t the rafter sides by battening (13). Th material must be led clear of the wa ends to prevent any condensation fro seeping into a wall cavity. Always sta laying at the ridge and work down wards, overlapping the ends so tha any moisture seeping through the ro runs away at the eaves—not into th roof.

The rafters can then be covered wit

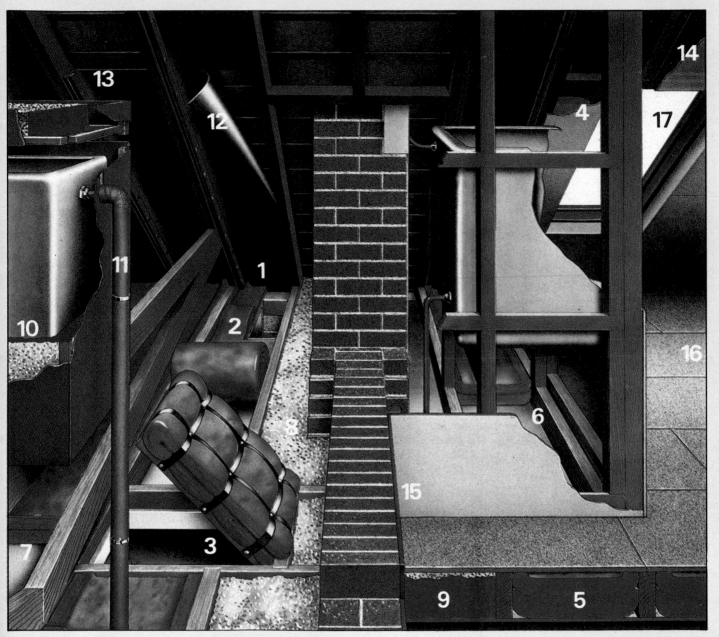

insulating softboard (14), and finished off with tempered hardboard if desired.

Living area conversion

In a loft conversion for a living area, insulation can be provided by blanket material, or by solid and easily worked slabs of polystyrene, rockwool or fibreboard.

The same types of 'solid' insulation can be used on the party wall between your loft and your neighbour's, particularly where his loft remains uninsulated.

If appearance is important and rising sound from next door is a problem, box in the insulation behind a false wall.

The floor in a loft room can take a variety of forms, but chipboard is best (16). Fix it with screws, not nails, to avoid the possibility that hammering will crack or loosen the ceiling below.

In planning the conversion consider installing a professionally double-glazed window, or install a sealed-unit yourself (17). The roof is, after all, usually the most exposed part of the

house and the additional cost of double-glazing—if kept simple—is unlikely to have much effect on the overall cost of the conversion.

If efficient underfloor insulation is installed (in part to act as sound insulation), rising heat from the house will not reach the loft area and additional heating must be provided there. So if providing it would be too expensive or inconvenient, you would be better to omit the sub-floor insulation altogether.

John Harwood

1 Take blanket insulation right up to the wall plate at the eaves, and tuck in the edges at the joists if the blanket is too wide

2 Where possible, tuck the insulation under obstructions. Note the use of a stout plank as a working platform

3 Blanket material can be easily cut to shape with large scissors or garden shears. Offcuts can be used for pipe lagging and elsewhere

4 Loose-fill material is a quick and effective way of dealing with awkward spots such as around the chimney stack and wiring boards

5 Level off the loose-fill to the top of the joists. If these are very deep, use a 'T'-shaped board cut to give the required depth of material

6 Allow plenty of overlap when covering the loft door—this prevents draughts—but do not insulate beneath the water tank

case may not take kindly to repeated knocks while you are laying the insulating material.

Planning the work

When laying blanket insulation, it is infuriating to find that every roll ends short of the mark or repeatedly needs cutting at, say, a particularly large roof member—leaving an almost useless offcut.

The most convenient place for rolls to end is away from the eaves—it is difficult enough having to stretch into these inaccessible areas just to push the insulation home. You should therefore plan on working away from the eaves wherever possible. Any offcuts can be used up later to insulate a more accessible strip in the middle of the loft area.

Laying materials

When you come to lay your insulation, simply follow the set pattern of joists across the roof. Loose-fill material can be levelled to the correct depth using a template made from thick card or wood off-cut. Shape this to fit the space between joists (fig.5). Like roll materials, loose-fill should be laid working inwards from the eaves. Level the filling towards a clear space in the middle of the loft where addition and removal will present far less of a problem.

Roll material can be cut to length and shape with large scissors or slashed, carefully, with a handyman's knife. Awkward shapes are more conveniently torn from a supply length. Be generous in the cutting length so that you can tuck in the surplus at the end. Where two lengths join, either tightly butt the two ends or leave the excess to overlap by about 100mm. Offcuts can be used to fill small gaps between lengths.

Around the edges of the loft, strong draughts can be prevented by arranging for the roll ends to be turned up between the rafters—allow extra material for this if necessary. But in most cases you need insulate only as far as the wall-plate—the barrier between the joists and eaves (fig. 1).

The loft area is finished off by insulating the access trap or door with spare lengths of rolled insulation, glued, tied or tacked in place. Allow the material to overspill when the trap or door is closed, so that any draughts are excluded.

Partial loft conversions

Boarding over the joists after you have insulated the loft will reduce heat loss still further. But if you may want to carry out a full-scale loft conversion later, as described later on in the course, do not lay a permanent floor; your ceiling joists (probably only 100mm × 50mm, in UK houses) will have to be strengthened for a permanent habitable room. Instead, lay a temporary chipboard floor, screwing down the chipboard so you can lift and re-lay it later.

If the loft already has a floor, lift about one board in five and force loose-fill material between the joists.

A dozen ways to reduce heat loss

Jobs for the specialist

1. If the fireplace is no longer used, have the chimney stopped and vented to prevent an upwards draught

2. Some types of board or blanket insulation need to be fitted with care to prevent roof damage and excessive condensation

3. Spray-blown loft and cavity wall insulation are both extremely effective, but involve considerable expense

4. Insulation can be fitted above a false ceiling—useful when access to the roof space is not possible

5. Sealed-unit double glazing has to be installed by a professional as some structural work is involved

6. Floor cavity insulation involves considerable turmoil unless laid at the time of building or when flooring repairs are made

Jobs you can do yourself

7. Some forms of blanket insulation can be tacked to the rafters and covered by hardboard or softboard

8. Insulation placed between the joists, a covering for this, and lagging of tanks and pipes are jobs easily done

9. Another inexpensive and effective insulation job is cutting out draughts around doors, windows and unused chimneys and fireplaces

10. A bigger job, cheaper than cavity insulation and almost as effective, is to panel insulate the inside of the outer leaf of a cavity wall

11. Secondary sash double glazing, provided in kit form, is usually easily fitted to conventional windows

12. Thicker carpets help greatly to prevent heat loss through floors with gaps between the boards

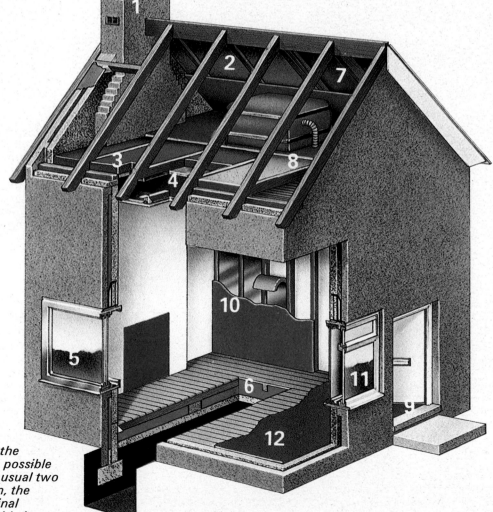

B. *Insulating your home—the possibilities. Although it is possible to combine more than the usual two or three forms of insulation, the cost-effectiveness of the final combination is worth considering*

John Harwood

Draughtproofing

● **The causes of draughts** ● **How to check for draughts using a lighted candle or smoking taper** ● **Sealing doors and windows** ● **Using ready-made and improvised door strips for problem draughts** ● **Curing other draughts**

Heat losses caused by draughts are effectively, easily and cheaply eliminated with efficient draughtproofing. Of all the forms of home insulation, draughtproofing brings with it the most quickly noticed improvement in personal comfort—and immediate savings in fuel costs.

Research has shown that up to 15% of all household heat losses are attributable to this persistent and niggling fault. Many other forms of heat insulation—and therefore heating—are largely wasted if draughts are present nearby. The most noticeable problems occur in the main living areas of the home.

In any room, a badly fitting door or window is likely to be the main offender—but less obvious sources of draughts can be significant. A weakly-sprung letter-box flap, cracks in brickwork, and gaps caused by collapsed mortar around door and window frames, or gaps in the siding or weather board of a timber clad house, all contribute to heat loss.

In a centrally-heated home these draughts may not be as noticeable as those in a house with single-room spot heating where draughts combine to produce cold spots. For reasons of economy it makes sense to try and eliminate the problem. In most cases, the job is not too difficult.

A. *A flickering flame indicates the presence of a draught and an unnecessary loss of heat which is easily and cheaply remedied. Use a candle for draught detection only where it is safe to do so. A smoking taper—such as a smouldering shoe lace—ought to be used otherwise*

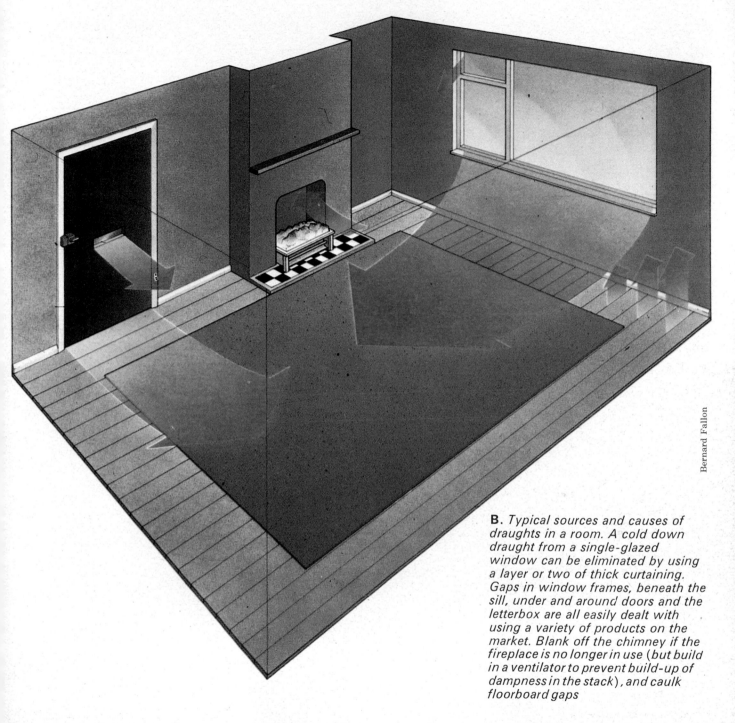

B. *Typical sources and causes of draughts in a room. A cold down draught from a single-glazed window can be eliminated by using a layer or two of thick curtaining. Gaps in window frames, beneath the sill, under and around doors and the letterbox are all easily dealt with using a variety of products on the market. Blank off the chimney if the fireplace is no longer in use (but build in a ventilator to prevent build-up of dampness in the stack), and caulk floorboard gaps*

Bernard Fallon

The causes of draughts

Draughts are mostly the result of air pressure differences within a house but they will also occur wherever there is a large gap to the outside, or between a cold and a heated room such as hall and sitting room.

Convection currents are the main cause of air pressure changes, however slight, and the effect can extend from a single room to a whole house. In a single room a large expanse of cold single-glazed window often gives rise to cold down-draughts (fig. B), even if the whole room is sealed off as a unit. More usually, this cold window down-draught combines with seepage around doors and cracks to make living conditions very uncomfortable.

A greater problem is caused by an open-grate fireplace or, indeed, any fuel-burning appliance with a single chimney flue to the outside. Room air is required for the combustion process. This—and the fact that additional heated air rises up the chimney along with the fumes—creates a partial vacuum in the room which encourages incoming air seepage through gaps around ill-fitting door and window frames.

Locating draughts

If there is any doubt about their whereabouts, the job of locating draughts is best done on a cold and windy day. Use a bare candle flame (away from curtains and other inflammable fittings) to detect the slightest movement of air. If you have one, a smoking taper will give better visual indication and is safer.

C. *A badly-hung or warped door may need extensive work or, in some cases, replacement*

Hold the candle flame or taper close to suspect areas around windows and door frames, watching carefully to see which way the smoke is drawn. Also, check through-wall fittings and pipework where filling looks to be in need of repair.

If possible, seal each area as you proceed. Work from room to room, taking in the hall and other connecting areas as you go.

When draughtproofing each room do not forget to allow enough ventilation for any fuel-burning appliance that may be in use there. Even if a ventilator grille is provided, this may be positioned badly in relation to the appliance. Consider repositioning the grille closer to the appliance to reduce cold draughts across a room. A ventilator grille can be let into suspended flooring or into a nearby external wall.

Building and safety regulations insist on suitable arrangements for ventilation of fuel-burning appliances and this point must be considered in any project that involves extensive draughtproofing.

Sealing doors and windows

Sealing doors and windows accounts for most of the draughtproofing that is likely to be needed. Though in each case the job can be simple and inexpensive, better looking fittings are available at greater cost.

At the cheapest end of the scale of proprietary draught-excluding products is strip-plastics sponge, attached to a self-adhesive backing and cut to length off a supply reel. With the backing peeled off, the sponge strip can be stuck in place on the cleaned contact surface between a door or

D. *Strip material—here ribbed rubber —is easily fitted and an inexpensive draughtproofing aid*

window and its frame (fig. D).

Strip-plastics sponge is an effective draughtproofer—providing it is used around the whole frame. However, it does tend to get dirty and tattered, and may disintegrate if exposed to damp and sunshine for any length of time. The wipe-clean surfaced type should last longer but is more expensive.

Perhaps as cheap—and certainly more effective when used in old, warped or rustic frames—is one of the new-generation of mastic-like sealants such as silicone rubber. Squeezed from a tube in a continuous, even length along the contact area between window and frame (fig. E), it acts as a rot-proof barrier against moisture and draughts.

Though the sealant is flexible enough to take up the irregularities of the frame and window, it can be removed when required. Allow up to a day for

it to dry completely, although windows can be shut after just a few hours.

Rigid strips of polypropylene, vinyl, phosphor-bronze or aluminium can be used in place of foam strip. Though no more efficient, these sprung, hinge-like strips do last indefinitely and are a better proposition on doorways to the outside.

Cut to length and tacked in place round the door or window rebate the strips are easily fitted. As the door or window is closed the two halves of the 'hinge' close together— one side fixed to the door frame, the other sprung against the door.

The plastics types should last as long as their equivalents in metal and are easier to fit, though special aluminium strip is necessary for metal-framed windows. The metal ones have ready-punched fixing holes. All types of hinged strip can cause jamming if fitted to an already tight door and frame, in which case foam strip would be better.

Secondary-sash double-glazing also acts as a fairly efficient draught-proofing aid for windows but ought to be used in conjunction with excluding strip in order to prevent undue condensation build-up when it is fitted.

Mastic can again be used for making good small gaps between a door or window frame and the accompanying brickwork where the filler mortar has crumbled. But purpose-made cellulose, or vinyl-based filler is cheaper and usually easier to apply.

Take a particularly close look at the underside of window sills—especially large ones such as those found in some types of bay window—and check for draughty gaps there. Use cement or filler to seal these (fig. F).

E. *Sealant can be squeezed into the most inaccessible parts of a door or window frame*

F. *Take a close look at the underside of window sills, and use filler to make good any gaps*

Even the finest of cracks can still let in a powerful draught if the conditions are right. In this case, an inconspicuous fillet of wood filler may be all that is required.

Timber clad houses

One source of draughts in timber clad houses is the inevitable gaps between the weatherboard, clapboard or shingles sections, and between these materials and door and window frames. These gaps should be filled with an appropriate mastic (caulking compound)—these days, often silicone. Clean out the old caulking, and wipe the area with a rag soaked in white spirit, turpentine, or other solvent. Caulking is available in disposable cartridges, and is forced into the gap using a cartridge gun (fig. H). Make sure the bead of caulking adheres to both sides of the joint. Very deep or wide gaps may need some packing out first.

Door strips

There are many types of draught excluder for the gaps under a door.

Strips of inexpensive rubber or plastics draught-excluder about 30mm wide can be screwed or tacked to the lower edge of the door on one or both sides (fig. J). But these tend to wear quickly, especially if positioned too low and hard against floor covering. Position each strip so that the edge just indents, or is bent by, the floor covering against which it rests.

A better long-term proposition is a metal door sill and door seal arrangement (fig. K) fixed to the outside of the door. A weatherproofing shield can be fitted instead of this to protect a sill fixed to the floor (fig. L).

Better for inside the house—and well-suited to sliding doors—is the brushpile type of strip, the bristles of which compress to form a very effective seal (fig. M). This can be used in conjunction with full carpeting in most instances, but is particularly suited to polished wood or tiled floors. When fitting, adjust the strip so that the fibres are very slightly bent when the door is closed.

Another solution is to use a 'rise and fall' excluder, particularly where a hard object—such as a door mat—has to be crossed. In this case, adjustable strip with an angled striking face is kept in place by a hollow moulding attached to the base of the door. In the closed-door position, the strip self-levels (if it can be arranged, against the mat or carpet being used). As the door is opened the strip is forced up-

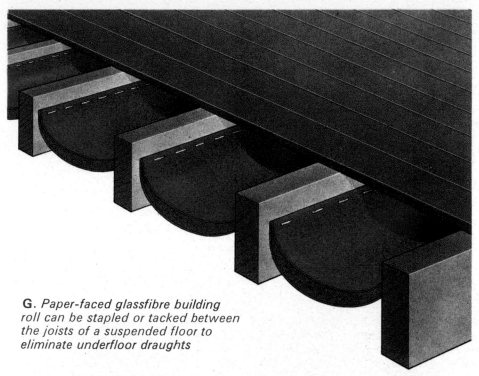

G. Paper-faced glassfibre building roll can be stapled or tacked between the joists of a suspended floor to eliminate underfloor draughts

wards as its angled face strikes the floor covering (fig. N).

At the other extreme, a substantial gap of more than 20mm ought to be built up to reduce the eventual gap between the fitting and the base of the door. Threshold strips provide a partial answer, but you may find that these have to be fitted over thin battens to fill the extra space (fig. O). Battening used on its own and covered by carpeting can also act as an excellent seal and this inexpensive idea is well worth considering. Use padding in the form of offcuts of carpet to build up either side of the batten before laying the main carpet over (fig. P).

Dealing with other draughts

Bare floorboards may look great, but they can also be a source of strong draughts which you cannot afford to neglect. The tongued-and-grooved types (see pages 224-229) are designed to get round the problem but even so, some joins—especially those near the skirting—may need attention. The worst offender is the old, square-edge boarding. Here, even fitted carpet is not always completely successful at excluding draughts.

The best solution is to fill the gaps between the boards, either with one of the proprietary mastic-like compounds described above (choose one recom-

H. Gaps between wood sidings and window frames can be sealed with mastic applied from a gun

I. Draughtproofing the rear of a letterbox using a brushpile screen which is screwed in

J. *Draught-excluding strip is easily attached to the door base although plastics types are unlikely to last very long*

K. *A rubber seal set into a metal frame acts as a heavy-duty draught-excluder that is ideal for using on outer doors*

L. *A combination of threshold seal and door-mounted weather shield is the best option for heavy-duty applications*

M. *Brushpile strip is easily fitted to the base of a door and is ideal where floors are uneven*

N. *A rise and fall excluder is an ideal draughtproofing aid where floor covering depths alter*

O. *A well-fitted door often needs no more than a threshold bar with its neoprene insert*

P. *If full carpeting is being laid, gaps under doors can be built up using a suitable thickness of timber batten laid across the threshold and beneath the carpet*

mended for flooring use) or with papier mâché.

When using filler, smooth it into each joint with a piece of electrical flex. If you decide on papier mâché, use a wood stain to match it to the colour of the floorboards.

If skirting boards (baseboards) are the problem use fillets of mastic, filler paste or cement as necessary. The gap between the skirting and floor boards is a common source of draughts and can usually be eliminated by wall-to-wall carpeting.

If suspended flooring (page 225) is being installed or repaired, or if you have crawl space under the house, you can prevent quite heavy heat losses by insulating between the joists. There are two kinds. Paper-faced glassfibre batts (fig. G), commonest in Britain, have flanged edges for easy stapling to the joists. Foil-backed batts, common in the US and Canada, are rammed between the joists and held in place by wire mesh stapled to the bottoms of the joists. The foil vapour barrier must face upwards.

Make sure the loft trap or attic door is treated in the same way as others using the same methods of draught-proofing. If the loft area has been properly insulated, overlapping material at the edges of the door normally provides a good enough seal.

Then there's the letterbox. Here, you can fasten a piece of rubber or old carpet to the inside of the flap. But for a better-looking job, fit a stronger spring and line the slit with foam strip, or exchange the old flap for the new type with brush inserts. Another type fits behind the flap (fig. I) and is easily screwed into place.

Double-glazing

● The common and not-so-common benefits of double-glazing ● Inexpensive versus costly DIY double-glazing methods ● Sound insulation ● The effect of width space ● Curing condensation problems ● Where to start double-glazing

Below: *Fitting most forms of simple double-glazing requires no more than a screwdriver, drill and cutting implements. Here, the side track of a Polycell fixed window kit is being screwed into place in line with top and bottom tracks*

Glass is not a very good material for keeping in heat—for a given area, you will lose more heat through the windows of your house than through the walls or roof. The way to reduce heat losses via windows, and so cut your heating bills, is to double-glaze them—instead of having a single pane of glass, the windows have two parallel panes separated by a trapped layer of air. But do be careful when you install double-glazing that you can easily open the windows in the event of fire.

There are many ways of providing two parallel sheets of glass in a window —from sheets of polythene taped to the inside frame of an existing window, (about the cheapest method) to professionally-installed, purpose-made replacement windows (better looking, but the most expensive method). With existing windows in the UK, double-

glazing usually takes the form of an additional window of some sort mounted on the inside of the existing frame—this is called **secondary glazing**. In the US and Canada, double-glazing often takes the form of an additional window mounted on the outside of the existing one—these are usually called *storm windows*. Storm windows, and indeed internal secondary glazing systems, can be either permanent or removable for the summer; storm windows might also double as fly screens, or you might swop removable ones for similarly-shaped fly screens in the summer.

The benefits of double-glazing

The most obvious reason for double-glazing is to reduce fuel bills. In the UK, however, the amount of fuel saved is not likely to make anything but the very simplest and cheapest form of double-glazing system worthwhile—but this is not true in many parts of Canada, and some parts of the US: indeed even the additional cost of *triple-glazing* (three parallel sheets of glass, with two air spaces) may be cost-effective in some areas.

Double-glazing does have other benefits, though. Particularly with

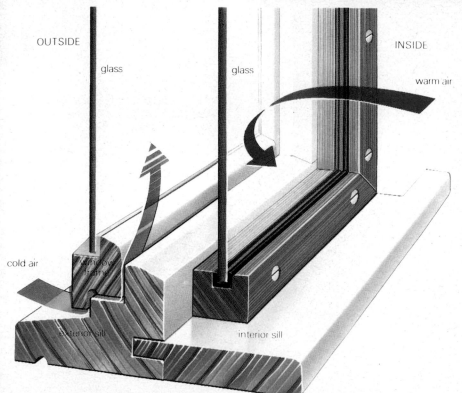

Above: *Secondary double-glazing cuts down the cooling downdraught effect of large areas of glass and eliminates frame draughts*

OUTSIDE

glass

glass

INSIDE

warm air

cold air

window frame

exterior sill

interior sill

Advertising Arts

large windows it reduces the cooling downdraught effect that can make a room feel chilly even when heated properly, and can severely restrict the area of the room that is comfortable to sit in. It reduces condensation and, if the right system is chosen, can dramatically improve sound insulation. It is also worthwhile working out the cost-benefit of double-glazing if you are installing a new central heating system: with double-glazing, you will need a smaller heating system, so you can offset some of the costs against the savings here.

Double-glazing often has a dramatic effect on the level of draughts through the windows, but this is mainly because the new windows are fitting better than the old ones: in effect, you are draught proofing (see pages 420 to 424). And if you think this is the main benefit you will get from double-glazing, you will find that weatherstripping materials are a lot cheaper.

There are a huge variety of double-glazing systems available, especially in

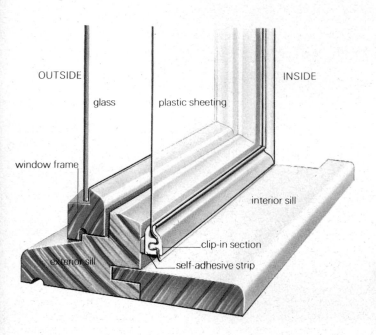

A. *In the Say-vit system, polyester film is held taut across the window by a snap-together frame. Branded products shown in these illustrations are available in Britain.*

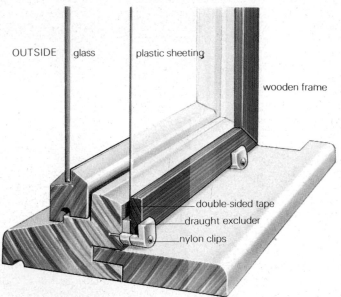

B. *Another method of fixing plastics sheeting over a window is to use a wooden frame. This can be clipped or screwed into position*

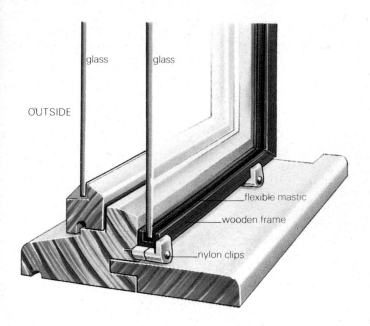

C. *Glass is a much better long-term proposition for secondary glazing, particularly in the case of removable units. A home-made frame is shown*

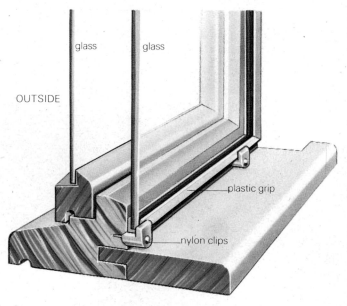

D. *A clip and frame arrangement is an ideal low-cost solution for the secondary glazing of individual panes and small fixed windows*

the UK. The figures on these two pages and overleaf show some of the different types, which can be divided roughly into four categories.

Simple systems are at the cheapest end of the scale, and the cheapest of these are based on plastics sheeting, which come in many thicknesses, ranging from that used for food-wrapping to acrylic sheet such as Perspex. In between there are numerous other plastics forms, including the popular middle-of-the-road choice for double-glazing on a budget: acetate sheets, available in various thicknesses.

The disadvantages of thin plastics film, such as food wrap, is that even when fitted well it tends to look terrible. Polythene sheeting is little better, as it tends to whiten and become more brittle when exposed to sunshine. Acetate sheet, which keeps its clarity well, is a better choice—even if there are problems over the dust-attracting static that tends to form, especially near curtains.

A further disadvantage of all forms of plastics sheeting is that it usually has to be discarded when removed for window cleaning. You may also risk damaging the paintwork when you pull away the double-sided adhesive tape normally used to fix the sheet or frame in place (fig. A).

It is possible to incorporate thicker plastics sheeting within a frame arrangement constructed from wood battening or plastic channelling, perhaps using components from a double-glazing kit. The frame (fig. B) can clip into place for easy removal when cleaning or storage is required.

For thicker plastics (acrylic) sheet or, even, another sheet of glass, you can make a more substantial frame (fig. C). But this or any other frame and the window frame which supports it, must be capable of taking the weight of the glazing material used.

If you choose to use glass, 4mm float is normally sufficient but your glass supplier will be able to advise on local requirements if you are in any doubt. For small windows and thin 'horticultural' glass, a clip and frame arrangement (fig. D) is normally adequate providing you can achieve a good seal with the window.

Secondary-sash glazing describes several methods of providing a more permanent form of double-glazing. With these, the second sheet of glass is supported against the window frame by a hinge arrangement (fig. E), or in channels which permit horizontal sliding for opening and closing. Some of these frames are supplied ready-glazed and complete with all fittings, including the seals so important to these designs. Alternatively, you may prefer to construct your own secondary-sash arrangement using components from some of the many kits available. All forms of secondary-sash double-glazing permit access for easy cleaning of inner window surfaces, and enable you to open the window for ventilation in dry weather if required.

Extruded aluminium frames are most commonly used for secondary-sash systems, particularly those which are supplied ready-glazed.

Coupled glazing is an even more 'permanent' variation (fig. G) where, in effect, two window frames are employed in place of one. This arrangement is particularly suitable for windows with a narrow sill which cannot take a sliding secondary sash or other form of glazing frame. Both windows open and close as one, but the additional one is hinged and clipped to enable easy separation for cleaning. A form of coupled window can be used for vertical sash windows, though the counterweights on the cord may need to be increased slightly.

Although coupled windows are available factory-made in a variety of standard sizes, making your own should not present too many difficulties.

Storm windows, although also mounted on the outside, are not often coupled to the original window, but are rigidly fixed to the frame.

Sealed units (sometimes called insulating glass) consist of two layers of glass, with an air gap between, sealed together in the factory. You install the complete unit in the window frame opening in place of the existing single sheet of glass. These are covered in the next section.

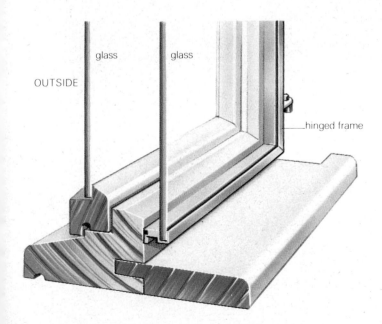

E. *Aluminium frame kits offer good looks and strength sufficient for fairly large areas of glass, necessary for hinged units. Extra hinges can be used.*

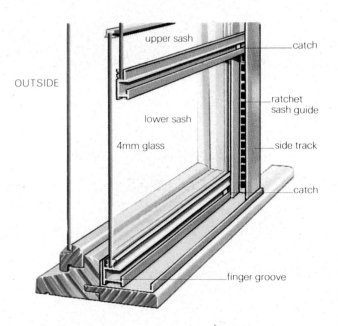

F. *Vertical sash windows may be secondary glazed with a hinged, fixed, or vertically sliding unit such the Polycell version shown above*

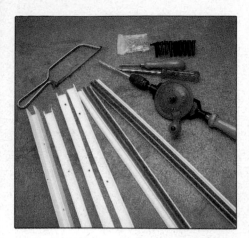

1 The Polycell kit for fixed secondary glazing and the few tools required for cutting and fixing. Glass of the right size is extra

2 Measure off the required length of top track to fit across the width of the soffit or lintel. Use a try square to mark cutting lines

3 Use a small hacksaw or fine-bladed saw to cut the track to length. Take your time over the job to ensure a clean square cut

Width of air space

The heat insulation property of double glazing varies with the width of the enclosed air space. The optimum space depends very much on the temperature difference between the inside and outside surfaces, but is usually taken as 20mm in temperate zones when heating is up to normal standards. For easier fitting, this gap is reduced to 12mm in factory-sealed insulating glass and the difference in heat loss can be considered negligible. A gap of less than 12mm leads to progressively greater heat losses.

The heat loss, or *thermal transmittance*, of a single pane of glass under average conditions of use and exposure is taken to be 5.6 watts per square metre of glass, for each degree Centigrade temperature difference between the inner and outer surfaces. This is expressed as $5.6W/m^2$ °C. A 20mm air gap between two sheets of glass almost halves the heat loss to $2.9W/m^2$ °C. Insulating glass (factory-sealed double-glazed units) yields figures of 3.0 and $3.4W/m^2$ °C for air gaps of 12mm and 6mm respectively.

Sound insulation

Sound insulation is often one of the most important considerations when planning a double-glazing scheme, particularly if your home suffers greatly from the noise of a busy road or nearby airport.

Any double-glazing reduces noise on account of the trapped airspace between panes and as this gap increases, so sound insulation improves. However, the gap needs to be at least

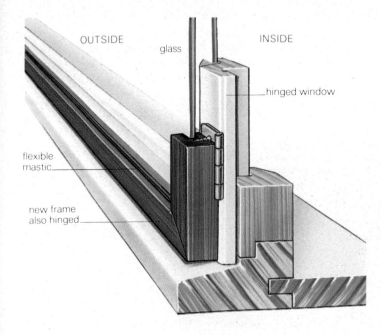

OUTSIDE INSIDE

glass

hinged window

flexible mastic

new frame also hinged

G. *A coupled window, with the secondary glazing attached to the outside of the existing window frame, leaves the inside unobstructed*

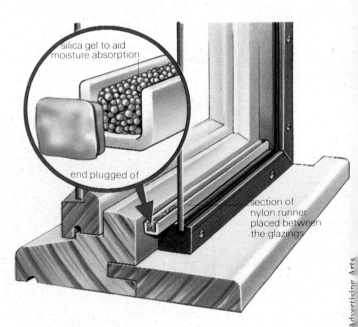

silica gel to aid moisture absorption

end plugged of

section of nylon runner placed between the glazings

H. *In semi-permanent arrangements use silica gel to absorb trapped moisture. If air-gap condensation is severe, provide drain holes to outside frame sill*

Advertising Arts

4 *Unless the window frame is known to be truly square, individually measure off and cut the remaining tracks to length*

5 *Position the top track to leave as deep an air gap as necessary before marking screw positions with a bradawl*

6 *Drill pilot holes in the top frame or soffit. Use a masonry bit if you are screwing into plaster, brick or concrete*

100mm—and preferably 150mm with 4mm glass—for the best combination of sound and thermal insulation. While a bigger gap of up to about 400mm improves sound insulation, thermal insulation is greatly reduced because of the convection currents that then have space to form between the two panes of glass.

Whatever type of double-glazing you use, fitting it to allow a gap of 100mm or more is often difficult on most types of domestic window. So, if thermal insulation is important, you may have to make suitable modifications to the window frame surrounds.

Factory-made sealed units usually have an air spacing of between 5mm and 12mm and the sound insulation properties these may have are due only to the weight of glass involved. However, if used as a secondary unit this insulating glass can be positioned to provide the necessary gap, in which case further benefits are provided by the additional trapped layer of this multiple glazing set-up.

Where the gap width permits, you can achieve additional sound insulation by using acoustic tiles to line the soffit, reveal and sill of the window. Bear in mind that this insulation should not impede drainage arrangements which may have to be provided.

Condensation problems

A frequent problem with single-glazed windows is condensation, which can reach severe proportions if the atmosphere indoors is very humid. Over a period of time this ruins fixtures and fittings and may even cause wood framework to rot, replacement of which must be the first priority in any double-glazing project.

7 *Screw the top track into place, plugging screw holes if fixing to plaster and brick or concrete. Drive screws fully home*

Although double-glazing does not always eliminate condensation, it goes a long way towards curbing the problem—especially if fitted properly. Secondary-sash and coupled double-glazing present a slightly different problem in that it is difficult to prevent slight condensation on the inner surfaces, although you can take measures to reduce this effect.

Drilling a series of holes, at an angle downwards through the window frame, enables the air gap to 'breathe'—but no more—and so prevents a build up of too much moisture. Or, you can place *silica gel*, a moisture absorber, in the air gap on shallow trays made of up-ended channelling (fig. H). The silica gel has to be removed and dried from time to time.

Insulating glass normally has a filling of inert gas sealed within the

8 *With the top and bottom tracks aligned with each other and set squarely in the window reveals, position and fix the side tracks*

9 *Use a wood offcut to tap and force edging strip fully home on the glass edges. Then slip the glazed frame into the window tracks*

unit. Condensation between the panes should not be a problem and there is usually some form of replacement guarantee to this effect, providing the seal remains intact.

Condensation is likely to occur if there is a poor seal between a secondary-sash and the supporting frame, a very real problem with some of the cheaper DIY double-glazing kits as adequate precautions cannot normally be taken. Always provide a generous and effective seal if you can, but make sure you install your glazing on a cold, dry day as the moisture content of the air is at its lowest then. Even with removable double-glazing arrangements such as secondary-sash systems, it may be worth adding a 'bedding seal' of temporary or permanent nature, particularly for opening windows.

Curing draughts
Draughts are an unwanted feature of every house, and many originate from badly-fitting windows or doors. Most problems of this nature are easily put right (see pages 420-424) and must not be allowed to go unchecked when double-glazing is installed as many of the benefits may then be lost. Draught-proofing between an air gap and the inner glazing sheet is especially important if condensation is to be minimized or eliminated.

If a frame, window or door is in a particularly bad state of repair, it may be easier and cheaper in the long run to consider fitting a double-glazed replacement from the outset of any improvement scheme.

Where to glaze
In most cases, double-glazing is an improvement job which is undertaken in stages as both weather and funds permit. Deciding quite where to start can be a problem, so base your choice on those rooms which you use a lot, those kept at the highest temperatures, and those which have the largest area of glazing.

The living room, sitting room and kitchen are obvious starting points and as these are likely to account for much of the groundfloor glazing, it is a good idea to choose one, matched system for all of them. Double-glazing upstairs is a luxury by comparison, but should be considered in your long-term plans. Temperatures here are usually kept lower, and even if heating is turned off at night, this hardly matters when you are snugly asleep.

Take care to match the likely strength of a glazing kit with the area of glass that it has to support.

Fitting simple double-glazing

Most forms of double-glazing in kit form are easily installed by the home handyman. Of these, the various forms manufactured from aluminium section tend to be more durable and better looking than their plastics counterparts which often cost as much. With all forms, particular care should be taken to ensure clean, square cuts as errors here can greatly mar the finished appearance. Take care to avoid scuffing aluminium which readily shows this ill-treatment. Buy height and width kits oversize.

10 *This Cosyframe kit consists of aluminium glazing frame, glazing strip and sealing strip, and corner components*

14 *Slip some glazing strip along the edges of the glass sheet, cutting to length only when any stretching has contracted*

15 *Use a block of wood to push the glazing strip fully home making final trimmings of length as necessary*

19 *Lubricate with soap and water the sealing strip as this is inserted within the frame. A blunt screwdriver or knife is useful here*

20 *Once the frame corner screws have been tightened, position the glazed frame in the window. Use wood offcuts to position the frame*

11 Measure off the required height and width of frame required, carefully matching the opposite sides to ensure squareness

12 Use a fine-toothed hacksaw for making a clean, square cut. Remove any burrs with a file as these will impede assembly

13 Tap home the corner pieces —with this kit, self-tapping screws are located but not tightened at this stage

16 Lubricate the glazing strip with soap and water and then slip into position the first of the four parts of the aluminium frame

17 Protect the aluminium with an offcut of wood when tapping the frame fully home. The frame must be tight fitting for safety

18 Use a wood offcut as shown to remove an incorrectly positioned frame. Lubricate the glazing seal before repeating

21 Use a bradawl to mark and drill pilot holes for fixing the frame hinges. On high windows provide additional hinges

22 When the hinges have been screwed into position, check that the frame opens and closes properly along its supporting length

23 Position the turn-catches near to the top and bottom of the opening side of the frame. These should be tight fitting

Further double-glazing

Ray Duns

● **Permanently glazed secondary windows** ● **Using manufactured frames for secondary glazing** ● **Replacement windows and door** ● **The need for a sub-frame** ● **Comfort, safety and security aspects of double-glazing**

Even the simplest forms of double-glazing can be effective at keeping heat in, and possibly at keeping noise out (see pages 425 to 431). But many of these simple types are not very attractive, nor are they very durable.

A short step from some of the simple double-glazing kits is the installation of home-made, permanently-glazed secondary windows which can have a much more attractive appearance. These, however, are rather more expensive and are unlikely to be a worthwhile investment (in strict financial terms) in the UK, though almost certainly they will be in Canada and

parts of America.

Secondary frames may fit either inside the existing window, or outside it as a coupled window, or a storm window—see page 427. The frames may be fixed in place—the best solution for a good, tight seal—or sliding or hinged —to give easy access for cleaning and ventilation.

The greatest problem with secondary systems and coupled windows is preventing draughts and condensation. It is essential that your double-glazing system fits the window properly to keep maintenance problems to a minimum (see below). Envisaging problems of this sort, you may prefer to buy a factory-made secondary glazing unit and install this yourself.

The choice ranges from wood, plastics and aluminium glazing frames you fit and glaze yourself, through various forms of factory-made ready-glazed secondary systems (nearly always of the sliding type), and on to the most expensive option which is a complete replacement window or patio door. These are usually fitted with *sealed-unit* type double-glazing (insulating glass), but may use conventional glazing if a large-gap airspace for improved sound insulation is required.

Secondary glazing

If you decide to stick to a secondary glazing system and choose to employ a more rugged and permanent method than that provided by many of the simple kits, a fixed secondary frame (fig. C) is often the answer.

Many firms can make one to a special size if one of the many standard sizes is not suitable and if you can have these glazed inexpensively, this is a very good way of obtaining a professional standard of double-glazing at comparatively low cost.

But although a fixed secondary glazing system is attractive from the point of view of long life, installation is often an involved process. You must take particular care to prevent condensation forming after assembly, and to make provision for cleaning and ventilation.

The secondary frame, once glazed, should be installed on a cold and dry day (as all with double-glazing).

'Breathing holes' of 2-3mm diameter are drilled in the frame to dissipate moisture drawn through the woodwork surrounding the air gap without directly admitting outside damp.

Fitting becomes more difficult if the frame has a shallow sill, or if a frame is being fitted against an existing metal-framed window which has no woodwork. In this case, a sub-frame of 30mm x 30mm timber can be fitted to the window reveal, leaving a sufficient gap for clearance of existing protruding handles and other immovable fixtures (fig. A). But fitted properly, the frame should be suitable for all forms of double-glazing, including the simpler types.

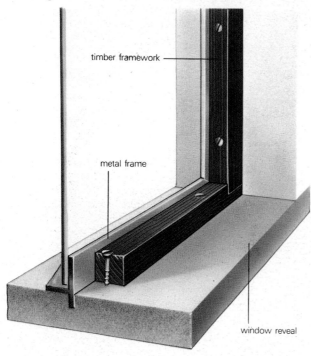

A. *Secondary glazing can be attached to a metal framed window by constructing a suitable timber sub-frame. Position this to clear any handles*

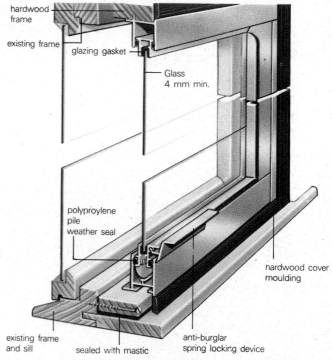

B. *A typical made-to-measure lift-out unit (Everest)—a comparatively low-cost system. Branded products in these illustrations are available in Britain.*

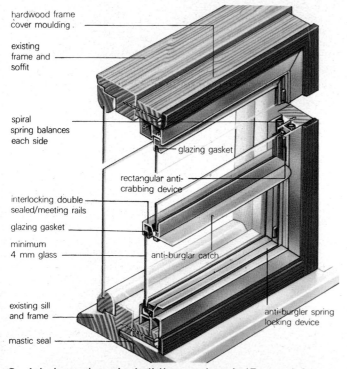

C. *A balanced vertical sliding-sash unit (Everest) for the secondary glazing of existing sliding sash windows that remain in continual use*

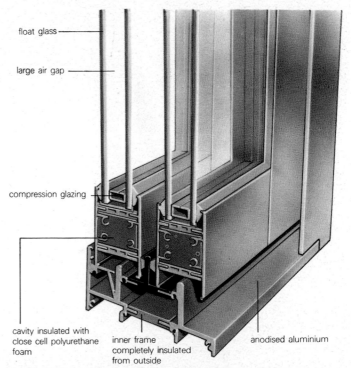

D. *Cross-sectional view of double-glazed patio door (Therm-A-Stor) showing precautions taken to avoid heat loss and condensation within the frame*

433

Secondary glazing of this type differs only slightly from that for a coupled window and fitting problems are much the same.

Factory-made units
The first major step up from simple systems is the fitting of factory-made ready-glazed secondary systems (figs. B and C). Some firms can provide these units for you to fit yourself, whereas others may insist on an all-in professional service.

There is little doubt that these units provide the best compromise as far as performance, cost and looks are concerned, but they are still an extremely expensive proposition if fitted throughout the house. A better idea is to install factory-made frames only in the rooms you use most often.

In most systems, an extruded aluminium frame is attached to existing window framework with a mastic or other suitable sealant used to make good small irregularities and to prevent draughts at the frame edge—a potential cause of condensation.

A brick window opening is rarely truly square and to offset this fact, the better-quality units usually employ a sub-frame. This is fitted first, either to the bare brickwork at the window reveal or to the existing window frame, if this is in good condition. The new frame is then attached to the sub-frame, the fixing screws concealed beneath moulding.

The sub-frame should be made of hardwood to eliminate long-term problems such as warping and splitting. And if the frame is attached to brickwork, it is essential that fitting and construction are of a high standard.

A similar procedure is employed for the installation of complete replacement windows and patio doors. A variation is the use of an additional aluminium sub-frame, which must be carefully fitted to avoid reducing the glazing's insulating properties and—over the long term—to prevent a build-up of trapped water.

When measuring up for a frame you are constructing yourself or having made to a special (non-standard) size, allow for a small strip of bedding and sealing mastic or putty at the edges.

Other double-glazing options
A number of budget forms of replacement windows are available, some of which combine the maximum use of timber framework with a minimum use of aluminium—contributing greatly to their effectiveness as insulators. The more expensive frames do this by incorporating 'thermal breaks'—achieved by internal insulation, or by employing a split construction.

Insulating glass
This is one name given to double-glazing which consists of two panes of glass sealed together in the factory with a gap between them—*sealed units* is another name. The gap between the units is filled with dehumidified air or an inert gas to prevent condensation. The units are fitted as replacements for existing single panes, but the window frames must be able to support the additional weight. If the rebate in the frame is not deep enough to take a standard unit, a stepped type (fig. E) can be used.

But you can obtain greater benefits by combining these insulating glass sheets within secondary glazing arrangements, so that triple or multiple glazing results. Multiple glazing is unlikely to be cost-effective in the UK, but may be in Canada and some parts of America.

Used in place of single glazing, insulating glass should—under identical conditions—show a noticeable reduction in the amount of condensation on the inner surface. Claims can seem exaggerated if the influencing factors—relative humidity, surface temperature differences and ventilation—alter: a point worth bearing in mind if you are comparing ready-glazed units with insulating glass (such as patio doors).

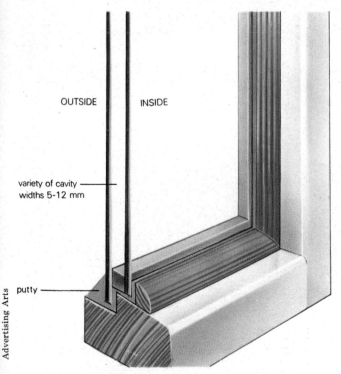

OUTSIDE INSIDE

variety of cavity widths 5-12 mm

putty

E. *Insulating glass is available in many standard sizes. The 'stepped' form here is shown fitted to a wooden frame. The 'standard' form is square-edged*

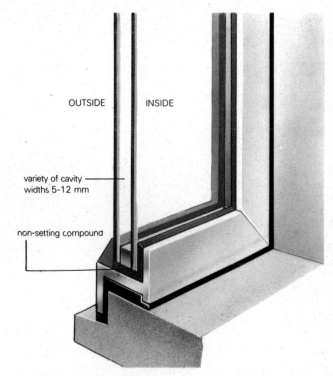

OUTSIDE INSIDE

variety of cavity widths 5-12 mm

non-setting compound

F. *Double-glazing metal-framed windows can be a problem and an inner sub-frame of wood is not always possible. Insulating glass is a convenient solution*

The sealing methods used for insulating glass—and also for secondary glazing units—are also worth comparing. Choose systems and methods which employ a tight-fitting, but supple, 'soft' seal, as this reduces movement and vibration of the glass. Opening windows and doors, and large-area sheets exposed to strong winds are particularly susceptible to trouble of this kind.

Consider using professional help to install a particularly large area of insulating glass (or, indeed, standard glass) as experienced handling and fitting is required to avoid damaging the seal. Take particular care handling stepped insulating glass.

Comfort, safety and security

Draughtproofing and double-glazing can literally seal up a home, so providing adequate ventilation is particularly important. It comes down to striking a happy balance between heating and ventilation from the point of view of comfort, otherwise a build-up of internal humidity will result in severe condensation problems—perhaps far worse than you experienced before double-glazing.

You must provide adequate ventilation for fuel-burning appliances, even if this means going to the lengths of installing a ventilator grille near the appliance once the double-glazing (and draughtproofing) has been installed.

The reduction in heat losses brought about by double-glazing often encourges greater use of windows and patio-doors—both as a replacement for existing walling and windows, and as part of the design of structural extensions. The resulting increased area of glazing poses safety and security problems which cannot be ignored—even in terms of the single window, where one large area of glass is likely to be used in place of several small ones in individual frames.

Windows near doorways or stairs are particular danger areas. In these and similar instances, the risks of injury can be reduced if you employ safety glass in place of normal float or decorative glass. Safety glass goes through an annealing process which increases its resistance to smashing. And if it does break, the glass fractures into small, comparatively safe pieces rather than splinters.

All forms of glass should be handled with care, using heavy-duty gloves at

1 You can install insulating glass in place of single glass when reglazing. Start by removing all the old putty first

2 Offer up the insulating glass to check the fit. Glaziers can make up non-standard sizes. Take care not to damage the seal

3 Line the bead with back putty, the depth of which can be kept to a constant recommended minimum of 5mm by using little spacers

4 Push the glass into the frame so it is seated properly and fix with glazing pins. Trim off the excess back putty with a knife

5 Apply nodules of exterior grade putty and smooth this down to form an even surface using the curved part of a putty knife

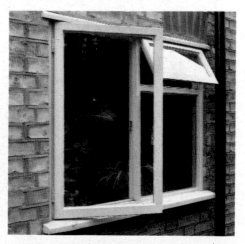

6 Insulating glass should only be used in windows that have a frame strong enough to support the double thickness of glass

all times—even on sheets with ground edges. Sharp edges can damage the plastics seals of many of the systems you can glaze yourself. Ask your glass supplier to remove these, or do the job yourself with a carborundum block.

For safety in the event of a fire, ensure that one or more easily accessible windows on each floor can be unlocked and opened quickly.

Take great pains to avoid fitting large sheets of glass in weak or badly supported frames—particularly those of opening windows and patio doors.

Large areas of glass or a window with two sheets of glass instead of one is unlikely to deter an intruder intent on forcing an entry—and quite possibly the reverse will apply. Opening windows should incorporate—or be provided with—locking handles or catches. Recessed locks and safety bolts (fitting into adjacent panels) should feature on all patio doors.

Many of the cheaper types of kit system have no provision for a lock, and you must take care to see that outer windows are properly locked at all times when double-glazing is in use. If possible, though, lock both inner and outer opening windows.

Maintenance

The more expensive your initial installation, the less likely the need for maintenance and running repairs. The seals of insulating glass should be inspected for wear every few years, but faults here are likely to show up in the form of condensation. Carry out these and other checks before really wet and cold weather sets in.

Wood frames can be checked for warping and splitting, and local repairs can be made as necessary.

Cleaning away dust and condensation is likely to be the most frequent maintenance job on most forms of secondary glazing—particularly the cheaper units—but many systems allow for this to be done quickly and efficiently. After you have cleaned the inner surfaces, inspect the various seals for signs of wear and make replacements where necessary.

Choose to spring-clean on a cool, dry day and thoroughly ventilate the room before you refit the secondary glazing to avoid an immediate return of condensation. Never allow condensation which is present to puddle: over a period of time this can rot the frame between the two sheets of glass. If condensation returns quickly in spite of reasonable precautions, suspect damage to the seals between the air gap and inside of the house.

Double-glazed patio door

Professionally installed double-glazing is a major home-improvement expense. A typical job is replacing old French doors with a custom-built unit having sliding doors. A patio door conversion of this nature may require the removal of the low walling on each side of the threshold. This type of structural work is usually carried out by the installers themselves.

The picture sequence shows the main stages in the installation of a Therm-A-Stor patio door, typical in being constructed from alloy extrusion which is fitted to a hardwood sub-frame. Both frames are assembled on the premises. The 'moving' part

of the frame and the fast frame are manufactured with separate inner and outer sections which are secured together by means of a continuous non-conductive material, and the corners are secured by fastenings with secret fixings.

Sealed units of up to 32mm thickness can be accommodated by this design, permitting an air gap of 20mm which is considered the optimum by this manufacturer.

Safety and security are important aspects to consider. With this design —capable of withstanding the strongest gale-force winds—a hook-type lock is employed.

4 *The aluminium frame is put together at the same time as the sub-frame is constructed to ensure a perfectly matched fit*

5 *The aluminium main frame is fixed to the hardwood sub-frame with screws. The number of fixings depends on the door size*

9 *Fitting the sliding door in place. Handles, the lock, a threshold plate and side trims are all then added to the structure*

10 *Inner and outer walls are then made good. Extensive repairs to the frame surrounds have to be made earlier*

1 The first stage of installing a patio door is the removal of the old door and window frame and short-wall brickwork at the sides

2 The wooden sub-frame is custom built to fit the aperture. This is normally manufactured on the spot for greatest accuracy

3 The sub-frame is checked for fit and then screwed into place. A bedding seal of suitable mastic helps prevent frame draughts

6 The 'fast' frame is inserted within the main frame. The weight of glass is substantial and the frame design must consider this

7 Edge stripping and draught excluders are then added to the 'fixed' and 'moving' frames, and to the main frame itself

8 The moving frame runs on small nylon or stainless-steel rollers which are adjusted prior to installing the frame

11 Gaps and cracks can be filled using a suitable general purpose mastic. Efficient draught-proofing of the frame is essential

12 The final stage is varnishing the hardwood frame both indoors and out. A polyurethane type is best for this purpose

13 The completed installation should look good and be capable of putting up with considerable use

Gavin Cochrane

Fit a window lock

Whatever type of window you have, you want to be sure that it is secure and burglar-proof. Window security devices are cheap, easy to fit and can be obtained to suit all different types of window. Three are shown here.

The picture at the top of the page shows a lock for a casement window. Screw it to the frame under the casement stay. When locked, it prevents the stay from being lifted.

The centre pictures show another type of casement lock. Fit the pin to the frame so that it projects through the stay. You can then lock the stay by screwing the barrel on to the pin using the key.

Finally, for sash windows, you can fit a lock which screws through both frames to prevent them moving. Fit it through a drilled hole.

Ventilation in the bathroom

● Making the WC a better place to be ● Getting round the moisture problem in a badly ventilated bathroom ● How often you need to change the air ● Installing a wall mounted fan ● Fitting a ceiling mounted fan

Traditionally the smallest room in the house, a WC can quickly become unpleasant to those who have to use it afterwards unless special care is taken to provide adequate ventilation. An opening window is an effective solution but is sometimes uncomfortable, especially in cold weather when there is the additional problem of household draughts and resulting heat loss.

A power extractor fan, operated either by the light switch or independently, is a simple solution and a provision considered essential—by law in the UK—for WCs that do not have windows.

A slightly different problem exists when it comes to bathroom ventilation. Here, the high moisture content of the air produced by running a bath or shower quickly condenses to form water droplets and puddles which are not readily removed simply by opening a window for a few minutes. The problem is aggravated by the fact that the room is likely to be used only for a short time, thus discouraging opening of the window both during and after bath time.

An efficient extractor fan is the only convenient solution, and its cost can be weighed against the improved atmosphere of the bathroom when it is being used, and the reduced risk of damage to fixtures and fittings resulting from the lower levels of condensation that then form.

About 15 to 20 air changes an hour is considered satisfactory for a bathroom, with 10 to 15 for an enclosed toilet. Find the volume of your room by multiplying height by width and length. Then multiply this figure by the recommended number of full air changes, and use the result to determine which make and model of fan is best for your needs.

Some models are specifically intended for low-volume work, so always err on the side of a more powerful unit if you are in any doubt. Most of the fan manufacturers provide precise guidelines on choosing one or other of their models.

Siting the fan

The best place to put an extractor fan is on the wall opposite the main doorway for the room, as high up as you can and above any source of moisture. Replacement air then has to travel across the room, ensuring that ventilation is complete.

You can mount the fan in a non-opening section of window, either by cutting a hole in the glass (see pages 448 to 449), or by replacing the whole pane with a suitable sheet of wood and fitting it within this.

Window mounting is not normally much of an aesthetic problem as far as interior WC design is concerned but in most cases, there is only one window. Since opening capability should be preserved, this sometimes rules out using the window as a site for the extractor fan. A similar problem exists in most small bathrooms and the additional loss of window light normally means that the fan has to be located elsewhere.

The wall position which best meets the ventilation requirements is high up, next to the window, where there is often an air-brick or ventilator grille. This can be removed and the ventilator fan installed in its place.

Below: *A ceiling-mounted fan is an unobtrusive and effective method of relieving the condensation problems of a badly ventilated bathroom*

John Ward

A. *In a totally enclosed WC, some form of forced ventilation is very necessary. Position the fan where it can easily be ducted*

B. *In order to get the maximum effect, mount a ceiling fan right above the bath so rising steam is extracted before it has chance to cool. The fan can be discharged directly into unused roof space only if this area is well ventilated. Otherwise, sloped ducting to the outside is necessary*

If you have the choice, select an outer wall which is protected from strong winds by surrounding buildings or trees. Otherwise you may have to fit a co-ordinated shutter—perhaps in conjunction with a protective outer cowl—to counter back-draughts in strong winds.

Moisture is the main problem in bathroom ventilation and it must be discharged where it will do no harm. This requirement means that, if an outer wall is not available for mounting the fan, special care has to be taken in ducting the fan to the outside.

Fitting a wall mounted fan
The best place to locate a wall mounted fan is on an outer wall as this means that no additional ducting is required for the outlet. In most cases, a hole of 100mm diameter would be required

for this. In addition an access hole (for a 20mm conduit) needs to be provided for a through-wall electrical connection. Alternatively a chase has to be made so a wire can be run from a suitable source out of the room.

Follow the manufacturer's instructions for marking up the position of the fan as the recommended sequence varies from model to model.

Take great care to avoid concealed pipework and wiring. Taps and switches in the same vertical plane could indicate trouble, so locate the fan just to one side if you can.

With a masonry wall, carefully chip away covering plasterwork and old wallpaper using cold chisel or small bolster so that you expose brickwork beneath. Try to locate the corner of a mortar joint as the plaster is gradually removed and use this as the 'weak spot'

for making the outlet hole with a drill or chisel.

Carefully nibble or drill away the mortar and adjacent brickwork corners, then split the first whole brick with a hammer and bolster. Continue in this way until the hole is just larger than that required for the outlet hole and connecting duct. For neatness, remove whole bricks where you can but keep these for re-use.

This initial cutting work is much easier if you use a heavy-duty masonry drill, available from hire shops.

If you are dealing with a cavity wall, you also have to breach the outer leaf —a job that is better done from the outside. But first drill through pilot holes from the inside to avoid making any mistake in the position. Arrange to drill these through mortar joints so that afterwards you can remove whole

bricks. Take care to prevent too much rubbish falling down the cavity—it could cause damp problems.

The covering of a timber-framed wall is usually easy to cut away with a jig-saw or similar. Avoid positioning the fan over vertical studs (see pages 193 to 199). Find studs by tapping or drilling small trial holes.

When assembling the fan components, use a length of sleeving to line any cavity and prevent moisture-laden air from discharging into it. The sleeve should slope slightly to the outside, which can usually be arranged during final fixing of the fan.

Follow the manufacturer's assembly instructions to install the fan unit itself. Much of the making good will probably have to be done beforehand, which means shaping the surrounding brickwork, repositioning cut bricks, and finally using heavy-duty filler or a suitable mastic to entirely eliminate through-wall draughts.

Inner walls usually present much less of a problem but additional work may be involved in providing suitable ducting to the outside, where again a hole must be made. For health reasons and personal comfort a WC ventilator should not be vented to another room or an accompanying corridor. To avoid unnecessary ducting—strictly speaking necessary only for moisture-laden air—consider installing a ceiling mounted fan so that foul air can be discharged into unused roof space.

This position also permits ducting between floors in the case of downstairs toilets and bathrooms. Raising and refixing floorboarding on the floor above—instead of boxing in a duct—is often a small price to pay for the improved looks of the installation.

Panel mounting

If a wall fixing is required, it is sometimes more convenient to use some method of panel fixing—especially if a purpose-built boxed-off duct has to be constructed with the room design in mind. A similar approach could be used for a ceiling mounted fan.

A panel-mounted fan can also be installed where additional work may prove difficult. So instead of bricking up a small and useless WC 'high window', you could use inner and outer panels of suitably-treated exterior grade plywood to seal up the window after removal of the glass. The wood could be cut to accept the extractor fan And, later, if it was decided to re-commission the window no permanent damage will have been done to the frame at all.

Above: *Various methods of ducting an extractor fan to the outside. Which method you choose to use depends principally on the location of the fan, and it pays to consider ducting problems in advance so that you can find the most practical site. Although rigid pipework is shown here, flexible ducting may prove easier to install, especially where the runs are made through walling and partitions. Avoid steep angles in the duct route, particularly those where condensed steam may have a chance to collect. Fit a protective grille or cowl to the exposed pipe end*

Venner Artists

Fitting a ceiling mounted fan

The best place to put a ceiling mounted fan is right above the bath or shower enclosure, as most of the problem moisture is likely to originate from these. The fan must be located between the joists and requires a hole in the ceiling of up to 300mm diameter, the exact measurement varying between models and makes.

Superficial bodywork may make the actual diameter of the appliance greater than the distance separating the joists, so check styling and measurements carefully when choosing a suitable fan.

The next stage is to make a pilot hole through the ceiling. Go into the roof space first to check the area for pipes, wiring and obstructions around where the hole is to be made. Use support walling and lamp wiring roses to get your bearings. If necessary make a sketch of the joist plan and take any useful measurements from key details. Cross-check these when you go back to the bathroom.

In older houses, settling and condensation effects often show up the joist pattern in the ceiling plaster, and really it is only a matter of precaution that the loft space area is inspected for obstructions. But where this is not so, take plenty of time over locating the fan; before you cut the hole for the fitting, you always start by drilling a pilot hole safely in the waste area.

Drill the pilot hole from the bathroom side. Check its position from above, if necessary drilling another hole from below until the true centre of the fitting aperture is obtained.

When you have an accurate centre, mark the cutting line for the aperture. This is likely to be a circle, so rig up a simple compass affair using two pencils and a length of string to produce this Alternatively, use a suitable template such as a large diameter biscuit tin lid or similar.

The hole must be cut very carefully, both to avoid cracking and damaging the plaster beyond it and to minimize the amount of making good required after the fan is fitted.

To be absolutely safe, drill further pilot holes along the circumference, then gently chip away the plaster from the middle. Use an old cold chisel or small bolster to nibble away the plaster until you reach the edge line. Offer up the fan fixing to check it for correct fitting as you near completion.

If other materials such as softboard or plasterboard are used for the ceiling, it may be possible to use a pad saw or power jig saw to cut the hole. But

1 *Position the fan slightly away from the wall. Mark the screw holes and duct and conduit apertures specified by the manufacturer*

2 *Carefully drill a pilot hole in the waste area of the duct aperture. Check from above that the position of the hole is correct*

6 *The electrical connections are not normally difficult to do providing you follow the manufacturer's instructions closely*

7 *Screw on the fan cover and test the connections. Some models may have a separate timer which needs adjusting*

do use the correct blade for the job.

From here onwards follow the specific installation instructions that apply to your fan. If you have been careful, you are likely to find that the fixing flange and the bodywork of the fan are sufficient to conceal small irregularities in the hole, so that making good becomes unnecessary except to strengthen the fixing. Use general purpose filler for making good unsightly cracks and dents which remain exposed. If you plan to decorate the ceiling, do this before fixing the fan **base** permanently.

Providing ducts

Ducting has to be used when the fan is mounted on an internal wall and needs to be discharged to the outside, and also when steam and condensation occur. Moisture-laden air must not be discharged into the roof space or eaves as damp damage may occur over a period of time. If the ducting cannot go through a wall, but must pass through the roof, a roof cover must be fitted at the outlet.

For the small-sized WC ventilator shown, standard 102mm plastics ducting is used. This can be led along the

3 *Then cut out the duct aperture using a suitable pad saw. Old plaster may not cut true, so make this good before proceeding*

4 *Pull the power and lighting cables through. These are connected to the mains and lighting switch as specified by the maker*

5 *Fix the fan to the ceiling, using standard cavity wall fittings. Heavy fans may need additional support from above*

8 *Push-fit PVC pipework has been employed for the ducting. Ready made bends are used and the pipe run is kept as short as possible*

9 *Secure the upright that goes through the roof with a brace nailed to the rafters, vital if the outside is exposed to strong winds*

10 *Fit some form of cowl to the exposed pipe end. Use mastic and apron flashing to waterproof the roof joint area*

I. *Most extractor fans can be connected to the supply through a suitable double pole isolating switch. A 3A/5A fused spur with switch and indicator is ideal*

J. *For an enclosed wc fan, the switching can be combined with that used to operate the light. Wiring colours and details in these two drawings apply to the UK only*

Venner Artists

inside of a deep stud-partition wall, beneath floorboards and between joists, or along purpose-built boxing to an outside wall where it ends in a special grille. Similar forms of ducting are used for ceiling-mounted extractor fans when moisture-laden air has to be led to the outside. You can use rigid PVC pipework components in place of flexible ducting, but additional bracing will probably be required to hold the pipework firmly in place. Figs. C to H show some typical ways of ducting both wall- and ceiling-mounted fans, using push-fit piping.

Where possible, use flexible ducting hose. Try also to keep the route as short and straight as possible, and angled slightly downwards to prevent collection of condensed moisture.

Moisture content is much less of a problem with WC ventilation, so the ducting can be terminated high up in unused roof space, or in the eaves.

Electrical connections

It is important to follow manufacturer's specific instructions when you come to make the electrical connections, particularly where a fan is being used in damp conditions such as a bathroom or separate shower. Details here are basically for UK electrical systems. In Canada, check if you are allowed to do the work yourself or have to employ a professional.

The WC fan installed in figs 1 to 10 is connected to the supply via a suitable on/off double-pole isolating switch using 0.5mm three-core cable. Protection is provided by a 3 amp fuse if a 13 amp plug is used for the connection, or a 5 amp fuse if wiring is carried from the distribution board. Alternatively, install it on a fused spur (see pages 356 to 359 and Part 5 of the Home Electrics course). The fan must be earthed (grounded) properly.

This fan has a timer and remains activated for up to twenty minutes after the light is switched off if connected in this way.

In the UK, the ceiling mounted bathroom fan must be wired to the supply in such a way that plug and socket are outside the bathroom itself. Either run a fused spur to the ceiling—perhaps via adjacent walling—or use existing supply wiring in the roof space.

The electrical connections for heavy-duty fans with variable control devices are more involved, as additional wiring is normally necessary. In this case, running the wires through conduits makes for a neater job and protects the connections from the effects of future improvements.

Make a linen box

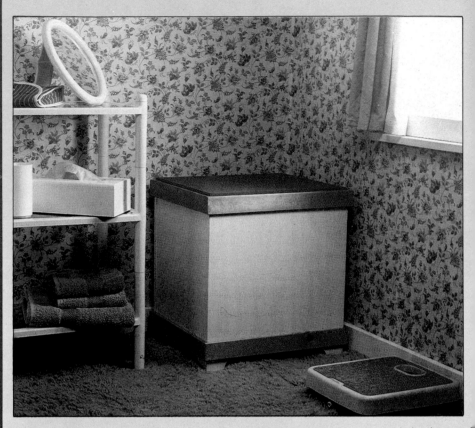

This handy linen box is convenient for keeping your bathroom tidy—and it is also a useful little stool. It is made of white melamine faced chipboard, which is easy to keep clean, and has a cork top to make the seat more comfortable.

It is easy to make—you can use almost any method of jointing chipboard, but the dowel joints shown in the drawings give a strong, neat corner construction.

Cut out the four side panels and shape the base cut-outs, using a coping saw for the curved cuts. Then fit the battens to support the base on the inside and make the corner joints using your preferred method.

Add the softwood trim to the outside of the box. The drawing shows simple butt jointed corners, but you can use a mitre joint for a neater finish if you prefer.

Cut out and fit the base panel. This can be made from plywood, hardboard or melamine faced hardboard.

Make the top from another piece of melamine faced chipboard. The drawing shows how to make a simple lift-off top by framing this with a softwood

trim matching that around the base of the box. Join the softwood to the edge of the top with dowel joints or even glue and panel pins. Complete the top by adding a cork panel to the upper surface. You can use tiles or sheet cork, but make sure it is the hard-wearing type and not that designed for use on walls; the latter will not stand up to the wear. Bevel the edges of the cork for a neat finish using short strokes from a planer file.

As an alternative to the lift-off lid you can hinge the top. Use butt hinges, cranked hinges or concealed cabinet hinges. You will have to omit the softwood trim along the back edge. Instead of fitting it to the lid, cut it into two long strips and bevel the edges at 45°. Fit one half to the lid and one to the box. The V which you cut out will then allow the lid to open back to 90°. Fit a locking stay to retain the lid in the opened position for easy access.

The melamine faced chipboard needs no finishing other than iron-on edging strip. Finish the softwood trim with lacquer or gloss paint as you prefer but be sure to match it to the box.

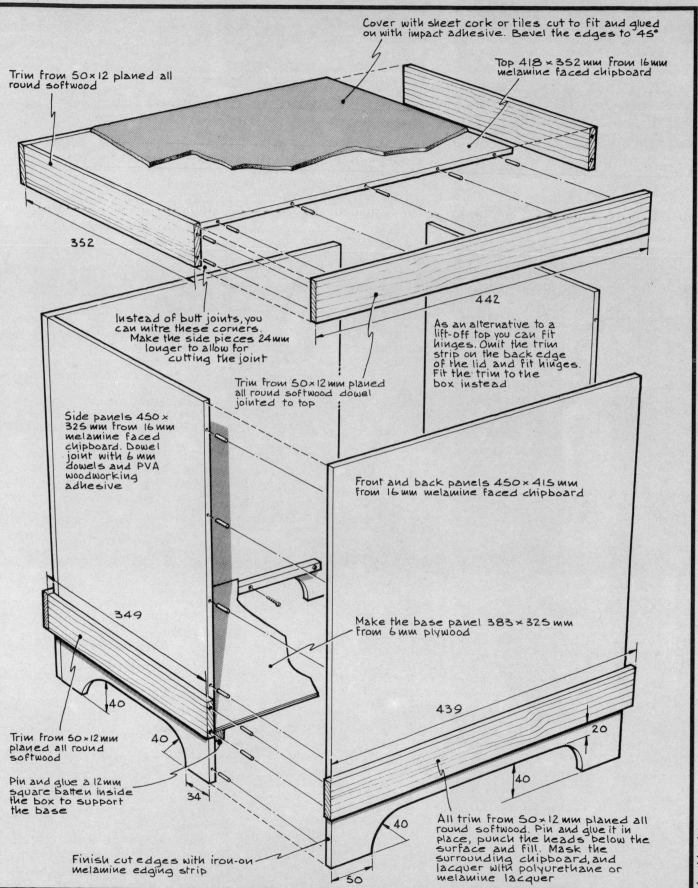

Cover with sheet cork or tiles cut to fit and glued on with impact adhesive. Bevel the edges to 45°

Top 418 × 352 mm from 16 mm melamine faced chipboard

Trim from 50×12 planed all round softwood

352

Instead of butt joints, you can mitre these corners. Make the side pieces 24 mm longer to allow for cutting the joint

442

As an alternative to a lift-off top you can fit hinges. Omit the trim strip on the back edge of the lid and fit hinges. Fit the trim to the box instead

Trim from 50×12 mm planed all round softwood dowel jointed to top

Side panels 450 × 325 mm from 16 mm melamine faced chipboard. Dowel joint with 6 mm dowels and PVA woodworking adhesive

Front and back panels 450 × 415 mm from 16 mm melamine faced chipboard

349

Make the base panel 383 × 325 mm from 6 mm plywood

439

40

Trim from 50×12 mm planed all round softwood

40

40

20

34

Pin and glue a 12 mm square batten inside the box to support the base

40

Finish cut edges with iron-on melamine edging strip

50

40

All trim from 50×12 mm planed all round softwood. Pin and glue it in place, punch the heads below the surface and fill. Mask the surrounding chipboard, and lacquer with polyurethane or melamine lacquer

Ventilation in the kitchen

● Why you need ventilation ● Calculating requirements ● Positioning the ventilator ● Heater ventilation ● Ventilation for other appliances ● Fitting an extractor fan ● Fitting an extractor cooker hood and duct

Gavin Cochrane

Lingering cooking smells and an excessive amount of steam condensation create an unpleasant and unhealthy environment in the kitchen. Fitted ventilation gets round the problem, and still allows you to keep the room warm and comfortable.

With improved heating, better draught proofing and double-glazing more common today, the home (at worst) or a room (at least) becomes a sort of sealed unit where internally generated smoke and steam can remain trapped.

The higher the room temperature, the larger the potential moisture content (humidity) of the air and the greater the likelihood of condensation forming. This can ruin paint and wallpaper—and given time, plasterwork—in the same way as damp. In the kitchen, condensation can cause unsightly mould growths while moisture-borne particles of grease act as a breeding ground for germs.

Raising the room temperature increases the moisture-carrying capacity of the air but is not in itself a successful way of preventing condensation. For this to be achieved the moisture-laden air must be carried out of the house altogether—the job of a ventilator or extractor fan.

Calculating your requirements
The cheapest form of kitchen ventilation is a self-actuating, window-mounted plastic ventilator. But although these are comparatively easy to fit, they cannot normally cope with the demands of a kitchen and some form of mechanical ventilation should be used instead.

If a combination of moisture and cooking fumes is the problem, the choice of kitchen ventilator is normally between a wall- and a window-mounted extractor fan.

Extractor fans (exhaust fans) blow stale inside air to the outside. Unless draughtproofing is completely efficient —a most unlikely possibility—this air is replaced by seepage into the kitchen from elsewhere. Between ten and twenty 'air changes' an hour are considered necessary for a kitchen. The lower figure applies when the room temperature is high and the cooking times are short, the higher figure when the kitchen is particularly cold

Left: *Extractor fan mounted at the top of a non-opening window pane*

446

Bernard Fallon

Above: *A clothes drier is one of the appliances worth ducting directly to the outside. The hole in the wall should be wide of, and below, the exit point on the drier, and sloping slightly to the outside*

or hot and steam and fumes are obviously troublesome—such as when cooking for several people.

One air change is equivalent to the volume of a room, so to help select the right extractor fan calculate your kitchen's volume (length × height × width, in metres) and multiply this by between ten and twenty, as outlined, to find the hourly capacity required. Divide this figure by sixty if a fan's capacity is quoted in minutes. Always err on the side of a more powerful machine if in doubt.

If draught-proofing is efficient, an extractor may reduce the air pressure in the kitchen to a point where the efficiency of the fan is impaired. The problem can be made even worse by having a fuel burner in the room. To get round it, you must fit an air inlet, preferably as far from the extractor fan as possible.

If cooking fumes alone need to be removed, an extractor hood mounted above the stove may provide adequate ventilation. This can be either of the recirculating type—where steam-borne grease and smoke are filtered out before air is returned—or an extractor type where partly-filtered air is ducted to the outside.

Right: *Position the extractor as far as possible away from air inlets such as the door and ventilators*

The latter type is considered more efficient, though installation procedures are more involved (see the project that follows).

Heat, too, is expelled by extractor fans but this should not be much of a problem at cooking times. Recirculating cooker hoods require frequent cleaning and replacement of their filters to keep them fully efficient. Some models can be converted into extractors by fitting an optional blanking plate and duct.

Heater ventilation

If your heating system uses a fuel-burning (non-electric) appliance, an adequate fresh air supply to this is essential—for both good combustion and the removal of toxic waste gases.

Unless your appliance incorporates a 'balanced flue' which lets in as much air as it expels fumes, effective draughtproofing of a room could starve the appliance of air and cause fumes to be drawn down the flue.

Central heating appliances are often located within the kitchen area in British homes, and this is another consideration in any kitchen ventilation project. An air vent on a door, or airbrick on an outside wall close to the burner, is a simple solution which

should not impede other arrangements.

Another method is to fit a ventilator plate in floorboarding close to the appliance, though this is possible only if you have a suspended floor. The grille should be placed as close to the burner as possible to prevent floor-level draughts.

At its extreme, an adequate air supply to a burner can be provided by a wall or underfloor duct linked to the outside.

Ventilation for other appliances

Another appliance that may need ducting to the outside is a clothes drier. A wall -or window-mounted extractor fan can be used as an alternative but is usually less effective at preventing condensation build-up.

The procedure for fitting a duct is the same as for a stove hood (see page 450) though the specific instructions supplied by the appliance manufacturer should be followed.

In the case of a clothes-drier duct, avoid sharp bends and fine-meshed grilles which may collect minute, moisture-borne fibre particles. These need cleaning from time to time in any case, so leave some access to the duct ends and make sure the outside grille can be removed for cleaning.

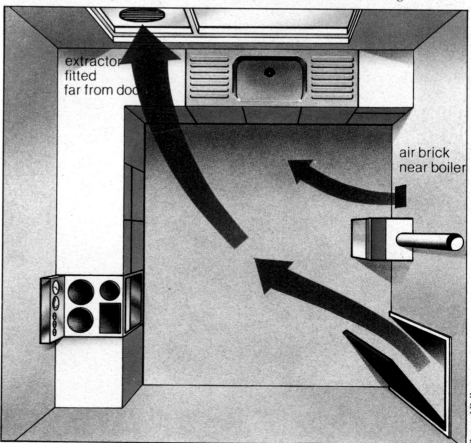

extractor fitted far from door

air brick near boiler

Bernard Fallon

Fitting an extractor fan

Positioning a ventilator

You can mount an extractor fan (exhaust fan) in a convenient external wall or window. Either way, it should be located as close to the ceiling as possible, near the sink and stove but not right above these unless the window or wall here is high.

Window mounting requires that a hole be cut in the glass. Although not a difficult task (see opposite) accidental breakage is all too easy. Using a replacement pane with a hole cut in it by the glazier makes fan installation much easier.

external grille

flange assembly

ring assembly

impeller

A. *When the hole has been cut, fit the flange and gasket assembly of the unit in place. The components screw together with this unit*

B. *A fused spur needs to be wired to a junction box situated close to the fan. Conceal the wire using plastics duct to the junction box*

C. *After you have completed the wiring, fit the face-plate by snapping it into place on the lugs provided on the box*

D. *Pull-cord switches hanging from the extractor fan allow you to operate the fan conveniently, and with safety*

socket assembly

motor and shutter assembly

internal grille

housing assembly

Above: *The Vent-Axia 150 is one of a number of extractor fans for domestic use sold in Britain. As with others, the design is based on interchangeable components, which enables straightforward assembly and maintenance. Flange and ring arrangements—each with gasket—are screwed together to fix the unit in place*

A plywood board, holed and trimmed to size, can be used instead of glass, but needs to be of exterior grade plywood and to be well sealed or painted.

The appeal of window mounting is that no structural work is involved. Offset against this is the obstructed view, restricted window opening for summer time ventilation and the untidy appearance of the unit.

It takes a little longer to install a wall-mounted fan but the additional effort is usually considered worthwhile. The necessary removal of inner and outer brickwork is not a difficult job for the handyman (see pages 178 to 182 and figs 1 and 2).

The hole should not be made any nearer than two bricks' lengths to a wall edge otherwise structural weakening may occur. In the case of a cavity wall, a liner must be used to seal off the cavity or fumes and moisture will be expelled into it.

Extractor fans are also used to give ventilation to internal rooms. Do not be tempted, though, to have the outlet from a fan discharge into an unused chimney flue—this is likely to cause condensation problems.

1. *Adjust the circle scribe and clamp*
2. *Scribe outer and then inner circle after oiling cutter and work area*

3. *Score criss-cross lines over area of inner circle*
4. *Tap scoring and then knock out circle*

6. *Nibble away any remaining bits gently, using a pair of pliers*

5. *Score to outer circle then tap and knock out*

Fitting an extractor hood

A cooker hood is placed directly above the hobs, and is not normally used in conjunction with stoves having an eye-level grill assembly. The hood should be sited squarely over the cooking area and no less than 600mm above it. Most cooker hoods hook or slip on to brackets fixed to the wall, enabling them to be removed for filter maintenance and cleaning.

If the hood is to be used as an extractor with ducting to the outside, consider relocating the stove if this will make the work easier and shorten the path for the duct. Hoods can be ducted directly to the outside but, if the stove is to remain in the most convenient spot, a length of flexible duct piping is usually required (see figs. 1 to 11). This can be concealed by a dummy section fitted cupboard, or by purpose-made boxing-in. Flexible pipe duct can be used for an extractor fan which cannot be located on an outside wall, but keep the length short.

Fitting a cooker hood above a stove or mounted hob unit presents very few difficulties. If the hood is of the type that simply filters and recirculates the air, little work is required. An extraction hood is much more efficient in clearing cooking fumes. However, additional work is required in providing a duct to an outside wall, making a hole in the wall and concealing the flexible hose that connects the hood to the outside. Taken individually, none of these jobs is particularly complicated but a full day should be allowed for the project.

Making a hole in the wall is a straightforward but major part of the operation (see pages 178 to 182 for details). Line the hole to prevent draughts and heat loss. Slope the hole downwards to the outside slightly if this is possible. A purpose-made ducting kit (which may or may not be supplied with the extractor hood) should be fitted according to the manufacturer's instructions.

If possible, re-plan your kitchen so that ducting can be reduced to a minimum by placing the stove nearer to an outside wall.

4 Fix a cover on the outside if one is not included in the kit. This one simply nails into place after fitting to the duct liner

8 To fit the duct to the hood attach the supplied hose plate to the rear of the cooker hood unit, following the maker's instructions

Venner Artists

1 Expose the brickwork at the point where the duct is required. Drill or chisel through to the outside (*see pages 178 to 182*)

2 Widen the hole in the wall from the outside to a width slightly greater than the duct fitting, insert the liner and make good the gap

3 Attach the flexible duct hose to the fixed inner duct plate. The hose is then directed to the cooker hood as tidily as possible

5 The cooker hood itself should be positioned square to, and about 600mm above, the cooker hob area. Use a measure and level

6 A template is usually provided to enable precise location of the fixing screws or brackets which support the weight of the hood

7 For efficient operation—and looks—the hood should be levelled off. Fine adjustments are made by a nut and screw arrangement

9 The duct will have to pass through any surrounding built-in cupboards. Prepare and drill holes as required

10 When the duct hole has been completed—a power jig saw is ideal here—mount the cupboard above the hood

11 Prior to fitting the last section of cupboard or boxing, connect the flexible hose to the hood and smoke test for leaks

James Johnson

451

ELECTRICITY IN THE HOME

How electricity works

Electric current explained ● Units of electrical measurement ● Loop, radial and ring-main circuits ● Earthing ● Fuses and circuit breakers ● Mending fuses ● Wiring a plug

Electricity in the home is something which we all take for granted—and would be lost without. Yet electricity is also highly dangerous if it is not treated with the respect it deserves. For the do-it-yourself enthusiast, this means having a sound knowledge of the way in which domestic installations work before tackling any electrical job with confidence.

Electricity and the law
In the UK, regulations covering wiring are compiled by the Institute of Electrical Engineers. Anyone may do his own wiring, but the IEE regulations must be complied with. These require that all electrical installations be tested on completion by the relevant electricity supply board.

In the US and Canada, the ordinances laying down what you are permitted to do vary from area to area. In some communities you may do complex installations; in some, only partial installations; in others, you may not touch the permanent wiring at all. So check with your local building inspector before you do any work.

Electrical measures
An electric current consists of a flow of minute particles called electrons. This flow can be likened to the flow of water from a tap connected by a pipe to a tank.

For water to flow when the tap is opened, the tank must be at a higher level than the tap. And the greater the height of the tank, the higher the pressure of the water that comes out of the tap. So water at high pressure has a greater rate of flow, or current, than water at low pressure.

The *voltage* in an electrical circuit corresponds with the *pressure* of the water in the pipe. The *rate* of flow of an electric current is measured in *amperes* and is equivalent to the flow of water along the pipe—that is, how much comes out at any given time.

Electrical power is measured in *watts*. This term applies to the electrical equipment itself and is a measurement of the rate at which it uses electricity. An average electric light bulb uses only about 100 watts, whereas a powerful electric heater might use 3,000 watts (3 kilowatts). The relationship between amps, volts and watts is expressed in the formula:

$$\frac{\text{Watts}}{\text{Volts}} = \text{Amps}$$

This formula is useful for determining both the correct size of cable to use for an appliance and, in British systems, the correct size of cartridge fuse inserted in its plug.

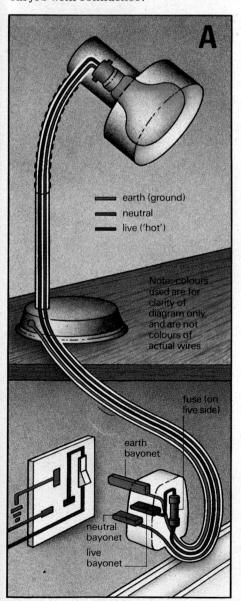

earth (ground)
neutral
live ('hot')

Note: colours used are for clarity of diagram only, and are not colours of actual wires

fuse (on live side)

earth bayonet

neutral bayonet

live bayonet

A: *Power runs to an appliance via the live wire and returns via the neutral. To safeguard against electric shocks, the switch is always on the 'live' side*
B: *For a wall switch, the live current must be diverted down the wall and back. Usually a standard two-wire cable is used, with wires of—confusingly—different colours. But both wires are in fact 'live'*

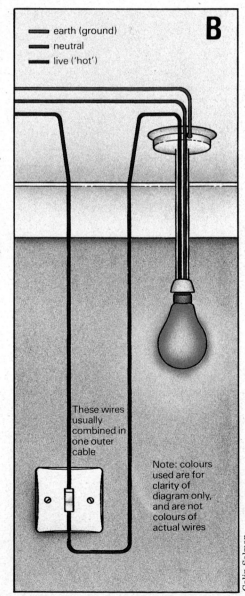

earth (ground)
neutral
live ('hot')

These wires usually combined in one outer cable

Note: colours used are for clarity of diagram only, and are not colours of actual wires

Colin Salmon

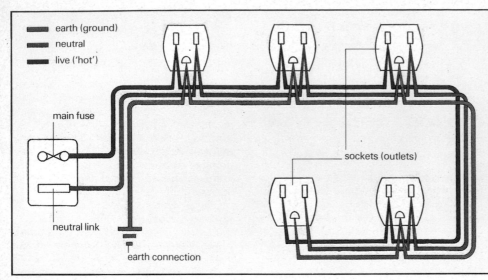

Loop circuit

C. *Typical loop circuit, with each light or power outlet 'looped off' from the one before. In British circuits, the live wire is red, the neutral black, and the earth is bare copper covered with a green plastic sleeve inside the socket. In US and Canadian circuits, the live wire is black and connects to the brass terminal ('black to brass') and the neutral is white and connects to the white metal terminal. The ground wire is bare copper, sometimes terminating in a green-plastic-covered 'jumper'.*

Labels in figure C: earth (ground); neutral; live ('hot'); main fuse; neutral link; earth connection; sockets (outlets)

Domestic installations

The comparison between the flow of water in a pipe and an electric current in a wire is not exact: electricity requires a closed loop—a circuit—in order to work.

Electricity comes into the home from a local transformer through an armoured service cable or via overhead wires. The service cable is connected to a fuse unit—called the company fuse—which is sealed by the electricity board or company. From here, power flows along the live supply wire and through the meter to the consumer unit—a combined fuse box and main switch, of which fig. E is one example. The live supply wire is usually encased in two separate sheaths. The electricity then flows through your lights and appliances before returning to the local transformer along the neutral wire. A third wire, the earth, connects the appliance casing to the main fuse box casing and then to the ground. Unless a fault develops, it carries no current.

Loop circuits

In the US and Canada—and most other parts of the world—power and lighting outlets are served by a system called *loop* wiring (fig. C). In this system the live, neutral and earth wires run outwards from the main switch to the first light (or power socket). From there they are 'looped off' to the second light; from the second light to the third; and so on. The number of lights and/or power outlets on each circuit is limited by local ordinances, so that every house needs a number of circuits. In some such systems, an individual circuit will supply both lighting and power outlets. In others, the lighting circuits and those that supply wall sockets (for appliances and so on) are separate installations.

In the UK, lighting circuits are still of the loop type. And up until 1947, power circuits were also of a similar type called *radial* wiring, in which each socket was served by a live, neutral and earth cable direct from the main fuse board. These older British systems are fitted with three varieties of round pin sockets rated at 15 amps, 5 amps and 2 amps. The configuration of the pins is the same in all three cases but reduces in size with current rating.

In all loop and radial systems, because the plugs that fit the sockets have no fuse of their own to help protect appliances, the circuit fuses in the fuse box must be kept to as low an amp rating as possible in order to give both the cable and the appliance a reasonable degree of protection from overload.

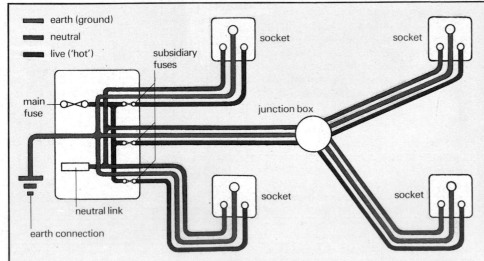

Radial circuit

D. *Radial circuit of the type used in British installations before 1947. The wire colours are the same—red (live), black (neutral) and green (earth) as in newer wiring, but the sockets have no fuses, being protected instead by fuses at the main switchboard. When re-wiring, the metal conduit from the old system is often useful as a means of feeding new wires through the wall plaster. But the ends of this conduit often have to be cut off so they cannot touch a live wire in the new sockets or switches.*

Labels in figure D: earth (ground); neutral; live ('hot'); subsidiary fuses; main fuse; neutral link; earth connection; socket; junction box

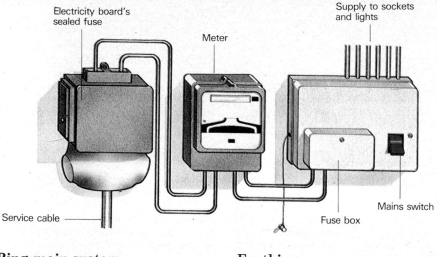

Electricity board's sealed fuse

Meter

Supply to sockets and lights

Mains switch

Fuse box

Service cable

E. *Electricity enters the house through an armoured service cable connected to the company fuse. From here, power flows to the meter*

Ring-main system

In Britain, houses wired since 1947 use, for power socket circuits only, a different wiring system known as the *ring-main* circuit (fig. F). In this system, the live, neutral and earth wires run in a complete circle from the main switch to each socket in turn, and then back to the consumer unit. There is generally one ring for each floor of a house, with 'spurs' reaching out from it to supply isolated sockets and appliances which take a lot of power, such as the stove.

Plugs and socket outlets in ring-main circuits are of the 13-amp rectangular pin type. These are much safer than the old round-pin types because the sockets have shutters inside which automatically close when a plug is withdrawn. Furthermore, ring-main plugs, unlike other types, carry their own cartridge fuses. This means that should an individual appliance become faulty, only the fuse in its own plug—and not the main fuse for the whole circuit—will 'blow'.

Earthing

Should a live wire come into contact with the metal casing of an appliance, anyone who touches the appliance is liable to receive a severe electric shock. For this reason, domestic appliances—apart from ones that are double insulated—have an earth wire connected to their outer casings and led indirectly to ground.

This is so that, if a live wire makes contact with the casing, the electricity will follow the path of least resistance to the ground. That is, it will flow through the earth wire (grounding) instead of the person's body. At the same time, a live wire coming into contact with earthed metalwork will result in a large current flow that will blow the fuse.

The electricity flows from the live wire in this way because it is trying to reach the neutral—which is connected to earth back at the electricity board transformer. This system has been found to be the safest way of disposing of unwanted current.

Fuses

A fuse is a deliberately weak link in the wiring, thinner than the wires on either side. If an overload occurs, the fuse wire melts and cuts off the current before the heat from the overload can damage equipment or cause a fire.

Fuses should always be of the nearest available size above the amperage of the appliance or circuit that they protect. Most electrical appliances have their wattage marked on a small plate fixed to the back or base of the unit. So, for an appliance connected to a ring-main, you can use the formula above to find the amp rating and hence the correct fuse to go in the appliance's plug.

For example, say an electric fire has a rating of 3 kilowatts and the voltage of the mains is 240 volts. The current taken by the fire is found by dividing the watts—3,000—by the volts—240—which gives a result of 12.5 amps. Therefore, the fire should be protected with a 13-amp fuse, the nearest higher size available.

In Britain, it is recommended practice to use 3-amp cartridge fuses, colour coded red, for all appliances rated up to 720 watts, and 13-amp fuses, colour coded brown, for everything else up to a maximum rating of 3 kilowatts.

Most plugs come fitted with 13-amp fuses, the largest available size. But some appliances, portable TV sets for example, can be damaged by a current of less than 13 amps. So it pays to use the formula and check that the plugs on appliances are fitted with the correct size of fuse.

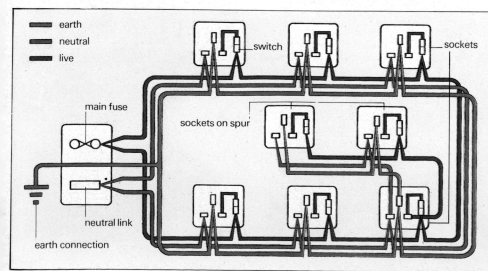

earth

neutral

live

switch

sockets

main fuse

sockets on spur

neutral link

earth connection

Ring-main

F. *The ring-main, exclusive to British houses. Each wire (the red 'live' for example) goes from the consumer unit to each socket in turn, and then back to the consumer unit, where the 'inward' and 'outward' ends are wired in together into the same hole in the appropriate terminal block. Each ring-main is protected by its own fuse in the consumer unit. In addition, each appliance that it serves has a fuse in the plug, lessening the chance of the main fuse blowing.*

Colin Salmon

Mend a fuse

There are three main types of circuit fuse: wire fuses, cartridge fuses and circuit breakers. It is important to know which type you have and to keep a supply of spare fuse wire or cartridges. Circuit breakers need no spares as they are switches which automatically shut off if the circuit is overloaded at any time.

Most fuse boxes are covered by a plate which either clips on or screws into place. **Always turn off the mains switch before removing the plate or touching any fuse.**

With the plate removed you will see a row of fuse carriers made of porcelain or moulded plastic (fig. G). Some are colour coded on the back: white for 5 amp lighting circuits, blue for 15 amp heating circuits and red for 30 amp power socket circuits. Alternatively, the amperage may be stamped on the back of the holder.

As a further guide it is a good idea to mark the fuse holders with the purpose of the circuit they protect—'1st floor sockets', 'Ground floor lights' and so on.

Take out the first fuse—the holders simply pull out and clip back into place—then replace the cover and turn the mains switch back on.

Check each circuit until you find the one that has stopped working. Turn off the mains again, remove the cover and mark the fuse holder accordingly. Afterwards, clip it back into place and repeat the operation for the other fuses in the box.

When a fuse blows, the first thing to do is to discover the cause and rectify it. If you suspect that the failure is due to a faulty appliance, unplug it and do not use it again until it has been mended.

Sometimes fuses blow for no obvious reason. It may be that the fuse has just worn out in which case when it is replaced, the current will flow as before. But if a fuse keeps blowing each time it is replaced, there may well be a serious fault somewhere in the wiring and you should contact an electrician.

Once the fault that caused the fuse to blow has been put right, locate the blown fuse. On *bridge wire* fuse holders (fig. G), the fuse wire is held in position by a screw at either end. The wire runs over the surface of the holder, so a broken fuse can be clearly seen. In *protected wire* fuse holders, the wire runs through a tube inside the holder. To check it, gently try to prise the wire out of the tube with a small screwdriver. If the fuse is blown, half of the wire will come away.

To mend a wire fuse, loosen the screws and discard the broken wire. Replacement fuse wire is sold ready for use, mounted on a card. Use wire-cutters to cut a new length of wire of the correct amperage rating. Wrap the ends of the wire around the screws in a clockwise direction so that when you retighten the screws the wire is not dislodged. Finally, replace the holder and fuse box cover and switch the power back on.

In cartridge fuses, the wire is encased in the cartridge and can only be checked, at this stage, by replacement. Unclip the old cartridge and fit a replacement of the same amperage rating as the original.

When a circuit breaker shuts off, locate the fault that has caused it to do so, then reset the switch or button on the affected circuit.

When mending fuses, on no account be tempted to use a fuse of too high an amperage rating—you will be putting your entire electrical system at risk.

All the equipment you need for mending fuses—screwdriver, torch, wire cutters and different sizes of fuse wire or cartridges—should be electrically insulated.

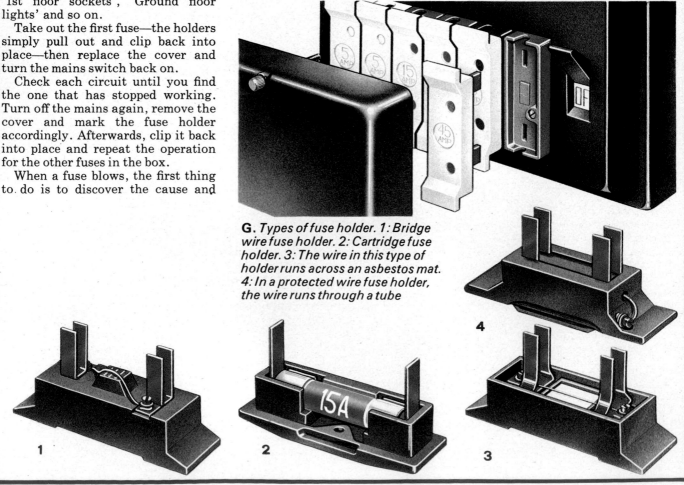

G. *Types of fuse holder. 1: Bridge wire fuse holder. 2: Cartridge fuse holder. 3: The wire in this type of holder runs across an asbestos mat. 4: In a protected wire fuse holder, the wire runs through a tube*

Wire a plug

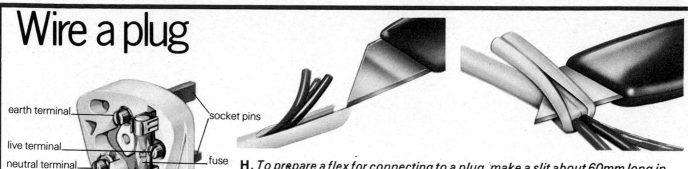

earth terminal

live terminal

neutral terminal

cord grip

socket pins

fuse

H. *To prepare a flex for connecting to a plug, make a slit about 60mm long in the outer sheath, using a sharp knife. Take care not to damage the wires inside. Bend the parted sheath away from the wires and cut off*

Cheap accessories invariably heat up in use—producing a fire risk—so it is important to use high quality plugs. Furthermore, it is essential to wire plugs correctly—incorrect wiring can be dangerous.

Remove the cover of the plug, by unscrewing the large screw between the pins, to reveal the three terminals which are attached to the pins of the plug. As you look at the plug, the terminal at the top connects to the green and yellow earth wire. The brown live wire connects via the fuse to the live pin on the right, and the blue neutral wire to the neutral terminal on the left.

Some older appliances have differently coloured wires; green for earth, red for live and black for neutral.

Appliances that are double insulated—such as television sets—do not have an earth wire so the earthing terminal should be left unconnected.

Loosen the cord grip which is secured by two screws at the base of the plug. The cord grip is to clamp the sheathing of the flex to the plug to prevent it from being pulled out accidentally. Some modern plugs are fitted with a fixed plastic gate in place of a conventional cord grip.

The sheathing of the flex must now be removed to a distance of about 60mm to allow the earthing wire to reach its terminal. Slit the outer sheath of the flex with a sharp knife taking care not to damage the wires (fig. H). Wires with damaged insulation should never be used.

Put the flex under the cord grip and firmly tighten the fixing screws so that the grip clamps the sheathing firmly in place. On plugs with a plastic gate, the sheathing should be pressed into position between the two halves of the gate.

Cut the three wires with wire clippers so that each can wrap round or

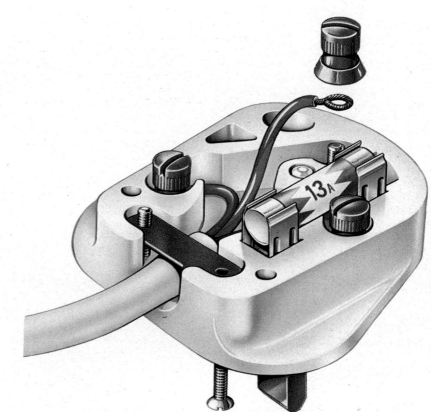

J. *Secure the flex in the cord grip by tightening its fixing screws. Strip the insulation from the end of the three wires, baring only enough wire to wrap safely around each terminal. Twist the strands and form a loop*

pass through its terminal, then use a wire stripper to remove the insulation from the ends. Bare enough wire to fit around the terminal. Twist the strands making up each wire together then fasten the wires to their terminals making sure that there are no loose strands left free.

Remove the terminal nut and washer and form the wire into a closed, clockwise loop around the terminal so that it will not unravel it when the wire is being retightened (fig. J). Replace the washer and nut and tighten.

In some plugs, the wire passes through a hole and is secured by a small screw at the top of the terminal. Here, the wire should be bent double before being inserted.

Finish off by clipping a working fuse into the fuseholder, making sure it is of the right amp rating for the appliance. Screw on the cover of the plug and it is ready for use.

Round pin plugs should be wired up in the same way as 13 amp plugs but, as they have no fuse, make sure that the current rating of the plug is adequate for the connected load.

Understanding the wiring

Cable and flex ● Colour codings ● Using flex safely ● Junction-box and loop-in circuits ● Cutting and fitting cable ● Installing an extra ceiling light ● Wiring an extension ● Fitting and connecting a ceiling rose

B. Right: *In a junction-box lighting circuit, each ceiling rose and switch is wired to a junction box above the ceiling.* **Below:** *In a modern loop-in system, the cable runs from the fuse box to each ceiling rose in turn. The switches are wired into the roses*

The bulk of the work in any electrical project is installing wiring. In some North American localities such work must be undertaken by qualified electricians—though a knowledge of the system is still helpful to the layman. In Britain you can do your own wiring, provided the work is inspected by the supply authority.

Electrical wiring in the home is made up of *fixed* wiring and *flexible* wiring. Fixed wiring, housed within the 'fabric' of the home, carries electrical current from the consumer unit (main fuse box) to fixed outlets such as sockets and lights. Flexible wiring provides the final link from a socket to an appliance, or from a ceiling rose to a lampholder.

A. *Some types of flex and cable used in the UK. Note that Canadian flexes and cables are different, and colour coding is different too.* **(a)** *Twin and earth cable used for lighting circuits. Red is live, black is usually neutral, but might be live if connected to a light switch.* **(b)** *The same sort of cable but larger and used for ring mains.* **(c)** *Flex—used for connecting appliances. The colour coding is different.*

Electrical cable

Fixed wiring consists of *cable*. This is made up of individual wires, or *conductors*, which carry the current, and *insulation* to prevent the current from leaking. In new wiring, the live and neutral conductors are usually insulated separately in colour-coded plastic sheaths then laid together with a bare earth wire in a common, outer sheath. In some older installations, each conductor runs separately within its own inner, colour-coded and outer sheaths. In others the live and neutral conductors are housed in the same outer sheath but the earth runs separately.

In **Britain,** the colour coding for cables is: red for live, black for neutral, and green/yellow striped for earth where this is insulated.

In the **US** and **Canada,** the colour coding is: black for live (or black and red where there are two line wires), white for neutral, and green for earth where this is insulated.

Modern cable is insulated with PVC which has an indefinite life and is impervious to damp and most common chemicals. Older installations may have been wired with rubber-insulated cable. This has a life of only about 30 years, after which it may begin to break up and become a potential danger. If your wiring is of this type, do not attempt to extend it.

Fixed wiring runs around the home hidden beneath floorboards and buried in walls. When recessed in solid plaster, the cable is protected by a length of plastic or metal tube called a *conduit.* Beneath floorboards, the cable can run freely along the sides of, or through holes bored in, the floor joists. When laid beneath floorboards, the cable should be slack, but well supported—either by lying on a ceiling of the floor below, or by being secured in place with cable clips.

Electrical flex

The conductors in flexible wiring, or *flex*, are made up of a number of thin wires. This enables them to stand up to repeated twisting and coiling,

as occurs when the flex is wrapped around an unused appliance. But though flex is strong along its length, it should never be strained at the ends. Never pull a plug out of a socket by the flex or you may strain the terminals, making the plug and flex potentially dangerous.

In **Britain,** the conductors in three-core flex are colour coded brown for live, blue for neutral, green and yellow for earth. Older appliances may have flex with the same colour coding as cable: red (live), black (neutral) and green (earth). In the **US** and **Canada,** the live (hot) wire is black, the neutral white, and the earth green.

The two-core flex for double-insulated appliances requiring no earth is not always colour coded. The conductors in a table lamp flex, for example, are often insulated in transparent plastic because on non-earthed appliances, it does not matter which conductor connects to which terminal.

There are various thicknesses of flex conductor—appliances of high wattage ratings requiring thicker conductors than those of a lower rating.

If you need to lengthen a flex for any reason, make sure that the new length is of the same type as the existing flex and use a factory-made connector of the correct amp rating to connect the two. Never use insulating tape to join the conductors.

Lighting circuits

Older houses often have *junction-box* lighting circuits. In this system, the cable runs from the fuse box to junction boxes above the ceiling. Separate cables then run from the junction boxes to ceiling roses and light switches. You should not add a light to a junction-box circuit without seeking expert advice.

In the modern *loop-in* system the wiring is continuous, running from the fuse box to each ceiling rose in turn. The switches are wired directly to the roses. A light controlled by its own switch can be added to a loop-in system by wiring an extension from the circuit cable running into an existing ceiling rose.

junction box

ceiling rose

ceiling rose

separate
lighting
fuse box

switch

switch

ceiling rose

switch

switch

ceiling rose

ceiling rose

ceiling rose

main fuse box

switch

switch

An extra light in the ceiling

Installing an extra light connected to an existing one, and controlled by the same switch, is a straightforward project.

The main items you need are a lampholder to take the light bulb and a new ceiling rose. For connecting these two, buy 1mm² flex. If the lampholder you plan to use is brass, it will have to be earthed, so buy three-core flex. Otherwise buy two-core. For connecting the new ceiling rose to the old one, buy 1mm² twin-with-earth cable, allowing about 0.5m more than the distance across the ceiling between the two lights. Also buy a short length of 2mm green/yellow PVC sleeving to insulate each earth wire.

Preparing to wire

Decide where you want to situate the light and drill a small pilot hole up through the ceiling.

From the floor above, locate the hole and the existing ceiling rose. Unless you are working in the attic, this necessitates the removal of floorboards (see pages 224-226). Enlarge the hole with a 13mm bit. If the hole has emerged in an awkward position, such as too close to a joist, alter its position slightly—the original hole can be filled in later.

To mount the new ceiling rose base, a piece of 150mm × 25mm blockboard is fitted between the joists over the hole. Measure the distance between one of the joists and the hole and transfer the measurement to the piece of board. Drill a 13mm hole in the board, fit it over the hole in the ceiling and attach it with angle brackets to the joists on either side. You can now fix the rose base to the ceiling below. Make sure that its hole is in line with the hole in the ceiling and screw it through the plaster into the blockboard (fig. 1).

Go back into the ceiling and run a length of cable from the existing light's ceiling rose to the new rose, allowing a generous amount at either end for cutting and wiring-in. If the cable route is parallel with the joists the cable can lie unclipped between them. If it runs at right angles to joists which are carrying floorboards, however, you will have to drill holes through the joists. Drill these at least 50mm from the tops of the joists to prevent damage by nails when the floorboards are replaced.

Left: *An extra light can be fitted to a ceiling to bring a gloomy corner of a room to life*

Next, prepare the cable for connection. First slit it for about 50mm from the end by sliding the blade of a handyman's knife between the live wire and the bare earth wire. If you angle the blade slightly against the bare wire as you go, you will find you can split the outer insulation sheath without cutting through the red insulation on the live wire itself. With the sheathing removed for about 50mm (fig. 2), strip about 6mm of insulation from the end of each wire with a pair of wire strippers.

Wiring the new ceiling rose
Return to the floor below and prepare both ends of the flex that will run from the ceiling rose to the lampholder. Remove about 75mm of sheathing from the end to be connected to the ceiling rose and 50mm from the end for the lampholder. Bare the ends of the wires. Sleeve the bare earth wire of the new cable (fig. 2) and connect the cable and the flex to the ceiling rose. It does not matter which of the ceiling rose terminals you use for which group of wires as long as you group the wires correctly in the same terminal block—the two lives (red cable and brown flex) together; the two neutrals (black cable and blue flex) together; and both earth wires together if your flex includes an earth wire.

Tighten all the terminal screws and hook the flex wires over the two anchor pieces in the base of the ceiling rose. These are designed to take the weight of the hanging light off the terminal screws. Slip the ceiling rose cover up over the flex and screw it onto the base. Then connect the lampholder to the other end of the flex, again hooking the wires over the anchor pieces provided and making sure that the terminals are fully tightened.

Wiring-in the extension
Before wiring-in the extension, you need to isolate the electric circuit you plan to work on. To do this, turn on the light to which the extension is to be made, and keep pulling fuses out of the consumer unit until the light goes off. (Turn off the power at the main switch as you withdraw or replace each fuse). Once you have found and removed the fuse for the circuit you want to work on you can turn the main switch on again. This allows you, if you need light during the wiring process, to plug a standard lamp into a wall socket.

Since both lights are to be operated by the same switch, they are wired-in *in parallel*—that is, connected to the same terminals in the lighting circuit.

So the first thing to do is to identify the terminals (or multi-hole terminal blocks) to which the **flex** of the existing light pendant is connected. These are the terminals to which the live and neutral wires of the new cable must also be connected.

If the existing pendant flex has coloured conductor wires, wire the red live wire of the new cable to the same terminal as the brown flex wire of the old light pendant. Similarly, wire the black neutral wire of the new cable to the same terminal as the blue flex wire.

If the existing flex is not colour-coded, you cannot tell which side is the live. This does not matter, so long as your new cable is connected to the same terminals as the old **flex,** and not to any other terminal (such as the switch terminal).

In either case, you may find you have to push one old wire and one new one into the same terminal hole. This again does not matter, so long as both are secure.

Before connecting the bare earth wire of the new cable, sheath it in sleeving as in fig. 2.

Make sure that all the wires in each terminal block are securely connected, replace the ceiling rose cover and you are ready to switch on.

1 *Drill a hole in a piece of board and fit it into place. The cables run through the hole into the base of the ceiling rose*

2 *Before connecting a cable, sleeve the bare earth wire in a length of PVC sleeving. Leave about 6mm of bare earth wire protruding*

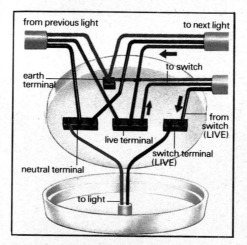

3 *In an existing, modern rose, you will find groups of terminals. Identify those the light bulb is connected to*

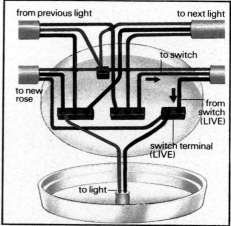

4 *Connect the cable for the new rose to the terminals you have already identified. Other terminals need not be disturbed*

All about sockets

● **Flush- and surface-mounted socket outlets** ●
Using plug adaptors ● **Installing extra socket
outlets** ● **Wiring sockets** ● **Converting single
into double sockets** ● **Running a spur from an
existing socket**

Today, the average home is equipped
with a far greater number of electrical
appliances than was the case a few
years ago. And if many of these appli-
ances are in use at the same time,
there may not be enough socket out-
lets to go round.

Socket outlets

In the UK, the sockets which have
three rectangular holes to accept the
pins of 13 amp plugs are used on ring
mains circuits and on some partially
modernized radial circuits (see pages
453 to 455). Socket outlets with round
holes for 2 amp, 5 amp and 15 amp
plugs are used only on radial circuits
and usually indicate that the circuit is

over 30 years old. The rubber insu-
lation on the fixed wiring in these
older circuits eventually begins to
break up, so a house with such a
circuit may need rewiring altogether.

Modern socket outlets can be flush-
or surface-mounted. The flush type
(fig. A) is screwed onto a metal box—
sometimes called a *pattress*—which
houses the cables and is recessed into
the wall. For surface mounting, the
same sort of socket is used, but this
time screwed to a plastic box which is
fixed to the wall surface. Surface-
mounting is usually easier, but because
the sockets protrude they may be more
easily damaged.

The boxes for flush-mounted sockets
are usually 25-35mm deep, though
some sockets can be mounted semi-
flush on a 16mm deep box. These have
the advantage that, when cutting the
housing in a masonry wall, you do not
have to cut away much, if any, of the
wall material behind the plaster.

Socket cover plates and, in the case
of surface-mounted sockets, the box
as well, are usually made of white
plastic. But for installations in places

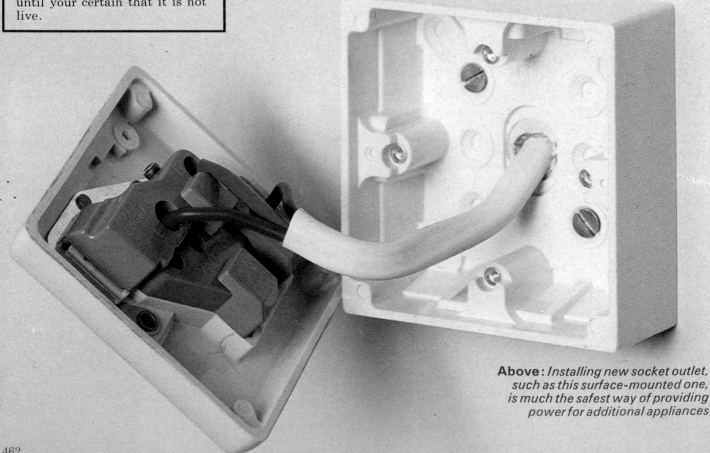

Above: *Installing new socket outlet,
such as this surface-mounted one,
is much the safest way of providing
power for additional appliances*

Ray Duns

462

A. *Flush-mounted socket and two-way plug adaptor. Boxes for flush-mounted sockets are 25-35mm deep*

B. *Surface-mounted socket and 13 amp plug. The live and neutral pins are sleeved for protection*

Venner

like garages where outlets have to be more durable, sockets with metal cover plates and boxes are available.

In the UK, regulations require the live and neutral holes of 13 amp sockets to be fitted with protective shutters to prevent people (children especially) from poking metal objects inside with possibly fatal results. Most sockets also have a built-in switch to minimize the danger of touching live parts when you insert or remove a plug. Some switched sockets include a neon indicator light to show when the socket is on. Switches are usually single-pole, cutting off the supply in the live wire only. This is usually sufficient: to totally isolate an appliance, remove the plug.

In a bathroom, where the presence of water increases the risk of electric shocks, the only sockets that can be installed are those specially designed for electric razors.

Plug adaptors
In rooms where there are too few sockets to go round, or where appliances are too far from free sockets, plug adaptors—sometimes called socket adaptors—are often used to plug two or three appliances into the same socket (fig. A).

A two-way adaptor with a fuse of the correct size is satisfactory for temporarily connecting low wattage appliances, such as table lamps or the hi-fi. But it is not advisable to use an adaptor for long periods or to plug in a high wattage appliance, such as a bar heater. By far the best approach is to add extra sockets.

Adding socket outlets
If a room has an inadequate number of socket outlets and you have a ring-main circuit, you can add extra ones without too much difficulty.

Even if you have enough sockets in your home, they may not be positioned where they are most needed. An extra socket or two can help.

A ring circuit can have an unlimited number of socket outlets and ideally, each room should have about four. The circuit should serve a floor area of not more than 100m², which is more than the area of an average two-storey house. So, if you decide to install extra sockets, there is no limit to the number you can add as long as they do not extend the circuit beyond the 100m² maximum.

Sockets are almost always mounted

C. *Sockets on a spur may have one or two sets of wires running into them, while those on the main circuit have two or three. A new spur can be run only from circuit sockets which are connected to two sets of cables*

Spur

mains circuit

mains circuit

A spur from the ring main

Running a spur from an existing socket means that you can place the new socket almost anywhere you like. Another advantage is that you do not have to run cables from the ring main under floorboards. You can simply feed it around a channel—or chase—cut into the wall.

To wire the spur, you need a sufficient length of 2.5mm² cable 'twin with earth' to stretch from the existing socket to the site of the new one. You also need a similar length of oval PVC conduit with securing clips and about 1m of green and yellow PVC sleeving (see page 458).

Choose as your source for the spur a socket as close to the proposed site as possible. The work will also be easier if the source is a twin socket—the larger box will have more room for an extra cable.

Before starting work, isolate the supply. Check on the suitability of your source socket by unscrewing the cover plate, easing it from the wall and comparing the wiring with the diagram in fig. C. If a spur has already been taken from it or the socket itself is on a spur, it is not suitable. When you have located a suitable socket, unscrew the terminal screws and re-remove and untwist the wires. Prise the box away from its recess and knock out one of the punched holes on the relevant side.

Hold the new box in position on the wall and draw around it to mark out its recess. Using a straight edge as a guide, draw two parallel lines about 25mm apart, between the new position and the existing recess, for the cable chase. Next cut the new recess and the chase with a hammer and bolster (see pages 178 to 182). The chase should be about 6mm deeper than the thickness of the conduit.

When the recess and chase are completed, knock out one of the punched holes in the new box and install it in its recess. Refit the box of the other socket as well, then cut the conduit to length so that it will protrude about 10mm into each box when installed in the chase. Fit the conduit, secure it with its clips, then make good the plaster.

Wait until the plaster is dry before you start wiring. Push the cable through the conduit so that about 200mm of cable protrude into each box, then remove the outer sheathing back to the edge of the box at both ends. Strip about 20mm of insulation from the live and neutral cores and sleeve the earth wires with lengths of green and yellow PVC sleeving, leaving about 20mm of bare wire protruding. Wire up the new socket cover plate as shown in fig. D and screw the plate into place.

Returning to the other box, connect the three red wires together and the three black wires together. If the original earth wires have not been sleeved, sleeve them at this stage then twist them together. Wire the plate up as shown in fig. E and screw it back on to the box. Turn the power on again and plug an appliance into the new socket to check that it is wired correctly.

D. *Wiring up a single socket. Strip about 20mm insulation from the cores and connect to the terminals*

on a wall and should be positioned at a minimum height of 150mm above the floor level, or the working surface in a kitchen.

Though new sockets can be installed directly from the ring, it is often easier to wire it on a *spur*—an extension taken from the back of an existing socket.

Each existing socket outlet, or double outlet, can supply no more than two additional outlets (or one double outlet) in this way.

E. *Connecting a twin socket. Cover bare earth wires with lengths of PVC sleeving before connecting*

Single into twin socket
An even easier method of adding sockets is by converting single socket outlets into double ones. Where single sockets have been installed, the number of outlets in a room can be doubled, though none will be in new positions.

If you are working in an area of good natural light, turn off the electricity supply at the mains. If not, isolate the supply by removing the relevant circuit fuse and leave the lighting circuits functioning (see pages 453 to 457).

You must now find out whether or not your chosen socket is suitable for conversion. If it is a single socket on a spur, or if it is on the main circuit,

F. *Unscrew the cover of an existing socket to check that it is suitable for connecting to a spur*

G. *Mark the position for the new spur socket, then cut the recess for the box and the cable chase*

H. *Push a cable through the conduit from the original box. Remove the outer sheathing*

I. *With the sheathing removed back to the edge of the box, bare the ends of the wires with wire strippers*

J. *With older cables, using separate strands, twist the ends of each groups of wires together*

K. *Wire up the cover plate and screw it back into place on its mounting box. Then test the new socket*

the socket can be converted without any problems. But if it is one of two sockets on a spur, no more outlets can be added to the spur.

To check the position of the socket in the circuit, unscrew the cover plate, ease it from the wall and examine the wiring. Two sets of wires connected to the plate suggests that the socket is probably not a spur. To make quite sure, examine the wiring in the nearest sockets on either side. If either of these has one set, or three sets of wires, the socket is on a spur and should not be converted (fig. C). If the selected socket has three sets of wires, it is supplying a spur and can be converted without any problems.

When you have satisfied yourself that the socket outlet is suitable, undo the terminal screws holding the cable cores into the plate and gently remove the cores inside. If the live, neutral and earth cores are twisted together, untwist them and then undo the mounting screws holding the metal box into its recess. Prise the box from the recess with a screwdriver or an old chisel, taking care not to damage the cables.

To house the new, twin socket box, the recess must be extended. Mark the position on the wall and cut out the plaster and brickwork to the depth of the new box with a hammer and bolster (see pages 178 to 182). Knock out the

punched holes in the box to accept the cables, feed these through, and position and screw the box into place using wall plugs. Twist the wires together again and wire up the twin cover plate as shown in fig. E. Screw the plate on to the box, switch on the power and test the socket.

The above procedure also applies to fitting a surface-mounted twin socket though in this case, no recess is needed—the box simply screws to the wall. If you replace a flush single socket with a surface-mounted twin, remove the old cover plate but leave the recessed box in place—removing it is only likely to damage the wall, and make the job more difficult.

465

Install a 30 amp supply

The two types of house circuits ● The demands of a cooker supply ● Which cable to use ● Control units ● Installing the supply ● Connecting up ● Connecting a fuse unit ● Electric shower unit circuits

Most homes in the UK are equipped with one or other of the two main types of 30 amp electrical circuit. Modern houses have a 30 amp ring circuit—a multi-outlet circuit supplying numerous 13 amp sockets and fixed appliances via fused outlets. Some older houses have a 30 amp multi-outlet radial circuit which supplies a limited number of 13 amp socket outlets and/or fixed appliances via fused outlets (see pages 453 to 455). In all cases, the outlets have a maximum capacity of 13 amps.

But some appliances, notably electric cookers and electric shower units, require their own separate 30 amp or 45 amp circuit (called a *radial final sub-circuit*) because of their high power rating.

Note that you should not confuse a 30 amp radial circuit with the older,

15 amp, 5 amp and 2 amp (round pin) radial circuits installed until about 1947. If you have one of these, your house is almost certainly long overdue for complete rewiring.

Canadian wiring practice is different, and uses more such single outlet circuits. That for a range will usually be on a 240 volt supply and the current rating and cable used may vary. The detailed information given here applies *only* to UK systems.

Electric cooker circuit

Essentially, electric cooker circuits consist of a cable running from a circuit fuseway in the consumer unit to a control switch, and then on to the cooker itself.

The current rating of the fuse, or MCB (miniature circuit breaker), and of the cable in the circuit is deter-

mined by the current demand of the cooker. The majority of domestic electric cookers have a loading of between 10,000 watts and 13,000 watts. On the 240 volts electricity supply standard in the UK, the maximum possible current demand of a 10,000 watt cooker is 42 amps, and of a 13,000 watt cooker, 54 amps.

However, because of the oven thermostat and variable controls of the boiling rings, there will never be more than a momentary maximum demand. UK regulations provide a simple formula for assessing the current demand of a domestic cooker, in which the first 10 amps are rated at 100 percent, and the remaining current at 30 percent. A socket connected to the control unit is rated at 5 amps.

This means that a socket and a 10,000 watt cooker drawing a theoretical 42 amps have an assessed demand of 25 amps. And a 13,000 watt cooker with a theoretical 54 amp demand, plus socket, is assessed as 28 amps. Consequently, most cookers fall well within a current rating of 30 amps. Only very large ones and those with double ovens require a 45 amp circuit.

Ray Duns

Consumer unit to control switch

Hopefully your existing consumer unit will have a spare fuseway from which to run the cable.

However, where there is no spare fuseway—and usually where you have a large cooker requiring a 45 amp circuit—you must install a separate mains switch and fuse unit, called a switchfuse unit.

The cable

The only difference between a 45 amp and a 30 amp circuit is the size of the cable. If your calculations have shown you that a 30 amp fuse is adequate for your cooker, then you need cable with a current rating of at least 30 amps— $6mm^2$ twin and earth PVC sheathed will usually do. With a 45 amp fuse, $10mm^2$ cable (sometimes bigger) is needed.

The cable should obviously take the shortest possible route from the switchfuse unit to the cooker control unit. Where there are no solid floors it is an easy task to run the cable straight down from the switchfuse unit, under the floorboards, to emerge once again immediately below the planned position of the control unit.

However, should you need to run a cable across the direction of the joists, these must be drilled—not notched—

A. Above and right: *The 45 amp double-pole main switch and 13 amp switched socket is used in the circuit to the electric cooker to isolate the supply. The control unit is normally fixed at about 1.5m above floor level and preferably to one side of the cooker*

at least 38mm below the top edge of the joist.

But, where, as in many kitchens, there is a solid floor, it is advisable to take the cable up from the switchfuse unit, into the ceiling void, across and between the joists, and then down the kitchen wall to the control switch.

Positioning the control unit

The control unit is normally fixed at about 1.5m above floor level, and to one side of the cooker. UK regulations require that the switch should not be more than 2m from the cooker, to allow for rapid access in emergencies.

Control units come in various styles, either surface or flush mounting, with or without neon 'power' indicators, and with or without a kettle socket

Left: *The components necessary for a 30 amp circuit to an electric cooker and an electric shower. Left to right: A cooker control switch with socket, outlet boxes, cooker control switch, service connector unit, and a cord switch*

outlet. The current rating is always 50 amps. If it is necessary to fix the switch above the cooker, one without a socket is recommended to avoid the risk of a flex trailing across a hot ring.

Control unit to cooker

To allow a free-standing cooker to be moved for cleaning or servicing, you must run the last section of cable in the form of a trailing loop. The first few feet can either be fixed to or buried in the wall immediately below and behind the unit.

467

If you opt for burial, you must install an outlet box (fig. C). You can either use a through box, simply anchoring the uncut cable with a clamp, or a terminal box, which would make it possible to remove the cooker altogether.

Split-level cookers

In the UK, regulations regard the separate hob and oven sections of a split-level cooker as one—and therefore on one circuit—providing that both sections are within 2m of the control unit.

Following these rules, you can install the two sections up to 4m apart as long as the control unit is midway between them. And if one of the sections is installed more than 2m away from the control unit, it can share the circuit but needs a second control switch. In all cases, the cable fitted on the cooker side of the control unit must be the same size as the circuit cable.

Electric shower unit circuit

An electric shower unit is an instantaneous electric water heater in which the water is heated as it flows over the element unit. To provide adequate hot water the element has a loading of 6000 watts or in some cases 7000 watts, with respective current demands of 26 and 29 amps.

To install a shower unit you will therefore need a 30 amp fuseway, a length of 30 amp twin and earth PVC sheathed cable, a double pole isolating switch, and a length of sheathed flexible cord or cable to connect the shower unit to the isolating switch. In some cases a flex, or *cord*, outlet

468

through box

junction box

Nigel Osborne

C. Above: *To facilitate cleaning or servicing a free standing cooker must have a trailing loop of cable connecting it to the supply, allowing it to be easily moved. You can fix the first few feet of cable to the wall, and simply leave a loop. It is best, however, to bury the first few feet of cable in the wall; in this case it is necessary to install a cable outlet box at the point where the cable emerges.* **Left:** *The simple through box is just a cable clamp for an uncut cable.* **Right:** *A junction box—which is the best unit to use if you ever wish to remove the cooker*

unit is required for the final connection to the shower unit (see pages 384 to 385).

Running the cable
On an electric shower installation, use a twin and earth PVC sheathed cable with a current rating of not less than 30 amps to match the circuit fuse or MCB in the consumer unit. The circuit cable running from the 30 amp fuseway to the 30 amp double-pole isolating switch should run in the same way as that for a cooker.

It is dangerous to have an electric switch or socket within reach of wet hands, so you must install either a cord-operated ceiling switch in the bathroom or a wall-mounted switch outside (fig. D).

A special 30 amp double pole switch with neon indicator is available for cord operation and is mounted on a standard, square-moulded plastic box. To install this unit, first remove the knockout blank in the base for the two cables; one is the circuit cable, the other is the shower unit connecting cable. Pierce a hole in the ceiling for the two cables, connect them to the switch, then fix the unit to a timber joist using wood screws.

Some shower units are supplied with a 3-core circular sheathed flex. Do not remove this; instead, run both it and the cable from the isolating switch into a cord outlet unit mounted on a square-moulded plastic box and fixed near the shower unit.

In rooms other than the bathroom mount a 30 amp double-pole switch outside the showering cubicle, in a position where it cannot be reached by anyone using the shower.

All the necessary controls are on the shower unit itself and are all non-electrical, the heater circuit being controlled by a water-operated pressure switch.

Connecting up the switch
The 30 amp cord-operated ceiling switch is a double-pole switch and therefore has two pairs of terminals. Each respective pair is marked L for live and N for neutral. One pair takes the cable from the consumer unit, and these are marked SUPPLY or MAINS. The other terminals are for the cable to the shower unit, and are marked LOAD.

Connection at the consumer unit
With all the other wiring completed, your final task is to connect the cooker or shower circuit to the mains, either at a spare fuseway in the con-

sumer unit—or if that is not possible—to a separate switchfuse unit. The installation of, and connection to, a switchfuse unit is described in the panel opposite.

To connect to a fuseway, turn off the mainswitch and remove the consumer unit cover. On some models you must first remove the fuse carriers or MCB's.

Cut the new circuit cable, allowing about 300mm for the inside of the unit. Trim about 250mm of outer sheathing from the cable, strip about 9mm of insulation from the live and neutral wires, then sheath all but 9mm of the bare earth wire with green and yellow PVC sleeving.

Next, knock out a blank from the consumer unit case and thread in the three wires until there is about 50mm of sheathing within the unit. Connect the red wire to the terminal of the spare fuseway, and the black wire to the neutral terminal block—which will already have some neutral wires connected to it in any case. Connect the sleeved earth wire to the common earth terminal block. Carefully replace the fuse carriers or MCBs, if you have had to remove these. Then put back the cover.

Finally, fit the new 30 amp fuse unit (or MCB) and if the fuse is rewirable, check that it contains a 30 amp fuse wire. Replace the cover of the consumer unit, turn on the mainswitch and you are ready to test the new installation. If any appliances refuse to work recheck the wiring.

D. *In the case of an electric shower unit regulations require that the control switch is out of reach of a person using the shower. Also, because a wall switch may not be installed in a bathroom, you must use either a cord-operated ceiling switch or a wall-mounted switch outside the bathroom. The former* **(above)** *with a neon 'power on' indicator is probably the best and most convenient*
Below: *The double-pole cord-operated switch is fitted to the bathroom ceiling. Run the supply cable through the ceiling and connect the shower via a cord outlet unit*

cord operated
double-pole switch

electric
shower
unit

Connecting a fuse unit

E. *Sometimes it is necessary to install a switchfuse unit adjacent to the consumer unit from which to take the mains supply (below). Electricity Boards often insist that a 60 amp double-pole terminal block (bottom and top right) is fitted adjacent to the meter—the Board have to connect it up by law*

Where there is no spare fuseway on an existing 30 amp consumer unit, or the circuit requires a 45 amp installation, you must install a switchfuse unit.

In the UK, you cannot make the final connection to the meter yourself, but must contact the Electricity Board to do it for you. At the same time, they can check over the rest of your installation to ensure that it is safe.

A switchfuse unit is a one-way consumer unit consisting of a double-pole mainswitch and a single-pole fuseway fitted with either a fuse or an MCB (an MCB is best, and a cartridge fuse next best). Both two-way and three-way consumer units are available, and you should consider installing these if future electrical extensions are anticipated.

Fit the unit to the wall adjacent to the existing consumer unit. Then connect three single-core, double insulated PVC sheathed cables—one with red, one with black, and one with green and yellow insulation—to the appropriate L (live), N (neutral) and earth mains terminals. The cables should be cut to about 1m in length, and then left for the Electricity Board to connect up. The Board stipulates the cable size —usually 16mm²—which is determined by the current rating of the Board's service fuse.

To prepare the end of the circuit cable first cut it to the correct length, allowing a short amount for the inside of the switchfuse unit. Trim about 300mm of outer sheathing from the cable, strip about 9mm of insulation from the live and neutral wires, then sheath all but 9mm of the bare earth wire with green and yellow PVC sleeving.

Connect the wires to the appropriate fuseway terminals, insert the fuse unit if necessary then notify the Electricity Board that the circuit needs connecting to the mains.

Electricity Boards often insist that a 60 amp double-pole terminal block is installed between the consumer unit and the electricity meter (fig. E). Though you can fit this yourself—but not wire it—it is generally easier to pay the Board to do it for you especially as they have to wire it up for you in the first place.

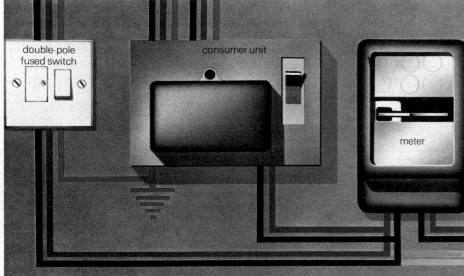

double-pole fused switch

consumer unit

meter

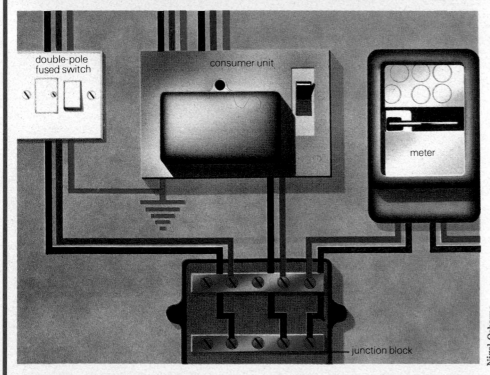

double-pole fused switch

consumer unit

meter

junction block

Nigel Osborne

- Types of burglar alarm: microwave, ultrasonic, and infra-red detectors ● Types of sensor
- Loop alarm kits for domestic applications
- Planning and fitting the system

Ray Duns

Burglary is one of the most worrying types of crime to both householders and flat dwellers alike. Not only are possessions vulnerable: senseless vandalism and personal attack have become increasingly common.

Burglar alarms help to make your home secure in a number of ways: they warn you of an intruder if you are asleep at night; they alert your neighbours if a burglar strikes while you are away; their presence helps deter would-be thieves; and the sound of the alarm should frighten a burglar out of your home before he has a chance to take anything or do any damage to your property.

Types of burglar alarm

There are several types of alarm available, some of which you can fit yourself. *Ultrasonic detectors* are alarms which employ frequency sound pulses

generated by a tiny speaker. The pulses are bounced off room surfaces and are constantly monitored by a microphone, usually housed in the same unit. Any change in the sound pattern triggers the alarm. Ultrasonic detectors are small, easy to fit, and easy to disguise from the burglar. Some can be disguised as hi-fi speakers, others can be housed in unobtrusive corners. The disadvantages of this system are that they may be triggered by such things as traffic noise or blustery wind, and they cannot really be used while you are still moving around elsewhere in the house.

Microwave detectors work on a similar principle to ultrasonic detectors, except that they use radio waves. This kind of alarm is simple to fit, is easily disguised, and very effective. It is less prone to false alarms than the ultrasonic system but, again, is of

Above: *Burglar alarm kits like this one by Yale come with almost everything you need for the job, including control box, sensors and wiring*

little use when the house is occupied.

Microwave alarms are a cheap and effective way to protect a fairly large, isolated property while you are away from home. They detect movement over a wide area and are difficult for the intruder to disable because there is very little vulnerable wiring and the alarm cannot be approached without triggering it.

If you consider a microwave system on the ground of cost and ease of fitting, try to select the ceiling-mounted type, which may, with adjustment, allow you to move about in the upstairs part of the house when you go to bed. However, you will not be able to come downstairs without

Bernard Fallon

A. *Microwave and ultrasonic detectors should be positioned to scan a likely entry point. These are best used in deserted properties as they register any change in the reflected waves caused by moving objects.*

B. *An Infra-red detector beam can be laced across a hall or other thoroughfare to increase coverage. The projector and sensor are set into the wall but the mirrors need careful alignment—a job that may call for professional assistance*

first turning off the alarm.

At least one type of ultrasonic alarm is available in the form of a dummy hi-fi speaker, which has the further advantage of being battery powered. However, this system is fairly expensive, and lacks the flexibility that can be incorporated in an *electronic loop system*.

The basis of electronic loop systems is an unbroken wiring circuit, along which is strung a number of different sensors, all fixed at strategic points. There is nothing to stop you moving about the house once the system is activated.

Open circuits are completed when one of the sensors is activated. As soon as current flows, the control box triggers a bell or siren. The bell circuit is electrically latched so that it cannot be switched off except by a master key.

Closed circuit systems are kept alert by a trickle of electric current. When a sensor is activated the circuit is broken and this triggers the alarm in the same way as an open circuit.

Alarm systems of this type are available for do-it-yourself fittings. Most kits contain a control panel which can be used for both open and closed circuits. They have a basic number of sensors of different types, though additional sensors can be attached. Included in the kits are an exterior or interior ringing alarm bell (sometimes both) and the necessary wiring to connect up the whole system. Electronic loop systems can be powered by mains or battery, or a combination of the two to guard against mains failure.

A projected beam of invisible light aligned between an emitter and a sensor, forms the system used by *infra-red detectors*. If the infra-red beam is broken, the alarm is triggered. To increase their effectiveness, beams can be laced over an area using a series of reflectors (fig. B).

Infra-red systems are often used in high security areas in conjunction with other types of alarm. They have the advantage of being confined to a certain area, enabling free movement elsewhere in the house, but can work to the burglar's advantage, unless you have a really sophisticated lacing of beams covering a wider area. Such systems are complex to install, and are best left to a professional security firm.

Types of sensor

Sensors are the detection devices fitted along a loop circuit to doors and windows and other possible break-in entry points. When a door is opened or a window smashed the circuit is disrupted and the alarm is activated.

There are several types of sensor on the market:

A *microswitch sensor* is a tiny electrical switch activated by a plunger arrangement. The plunger is held down by a closed door or window to complete a closed circuit. If that door or window is opened, the plunger is released, breaking the circuit and triggering the alarm.

A *magnetic reed contact* is a very simple sensor which is featured in very many alarm packages in one form or another. Current is passed through two fine magnetic reeds, sealed in a glass tube. The tube is fitted in a case, in line with the loop circuit, to the frame of a door (or certain types of windows). A similar case containing a magnet is fitted adjacent to the reed tube, on or in the door itself. The two cases are fitted parallel to each other at the opening edge of the door, usually less than 3–5mm apart. It is particu-

473

C. *The popular and readily adaptable electronic loop system makes use of both open and closed circuits. In addition to the normal range of sensors, a heat detecting device can be fitted to warn of fire*

control unit
(power-battery or mains)

alarm bell (wires concealed)
located conspicuously
but out of reach

alarm bell or siren

master on/off test switch

panic button
on open circuit

panic button near bed

pressure mat on open circuit
(alarm sounds if circuit is completed)

magnetic reed contact and
vibration sensors on closed
circuit (alarm operates if
circuit is broken)

to exterior alarm
(wires chased or
otherwise concealed)

from panic button

remote control switch
in bedroom

wiring tucked
into door frame

possible site of additional
pressure mat

magnetic
reed contact

control box

vibration sensors
on windows

magnetic reed contact

tell-tale wires
concealed

pressure mat

wiring beneath
carpet or flooring

larly important that the two halves of this sensor are correctly aligned.

While the door remains closed, the magnet holds the two concealed reeds together to complete a closed circuit. If the door is then opened by more than the release distance—which varies from 10–35mm depending on the type of switch installed—the reeds spring apart and activate the alarm.

This type of sensor should be fitted either recessed into both door and frame, or on the inside face of the doorway where it cannot be detected. Cylindrical sensors can be fitted simply by drilling holes of the appropriate size in the door and frame. Concealment is important, as an experienced burglar will certainly be able to use a magnet to keep the reeds together as the door is opened.

Metallic foil detectors are available in self-adhesive rolls for attachment to window glass. Current flows down the foil in a closed circuit and if the window is broken, this is disrupted and the alarm sounds. The foil is attached at each end to connector blocks to ensure correct electrical connection. These, too, are available backed with adhesive so they can be attached easily to the glass.

Metallic foil detectors have the advantage of advertising to the would-be intruder that your home is protected. They should be fitted to the inside of the glass, close to any window catches. A potential disadvantage is that metallic foil is rather fragile, which makes the windows more difficult to clean properly.

Vibration contacts are taking over from metallic foil as window sensors because they look neater, are easier to install, and are a better safeguard for modern, large-area windows. They are closed circuit devices contained in self-adhesive cases which can be mounted at suitable points on the glass itself. A setting screw is then adjusted to ignore ordinary low-level vibrations caused by wind and traffic. Heavy vibration breaks the circuit and the alarm sounds.

Some of the kits contain vibration contacts and most other kits offer them as an optional extra. Since windows are the most obvious means of entry for the intruder and because metallic foil can look unattractive, this kind of sensor is well worth fitting.

Sound detectors are basically tiny microphones which are fitted to windows to detect the sound of breaking glass. They are very sensitive, but not normally used in domestic installations because they need additional

wiring to amplify the minute amounts of current running through them.

Inertia detectors, sophisticated sensors used in high security systems, also require additional circuitry. They respond to movement in windows, doors, gates, and even walls (such as bank vaults). But these are unlikely to be used in a domestic context.

Most installations also include one or more *pressure mats*. These are open-circuit devices, wired up to a separate pair of contacts in the control box (fig. 9). An intruder stepping on the mat completes the circuit and activates the alarm.

Pressure mats must be installed against a firm floor, under both carpet and underfelt. They are usually employed as a second line of defence at the foot of the stairs, inside the front door, in front of the television set, or next to a particularly vulnerable win-

dow. You may be able to cut down on wiring by using special connectors.

Panic buttons (or personal attack buttons) are open circuit devices linked to their own separate terminals in the control box and, usually, they can be kept constantly activated during the day. If you are attacked by an intruder, you press the button to activate the alarm.

Panic buttons are usually fixed just inside the front door but the bedroom is another likely site for such a device. There is no need to conceal the wiring, save for appearance's sake.

Loop alarm kits

Most alarm kits come complete with a range of different sensors; they also contain wiring and instructions for linking them to the *control box*. This contains a number of terminals for connection of open circuits, closed

1 Plan a convenient location for the control box and mark the fixing holes for this. Screw the box firmly into place

2 If necessary, wire up the magnetic reed contacts using wire provided with the kit. Check the magnetic action is satisfactory

3 The reed section of the sensor is located on the door frame. In some kits, this is set into the woodwork to remain out of view

4 With the door shut, butt the magnet section against the reed section and then screw it into place

5 Pin the wires to the corner of the door frame, then run the connecting lengths out of sight behind the door frame edges

6 For a cylindrical reed sensor, drill a hole into the door frame which faces the door edge. Drill a smaller hole right through for wiring

7 Wire up the reed contact and insert it carefully into the hole you have drilled. Feed the wire through the back of the frame

circuits, panic buttons and—sometimes—smoke detectors.

Into the control box comes electric power to maintain the closed circuits in the alert mode and to power the alarm bell itself.

Some systems rely entirely on battery power. They use very small currents to maintain the circuits, but the batteries drain rapidly once the alarm is sounded. As batteries are becoming extremely expensive, it is worth considering an alarm system which uses either tiny voltages from relatively cheap batteries, rechargeable batteries, or operates from the mains.

Some systems take their mains power from an ordinary plug socket or fixed outlet, others through a transformer (like an electric doorbell), so in each case a little electrical expertise is required to fit them.

The disadvantage of a mains powered system is that it is affected by power cuts. Also, the power and alarm bell cables must both be well concealed to prevent tampering, as the easiest way to immobilize this kind of an alarm system is to disconnect either of these.

The best alarm kits use a combination of mains and battery power so that if the mains fails or is tampered with, the system switches automatically to battery power.

Regular sounding of the alarm will annoy your neighbours and tends to make them ignore the alarm if there is a real emergency. Most control boxes have facilities for testing, such as a small light to show that the circuit is working. The test provides a ready check that you have closed all the doors and windows before you go out or to bed. And for systems that

rely on battery power there should be a battery life indicator as well.

All alarm systems have some kind of keyed *master control switch* which enables you to set the alarm and turn it off. There is usually a time delay to give you a few seconds to enter or leave the house or get away from the alarm-sensitive areas.

Some systems merely have a key switch on the control box. Others can incorporate remote switches and these may be elsewhere in the house, often by the front door. A remote shunt switch can be incorporated into some kinds of door lock, and these are wired into the alarm circuit of a closed circuit loop. Other kinds of switches are wired independently to the control panel and control the power to all the alarm circuits, whether open or closed. Many alarms incorporate both types.

Alarm systems usually make use of small bells which produce a very loud sound. Once the bell is activated it can only be turned off by the master switch key. Closing the door does not stop the alarm, because the bell circuits are electrically latched. Alarm kits may incorporate an interior bell, an exterior bell, or both.

The purpose of interior bells is to frighten the intruder out of your house, so locate these in an inaccesible spot such as at the top of the stair well. Exterior bells, which come in weatherproof cases, are intended to alert neighbours and passers-by. They should be installed high, out of reach, with the wiring to them passing

8 Fit the magnet section into a hole drilled in the door edge. Connect the reed contact to the closed circuit loop

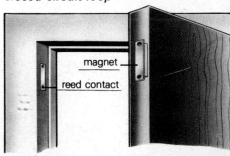

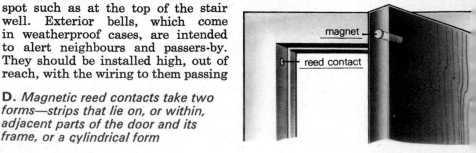

D. Magnetic reed contacts take two forms—strips that lie on, or within, adjacent parts of the door and its frame, or a cylindrical form

directly through the wall to prevent tampering.

Opinion is divided as to whether a visible exterior alarm is a deterrent or an advertisement to the would-be thief. Some authorities recommend that external bells be fitted at the back of the house. If you believe in the deterrent theory, it is possible to buy dummy alarm cases with your kit.

Most alarm kits come with a number of magnetic reed sensors, perhaps a couple of vibration sensors, and usually one or two pressure mats. They also contain wiring, one or more bells, and a control box to which additional sensors and panic buttons can be fitted. The kit illustrated is suitable for a small house.

Planning and fitting the system

When you plan your alarm system, concentrate the alarm sensors at vulnerable points such as windows and doors, and around any inside region where the burglar is likely to go—such as the hallway. Start by thoroughly surveying your ground floor and draw up a plan, noting the vulnerable areas likely. Mark out a circuit line for the closed circuit sensors which links them up in the most economical way. The actual positioning of the sensors may depend to some extent on your circuit plan.

All doors to the outside should be included in the closed loop, especially those with any areas of glass such as sliding patio doors. The latter can be fitted with a magnetic reed sensor which is shielded from the metal.

Fit sensors to some interior doors as well. Select those which a burglar would have to open to get to your valuables, assuming he had slipped in through a vulnerable window or door.

All ground floor windows are vulnerable but pay special attention to large bay windows, and windows concealed from general view at the back of the house and down alleyways. Fit either metallic tape sensors or vibration sensors.

Look also at your first floor windows. Those that are close to a porch roof or drainpipe are vulnerable and can be included in a closed circuit.

Fit pressure mats at strategic points, such as at the bottom of the stairs or in front of valuable objects. Small

9 Another commonly used sensor is a pressure mat, which is best located near a likely entry point or passageway

pressure mats are available for fitting further up the stairs.

Locate the control box in a position which is out of sight, but not so far from the door that you cannot leave the house having just activated the system. The control box is fixed to the wall, or a mounting panel, using plugs and screws.

Remember that the power cable, and sensor and alarm connections must be concealed to prevent tampering. Open circuit wiring for pressure mats can run under floor coverings.

Where wiring must cross a door, run it under the carpet, over the door frame or through a flexible door cable which most kits offer as an accessory. Power and alarm bell connections should be concealed at ground level: if possible run the wiring beneath floorboarding. It may be advisable to chase other wires in plasterwork for maximum protection.

You do not need to conceal closed circuit wiring because if anyone cuts it the alarm will sound automatically. However, its presence may betray the exact position of flush-mounted sensors in a door frame.

Finally, test the circuit according to the manufacturer's instructions. Not all kits have facility for testing open circuits without sounding the alarm bell momentarily. The most sophisticated kits have a low volume buzzer which cuts in when testing.

In the UK you can obtain free professional advice about the installation of an alarm system from the Crime Prevention Officer at your local police station. Inform the police if you fit an alarm and give them the names of two keyholders who can switch it off.

E. *Metallic foil used to complete the circuit is a visible deterrent but vibration sensors are now usually preferred for windows*

connectors

foil strip

10 *All connecting wires should be concealed from view to discourage tampering—but this is not essential for closed circuits*

11 *When all wiring is complete, test each individual sensor for correct working. Check batteries from time to time*

PLANNING KITCHENS AND BATHROOMS

Plan your kitchen

A well planned kitchen should be easy to use, easy to clean and still be a pleasant place in which to work. Even the smallest kitchens can meet all these requirements

Below: *A U-shaped kitchen which has all the essential equipment set out in a convenient 'work triangle'— and still finds room for a flap-down table and an enviable amount of worktop space*

Even if you have a small kitchen, careful planning, a little reorganization and a fair amount of improvisation can transform it into an efficient and pleasant place to be.

Studies have shown that in most kitchens, the activity centres around three main areas—those of food storage (pantry and refrigerator), the sink and the stove. From this information, the idea of an ideal work triangle has evolved: this forms the basis of kitchen planning no matter what the size of your kitchen.

The corners of the triangle are ideally linked by work surfaces, providing areas for food preparation, mixing and serving. The perfect work triangle keeps distances between the sink, fridge and stove as short as possible. Ideally, a trip around it should measure between 3.5m and 7m.

Making a plan of the layout

The best way of planning a kitchen is to draw up a scale plan of the layout on graph paper. You can use any scale you like—although 1/25, where each 5mm square of graph paper represents 100mm of kitchen, is normally the most convenient.

Start by drawing the basic outline. Mark on it all fixed objects—the radiators, power points, chimney breast, alcoves—and also the swing of doors and windows.

Next, on a separate sheet of graph paper and to the same scale as your outline, draw up the outlines of your chosen units and appliances. Having labelled them for easy identification, cut out the shapes and transfer them to your outline plan. Juggle them around on the graph until you have a sensible, practical arrangement.

When positioning appliances, start with the sink: unless you want to be bothered with the lengthy and sometimes expensive process of moving it, it is best left where it is.

A small sink with only one drainer is best for a small kitchen and where space is really limited, consider doing without a drainer altogether. Use a

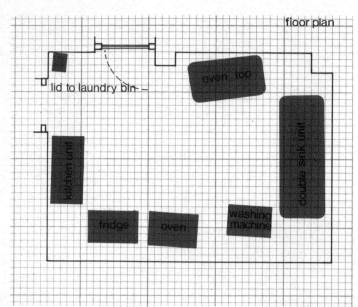

floor plan

oven top

lid to laundry bin —

kitchen unit

double sink unit

fridge

oven

washing machine

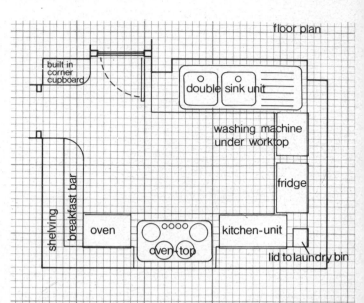

floor plan

built in corner cupboard

double sink unit

washing machine under worktop

fridge

shelving

breakfast bar

oven

oven top

kitchen-unit

lid to laundry bin

Above and above right: *Use coloured shapes to the same scale as your plan to represent all the units. Move them around until you have the most practical arrangement*

Right: *A central island incorporating a hob unit and food-preparation sink makes cooking easy in this kitchen. Knives too are easily reached.*

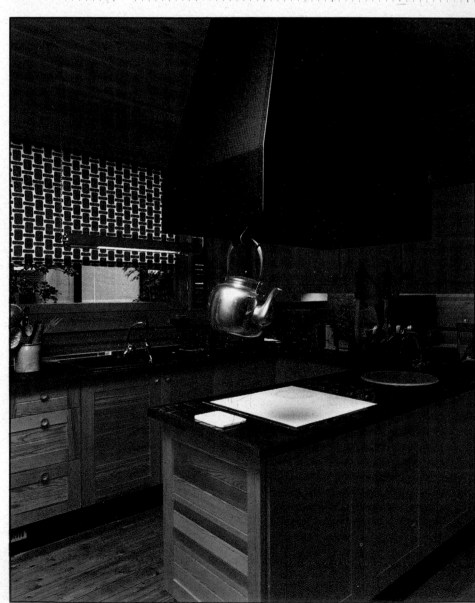

draining rack instead, standing it on the window ledge or screwing it to the wall. If the rack is of the decorative wooden kind, it can act as a display area that also saves on cupboard space elsewhere.

By making a wall plan as well as a floor one, you will have a more comprehensive idea of the space available. Before you make plans for your walls, however, check what they are made of—a partition made of a plasterboard and honeycomb paper 'sandwich', for example, is no place to hang a heavy wall cupboard.

If you have an expanse of wall measuring around 3m, you can have what is considered the ideal kitchen layout of worksurface, sink, worksurface, cooker, worksurface. Otherwise, the three most common kitchen layouts are the galley, L-shaped and U-shaped. The ideal triangle can be incorporated into all of them.

Useful measurements

The average height of manufactured units is between 950mm and 975mm—the most comfortable height for the average woman of 1.6m. However, if for some reason you want a different height, you can make your own units or buy an adjustable system.

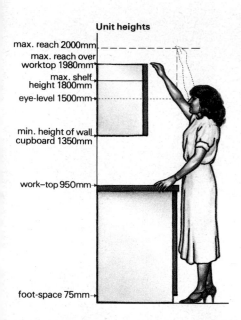

Unit heights

max. reach 2000mm
max. reach over worktop 1980mm
max. shelf height 1800mm
eye-level 1500mm
min. height of wall cupboard 1350mm
work–top 950mm
foot-space 75mm

Left: The heights of the work surfaces and cupboards should all be near to these average figures

Right: A sophisticated example of how tiles can be used effectively on all kitchen surfaces, including the frames of the units

Elizabeth Whiting

If possible, the width of the gangway in a galley-type kitchen should be not less than 1200mm. This allows enough space for one person to bend down to a cupboard and for another to move past at the same time without too much of a squeeze.

The average-sized adult has difficulty reaching higher than 1520mm so try to store items which are used regularly at or below this height. Where there is no worksurface to lean over, the height of the shelf or cupboard can be raised a little. Site wall cupboards at least 400mm above the work surface or they will obscure the back of it.

For sitting on high stools, the

recommended space underneath a worksurface is 900mm. This space is also sufficient for storing the stool so you are not repeatedly tripping over it. The stool should be low enough to give knee space of around 150mm underneath the worktop.

The worktop should project at least 19mm beyond the unit base to allow for something to be held at the edge to catch the crumbs when wiping it down after use.

Free-standing stoves are not insulated so you should leave an all-round gap of at least 100mm between one and the surrounding worktops. This also makes it easier to clean.

Space-saving ideas

Owners of small kitchens can learn a lot about the economic use of space by studying the insides of caravans or boats. But to make more space, you may have to consider moving certain appliances, such as the freezer, to another part of the house.

Consider, also, what you want out of the kitchen. Decide whether your worksurfaces will all be required for food preparation, or whether some of the space can be used for eating or for display purposes.

With a small kitchen you may have to make some compromises, although there is no reason why it should not still function as well. As far as appliances are concerned, it is worth shopping around for these, not only

because you may get a bargain, but also because you may find smaller versions fairly easily.

Upright, four-burner gas stoves and plug-in, electric stovettes with a two unit hot-plate and half-size oven are ideal space savers and ample for two people.

Half-oven stoves can stand on a laminated bottle rack or cupboard, giving you extra storage space instead of an oven which is never fully utilized. The stove top can be fitted with a hinged cover to provide another worksurface when the burners or rings are not in use.

Think about whether it would be best to have a refrigerator with a left-hand or right-hand opening door and try to position it so that you can open the door completely. Decide also whether your family needs call for a large fridge-freezer or a small model that will fit under the work bench.

Below: The distance between the fridge, sink and stove should be as close as possible to the ideal work triangle of between 3.5m and 7m. The shape works in most kitchens

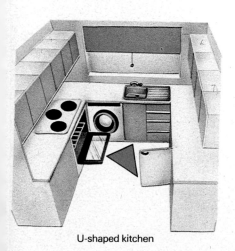

U-shaped kitchen

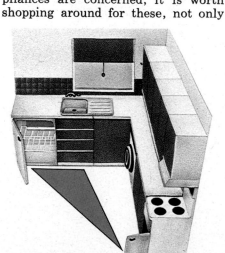

L-shaped kitchen

single-line kitchen

481

Tim Street-Porter/EWA

Bridgitte Beart

Above: *A fresh-looking kitchen which is both compact and practical. The sets of storage jars are decorative without creating a clutter*

Below: *A busy farmhouse look for this narrow galley kitchen—with not an inch of wasted space*

Elizabeth Whiting

Above: *An ultra-modern kitchen combining an efficient 'work triangle' with ample seating for four*

Similar space saving can be achieved by siting a dishwasher under the bench.

In Britain, where washing machines are often in the kitchen, remember that a front-loading automatic washing machine takes up less space than other types, but must be positioned where it can be plumbed in easily—the object is rather defeated if you have to drag the machine into the middle of the room to use it. If your washing machine is set at right angles to the sink unit, put a hatch on the worksurface which covers the 'dead' area and use this space for storing such things as a washing basket or shopping bags.

If you have to site a heater in the kitchen and floor space is at a premium, consider opting for one of the wall-mounted types. You can also save floor space by using a waste bin which is small enough to fit in the cupboard under the sink.

Pull-out or fold-away boards, providing they are stable and solid, make space-saving alternatives to a kitchen table. The foldaway type of table, hinged to a wall bracket and matched to fold-up wooden chairs, is particularly efficient.

Storage suggestions

The whole business of designing a kitchen is easier if you are starting with an empty one. But if you have to

work around other people's ideas, remember that the floor and wall cupboards can be moved to suit your needs quite easily.

If the kitchen is extra narrow, do not waste valuable floor space by installing factory-made units on both sides. Built-in, floor-to-ceiling cupboards, which can be as narrow as 300mm deep, are a much more economical way of using space.

You can use the underneath of open shelves for storage jars—any old jars with metal screw-tops will do. Simply screw the lid, with two screws, to the underside of the shelf: you can then unscrew the jar from the lid as required. Alternatively, special storage containers are available which slot into a plastic track screwed to the bottom of the shelf.

It is usual to site wall cupboards over the worksurfaces, but if you find it rather dismal staring at blank cupboards while working, try putting all the wall cupboards together in a batch from ceiling to floor. Remember to adjust the handles on each cupboard according to their position in the cupboard stack.

As most wall cupboards are only about 350mm deep, they do not intrude on the room yet provide plenty of

storage space. This is particularly useful in a narrow kitchen which also acts as a throughway. Space-saving cupboards should have sliding, rather than hinged, doors.

Try to position floor units so that they fit right into the corners. This helps give the kitchen a really fitted look as well as providing more surface and storage space. And you should not forget to exploit your ceiling—a hanging basket makes an unusual change from the usual plastic vegetable racks.

If you do not have room for wall cupboards or shelves on your walls, a shelf hanging from the ceiling looks most attractive. Use plasticized rope through the front and back of both ends of the shelf to support it.

Wooden garden trellis can also be screwed through battens on to the ceiling and used to hang baking trays, frying pans, and other utensils which are not in daily use.

Old made new
Imagination is what counts when you are fitting out a kitchen economically. To make this work for you, have a clear idea of the style you want, then keep looking for things that fit it.

If you are tired of your existing units, try refurbishing them. Stick new laminates and handles on the door and drawer fronts—easy to do and much cheaper than buying whole new units—and far less trouble.

Once painted and given new handles, a hotchpotch of wooden cabinets can look really unusual. Even a narrow chest of drawers can make a useful storage place if the drawers are sectioned off so that the contents cannot get mixed up. A continuous worktop over the whole run of cabinets will harmonize them.

Tiling the work surfaces makes an attractive change from the usual laminates. Remember to use specially toughened tiles and an adhesive which is resistant to heat and water.

Shop around for space-saving ideas to use inside the cupboards. Carousel baskets and plate racks, for example, not only make the most of cupboard space but also make it easier to get at the things inside. Deep basket drawers can be used to store bulky objects or even act as vegetable racks.

An ordinary bookshelf placed on top of a chest of drawers makes an attractive dresser. If there is no room for it in the kitchen, the dresser will look equally good in a living room where it can be used to store and display such things as crockery, cutlery and glassware.

An old broom handle can be varnished or painted and fitted with decorative ends to look like a curtain pole. You can then screw it on to the wall and use it for hanging and displaying kitchen utensils. Open-plan display looks very decorative and gives the kitchen an identity of its own.

Safety hints
Safety is an important consideration in the kitchen. Although this is where a high proportion of accidents happen, careful planning can help prevent most of them.
1. Keep cupboard doors shut—somebody could get hurt walking into one.
2. Do not let steam pour onto electrical sockets.
3. Store sharp knives somewhere inaccessible to children.
4. A small child could cut himself on tins left in pedal bins.
5. Turn pan handles inwards so children cannot pull them over.
6. Curtains and cloths near a stove are a fire risk. Try to position the stove away from the window.
7. Clean up immediately anything spilt on the floor.
8. Trailing electrical flexes are dangerous.
9. Everyday foods should not be placed out of easy reach.
10. Do not overload sockets nor site them too close to the sink.
11. Put sharp utensils away after use.
12. Poisonous products must be stored well away from a child's reach.
13. Someone could easily trip over things left on the floor.

Flap-down breakfast table

Gavin Cochrane

It takes only a few basic materials to make this attractive flap-down table. And the snap-lock hinge makes it strong enough to bear the weight of all the essentials of a meal for two.

When not in use, the table takes up no space at all—which makes it a practical proposition for even the smallest of kitchens. Of course, if your kitchen is wide enough, the table could be left up.

Covered in heat-resistant laminate, even a hot coffee or tea pot will not damage it. And a quick wipe-down leaves it looking as good as new.

Although shown here as a fold-away breakfast bar, this flap-down table could also be used in other rooms to make an unobtrusive yet accessible work surface. In a sewing room for

Above: *The completed table*
Right: *Unobtrusive when not in use*
Below: *The simple, strong hinge*

example, the table is more than strong enough to bear the weight of a sewing machine. All you must do is check the wall to which you are fixing the table. On plasterboard partition wall, for instance, you must secure the table to the studs or nogging.

Snap-lock hinges, which make this flap-down table so easy to use, are available from do-it-yourself stores, although their exact design may vary according to which type you buy.

484

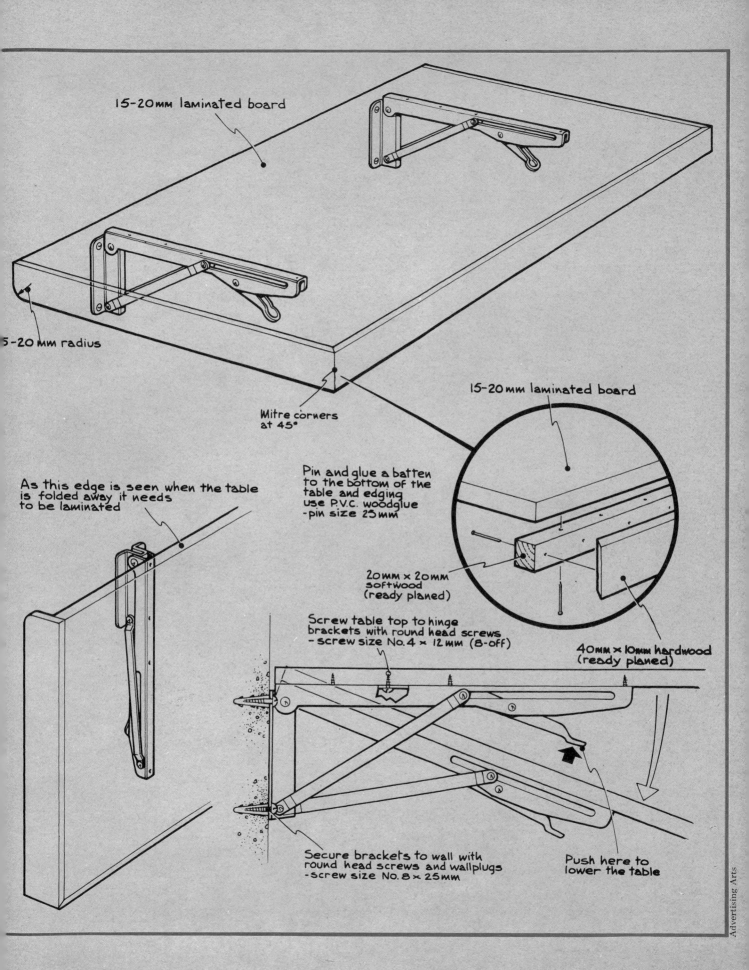

15-20mm laminated board

5-20 mm radius

Mitre corners at 45°

15-20mm laminated board

Pin and glue a batten to the bottom of the table and edging use P.V.C. woodglue - pin size 25mm

20mm x 20mm softwood (ready planed)

40mm x 10mm hardwood (ready planed)

As this edge is seen when the table is folded away it needs to be laminated

Screw table top to hinge brackets with round head screws - screw size No.4 × 12mm (8-off)

Push here to lower the table

Secure brackets to wall with round head screws and wallplugs - screw size No.8 × 25mm

Brighten up the kitchen

You do not have to spend a fortune to bring the kitchen up to date. Careful thought and a streamlined visual approach can work wonders with any kitchen

The problem is a common one, and often comes to light when you are thinking of redecorating the kitchen: the existing fittings are basically sound but look shabby and old-fashioned and do not provide quite the storage you need. One solution is to refit the kitchen completely with modern units planned to fit the space, but this is a very expensive answer. An alternative is to dress up the existing units and tie these in to the colour scheme to give an overall designed look to the kitchen, building in more storage where necessary. The designs overleaf show how a typical kitchen can be transformed and how you can give a new look to common, older types of kitchen unit.

The first thing to do is to take a good look at the existing kitchen and decide where you need alterations to the storage space or working area. This kitchen had an obvious wasted space over the sink, and a simple design for extra shelving (see pages 488 and 489) utilizes this space highly effectively while providing a draining rack for plates and cups.

The other area of wasted space in this kitchen was between the upper and lower storage cupboards either side of the worktop (countertop) on the other side of the room.

The old plastic laminate surface was tiled over and a simple herb and spice rack built in between the new surface and the cupboards above. See page 489 for the complete design.

The next thing you should do is to decide on the overall look you want to achieve. Some simple sketches can be a big help here. The horizontal emphasis aimed for in this design gives a modern look, ties in with the level of the work surface and is very easy to achieve. The old-style handles on the cupboard doors were changed for modern, extruded aluminium handle sections.

You can buy these in a very wide range of styles, which makes them easy to fit to almost any door or drawer. If your cupboard doors have curved edges, which many did in this kitchen, plane them down as shown to give a square edge. To carry on the horizontal look, hardwood strips were pinned on between the doors and drawers. These helped to tie separate units together horizontally. By overlapping the strip running along above the worktop, it provided a mounting for a concealed striplight to illuminate the work surface below. The same hardwood was used to make handle sections for the sink unit to match it to the look of the other units (see opposite). You could use a handle section in aluminium here too.

At the same time as the modernization of the door handles, make good any of the surfaces which have become damaged. Fill any scratches or knocks on the doors, and take the opportunity to resurface the worktops, perhaps using unglazed ceramic tiles. Alternatively you could simply glue on new decorative laminate. If the door hinges are damaged, replace them. If the drawers are not running smoothly, plane them to fit or reset the runners as necessary. Tidy up any of the internal shelving and repaint.

To help you get the overall look to your kitchen, repaint the units in a colour which will blend with any of the fittings which cannot be changed using a good quality gloss paint. If you do not plan to change the flooring, use a colour to blend with it.

New wall tiles help to dress up the kitchen, especially if you use a toning colour. Tiling a wall is covered on pages 103 to 107. This is probably the easiest way to deal with the area around the sink, which in old kitchens is often very untidy looking, especially if it has been replumbed.

The total cost and time involved in modernizing your kitchen in this way are very small compared with the money and effort required to refit completely. The ideas shown in the next few pages can easily be adapted to suit many types of standard unit.

Right: *A new look for an old kitchen. A haphazard collection of old units can be transformed by very simple methods to make better use of the space and give a coherent look*

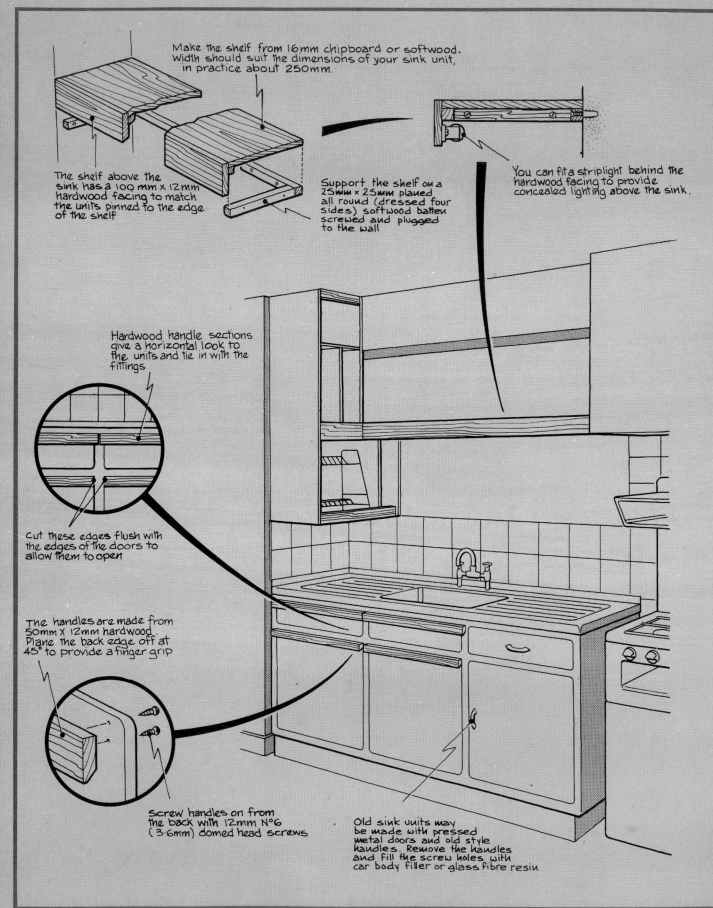

Make the shelf from 16mm chipboard or softwood. Width should suit the dimensions of your sink unit, in practice about 250mm.

The shelf above the sink has a 100mm x 12mm hardwood facing to match the units pinned to the edge of the shelf

Support the shelf on a 25mm x 25mm planed all round (dressed four sides) softwood batten screwed and plugged to the wall

You can fit a striplight behind the hardwood facing to provide concealed lighting above the sink.

Hardwood handle sections give a horizontal look to the units and tie in with the fittings

Cut these edges flush with the edges of the doors to allow them to open

The handles are made from 50mm x 12mm hardwood. Plane the back edge off at 45° to provide a finger grip

Screw handles on from the back with 12mm N°6 (3.6mm) domed head screws

Old sink units may be made with pressed metal doors and old style handles. Remove the handles and fill the screw holes with car body filler or glass fibre resin

Advertising Arts

Streamline the sink unit

Sink units can pose something of a problem when it comes to redecorating. Older ones often have cupboards and drawers made from pressed metal, and it is difficult to make structural alterations to these or even to change the handles. Wooden units are much easier to modernize, as shown on page 387. This design takes one of the metal type and looks at ways of modernizing it and getting it to tie in with the new look for the kitchen.

The first thing to do is to remove the old handles. The holes these leave will have to be filled with a filler for metal—one of the car body repair pastes is very suitable. Give the whole unit a good rubbing down and paint it to match the overall colour scheme. To get that horizontal look, you could use aluminium handle strip as shown on page 387, but the design shown uses handles made up from hardwood to match those on the other units. The drawing opposite gives details of how to make these and screw them in place.

You can continue the horizontal look by fitting a simple shelf over the sink and edging this with the same hardwood strip that was used for the units. This gives you useful hanging space for pots and pans where they can drain on to the draining board. Arrange draining space for plates and cups by making a unit to take a standard wire drainer like the one shown overleaf which can be adapted to fit most spaces.

Clive Helm

Below and below right: *The area around the sink is often untidy-looking with shabby or damaged tiles. After retiling and adding extra storage space, the whole area is transformed to be much more useful and neater*

Right: *How to achieve a new look for old doors. The pressed metal doors on this type of unit have been repainted and fitted with hardwood strips for handles to blend in with the decor and continue the line of the other units*

BMV

Clive Helm

Extra shelves above the sink

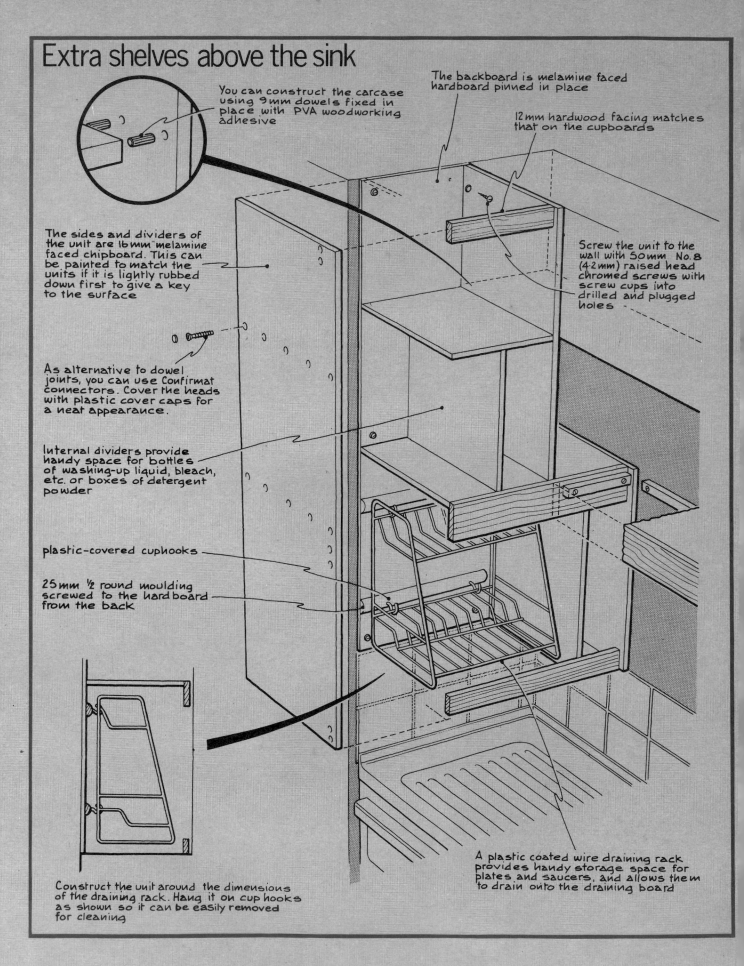

You can construct the carcase using 9mm dowels fixed in place with PVA woodworking adhesive

The backboard is melamine faced hardboard pinned in place

12mm hardwood facing matches that on the cupboards

The sides and dividers of the unit are 16mm melamine faced chipboard. This can be painted to match the units if it is lightly rubbed down first to give a key to the surface

Screw the unit to the wall with 50mm No.8 (4.2mm) raised head chromed screws with screw cups into drilled and plugged holes

As alternative to dowel joints, you can use Confirmat connectors. Cover the heads with plastic cover caps for a neat appearance.

Internal dividers provide handy space for bottles of washing-up liquid, bleach, etc. or boxes of detergent powder

plastic-covered cuphooks

25mm ½ round moulding screwed to the hardboard from the back

A plastic coated wire draining rack provides handy storage space for plates and saucers, and allows them to drain onto the draining board

Construct the unit around the dimensions of the draining rack. Hang it on cup hooks as shown so it can be easily removed for cleaning

Dress up your doors

Clive Helm

BMV

Clive Helm

Doors on older kitchen units commonly have rounded edges and moulded plastic handles. To obtain a modern, linear look, square off the door edges as shown and fit aluminium handle section along the top or bottom. Remove old style handles, fill the holes and paint the surfaces to match an overall colour scheme. Fit hardwood strips to emphasize the horizontal and co-ordinate with the sink unit.

Pin 10 mm hardwood facings to the old units with 20 mm panel pins. Sink the heads with a nail punch and fill the holes. Finish with lacquer

On upper cupboards, fit the aluminium extrusions below the doors and screw on using 15 mm No. 6 (3·5 mm) countersunk woodscrews. Make sure that the screw holes are well countersunk or the screw heads may protrude

Remove old door handles and fill the holes with stopping or filler

A 10 mm hardwood strip emphasizes the horizontal look and helps to tie the units together visually. Overlap this edging as shown so a concealed striplight can be fitted behind

Screw the handle section to the top edges of the lower doors and drawers using 15 mm No. 6 (3·6 mm) countersunk woodscrews

You can buy extruded aluminium handle section in various sections

On old cupboard doors with rounded edges plane this edge off flush

Advertising Arts

491

Redesigning the bathroom

● Causes of dissatisfaction ● Relieving congestion ● Planning a layout ● Plumbing ● Relocating drainage ● Curing condensation ● Buying bathroom furniture ● Space requirements for bathroom appliances ● Two bathrooms redesigned

H & R Johnson Tiles Ltd

Steve Cross

A. Left: *Redesigning a bathroom requires careful planning due to the expense and the scale of plumbing work involved. Approached carefully, however, a major conversion can be well worthwhile—adding comfort and luxury to your facilities*

This particular section on bathroom renovation takes an in-depth look at the roots of dissatisfaction with your existing bathroom facilities and provides a number of ideas and solutions to common bathroom problems. Redesigning a bathroom is not something that should be undertaken lightly, not only because it is likely to lead to considerable expense, but also because once the work has been done there is little you can easily do should you be unhappy with the results.

The key to successfully redesigning the bathroom therefore lies primarily in the planning stages and in the correct assessment of your particular problems. This is the subject of this section because if you do not get the initial

B. Below: *When laying out your bathroom consider the amount of space each piece of equipment needs: shown here are the basic requirements of a bath, bidet, WC, and a fully-enclosed shower cabinet*

planning just right the finished design will just not work.

Unless all you need is some form of cosmetic renovation—simple redecoration, or perhaps fitting new tiles—you will find that there are four main categories of bathroom problems: congestion; layouts; fittings; and condensation or cold. All too often a single room combines all four, but if you consider each of the problem areas carefully, you may find that solving one may make the others far easier to deal with later on.

Congestion

When too many people want to use the bathroom at the same time, this can be a major source of family friction. The best solution here is to see whether it is possible to provide extra facilities elsewhere in the house so that the whole family does not have to rely on access to a single bathroom.

Remember that a small WC and hand basin can be accommodated in a space as small as 1300mm × 800mm, so even if you are not fortunate enough to live in a large house you may be able to find room for such a project. Although a WC must always have washing facilities nearby, this need not be a problem as plenty of tiny basins are available—you can even get triangular ones designed to fit into a corner. The main restrictions concern the proximity of suitable soil and waste drainage pipes, and proper ventilation will also have to be provided (see below).

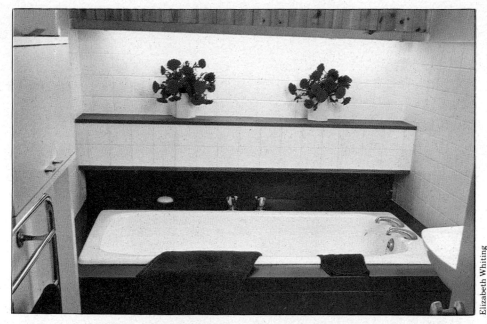

Elizabeth Whiting

C. Above: *The apparent size of this small bathroom has been increased by removing the WC and by using white paint on the walls. Concealed lighting and extra storage space add to the effect*

If you find that you can instal a separate WC elsewhere in the house, and your bathroom is very small, it is worth considering removing the existing WC and making space for a shower or bidet. The only real disadvantage in not having a WC in the bathroom is that, for families with babies, this is the ideal place for changing nappies.

Pressure on single bathrooms can also be relieved by installing wash basins in one or more bedrooms. This solution is particularly effective if some members of the household exclude others from the bathroom by lengthy make-up and hair washing sessions. Wherever possible, instal new basins where they will get maximum use. Remember that inset vanity basins can quite easily be installed in a worktop or cupboard.

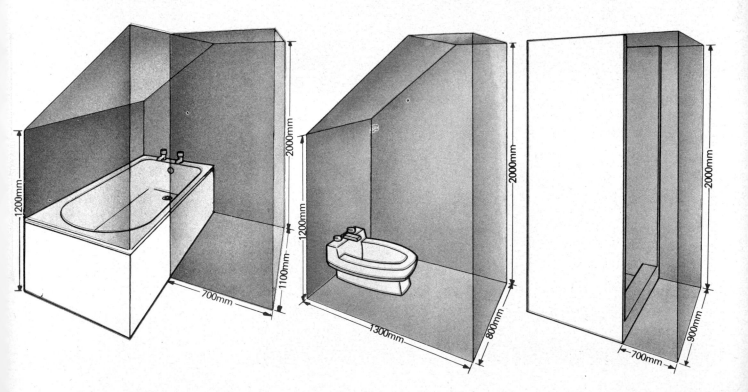

Elizabeth Whiting

D. Above: *Cheap but chic: painted brick walls and minimal ornamentation have made this attic into a useful second bathroom for very little cost*

Alternatively, you can cut down on the time that each person spends in the bathroom by installing – and encouraging the use of – a shower. These have the added advantage of using less water than a bath, and even if space or your budget excludes the possibility of fitting a separate shower, you can easily convert your present bath by fitting new taps with an integral shower attachment. A completely separate shower room, including a hand basin, needs only 1600mm × 900mm of space, and you may find that it is worth reducing the size of a large bedroom to instal one.

Layouts

Inappropriate overall design is the second area for dissatisfaction, and this can often be improved in all but the very smallest bathrooms. The two main considerations that dictate the layout are the plumbing system and the need to provide sufficient space around the various fixtures for them to be used comfortably. Otherwise, the only considerations are the positions of the windows and doors.

Use the following guidelines to help you to design a new layout.

Drainage: The first priority in drainage planning is the location of the WC as this must be close to a soil stack or drain. If you wish to move an upstairs WC it will probably be necessary to instal a new soil stack, and whereas this is perfectly possible, it can prove to be an extremely expensive option. The location of ground floor WCs is less restricted as they are usually connected directly to a drain via an underground bend; but you should keep the unit next to the outside wall near the manhole cover as laying new drains beneath floors in the house is very disruptive.

The waste pipes for the other fittings can often be run round one or more sides

494

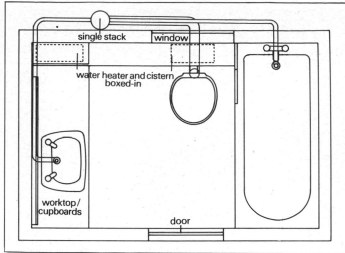

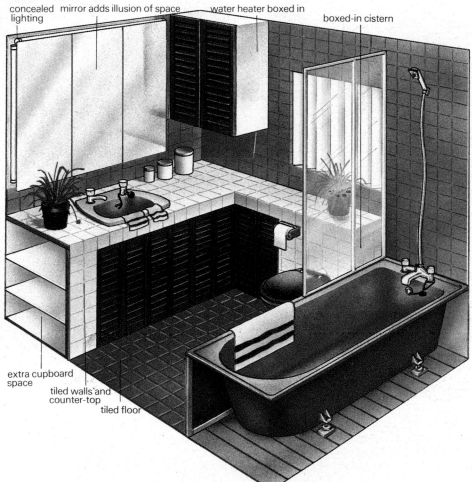
concealed lighting | mirror adds illusion of space | water heater boxed in | boxed-in cistern

extra cupboard space
tiled walls and counter-top
tiled floor

Ray Duns

Steve Cross

E. Above: *A basic but not uncomfortable bathroom. The colour scheme, badly positioned basin and inefficient use of available space offer plenty of scope for an attractive conversion*

of the room as they tend to be small diameter, but the ideal is always to aim for short pipe runs with as few bends as possible. All pipes connecting the wastes to a waste stack, combined soil/waste stack or drain (usually via a sub-stack) should slope gently downwards at the right gradients.

In the UK and in Canada, work on the drainage system is covered by building regulations and you must check that your proposed plans are acceptable. This applies for inside and outside drainage; both for new systems and for work on an existing system.

Ventilation: Regulations about general bathroom ventilation stipulate minimum standards—either by opening windows or by mechanical means (such as an extractor fan). There are also regulations concerning the ventilation of WCs, and if you are considering installing a new WC elsewhere in the house, it is essential that you check with your local building inspector that your proposals meet the minimum standards.

Plumbing: The positions of the various washing facilities in the bathroom are influenced to a degree by the supply pipes for hot and cold water. Long runs of hot water pipe are not only unsightly, but also waste energy, so these should be avoided if at all possible. In a low pressure plumbing system the priority for cold water pipes is to get a sufficient head of pressure by ensuring that the tank is placed high enough above the taps. This is usually only a problem in a flat or attic in which a shower is installed. There should be a minimum of 1200mm

between the draw off point of the cold water tank and the shower outlet. Where this is not possible, an electric pump can be fitted to boost the pressure.

Space planning: One of the major considerations in bathroom design is the space that is provided around the various fittings. If the bathroom is to be comfortable to use, you must allow sufficient area, but remember that the minimum

F. Top right: *A ground plan of one possible—and very simple—conversion*
G. Above: *A sketch of the conversion showing how the basin has been moved and boxed in to create far more storage space. All surfaces are easy-to-clean tiles, and the wall-mounted water heater is enclosed. Although the WC cistern is also boxed in, it has not been moved and no extra plumbing is necessary*

495

Ray Duns

H. Above: *A separate bathroom and WC in an old house. Both rooms are cramped, the appliances are awkwardly placed, and plumbing and wiring are obsolete*

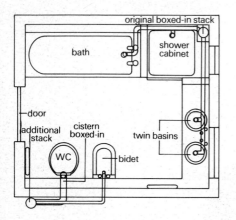

I. *A ground plan of one possible conversion. WC and bathroom have been made into one, the positions of the bath and WC interchanged, and a new soil stack installed inside the house*

adjacent floor areas given in fig. B can overlap if the bathroom is only likely to be used by one person at a time, as is often the case.

The really crucial area is around the basin where there must be at least 200mm elbow room on either side and 700mm of space in front to allow comfortable washing. Showers with walls on one or two sides need a clear floor space of 400mm next to the tray for access and dressing, while those enclosed on three sides require 700mm in front.

Make sure that you have easy access to bath taps, and a minimum space of 700mm × 1100mm next to the bath for climbing out and drying. Where children have to be supervised the more space next to the bath the better, and a stool or covered WC pan provides a useful seat for adults or for babies being dried.

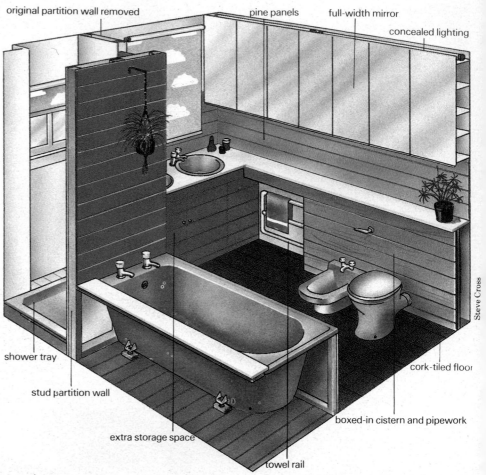

Steve Cross

J. Above: *A sketch of the conversion showing how the new large room now accommodates a bidet and a shower cabinet with its own window. Cork tiles on the floor and timber panels on the walls aid insulation and the mirrors above the boxed-in WC cistern add to the feeling of space*

If no shower is to be fitted to the bath and you do not intend standing up in it, you can position the bath below a sloping ceiling with just enough headroom to get in and sit down (fig. B). 1200mm headroom above the base of the bath is usually adequate, but check the space beforehand by going through the actions.

In the same way—and as long as there are no problems with drainage—you can fit a WC into a space with restricted headroom (for example below stairs, or under the eaves in a top floor room). 2000mm headroom is needed to stand in front of the pan, but the roofline can slope down to 1200mm behind the cistern (fig. B). Clear space of 600mm × 800mm should be left in front of the WC for access. A bidet requires similar space above and in front, plus 200mm knee space either side (fig. B).

Windows and doors: Try to avoid placing the bath next to a window as this will make opening the window difficult and will leave bathers prone to draughts. If you find that it is not possible to avoid such an arrangement, double-glazing the window will improve conditions (see pages 425 to 431). However, this may improve insulation at the expense of good ventilation and care will have to be taken if condensation is to be avoided.

Where there is a choice, avoid having the door opening to give a direct view of the WC in case it is accidentally left unlocked by the occupant. When rearranging fittings, ensure that enough space is left for the door to swing open and for a person to step into the room and shut the door comfortably. If necessary doors can be rehung to open outwards (see pages 246 to 250) but take care that they will not hit anyone passing outside if opened suddenly.

If there is a real space problem, nonstandard doors may provide the solution—610mm is an adequate width for either a bathroom or a WC. Sliding doors save space, but they are difficult to soundproof and can be awkward to use unless very carefully installed.

Fixtures and fittings

The third category of problems centres on unsatisfactory fittings, but before replacing everything in sight, make sure that the real cause of your dissatisfaction is with the design or condition of the fittings and not with the layout. Repositioning fittings is far cheaper than replacing them, so before investing in a new suite, plan your layout using the guidelines given above. However stylish a new suite, if it does not fit the available space to best advantage the bathroom will probably look better, but will certainly not work better.

Decide on the layout first as the choice of good fittings is much wider than the choice of good layouts. And when you come to choose new fittings, bear in mind that these are likely to be changed far less frequently than furniture and decorations, so take care over your choice of colour and design. Currently fashionable shapes and colours may look hopelessly outdated in 10 years time. Vast ranges of bathroom fittings are now available, varying in design, materials, colour and—inevitably—cost. The only way that you can make a good choice is by visiting a specialist bathroom showroom, or by studying the sales literature of all the major manufacturers. Take your time over your final choice, because a new suite represents a substantial investment. Also, check that the fittings of your choice satisfy local authority plumbing and drainage regulations.

K. Below: *A large and spacious bathroom which combines attractive pine panelling with the warmth of mosaic patterned vinyl sheet on the floor and bath wall*

L. Above: *Baths can be fitted into awkwardly-shaped rooms like this one, which uses cork tiles and murals to relieve the oppressiveness of a low ceiling*

Condensation/cold

A permanent solution to the problems that fall into this fourth category requires a careful analysis of existing conditions. Good ventilation and some form of permanent background heating are essential to cope with condensation caused by hot vapour-laden air meeting cold surfaces. Improved insulation and appropriate wall coverings help but are not sufficient alone.

Good ventilation will remove moisture-laden air but at the same time replace warm air with cold. A ventilation system should therefore be variable and windows should be capable of being opened wide for steamy conditions and left slightly ajar at other times. An alternative is to instal a mechanical air extraction system; as mentioned above, the regulations of many countries make this mandatory in windowless rooms.

Space heating is a good precaution against excessive condensation, but it is important to remember that walls and ceilings can be kept far below a room temperature suitable for people and still help to alleviate condensation problems. So for fuel economy it is best to have a background source to warm the structure plus a supplementary source which can be switched on when the room is in use.

Bathrooms are often neglected when general heating for the house is being considered but they should be capable of being made warmer than the rest of the house. If you have 'wet' central heating it is simplest to add another radiator to the existing system—either to increase the comfort conditions of your present bathroom or when installing a

497

separate shower room. However, this has the disadvantage that in summer when the heating is switched off there is no way of warming towels. It may be better to plumb-in a radiator or heated towel rail to the hot water system if the cylinder is situated particularly near to the bathroom. Alternatively, you could fit an electrically heated oil-filled radiator which would be sufficient to heat a smaller room.

Wall-mounted electric fan heaters or tubular radiant heaters are less satisfactory as they can only warm the room effectively if they are switched on some time in advance.

Good insulation of walls and roofs is essential, and is particularly important in older houses. If the bathroom is in an attic or on an outside wall, poor insulation frequently contributes to condensation. The insulation of brick walls can be improved by fixing foil-backed plasterboard to softwood battens screwed to the wall to leave a 25mm to 50mm air space, and roofs can be insulated by fitting glass fibre insulation quilt between the rafters and covering it with foil-backed plasterboard. The foil is essential as it prevents moisture from condensing on the rafters.

M. Above: *Despite a limited budget and lack of space, creative use of cheerful colours and accessories can transform even the pokiest bathroom*

Elizabeth Whiting

N. Above: *Imaginative use of an older cellar: walls, ceiling, and steps have all been plastered and painted, and the old skylights still provide some daylight*

O. Left: *A converted bedroom in an old cottage. The chimney breast is still a major feature while the inverted dormer window subtly illuminates the bath*

Adding a cork or timber finish to the walls or ceilings also improves the insulation value. Alternatively, use polystyrene ceiling tiles for insulation, but make sure that those you choose are designed to withstand damp conditions.

Other considerations

The four categories described above are the main problem areas to be investigated when redesigning a bathroom. However, there are some further considerations to think about before any final decisions can be taken.

Careful planning of the lighting in your bathroom can make a tremendous difference to the finished effect. The most critical area is the shaving or make-up mirror which should ideally be lit so that no part of the face is in shadows. The common arrangement of a strip light above the mirror only illuminates the top half of the face—but if you find that this is the only alternative open to you, make sure that the light is at least 500mm long.

The ideal of an arrangement similar to those used in theatrical dressing rooms in which there are rows of incandescent bulbs all round the mirror is, unfortunately, unsuitable—water splashing on the

Condor Public Relations Ltd.

498

bulbs could cause them to shatter. The best alternative is to have a strip light down each side. Alternatively, spotlights can be positioned so that they shine on the face, but in this case you have to ensure that the lights are not so close that they can be adjusted by anyone standing at the basin with wet hands.

Mirror lights may be sufficient to illuminate a small room, but if a supplementary source is required, ensure that it

P. Below: *Space efficiency in a family house: the cupboard under the stairs makes an ideal second WC and shower room to take the load off the bathroom*

does not reflect in the mirror and cause glare. In the UK, remember that light switches should be of the pull cord type in the bathroom.

Storage: Another area in which you can improve the appearance and convenience of your bathroom is in the storage facilities. The basic rule is to store items nearest to their point of use—nothing is more irritating than having to climb out of the bath dripping wet to fetch a forgotten shampoo bottle.

Collecting a litter of accessories around the rim of the bath is no solution as this makes cleaning difficult and bottles can get knocked off too easily. For the bath

the ideal solution is to provide a long narrow shelf about 100mm wide running the length of the bath and at least 500mm above it. Not all layouts can accommodate this but there is usually space for some shelving within easy reach.

Other useful storage can be made by boxing-in fixtures such as the basin. Shelving underneath is always useful, and the counter top around the basin can accommodate frequently used bottles and containers.

Medicines are traditionally kept in bathrooms but they must be kept out of reach of children. Make sure that any medicine cabinet has child-proof locks.

Condor Public Relations Ltd

Bathroom problems solved

Whatever the problem in your bathroom, there is bound to be a way round it. And quite often, it is the simplest solutions which bring about the most startling transformations

Elizabeth Whiting

holder and a brown plastic-framed mirror will complete the look and tone down the harsh qualities of the sanitary fittings.

A white bathroom suite is enlivened by covering the walls with a patterned wallpaper which has a white background. Sealed cork flooring can then be laid and run up the sides of the bath to hide the back or side panels, adding warmth to the room.

The blind or curtains could be in a design which matches the wallpaper, or in an accent colour such as bright green. With white sanitaryware, the accessories and towels will predominate: these could all be in one strong colour such as burgundy or green.

If the sanitaryware is in a pale lemon, depth can be added to the colour by tiling the splashbacks with mustard-coloured tiles and choosing a wallpaper which has the same mustard shade in its pattern. Cork tiles or fawn carpeting could be used to cover the floor and sides of the bath. Brown curtains or blinds combined with pine accessories such as

Left: *An old-fashioned bathroom suite which has been boxed-in and decorated in such a way that the eye is immediately distracted upwards*

Below: *An unusual tap arrangement, plus ingenious use of sealed cork tiles as a wallcovering and splashback, bring a traditional white suite to life*

Disguising old fittings

Moving into a new home often means that you have also inherited a modern bathroom suite in a pale colour which you do not like. But clever use of decoration and accessories can either underplay the colour of the suite by drawing attention away from it, or else make it seem a warmer shade.

If your bathroom has a pale pink bathroom suite, give it a more sophisticated look by choosing a patterned wallpaper containing dusky pink as a predominant colour. Cover the floor with a washable brown carpet, running it up the sides of the bath.

If the wallpaper has a co-ordinating fabric, make blinds or curtains in this —or from a dusky pink or deep brown fabric. Brown accessories, such as bath rack, soap dish, toothbrush

Crayonne

If the inside of a cast-iron bath is in a bad condition it can be painted with an enamel bath paint—although this is not always very successful. It is better just to clean the bath with an extra-strong cleaning agent.

Where the bathroom has old sanitaryware it is sensible to choose 'classic' style decoration which will blend sympathetically with the suite. Carefully chosen, a marbled or embossed paper will add an unmistakable 'vintage' character to a bathroom—useful if you are trying to make the most of old wall tiles.

The basin: An unsightly wash basin can be largely hidden by building a vanitory unit around it. This will not only smarten up the basin—hiding the plumbing underneath—but also provide storage space for toilet requisites. Again, new taps can be added for an improved appearance, as can a new plug and chain.

The wc: An old high-level cistern can be disguised by building a cupboard around it, with a hole drilled in the base for the chain and handle. A new chain and handle will help and the wc seat can easily be replaced by bolting on a new one. The addition of a new seat cover and pedestal mat gives the wc a fresh lease of life.

Left: *Colour-matched accessories give a small bathroom an uncluttered appearance, especially if the towels are chosen to harmonize*

Below: *A standard toilet made far from ordinary. The paper-holder and painting add a touch of class*

Bill McLaughlin

towel rail, shelf and bath rack will make the suite seem bolder.

A sky blue bathroom suite can be made to seem deeper and more dramatic by covering the walls in either deep blue tiles or a deep blue patterned wallpaper. Flooring could be in a shade such as beige—carried up the sides of the bath—and matched to deep blue plastic accessories, beige towels and deep blue bath set.

Accessories

Although redecorating is the most obvious way of changing the face of a bathroom, equipping it with new accessories can be just as effective and certainly requires less effort. The accessories can be used to colour coordinate with the sanitaryware giving your bathroom a certain 'look'—bold and vibrant; streamlined and efficient; contemporary; or even a look which is predominantly female. It may have to be a family decision.

A huge range of fitments—in metal, ceramics and plastic—is available from department stores, chain stores and specialist bathroom shops. You can buy not only a whole range of accessories in one colour and style, but colour matched towels and bath mats as well. In a large bathroom there is scope for mixing the colour of accessories, but in a small one, matching accessories are easier on the eye.

If sanitaryware has passed its prime in terms of appearance but still functions perfectly, you can improve things by using clever disguise tactics.

The bath: Boxing-in an unattractive bath can drastically improve its appearance. Hardboard can be fitted around the bath underneath the lip and then decorated with paint or wallpaper—sealed with polyurethane varnish to protect it from splashes. Alternatively, floor coverings such as sealed cork, vinyl or carpeting can be continued from the floor right up the sides of the bath.

Rather than trying to disguise an old bath which has cast-iron legs or ball and claw feet, you can make it a feature of the bathroom by painting the outside in a bold colour.

Bill McLaughlin

Above: *Even in dark colours, a bathroom can look spacious—if enlivened with bright accessories*

Lack of space

Where space in a bathroom is limited, the illusion of extra space can be created by careful choice of decor. There are three principal ways to visually enlarge a room—by using colour, by carefully arranging the wall decoration or by using mirrors.

Pale colours cause the walls to 'recede', making the overall space appear correspondingly larger, while bright dominant shades tend to bring the walls closer together.

The same is true when choosing patterned wallpaper or tiles for the walls of a small bathroom—a small pattern in a muted colour makes the room seem larger while a bold pattern in a bright colour overwhelms small rooms and creates an oppressive, claustrophobic effect.

Hanging wallpaper horizontally is yet another way of creating an illu-sion of extra space, linear-patterned wallpapers being the most effective. This technique can also be employed to seemingly alter the shape of the room, using horizontal wallpaper on just one or two walls.

Mirrors give a more solid illusion of enlarged space. As an added bonus, they make a dark room seem lighter by reflecting whatever space is avail-able around the room. On an end wall, a large mirror makes the bath-room seem twice as long: a large mirror on a side wall makes the room look twice as wide.

Mirror tiles, either tinted or plain, are another sensible choice for the bathroom. Easy to fix to the wall—they have adhesive pads at the back of them—they are easier to handle than a large sheet mirror. And because the joints break up reflected images, they can be used more extensively without fear of having your reflection follow you around. Like all mirrors, mirror tiles should be fitted so that air can flow behind them—damp tends to ruin mirror finishes.

Ugly pipework

Old bathrooms often contain a great deal of ugly pipework in need of dis-guising. This can either be done by boxing in the exposed pipes, or by fitting wood panelling over them.

As wood panelling can be secured over almost anything—including old ceramic tiles and chipped walls—it is an effective way of disguising pipe-work as well as being an attractive form of decoration. The panelling can be vertical, horizontal or diagonal.

An alternative way to approach the problem of exposed pipes is to actually make them a feature of the room by picking the pipework out in bright, strong colours.

The Picture Library

Above: *V-jointed pine-panelling is a smart way to liven up a bath and hide its plumbing. Matching shutters complete the 'country' look*

Below: *What you cannot conceal— decorate! Given vivid treatment, ugly pipework is transformed into a main feature of the room*

Susan Griggs

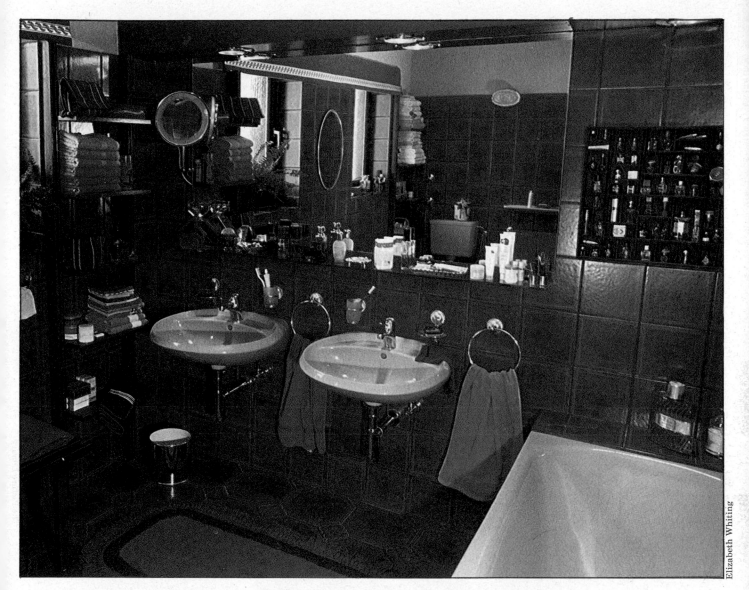

Storage problems

In a small bathroom every bit of spare space may need to be utilized for storing things.

Open shelves: Open shelving—made from materials such as sealed or painted solid timber or melamine-faced chipboard—can be used satisfactorily to store many items. Glass needs to be kept spotlessly clean to look its best.

Narrow shelves can be fitted in many places in a bathroom, such as along the wall side of the bath; above the bath taps; above the wc cistern; and even between the wc bowl and cistern. Take care when storing breakable items such as glass bottles and jars on shelves above the wash basin as they could chip or shatter the enamel if they fell.

Basin: Building a vanitory unit around a basin provides a logical

Above: *If you have nowhere to put things, flaunt them as brazenly as the bathroom permits*

place to store toiletries with the added advantage that plumbing and waste pipes are hidden. Drawbacks are that water tends to lie on the surface of the unit in puddles while the edge detail between basin and surface often becomes grimy.

Medicine cabinets: Mirror-fronted cabinets are sold in a variety of materials, including pine, enamelled steel and coloured plastic and many are included in co-ordinated accessory ranges. Some cabinets have fluorescent lighting above the mirror, shaving sockets, drawers and shelves, and items such as toothbrush racks fitted inside them.

If there are children in the household, the cabinet will have to be lockable.

Cold and damp

A bathroom which has a cold floor—both to the touch and in appearance—not only makes the room look clinical, but also shocks the senses when early morning bare feet come into contact with it. A floorcovering which is soft to the touch and easy on the eye will make the bathroom a more comfortable place and create a feeling of cosiness and warmth.

The idea of carpeting a bathroom is often dismissed as being impractical, both because of the expense and because of the amount of water likely to be splashed around. However, synthetic fibre carpeting—in materials such as acrylic and nylon—is sold by a number of manufacturers. This has a synthetic or rubber backing which does not absorb water—and consequently does not rot. For a luxurious look, the carpeting can be extended

Space-saving storage

Gavin Cochrane

Above and left: *The completed project in soft, neutral colours which blend beautifully with the bath and which allow any number of colours of accessories to be displayed. Note how neatly the sliding door arrangement has been extended underneath the tiles. The space created here can be used for dirty washing or other bathroom effects such as spare toilet paper or washing powder*

Use high rebate so doors can be removed by lifting and pulling forward

One of the most irritating features of a small bathroom is the lack of storage space. In this design, every bit of space is put to good use. The area surrounding the bath has been boxed off with sliding doors and can be used for storing such unsightly items as floor cloths and other cleaning materials.

An inset section in the wall has been created by constructing a simple framework of softwood battens, then screwing chipboard sheets over the top. This makes an ideal surface on which to lay ceramic tiles.

The glass shelves set into the tiled alcove can display some of the more attractive bathroom accessories: bottles of perfume, boxes of soap, storage jars full of crystals or plants.

A great advantage of the design is that it can be easily adapted to suit your own personal needs—all you need to do is choose tiles and paint which match the existing decor.

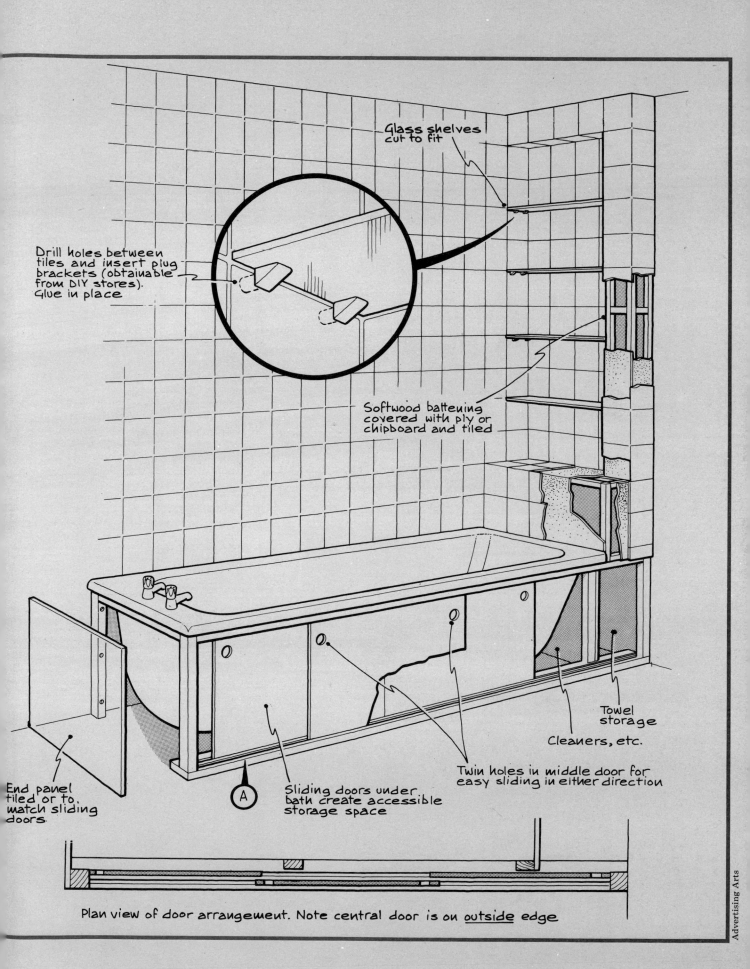

Glass shelves cut to fit

Drill holes between tiles and insert plug brackets (obtainable from DIY stores). Glue in place

Softwood battening covered with ply or chipboard and tiled

Towel storage

Cleaners, etc.

Twin holes in middle door for easy sliding in either direction

Sliding doors under bath create accessible storage space

End panel tiled or to match sliding doors

Ⓐ

Plan view of door arrangement. Note central door is on outside) edge

up the sides of the bath.

Vinyl floorings—sold in both sheet and tile form—are relatively soft underfoot and come in a wide variety of patterns and colours. They, too, can be extended up the sides of the bath to hide the back and side panels. The greatest advantage of vinyl flooring is that it is easily cleaned and does not require polishing.

Sealed cork tiles add a warm touch to a cold-looking bathroom and like other tiles, can be taken up onto the walls and surfaces around baths and wash hand-basins.

Where a bathroom has a solid flooring such as ceramic tiles, it can be 'softened' by the addition of a cotton, tumble-twist rug. These are available in a variety of shades to colour co-ordinate with your bathroom decor and can be taken up and machine washed.

Condensation is often the biggest single problem in a bathroom, especially where gloss paint and ceramic tiles have been used on the walls. An extractor fan copes effectively with this by carrying the water-laden air away before it condenses. It has the added advantage of keeping the room fresh, dispensing with the need to keep the window open. But because it carries out a lot of warm air, an extractor fan is not suited to a bathroom which is already cold.

Condensation can also be minimized

Above: *Coldness has been banished from this bathroom by using warm colours*

Below: *Lift dull white tiles from a 'clinical' level with bold poster colours and dramatic coloured tiles*

by keeping the bathroom warm and if you have not got central heating, a wall fire or heated towel rail combined with warm furnishings should help. Wall fires must be operated by a pull cord and should be fitted high enough that they cannot be touched with wet hands.

The limitations set by your heating and ventilation should be considered when you are choosing decorations. An attractive stone floor will be unbearably cold without underfloor heating. Likewise, metallic-papered walls will create endless condensation problems without proper ventilation.

Problems with tiles

Where bathroom walls have been tiled, they may be chipped and cracked. Or, if they have been used only for splash surfaces and window ledges, they may leave random shapes.

If you decide to replace the tiles you do not need to remove the old ones and make good the wall underneath; provided they are firmly fixed, you can apply new tiles over them.

An economical way of disguising tiles which are basically sound but look dingy is to paint them with two or three coats of vinyl gloss in a shade to match the decor.

Alternatively, you could stencil patterns on individual tiles at regular intervals.

INDEX

cross pein hammer, 11, 118
cross-tongued mitre joint, 145–6
Croydon valve, 389
curing concrete, 288
cutting-in (painting), 74
cyanacrylate adhesive, 125

D

damp problems, 82, 89, 92–3, 258
damp-proof course/membrane, 191–2,
 235, 236, 291, 295, 305
death watch beetle, 261
decay in wood, 241, 256–9
decking, roof, 298
decorating tools, 12
demolition, loadbearing wall, 184–192
diagonal bridging, *see* herring-bone
 strutting
direct flow hot water system, 377–8,
 382
donkey's ear, 145
 design, 149
door closer, automatic, 268, 269
door strips, 423
doors
 decoration, 73–4, 75
 fire resistance, 268–9
 hanging, 248, 250
 hinge fixing, 246–7
 repairing, 246–250
 sealing, 422–3
 unsticking, 248–9
doorways, in stud wall, 197–8
double glazing, 425–438
 benefits, 425–6, 430, 435–6
 condensation, 429–30
 fitting, 430–31, 432–4
 insulation value, 428
 maintenance, 436
 types of, 425, 434
double socket outlets, 464–5
dowelled mitre joints, 147
downlighters, 171
downpipes (downspouts), 349–50, 353
 fitting, 411–12
 painting, 83–4
drain auger, 398
drain blockages, 398–402
drain-waste-vent, 401
drainage, bathroom, 494
draining rack, 490
draughtproofing, 420–24, 430
drill bits, 11, 39–43
drill tidy design, 44
drilling technique, 122
 masonry, 42
 screw holes, 120–21
drills, 11
 electric, 32–7, 118
 sanding attachments, 54–5

drip groove, 333
drum sanders, 56
dry lining, 212–13, 217–19
dry rot treatments, 256–9
dustbin screens, 324–5

E

Earthing, 455
eavestroughs, *see* guttering
efflorescence, 88
eggshell finish, 77
electricity principles, 453–7
 regulations, 453, 462
electronic loop detectors, 473
emulsion paints, 77
end nailing, 197
engineering bricks, 282
engineer's hammer, *see* ball pein
 hammer
English bond, 278
English garden wall bond, 278–9
environment, working, 28–9
epoxy adhesives, 125
expansion tank, 378, 405
extension leads, 30
exterior painting, 82–6
 walls, 91
extractor fans, 439–40
 ceiling-mounted, 442
 ducts for, 442, 444
 electrical connections, 444
 wall-mounted, 440–41, 448–9
extractor hood, 447, 450–51

F

Face bricks, 282
face nailing, 197
fascias, 298, 301
feather fence, 363
feathered mitre joint, 145–6
felt, roofing, 303–305
 removing, 310
fence, close-boarded, 318–25
fence post repairs, 361–2, 364
fencing repairs, 360–64
fencing spurs, 361
fender wall, 234–5
file clamp, 23
files, 11
fillers, 61, 72, 85
finish plaster, 207
finishing coat, 210
fire alarms, 269–70
fire blankets, 270
fire check boards, 268
fire doors, 268–9
fire precautions, 30, 265–70
 danger points, 266–7, 270

extinguishers, 270
fire resistant materials, 267–9
fire stops, 268
fireplace construction, 201–206
firmer chisels, 111
firring pieces, 298, 302
fixed wiring, 458
fixing strips (for slates), 357
flagstone paths, 369
flaking paint, 84–5
flame retardant paint, 269
flap wheels, 56
flashing, roof, 303–304
 fixing, 311
flat bits, *see* spade bits
flat roof construction, 296–305
Flemish bond, 278
Flemish garden wall bond, 279
flex, electrical, 458
flexible wiring, 458
float, skimming, 208
float glass, 339
float valves, 387–8
floating coat, 207, 208–10
floorboards
 fixing, 224–9
 stripping, 230–233
floors
 making-good, 191, 238–9
 sanding, 231, 233
 smoke leakage prevention, 268
floor covering
 bathroom, 503, 505
 vinyl, 92–5, 98
floor joists, 234–9
floor tiling, 92–5, 97–102
 quarry tiles, 172–7
flooring saw, 226
flow booster, 381
flue blocks, 205, 206
fluorescent lighting, 169
fluting, 39–40
formwork, concrete, 286
frass, 261, 262
furniture beetles, 260–61
fuses, 455
 mending, 456

G

Gable roofs, 354
Garston ball valve, 389
gauged mortar, 279
gauges, maintenance of, 19
gauging (brickwork), 273
G-cramps, 10, 125
glass
 circular holes, 449
 cutting, 242
 drilling, 43
 replacing, 338–42

window glass, 435–6
see also under fire precautions
sanding
 by hand, 153
 floor, 231, 233
 power, 53–8
sanding block, 153
sanding discs, 55
sarking, 298, 302
sash cords, renewing, 242–3
sash cramps, 10, 125
sash windows, 245, 247–9
saw teeth, 22
saw vice, 26
sawing technique, 152–3
saws, 10, 150
 jamming, 153
 maintenance, 21–4
 power, 45–52
scaffolding, 90
scotch glue, *see* animal glue
scrapers, sharpening, 18–19
scratcher, 208
screwdrivers, 11, 25, 118
screwholes, drilling, 120–21
screws, types of, 121
scrolling blade, 52
sealed units, 427, 432, 434
secondary glazing, 425, 432–4
secondary-sash glazing, 427
security precautions, 155–9
semi-dry screed, 174–5
serving hatch design, 182–3
setting (saw), 23
setting coat, 207
shank hole, 120
sharpening processes, 16–19, 130–31
sheet vinyl, 101–102
shingles, asphalt, 359
shower heater, electric, 381, 384–5
 circuit, 468, 470
showers, 380–85
silica gel, 429
silicon carbide paper, 11
sills, window, 332–7
single stack drainage system, 401
sink unit, modernizing, 488–9
siphonic W.C. pan, 387
site preparation, 285–6
sizing, 61
skew nailing, 197
skylights, 307
slate roofs, 354–9
 removing, 310
slater's tools, 357
sleeper walls, 234
sliding bevel square, 143
sliding-sash windows, 240
slip stones, 15
slot cutting, 49
soakers, 311
socket outlets, 462–5

sofa design, 133–5
soffits, 298, 301
solid strutting, 236
sound detectors, 475
sound insulation, 428–9
spade bits, 25, 40–41
spanners, 12
spindles, leaking tap, 373, 375
spirit-level, 10
split level cookers, 468
spokeshaves, sharpening, 18
spot board, 207
sprigs, glazing, 341
spur
 electrical, 464–5
 fence post, 361–2
square-edge boards, 224, 228
stabilizing solution, 89
stains, carpet, 255
staircase, 161–5
 building regulations, 165
sticking windows, 244
stile (timber), 136, 249
stone sills, 336
stopcocks, 377
stop-valve tap, 373
storage space, bathroom, 499, 503, 504
storage tanks, 377
storm windows, 425
S-trap, 387
stretcher bond, 273, 278
strip lighting, 169
stripping floorboards, 230–233
stripping wallpaper, 61
strip, leather, 16
strutting, 298
stucco, *see* rendering
stud wall, 193–200
 felt-covered, 200
 openings in, 181, 182
studio windows, 312–17
Supataps, 372–3
super glues, 125
swan neck, 350
swing brace, 118
switch fuse unit, 471
swivel nozzles, leaking, 375
synthetic resin cements, 125
syphonage, 400–401

T

Tamping beam, 287
tank cutter, 42
tape measure, 10
taping knife, 220
taps, repairing, 371–5
tarmac drive repairs, 367–9
teapot stand design, 142
template former, 100
tenon joints, 136–41

tenon saw, 10, 22, 150
thermal transmittance, 428
thermal wallboard, 212, 217–18
thermostats, 404, 405
13 amp circuits, 462–5
30 amp supply circuits, 466–71
thixotropic paints, 77
throat forming lintel, 203, 205
throat restrictor, 203
tiled step feature, 96
tiles
 ceramic, 103–109
 cork, 93
 floor, 92–5, 97–102
 quarry, 172–7
 removing, 310
 renovating, 506
 vinyl, 92–5, 98
tile-topped table, 108–109
tiling, preparing a floor, 92–96
timber preservatives, 319, 360–61
tingle, 282
toe nailing, 197
toilets, 386–92
tongued-and-grooved boards, 224,
 225–6, 228
tool kit, 9–14
tools, 9–12
 maintenance of, 15–26
 storage of, 12
topping, 23
Torbeck valve, 389–90
toxic substances, precautions with,
 30–31
trimming joists, 237
trinket box design, 116–17
triple-glazing, 425
trowel
 gauging, 208
 laying-on, 207
try square, 10, 151
twin socket outlets, 464–5
twist bits, 39, 40
 sharpening, 25
Tyrolean finish, 346, 347

U

Ulmia cramp system, 145
ultrasonic detectors, 472
undercoat, 73
urea formaldehyde adhesive, 125

V

Vacuuming carpets, 253
valleys, roof, 356
 flashing, 359
vapour barriers, 416
vapour check wallboard, 212

ventilation
 bathrooms and W.C., 439–445, 495
 kitchen, 446–451
 mechanical, 439–44, 446
ventilation ducts, 441, 443, 447
verge slate, 354
vibration contacts, 475
vice, 10
vinyl tiles, 92–5, 98
vinyl sheet, 101–102
voltage, 453

W

Wallboard, 211–12, 217–18
wallpapering, 60–65
 borders, 64
 ceilings, 66–70
wall-plates
 for joists, 235
 for roof, 296, 299
wall supports, 186–7, 188, 189–90
walls

building a stud, 193–200
making holes in, 178–83
painting, 76–9
painting outside, 88–91
Warrington hammer, *see* cross-pein
 hammer
wash basin, 501
washdown W.C. pan, 387
washer replacement, 371–3
washing machine, plumbing in, 393–7
Washita stone, 15
water bar, steel, 333
water supply systems, 377
watts, 453
W.C. pans, 386–92, 501
W.C. cisterns, 387
web cramp, 125, 145
wedged joints, 137, 141
wet and dry paper, 11
wet central heating system, 378–9,
 403–404
wet and dry rot, 256–264
 wet rot treatments, 256, 259
whetstone, *see* oilstone

window catches, 159
window frames, 240–245
window locks, 159, 438
window reveals, papering, 64
window sills, 332–7
windows
 painting, 74, 84
 roof, 306–11
 sealing, 422–3
 studio, 312–17
 tiling around, 105
wine rack design, 154
wire fuses, 456
wiring, electrical, 458–61
wobble washers, 49–50
wood bits, 40
woodboring weevil, 261
woodwork painting, 71–4
woodworm, 260–64
 treatment, 262–4
workbench, 9, 150
workshop safety, 27–31
wrenches, 12